CALIFORNIA

3-WAY FINE ARTS RELOCATION SERVICES 408.745.7500
1120 Karlstad Dr., Sunnyvale 94089

CONTEMPORARY INSTALLATION 213.931.3800
5142 W. Jefferson Blvd., Los Angeles 90016

FINE ART SHIPPING INC. 800.421.7464
1721 21st St., Santa Monica 90404 FAX: 213.828.0232

L.A. PACKING & CRATING, INC. 213.837.5991
8501 Stellar Dr., Culver City 90232 FAX: 213.837.5995

NIPPON EXPRESS LOS ANGELES (AIR CARGO) 213.536.6200
5422 Rosecrans Ave., Lawndale 90260

NIPPON EXPRESS LOS ANGELES (OCEAN CARGO) 213.532.6300
970 Francisco St., Torrance 90502

NIPPON EXPRESS SAN FRANCISCO (AIR CARGO) 415.583.4480
401 E. Grand Ave. S., San Francisco 94080

NIPPON EXPRESS SAN FRANCISCO (OCEAN CARGO) 415.761.1411
400 Valley Dr., Brisbane 94005

PRECISION PACKING & FRAMING, 801 N. Lake St., Burbank 91502 213.849.2113

PROFESSIONAL PACKERS & FORWARDERS, INC. 213.202.6800
5930 W. Jefferson Blvd., Los Angeles 90016 FAX: 213.202.7889

RICHARDSON FINE ART HANDLERS 415.431.3828
540 De Haro St., San Francisco 94107

SHIP/ART INTERNATIONAL 800.878.0100
2425 Fillmore St., Ste. 200, San Francisco 94115 FAX: 415.952.8958

FLORIDA

ARTMOVES INC., 225 Northwest 26th St., Miami 33127 305.576.7576

ILLINOIS

ALLIED VAN LINES SPECIAL PRODUCTS DIV. 708.717.3000
300 Park Pl., Naperville 60563

TERRY DOWD, INC. 312.342.1808
1808 N. Damen Ave., Chicago 60647 FAX: 312.342.8650

ICON SERVICES CORPORATION 312.733.4266
417 N. Sangamon St., Chicago 60622 FAX: 312.733.6496

NIPPON EXPRESS (AIR CARGO), 1151 Ellis St., Bensenville 60106 708.350.7400

NIPPON EXPRESS (OCEAN CARGO) 708.350.0202
950 N. Edgewood Ave., Wooddale 60191

INDIANA

NORTH AMERICAN VAN LINES, P.O. Box 988, Fort Wayne 46801 219.429.3775

MARYLAND

U.S. ART CO., INC., 8350 Bristol Ct., Jessup 20794 800.253.3151

MASSACHUSETTS

U.S. ART CO., INC. 800.872.7826
16 Randolph St., Boston 02118 FAX: 617.338.5337

MISSOURI

UNITED VAN LINES, 1 United Dr., Fenton 63026 314.326.3100

NEW MEXICO

THE ART HANDLERS, 1570 Pacheco, Ste. E14, Santa Fe 87501 505.982.0228

SOUTHWEST CRATING, 418 Montezuma St., Santa Fe 87501 505.988.3888

NEW YORK

ARTPAK 914.232.1502
43 Katonah Ave., Katonah 10536 FAX: 914.232.3831

ARTPAK TRANSPORT LTD. 212.529.1987
708 Broadway, New York 10003 FAX: 212.529.1169

CIRKER'S HAYES STORAGE WAREHOUSE INC. 212.838.2525
305 E. 61st St., New York 10021 FAX: 212.486.3188

D.A.D. TRUCKING INC. 212.226.0054
419 Broome St., New York 10013 FAX: 212.226.1070

EAGLE TRANSFER 212.966.4100
401 Washington St., New York 10013 FAX: 212.966.4828

FINE ARTS EXPRESS 718.361.7357
3500 47th Ave., Long Island City 11101 FAX: 718.937.9707

HUDSON SHIPPING CO. 212.487.2600
90 West St., New York 10006 FAX: 212.487.2637

JUDSON ART WAREHOUSE, INC. 718.937.5500
49-20 Fifth St., Long Island City 11101 FAX: 718.937.5860

W.R. KEATING & CO. 718.481.5400
150-16 132nd Ave., Jamaica 11434 FAX: 718.528.0871

MASTERPIECE INTERNATIONAL 212.825.7000
90 Washington St., New York 10006 FAX: 212.825.7010

NIPPON EXPRESS (AIR CARGO), 10 E. 37th St., New York 10016 212.683.4940

NIPPON EXPRESS (OCEAN CARGO) 212.432.9490
1 World Trade Center, #1769, New York 10048

OLLENDORFF FINE ARTS, 21-44 44th Rd., Long Island City 11101 800.221.6500

SOFIA BROS., INC., 475 Amsterdam Ave., New York 10024 212.873.3600

U.S. ART CO., INC., 159 21st St., Brooklyn 11232 718.788.3217

TEXAS

FINE ARTS EXPRESS SOUTHWEST 713.691.5461
465 West 38th St., Houston 77018 FAX: 713.691.0123

WASHINGTON

ARTECH 206.284.8822
169 Western Ave. W., Seattle 98119 FAX: 206.284.3743

NIPPON EXPRESS, 18303 8th Ave. S., Seattle 98148 206.243.7891

CANADA

BRITISH COLUMBIA

NIPPON EXPRESS 604.278.8022
Vancouver Int'l. Airport, Bldg. D, Richmond V7B 1T9

ONTARIO

CURRIER & SMITH LIMITED 416.599.6421
333 Adelaide St. W., 3rd Fl, Toronto M5V1R5 FAX: 416.599.2548

NIPPON EXPRESS (AIR CARGO) 416.676.0800
Peason Int'l. Airport, Bld. B, Rm. 101, Toronto AMS L5P 1B2

NIPPON EXPRESS (OCEAN CARGO) 416.671.3420
6390 N.W. Dr., Mississauga L4V 1S1

PROVINCE OF QUEBEC

NIPPON EXPRESS 514.631.6436
Montreal Int'l. Airport, Bld. 3, P.O. Box 551, Jorval H4Y 1B3

MEXICO

FEDERAL DISTRICT

NIPPON EXPRESS 525.211.5580
Rio Elba 10, 202, Col. Cuauhtemoc, C.P. 06500 Mexico

THE JOURNAL OF ART 212.387.3650
300 Park Ave. S., New York, NY 10010
Frequency: 10 Issues; Subscription Rate: $40/year
Editor: Daniela Guglielmino, Managing Editor

'OLE WORLD 415.671.9852
P.O. Box 5986, Concord, CA 94524
Frequency: Bi-Monthly; Subscription Rate: $15/year
Editor: Zachary Shatz

'RAVELING EXHIBITION INFO SERVICE NEWSLETTER 813.581.7328
P.O. Box 1608, Largo, FL 34294
Frequency: Bi-Monthly; Subscription Rate: $30/year Non-profit; $35/year others
Editor: S.R. Howarth

JMBRELLA 818.797.0514
P.O. Box 40100, Pasadena, CA 91114 FAX: 818.794.5445
Frequency: Irregular; Subscription Rate: $15/year Individuals; $25/year Institutions
Editor: Judith Hoffberg

'IE DES ARTS 514.282.0205
200 St. Jacques, Ste. 600, Montreal, PQ H2Y 1M1 FAX: 514.282.0235
Frequency: Quarterly; Subscription Rate: $27/year Canada
Editor: JeanClaude LeBlond

VALTERS ART GALLERY BULLETIN 301.547.9000
600 N. Charles St., Baltimore, MD 21201 FAX: 301.783.7969
Frequency: 10 Issues; Subscription Rate: $12/year
Editor: Valerie Arnade

WASHINGTON INTERNATIONAL ARTS LETTER 515.255.5577
P.O. Box 12010, Des Moines, IA 50312
Frequency: 10 Issues; Subscription Rate: $40/year Individuals;
$57.60/year Institutions
Editor: Nancy Sandel, Editor-in-Chief; Critic: James Duncan

VESTART 916.885.0969
P.O. Box 6868, Auburn, CA 95604
Frequency: 24 Issues; Subscription Rate: $15/year
Editor: Martha Garcia

▶AILY NEWSPAPERS

ATLANTA JOURNAL & CONSTITUTION 404.526.5151
P.O. Box 4689, Atlanta, GA 30302 FAX: 404.526.5509
Editor: Bob Longino, Special Svcs.; Critic: Catherine Fox

OSTON GLOBE 617.929.2000
P.O. Box 2378, Boston, MA 02107 FAX: 617.929.3186
Editor: Mary Jane Wilkinson, Arts; Critics: Christine Temin & Nancy Stapen

OSTON HERALD 617.426.3000
P.O. Box 2096, Boston, MA 02106 FAX: 617.695.9949
Editor: Bill Weber, Asst. Managing Editor, Arts & Entertainment; Critics: Joanne Silver & Mary Sherman

CHICAGO SUN-TIMES 312.321.3000
401 N. Wabash, Chicago, IL 60611
Editor: P.J. Bednarski, Entertainment

CHICAGO TRIBUNE 312.222.3232
435 N. Michigan Ave., Chicago, IL 60611
Editor: Doug Balz, Arts; Critic: Alan Artner

CINCINNATI POST 513.352.2000
125 E. Court St., Cincinnati, OH 45202 FAX: 513.621.3962
Editor: Nancy Berlier, Features; Critic: Jerry Stein

DALLAS MORNING NEWS 214.977.8222
P.O. Box 655237, Dallas, TX 75265 FAX: 214.977.8321
Editor: Tom Kessler, Arts & Entertainment; Critic: Janet Kutner

DALLAS TIMES HERALD 214.720.6111
1101 Pacific, Dallas, TX 75202 Fax: 214.720.6841
Editor: Hector Cantu, Asst. Features Editor

DENVER POST 303.820.1010
1560 Broadway, Denver, CO 80202
Critic: Steve Rosen

DETROIT FREE PRESS 313.223.6400
321 W. Lafayette, Detroit, MI 48226 FAX: 313.222.4726
Editor: Peggy Castine, Entertainment; Critic: Marsha Miro

HOUSTON CHRONICLE 713.220.7171
P.O. Box 4260, Houston, TX 77210
Editor: Melissa Aguilar, Arts & Entertainment

LOS ANGELES TIMES 213.237.7000
Times-Mirror Square, Los Angeles, CA 90053
Editor: Charles Champlin, Arts; Critic: William Wilson

MIAMI HERALD 305.350.2111
1 Herald Plaza, Miami, FL 33136 FAX: 305.376.3508
Editor: Ileana Oroza, Arts & Entertainment; Critic: Helen Kohen

MINNEAPOLIS STAR TRIBUNE 612.673.4000
425 Portland, Minneapolis, MN 55488 FAX: 612.673.4359
Editor: John Habich, Arts & Entertainment; Critic: Mary Abbe

NEW YORK TIMES 212.556.1234
229 W. 43rd St., New York, NY 10036
Editor: John Kimmerman, Arts; Critic: Roberta Smith

PALM BEACH DAILY NEWS 407.655.5755
265 Royal Poinciana Way, Palm Beach, FL 33480 FAX: 407.655.4594
Editor: Joanna Hill; Critic: Michael Gaeta

PHILADELPHIA INQUIRER 215.854.2000
400 N. Broad St., Philadelphia, PA 19101 FAX: 215.854.4795
Editor: Howie Shapiro, Fine Arts; Critic: Ed Sozanski

PHOENIX GAZETTE 602.271.8000
120 E. Van Buren, Phoenix, AZ 85002 FAX: 602.271.8911
Editor: Dave Wagner, City; Critics: Ken La Fave & Lynn Pyne

ST. LOUIS POST-DISPATCH 314.622.7000
900 N. Tucker, St. Louis, MO 63103 FAX: 314.622.7093
Editor: Robert Duffy, Arts & Entertainment

SAN FRANCISCO CHRONICLE 415.777.1111
275 5th St., San Francisco, CA 94103
Editor: Ken Baker, Arts

SCOTTSDALE DAILY PROGRESS 602.941.2300
7320 E. Earll Dr., Scottsdale, AZ 85252 FAX: 602.946.9354
Editor: Doug McDaniel, Scottsdale Life; Critic: Joe Young

SEATTLE TIMES 206.464.2111
P.O. Box 70, Seattle, WA 78111 FAX: 206.382.8879
Editor: Jan Even, Arts & Entertainment; Critic: Delores M. Tarzan Ament

SUN SENTINEL 305.356.4000
200 E. Las Olas Blvd., Ft. Lauderdale, FL 33301 FAX: 305.356.4676
Editor: John Dolen, Entertainment; Critic: Roger Hurlburt

TORONTO STAR 416.367.2000
1 Younge St., Toronto, ON M5E 1E6 FAX: 416.869.4416
Editor: Vian Ewart; Critic: Christopher Hume

USA TODAY 703.276.3400
1000 Wilson Blvd., Arlington, VA 22229 FAX: 703.247.3196
Editor: Susan Weiss, Managing Editor of Life; Critic: David Patrick Stearns

VANCOUVER PROVINCE 604.732.2222
2250 Granville, Vancouver, BC V6H 3G2 FAX: 604.732.2720
Editor: Peter Clough; Critic: Art Perry

THE WALL STREET JOURNAL 212.416.2000
200 Liberty St., New York, NY 10281 FAX: 212.416.2658
Editor: Raymond Sokolov, Arts & Leisure

THE WASHINGTON POST 202.334.7470
1150 15th St., Washington, DC 20071 FAX: 202.334.5587
Editor: Mary Hadar, Arts & Style; Critic: Paul Richard

PERIODICALS *(cont.)*

GESTA 212.928.1146
The Cloisters, Ft. Tryon, New York, NY 10040 FAX: 212.795.3640
Frequency: 2 Issues; Subscription Rate: $30/year Individuals; $50/year Institutions
Editor: Lucy Freeman-Sandler

GRAPHIC DESIGN: USA 212.759.8813
120 E. 56th St., New York, NY 10022 FAX: 212.753.5990
Frequency: Monthly; Subscription Rate: $60/year
Editor: Susan Benson; Critic: Gordon Kaye

GRAPHITI 415.243.8244
665 Third St., Ste. 530, San Francisco, CA 94107
Frequency: Quarterly; Subscription Rate: Membership
Editor: R. Biggs

HERESIES 212.227.2108
Canal St. Station, Box 1306, New York, NY 10013
Frequency: 2 Issues; Subscription Rate: $23/4 Issues
Editor: Avis Lang, Managing Editor

HIGH PERFORMANCE 213.315.9383
1641 18th St., Santa Monica, CA 90404 FAX: 213.453.4347
Frequency: Quarterly; Subscription Rate: $20/year Individuals;
$24/year Institutions
Editor: Steven Durland; Critic: Gurillermo Gomez-Pena

ID: INDUSTRIAL DESIGN MAGAZINE 212.695.4955
330 W. 42nd St., New York, NY 10036 FAX: 212.868.4019
Frequency: Bi-Monthly; Subscription Rate: $55/year
Editor: Anetta Hanna

IFAR REPORTS 212.879.1780
46 E. 70th St., New York, NY 10021 FAX: 212.734.4174
Frequency: 10 Issues; Subscription Rate: $50/year Individuals; $65/year Institutions
Editor: Anna J. Kisluk

ILLUSTRATOR 612.339.6656
500 S. Fourth St., Minneapolis, MN 55415
Frequency: 2 Issues; Subscription Rate: $4/year
Editor: Don Jardine

INT'L REVIEW OF AFRICAN AMERICAN ART 305.625.0734
2211 Sterling, Ft. Lauderdale, FL 33312 FAX: 305.983.8441
Frequency: 6 Issues; Subscription Rate: $36/year
Editor: Samella Lewis

JOURNAL OF AESTHETICS & ART CRITICISM 608.262.5839
114 N Murray St., Madison, WI 53715
Frequency: Quarterly; Subscription Rate: $45/year
Editor: Donald Crawford

JOURNAL OF CANADIAN ART HISTORY 514.848.4699
1455 blvd de Maisonneuve, ouest, Montreal, PQ H3G 1M8 FAX: 514.848.3494
Frequency: 2 Issues; Subscription Rate: $20/year Canada; $25/year U.S.
Editor: Sandra Paikowsky, Editor & Co-Publisher

JOURNAL OF THE AMER. INST. FOR CONSERVATION 202.232.6636
OF HIST. & ARTISTIC WORKS FAX: 202.232.6630
1400 16th St. N.W., Ste. 340, Washington, DC 20036
Frequency: 2 Issues; Subscription Rate: $35/year
Editor: Elisabeth West Fitzhugh

LATIN AMERICAN ART 602.947.8422
P.O. Box 9888, Scottsdale, AZ 85252 FAX: 602.947.8497
Frequency: Quarterly; Subscription Rate: $24/year Individuals;
$36/year Institutions
Editor: Julianna Murphy-Cambell

LIGHTWORKS MAGAZINE * 313.626.8026
P.O. Box 1202, Birmingham, MI 48012
Frequency: 2 Issues; Subscription Rate: $20 per issue
Editor: Charlton Burch; Critic: Gary S. Vasilash

MUSEUM & ARTS WASHINGTON 202.659.5973
1707 L St. N.W., Ste. 222, Washington, DC 20036 Fax: 202.457.8148
Frequency: Bi-Monthly; Subscription Rate: $18/year
Editor: Mary Gabriel, Executive Editor

MUSEUM NEWS 202.289.1818
1225 Eye St. N.W., Ste. 200, Washington, DC 20005
Frequency: Bi-Monthly; Subscription Rate: $34/year
Editor: Bill Anderson

NEW ART EXAMINER 312.786.0200
1255 S. Wabash, 4th Fl., Chicago, IL 60605 FAX: 312.786.1565
Frequency: 11 Issues; Subscription Rate: $29/year
Editor: Allison Gamble

NEW OBSERVATIONS 212.966.6071
142 Greene St., New York, NY 10012
Frequency: 8 Issues; Subscription Rate: $22/year
Editor: Erika Knerr

OCTOBER 212.255.5537
19 Union Square W., 12th Fl., New York, NY 10003 Fax: 212.633.0144
Frequency: Quarterly; Subscription Rate: $25/year Individuals;
$60/year Institutions

ORNAMENT 619.599.0222
P.O. Box 2349, San Marcos, CA 92079 FAX: 619.599.0228
Frequency: Quarterly; Subscription Rate: $25/year
Editor: Robert Liu

PARACHUTE 514.842.9805
4060 Blvd. St. Laurent, Ste. 501, Montreal, PQ H2W 1Y9 Fax: 514.287.7146
Frequency: Quarterly; Subscription Rate: $40/year Canada
Editor: Chantal Pontbriand

PRINT 212.463.0600
104 Fifth Ave., 9th Fl., New York, NY 10011
Frequency: Bi-Monthly; Subscription Rate: $53/year
Editor: Martin Fox

PRINT COLLECTOR'S NEWSLETTER 212.988.5959
119 E. 79th St., New York, NY 10021 FAX: 212.988.6107
Frequency: Bi-Monthly; Subscription Rate: $54/year
Editor: Jacqueline Brody

PROGRESSIVE ARCHITECTURE 203.348.7531
600 Summer St., P.O. Box 361, Stamford, CT 06904 Fax: 216.696.8765
Frequency: Monthly; Subscription Rate: $48/year
Editor: John Morris Dixon

SCHOOL ARTS 508.754.7201
50 Portland St., Worcester, MA 01608 FAX: 508.753.3834
Frequency: 9 Issues; Subscription Rate: $21/year
Editor: Kent Anderson, M.D.

SCULPTURE 202.965.6066
1050 Potomac St. N.W., Washington, DC 20007 FAX: 202.965.7318
Frequency: Bi-Monthly; Subscription Rate: $40/year
Editor: Suzanne Ramljak

SCULPTURE REVIEW 212.889.6960
15 E. 26th St., Rm. 1906, New York, NY 10010 FAX: 212.545.0779
Frequency: Quarterly; Subscription Rate: $20/year to non-members
Editor: Fritz Cleary

SMITHSONIAN STUDIES IN AMERICAN ART 212.679.7300
200 Madison Ave., New York, NY 10016
Frequency: 4 Issues; Subscription Rate: $35/year Individuals; $60/year Institutions
Editor: Lisa Siegrist; Critic: Lucy Lippard

SOCIETY OF ARCHITECTURAL HISTORIANS JOURNAL 215.735.0224
1232 Pine St., Philadelphia, PA 19107 FAX: 215.735.2590
Frequency: Quarterly; Subscription Rate: $55/year Individuals;
$110/year Institutions
Editor: Patricia Waddy

SOUTHWEST ART 713.850.0990
P.O. Box 460535, Houston, TX 77256 FAX: 713.850.1314
Frequency: Monthly; Subscription Rate: $27.50/year
Editor: Susan Hallsten McGarry

STAINED GLASS 816.524.9340
6 S.W. Second St., Ste. 7, Lee's Summit, MO 64111 FAX: 816.524.9405
Frequency: Quarterly; Subscription Rate: $24/year
Editor: Richard Hoover

STUDIES IN ART EDUCATION 703.860.8000
1916 Association Dr., Reston, VA 22091 FAX: 703.860.2960
Frequency: 4 Issues; Subscription Rate: $25/year to non-members
Editor: Karen A. Hamblen

TAMARIND PAPERS 505.277.3901
108 Cornell Ave. S.E., Albuquerque, NM 87106
Frequency: Annual; Subscription Rate: $20/2 Years
Editor: Linda Tyler, Asst. Editor

TECHNOLOGY & CONSERVATION 617.227.8581
1 Emerson Pl., Ste. 16M, Boston, MA 02114
Frequency: Quarterly; Subscription Rate: $20/year
Editor: S.E. Schur

ART JOURNAL
212.691.1051
275 Seventh Ave., 5th Fl., New York, NY 10001 FAX: 212.627.2381
Frequency: Quarterly; Subscription Rate: $30/year to non-members
Editor: Virginia Wageman, Managing Editor

ART MATERIAL TRADE NEWS
404.256.9800
6255 Barfield Rd., Atlanta, GA 30328 FAX: 404.256.3116
Frequency: Monthly; Subscription Rate: $38/year
Editor: Tom Cooper; Critic: David Davenport

ART NEW ENGLAND
617.782.3008
425 Washington, Brighton, MA 02135
Frequency: 6 Issues; Subscription Rate: $20/year
Editor: Stephanie Adelman; Critic: Charles Giuliano

ARTNEWS
212.398.1690
48 W. 38th St., New York, NY 10018 FAX: 212.819.0394
Frequency: 10 Issues; Subscription Rate: $32.95/year
Editor: Milton Esterow, Editor & Publisher; Critic: Eleonore Heartney

ARTNEWSLETTER
212.398.1690
48 W. 38th St., New York, NY 10018
Frequency: Bi-Weekly; Subscription Rate: $179/year
Editor: Bonnie Barrett Stretch

ART NOW: GALLERY GUIDE: NATIONAL EDITION
908.322.8333
320 Bonnie Burn Rd., Scotch Plains, NJ 07076 FAX: 908.322.1763
Frequency: Monthly; Subscription Rate: $35/year
Editor: Patty Schlager, Midwest/Chicago/SE Editor

ART OF CALIFORNIA
707.226.1776
1125 Jefferson St., Napa, CA 94559 FAX: 707.226.2079
Frequency: Bi-Monthly; Subscription Rate: $29.95/year
Editor: Monica Garcia; Critic: Heather Sealy-Lineberry

ART OF THE WEST
612.935.5850
15612 Hwy. 7, Ste. 235, Minnetonka, MN 55345 FAX: 612.935.6546
Frequency: Bi-Monthly; Subscription Rate: $21/year
Editor: Vicki Stavig

ART PAPERS
404.588.1837
P.O. Box 77348, Atlanta, GA 30357
Frequency: Bi-Monthly; Subscription Rate: $20/year
Editor: Glenn Harper

ARTPOST MAGAZINE
416.364.5541
80 Spadina Ave., Ste. 302, Toronto, ON M5V 2J4 FAX: 416.364.5543
Frequency: Quarterly; Subscription Rate: $15/year Canada; $20/year U.S.
Editor: Pat Fleisher; Critic: Virgil Hammock

ARTS
612.870.3046
2400 Third Ave. S., Minneapolis, MN 55404 FAX: 612.870.3004
Frequency: Monthly; Subscription Rate: No charge
Editor: Kira Obolensky

ARTS MAGAZINE
212.431.4410
561 Broadway, New York, NY 10012 FAX: 212.431.4682
Frequency: 10 Issues; Subscription Rate: $29.95/year
Editor: Barry Schwabsky

ARTS QUARTERLY
504.488.2631
P.O. Box 19123, New Orleans, LA 70179 FAX: 504.482.6662
Frequency: Quarterly; Subscription Rate: $10/year
Editor: Wanda O'Shello

ARTSPACE
505.842.1560
P.O. Box 4547, Albuquerque, NM 87196
Frequency: Bi-Monthly; Subscription Rate: $23/year
Editor: William Peterson; Critic: Peter Colthier

ART STUDENTS LEAGUE NEWS
212.247.4510
215 W. 57th St., New York, NY 10019
Frequency: Quarterly; Subscription Rate: Membership
Editor: Lawrence Campbell

ART THERAPY
708.949.6064
1202 Allanson Rd., Mundelein, IL 60060 FAX: 708.566.4580
Frequency: 3 Issues; Subscription Rate: $25/year Individuals; $42/year Foreign
Editor: Gary Barlow

ART TODAY
316.946.0600
Box 12830, Wichita, KS 67277 FAX: 316.946.0675
Frequency: Quarterly; Subscription Rate: $16/year
Editor: Jesse Mullins

ARTWEEK
408.279.2293
12 S. 1st St., Ste. 520, San Jose, CA 95113 FAX: 408.279.2432
Frequency: Weekly; Subscription Rate: $28/year Individuals; $32/year Institutions
Editor: Bruce Nixon; Critic: Lance Carlson

ART/WORLD
516.626.0914
55 Wheatley Rd., Glen Head, NY 11545
Frequency: 10 Issues; Subscription Rate: $20/year
Editor: Theodora Hooton, Managing Editor

AVISO
202.289.1818
1225 I St. N.W., Ste. 200, Washington, DC 20005 FAX: 202.289.6578
Frequency: Monthly; Subscription Rate: $30/year
Editor: Bill Anderson

BOMB
212.431.3943
594 Broadway, New York, NY 10012
Frequency: 4 Issues; Subscription Rate: $16/year
Editor: Betsy Sussler

CALLIGRAPHY REVIEW
405.364.8794
1624 24th Ave. S.W., Norman, OK 73072
Frequency: Quarterly; Subscription Rate: $36/year
Editor: Karyn Gilman

CANADIAN ART
416.360.0044
70 The Esplanade, 4th Fl., Toronto, ON M5E 1R2 Fax: 416.941.9038
Frequency: Quarterly; Subscription Rate: $21.37/year Canada
Editor: Jocelyn Laurence

CERAMICS MONTHLY
614.488.8236
P.O. Box 12448, Columbus, OH 43212
Frequency: 10 Issues; Subscription Rate: $22/year
Editor: William Hunt

CLARION
212.977.7170
61 W. 62nd St., New York, NY 10023
Frequency: Quarterly; Subscription Rate: Membership
Editor: Jacqueline Atkins

COMMUNICATION ARTS
415.326.6040
410 Sherman Ave., Box 10300, Palo Alto, CA 94303
Frequency: 8 Issues; Subscription Rate: $50/year
Editor: Patrick Coyne

CONNOISSEUR
212.492.1300
1790 Broadway, New York, NY 10019
Frequency: Monthly; Subscription Rate: $24.95/year
Editor: Gail Love

CORPORATE ARTNEWS
212.398.1690
48 W. 38th St., New York, NY 10018
Frequency: Monthly; Subscription Rate: $110/year
Editor: Richard Walker

DIALOGUE
614.621.3704
Box 2572, Columbus, OH 43216 FAX: 614.621.2448
Frequency: Bi-Monthly; Subscription Rate: $16/year Individuals; $20/year Institutions
Editor: Lorrie Noel Dirkse

DRAWING
212.563.4822
15 Penn Plaza, P.O. Box 66, 415 7th Ave., New York, NY 10001 FAX: 212.563.482
Frequency: Bi-Monthly; Subscription Rate: Membership
Editor: Paul Cummings

FIBERARTS
704.253.0468
50 College St., Asheville, NC 28801 FAX: 704.253.7952
Frequency: 5 Issues; Subscription Rate: $21/year
Editor: Ann Batchelder

THE FINE ART INDEX
800.523.8849
750 N. Rush, Ste. 1304, Chicago, IL 60611 FAX: 312-335-1922
Frequency: Annual; Subscription Rate: $69.95
Editor: Kathryn A. Lappin

FLASH ART
212.477.4905
799 Broadway, Rm. 236, New York, NY 10003 FAX: 212.477.5016
Frequency: 6 Issues; Subscription Rate: $60/year
Editor: Gilda Williams, Editorial Assistant

FRAME/WORK
213.482.3566
1052 W. Sixth St., Ste. 424, Los Angeles, CA 90017
Frequency: 3 Issues; Subscription Rate: $15/year Individuals; $25/year Institutions
Editor: Box Muffoletto

INSURERS

ALLEN INSURANCE ASSOCIATES 213.933.3770
 5750 Wilshire Blvd., Ste. 525, Los Angeles, CA 90036

FRENKEL & CO. INC. 212.267.2200
 123 William St., New York, NY 10038

HOLMAN INSURANCE BROKERS LTD. 416.886.5630
 165 E. Beaver Creek Rd., Ste. 18, Richmond Hill, ON L4B 2N2

HUNTINGTON T. BLOCK 800.424.8830
 2101 L St., N.W., Washington, DC 20037 FAX: 202.331.8409

JAMES B. KNOX, CA ASSOC. INSUR. BROKERS 415.543.0890
 390 4th St., San Francisco, CA 94107

NORDSTERN INSURANCE CO., AMERICA 212.602.9300
 116 John St., New York, NY 10038

NEW NORTHERN BROKERAGE 212.371.2800
 950 Third Ave., 18th Fl., New York, NY 10022 FAX: 212.371.3479

REPUBLIC HOGG ROBINSON OF NEW YORK 212.682.7500
 355 Lexington Ave., New York, NY 10017

SMITH KRAMER, INC. 816.756.3777
 1622 Westport Rd., Kansas City, MO 64111

YORK INTERNATIONAL AGENCY, INC. 212.980.1144
 6 Executive Plaza, Yonkers, NY 10701

PUBLICATIONS

PERIODICALS

ACA UPDATE 212.245.4510
 1285 Ave. of the Americas, 3rd Fl., New York, NY 10019 FAX: 212.245.4514
 Frequency: Monthly; Subscription Rate: Membership
 Editor: Douglas Rose

AFRICAN ARTS 213.825.1218
 405 Hilgard Ave., Los Angeles, CA 90024
 Frequency: Quarterly; Subscription Rate: $36/year
 Editor: Donald Cosentino

AFTERIMAGE 716.442.8676
 31 Prince St., Rochester, NY 14607
 Frequency: 9 Issues; Subscription Rate: $30/year Individual; $40/year Institution
 Editor: Grant Kester; Critic: Deborah Bright

AHA! HISPANIC ARTS NEWS 212.860.5445
 173 E. 116th St., 2nd Fl., New York, NY 10029 FAX: 212.427.2787
 Frequency: 9 Issues; Subscription Rate: $15/year Individual; $25/year Institution
 Editor: Dolores Prida

AMERICAN ART JOURNAL 212.541.9600
 40 W. 57th St., 5th Fl., New York, NY 10019
 Frequency: 2 Issues; Subscription Rate: $35/year
 Editor: Jane Van Norman Turano

AMERICAN ARTIST 212.764.7300
 1515 Broadway, New York, NY 10036 FAX: 212.536.5351
 Frequency: Monthly; Subscription Rate: $24/year
 Editor: Stephen Doherty

AMERICAN CRAFT 212.956.3535
 72 Spring St., New York, NY 10012 FAX: 212.274.0650
 Frequency: Bi-Monthly; Subscription Rate: Membership
 Editor: Lois Moran

AMERICAN INDIAN ART MAGAZINE 602.994.5445
 7314 E. Osborn Dr., Scottsdale, AZ 85251 FAX: 602.945.9533
 Frequency: Quarterly; Subscription Rate: $20/year
 Editor: Roanne Goldfein

AMERICAN JOURNAL OF ARCHAEOLOGY 617.353.9364
 675 Commonwealth Ave., Boston, MA 02215 FAX: 617.353.6550
 Frequency: Quarterly; Subscription Rate: $50/year Individual; $90/year Institution
 Editor: Fred Kleiner

AMERICAN WATERCOLOR SOCIETY NEWSLETTER 212.206.8986
 47 Fifth Ave., New York, NY 10003
 Frequency: 2 Issues; Subscription Rate: Membership
 Editor: Kent Coes

APERTURE 212.505.5555
 20 E. 23rd St., New York, NY 10010 FAX: 212.979.7759
 Frequency: Quarterly; Subscription Rate: $40/year
 Editor: Charles Hagan

ARCHAEOLOGY 212.732.5154
 135 Williams St., 8th Fl., New York, NY 10038 FAX: 212.732.5707
 Frequency: Bi-Monthly; Subscription Rate: $20/year
 Editor: Peter Young

ARCHITECTURAL DIGEST 213.965.3700
 5900 Wilshire Blvd., Los Angeles, CA 90036 FAX: 213.937.1458
 Frequency: Monthly; Subscription Rate: $39.95/year
 Editor: Paige Rense

ARCHIVES OF AMERICAN ART 202.357.2781
 8th & G St. N.W., Washington, DC 20560 FAX: 202.786.2608
 Frequency: Quarterly; Subscription Rate: $35/year
 Editor: Garnett McCoy

ART & ANTIQUES 212.922.9250
 633 Third Ave., New York, NY 10017 FAX: 212.924.1097
 Frequency: 10 Issues; Subscription Rate: $27/year
 Editor: Jeffrey Schaire

ART & AUCTION 212.582.5633
 250 W. 57th St., New York, NY 10107 FAX: 212.246.3891
 Frequency: 11 Issues; Subscription Rate: $42/year
 Editor: Amy Page; Critic: Charles Riley

ART BULLETIN 212.691.1051
 275 Seventh Ave., New York, NY 10001 FAX: 212.607.2381
 Frequency: Quarterly; Subscription Rate: Membership
 Editor: Richard Brilliant

ART BUSINESS NEWS 203.356.1745
 Box 3837, Stamford, CT 06905 FAX: 203.356.1903
 Frequency: Monthly; Subscription Rate: $25/year
 Editor: Jo Yanow-Schwartz, Executive Editor

ART COM: CONTEMPORARY ART COMMUNICATIONS 415.431.7524
 P.O. Box 193123, Rincon Ctr., San Francisco, CA 94119
 Frequency: Monthly; Subscription Rate: Electronically Available
 Editor: Anna Couey

ART DIRECTION 212.889.6500
 10 E. 39th St., 6th Fl., New York, NY 10016 FAX: 212.889.6504
 Frequency: Monthly; Subscription Rate: $27.50/year
 Editor: Dan Barron

ART DOCUMENTATION 602.881.8479
 3900 E. Timrod St., Tucson, AZ 85711 FAX: 602.322.6778
 Frequency: 4 Issues; Subscription Rate: $55/year Individual; $75/year Institution
 Editor: Beryl Smith; Critic: Judy Dyki

ART EDUCATION 703.860.8000
 1916 Association Dr., Reston, VA 22091 FAX: 703.860.2960
 Frequency: Bi-Monthly; Subscription Rate: $50/year to non-members
 Editor: Jerome Hausman

ARTFORUM 212.475.4000
 65 Bleecker St., New York, NY 10012 FAX: 212.529.1257
 Frequency: 10 Issues; Subscription Rate: $46/year
 Editor: Ida Panicelli

ART HAZARDS NEWS 212.227.6220
 5 Beekman St., New York, NY 10038
 Frequency: 5 Issues; Subscription Rate: $21/year
 Editor: Michael McCann

ART IN AMERICA 212.941.2800
 575 Broadway, New York, NY 10012 FAX: 212.941.2885
 Frequency: Monthly; Subscription Rate: $39.95/year
 Editor: Elizabeth C. Baker

ARTIST'S MAGAZINE 513.531.2222
 1507 Dana Ave., Cincinnati, OH 45207
 Frequency: Monthly; Subscription Rate: $21/year
 Editor: Michael Ward

ARLBOROUGH GRAPHICS	212.541.4900
40 W. 57th St., New York 10019	FAX: 212.541.4948
ULTIPLES, INC.	212.977.7160
24 W. 57th St, New York 10019	FAX: 212.581.5187
ACE PRINTS	212.421.3237
32 E. 57th St., 3rd Fl., New York 10022	FAX: 212.451.7280
ARASOL PRESS, LTD.	212.431.9387
289 Church St., New York 10013	FAX: 212.941.7704
ETERSBURG PRESS	212.420.0890
380 Lafayette, New York 10003	FAX: 212.420.1617
DITIONS SCHELLMANN	212.219.1821
50 Greene St., New York 10013	FAX: 212.941.9206
OLO GALLERY	212.925.3599
578 Broadway, Ste. 606, New York 10012	FAX: 212.226.3251

STYRIA STUDIO	212.226.1373
426 Broome St., New York 10013	FAX: 212.226.1072
JOHN SZOKE GRAPHICS INC., 164 Mercer St., New York 10012	212.219.8300
TYLER GRAPHICS	914.241.2707
250 Kisco Ave., Mount Kisco 10549	FAX: 914.241.7756
ULAE, 5 Skidmore Pl., West Islip 11795	516.669.7484

NORTH CAROLINA

BILTMORE PRESS, INC., 205 College St., Asheville 28801	704.252.4476

CANADA

BRITISH COLUMBIA

PRIOR EDITIONS, 303-1028 Hamilton St., Vancouver V6B 2R9	604.685.0535

CALIFORNIA

ESTHETIC FRAMERS DESIGN	213.622.4143
1275 E. 6th St., Los Angeles 90021	FAX: 213.622.3331
CITY PICTURE FRAME	415.543.4105
520 3rd St., #555, San Francisco 94107	FAX: 415.543.2740
M. ARTISTS SERVICES, 1931 Turk St., San Francisco 94115	415.563.0456
OCHS STUDIOS, 330 N. La Brea Ave., Los Angeles 90036	213.933.7263
AN FRANCISCO ART FRAMING SERVICE, INC.	415.543.1013
425 Second St., 3rd Fl., San Francisco 94107	
ERRY SOLOMON ENTERPRISES INC.	213.851.7241
960 N. La Brea, Los Angeles 90038	FAX: 213.851.5928
TERLING ART SERVICES	415.641.8124
2565 Third St., Ste. 341, San Francisco 94107	

GEORGIA

GALLERY 515, 515 E. Paces Ferry Rd., Atlanta 30305	404.233.2911
MUSEUM SERVICES, LTD., 75 Bennett St. N-2, Atlanta 30309	404.352.6935

ILLINOIS

ARTISTS' FRAME SERVICE INC.	312.248.7713
1915 N. Clybourn Ave., Chicago 60614	FAX: 312.248.3997
CALLIHAN & MELVILLE FINE FRAMING	312.252.7525
2049 N. Hoyne, Chicago 60647	FAX: 312.252.7525
FRAMEWAY STUDIOS, INC., 875 N.Orleans, Chicago 60610	312.751.1660
FREDERIC'S FRAME STUDIO INC.	312.243.2950
1230 W. Jackson, Chicago 60607	FAX: 312.243.4673
SEABERG PICTURE FRAME CO., 820 N. Franklin, Chicago 60610	312.440.0040
ROSS WETZEL PAPER SOURCE	312.337.0798
730 N. Franklin, #111, Chicago 60610	FAX: 312.337.0741

MARYLAND

THE BEVELED EDGE, 1750 Union Ave., Baltimore 21211	301.366.6711
FRAMES BY REBECCA, 8923 Brookville Rd., Silver Springs 20910	301.588.8588

NEW MEXICO

GAVIN COLLIER & CO., 815 Early St., Santa Fe 87501	505.982.9772

NEW YORK

DRUMMOND FRAMING, 27 E. 21st St., 2nd Fl, New York 10010	212.254.5033
THE HOUSE OF HEYDENRYK	212.249.4903
417 E. 76th St., New York 10021	FAX: 212.472.9010

JULIUS LOWY FRAME & RESTORING CO., INC.	212.861.8585
223 E. 80th St., New York 10021	FAX: 212.988.0443
JULIUS LOWY FRAME & RESTORING CO., INC.	212.586.2050
28 W. End Ave., New York 10023	FAX: 212.489.1948
SHEPHERD GALLERY SERVICES, INC.	212.744.3392
21 E. 84th St., New York 10028	FAX: 212.772.1314

OREGON

FRAMEWORKS, 417 N.W. Ninth Ave., Portland 97209	503.222.5128
GUNNERIES PICTURE FRAMING, 2 N. Tenth Ave., Portland 97209	503.227.4832
KATAYAMA FRAMING, 2258 N.W. Raleigh, Portland 97210	503.224.3334

PENNSYLVANIA

B & D FRAMES, INC., 309 Arch St., Philadelphia 19106	215.923.3540
LARRY BECKER, 43 N. 2nd St., Philadelphia 19106	215.925.5389
MADD FRAMES, INC., 222A Moore St., Philadelphia 19148	215.339.5333
PERAKIS FRAMES, 18 Bank St., Philadelphia 19106	215.627.7700

TEXAS

ART FRAMERS, 2045 SW Freeway, Houston 77098	713.529.4353
FRAMEWORK	713.868.0011
4914 Dickson, Houston 77007	FAX: 713.868.4165
VINYARD FRAME DESIGN, 1435 Dragon St., Dallas 75207	214.747.1742

WASHINGTON

GALLERY FRAMES, 205 James St., Seattle 98104	206.624.6862
CHRISTINE KLYVER, 6745 3rd Ave. N.W., Seattle 98117	206.781.9153
PLASTEEL, 824 12th Ave., Seattle 98122	206.324.3379

WISCONSIN

SCHRAGER AUCTION GALLERIES LTD.	414.873.3738
2915 N. Sherman, Milwaukee	FAX: 414.873.5229

CANADA

BRITISH COLUMBIA

HEFFEL GALLERY LIMITED, 2247 Granville St., Vancouver V6H 3G1	604.732.6505

ONTARIO

ART & GALLERY SERVICES, 345 Sorauren Ave., Toronto M6R 2G5	416.534.7399

FLORIDA

OLD ART RESTORATION, KEN PERENI | 813.393.3143
13255 Boca Ciega Ave., Madeira Beach 33708

ILLINOIS

CHICAGO CONSERVATION CENTER, BARRY BAUMAN | 312.944.5401
730 N. Franklin, #701, Chicago 60610 | FAX: 312.944.5479

RICK STRILKEY FINE ART RESTORATION | 312.477.0005
4225 N. Lincoln Ave., Chicago 60618

NEW JERSEY

RABIN & KRUEGER PAINTINGS, BERNARD RABIN | 609.655.5313
260A Monroe Road, Cranbury 08512

NEW YORK

ART CONSERVATION RESEARCH FOUNDATION LTD., | 212.874.3925
115 W. 73rd St., #2A, New York 10023-2940 | FAX: 212.874.3925

ART RESTORATION BY DEMETRIUS, INC., DEMETRIUS ALFONSO | 212.768.3840
28 W. 39th St., New York 10028

GUSTAV BERGER, 115 W. 73rd St., #2A, New York 10023 | 212.496.5350

DIANNE DWYER, 37 E. 67th St., #3A, New York 10021 | 312.861.2781

ALAIN GOLDRACH, 207 E. 84th St., New York 10028 | 212.517.5946

DANIEL GOLDREYER, LTD. | 718.361.8444
37-31 29th St., Long Island City 11101 | FAX: 718.361.2799

MARCO GRASSI | 212.226.6616
599 Broadway, New York 10012 | FAX: 212.226.5496

JULIUS LOWY, INC.
223 East 80th Avenue, New York 10021 Fax: 212.988.0443 | 212.861.8585
28 West End Avenue, New York 10023 Fax: 212.489.1948 | 212.586.2050

TERRENCE MAHON, 381 Park Ave. South, New York 10016 | 212.685.9050

FRANCIS MORO, 234 West 56th St., New York 10019 | 212.265.3481

CLAUDIO RIGOSI, 207 East 84th St., New York 10028 | 212.535.4585

ORRIN H. RILEY, LTD., 361 W. 36th St., New York 10018 | 212.695.1322

DIEGO SALAZAR, 38 W. 56th St., New York 10019 | 212.397.8328

ROBERT SAWCHUCK | 212.369.4880
1083 Fifth Ave., New York 10128 | FAX: 212.360.6795

KATHRIN SCHEEL-BISACCA | 212.243.4560
110 West 26th St., 6th Fl., New York 10001

CHARLES VON NOSTITZ, 361 West 36th St., New York 10018 | 212.465.9837

TEXAS

PERRY HUSTON & ASSOCIATES | 817.589.7778
7440 Whitehall St., Fort Worth 76118

WYNNE PHELAN, 2215 Stanmore Dr., Houston 77019 | 713.522.4022

CANADA

O N T A R I O

CANADIAN ASSOC. OF PROF. CONSERVATORS, REFERRAL SERVICE
280 Metcalfe, Ste. 400, Ottawa K2P 1R7 | 613.232.2290

LEGRIS CONSERVATION, PAT LEGRIS, RR #2, Carp K0A 1L0 | 613.831.3405

RESTORE ART, CZAR LASZLO | 416.539.8069
23 Morrow Ave., Toronto M6R 2H9

FINE ART PUBLISHERS

CALIFORNIA

ARION PRESS | 415.777.9651
460 Bryant St., San Francisco 94107 | FAX: 415.777.2730

CIRRUS EDITIONS LTD. | 213.680.3473
542 S. Alameda St., Los Angeles 90013 | FAX: 213.680.0930

CROWN POINT PRESS | 415.974.6273
657 Howard St., San Francisco 94105

GEMINI G.E.L. | 213.651.0513
8365 Melrose Ave., Los Angeles 90069

HINE EDITIONS/LIMESTONE PRESS | 415.777.2214
357 Tehama, San Francisco 94103 | FAX: 415.495.2665

MIXOGRAPHIA | 213.232.1158
1419 E. Adams Blvd., Los Angeles 90011 | FAX: 213.232.1655

THE REMBA GALLERY | 213.576.1011
918 Colorado Ave., Santa Monica 90401 | FAX: 213.458.9688

COLORADO

SHARK'S INC. | 303.443.4601
2020 Ninth St., Boulder 80302 | FAX: 303.443.1245

INDIANA

ECHO PRESS | 812.855.0476
1901 E. Tenth St., Bloomington 47408 | FAX: 812.855.0477

MICHIGAN

LAKESIDE STUDIO | 616.469.1377
15251 S. Lakeshore Rd., Lakeside 49116

MINNESOTA

VERMILLION EDITIONS, LTD. | 612.379.7281
2919 Como Ave. S.E., Minneapolis 55414 | FAX: 612.379.7284

NEW YORK

HARRY N. ABRAMS INC. | 212.206.7715
100 Fifth Ave., New York 10011 | FAX: 212.645.8437

ASSOCIATED AMERICAN ARTISTS | 212.399.5510
20 W. 57th St, New York 10019 | FAX: 212.582.9697

PETER BLUM EDITION | 212.475.0227
14 W. 10th Street, New York 10011 | FAX: 212.254.9250

BROOKE ALEXANDER, INC. | 212.925.4338
59 Wooster St., New York 10012 | FAX: 212.941.9565

LEO CASTELLI GRAPHICS | 212.941.9855
578 Broadway, New York 10012 | FAX: 212.941.0093

CROWN POINT PRESS, 568 Broadway, New York 10012 | 212.226.5476

ELEANOR ETTINGER INC. | 212.807.7607
155 Ave. of the Americas, New York 10013

RONALD FELDMAN FINE ARTS | 212.226.3232
31 Mercer St., New York 10013 | FAX: 212.941.1536

GEMINI G.E.L. AT JONI MOISANT WEYL | 212.219.1446
375 W. Broadway, 2nd Fl., New York 10012 | FAX: 212.334.3109

BARBARA GLADSTONE EDITIONS | 212.431.3334
99 Greene St., New York 10012

WILLIAM KATZ | 212.773.3067
277 Park Ave., New York 10172 | FAX: 212.773.1533

KNOEDLER PUBLISHING, 19 E. 70th St., New York 10021 | 212.794.0577

EDITIONS ILENE KURTZ | 212.226.2771
568 Broadway, Rm. 1004, New York 10012 | FAX: 212.431.1184

LANDFALL PRESS INC. | 212.274.0740
584 Broadway, Suite 308, New York 10012 | FAX: 212.274.0743

MAINE

BARRIDOFF GALLERIES 207.772.5011
 P.O. Box 9715, Portland 04104 FAX: 207.772.5049

JAMES D. JULIA, INC. 207.453.7125
 P.O. Box 830, Fairfield 04937 FAX: 207.453.2502
 Contemporary Art Auction Contact: Ed Swan

RICHARD W. OLIVER, AUCTION GALLERY 207.985.3600
 Plaza 1, Route 1, Kennebunk 04043 FAX: 207.985.7734
 Contemporary Art Auction Contact: Peter F. Fagley

MARYLAND

HARRIS AUCTION GALLERIES 301.728.7040
 875 N. Howard St., Baltimore 21201 FAX: 301.728.0449

C.G. SLOAN & CO. 301.468.4911
 4920 Wyconda Rd., North Bethesda 20852

MASSACHUSETTS

RICHARD A. BOURNE & CO., Box 141, Hyannis Port 02647 508.775.0797
 Contemporary Art Auction Contact: Thomas Bourne

BRADFORD AUCTION GALLERIES LTD. 413.229.6667
 Route 7, P.O. Box 160, Sheffield 01257

DOUGLAS AUCTIONEERS 413.665.2877
 Route 5, South Deerfield 01373 FAX: 413.665.2877

ROBERT C. ELDRED CO., INC. 508.385.3116
 Box 796, Rte. 6A, East Dennis 02641 FAX: 508.385.7201

GROGAN & CO. 617.566.4100
 890 Commonwealth Ave., Boston 02215 FAX: 617.566.7715
 Contemporary Art Auction Contact: Martha Richardson

SANDWICH AUCTION HOUSE 508.888.1926
 15 Tupper Rd., Sandwich 02563
 Contemporary Art Auction Contact: Donna Johnson

SKINNER, INC. 508.779.6241
 357 Maine St., Bolton 01740 FAX: 508.779.5144
 Contemporary Art Auction Contact: Colleene Fesko

NEW JERSEY

GREG MANNING AUCTIONS, INC. 201.299.1800
 115 Main Rd., Montville 07045 FAX: 201.299.9026
 Contemporary Art Auction Contact: Bill Tully

NEW YORK

CHRISTIE'S 212.546.1000
 502 Park Ave., New York 10021 FAX: 212.371.5438
 Contemporary Art Auction Contact: Diane Upright
 Contemporary Print Auction Contact: Elizabeth Hahn

CHRISTIE'S EAST 212.606.0400
 219 E. 67th St., New York 10021
 Contemporary Art Auction Contact: Holly Fechtmeyer

WILLIAM DOYLE GALLERIES 212.427.2730
 175 E. 87th St., New York 10128 FAX: 212.369.0892

GREAT GATSBY'S 800.342.1744
 91 University Place, New York 10003

GUERNSEY'S 212.794.2280
 108 1/2 E. 73rd St., New York 10021 FAX: 212.744.3638
 Contemporary Art Auction Contact: Arlan Ettinger

HESSE GALLERIES, 53 Main St., Otego 13825 607.988.6322
 Contemporary Art Auction Contact: Matthew J. Hesse

ILLUSTRATION HOUSE, INC., 96 Spring St., New York 10012 212.966.9444
 Contemporary Art Auction Contact: Fred Taraba

MAPES AUCTIONEERS 607.754.9193
 1600 Vestal Parkway West, Vestal 13850 FAX: 607.786.3549

SOTHEBY'S, 1334 York Ave., New York 10021 212.606.7000

SWANN GALLERIES INC. 212.254.4710
 104 E. 25th St., New York 10010 FAX: 212.979.1017
 Contemporary Art Auction Contact: George Lowry, Martin Barooshian

TEPPER GALLERIES 212.677.5300
 110 E. 25th St., New York 10010 FAX: 212.673.3686
 Contemporary Art Auction Contact: Frances White

OHIO

WOLF'S AUCTION GALLERY 216.575.9653
 1239 W. Sixth St., Cleveland 44113 FAX: 216.621.8011
 Contemporary Art Auction Contact: Rachel Davis

PENNSYLVANIA

FREEMAN/FINE ARTS OF PHILADELPHIA 215.563.9275
 1808 Chestnut St., Philadelphia 19103 FAX: 215.563.8236

RHODE ISLAND

ARMAN'S NEWPORT 401.683.3100
 Box 3239, Newport 02840 FAX: 401.683.4044
 Contemporary Art Auction Contact: David Arman

TEXAS

CLEMENTS AUCTION GALLERY 214.226.1520
 Box 727, Forney 75126 FAX: 214.552.9878
 Contemporary Art Auction Contact: Jeff Garrett

CANADA

ONTARIO

D&J RITCHIE 416.364.1864
 429 Richmond St. East, Toronto M5A 1R1 FAX: 416.364.0704
 Contemporary Art Auction Contact: Susan Robertson

SOTHEBY'S 416.926.1774
 9 Hazelton Avenue, Toronto M5R 2E1 FAX: 416.926.9179

WADDINGTON MCLEAN & CO. 416.362.1678
 189 Queen St. East, Toronto M5A 1S2 FAX: 416.362.0905
 Contemporary Art Auction Contact: Duncan McLean

CONSERVATORS

CALIFORNIA

BALBOA ART CONSERVATION CENTER 619.236.9702
 1649 El Parado-Balboa Park, San Diego 92101

CONSERVATION OF PAINTINGS, LTD., DENISE DOMERGUE 213.453.7717
 2046 Broadway, Santa Monica 90404 FAX: 213.828.5933

DAEDELUS, ANITA NOERMIG, 6020 Adeline St., Oakland 94608 415.658.4566

FINE ART CONSERVATION LABORATORIES, SCOTT M. HASKINS
 Los Angeles 213.620.9125
 Santa Barbara 805.564.3438
 San Francisco 415.397.9294

FINE ARTS CONSERVATION, JUDITH RIENIETS 415.931.5346
 2936 Lyon St., #B, San Francisco 94123

LINDA SHAFFER, CONSERVATION OF WORKS OF ART ON PAPER
 1706 S. Genesee, Los Angeles 90019 213.936.9112

COLORADO

ROCKY MOUNTAIN CONSERVATION CENTER 303.733.2712
 2420 S. University Blvd., Denver 80208 FAX: 303.871.4000

DISTRICT OF COLUMBIA

ENGRID ROSE, WORKS ON PAPER 202.364.0599
 3304 Runny Mede Pl. N.W., Washington 20015

FAIC, CONSERVATION SERVICES REFERRAL SYSTEM, 202.232.6636
 1400 16th St., N.W., Ste. 340, Washington 20036 FAX: 202.232.6630

ASIA (cont.)

TOKYO ART EXPO
March 18 - 22, 1992; Tokyo International Trade Center

Art Press Center, Inc. 81.3.3505.1221
2-2-5 Roppongi, Minato-ku, Tokyo 106 Japan FAX: 81.3.3505.5997

92 SEOUL INTERNATIONAL ARTS & CRAFT FAIR
March 20 - 24, 1992; KOEX Center, Seoul, Korea

Korea-France Culture & Arts Association 822.551.6330
#15S Sam Sung-dong, Kangnam-ku, KOEX 3B-06, Seoul, Korea FAX: 822.551.6560
Contact: Q.C. Kim

ARTIST ORGANIZATIONS

ALLIED ARTISTS OF AMERICA, INC. 212.582.6411
National Arts Club, 15 Gramercy S., New York, NY 10003
Contact: Marion Roller, Pres.

AMERICAN ABSTRACT ARTISTS 212.874.0747
470 W. End Ave., Apt. 9D, New York, NY 10024
Contact: Beatrice Riese, Pres.

AMERICAN ARTISTS PROFESSIONAL LEAGUE 212.645.1345
47 5th Ave., New York, NY 10003
Contact: Leo Yeni, Pres.

AMERICAN SOCIETY OF ARTISTS, INC. 708.751.2500
P.O. Box 1326, Palatine, IL 60078
Contact: Nancy J. Fregin, Pres.

AMERICAN SOCIETY OF CONTEMPORARY ARTISTS 212.549.2923
3965 Sedgwick Ave., Bronx, NY 10463
Contact: Bernarl Olshan, Pres.

AMERICAN WATERCOLOR SOCIETY 212.206.8986
47 Fifth Ave., New York, NY 10003
Contact: William Gorman, Pres.

ASSOCIATION OF HISPANIC ART, INC. 212.860.5445
173 E. 116th St., New York, NY 10029
Contact: Jane Arce-Bello, Exec. Dir.

CHICAGO ARTISTS' COALITION 312.670.2060
5 W. Grand Ave., Chicago, IL 60610
Contact: Arlene Rakoncay, Dir.

COALITION OF WOMEN'S ART ORGANIZATION 414.284.4458
123 E. Beutel Rd., Port Washington, WI 53074
Contact: Dorothy Provis, Pres.

FED. OF MODERN PAINTERS & SCULPTORS 212.568.2981
234 W. 21st St., New York, NY 10011
Contact: Haim Mendelson, Pres.

MICHIGAN GUILD OF ARTISTS & ARTISANS 313.662.3382
118 N. Fourth Ave., Ann Arbor, MI 48104
Contact: Joseph Jaworek, Dir. Membership

NATIONAL ARTISTS EQUITY ASSOCIATION 202.628.9633
Central Station, P.O. Box 28068, Washington, DC 20038
Contact: James Minden, Pres.

NATIONAL ASSOCIATION OF WOMEN ARTISTS 212.675.1616
41 Union Square W., Rm. 906, New York, NY 10003

NATIONAL SCULPTURE SOCIETY 212.889.6960
15 E. 26th St., New York, NY 10010
Contact: Stanley Bleifeld, Pres.

NATIONAL SOCIETY OF MURAL PAINTERS, INC. 516.374.0113
Amer. Fine Arts Society, 215 W. 57th St., New York, NY 10019
Contact: Rhoda Andors, Pres.

NATIONAL SOCIETY OF PAINTERS IN CASEIN & ACRYLIC, INC.
32 Union Sq. East, New York, NY 10003
Contact: Douglas Wiltrout, Pres.

NATIONAL WATERCOLOR SOCIETY 213.923.4933
7937 E. 4th Place, Downey, CA 90241
Contact: Willellyn McFarland, Pres.

SCULPTORS GUILD, INC. 212.431.5669
110 Greene St., New York, NY 10012

SCULPTOR'S SOCIETY OF CANADA 416.962.1138
3060 Bloor St. E., Ste. 301, Toronto, ON M4W 3M3
Contact: Maria Rahmer, Pres.

WOMEN'S CAUCUS FOR ART 215.854.0922
Moore College of Art, 20th & the Pkwy, Philadelphia, PA 19103

AUCTION HOUSES

CALIFORNIA

A.N. ABELL AUCTION COMPANY 213.734.4151
1911 W. Adams Blvd., Los Angeles 90018 FAX: 213.734.0137
Contemporary Art Auction Contact: Donald Schireson

BUTTERFIELD & BUTTERFIELD 415.861.7500
220 San Bruno Ave., San Francisco 94103 FAX: 415.861.8951
Contemporary Art Auction Contact: Karen Tallackson
Contemporary Print Auction Contact: Barry Heisler

BUTTERFIELD & BUTTERFIELD 213.850.7500
7601 Sunset Blvd., Los Angeles 90046 FAX: 213.850.5843
Contemporary Art Auction Contact: Scott Levitt
Contemporary Print Auction Contact: Laura Horn

WINTER ASSOCIATES 203.793.0288
21 Cooke St., P.O. Box 823, Plainville 06062
Contemporary Art Auction Contact: Linda Stamm

DISTRICT OF COLUMBIA

ADAM A. WESCHLER & SON 202.628.1281
909 E St. N.W., Washington 20004 FAX: 202.628.2366
Contemporary Art Auction Contact: Eda Martin-Joyce

ILLINOIS

DUNNING'S AUCTION SERVICE, INC. 708.741.3483
755 Church Rd., Elgin 60123
Contemporary Art Auction Contact: Shawn Dunning

HANZEL GALLERIES, INC. 312.922.6234
1120 S. Michigan Ave., Chicago 60605
Contemporary Art Auction Contact: John Hanzel

LESLIE HINDMAN AUCTIONEERS 312.670.0010
215 W. Ohio St., Chicago 60610
Contemporary Art Auction Contact: Tracy Harris

INDIANA

KRUSE INTERNATIONAL 219.925.5600
Box 190, Auburn 46706 FAX: 219.925.5467
Contemporary Art Auction Contact: Mitchell Kruse

LOUISIANA

NEAL AUCTION COMPANY 504.899.5329
4038 Magazine St., New Orleans 70115 FAX: 504.897.3808

NORTH AMERICA

ART CALIFORNIA
September 30 - October 4, 1992; Moscone Center, San Francisco

International Fine Art Expositions 213.820.0498
11640 San Vicente Blvd., #108, Los Angeles, CA 90049 FAX: 213.820.5426
Contact: Stacy Brechbill

ART CHICAGO
May 13 - 18, 1992; Expocenter, Chicago

International Fine Art Expositions 213.820.0498
11640 San Vicente Blvd., #108, Los Angeles, CA 90049 FAX: 213.820.5426
Contact: Stacy Brechbill

ART/LA THE 6TH INTERNATIONAL CONTEMPORARY ART FAIR
November 20 - 24, 1991; Los Angeles Convention Center

ART/LA 213.271.3200
8930 Keith Ave., Los Angeles, CA 90069 FAX: 213.271.8409
Contact: Ian Grimshaw, Director

ART MIAMI
January 8 - 12, 1992; Miami Beach Convention Center

International Fine Art Expositions 213.820.0498
11640 San Vicente Blvd., #108, Los Angeles, CA 90049 FAX: 213.820.5426
Contact: Stacy Brechbill

ART NEW YORK
October 29 - November 1, 1992; Jacob K. Javits Convention Center, New York

International Fine Art Expositions 213.820.0498
11640 San Vicente Blvd., #108, Los Angeles, CA 90049 FAX: 213.820.5426
Contact: Stacy Brechbill

THE ART SHOW
February 27 - March 2, 1992; Preview February 26. 7th Regiment Armory, New York

Art Dealers Association of America 212.940.8925
575 Madison Ave., New York, NY 10022 FAX: 212.940.8776
Contact: Rose R. Weil

CHICAGO INTERNATIONAL ART EXPOSITION
May 14 - 19, 1992; Donnelley Hall at McCormick Place, Chicago

The Lakeside Group 312.787.6858
600 N. McClurg Ct., Chicago, IL 60611 FAX: 312.787.2928
Contact: Mary Michalik

CHICAGO INTERNATIONAL NEW ART FORMS EXPOSITION
September 19 - 22, 1991; Navy Pier, Chicago

The Lakeside Group 312.787.6858
600 N. McClurg Ct., Chicago, IL 60611 FAX: 312.787.2928
Contact: Mark Lyman

CHICAGO PHOTOGRAPHIC PRINT FAIR
September 13 - 15, 1991; Columbia College Art Gallery, Chicago

Chicago Photographic Print Fair 312.549.1553
P.O. Box 138089, Chicago, IL 60613 FAX: 312.728.7915
Contact: Steve Daiter, Jerry Zbiral

THE FIRST LOS ANGELES PHOTOGRAPHIC PRINT EXPOSITION
January 10 - 12, 1992; Butterfield & Butterfield, Los Angeles

The Los Angeles Photographic Print Exposition 213.654.1890
P.O. Box 69248, Los Angeles, CA 90069 FAX: 213.654.1625
Contact: Stephen Cohen

MODERNISM
November 21 - 24, 1991, Preview November 20; 7th Regiment Armory, New York

Sanford L. Smith & Associates, Ltd. 212.777.5218
68 E. 7th St., New York, NY 10003 FAX: 212.477.6490
Contact: Sanford L. Smith

THE PRINT FAIR
November 1 - 3, 1991, Preview October 31; 7th Regiment Armory, New York

International Fine Print Dealers Association (IFPDA) 212.777.5218
c/o Sanford L. Smith & Associates, Ltd. FAX: 212.477.6490
68 E. 7th St., New York, NY 10003

WORKS ON PAPER 92
April 3 - 5, 1992, Preview April 2; 7th Regiment Armory, New York

Sanford L. Smith & Associates, Ltd. 212.777.5218
68 E. 7th St., New York, NY 10003 FAX: 212.477.6490
Contact: Sanford L. Smith

EUROPE

ART 23 92 & EDITION 3/92 BASEL
June 17 - 22, 1992; Basel Fairgrounds

Swiss Industries Fair 41.61.686.20.20
Messeplatz, P.O. Box CH-4021, Basel, Switzerland FAX: 41.61.691.20.21
Contact: Marianne El Hariri, Fair Management

ARCO 92 MADRID
February 13 - 18, 1992; Madrid

IFEMA 34.1.470.10.14
Av. de Portugal, Madrid, Spain 28011 FAX: 34.1.470.25.01

ARTE FIERA 92 BOLOGNA
January 24 - 27, 1992

Ente Autonomo per le Fiere di Bologna 39.51.282.111
Pza. Costituzione, 6, Bologna, Italy 40128 FAX: 39.51.282.332

ART FRANKFURT
March 27 - 31, 1992; Frankfurt Fairgrounds

Messe Frankfurt GmbH 49.69.75.75.66.54
Ludwig-Erhard-Anlage 1, 6000 Frankfurt Main1, Germany FAX: 49.69.75.75.66.08
Contact: Ulrike Schafer, Project Manager

ART/LONDON 92, THE 7TH INTERNATIONAL CONTEMPORARY ART FAIR
March 19 - 22, 1992; Olympia, London

Interbuild Exhibitions Ltd. 44.71.486.1951
11 Manchester Square, London, UK W1M 5AB FAX: 44.71.224.2719
Contact: Joanna Pennell

DOCUMENTA IX
June 13 - September 20, 1992; Kassel, Germany

Documenta GmbH 49.561.77.00.34
Friedrichsplatz, 3500 Kassel, Germany FAX: 49.561.77.42.76
Contact: Jan Hoet, Artistic Director

THE EUROPEAN FINE ART FAIR
March 14 - 22, 1992; Maastricht, The Netherlands

The European Fine Art Foundation 31.73.14.51.65
P.O. Box 1035, 5211 KT's Hertogenbosch, The Netherlands FAX: 31.73.14.73.60
Contact: Chris van der Ven

FIAC
October 5 - 13, 1991; Grand Palais des Champs Elysees, Paris

O.I.P. 33.1.45.62.8458
62, rue de Miromesnil, 75008 Paris, France FAX: 33.1.45.63.8982
Contact: Jessie Westenholz

FOIRE D'ART ACTUEL
End of April, 1993; Palais de Expositions du Heysel, Bruxelles

Association des Galeries d'Art de Belgique 32.2.648.84.93
rue Vilain XIV, 14, 1050 Bruxelles, Belgium FAX: 32.2.648.87.01
Contact: Albert Baronian, President

INTERNAZIONALE D'ARTE CONTEMPORANEA
Dates to be determined.

Expo CTS 39.2.771.81
via Serbelloni, 2, 20122 Milano, Italy FAX: 39.2.781.828
Contact: Antonio Cendali, Secretary General

LINEART GENT
November 2 - 10, 1991; Flanders Expo, Belgium

Internationale Jaarbeurs van Vlaanderen 32.91.22.40.22
Congrescentrum, B-9000 Gent, Belgium FAX: 32.91.20.10.81
Contact: Prof. J.P. Ballegeer

ASIA

NICAF YOKOHAMA 92-INTERNATIONAL CONTEMPORAY ART FAIR
March 13 - 17, 1992; Pacifico Yokohama Exhibition Hall

International Contemporary Art Fair Committee 81.3.3505.8811
Kobayakawa Bldg. 6F, 1-9-16, Higashi-Azabu, Minato-ku FAX: 81.3.3505.8812
Tokyo 106 Japan
Contact: Fukusaburo Maeda, Chairman

THE 2ND ANNUAL TOYKO INTERNATIONAL ART SHOW 92
January 23 - 28, 1992; Tokyo International Trade Center

Art Press Center, Inc. 81.3.3505.1221
2-2-5 Roppongi, Minato-ku, Tokyo 106 Japan FAX: 81.3.3505.5997

NORTH CAROLINA

PAUL ARTHUR CLIFFORD, ASA, 315 Geitner Ave., Newton 28658 — 704.464.2348

OHIO

LILA M. HELD, ASA — 216.561.4420
3330 Warrensville Center Rd., #203, Shaker Heights 44122

OKLAHOMA

MARGOT L. NESBIT, ASA, 1703 N. Hudson, Oklahoma City 73103 — 405.525.5535

R.R. WILLIAMSON, JR., ASA — 405.843.9856
1719 Dorchester Dr., Oklahoma City 73120

OREGON

JACK P. MONGEON, ASA — 503.223.9093
Galerie Mongeon, 521 S.W. Stark St., Portland 97204

PENNSYLVANIA

JEFFREY P. FULLER, ASA, 132 S. 17th St., Philadelphia 19103 — 215.564.9977

E. CROSBY WILLET, ASA, 10 E. Moreland Ave., Philadelphia 19118 — 215.247.5721

TEXAS

DR. THEODORE R. COLEMAN, AM SCV — 214.339.4041
422 Coombs Creek Dr., Dallas 75211

LOWELL D. COLLINS, ASA — 713.622.6962
Lowell Collins Gallery, 2903 Saint St., Houston 77027

NELDA S. LEE, ASA, P.O. Box 4268, Odessa 79760 — 915.366.8426

C. VAN NORTHRUP, ASA, 14110 Dallas Pkwy, #200, Dallas 75240 — 214.239.9314

SALLY TUCKER SOLITO, AM — 713.529.8375
Tucker Appraisal Associates, P.O. Box 130605, Houston 77219

YVONNE SOUREAL TURNER, ASA — 817.737.9700
1100 Pebble Creek Rd., Fort Worth 76107

VIRGINIA

MINNIE B. ODOROFF, ASA — 703.549.4060
400 Madison St., #2007, Alexandria 22314

JAMES M. SILBERMAN, ASA, 2110 Popkins Lane, Alexandria 22307 — 703.765.6534

ART ASSOCIATIONS

ARIZONA

SCOTTSDALE GALLERY ASSOCIATION — 602.941.0900
7031 E. Cambelback Rd., Ste. 522, Scottsdale 85251 — FAX: 602.941.0814
Contact: Constance Calhoun

CALIFORNIA

ART DEALERS ASSOCIATION OF CALIFORNIA — 213.652.7465
718 N. Lacienaga, Los Angeles 90069
Contact: Mary Jane Maxwell

SAN FRANCISCO ART DEALERS ASSOCIATION — 415.626.7498
1717 Seventeenth St., San Francisco 94103
Contact: Wendy Turner

SANTA MONICA/VENICE ART DEALERS ASSOCIATION — 213.319.9956
P.O. Box 1591, Santa Monica 90506-1591 — FAX: 213.319.9959
Contact: Lynn Crandall

COLORADO

DENVER ART DEALERS ASSOCIATION — 303.292.1401
c/o The Carol Siple Gallery Ltd., 1401 17th St., Denver 80202
Contact: Carol Siple

DISTRICT OF COLUMBIA

AMERICAN ASSOCIATION OF MUSEUMS — 202.289.1818
1225 Eye St. N.W., Ste. 200, Washington 20005
Contact: Edward Able

ILLINOIS

CHICAGO ART DEALERS ASSOCIATION — 312.649.0064
107 A W. Delaware Place, Chicago 60610
Contact: Natalie Van Straaten

INTERNATIONAL SOCIETY OF APPRAISERS — 800.ISA.0105
P.O. Box 726, Hoffman Estates 60195
Contact: Janis Walters

MARYLAND

PRINT COUNCIL OF AMERICA — 301.396.6345
c/o The Baltimore Museum, 10 Art Museum, Baltimore 21218
Contact: Jay McKean Fisher

MASSACHUSETTS

BOSTON ART DEALERS ASSOCIATION — 617.267.9060
c/o Gallery Naga, 67 Newbury St., Boston 02116
Contact: Arthur Dion

NEW JERSEY

THE ASSOCIATION OF INT'L. PHOTOGRAPHY ART DEALERS — 201.664.4600
93 Standish Rd., Hinsdale 07642

NEW MEXICO

SANTA FE GALLERY ASSOCIATION — 505.989.9888
P.O. Box 9245, Santa Fe 87504
Contact: John Schaefer

NEW YORK

ART DEALERS ASSOCIATION OF AMERICA — 212.940.8925
575 Madison Ave., New York 10022 — FAX: 212.940.8776

ASSOCIATION OF ART MUSEUM DIRECTORS — 212.249.4423
41 E. 65th St., New York 10021
Contact: Millicent Gaudieri

INTERNATIONAL FINE PRINT DEALERS ASSOCIATION — 212.759.4469
485 Madison Ave., New York 10022

NATIONAL ANTIQUE & ART DEALERS ASSOCIATION — 212.826.9707
15 E. 57th St., New York 10022
Contact: Mark Jacoby

PENNSYLVANIA

PHILADELPHIA ART DEALERS ASSOCIATION — 215.545.7562
c/o Janet Fleisher Gallery, 211 S. 17th St., Philadelphia 19103
Contact: Janet Fleisher

TEXAS

DALLAS ART DEALERS ASSOCIATION — 214.720.4044
c/o David Dike Fine Art, 2613 Fairmont, Dallas 75201
Contact: David Dike

HOUSTON ART DEALERS ASSOCIATION INC.
P.O. Box 980693, Houston 77098-0693

WASHINGTON

SEATTLE ART DEALERS ASSOCIATION — 206.624.0770
c/o Greg Kucera Gallery, 608 2nd Ave., Seattle 98104-2204 — FAX: 206.624.4720
Contact: Greg Kucera

CANADA

BRITISH COLUMBIA

PROFESSIONAL ART DEALERS ASSOCIATION OF CANADA — 416.979.1276
296 Richmond St. West, Ste. 502, Toronto M5V 1X2
Contact: Sheila Jans

ARIZONA

CORINNE CAIN, ASA 602.279.2167
5726 N. 10th St., #6, Phoenix 85014 FAX: 602.241.9733

CALIFORNIA

MARGARET & VERNON ANDERSON, ASA 818.241.8598
Anderson Appraisal Service, 1606 Idlewood Rd., Glendale 91202

CAROL A. ARIEFF, ASA 415.776.3746
Carol A. Arieff & Associates, 1922 Jackson St., San Francisco 94109

JAMES B. BYRNES, ASA, AAA 213.851.0128
7820 Mulholland Dr., Los Angeles 90036

C. LEE CLARK, ASA 805.325.7094
C.L. Clark Galleries, 1818 V St., Bakersfield 93301

HENRY K. CORDIER, ASA RETIRED 213.459.2066
3503 Shore Heights Dr., Malibu 90265

DENA HALL, ASA 818.887.4399
4554 Poe Ave., Woodland Hills 91364

BETTY R. HILLER, ASA 619.485.7022
11937 Bajada Rd., San Diego 92128

MARCUS HOFFMAN, ASA 415.421.5193
Maxwell Galleries, 551 Sutter St., San Francisco 94102

DOUGLAS JONES, ASA 619.459.1370
1264 Prospect St., La Jolla 92037

JOHN KENNEDY, AM, P.O. Box 1844, Carmel 93921 408.625.3315

BARRY A. KITNICK, ASA 818.907.8384
16133 Ventura Blvd., #825, Encino 91436

BETTE LEVIN, ASA 415.564.2224
930 Noriega St., San Francisco 94122

NAOMI B. LEVINSON, ASA, CAPP 415.435.1725
Bernhard Associates, 68 Peninsula Rd., Belvedere 94920

ALEX SABBADINI, FASA 916.488.5756
2701 Cottage Way, Sacramento 95825

HARRIS J. STEWART, ASA 415.391.8185
Walton-Gilbert Galleries, 555 Sutter St., Ste. 305, San Francisco 94102

CHRISTIAN M. TITLE, ASA 213.652.0525
De Ville Galleries, Inc., 8751 Melrose Ave., Los Angeles 90069

GLORIA VANJAK, ASA 213.937.6780
400 S. Burnside Ave., Los Angeles 90036

COLORADO

ANIE M. KING, ASA 303.777.6423
Connoisseur Appraisers, 825 E. Speer Blvd., Denver 80218

JACK H. KUNIN, ASA, 180 Cook St., Ste. 111E, Denver 80206 303.322.0563

CAROL E. LEVIN, ASA, 9560 E. Powers Place, Englewood 80111 303.773.3136

CONNECTICUT

MARGARET P. ANDERSON, ASA 203.259.1809
Pomeroy-Anderson Inc., P.O. Box 787, Southport 06490

DISTRICT OF COLUMBIA

THEODORE A. COOPER, ASA, 3233 P St. N.W., Washington 20007 202.965.3800

NANCY W. EDELMAN, ASA 202.722.2968
4319 Argyle Terrace N.W., Washington 20011

LINDA LICHTENBERG KAPLAN, ASA 202.234.0309
2154 Wyoming Ave. N.W., Washington 20008

BENJAMIN E. WESCHLER, ASA, 905-9 E St. N.W., Washington 20004 202.628.1281

FLORIDA

ANTHONY CAPODILUPO, ISA, P.O. Box 85, Hollywood 33022 305.931.3800

MICHAEL B. COWEN, ASA, 233 Cedar Park Circle, Sarasota 34242 813.349.8177

SHARON M. KERWICK, ASA, ISA 305.565.9031
1633 N.E. 24th St., Fort Lauderdale 33305 FAX: 305.564.0648

HARRIS J. SAMUELS, ASA 305.362.0590
P.O. Box 171467, Hialeah 33017 FAX: 305.362.2073

JAMES M. SILBERMAN, ASA, 7768 Fairway Dr., Sarasota 34238 813.923.6809

GEORGIA

FRANCES ARONSON, ASA 404.262.7331
Frances Aronson Fine Arts, P.O. Box 11835, Atlanta 30355 FAX: 404.231.4045

HAWAII

TIM MORROW, ASA 808.661.0696
The Gallery, Ltd., 716 Front St., Lahaina Maui 96761

ILLINOIS

RICHARDRAYMOND ALASKO, ASA 312.750.1818
The Alasko Company, 360 N. Michigan Ave., Ste. 803, Chicago 60601

PAMELA P. BARDO, ASA 312.372.9216
Bardo & Associates, Inc., 55 E. Washington St., Ste. 1336, Chicago 60602

INTERNATIONAL SOCIETY OF APPRAISERS, REFERRAL SERVICE 800.ISA.0105
P.O. Box 726, Hoffman Estates 60195

BARBARA K. LEVIN, ASA 312.528.6456

DENNIS ROSENTHAL 312.642.2966
J. Rosenthal Fine Arts, Ltd., 230 W. Superior, Chicago 60610

VICTORIA SCOGLAND, ASA 708.295.0080
V.S. Valuations, Ltd., 222 Wisconsin Ave., Lake Forest 60045

INDIANA

SHARON A. THEOBALD, ASA 317.463.1268
2167 Tecumseh Park Lane, West Lafayette 47906

KANSAS

MARGARET G. HILMES, ASA 913.381.5558
3019 W. 84th Terrace, Leawood 66206

MARYLAND

MARYLOUISE M. DAY, FASA 301.229.4626
4928 Sentinel Dr., Suite 304, Bethesda 20816

MISSOURI

ELIZABETH M. BALAGBROUGH, FASA 314.962.4752
340 South Elm, St. Louis 63119 FAX: 314.962.9645

FRANK, MOLLIE & RON ZOGLIN, ASA 816.444.4774
Brookside Antiques, 6219 Oak, Kansas City 64113

NEW JERSEY

RICHARD P. BONCZA, AM, 40-24 Taylor Rd., Fair Lawn 07410 201.796.5822

NEW YORK

GEORGE M. COHEN, ASA 516.368.0964
80 Wintercress Lane, East Northport 11731

ELLEN LAKE EWALD, ASA 212.989.5151
O'Toole-Ewald Art Assoc., Inc., 1133 Broadway, NY 10010 FAX: 212.242.1629

ROBERT MYRON, ASA, 401 Garden Blvd., Garden City South 11530 516.483.1147

MARJORIE NEIKRUG, ASA 212.288.7741
Neikrug/Rosenberg, 224 E. 68th St., #6, NY 10021

JAMES ST. L. O'TOOLE, ASA 212.838.1750
O'Toole-Ewald Art Assoc., Inc., 1133 Broadway, NY 10010 FAX: 212.242.1629

ANTHONY J. PELUSO, JR., ASA, 710 Warburton Ave., Yonkers 10701 914.969.5176

LUCILLE RUBIN, AM, Seneca Trail, Harrison 10528 914.835.1095

ANTON RUDERT, JR., ASA, 30 E. 42nd St., NY 10017 212.661.0595

M.R. SCHWEITZER, ASA, 18 E. 84th, NY 10028 212.535.5430

LEON SEVILLA, ASA 212.628.5702
Sevilla Art Studio, Ltd., 207 E. 84th St., NY 10028

ROBERT C. SIMON, ASA, 225 E. 57th St., NY 10022 212.758.0335

EUGENE Y.C. SUNG, ASA, 3 Greenway Terrace, Forest Hills 11375 718.261.2084

MARY M. WALSH, AM, 71 W. 68th St., Apt. A, NY 10023 212.873.4602

BUSINESS SERVICES

S *(cont.)*

ARTIST INDEXES

S *(cont.)*

SMALLWOOD, MICHAEL
Addison/Ripley Gallery — 414

SMILLIE, G.
Secondary Market Source(s):
Previti Gallery — 441

SMILOW, PAMELA
Elaine Horwitch Galleries — 403

SMIT, ROBERT
Helen Drutt Gallery — 448

SMITH, AL
Franz Bader Gallery — 414

SMITH, ALBERT
871 Fine Arts Gallery — 408

SMITH, ALEXIS
Josh Baer Gallery — 428
Cirrus Gallery — 404
Margo Leavin Gallery — 219, 406

SMITH, ANN
Galerie International — 449

SMITH, CARY
Linda Cathcart Gallery — 411
Ealan Wingate Gallery — 446

SMITH, CLARICE
Kennedy Galleries, Inc. — 437

SMITH, DAVID
Washburn Gallery — 445
Knoedler & Co. — 437
Margo Leavin Gallery — 219, 406, 514
P•P•O•W — 441
Secondary Market Source(s):
Ameringer & Avard Fine Art — 428
Sid Deutsch Gallery — 431
Meredith Long & Co. — 451
Salander-O'Reilly Galleries — 406, 442
Susan Sheehan Gallery — 443
Simon/Neuman Gallery — 443
Susan Teller Gallery — 445
Zabriskie Gallery — 446

SMITH, EUGENE
Michael Shapiro Gallery — 410
Secondary Market Source(s):
Simon Lowinsky Gallery — 438
Vision Gallery — 410

SMITH, GORDON
Secondary Market Source(s):
Heffel Gallery, Ltd. — 452

SMITH, HASSEL
Secondary Market Source(s):
David Stuart Galleries — 407

SMITH, HENRY PEMBER
Secondary Market Source(s):
The Cooley Gallery — 414

SMITH, HOUGHTON
Grace Borgenicht Gallery — 429

SMITH, HOWARD
LeMieux Galleries — 422

SMITH, ISAAC
Peregrine Gallery — 450

SMITH, JAMES
Joy Horwich Gallery — 419
Locus — 426

SMITH, JAUNE (QTS)
Jan Cicero Gallery — 418
LewAllen Gallery — 426
Bernice Steinbaum Gallery — 444

SMITH, JEFFREY
de Andino Fine Arts — 414

SMITH, JERRY
Carl Hammer Gallery — 419

SMITH, KIKI
Fawbush Gallery — 432
Galerie Rene Blouin — 454
Shoshana Wayne Gallery — 412

SMITH, KIMBER
Luise Ross Gallery — 442
Secondary Market Source(s):
Douglas Drake Gallery — 432

SMITH, LAMAR SCOTT
Gilman-Gruen Gallery — 419
Robinson Galleries — 451

SMITH, LEE
Koplin Gallery — 411
Texas Gallery — 451
Barry Whistler Gallery — 450

SMITH, LEON POLK
Meyers/Bloom — 412

SMITH, LESLIE
LeMieux Galleries — 422
John Szoke Gallery — 444

SMITH, LINDA K.
K Kimpton Gallery — 409

SMITH, LOWELL E.
Altermann & Morris Galleries — 449, 450

SMITH, MARK S.
Still-Zinsel Contemporary — 423

SMITH, MARY ANN
Blackfish Gallery — 447

SMITH, MARY T.
Secondary Market Source(s):
Brigitte Schluger Gallery — 413

SMITH, MATTHEW
Cavin-Morris, Inc. — 430
Groveland Gallery — 425

SMITH, MELISSA
Hall-Barnett Gallery — 422

SMITH, MICHAEL
The Drabinsky Gallery — 453

SMITH, PAT
Fenix Gallery — 427

SMITH, PAULA EUBANK
Sandler Hudson Gallery — 417

SMITH, PHILIP
Jason McCoy, Inc. — 439

SMITH, REBECCA
LedisFlam Gallery — 437

SMITH, RICHARD
Feigen, Inc. — 418
Tyler Graphics, Ltd. — 427
Secondary Market Source(s):
Richard L. Feigen & Co. — 432
Dolly Fiterman Fine Arts — 425

SMITH, SAM
Robinson Galleries — 451

SMITH, SETCHIE
Hall-Barnett Gallery — 422

SMITH, SHERRI
Secondary Market Source(s):
Sandy Carson Gallery — 413

SMITH, SUSAN
Margarete Roeder Gallery — 441

SMITH, TONY
Paula Cooper Gallery — 430
Secondary Market Source(s):
Lennon, Weinberg, Inc. — 438
Thomas Segal Gallery — 424

SMITH, VINCENT
G.R. N'Namdi Gallery — 424

SMITH, VIRGINIA
Sandler Hudson Gallery — 417

SMITH, WALTER G.
Secondary Market Source(s):
Alan M. Goffman — 434

SMITHSON, ROBERT
John Weber Gallery — 445
Secondary Market Source(s):
Diane Brown Gallery — 430
Tomoko Liguori Gallery — 445

SMOCK, KRISTINE
Secondary Market Source(s):
Brigitte Schluger Gallery — 413

SMY, WOLFGANG
Steuart Levy Gallery — 438

SNEAD, BEN
Lewis Lehr, Inc. — 438

SNELL, ERIC
Olga Korper Gallery — 453

SNELSON, KENNETH
Wenger Gallery — 407
Zabriskie Gallery — 446

SNIDOW, GORDON
Secondary Market Source(s):
Altermann & Morris Galleries — 449, 450

SNOW, MICHAEL
S.L. Simpson Gallery — 454

SNYDER, CRAIG
Viridian Gallery — 445

SNYDER, DAN
The Allrich Gallery — 408

SNYDER, DAVID
Dart Gallery — 418

SNYDER, GEORGE
Arden Gallery — 423

SNYDER, GEORGE *(cont.)*
Eva Cohon Gallery, Ltd. — 418
Secondary Market Source(s):
Marguerite Oestreicher Fine Arts — 422

SNYDER, JOAN
Compass Rose Gallery — 418
Hirschl & Adler Modern — 220, 436
Nielsen Gallery — 424
Secondary Market Source(s):
Ann Jaffe Gallery — 415

SNYDER, JOHN
Bockley Gallery — 425
Carl Hammer Gallery — 419

SOCHA, DAN
CCA — 418

SOFER, KEN
M-13 Gallery — 439

SOIHL, STEPHAN
Blackfish Gallery — 447

SOKOLOWSKI, LINDA
Kraushaar Galleries, Inc. — 437

SOLANO, SUSANNA
Crown Point Press — 409, 431

SOLC, JAROSLAV
Portals Ltd. — 420

SOLDNER, PAUL
Maurine Littleton Gallery — 415

SOLIEN, T.L.
John C. Stoller & Co. — 425
Secondary Market Source(s):
Lemberg Gallery — 424
Thomson Gallery — 425

SOLLOD, ELLEN
Ginny Williams Gallery — 413

SOLMAN, JOSEPH
Robert Brown Gallery — 414
Salander-O'Reilly Galleries — 442

SOLMSSEN II, KURT
Tatistcheff Gallery, Inc. — 412

SOLOMON
Secondary Market Source(s):
Bettal Gallery — 429

SOLOMON, DAN
Klonaridis, Inc. — 453

SOLOW, PETER
Meredith Long & Co. — 451

SOMERSON, ROSANNE
Peter Joseph Gallery — 436

SOMMER, FREDERICK
Secondary Market Source(s):
Pace/MacGill Gallery — 441

SONFIST, ALAN
Secondary Market Source(s):
LedisFlam Gallery — 437

SONNEMAN, EVE
Secondary Market Source(s):
Cirrus Gallery — 404
Texas Gallery — 451
Zabriskie Gallery — 446

SONNIER, KEITH
Leo Castelli Gallery — 430, 360, 514
Susanne Hilberry Gallery — 424
Tilden-Foley Gallery — 423
Secondary Market Source(s):
Tony Shafrazi Gallery — 443

SOOSLOFF, PHILIP
Goldman Kraft Gallery — 419

SOREFF, HELEN
M-13 Gallery — 439

SOREL, EDWARD
Secondary Market Source(s):
Sacks Fine Art — 442

SOREN
Stephen Rosenberg Gallery — 442

SORIA, BECKY
Secondary Market Source(s):
Toni Jones Aries Gallery — 451

SORIANO, RAFAEL
Galerie Thomas R. Monahan — 419

SORIANO, JUAN
Kimberly Gallery — 405, 415
Secondary Market Source(s):
Jansen-Perez Gallery — 451

SORMAN, SCOTT
Secondary Market Source(s):
Charles Whitchurch Gallery — 403

SORMAN, STEVEN
Dolan/Maxwell — 448
Michael Dunev Gallery — 409
Klein Art Works — 420
Eve Mannes Gallery — 417
Thomson Gallery — 425
Tyler Graphics, Ltd. — 427
Secondary Market Source(s):
Augen Gallery — 447
Michele Birnbaum Fine Art — 429
Lemberg Gallery — 424
Perimeter Gallery — 420

SOSNO, SACHA
J. Rosenthal Fine Arts, Ltd. — 294, 421, 514

SOSS, RICK
Stephen Wirtz Gallery — 361, 410, 514

SOTO, JESUS RAFAEL
Humphrey Fine Art — 362, 436, 514
Secondary Market Source(s):
M. Gutierrez Fine Arts, Inc. — 416

SOTTSASS, ETTORE
BlumHelman Gallery, Inc. — 429
Secondary Market Source(s):
Edition John A. Schweitzer — 454
Galerie John A. Schweitzer — 454
Poirier Schweitzer — 455

SOULAGES, PIERRE
ACA Galleries — 427
The Remba Gallery/Mixografia — 412
Secondary Market Source(s):
Denise Cade-Art Prospect, Inc. — 430
Gallery K — 414
Gimpel/Weitzenhoffer Gallery — 434

SOULIE, TONY
Denise Cade-Art Prospect, Inc. — 430

SOUTHARD, DOM
Gallery 1616 — 419

SOUTINE, CHAIM
Secondary Market Source(s):
Leila Taghinia-Milani — 444

SOUTINE, ILYSE
Rubin Spangle Gallery — 442

SOUZA, AL
Moody Gallery — 451
Barry Whistler Gallery — 450

SOVAK, PRAVOSLAV
Achim Moeller Fine Art — 440

SOYER, ISAAC
Janet Marqusee Fine Arts, Ltd. — 439

SOYER, MOSES
Secondary Market Source(s):
Michael Rosenfeld Gallery — 442
Rosenfeld Fine Arts — 442

SOYER, RAPHAEL M.
Sylvan Cole — 430
Forum Gallery — 221, 433, 514
Secondary Market Source(s):
ACA Galleries — 427
Sid Deutsch Gallery — 431
Glass Art Gallery — 434
Daniel E. Lewitt Fine Art — 438
Michael Rosenfeld Gallery — 442
Rosenfeld Fine Arts — 442

SPAFFORD, MICHAEL
Francine Seders Gallery, Ltd. — 452

SPALATIN, MARCO
Gremillion & Co. Fine Art — 450
Secondary Market Source(s):
Mangel Gallery — 448

SPALDING, JEFFREY
The Drabinsky Gallery — 453
Diane Farris Gallery — 452

SPALDING, KELLY
Genovese Gallery & Annex — 423

SPALLETTI, ETTORE
Burnett Miller Gallery — 406

SPANDORFEH, MERLE
Secondary Market Source(s):
Mangel Gallery — 448

SPANO, MICHAEL
Laurence Miller Gallery — 439

SPARACIO, JOHN
Gallery Axiom — 448

SPARROW, SIMON
Carl Hammer Gallery — 419



MOONEY, MICHAEL
Secondary Market Source(s):
E.M. Donahue Gallery — 431
MOORE, BENJAMIN
Connell Gallery/Great
American Gallery — 417
LewAllen Gallery — 426
MOORE, BOB
del Mano Gallery — 404, 407
MOORE, CLAIRE MAHL
Susan Teller Gallery — 445
MOORE, COLAS
Diane Nelson Gallery — 404
MOORE, GEORGE
Anne Plumb Gallery — 441
MOORE, HENRY
Lillian Heidenberg Gallery — 435
Marlborough Gallery, Inc. — 439
Secondary Market Source(s):
Anderson-Gould Fine Art — 428
Randall Beck Gallery — 423
John Berggruen Gallery — 408
Robert Brown Gallery — 414
Feingarten Galleries — 405
Dolly Fiterman Fine Arts — 425
Arij Gasiunasen Fine Art — 416
James Goodman Gallery — 434
Richard Gray Gallery — 419
The Greenberg Gallery — 426
Nohra Haime Gallery — 435
Hokin Gallery — 415, 416
Alexander Kahan Fine Arts — 436
Kent Gallery, Inc. — 437
Jan Krugier Gallery — 437
Achim Moeller Fine Art — 440
Newspace — 406
Herbert Palmer Gallery — 406
Stephen Solovy Fine Art — 421
Philippe Staib Gallery — 444
Tasende Gallery — 404
Waddington & Gorce, Inc. — 455
Weintraub Gallery — 445
Gerhard Wurzer Gallery — 451
MOORE, JAMES
Schmidt Bingham — 443
MOORE, JAMES B.
William Sawyer Gallery — 410
MOORE, JERI
Kyle Belding Gallery — 413
Secondary Market Source(s):
Inman Gallery — 451
MOORE, JOHN
Hirschl & Adler Modern — 436
Levinson Kane Gallery — 423
MOORE, MARJORIE
Howard Yezerski Gallery — 424
MOORE, PAT MOBERLEY
Archway Gallery — 450
MOORE, STEPHEN T.
David Adamson Gallery — 414
MOORE, SUSAN
Janet Fleisher Gallery — 448
Secondary Market Source(s):
Michele Birnbaum Fine Art — 429
MOORE, TONY
Secondary Market Source(s):
Portico New York, Inc. — 441
MOORE, WILLIAM
Laura Russo Gallery — 447
MOPPETT, CARROLL
Wynick/Tuck Gallery — 454
MOQUIN, RICHARD
Michael Dunev Gallery — 409
MORALES, ARMANDO
Claude Bernard Gallery, Ltd. — 429
Gary Nader Fine Arts — 416
Secondary Market Source(s):
M. Gutierrez Fine Arts, Inc. — 416
MORALES, JESUS
Richard Green Gallery — 411
MORALES, RODOLFO
Kimberly Gallery — 405, 415
MORANDI, GIORGIO
Secondary Market Source(s):
Philippe Daverio Gallery — 431
Stephen Haller Fine Art — 435

MOREAU, ANNE
Gallery 1616 — 419
MOREHEAD, GERRY
Michael Klein, Inc. — 437
MOREL, DOMINIQUE
Kay Garvey Gallery — 419
MORENO, DAVID
CCA — 418
Feature — 432
MORENO, DOLLY
Secondary Market Source(s):
Charles Whitchurch Gallery — 403
MORGAN, CLARENCE
Sandler Hudson Gallery — 417
MORGAN, DOROTHY
John Pence Gallery — 410
MORGON, ELEMORE
Arthur Roger Gallery — 422
MORGAN, GERTRUDE
Secondary Market Source(s):
Gasperi Gallery — 422
MORGAN, IKE
Secondary Market Source(s):
Brigitte Schluger Gallery — 413
MORGAN, KENNETH
O.K. Harris Works of Art — 435
MORGAN, ROBERT
Secondary Market Source(s):
Butters Gallery, Ltd. — 447
MORGAN, SALLY
Jan Weiss Gallery — 445
MORGANA, AIMEE
Secondary Market Source(s):
American Fine Arts Co. — 428
MORGAREIDGE, JOYCE
Blackfish Gallery — 447
MORHOUS, RICHARD
Lisa Harris Gallery — 452
MORIARTY, DAVID
David Beitzel Gallery — 429
MORIMURA, YASUMASA
Secondary Market Source(s):
Fay Gold Gallery — 417
Thomas Segal Gallery — 424
MORIN, JEANIERRE
Michel Tetreault Art Contemporain — 455
MORIN, MICHEL
Waddington & Gorce, Inc. — 455
MORINQUE, HIROKI
Joanne Chappell Gallery — 408
MORISOT, BERTHE
Secondary Market Source(s):
Louis Stern Galleries — 403
MORLEY, MALCOLM
Gemini G.E.L. — 405, 434
The Pace Gallery — 441
Tyler Graphics, Ltd. — 427
Secondary Market Source(s):
Addison/Ripley Gallery — 414
Simon Capstick-Dale Fine Art — 430
Nohra Haime Gallery — 435
Lennon, Weinberg, Inc. — 438
Levinson Kane Gallery — 423
Margulies Taplin Gallery — 415
MOROLES, JESUS BAUTISTA
Davis/McClain Gallery — 450
Secondary Market Source(s):
Eve Mannes Gallery — 417
MORPER, DANIEL
Robischon Gallery — 413
Tatistcheff & Co., Inc. — 444
MORPHESIS, JIM
Hal Katzen Gallery — 437
Littlejohn-Smith Gallery — 438
Tortue Gallery — 412
The Works Gallery 175, 403, 404, 508
Secondary Market Source(s):
Gwenda Jay Gallery — 419
Charles Whitchurch Gallery — 403
MORPHOSIS
Secondary Market Source(s):
Gwenda Jay Gallery — 419
MORREL, OWEN
Philippe Staib Gallery — 444
MORRI, SARAH
Postmasters Gallery — 441

MORRICE, JAMES WILSON
Galerie Bernard Desroches — 454
MORRIS, CARL
Kraushaar Galleries, Inc. — 437
Laura Russo Gallery — 447
MORRIS, CAROL SPENCER
Secondary Market Source(s):
Biota Gallery — 412
MORRIS, DARREL
Dart Gallery — 418
MORRIS, E.K.
Secondary Market Source(s):
Couturier Gallery — 404
MORRIS, GEORGE L.K
Secondary Market Source(s):
Sid Deutsch Gallery — 431
MORRIS, HILDA
Laura Russo Gallery — 447
MORRIS, JAMES
Dorothy Weiss Gallery — 410
MORRIS, KATHLEEN
The Lowe Gallery 176, 417, 508
Robischon Gallery — 413
MORRIS, MICHAEL
Evelyn Aimis Gallery — 453
MORRIS, REGAN
Galerie Brenda Wallace — 455
MORRIS, ROBERT
Leo Castelli Gallery — 430
Margo Leavin Gallery — 406
Secondary Market Source(s):
Joy Berman Galleries — 447
Richard/Bennett Gallery — 406
MORRIS, ROBIN
Secondary Market Source(s):
Madison Galleries — 406
MORRIS, WILLIAM
The Glass Art Gallery, Inc. — 453
Helander Gallery — 416
Heller Gallery — 435
LewAllen Gallery — 426
Betsy Rosenfield Gallery — 421
Lisa Sette Gallery — 403
The Works Gallery — 449
MORRIS, WRIGHT
Alinder Gallery — 403
The Witkin Gallery, Inc. — 446
MORRISON, FRED
Alex Gallery — 414
MORRISON, GEORGE
Bockley Gallery — 425
MORRISON, MARY
Alpha Gallery — 413
MORRISON, MONTANA
Oskar Friedl Gallery — 418
MORRISROE, MARK
Pat Hearn Gallery — 435
MORRISSEY-MCGOFF, DEBORAH
Toni Birckhead Gallery — 446
MORROW, TIFFANIE
Newspace — 406
MORSBERGER, PHILIP
Rena Bransten Gallery — 408
MORT, GREG
Franz Bader Gallery — 414
MORTENSEN, GORDON
Secondary Market Source(s):
Jane Haslem Gallery — 414
MOSCA, AUGUST
Secondary Market Source(s):
Daniel E. Lewitt Fine Art — 438
MOSER, CHARLES
Schmidt Bingham — 443
MOSER, MARIA
Marsha Mateyka Gallery — 415
MOSER, WILHELM
Charles Cowles Gallery, Inc. — 431
MOSES, DOROTHY NORRIS
Jack Meier Gallery — 451
MOSES, ED
Cirrus Gallery — 404
Louver Gallery — 438
Texas Gallery — 451
Secondary Market Source(s):
Sharon Truax Fine Art — 412
Jan Turner Gallery — 407

MOSES, FORREST
Munson Gallery — 426
MOSES, GRANDMA
Galerie St. Etienne — 433
MOSES, JACQUELINE
Kay Garvey Gallery — 419
MOSHER, KIRSTEN
Daniel Newburg Gallery — 440
MOSKOWITZ, IRA
Brewster Gallery — 429
MOSKOWITZ, ROBERT
BlumHelman Gallery, Inc. — 429
Crown Point Press — 409, 431
Secondary Market Source(s):
Edition John A. Schweitzer — 454
Francine Ellman Gallery — 405
Galerie John A. Schweitzer — 454
Poirier Schweitzer — 455
MOSKOWITZ, SHIRLEY
Dolan/Maxwell — 448
MOSS, BEN FRANK
Kraushaar Galleries, Inc. — 437
MOSSET, OLIVIER
John Gibson Gallery — 434
Secondary Market Source(s):
Tony Shafrazi Gallery — 443
MOSTEL, TOBY & ZERO
Secondary Market Source(s):
Frank Bustamante Gallery — 430
MOTHERWELL, ROBERT
Associated American Artists — 428
A Clean, Well-Lighted Place — 430
Marisa del Re Gallery — 431
Gemini G.E.L. — 405
Graystone 274, 409
Harcourts Modern &
Contemporary Art — 409
Kass/Meridian — 419
Knoedler & Co. — 437
Manny Silverman Gallery — 406
Tyler Graphics, Ltd. — 427
Secondary Market Source(s):
Adams-Middleton Gallery — 449
Addison/Ripley Gallery — 414
Ameringer & Avard Fine Art — 428
Augen Gallery — 447
Randall Beck Gallery — 423
John Berggruen Gallery — 408
Michele Birnbaum Fine Art — 429
Joanne Chappell Gallery — 408
Dolan/Maxwell — 448
Douglas Drake Gallery — 432
Michael Dunev Gallery — 409
Dunlap Freidenrich Fine Art — 407
Edition John A. Schweitzer — 454
Francine Ellman Gallery — 405
Thomas Erben Gallery, Inc. — 432
Gallery K — 414
Gallery One Arts, Inc. — 453
Galerie John A. Schweitzer 177, 454
The Golden Gallery — 423
Gordon Gallery — 411
The Greenberg Gallery — 426
The Harcus Gallery — 423
Harris Gallery — 450
Jamison/Thomas Gallery — 447
B R Kornblatt Gallery — 415
Greg Kucera Gallery — 452
Levinson Kane Gallery — 423
Locks Gallery — 448
Meredith Long & Co. — 451
Mangel Gallery — 448
Marsha Mateyka Gallery — 415
Achim Moeller Fine Art — 440
Poirier Schweitzer — 455
J. Rosenthal Fine Arts, Ltd. — 421
Rubin Spangle Gallery — 442
Mary Ryan Gallery Inc. — 442
Shoshana Wayne Gallery — 412
Sragow Gallery — 444
John C. Stoller & Co. — 425
Thomson Gallery — 425
Edward Tyler Nahem Fine Art — 445
Charles Whitchurch Gallery — 403
MOTHNER, CAROL
Gerald Peters Gallery — 426

Column 1

MALEVICH, KASIMIR
Secondary Market Source(s):
The Carus Gallery — 430

MALONEY, JOE
Laurence Miller Gallery — 439

MALTULKA, JAN
Secondary Market Source(s):
Sid Deutsch Gallery — 431

MALTZ, RUSSELL
Stark Gallery — 444

MALVA, GEORGE
Centurion Galleries, Ltd. — 418

MANAFO, JANET
Sherry French Gallery — 433

MANCUSO, JOE
Davis/McClain Gallery — 450

MANCUSO, STACY
Barbara Gillman Gallery — 416

MANDEL, MIKE
Secondary Market Source(s):
Douglas Drake Gallery — 432

MANDEL, ROSE
Michael Shapiro Gallery — 410

MANE-KATZ
Secondary Market Source(s):
Alexander Kahan Fine Arts — 436

MANES, PAUL
Kouros Gallery — 437
Jan Turner Gallery — 407
Secondary Market Source(s):
Moody Gallery — 451

MANET, EDOUARD
Secondary Market Source(s):
Thomas Erben Gallery, Inc. — 432
Leila Taghinia-Milani — 444

MANGIARACINA, CHRIS
Barbara Gillman Gallery — 416

MANGO, ROBERT
Neo Persona Gallery — 440

MANGOLD, ROBERT
Artyard — 347, 413, 507

MANGOLD, ROBERT
Brooke Alexander Editions — 428
Crown Point Press — 409, 431
Rhona Hoffman Gallery — 419
The Pace Gallery — 164, 441, 507
Secondary Market Source(s):
CCA — 418
Jamison/Thomas Gallery — 447
Barbara Mathes — 439
Marc Richards Gallery — 412
Susan Sheehan Gallery — 443

MANGOLD, SYLVIA PLIMACK
Brooke Alexander — 428

MANGUIN, HENRI
Secondary Market Source(s):
Lillian Heidenberg Gallery — 435

MANIGAULT
Secondary Market Source(s):
Sacks Fine Art — 442

MANJARRIS, MICHAEL
Secondary Market Source(s):
Marguerite Oestreicher Fine Art — 422

MANN, DAVID
LedisFlam Gallery — 437

MANN, L.M.
Santa Fé East — 427

MANN, SALLY
Fraenkel Gallery — 409
Houk Gallery — 419

MANNARINO, JUDY
Secondary Market Source(s):
LedisFlam Gallery — 437

MANNERS, PAUL
Secondary Market Source(s):
Marx Gallery — 420

MANNING, JOHN
Peter Rose Gallery — 442

MANNING, WILLIAM
Anita Shapolsky Gallery — 443

MANNOR, MARGALIT
Bertha Urdang Gallery — 445

MANOUKIAN, SETA
Sherry Frumkin Gallery — 411

MANSO, LEO
Steuart Levy Gallery — 438

Column 2

MANSPEIZER, SUSAN
Viridian Gallery — 445

MANUAL
Jayne H. Baum Gallery — 428
Moody Gallery — 451

MANVILLE, ELSIE
Kraushaar Galleries, Inc. — 437

MANZAVRAKOS, MICHAEL
Dolan/Maxwell — 448

MANZONI, PIERO
Hirschl & Adler Modern — 165, 436

MANZU, GIACOMO
Tasende Gallery — 404
Secondary Market Source(s):
Alexander Kahan Fine Arts — 436
Weintraub Gallery — 445

MAPPLETHORPE, ROBERT
G. Ray Hawkins Gallery — 411
Robert Miller Gallery — 440
Betsy Rosenfield Gallery — 421
Michael Shapiro Gallery — 410
Secondary Market Source(s):
Hal Bromm Gallery — 429
Linda Cathcart Gallery — 411
Edition John A. Schweitzer — 454
Fahey/Klein Gallery — 405
Flanders Contemporary Art — 425
Fraenkel Gallery — 409
Galerie John A. Schweitzer — 454
Barbara Gillman Gallery — 416
Fay Gold Gallery — 417
Caren Golden Fine Arts — 434
Richard Green Gallery — 411
Houk Gallery — 419
Simon Lowinsky Gallery — 438
Poirier Schweitzer — 455
J. Rosenthal Fine Arts, Ltd. — 421
Texas Gallery — 451
Thomson Gallery — 425
Wessel O'Connor Gallery — 446

MARAK, LOUIS
Dorothy Weiss Gallery — 410

MARAVELL, NICHOLAS
O.K. Harris Works of Art — 435
O.K. Harris Works of Art — 424

MARCA-RELLI, CONRAD
Marisa del Re Gallery — 431
Secondary Market Source(s):
Hokin Gallery — 416

MARCACCIO, FABIAN
Stux Gallery — 444

MARCIUS-SIMONS, PICKNEY
Secondary Market Source(s):
Sacks Fine Art — 442

MARCKS, GERHARD
Lafayette Parke Gallery — 437

MARCLAY, CHRISTIAN
Trans Avant-Garde Gallery — 410
Secondary Market Source(s):
Andrea Ruggieri Gallery — 415
Solo Gallery/Solo Press — 444

MARCUS, ELLI
The Witkin Gallery, Inc. — 446

MARCUS, PAUL
P•P•O•W — 441

MARCUS, PETER
Jan Cicero Gallery — 418
Secondary Market Source(s):
Locus — 426

MARCUS, STANLEY
Neville-Sargent Gallery — 420

MARDEN, BRICE
Mary Boone Gallery — 166, 429, 507
A Clean, Well-Lighted Place — 430
Crown Point Press — 409, 431
Matthew Marks — 439
Secondary Market Source(s):
Robert Brown Gallery — 414
Paula Cooper Gallery — 430
Edition John A. Schweitzer — 454
Galerie Samuel Lallouz — 454
Galerie John A. Schweitzer — 454
Hirschl & Adler Modern — 436
Margo Leavin Gallery — 406
Jason McCoy Inc. — 439
Poirier Schweitzer — 455

Column 3

MARDEN, BRICE (cont.)
Secondary Market Source(s):
Mary Ryan Gallery Inc. — 442
Susan Sheehan Gallery — 443
Stephen Solovy Fine Art — 421

MARDOSZ, CHUCK
The Carol Siple Gallery, Ltd. — 413

MARGERUM, HUGH
Robischon Gallery — 413

MARGO, BORIS
Steuart Levy Gallery — 438
Secondary Market Source(s):
Sacks Fine Art — 442

MARGOLIS, MARGO
Beth Urdang Fine Art — 424

MARGOLIUS, BETSY
Payton Rule Gallery — 413

MARGULIS, MARTHA
Reece Galleries — 441

MARIANI, CARLO MARIA
Hirschl & Adler Modern — 436
Secondary Market Source(s):
Robert Brown Gallery — 414

MARIKA, DENISE
Akin Gallery — 423

MARIN, JOHN
Kennedy Galleries, Inc. — 437
Secondary Market Source(s):
Sid Deutsch Gallery — 431
Jordan-Volpe Gallery, Inc. — 436

MARINARO, DIANE
Chinoh Art Gallery — 430
Trinity Gallery — 417

MARINI, MARINO
Miller Gallery — 446
Secondary Market Source(s):
Avanti Galleries, Inc. — 428
Alexander Kahan Fine Arts — 436
Kent Gallery, Inc. — 437
Nahan Galleries — 440
Tasende Gallery — 404
Weintraub Gallery — 445

MARINO, CAROL
Jane Corkin Gallery — 392, 453, 507

MARINSKY, HARRY
Hammer Galleries — 435

MARIONI, DANTE
LewAllen Gallery — 426
William Traver Gallery — 452

MARIONI, PAUL
William Traver Gallery — 452

MARIONI, TOM
Crown Point Press — 409, 431
Secondary Market Source(s):
The Fabric Workshop — 448

MARISOL
Sidney Janis Gallery — 436

MARK, MARY ELLEN
Robert Koch Gallery — 409

MARK, PHYLLIS
SoHo 20 — 443

MARKS, ROBERTA
Barbara Gillman Gallery — 416
Helander Gallery — 416

MARK, WENDY
Forum Gallery — 433

MARKS, SJAK
Larry Becker — 447

MARKUS, KURT
Staley-Wise — 444

MARLOW, KEN
Taggart & Jorgensen Gallery — 415

MARON, HENRY
Neville-Sargent Gallery — 420

MARQUARDT, ROSARIO
Barbara Gillman Gallery — 416

MARQUET, ALBERT
Secondary Market Source(s):
Hilde Gerst Gallery — 434

MARQUIS, RICHARD
Kurland/Summers Gallery — 348, 406, 507

MARS, PETER
Mars Gallery — 420

MARS, TON
Jan Turner Gallery — 407

Column 4

MARSH, DIANE
Janus Gallery — 426
Tortue Gallery — 412

MARSH, REGINALD
Janet Marqusee Fine Arts, Ltd. — 439
Kennedy Galleries, Inc. — 437
Secondary Market Source(s):
Aaron Galleries — 417
ACA Galleries — 427
Sid Deutsch Gallery — 431
Midtown Payson Galleries — 439
Pensler Galleries — 415
Michael Rosenfeld Gallery — 442
Rosenfeld Fine Arts — 442
Schutz & Co. — 443

MARSH, TONY
Swidler Gallery — 425

MARSHALL, JAMES
Sena Galleries — 427

MARSHALL, KATHLEEN
David Lewinson Gallery — 403

MARSHALL, KERRY JAMES
Koplin Gallery — 411

MARSHALL, NEIL
Secondary Market Source(s):
Associated American Artists — 428

MARSHALL, VICKY
Patrick Doheny Fine Art, Ltd. — 452
The Drabinsky Gallery — 453

MARTELL, MAXINE
Joanne Warfield Gallery — 407

MARTIN, AGNES
The Pace Gallery — 167, 441, 507
Secondary Market Source(s):
Mary Boone Gallery — 429
Edition John A. Schweitzer — 454
The Elkon Gallery, Inc. — 432
Galerie John A. Schweitzer — 454
Margo Leavin Gallery — 406
Barbara Mathes — 439
Poirier Schweitzer — 455
John C. Stoller & Co. — 425
Trans Avant-Garde Gallery — 410

MARTIN, CHRIS
John Good Gallery — 434

MARTIN, DENNIS
Louis K. Meisel Gallery — 439

MARTIN, FRAN
John Berggruen Gallery — 408

MARTIN, FRANK
Lynn Goode Gallery — 450
Lisa Sette Gallery — 403
Secondary Market Source(s):
Swidler Gallery — 425

MARTIN, GARY
The Works Gallery — 403, 404

MARTIN, HENRI
Secondary Market Source(s):
Galerie Bernard Desroches — 454
Hilde Gerst Gallery — 434

MARTIN, JOHN
Secondary Market Source(s):
Fitch-Febvrel Gallery — 433

MARTIN, KEITH M.
Secondary Market Source(s):
Bill Bace Gallery — 428

MARTIN, KNOX
Gremillion & Co. Fine Art — 450

MARTIN, RON
Carmen Lamanna Gallery — 453

MARTIN, WALTER
P•P•O•W — 441

MARTINAZZI, BRUNO
Helen Drutt Gallery — 448

MARTINEAU, ANTON
Avanti Galleries, Inc. — 428

MARTINEZ, CESAR
Lynn Goode Gallery — 450
Jansen-Perez Gallery — 451

MARTINEZ, DANIEL J.
Robert Berman Gallery — 411

MARTINEZ, MIGUEL
Michael McCormick — 427

MARTINEZ, RICARDO
Secondary Market Source(s):
Brewster Gallery — 429

L (cont.)

LOOTZ, EVA
David Beitzel Gallery 429

LOPER, SHARON
Biota Gallery 412

LOPES-CURVAL, CATHERINE
Humphrey Fine Art 436

LORAN, ERLE
Secondary Market Source(s):
871 Fine Arts Gallery 408

LORD, ANDREW
Brooke Alexander Editions 428

LORD, CHIP
Rena Bransten Gallery 408

LORD, CINDY LEE
Secondary Market Source(s):
Hassel Haeseler Gallery 413

LORENZ, NANCY
Genovese Gallery & Annex 423

LOSHBAUGH, LYNNE
Brigitte Schluger Gallery 413

LOSTETTER, AL
Secondary Market Source(s):
Munson Gallery 426

LOSTUTTER, ROBERT
Secondary Market Source(s):
Dart Gallery 418

LOTTON, CHARLES
Miller Gallery 446

LOUIS, MORRIS
Andre Emmerich Gallery 432
Secondary Market Source(s):
Ameringer & Avard Fine Art 428
Gallery One Arts, Inc. 453
Margo Leavin Gallery 406
Newspace 406
Philip Samuels Fine Art 426
Stephen Solovy Fine Art 421

LOVELL, TOM
Secondary Market Source(s):
Altermann & Morris Galleries 449, 450

LOVING, ALVIN
G.R. N'Namdi Gallery 424

LOVING, REG
James Gallery 451
Janus Gallery 426
Robischon Gallery 413

LOW, JEFF
Francine Ellman Gallery 405

LOWE, ROBERT
Adams-Middleton Gallery 449
Gallery Camino Real 415
O.K. Harris Works of Art 435

LOZANO, FRANCISCO
Lladro Art Gallery 438

LOZOWICK, LOUIS
Sid Deutsch Gallery 431
Secondary Market Source(s):
Associated American Artists 428

LUCAS, BONNIE
Souyun Yi Gallery 446

LUCAS, CHRISTOPHER
John Good Gallery 434
Secondary Market Source(s):
Jan Turner Gallery 407

LUCCHESI, BRUNO
Forum Gallery 433

LUCE, KEN
Eugene Binder Gallery 449
Davis/McClain Gallery 450

LUCE, MAXIMILIEN
Secondary Market Source(s):
Galerie Bernard Desroches 454
Alexander Kahan Fine Arts 436
Soufer Gallery 444
Louis Stern Galleries 403

LUCEBERT
Secondary Market Source(s):
Avanti Galleries, Inc. 428

LUCERO, MICHAEL
Fay Gold Gallery 344, 417, 506
Dorothy Weiss Gallery 410

LUCIEN, FREDERIQUE
Lennon, Weinberg, Inc. 438

LUCIER, ALVIN
Jack Tilton Gallery 445

LUCIONI, LUIGI
Richard York Gallery 446

LUCKMAN, STEWART
Forum Gallery 425

LUCY
Zaks Gallery 421
Secondary Market Source(s):
Brigitte Schluger Gallery 413

LUEBTOW, JOHN GILBERT
Kurland/Summers
Gallery 345, 406, 507

LUINO, BERNARDINO
Gallery Henoch 433

LUKACS, ATTILA RICHARD
Diane Farris Gallery 162, 452, 507

LUKS, GEORGE
Kennedy Galleries, Inc. 437
Secondary Market Source(s):
Berry-Hill Galleries, Inc. 429

LUM, KEN
The Andrea Rosen Gallery 442

LUMPKINS, WILLIAM
Munson Gallery 426

LUND, DAVID
Grace Borgenicht Gallery 429

LUND, JANE
Forum Gallery 433

LUNDEBERG, HELEN
Tobey C. Moss Gallery 406

LUNDEEN, GEORGE
Prince Galleries 421

LUNDIN, NORMAN
Adams-Middleton Gallery 449
Olga Dollar Gallery 409
Stephen Haller Fine Art 435
Francine Seders Gallery Ltd. 452
Space Gallery 407

LUNDY, ANSTIS
Secondary Market Source(s):
Moody Gallery 451

LUNEAU, CLAUDE
Olga Korper Gallery 453

LUNNING, MARK
Inkfish Gallery 413

LUONGO, ALDO
Secondary Market Source(s):
Gene Sinser Gallery 407

LUPERTZ, MARKUS
Crown Point Press 409, 431
Hine Editions/Limestone Press 409
Michael Werner Gallery 446
Secondary Market Source(s):
Rena Bransten Gallery 408
Perimeter Gallery 420
Thomson Gallery 425

LUPUS
Lannon Cole Gallery 420

LURCAT, JEAN
Secondary Market Source(s):
Simon Capstick-Dale Fine Art 430

LUTES, JIM
Dart Gallery 418
LedisFlam Gallery 437

LUTZ, WINIFRED
Dolan/Maxwell 448

LUYCKX, BENOIT
Le Marie Tranier Gallery 415

LUYTEN, MARK
Damon Brandt 429

LYBECKER, KIRK
Cudahy's Gallery Inc. 431
Margulies Taplin Gallery 415

LYMAN, MELA
Thomas Segal Gallery 424

LYNCH, DAVID
James Corcoran Gallery 411

LYNCH, MIKE
Groveland Gallery 425
John Pence Gallery 410

LYNDS, CLYDE
Jessica Berwind Gallery 447
O.K. Harris Works of Art 435

LYNE, ANN
Franz Bader Gallery 414

LYNES, GEORGE PLATT
Robert Miller Gallery 440

LYNES, GEORGE PLATT
Michael Shapiro Gallery 410
Secondary Market Source(s):
Wessel O'Connor Gallery 446

LYON, DANNY
Jan Kesner Gallery 405
Secondary Market Source(s):
Robert Koch Gallery 409
Simon Lowinsky Gallery 438

LYON, JOAN
Lydon Fine Art 420

LYON, LUCY
Elaine Horwitch Galleries 403

LYONS, MITCH
Rosenfeld Gallery 449

LYTH, HARALD
Simon/Neuman Gallery 443

M

MAAKESTAD, ERIC
Secondary Market Source(s):
Lloyd Shin Gallery 421

MABE, JONI
Sandler Hudson Gallery 417

MABE, MANABU
Secondary Market Source(s):
Ergane Gallery 432

MABERRY, PHILLIP
Gallery Camino Real 415

MACAVOY, LIBBY
Alex Gallery 414

MACCASH, DOUGLAS JAMES
Still-Zinsel Contemporary 423

MACCONNEL, KIM
Holly Solomon Gallery 444

MACDONALD, CHRIS
Baron/Boisante Gallery 428
David Beitzel Gallery 429

MACDONALD, KEVIN
David Adamson Gallery 163, 414, 507

MACDONALD, RICHARD
CFM Gallery 346, 430, 507

MACGREGOR, MARILYN
Erika Meyerovich Gallery 410

MACHINA, JILL
Artemisia Gallery 417

MACK, DAVID
Secondary Market Source(s):
Lannon Cole Gallery 420

MACKENZIE, LANDON
Wynick/Tuck Gallery 454

MACKIEWICZ, JOHN
O.K. Harris Works of Art 435

MACKLEM, JENNIFER
Michel Tetreault Art Contemporain 455

MACLEAN, ALEX
Secondary Market Source(s):
Kathleen Ewing Gallery 414

MACPHEE, MEDRIE
Philippe Daverio Gallery 431

MACRAE, WENDELL
The Witkin Gallery, Inc. 446

MACWITHEY, DOUGLAS
Barry Whistler Gallery 450

MADIGAN, MARTHA
Secondary Market Source(s):
Jeffrey Fuller Fine Art, Ltd. 448

MADLENER, JORG
Humphrey Fine Art 436

MADSEN, BARBARA
Thomson Gallery 425

MADSEN, LOREN
McKee Gallery 439
Secondary Market Source(s):
Haines Gallery 409

MADZO, DAVID
Thomas Barry Fine Arts 425

MADZO, MICHAEL
Couturier Gallery 404

MAET, MARC
Jack Shainman Gallery, Inc. 443

MAEYRY, SOILE YLI
Amos Eno Gallery 432

MAFFEI, NICHOLAS
M-13 Gallery 439

MAGAFAN, ETHEL
Midtown Payson Galleries 439

MAGAR, TONY
New Gallery 451

MAGEE, ALAN
Edith Caldwell Gallery 408
Schmidt Bingham 443
Secondary Market Source(s):
Munson Gallery 426

MAGGI, RUGGERO
Modern Realism 450

MAGGIOTTO, JOHN
Laurence Miller Gallery 439

MAGIN, LUIS
L. A. Impression 412

MAGINN, NANCY
Robischon Gallery 413

MAGLICH, MICHAEL
Jan Turner Gallery 407

MAGNANI, ALBERTO
Jaffe Baker Gallery 415
Secondary Market Source(s):
Ann Jaffe Gallery 415

MAGRITTE, RENE
Secondary Market Source(s):
The Elkon Gallery, Inc. 432
Thomas Erben Gallery, Inc. 432
Gallery Schlesinger Limited 434
Martha Schaeffer Fine Art 443

MAGUIRE, MAURA
Bill Bace Gallery 428

MAHAFFEY, MERRILL
Jan Cicero Gallery 418
Elaine Horwitch Galleries 403, 426

MAHAFFEY, NOEL
Secondary Market Source(s):
J. Rosenthal Fine Arts, Ltd. 421

MAHMOUD, BEN
Zaks Gallery 421

MAHN, INGE
Diane Brown Gallery 430

MAHOSKY, MARK
Gimpel/Weitzenhoffer Gallery 434

MAHURIN, MATT
Fahey/Klein Gallery 405

MAILLIE, MYLES
Wyndy Morehead Fine Arts 422

MAILLOL, ARISTIDE
Secondary Market Source(s):
Bruton Gallery, Inc. 430

MAILMAN, CYNTHIA
SoHo 20 443

MAIMON, ISAAC
Swahn Fine Arts Gallery 408

MAIONE, ROBERT
Secondary Market Source(s):
John Pence Gallery 410

MAIOR, PHILIP
The Carol Siple Gallery, Ltd. 413

MAISNER, BERNARD
Cavin-Morris Inc. 430

MAITLAND, VIRGINIA
Alpha Gallery 413

MAJERCAK, ZDENO
Secondary Market Source(s):
O.K. Harris Works of Art 435

MAJORE, FRANK
Holly Solomon Gallery 444

MAKAREVICH, IGOR
Phyllis Kind Gallery 419, 432

MAKEPEACE, JOHN
Secondary Market Source(s):
Peter Joseph Gallery 430

MAKI, LUCY
Linda Durham Gallery 420

MAKON, CHRISTOPHER
Govinda Gallery 414

MAKTIMA, DWAYNE
Merrill B. Domas Indian Art 427

MALAGRINO, SILVIA
Artemisia Gallery 417

MALARIS, WILLIAM
Secondary Market Source(s):
Gallery 1616 417

FRANKENTHALER, HELEN *(cont.)*
John Berggruen Gallery	408
Joanne Chappell Gallery	408
Cirrus Gallery	404
de Andino Fine Arts	414
Douglas Drake Gallery	432
Edition John A. Schweitzer	454
Flanders Contemporary Art	425
Galeria Joan Prats	433
Galerie John A. Schweitzer	454
Arij Gasiunasen Fine Art	416
Fay Gold Gallery	417
The Golden Gallery	423
The Greenberg Gallery	426
Hokin Gallery	415, 416
Greg Kucera Gallery	452
Meredith Long & Co.	451
Linda Moore Gallery	408
Herbert Palmer Gallery	406
Gerald Peters Gallery	426, 450
Poirier Schweitzer	455
Jack Rutberg Fine Arts	406
Martha Schaeffer Fine Art	443
Miriam Shiell Fine Art Ltd.	454
Charles Whitchurch Gallery	403

FRASCONI, ANTONIO
Terry Dintenfass Gallery	431

FRASER, ANDREA
American Fine Arts Co.	428

FRASER, SCOTT
Grand Central Art Galleries	435

FRAZOWATZ, FREDERICK
Michael Ingbar Gallery	436

FRECKELTON, SONDRA
Maxwell Davidson Gallery	431

FREDERICK, LINDEN
The Cooley Gallery	**110, 414, 500**

FREDERICK, ROBILEE
K Kimpton Gallery	409

FREDMAN, FAIYA
The Annex Gallery	407

FREEDMAN, MAURICE
Midtown Payson Galleries	439

FREEL, LINDA
Secondary Market Source(s):
Zaks Gallery	421

FREELAND, BILL
Dolan/Maxwell	448

FREEMAN, KATHRYN
Tatistcheff & Co., Inc.	444

FREEMAN, ROBERT
Wendell Street Gallery	424

FREEMAN, TINA
Arthur Roger Gallery	422

FREIDMAN, STANLEY
Secondary Market Source(s):
Contemporary Realist Gallery	408

FREILICHER, JANE
Fischbach Gallery	433

FRENCH, CHRISTOPHER
Marsha Mateyka Gallery	415

FRENCH, CRAIG
Diane Nelson Gallery	404

FRENCH, JARED
Midtown Payson Galleries	439

FRENCH, JOHN
Mary Delahoyd Gallery	431

FRENCH, MICHAEL
Humphrey Fine Art	436
Roberts Gallery Limited	454

FRERE, MICHEL
Pamela Auchincloss Gallery	428
Jan Turner Gallery	407

FREUD, LUCIAN
Brooke Alexander	428

Secondary Market Source(s):
Simon Capstick-Dale Fine Art	430
Mary Ryan Gallery Inc.	442
Stiebel Modern	444
John C. Stoller & Co.	425

FREY, VIOLA
Asher/Faure	404
Rena Bransten Gallery	408
Nancy Hoffman Gallery	436

FREY, VIOLA *(cont.)*
Secondary Market Source(s):
Helander Gallery	416

FREYMAN, ERIK
Secondary Market Source(s):
Benedetti Gallery	429

FRICKER, H.R.
Modern Realism	450

FRIED, HOWARD
Secondary Market Source(s):
Gallery Paule Anglim	409

FRIED, NANCY
Graham Modern	435

FRIEDBERG, RACHEL
Avanti Galleries, Inc.	428

FRIEDKIN, ANTHONY
G. Ray Hawkins Gallery	411

FRIEDLAENDER, BILGE
Jessica Berwind Gallery	447

FRIEDLAENDER, JOHNNY
Galerie Select Ltd.	433

FRIEDLANDER, LEE
Houk Gallery	419
Laurence Miller Gallery	439
Zabriskie Gallery	446

Secondary Market Source(s):
Texas Gallery	451

FRIEDMAN, ARNOLD
Salander-O'Reilly Galleries	406, 442

Secondary Market Source(s):
Zabriskie Gallery	446

FRIEDMAN, BENNO
Andrea Marquit Fine Arts	424

FRIEDMAN, BETSY
Jane Haslem Gallery	414

Secondary Market Source(s):
Bettal Gallery	429
Sid Deutsch Gallery	431

FRIEDMAN, HAYES
Jane Haslem Gallery	414

FRIEDMAN, JON
Uptown Gallery, Inc.	445

FRIEDMAN, LANCE
Marx Gallery	420

FRIEDMAN, TOM
Feature	432

FRIEDMAN, VICTOR
The Witkin Gallery, Inc.	446

FRIEDMAN, WARNER
Schillay & Rehs	443

FRIEDMAN, GLORIA
Curt Marcus Gallery	439

FRIEDMANN, MANUELA
Takada Fine Arts	410

FRIELDS, GARY
Secondary Market Source(s):
Lanning Gallery	451

FRIELICHER, JANE
Secondary Market Source(s):
John Szoke Gallery	444

FRIEND, PATRICIA
Franz Bader Gallery	414

FRIESEKE, FREDERICK
Secondary Market Source(s):
Berry-Hill Galleries, Inc.	429

FRIESZ, RAY
Charles Whitchurch Gallery	**111, 403, 500**

FRIGERIO, ISMAEL
Scott Alan Gallery	443

FRINK, ELISABETH
Terry Dintenfass Gallery	431

FRISCH, BRIGITTA
Secondary Market Source(s):
Toni Jones Aries Gallery	451

FRISCH, JURGEN
Charles Whitchurch Gallery	403

FROLIC, IRENE
Grohe Glass Gallery	423

FROST, A.B.
Secondary Market Source(s):
J.N. Bartfield Galleries	428

FROST, STUART
Babcock Galleries	428

FRYLING, DAWN
Christopher Grimes Gallery	411

FRYLING, DAWN *(cont.)*
Secondary Market Source(s):
Gallery Paule Anglim	409

FUDGE, JOHN
Michael Leonard & Associates	438

Secondary Market Source(s):
Payton Rule Gallery	413

FUJII, CHUICHI
Klein Art Works	420

FUJII, TAZUKO
Secondary Market Source(s):
Viridian Gallery	445

FUJITA, KENJI
Luhring Augustine Gallery	438

FUJITA, KYOHEI
Heller Gallery	435
Maurine Littleton Gallery	415

FUKUI, NOBU
Gallery Camino Real	415

FULLER, BUCKMINSTER
Carl Solway Gallery	446

FULLER, VICTORIA
Payton Rule Gallery	**327, 413, 500**

FULLER, WILLIAM
Secondary Market Source(s):
Ginny Williams Gallery	413

FULMER, BETTY
Mary Bell Galleries	417

FULTON, HAMISH
Crown Point Press	409, 431
John Weber Gallery	445

FUNAKOSHI, KATSURA
Crown Point Press	409, 431

FUNCK, ZELLA
Marguerite Oestreicher Fine Arts	422

FUNCKE, APRIL
Secondary Market Source(s):
Contemporary Realist Gallery	408

FUNKE, JAROMIR
Secondary Market Source(s):
Robert Koch Gallery	409

FURCHGOTT, TERRY
Lisa Harris Gallery	**112, 452, 500**

FURMAN, DAVID
Tortue Gallery	412

Secondary Market Source(s):
O.K. Harris Works of Art	435
O.K. Harris Works of Art	424

FURUMO, PAM
Alpha Gallery	413

FUSARO, JEAN
Galerie Tamenaga	433

FUSS, ADAM
Robert Miller Gallery	440

FUSSMANN, KLAUS
Rutgers Barclay Gallery	426
Worthington Gallery	421

Secondary Market Source(s):
Wenger Gallery	407

G

GABRIELSE, PETER
Secondary Market Source(s):
O.K. Harris Works of Art	435

GADONSKI, ROBERT
Ruth Volid Gallery	421

GAGLIANI, OLIVER
The Witkin Gallery, Inc.	446

GAGNON, CHARLES
Galerie Rene Blouin	454

GAGNON, CLARENCE
Galerie Bernard Desroches	454

Secondary Market Source(s):
Waddington & Gorce, Inc.	455

GAHR, DON
Thomas Barry Fine Arts	425

GAINES, CHARLES
John Weber Gallery	445

Secondary Market Source(s):
Dorothy Goldeen Gallery	411

GAJSAK, ANDELKA
Carolyn Hill Gallery	436

GALAN, JULIO
Annina Nosei Gallery	440

GALANIN, IGOR
David Findlay Galleries	433

GALE, DAVID
Gallery of Functional Art	411

GALEN, ELAINE
SoHo 20	443

GALL, SALLY
Lieberman & Saul Gallery	438

Secondary Market Source(s):
Linda Cathcart Gallery	411
Texas Gallery	451

GALL, VINCENT
Secondary Market Source(s):
Annina Nosei Gallery	440

GALLAGHER, CYNTHIA
The More Gallery, Inc.	448

GALLAGHER, DENNIS
Rena Bransten Gallery	408

GALLAGHER, MICHAEL J.
Susan Teller Gallery	445

GALLATIN, ALBERT E.
Secondary Market Source(s):
Sid Deutsch Gallery	431
Snyder Fine Art	443

GALLAWAY, MARY LOUISE
Gremillion & Co. Fine Art	450

GALLEGOS, ROBERT
Secondary Market Source(s):
Brigitte Schluger Gallery	413

GALLIGANI, LUIGI
Dunlap Freidenrich Fine Art	407

GALLO, FRANK
Secondary Market Source(s):
Gilman-Gruen Gallery	419
Paul McCarron	439

GALLO, GEORGE
Grand Central Art Galleries	435

GALUSZKA, FRANK
The More Gallery, Inc.	448

GAMARRA, JOSE
M. Gutierrez Fine Arts, Inc.	416

GAMBILL, JEFF
Rosamund Felsen Gallery	405

GAMBOA, DIANE
Williams/Lamb Gallery	404

GAMOND, MARTA
Arch Gallery	428

GANDER, CHRIS
Laura Russo Gallery	447

GANDOLFI, DIANA GONZALES
Randall Beck Gallery	423

GANDOLFI, PAOLA
Secondary Market Source(s):
Philippe Daverio Gallery	431

GANSO, EMIL
Secondary Market Source(s):
Rosenfeld Fine Arts	442

GANSOVSKAYA, ILONA SEVEROVN
Secondary Market Source(s):
Michael Kizhner Fine Art	405

GANZ, KAREN
Francine Seders Gallery Ltd.	452

GAO, JIN
Grand Central Art Galleries	435

GAON, SIMON
Frank Bustamante Gallery	430

GARABEDIAN, CHARLES
Cirrus Gallery	404

GARANCE
Humphrey Fine Art	436

GARBE, WILLIAM
Jason McCoy, Inc.	439

GARBER, JOSH
Klein Art Works	420

GARBERT, BERNHARD
Margarete Roeder Gallery	441

GARCIA, ANTONIO LOPEZ
Marlborough Gallery, Inc.	439

GARCIA, EFFIE
Merrill B. Domas Indian Art	422

GARCIA, JORGE LOPEZ
L. A. Impression	412

GARCIA, RUPERT
Rena Bransten Gallery	408
Daniel Saxon Gallery	406

GARCIA-FERRAZ, NEREYDA
Deson-Saunders Gallery	418

D (cont.)

B (cont.)

BASS, TONY
Southwest Gallery — 450

BASTIEN, LYNE
Secondary Market Source(s):
Prior Editions — 453

BATCHELLER, ED
The Gallery Three-Zero — 434

BATCHELOR, BETSEY
Jessica Berwind Gallery — 447

BATEMAN, RONALD
Locks Gallery — 448

BATES, DAVID
John Berggruen Gallery — 408
Eugene Binder Gallery — 449
Charles Cowles Gallery, Inc. — 49, 431, 492
LewAllen Gallery — 426
Arthur Roger Gallery — 422
Secondary Market Source(s):
Peregrine Gallery — 450

BATHO, JOHN
Zabriskie Gallery — 446

BATTENBERG, JOHN
Anderson & Anderson Gallery — 425
Harcourts Modern & Contemporary Art — 409

BATTENFIELD, JACKIE
The Allrich Gallery — 408

BATTISTE, JOANNE
Brigitte Schluger Gallery — 413

BAUER, CECILE
Jan Turner Gallery — 407

BAUER, ROBERT
Thomas Segal Gallery — 424

BAUER, RUDOLF
Portico New York, Inc. — 50, 441, 492
Secondary Market Source(s):
Sid Deutsch Gallery — 431
Kouros Gallery — 437

BAUER, RUTH
Hokin Kaufman Gallery — 419

BAUERMEISTER, MARY
Secondary Market Source(s):
Virginia Lust Gallery — 438

BAUM, DON
Betsy Rosenfield Gallery — 421

BAUM, MARILYN
Secondary Market Source(s):
Olga Dollar Gallery — 409

BAUMAN, ARTHUR
John Szoke Gallery — 444

BAUMANN, GUSTAVE
Secondary Market Source(s):
Aaron Galleries — 417

BAUMANN-HUDSON, EDITH
Modernism Inc. — 410

BAUR, MIKE
Zaks Gallery — 421

BAUR, RUDOLPHE
Secondary Market Source(s):
Alexander Kahan Fine Arts — 436

BAUTISTA MOROLES, JESUS
Janus Gallery — 426
Klein Art Works — 420

BAXTER, IAIN
Carmen Lamanna Gallery — 453

BAY-SCHMIDT, NAYA
Gordon Gallery — 411

BAYER, ARLYNE
Andrea Marquit Fine Arts — 424

BAYER, HERBERT
Saidenberg Gallery — 442
Secondary Market Source(s):
Turner/Krull Gallery — 407

BAYNARD, ED
Tyler Graphics, Ltd. — 427

BAZIOTES, WILLIAM
BlumHelman Gallery, Inc. — 429
Secondary Market Source(s):
Richard L. Feigen & Co. — 432
Jason McCoy Inc. — 439

BEAL, G.
Kraushaar Galleries, Inc. — 437

BEAL, JACK
Frumkin/Adams Gallery — 433

BEAL, THADDEUS
Akin Gallery — 423

BEALL, NINA
Parkerson Gallery — 451

BEAN, BENNETT
Gimpel/Weitzenhoffer Gallery — 434
Esther Saks Gallery — 421
The Works Gallery — 449

BEARDEN, ROMARE
ACA Galleries — 427
Wendell Street Gallery — 424
Secondary Market Source(s):
Bomani Gallery — 408
Sid Deutsch Gallery — 431
Galerie Royale, Ltd. — 422
The McIntosh Gallery — 417
G.R. N'Namdi Gallery — 424
John Szoke Gallery — 444

BEASLEY, GEORGE
Alex Gallery — 414

BEASLEY, PHOEBE
Eve Mannes Gallery — 417

BEATON, CECIL
Secondary Market Source(s):
Lewis Lehr, Inc. — 438

BEAUCHAMP, ROBERT
M-13 Gallery — 439

BEAUCHEMIN, MICHAEL
The Lowe Gallery — 51, 417, 492

BEAUMONT, LINDA
William Traver Gallery — 452

BECCARD, HELEN LOUISE
Secondary Market Source(s):
Aaron Galleries — 417

BECHER, BERND & HILLA
Fraenkel Gallery — 409
Secondary Market Source(s):
Caren Golden Fine Arts — 434

BECHET, JR, RON
Galerie Simonne Stern — 422

BECHTLE, ROBERT
Crown Point Press — 409, 431
Gallery Paule Anglim — 409
O.K. Harris Works of Art — 435
Secondary Market Source(s):
Bruce R. Lewin Fine Art — 438
Louis K. Meisel Gallery — 439

BECHTLER, ANDREAS
Jerald Melberg Gallery Inc. — 446

BECK, MICHAEL
Tatistcheff & Co., Inc. — 444

BECK-BROWN, DAVID
David Lewinson Gallery — 403

BECK-FRIEDMAN, TORA
Bill Bace Gallery — 428

BECKER, MICHAEL
Helen Drutt Gallery — 448
Galerie Timothy Tew — 417
Lannon Cole Gallery — 420
Secondary Market Source(s):
Jane Haslem Gallery — 414

BECKETT, MANDA
Lisa Harris Gallery — 452

BECKMAN, FORD
Tony Shafrazi Gallery — 443
Secondary Market Source(s):
John C. Stoller & Co. — 425

BECKMAN, RICHARD
Secondary Market Source(s):
The Works Gallery — 403, 404

BECKMAN, WILLIAM
Stiebel Modern — 52, 444, 492

BECKMANN, MAX
Lafayette Parke Gallery — 437
Secondary Market Source(s):
Alpha Gallery — 423
Frumkin/Adams Gallery — 433
Isselbacher Gallery — 436
Jack Rutberg Fine Arts — 406

BECKTELL, CAROL
Albertson-Peterson Gallery — 417

BEDIA, JOSE
Frumkin/Adams Gallery — 433

BEDNAR, JOSEPH
Secondary Market Source(s):
Frank Bustamante Gallery — 430

BEECH, JOHN
Gallery Paule Anglim — 409

BEECHAM, GARY
Marx Gallery — 420

BEELER, JOE
Mongerson-Wunderlich — 420
Secondary Market Source(s):
Altermann & Morris Galleries — 449, 450

BEEMAN, MALINDA
Lynn Goode Gallery — 450

BEERS, DEBRA
Secondary Market Source(s):
Butters Gallery, Ltd. — 447

BEFELEIN, ALEXANDER
Galerie Select Ltd. — 433

BEHNKE, LEIGH
Fischbach Gallery — 433

BEHNKEN, WILLIAM
Secondary Market Source(s):
Morningstar Gallery Ltd. — 440

BEHRENS, HOWARD
Swahn Fine Arts Gallery — 408

BEJAR, FELICIANO
Kimberly Gallery — 405, 415

BEKKER, DAVID
Secondary Market Source(s):
Toni Jones Aries Gallery — 451

BELCHER, ALAN
Josh Baer Gallery — 428
Robbin Lockett Gallery — 420

BELCHER, BETSY
Conduit Gallery — 449

BELDNER, RAY
Haines Gallery — 409

BELENOK, PYOTR
Secondary Market Source(s)::
Michael Kizhner Fine Art — 53, 405

BELIK, JAROSLAV
Secondary Market Source(s):
New Gallery — 451

BELINOFF, DEANNE
The Works Gallery — 403, 404

BELIVEAU, PAUL
The Drabinsky Gallery — 453

BELKIN, ARIELLA
Art Options — 410

BELL, CHARLES
Louis K. Meisel Gallery — 439
Modernism Inc. — 410

BELL, DOZIER
Schmidt Bingham — 443

BELL, JAY PAUL
Neville-Sargent Gallery — 420

BELL, LARRY
Braunstein/Quay Gallery — 408
Kiyo Higashi Gallery — 405
New Gallery — 451
Sena Galleries — 427
The Works Gallery — 403, 404
Secondary Market Source(s):
Tony Shafrazi Gallery — 443
Jan Turner Gallery — 407

BELL, LELAND
Salander-O'Reilly Galleries — 406, 442

BELL, SCOTT
Peter Miller Gallery — 420

BELL, TREVOR
Gloria Luria Gallery — 415
Lydon Fine Art — 420
Eve Mannes Gallery — 417

BELLANY, JOHN
Ruth Siegel Gallery — 443

BELLEFLEUR, LEON
Walter Klinkhoff Gallery — 455

BELLINI, LUCETTE
Kenneth Raymond Gallery — 416

BELLMER, HANS
Secondary Market Source(s):
Galerie Select Ltd. — 433
Virginia Lust Gallery — 438

BELLOCQ, E.J.
Secondary Market Source(s):
Fraenkel Gallery — 409

BELLOWS, GEORGE
Kennedy Galleries, Inc. — 437

BELLOWS, GEORGE *(cont.)*
Secondary Market Source(s):
Aaron Galleries — 417
Adelson Galleries, Inc. — 427
Associated American Artists — 428
Berry-Hill Galleries, Inc. — 429
Susan Sheehan Gallery — 443
David Tunick, Inc. — 445

BELLOWS, KENT
Tatistcheff & Co., Inc. — 444

BELLUCCI, ROBERT
Grohe Glass Gallery — 423

BELTZIG, STEFAN
Secondary Market Source(s):
O.K. Harris Works of Art — 435

BELVILLE, SCOTT
Sandler Hudson Gallery — 417
Secondary Market Source(s):
Thomas Barry Fine Arts — 425

BEMIS, RAYE
Klein Art Works — 420

BENAIM, RICARDO
Reece Galleries — 441

BENCA, ADOLF
M-13 Gallery — 439

BENDER, BRETT
Galerie Nadeau — 448

BENES, BARTON
Feingarten Galleries — 405

BENGLIS, LYNDA
Paula Cooper Gallery — 430
Heath Gallery, Inc. — 417
Susanne Hilberry Gallery — 424
Margo Leavin Gallery — 306, 406, 492
Texas Gallery — 451
Tilden-Foley Gallery — 423
Secondary Market Source(s):
Linda Cathcart Gallery — 411
Sena Galleries — 427
Solo Gallery/Solo Press — 261, 444, 492

BENGSTON, BILLY AL
Corcoran Gallery — 252, 411
Texas Gallery — 451
The Works Gallery — 403, 404
Secondary Market Source(s):
Cirrus Gallery — 404

BENJAMIN, CLIFF
Burnett Miller Gallery — 406

BENJAMIN, KARL
Ruth Bachofner Gallery — 410
Francine Seders Gallery Ltd. — 452

BENJAMIN, JILL
Kenneth Raymond Gallery — 416

BENN, BEN
Secondary Market Source(s):
Daniel E. Lewitt Fine Art — 438

BENNER, SUE
Lucy Berman Gallery — 407
Feature — 432
Galerie Brenda Wallace — 455

BENNETT, JOHN
Denise Cade-Art Prospect Inc. — 430

BENNETT, TONY
Grand Central Art Galleries — 435

BENNEY, PAUL
P•P•O•W — 44

BENNO, BENJAMIN
Michael Rosenfeld Gallery — 442

BENOIT, CLAUDEHILIPP
Galerie Brenda Wallace — 45

BENRIMO, TOM
Secondary Market Source(s):
Sid Deutsch Gallery — 43
Valley House Gallery, Inc. — 45

BENSON, FRANK
Secondary Market Source(s):
Berry-Hill Galleries, Inc. — 42

BENSON, PAUL
M.C. Gallery, Inc. — 42

BENSON, RICHARD
Jan Kesner Gallery — 40
Washburn Gallery — 44

BENTLEY, CLAUDE
Boritzer/Gray Gallery — 41

BENTON, FLETCHER
John Berggruen Gallery — 40

INDEXES

WINSLOW, JOHN
b. Washington, DC
(1938 - present)

John Winslow studied architecture at Princeton University and received his BA in 1960, then studied painting to earn his MA in 1963. John received the Louis Comfort Tiffany Award in Painting in 1965. He has been a professor of Painting at the Catholic University, Washington, DC since 1969. John Winslow has exhibited at museums and galleries across the country including the Corcoran Gallery of Art; Wadsworth Athenaeum; Fogg Museum; Minneapolis Inst of Arts; Ft Worth Art Museum; San Francisco Museum of Modern Art; High Museum of Art; Brooklyn Museum; San Antonio Museum; Indianapolis Museum of Art; Tucson Museum; Carnegie Inst; Philadelphia Museum of Art; Milwaukee Art Center; and the Inst of Contemp Art, Boston. Public collections include the New Orleans Museum of Art; the Corcoran Gallery; the Metropolitan Opera-Lincoln Center; The Butler Inst of American Art; and the Lauren Rogers Museum, Laurel, MS.
(See page 244)

WOELFFER, EMERSON
b. Chicago, Illinois
(1914 - present)

Chronology: The School of the Art Inst of Chicago, 35-37; joins the WPA Arts Program, 38; joins US Army Air Force, assigned as topographical draftsman, 39; is discharged, 42; becomes faculty member of the Inst of Design, Chicago, IL, 42-49; solo exhibition and visiting professorship at Black Mountain College, NC, 49; travels and works in Yucatan, Mexico, 49; becomes painting instructor at CO Springs Fine Arts Center, 50-56; solo exhibition at Art Inst of Chicago, IL, 51; solo exhibitions at the Paul Kantor Gallery, Beverly Hills, CA, 56, 60; travels throughout Europe, lives for 18 months in Forio d'Ischia, Naples, Italy, 57-59; solo exhibitions at Poindexter Gallery, NYC, 59-61; becomes painting instructor at Chouinard Art Inst, LA, CA, 59-61; retrospective exhibition at La Jolla Art Center, CA, 61; receives fellowship from Tamarind Lithography Workshop, CA, 61; retrospective exhibition at Pasadena Art Museum, CA, 62; solo exhibition at the Santa Barbara Museum of Art, CA, 64; receives Guggenheim Fellowship, travels to France, Italy, Spain and England, 67; becomes instructor at the CA Inst of the Arts, Valencia, 69-73; receives grant from the NEA, 74; retrospective exhibition at the Newport Harbor Art Museum, CA, 74; becomes Chair of Painting Dept, Otis Art Inst, LA, CA, 74; solo exhibitions at the Phillips Collection, Wash, DC, 74; solo exhibitions at Poindexter Gallery, NYC, Gruenebaum, NYC, 76, 78-79; retrospective exhibition at The Art Gallery, CA State Univ at Fullerton, 81; solo exhibition at Manny Silverman Gallery, LA, CA, 90; receives honorary doctorate degree from Otis Parsons Art Inst/The New School of Social Research, 91; retrospective planned, Otis Parsons Art Inst/The New School of Social Research, 92-93.
(See page 245)

WÖLFLI, ADOLF
b. Bowil, Emmenthal
(1864 - 1930)

Chronology: 1890-1892: Wolfli is imprisoned in the St Johannsen prison. 1899: Wolfli begins his artistic production. No works from this time are known to be extant. 1904-1906: First drawings on record. 1908: Wolfli begins work on his narrative oeuvre, which he continues to the end of his life. 1916: From now on Wolfli signs his works- St Adolf II. 1921: Walter Morgenthaler publishes his monograph- A Mentally Ill Person As Artist. 1930: On Nov 6, Adolf Wolfli dies of intestinal cancer.
Selected Solo Exhibitions: Adolf Wolfli, travelling exhibition, 76-80: Kunstmuseum Bern; Kestner Gesellschaft, Hanover, W Germany, 76; Wurtembergischer Kunstverein, Stuttgart, W Germany, 76; Moderna Museet, Stockholm, Sweden, 76; Stedelijk Museum, Amsterdam, The Netherlands, 76; Palais des Beaux-Arts, Bruxelles, Belgium, 76; Kolner Kunstverein, Cologne, W Germany,76; Museum des 20. Jahrhundrerts, Vienna, 76; Kulturhaus, Graz, Austria, 76; Busch-Reisinger Museum, Cambridge, MA, 76; Museum of Contemp Art, Chicago, IL, 76; Des Moines Art Center, IA, 76; Inst of Contemp Arts, London, 76; Centre Nat'l d'Art et de Culture Georges Pompidou, Paris, 76; Adolf Wolfli: Cahier Geographique no. 12, Collection de l'Art, Brut, Lausanne, 81; Hochschule der Kunste, Berlin, 82.
(See page 258)

WOOD, ALAN
b. Widnes, Lancashire, England
(1935 - present)

Alan Wood is a British born Canadian artist presently living in Vancouver, Canada. His complex and powerful canvas and wood constructions recently received the following praise from Giles Auty writing in The Spectator after viewing Wood's recent show in London: "His semi-abstract constructions are a synthesis of his experience of the beautiful wooded landscape near Vancouver. These are impressive works which would make rewarding additions to public or private collections." With upcoming exhibitions in the United States, England and Japan, Wood seems poised to receive international acclaim in the year ahead.
(See page 246)

WYETH, ANDREW NEWELL
b. Chadds Ford, Pennsylvania
(1917 - present)

Andrew Wyeth, one of America's most popular contemporary artists, is regarded as the foremost exponent of the realist tradition today. Wyeth's poetic images have remained faithful to a naturalistic depiction of the world around him. Wyeth received his earliest training from his father, the illustrator NC Wyeth. However, for the most part, Wyeth developed his skills on his own, once stating that he "worked everything out by trial and error." His earliest influences, in addition to his father, were the paintings of Winslow Homer and the prints of Albrecht Durer. Wyeth had his first solo exhibition in 1937, at the Macbeth Gallery in New York City. The show, which consisted of a display of colorful watercolor renderings of Maine sold out within twenty-four hours. Taken aback by the immediacy of his success, Wyeth decided to focus his creative energies on an art of deeper "substance." Wyeth divides his painting between Maine and Pennsylvania, he works in pencil, watercolor, drybrush and is especially known for having mastered the medium of tempera.
(See pages 247 & 282)

YAMADA, TAKESHI
b. Osaka, Japan
(1960 - present)

Takeshi Yamada moved to the United States as a student in 1983. He earned a BFA from the Maryland Inst of Art and a MFA from the University of Michigan. Yamada spent some time in New Orleans and currently resides in Chicago. Takeshi fuses Eastern philosophy, Western architecture and cross cultural mythology in his "post-photorealistic" works. His paintings depict urban allegories of cities such as New York, New Orleans and Chicago. Yamada has paintings in the University of Michigan Museum of Art, the New Orleans Museum of Art, the Louisiana State Museum and the NSA Chicago Culture Center.
(See page 248)

TULL, WILLIAM F. (1924 - present)
b. Normal, Illinois

Education: Univ of IL, BFA; James Millikin Univ. William Tull of Santa Fe/Phoenix is represented at the Santa Fé East Gallery; his paintings reflect the nurturing desert aura of the American Southwest. **Selected Exhibitions:** Art Wagon Gallery, Scottsdale, AZ, 66; Jean Seth's Canyon Road Gallery, 70's; Palm Springs, LA, Denver, Europe. He began custom designing adobe earth homes in the late 60's; was a prime force in the resurrection of adobe made structures compatible with modern building codes; profiled in PBS documentary; premiered at Whitney Museum of American Art, NYC, 90; principle designer of new community Adobe de la Tierra, Carefree, AZ. **Selected Publications:** Tull, Northland Press, 79; Southwest Profile, Phoenix Home & Garden. **Films:** Letting the Moonlight In, William Linsman, 88. **Selected Commissions:** Southwestern Bell Corp, St Louis, MO, 85.
(See page 237)

TYLER, VALTON (1944 - present)
b. Texas City, Texas

Valton Tyler is an outsider. His images and iconography are totally personal and unrelated to the expressions of other artists. Unincumbered by a formal art education, he paints with an honesty and pureness of spirit. Born with a unique vision of the world, he has developed the ability to transfer almost effortlessly this vision to a two-dimensional medium. His innate sense of composition and color and his natural skill as a painter often mask any hint that he is unversed in art history and that he is largely self-taught. Born in Texas City, Texas, in 1944, his first memories are of disaster. A fertilizer ship in the harbor exploded when he was three years old leaving Valton with vivid visual memories of the devastation. This event coupled with a truly disfunctional family caused Valton to withdraw into a private world revealed only in his paintings.
(See page 238)

URUETA, CORDELIA (1903 - present)
b. Coyoacan, Mexico

Cordelia Urueta resides in Mexico City, Mexico. **Selected Exhibitions:** Salon de la Plastica, Mexicana, Mexico City, Mexico, 50; Andre Weil Gallery, Paris, France, 52; Nat'l Inst of Fine Arts, Mexico City, 58, 60; Proteo Gallery, Mexico City, 60; VI Int'l Biennial, Sao Paulo, Brazil, 61; Jacobo Glantz Gallery, Mexico City, 61; Museum of Modern Art, Mexico City, 64-65, 70, 75, 85; Galeria de Arte Mexicano, Mexico City, 67, 72, 80; Nat'l Univ of Mexico, Mexico City, 68; X Int'l Biennial, Sao Paulo, Brazil, 69; Nat'l Museum of Modern Art, Kyoto, Japan, 75; Petit Palais, Paris, France, 82; Interamerican Biennial, Havana, Cuba, 85; Kimberly Gallery, Wash, DC, 87, 89-91; Kimberly Gallery, LA, CA, 91.
(See page 239)

VAADIA, BOAZ (1951 - present)
b. Israel

Selected Group Exhibitions: Hofstra Museum Outdoor Sculpture Installation, Hofstra Univ, Hempstead, NY, 90; Other Gods: Containers of Belief, Emerson Museum of Art, Syracuse, NY, travelled. **Selected Bibliog:** Art in Israel, Amnon Barzel, Giancarlo Politi Editore, Milan, Italy, 88. **Selected Collections:** Metropolitan Museum of Art, NYC; San Francisco Museum of Modern Art, SF, CA. **Selected Awards:** Ariana Foundation for the Arts, NYC, 86; NEA, 88.
(See page 369)

VAN ALSTINE, JOHN (1952 - present)
b. Johnstown, New York

Selected Solo Exhibitions: Herbert F Johnson Museum, Ithaca, NY, 76; Museum of Nat'l Arts Fndtn, NY, 87; Phillips Collection, Wash, DC, 87; Jersey City Museum, NJ, 88; Diane Brown Gallery, NY, 84; Osuna Gallery, Wash, DC, 81, 83, 85, 89; George Ciscle Gallery, Baltimore, MD, 86, 88; C Grimaldis Gallery, Baltimore, MD, 84, 91; Gerald Peters Gallery, Santa Fe, NM, 89, 91; Nohra Haime Gallery, NY, 88-91; Franz Bader Gallery, Wash, DC, 90-91. **Selected Collections:** The Hirshhorn Museum & Sculpture Garden, Wash, DC; Nat'l Museum of American Art, Wash, DC; Baltimore Museum of Art, MD; Corcoran Gallery of Art, Wash, DC; Denver Art Museum, CO; Newark Museum of Art, NJ; Museum of Art, Lisbon, Portugal. **Selected Awards:** Louis C Tiffany Foundation Fellowship, 80; NJ Council on the Arts, Individual Artist Fellowship, 84, 86; NEA, Individual Artist Fellowship, Sculpture, 86.
See page 370)

VAN VRANKEN, ROBERT

Selected Group Exhibitions: Contemp Masters, Glenn Dash Gallery, LA, CA. **Selected Bibliog:** The Expressionist Surface: Contemp Art in Plaster, The Queens Museum, Flushing, NY, Barbara C Matlsky, 90; The New York Times, Plaster as a Medium, Not Just an Interim Step, Michael Brenson, July 13, 90. **Selected Grants:** Yaddo, Artists Residency, 90; MacDowell Colony for the Arts; Artists Residency, 86, 88.
See page 240)

VOLTI, ANTONIUCCI (1915 - present)
b. Albano, Italy

One of the important French sculptors of this century, Volti's sculpture and drawings have been acclaimed for the past fifty years in Europe, North America and now Japan. His classical yet modern, silent, graceful, smooth and rounded ladies of bronze are in fine collections around the world. Many of his works are permanently displayed in the Musee Volti in Ville Franche-sur-Mer and commissions can be seen in city squares and museums throughout France. This work has become increasingly difficult to acquire. As we head into the 21st century these works, indeed, all the works by prominent 20th-century artists will become rarer and less accessible to the average collector.
See page 371)

WALTON, WILLIAM E. (1935 - present)
b. Camden, New Jersey

William Walton resides in Philadelphia, Pennsylvania and Wall, New Jersey. He studied at The Inst of Design in Chicago, and worked in various printmaking studios, including Falcon Press in Philadelphia with Eugene Feldman, until turning full-time to his own work in 1965. Teaching includes Drexel Univ, Philadelphia and Moore College of Art, Philadelphia, PA. Bibliography includes: ARTnews, 12/86; New Art Examiner, 1/87, 4/90; Dialogue, 5/87; The Philadelphia Inquirer, 10/88, 1/90; Artforum, 3/90; and Contemporanea, 4/90, among others. Work in private collections in New York, California and Pennsylvania, including the Philadelphia Museum of Art. **Selected Solo Exhibitions:** Seven or Eight More Places, Larry Becker Gallery, Philadelphia, PA, 89; Six or Seven Places in One Place, Morris Gallery, Pennsylvania Academy of Fine Arts, Philadelphia, PA, 90; One Place/The Same Place, North Dakota Museum of Art, Grand Forks, ND, 91. Larry Becker Gallery, Philadelphia, PA, 92. **Selected Group Exhibitions:** Artists Choose Artists, The Inst of Contemp Art/Univ of PA, Philadelphia, 91.
(See page 372)

WEBER, MAX (1881 - 1961)
b. Bialystok, USSR

Education: Pratt Inst, Brooklyn, under Arthur Wesley Dow, 1898-1900; Academie Julian, Paris, 1905; Academie Colarossi & Academie de la Grande Chaumiere, Paris; studied with Henri Matisse, Paris, 1907. **Selected Solo Exhibitions:** Whitney Museum of American Art, NYC, 49; CA Palace of the Legion of Honor, SF, 49; Walker Art Center, Minneapolis, MN, 49; The Jewish Museum, NYC, 56; Rose Art Gallery, Brandeis Univ, Waltham, MA, 57; Newark Museum, NJ, 59; Pratt Inst, Brooklyn, NY, 59; American Academy of Arts & Letters, NYC, 62; The Downtown Gallery, 63; Bernard Danenberg Galleries, NYC, 74; Forum Gallery, NYC, 74-75, 79, 81, 86, 88, 90-91; Museum of Fine Arts, Houston, TX, 92; Corcoran Gallery of Art, Wash, DC, 92; Albright-Knox Art Gallery, Buffalo, NY, 92; Brooklyn Museum, NY, 92; LA County Museum of Art, CA, 92. **Selected Collections:** Baltimore Museum of Art, MD; Detroit Inst of Arts, MI; Fogg Art Museum, Cambridge, MA; Museum of Modern Art, NYC; Nat'l Gallery of Art, Wash, DC.
(See page 242)

WEBER, STEPHANIE
b. Lubbock, Texas

Selected Solo Exhibitions: Orange Co Center for Contemp Art, CA, 85; Skirball Museum, LA Jewish Museum, CA,85; ARCO Galleries, Anchorage, Alaska, 85; AZ State Univ, Tempe, 85; CA State Univ, Long Beach, Univ Art Museum, 85; Shwayder Galleries, Univ of Denver, CO, 86; Ivory/Kimpton Gallery, SF, CA, 86; Stella/Polaris Gallery, LA, CA, 87; Irvine Fine Arts Center, CA, 88-89; Richmond Art Center, VA, 88; Littlejohn/Smith, NYC, 88; Eve Mannes Gallery, Altanta, GA, 89; Bank of America World Hq, SF, CA, 89; Butters Gallery, Portland, OR, 89; Merging One Gallery, Santa Monica, CA, 89; Sonoma State Univ, 89, travelled; Klein ArtWorks, Chicago, IL, 92. **Selected Group Exhibitions:** American Abstraction Show, Louis Meisel Gallery, NYC, 85; Contemp Themes II, NY Jewish Museum, 86; Small Works, June Kelly Gallery, NYC, 87; CA Crossroads, Koll Center, Newport, CA, 88; New American Abstraction, USIA Int'l Travelling Exhibit, 89-90. **Selected Collections:** Nat'l Museum of American Art, Wash, DC; Philadelphia Museum of Art, PA; Brooklyn Museum, NY; Library of Congress, Wash, DC; NY Public Library, NYC; Coca Cola Company. Guest Workshops, Lectures & Residencies: American Academy in Rome, Italy, 86; Newport Harbor Museum, CA, 86; LA County Museum of Art, CA, 86; Nsiya Nat'l Seminar in the Arts, Israel, 86; Guest Artist Seminar, JFK Univ, CA, 87; Sonoma State Univ, 88.
(See page 243)

WEGMAN, WILLIAM (1943 - present)
b. Holyoke, Massachusetts

Education: MA College of Art, Boston, BFA; Univ of IL, Urbana, IL, MFA. **Selected Solo Exhibitions:** Thomas Solomon's Garage, SF, CA, 88; Fraenkel Gallery, SF, 88; San Francisco Museum of Modern Art, CA, 88; Baudoin Lebon, Paris, 89; Pace/MacGill, NYC, 88, 90; James Corcoran Gallery, LA, CA, 90; Linda Cathcart Gallery, LA, CA, 90; Holly Solomon Gallery, NYC, 86, 88, 90; Sperone Westwater, NYC, 90; Neuberger Museum, NYC, 91; Fay Gold Gallery, Atlanta, GA, 91; Kunstmuseum, Luzern, Switz; Stedelijk Museum, Amsterdam; Frankfurt Kunstverein, Frankfurt; Centre Nat'l D'Art et de Culture Georgies Pompidou, Paris; Inst of Contemp Arts, Boston; Ringling Museum Sarasota, tour 90-91. **Selected Group Exhibitions:** Victoria & Albert Museum, London, 89; Biennial Exhibition, Whitney Museum of American Art, NYC, 89; Galerie Langer Fain, Paris, France, 90; Milwaukee Art Museum, WI, 90; USSO Tokyo, Japan, 90. **Selected Collections:** Albright-Knox Gallery of Art, Buffalo, NY; Australian Nat'l Gallery, Canberra, Australia; Brooklyn Museum, NY; Carnegie Inst, Museum of Art, PA; Chase Manhattan Bank, NY; Corcoran Gallery of Art, Wash, DC; The Contemp Museum, Honolulu; The Menil Collection, Houston, TX; Museum of Fine Art, Houston, TX; Museum of Modern Art, NY; San Francisco Museum of Modern Art, CA; St Louis Museum of Art, MO; Southeastern Center for Contemp Art, Winston-Salem; Walker Art Center, Minneapolis, MN; Whitney Museum of American Art, NYC.
(See page 400)

WINOKUR, PAULA (1935 - present)
b. Philadelphia, Pennsylvania

Selected Exhibitions: Philadelphia Museum of Art, PA, 76; Renwick Gallery, Smithsonian Institution, Wash, DC, 80; Ceramic Int'l, Gent, Belgium, 81; The Clay Studio, Philadelphia, PA, 83; Soup, Soup, Beautiful Soup, Campbell Museum, Camden, New Jersey, 84; Missouri Botanical Gardens, St Louis, 85; American Craft Museum, NYC, 86; Philadelphia Art Museum, PA, 90; solo show, Helen Drutt Gallery, NYC, 91; Moore College of Art, Philadelphia, PA, 92. **Selected Collections:** included in numerous private, public and museum collections. **Selected Bibliog:** Philadelphia: Three Centuries of American Art, Philadelphia Museum of Art, PA, 76; Craft Today: Poetry of the Physical, American Museum, 86; The New Traditions: The New Ceramics, Peter Dormer, 86; Paula Winokur: Catalogue, essay by HW Drutt, 86; Ceramics Monthly, Mar 89. **Selected Commissions:** numerous architectural doorways, mantels and fireplace commissions, USA. **Selected Awards:** Nat'l Council on Education in the Ceramic Arts, Honorary Fellowship, 83; PA Council for the Arts Grant, 86; Craftsman Fellowship Award, NEA, 76, 88.
(See page 374)

TAMAYO, RUFINO (1899 - 1991)
b. Oaxaca, Mexico

Rufino Tamayo was born of Zapotec Indian ancestry, and studied art at the Academy of San Carlos, Mexico City, for one and a half years, and then continued study on his own. In 1921 he was appointed Head Designer in the Department of Ethnographic Drawings at the Museum of Archaeology, Mexico City. In 1926, with composer Carlos Chavez, he made his first trip to New York, where he remained until 1928. He returned in 1936 and was based in New York until 1950, teaching art at the Dalton School in Manhattan. He met Marcel Duchamp, Stuart Davis, Reginald Marsh, Yasuo Kuniyoshi and other New York artists, but he was especially impressed by Picasso's Guernica in 1939. He painted a large mural for Smith College, Northampton, Massachusetts, in 1943. He made his first trip to Paris in 1949, living in Europe intermittently until 1964. He then returned to Mexico, where he was based until his death in 1991. Known for his generosity to the Mexican people and his support of young artists, Tamayo endowed two museums with his collections: the Rufino Tamayo Museum in his native Oaxaca which houses his prestigious collection of pre-Columbian art and the Tamayo Museum in Mexico City which is the first museum of international contemporary art in Mexico. Tamayo's last major artistic achievement was in sculpture. Asked to do a sculpture for a steel company in Monterrey, Mexico, he became fascinated with the project and over a five-year period completed a suite of eight monumental figures in steel patinated with a chemical compound which was developed especially for him to meet his requirement that the sculptures duplicate the texture of his paintings. Late in life Tamayo was honored with many retrospective exhibitions in New York, Mexico City, Madrid, Berlin, Oslo, Moscow and Leningrad.
(See page 366)

Rufino Tamayo helped change the course of Mexican art history by adapting the indigenous vocabulary of his Indian forebears rather than following the European realist esthetic of the Mexican muralists. Yet, although his art speaks, as he remarked, in "a Mexican accent," it reflects universal concerns. Works by Tamayo hang in collections throughout the world, including the Museum of Modern Art, New York; Musee d'Art Moderne, Paris; Tate Gallery, London; Museum of Fine Arts, Jerusalem; and Museo de Arte Arte Moderno, Mexico. **Selected Solo Exhibitions:** Albertina Museum, Vienna, Austria, 83; Nat'l Inst of Fine Arts, Mexico City, 87; Modern Museum of Art, Santa Ana, CA, 87; Mixografia Gallery, LA, CA, 88; Edvard Munch Museum, Oslo, Norway, 89; Marlborough Gallery, NYC, 90; Staadliche Kunsthalle, Berlin, 90; Hermitage Museum, Leningrad, USSR, 90; Riverside Art Museum, CA, 91.
(See pages 280)

TATOM, KIRK (1949-present)
b. Manhattan, Kansas

Education: Univ of Utah; Kansas City Art Inst. **Selected Exhibitions:** New Mexico Biennial, Santa Fe, NM, 73; Hallmark Annual Exhibition, Kansas City, KS, 76; Ratliffe-Williams Gallery, Sedona, AZ, 85, 87; Quiet Realities I, Santa Fe East, NM, 85; New Artists Show, Canyon Gallery, Santa Fe, NM, 86; Evolving Forms, Moran Gallery, Scottsdale, AZ, 87; Houshang Gallery, Dallas, TX, 87; Zimmerman/Saturn Gallery, Nashville, TN, 88; Naples Gallery, FL, 89; Squashblossom Contemp Gallery, Palm Desert, CA, 90. **Selected Collections:** Smithsonian Institution, Wash, DC; Staats Int'l, Boston, MA; First Union Bank of Nashville, TN; Baptist Medical Center of Oklahoma. **Selected Bibliog:** Palm Springs Life, Designers West Magazine.
(See page 367)

TCHAKALIAN, SAM (1929 - present)
b. Shanghai, China

Education: San Francisco State College, CA, 52, BA, psych; 58, MFA. **Selected Solo Exhibitions:** Emmanuel Walter Gallery , SF, CA, 82; Modernism, SF, CA, 86, 87, 91; The Nat'l Museum of Contemp Art, Seoul, Korea, 89. **Selected Group Exhibitions:** Univ Art Museum, Univ of CA, Berkeley, 87; Security Pacific Gallery, SF, CA, 91. **Selected Collections:** Albright-Knox Art Gallery, Buffalo, NY; Brooklyn, NY; Crocker Art Museum, Sacramento, CA; Mills College Art Gallery, Oakland, CA; Milwaukee Art Center, WI. **Selected Awards:** Adeline Kent Award, SF Art Inst, CA, 81; Maestro/Apprentice Program, CA Arts Council, 82; Fellowship Grant, NEA, 75, 81, 89.
(See page 231)

TEAGUE, MICHAEL (1958 - present)
b. Forest City, Arkansas

Education: Memphis State Univ, TN; Creative Achievement in Art Award, Cum Laude, Dean's List, Honor Society, 85, BFA; IN Univ, Bloomington, assoc instructorship, fee scholarship, Student of Fine Arts Assoc, 86-88, MFA. **Teaching Experience:** Drawing Instructor at IN Univ, 87-88. **Work Experience:** tracked asteroids for Smithsonian Inst/ IN Univ's Astronomy Dept, 86-87. **Selected Exhibitions:** Circuit Playhouse, 81; Memphis State Univ, Fine Arts Summer Shows, Museum of Fine Art, 82-83; Memphis State Univ, BFA Show, BFA Gallery, April 84; Christmas Show, Bingham's Gallery of Memphis, 85; Grad Painting Show, Arbutus Gallery, Oct 87; MFA Thesis Exhibition, IN Univ Museum of Fine Arts, April 88; DeGraaf Fine Arts Inc, Chicago, 88, 90. **Selected Collections:** Robert Fogelman, Memphis, TN; Federal Express, Memphis, TN; Thomas Hyndman, Saratoga Springs, NY; Georgia Strange, Bloomington, IN.
(See page 232)

THORNYCROFT, ANN (1944 - present)
b. England (immigrated to US in 1969)

Education: Central School of Art, London, England, 66, BA; Chelsea School of Art, London, 68, Higher Diploma in Art. **Selected Solo Exhibitions:** Rosamund Feldsen Gallery, LA, CA, 79-81; West Beach Cafe, Venice, CA, 81; Thomas Babeor Gallery, La Jolla, CA, 82, 87; Ochi Gallery, Boise, ID, 85; Irene Drori, LA, CA, 85. **Selected Group Exhibitions:** The Michael & Dorothy Blankfort Collection, LA County Museum of Art, CA, 82; Selections from Security Pacific Bank, LA Municipal Art Gallery, Barnsdall Park, CA, 82; LA Pattern Painters, ARCO Center for Visual Art, LA, CA, 83; Nancy Yewell Collection: Baxter Art Gallery, Caltech, Pasadena, CA, 83; Hundreds of Drawings, Artists' Space, NYC, 83; Contemp Printmaking, College of the Mainland, Texas City, TX, 84; Olympic Show, LA County Museum of Art, CA, 84; Contemp Watercolors, San Diego State Univ, CA, 84; The Works Gallery, Long Beach, CA, 84, 91; James A Doolittle Theatre, Hollywood, CA, 85; Pink's Fine Arts, LA, CA, 85; Celebration of CA Art, Music Center, Mercado, LA, 86; 10th Anniv Drawing Exhibit, Roberts Art Gallery, Santa Monica HS, CA, 88; Works Gallery, Long Beach, CA, 91. **Selected Bibliog:** The Galleries, LA Times, Robert McDonald, April 87; My Heart Belongs to Pasadena, Pasadena Art Alliance, Feb 86.
(See page 233)

TIPTON, RANDALL (1953 - present)
b. Fontana, California

Education: Riverside City College, CA, 72; Mendocino Art Center, CA, 77; Santa Fe Inst of Fine Arts, Master Class with Richard Diebenkorn, 85; 1991 Santa Fe Drawing Group, est 1930's. **Selected Solo Exhibitions:** Southwest Landscape, Sangre de Cristo Arts Center, Pueblo, CO, 85; White Bird Gallery, OR, 87, 89; Maveety Gallery, OR, 90. **Selected Group Exhibitions:** Southwestern Images, Santa Fe Festival of the Arts, NM, 81; Seth's Canyon Road Gallery, Santa Fe, NM, 83; NM Watercolor, New Artists, Taos Art Center, NM, 84; Four Landscape Painters, Armory for the Arts, NM, 85; Taos Connections Gallery, Denver, CO, 88; Tri-State Exhibition, El Paso, TX, 89; New Names/New Works, Santa Fe East, NM, 89; Watercolor USA, Springfield Art Museum, Springfield, MO, 89; Between Dream & Reality, Santa Fe East, NM, 91. **Selected Collections:** US West Telecommunications; Texas Instruments; Hewlett Packard; Newsweek.
(See page 234)

TODD, MARK (1950 - present)
b. Leon, Iowa

Selected Solo/Duo Exhibitions: The One Seguin Art Center, Seguin, TX , w/ Tom Allen, 80; Toni Jones Gallery, Houston, TX, 81; w/ Susan Todd, 82; The Heights Gallery, Little Rock, AK, 83; w/ Robert McGehee, 86; Southwest Univ, Georgetown, TX, w/ Neil Wilson, 85; Lessons in Life, Foster Goldstrom, NYC, 88; Kent Matricardi & Mark Todd, Univ Club Gallery, Chicago, IL, 88; Forum, Int'l Art Fair, Hamburg, W Germany, 89; Art P Gallery, Munich, W Germany, 89; Ghent Art Fair, representing Vera Van Laer Gallery, Ghent, Belgium, 89; Vera Van Laer Gallery, Knokke, Belgium, 90. **Selected Group Exhibitions:** Contemp Icons & Explorations, 92, travelled; Art Frankfurt Int'l Art Fair, W Germany, 90; Nice Art Fair, France, 90; James Gallery, Houston, TX, 90; LINEART, Ghent, Belgium, 90. **Selected Awards:** Faculty Research Grant, SWTSU, San Marcos, TX, 85-86; Mid-American Arts Alliance/Texas Award in Painting, Prints, Drawings and Artists Books, 86-87; Faculty Developmental Leave, lived and worked in England, Germany, Italy & Ireland.
(See page 256)

TODD, MICHAEL (1935 - present)
b. Omaha, Nebraska

Education: Univ of Notre Dame, South Bend, IN, 57, BA; Univ of CA, LA, 59, MA. **Teaching Experience:** Univ of CA, LA, 59-61; Bennington College, Bennington, VT, 66-68; Univ of CA, San Diego, 68-76; CA Inst of the Arts, Valencia, CA, 76-77; Pasadena Art Center, CA, 77; Otis/Parsons Art Inst, LA, CA, 78. **Selected Solo Exhibitions:** Paule Anglim Gallery, SF, CA, 78, 80, 82, 84; Lang Art Gallery, Santa Moncia, CA, 80; Tortue Gallery, Santa Monica, CA, 79-82, 84, 87-88; Charles Cowles Gallery, NYC, 81,83, 85; Paul Klein Gallery, Chicago, IL, 83, 85, 87-88; BR Kornblatt Gallery, Wash, DC, 83, 85, 87; Bemis Project Gallery, Omaha, NE, 86; Triton Museum, Santa Clara, CA, 86; Chapman College, Orange, CA, 88; Laguna Art Museum, Laguna Beach, CA, 88; The Works Gallery, Long Beach, CA, 91, 92. **Selected Group Exhibitions:** Lost & Found, Pence Gallery, Santa Monica, CA, 88; Molten Metal, Security Pacific Plaza, LA, CA, 88; Professor's Choice III, Pomona College, Claremont, CA, 88; West Coast Contemp, Sierra Nevada, Museum of Art, Reno, NV, 88. **Selected Awards:** Woodrow Wilson Fellowship, 57-59; Fulbright Fellowship to Paris, 61-63; NEA, 74-75.
(See page 368)

TOPOLSKI, ANDREW (1952 - present)
b. Buffalo, New York

Education: State Univ of New York, Buffalo, 77, MFA. **Selected Solo Exhibitions:** Brooklyn Museum, NY, 87; Museum Bochum, W Germany, 89; Galerie MS, Munster, W Germany, 89; Galerie Schuppenhauer, Cologne, W Germany, 91; AB Galeries, Paris, France, 89, 91; Galerie von der Tann, Berlin, W Germany, 89, 91; Stark Gallery, NY, 91; Jessica Berwind Gallery, Philadelphia, PA, 89, 91. **Selected Group Exhibitions:** Brooklyn Museum, NY, 86; Albright-Knox Art Gallery, Brooklyn, NY, 81-83, 88; Museum Bochum, W Germany, 88; US State Dept Travelling Exhibition; Hood Museum, Dartmouth College, Hanover, NH, 90; Spala Galerie, Prague, Czechoslovakia. **Selected Commissions:** Monumental Sculpture Commission, Mobil Technical Center, Pennington, NJ. **Selected Awards:** Augustus Saint-Gaudens Memorial Fellowship, 86; Pollack-Krasner Foundation, 89.
(See page 257)

TORLAKSON, JAMES (1951 - present)
b. San Francisco, California

Education: California College of Arts & Crafts, Oakland, 73, BFA; San Francisco State Univ, San Francisco, 74, MA. **Selected Solo Exhibitions:** John Berggruen Gallery, SF, CA, 91; Cudahy's Gallery Inc, NYC, 92. **Selected Group Exhibitions:** Contemp American Realism since 1960, PA Academy of Fine Art, Philadelphia, 81-84, travelled; American Realism: 20th Century Drawings & Watercolors, San Francisco Museum of Modern Art, SF, CA, 85; New Horizons in American Realism, Flint Inst of Art, MI, 91, travelled. **Selected Collections:** San Francisco Museum of Modern Art, CA; Art Inst of Chicago, IL; Brooklyn Museum, NY; Denver Art Museum, CO; Boise Art Museum, ID; Oakland Museum, CA; numerous private collections in America & Europe. **Selected Bibliog:** Contemp American Realism, Frank Goodyear, NY Graphics Society, 81; American Realism, 20th Century Drawing/Watercolor, Alvin Martin, Harry Abrams, NYC.
(See page 235)

TRAYLOR, BILL (1854 - 1947)
b. Benton, Alabama

Bill Traylor was born into slavery in 1854. He was discovered on the streets of Montgomery, Alabama at the age of eighty-four. Despite being homeless and crippled by rheumatism, he had begun an intensely creative period of art making that lasted four years (1939-1942) and produced approximately one thousand drawings. The images in his drawings are simple and direct, dealing with singular images of animals , daily life and visualizations of African oral history, and folk tales. The drawings were executed in flat, near silhouette shapes in pencil, or poster paint on found paper. Traylor's drawings have been exhibited throughout the world since their re-discovery in 1980, and have added immeasurably to the understanding of African-American culture.
(See page 236)

STOCK, MARK (1951 - present)
b. Frankfurt, Germany

Education: Univ of S Florida, Tampa, 76, BA. **Selected Solo Exhibitions:** Univ of S FL, Tampa, 80; Hirschl & Adler Modern, NY, 81; Laguna Art Museum, Laguna Beach, CA, 86; Tortue Gallery, Santa Monica, CA, 85, 87, 88; Modernism, SF, CA, 87-90. **Selected Group Exhibitions:** Leo Castellli Gallery, NY, 80; Thomas Jefferson Building of the Library of Congress, Wash, DC, 83; Brooklyn Museum, NY, 76, 78, 80, 83-84; Tatischeff Gallery, NYC, 86, 90; CA State Univ, San Bernardino, 87; Security Pacific Plaza, LA, CA, 89; Jane Voorhees Zimmerli Art Museum, Rutgers Univ, NJ, 90. **Collaborations:** Set design, LA Chamber Ballet productions, Japan American Theatre, LA, Son Nice, 90; Dimitri, 89; Johnny Dakota Writes it Down, at Night House Theatre, LA, 84; Tracers, Take Stock, at Royce Hall, Univ of CA, LA, 81. Set & costume design, LA Chamber Ballet productions, Japan American Theatre, LA, Orpheus, 88; The Little Prince, 86. **Selected Collections:** Achenbach Foundation for Graphic Art, CA Palace of the Legion of Honor, SF; Brooklyn Museum, NY; DeSaisset Museum, Santa Clara Univ, Santa Clara, CA; Library of Congress, Wash, DC; Museum of Modern Art, NYC.
(See page 226)

STONE, CRAIG CREE (1955 - present)
b. Reno, Nevada

Education: CA State Univ, Long Beach, 78, BA; 80, MA; 88, MFA. **Selected Solo Exhibitions:** Instant History: Retaining Resemblance, The Works Gallery, Long Beach, CA, 90; Retaining Resemblance: Artifacts 1979-89, Saddleback College Art Gallery, Mission Viejo, CA, 89; Don' Let Frenchmen, The Works Gallery, Long Beach, CA, 89; Craig Cree Stone: New Work, Functional Art Gallery, LA, CA, 85; Another Washington, Orange Co Center for Contemp Arts, Santa Ana, 84; Craig Stone at Newport Harbor, Newport Art Museum, CA, 82; The Works Gallery, Long Beach, CA, 92. **Selected Group Exhibitions:** Benish, Geer, Green, Millei, Stone at Claremont Grad School, CA, 90; Heal the Bay Surfboard, Corcoran Gallery of Art, Santa Monica, CA, 90; Frankly Functional, LA Municipal Gallery, Barnsdall Park, LA, CA, 87; Sculpture & Drawing , Long Beach Museum of Art, CA, 86; New Designs in Furniture, LA Inst for Contemp Art, LA, CA, 85; Art & the Familiar Object, Plaza Gallery, LA, CA. **Public Works:** Long Beach City Percent for the Public Arts, Krinsky Project, CA, 90. **Selected Awards:** Distinguished Master's Thesis Award, Western Assoc of Grad School, Univ Microfilms Int'l, 89; Artist-in-Residence in Wash, DC, Long Beach Museum of Art & Capitol Classroom, 82.
(See page 295)

STRAUTMANIS, EDVINS (1933 - present)
b. Leipaja, Latvia

Selected Solo Exhibitions: LoGiudice Gallery, NYC, 70, 73; Grayson Gallery, Chicago, IL, 83; Allan Stone Gallery, NYC, 75-82; Bockley Gallery, Minneapolis, MN, 85; Brigitta Jacobs Galerie, Oldenburg, W Germany, 87; Galerie Netta Linde, Lubbecke, W Germany, 87; Galerie Netta Linde, Lubbecke, 91; Stephen Rosenberg Gallery, NYC, 90-91. **Selected Group Exhibitions:** Noah Goldowsky Gallery, NYC, 67; Whitney Museum Sculpture Annual, 68; Art Inst of Chicago, IL, 70; Indianapolis Museum of Art, IN, 70, 74; Dart Gallery, Chicago, IL,76; Stephen Rosenberg Gallery, NYC, 83, 91; Northern IL Univ, DeKalb, 83; Kouros Gallery, NYC, 87; Galerie Sylvia Menzel, Berlin, 88. **Selected Collections:** Herbert F. Johnson Museum of Art; Kunsthaus, Zurich, Switz; Latvian State Museum of Art; Sydney & Francis Lewis Foundation: Minneapolis Inst of Arts; Museum of Contemp Art, Chicago; Phoenix Museum of Art. **Selected Bibliog:** Arts, Dennis Adrian, Sept 77; Arts, Herman Cherry, Nov 82; Arts, David Maitlin, Arts, Nov 84; NY Times, John Russell, Feb 13, 87; Art in America, Frederick Ted Castle, Sept 90.
(See page 227)

STROMBOTNE, JAMES (1934 - present)
b. South Dakota

Education: Pomona College, 56, BA; Claremont Graduate School, 59, MFA. **Selected Solo Exhibitions:** Pasadena Art Museum, CA, 61; Crocker Art Museum, Sacramento, CA, 68; Santa Barbara Museum of Art, CA, 71; Int'l Museum of Erotic Art, SF, CA, 75; Inland Empire Gallery, Riverside, CA, 76; Newport Harbor Art Museum, Newport Beach, CA, 80; Abraxas Gallery, Newport Beach, CA, 79-81; Jacqueline Anhalt Gallery, LA, CA, 81; Eilat Gordin Gallery, LA, CA, 85-87; Municipal Art Gallery, LA, CA, 89; Sherry Frumkin Gallery, Santa Monica, CA, 90. **Selected Collections:** Museum of Modern Art, NYC; Whitney Museum of American Art, NYC; San Francisco Museum of Art, CA; City Museum of St Louis, MO; Santa Barbara Museum of Art, CA; San Diego Fine Arts Gallery, CA; La Jolla Art Museum, CA; Amon Carter Museum, Houston, TX; Grunwald Center for the Graphic Arts, Univ of CA, LA; Los Angeles County Museum of Art, CA; Pasadena Art Museum, CA; Hirshhorn Museum & Sculpture Garden, Wash, DC; Art Inst of Chicago, IL. **Selected Awards:** Art in America, New Talent Award, 56; Honnold Travelling Fellowship, Pomona College, 56; John Simon Guggenheim Memorial Fellowship, 62-63; Tamarind Lithography Workshop Fellowship, 68.
(See page 228)

SURLS, JAMES (1943 - present)
b. Terrell, Texas

Selected Solo Exhibitions: James Surls: New Sculpture, Allan Frumkin Gallery, NY, 80; Daniel Weinberg Gallery, SF, CA, 81; Currents 16: James Surls, St Louis Art Museum, MO, 82; Sculpture & Drawings by James Surls, Honolulu Academy of Art, HI, 84; New Work, Pittsburgh Center for the Arts, PA, 87. **Selected Group Exhibitions:** New Art from a New City: Houston, Salzburger Kunstverein, Salzburg, Austria, 83; Biennial Exhibition, Whitney Museum of American Art, NY, 85; 75th American Exhibition, Art Inst of Chicago, IL, 86; Structure to Resemblance, Albright-Knox Art Gallery, Buffalo, NY, 87; Contemp Art from Texas, Groninger Museum, The Netherlands, 88; Direction & Diversity, Museum of Fine Arts, Houston, TX, 88; Word as Image: American Art 60-90, travelling exhibition, organized by the Milwaukee Art Museum, 90; Sticks & Stones, Katonah Museum of Art, NY, 91.
(See page 364)

SUTHERLAND, ROBERT (1941 - present)
b. Vancouver, Canada

Sutherland, whose space art is largely funded by the Canada Council Exploration Program, will be the first to have his work exhibited in space, probably on the NASA planned mission to Mars. "I'm the first of a new breed of artists," he says, explaining that artists and scientists will work together in the future. "Artists will be very important people in the next century. Artists willl finally become partners in life and society, something that hasn't been true for at least a hundred years." Using lasers, light, plastic, pipe, marble, brick, steel and materials only recently invented, Sutherland has created artworks that will become an integral part of a project approved by the newly formed Canadian Space program to study the effects of visual stimulation, and the lack of it, over long-duration space flights.
(See page 296)

SWANSON, FRANK

Frank Swanson has been working exclusively in stone since he graduated from the Univ of Denver in 1970. He has exhibited in many invitational & juried shows around the country. During 1972 & 73, Frank made a working tour of Europe & worked with many different types of stone. In 1980, he designed and built a unique stone saw with which he can complete innovative sculpture on a monumental scale, work that had previously been considered impossible in stone. Frank Swanson has been commissioned works at the Dell Corp in Skokie, IL; Mesa College, AZ; The Oliva Co of Colorado Springs, CO; Rose Medical Center, Denver, CO; Denver Botanic Gardens; Byer Museum, Evanston, IL; American Federal Savings, CO Springs; Garden of the Gods Country Club, CO Springs; & Mutual of NY. Frank is a founding member of the innovative and highly regarded FORM Inc, a corp of nine outstanding sculptors who specialize in large-scale contemp sculpture. Besides creating these large-scale works with various types of stone, he has created more than 90 sculptures in the range of 2 to 4 feet tall. The challenge of each different stone is a compelling force in his work, and his artistic statements are strongly influenced by the constant dialogue between the artist and the stone.
(See page 365)

SYVERSON, CRAIG (1961 - present)
b. Long Beach, California

My artwork is concerned with exploring the inherent beauty, intelligence and power that lies within the natural worlds, as revealed through the alchemical process. Every visible color or form in my work results from various transformations of natural materials from their pure state, i.e. ground minerals, pure metallic leaf. In some cases the materials are chemically altered to yield an image, as in the patination of silver and copper, or their original form is changed completely. The only processed art materials that I use are for adhesion or archival protection, and they are always colorless or unseen. I believe that in order to best use the alchemical process on the materials I use, I must also use a corresponding process on myself, and through the transmutation of dense matter, the light of the spirit can be revealed.
(See page 229)

TAAFFE, PHILIP (1955 - present)
b. Elizabeth, New Jersey

Philip Taaffe presently lives in New York City, New York and Naples, Italy. **Selected Solo Exhibitions:** Roger Litz Gallery, NYC, 82; Galerie Ascan Crone, Hamburg, W Germany, 84, 86; Pat Hearn Gallery, NYC, 84, 86-88; Galerie Paul Maenz, Hamburg, 86; Mario Diacono Gallery, Boston, MA, 87; Donald Young Gallery, Chicago, IL, 88; Mary Boone Gallery, NYC, 88; Max Hetzler, Cologne, W Germany, 91; Touko Museum of Contemp Art, Tokyo, 91. **Selected Group Exhibitions:** Biennial Exhibition, Whitney Museum of American Art, NYC, 87, 91; Post Abstract Abstraction, Aldrich Museum of Contemp Art, Ridgefield, CT, 87; Galerie Paul Maenz, Cologne, W Germany,87; Simila/Dissimilia, Kunsthalle, Dusseldorf, W Germany, 87; Mary Boone Gallery, NYC, 87; Generations of Geometry, Whitney Museum at Equitable Center, NYC, 87; Recent Tendencies in Black & White, Sidney Janis Gallery, NYC, 87; NY Art Now, Saatchi Collection, London, 87; Primary Structures, Rhona Hoffman Gallery, Chicago, IL, 87; Who's Afraid of Red, Yellow & Blue, Museum Fredericianum, Kassel, W Germany, 88; Drawings, Luhring, Augustine & Hodes, NYC, 88; Galerie Monika Spruth, Cologne, W Germany,88; Abstraction in Question, John & Mable Ringling Museum of Art, Sarasota, FL, 89; Who Framed Modern Art or the Quantitative Life of Roger Rabbit, Sidney Janis Gallery, NYC, 91; Glen Baxter, Philip Taaffe, James Welling, Galerie Samia Saouma, Paris, France, 91.
(See page 230)

SMITH, ALEXIS
(1949 - present)
b. Los Angeles, California

Education: Univ of CA at Irvine, 66-70, BA. **Teaching Experience:** Univ of CA, LA, 85-88; Skowhegan School of Painting & Sculpture, ME. **Selected Solo Exhibitions:** Rapido, Art Galleries, Univ of CA at Santa Barbara, 75; Whitney Museum of American Art, NYC, 75; Long Beach Museum of Art, Long Beach, CA, 75; Viewpoint, Walker Art Center, Minneapolis, MN, 86; Currents, The Inst of Contemp Art, Boston, 86; Alexis Smith & Joseph Cornell: Parallels, Aspen Art Center, CO, 87; Same Old Paradise, Grand Lobby Installation, The Brooklyn Museum, NY, 87-88; On the Road, Margo Leavin Gallery, LA, CA, 88; Past Lives, Santa Monica Museum of Art, CA, artist's book, 89; Alexis Smith: Public Works, Univ of CA, San Diego, 91; Retrospective scheduled to open in the fall of 91 at the Whitney Museum of American Art, NYC. **Selected Group Exhibitions:** An Int'l Survey of Recent Painting & Sculpture, works in installation, Museum of Modern Art, NYC, 84; Artpark, Lewistown, NYC, 85; Individuals: A Selected History of Contemp Art, 1945-86, Museum of Contemp Art, LA, CA; Avant-garde in the 80's, LA County Museum of Art, CA, 87; Making Their Mark: Women Artists, Cincinnati Art Museum, OH, 89; Forty Years of CA Assemblage, Wight Art Gallery, Univ of CA, LA, 89; Image World: Art & Media Culture, Whitney Museum of American Art, NYC, 89-90; 20th Century Collage, Margo Leavin Gallery, LA, CA, 91, travelled. **Selected Commissions:** Niagara, granite monument, Artpark, Lewiston, NY; Snake Path, outdoor tiled pathway, The Stuart Collection, Univ of CA at San Diego, La Jolla, CA; Terrazzo floor designs for south & west lobbies, LA Convention Center Expansion Project, in conjunction with Pei, Cobb, Freed & Partners, architects, scheduled for completion in 1994. Visiting Artist Programs: LA County Museum, 88; Wight Gallery, Univ of CA, LA, 89; Museum of Contemp Art, LA, 90.
(See page 219)

SONNIER, KEITH
(1941 - present)
b. Mamou, Louisiana

Education: Univ of SW Louisiana, 63, BA; France study trip, 63-64; Rutger's Univ, 66, MFA. **Selected Solo Exhibitions:** Keith Sonnier, Expanded File Series 1969-89, Galerie Jurgen Becker, Hamburg, W Germany, 89-90; Travelling Survey Exhibition, Douglas Hyde Gallery, Dublin, Ireland, 90, travelled; Stadtsches Museum Abteiberg, Monchengladbach, W Germany, 90; Blum Helman Gallery, Santa Monica, CA, 90; Galerie Faust, Geneva, Switz, 90; Works in Light: 1972-90, Harcus Gallery, Boston, MA, 90; The Experience of Space, Liverpool Gallery, Bruxelles, Belgium, 90; Galleria Il Ponte, Rome, Italy, 90; Centric 41, Univ Art Museum, CA State Univ, Long Beach, CA, 90. **Selected Group Exhibitions:** Drawings/Sculptures, Galerie Hubert Winter, Vienna, Austria, 90; The New Sculpture 1965-75, Museum of Contemp Art at the Temporary Contemp, LA, CA, 91; Physicality, Hunter College Art Gallery, NYC, 91; Dan Flavin, Maurizio Nannucci, Keith Sonnier: Neons, Galerie Anselm Dreher, Berlin, W Germany, 91; Frankfurt Kunstmesse, representing Galleria Il Ponte, Rome, Italy, Germany, 91. **Selected Collections:** Museum of Modern Art, NYC; Whitney Museum of American Art, NYC; Moderna Museet, Stockholm, Sweden; Museum of Contemp Art, LA, CA; Hara Museum of Contemp Art, Tokyo, Japan.
(See page 360)

SOSNO, SACHA
(1937 - present)
b. Riga, Latvia

Education: L'Ecole de Nice, Art of Obliteration. **Selected Solo Exhibitions:** Studio Ferrero, Nice, France, 72; Galleria Duemilla, Bologne, Italy, 73; Galerie Mony Calatchi, Paris, France, 74; Galeria Alvarez, Porto, Portugal, 76; Musee de St Paul, St Paul-de-Vence, France, 79; Galerie Cours St Pierre, Geneva, Switz, 84; Galerie Rouf, Munich, W Germany, 86; Galerie de l'Orangerie, Geneva, Switz, 87; Norton Museum of Art, Tampa, FL, 88; Tampa Museum of Art, FL, 89; Galerie Arts of this Century Paris, France, 91. **Selected Group Exhibitions:** Espace Cardin, Paris, France, 75; CAYC, Buenos Aires, Argentina, 75; Arc 2, Musee d'Art Moderne de la ville de Paris, France, 75; Biennale di Venezula, Italy, 76; Musee des Beaux Arts Andre Malraux, Le Havre, France, 80; Aldrich Museum of Contemp Art, CT, 85; Musee de Boulogne-Billancourt, France, 86; Musee des Arts Decoratifs, Paris, France, 87; Queens Museum, NY, 88; Gallery OK Harris, Miami, FL, 89; SAGA, Grand Palais, Paris, France, 89; Baas Museum, Miami, FL, 90; Gallery Marissa del Re, Monaco, 91.
(See page 294)

SOSS, RICK
(1956 - present)
b. San Francisco, California

Education: Univ of CA, Berkeley, BA, MFA. He presently lives in Burlingame, California. **Selected Solo Exhibitions:** Rick Soss: Society for the Encouragement of Contemp Art Exhibition, San Francisco Museum of Modern Art, CA, 85; Stephen Wirtz Gallery, SF, CA, 86, 90; Ginny Williams Gallery, Denver, CO, 88. **Selected Group Exhibitions:** Works in Bronze: A Modern Survey, Palm Springs Desert Museum, CA, 86, travelled; CA Figurative Sculpture, Palm Springs Desert Museum, CA, 87; Four Bay Area Artists, Nancy Hoffman Gallery, NYC, 87. **Selected Collections:** BankAmerica, SF, CA; DeSaisset Museum, Santa Clara Univ, Santa Clara, CA; Security Pacific Nat'l Bank, SF, CA; Sheldon Memorial Art Gallery, Lincoln, NB; Shima Corp, Tokyo, Japan.
(See page 361)

SOTO, JESUS RAFAEL
(1923 - present)
b. Ciudad Bolivar, Venezuela

Internationally renowned sculptor Jesus Rafael Soto is represented in the public collections of the world's leading museums, including: the Museum of Modern Art in New York City, Paris, Melbourne, Rome, Madrid and Stockholm; London's Tate Gallery and the Victoria and Albert Museum; Amsterdam's Stedelijk Museum; Dublin's Nat'l Museum; the Guggenheim Museum in New York; the Hirshhorn Museum & Sculpture Garden in Washington, DC, and the Nat'l Museum in Jerusalem. The subject of 14 films, Soto has created more than 25 monumental works, integrated in architecture and permanently installed throughout the world, among them: the Centre Georges Pompidou in Paris; the Banque Royale du Canada in Toronto; and the Deutsche Bundesbank in Frankfurt. He created a monumental sphere for the Olympic Sculpture Park in Seoul, Korea, and the signature pieces for Art Miami '91 and Madrid's upcoming ARCO 92. An 80-piece retrospective recently completed a year-long tour of the public museums in Japan.
(See page 362)

SOYER, RAPHAEL
(1899 - 1987)
b. Borisoglebsk, USSR

Selected Solo Exhibitions: Daniel Gallery, NYC, 29; L'Elan Gallery, NYC, 32, 35, 38; Valentine Gallery, NYC, 33, Macbeth Gallery, NYC, 35; Rehn Gallery, NYC, 39; Associated American Artists Galleries, NYC, 41, 48, 53; Wehye Gallery, NYC, 44; Babcock Gallery, NYC, 57; Krasner Gallery, NYC, 57; ACA Gallery, NYC, 61; Alfredo Valente Gallery, NYC, 61; Whitney Museum of American Art, NYC, 67; Georgia Museum of Fine Art, Univ of GA, Atlanta, 68; Nat'l Collection of Fine Arts, Wash, DC, 77; Galerie Albert, Loeb, Paris, 80; Hirshhorn Museum & Sculpture Garden, Wash, DC, 82; Univ Art Museum, Univ of CA, Santa Barbara, 83; Pembroke Gallery, Houston, TX, 83; Snug Harbor Cultural Center, Staten Island, NY, 83; Cooper Union for the Advancement of Science & Art, NYC; Boston Univ Art Gallery, MA, 84; Forum Gallery, NYC, 64, 66, 72, 77, 81-82, 85, 87, 90. **Selected Collections:** Albright-Knox Art Gallery, Buffalo, NY; Baltimore Museum of Art, MD; Brooklyn Museum, NY; Butler Art Inst, Youngstown, OH; Corcoran Gallery of Art, Wash, DC; Hirshhorn Museum & Sculpture Garden, Wash, DC; Whitney Museum of American Art, NYC.
(See page 221)

SPATZ-RABINOWITZ, ELAINE
b. New York City, New York

Selected Solo Exhibitions: Allen Stone Gallery, NYC, 81; Sudden Difficulties, installation/performance with Peter Sellars, ICA, Boston, MA, 83; Kathryn Markel Gallery, NYC, 84; ACA Galleries, NYC, 87; New Works New England, DeCordova Museum, Lincoln, MA, 87; Howard Yezerski Gallery, Boston, MA, 89, 91. **Selected Group Exhibitions:** Art of the State, Fed Reserve Bank, Boston, MA, 85; Five Woman Artists, Maris Gallery, Westfield State College, MA, 87; Triennial, Brockton Museum, MA, 80, 87, 90; On View, Wellesley College Faculty Show, Wellesley College Museum, 90. **Stage Designs:** Orchids in the Moonlight, American Repertory Theatre, Cambridge, MA, 82; Orlando, American Repertory Theatre, Cambridge, MA, 82, with Peter Sellars; Julius Ceasar, Opera Nat'l, Theatre Royal de la Monnaie, Bruxelles, Belgium, 88; Opera Company of Boston, 87, with Peter Sellars; PepsiCo Summerfare, Purchase, NY, 85. **Selected Fellowships:** Recipient of the Bunting Fellowship, Mary Ingram Bunting Inst, Radcliffe College, Cambridge, MA, 84-85.
(See page 222)

SPRAGUE, ROGER
(1937 - present)
b. Buffalo, New York

Education: Univ of OK, BFA. **Selected Exhibitions:** Wichita Art Museum, KS, 62; Five Artists NY Debut, Larcada Gallery, NYC, 66; Adam Gallery, NYC, 71; Festival Santa Fe, NM, 80; Artist Co-op Guest Show, Santa Fe, NM, 81; Robert Nichols Gallery, Santa Fe, NM, 81; Group Spring Show, Brandywine Gallery, Albuquerque, 81; New Mexico Old & New, Santa Fe East, NM, 82, 87; Three Artist Group Show, Santa Fe East, NM, 83; Quiet Realities, Santa Fe East, 85; Artists of Santa Fe, Oklahoma City, 85; Inspirations: Churches of New Mexico, Museum of Fine Arts, Santa Fe, 86; Western Images Gallery, NYC, 88-89; RB Sprague: Santa Fe Views, Santa Fe East, NM, 89; Small Works, Leslie Levy Fine Art, Scottsdale, AZ, 90; Marilyn Butler, Scottsdale, AZ, 90.
(See page 223)

SPRICK, DANIEL
(1953 - present)
b. Little Rock, Arkansas

Education: Mesa College, Grand Junction, CO, 71-73; Ramon Froman School of Art, Cloudcroft, NM, 75-77; Nat'l Academy of Design, NYC, 76; Univ of N CO, Greeley, CO, 78, BA; Art Students League of NY, 82. **Selected Solo Exhibitions:** Clara Hatton Gallery, CO State Univ, Ft Collins, CO, 87 and The Art Center at Appalshop Inc, Whitesburg, CO, 87; Univ of N CO, Greeley, CO, 81. **Selected Group Exhibitions:** Revelation & Devotion, 89, travelled; Colorado 1990, Denver Art Museum, CO, 90; Artists of America, CO History Museum, Denver, 90; Monochrome Polychrome, FL State Univ Gallery & Museum, 90; Waiting for Cadmium, Sherry French Gallery, NYC, 90. **Selected Collections:** American Museum, El Paso, TX; Belvac Production Machinery, Lynchberg, VA; Gallagher Chartered, Wash, DC.
(See page 224)

SPROTTE, SIEGWARD
(1913 - present)
b. Potsdam, Dresden

East and West, Orient and Occident are not at odds in Sprotte's painting and philosophy — according to international critics Will Grohmann in Berlin, Franz Roh in Munich, HLC Jaffe in Amsterdam, and Herbert Reed in London. Sprotte himself says: "I have lived and worked on two parallel tracks for many years now. Initially I adhered strictly to an Old Master style in the Cinquecento tradition, tempera and oils on wood. Then in Denmark at the age of 21 I began to work on Chinese and Japanese papers without sketching or correction." Siegward Sprotte has been exhibiting for more than 60 years all over Europe, in the West Indies and the United States. Sprotte's paintings can be found in prestigious museum collections: Pushkin State Museum of Fine Arts, Moscow; Museum of Art, Carnegie Inst, Pittsburgh, PA; Centro Arte Moderna, Gulbenkian Museum, Lisbon, Portugal; Mellon Collection, Wash, DC; Museum Aabenraa, Denmark; Albertina Wien, Vienna, Austria; Museum Altona, Hamburg; Berlinische Galerie, Berlin; Berlin Museum; Gallery of Modern Art, Oslo, Norway; Museum Potsdam, Staatliche Gemaeldesammlung, Dresden, E Germany; Staatsgalerie fur Moderne Kunst, Stuttgart, W Germany.
(See page 225)

STEVENS, PETER
(1955 - present)
b. New York City, New York

Education: Sarah Lawrence College, 77, BA. Peter Stevens lives in New York City. **Selected Solo Exhibitions:** Graham Modern, NYC, 85, 87, 90; The Lamont Gallery, Phillips Exeter Academy, Exeter, NH, 88; Addison/Ripley Gallery, Wash, DC, 90. **Selected Group Exhibitions:** SoHo Center for Visual Arts, NYC, 81; Addison Gallery of American Art, Andover, MA, 83; Houghton House Gallery, Hobart & William Smith Colleges, Geneva, NY, 83; McNay Art Museum, Dallas, TX, 86; Cold Spring Harbor Lab, NY, 87; Art in General/The Human Arts Assoc, NYC, 88; Arnold & Porter, Wash, DC, 88; Int'l Sculpture Center, Washington Harbor, Wash, DC, 88; Graham Modern, NYC, 90-91; USX Tower, Pittsburgh, PA, 90; Jane Voorhees Zimmerli Art Museum, Rutgers Univ, 90. **Selected Bibliog:** The NY Times, Michael Brenson, Jan 26, 90; Grandiose & Apocalyptic, The Wall St Journal, Jack Flam, Jan 24, 90; Summer Yellows, The NY Times, Grace Glueck, July 26, 86; Sculpture as Outdoor Experiment, The NY Times, Helen Harrison, Sept 87; Art New England, Dustan Knight, Mar 89; Peter Stevens, Arts Magazine, Robert Mahoney, April 86; Sculpture Magazine, Liz Markus, May/June 90; ARTnews, Daniel Waterman, May 90.
(See page 363)

SALLE, DAVID (1952 - present)
b. Norman, Oklahoma

David Salle presently lives in New York City, New York. **Selected Solo Exhibitions:** Mary Boone Gallery, NYC, 81-83, 85, 86-88; Larry Gagosian Gallery, LA, CA, 81, 83; Leo Castelli Gallery, NYC, 82, 84, 86; Galerie Michael Werner, Cologne, 85, 89; Mario Diacono Gallery, Boston, MA, 86, 90;Whitney Museum of American Art, NYC, 87; The Menil Collection, Houston, TX, 88; Fundacion Caja de Pensiones, Madrid, 88; Bayerische Staatgemaldesammlungen, Munich, W Germany, 89; Waddington Galleries, London, 89; Waddington Graphics, London, 90; Fred Hoffman Gallery, LA, CA, 90; Gagosian Gallery, NYC, 91. **Selected Group Exhibitions:** Museum of Art, Ft Lauderdale, FL, 86; Biennale of Sydney, Australia, 86; Stedlijk van Abbemuseum, Eindoven,86; Ludwig Museum, Colonia, 86; Frankfurter Kunstverein, Frankfurt, W Germany, 86; LA County Museum of Art Museum, CA, 87; Centre Georges Pompidou, Paris, 87; The Aldrich Museum of Contemp Art, Ridgefield, NY, 87; Sara Hilden Art Museum, Suomi, Canada, 88; Leo Castelli Gallery, NYC, 90, 91; Salama-Caro Gallery, London, 90; Museum of Modern Art, NYC, 90; Locks Gallery, Philadelphia, PA, 91; Perry Rubenstein, NYC, 91; Virginia Beach Center for the Arts, 91; Guild Hall, E Hampton, NY, 91; Oakland Museum of Art, CA, 91.
(See page 211)

SAMARAS, LUCAS (1936 - present)
b. Kastoria Macedonia, Greece

Chronology: moves to the US, 48; Rutgers Univ, New Brunswick, NJ, scholarship, studies with Allan Kaprow & George Segal, 55-59; Columbia Univ, NYC, Woodrow Wilson Fellowship, 59; joins Rueben Gallery, NYC, 60; joins Greene Gallery, NYC,61; joins The Pace Gallery, NYC, 65; Self, film with Kim Levin, 69; retrospective of boxes at Museum of Contemp Art, Chicago, IL, 71; Whitney Museum of American Art, NYC, 72; large-scale Cor-ten steel sculpture installation, Hale Boggs Federal Courthouse, New Orleans, LA, commissioned by General Services Admin for Fine Arts, 76; Samaras Pastels, Denver Art Museum, 82, travelled; Photos Polaroid Photographs 1969-1983, Cambridge, MA, 83, travelled; Lucas Samaras: Objects & Subjects 1969-86, Denver Art Museum, 88, travelled.
(See page 359)

SANABRIA, SHERRY ZVARES (1937 - present)
b. Washington, DC

Sherry Zvares Sanabria received a BA degree from George Washington University and a MFA from the American University. Her paintings have been exhibited in many group and one person shows since 1973, including a group show at the Corcoran Gallery of Art and a one person show at The Phillips Collection in 1980 of the Excavation Site Series. This group of thirteen paintings of a construction site were described in the accompanying catalog by art historian David Tannous. "A sense of contemplative exploration is established, a mood of tranquility...The light itself, weighty with definition, seems changeless, impossible to alter." This description is appropriate to the artists work today particularly to the Ellis Island Interiors which will be shown at Ellis Island in 1992. Ms. Sanabria is represented in many national/public collections including the Phillips Collection, The Washington Press, Phillip Morris USA and Sallie Mae. The artist is currently working on a series of paintings of concentration camp interiors which will be exhibited in 1992 at the David Adamson Gallery in Washington, DC.
(See page 212)

SCHNABEL, JULIAN (1951 - present)
b. New York City, New York

Chronology: Univ of Houston, TX, 69-73; Whitney Museum Independent Study Program, NYC, 73-74; Contemp Arts Museum, Houston, 75; first solo show in Europe, Galerie December, Dusseldorf, 78; Mary Boone Gallery, NYC, 79; The Pace Gallery, 84; selection of paintings, Whitechapel, London, 86-88, travelled; Kabuki Paintings, exhibition at Osaka Nat'l Museum of Modern Art, 89, travelled; Kunsthalle, Basel, Switz, 89; Musee d'Art Contemporain, Bordeaux, France, 89; Museo d'Arte Contemporanea, Prato, 89; Works on Paper 1975-88, Museum fur Gegenwartskunst Basel, 89-90, travelled; Sculpture 1987-89, The Pace Gallery, 90.
(See page 214)

SCOTT, NIGEL (1956 - present)
b. Jamaica

Nigel Scott presently lives in Paris, France. **Selected Solo Exhibitions:** 10 Prints of Paris, Peter Pan, Toronto, Canada, 84; Recent Work from Toronto & Paris, Jane Corkin Gallery, Toronto, 86-91. **Selected Group Exhibitions:** Canadian Contemp Photography, The Watson Gallery, Houston, TX, 86; Photography on the Edge, Haggerty Museum, Marquette Univ, Milwaukee, WI, 88; Fashion Photography: Then & Now, Holly Solomon Gallery, NYC, 89; Galerie Elca London, Montreal, Quebec, 89; The Curators Choose-Contemp Canadian Art, Art Gallery of Ontario, Toronto, 89; Is There Still Life in the Still Life or is Nature Morte?, Houston, TX, 90; Children in Photography: 150 Years, sponsored by the Winnipeg Art Gallery & travelling to 10 museums across Canada, 90-92.
(See page 397)

SHENG, SHAN SHAN (1957 - present)
b. Shanghai, China

Shan Shan Sheng graduated from Mount Holyoke College with distinguish in 1983 and earned a MFA from University of Massachusetts, Amherst in 1986. In 1987 she was an Artist-in-Resident at Harvard University, Cambridge, Massachusetts. She has held 15 solo exhibitions in Chicago, New York, Boston, Wisconsin, California, and enormous group shows throughout the US. Her works have been commissioned and collected by Harvard University, University of Massachusetts, University of Wisconsin and some corporations as well as many private collectors in the US. Her works are represented by East West Contemporary Art in Chicago and Arden Gallery in Boston.
(See page 215)

SHIPLEY, DAVID (1952 - present)
b. Lubbock, Texas

Education: Dallas Art Inst, TX, 74; Univ of TX, Austin, 75-76; TX Tech Univ, 76-79, BA; American Academy of Dramatic Arts, Pasadena, CA, 81-82. **Selected Exhibitions:** Univ of TX, Austin, Juried Student Show, 75-76; TX Tech Univ, Lubbock, 77; Wesley Foundation, Lubbock, 78; Hodges Community Center, paintings, juried show, Lubbock, 78; City Show, San Antonio, TX, 79; Mountain View College, juried show, Dallas, TX, 79; Lubbock Artist' s Assoc, juried show, TX, 79; St John's Annual Art Festival, Sacramento, CA, 83; Swartz/Cierlak, Santa Monica, CA, 87-89; Erica's Restaurant, consignment exhibition, Pacific Palisades, CA, 89; DeVorzon Gallery, W Hollywood, CA, 90; Spiritual Torrents: a Study in Contrasts, Biota Gallery, W Hollywood, CA, 91. **Selected Commissions:** Gil Shiva, 88; Greg Helm, 89; Woody Keith, 89; Chantal Westerman, 90; Athletes & Entertainers for Kids: the Shipley Humanitarian Award, presented by Ryan White to Ronald & Nancy Reagan, 90. **Selected Awards:** Images of Aging, North TX State Univ, First Prize in Drawing, 80; Artist Guild, Post, TX, Honorable Mention, 83.
(See page 292)

SHIVES, ARNOLD (1943 - present)
b. Vancouver, Canada

Education: Univ of British Columbia, Canada, 62-64; San Francisco Art Insitiute, CA, 64-66, BFA, painting; Stanford Univ, CA, 66-68, MA, painting. Teachers: Gordon Smith, Richard Diebenkorn, Stephen DeStaebler, Frank Lobdell, Nathan Oliveira. **Selected Solo Exhibitions:** Art Gallery of Greater Victoria, 83-84; Wade Gallery, Vancouver, 87; Kathleen Laverty Gallery, Edmonton, 87; Heffel Gallery, Vancouver, 89. **Selected Group Exhibitions:** Art Gallery of Brant, 81-82; Art Gallery of Ontario, 82; Vancouver Art Gallery, 83; Nickle Arts Museum, Calgary, 83; Mira Godard Gallery, Toronto, 84; Achenbach Foundation, CA Palace of the Legion of Honor, SF, CA, 85; Wade Gallery, LA, CA, 87; Memorial Univ of Newfoundland, St John's, 88. **Selected Collections:** Achenbach Foundation, SF, CA; The NY Public Library, NYC; Macdonald Stewart Art Centre, Guelph, Ontario; San Francisco Museum of Modern Art, CA; Kitchener-Waterloo Art Gallery; Univ of Alberta Hospital, Edmonton; Univ of Western Ontario Hospital, London, Ontario; British Columbia Art Collection, Victoria; City of Vancouver; Yukon Permanent Collection; Nat'l Gallery of Canada; British Pacific Properties; Canadian Bar Assoc; Citicorp, Ltd; Esso Resources Canada; Daon Corp; Gulf Oil Corp; Thorne Riddell & Co. **Selected Awards:** Purchase Award, Malaspina Printmakers, 80; Canada Council Project Grant, 82; Juror, Canada Council Art Bank, 84; Juror, Manitoba Printmakers Assoc, Winnipeg, 86; Octogon Expedition, Comox Glacier, Canada, 88.
(See page 216)

SIERRA, PAUL (1944 - present)
b. Havana, Cuba

Education: The School of the Art Inst of Chicago, IL; The American Academy of Art, Chicago, IL. **Selected Solo Exhibitions:** Gwenda Jay Gallery, Chicago, IL, 88, 91-92; Barbara Gillman Gallery, Miami, FL, 89; Univ of IL, Chicago Circle Campus, 89; Louis Newman Galleries, Beverly Hills, CA, 89-90; Scott Alan Gallery, NYC, 90. **Selected Group Exhibitions:** '89 Chicago, 78th Annual Exhibition, Maier Museum of Art, Lynchburg, VA, 89-90; Partners in Purchase, Selected Works, '76-87, State of IL Art Gallery, Chicago & Lakeview Museum of Arts & Sciences, Peoria, IL, 89-90; Chicago Art Today, Gallery of Contemp Art, Colorado Springs, CO, 91. **Travelling Exhibitions:** Art & the Law, Minnneapolis Convention Center, MN; State of IL Center, Chicago; State Capital Building, St Paul, MN, 90; The Emotional Landscape, Rock Valley College, Rockford, IL; State of IL Center, Chicago, 90-91; Environmental Figurations, IL State Museum at the Lockport Gallery, Lockport; IL State Museum, Springfield, IL, 90-91. **Selected Collections:** Arthur Andersen & Co, Chicago, IL; AT&T, Chicago, IL & NYC; Harold Washington Library, Chicago, IL; Rolli Foundation Museum, Montevideo, Uruaguay. **Selected Bibliog:** Sierra's New Works, The Chicago Tribune, David McCracken, Feb 9, 90; Abreu, Flemming, Sierra: nuevos artistas, Ahlander Leslie Judd, Arte/en Colombia Internacional, Oct 90. **Selected Awards:** Cintas Foundation Fellowship, 90; IL Art Council, Painting Award, 89.
(See page 217)

SILVERMAN, SHERRI (1951 - present)
b. Atlanta, Georgia

Education: Emory Univ, Atlanta, GA, 71, BA; Brandeis Univ, Waltham, MA, 74, MA. Presently lives and works in Santa Fe, New Mexico. Sherri Silverman is represented by Santa Fe East, NM; Fay Gold Gallery, Atlanta, GA; Taba/Artfolio, Bethesda, MD. **Selected Group Exhibitions:** Creating Coherence, Unity Gallery, Fairfield, IA, 80; Enlightened Images, Artfolio/Mindy DeHudy Contemp Art, Boston, MA, 87; The Elegant Pastel, Artfolio/Mindy DeHudy Contemp Art, MA, 88; Artworks/Camera Works, Gallery at the Rep, Santa Fe, NM, 89; New Names/New Works II, Santa Fe East, NM, 90; Upper Canyon Views of Nature, Randall Davey Audubon Center, Santa Fe, NM, 90; Visions of Excellence, Albuquerque United Artists Juried Show, NM, 91. **Selected Collections:** Fidelity Investment Corp, Boston, MA; MCI Telecommunications Corporation, Arlington, VA; Steven & Joyce Melander-Dayton, Santa Fe, NM. Grants: Witter Bynner Foundation, 89, 90.
(See page 218)

SKOGLUND, SANDY (1946 - present)
b. Massachusetts

Education: Smith College, North Hampton, MA, BA; Univ of IA, IA City, MFA; **Selected Solo Exhibitions:** Greenberg Gallery, St Louis, MO, 81, 83; Leo Castelli, NYC, 81, 83; Galerie Watari, Tokyo, Japan, 84; Castelli Uptown Gallery, NYC, 87; Damon Brandt Gallery, NYC, 88; Lorence Monk Gallery, NYC, 88; Gallerie Urbi et Orbi, Paris, France, 89; JJ Brookings Gallery, San Jose, CA, 89; George Eastman House, Int'l Museum of Photography, Rochester, NY, 90; The Denver Art Museum, CO, 90; GH Dalsheimer Gallery, Baltimore, MD, 90; Parco Gallery, Tokyo, Japan, 90; Janet Borden Inc, NYC, 90; Temple Gallery, Tyler School of Art, Philadelphia, PA, 90; Carl Soloway Gallery, Cincinnati, OH, 91; Fay Gold Gallery, Atlanta, GA, 87, 91. **Selected Group Exhibitions:** Cincinnati Art Museum, OH, 89; Nat'l Museum of American Art, Wash, DC, 89; Zur Stockeregg Galerie fur Kunstphotographie, Zurich, Switz, 89; Centre George Pompidou, Paris, France, 89; Biennale de Marseille, France, 90; Centre d'Arte, Barcelona, Spain, 90; Int'l Center for Photography, NYC, 90. **Selected Collections:** Baltimore Museum of Art, MD; The Brooklyn Museum, NY; Centre Georges Pompidou, Paris, France; Museum of Fine Art, Dallas, TX; Denver Museum of Art, CO; High Museum of Art, Atlanta, GA, Metropolitan Museum of Art, NYC; New Orleans Museum of Art, LA.
(See page 293)

ROJAS, ELMAR
(1938 - present)
b. Guatemala

Elmar Rojas resides in Guatemala City, Guatemala. **Selected Solo Exhibitions:** Panamanian Art Inst, Panama, 63; Hispanic Cultural Inst, Madrid, 64; Forma Gallery, El Salvador, 66-68; Pan American Union, Wash, DC, 71; First Federal Gallery, San Juan, Puerto Rico, 73; Forma Gallery, Buenos Aries, Argentina, 80; La Galeria, Quito, Ecuador, 82; Museum of Contemp Art, Panama, 82; Arte Actual, Santiago, Chile, 83; Galeria Habitante, Panama, 87; Galeria Nueve, Lima, Peru, 88; La Galeria, Quito, Ecuador, 88; Kimberly Gallery, Wash, DC, 88; Galeria Valanti, Costa Rica, 90; Anita Shapolsky Gallery, NYC, 91; Berheim Gallery, Panama, 91; Elite Fine Art, Coral Gables, FL, 91-92; Museum of Modern Art, Guatemala,92; Museum of Art, Sao Paulo, Brazil, 92. **Selected Group Exhibitions:** Museum of Latin America, Wash, DC, 77; San Gregorio Palace, Venice, Italy, 78; Casa de las Americas, Havana, Cuba, 79; Forma Gallery, Buenos Aries, Argentina, 79; Contemp Guatemalan Artists in Texas, Austin, Dallas, Galveston, Houston, Temple & San Antonio, 81; Museum of Contemp Art of Latin America, Wash, DC, 90; Kimberly Gallery, Wash, DC, 91.
(See page 202)

ROOT, PEGGY N.
(1958 - present)
b. Sarasota, Florida

"When I go out to paint a landscape, I have no preconceived concept or program. The actual beauty of a bit of sunlight on the trunk of a pine tree is too rich, too subtle to be anticipated. Any prior idea world be excess baggage. The poetry is there but a painter needs to 'travel light' to see it. In this sense, a landscape painter is a reporter on the beauty of God's world. The degree of success that the painter has in retelling the story is dependent on his craft. The craft is the means, not the end. I love to paint in all seasons and weather conditions, despite the occasional discomfort. I love to watch the small changes that occur day to day in a particular spot. Because nature is so complex, so beautiful on so many different levels at the same time, landscape painting is both a joyful and a humbling occupation."
(See page 203)

ROSENQUIST, JAMES
(1933 - present)
b. Grand Forks, North Dakota

Selected Solo Exhibitions: Leo Castelli Gallery, NYC, 90; Welcome to the Water Planet, Museum of Modern Art, NYC, 90; Welcome to the Water Planet & House of Fire 1988-89, Erika Meyerovich Gallery, SF, CA, 90 & Richard Feigen & Co, Chicago, IL, 90. **Selected Group Exhibitions:** Heland Wetterling Gallery, Stockholm, Sweden, 89; Word as Image: American Art 1960-90, Milwaukee Art Museum, WI, 90, travelled; Committed to Print, Newport Harbor Art Museum, Newport Beach, CA, 90; Art What Thou Eat, Edith C Blum Art Inst, Annandale-on-the-Hudson, NY, 90, travelled; American Pop Art, Museum of Modern Art of Ft Wayne, IN, 90; Tokyo Art Expo, representing Leo Castelli Gallery, Japan, 91; Art Miami '91: Int'l Art Expo, Miami Beach Convention Center, Fl, 91; Twentieth Century Collage, Margo Leavin Gallery, LA, CA, 91; Prints, Dorsky Gallery, NYC, 91; Lichtenstein, Rauschenberg, Rosenquist, Galerie Nichido, Tokyo, Japan, 91. **Selected Awards:** Minneapolis School of Art at the Minneapolis Art Inst scholarship, 48; Art Students League scholarship, 55; Prize for 1962 work, A Lot to Like, 63; First Prize, Painting for the American Negro at the Int'l Prize Exhibition, Buenos Aries, 65; World Print Award from the World Print Council, 83.
(See page 204)

The Bird of Paradise Approaches the Hot Water Planet, created in collaboration with Tyler Graphics, embodies an ecological orientation. Seen from a cosmic perspective, the earth is depicted as radiant and powerful in its fecundity, yet fragile and in need of care. They remind us of our interconnectedness with plant life, of the absolute importance of water and sun for all living things. In their tremendous scale, texture and color, the large prints in James Rosenquist's Welcome to the Water Planet Series have an impact comparable to his paintings. These images demand involvement, reaching the viewer below the level of conscious thought; the affective experience gained through seeing them precedes yet amplifies the perspective gained by thinking about them.
(See page 278)

ROSSBERG, SARA
(1952 - present)
b. Recklinghausen, West Germany

Education: Academy of Fine Art, Frankfurt, W Germany, 71-76; Camberwell School of Art, London, England, 76-78. **Selected Solo Exhibitions:** Academy of Fine Art, Frankfurt, W Germany, 73; Kunstkeller, Bern, Switz, 87; Nicholas Treadwell Gallery, Kent, England, 87; Thum Gallery, London, 88, 91; Newport Museum and Art Gallery, 89, travelled; Rosenberg & Stiebel, NYC,90; Louis Newman Gallery, LA, CA, 90; Stiebel Modern, NYC, 91. **Selected Group Exhibitions:** Kunsthalle, Darmstadt, W Germany, 75; Wiesbaden Museum, W Germany, 75; Forum Junger Kunst, travelled; Recklinghausen, W Germany, 75; Self Portrait, A Modern View, Artiste, Bath, travelled, 87; Nat'l Portrait Gallery, London, 87, 90; Walker Art Gallery, Liverpool, 87; Stiebel Modern, NYC, 91.
(See page 205)

RUBEN, RICHARDS
(1925 - present)
b. Los Angeles, California

Richards Ruben is an artist who constantly searches for new ideas in unexplored territories. He provokes the creative possibilities of sight by utilizing familiar forms and suggestive colors to question the boundaries and limitations with which we restrict ourselves when looking at objects of art or the horizon of our environment. Richards Ruben paints in a very sculptural way. He draws with his stretcher bars, carving them and shaping the canvas to reflect his interest in how the inner rhythms of the image corresponds with the outer edges of the canvas as well as the canvas' interaction with the wall. The canvas is an extension of the painted image emanating a liberating effect of structure and color. The gentle contoured edges arch, swell and contract in a fluid movement. Ruben's imagery suggests collections of moments in the passage of time. His challenging compositions are balanced by soft rhythmically repeated accents of floating clouds of saturated color fields resulting in paintings that are filled with vitality and are symbolically suggestive.
(See page 206)

RUBIN, MICHAEL
(1946 - present)
b. Quincy, Illinois

"In 1987 I forced myself in my paintings to move an overall field where shape as definition was at a minimum," says Michael Rubin. "The only exception I gave to this self-discipline was in my printmaking. Here I allowed the transparency of my years as a watercolorist to remain—my calligraphic instinct to continue. This and the organic composition are the primary differences between the paintings and prints." Rubin creates graphic works with Shark's Incorporated. A cursory glance at his work discloses random entanglements of brilliant hues. Looked at more closely, the freely applied skeins of color reveal a subtle, yet unmistakable pattern. This interplay between spontaneity and planning reflects an achievement metaphysical in implication. Michael Rubin, through the esthetics of absolute abstraction, offers us an experience as science and religion communicate via formula and ritual: in his art one can find order amidst the chaos. **Selected Exhibitions:** London Printmakers Council, London, 82; Edinburgh Arts Festival, Scotland, 83; Charlotte Press, Newcastle England, 83; Shark's Incorporated, LA Int'l Art Fair, CA, 88-89; Philip Samuels Fine Art, St Louis, MO, 89; Jeffrey Wilkey Gallery, Seattle, WA, 91; Shark's Incorporated, Chicago Int'l Art Expo, IL, 85-91; Hokin Gallery, Palm Beach, FL, 91.
(See page 207 & 279)

RUFF, THOMAS
(1958 - present)
b. Zel am Harmersbach, Germany

Education: studied at the Staatliche Kunstakademie in Dusseldorf under Bernd Becher. **Selected Solo Exhibitions:** Mai 36 Galerie, Lucerne, Switz, 88, 90; Ydessa Hendeles Art Foundation, Toronto, Canada, 88; Galerie Bebert, Rotterdam, The Netherlands, 89; Cornerhouse, Manchester, England, 89; Galerie Philip Nelson, Lyon, France, 89; 303 Gallery, NYC, 89, 90; XPO Gallery, Hamburg, W Germany, 89; Galerie Johnen & Schottle, Cologne, W Germany, 89, 91; De Appel Foundation, Amsterdam, The Netherlands, 89; Galerie Schottle, Munich, W Germany, 89; Galerie Nikolaus Sonne, Berlin, W Germany, 90; Kunsthalle, Zurich, Switz, 90; Galerie Crousel-Robelin Bama, Paris, France, 90; Stuart Regan Gallery, LA, CA, 90; Kunstverein, Munich, W Germany, 91; Lia Rumma, Naples, Italy, 91. **Selected Group Exhibitions:** 303 Gallery, NYC, 89, 91; Galerie Ghislaine Hussenot, Paris, France, 89; Galerie Grita Insam, Vienna, Austria, 89; Robin Lockett Gallery, Chicago, IL, 89; Kunstrai, Amsterdam, The Netherlands, 89; Centro Santa Monica, Barcelona, Spain, 90; Kunstmuseum, Bonn, W Germany, 90; Galeria Comicos, Lisbon, Portugal, 90; Galerie Johnen & Schottle, Cologne, W Germany, 90; Fondation Cartier, Jouy-en-Josas, France, 90; Victoria Miro Gallery, London, England, 90; The Aldrich Museum of Contemp Art, Ridgefield, CT, 90.
(See page 291)

RUNION, SCOTT
(1962 - present)
b. Stockton, California

Education: CA State Univ, Sacramento, 80-82; Art Inst of Chicago, IL, 84, BFA. **Teaching Experience:** Summer Art Program, Univ of the Pacific, Stockton, CA, 88; Drawing Instructor Delta College, Stockton, CA, 86, 89-90. **Work Experience:** Terra Cotta Building Restoration for Architectural Terra Cotta & Tile, Chicago, IL, 84-85. **Selected Exhibitions:** Haggin Museum 31st & 32nd Annual Exhibition, 82-83; The School of the Art Inst of Chicago, 84; Art Inst of Chicago, IL, Fellowship Show, 85; Himovitz Salomon Gallery, Sacramento, CA, 88; Chanel 10 Interview, Sacramento, 88; New Age Gallery, Sacramento, 88; Vorpal Gallery, SF, CA, 88-89; Hearst Art Gallery, Contra Coast Contemp Collections, St Mary's College, 88; Crocker Art Museum, Art Auction, Sacramento, CA, 89; Michael Himovitz Gallery, Sacramento, 89; Rising Star Show Paragary's, Sacramento, 90; Dito Gallery, Sacramento, 90; Univ of IL, Champaign, 90. **Selected Bibliog:** Stockton Record, Sept 90; May 28, 89; July 3, 88; Sacramento Bee, June 90; July 17, 88; American Way Magazine, April 15, 90; Magazine of Design & Style, SF Magazine, Mar 90; On the Wing, Magazine of Arts, Mar 90; American Artists Book, Les Krantz, Jan 90.
(See page 358)

RUSCHA, ED
(1937 - present)
b. Omaha, Nebraska

Selected Solo Exhibitions: Galerie Ghislaine Hussenot, Paris, France, 90; Fundacio Caixa de Pensions, Barcelona, Spain, 90; Texas Gallery, Houston, 90; Whitney Museum of American Art, NYC, 90; Karsten Schubert Gallery, London, England, 90; Serpentine Gallery, Kensington Gardens, London, 90; Museum of Contemp Art, LA, CA, 91; Galerie Carola Mosch Multiples & Editions, Berlin, W Germany, 91; Castelli Graphics, NYC, 91. **Selected Group Exhibitions:** Con/Texts, Moody Gallery, Houston, TX, 90; LA Apts, Whitney Museum of American Art, NYC, 90; American Pop Art, Ft Worth Museum of Modern Art, TX, 90; American Masters of the 60's, Tony Shafrazi Gallery, NYC, 90; Language in Art, Aldrich Museum of Contemp Art, Ridgefield, CT, 90; Leo Castelli Post Pop Artists, Nadia Bassanese Studio d'Arte, Trieste, Italy, 90; High & Low, Museum of Modern Art, NYC, 90, travelled. Word as Image, Milwaukee Art Museum, WI, 90, travelled; Twentieth Century Collage, Margo Leavin Gallery, LA, CA, 91; Large Scale Works on Paper, John Berggreun Gallery, SF, CA, 91; The Art Show at the Armory, representing James Goodman Gallery, NYC, 91; Not on Canvas, Asher Faure Gallery, LA, CA, 91; Tokyo Art Expo, representing Leo Castelli Gallery, Japan, 91; Carnegie Hall Centennial Fine Art Portfolio, The Marlborough Gallery, NYC, 91; Prints, Dorsky Gallery, NYC, 91; Metropolis, Altes Museum, Martin-Gropius-Bau, Berlin, W Germany, 91. **Selected Collections:** Art Inst of Chicago, IL; High Museum of Art, Atlanta, GA; Hirshhorn Museum & Sculpture Garden, Wash, DC; Tate Gallery, London, England; Whitney Museum of American Art, NYC; Museum of Modern Art, NYC.
(See pages 208 & 209)

SAFTEL, ANDREW
(1959 - present)
b. Bristol, Rhode Island

Education: New England College, Arundel, Sussex, England, 77; San Francisco Art Inst, CA, 81, BFA Printmaking. **Selected Solo Exhibitions:** Kyle Belding Gallery, Denver, CO, 89, 90; Carlton Cobb Gallery, Atlanta, GA, 89, 90; The Lowe Gallery, Atlanta, GA, 91; Cumberland Gallery, Nashville, TN, 91. **Selected Group Exhibitions:** 20th Dulin Nat'l Works on Paper Exhibition, Knoxville Museum of Art, TN, 88; Ewing Gallery of Art & Architecture, Univ of TN, Knoxville, 88; Sublette Gallery, Knoxville, TN, 89; Directors Choice, Virginia Miller Gallery, Miami, FL, 89; Southern Visions, Sarratt Gallery, Vanderbilt Univ, Nashville, TN, 90; The Lowe Gallery, Atlanta, GA, 90; Gallery Artists Exhibition, Virginia Miller Gallery, Miami, FL, 90.
(See page 210)

OLLOCK, BRUCE (1951 - present)
b. Painesville, Ohio

Education: Carnegie-Mellon Univ, Pittsburgh, PA, 71-72; Cleveland Inst of Art, OH, 73-76, BFA; Temple Univ Abroad, Rome, Italy, 76-77; Tyler School of Art, Philadelphia, PA, 77-78, MFA. **Selected Solo Exhibitions:** Cavin Morris Inc, NYC, 86; Janet Fleisher Gallery, Philadelphia, PA, 7, 90-91; Morris Gallery, PA Academy of Fine Arts, Philadelphia, 90; Design Arts Gallery, Nesbitt College of Design Arts, Drexel Univ, Philadelphia, PA, 90. **Selected Group Exhibitions:** scale:small, Rosa Esman Gallery, NYC, 88; May Show, Cleveland Museum of Art, OH, 88; Perspectives from Pennsylvania, Carnegie-Mellon Univ, Pittsburgh, PA, 88; Incohate Forces, Cavin Morris Inc, NYC, 90. **Selected Collections:** Harry Anderson; Philadelphia Museum of Art; Arthur Andersen & Co; Prudential Life Insurance. **Outdoor Works:** One Percent Public Art Installation Commission, Sidewalk Mosaic, Philadelphia, PA, 90. **Selected Bibliog:** New Art Examiner, Miriam Seidel, Mar 87; Philadelphia Inquirer, Mar 90; Philadelphia Inquirer, Feb 90. **Selected Awards:** Small Works Annual, Best of Show, Washington Square East Gallery, NYC, 80; PA Council on the Arts, Artist Fellowship Grant, 83; MacDowell Colony Fellowship, 87; Distinguished Artist Award, Contemp Philadelphia Artists, PA, 90.
(See page 192)

OND, CLAYTON (1941 - present)
b. Mineola, New York

Education: Carnegie Inst of Tech, BFA; Pratt Inst, MFA. **Selected Solo Exhibitions:** Schenectady Museum of Art, NY; Phoenix Museum of Art, AZ; Sheldon Memorial Art Gallery, Lincoln, NB; Montgomery Museum of Art; Corcoran Gallery of Art, Dupont Center, Wash, DC. **Selected Group Exhibitions:** Basel Int'l Art Fair, Switz; FIA Grand Palace, Paris, France; City Museum & Art Gallery, Hong Kong; Whitney Museum of American Art, NYC. Guest Artist, Lecturer: Smithsonian Inst, Wash, DC; SUNY, New Paltz & Oneonta; Univ of Notre Dame. **Selected Collections:** Albright-Knox Museum, Buffalo, NY; Boston Museum of Fine Arts, MA; Art Inst of Chicago, IL; Israel Museum, Jerusalem; Library of Congress, Wash, DC. **Selected Commissions:** Publishers, dealers, institutions & private collections, including: NY State Council for the Arts; Assoc American Artists' Gallery; National Air & Space Museum. **Selected Grants:** NEA grant, Seminar '73, Montgomery, AL.
(See page 193)

OTTER, PATRICIA BOINEST (1940 - present)
b. Charleston, North Carolina

Selected Solo Exhibitions: Spoleto Festival, Charleston, SC, 79; Univ of Montevallo, AL, 79; Kennedy Douglas Centre for the Arts, Florence, AL, 79; Univ of AL, Huntsville, 79; Anniston Museum, AL, 79; Hunter Museum, Chattanooga, TN, 81; Birmingham Civic Centre, AL, 86; Overlays of Memory, Anniston Museum, AL, 86; Inner Selections of Time & Place, Lowe Gallery, Atlanta, GA, 90. **Selected Group Exhibitions:** Seven Natures, Anniston Museum, AL, 79; Women Artists Invitational Travelling Exhibition, 79; Southern Exposure, A Southeastern Invitational, New Orleans, LA, 80; SECAC Exhibition, Richmond, VA, 84; Birmingham Southern College, 85; Mississippi Univ for Women, 85; Atlanta College of Art Gallery, 88; Lowe Gallery, Atlanta, GA, 91. **Selected Awards:** Southeastern College of Art Assoc grant recipient, 84; finalist, Alabama Veterans Memorial Design Competition, collaboration with architects Julian Jenkins, Julia Otter & Jeoffrey Clever, 90.
(See page 194)

RINCE, MITZI (1950 - present)
b. Shreveport, Louisiana

Education: LA State Univ, 73, BFA: Glassel Art School, Houston, 77; Anderson Ranch Artist-in-Residence Program, 83. **Selected Exhibitions:** Salon Int'l de Sherbrook, Quebec, Canada, 83; Smith-Anderson Gallery, Palo Alto, CA, 90; Michael Dunev Gallery, SF, CA, 90, 91; Hal Katzen Gallery, NYC, 91. **Selected Group Exhibitions:** San Francisco Museum of Modern Art-Rental Gallery, CA, 89; Virginia Miller Gallery, Coral Gables, FL, 90; Simon Gallery, Berkeley, CA, 90; Iturralde Gallery, La Jolla, CA, 90; Mind and Matter—New American Abstraction, travelling exhibit to Asia, organized by World Print, SF, CA, 90; Nat'l Museum of American Art, Santiago, Chile, 91; Margulies-Tatlin Gallery, Miami, FL, 91; Michael Dunev Gallery, SF, CA, 91; The Painted Monotype, Gallery Joan Prats, NYC, 91; Olga Dollar Gallery, SF, CA, 91; Graystone, SF, CA, 91. **Selected Collections:** San Francisco Int'l Airport, CA; Mexican Museum, SF, CA; Oakland Museum, Oakland, CA; Alternative Museum, NYC; Genstar Container Corp, SF, CA; Tuttle & Taylor, SF, CA; L'Auberge du Soleil, Napa, CA; Koblentz, Cahen, , CA.
(See page 195)

AMOS RIVERA, GUSTAVO (1940 - present)
b. Ciudad Acuña, Coahuila, Mexico

Education: Self-taught. **Selected Solo Exhibitions:** Alternative Museum, NYC, 88; San Jose Museum of Contemp Art, San Jose, CA, 89; Smith-Anderson Gallery, Palo Alto, CA, 90; Michael Dunev Gallery, SF, CA, 90, 91; Hal Katzen Gallery, NYC, 91. **Selected Group Exhibitions:** San Francisco Museum of Modern Art-Rental Gallery, CA, 89; Virginia Miller Gallery, Coral Gables, FL, 90; Simon Gallery, Berkeley, CA, 90; Iturralde Gallery, La Jolla, CA, 91; The Painted Monotype, Gallery Joan Prats, NYC, 91; Olga Dollar Gallery, SF, CA, 91; Graystone, SF, CA, 91. **Selected Collections:** San Francisco Int'l Airport, CA; Mexican Museum, SF, CA; Oakland Museum, Oakland, CA; Alternative Museum, NYC; Genstar Container Corp, SF, CA; Tuttle & Taylor, SF, CA; L'Auberge du Soleil, Napa, CA; Koblentz, Cahen, , CA.
(See page 196)

AO, MASSINO (1950 - present)
b. San Salvatore Telesino, Italy

A young Italian living in the Umbrian hills north of Rome, his paintings bring to mind the work of the Old Masters. His canvases intertwine the mood and spirit of the Italian school of the 16th and 17th centuries with a contemporary mystical viewpoint. The moon faces that dominate much of his current work place an old, all-knowing presence in the haunting landscapes of dreams known but forgotten. One of the youngest artists to be honored with an exhibition at the prestigious Tour Hommage museum in Acosta, Italy, his work was first shown in the United States by CFM Gallery in New York. His extraordinary drawings and etchings continue the Italian tradition of genius best exemplified by Leonardo da Vinci, Pontormo and Michelangelo. When asked if it wasn't difficult to get what his mind sees on canvas, his response was, "That's easy. Painting the picture in my head is what's hard."
(See page 197)

RAY, MAN (1890 - 1976)
b. Philadelphia, Pennsylvania (Emmanuel Rudnitzky)

Selected Exhibitions: Daniel Gallery, NYC, 15-16, 19, 26-27; Rayographs & Objects, Galerie Surrealiste, Paris, 26; Rayographs & Paintings, Galerie Quatre Chemins, Paris, 29; Julien Levy Gallery, NYC, 32; Photographs & Rayographs, Wadsworth Atheneum, Hartford, CT, 35; Rayographs & Paintings, Galerie Adlan, Barcelona, Spain, 35; Palais des Beaux-Arts, Bruxelles, Belgium, 37; Galerie de Beaunne, Paris, France, 39, travelled to London Gallery; MH de Young Memorial Museum, SF, CA, 41; Galerie Berggruen, Paris, 51; Galerie Furstenberg, Paris, 54; Man Ray: L'Oeuvre Photographique, Bibliotheque Nationale, Paris, 62; LA County Museum of Art, 66, retrospective; Philadelphia Museum of Art, 70; Metropolitan Museum of Art, NYC, 73; Man Ray: Fotografia, at the Biennale, Venice, 76; Man Ray: Photographe, Centre Pompidou, Paris, 81; Perpetual Motif: The Art of Man Ray, Nat'l Museum of American Art, Wash, DC, 88.
(See page 395)

REGISTER, JOHN (1939 - present)
b. New York City, New York

Selected Solo Exhibitions: David Stuart Gallery, LA, CA, 75, 77; William Sawyer Gallery, SF, CA, 78; Boehm Gallery, SD, CA, 79; Elaine Benson Gallery, Bridgehampton, NY, 80; Malibu Art & Design, Malibu, CA; Laguna Art Museum, Laguna Beach, CA, 86; Pepperdine Univ, Malibu, CA, 88; Modernism, SF, CA, 82, 85, 88, 90, 91. **Selected Group Exhibitions:** Fine Arts Museums of SF, CA, 77; Thomas Segal Gallery, Boston, MA, 78; ARCO Center for Visual Art, LA, CA, 78; The Parrish Museum, Southampton, NY, 81, 83; Hirschl & Adler Galleries, NYC, 81; Bologna & Landi Gallery, East Hampton, NY, 82; Laguna Art Museum, Laguna Beach, CA, 82, 86; Modernism, SF, CA, 83, 91; Guild Hall Museum, East Hampton, NY, 83; Ruth Siegel Gallery, NYC, 86; Santa Monica Heritage Museum, Santa Monica, CA, 89. **Selected Collections:** Arkansas Arts Center, Little Rock; Guild Hall Museum, East Hampton, NY; Laguna Art Museum, Laguna Beach, CA; San Francisco Museum of Modern Art, CA. **Selected Awards:** The Francis J Greenburger Foundation Award, 86.
(See page 198)

RISTOW, MARY (1953 - present)
b. Vermillion, South Dakota

Mary Ristow received her MFA from the University of Wyoming in 1978. She is strongly influenced by the spontaneous quality in Dubuffet's art. Ristow has shown her work extensively throughout the Southwest, and has had solo shows in Santa Fe at the Janus Gallery in 1991 and at the Rettig y Martinez Gallery in 1987. She has participated in group shows at the Museum of Fine Arts in Roswell, NM, the Janus Gallery, and elsewhere, including Chicago and Denver. Ristow's drawings and prints are in private collections and museums throughout the Southwest, including the Museum of Fine Arts, Houston, and in the Tamarind Collection at the Univ of NM in Albuquerque. In 1990 she was invited to be a guest artist at the Tamarind Inst in Albuquerque, NM, and in 1984 she was the recipient of the Best of Show Award in the Wyoming Women Artists Juried Show. Ristow moved to Santa Fe in 1986, where she continues to show her work at the Janus Gallery.
(See page 255)

ROBERTS, HOLLY (1951 - present)
b. Boulder, Colorado

Chronology: Receives MFA from Arizona State Univ, 81; awarded Ferguson Grant, Friends of Photography, 86; awarded NEA Grant, 86; group show: Contemp Photo Since 1940, Los Angeles, CA, 87; group show: Introductions: Extended Images, Museum of Photography, San Diego, 87; awarded another NEA Grant, 88; monograph published by Friends of Photography, 90; solo show: Photographic Resource Center, Boston Univ, MA, 90; solo show: Friends of Photography, 90; group show: La Photographie en Miettes, Musee Nat'l d'Art Moderne, Centre George Pompidou, Paris, 91; solo show at the Univ of St Louis, MO, 92.
(See page 200)

RODCHENKO, ALEXANDER (1891 - 1956)
b. St Petersburg (Leningrad), USSR

Chronology: Student at Kazan Art School, studies & teaches, meets Stepanova, 1911; moves to Moscow, 1914; attends Stroganov Artistic & Industrial Inst, 14-16; settles in Moscow, exhibits, 16; founds Painter's Union, becomes Secretary of Federation, 17; director of Narkompros (the People's Commissariat for Education), 18-22; makes linecuts, architectural designs, 19; makes spatial construction, 19-21; works with the important publishing houses and magazines, collaborates with Mayakovsky, 23; illustrates Pro Eto, 23; makes advertising and union posters, 23-25; devotes himself to photography, portraits of Mayakovsky and others, 24; works for film industry designing sets, furnishings, costumes, 25; teaches photography at State Printing Works, 30; makes Soviet photographic album, 34-38; circus subjects, collages & photographs, 35-41; edits album The Soviet State Farm, 38-40; takes refuge during WWII, makes propaganda posters, photographs, 41-42; returns to Moscow, 42; works with daughter, VA Rodchenko, on photographic albums, 47-55; Alexander Rodchenko dies in Moscow, 56.
(See page 396)

RODRIGUE, GEORGE (1944 - present)
b. New Iberia, Louisiana

George Rodrigue is an American folklore painter. He studied at California's Art Center College of Design. Rodrigue's 25 years of painting have brought him awards from throughout the United States and Europe. In Italy, Rodrigue was awarded a gold medal for outstanding creativity in the field of painting. France's oldest juried art exhibition, Le Salon, awarded him an honorary medal at its 1974 Grand Palais show. He has many published books, articles, films and TV appearances to his credit. He was one of the first Americans to have a one-artist show in Moscow. The Carter White House selected his first book as its official State Department gift, and the Republican party commissioned portraits of both President Ronald Reagan and George Bush. His most recent work, the Blue Dog series, a cross between Rodrigue's once studio companion and the legend of the Loup-Garou, has received the most critical acclaim.
(See page 201)

OVERFIELD, RICHARD (1943 - present)
b. Louisville, Kentucky

Education: Univ of AZ, 62; US Army Signal Center & School, 63; Ft Monmouth, NJ, 63; Univ of MD, 64; Cochise College, Douglas, AZ, 66 ; AZ State Univ, 70, BA; Univ of WA, 72, grad study; Western WA State Univ, 75; moved to Vancouver in 78. **Selected Solo Exhibitions:** Unitarian Gallery, Tacoma, WA, 75; The Artist's Gallery, Seattle, WA, 77; Leah Levy Gallery, SF, CA, 78-80, 83; Circle Gallery, Vancouver, Canada, 79; Seattle Art Museum Gallery, WA, 80; Franz Wynans Gallery, Vancouver, Canada, 82-83; BankAmerica World Headquarters, SF, CA, 83; Canadian Cultural Centre, Paris, France, 86; Fiona Whitney Gallery, LA, CA, 86; Galerie Dresdnere, Toronto, Canada, 90-91; Heffel Gallery, Ltd, Vancouver, Canada, 92. **Selected Group Exhibitions:** Leah Levy Gallery, SF, CA, 77,81-83; The Jackson St Gallery, Seattle, WA, 84; Group Show Gallery Artists, Fiona Whitney Gallery, LA, CA, 86; Galerie Dresdnere, Toronto, 89-91; Whatcom County Art Museum, Bellingham, WA, 90. **Selected Collections:** Achenbach Foundation for the Graphic Arts, CA Palace for the Legion of Honor, MH deYoung Memorial Museum, SF; IBM, SF, CA; BankAmerica, SF, CA; Itel Corp, Tokyo, Japan; Crocker Nat'l Bank, SF, CA; The Canada Council Art Bank, Ottawa; Canadian Comm Bank, Vancouver & Edmonton, Alberta; Lavalin Bank, Montreal, Quebec. **Selected Awards:** Phoenix Award of Merit, Phoenix College, AZ; Academic Scholarship, AZ State Univ, Tempe; Canada Council Arts Grant B in Painting; Neva-Shelby Foundation, Artist of the Year, 86. See page185.
(See page 185)

PARKER, LUCINDA (1942 - present)
b. Boston, Massachusetts

Education: Reed College and Portland Art Museum Art School Combined Program, 66, BA; Pratt Inst, NYC, 68, MFA. **Selected Solo Exhibitions:** Laura Russo Gallery, Portland, OR, 87, 89, 91; Davidson Gallery, Seattle, WA, 89; Documents Northwest: the PONCHO Series, Seattle Art Museum, WA, 86; Brunswick Gallery, Missoula, MT, 83. **Selected Group Exhibitions:** Childe Hassam Fund Purchase Exhibition, American Acad of Arts & Letters, 80; West Coast Painters, Univ of HI at Hilo, 87; Northwest Expressionism, Portland Art Museum, OR, 87, travelled; Views & Visions, Invitational, Seattle Art Museum, WA, 90; Contemp Art from the Collection, Invitational, OR Art Inst, Portland, OR, 90; Unabandoned Abstraction, Marylhurst College, OR, 91. **Selected Collections:** Portland Art Museum, OR; Seattle Museum, WA; Claremont Resort Hotel, Oakland, CA; Oregon Convention Center, Portland, OR; State of OR: Western Oregon State College, Monmouth, OR; HJ Heinz, Pittsburgh, PA.
(See page 186)

PARKES, MICHAEL (1944 - present)
b. Sikeston, Missouri

Michael Parkes has a Masters in Painting from Kent State and currently lives in Spain. He is one of the only artists today creating original lithographs on stone. His images conjure worlds and obsessions that usually exist only in the mind. The ability to capture universal dreams, coupled with an extraordinary technical virtuosity is what sets him apart. Utilizing mythologies and histories from a myriad of cultures and religions he superimposes his own mysticism and insights to create truly original images which both excite and stimulate. Looking at his work, one becomes aware of thoughts and feelings buried deep in their unconscious. There is a familiarity of experience, sometimes humorous, sometimes haunting, sometimes melancholy, sometimes joyous, that lies on the edge of memory and stirs the emotions. Each image is everchanging; there is always something new to find no matter how many times it is seen.
(See page 277)

PASCHKE, ED (1939 - present)
b. Chicago, Illinois

Education: School of the Art Inst of Chicago, IL, 61, BFA; 70, MFA. **Selected Collections:** Metropolitan Museum of Art, NYC; Whitney Museum of American Art, NYC; Nat'l Museum of American Art, Smithsonian Institution, Wash, DC; Centre Georges Pompidou, Paris; Musee d'Art Moderne Nationale, Paris; The Art Inst of Chicago, IL; Museum Boymans, Rotterdam, The Netherlands; Museum Moderner Kunst, Vienna, Austria; Museum of Contemp Art, Chicago, IL; Brooklyn Museum, NY; Baltimore Museum of Art, MD; VA Museum of Fine Arts, Richmond; Kalamazoo Inst of the Arts, MI.
(See page 187)

PAVLIK, MICHAEL (1941 - present)
b. Prague, Czechoslovokia

Education: College of Applied Design, Prague, Czech, MA, Art & Design. **Selected Exhibitions:** Holsten Gallery, Palm Beach, FL, 85, 87, 91; Snyderman Gallery, Philadelphia, PA, 85; Hokkaido Museum, Sapporo, Japan, 85; Heller Gallery, NYC, 86-87, 89-90; American Craft Museum , NYC, 86; Betsy Rosenfeld Gallery, Chicago, IL, 88-90; Habatat Gallery, Detroit, MI, 88; Sanske Gallery, Zurich, Switz, 90. **Selected Collections:** The Corning Museum of Glass, NY; Cooper-Hewitt Museum, NYC; Hessisches Landesmuseum Darmstadt, Darmstadt, W Germany; High Museum of Art, Atlanta, GA; Hokkaido Museum of Modern Art, Sapporo, Japan; Musee des art Decoratifs, Lausanne, Switz; Museum fur Kunst und Gewerbe, Hamburg, W Germany; Museum of Art, Carnegie Inst, Pittsburgh, PA; Philadelphia Museum of Art, PA; Toledo Museum of Art, OH; Univ of NE, Lincoln; Whitney Museum of American Art, NYC. **Selected Grant:** NEA Grant, 84.
(See page 353)

PEART, JERRY (1948 - present)
b. Winslow, Arizona

Jerry Peart's career began in the early 1970's after he received his BFA from Arizona State University and his MFA from Southern Illinois University. From 1970-84 Peart held many teaching, lecturing and curating positions in Illinois, Michigan and Arizona. He has participated in 40 group exhibitions and held nine one-man shows in museums and galleries all over the country. Peart is perhaps best known for the over thirty monumental-scale public commissions he has received, including his most recent work, The Garden, 91, a 30' high work in painted aluminum in Charlotte, North Carolina. His exuberantly painted aluminum sculptures add excitement and elegance to a variety of sites all over the country.
(See page 354)

PENCK, A.R. (1939 - present)
b. Dresden, East Germany

Chronology: Currently lives and works in Dublin, London, Dusseldorf and Cologne. He works as a Professor at the Academy in Dusseldorf. In 1939 born Ralf Winkler; painting first oil at age 10; sales of portraits. In 1956 the first exhibition of his paintings were held in Dresden; apprenticeship as a designer began; works with paints, sculpture, film, writing, plaster and music. In 1964, exhibition at the Puschkin-Haus; 1966, first "standart" paintings are made. First exhibition in Galerie Michael Werner, uses the pseudonym "A.R. Penck" in 1969. In 1970 "Standart making" and "Was ist Standart" were published . In 1972 exhibition of the "Standart-Modele" and first exhibition of drawings in the Museum of Art in Basel. In 1973, disciplinary induction to the People's Army. In 1976 is awarded the "Will-Grohmann-Preis", in 1977 first wooden sculpture was created. In 1980, emigrates to German Federal Republic. In 1982, first issue of "Krater und Wolke"is published, and Penck is editor. Participates in the Biennale in Venice, 1984 and receives the Art prize from Aachen. Small bronze sculptures are created in 1985, then marble in 1986. Most recently, in 1987, Penck is involved in a retrospective of paintings and drawings in the Nationalgalerie Berlin and Kunsthaus, Zurich; sculpture and drawings in the Kestner-Gesellschaft, Hannover; receives the Art prize of the NORD/LB.
(See page 189)

PIPPEN, RON (1943 - present)
b. Los Angeles, California

Education: Chouinard Art Inst, LA, CA, 64-68; Instituto de Gnosologia, Arica, Chile, 70. **Selected Fellowships:** CA Arts Council, 90. **Selected Solo Exhibitions:** Thinking Eye Gallery, LA, CA, 86-87, 89; Palos Verdes Art Center, Rancho Palos Verdes, CA, 86; Univ Art Museum, CA State Univ, Long Beach, 88; Santa Barbara Contemp Arts Forum, CA, 88; Loma Linda Univ, Riverside, CA, 90; Sun Valley Center for the Arts & Humanities, ID, 90, 92; Sherry Frumkin Gallery, Santa Monica, CA, 90, 92. CA State Univ, Dominguez Hills, CA, 91. **Selected Collections:** Tuscon Museum of Art, AZ; The Burkus Collection, Santa Barbara, CA. **Selected Bibliog:** LA Times, illustrated interview with Shauna Snow, 91; Visions, illustrated review, Spring issue, 91. **Selected Commissions:** AZ Designer Craftsmen, 81; CA Arts Council, 85; Balboa Building, Santa Barbara, CA, 88.
(See page 355)

PIQTOUKUN, DAVID RUBEN (1950 - present)
b. Paulatuk, Northwest Territories, Canada

Internationally renowned artist David Ruben Piqtoukun believes that the contemporary native artist has assumed the traditional role of shaman, interpreting through his art the relationship between man and the natural world. This remarkable artist resides in Toronto, Canada. Piqtoukun's work is represented in major collections around the world including UNESCO, Paris; the Canadian Embassy, Washington, DC; Winnipeg Art Gallery; and the McMichael Collection, Kleinburg. The artist has received commissions from the Canadian Embassy, Telefilm Canada, and the Alberta Treasury Board, conducted numerous workshops in Canada and abroad, and has been a guest artist in several Arctic communities, Africa and Japan. Some of Piqtoukun's pieces are currently touring worldwide with the Masters of the Arctic exhibition. His work is published in several catalogues including Inuit Art of the 70's, 79; Artic Vision, 84; Masters of the Arctic, 89; Out of Tradition, 89.
(See page 356)

PLAVINSKY, DMITRI (1938 - present)
b. Moscow, USSR

Dmitri graduated from Moscow Regional Art College in 1956, having studied with V Shestakov and L Fedorov. During this time, he furthered his childhood interest and love for classical music. In 1957, Plavinsky worked with the International Studio of Artists of Worldwide Festival of the Youth and Students. A trip to Central Asia in 1958 awakened his interests in history, archeology and paleontology. He also became infatuated with the poetry of V Klebnikov, which inspired him to work with the themes of words; their sounds and their timing. The Voices of Silence, 1962, now in the Museum of Modern Art, New York, was in the artist's own words,"...lines of fate of different cultures in time given the palm print of a single time." He further developed the theme in Coelacanth, 1965, also in the Museum of Modern Art. He calls this "the image of the most ancient fish who, in birth-pangs, delivers humankind." The artist's themes have been involved with fish, books and musical scriptures. He has been using subtle images of these subjects to materialize his ideas about Time as the unity of the past and present—nature and civilization. In the past few years, Plavinsky has created a series based upon the rhythmical construction in the musical scriptures of Bach, Mozart, Stravinsky and G Crumb. The artist's works can be found in many museums including the Pushkin and Tretyakov in Moscow, the Ludwig Museum in Germany, the Museum of Modern Art, New York, the State Russian Museum in Leningrad and the Museum of Contemp Russian Art, Montgeron, France.
(See page 190)

POLKE, SIGMAR (1941 - present)
b. Oels, Germany

Education: Staatlichen Kunstakademie, Dusseldorf, W Germany, 61-67. Lives in Cologne, W Germany. **Selected Solo Exhibitions:** Stadtisches Kunstmuseum, Bonn, W Germany, 84, 88; Galerie Klein, Bonn, 84; Galerie Nachst St Stephan, Vienna, Austria, 84; Kunsthaus, Zurich, Switz, 84; Josef-Haubrich Kunsthalle, Cologne, W Germany, 84; Marian Goodman Gallery, NYC, 84; Galerie Schmela, Dusseldorf, W Germany, 85; Galerie Bama, Paris, France, 85; Alfred Kren Gallery, NYC, 85; Galerie Thomas Borgmann, Cologne, W Germany, 86; Mary Boone Gallery, NYC, 86, 88-90; Musee d'Art Moderne de la Ville de Paris, ARC, Paris, France, 88; Jablonka Galerie, Cologne, W Germany, 89; Galerie Crousel-Robelin Bama, Paris, France, 89; Staatliche Kunsthalle, Baden-Baden, W Germany, 89; Galerie Marie-Louise Wirth, Zurich, Switz, 90; Michael Werner Gallery, NYC, 90; San Francisco Museum of Modern Art, CA, 90, travelled; Hirshhorn Museum & Sculpture Garden, Wash, DC, 91; Brooklyn Museum, NY, 91.
(See page 191)

NEBEKER, ROYAL (1945 - present)
b. San Francisco, California

Education: Brigham Young Univ, Provo, UT, 69, MFA; Nat'l School of Arts & Crafts, Oslo, Norway, 72, MA. **Selected Solo Exhibitions:** Courtyard Gallery, Portland, OR, 79, 80; The Long Island Printmakers Society, Long Island, NY, 81; Ft Lewis College, Durango, CO, 81; Finnish Arts Council Gallery, Helsinki, Finland, 81; Jackson St Gallery, Seattle, WA, 82; Metro Gallery, LA, CA, 84; State Univ of NY, Long Island, 84; Strand Galleriet, Stockholm, Sweden, 84; Global Graphics Gallery, Malmo, Sweden, 84; Global Gallery, Helsinki, Finland, 84; Frogner Gallerie, Aalesund, Norway, 83-85; Gallery Levy, Hamburg, Germany, 82, 84-85; Bluxome Gallery, SF, CA, 86-87; Gallerie Levy, Paris, France, 88; Gallerie Gimele, Malmo, Sweden, 88; Himovitz Gallery, Sacramento, CA, 85, 89; Francine Seders Gallery, Seattle WA, 87, 89; Augen Gallery, Portland, OR, 84, 86-89. **Selected Group Exhibitions:** Expo 86, Oregon Pavilion, Vancouver, Canada, 86; Bluxome Gallery, SF, CA, 88; Galerie Levy, Madrid, Spain & Heidelberg, Germany, 88; Francine Seders Gallery, Seattle, WA, 88; Caroline Corre, Paris, France, 88; Seattle Art Museum, Monotypes, 89. **Selected Collections:** Nat'l Gallery, Krakow, Poland ; IBM; Univ of NM Art Museum; Univ of CA, LA Print Collection; Tamarind Inst, NM. **Selected Awards:** Ft Lewis College, Artist-in-Residence, 81; Tamarind Inst, Guest Edition, Albuquerque, NM, 79.
(See page 180)

NEWMAN, JOHN (1952 - present)
b. New York City, New York

Education: Independent Study Program, Whitney Museum of American Art, NYC, 72; Oberlin College, OH, 73, BA; Yale School of Art, CT, 75, MFA. **Selected Solo Exhibitions:** Center for Advanced Visual Studies, MA Inst of Tech, Cambridge, 77; Thomas Segal Gallery, Boston, MA, 79; Reed College, Portland, OR, 81; Daniel Weinberg Gallery, LA, CA, 85, 88; Jeffrey Hoffeld & Co, NYC, 86 Jay Gorney Modern Art, NYC, 87; NY Academy of Sciences, NYC, 88; Editions Ilene Kurtz, NYC, 88; Gagosian Gallery, NYC, 88; Heland Wetterling Gallery, Stockholm, Sweden, 90; Galerie Schmela, Dusseldorf, W Germany, 90; David Nolan Gallery, NYC, 90-91; Galerie Jahn und Fusban, Munich, W Germany, 90; John Berggruen Gallery, SF, CA, 91; Galeria Carola Mosch, Berlin, Germany, 91. **Selected Collections:** Whitney Museum of American Art, NYC; Metropolitan Museum of Art, NYC; Storm King Art Center, Mountainville, NY; Walker Art Center, Minneapolis, MN; Art Inst of Chicago, IL. **Selected Commissions:** Northrop Industries, LA, CA, 84; Dept of Transportation, Wash, DC, 84; General Mills Outdoor Sculpture Park, Minneapolis, MN, 89; Storm King Art Center, NY, 89
(See page 275)

NEWMAN, WILLIAM (1948 - present)
b. Great Lakes, Illinois

William Newman received a BFA from Maryland Inst of Art in 1971 and a MFA from University of Maryland in 1974. He was a recipient of a Ford Foundation Grant in 1975. Mr Newman was the Geico Chair of Painting at the Corcoran School of Art in Washington, DC in 1982 where he is currently teaching Painting and Computer Art. Mr Newman has created large public murals including a GSA commission. He has exhibited here in the US and abroad and his work was included in exhibitions at the Corcoran Gallery of Art, Bronx Museum of Art and the Every Thing But exhibition at The Kitchen in New York City. He is represented in the Project Rembrandt Biennial, Against the Odds, at the Met Life Gallery in New York which runs 1991-1992. His new mixed media computer paintings were recently exhibited at the David Adamson Gallery in Washington, DC.
(See page 181)

NONN, THOMAS (1934 - present)
b. Budapest, Hungary

Thomas Nonn came to the US in 1957. In a truly abstract expressionist style, Thomas Nonn explores the subjects that interest him by expanding on the medium of paint on canvas. The surfaces of his wood and canvas paintings are covered with variegated media like metallic powders, pigments, sand, or stone dust which are then burned and manipulated with acids, bleaches and vinegars. Thomas Nonn creates color journeys across the surface of burnt orange and copper oxidized green or blue-grey that continue to change even after he finishes them insuring a kind of after life. Much of Thomas Nonn's imagery has a dual nature—one of an autobiographical kind relating to his war-torn youth of surviving a Stalinist holocaust where he was surrounded by burned out buildings with darkened facades and an environmental kind concerning issues that threaten our very own survival such as the destruction of the rain forest and the Exxon Valdez oil spill. These dual concerns merge into a composite of micro and macro views illuminating Nonn's fascination with time and change.
(See page 182)

OLDENBURG, CLAES (1929 - present)
b. Stockholm, Sweden

Chronology: Yale Univ, New Haven, CT, 46-50, BA, English & Art; studies intermittently at the School of the Art Inst of Chicago, IL, 51-54; moves to NYC, 56; Ray-Gun Show: The Home & The Street, first solo show in NY at the Judson Gallery, Judson Memorial Church, 60; Claes Oldenburg: Object Into Monument, Pasadena Art Museum, 71; Brandeis Univ, Medal for Sculpture, 71; inducted as a member of the American Academy & Inst of Arts & Letters, 75; Skowhegan Medal for Sculpture, 72; marries Coosje van Bruggen, 77; The Mouse Museum, The Ray-Gun Wing: Two Collections, Two Buildings, Museum of Contemp Art, Chicago, IL, 77, travelled; Coltelli/Ship I, II, originally made for 'Il Corso del Coltello' in Venice, 85-87, travelled.
(See page 351)

OLITSKI, JULES (1922 - present)
b. Snovsk, Russia

Education: Nat'l Academy of Design, NYC, 39-42; Beaux Arts Inst, NYC, 40-42; Ossip Zadkine School, Paris, 49; Academie de la Grand Chaumiere, Paris, 49-50; NY Univ, NYC, 52, BA; 54, MA. **Teaching Experience:** Post College of Long Island Univ, Fine Arts Division Chairman, NY, 56-63; Bennington College, Bennington, VT, 63-67. **Selected Solo Exhibitions:** M Knoedler & CO, NYC, 81, 83, 85, 87; Meredith Long & Co, Houston, TX, 87; Gallery Camino Real, Boca Raton, FL, 87; Galerie Wentzel, Cologne, W Germany,87-88; Andre Emmerich Gallery, NYC, 87-89; Gallery One, Toronto, 81-84, 86-88; Edith C Blum Art Inst, Bard College, Annandale-on-Hudson, NY, 87; Hokin Gallery, Palm Beach, FL, 88; Assoc American Artists, NYC, 89; Buschlen Mowatt Gallery, Vancouver, Canada, 90; Frances Graham-Dixon Gallery, London, 90. **Selected Collections:** Albright-Knox College, Buffalo, NY; Art Inst of Chicago, IL; Solomon R Guggenheim Museum, NYC; Whitney Museum of American Art, NYC. **Selected Awards:** 1961 Pittsburgh Int'l Exhibition of Contemp Painting & Sculpture, Carnegie Inst, PA, Second Prize; 30th Biennial Exhibition of Contemp Painters, Corcoran Gallery of Art, Wash, DC, Corcoran Gold Medal & William AC Clark Prize, 67; 1975 Award for Distinction in the Arts, Univ Union, Univ of SC, 75; Milton & Sally Avery Distinguished Professorship, Bard College, NY, 87.
(See page 183)

OROPALLO, DEBORAH (1954 - present)
b. Hackensack, New Jersey

Education: Alfred Univ, NYC, 70, BFA; Univ of CA, Berkeley, 82, MA; 83, MFA. Deborah Oropallo lives in Berkeley, California. **Selected Solo Exhibitions:** Stephen Wirtz Gallery, San Francisco, CA, 86, 88, 90;Currents/Deborah Oropallo, Inst of Contemp Art, Boston, MA, 90; Artspace, SF, CA, 90; Greenville County Museum of Art, SC, 91; Germans van Eck Gallery, NYC, 91; Ann Jaffe Gallery, Bay Harbor Island, FL, 91; Raab Gallery; London, England, 92. **Selected Group Exhibitions:** Whitney Museum of American Art, NYC, 89; Milwaukee Art Museum, WI, 90; Contemp Art Museum, Houston, TX, 90; Aldrich Museum of Contemp Art, Ridgefield, CT, 90; Oakland Museum, CA, 91.
(See page 184)

ORR, ERIC (1939 - present)
b. Covington, Kentucky

Renegade from the tradition-ridden art world of the 1960's, Eric Orr established himself as one of the contemporary avant-garde, an artist willing to take risks, and stretch the constrictive boundaries of art. Rather than produce 'collectible' objects, he created site-specific installations—experiments in perceptual phenomena—intentionally intangible, transitory and temporal. In 1976, Orr was incorporating aspects of shamanism into his work. He created enigmatic wall reliefs composed of unusual media: lead, meteorite dust, human bone fragments, and pulverized radio parts. Still intrigued with the physical aspects of nature and shamanism, Orr is creating a remarkable series of stelae-like fountains made of bronze, gold-leaf, marble and granite. Incorporating sensuous water panels, these fountains often include the most captivating of elements: fire. Thus, Orr reminds us of our ultimate dependence on nature and holds up the mirror to our primeval past. **Education:** Univ of CA at Berkeley; Univ of Mexico; New School of Social Research; Ecole de Paraphysiques, Paris; Univ of Cincinnati. **Selected Solo Exhibitions:** James Corcoran Gallery, LA, CA, 88, 89; Anders Tornberg, Lund, Sweden, 89; Scott Hanson Gallery, NYC, 89; Hyundai Gallery, Seoul, Korea, 89; Galerie Georges Lavrov, Paris, France, 89; The Works Gallery, Long Beach, CA, 90; Vreg Baghoomian Gallery, NYC, 90. **Selected Collections:** The State of CA; LA County Museum; Museum of Modern Art, NYC; Yale Univ, CT.
(See page 352)

OSTREM, DAVID (1945 - present)
b. Portland, Oregon

Selected Solo Exhibitions: Or Gallery, Vancouver, Canada, 87; Pitt Int'l Galleries, Vancouver, Canada, 88; Burnaby Public Art Gallery, Canada, 90; Prior Editions, Vancouver, Canada, 91. **Selected Group Exhibitions:** Surrey Art Gallery, Surrey, Canada, 82; Western Front Gallery, Vancouver, Canada, 82; Contemp Artists Gallery, Vancouver, Canada, 84; Artropolis, Vancouver, Canada, 83, 87, 90; Vancouver Art Gallery, Canada, 83, 87, 91. **Selected Collections:** Canada Council Art Bank, Ottawa, Canada; Vancouver Art Gallery; Surrey Art Gallery; Toronto Dominur Bank, Toronto, ON. **Selected Awards:** Canada Council Visual Arts Award, 84, 89, 90; Vancouver Inst for the Visual Arts Award, 90; British Columbia: Project Assistance for Visual Artists, 90.
(See page 276)

OUTERBRIDGE, JR, PAUL (1896 - 1958)
b. New York City, New York

Chronology: Attended elementary school in New York, later at the Hill School, Pottstown, PA, 1906; finishing at the Cutler School, NYC. NY, 14; studied anatomy & aesthetics at the Art Students' League, NYC, designed posters for the Winter Garden revues, 15; worked with Rollo Peters on stage design, produced his own revue in Bermuda, took a studio in Greenwich Village, 16; joined the Royal Flying Corps & later the Army, 17; travelled to Hollywood & returned to NYC, 18; married Paula Smith, took up photography, entered Clarence H White School, 21; Kitchen Table, picture published by Vanity Fair, 21-22; talks with Stieglitz, studies with Archipenko, 23; many commercial accounts, 24; leaves for Europe, works for Paris Vogue, meets Man Ray, Brancusi, Picasso, Picabia, Hoyningen-Huene, Duchamp, Stravinsky, Dali & Braque, 25; freelance work, 27; builds large studio in Paris financed by Outerbridge & Mason Siegal, 27; works in motion pictures in Berlin, later in London for Dupont's film, Variety, 28; returns to New York, 29; experiments with Carbro color, sets up a country studio outside of New York, highly successful commercial color photographer, 36; publishes book, Photographing in Color, 40; moves to Hollywood, and then to Laguna Beach to set up a small portrait studio, 43; marries Lois Weir, enters partnership of Lois-Paul Originals in women's fashions, 45; travels to make picture stories for magazines, 47; travels to South America, 50; writes column for US Camera magazine, 54; Paul Outerbridge, Jr dies of cancer on Oct 17, 58.
(See page 394)

McDERMOTT, DAVID (1952 - present)
b. Hollywood, California

McGOUGH, PETER (1958 - present)
b. Syracuse, New York

Selected Solo Exhibitions: Pat Hearn Gallery, NY, 86; Lucio Amelio Gallery, Naples, Italy, 86; Frankfurter Kunstverein, Frankfurt, W Germany, 86; Mario Diacono Gallery, Boston, MA, 87; Massimo Audiello Gallery, NYC, 85-88; Robert Miller Gallery, NYC, 89; Sperone Westwater Gallery, NYC, 90; Fay Gold Gallery, Atlanta, GA, 91. **Selected Group Exhibitions:** Whitney Museum of American Art, NYC, 87; Inst of Contemp Art & Museum of Fine Arts, Boston, MA, 88-89; Centre Georges Pompidou, Paris, France, 89; Frankfurter Kunstverein, Frankfurt, W Germany, 89; PPS Galerie FC Gundlach, Hamburg, W Germany, 89; Inst of Contemp Art, Boston, MA, 89; Improvissione Prima Gallery, Trento, Italy, 90; Independent Curators Inc, NYC, 90-92; Biennial Exhibition, Whitney Museum of American Art, NYC, 90-92. **Selected Collections:** Museum of Fine Arts, Boston, MA; Security Pacific Nat'l Bank.
(See page 393)

MELCHIOR, ISABELLE (1950 - present)
b. Paris, France

Education: Ecole d'Art Appliques, school of drawing, Paris, France, 71, diploma; Ecole Nationale Superieure des Beaux-Art, Paris, France, 75, MFA; Painting studies with Cesar (student of Germaine Richier), 75; Painting studies with Augereau (student of Fernand Leger), 75; Drawing studies with Marcel Gili (founder of the salon, Realites Novelles), 75. Since 1982, Melchior has concentrated her efforts as a painter. Analysis of dimension and form are based in her sculptural studies and the paintings project a sense of depth peculiar to painters that sculpt. Melchior is the consummate artist, recognizable as only herself, in addition to sculpture and paintings, her drawings, pastels, watercolors and etchings are masterful. Catalogue available. **Selected Solo Exhibitions:** Academie de France, Villa Medicis, Rome, 81; Mairie de Montereau, Montereau, France, 83; Galerie Bernanos, Paris, 87; Galerie Anne Blanc, Paris, 87, 90; Galerie Timothy Tew, Atlanta, GA, 88-89, 91; French Embassy, Prague, Czech, 89; Galerie David, Lyon, France, 91; Galerie St Paul, Paris, France, 91. **Selected Group Exhibitions:** Salon de la Jeune Peinture, Paris, 87; Rotary Club, St Malo, France, 87; Frances Aronson Gallery, Atlanta, GA, 88; Spectrum, Hunter Museum, Chattanooga, TN, 89, 90; Galerie Timothy Tew, Atlanta, GA, 90; Tal Coat and Melchior, Pardubice, Czech, 90. **Illustrations:** Engravings, Mozartiana, poetry by W Holan, 91. **Selected Commissions:** Hotel Meridien, Colombo, Ceylon, 84; Les Bernardines Theatre, Marseille, France, Hanjo, by Mishima, dir Beatrice Houplain, 91.
(See page 170)

MENDENHALL, KIM (1949 - present)
b. New York City, New York

Education: CA College of Arts & Crafts, Oakland, 70, BFA; Mills College, Oakland, CA, 76. Selected Solo Exhibitions: Cudahy's Gallery Inc, NYC, 91. **Selected Group Exhibitions:** Oakland's Artist '90, Oakland Museum, CA, 90; Contemp Realist Paintings, J Rosenthal Gallery, Chicago, IL, 90; Cudahy's Gallery Inc, NYC, 91. **Selected Bibliog:** Realism, Walnut Creek Civic Art Gallery, CA, Jan 90, catalogue; Oakland's Artists '90, Oakland Museum, CA, Mar 90, catalogue; Vigor and Diversity in Oakland, SF Chronicle, Kenneth Baker, May 13, 90, newspaper. **Selected Collections:** Home Savings and Loan, CA; Oakland Museum, CA; numerous private collections in America and Europe.
(See page 171)

METZLER, KURT LAURENZ (1941 - present)
b. St Gallen, Switzerland

Education: Kunstgewerneschule, Zurich, Switz, 63, Diploma in Stone Sculpting. **Selected Solo Exhibitions:** Ausstellung, East Hampton, USA, 65; Galerie Daniel Keel, Zurich, 67; Galerie Atelier Bettina, Zurich, 69; Bellerive Museum, Zurich, 69; Galerie Ida Niggli, St Gallen, 70; Galerie Semiha Huber, Zurich, 71; Galerie d'Eendt, Amsterdam, 71; Galerie Scholss Reseck, Neckarrems, Stuttgart, 72; Galerie Meier, Lausanne, 74; Galerie Scheidegger und Maurer, Zurich, 74; Galerie Hilt, Basel, 76; Sadthaus, Uster, 77; Galerie Ludin, Basel, 78; Galerie Ernst Scheidegger, Zurich,76, 78, 83; Galerie E Benson, Bridge Hampton, NY, USA, 78; Galerie Kunst im Riegelhaus, Huttwilen, 79; Galerie Home, St Gallen, Switz, 79; Galerie Matasci, Tenero, 80; Galerie Royag, Dusseldorf, 81 & Zurich, 82. **Selected Group Exhibitions:** Art Basel, Switz, 70-80; Schweizerische Plastik-Ausstellung, Ascona, 75 & Biel, 75, 80; Bottega, Arzo, 81; Galerie Benkert, Kusnacht, 82; Galerie Arche, Frauenfeld, 82; Galerie Royag, Zurich, 82.
(See page 349)

MEYERS, EDDWIN

Eddwin Meyers lives and works in Chicago. He has developed a realism in which technical virtuosity provokes both meditation and psychic shock. He creates a world drawn well enough to defy disbelief, yet he places viewers firmly within his realm where ideas and emotions count more than appearances. Meyers, whose work often features himself as its main image, places explicitly real figures in a mental landscape dotted with the question of self. Perfectly rendered objects from middle class life combine into a murky subworld which stymies both introspection and self-expression. His figures are informal, dressed for a casual Sunday afternoon, yet they float uneasily in a world which denies them peace. Meyers has painted professionally since 1974. He studied first at Southern Illinois University, and in France, where he studied Old Master techniques at the Atelier Neo-Medici. He has shown extensively in the United States and Europe.
(See page 172)

MILTON, PETER (1930 - present)
b. Lower Merion, Pennsylvania

Peter Milton studied Art at Yale University and received his BFA in 1954. He taught at the Maryland Inst, College of Art, in Baltimore from 1961-68. Milton received the Louis Comfort Tiffany Foundation Grant in Graphics in 1964. He has exhibited widely in the US and Europe. His works are held in more than 300 public collections, including the Baltimore Museum, MD; Bibliotheque Nationale, Paris; Brooklyn Museum, NYC; Cincinnati Art Museum, OH; Cleveland Museum, OH; Corcoran Gallery of Art, Wash, DC; Carnegie Museum, Pittsburgh, PA; Fine Arts Museum of San Francisco, CA; High Museum of Art, Atlanta, GA; Hirshhorn Museum & Sculpture Garden, Wash, DC; Library of Congress, Wash, DC; Los Angeles County Museum of Art, CA; Metropolitan Museum of Art, NYC; Museum of Fine Arts, Boston, MA; Museo de Arte Moderno-Bogota Columbia; Museum of Modern Art, NYC; Nat'l Museum of American Art, Wash, DC; Nat'l Gallery of Art, Wash, DC; Philadelphia Museum of Art. PA; Phillips Collection, Wash, DC; Portland Art Museum, OR; Seattle Art Museum, WA; Tate Gallery, London, England.
(See page 273)

MIRETSKY, DAVID

Miretsky's paintings lend insight into human characters. He has borrowed imagery from his native culture to make provocative statements about the human condition whose relevance extends far beyond Russian society. The evolution of his art reflects the happiness and success he has found in American life. He continues to paint in the same traditions, displaying the potential tenderness in human relationships; yet his subjects have become less somber and more elegant. While the landscapes begin to dominate with their naturalness and sophistication of color, the altered elements of composition continue to amplify the impact of the subject.
(See page 173)

MONVOISIN, BRUNO (1953 - present)
b. Paris, France

It is almost impossible to describe the paintings of this Paris born artist. His fay canvases present a world somewhere between animal, vegetable and mineral. In fact, each of his works do include vegetable matter—usually in the form of a person, a man-made metal object and a mineral jewel. The seemingly simple, brightly colored tableaux when scrutinized reveal a master's technique in his use of oils. At 32 he has a long list of gallery exhibitions, both individual and group, as well as numerous civic invitational shows and salons.
(See page 174)

MORPHESIS, JIM (1948 - present)
b. Philadelphia, Pennsylvania

Education: Tyler School of Art, Philadelphia, PA, 70, BSA; CA Inst of the Arts, 72, NSA. He presently lives in New York City, New York. **Selected Solo Exhibitions:** Freidus/Ordover Gallery, NYC, 83; Fisher Gallery, Univ of S CA, LA, 86; Acme Art, SF, CA, 87; LA County Museum of Art, CA, 87; Deson-Saunders Gallery, Chicago, IL, 90; Torture Gallery, Santa Monica, CA, 90; The Works Gallery, Costa Mesa, 90. **Selected Group Exhibitions:** Avant-Garde in the '80's, LA County Museum of Art, CA, 87; American Painting: Abstract Expressionism & After, San Francisco Museum of Modern Art, CA, 87; Art in the Public Eye, Security Pacific Gallery, Costa Mesa, CA, 89; Images of Death in Contemp Art, Haggerty Museum, Marquette Univ, Milwaukee, WI, 90; Cruciformed: Images of the Cross since 1980, Cleveland Center for Contemp Art, OH, 91.
(See page 175)

MORRIS, KATHLEEN (1946 - present)
b. Oklahoma City, Oklahoma

Kathleen Morris' expressionistic figurative paintings, with their dream-like imagery, speak to the viewer's inner world. "The Psyche is the subject; Eros, if not actually on stage, is always in the wings," says critic Barbara Cottwright. Curator and critic Malin Wilson adds, "Morris is intense and her style sweeping." Morris herself says, "Because I feel there is both beauty and horror in our existence, I like to have an edge in my work, which may be bothersome to some." **Education:** Accademia Carrara, Bergamo, Italy. **Selected Solo Exhibitions:** Perception Gallery, OK City, OK, 82; Museum of Fine Arts, OK City, OK, 83; St Mark's Gallery, NYC, 84; Gallery 836, Santa Fe, NM, 86; Beverly Gordon Gallery, Dallas, TX, 86; Sena Galleries East, Santa Fe, NM, 88-89; The Lowe Gallery, Atlanta, GA, 90. **Selected Group Exhibitions:** Salon d'Automne, Grand Palais, Paris, France, 83; Munson Gallery, Santa Fe, NM, 84; Sena Galleries East, Santa Fe, NM, 86. **Selected Awards:** NEA Award Nomination.
(See page 176)

MURPHY, TODD (1962 - present)
b. Chicago, Illinois

Education: Univ of GA, 86, BFA. **Selected Exhibitions:** Janice Hunt Gallery, Atlanta, GA, 89; Spotlight on GA Artists Annual Exhibit, 89, 91; selected cities of Italy tour and exhibitions, 89; Tampa Museum of Art, Tampa, FL, 90; Fay Gold Gallery, Atlanta, GA, 90; The Lowe Gallery, Atlanta, GA, 90, 91; McKissick Museum of Art, Columbia, SC, 91. **Selected Collections:** High Museum of Art, Atlanta, GA; Tampa Museum of Art, FL; McKissick Museum of Art, Columbia, SC; Univ of GA, Athens; John Portman & Assoc, Atlanta, GA; Arthur Andersen & Co; plus numerous private collections in NY, LA, Chicago, Philadelphia & Atlanta.
(See page 178)

MUSSOFF, JODY (1952 - present)
b. Pittsburgh, Pennsylvania

Jody Mussoff was born in 1952 and received her art training at Carnegie-Mellon University and the Corcoran School of Art. Ms Mussoff has exhibited since 1980 in the US and abroad. Her work has been included in exhibitions at the Corcoran Gallery of Art, the Hirshhorn Museum & Sculpture Garden, Indianapolis Museum of Art and the Virginia Museum. Ms Mussoff has had solo exhibitions at Monique Nolton in New York; Gallery K in Washington DC and Origrafica in Malmo, Sweden. A one-person exhibition is planned in 1992 at the David Adamson Gallery in Washington, DC. Reviews of her work have been in The Washington Post, Village Voice, Arts Magazine, The New York Times, Art in America and The Washington Times. Her public collections include Chemical Bank, Prudential Insurance Corp, Philip Morris Corp, Hirshhorn Museum & Sculpture Garden, Kunsthalle Nurnberg, W Germany.
(See page 179)

NAUMAN, BRUCE (1941 - present)
b. Ft Wayne, Indiana

Selected Solo Exhibitions: Bruce Nauman Heads & Bodies, Dusseldorf, W Germany, 89; Galerie Yvon Lambert, Paris, France, 89; Bruce Nauman, at the Gallery Ronny Van de Velde, Antwerp, Belgium, 90; Galerie Jurgen-Becker, Hamburg, W Germany, 90; Galerie Langer Fain, Paris, France, 90; Daniel Weinberg Gallery, Santa Monica, CA, 90; Bruce Nauman: A Survey, Anthony d'Offay Gallery, London, England, 90; Sperone Westwater Gallery, NYC, 90; Leo Castelli Gallery, NYC, 90; Bruce Nauman: Human Nature/Animal Nature, Museum fur Gegenwartskunst, Basel, Switz, 90; Prints & Multiples, Galerie B Coppens & R Van de Velde, Bruxelles, Belgium, 90; **Selected Installations:** Animal Pyramid, permanent installation, Des Moines Art Center, IA. **Selected Group Exhibitions:** Tokyo Art Expo, representing Leo Castelli Gallery, Japan, 91; Drawings for Sculpture, JGM Galerie, Paris, France, 91; Galerie Nickolaus Sonne, Berlin, Germany, 91; Biennial Exhibition, Whitney Museum of American Art, NYC, 91; Drawings for Sculpture: From Rodin to Robert Morris, JGM Galerie, Paris, France, 91; Twentieth Century Art, Galerie Beyeler, Basel, Switz, 91; Mechanika, The Contemp Arts Center, Cincinnati, OH, 91; Metropolis, Altes Museum, Martin-Gropius-Bau, Berlin, Germany, 91; Body as Site, School of Visual Arts, NYC, 91; films shown; Not on Canvas, Asher Faure Gallery, LA, CA, 91.
(See page 350)

LUEBTOW, JOHN GILBERT (1944 - present)
b. Milwaukee, Wisconsin

Education: Rufus King HS, Milwaukee, WI, 58-62; North Central College, Naperville, IL, 62-64; CA Lutheran College, Thousand Oaks, 64-67, BA; Univ of CA, LA, 67-69, MFA, Ceramics; Zr. Maria Regina Coel Language School, Vught, The Netherlands, 70, Cert of Competency, Dutch; Univ of CA, LA, 73-76, MFA, Media-Glass. **Selected Commissions:** Saks Fifth Ave, FL, IL, CA, MN, 80-81, 83, 89; Sheraton Grand Hotel, LA, CA, 84; Hilton in the Park, Anaheim, CA, 84; Marshall Fields, Chicago, IL, 84; Koll Center, Irvine, CA, 85; Cumberland Center, Cobb Co, GA, 85; Sheraton Inner Hotel, Baltimore, MD, 85; Hilton Hotel, SF, CA, 85; Hollywood Roosevelt Hotel, CA, 85; Redken Corp, Canoga Park, CA, 85; Huntcor Corp, Phoenix, AZ, 85; Bankers Life, Des Moines, IA, 85; HSH Princess Caroline of Monaco for Intercoiffure Maison des Nations, 85; Redken Laboratories, Manufacturing Facilities, Florence, Kentucky, 85; Anna Hotel, Nippon Airways, Tokyo, Japan, 86; Sheraton Hotel, Singapore, 86; Trammell-Crow Co, Pasadena, CA, 86; Hyatt on Collins, Melbourne, Australia, 86; Loeb & Loeb, LA, CA, 87; Thelen Marrin, Johnson & Bridges, LA, CA, 88; Royal Caribbean Cruise Lines, Copenhagen, Denmark, 88; Barker Patrinel Group, SF, CA, 88; Barker Patrinely Group, SF, CA, 88; Hewlett-Packard, Mountain View, CA, 88, 89; Charles E Smith Co, Arlington, VA, 89; Rose Hills Memorial Park, Whittier, CA, 90; ARCO, LA, CA, 90; Carnation CO, Glendale, CA, 90; Soloman & Gloria Kamm, Encino, CA, 90; Coblentz, Cahen, McCabe & Breyer, SF, CA, 91; Frank Residence, Brentwood, 91; Chaiken Residence, Lake Tahoe, NV, 91.
(See page 345)

LUKACS, ATTILA RICHARD (1962 - present)
b. Alberta, Canada

Education: ECCAD, Vancouver, Canada, 85, with Honors. **Selected Exhibitions:** Morality Tales: History Painting in the 80's, Grey Art Gallery, NYC, 87; Toyama Now '87: New Art Around the Pacific, Museum of Modern Art, Toyama, Japan, 87; Kunstlerhaus Bethanien, Berlin, 88; The Power Plant, Toronto, 89; 49th Parallel, NYC, 89; Diane Farris Gallery, Vancouver, 84-86, 88, 90; Moderne Kunst Dietmar Werle, Cologne, W Germany, 88, 90; Illingworth Kerr Gallery, Alberta College of Art, Calgary, Alberta, 90; Museo de Arte Contemporaneo de Monterrey, Mexico, 91; Seoul Int'l Art Festival, Nat'l Museum of Contemp Art, Korea, 91; Wurtternbergischer Kunstverein, The Golden Age, Stuttgart, Germany, Nov, 91; Diane Farris Gallery at Walden House, NYC, 92; Documenta 9, Kassel, W Germany, June 92; Diane Farris Gallery, Vancouver, June 92. **Selected Awards:** Canada Council, 86-87, 89-90. **Selected Grants:** Studio Grant, Kunstlerhaus Bethanien, Berlin, 86-88.
(See page 162)

MacDONALD, KEVIN (1946 - present)
b. Washington, DC

Kevin MacDonald attended George Washington University and the Corcoran School of Art, Washington, DC. His work is in many permanent collections including The Metropolitan Museum of Art, the Corcoran Gallery of Art, The Phillips Collections, Nat'l Museum of American Art, Iowa Museum of Art, and the Hirshhorn Museum & Sculpture Garden. Mr MacDonald has exhibited both nationally and abroad, most recently his work was included in shows in Japan and the USSR. Reviews of his work has been included in Art News, Art in America, Art International, The New Art Examiner, The Washington Post, The Washington Times and the Washington Review. The artist resides in Maryland and his work is exhibited at the David Adamson Gallery in Washington, DC.
(See page 163)

MacDONALD, RICHARD (1946 - present)
b. Pasadena, California

After graduating cum laude from the Art Center College of Design in Los Angeles, Richard MacDonald went on to win many awards as an illustrator and painter. He turned to sculpture when he discovered that the medium both stimulated and inspired his creativity. His work, so far, concentrated on the performing arts where his exquisite understanding of the human anatomy and the soul of performance has blended into the creation of mimes, dancers and heroic figures that are provocative as well as technically brilliant. His sculptures recall those of another age, often drawing comparisons to Rodin. While remaining classical, his innovative use of patinas for the bronzes brings something powerful, majestic and contemporary to his figures. His recent work utilizing lucite brings that material into acceptance as a true sculpture medium and proves that it can be much more than a 'decorator' oddity.
(See page 346)

MANGOLD, ROBERT (1937 - present)
b. North Tonawanda, New York

Chronology: Cleveland Inst of Art, OH, 56-60; Yale Univ, New Haven, CT, Summer Fellowship, 9; 61, BFA; 63, MFA; Yale Univ School of Art & Architecture, 60-62; solo show, Thibaut Gallery, NYC, 64; Solomon R Guggenheim Museum, NYC, 71; Haus Lange, Krenfield; Portland Center for the Visual Arts, OR; Kunsthalle, Basel, Switz, 77; Paintings 1970-82, Drawings & Prints, Stedelijk Museum, Amsterdam, 82; Robert Mangold: Paintings 1971-84; Akron Art Museum, 84-86, travelled; Painting on Paper & Recente Werken/Recent Works, Bonnefautenmuseum, Maastricht, The Netherlands, 88-89; joins The Pace Gallery, NYC, 91.
(See page 164)

MANGOLD, ROBERT (1930 - present)
b. Huntingburg, Indiana

Education: IN Univ, Bloomington, 60, MFA. **Selected Exhibitions:** Artist's Studio, Denver, CO, 79, 83; Artyard, Denver, CO, 86, 88, 91; Sculpture in the Park, Loveland, CO, 87, 88; Angela de la Mota Galleria, Barcelona, Spain, 88; 14 de Colorado, Trajecta, Barcelona, Spain, 88; Grand Exhibition of Int'l Sculptors, Center of Museological Research & Services, Nat'l Autonomous Univ of Mexico, Mexico City, 90; Expositvm Galleria de Arte, Mexico City, Mexico, 90. Nat'l Invitational Exhibitions: Shidoni 7th & 8th Annual Outdoor Sculpture Shows, Tesuque, NM, 81-82; 5 Sculptors, Elaine Horwitch Gallery, Palm Springs, CA, 89. **Selected Collections:** Walker Field Airport, Grand Junction, CO; Mr & Mrs George Cannon Collection; Univ of Denver Collection, CO; IN Univ, Bloomington; Pella Corp, Pella, IA; Museum of Outdoor Art, Englewood, CO; Ginny Williams Collection; Bryan Pulte Collection; Yakone Open-Air Museum, Tokyo, Japan. Grants: Museum of Outdoor Art, Education Program, John Madden Co, Englewood, CO, 89. **Selected Awards:** Superior 6th Henry Moore Grand Prize, Hakone Open-Air Exhibition, Tokyo, Japan, 89; AFKEY, Denver Art Museum, CO.
(See page 347)

MARDEN, BRICE (1938 - present)
b. Bronxville, New York

Education: Boston Univ School of Fine and Applied Arts, MA, 61, BFA; Yale Univ School of Art and Architecture, New Haven, CT, 63, MFA. Lives in New York City, New York. **Selected Solo Exhibitions:** Wilcox Gallery, Swarthmore College, Swarthmore, PA, 64; Bykert Gallery, NYC, 66, 68-70, 72-74, Galerie Yvon Lambert, Paris, France, 69, 73; Galleria Francoise Lambert, Milan, Italy, 70, 73; Konrad Fischer, Dusseldorf, W Germany, 71-73, 75, 80; Gian Enzo Sperone, Turin, Italy, 71; Locksley-Shea Gallery, Minneapolis, MN, 72, 74; Jack Glenn Gallery, Corona del Mar, CA, 73; Cirrus Gallery, LA, CA, 74; Sable-Castelli Gallery, Toronto, Canada, 74; Drawings 1964-1974, Contemp Arts Museum, Houston, TX; Loretto-Hilton Gallery, Webster Univ, St Louis, MO, Bykert Gallery, NYC; Ft Worth Art Museum, TX, 74; Drawings, Minneapolis Inst of Arts, Minneapolis, MN, 75; D'Allesandro/Ferranti, Rome, Italy, 75; Solomon R Guggenheim Museum, NYC, 75; Sperone Westwater Fischer, NYC, 76; Max Protetch Gallery, Wash, DC, 77; Bell Gallery, Brown Univ, Providence, RI, 77; Jean & Karen Bernier, Athens, Greece, 77; Gian Sperone, Rome, Italy, 77; Pace Gallery, NYC, 78, 80, 82, 84; Kunstraum, Munich, W Germany, 79; Institut fur Moderne Kunst, Nurnberg, W Germany, 79; Ink, Zurich, Switz, 80; Stedelijk Museum, Amsterdam, The Netherlands, 81; Whitechapel Art Gallery, London, England, 81; Daniel Weinberg Gallery, LA, CA, 84; Saachi Collection, London, England, 85; Mary Boone Gallery, NYC, 87, 88; Anthony d'Offay Gallery, London, England, 87; Galerie Montenay, Paris, France, 87; Galerie Michael Werner, Cologne, W Germany, 89; Larry Gagosian Gallery, NYC, 91; Gallery of Fine Arts, Boston, MA, 91; Dia Center for the Arts, NYC, 91; Walker Art Center, Minneapolis, MN, 92.
(See page 166)

MARINO, CAROL (1943 - present)
b. United States

Selected Solo Exhibitions: Baldwin St Gallery, Toronto, 73; David Mirvish Gallery, Toronto, 76; Marcuse Pfeifer Gallery, NYC, 81; Jane Corkin Gallery, Toronto, 82; Life Forces, Agnes Etherington Art Centre, Queen's Univ, 87; Large Scale Recent Work, Jane Corkin Gallery, Toronto, Canada, 91. **Selected Group Exhibitions:** Nat'l Film Board, Int'l Women's Year, 75; Bologna, Italy, 77; 12 Contemp Canadians, The Watson Gallery, Houston, TX, 86; Figurative Force, The Gallery/Stratford, Ontario, Canada, 88; Art Cologne, W Germany, 89, 90; Los Angeles Art Fair, CA, 89, 90; Chicago, Art Fair, IL, 88-91; Basel Art Fair, 89-91. **Selected Collections:** Museum of Fine Arts, Houston, TX; Winnipeg Arts Gallery; Nickle Arts Museum, Calgary, Canada; Art Gallery of Hamilton; Agnes Etherington Art Centre, Queen's Univ; Alias Research Inc; Spectrum Mutual Funds; Prudential Insurance Company of America; Imperial Oil; CIL. **Selected Publications:** The Female Eye, Ottawa, Nat'l Film Board, 75; Life Forces, Photographs by Carol Marino, edited by Michael Bell, 87; Children in Photography: 150 Years, Firefly Books, 90.
(See page 392)

MARQUIS, RICHARD (1945 - present)
b. Bumblebee, Arizona

Education: Univ of CA, Berkeley, 71, MA. **Current Position:** Independent Solo Artist. **Selected Collections:** American Craft Museum, NYC; Art Museum, Wagga Wagga, New South Wales, Australia; Australian Arts Council, Sydney; Australian Nat'l Gallery, Canberra; Finnish Nat'l Glass Museum, Rlihlmaki, Finland; IN Univ Art Museum, Bloomington; Kunstmuseum der Stadt, Dusseldorf, W Germany; Lannan Foundation, Palm Beach, FL; Museum of Art, Auckland, New Zealand; Museum of Art, Rhode Island School of Design, Providence; Museum of Applied Arts and Sciences, Sydney, Australia; Museum for Kuntshandwerk, Frankfurt, W Germany; Nat'l Gallery of Victoria, Melbourne, Australia; Nat'l Glass Museum, Leerdam, The Netherlands; New Orleans Art Museum, LA; Philadelphia Museum of Art, PA; Queen Victoria Art Museum Art Museum, Launceton, Tasmania, Australia; Sea of Japan Collection, Japan; The Corning Museum of Glass, NY; The Craft and Folk Art Museum, LA, CA; The Detroit Inst of Art, MI; Smithsonian Institution, Wash, DC; Toledo Art Museum, OH; Topeka Public Library, Glass Collection, KS.
(See page 348)

MARTIN, AGNES (1912 - present)
b. Maklin, Saskatchewan, Canada

Chronology: moved to the US, studied at Western WA State College, Bellingham, 31-33; Columbia Univ, NYC, 42, BA; 52, MFA; became US Citizen, 50; moved to NY, 57; Betty Parsons Gallery, NYC, 58; moved to NM, 67; abandoned painting, 67-74; On a Clear Day, suite of prints, published, 71; Inst of Contemp Art, Univ of PA, Philadelphia, retrospective, 73; beginning of association The Pace Gallery, NYC, 75; inducted as a member of the American Academy & Inst of Arts & Letters, 89; Jawlensky Prize from Museum Wiesbaden, 90; Agnes Martin: Paintings & Drawings 1974-90, Stedlijk Museum, Amsterdam, The Netherlands, 91-92, retrospective.
(See page 167)

MAXIM, DAVID (1945 - present)
b. Los Angeles, California

Education: Univ of CA, LA, 66, BA; 68, MA. **Selected Solo Exhibitions:** Foster Goldstrom Fine Arts, SF,CA, 80-83, Dallas, TX, 85-86, NYC, 89-91; Santa Barbara City College Gallery, CA, 80; Univ Art Gallery, CA State Univ, Stanislaus, Turlock, CA, 85; Smith-Anderson Gallery, Palo-Alto, CA, 85; The Labors of Hercules, The Artist's Studio, SF, CA, 86; Southwest State Univ, San Marcos, TX, 87; Forum, Hamburg Kunstmesse, Hamburg, W Germany, 88; Galerie Sander, Darmstadt, W Germany, 91. **Selected Group Exhibitions:** Art Frankfurt, Kunstmesse Frankfurt, W Germany, 89-91; Sculpture Invitational, Kipp Gallery, IUP, Indiana, PA, 89; Contemp Icons & Explorations, travelled to: Sunrise Museums, Charleston, V, 90; Robeson Center for the Arts & Sciences, Binghampton, NY, 90; Hunter Museum of Art, Chattanooga, TN, 90; Mississippi Museum of Art, Jackson, 91; Memphis Brooks Museum of Art, TN, 91. Art Junction, Nice, France, 90; Permanent Collection, Sunrise Museum, Charlotte, WV, 91; 10 Jahre Galerie Sander, 91. **Selected Collections:** Museum fur Moderne Kunst, Frankfurt, W Germany; Carnegie Inst of Art, Pittsburgh, PA; Davenport Museum of Art, IA; San Francisco Museum of Modern Art, CA.
(See page 169)

LEONARD, MICHAEL (1933 - present)
b. Bangalore, India

Education: St Martins School of Art, London, England, 54-57. **Selected Solo Exhibitions:** Fischer Fine Art, London, 74, 77, 80, 83; Harriet Griffin, NYC, 88; Gemeentemuseum, Arnhem, The Netherlands, 88; Artsite Gallery, Bath, England, 89; Stiebel Modern, NYC, 92. **Selected Group Exhibitions:** Fischer Fine Art, London, 72-73, 75-76, 78-79, 81; Realismus und Realitaet, Kunsthalle, Darmstadt, W Germany, 75; Aspects of Realism, touring exhibition in Canada, 76, 78; John Moore's Liverpool Exhibition 10, England, 76; The Craft of Art, Peter Moore's Liverpool Project 5, Walker Art Gallery, Liverpool, 79-80; Nudes, Angela Flowers, London, 80-81; Urban Landscapes, Oldham Museum & Art Gallery, Oldham, England, 83; Contemp British Painters, Museo Municipal, Madrid, 83; British Realists, Robin Gibson Gallery, Darlinghurst, New South Wales, 83; The Male Nude: A Modern View, Homeworks, London, 83; The Self Portrait: A Modern View, Artsite, Bath, 87-88; In Human Terms, Stiebel Modern, NYC, 91.
(See page 155)

LERE, MARK (1950 - present)
b. LaMoure, North Dakota

Education: Metropolitan State College, Denver, CO, 73, BFA; Univ of CA at Irvine, 76, MFA. **Selected Solo Exhibitions:** New & Selected Work, Museum of Contemp Art, LA, CA, 85; Mark Lere Sculpture, Carnegie-Mellon Univ Art Gallery, Pittsburgh, PA, 86; Margo Leavin Gallery, 86, 88, 90. **Selected Group Exhibitions:** Figurative Impulses, Santa Barbara Museum of Art, 88; Objects of Potential, Wiegand Gallery, College of Notre Dame, Belmont, CA, 89; American Sculptors, Kamakura Gallery, Tokyo, Japan, 89; Recent Acquisitions, John Berggruen Gallery, SF, CA, 90; New Sculpture, Eve Mannes Gallery, Atlanta, GA, 90; Lead & Wax, Stephen Wirtz Gallery, SF, CA, 90; Contemp Bronze, Process & Object, Atlanta College of Art, GA, 91; Big Objects, Tacoma Art Museum, WA, 91; Individual Realities, Sezon Museum of Art, Tokyo, Japan, 91; 20th Century Collage, Margo Leavin Gallery, LA, CA, 91. **Selected Bibliog:** Close Encounters with Sculptures by Mark Lere, LA Times, Suvan Geer, Oct 31, 90; Art Pick of the Week: Mark Lere, Doug Edge-Context, LA Weekly, Peter Frank, Oct/Nov 90.
(See page 340)

LEVINE, DAVID (1926 - present)
b. Brooklyn, New York

Education: Pratt Inst, Brooklyn, NY, 36-38; Tyler School of Fine Arts, Temple Univ, Philadelphia, PA, 49, BS, BFA; Studied under Hans Hoffman in NYC, 49. **Selected Solo Exhibitions:** Davis Gallery, NYC, 53, with subsequent shows from 54-63; Forum Gallery, NYC, 63, with subsequent shows in 65, 67-68, 70-71, 74, 76, 78-79, 82, 85-89; New York Univ, NYC, 68; Georgia Museum of Art, Univ of GA, Athens, 68; Univ of MN, Minneapolis, 68; CA Palace of the Legion of Honor, SF, 68, 71; Davidson Art Center, Wesleyan Univ, Middletown, CT, 70; Lunn Gallery, Wash, DC, 71; Princeton Gallery of Fine Art, Princeton, NJ, 72; Pierson College, Yale Univ, New Haven, CT, 73; Hirshhorn Museum & Sculpture Garden, Wash, DC, 76; Frye Art Museum, Seattle, WA, 77; Galerie Claude Bernard, Paris, 79, with subsequent shows in 83-85, 88; Univ of CT, Storrs, 79; The Phillips Collection, Wash, DC, 80; Pierpont Morgan Library, NYC, 81; Fine Arts Museum of San Francisco, CA, 84; Ashmolean Museum, Oxford, England, 87; Wichita Art Museum, KS, 88; Louis Newman Galleries, Beverly Hills, CA, 89; Susan Conway Carroll Gallery, Wash, DC, 91. **Selected Collections:** Brooklyn Museum, NY; Cleveland Museum of Art, OH; Hirshhorn Museum & Sculpture Garden, Wash, DC; Fine Arts Museum of San Francisco, CA; Metropolitan Museum of Art, NYC; Museum of Art, Penn State Univ, Univ Park, PA; Newark Museum, NJ.
(See page 156)

LEVINE, ERIK (1960 - present)
b. Los Angeles, California

Education: CA State Univ, Northridge, 80-81; Univ of CA, LA, 82. **Selected Solo Exhibitions:** Diane Brown Gallery, NYC, 88-90; The Louisiana Museum of Modern Art, Humlebaek, Denmark, 89; Fundacio Joan Miro, Barcelona, Spain, 89; Halle Sud, Geneva, Switz, 89; Brandts Klaedefabrik, Odense, Denmark, 89; Meyers/Brown Gallery, Santa Monica, CA, 90. **Selected Group Exhibitions:** Bess Cutler Gallery, NYC, 88; Whitney Museum at Equitable Center, NYC, 88; Meyers/Bloom Gallery, Santa Monica, CA, 88; High Museum of American Art, Atlanta, GA, 89; La Jolla Museum of Contemp Art, CA, 89; Henry Art Gallery, Seattle, WA, 89; BMW Gallery, NYC, 89; Parrish Art Museum, Southampton, NY, 90. **Selected Collections:** Albright-Knox Art Gallery, Buffalo, NY; City of Geneva, Switz, for the future Museum of Modern Art; High Museum of Art, Atlanta, GA; Hirshhorn Museum & Sculpture Garden, Wash, DC. **Selected Bibliog:** Sculpture that Demands a Viewer Involvement, The NY Times, Phyllis Braff, Jan 17, 90; Perfectly Crafted Plywood: Erik Levine, LA Times, Suvan Geer, Nov 3, 90; Levine's Round House Going Up, Star Tribune, McConnell, Aug 21, 90; Sculptor Erik Levine Emphasizes the Intellectual, LA Times/Calendar, Shauna Snow, Nov 4, 90. **Selected Commissions:** Round House, Walker Art Center, Minneapolis, MN.
(See page 341)

LEVINE, JACK (1915 - present)
b. Boston, Massachusetts

Jack Levine is a social satirist whose canvases have parodied everything from gangsters to American tourists. He is also known for his lyrical portraits and spiritual paintings of old testament prophets and teachers. Levine's paintings have a degree of depth and luminosity found in old master paintings. Kenneth Prescott has written about Jack Levine that he is, "...foremost interested in the art of painting. The subject matter is a device around which the artist has organized his masterful brushwork, opaque and translucent...With renewed interest in the technique of the old masters...the thought that Levine may one day be considered a forerunner of this new breed is intriguing; that, to Jack Levine, would indeed be sweet irony, having suffered neglect in the heyday of abstraction and disregard for traditional artistic skills."
(See page 157)

LEVINE, SHERRIE (1947 - present)
b. Hazelton, Pennsylvania

Education: Univ of Wisconsin, Madison, WI, 69, BA; Univ of Wisconsin, Madison, WI, 73, MFA; Lives in New York City, New York and Santa Monica, California. **Selected Solo Exhibitions:** De Saisset Art Museum, Santa Clara, CA, 74; 3 Mercer St, NYC, 77-78; Hallways, Buffalo, NY, 78; The Kitchen, NYC, 79; Metro Pictures, NYC, 81; A&M Artworks, NYC, 82, 84; Baskerville & Watson Gallery, 83, 85; Richard Kuhlenschmidt Gallery, LA, CA, 83; Nature Morte Gallery, NYC, 84; Ace, Montreal, Canada, 84; Block Gallery, Northwestern Univ, Evanston, IL, 85; Richard Kuhlenschmidt Gallery, LA, CA, 85; Daniel Weinberg Gallery, LA, CA, 86; Donald Young Gallery, Chicago, IL, 87; Wadsworth Atheneum, Hartford, CT, 87; Mary Boone Gallery, NYC, 87, 89, 91; Hirshhorn Museum & Sculpture Garden, Wash, DC, 88; High Museum of Art, Atlanta, GA, 88; Galerie Nachst St Stephan, Vienna, Austria, 88; Westfalisches Landesmuseum, Munster, W Germany, 92; Rooseum Centre for Contemp Art, Malmo, Sweden, 92; Fondation nationale des arts, Paris, France, 92.
(See page 158)

LICHTENSTEIN, ROY (1923 - present)
b. New York City, New York

Selected Solo Exhibitions: Roy Lichtenstein Bronze Sculpture, 65 Thompson St, NYC, 89; Brushstroke Figures, Leo Castelli Gallery & Graphics, NYC, 89; Reflections, Leo Castelli Gallery, NY, 89; The Mirror Paintings, Mary Boone Gallery, NYC, 89; Reflections Series, Leo Castelli Graphics, NY, 90; Roy Lichtenstein: The Prints, Palazzo delle Alberte, Trento, Italy, 90; Interior Series, Litho, Woodblock, Screenprints, Gemini GEL, LA, CA, 91; Best Buddies Benefit; Leo Castelli Graphics, NYC, 91; Modern Head, temp installation courtesy of James Goodman & Jeffrey H Loria & Co, Battery Park City, NYC, 91. **Selected Group Exhibitions:** Tokyo Art Expo, representing Leo Castelli Gallery, Japan, 91; Lichtenstein, Rauschenberg, Rosenquist, Galerie Nichido, Tokyo, Japan, 91; Selections from the Permanent Collection 1960-75, Museum of Contemp Art at CA Plaza, LA, 91; Lichtenstein & Stella, Galerie Beyeler, Basel, Switz, 91; Large Scale Works on Paper, John Berggruen Gallery, SF, CA, 91; Art Show at the Armory, representing James Goodman Gallery, NYC, 91; El Sueno de Egipto, Campos Eliseos y Jorge Eliot, Polanco, Mexico, 91; Directions: Paintings, Sculpture, Prints, Locks Gallery, Philadelphia, PA, 91; Art Miami '91: Int'l Art Expo, Miami Beach, FL, 91; Who Framed Modern Art or the Quantitative Life of Roger Rabbit, Sidney Janis Gallery, NYC, 91; 20th Century Collage, Margo Leavin Gallery, LA, CA, 91; Masterpieces from the Permanent Collection, Museum of Contemp Art at CA Plaza, LA, CA, 91.
(See page 159)

LINN, STEVE (1943 - present)
b. Chicago, Illinois

Education: Univ of IL, 65, BS. **Selected Collections & Commissions:** The Stitzel Co, Pasadena, CA; Prudential Insurance Co, Newark, NJ; Indianapolis Museum of Art, IN; Bayly Art Museum, Univ of VA, Charlottesville; Ile-Ife Foundation, Philadelphia, PA; Lando Corp, OK City, OK; Electra-Asylum Records, NYC; M Hall & Co, Ft Worth, TX; The Fair Dept Stores, Worcester, MA; Nassau West Corp Center, Reckson Assoc, Mitchel Field, Long Island, NY; Nat'l Baseball Hall of Fame, Cooperstown, NY; Albany Museum of Art, GA; Jack Resnick & Sons, NYC; Craft & Folk Art Museum, LA, CA.
(See page 342)

LIVINGSTON, JACK (1953 - present)
b. Alliance, Nebraska

Jack Livingston is a self-taught artist, though he did attend the literary classes and workshops taught by William Borroughs, Allen Ginsberg, Gregory Corcso, Ann Waldman and others at Naropa Inst, Boulder, Colorado, mid 1970's. Moved to Houston, Texas, 1980. Literary Program Director for Diverseworks, Houston Alternative Artspace, 1988 to present. Founder and Co-director of Antitrust, an artists' political action collective serving the Houston area, 1989 to present. **Selected Exhibitions:** Other Half Gallery, Denver, CO, 80; Lawndale Alternative Artspace, Houston, TX, 83; Center for Art & Performance, Houston, 83; College of the Mainland, Texas City, TX; McMurtry Gallery, Houston, 85; Diverseworks, Houston, 86; Carson Sapiro Gallery, Denver, CO, 88; Lanning Gallery, Houston, 91. **Selected Collections:** Transco Energy Corp, Houston; The Menil Collection, Houston; Sally Sprout & Doug Blake, Houston; Susan Murry, Houston; Robert & Judy Mackey, Houston; Sharon Hill, Houston; Lucinda Carlton, Houston; Fred Krasny, Houston; Kelley Simms, Houston; Kerry Inman, Houston; Elizabeth McBride, Houston; Cassandra Dickson, Houston.
(See page 160)

LONGOBARDI, PAM (1958 - present)
b. Montclare, New Jersey

Selected Solo Exhibitions: Brunswick Gallery, Missoula, MT, 87; Matrix Gallery, Sacramento, CA, 88; Ewing Art Gallery, Univ of TN, Knoxville, 88; Taller Galleria Ft, Cadaques, Spain, 89; Kyle Belding Gallery, Denver, CO, 89; Merwin Gallery of Art, IL Wesleyan Univ, Bloomington, 89; Grey Art Gallery, E Carolina Univ, Greenville, NC, 89; Artemisia Gallery, Chicago, IL, 90; Visiting Artist Exhibition, Louisiana State Univ, Baton Rouge, 90. **Selected Group Exhibitions:** Miniatures: Small Works Invitational, San Francisco Museum of Modern Art, CA, 87; Large Scale Drawing Invitational, Hopkins Centre, Dartmouth College, Hanover, NH, 88; Contemp American Drawing, Wake Forest Univ, Winston-Salem, NC, 88; San Francisco Museum of Modern Art Rental Gallery, 90. **Selected Awards:** Premier, Taller Galleria Ft, Cadaques, Spain, publication of a print edition, 87; AVA Nomination, Awards for the Visual Arts, SECA, Winston-Salem, NC Research Fellowship Abroad/Spain, Univ of TN, Knoxville, 89.
(See page 161)

LUCERO, MICHAEL (1953 - present)
b. Tracy, California

Education: Humbolt State Univ, Arcata, CA, 75, BA; Univ of WA, Seattle, 78, MFA. He presently lives and works in New York City, New York. **Selected Solo Exhibitions:** Fuller Goldeen Gallery, SF, CA, 85; Hokin Kaufman Gallery, Chicago, IL, 86; Charles Cowles Gallery, NYC, 81, 83-84, 86; Linda Farris Gallery, Seattle, WA, 82, 87; ACA Contemp, NYC, 88; Contemp Arts Center, Cincinnati, OH, 90; Clay in the East, Anderson, Gallery, VA Commonwealth Univ, Richmond, 90; Dorothy Weiss, SF, CA, 91; Fay Gold Gallery, Atlanta, GA, 91. **Selected Group Exhibitions:** American Craft Museum, NYC, 90; LA State Univ Art Gallery, Baton Rouge, 90; Stanford Museum, Stanford, MA, 90; CA State Univ Art Gallery, Chico, CA, 90; Cooper Carry Studio, Atlanta, GA, 91; Bellas Artes, Santa Fe, NM, 90-91. **Selected Collections:** American Craft Museum, NYC; High Museum of Art, Atlanta, GA; Hirshhorn Museum & Sculpture Garden, Wash, DC; Metropolitan Museum of Art, NYC; San Francisco Museum of Modern Art, CA; Seattle Art Museum, WA.
(See page 344)

KRAISLER, DAVID (1940 - present)
b. New York City, New York

David Kraisler studied at the Otis Art Institute in Los Angeles and received his BA degree in architecture from the University of Oklahoma in 1966. He also studied at the Frank Lloyd Wright Foundations in Spring Green, Wisconsin and Scottsdale, Arizona. Early influences on his work in addition to Frank Lloyd Wright were the architects Bruce Goff and Herb Greene. His career was launched as a sculptor in Los Angeles, where he was also part owner of the West Coast Sculptors' Foundry. After completing several sculpture commissions in Southern California, he relocated to Scottsdale, Arizona, where he designed and hand-built his residence and studio. In addition to many residential commissions throughout the United States, Kraisler has executed numerous large-scale public works of ferro cement with fresco and corten steel such as Three Druids, Tuscon Community Centre, AZ; The Bridge, Scottsdale Civic Center, AZ; Vertical Cholla, Baptist Medical Center, OK City, OK; and The Theater, American Republic Insurance Co, Des Moines, IA. His most recent major installation is a large outdoor environmental sculpture for the new hotel and shopping complex, Piazza Carmel in San Diego, CA, completed in June, 91.
(See page 337)

KRUGER, BARBARA (1945 - present)
b. Newark, New Jersey

Education: Syracuse Univ, NY, 65; Parsons School of Design, NYC, 66. She presently lives in New York City, New York. **Selected Solo Exhibitions:** Artists Space Gallery, NYC, 74; Fischbach Gallery, Chicago, IL, 75; John Doyle Gallery, Chicago, IL, 76; Franklin Furnace Archive, NYC, 79; Printed Matter, NYC, 79; PS 1, Long Island City, NY, 80; Larry Gagosian Gallery, LA, CA, 82, 83; CEPA/Hallwalls Gallery, Buffalo, NY, 82; Inst of Contemp Art, London, England, 83; Annina Nosei Gallery, NYC, 83, 84, 86; Kunsthalle Basel, Switz, 84; Kajima Gallery, Montreal, Canada, 84; Noveau Musee, Lyons, France, 84; Watershed Gallery, Bristol, England, 84; Rhona Hoffman Gallery, Chicago, IL, 84, 86, 90; Crousel/Hussenot Gallery, Paris, France, 84, 87; Los Angeles County Museum of Art, CA, 85; Wadsworth Atheneum, Hartford, CT, 85; Contemp Arts Museum, Houston, TX, 86; University Art Museum, Berkeley, CA, 86; Hillman/Holland Gallery, Atlanta, GA, 86; Krannert Art Museum, Univ of IL, Champaign, IL, 86; Mary Boone Gallery, NYC, 87, 89, 91; Monika Spruth Galerie, Cologne, W Germany, 87, 90; Nat'l Art Gallery, Wellington, New Zealand, 88; Galerie Bebert, Rotterdam, The Netherlands, 89; Fred Hoffman Gallery, Santa Monica, CA, 89; Duke Univ Museum of Art, Durham, NC, 90; Kolnischer Kunstverein, Cologne, W Germany, 90.
(See page 148)

KUHN, WALTER (1877 - 1949)
b. Brooklyn, New York

Walt Kuhn is best known for his portraits, characterized by forceful directness and circus themes. Kuhn's still lifes and landscapes are similarly powerful in their simplicity and emotional intensity. Kuhn was a principal organizer of the Armory Show of 1913. He travelled through Europe to assemble the art that introduced the modern movement to America. His direct contact with European art propelled him artistically into a period of experimentation with color and abstraction, which fused with the figurative realism of the Ashcan School to produce his mature style. Kuhn steadfastly refused to speak about his work, preferring that the drawings and paintings do the talking, but a letter sent in 1929 to a student explains Kuhn's interest in the solitary figure: "Use less material in your subject matter...Try for bigger range of light and dark, be more your robust self. Bang it on strong."
See page 149)

KUNISHIMA, SEIJI (1937 - present)
b. Nagoya, Japan

Selected Solo Exhibitions: Univ Art Museum, Univ of CA, Santa Barbara, 79; Akira Ikeda Gallery, Nagoya, Japan, 88; Tokyo in 85; Allport Gallery, SF, CA, 87, 89; Nob Gallery, Okazaki, Japan, 89; Space Gallery, LA, CA, 76-77, 80, 82, 84-85, 87-88, 90; Sakura Gallery, Nagoya, Japan, 75, 77-78, 81, 83, 85, 87-88, 90. **Selected Group Exhibitions:** Japanese Sculptors, Sculpture Center, NYC, 79; Stephen Wirtz Gallery, SF, CA, 82; Angles Gallery, Santa Monica, CA, 85; Perceptions of Japan, Brattleboro Museum, VT, 87, travelled; ACAFI, First Australian Contemp Art Fair, Melbourne, Australia, 88. **Selected Collections:** Grand Rapids Art Museum, MI; Citicorp Bank, NYC; Atlantic Richfield Corp, LA, CA; Mid-Atlantic Toyota Corp, Columbia, MD; Nippon Steel USA Inc, LA, CA; Japanese Consulate, LA, CA. **Selected Commissions:** SF Int'l Airport, CA; Pacific Southwest Realty Co, Brea, CA; CA First Bank, LA.
(See page 338)

KWAK, HOON (1941 - present)
b. Korea

Education: Seoul Nat'l Univ, BFA; CA State Univ, BA; MFA. **Selected Solo Exhibitions:** Transaction Gallery, LA, CA, 82; Art Space Gallery, LA, CA, 83; Dongsanbang Gallery, Seoul, Korea, 83; Q Gallery, Tokyo, Japan, 84; Duson Gallery, Seoul, Korea, 85; Karl Bornstein Gallery, Santa Monica, CA, 85, 89; Harcourts Contemp, SF, CA, 86; Duson & Pyung Gallery, Seoul, Korea, 87; Inkong Gallery, Taegu, Korea, 87; LA Int'l Art Fair, Sun Art Gallery, Seoul, Korea, 87, 88; Ianneti Lanzone Gallery, SF, CA, 88; The Works Gallery, Long Beach, CA, 89; Tokyo Art Fair, Japan, 90; Naviglio Gallery, Milan, Italy, 90; MacQuarie Gallery, Sydney, Australia, 90. **Selected Collections:** Security Pacific Nat'l Bank, LA, CA; Amoco Production Company, Denver, CO; Minot State College, Minot, ND; Pensacola State Jr College, FL; First LA Bank, LA, CA; Columbia Picture Co, LA, CA; Modern Art Museum, Seoul, Korea; Santen Seyak Co, Tokyo, Japan; Wilshire House, LA, CA; Bel Air Hotel, LA, CA; Manatt, Phelps, Rothenberg & Tunney Co, LA, CA; American Food & Beverage Co, LA, CA.
(See page 150)

LAEMMLE, CHERYL (1947 - present)
b. Minneapolis, Minnesota

Education: Humbolt State Univ, Arcata, CA, 74, BA; WA State Univ, Pullman, WA, 78, MFA. She presently lives and works in New York City, New York. **Selected Solo Exhibitions:** Hokin Kaufman Gallery, Chicago, IL, 86; Fay Gold Gallery, Atlanta, GA, 89; Rena Bransten Gallery, SF, CA, 89; Nat'l Museum of Women in the Arts, Wash, DC, 90; Greg Kucera Gallery, Seattle, WA, 90; Whitenfass Gallery, NYC, 91. **Selected Group Exhibitions:** Tweed Museum of Art, Duluth, MN, 89, travelled; Hudson River Museum, Yonkers, NY, 89; Whitney Museum of American Art, NYC, 90; Mint Museum of Art, Charlotte, NC, 91. **Selected Collections:** Chase Manhattan Bank Collection, NYC; Metropolitan Museum of Art, NYC; Nat'l Museum of Women in the Arts, Wash, DC; Walker Art Center, MN; Corcoran Gallery of Art, Wash, DC; High Museum of Art, Atlanta, GA.
(See page 151)

LALOUSCHEK, ELISABETH (1955 - present)
b. Vienna, Austria

Education: City & Guilds of London Art School, England, 75-79; Royal College of Art, London, 80-83, MFA. Ms Lalouschek lives in US and Mexico, 83-85; studio in Paris, 86; mural for the Austrian Inst in Paris, 86; studio in London, 87-88; studio in Mexico, 89-90. **Selected Solo Exhibitions:** The October Gallery, London Heaven, London, 83, 87, 90; Project Tibet, Santa Fe, NM, 84; Biarritz 16, Mexico City, Mexico, 84-85; Galeria Ridcor, Merida, Yucatan, Mexico, 85; DeGraaf Fine Arts, Chicago, IL, 89-90. **Selected Group Exhibitions:** Guildhall, London, 79; Royal Academy Summer Show, London, 82; Royal College of Art Degree Show, London, 83; Christie's Inaugural, London, 83; Royal Academy Show, London, 83; Museum of Modern Art, Mexico City, 85; Art 87, Business & Design Centre, London, 87; Diorama Gallery, London, 87; Summer Show, The October Gallery, London, 88-89; Blast R-101, London, 88; Jennifer Kleiber, Chicago, IL, 88; Chicago Art Fair, Chicago, IL, 90. **Selected Awards:** David Murray Landscape Award, London, 78; Austrian State Scholarship, 80; British Council Scholarship, 81-83; George Rowney Bicentennial Special Award, 83; Paris Scholarship, 86.
(See page 152)

LANDIS, GEOFFREY (1952 - present)
b. Philadelphia, Pennsylvania

Education: Franklin & Marshall College, Lancaster, PA, 74, BA, Art History; Univ of NM, Albuquerque, 74-75. **Selected Solo Exhibitions:** Seth's Canyon Road Gallery, Santa Fe, NM, 81, 83, 88; Larel Seth Gallery, Santa Fe, NM, 85; Kimo Theatre Gallery, Albuquerque, NM; On View Gallery, Indianapolis, IN, 90. **Selected Group Exhibitions:** Santa Fe Festival of the Arts, 79-80; Seth's Canyon Road Gallery, Santa Fe, NM, 79; Wichita Arts Assoc, KS, 81; Alumnae/Faculty Show, Franklin & Marshall College, Lancaster, PA, 82; Dubose Gallery, Houston, 83; Arts Signature Gallery, Tulsa, OK, 84; Elaine Horowitch Galleries, Santa Fe, NM, 84; Nimbus Gallery, Dallas 87; Le Stat, Santa Fe, 87. **Arts Management:** Assoc Director, Fenn Galleries, Santa Fe, NM, 86; Director, Foyer Gallery.
(See page 153)

LA NOUE, TERENCE (1941 - present)
b. Hammond, Indiana

Education: Ohio Wesleyan Univ, Delaware, OH, 64, BFA; Hochschule fur Bildende Kunst, W Berlin, Germany, Fulbright Meister Student, 65; Cornell Univ, Ithaca, NY, 67, MFA. **Selected Solo Exhibitions:** Denison Univ, Granville, OH, 64; Galerie Springer, W Berlin, 65, 88; Cornell Univ, Ithaca, NY, 67, Trinity College, Hartford, CT, 68-70; Paley & Lowe Inc, NYC, 71-73; Nancy Hoffman Gallery, 76-78, 81; Galerie Farideh Cadot, Paris, France, 77, 79; Nicola Jacobs Gallery, London, England, 81; Fabian Carlson Gallery, Gothenborg, Sweden, 82; The Arts Club of Chicago, IL, 83; Zolla/Lieberman Gallery, Chicago, IL, 84, 86, 88, 91; Davis/McClain Gallery, Houston, TX, 86, 88-89; Dorothy Goldeen Gallery, Santa Monica, CA, 87, 89-90; Andre Emmerich Gallery, NYC, 87-90; Amerika Haus Berlin, W Germany, 88; Heland Wetterling Gallery, Stockholm, Sweden, 89-90; Galerie Keeser-Bohbot, Hamburg, W Germany, 91; Galerie Charchut & Werth, Dusseldorf, W Germany, 91. **Selected Collections:** Albright-Knox Art Gallery, Buffalo, NY; Indianapolis Museum of Art, IN; Walker Art Center, Minneapolis, MN; Whitney Museum of American Art, NYC; Solomon R Guggenheim Museum, NYC; Brooklyn Museum, NY; Museum of Modern Art, NYC; United States Embassy, Beijing, China.
(See page 272)

LAURO, ROBERTO (1932 - present)
b. Isle of Jersey, England

The constant variation of light and color on the Isle of Jersey, where Lauro was born, are remembered today in the artist's paintings and sculpture. Lauro studied art in Amsterdam, Bern and Zurich. In 1958 he began working as a painter and an industrial graphic designer. His work has been shown in national and international industrial exhibitions in Yugoslavia, Poland, Iraq, Iran, Turkey, Zimbabwe and Egypt. He has created several large-scale sculptures, fountains and murals for public and private buildings. In 1980 he began creating wall sculptures that use metal as a basic material. His most important artistic development evolved in 1989, the unique blending of metal and glass. Over the years, he has received several awards for public works completed in Switzerland: a theatre in Witherthur, the Ripischtal Military Base, and the Graduate/Highschool of Wetzikon. Since 1964, Roberto Lauro has been exhibiting throughout Europe, Switzerland, Germany, France and Austria. He is represented exclusively by the Eleonore Austerer Gallery of San Francisco.
(See page 339)

LAVENSON, ALMA (1897 - 1989)
b. San Francisco, California

Around 1918 Alma Lavenson began as an amateur photographer and by the late 1920's she was published and had frequent exhibitions. During the 1930's she had one-person exhibitions at the Brooklyn Museum and the MH de Young Memorial Museum in San Francisco. Others include the San Francisco Museum of Modern Art in 1942, 48 and 1960, as well as The Friends of Photography, 87, 90, and the Baltimore Museum of Art in 1988. Her work was evocative of her own modernist vision as well as that Group f/64, whose inaugural exhibition featured her work alongside that of Imogen Cunningham, Edward Weston and Ansel Adams. As an important woman photographer, her work has been featured in significant exhibitions and publications focusing on a modernist vision between the two World Wars. Alma Lavenson's contribution to photography can be seen in Susan Ehrens' book, Alma Lavenson: Photographs.
(See page 391)

LAWRENCE, JACOB (1917 - present)
b. Atlantic City, New Jersey

Selected Solo Exhibitions: Jacob Lawrence, Retrospective Show, touring exhibition organized by the Whitney Museum of American Art, NYC, 74; Jacob Lawrence, American Painter, touring exhibition organized by the Seattle Art Museum, WA, 86, 87; Francine Seders Gallery, Seattle, WA, 76, 78-79, 82, 85, 90. **Selected Collections:** American Academy and Inst of Arts and Letters, NYC; Hirshhorn Museum & Sculpture Garden, Wash, DC; Metropolitan Museum of Art, NYC; Museum of Modern Art, NYC; Nat'l Collection of Fine Arts, Smithsonian Institution, Washington, DC; The Phillips Collection, Washington, DC; Whitney Museum of American Art, NYC. **Murals:** Events in the Life of Harold Washington, City of Chicago Public Art Program, Harold Washington Library Center, IL, 91; New York in Transit, NYC Public Development Corp, Times Square Subway Complex, NYC, 91. **Honors & Selected Awards:** Springarn Medal, Nat'l Assoc for the Advancement of Colored People, 70; Member American Academy of Arts and Letters, 83.
(See page 154)

KELLEY, HEATHER RYAN
(1954 - present)
b. New Haven, Connecticut

Education: Southern Methodist Univ, Dallas, TX, 71-75, BFA; Northwestern St Univ, LA, 84, MA. Teaching Experience: McNeese State Univ, Lake Charles, LA, Assoc Prof. Heather has one son, Mathew Ryan Kelley, born 1978, they presently live in Lake Charles, Louisiana. **Selected Solo Exhibitions:** Scientific Digressions, Aaron Hastings Gallery, New Orleans, LA, 85; Laszlo's Cellar, Mario Villa Gallery, New Orleans, LA, 87; Divine Monuments, Abercrombie Gallery, Lake Charles, LA, 88; Everyman, Mario Villa Gallery, LA, 89; Recent Works on Paper, Ruth Wiseman Gallery, Dallas, TX, 89; Dreams, Abercrombie Gallery, Lake Charles, LA, 89; Monuments, Texas A&M Univ, College Station, TX, 89; Paintings & Drawings, Ecco Italian Design, Jackson, MS, 89 Signals, Still-Zinsel Contemporary, New Orleans, LA, 90; Bloomsday, Abercrombie Gallery, Lake Charles, LA, 91. Competetive Exhibitions: 55th Annual Nat'l Butler Mid-Year Exhibition; 10th Annual Henley Southeastern Spectrum; 10th & 12th Annual Paper in Particular; Image of the Horse; Small Works 1990; Del Mar 21st & 24th Annual Drawings & Small Sculpture Show; 50th & 51st Annual Nat'l Contemp Painting Exhibition 32nd Chautauqua Nat'l Exhibition; Sept Competition; 23rd Univ of Delaware Biennial Exhibition 8th Annual Auburn Works on Paper; LaGrange XI; 18th & 22nd W&J Nat'l Painting Show; 2nd & 3rd Art of Today Int'l, Budapest. **Selected Awards:** Distinguished Faculty Award, 87; Shearman Research Fellowship, 88, 89, 91; Calcasieu Arts & Humanities Project Assistance Grant, 91.
(See page 140)

KELLY, ROBERT
(1956 - present)
b. Santa Fe, New Mexico

Education: Harvard Univ, Cambridge, MA, 78, BA. **Selected Fellowships:** MacDowell Colony, Peterborough, NH, 80; Michael Karolyi Memorial Foundation, Artist-in-Residence, Vence, France, 81. **Selected Solo Exhibitions:** Clark Gallery, Lincoln, MA, 85; Victoria Munroe Gallery, NYC, 87; Moloney Gallery, Santa Monica, CA, 88; Galleri Weinberger, Copenhagen, Denmark, 89; Linda Durham Gallery, Santa Fe, NM, 90. **Selected Group Exhibitions:** Art & Architecture, Acock Schlegel Architects/Brenda Kroos Gallery, Columbus, OH, 88; Houseguests Invitational, Linda Durham Gallery, NM, 88; Joan Mitchell, Michael Goldberg, Robert Kelly & Linda Lovet, Galleri Weinberger, Copenhagen, Denmark, 89; Monotypes from the Garner Tullis Workshop, Person/Lindell Gallery, Helsinki, Finland, 89; Los Angeles Int'l Contemp Art Expo, CA, 88-89; Chicago Int'l Art Expo, Navy Pier, IL, 89-90. **Selected Collections:** AT&T, NYC; Price Waterhouse, Boston, MA; The Body Shop Int'l, London, England. **Selected Bibliog:** Review: Maloney Gallery, LA Times, Marlena Donohue, Jan 22, 88; Review: Linda Durham Gallery Show, Albuquerque Journal, David Bell, Mar 8, 88.
(See page 141)

KENNA, MICHAEL
(1953 - present)
b. Widnes, Cheshire, England

Michael Kenna presently lives in San Francisco, California. **Selected Solo Exhibitions:** Galerie Michele Chomette, Paris, 87, 91; Catherine Edelman Gallery, Chicago, IL, 90, 91; Fox Talbot Museum, Lacock, England, 87; Germans van Eck, NYC, 88, 90; Hamiltons Gallery, London, 89, 91; Long Beach Museum of Art, Long Beach, CA, 88; Gallery Min, Tokyo, 90; Nat'l Central for Photography, Bath, Avon, England, 88; Palace of the Legion of Honor, SF, CA, 91; JB Speed Art Museum, Louisville, KY, 88; Galerie Zur Stockeregg, Zurich, Switz, 86; Tampa Museum of Art, FL, 88; Weston Gallery, Carmel, CA, 85, 88; Stephen Wirtz Gallery, SF, CA, 81, 87, 90. **Selected Collections:** Art Inst of Chicago, IL; Bibliotheque Nationale, Paris; Denver Art Museum, CO; San Francisco Museum of Modern Art, CA; Victoria & Albert Museum, London.
(See page 388)

KERTÉSZ, ANDRÉ
(1894 - 1985)
b. Budapest, Hungary

Chronology: Andre Kertesz moves to Paris, 1925; first solo exhibition, Au Sacre du Printemps Gallery, Paris, 27; exhibits in First Independent Salon of Photography, 28; Staatliche Museum Kunstbibliothek, Berlin & Konig-Albert Museum, Zwickau purchase work, 29; exhibits Modern European Photography, Julian Levy Gallery, NYC, 32; publishes Enfants, 33; publishes Paris Vu Park Andre Kertesz, 34; moves to NY, 36; works for Harper's Bazaar, Vogue, Town & Country, Look, House & Garden, 37-49; publishes Day of Paris, 45; Art Inst of Chicago, IL, solo exhibition, 46; Bibliotheque Nationale, Paris, solo exhibition, 63; Museum of Modern Art, NY, solo show, publishes Andre Kertesz, Photographer, intro by John Szarkowski, 64-65; sells first 'vintage' photographs, 73; receives Guggenheim Fellowship & publishes J'aime Paris, 74; publishes Distortions, 76; receives Medal of the City of Paris, 80; publishes From My Window, 81; publishes A Lifetime of Perception, 82; Retrospective Exhibition: Andre Kertesz: A Lifetime of Perception, 1917-82; travelled exhibition to ten museums including the Winnepeg Art Gallery & Akron Museum, 82-85; receives Legion of Honour & Grand Prix Nat'l of Photography, 83; Andre Kertesz dies in New York, 85.

(See page 389)

KIM, KU-LIM
(1936 - present)
b. Dae-GU, Korea

"Art reflects our time and the forces shaping our experience," says Ku-Lim Kim. "As our life becomes more complex, our art consolidates and amalgamates the layers of our experiences." In his divided canvas collages, strongly contrasting panels of fragmented images create a structural tension evoking the discontinuity and tension of the modern world. Yet the structure also recalls the principle of Yin and Yang, the paradoxical duality Kim sees as permeating and unifying the welter of chaos and cross-tendencies shimmering on the surface of a deeper reality. **Education:** Art Students League. **Selected Exhibitions:** Nat'l Museum of Contemp Art, Seoul, Korea, exhibitions, 63-89; Twelfth Biennale, Sao Paulo, Brazil, 73; Israel Museum, Jerusalem, 75; Brooklyn Museum, NY, 81; Eighth Int'l Print Biennale, London, England, 83; Int'l Print Biennale, Ljubljana, Yugoslavia, 83; Riverdale Gallery, NYC, 85; Art Center, NJ, 87; Hyundai Gallery, Seoul, Korea, 87; Simmonson Gallery, LA, CA, 89; Tokyo Art Expo, 90; Modern Museum of Art, Santa Ana, CA, 91; Charles Whitchurch Gallery, Huntington Beach, CA, 91.
(See page 142)

KINNE, LILO
(1950 - present)
b. Volklingen, Germany

Lilo Kinne sees her present life as an integration and harmonization of various already embodied personalities, each pursuing partial goals in their epochs and cultures. To reactivate these potentials, Mrs Kinne first subconsciously penetrated, both intellectually and emotionally, fields of science and different cultures she felt attracted to. After studies in Technical Medicine, 68-70, research with radioisotopes, allowed her to develop extreme manual precision and to study in great detail the principles by which matter acts; in this period Mrs Kinne painted as a means of self-research and therapy. During further studies in Philosophy, Fine Arts, History of Art and Education at the Universities of Stuttgart and Tubingen, W Germany, 75-79, she founded the Institute for the Research on the Existence, IRE, in 1978. From 1977-81, several long term in-depth explorations were realized in Asia (India, Ceylon, Nepal, Thailand, Japan), Africa (Egypt, Sudan), North America and several countries in Europe during which Mrs Kinne assimilated and united within herself many essential elements of human existence. In 1980, due to specific circumstances and as a culmination of a purification process, Mrs Kinne destroyed all autobiographical material, paintings, scripts and personal belongings accumulated until then. This detachment from herself, together with the birth of her son in 1981, led Lilo Kinne to the perception of being a multidimensional personality. An additional important emotional catharsis, relating to a former existence, took place during Mrs Kinne's stay in Paris, France, 82-89, and which finally led to the 'Louis XVI Series' painted in New York in 1989. She creates her paintings as mediators of values of consciousness. The paintings document, in their synergy and mutual completion, of the verbal and visual expression, a highly complex consciousness perceiving existence in its multidimensional complexity.
(See page 143)

KLAMEN, DAVID
(1961 - present)
b. Dixon, Illinois

An artist who consistently awes and whose work is magnetic in its mystery, David Klamen works and lives in Chicago, Illinois. Klamen received his BFA from the University of Illinois, Champaign/Urbana and his MFA from the Art Institute of Chicago. During the mid 1980's he began to exhibit his paintings in local galleries and museums while also teaching at Indiana University and Valparaiso University. Since then he has had eight solo shows, including two in Rome and Trento, Italy, and has participated in 27 group shows across the US and in Canada. He is newly represented by Richard Gray Gallery, Chicago, where he is scheduled for a one-man show in early 1992. Working primarily in oil on canvas, Klamen has developed a style which is at once realistic and enigmatic. His mastery of deep, rich color and varnish complements his choice of dark, and ominous scenes, creating a powerful and dramatic effect.
(See page 144)

KLEIN, YVES
(1928 - 1962)
b. Nice, France

Selected Solo Exhibitions: Museum of Modern Art, Belgrade, Yugoslavia, 71; Kunstverein, Hannover, W Germany, 71; Kunsthalle, Bern, Switz, 71; Chateau-Museum, Cagnes-sur-Mer, France, 72; Galerie Karl Flinker, Paris, 73, 76; Gimpel-Hanover Gallery, Zurich, Switz, 73; Gimpel & Fils, London, 73; Kaiser-Wilhelm Museum, Krefeld, 73; Stadtische Kunstsammlungen, Ludwigishafen, Germany, 74; Tate Gallery, London, England, 74; Nationalgalerie, Berlin, 76; Sidney Janis Gallery, NYC, 77; Antwerp Gallery, Antwerp, Belgium, 77; Galerie Bonnier, Geneva, 79; Fuji TV, Tokyo, 79; Yves Arman Gallery, NYC, 80; Rice Univ Museum, Houston, TX, 82; Centre Georges Pompidou, Paris, 83; Musee de Karuzawa, Tokyo, Japan, 85-86; Gagosian Gallery, NYC, 89. **Selected Group Exhibitions:** Galerie Mathias Fels, Paris, 70; Documenta V, Kassel, Germany, 72; Kaiser Wilhelm Museum, Krefeld, 73; Galerie Finkler, Basel, Switz, 74; Westkunst, Cologne, W Germany 81; XXe Biennale Int'l de Sao Paolo, Brazil, 89; Hirschl & Adler Modern, NYC, 89.
(See page 145)

KOS, HELGA
(1955 - present)
b. Huyzen, The Netherlands

"Reality is not experienced only as spots of time, but complicated groups of images," says Helga Kos. "When I reflect on something, all these images come back to me at once. Now I see a boy with his hand before his mouth, but just a moment before I saw his mouth. I 'know' his mouth; I still see it even though it is not visible." In her art Kos attempts to embody this concept, implying the more complete knowledge memory affords us by sketching variations of images set off in different sections of the picture plane. **Education:** Gerrit Rietveld Academy of Art, Amsterdam. **Selected Solo Exhibitions:** Sonsbeek Int'l Art Centre, Arnhem, The Netherlands, 90; Galerie Traject, Utrecht, The Netherlands, 90; Art Gallery A'pert, Amsterdam, The Netherlands, 91. **Selected Group Exhibitions:** Gemeente Museum, Arnhem, 83; Singer Museum, Laren, 86; Stedlijk Museum, Amsterdam, 88; BMW-Hochhaus, Munich, W Germany, 89; Charles Whitchurch Gallery, Huntington Beach, CA, 91. **Selected Awards:** Prix de Rome, 81, Silver Medal.
(See page 146)

KOUDELKA, JOSEF
(1938 - present)
b. Moravia, Czechoslovakia

Chronology: Studies engineering at the Technical University, Prague, 56-61; Works as aeronautical engineer in Prague and Bratislova, 61-67; Resign from engineering post, begins to photograph full time, 67; Awarded Robert Capa Gold Medal for photographs of Warsaw Pact armies' invasion of Prague in 1968, 69; Becomes a member of Magnum Photos, 71; Received Arts Council of Great Britain Award, 73; Awarded Prix Nadar, Paris, for the book, Gitans: La fin du voyage, 78; Awarded NEA Grant, 80; Awarded Grand Prix Nat'l de la Photographie, France, 80; "Exiles" wins Infinity Award, Int'l Center of Photography, 89; "Exiles" wins photographic book of the year award, Maine Photographic Workshop, 89.
(See page 390)

KOUTROULIS, ARIS
(1938 - present)
b. Athens, Greece

Selected Collection: Museum of Modern Art, NYC; Nat'l Gallery of Art, Washington, DC; LA County Museum of Art, CA. **Selected Bibliography:** Probable Dimensions, series of etchings, published by David Klein, OK Harris, Birmingham, MI, 91; CAA/USA, Cranbrook Academy of Art Museum, Bloomfield Hills, MI, foreword: Roy Slade, 82, catalogue; Detroit News, Painter of Horizontal Lines Throws Us a New Curve, Joy Hakanson Colby, Mar 8, 91. **Selected Commissions:** Arbor Drugs Corporate Headquarters, Troy, MI, 84; Standard Oil Corporation, San Ramon, CA, 84. **Selected Awards:** Michigan Foundation Art Award, 75.
(See page 147)

ILES, BILL
(1943 - present)
b. Dry Creek, Louisiana

Education: McNeese State, Lake Charles, LA, 67, BA; Louisiana Tech, 68, MA; 75, MFA. **Teaching Experience:** Standing Rock Indian Reservation, 68-70; Louisiana College, 70-72; Northeast Louisiana State, 75-77; McNeese State, 77-91; Chairman & Prof of Art, McNeese State, presently. Bill Iles presently lives in Lake Charles, Louisiana. **Selected Solo Exhibitions:** Salt Lick, Still-Zinsel Contemporary, New Orleans, LA, 89; Two Lane Blacktop, Louisiana College, 89; Farm Road, Univ Art Gallery, Texas A&M Univ, 90; Gulf Coast Highway, Univ Art Center, Auburn Univ, at Montgomery, 90. **Competitive Exhibitions:** Art in Public Places Inaugural Exhibition, LA Division of the Arts, 80; Art & the Law, Nat'l Tour Exhibition, 81; Biennial Exhibition of Piedmont Painting & Sculpture, 81; Rutger's Nat'l Drawing Exhibition, New Brunswick, NJ, 81; Auburn Works on Paper Touring Exhibition, 88; Artist's Liasion, Evanston Arts Center, 88; Louisiana Realism in the 1980's, New Orleans, LA; Drawing & Prints by LA Artist, First Place Award, LSU; Greater Midwest Int'l IV; MO State Univ; Small Works, NYC, 90; Dimensions, Winston-Salem, NC, 90. **Selected Grants:** Sherman Research Fellowship, 88. **Selected Awards:** 24th Univ Delaware Biennial; Pensacola Nat'l Drawing Exhibition; 23rd Delmar Nat'l; 8th Annual Auburn Works on Paper Nat'l; Appalachian National Drawing Competition; 23rd Delta Annual Exhibition/Arkansas Arts Center; Spar Nat'l, Shreveport.
(See page 138)

JACOBS, DIANA
(1950 - present)
b. Glen Cove, New York

Thematically, my work has changed very little over the years. I began exploring 'the Garden', the idea of paradise in my early oil paintings. These were landscapes done in an impressionist style, solving problems of light and color. From that broad sense of 'the Garden' I moved in closer to the forms within the landscape, drawing and painting the plant and flower elements I found there. At this time I began to incorporate the nude in my work and artifacts became more important. My current work is a melange of techniques and symbols. The scale is small, I want the viewer intimately closer. The pieces are not a code, but an evocative and expressive combination of elements to be taken as a whole. **Education:** Univ of PA, Pittsburgh, 72, BA; Carnegie-Mellon Univ, Pittsburgh, PA, art courses; Natural History Museum, LA, CA, certificates in Botanical & Zoological Illustration. **Selected Exhibitions:** First Nat'l Portrait Competition, Group Show, Broadway Arts Building, Asheville, NC, 90; The Art of Love, Riverside, CA, 90; Bodies of Work: Parental Guidance Suggested, Biota Gallery, LA, CA, 91. **Selected Publications:** Celebrating the Wild Mushroom, Sara Ann Friedman, 86; illustrator of various articles in Cactus and Succulents Journal. Selected Commissions: Lorimar Telepictures, LA, CA; Volunteer Services to Animals, LA, CA.
(See page 254)

JARDIN, EUGENE
(1947 - present)
b. Hannover, Germany

Education: Michaelis School of Art, Univ of Capetown, S Africa, 73-74. **Selected Solo Exhibitions:** Gallery West, LA, CA, 80, 84; A Retrospective of Commissioned Portraits, Gallery West, LA, CA, 82; Pasadena City College Art Gallery, CA, 83; Linda Goodman Gallery, Johannesburg, S Africa, 84; Michael Kohn Gallery, LA, CA, 86. **Selected Group Exhibitions:** Midsummers Day's Dream, Security Pacific Bank, LA, CA, 83; Masks, Masquerdes, Megillot, Hebrew Union College, Skirball Museum, Univ of S CA, LA, 84; LA Invitational, Michael Kohn Gallery, LA, CA, 86; Portraiture, Otis-Parsons Inst, LA, CA, 88; June Review, Shidoni Contemp Inst, Tesuque, NM, 89; 4th Int'l Contemp Art Fair, LA, CA, 89; Long Beach Museum, CA, 89; Two Man Show, Shidoni Contemp Gallery, NM, 90. **Selected Collections:** Johnny Carson, Malibu, CA; Jodie Foster, Woodland Hills, CA; Jane Seymour, LA, CA; Chase Manhattan Bank Collection; Museum of Capetown, S Africa. **Selected Bibliog:** LA Times, Review, Colin Gardner, Jan 17, 86; New Mexican, Pasatiempo, Simone Ellis, May 18, 90.
(See page 331)

JENKINS, JIM
(1955 - present)
b. Columbus, Indiana

Education: Murray State Univ, Murray, KY, BFA, 79; Syracuse Univ, NY, 81, MFA. **Teaching Experience:** Assoc Prof of Art/Sculpture, CA State Univ, Fullerton, 81. **Selected Solo Exhibitions:** Museum of Neon Art, LA, CA, 83; Koslow Gallery, LA, CA, 89; DeGraaf Fine Art Inc, Chicago, IL, 91. **Selected Group Exhibitions:** Armanenta, Chrysalis Gallery, Claremont, CA, 83; Future World Expo '83, LA Convention Center, 83, CA; Magical Mystery Tour, LA Municipal Art Gallery, Barnsdall Art Park, CA, 84; Art & the Familiar Object, Gallery at the Plaza, Security Pacific Corp, 84; Nat'l Invitational Sculpture Exhibition, AZ State Univ, Tempe, 84; A Serious Look At Humor, Irvine Fine Arts Center, Irvine, CA, 85; Loco-Motion, Exploratorium Gallery, CA State Univ, LA, 85; New Visions, LA County Fairplex, Pomona, CA, 86; Eccentric Machines, Nat'l Invitational Exhibition of Kinetic Sculpture, Kohler, 87; Eclectic Electric, Museum of Neon Art, LA, CA, 88; Five Emerging Talents, Spectrum Gallery, Palm Desert, CA, 89; Kinetics, Couturier Gallery, LA, CA, 90; Sculpture: Inside-Outside/33 Works by 11 American Artists, DeGraaf Fine Art, Chicago, IL, 90; Framing the Magic Circle, Gallery at the Plaza, Security Pacific Corp, LA, CA, 90. **Selected Publications:** Co-Author of Motion Motion: Kinetic Art, 85-89. **Selected Commissions:** Large-scale kinetic sculpture featured in Universal Studios film, Crackers, dir Louis Malle, released 84.
(See page 332)

JIMENEZ, LUIS
(1940 - present)
b. El Paso, Texas

Education: Univ of TX at El Paso, 64, BS; Ciudad Universiataria, Mexico City, 64. **Selected Solo Exhibitions:** Joslyn Art Museum, Houston, TX, 80; Laguna Gloria Museum, Austin, TX, 83; Univ of AZ, Museum of Art, Tucson, 85; LewAllen Gallery, Santa Fe, NM, 86; Univ of TX, El Paso, TX, 86; Moody Gallery, Houston, TX, 90. Selected **Group Exhibitions:** Hispanic Art in the US: 30 Contemp Painters & Sculptors, Museum of Fine Arts, Houston, TX, 87, travelled; Different Drummers, Hirshhorn Museum & Sculpture Garden, Wash, DC, 88; A Century of Sculpture in Texas, 1889-1989, Archer M Huntington Art Gallery, Univ of TX, Austin, 89-90; The Decade Show: Frameworks of Identity in the 1980's, Museum of Contemp Hispanic Art, New Museum of Contemp Art & the Studio Museum in NY, 90. **Selected Bibliog:** Texas: State of the Art, Art in America, Jamey Gambrell, Mar 87; Devotees of the Fantastic, Mark Stevens, Newsweek, Sept 87; Luis Jimenez, Jr, Artspace, William Peterson, Sum 88.
(See page 333)

JOHNS, JASPER
(1930 - present)
b. Augusta, Georgia

Selected Solo Exhibitions: Drawings of Japser Johns, Nat'l Gallery of Art, Wash, DC, 90, travels to Switzerland, England & parts of the US; Anthony d'Offay Gallery, London, 90-91; Jasper Johns, Printed Symbols, Walker Center, Minneapolis, MN, 90, travelled; The Jasper Johns Prints Exhibition, Isetan Museum of Art, Tokyo, 90, travelled; Jasper Johns Prints, Brenau College, Gainesville, GA, 91. **Selected Group Exhibitions:** Art Miami '91, Miami Beach Convention Center, FL, 91; Masterpieces from the Permanent Collection, Museum of Contemp Art at CA Plaza, LA, 91; Tokyo Art Expo, representing Leo Castelli Gallery, Japan, 91; Seven Master Printmakers, Museum of Modern Art, NYC, 91; 91 Biennial Exhibition, Whitney Museum of American Art, NYC, 90. **Selected Collections:** Museum of Modern Art, NYC; Kunstmuseum Basel, Switz; Hirshhorn Museum & Sculpture Garden, Wash, DC; Moderna Museet, Stockholm, Sweden. The Victoria & Albert Museum, London. **Selected Awards:** Honorary Academician, Royal Academy of Arts, London, 89; Officier, Ordre des Arts et Lettres, Republique Francaise, 90; Nat'l Medal of Arts, The White House, presented by President Bush, 90.
(See pages 139 & 271)

JUDD, DONALD
(1928 - present)
b. Exelsior Springs, Missouri

Chronology: College of Wm & Mary, Williamsburg, VA, 48-49; Columbia Univ, NYC, 49-53, BS, Philosophy, cum laude; 57-62, MFA, Art History; solo show, Whitney Museum of American Art, NYC, 68; Complete Writings 1959-75, published, 75; Kunstmuseum, Basel, 76, travelled; Catalogue Raisonne of Paintings, Objects & Woodblocks 1960-74, published in conjunction with The National Gallery of Canada, Ottawa, 76; Chianti Foundation, Marfa, TX, permanent installation, 86; Complete Writings 1975-86, published, 87; Donald Judd, Sculptures 1965-87, Stedelijk Van Abbemuseum, Eindhoven, 87-88, travelled; Donald Judd—Architektur, published, 89 & exhibited at the Osterreichisches Museum fur Angewandte Kunst, Vienna, 91; solo show, The Pace Gallery, NYC, 91.
(See page 334)

KANE, MITCHELL
(1956 - present)
b. Chicago, Illinois

Education: University of Puget Sound, WA, 74-76; Yale University, 77; School of the Art Inst of Chicago, IL, 76, BFA; 85, MFA. **Selected Solo Exhibitions:** Robbin Lockett Gallery, Chicago, IL, 88-89; Andrea Rosen Gallery, NYC, 90-91; Galerie Ralph Wernicke, Stuttgart, Germany, 91; Survey and War with Mexico 1846-1848, Herron Gallery, IUPUI, Indianapolis, IN, 91. **Selected Group Exhibitions:** Novi Territori Dell'Arte: Europa-America, Fondazione Michetti, Francavilla al Mare, and Rome, curated by Achille Bonito Oliva, 87; Surfaces: Two Decades of Painting in Chicago, Terra Museum of American Art, Chicago, IL, 87; Latitudes, Aspen Art Museum, CO, 88; In the Beginning..., Cleveland Center for Arts, OH, 90; To Know a Hawk from a Dove, Wolff Gallery, NYC, 90; Stendhal Syndrome: The Cure, Andrea Rosen Gallery, NYC, 90; Get Well Soon, Robbin Lockett Gallery, Chicago, IL, 90; New Generations, Carnegie-Mellon Art Gallery, Pittsburgh, PA, 90; Cabrera-Gerber-Kane, Trans Avante-Garde Gallery, SF, CA, 91; Gulliver's Travels, Galerie Sophia Ungers, Cologne, W Germany, 91.
(See page 290)

KANEKO, JUN
(1942 - present)
b. Nagoya, Japan

Education: 1970, Claremont Graduate School; 1966, University of California at Berkley, Berkley, CA; 1964, Chouinard Art Institute, Los Angeles, CA; 1964, California Institute of Art, Los Angeles, CA **Teaching Experience:** 1979-1986, Cranbrook Academy of Art, Bloomfield Hills, CA; 1973-1975, Rhode Island School of Design, Providence, RI; 1974, Scripps College, Claremont, CA; Selected Collections: Philadelphia Museum of Art, Philadelphia, PA; Everson Museum of Art, Syracuse, NY; American Crafts Museum, New York, NY; Yamaguchi Prefectural Museum of Art, Yamaguchi, Japan; Museum of Contemporary Art, Honolulu, HI; Sheldon Memorial Art Gallery, Lincoln, NE; Detroit Institute of Art, Detroit, MI. **Selected Museum Exhibitions:** 1989, Society for Art in Craft, Pittsburgh, PA; 1988, East Meets West, International Ceramic Show at Olympics, Seoul, Korea; 1987, The Eloquent Object, Thilbrook Museum of Art, Tulsa OK; Syracuse National Ceramics Show, Everson Museum of Art, Syracuse, NY; Contemporary Ceramics, Yamaguchi Museum, Japan; Contemporary American Ceramics Show, National Museum of Contemporary Art, Seoul, Korea; Clay Revision, Seattle Art Museum, Seattle, WA; 1986, Contemporary Japanese Ceramics Show, Everson Museum of Art, Syracuse, NY; Craft Today, American Crafts Museum, New York, NY; Contemporary American Ceramics Show, Arabia Museum, Helsinki, Finland. Grants: 1985 and 1979, National Endowment For The Arts, 1967, Archie Bray Foundation.
(See page 335)

KATZ, MEL
(1932 - present)
b. Brooklyn, New York

Education: Cooper Union, NYC; Brooklyn Museum Art School, NY. **Selected Fellowships:** Western States Arts Foundation, 75, NEA, 76. **Selected Solo Exhibitions:** Linda Farris Gallery, Seattle, WA, 75, 77-78, 80, 82; Foundation Gallery, NYC; The Fountain Gallery of Art, Portland, OR, 70, 73, 75-76, 79-83, 85; Lynne McAllister Gallery, Seattle, WA, 87; Perspective Series 12: Mel Katz, Retrospective, Portland Art Museum, OR, 88; Laura Russo Gallery, Portland, OR, 87, 89, 91; **Selected Group Exhibitions:** Art of the Northwest 1890-1990, Oregon Historical Society, Portland, 90; Modern Art from the Pacific Northwest, Seattle Art Museum, WA, 90; Unabandoned Abstraction, Marylhurst College, OR, 91. **Selected Collections:** Portland Art Museum, OR; Seattle Art Museum, WA; Claremont Resort Hotel, Oakland, CA; Powers Gallery of Contemp Art, Univ of Sydney, Australia; Selected Commissions: Russell Dev, Portland, OR; Cascade Estates, Portland, OR.
(See page 336)

HARTIGAN, GRACE (1922 - present)
b. Newark, New Jersey

Grace Hartigan, an internationally known and acclaimed painter has exhibited at the C Grimaldis Gallery since 1979. Her work is in most of the major US museums: The Metropolitan Museum of Art, and Whitney Museum of American Art, the Museum of Modern Art, the Baltimore Museum of Art, and the Museum of Fine Arts in Boston. In the early 1950's Hartigan "lived the life" with the avant-garde group of de Kooning, Pollack, Rivers and Motherwell; the artists who congregated at the Cedar Bar, formed by the Artist's Club, and eventually came to be known as the Abstract Expressionists. Hartigan has taken on difficult themes while remaining true to the human figure neither aspect of which is usually associated with abstract expressionism, and indeed she has gone far beyond those halcyon days of the 1950's. She has frequently used illustrations from popular culture, books of paper dolls, historical figures or movie stars, as the point of fulcrum for her lush, painterly images.
(See page 129)

HAWKINS, WILLIAM L. (1895 - 1990)
b. Kentucky

William L Hawkins moved to Columbus, Ohio in 1916. Throughout his long life, he held an assortment of unskilled jobs. Although he was drawing as early as the 1930's, he did not begin to paint until the late 1970's. Initially he painted with inexpensive and readily available materials: house paints, pieces of plywood, masonite and a blunt brush. He couldn't afford frames, so he painted elaborate borders around his pictures. With his selective eye he culled images from newspapers, magazines and advertisements, and stored them in his suitcase archive. He would transform these images, together with his own recollections and impressions, into vivid paintings of animals, American icons, and buildings from downtown Columbus. Though barely able to read and write, he incorporated his signature and birth date into most of his paintings as a powerful visual element. Hawkins suffered a stroke in 1989, and died several months later. The goals of his art occasioned much thought, and once he remarked, "You have to do something wonderful, so people know who you are."
(See page 130)

HELD, AL (1928 - present)
b. New York City, New York

Education: studies at the Arts Students League, New York & the Academie de la Grande Chaumiere, Paris. 1952: First solo exhibition, Galerie Huit, Paris. 1965-91: solo exhibitions, Andre Emmerich Gallery, New York. 1966: Stedelijk Museum, Amsterdam; Nat'l Museum of Modern Art, Tokyo, travels to India & Australia. 1968: San Francisco Museum of Art; Corcoran Gallery of Art, Wash, DC. 1968-69: Inst of Contemp Art of the Univ of Pennsylvania, travels to the Contemp Arts Museum in Houston. 1974: Whitney Museum of American Art, NYC. 1978: Inst of Contemp Art, Boston, MA; Albright-Knox Gallery, Buffalo, NY, travels to museums in Newport Beach; Oakland; Cincinnati; Corpus Christi & Champaign. 1980: travelling exhibition thru Milwaukee Art Museum, WI. 1985: travelling exhibition thru Independent Curators, Inc. 1986: Museum of Modern Art. 1986-87: Rose Art Museum. 1986-88: travelling exhibition thru Independent Curators, Inc. 1987: Whitney Museum at Equitable Center, NYC. 1988-89: travelling exhibition thru Instituto de Estudios Norteamericanos in Spain; Portugal & New York.
(See page 131)

HILL, CHARLES CHRISTOPHER (1948 - present)
b. Greensburg, Pennsylvania

Education: Univ of CA at Irvine, BA, MFA. Teaching Experience: Art Center College of Design, Pasadena, CA, 78. **Selected Solo Exhibitions:** Galerie Maurer, Zurich, Switz, 81-82; Simon Lowinsky Gallery, SF, CA, 81; Baudoin Lebon, Paris, France, 82, 85, 91; Galerie Krebs, Bern, Switz, 82; Abbaye Saint-Andre, Maymac, France, 83; Van Straaten Gallery, Chicago, IL 83; DBR Gallery, Cleveland, OH, 84; Galleria Del Cavallino, Venice, Italy, 85; Centre d'Action Culturelle de Saint-Brieuc, France, 87, Cirrus Gallery, 73-74, 76, 76, 78, 80, 82-84, 87-88, 91. **Selected Group Exhibitions:** The Cutting Edge, Kalamazoo Inst of Arts, MI, 87; Multimedia Abstract Art, ISD Interiors, LA, CA, 87; Le Bambou, Galerie Nicole Dortindeguey, Anduze, France, 88. **Selected Bibliog:** Paper, Scissors, Stone, Exposure, Sept/Oct, 88; Pick of the Week, LA Weekly, Peter Frank, Oct 88; Downtown, LA Times, Marlena Donahue, Oct 7, 88. **Selected Publications:** The Smells of Summer, Charles Christopher Hill & Kristine McKenna, published by Jacob Samuel, Santa Monica, CA, 89. **Selected Awards:** New Talent, LA County Museum of Art, 76; NEA, 76; Mentions Speciales du Jury, VIII Festival Int'l la Peinture, Cagnes-sur-Mer, France, 76.
(See page 132)

HIRATSUKA, YUJI (1954 - present)
b. Osaka, Japan

Education: Tokyo Gakugei Univ, Koganei-shi, Tokyo, Japan, 1978, BS; New Mexico State Univ, Las Cruces, 87, MA; Indiana Univ, Bloomington, 90, MFA. **Selected Solo Exhibitions:** Gallery Shirakawa, Kyoto, Japan, 88; Exhibit A Gallery, The Savannah College of Fine Arts and Design, Savannah, GA, 88; Chicago Center for the Print, IL, 89-90; Gilbert Luber Gallery, Philadelphia, PA, 90; Junction Gallery, Peoria, IL, 90; Chicago Center for the Print, Chicago, IL 90. **Selected Group Exhibitions:** Pratt Silvermine, Pratt Graphic Center, NYC, 86; 5th Int'l Biennial Exhibition of Portrait, Drawings & Graphics '88, Tuzla, Yugoslavia, Grand Diploma Award, 88; The 6th Seoul Int'l Print Biennale, Korea, 88. **Selected Collections:** Int'l Graphic Arts Foundation, New Canaan, CT; The Print Club, Philadelphia, PA; Brainerd Art Gallery, Potsdam, State Univ of NY; Firehouse Gallery, Nassau Comm College, Long Island, NY.
(See page 270)

HOCKNEY, DAVID (1937 - present)
b. Bradford, England

1953-57: Studies at Bradford College of Art, England. 1959-62: Studies Royal College of Art, London, England. 1963-91: Solo exhibitions Kasmin/Knoedler Gallery, London. 1964: Moves to Los Angeles; makes first Swimming Pool Paintings. 1970: Whitechapel Gallery, London; travelling retrospective. 1972-91: Solo exhibitions, Andre Emmerich Gallery. 1973-75: Lives in Paris. 1975: Designs production of Stravinsky's "The Rake's Progress." 1976: Returns to LA and begins working with photography. 1978-80: Yale Center for British Art travelling exhibition. 1978: Designs production of Mozart's "The Magic Flute." 1980-81: Designs The Stravinsky Triple Bill & the French Triple Bill for Metropolitan Opera. 1982: First composite Polaroids & photo collages. 1983: Walker Art Center, Minneapolis, MN. 1985: Int'l Center of Photography, exhibition & award. 1986: Creates first Home Made Prints on Photocopiers. 1988-89: Los Angeles County Museum of Art, CA; Metropolitan Museum of Art, NYC; Tate Gallery, London, England.
(See page 133)

HOFMANN, HANS (1880 - 1966)
b. Weissenburg, Germany

1910: First solo exhibition, Paul Cassier, Berlin. 1914-30: opens School for Modern Art, Munich. 1932: moves to New York, teaches at Art Students League. 1934: opens Hans Hofmann School of Fine Arts, NY. 1944: First American solo exhibition, Art of This Century Gallery, NYC. 1947-66: **Selected Solo Exhibitions:** Kootz Gallery, NYC. 1954: Baltimore Museum of Art, MA. 1957: Whitney Museum of American Art, NYC, 1962, travels; Frankische Galerie Am Marientor, organizes retrospective, Nuremberg; Germany; travels to Cologne & Berlin. 1963-65: Museum of Modern Art, travels to US; Argentina; The Netherlands; Italy & Germany. 1967-91: Andre Emmerich Gallery, NYC. 1973-74: Museum of Art, Ann Arbor, MI; Currier Gallery of Art Manchester, NH, under auspices of Int'l Exhibitions Foundation travels to museums around USA. 1976: Hirshhorn Museum & Sculpture Garden, Wash, DC, travels to Museum of Fine Arts, Houston, TX. 1985: Ft Worth Art Museum, TX. 1988: Tate Gallery, London, England. 1990: Whitney Museum of American Art, NYC.
(See page 134)

HOLMES, FRANK (1935 - present)
b. Detroit, Michigan

Education: Pratt Inst, 62, BFA; Ohio Univ, Athens, 72, MFA; **Teaching Experience:** Parsons School of Design, NYC, 63-68; NY Inst of Technology, Old Westbury, 68-70; Ohio Univ, Athens, 72-73; CW Post Center, Long Island Univ, Greenvale, NY, 76-80. **Selected Solo Exhibitions:** Dayton Art Inst, Dayton, OH, 72; Myrna Citron Gallery, NYC, 77; Monique Knowlton Gallery, NYC, 79-80; TLK Gallery, Costa Mesa, CA, 83; Partners Gallery, Bethesda, MD, 87, 89; Galerie Tamenaga, NYC, 91. **Selected Awards:** Prix de Rome Fellowship, 73-75; Lazarus Travelling Fellowship, The American Academy in Rome, Italy, 74-75; The Ingram Merrill Fellowship, NY, 77-78.
(See page 135)

HOY, CAROL (1948 - present)
b. Denton, Texas

Carol Hoy's background in Abstract Expressionist Color Theory, her training in Chinese Brush Paintings, and her intuitive sense of composition bring the viewer paintings that are sumptuous and exuberant. Landscapes, figures and interiors are captured on location since Hoy considers painting from a cornerstone of her aesthetic. Drama, playfulness and abundance characterize her images. She fills her canvases, bringing casein and oil paint to life through her extraordinary use of color. Chartruse, ochre, turquoise and cobalt blue are juxtaposed and harmonize, giving her compositions a formal weight and power while maintaining an optimistic joyfulness. Hoy earned a BFA from Southern Methodist University and an MFA from the University of Iowa. She studied Colorist Abstract Expressionism on the East Coast and was awarded two terms as Painting Fellow at The Provincetown Fine Arts Work Center in 1975 and 1976. Her further education has included studies at the James Gahagan School of Fine Art, and Naropa Inst. Her work is in numerous private and corporate collections including the Mount Sinai Medical Center in New York and the Sierra Tucson Medical Center in Arizona.
(See page 136)

HUNT, RICHARD (1935 - present)
b. Chicago, Illinois

Education: Univ of IL, Chicago; Univ of Chicago, IL; School of the Art Inst of Chicago, IL 57, BAE; Awarded James Nelson Raymond Foreign Travel Fellowship upon graduation: travel & study, England, France, Spain, Italy, 57-58. Professorships: Harvard Univ, Cambridge, MA, 89-90; Kalamazoo College, MI, 90; State Univ of NY, Binghampton. Honorary Degrees: Northwestern Univ, Evanston, IL, 84; Monmouth College, IL, 86; Roosevelt Univ, Chicago, IL, 87. **Selected Fellowships:** Guggenheim Fellowship, 62-63; Tamarind Artist Fellowship, 65; Cassandra Foundation Fellowship, 70. Cultural Activities: Director, Int'l Sculpture Center, 84-present; Advisory Committee, Getty Center for Education in Arts, 84-88; Board of Governors, School of the Art Inst of Chicago, IL, 85-90. **Selected Solo Exhibitions:** Printworks Gallery, Chicago, IL, 90; Century City, LA, CA, 87; DeGraaf Gallery, LA, CA, 87. **Selected Collections:** Albright-Knox Gallery, Buffalo, NY; The Art Inst of Chicago, IL; Hirshhorn Museum & Sculpture Garden, Wash, DC; Metropolitan Museum of Art, NYC; Museum of Modern Art, NYC; Whitney Museum of American Art, NYC. **Selected Commissions:** Eagle Columns, Jonquil Park, Chicago, IL,89; Freedmen's Columns, Howard Univ, Wash, DC, 89; Wisdom Bridge, Atlanta Public Library, GA, 90.
(See page 330)

IDEAL, PHILLIS (1942 - present)
b. Roswell, New Mexico

Education: Univ of NM, Albuquerque, NM, 64, BFA; Univ of CA at Berkeley, 76, MFA. **Selected Exhibitions:** Richard Green Gallery, NYC, 86, 88; Museum of Fine Arts, Santa Fe, NM, 86; Passages, Fresno Art Center & Museum, CA, 87; Faculty Exhibition, New Mexico State Univ, Las Cruces, 87; Oscarsson Siegeltuch Gallery, NYC, 87; Romantic Science, Contemp Art at One Penn Plaza, curated by Stephen Westfall, NYC, 87; John Davis Gallery, NYC, 88; Mixed Media, Ruggiero Henis Gallery, NYC, 88; Nature in Art, Contemp Art at One Penn Plaza, curated by Ronnie Cohen, NYC, 88; Inadmissible Evidence, SUNY Purchase, the Visual Arts Gallery, Purchase NY, 88; Other Painting, curated by Terry R Meyers & David Page for Independent Curators Inc, 91, travelled; Ruggiero Gallery, NYC, 91; Linda Durham Gallery, Santa Fe, NM, 87, 89, 91. **Selected Collections:** Roswell Nat'l Bank, NM; Crocker Nat'l Bank, SF, CA; Skidmore, Owings & Merrill, Chicago, IL; Prudential Insurance Collection, Newark, NJ. **Selected Bibliog:** Art, Stephen Westfall, Jan 85; Empowered Painting, Santa Fe, Artspace, Fall 86; Review of Exhibitions: Santa Fe, Art in America, David Bell, Jan 87.
(See page 137)

GREINER, WILLIAM K. (1957 - present)
b. New Orleans, Louisiana

Education: Bradford College, Bradford, MA, 80, AA; Tufts Univ, Medford School of the Museum of Fine Arts, Boston, MA, 82, BFA, Photography; Suffolk Univ, Boston, MA, 85, MBA, Finance. **Selected Exhibitions:** Louisiana Video Festival, Video Group Show, Contemp Arts Center, New Orleans, 80; Student Group Show, Bradford College, MA, 80; Two Artists, Laura Knott Gallery, Bradford, MA, 80; Never Fail Images, group show, School of the Museum of Fine Arts, Boston, MA, 81; Tour de France Series, Lexington High School, MA, 85; X-ART Gallery, New Orleans, LA, 88; Art in Mystery, Newman Center, Univ of New Orleans, LA, 91; Oestreicher Fine Arts, New Orleans, LA, 91; American Landscape Photographers, Addison Gallery, of American Art, Andover, MA, 92. **Selected Collections:** Museum of Modern Art; New Orleans Museum of Art; Addison Gallery of American Art, Andover, MA. **Selected Publications:** Bicycling Magazine, 81-82; Tour de France, Coverage, NY Times, 82-83; Harcourt, Brace & World, Book Cover, 85. **Selected Awards:** George Haseltine Visual Arts Award, Bradford College, MA, 80; Visual Arts Prize, Suffolk Univ, VA, 84.
(See page 387)

GRENON, GREGORY (1948 - present)
b. Detroit, Michigan

Gregory Grenon's direct and emotional approach to each painting is rooted in the blue-collar sensibility of his Detroit upbringing. Detroit spawned an independent and unstructured school of painting in the seventies known as the 'Cass Corridor,' named for the rough neighborhood where artists made their studios. This Detroit locale lent a grittiness and determination to much of the work, and Grenon's recent reverse paintings on glass continue to emphasize the physical urgency and intense coloration of each painting rather than the conceptual structure which also informs his work. The format of Grenon's paintings push the figurative tradition, but they triumph as vigorous and visionary color compositions. Grenon's paintings can be viewed in numerous private and public collections and the popular demand for his unique glass paintings has led to one-man exhibitions scheduled on both coasts during the 1991-92 season.
(See page 120)

GROFF, JAMES (1937 - present)
b. Kankakee, Illinois

James Groff's technique ranges from a minimalist treatment of line to an expressionist exploration of color and subtle pictorial depths. Even when spontaneously created, his forms imply an intelligent and sensitive mind guiding the composition while learning from the act of creation. The works can appear deceptively simple, yet never are they facile. They emerge as the result of mature contemplation and a commitment to experimenting with whatever methods are required to body forth his vision. Groff's abstract images hover before the viewer, embodying in visual metaphor an interplay of emotion and reason—both elements in a state of equilibrium. **Education:** Southern IL Univ, Carbondale,61, MFA. **Selected Exhibitions:** Dolan Maxwell, Philadelphia, PA, 83; Dubose Gallery, Houston, TX, 83; Simone Stern, New Orleans, LA, 84; Harcourts Contemp, SF, CA, 84; Malton Gallery, Cincinnati, OH, 85; William Campbell Contemp Fine Art, Ft Worth, TX, 87; Gremillion Fine Art, Houston, TX, 90; Nichols & Ward Gallery, Mission Viejo, 90; Charles Whitchurch Gallery, Huntington Beach, CA, 91; Van Straaten Gallery, Chicago Int'l Art Expo, IL, 91.
(See page 121)

GRONK (1954 - present)
b. Los Angeles, California

Gronk lives in Los Angeles, California. **Selected Exhibitions:** Los Angeles County Museum of Art, CA, 89; Deson-Saunders Gallery, Chicago, IL, 89; Houston Fine Arts Museum, TX, 89; Denver Art Museum, CO, 90; San Francisco Museum of Modern Art, CA, 90; William Traver Gallery, Seattle, WA, 90; Wight Art Gallery, Univ of CA, LA, 90; Daniel Saxon Gallery, LA, CA, 91; Nat'l Museum of American Art, Wash, DC, 92; Kimberly Gallery, Wash, DC, 92; Galerie Claude Samuel, Paris, 92. **Selected Collections:** AT&T; Philip Morris Corp; Corcoran Gallery of Art, Wash, DC; Denver Art Museum, CO.
(See page 122)

GROSS, MICHAEL (1953 - present)
b. Chicago, Illinois

By entwining figures, animals, skulls and the occasional odd phrase, Gross designs his characters to appear almost cartoon-like at first glance. Popping eyes and menacing grimaces lend a subtly disturbing tone to his pieces. People grope and scratch the clay surfaces as well as each other, trying to hold on to some kind of non-existent support, desperation and pain in their demeanor. Gross' hand-built vessels are really just the blank canvas that leads to the artist's visual commentaries on everything from his view of the world to environmental destruction to sexy lingerie.
(See page 329)

GROSS, SIDNEY (1921 - 1969)
b. New York City, New York

Education: Art Students League, 39-42, Schnackenburg Scholarship, 40. **Teaching Experience:** Columbia Univ, NYC, painting & drawing, 59-63; Art Students League, staff teacher, 60-67, until Nov 69; Prof of Art, Univ of MD, 67-Nov 69. **Selected Solo Exhibitions:** Frank Rehn Gallery, NYC, 14 exhibits from 1949-72; Seasons Galleries, The Hague, The Netherlands, 77. Nat'l & Int'l Invitational Exhibitions: Whitney Museum of American Art, NYC, intermittently since 45; Armory Show, 45; Brooklyn Museum, NY, 45; Metropolitan Museum, NYC, 50; Museum of Modern Art, NYC, 49, 59, 61; Carnegie Inst, Pittsburgh, PA, intermittently since 46; Corcoran Gallery of Art, Wash, DC, intermittently since 45; Inst of Contemp Art, Boston, MA, 51; Butler Art Inst, Youngstown, OH, intermittently since 53; Joslyn Art Museum, Omaha, NE, 54; Art USA, 58-59; American Academy of Arts & Letters, 50, 55, 58; Nat'l Inst of Arts & Letters; 67; American Fed of Arts, national tour, 58-60; Hallmark, European Tour, 52. **Selected Collections:** Columbia Univ, 62; Brandeis Univ, 58; Cornell Univ, 58; Mt Holyoke College, 50; MI State Univ, 60; Univ of Rochester, 66; Univ of IL, 59; Univ of Omaha, 51; James Michner Collection at the Univ of Texas, 67; OK Art Center, 68. **Memberships:** Federation of Modern Painters & Sculptors. **Honors:** Art Students League Scholarship 39; Schnackenberg Scholarship, Art Students League, 40. **Selected Awards:** Purchased twice by the Childe Hassam Fund of the American Academy of Arts & Letters, 50, 51; Tiffany Fellowship, 49; Hallmark Art Award, 49; Art USA, Grand Prize, 58.
(See page 123)

HAESELER, JOHN T. (1951 - present)
b. Cedar Rapids, Iowa

John T Haeseler's portraits explore his obsession with transformation and transcendence. The interest is spiritual in nature. Haeseler examines the limits of gender by transforming his own image into that of a woman. This metamorphosis transcends gender identity and achieves a new freedom which comments both on personal experience and conditions unobtainable in everyday reality. The abstract paintings are an adjunct to the artist's process. These works are often generative. Their subjects are painterly statements about metamorphosis feeding directly into the portrait work. Most recently, Haeseler has extended his self-portrait and abstract works into an exploration of others. This has resulted in a body of portraits which strive to create in their subjects a balance of the relationship between community and self-awareness, abstract and real. Photographic images are integrated into painting. A modern synthesis results in which media blend with artistic expression.
(See page 124)

HALL, JOHN (1943 - present)
b. Edmonton, Alberta, Canada

One of Canada's leading painters and a pioneering figure in his field, John Hall studied at the Alberta College of Art, Calgary and the Instituto Allende, San Miguel de Allende, Mexico. His work has been exhibited and/or collected by every significant gallery across Canada, including the National Gallery of Canada; Art Gallery of Ontario, Toronto; Montreal Museum of Fine Art and Vancouver Art Gallery. His work is in many private and corporate collections, including: Cineplex Odeon, Toronto, New York, NOVA Corporation; Petro-Canada Ltd; Lavalin Inc; and the Royal Bank of Canada. Extensively discussed, studied and documented by many of the country's most significant critics, curators and art scholars, particularly with regard to the conceptual aspect of his work and process. Most recent catalogue: "Imitations of Life: John Hall's Still Life Portraits," a ten year survey exhibition circulated to public galleries across Canada.
(See page 125)

HAMMERSLEY, FREDERICK (1919 - present)
b. Salt Lake City, Utah

Education: Univ of ID, Pocatello, 36-38; Chouinard Art School, LA, CA, 40-42, 46-47; Ecole des Beaux Arts, Paris, France, 45; Jepson Art School, LA, CA, 47-50. **Selected Group Exhibitions:** Roswell Museum & Art Center, NM, 89; Museum of Fine Arts, Santa Fe, NM, 89-90; Turning the Tide: Early LA Modernists, 1920-1956, Laguna Art Museum, Laguna Beach, CA, 90-92, travelled. **Selected Collections:** Albuquerque Museum, NM; Corcoran Gallery of Art, Wash, DC; Butler Inst of American Art, Youngstown, OH; La Jolla Museum of Art, CA; LA County Museum of Art, CA; Museum of NM, Santa Fe; Oakland Museum, CA; SF Museum of Mod Art, CA; Santa Barbara Museum of Art, CA; Univ Art Museum, Berkeley,CA; Univ of NB, Lincoln; Univ of New Mexico, Albuquerque. **Selected Awards:** John Simon Guggenheim Fellowship, Painting, 73; NEA Grant, Painting, 75, 77.
(See page 126)

HANNAN, GREG
b. Washington, DC

Education: George Washington Univ, Wash, DC; Corcoran School of Art, Wash, DC. He presently lives and works in Washington , DC. **Selected Solo Exhibitions:** Jane Haslem Gallery, Wash, DC, 74; Mt St Vincent Univ Gallery, Halifax, Nova Scotia, 75; The Washington Project for the Arts, 83; Narrative Paper, Osuna Gallery, Wash, DC, 86; Addison/Ripley Gallery, Wash, DC, 88, 91; Arnold & Porter, Wash, DC, 89; Memory, Time & Recognition: Greg Hannan & Sabina Ott, Corcoran Gallery of Art, Wash, DC. **Selected Group Exhibitions:** 36 Hours, Museum of Temporary Art, Wash, DC, 80; Options: Washington, 81, The Washington Project for the Arts, Wash, DC, 81; Hanover, Osuna Gallery, Wash, DC, 82; Four Images, Montpelier Art Center, Laurel, MD, 82; Osuna at Schuster, Ganno Univ, Erie, PA, 83; A Celebration of the South, Columbia, SC, 84; The Washington Show, Corcoran Gallery of Art, Wash, DC, 85; Painting '86, Arlington Arts Center, Arlington, VA, 86; Ten Washington Artists, Southeastern Center for Contemp Art, Winston-Salem, NC, 87; Works on Paper, Jane Haslem Gallery, Wash, DC, 87; Artscape '88, Maryland Inst, College of Art, Baltimore, MD, 88; Washington Artists: Those Who Left/Those Who Stayed, Franz Bader Gallery, Wash, DC, 89. Messages in The Medium, The Washington Times, July 25, 87; Hannan's Ocean of Imagery, The Washington Post, Sept 24, 88; Hannan & Cernuda evince enlarged visions, The Washington Times, Sept, 22, 88.
(See page 127)

HARRIS, RONNA S.
b. Los Angeles, California

Education: SF Art Inst, CA, 73; CA State Univ, Northridge, CA, 74, BA; Univ of CA, Santa Barbara, 577, MFA. **Selected Solo Exhibitions:** Sculpture Space Gallery, S Miami, FL, 87; Vero Beach Center for the Arts, FL, 88; Gellert Fine Art Gallery, Bay Harbor Islands, FL, 88; Newcomb Gallery, Tulane Univ, New Orleans, LA, 90; Still-Zinsel Contemporary, New Orleans, LA, 90. **Selected Group Exhibitions:** Invitational: Fact/Fiction/ Fantasy, Ewing Gallery, Knoxville, TN, 88, travelled; New Gallery, Coral Gables, FL, 88; Maralyn Wilson Gallery, Birmingham, AL, 88; Gellert Fine Arts Gallery, Bay Harbor Islands, FL, 90; Alexander F Milliken Gallery, NYC, 90; Still-Zinsel Contemporary, New Orleans, LA, 90. **Selected Collections:** Jacksonville Art Museum, FL; Marshall Bennett, Chicago, IL; Southeast Bank, FL. **Selected Bibliog:** Art in America, Aug 85, Mar & Aug 84; ARTnews, Nov 88; The Way of the Woman Artist, Dade Co Television, educational channel, WCA Miami Chapter, 89. **Selected Awards:** Merit Award, FL Pastel Assoc & Broward Art Guild, Ft Lauderdale, 88; Newcomb Foundation Grant, Newcomb College, Tulane Univ, New Orleans, LA, 90; Summer Fellowship, Senate Committee on Research, Tulane Univ, New Orleans, LA.
(See page 128)

FREDERICK, LINDEN (1953 - present)
b. Amsterdam, New York

The Cooley Gallery is proud to be presenting the art of Linden Frederick. Contemporary realism has seen a great resurgence of support in the last several years. While there are a number of very talented and crafted realist painters working today, it is especially exciting to discover an artist whose work, while based on a traditional style is uniquely distinct in its inherent vision, character and spirit. Indeed, Frederick is a superb craftsman, but his artwork goes much deeper, exploring the beauty and intrigue of both the rural and urban landscape. Like a composer of orchestral music, Frederick carefully works on individual aspects of painting in order to create a masterpiece that appears spontaneous and is unified in its elements. He does this by working the image over and over again in a series of watercolor, gouache and oil sketches. Meticulous and painstakingly wrought, the sketches prepare the artist for the final major work and afford Frederick the opportunity to manipulate his glazes based around three colors. Frederick captures the pictorial possibilities of everyday life—masses, forms, lines and surfaces, and the effects of light on them. Without sentimentality, yet emotive, the paintings convey a deep appreciation of the environment in all its guises. The finished work is consistently captivating. The evolution of his paintings begins with repetition and structure, yet softens in its maturity to achieve the artist's ultimate goal of conveying mood.
(See page 110)

FRIESZ, RAY (1930 - present)
b. Moberly, Missouri

The art of Ray Friesz has two major orientations. In the first, mimetic approach, he creates deeply textured organic shapes. These forms participate in a dialogue between medium and world, with the world ultimately emerging—as if from within the canvas and paint—as landscape. In the second approach, expressionist gesturalism suffused with a neo-impressionist feeling for plain air creates forms evocative of organic mass and atmosphere, but inhabiting a more abstract realm. Shapes create their own space, and refer primarily to themselves—or to inner landscapes. In both orientations Friesz' masterful handling of drip-spatter technique creates paintings of lyricism and depth—works S Perkoff of Artforum has called "paintings to the exploding point, but with subtlety and restraint." **Education:** Biola University. **Selected Exhibitions:** Ryder Gallery, LA, CA, 61-67; Joan Ankrum Gallery, LA, CA, 68; Adele Bednarz, LA, CA, 69; Long Beach Museum, CA, 69; Laguna Beach Museum, CA, 73; Jack Glenn Gallery, 76; Downey Museum, 78; Shearson Lehman Corp, 87; Charles Whitchurch Gallery, Huntington Beach, CA, 91. **Selected Awards:** LA County Museum of Art, New Talent Award, 66.
(See page 111)

FULLER, VICTORIA (1953 - present)
b. Allentown, Pennsylvania

Education: Univ of Denver, CO, 71-73; San Francisco Art Inst, CA, 79; Regis College, Denver, CO, 80, BA. **Independent Study:** Parsons in Paris, 82; Sculpture Center, NYC, 84; School of Visual Arts, NYC, 84; Marble and Art Inst, Pietrasanta, Italy, 88; Anderson Ranch Art Center, Snowmass, CO, workshops with Jim Dine, James Surls, Red Grooms, Robert & Sylvia Mangold, Terry Allen & Roger Brown, 90-91; assistant to Deborah Butterfield, 90-91. Victoria Fuller presently lives in Aspen, Colorado. **Selected Exhibitions:** W Broadway Gallery, NYC, 83; Hudson Valley Artist Assoc, curated by Barbara Haskell, 85; Whitney Museum of American Art, NY, 85; Feast for the Eyes, Allentown Art Museum, PA, group exhibition with Red Grooms, Jack Beal, David Gilhooly, Claes Oldenburg, Alice Neel, Jasper Johns, 86; Works by Women Sculptors, Laura Paul Gallery, Cincinnati, OH, 87; Objects, Fragments & Treasures, Payton Rule Gallery, Denver, CO, 87; Artist's of the Roaring Fork, Aspen Art Museum, 88; Aspen Art Museum Artist-in-Residence, appointed to work with elementary school children to create environmental installation, CO, 89; Payton Rule Gallery, Denver, CO, 90-91. Arts 81, Boulder Art Center Jurors Award, CO, 81; Anderson Ranch Art Center, Resident Painting Program, 83; Creative Fellowships in the Visual Arts, Sculpture, Colorado Council on the Arts & Humanities, 86.
(See page 327)

FURCHGOTT, TERRY (1948 - present)
b. New York City, New York

Education: Radcliffe College, Cambridge, 66-70, BA, Honors, Art History; Boston Museum School, MA, 70-71; Camden Arts Centre, London England, 72-75; Stanhope Inst, London, 73-75. **Selected Exhibitions:** Royal Academy Summer Exhibition, London, 76; Wivenhoe Arts Centre, Essex, England, 77; Uptown Artworks Gallery, Seattle, WA, 81; Kirsten Gallery, Seattle, WA, 82; The Polack Gallery, Mercer Island, WA, 86; Stone Press Gallery, Seattle, WA, 87; Lisa Harris Gallery, Seattle, 87-88, 90; Seattle Art Museum, WA, 88. **Selected Collections:** Federal Home Loan Bank, Seattle, WA; Providence Hospital, Seattle, WA; Group Health Central Hospital, Seattle. **Selected Bibliog:** Poets & Artists Calendar, Bainbridge Arts Council, Bainbridge Island, WA, 87, 91; West Coast Artists, Cedco Pub Co, San Rafael, CA, 91. **Selected Grants:** King Co Arts Commission, Individual Artist Support Grant, 89.
(See page 112)

GASTALDI, JEROME (1945 - present)
b. Oakland, California

Gastaldi conjures up a disturbing nether world by paint thoughtfully yet spontaneously applied. As critic Lita Barrie remarks, he is "one of those rare artists who thinks in paint, rather than simply using paint for illustration." In some works his power is overtly evident in the stark imagery and free, rough strokes. In others, his treatment is delicate. Light seems to emanate from within the picture plane, lending a spiritual resonance more fundamental and universal than the Christian and Jewish symbols he occasionally employs. Daunting images are mediated by a composition ordering the chaos, or by subtle brushstrokes suggesting movement, release, even a kind of teleology. Jerome Gastaldi was educated at Orange Coast College, California. With his solo exhibitions at Charles Whitchurch Gallery, Huntington Beach, CA, 1991, and Nichols & Ward Gallery, Mission Viejo, CA, in 1991, and the group show at the Venice, CA Art Walk, 1991, Jerome Gastaldi has only recently begun to display his work. Exhibition dates and venues will be given upon request through the Charles Whitchurch Gallery.
(See page 113)

GENOVES, FRANCESC (1944 - present)
b. Barcelona, Spain

While studying at the Conservatorio de Artes Suntuarias Massana, he won numerous art competitions and awards in successive years. He continued his studies at the Conservatorio de las Artes del Libro in Barcelona, the Escuela de Bellas Artes del Libro, and the Escuela de Bellas Artes de San Jorge also in Barcelona. His exceptional artistic abilities were recognized at an early age, and he was strongly influenced by the rich artistic traditions of his native Catalonia and by the Arte Povera movement of Italy. In 1966, he won a major competition for young painters in Geneva. That same year, he was awarded the first prize, Premio de la Pintura Joven, in Barcelona. Since 1977, Francesc Genoves has been invited to participate in international art exhibitions throughout Europe. In 1983, he was honored in France. With several artists participating, he was awarded the international grand prize and received the Medaille de Honneur from the city of Evian, France; his first international grand prize award.
(See page 114)

GERTSCH, FRANZ (1930 - present)
b. Morigen, Canton of Berne, Switzerland

Franz Gertsch presently lives and works in Ruschegg-Heubach, Switzerland. **Selected Solo Exhibitions:** Anliikerkeller, Bern, Switz, 62; Galerie Krebs, Bern, Switz, 68; Galerie Stampa, Basel, 70; Galerie Verna, Zurich, Switz, 71; Kunstmuseum, Luzern, Switz, 72; Nancy Hoffman Gallery, NYC, 73; Akademie der Kunste, Berlin, 75; Kunstverein Braunschweig, 75; Kunsthalle Dusseldorf, 75; Kunsthalle Basel, 75, 86; Galerie Veith Turske, Cologne, 75, 77-78; Akademie der Kunste, Berlin, 75; Kunsthaus Zurich; Kunstmuseum Hannover mit Sammlung Sprengel, 80; Louis K Meisel Gallery, NYC, 81; Knoedler, Zurich, 83; Kunsthalle Bern, 86; Museum moderner Kunst, Vienna, 86; Turske & Turske, Zurich, 87; Galerie Michael Haas, Berlin, 88-89; Musee Rath, Geneva, 89; Perimeter Gallery, Chicago, IL 89; Museum of Modern Art, NYC, 90; San Jose Museum of Art, CA, 91; Hirshhorn Museum & Sculpture Garden, Wash, DC, 91; Stadtische Galerie, Munich, 91, travelled. **Selected Collections:** Vienna Museum of Modern Art; Louis K & Susan Meisel, NY; Kunstmuseum, Bern; Staatsgallerie, Stuttgart; Bayerische Staatsgemaldesammlung, Munich; Sprengel Museum, Hannover; Nationalgalerie, Berlin; Robert Shimshak, CA; Kunsthaus, Zurich; Thomas Hess Collection, CA.
(See page 269)

GILLESPIE, GREGORY (1936 - present)
b. Roselle Park, New Jersey

Education: The Cooper Union for the Advancement of Science and Art, NYC, 50-54; San Francisco Art Inst, CA, 60-62, BFA, MFA. He presently lives and works in Massachusetts. **Selected Solo Exhibitions:** Forum Gallery, NYC, 66, 68, 70, 72-73, 76, 77, 79, 82, 84, 86, 89, 91; American Academy in Rome, Italy, 69; Georgia Museum of Art, Univ of GA, Athens, 70; The Alpha Gallery, Boston, MA, 71, 74, 82; Smith College Museum of Art, Northampton, MA, 71; Galleria IL Fante di Spade, Rome & Milan, 74; Galerie Veith Turske, Cologne, 75, 77-78; Berggruen Gallery, SF, CA, 83; Joseph and Margaret Muscarelle Museum of Art, College of Wm and Mary, Williamsburg, VA, 83; Duke Univ Art Museum, Durham, NC, 86; Atrium Gallery, Univ of CT, Storrs, 86; J Rosenthal Fine Arts Ltd, Chicago, IL, 88; Cooper Union for the Advancement of Science and Art, NYC, 89; Nielsen Gallery, Boston, MA, 89. **Selected Collections:** Metropolitan Museum of Art, NYC; Whitney Museum of American Art, NYC; Hirshhorn Museum & Sculpture Garden, Wash, DC; The Nat'l Museum of American Art, Wash, DC; Museum of Fine Arts, Boston, MA. Grants: Fulbright-Hays Grant, 62-63; Chester Dale Fellowship, 64-66; Louis Comfort Tiffany Foundation Grant, 67.
(See page 115)

GOODACRE, GLENNA (1939 - present)
b. Lubbock, Texas

Glenna Goodacre completed her initial studies at Colorado College, CO and the Art Students' League in New York. Adeptly expressing the nuances of the human form, she has earned membership in the National Academy of Western Art, the National Sculpture Society and a retrospective at the Gilcrease Museum. Most recently, Goodacre has taken on the challenge of large-scale sculpture and the results are being taken by public and private collectors in museums, parks and gardens. Her figures are not always references to specific people, but frequently more universal in content. Sea World of Texas commissioned five life-size bronzes for its Walk of Texas Heroes and Goodacre's 'Sidewalk Society' of nine larger-than-life bronzes have recently been installed in Albuquerque, New Mexico.
(See page 328)

GREGOR, HAROLD (1929 - present)
b. Detroit, Michigan

Harold Gregor has lived in the rural Midwest most of his life. He is a distinguished Professor at Illinois State University, but is more prominently known as a founder of the Heartland School of painters and influenced a generation of younger artists. Gregor has two approaches to landscape painting; a traditional and highly realistic panoramic format which imitates the endless horizon of central Illinois, as well as a more illusory aerial view which displays colorful patterns of rooftops and dirt roads on the topography. He has been shown regularly in New York and Chicago since the early 1970's and was recently featured in a mid-career museum retrospective. This year, he was awarded a commission to paint nine 9 x 12 foot canvases to be installed at the main entrance of the new State of Illinois Library in Springfield, Illinois.
(See page 118)

GREGORY, DREW (1947 - present)
b. Melbourne, Australia

Education: TSTC Melbourne Teachers College, Melbourne, Australia, 68; RMIT, Melbourne, Australia, 69. Lives in Strathewen, Victoria, Australia. **Selected Solo Exhibitions:** The Printmaker, Armdale, Victoria, Australia, 74; Artist's Showcase, Hurstbridge, Victoria, Australia, 74; Proforma Galleries, Queenbeyan, ACT, 75; Proforma Galleries, Paddington, Sydney, NSW, Australia, 75; Studio Papilio, Eltham, Victoria, Australia, 81-82; Eltham Gallery, Eltham, Victoria, Australia, 83-84, 86; Mornington Gallery, Mornington, Victoria, Australia, 87, 90-91; J Rosenthal Fine Arts Ltd, Chicago, IL 91. **Selected Collections:** Arthur Andersen, Melbourne, Australia; Commonwealth Art Bank, Australia; The Dromkeen Collection, Riddell, Victoria, Australia; Swinburne College, Melbourne, Australia; Whitley Streiber, NYC; Franklin Mint, Australia. Also represented in private collections throughout Australia, France, Germany, Sweden, United Kingdom and the USA.
(See page 119)

ETROG, SOREL (1933 - present)
b. Jassy, Romania

Sorel Etrog emigrated to Israel in 1950. **Education:** Tel Aviv Art Inst, 53-55; Brooklyn Art Museum School, 58, scholarship. **Selected Solo Exhibitions:** Mekler Gallery, LA, CA, 80; Hokin Gallery, Palm Beach, FL, 82; Gallery Moos, Toronto, Canada, 59, 61, 63, 65, 67, 81, 84. **Selected Collections:** Art Gallery of Ontario, Toronto; Museum of Fine Arts, Montreal; Museum of Tel Aviv; Kunstmuseum, Basel, Switz. **Selected Commissions:** Sunlife Centre, Toronto, 84; Olympic Park, Seoul Korea, 88. Curated Sculpture Exhibitions: Spectrum, Olympic Games, Montreal, 76; Contemp Outdoor Sculpture, the Guild Inn, Toronto, 82. Artist **Selected Publications:** The Bird that Doesn't Exist, C Aveline, Cavallino, Venice, 67; E Chocs, Ionesco, Martha Jackson, NY, 69; Imagination, Dead Imagine, S Beckett, Calder, London, 72. **Designed Awards:** Toronto Symphony 50th Anniv Coin, 68; Toronto Symphony 50th Anniv Coin, 73. **Sets & Costumes:** The Celtic Hero, WB Yeats, 78. **Films:** Wrote & Directed Film, Spiral, shown on CBC, 75; Illustrated, choreographed and arranged electronic music for Musicage, an installation in honor of John Cage's 70th birthday, Toronto, 82; The 'bodifestation' of The Kite, a tribute to Samuel Beckett, Toronto, 84.
(See page 325)

FELTUS, ALAN (1943 - present)
b. Washington, DC

Education: Tyler School of Fine Arts, Temple Univ, Philadelphia, PA, 61-62; Cooper Union for the Advancement of Science and Art, NYC, 66, BFA; School of Art and Architecture, Yale Univ, 68, MFA. **Selected Solo Exhibitions:** American Academy in Rome, Rome, Italy, 72; Jacob's Ladder Gallery, Wash, DC, 73; Northern Virginia Comm College, Annandale, 76; Forum Gallery, NYC, 76, 80, 83, 85, 87, 91; Wichita Art Museum, Wichita, KS, 87; Simms Fine Art, New Orleans, LA, 88. **Selected Collections:** American Medical Assoc, Wash, DC; Arkansas Arts Cntr, Little Rock; Bayly Museum, Charlottesville, VA; CA Palace of the Legion of Honor, SF, CA; Dayton Art Inst, Dayton, OH; Hirshhorn Museum & Sculpture Garden, Wash, DC; Nat Museum of American Art, Wash, DC; New Jersey State Museum, Trenton, NJ; Springfield Museum, Springfield, MA. **Selected Awards:** Rome Prize Fellowship, 70-72; Louis Comfort Tiffany Foundation Grant in Painting, 80; NEA Individual Fellowship, 81; Nat'l Academy of Design, Thomas B Clarke Prize, 84; Nat'l Academy of Design, Benjamin Altman Prize, 90.
(See page 100)

FINI, LEONOR (1908 - present)
b. Buenos Aries, Argentina

Leonor Fini was taken to live in Trieste before she was a year old. Raised in the bohemian salons of a radically changing Europe between the two World Wars, her preconsciousness was manifested in the creation of a persona of incredibly strong will and intense sensitivity. About 1932 she moved to Paris, and became allied with Max Ernst, with whom she was later exhibited at the Julien Levy Gallery in NY. Frequently shown with the Surrealists, she refused to join their movement. The 'enfant terrible' of the Paris art world, she became known for her portraits; theatre, ballet and movie designs and book illustrations, while the cognoscenti collected her extraordinary paintings. An artist's artist, her work still influences many artists and is in museums and collections worldwide. She lives and works in Paris and the Loire Valley. Over 30 books and 7 films have been made about her life and work.
(See page 101)

FINK, AARON (1955 - present)
b. Boston, Massachusetts

Education: Maryland College of Art, 77, BFA; Yale Univ, 79, MFA. **Selected Solo Exhibitions:** Castelli Uptown, NYC, 86; Hartje Galerie, Frankfurt, 86, 89; Roger Ramsey Gallery, Chicago, IL 90; Galerie Barbara Farber, Amsterdam, 85-91; David Beitzel Gallery, NYC, 88-91; Alpha Gallery, Boston, MA, 81-91. **Selected Group Exhibitions:** Inst of Contemp Art, Boston, MA, 83; Project Studio One, Long Island City, NY, 84; Bank of America, NYC, 84; Brooklyn Museum, NY, 86; Leo Castelli Gallery, NYC, 86; American Academy & Inst of Arts & Letters, NYC, 87; Nat'l Gallery of Art, Wash, DC, 89-90; DeCordova Museum, Lincoln, MA, 90; Museum of Fine Arts, Boston,MA, 90. **Selected Collections:** Art Inst of Chicago, IL; Boston Public Library, MA; Brooklyn Museum, NY; Library of Congress, Wash, DC; Metropolitan Museum of Art, NYC; Museum of Modern Art, NYC; Philadelphia Museum, PA. **Selected Bibliog:** Hartje Galerie, Frankfurt, 86; Alpha Gallery, Boston, MA, 89; Galerie Barbara Farber, Amsterdam, 91.
(See page 102)

FISCHL, ERIC (1948 - present)
b. New York City, New York

Education: California Inst of the Arts, Valencia, CA, 72, BFA. He presently lives in New York City, New York. **Selected Solo Exhibitions:** Dalhousie Art Gallery, Halifax, Canada, 75; Studio, Halifax, Canada, 76; Galerie B, Montreal, Canada, 76, 78; Edward Thorp Gallery, NYC, 80 - 82; Emily Davis Art Gallery, Univ of Akron, OH, 80; Sable-Castelli Gallery, Toronto, Canada, 81, 82, 85, 87; Univ of CO Art Galleries, Boulder, 82; Sir Georges Williams Art Galleries, Concordia Univ, Montreal, Canada, 83; Saidye Bronfman Centre, Montreal, Canada, 83; Larry Gagosian Gallery, LA, CA, 83; Mario Diacono Gallery, Rome, Italy, 83; Multiples/Marion Goodman Inc, NYC, 83; Nigel Greenwood Gallery, London, England, 83; Mary Boone Gallery, NYC, 84, 86-88, 90; Mendel Art Gallery, Saskatoon, Canada, 85; Stedelijk Van Abbe Museum, Eindhoven, The Netherlands, 85; Kunsthalle Basel, Switz, 85; Inst of Contemp Arts, London, England, 85; Art Gallery of Ontario, Toronto, Canada, 85; Mario Diacono Gallery, Boston, MA, 85; The Whitney Museum of American Art, NYC, 86; Larry Gagosian Gallery, LA, CA, 86; Daniel Weinberg Gallery, LA, CA, 86; Scenes Before the Eye exhibition, travelled, 86-87. Waddington Gallery, London, England, 89; Akademie der Bildenden Kunste, Vienna, Austria, 90; Musee Cantonal des Beaux-Arts de Lausanne, Lausanne, Switz, 90; Scenes and Sequences ehibition, travelled, 90; Cleveland Center for Contemp Art, OH, 90; Aarhus Kunstmuseum, Aarhus, Denmark, 91; Louisiana Museum of Modern Art, Humlebaek, Denmark, 91.
(See pages 103 & 386)

FISH, JULIA (1950 - present)
b. Toledo, Oregon

Education: Pacific Northwest College of Art, Portland, OR, 76, BFA; Maryland Inst, College of Art Mount Royal School of Painting, Baltimore, MD, 82, MFA. She presently lives and works in Chicago, Illinois. **Selected Solo Exhibitions:** Blackfish Gallery, Portland, OR, 82, 84; Robbin Lockett Gallery, Chicago, IL, 87, 91; Herron Gallery, Indianapolis Center for Contemp Art, Indianapolis, IN, 89; Loughelton Gallery, NYC, 89. **Selected Group Exhibitions:** Surfaces: Two Decades of Painting in Chicago, Terra Museum of American Art, Chicago, IL, 87; Julia Fish-Mary Heilmann-Julian Lethbridge Robbin Lockett Gallery, Chicago, IL, 88; Latitudes, Aspen Art Museum, CO, 88; Of Another Nature, Loughelton Gallery, NYC, 88; Discreet Power: New Issues in Reductivist Painting, Rockford Art Museum, Rockford, IL, 88; participated in On Kawara Date Paintings: 1966-88, Renaissance Society, Univ of Chicago, IL, 89; Prima Visione, Milano Internazionale D'Arte Contemporanea, Milan, Italy, 89; Toward the Future: Contemp Art in Context, Museum of Contemp Art, Chicago, IL, 90; New Generation, Carnegie-Mellon Art Gallery, Pittsburgh, PA, 90.
(See page 104)

FISHER, VERNON (1943 - present)
b. Ft Worth, Texas

Selected Solo Exhibitions: Texas Art, The Menil Collection, Houston, TX, 80; Vernon Fisher Kommt, Denise Rene/Hans Mayer Gallery, Dusseldorf, W Germany, 80; Breaking the Code, Franklin Furnace, NYC, NY, 81; Galerie T'Venster, The Rotterdam Arts Council, The Netherlands, 82; El Arte Narativo, Museo Rufino Tamayo, Mexico City, Mexico, 84; Wall Works, John Weber Gallery, NYC, 86; Avante-Garde in the 80's, Los Angeles County Museum of Art, CA, 87; Building our House, Barbara Gladstone Gallery, NYC, 87; Complementary Pairs, Hiram Butler Gallery, NYC, 87; Vernon Fisher Works: Parallel Lines, Hirshhorn Museum & Sculpture Garden, Wash, DC, 88; Vernon Fisher: Lost for Words, Dallas Museum of Art, TX, 88; Vernon Fisher, La Jolla Museum of Contemp Art, CA, 89-90, travelled.
(See page 105)

FITZPATRICK, TONY (1958 - present)
b. Chicago, Illinois

Selected Solo Exhibitions: Carnival at Midnight, Janet Fleisher Gallery Philadelphia, PA, 87; Coney Island, The Ghost, Todd Capp Gallery, NYC, 87; Bad Blood, Portraits of Murders, Todd Capp Gallery, NYC, 88; Hard Angels, Janet Fleisher Gallery, Philadelphia, PA, 88; Radio Birds, Mincher/Wilcox Gallery, SF, CA, 89; American Mysteries: The Diaries, Janet Fleisher Gallery, Philadelphia, PA, 90; Schmidt-Markow Gallery, St Louis, MO, 90; Carl Hammer Gallery, Chicago, IL, 91; Eugene Binder Gallery, Cologne, W Germany, 92; Cavin Morris Gallery, NYC, 92. **Selected Group Exhibitions:** Animals, Todd Capp Gallery, NYC, 87; Visionary Landscapes, Cavin Morris Inc, NYC, 87; Shape Shifting, Cavin Morris Inc, NYC, 88; Invitational, Clark Gallery, Lincoln, MA, 90; Visionary Healing, Contemporary Saints, Delaware Center for Contemp Art, Wilmington, DE, 91. **Selected Bibliog:** The Neighborhood, Society for Mad Poets Press, Chicago, IL, 86; The Midnights, Society for Mad Poets Press, Chicago, IL, 88; The Hard Angels, Janet Fleisher Gallery, Philadelphia, PA, 88. Selected Commissions: Chicago Magazine, Commemorative Portrait of Mayor Harold Washington, 88; A&M Records, album cover for The Neville Brothers: Yellow Moon, 89; Playboy Magazine, Interview with James Buster Douglas, 90.
(See page 253)

FRANCIS, KE (1943 - present)
b. Memphis, Tennessee

Selected Solo Exhibitions: Univ of S Mississippi, Hattiesburg, 87; Univ of Texas at El Paso, 87; Univ of Wyoming, Laramie, 87; Mississippi Governor's Mansion & Awards Reception, MS, 88; Roanoke Museum of Fine Art, installation, VA, 90. **Selected Group Exhibitions:** More than Land & Sky, Art from Appalachia Nat'l Museum of American Art, Wash, DC, Nat'l Touring Exhib, 82-84; New American Paperworks, World Print Council Int'l Touring Exhib, 83-85; Southern Exposure, Alternative Museum, NYC, 85; Fact/Fiction/Fantasy Recent Narrative Art in the SW, 87, travelled; The Conceptual Impulses, Three Tableau Works, Security Pacific Gallery, LA, CA, 90; Artist's Books, Fendrick Gallery, NYC, 90.
(See page 106)

FRANCIS, SAM (1923 - present)
b. San Mateo, California

Chronology: 1941-43: Studies medicine & psych, Univ of CA, Berkeley, 1943-45: Serves in US Army Air Corp, begins painting in army hospital in 1944. 1945-50: Studies with David Parks, School of Fine Arts, SF, CA; Univ of California, Berkeley, MA. 1950: Moves to Paris, studies at Academie Fernard Leger. 1952: First solo exhibition, Galerie du Dragon, Paris. 1955: First museum exhibition, Kunsthalle, Bern. 1957-91: Major exhibitions in museums & galleries in US, Asia & Europe. 1958: Paints triptych for the Kunsthalle, Basel. 1958-60: Moves to New York. 1960-75: Lives in Paris, Bern & Tokyo. 1967: Museum of Fine Arts Boston; Houston; Univ Art Museum, Berkeley, CA. 1969-91: Solo Exhibitions, Andre Emmerich Gallery, NYC, 1972: Albright-Knox Gallery, Buffalo, NY; Corcoran Gallery of Art, Wash, DC; Whitney Museum of American Art, NYC; Dallas Museum of Fine Art, TX; Oakland Museum, CA. 1975: Lives in Santa Monica, CA. 1980: Watercolor retrospective, Boston Inst of Contemp Art, travels under auspices of USIA to museums in Taiwan, Hong Kong, Manilla, Korea & Japan; The Phillips Collection, travelling exhibition to five cities in Japan.
(See pages 107, 267 & 268)

FRANKENTHALER, HELEN (1928 - present)
b. New York City, New York

Chronology: 1949: Bennington College, Vermont, BA. 1953: First solo exhibition: Mountain & Sea, Tibor de Nagy Gallery. 1959-91:Selected Solo Exhibitions, Andre Emmerich Gallery; "V Bienal" Museum de Arte Moderna, Sao Paulo, Brazil, travelled. 1960: The Jewish Museum. 1966: "Venice: XXXIII Int'l Biennial Exhibition of Art, represents USA. 1969: Whitney Museum of American Art, NYC, travels under the auspices Int'l Council of the Museum of Art. 1975: Corcoran Gallery of Art, Wash, DC, travelled to museums in Seattle, WA & Houston, TX. 1978: "Helen Frankenthaler Paintings, A Selection of Small Scale Painting". 1949-77: Andre Emmerich Gallery, travels under the auspices of USIA to Far East, Australia & Latin America. 1980: Clark Art Inst; Williams College, travels to museums in Wash, DC; Birmingham; Toledo; Palm Springs; Santa Barbara & Boston. 1985: Solomon R. Guggenheim, travels to museums in Edmonton; Toronto; Milwaukee; Baltimore; San Francisco; Houston & Boston. 1989: Museum of Modern Art; Modern Art Museum of Ft Worth; Los Angeles County Museum of Art; Detroit Inst of Art.
(See pages 108 & 109)

DEOM, JOHN
(1952 - present)
b. McLeansboro, Illinois

Education: Southern IL Univ, 76, BFA; 80, MFA; Atelie Neo-Medici, Verneuil-sur-Seine, France, 78-79. **Selected Solo Exhibitions:** Lilane Francois Gallery, Paris, France, 79, 82; Grand Palais, Paris, France, 79; Vergette Gallery, S IL Univ, Carbondale, 80; J Rosenthal Fine Arts Ltd, Chicago, IL, 90. **Selected Group Exhibitions:** J Rosenthal Fine Arts Ltd, Chicago, IL 83-85, 90-91; Artemsisia Gallery, Chicago, IL 85; Univ of WI, River Falls, 87; Arkansas Art Center, Little Rock, AK, 88; FL State Univ Museum, Tallahassee, 90. **Selected Collections:** Musee et Centre d'Art Contemporain le Prince Murat, Paris, France; Marshall Fields Co, Chicago, IL; AK Art Center, Little Rock; Newman Center, Carbondale, IL; S IL Univ, Carbondale, IL; Robert Rossi-Arnaud, Paris, France; Dr & Mrs Richard L Davidson, Chicago, IL; Mr & Mrs Sanford Besser, Little Rock, AK.
(See page 87)

deSOTO, LEWIS
(1954 - present)
b. San Bernadino, California

Education: Univ of CA, Riverside, 78, B; Claremont Grad School, CA, 81, MFA. **Teaching Experience:** Assoc Prof of Art, Otis Art Inst of Parsons School of Design, LA, CA, 83-85; Chairman of the Art Dept, Cornish College of the Arts, Seattle, WA, 85-88; Assoc Prof of Art, School of Creative Arts, SF State Univ, CA, 88-present. **Artist-in-Residence:** Headlands Center for the Arts, Ft Barry, Sausalito, CA, 10 month residency, 90. **Public Exhibitions:** Homes for Art, Nine-One-One Contemp Arts Center, Seattle, WA, Aug-Oct 87; Apparation of Passion, St Joan of Arc, The Ventura House, Projection, Seattle, WA.
(See page 289)

DESSAPT, GUY
(1938 - present)
b. France

Guy Dessapt's youthful interest in painting culminated with professional training at the highly acclaimed Art Decoratifs school in Paris. Subjects emanating from Dessapt's lifelong passion for travel are depicted through the merging of these visual experiences with his strikingly idiosyncratic impressionist style. Guy Desspat's paintings are strong in composition, rich in texture and exhibit a dazzling sense of color. His controlled use of acrylics and oils produces a unique, layered interplay of dimension and theme. Guy Dessapt currently spends most of his time between Paris, St Tropez, Venice and New York, providing him with constantly changing sources of visual inspiration and Revel Editions is honored to be Guy Dessapt's exclusive representative in the United States.
(See page 88)

DICKINSON, EDWIN WALTER
(1891 - 1978)

Edwin Walter Dickinson stands in the first rank of this country's important American painters. He was a unique figure whose balance of figurative traditions and experimental abstract designs were significant in the development of a modern sensibility for painting styles. When the Whitney Museum of American Art acquired Dickinson's The Fossil Hunters, the Editors of ARTnews wrote that it was "the year's best modern painting acquired by an American Public collection." Major exhibitions of his work have been organized by the Whitney Museum of American Art, Nat'l Academy of Design, Hirshhorn Museum & Sculpture Garden and in 1968 under the auspices of the Smithsonian Institution, a major selection of his work was exhibited at the 34th Esposizone Biennale Internazionale D'Arte in Venice. Babcock Galleries is the exclusive representative for the Heirs of Edwin Dickinson.
(See page 89)

DINE, JIM
(1935 - present)
b. Cincinnati, Ohio

Chronology: Ohio Univ, Athens, 57, BFA; moves to NYC, 58; The Smiling Workman, Judson Gallery, NYC, 59; solo show, Martha Hackson Gallery, NYC, 61; begins fourteen year association with Sonnabend Gallery, NY, Paris & Geneva, 62; moves to London, 67-71; Whitney Museum of American Art, NYC, retropsective, 70; returns to US, settles in Putney, VT, 70-85; begins association with The Pace Gallery, NYC, 76; Jim Dine: Paintings, Drawings, Etchings, 1976, The Pace Gallery, NYC, 77; elected to American Academy & Institute of Arts & Letters, NYC, 80; Jim Dine: Five Themes, Walker Art Center, Minneapolis, MN, 84-85, travelled; moves to NYC, 85; Drawings Jim Dine, 1973-87, The Contemp Arts Center, Cinncinati, OH, 88-90, travelled.
(See page 91)

DOMINEY, PAUL S.
(1943 - present)
b. Atlanta, Georgia

A native of Atlanta, GA, Paul Dominey attended classes at the High Museum of Art at the age of eleven, where he was awarded four scholarships for study at the junior school. After high school he attended the Cleveland Inst of Art where he received his BFA degree in painting in 1967. During his undergraduate and graduate years he studied painting with Louis Boza and Julian Stanzak; design with John Paul Miller and Kenneth F Bates; and five years of ceramics with Tashiko Takiezu. More recently he studied figure drawing with well-known artist Ben Smith.
(See page 92)

DORSET, ROGER
(1941 - present)
b. Rome, Georgia

Education: Atlanta College of Art, GA, 67, BFA; Tyler School of Art, Rome, Italy, 67-68; Tyler School of Art, Temple Univ, Philadelphia, PA, 69, MFA. **Selected Solo Exhibitions:** Atchinson Gallery, Birmingham, AL, 85; Sarratt Gallery, Vanderbilt Univ, Nashville, TN, 86; Western Carolina Univ, Cullowee, NC, 87; Great American Gallery, Atlanta, GA, 85-86, 88; Seminole College, Sanford, FL, 89. **Selected Group Exhibitions:** High Museum of Art, Atlanta, GA, 78; Poesea e Realta, Salerno, Italy, 80; Columbia Museum of Art, SC, 82; Image South Gallery, Atlanta, GA, 82-84; Muhlenberg College, Allentown, PA, 86; La Mama-La Galleria, NYC, 87; Atlanta College of Art Gallery, GA, 89; Nexus Contemp Arts Center, Atlanta, GA, 89; Arts Council of Richmond, VA, 89; New Visions Gallery, Atlanta, GA, 90. **Selected Bibliog:** The Atlanta Constitution, Mar 86; Feb 88; Art Papers, Nov 83; May 86; Artforum, May 88.
(See page 324)

DRTIKOL, FRANTISEK
(1883 - 1961)
b. Pribram, Bohemia (Chechoslovakia)

Chronology: Studies photography in Munich, 1901-03; travels & studies throughout Germany, Switzerland & Czechoslovakia and recruited into the army, 04-10; opens studio in Prague and begins to exhibit internationally, 10; active in military service in Hungary, 15-19; patents semi-tone photolithography, 25; becomes member of the art dept of the Umelecka Beseda art society, 28; ends photographic career and sells equipment & studio, 35; donates negatives, photographs and documents to the Museum of Decorative Arts, Prague, 42.
(See page 384)

DUBUFFET, JEAN
(1901 - 1985)
b. LeHavre, France

Chronology: Academie Julian, Paris, 18; stops painting, 24-33; marries Paulette Bret; death of his father, 27; starts wine business in Bercy, 30; begins to paint again; divorces Paulette Bret, 33-34; abandons art again; marries Emilie Carlu, 37; devotes himself to art, full-time, 42; solo show, Galerie Rene, Drouin, Paris, 44; begins collecting 'Art Brut', 45; first solo show in America, Pierre Matisse Gallery, NY, 47; L'Art Brut prefere aux arts culturels, published, 49; alternates living in Vence & Paris, 55; Jean Dubuffet 1942-60, Musee des Arts Decoratifs, Paris, 60-61; Museum of Modern Art, NYC, retrospective, 62; Retrospective at Tate Gallery, London; Stedelijk Museum, Amsterdam; Museum of Fine Arts, Dallas, TX; Walker Art Center, Minneapolis, MN; begins sculpting with plastic & polyester, 66; Painted Sculptures, Pace Gallery, NY, 68; Musee des Beaux-Arts, Montreal, retrospective, 69-70; Edificesand Monuments by Jean Dubuffet, Art Inst of Chicago, IL, 70-71; Dubuffet: Persons & Places, Museum of Modern Art, NYC, 72-73; Jean Dubuffet, a Retrospective Glance at Eighty, Solomon R Guggenheim Museum, NYC, 81; Partitions 1980-81; Psycho Sites 81, The Pace Gallery, NYC, 82-83; Mires, French Pavilion of the Biennale, Venice, 84; Non-Lieux, Musee National d'Art Moderne Centre, Georges Pompidou, Paris, 85; dies May 12 at his home, 85; Jean Dubuffet 1901-1985, Galleria Nazionale d'Arte Moderna, Rome, retrospective, 89-90; Retrospective Jean Dubuffet, Schirn Kunsthalle, Frankfurt, 90-91.
(See page 94)

DUDLEY, RANDY
(1950 - present)
b. Peoria, Illinois

Selected Exhibitions: Romance and Irony: Recent Painting in New York, Nat'l Gallery of New Zealand, Wellington; travelled; The 1980's: A New Generation, Metropolitan Museum of Art, NYC, 88. **Selected Collections:** Metropolitan Museum of Art, NYC; Brooklyn Museum, NY. **Selected Bibliog:** New Art, Harry N. Abrams Inc, NYC, 90; Exquisite Paintings, Orlando Museum of Art, FL; essay: Gerrit Henry, catalogue, 91; Fictions: A Skeleton of Pictures from the 18th, 19th & 20th Centuries, Kent Fine Art; Curt Marcus Gallery, NYC; Essay: Douglas Blau, catalogue, 87.
(See page 95)

DUGMORE, EDWARD
(1915 - present)
b. Hartford, Connecticut

Chronology: Awarded a scholarship to attend classes at the Hartford Art School, 34; spent summer in Kansas City, briefly studied with Thomas Hart Benton at The Kansas City Art Inst, 41; enters US Marine Corp, 43; moved to NYC, 44; moved to SF and began studying at the CA School of Fine Arts on the GI Bill, 48; first solo exhibition at the Metart Gallery, 50; moved to Guadalajara, Mexico, studied at the Univ of Guadalajara, 51; moved to NYC again, 52; first of three solo exhibitions at Stable Gallery, 53, 54, 56; solo exhibition Holland-Goldowsky Gallery, Chicago, IL, 59; first of four solo exhibitions at the Howard Wise Gallery, NYC, 60; received MV Kohnstamm Award, Art Inst of Chicago, IL, 62; received John Simon Guggenheim Fellowship Award, 66; visiting artist and solo exhibition at the Des Moines Art Center and Drake Univ, 72; received NEA grants, 76, 85; first solo exhibition at the Manny Silverman Gallery, LA, CA, 91.
(See page 96)

EDELSTEIN, JEAN
b. New York City, New York

Education: Univ of California, LA, 52; Art Students League, NYC, 47-48, scholarship; Pratt Inst, Brooklyn, NY, 44-47. **Selected Solo Exhibitions:** Laguna Beach Museum of Art, Laguna Beach, CA, 73; Marquoit Gallery, SF, CA, 73, 75; Karl Bornstein Gallery, Santa Monica, CA, 81; Gallery Te, Dinza, Tokyo, Japan, 83; Galerie Bruno Bussard, Bern, Switz, 83; Gallery Newz, Tokyo, Japan, 85; Ruth Bachofner Gallery, Santa Monica, CA, 85, 87, 89; Karta Pustaka, Yogyakarta, Java, Indonesia, 89; Pacific Asia Museum, Pasadena, CA, 90; LA Theatre Center, CA, 90; Sherry Frumkin Gallery, Santa Monica, CA, 92. **Selected Collections:** Laguna Beach Museum of Art, CA; Skirball Museum, Hebrew Union College, LA, CA; Toyota Corp, Torrance, CA; ARCO, LA, CA; Occidental Petroleum Corp, LA, CA; Bill Cosby, Jemmin Inc, LA, CA; Regent Hotel, Singapore; Sheraton Int'l O'Hare, Chicago, IL; Jon Douglas Company, Beverly Hills, CA; Steelcase Inc LA, CA; Century Plaza Hotel, LA, CA; Drexel Burnham Lambert Inc, Beverly Hills, CA.
(See page 98)

ERLEBACHER, MARTHA MAYER
(1937 - present)
b. Jersey City, New Jersey

Education: Gettysburg College,Gettysburg, PA; Pratt Inst, Brooklyn, NY, 60, BA; 63, MFA. **Selected Solo Exhibitions:** The Other Gallery, Philadelphia, PA, 67; Robert Schoelkopf, NYC, 73, with subsequent shows from 75-85; Dart Gallery, Chicago, IL, 76, with subsequent shows from 78-83; The Morris Gallery of the Pennsylvania Academy of Fine Arts, Philadelphia, PA, 78; Moore College of Art, Philadelphia, PA, 78; Weatherspoon Gallery, Univ of NC, Greensboro, 83; J Rosenthal Fine Arts Ltd, Chicago, IL, 87, 90; Kalamazoo Inst of Arts, Kalamazoo, MI, 89; Koplin Gallery, LA,CA, 89. **Selected Collections:** Yale Univ Art Gallery, New Haven, CT; Cleveland Museum of Art, OH; Ft Wayne Museum, IN; Art Inst of Chicago, IL; Philadelphia Museum of Art, PA; Fogg Museum of Art, Harvard Univ, Cambridge, MA; Albrecht Museum, St Joseph, MO; Pennsylvania Academy of the Fine Arts, Philadelphia; Penn State Univ, Museum of Art, Univ Park, PA; Claude Bernard Gallery, Paris, France.
(See page 99)

DALGLISH, JAMIE (1947 - present)
b. Bryn Mawr, Pennsylvania

Selected Group Exhibitions: Real Paint, Procter Art Center, Bard College, Annandale-on-Hudson, NYC, 88; Open/Shut: The Painting-Photography Continuum, Barbara Braathen Gallery, NYC, 88; Art Against AIDS, DIA Foundation, NY, NY, 87. **Selected Collections:** Chase Manhattan Bank, NY, NY; Polaroid Corporation, Cambridge, MA; Virginia Museum of Art, Richmond, VA. **Selected Bibliog:** Arts Magazine, Jamie Dalglish, Ted Castle, June 91; Details, Art and About, Cookie Mueller, Summer 88. Grant: Polaroid Corporation, 89.
(See page 81)

DAVENPORT, REBECCA READ (1943 - present)
b. Alexandria, Virginia

Education: Pratt Inst, NY, 70, BFA with Honors; Univ of North Carolina at Greensboro, 73, MFA. **Selected Exhibitions:** Corcoran Gallery of Art, Wash, DC, 72, 80; Chrysler Museum, Norfolk, VA, 76; ACA Gallery, NYC, 77; Cagnes-sur-Mer, France, 77, 78; Musee d'Art Moderne de la Ville de Paris, Paris, France, 78; PA Academy of Fine Arts, Philadelphia, 81; VA Museum of Fine Art, Richmond, 81, 83; Oakland Museum, CA, 81; Int'l Art Fair, Basel, Switz, 83; Art Against AIDS, Wash, DC, 90; de Andino Fine Arts, Wash, DC, 90. **Selected Collections:** Baltimore Museum of Art, MD; Corcoran Gallery of Art, Wash, DC; Fed Reserve Bank, Richmond, VA; Sidney Lewis Foundation, Richmond, VA; Chrysler Museum, Norfolk, VA. **Selected Awards:** Third Gold Palette, Cagnes-sur-Mer, France, 77; NEA, Artist Fellowship, 79.
(See page 82)

DAVET, MARC (1951 - present)
b. Fecamp, France

The once dark and brooding, yet incandescent paintings of this Parisian artist are reminiscent of Hieronymus Bosch. Of all the artists today, Davet is arguably Bosch's most direct artistic descendant. Davet's canvases undulate with figures, creatures and forms that challenge the imagination. Utilizing an amazing technique, he heightens the under light of each painting by working on a canvas covered with a base of thick white paint. It has been slathered on so as to leave raised ridges throughout. He considers each painting a living entity; the surface is the flesh and the ridges are the veins. To view his finished painting is to be transported to a world where there are no rules and no boundaries. One's dreams, one's nightmares, one's fears and most importantly, the crises of ones subconscious are the worlds Marc Davet has chosen to paint.
(See page 83)

DAVID, MICHAEL (1954 - present)
b. Reno, Nevada

Michael David is represented in numerous public collections, including the Metropolitan Museum of Art and Jewish Museum in New York, Museum of Contemporary Art in Los Angeles, Los Angeles County Museum of Art, The Houston Museum of Fine Arts, and The Ft Wayne Museum of Art. He has been awarded the Edward Albee Foundation Grant for three years, as well as a Guggenheim Fellowship and a grant from the National Endowment for the Arts. David has had a one-person exhibition at M Knoedler & Company annually since 1984. Other notable exhibitions include Michael David: Golem and Other Prints at The Metropolitan Museum of Art in 1988, as well as solo shows at Meredith Long Company in Houston. David's works have been included in group exhibitions at the Wetterling Gallery in Sweden, The Brooklyn Museum and The Jewish Museum. He presently lives and works in New York City, New York.
(See page 265)

DAVIDEK, STEFAN (1924 - present)
b. Flint, Michigan

Stefan Davidek, his wife Angela, and their four children presently live in Flint, Michigan. **Education:** Flint Inst of Art, under Jaroslav Brozik; Art Students League, NYC, under Morris Kantor & Howard Trafton; Cranbrook Academy of Art, under Fred Mitchell. **Teaching Experience:** Flint Inst of Art, MI; Haystack School, Deer Isle, ME; Tadlow Gallery, MI; Wayne State Univ, Detroit, MI. **Selected Solo Exhibitions:** Detroit Inst of Arts; Flint Inst of Art; Whitehall, MI; Tadlow Gallery of Fine Art, MI; Hackley Gallery, MI; Univ of Omaha, NB; Univ of ME; Albion College; DeGraaf Forsythe Galleries, Ann Arbor, MI & Chicago, IL. **Selected Awards:** Flint Inst of Art, 48, 50, 53, 55, 57, 60, 66, 68, 71, 73, 76, 78; Louise Keeler Award, Grand Rapids, MI, 56; Founders Award, Detroit Inst of Arts, 61, 72, 79; Lou Maxon Award, DIA, 61, 78; MI Annual, 66-67, 74, 76, 79.
(See page 84)

DAVIS, MICHAEL (1948 - present)
b. Los Angeles, California

Selected Solo Exhibitions: The Works Gallery, NYC, 88, 90; Karl Bornstein Gallery, Santa Monica, CA, 89; **Solo Installations:** Torches, United Federal Savings, Brea, CA, 88; CA State Univ, Long Beach, CA, 88; Grand Promenade, LA, CA, 88; Laguna Art Museum, Laguna Beach, CA, 88. **Installations in Progress:** Pacific Place, co-design with Nadel Architects, 90; Howard Hughes Parkway Project, Las Vegas, NV, 91; Federal Building, LA, 91; Moscone Convention Center, LA, 91; Metro Red Line, Vermont/Sunset Station, LA, CA, 91. **Selected Group Exhibitions:** The Works Gallery, Long Beach, CA, 87; Gallery at the Plaza, Security Pacific Corp, LA, 89; FHP Hippodrome Gallery, Long Beach, CA, 89; Muckenthaler Cultural Center, Fullerton, CA, 89; The Armory Show, Pasadena, CA, 90; Contemp Artists Services, LA, CA, 91. **Selected Collections:** Newport Harbor Art Museum, Newport Beach, CA; Albuquerque Art Museum, NM; CA State Univ, LA, CA. **Selected Awards:** NEA, Artists' Fellowship, 80, 86; Hand Hollow Foundation Artists' Fellowship.
(See page 319)

DAVY, WOODS (1949 - present)
b. Washington, DC

Education: St Albans School, Wash, DC, 68; Univ of NC, Chapel Hill, 72, BFA; Univ of IL, Champaign-Urbana, 75, MFA. **Selected Solo Exhibitions:** Thomas Babeor Gallery, La Jolla, CA, 89; The Works Gallery, Long Beach, CA, 90; Art in Public Buildings, CA Arts Council, CA State Univ, Fresno, 88; Art in Public Spaces, Nat'l Travelling Exhibition, 88; Art in the Parks, Beverly Hills, CA, 89; The Works Gallery, Long Beach, CA, 89; Fourth Biennial Art Auction, MOCA, LA, 90. **Selected Collections:** ARCO Sculpture Garden, American Film Inst, LA, CA; CA State Univ, Long Beach; Tishman West Inc, LA, CA. **Selected Bibliog:** Angeles Magazine, Sept 88; Art Talk, Jan 90; Long Beach Press-Telegram, May 90. **Large-Scale Outdoor Selected Commissions:** Edward J DeBartolo Corp, Desert Plaza, Palm Springs, CA, 87; Cranston Securities, Wash, DC, 87; Sookie Goldman Nature Center, WODOC, Beverly Hills, CA, 90. **Selected Awards:** Cedars Sinai Hospital, Art Advisory Committee, LA, CA, 86; Los Angeles County Museum of Art, Art & Architecture Tour, 89; Cultural Affairs Grant, City of LA, CA, 89-90.
(See page 320)

DeCREDICO, ALFRED (1944 - present)
b. Providence, Rhode Island

Education: Rhode Island School of Design, Providence, 66, BFA. **Teaching Experience:** Providence College, RI, 69; Harvard Univ Dept of Visual & Environmental Studies, Cambridge, MA, 85-88; RI School of Design, Providence, 81-present. He presently lives and works in Providence, Rhode Island. **Selected Solo Exhibitions:** Elise Meyer Gallery, NYC, 80, 84, 87; Levinson Kane Gallery, Boston, MA, 90; Reynolds Gallery, Pittsburgh, PA, 91; Betsy Rosenfeld Gallery, Chicago, IL, 90-91; Scott Alan Gallery, NYC, 91; Galerie Sigma, Vienna, Austria, 91; Galerie Sechzig, Feldkirch, Austria, 91. **Selected Group Exhibitions:** Betsy Rosenfeld Gallery, Chicago, IL, 90; Galerie Sigma, Vienna, Austria, 90; Boston Center for the Arts, MA, 91; Levinson Kane Gallery, Boston, MA, 91. **Selected Collections:** AK Art Center; Emerson Museum; LA County Museum, CA; DeCordova Museum; Worcester Art Museum. **Selected Awards:** Visiting Artist Mirmar Sinan Univ, Istanbul, Turkey, 88; Faculty Dev Grant, RISD, 89, 90; New England Foundation for the Arts Fellowship, 90; Rockefeller Foundation Fellowship/Bellagio Study & Conference Center, Bellagio, Italy, 90; Blanche E Colman Foundation, 91.
(See page 85)

DeJONG, CONSTANCE (1950 - present)
b. California

Education: Bowling Green State Univ, OH, 72, BA in Education; Univ of NM, Albuquerque, 75, MA; 81, MFA. **Selected Solo Exhibitions:** Jonson Gallery, Univ of NM, 89; Linda Durham Gallery, Santa Fe, NM, 81, 83, 85, 87, 89. **Selected Group Exhibitions:** Invitational, Armory for the Arts, Santa Fe, NM, 88; Return of the Soul to the World, Kimo Gallery, Albuquerque, NM, 89; Five New Painters, John Davis Gallery, NYC, 89; Recent Acquisitions, Museum of NM, Santa Fe, 90; New Acquisitions, l,982-90, Jonson Gallery, Univ of NM, Albuquerque, 90; Double-Vision, Colon Gallery & Linda Durham Gallery, Santa Fe, NM, 91; Spiritual Objects, The Works Gallery, Long Beach, CA, 91; Singular Visions, Museum of NM, Santa Fe, 91; The Plane Truth, Mulvane Art Museum, Washburn Univ, Topeka, KS, 91. **Selected Collections:** Albuquerque Museum, NM; Fine Arts Museum, Univ of NM, Albuquerque; NM Museum of Fine Arts, Santa Fe; Ciao, Albuquerque, NM; Baker & Botts, Houston, TX. **Selected Bibliog:** Timothy App & Constance DeJong, ARTnews, William Peterson, Jan 88; Galleries-SoHo, The New Yorker, Lisa Leidman, June 19, 89; Constance DeJong, Artspace, William Peterson, Nov/Dec 90. **Selected Awards:** Research Grant, Univ of NM, Albuquerque, 80; NEA Visual Artist Fellowship, Wash, DC, 82.
(See page 321)

DeLAP, TONY (1927 - present)
b. Oakland, California

Education: Menlo Jr College, CA; Claremont Graduate School. **Selected Solo Exhibitions:** Janus Gallery, LA, CA, 79, 81, 83, 85; Klein Gallery, Chicago, IL, 85; Modernism, SF, CA, 86, 89, 92; The Works Gallery, Long Beach, CA, 86, 89, 91-92; Jan Turner Gallery, LA, CA, 87, 89, 91; Allene LaPides Gallery, Santa Fe, NM, 92. **Selected Group Exhibitions:** Finish Fetish: LA's Cool School, Univ of S CA, 91; Constructive Concepts, Ersgard Gallery, Santa Monica, CA, 91; Living With Art Three, Miami Univ Museum, Oxford, OH, 91; Beginning the Decade, Laguna Art Museum, Laguna Beach, CA, 91; Abstract Paintings, Modernism, SF, CA, 91; Dialog, John Wayne Airport, Orange Co, CA, 91; Museum of Modern Art, NYC; Whitney Museum of American Art, NYC; Tate Gallery, London, England; Guggenheim Museum, NYC. **Outdoor Sculptures:** City of Santa Monica, CA; Univ Towers, The Marketplace, Irvine, CA; Pacific Mutual Plaza, Newport Beach, CA; LA Int'l Airport, CA; City of Inglewood, CA. **Selected Bibliog:** Reviews, USA, Flash Art, Alfred Jan, April 87; Magic & Precision, Artweek, Jamie Brunson, Jan 87; Tony DeLap & The Floating Lady, VARI Studios, AZ State Univ, 88; Art for the Public, Dayton Art Inst, OH, Mar 88; Tony DeLap/Paintings, Drawings, Prints, Modernism, Peter Frank, Feb 89. **Selected Awards:** Centinela Gateway Competition winner; NEA Painting Fellowship of $25,000, 83; LA Dept of Airports, Statewide Sculpture Comp, first prize, 76.
(See page 322)

De MARIA, WALTER (1935 - present)
b. Albany, California

Education: Univ of CA, Berkeley, 53-59, BA in History; MA in Art. From 1960 he has lived in New York City, New York. **Selected Solo Exhibitions:** Dia Art Foundation, NYC, 79-80; Centre Georges Pompidou, Paris, 81-82; Museum Boymans-van Beuningen, Rotterdam, The Netherlands, 84-85; Arthur M Sackler Museum, Cambridge, MA, 86; Xavier Fourcade Inc, NYC, 86; Staatsgalerie, Stuttgart, W Germany, 87-88; Magasin 3, Stockholm Konsthall, Stockholm, Sweden, 88; Moderna Museet, Stockholm, 89; Daimler-Benz, Nat'l Assembly, Paris, 89; Gagosian Gallery, NY, 89; 65 Thompson Street, NYC, 89. **Selected Group Exhibitions:** Zeitlos, Berlin, W Germany, 88; Viewpoints: Postwar Painting, Solomon R Guggenheim Museum, NYC, 88; Artificial Nature, Deste Foundation for Contemp Art, Greece, 90; Pharmakon '90, Nippon Conventional Center, Makuhari Messe, Tokyo, 90; POWER: Its Myths, Icons & Sculptures, Indianapolis Museum of Art, 91, travelled. **Selected Awards:** Guggenheim Fellowship, 69; Mather Sculpture Prize, 72nd Annual Exhibition, Art Inst of Chicago, 76; Int'l Prize for Fine Arts, State of Baden-Wurtemberg, W Germany, 86.
(See page 323)

CLOSE, CHUCK
(1940 - present)
b. Monroe, Washington

Chronology: Univ of WA, Seattle, 58-62, BA; Yale Univ School of Art & Architecture, New Haven, CT, 63, BFA; 64, MFA, 62-64; Akademie der Bildenen Kunste, Vienna on Fulbright Grant, 64-65; moved to NYC, 67; solo show, Bykert Gallery, NYC, 70; first solo show, Chuck Close: Recent Work, Pace Gallery, NYC, 77; retrospective at Walker Art Center, Minneapolis, MN, 80-81, travelled; Artist's Choice, Chuck Close: Head-On/The Modern Portrait, Museum of Modern Art, NYC, 91, travelled; Skowhegan Arts Medal, Skowhegan School of Painting & Sculpture, ME, 91; Academy-Institute Award from American Academy & Inst of Arts & Letters, NYC, 91.
(See page 75)

COLE, JOHN
(1936 - present)
b. London, England

Education: Pratt Inst, NYC, 55-58; 62-64; Pasadena City College, CA, 65-68. Selected Solo Exhibitions: Chehalis Library Museum, WA, 74; Magnolia Gallery, Bellingham, WA, 78; Chrysalis Gallery, Western Washington Univ, Bellingham, WA, 84; Roeder Home Gallery, Bellingham, WA, 85; Blue Horse Gallery, Bellingham, WA, 87-88, 90; Lisa Harris Gallery, Seattle, WA, 89, 91. **Selected Group Exhibitions:** Olympia Museum, WA, 74-75; Tacoma Museum, WA, 74, second prize; Frye Museum, Seattle, WA, 75; Whatcom Museum of History & Art, Allied Arts, Bellingham, WA, 85, 87; Jackson St Gallery, Seattle, WA, 87; Index Gallery, Clark College, Vancouver, WA, 87; Alonso/Sullivan Gallery, Seattle, WA, 87; Anacortes Art Gallery, WA, 88; Mercer Island Comm Center for Art, WA, 90; Seattle Art Museum, WA, 91.
(See page 76)

COLEMAN, JUDY
(1944 - present)
b. New York City, New York

Education: Cornell Univ, Ithaca, NY, 66, BA; Univ of CA, LA, 83, MFA. She presently lives in Venice, California. **Teaching Experience:** Teaching Asst, UCLA Dept of Art, 82-83; Instructor, Univ of CA, LA, Extension, 84-86. **Selected Solo Exhibitions:** G Ray Hawkins Gallery, LA, CA, 87, 89; Fay Gold Gallery, Atlanta, GA, 88; Laguna Museum of Art, Laguna Beach, CA, 89; Parco Gallery, Tokyo, Japan, 90; Fogg Art Museum, Harvard Univ, Print Room, Cambridge, MA, 91. Duo Exhibitions: Judy Coleman & Barbara Norfleet, Houston Center for Photography, TX, 84; Judy Coleman & Vladimir Zidlicky, Robert Koch Gallery, 88. **Selected Group Exhibitions:** The Photography of Invention, Nat'l Museum of Amerian Art, Smithsonian Institution, Wash, DC & Walker Art Center, Minneapolis, MN, 89; Recent Acquistions, G Ray Hawkins Gallery, Santa Monica, CA, 90; Art 21 '90, Basel, Switz, curated by Joshua Smith, 90. **Selected Collections:** Newport Harbor Art Museum, Newport Beach, CA; Laguna Museum of Art, Laguna Beach, CA; Grunwald Center for the Graphic Arts, Univ of CA, LA; Seattle Art Museum, WA. **Selected Bibliog:** Eight Visions: Works by Eight American Women, Parco Co Ltd, Tokyo, Japan, 88; Judy Coleman, Elaine Dines-Cox, Twin Palms Publishers, Altadena, CA, 89; The Photography of Invention: American Pictures of the '80's, Walker Art Center Calendar & Newsletter, July/Aug 90. **Selected Awards:** NEA, Fellowship Grant, Wash, DC, 84-85, 88-89.
(See page 380)

COLESCOTT, ROBERT
(1925 - present)
b. Oakland, California

Education: Univ of CA, Berkeley, 49, BA, MA; Student of Fernand Leger, Paris, France, 49-50. **Selected Collections:** Metropolitan Museum of Art, NYC; Museum of Modern Art, NYC; Museum of Fine Arts, Boston, MA; High Museum of Art, Atlanta, GA; Seattle Art Museum, Wash, DC; San Francisco Museum of Modern Art, CA; Denver Art Museum, CO; Oakland Art Museum, CA; Portland Art Museum, OR.
(See page 77)

COLVILLE, ALEX
(1920 - present)
b. Toronto, Canada

Alex Colville received a BFA from Mount Allison Univ, NB, in 1942. He then served in the Canadian Army from 1942-46, acting as Official War Artist from 1944, then taught at Mount Allison Univ as a professor from 1946-1963. Alex holds eight honorary degrees and from 1981-91, was Chancellor of Arcadia Univ, Wolfville, NS, the Officer of the Order of Canada in 1967 and Companion in 1982. His first solo show was at the New Brunswick Museum in 1951, with numerous subsequent showings. Hewitt and Banfer Galleries, New York, in 1953, 1955 and 1963 exhibited solo showings. The Marlborough Fine Art and Fischer Fine Art, London, were shown in 1970 and 1977. Kunsthalle, Dusseldorf and Gemeentemuseum, Arnhem included exhibits in 1977 as well. Retrospective 1983-84 at the Art Gallery of Ontario, Toronto; Montreal Museum of Fine Arts; Dalhouise Univ, Halifax; Vancouver Art Gallery; Staatliche Kunsthalle, Berlin; Museum Ludwig, Cologne were included. 1984-85 exhibition to Bejing Exhibition Hall, Univ of Hong Kong; and Teien Museum, Tokyo; Canada House, London. An exhibition of new and recent paintings at The Drabinsky Gallery, Toronto in October 1991.
(See page 79)

CONE, DAVIS
(1950 - present)
b. Augusta, Georgia

Selected Solo Exhibitions: OK Harris Works of Art, NYC, 79, 81, 82, 84, 88. **Selected Collections:** New Orleans Museum of Art, LA; High Museum of Art, Atlanta, GA. **Selected Bibliog:** In Sharp Focus: Super-Realism, Nassau County Museum of Art, Roslyn, NY; Introduction: Constance Schwartz, 91; Davis Cone: Theatre Paintings 1977-1983, Georgia Museum of Art, University of Georgia, Athens, GA; Essay: Linda Chase, 83; Hollywood on Main Street, The Movie House Painting of Davis Cone, Linda Chase, Overlook Press, Woodstock, NY, 88.
(See page 80)

CONNELL, JOHN
(1940 - present)
b. Atlanta, Georgia

Education: Brown Univ, Providence, RI, 58-60; Art Students' League, NYC, 60-61; NY Univ, NYC, 62. **Selected Solo Exhibitions:** Upstream Installation Statements..., State Fair Fine Arts Gallery, Albuquerque, NM, 85; Study for Creature Storage Shed IV, Installation, Conlon Grenfell Gallery, SD, CA, 86; Sneaking Up Thru High Grass, Installation, Linda Durham Gallery, Santa Fe, NM, 86; Kwan-Yin's Winter Garden, Linda Durham Gallery, NM, 87; Gone Fishing, Graham Modern, NYC, 87; 23 Waterbirds, Phoenix Biennial, AZ, 87; Seed Room, Installation, Linda Durham Gallery, Santa Fe, NM, 88. **Selected Group Exhibitions:** Erotica, Shidoni Gallery, Tesuque, NM, 87-88; The Raft Project, Blue Star Art Space, San Antonio, TX, 89; LA Int'l Contemp Art Expo, CA, 86-89; Chicago Int'l Art Expo, IL, 86-90; The Raft Project, Center for Contemp Arts, Santa Fe, NM, 90. **Selected Collections:** Museum of NM, Santa Fe; Metropolitan Museum of Art, NYC; Modern Art Museum of Ft Worth, TX. **Selected Awards:** The Construction of Kwan-Yin Lake, NM Arts Division Grant, Office of Cultural Affairs, NM, 85; The Construction of Kwan-Yin Lake, Inter-Arts Program Grant, NEA, 86.
(See page 316)

COOPER, JUDITH
(1938 - present)
b. Memphis, Tennessee

Judith Cooper has been a resident of New Orleans for many years. She attended Newcomb College and did graduate work at Tulane University. After receiving a PhD from Tulane, she taught French Language & Literature, did a brief stint as a photojournalist with a local weekly newspaper before embarking on a career in photography. Since then, she has taught photography classes at the Metro College division of the University of New Orleans as well as working as a freelance commercial photographer. Her work consists of hand colored black and white pieces featuring the colorful people and architecture of New Orleans has been included in numerous local and national exhibitions. In 1990 the New Orleans Museum of Art added Cooper's work to their 'Louisiana Collection'.
(See page 381)

COPLANS, JOHN
(1920 - present)
b. London, England

Selected Solo Exhibitions: Centre de Kerpape, Ploemeur, 88; Sala d'Exposiciones de la Fundacio Caixa de Pensions, Barcelona, Spain, 88; Galerie Lelong, Paris, France, 89; Blum/Helman Gallery, LA, CA, 89; Dart Gallery, Chicago, IL, 89; Musee de la Veille Charite, Marseille, France, 89; Salon d'Angle de la Regionale des Affaires Culturelles, Nantes, France, 89; Galeria Comicos, Luis Serpa, Lisbon, Portugal, 90; Boymans Museum, Rotterdam, The Netherlands, 90; Liverpool Gallery, Bruxelles, Belgium, 91; Galerie Lelong, NYC, 90-91; Howard Yezerski Gallery, Boston, MA, 92. **Selected Group Exhibitions:** The 2nd Israeli Photography Biennale, Mishkan Le'Omanut Museum of Art, Ein Harod, 88; Recent Acquisitions, Salon Decouvertes, Grand Palais, Paris, France, 90; The Decade Show, Museum of Contemp Hispanic Art, NYC, 90; Je est un Autre, Galeria Comicos, Lisbon, Portugal, 90; Biennial, Whitney Museum of American Art, NYC, 91.
(See page 382)

CRENSHAW, MELISSA
(1950 - present)
b. Kansas City, Kansas

DINSMORE, SYDNEY
(1957 - present)
b. Geneva, Switzerland

The recent multichannel image from the Choice and Circumstance series of holographic works reveals animated effects as the viewer moves back and forth. "The gentle shifting or alteration of the figure represents the variation or changes that we experience as we consider alternatives, choices, or perhaps, just a change in our point of view." Melissa Crenshaw is an artist who has been working with holography for over a decade. She is the Director of The Holographic Studio in Vancouver. Melissa has recently been honoured with the prestigious Sheerwater Award for her distinguished work using holography. Sydney Dinsmore is a Canadian artist with a strong curatorial background. She has served as the Director of the Interference Gallery in Toronto, and the Associates of the Museum of Holography in New York.
(See page 288)

CRIBBS, KE KE
(1951 - present)
b. Colorado Springs, Colorado

Ms Cribbs was schooled in Ireland, travelled in Europe, and lived on the island of Corsica for six years. She is a self-taught artist. **Selected Collections:** Los Angeles County Museum of Art, CA; Corning Museum of Glass, NY; Albuquerque Museum, NM; Kitazawa Museum, Japan; James Copley Library, CA.
(See page 317)

DAILEY, DAN
(1947 - present)
b. Philadelphia, Pennsylvania

Education: Philadelphia College of Art, 68, BFA; Rhode Island School of Design, Providence, 72, MFA. **Current Position:** Head of Glass Program, Massachusetts, College of Art, Boston; Independent artist/designer, Cristallerie Daum, Paris & Nancy, France; Advisor, New York Experimental Glass Workshop, NY Board of Trustees, The Haystack Mountain School of Craft, Deer Isle, ME; Designer, Fenton Art Glass Co, Williamstown, WV; Independent studio artist residing in Amesbury, MA. **Selected Collections:** American Craft Museum, NYC; Boston Museum of Fine Arts, MA; High Museum of Art, Atlanta, GA; Huntington Galleries, WV; Kestner Museum, Hannover, W Germany; Les Archives, Cristallerie Daum, Nancy, France; Los Angeles County Museum, CA; Musee des Arts Decoratifs, Palais du Louvre, Paris, France; Nat'l Gallery of Victoria, Melbourne, Australia; Nat'l Museum of Modern Art, Kyoto, Japan; New Indian Museum, Flagstaff, AZ; Philadelphia Museum of Art, PA; Brockton Art Museum, MA; Corning Museum of Glass, NY; Metropolitan Museum of Art, NYC; Smithsonian Institution, Wash, DC; Univ Museums, IL State Univ, Normal.
(See page 318)

CAPORAEL, SUZANNE (1949 - present)
b. Brooklyn, New York

A native of Brooklyn, New York, Suzanne Caporael received her MFA in 1979 from Otis Art Inst in Los Angeles, California. Caporael's paintings are included in the permanent collections of The Carnegie Museum of Art, The Art Inst of Chicago and the Los Angeles County Museum of Art, as well as the Newport Harbor Museum of Art and the Los Angeles Museum of Art, where she has also received one-woman exhibitions. Caporael's paintings are conceptual puzzles, teasing both the physical eye and the mind's eye. She combines the contradictory styles of painterly landscapes with cartoonish symbolism, creating an appealing yet obscure effect. She complicates matters further by giving the pieces provocative titles, causing word and image to play off of one another. The meaning of the pieces centers on the artists interest in the relationship between culture and nature.
(See page 68)

CARBONELL, MANUEL (1918 - present)
b. Santi Spiritus, Cuba

Manuel Carbonell graduated from the Academia de Bellas Artes de San Alejandro where he studied under Jose Sicres, a former pupil of Bourdelle. Later, he travelled and studied in Europe. His early period is characterized by religious sculptures in marble and stone. In 1954, he won his first International Award at the Biennial Hispano-Americana de Arte Internacional. In 1959, he arrived in exile in New York and begins to achieve that special distortion and exaggeration of the human body which distinguishes his work. In 1961, Carbonell starts experimenting with metal and bronze castings. This results in bold and powerful forms, where the human anatomy is refined to its essence. We see in his work the influence in the anatomy and force of Rodin, the monumentality of Moore and the plastic simplicity of Maillol, yet, the work is set apart by the originality of his creations, the uniqueness of his interpretations and the sense of universal beauty that he imparts to his work.
(See page 312)

CARO, ANTHONY (1924 - present)
b. New Malden, Surrey, England

Education: Charterhouse School, Farnborough, Hampshire, 37-42; Christ's College, Cambridge, 42-44; Regent Street Polytechnic, London, 47-52; Royal Academy Schools, London, 47-52. **Selected Solo Exhibitions:** Andre Emmerich Gallery, NYC, 88-89; Sylvia Cordish Fine Arts, Baltimore, MD, 88; Elisabeth Franck Gallery, Knokke-le-Zoute, Belgium, 88; Galerie Entzel, Cologne, W Germany, 88; Richard Gray Gallery, Chicago, IL, 89; Meredith Long & Co, Houston, 89; JGM Galerie, Paris, France, 89; C Grimaldis Gallery, Baltimore, MD, 89; Rutgers Barclay Gallery, Santa Fe, NM, 89; Annely Juda Fine Art, London, 89; Sala de Exposiciones del Banco Bibao Vizcaya, Barcelona, 89; Kathleen Laverty Gallery, Edmonton, 89; Walker Hill Art Gallery, Seoul, Korea, 89; Knoedler Gallery, London, 89; Fluxus Gallery, Porto, Portugal, 89; Galeria Acquavella, Caracas, Venezuela, 89; Galerie Lelong, Paris, 90; Gallery One, Toronto, 82, 87, 90; Gallery Kasahara, Osaka, Japan, 90; Fuji TV Gallery, Tokyo, Japan, 90; Musee des Beaux Arts, Calais, France, 90. **Selected Collections:** Art Gallery of Ontario, Toronto; British Council, London; Tate Gallery, London; Wallraf-Richartz Museum, Cologne, W Germany; Israel Museum, Jerusalem; Ulster Museum, Belfast, Ireland; Walker Art Center, Minneapolis, MN; Museum of Fine Arts, Boston, MA; Museum of Fine Arts, Dallas & Houston, TX. **Selected Awards:** Univ of Surrey, England, Honorary Degree, 87; appointed Knight's Bachelor, Queen's Birthday Honours, 87; American Academy of Arts & Sciences, Honorary Member, 88; Yale Univ, CT, Honorary Degree, 89.
(See page 313)

CASTANIS, MURIEL (1926 - present)
b. New York City, New York

Selected Solo Exhibitions: Context and Collaboration: The Sculptural Program for 580 California Street, SF, CA, Trout Gallery, Dickinson College, Carlisle, PA, 86. **Selected Group Exhibitions:** Art at the Gateway Center, Prudential Art Program, Newark, NJ, 90. **Selected Bibliog:** Post-Modernism: The New Classicism in Art and Architecture, Charles Jenks, Rizzoli Publications, 88; American Artists, Krantz Company Publishers, Chicago, IL, 90; New Art in an Old City, The Virlane Foundation and The K&B Corporation Collections, New Orleans, LA. **Selected Commissions:** Sculptures for 580 California Street, SF, CA; John Burgee Architects with Philip Johnson (completed 84), 83; Prudential Life Insurance Company, Newark, NJ, 88.
(See page 314)

CASTELLI, LUCIANO (1951 - present)
b. Lucerne, Switzerland

Luciano Castelli presently works and lives in Paris and Montepulciano, Italy. He began painting at the age of twenty when he became involved with a group of Lucerne artists called The Medici. Moving to Berlin in the late 70's Castelli became a prominent member of the Studio im Moritz Platz collective and is often associated with Neue Wilde Neoexpressionists such as Fetting and Salome. Castelli has been seen in the US in important exhibitions at the Museum of Modern Art, New York and the Hirshhorn Museum & Sculpture Garden in Washington, DC. A documentor of his own rich fantasy life, Castelli has painted a variety of exotic scenarios featuring himself accompanied by an entourage of sensuous women from all over the world. Both in his paintings and his woodcuts, Castelli uses broad strokes of brilliant color against his simple and expressively rendered figures.
(See page 69)

CHAET, BERNARD (1924 - present)
b. Boston, Massachusetts

Education: School of the Museum of Fine Arts, Boston & Tufts Univ, 42-47. **Selected Solo Exhibitions:** Stable Gallery, NYC, 59-67; Forum Gallery, NYC, 75; Delaware Art Museum, 82; J Rosenthal Fine Arts, Chicago, IL, 86-89; Marilyn Pearl Gallery, NYC, 77-89; Boston Public Library, 90-92, travelled; Alpha Gallery, Boston, MA, 68-91. **Selected Group Exhibitions:** Inst of Contemp Art, Boston, MA, 57; Corcoran Gallery of Art, Wash, DC, 62; Museum of Modern Art, NYC, 66; Yale Univ Art Gallery, 82; Univ of NC, 83; Hudson River Museum, Yonkers, NY, 84; Nat'l Academy of Design, NYC, 86; Hirshhorn Museum & Sculpture Garden, Wash, DC, 89. **Selected Collections:** Addison Gallery of American Art; Boston Public Library, MA; Brooklyn Museum, NY; DeCordova Museum; Fogg Art Museum at Harvard Univ, MA; Hirshhorn Museum & Sculpture Gardens, Wash, DC; Museum of Fine Arts, Boston, MA; Rose Art Museum; Worcester Art Museum; Yale Univ Art Gallery, New Haven, CT.
(See page 70)

CHE, CHUANG (1934 - present)
b. Peking, China

Education: Taiwan Normal Univ, 58. Teaching Experience: Prof of Art, Tunghai Univ, Taiwan. Chuang Che presently lives in Yonkers, NY. **Selected Solo Exhibitions:** Lung Man Gallery, Taipei, Taiwan, 78-80, 82, 84; Sather Gate Gallery, Berkeley, CA, 77; Freeman Gallery, East Lansing, MI, 79; Nat'l Museum of History, Taipei, Taiwan, 80; Robert Kidds Gallery, Birmingham, MI, 83; 83; Louis Newman Gallery, Beverly Hills, CA, 83; Hui Arts, Minneapolis, MN, 83; Art Center, Hong Kong, 83; Detroit Art Council, MI, 84. **Selected Group Exhibitions:** Kalamazoo Inst of Art, MI State Univ Krasage Art Center, 84-85; Contemp Art, China & Greece, Rodi KarKazis Gallery, Chicago, IL, 84; Overseas Chinese Artists, Taipei Art Museum, Taiwan, 84. **Selected Collections:** Chinese Cultural Center, NY; MA Inst of Technology, Boston; Nat'l Historical Museum, Taiwan.
(See page 71)

CHIHULY, DALE (1941 - present)
b. Tacoma, Washington

Selected Collections: Albright-Knox Gallery, Buffalo, NY; American Craft Museum, NYC; Australian Nat'l Gallery, Canberra; Boston Museum of Fine Arts, MA; Cooper-Hewitt Museum, The Smithsonian Institution's Nat'l Museum of Design, NY; Corning Museum of Glass, NY; Chrysler Museum, Norfolk, VA; Dallas Museum of Fine Arts, TX; Denver Art Museum, CO; The Detroit Inst of Arts, MI; Fine Arts Museum of the South, Mobile, AL; High Museum of Art, Atlanta, GA; Honolulu Academy of Arts, HI; Indianapolis Museum of Art, IN; JB Speed Art Museum, Louisville, KY; LA County Museum of Art, CA; Metropolitan Museum of Art, NYC; Musee des Arts Decoratifs, Paris; Museum of Art, Carnegie Inst, Pittsburgh; Museum of Art, Rhode Island School of Design, Providence; Museum of Modern Art, NYC; Museum Bellerive, Zurich, Switz; Museum of Contemp Art, Chicago, IL; Museum fur Kunst und Gewerbe, Hamburg, W Germany; Renwick Gallery, Nat'l Museum of American Art, Wash, DC; Nat'l Museum of Modern Art, Kyoto, Japan; New Orleans Museum of Art, LA; Newport Harbor Art Museum, CA; Philadelphia Museum of Art, PA; Phoenix Art Museum, AZ; Princeton Univ Art Museum, NJ; St Louis Art Museum, MO; San Francisco Museum of Modern Art, CA; Seattle Art Museum, WA; Toledo Museum of Art, OH; Tucson Museum of Art, AZ; Victoria & Albert Museum, London, England; Wadsworth Atheneum, Hartford, CT; Yale Univ Art Museum, New Haven, CT.
(See page 315)

CHISMAN, DALE (1943 - present)
b. Denver, Colorado

Education: Yale Univ, New Haven, CT, 64; Univ of CO, 63-65, BFA; 67-69, MFA; Royal College of Art, London, 66. **Selected Solo Exhibitions:** The Once Gallery, NYC, 75; Paintings, Cyndey Payton Gallery, Denver, CO, 88; New Paintings, Sena Galleries West, Santa Fe, MN, 91; Paintings 1990-91, Payton Rule Gallery, Denver, CO, 91. **Selected Group Exhibitions:** Six Painters, Brooklyn Museum, NY, 72; New Images, Martha Jackson Gallery, NYC, 73; New Acquisitions, Martha Jackson Gallery, NYC, 75; Contemp Western Artists, Robischon Gallery, Denver, CO, 87; Colorado: State of the Art, Co Springs Fine Arts Center, CO, 89; Colorado 1990, Denver Art Museum. **Selected Collections:** American Can Corp, Greenwich, CT; Chase Manhattan Bank, NYC; Chemical Bank, NYC; Nat'l Museum of American Art, Wash, DC; Denver Art Museum, CO; US West Communities Inc, Denver, CO. **Selected Awards:** MacDowell Colony Fellowship, 75; Colorado Council on the Arts & Humanities, 88-89.
(See page 72)

CHRISTO (1935 - present)
b. Gabrovo, Bulgaria (Christo Javacheff)

Education: Fine Arts Academy, Sofia, 52-56; Vienna Fine Arts Academy, Austria, 57. **Projects:** Packages and Wrapped Objects, 58; Project for the Packaging of a Public Building, 61; Iron Curtain Wall of Oil Barrels, 62; Store Fronts, NYC, 64; Packaged Museum of Contemp Art, Chicago, IL, 69; Wrapped Reichstag, Project for Berlin, 72; The Wall, Rome, 74; Running Fence, Sonoma & Marin Counties, CA, 76; Surrounded Islands, Biscayne Bay, Greater Miami, FL, 80-83; The Umbrellas, Project for Japan & Western USA, 85-present.
(See page 264)

CLEARY, MANON (1942 - present)
b. St Louis, Missouri

Education: Washington Univ, St Louis, MO, 64, BFA; Tyler School of Art, Philadelphia, PA, 68, MFA; Univ of Valencia, Spain, Corcoran School of Art, Washington, DC. **Selected Solo Exhibitions:** Tyler School of Art, Philadelphia, PA, 68; Franz Bader Gallery, Washington, DC, 72; Pyramid Gallery, Wash, DC, 74, with subsequent shows in 77 & 79; AJ Wood Gallery, Philadelphia, PA, 79; Osuna Gallery, Wash, DC, 80, with subsequent shows in 84 & 89; FAIC, Paris, France, 81; Iolas/Jackson Gallery, NYC, 82; Gulbenkian Foundation, Lisbon, Portugal, 85; Univ of District of Columbia, Wash, DC, 87; Tyler Gallery, State Univ of NY, Oswego, NY, 87. **Selected Collections:** Art Inst of Chicago,IL; Utah Museum of Fine Arts, Salt Lake City, UT; Nat'l Museum of Women in the Arts, Wash, DC; Mint Museum, Charlotte, NC; Corcoran Gallery of Art, Wash, DC; Tyler Gallery, State Univ of NY, Oswego; Rutgers Univ, Camden, NJ; Brooklyn Museum, NY.
(See page 73)

CLEMENTE, FRANCESCO (1952 - present)
b. Naples, France

He presently lives and works in Rome, Madras and New York. **Selected Solo Exhibitions:** Milwaukee Art Museum, 88, travelled; Cabinet des Estampes, Promenade du Pin, Geneva, Switz, 88; Museum of Contemp Art, Chicago, IL, 88; Mario Diacono Gallery, Boston, MA, 88; Fundacio Joan Miro, Parc de Montjuic, Barcelona, 88; Paul Maenz Gallery, Cologne, W Germany, 88; Dia Art Foundation, NYC, 88; Anthony d'Offay Gallery, London, 88, 89; Yvon Lambert, Paris, 88; Dia Art Foundation, Bridgehampton, NY, 88; Centro Cultural Arte Contemporaneo, Mexico, 89; Salvador Riera Galeria D'Art, Barcelona, 89; Vrej Baghoomian Gallery, NYC, 89; Sperone Westwater Gallery, NYC, 90; Philadelphia Museum of Art, PA, 89, travelled; Dolan/Maxwell, Philadelphia, PA, 90; Kunsthalle, Basel, Switz, 91; Perry Rubenstein, NYC, 91; Kunstmuseum Basel, Museum fur Gegenwartskunst, Switz, 91; Galerie Beyeler, Basel, 91. **Selected Group Exhibitions:** Phillipe Daverio Gallery, NYC, 91; Lorence Monk Gallery, NYC, 91; Brooke Alexander Editions: NYC, 91; Texas Gallery, Houston, 91; Jablonka Galerie, Cologne, W Germany, 91; Robert Miller Gallery, NYC, 91; Galerie Kaj Forsblom, Helinski, 91.
(See page 74)

BOYLE, JOHN B. (1941 - present)
b. London, Ontario

Education: Self-taught. **Selected Solo Exhibitions:** Latcham Gallery, Stouffville, 82; Tom Thomson Memorial Gallery, 83; Nancy Poole's Studio, Toronto, Ontario, 72-78, 81, 83-85, 89, 91; Susan Whitney Gallery, Regina, Saskatchewan, 86; London Regional Art Gallery, Ontario, travelled. **Selected Group Exhibitions:** London Regional Gallery, Ontario, 84; Concordia Univ, 84; Art Space, Peterborough, 86; Nancy Poole's Studio,Toronto, Ontario, 89; McIntosh Public Gallery, 89; Tom Thomson Gallery, 89. **Selected Collections:** The Nat'l Gallery of Canada; Art Gallery of Canada; London Regional Art Gallery, Ontario; Montreal Museum of Fine Arts. **Selected Bibliog:** Pavilions to Heroes, ArtsCanada, Michael Greenwood, July/Aug 81; John Boyle's Canadian Heroes, Metheum Pub Co Film, Dir: Janet Walczeska, 82; Canadian Forum, Scott Lauder, Feb, 82; Parachute, J Andreae, May 83; Vanguard, Oliver Girling, May 83. **Selected Grants:** Canada Council A Grant, 87. **Selected Awards:** New Queen St Subway Mural, commmissioned, porcelain on steel, 80; Ontario CAD/CAM commission of drawing to be transcribed on computer, 83; Suncor Commission, 84.
(See page 59)

BRADSHAW, GLENN (1922 - present)
b. Peoria, Illinois

Glenn Bradshaw studied at the Illinois State University where he earned a BS degree in 1947 and then at the University of Illinois where he received a MFA in 1950. Bradshaw is essentially a Midwesterner with combined careers as an artist and a Professor of Art at the University of Illinois. He is known for lyrical abstractions in casein tempera and collage. Bradshaw is a member of the American Watercolor Society, the National Watercolor Society and an Associate of the National Academy. He is a frequent juror for national and international exhibitions and a member of the Rocky Mountain National Watermedia Society and the Watercolor USA Honor Society. Bradshaw maintains studios in Central Illinois and Northern Wisconsin.
(See page 60)

BRITTO, ROMERO (1964 - present)
b. Brazil

Influenced by a marked heritage, Romero Britto has been painting since the age of 8, developing a style with a spirit uniquely his own which glows in each and every piece of work. With bright and exotic coloring, the works spontaneously express a lively curiosity and joie de vivre. The sense of newness in his work is more than just Britto's own originality, it is a reflection of the age he lives in, more specifically the apparent belief he has in progress—not just as art, but life and human kind. At the age of 16, Britto had his first public exhibitions at the Organization of the American States in the capital of Brazil, Brasilia. Since he has numerous exhibitions throughout South America, Europe and the US. Britto's canvases appear in the private collections of President George Bush, French President Francois Mitterand and the Queen of Sweden. Following the illustrious brushstrokes of Andy Warhol, Keith Haring & Ed Ruscha, 'Absolut Britto' ads started appearing nationally in November, 1990. The ad, a boldly outlined face sporting an Absolut Vodka as a hat and surrounded by trademark Britto symbols: hearts, flowers, musical notes and dollar signs, represents what the artist terms, "the good life: flowers, music, love." "Since everything in life moves toward one end, we should fill our life with color and hopes." This sentiment reflects Britto's view of art's effect on humanity. Britto has been living in the US since 1987, when an infatuation with the vibrant cultural atmosphere of Miami caused him to establish his residence and studio in S Florida.
(See page 61)

BRODSKY, EUGENE (1946 - present)
b. New York City, New York

Eugene Brodsky attended the New York Studio School and the Art Students League, NYC. Mr Brodsky has had seven one-person shows at OK Harris Works of Art in New York, 81-87. Mr Brodsky received a Tiffany Fellowship in 1977, a Guggenheim Memorial Foundation Fellowship in 1979, and another Guggenheim Memorial Foundation Fellowship in 1987. His work is a part of numerous prominent private collections as well as important public collections including the Metropolitan Museum of Art in New York, and the Power Art Gallery in Sydney, Australia. Eugene Brodsky is represented exclusively by OK Harris, Birmingham, MI.
(See page 62)

BROSK, JEFFREY (1947 - present)
b. Brooklyn, New York

Selected Solo Exhibitions: Max Hutchinson Gallery, NYC, 80-81, 83; Roanoke Museum of Fine Arts, VA, 85; Univ of MA, 87; Stephen Rosenberg Gallery, 88, 90, 92. **Selected Group Exhibitions:** Albright-Knox Gallery, Buffalo, NY, 79; Max Hutchinson Gallery, NYC, 82-85; McNay Art Inst, San Antonio, TX, 82; Sculpture Center, NYC, 84; Eight Artpark Projects, Toronto, Canada, 84; Virginia Beach Arts Center, VA, 86; Nina Freudenheim Gallery, Buffalo, NY, 86, 88; Stephen Rosenberg Gallery, NYC, 90-91. **Selected Installations:** Dag Hammarskjold Plaza, NYC, 79; Int'l Sculpture Conference, Oakland Museum, CA, 82; Artpark, NY, 83; Chicago Sculpture Int'l, Navy Pier, IL, 84; Connemara Foundation, Dallas, TX, 86; Fordham Univ/Lincoln Center, NY, 89. **Selected Bibliog:** Arts, Corrine Robins, Nov, 81; NY Times, John Caldwell, June 13, 82; NY Times, Grace Glueck, Dec 9, 83; Arts, Joan Marter, January 85 & Mar 87; NY Times, Michael Brenson, Dec 2, 88; Art in America, Stephen Westfall, April 89; NY Times, Vivian Raynor, July 8, 90; ARTnews, Dec 90.
(See page 309)

BROUWER, CHARLIE (1946 - present)
b. Holland, Michigan

"Each piece is symbolic. Through metaphor in art, I am able to make some connections between the world, mind and soul; between experience, imagination and faith. I want a direct link as an expression of physical and mortal freedom, and the idea that everybody has access to spiritual beliefs." **Education:** Grand Valley State Univ, 68, BA, English; Western MI Univ, Kalamazoo, 80, MA, Painting; 83, MFA, Sculpture. Teaching Experience: Sculpture Instructor, Western MI Univ, 85-86; Asst Prof of Art, Radford Univ, 87. **Selected Exhibitions:** Fetish Art: Obsessive Expressions, Rockford Art Museum, IL, 86; Southwestern MI Regional Comp, St Joseph, MI, 86, Best of Show Award; Battle Creek Art Center, MI, 87; Constructions, DeGraaf Fine Art Inc, Chicago, IL, 87; Kalamazoo Area Show, MI, 86-87; Rising: 1989, DeGraaf Fine Art Inc, IL, 89; Going Places, Arlington Arts Center, Arlington, VA, 89; Int'l Wood Sculpture Symposium, Nagyatad, Hungary, 89; Polish Sculpture Center, Orangery Gallery, Oronsko, Poland, 90; Int'l Symposium Group Exhibition, Asheville, NC, 90. **Selected Collections:** Upjohn Corp, Portage, MI; McDonalds Corp, Oakbrook, IL; Int'l Wood Sculpture Park, Hungary; Notoro Agency Gallery, Warsaw, Poland.
(See page 310)

BROWN, CALVIN (1952 - present)
b. Andover, Massachussetts

Education: Cooper Union, 74, BFA; Yale Univ, 78, MFA. **Selected Solo Exhibitions:** Andover Gallery, Andover, MA, 78; American Fine Arts, NYC, 86; Genovese Gallery, Boston, 90. **Selected Group Exhibitions:** Josef Gallery, NYC, 82; Selections 19, The Drawing Center, NYC, 82; Art on Paper, Weatherspoon Art Gallery, Univ of NC at Greensboro, 83; American Fine Arts, NYC, 86-88; Ultrasurd, SL Simpson Gallery, Toronto, Canada, 86; Paravision II, Margo Leavin Gallery, LA, CA, 86; Spiritual America, CEPA, Buffalo, NY, 86; Grand Design, Procter Art Center, Bard College, Annandale-on-Hudson, NY, 87; Generations of Geometry, Whitney Museum of American Art, Equitable Branch, NYC, 87; Black in the Light, Genovese Gallery, Boston, MA, 88; The Gold Show, Genovese Gallery, MA, 88; The II Int'l Biennial of Painting, Cuenca, Ecuador, 89; New England Impressions II, The Master Printers, Fitchburg Art Museum, MA, 89; Strange Attractors, Chicago, IL, 89; The Unique Print 1970's into 1990's, Museum of Fine Arts, 90. **Selected Bibliog:** Studies in Contrast, South End News, Cate McQuaid, May 24, 90; Making Modern Art with the Help of Assistants, The Boston Globe, Mary Sherman, May 24, 90; Calvin Brown at Genovese Gallery, Art New England, David Raymond, July/Aug 90.
(See page 63)

BROWN, ROGER (1941 - present)
b. Hamilton, Alabama

Education: American Academy of Art, Chicago, IL, 62-64; School of the Art Inst of Chicago, IL, 64-68, BFA, 78-70, MFA. **Selected Collections:** Metropolitan Museum of Art, NYC; Museum of Modern Art, NYC; Art Inst of Chicago, IL; Nat'l Museum of American Art, Wash, DC; Corcoran Gallery of Art, Wash, DC; Whitney Museum of American Art, NYC; High Museum of Art, Atlanta, GA; Dallas Museum of Fine Arts, TX; Museum of Contemp Art, Chicago, IL; Museum Moderner Kunst/Museum des 20. Jahrhundrerts, Vienna; Museum Boymans, Rotterdam, The Netherlands; State of IL College, Chicago; Akron Art Inst, OH; Indianapolis Museum of Art, IN; Montgomery Museum of Art, AL; Equitable Corp, commission for NBC Tower, Chicago, IL; Outdoor Mosaic Commission, Chicago, IL.
(See page 64)

BURCHFIELD, CHARLES E. (1893 - 1967)
b. Salem, Ohio

From the time he was fifteen, Charles Burchfield knew he would become a painter and that nature would be the central theme of his art. After four years at the Cleveland School of Art, 1912-16, he began to paint the woods and streams of his native Salem, Ohio, using his always vivid imagination to capture sounds, like those of insects and emotions, such as childhood fear of the dark. While nature was always his main concern, he was also deeply moved by the small towns and villages of Ohio and western New York. He lived most of his adult life in Gardenville, New York, and once wrote, "I love our life in the village, and all the facts of our existence, how good it all is." Charles Burchfield is represented in every major museum and collection of American art in the United States and abroad.
(See page 65)

CABRITA REIS, PEDRO (1956 - present)
b. Lisbon, Portugal

Pedro Cabrita Reis presently lives and works in Lisbon, Portugal. **Selected Solo Exhibitions:** Da Ordem e do Caos, Galeria Comicos, Lisbon, 86; Amina et Macula, Galerie Cintrik, Antwerp, Belgium, 87; A Sombra na Agua, Galeria Comicos, Lisbon, 88; Cabecas, Avores e Casas, Galeria Roma e Pavia, Porto, 88; Melancolia, Bess Cutler Gallery, NYC, 89; A Casa do Suaves Odores, galeria Comicos, Lisbon, 90; Alexandria, Covento de S Francisco, Beja, Portugal, 90; A Casa da Paixao e do Pensamento, Galeria Juana de Aizpuru, Madrid, 90; A Casa da Ordem Interior, Galerie Joost Declercq, Ghent, 90; Silencio e Vertigem, Igreja de Sta Clara-a-Velha, Coimbra, Portugal, 90; Cabrita Reis, Sculpture, Barbara Farber Gallery, Amsterdam, The Netherlands, 90; Vite Paralelle, Sala Boccioni, Milano, 91; Os Lugares Cegos, Galerie Jennifer Flay, Paris, 91; Rhona Hoffman Gallery Chicago, IL, 91; Burnett Miller Gallery, LA, CA, 91. Cabrita Reis, Gerardo Burmester, Nancy Dwyer, Stephen Huber, Galeria Roma e Pavia, Pedro Oliveira, Porto, 90; Ultima Frontera, 7 Artistes Portuguesos, Centre d'Art Santa Monica, Barcelona, Spain, 90; Cabrita Reis, Rui, Sanches, Fundacion Luis Cenduna, Seville, Spain, 90; Ponton, Temse, Belgium, 90; Carnets de Voyage I, Foundation Cartier, Paris, 90; Metropolis, Martin Gropius Bau, Berlin, 91.
(See pages 286 & 287)

CAGE, JOHN (1912 - present)
b. Los Angeles, California

John Cage, who is 80 years old in 1992, is an influential thinker who has contributed to the fields of music, art, poetry and philosophy. He is best known as a composer of music, but in the past 15 years he has developed a strong secondary career in visual art, working in printmaking, drawing and watercolor. His art has been shown in solo exhibitions at the Whitney Museum of American Art, New York; the Philadelphia Museum; the Phillips Collection, Washington, DC; the Albright-Knox Gallery, Buffalo; as well as many private galleries. He will participate in the Carnegie International Exhibition, Pittsburgh, this year. He is a member of the American Academy of Arts & Letters and has received medals of honor from the nations of France and Japan.
(See page 263)

CAMPANILE, DARIO (1948 - present)
b. Rome, Italy

While other children played, he sketched and painted everything he saw. An Honors Graduate from the Rome School of Industrial Design, he met Giorgio de Chirico whose encouragement and technical advice were instrumental in his choice of classical realism as the style he wished to pursue. His work was exhibited at the Galleria Esdra in Rome before be was 20. His time in the Italian army was spent painting for the Ministry of Defense. In 1972 a chance meeting resulted in his spending some time with Salvador Dali who referred to him as the 'Italian Master' and encouraged him to explore new dimensions in Surrealism and composition. Arriving in the US that same year, he was exhibited at the Acosta Gallery in Beverly Hills, within a month. He works today in Marin County, California where he continues pushing the boundaries of Surrealism and Neoclassical Realism.
(See page 67)

BEN TRE, HOWARD (1949 - present)
b. America

Selected Solo Exhibitions: Foster/White Gallery, Seattle, WA, 81, 83; John Berggruen Gallery, SF, CA, 86; Carnegie-Mellon Art Gallery, Pittsburgh, PA, 90; Clark Gallery, Lincoln, MA, 83,91; Charles Cowles Gallery, NYC, 85-86, 88-89; DeCordova Museum & Sculpture Park, Lincoln, MA, 90-91; Fay Gold Gallery, Atlanta, GA, 87; Dorothy Goldeen Gallery, Santa Monica, CA, 89. **Selected Collections:** Albright-Knox Gallery, Buffalo, NY; Brooklyn Museum, NY; Centro Cultural Arte Contemporano, Mexico City, MX; Chase Manhattan Bank, NYC; Detroit Inst of Arts, MI; High Museum of Art, Atlanta, GA; Hirshhorn Museum & Sculpture Garden, Wash, DC; Huntington Galleries, WV; Indianapolis Museum of Art, IN; Lannon Foundation Museum, Palm Beach, FL; LA County Museum of Art, CA; Metropolitan Museum of Art, NYC; Nat'l Museum of Modern Art, Tokyo, Japan; Phillips Collection, Wash, DC; Phoenix Art Museum, AZ; St Louis Art Museum, MO; Toledo Art Museum, OH; Laumeier Sculpture Park, St Louis, MO, 90.
(See page 307)

BERNHARD, RUTH (1905 - present)
b. Germany

The daughter of graphic artist Lucien Bernhard, Ruth Bernhard originally studied music at the Berlin Academy of Art. In 1927, she moved to New York and began photographing in 1930. Having met the photographer in 1935, Edward Weston became a major influence in Bernhard's artistic direction. Among her contemporaries and friends were Ansel Adams, Immogene Cunningham, Wynn Bullock and Minor White. An outstanding photographer of international reputation, the artist presently resides in San Francisco. Although she is primarily known for her classical figure studies, her innate curiosity and passion for life have motivated explorations into subject matter and concepts of remarkable diversity. Truly a contemporary woman in her art and life, Ms Bernhard's images reflect her intense responses to personal experiences.
(See page 378)

BICK, GEORGIE ELAYNE (1922 - present)
b. Tebessa Region, French Algeria, North Africa

Georgie Elayne Bick was exposed to the textile arts as a small child since many oriental rugs of the highest quality originate in the Tebessa Region, birthplace of Mrs Bick. Educated at the Lycee Laccaro in Bone, Georgie also studied for eleven years in private convent schools dedicated to the production and teaching of the textile arts. Mrs Bick's works are two-dimensional, pictorial tapestries of the Gobelin technique. They are handwoven on vertical tapestry looms (haute lisse) and conform specifically to the classic definition that "A tapestry must be entirely weft-faced." She weaves all her tapestries, each of which is from her own original design. This unique work is not repeated. Distribution of these works are made through galleries in Ann Arbor, MI and Chicago, IL. Foremost in the promotion of her pieces are the Forsythe Galleries, Ann Arbor, having presented her tapestries in biennial shows in 1971, 1973, 1975 and 1977. Through acquisition of pieces, Forsythe Galleries maintain a constant private and public collection of Georgie Bick's tapestries. Invitational Group Shows: Instructor's Invitational, Grand Rapids Museum, MI League Conference, 7; Women in the Arts Invitational Exhibit, Lee Hall Gallery, Northern MI Univ, 78. Workshops: MI League of Handweavers in Midland, Detroit, Grand Rapids, Kalamazoo, South Haven & Hartland; Michigan Guild, Farmington; Winsor Guild, Winsor, Ontario, Canada. Mrs Bick has written newspaper and magazine articles and has appeared on radio and television in the interest of tapestry weaving.
(See page 54)

BIERK, DAVID (1944 - present)
b. Appleton, Minnesota

David Bierk studied and earned his MFA at Humboldt State University at Arcata, California. He has lived in Peterborough, Ontario for the last twenty years where he was founder, in 1947, and, until 1987, Director of Artspace, one of Canada's most significant artist-run galleries. His work has been exhibited and/or collected by many public and private galleries in Canada, the United States and abroad including: the Nat'l Gallery of Canada; Art Gallery of Ontario, Toronto; Felicita Foundation, Escond, CA; Henry Art Gallery, Seattle; Piezo Electric, New York; and Odette Gilbert Gallery, London, England. Many private and corporate collections include: Prudential-Bache, NY; Metropolitan Life, NY; Reader's Digest, NY; Olympia and York Developments, Toronto and New York; Bank of America, Toronto; Les Trois Marches, Versailles, France; Grand Hyatt, Hong Kong. Several major Selected Commissions: currently an 18' x 20' painting for the restored Sherton Grande, in LA.
(See page 55)

BLACKWOOD, DAVID (1941 - present)
b. Wesleyville, Newfoundland

Education: Ontario College of Art Honours Diploma, 63; OCA travelling scholarship to study major collections in the USA, 63; Government of France Medal, 63; Art Master at Trinity College School, Port Hope, Ontario, 63; Artist-in-Residence, Erindale College, Univ of Toronto, 69-75; founded Erindale College Art Gallery, 71. **Selected Solo Exhibitions:** Royal West of England Academy, Bristol, UK, 86; Canada Cultural Center, Paris, France, 86; Zuider Zee Museum, Amsterdam, 86; Galleria Gian Ferrari, Milan, Italy, 86; Memorial Univ Art Gallery, St John's, Newfoundland, 86; The Madison Gallery, Toronto, 86-87; The Spurrell Gallery, St John's, Newfoundland, 86; Emma Butler Gallery, Toronto, 87,90; West End Gallery, Edmonton, 87, 89-90; Loffler Center, Toronto, 87; Gallery One, Toronto, 88, 90; Heffel Gallery, Vancouver, Canada, 89-90. **Selected Group Exhibitions:** 50th Anniv Canadian Society Painters in Watercolor, Art Gallery of Ontario, 75; Atlantic Graphics, Beaverbrook Art Gallery, 76; The Expressionist Image, Mt St Vincent Univ, Halifax, 78; People, Univ of New Brunswick Art Center, 81; Canadian Contemp Prints, Bronx Museum, NY, 82. **Selected Collections:** Nat'l Gallery of Canada; Ontario Dept of Education; Newfoundland Gov't; Dept of External Affairs; LaBatt's Limited; Her Majesty Queen Elizabeth II.
(See page 262)

BLECKNER, ROSS (1949 - present)
b. New York, New York

Education: New York Univ, NYC, 71, BA; California Inst of the Arts, Valencia, CA, 73, MFA; He presently lives in New York City, New York. **Selected Solo Exhibitions:** Cunningham Ward Gallery, NYC, 75; John Doyle Gallery, Chicago, IL, 76; Cunningham Ward Gallery, NYC, 77; Mary Boone Gallery, NYC, 79-81, 83, 86-88, 91; Patrick Verelist Galerie, Antwerp, Belgium, 82; Portico Row Gallery, Philadelphia, PA, 82; Nature Morte Gallery, NYC, 84; Boston Museum School, Boston, MA, 85; Mario Diacono Gallery, Boston, MA, 86, 89; Margo Leavin Gallery, LA, CA, 87; Waddington Gallery, London, England, 88; San Francisco Museum of Modern Art, CA, 88; Galerie Max Hetzler, Cologne, W Germany, 89; Milwaukee Art Museum, WI, 89; Contemp Arts Museum, Houston, TX, 89; Carnegie Museum of Art, Pittsburgh, PA, 89; Akira Ikeda Gallery, Tokyo, Japan, 89; Art Gallery of Ontario, Toronto, Canada, 90; Galeria Soledad Lorenzo, Madrid, Spain, 90; Heland Wetterling Gallery, Stockholm, Sweden, 90; Kunsthalle Zurich, Switz, 90; Kolnischer Kunstverein, Cologne, Germany, 91; Moderna Museet, Stockholm, Sweden, 91.
(See page 56)

BOGOMAZOV, ALEXANDER (1880 - 1930)
b. Yampol, USSR

Alexander Bogomazov lived and worked in Kiev except for brief periods: from 1907 to 1908 he studied in the studio of Yon and Rerberg in Moscow; he visited the Caucausus occasionally after 1906, and lived there from 1914 to 1917. In 1911 he completed his studies at the Kiev School of Art (where his colleagues included Alexandra Exter, Archipenko and Gritchenko), and participated in local exhibitions from 1912 to 1916. In 1914 he wrote an important theoretical treatise, Painting and its Elements. From 1914 to 1917, Bogomazov lived in the Caucausus where he produced his best analytic paintings based on the ideas elaborated in his 1914 treatise, and, being isolated, he was able to pursue an independent path towards non-objective art. Bogomazov refused all narrative implications, as he concentrated on rhythmic forces. In his 1914 treatise, he spoke of qualitative rhythms and advocated a new art: pure painting. Anticipating Malevich's Black Square by one year, he spoke of the black square as the "totality of signs in art." In 1922 he was invited to teach at the Kiev Inst of Art. Alexander Bogomazov died of tuberculosis in 1930.
(See page 57)

BONIFACHO (1937 - present)
b. Belgrade, Yugoslavia

Education: Sumatovachka School of Art, Belgrade, Yugoslavia, 57-59, drawing & painting; Univ of Belgrade, Yugoslavia, 59-65, Doctorate of Fine Arts, initiated & developed "rooftop painting;" Old Master techniques, fresco restoration, 66; Academia Della Bella Arte, Rome, 66; Atelier Kruger, Dusseldorf, W Germany; summer courses in old master techniques, fresco & restoration, 66; emigrated to Canada, 73; Became a Canadian citizen, 76. **Teaching Experience:** School of Fine Arts, Belgrade, Yugoslavia, 67-68, painting & drawing; private tutoring, Vancouver, Canada, 79-87. **Selected Solo Exhibitions:** Kolarcev Univ Gallery, Belgrade, Yugoslavia, 65; City Gallery of Contemp Art, Nis, Yugoslavia, 66; Gallery Covacic, Zagreb, Yugoslavia, 68; Gallery HIP, Warsaw, Poland, 69; Grafic Collective Gallery, Belgrade, 71; Gallery Scollard, Toronto, Ontario, 78; Contemp Art Gallery, Vancouver, Canada, 79; Burnaby Art Gallery, Burnaby, Canada, 82; Richmond Art Gallery, Richmond, Canada, 82; Lale Gallery, NYC, 85; Atelier Gallery, Vancouver, 87; Heffel Gallery Ltd, Vancouver, 88, 90-91; Quan-Schieder Gallery, Toronto, Ontario, 89-90; Participated in many juried exhibitions in Canada, 74-87. **Selected Group Exhibitions:** North of the Border, Whatcom County Museum, Bellingham, WA, 90; Nat'l Museum, Belgrade, Yugoslavia, 90; Artropolis, Vancouver, Canada, 90.
(See page 58)

BONOVITZ, JILL (1940 - present)
b. Philadelphia, Pennsylvania

Selected Exhibitions: Architectural Ceramics 1982, Women's Interart Center, NYC, 82; Women: Self Image, Women's Caucus for Art/Nat'l Conference '83, The Philadelphia Art Alliance, 83; Soup, Soup Beautiful Soup, Campbell Museum, Camden, NJ, 83; Contemp Arts: An Expanding View, Monmouth Museum of Art, Lincroft, NJ, 86; The Squibb Gallery, Princeton, NJ, 86; Contemp Crafts: A Concept in Flux, The Society for Art in Crafts, NYC & Pittsburgh, PA, 86; Functional Glamour, Museum voor Hedendaagse Kunst, Kruithaus Hertogenbosch, The Netherlands, 87; Helen Drutt Gallery, Philadelphia, 89; American Clay Artists, Port of History Museum, Philadelphia, 89; Philadelphia Artist: 1990, Helen Drutt Gallery, Philadelphia, 90; Contemp Philadelphia Artists, Philadelphia Museum of Art, PA, 90; From the Ground Up, Moore College of Art, Philadelphia, 92; Morris Gallery, PA Academy of Fine Art, Philadelphia, 92. **Selected Bibliog:** The New Ceramics: Trends & Traditions, Peter Dormer, 86; Functional Glamour, 87; Jill Bonovitz, Recent Work, essay by Judith Stein, 89. **Selected Commissions:** Architectural tile floors.
(See page 308)

BOURDEAU, ROBERT (1931 - present)
b. Canada

Selected Solo Exhibitions: Nat'l Film Board of Canada, 66, travelled; Agnes Etherington Art Centre, Queen's Univ, 79; Afterimage Gallery, Dallas, TX, 83; Jane Corkin Gallery, 91. Smithsonian Institution, Wash, DC, 68; Cahlon-sur-faone, France, 74; New England School of Photography, Cambridge, MA, 75; Nat'l Gallery, of Canada, Ottawa, 75, 77; The Witkin Gallery, NY, 76; Contemp Photography, The Watson Gallery, Houston, 86; Money Matters: A Critical Look at Bank Architecture, Museum of Fine Arts, Houston, 86. **Selected Collections:** Nat'l Gallery of Canada; Smithsonian Institution; Philadelphia Museum of Art; Canadian Centre for Architecture, Montreal; Winnipeg Art Gallery; Museum of Fine Arts, Houston; Museum of Fine Arts, Boston, MA. **Selected Bibliog:** Photography Year Book, England, 65; Camera, Switz, 69; The Photographer's Choice, Addison Press, 76; Robert Bourdeau, In Praise of the Lucid, Arts Canada, Ann Thomas, 77; Robert Bourdeau, Mintmark Press, 80; Photographs: 150 Years, Firefly Books, 89; Children in Photography: 150 Years, Firefly Books, 90.
(See page 379)

ARTIST BIOGRAPHIES

AVERBUCH, ILAN (1953 - present)
 b. Tel Aviv, Israel

Education: Wimbledon School of Art, England, 77-78; School of Visual Arts, NY, 79-82, BFA; Hunter College, NY, 83-84, MFA. **Selected Solo Exhibitions:** The Jewish Museum, NY, 86; Ambit Gallery, Tel Aviv, 86; Dad Galerie, Berlin, 86; OK Harris Works of Art, NYC, 87; Michael Haas, NYC, 87; Olga Korper, Toronto, 88, 91; Nancy Hoffman, NY, 91, 89; Lavignes-Bastille, Paris, 90; Michael Haas, Berlin, 90. **Selected Group Exhibitions:** Olga Korper Gallery, Toronto, 87; Mythos Berlin, Berlin, 87; Israel Museum, Jerusalem, 88; Brooklyn Museum, NY, 88; A Natural Order, Hudson River Museum, NY, 90; Construction in Process, Poland Historical Museum, Lodz, 90; NY Diary: Almost 25 Different Things, PS 1, Long Island City, NY, 91. **Selected Collections:** Art Gallery of Ontario, Canada; Israel Museum, Jerusalem; Kunstler House, Germany; Prudential Ins Co, NJ; TelAviv Museum, Israel. Selected Commissions: Kunstlerhaus, Bethanien, Berlin, 82; City of Tel Aviv, Israel, 89. **Selected Awards:** DAD Award, Berlin, Germany, 85-86.
(See page 304)

BACHELIER, ANNE (1949 - present)
 b. Grenoble, France

Anne studied at the Ecole de la Seyne sur Mer and the college du Beaux-Arts de Valence as well as spending four years as an apprentice at an etching studio. She first made her living painting on silk, but switched to oil on canvas in 1989. On first viewing, her phantom figures can be mistaken for demons or the risen dead; however, on a deeper level one sees that rather than painting disillusion and despair, she paints immortality, hope and serenity. Through the use of deceptively simple slashes of color and the manipulation of light and shadow, her paintings seek and find a higher level of existence. Often oriental in theme and style it is this simplicity that subdues the power of her themes and leads the viewer through the labyrinth to realize the peace existing within the universal consciousness.
(See page 47)

BALDESSARI, JOHN (1931 - present)
 b. National City, California

Education: CA State College at San Diego. He presently lives and works in Santa Monica, California. **Selected Solo Exhibitions:** La Jolla Museum of Art, CA, 60; Stedelijk Museum, Amsterdam, The Netherlands, 75; The Kitchen, NYC, 75, video; Artists Space, NYC, 78, films; New Work, Halle fur Internationale neue Kunst, Zurich, Switz, 79; The New Museum, NYC, 81 travelled; Margo Leavin Gallery, LA, CA, 84, 86, 88, 90; Le Consortium, Centre d'Art Contemporain, Dijon, France, 85; Univ Art Museum, Univ of CA, Berkeley, 85; Centre Nat'l D'Art Contemporain de Grenoble, France, 87; Primo Piano, Associazione Culturale, Rome, 88; Societe des Expositions, Palais des Beaux-Arts, Bruxelles, Belgium, 88, travelled; Centro National de Exposiciones, Madrid, 89, travelled; Museum of Contemp Art, LA, CA, 90, travelled; **Selected Group Exhibitions:** 1983 Biennial Exhibition, Whitney Museum of American Art, NYC, 83; Photography Used in Contemp Art, In & Around the 70's, Nat'l Museum of Modern Art, Tokyo, Japan, 83; XIII Biennale de Paris, 85; Carnegie Int'l: Contemp Art, Europe & America in Pittsburg, Museum of Art, Carnegie Inst, Pittsburgh, PA, 85-86; Individuals: A Selected History of Contemp Art 1945-86, Museum of Contemp Art, LA, CA, 86-88; LA Today, Contemp Visions, Amerika Haus, Berlin & LA Municipal Art Gallery, 87; Avant-garde in the 80's, LA County Museum of Art, 87.
(See page 285)

BARRETT, BILL (1934 - present)
 b. Los Angeles, California

Bill Barrett is the son of painter & artist-in-residence at the Univ of South Sewanee, in Tennessee. He has two sons and one daughter. Mr Barrett presently lives in New York City, New York, where he has a studio. **Education:** Univ of MI, Ann Arbor, 58, BS; 59, MS; 60, MFA. **Teaching Experience:** Eastern MI Univ, Ypsilanti; Cleveland Inst of Art, OH; Univ of the South, Sewanee, TN; City College of NY; Columbia Univ, NYC. Visiting Artist & Lecturer: Hanover College, IN; William Paterson College, NJ; Eastern MI Univ; Univ of MI; Akron Univ, OH; Cleveland Inst of Art, OH. **Selected Solo Exhibitions:** Benson Gallery, Bridgehampton, NY, 69-70; 72, 74, 77, 80-81; DeGraaf Forsythe Galleries, Ann Arbor, MI, 82; Sculpture Center, NYC, 83; Kouros Galleries, NYC, 85; Dan DeGraaf Galleries, Chicago, IL 85; Bellvue Hospital Sculpture Center, NYC, 85-86. **Selected Group Exhibitions:** Imprimatur Gallery, 84; Schulman Sculpture Garden, White Plains, NY, 84-85. **Selected Collections:** Guild Hall Museum of Art, Easthampton, NY; MI Education Assoc, Lansing. **Selected Bibliog:** Outdoor Sculpture, object & environment, Margaret A Robinette, Whitney Library of Design; The Process of Sculpture, Anthony Padovano, Doubleday. Selected Commissions: Univ of MI Dental School, Ann Arbor; Pennington Park, Paterson, NJ; Lincoln Nat'l Life Insurance Co, Ft Wayne, IN; Scottsdale Center for the Arts, AZ; City of NY Board of Education, New Dorp High School, Staten Island, NY.
(See page 305)

BASELITZ, GEORGE (1938 - present)
 b. Deutschbaselitz, Upper Lausitz, East Germany

Chronology: Academy of Fine & Applied Art in East Berlin, expelled because of 'socio-political immaturity'; becomes friends with AR Penck, 56; Academy of Fine Arts, W Berlin,57-62; marries Elke Kretzschmarl; son born, 62; first solo exhibition, Galerie Werner & Katz, W Berlin, 63; Villa Romana, Florence on a six-month grant; becomes interested in Mannerism, 65; moves to Osthofen near Worms, Germany, 66; executes first upside down painting, DerWaldAufdem Kopf, 69; Galerie Hans, Neundorf, Hamburg, annually 73-81; moves to Derneburg, near Hannover; first trip to New York; Sao Paulo Biennale, 75; studio in Florence, 76-81; Hans der Kunst, Munich; Kunsthalle Koln & Kunsthalle Bern, retrospectives, 76; Modell fur eine Skulptur, first sculpture completed; exhibited at German Pavilion at Venice Biennale, travelled, 80; first solo, Xavier Fourcade, 81; first sculpture show, Galerie Michael Werner, Cologne, W Germany, 83; Kunstmuseum Basel, Switz; Staatlichen Graphischen Sammlung der Neuen Pinakothek, Munich; Mary Boone, Michael Werner Gallery, NY; Vancouver Art Gallery, 84; Kunsthaus, Zurich, travelled, 90; first exhibition at Pace Gallery, NYC, 90.
(See page 48)

BATES, DAVID (1952 - present)
 b. Dallas, Texas

Selected Solo Exhibitions: David Bates, Forty Paintings, Modern Art Museum of Ft Worth, TX, 88, travelled; Eugene Binder Gallery, Dallas, TX, 89; John Berggruen Gallery, SF, CA, 89, 91; Arthur Roger Gallery, New Orleans, LA, 90. **Selected Collections:** Atlantic Richfield Corp, LA, CA; Chemical Bank, NYC; Contemp Arts Center, Honolulu, HI; Corcoran Gallery of Art, Wash, DC; Dallas Museum of Art, TX; Delaware Art Museum, Wilmington; Modern Art Museum of Ft Worth, TX; Hirshhorn Museum & Sculpture Garden, Wash, DC; JB Speed Museum, Louisville, KY; Knoxville Museum of Art, TN; Memphis Brooks Museum of Art, Memphis, TN; Metropolitan Museum of Art, NYC; Museum of Fine Arts, Houston, TX; New Orleans Museum of Art, LA; Phoenix Art Museum, AZ; San Francisco Museum of Modern Art, CA; Transamerica Corp, SF, CA; Whitney Museum of American Art, NYC.
(See page 49)

BAUER, RUDOLF (1889 - 1953)
 b. Lindenwald, Germany

Chronology: Rudolf Bauer, a published cartoonist, lived in Berlin. He then studied at the Academy of Fine Arts, Berlin, 1904-10; Bauer's first one-man exhibition at Der Sturm Gallery, Berlin, consisting of 120 works, 17; Bauer is represented in the 26th exhibition of the Societe Anonyme, NYC and at the Vassar College Art Museum, NYC, 23; Royal Palace Exhibition at the Royal Palace in Berlin, 27; Bauer meets Kandinsky in Berlin, 28; Bauer founds his own Museum in Berlin, Das Geistreich (the realm of the spirit), for the exhibition of Non-Objective paintings, 29; the exhibition 'Werke von Kandinsky und Bauer' opens at Das Geistreich, 32; The Bauhaus closes, 33; Bauer's first visit to America, 36; paintings by Rudolf Bauer are exhibited from the Solomon R Guggenheim Collection at Arts Club of Chicago, 36; Bauer designs a Duesenberg automobile. He exhibited 95 paintings in the Solomon R Guggenheim Collection. He is arrested by the Nazis and put in a concentration camp, 38; Solomon R Guggenheim & Hilla Rebay help Bauer to be released from the camp and return to America, 39; A loan exhibition from the Solomon R Guggenheim Collection is shown at the San Diego Art Gallery, CA, 41; Le Salon des Realities Nouvelles, Paris exhibition travels to Mannheim and Zurich, 47; exhibitions continue, Evolution to Non-Objectivity, Solomon R Guggenheim Museum, 52; acquisition of the 1930's & 1940's, Solomon R Guggenheim Museum, NY, 68; Rudolf Bauer 1889-1953, Galerie Gmurzynska, Cologne, Germany, 69, & Annely Juda Gallery, London, 70; Staeditches Museums, Wiesbaden, 76; Museum of the 20th Century, Vienna, 85; Museum Moderner Kunst, Vienna, 85; Masterworks from the Permanent Collection, Solomon R Guggenheim Museum, 89-90; Centennial Exhibition, Philadelphia Art Alliance, Mondrian Art Alliance, 90; ArtCologne, Rudolf Bauer & Hilla Rebay, 91.
(See page 50)

BEAUCHEMIN, MICHAEL (1957 - present)
 b. New London, Connecticut

"My work has to do with the treatment of dreams as a kind of alternate reality that rotates around our physical reality. By blending the 'outer' world through art, I can manifest bits and pieces of the 'inner' world. I call this 'rotorealism'. Through my art, I reciprocate subconscious data with real persons and events so that the two mesh; I like the hallucination." **Selected Solo Exhibitions:** Wet Paint Gallery, Miami FL, 87; Tampa Alliance of the Arts, juried, 87; The Lowe Gallery, Atlanta, GA, 90-91. **Selected Group Exhibitions:** Invitational: 48th Annual Exhibition of Contemp American Art, Society of Four Arts, Palm Beach, FL, 86; 25th Annual Ridge Arts Exhibition, Winterhaven, FL, 86; Clayton Galleries, Tampa, FL, 89; 3rd Biennial Exhibition, Polk Museum of Art, Lakeland, FL, 89.
(See page 51)

BECKMAN, WILLIAM (1942 - present)
 b. Maynard, Minnesota

Education: St Cloud State Univ, BA; Univ of Iowa, MA, MFA. **Selected Solo Exhibitions:** Allan Stone Gallery, NYC, 71-74, 76-78, 80; Frumkin/Adams Gallery, NYC, 82, 85-86, 88; Dossier of a Classical Woman, Stiebel Modern, NYC, 91-92, travels to IN Univ Museum, Bloomington. **Selected Group Exhibitions:** Painting & Sculpture Today, Indianapolis Museum of Art, IN, 69; Trends in Contemp Realist Painting, Museum of Fine Arts, Boston, MA, 74; Directions, Hirshhorn Museum & Sculpture Garden, Wash, DC, 81; Americkanische Malerei, Haus der Kunst, Munich, organized by the Whitney Museum of American Art, 82; Focus on the Figure, Whitney Museum of American Art, NYC, 82; Contemp American Realism, Pennsylvania Academy of the Fine Arts, Philadelphia, PA, 81-83; Drawing Acquisitions, 81-85, Whitney Museum of American Art, NYC, 85; Recent Acquistions, Hirshhorn Museum & Sculpture Garden, Wash, DC, 87.
(See page 52)

BENGLIS, LYNDA (1941 - present)
 b. Lake Charles, Louisiana

Selected Solo Exhibitions: The Clocktower, NYC, 73; The Kitchen, NYC, 88; Margo Leavin Gallery, LA, CA, 77, 82, 87, 89; Paula Cooper Gallery, NYC, 70-71, 74-75, 79, 82, 84, 87; Lynda Benglis: Dual Natures, High Museum of Art, Atlanta, GA, 91, travelled. Duo Exhibition with Keith Sonnier, Alexandria Museum of Art, LA, 87. **Selected Group Exhibitions:** Irawingss: The Pluralis Decade, American Pavilion, Venice Biennale, 80; 1981 Whitney Biennial, Whitney Museum of American Art, NYC, 81; PostMINIMALISM, the Aldrich Museum of Contemp Art, Ridgefield, CT; American Art since 1970, Whitney Museum of American Art, NYC, 84; Content, Hirshhorn Museum & Sculpture Garden, Wash, DC, 84; 20th Anniv of the NEA, Museum of Modern Art, NYC, 85; Structure to Resemblance, Albright-Knox Art Gallery, Buffalo, NY, 87; 50 Years of Collecting, Solomon R Guggenheim Museum, NYC, 87; A Bountiful Decade, Nelson-Atkins Museur of Art, Kansas City, MO, 87; Making their Mark, Cincinnati Art Museum, OH, 89, travelled; Contemp Art from NY: The Collection of the Chase Manhattan Bank, Yokohama Museum of Art, Japan; New Sculpture 1965-75: Between Geometry & Gesture, Whitney Museum of American Art, NYC, 90.
(See page 306)

Lynda Benglis has works in public collections including The Australian Nat'l Gallery; Birmingham Museum of Art; Detroit Inst of Arts, MI; Hokkaido Museum of Modern Art, Sapporo; Israel Museum, Jerusalem; Los Angeles County Museum of Art, CA; Milwaukee Art Museum, WI; Modern Art Museum of Ft Worth, TX; Museum of Fine Arts in Houston, NY; Museum of Modern Art, NYC; Nat'l Museum of American Art, Wash, DC; Nelson-Atkins Museum of Art, MO; Philadelphia Museum of Art, PA; Solomon R Guggenheim Museum, NYC and Whitney Museum of American Art, NYC. Lynda Benglis is represented by Paula Cooper Gallery. She has been awarded grants from the National Endowment for the Arts and a Guggenheim Fellowship. Commissions include Hartsfield Atlanta Int'l Airport and Pacific Telesis Center in San Francisco.
(See page 261)

ABAKANOWICZ, MAGDALENA (1930 - present)
b. Falenty, Poland

Magdalena Abakanowicz continues to live and work in Warsaw. She studied painting and drawing at the Academy of Fine Arts, Warsaw, from 1950-54. Recognized for her achievements as early as 1956, she received many awards and state honors in her country. In 1965, at the major international exhibition, the Sao Paulo Biennale, she won the gold medal for her one-person presentation . An honorary doctorate was bestowed upon her in 1974 by the Royal College of Art, London. In 1980 she received the Polonia Restituta, the cross of the Knights of the Polish Renaissance, and in 1985 she became a Knight of the Order of Arts and Letters, France. She has also won awards from the Foundations Gottfried von Herder, 79; Alfred Jurzykowski, 83; and Francis J Greenburger, 90. She has been Professor of Art at the Academy of Fine Arts, Poznan, Poland, since 1965. Abakanowicz has received over 50 one-person showings in museums and galleries worldwide since her first solo exhibition in Warsaw in 1960, as well as being included in numerous group exhibitions.
(See page 299)

ADAMS, ANSEL (1902 - 1984)
b. San Francisco, California

Selected Exhibitions: Smithsonian Institution, Wash, DC, 31; MH de Young Memorial Museum, SF, CA, 32, 63; Albright Art Gallery, Buffalo, NY, 34; An American Place, NY, 36; San Francisco Museum of Art, CA, 39; Museum of Modern Art, NYC, 44; Art Inst of Chicago, IL, 51; Int'l Museum of Photography, Rochester, NY, 52; Smithsonian Institution, Wash, DC, 52, travelled the US; Metropolitan Museum of Art, NYC, 74; Ansel Adams and the West, Museum of Modern Art, NYC, 79; Ansel Adams at an American Place, San Francisco Museum of Modern Art, CA, 82.
(See page 377)

ADAMS, PHOEBE (1953 - present)
b. Greenwich, Connecticut

Ms Adams was educated at the Philadelphia College of Art, where she received her BFA, the Skowhegan School of Painting & Sculpture, and SUNY, where she took a MA in 1978. She has been extensively featured in both solo and group exhibitions and has been the recipient of several awards, including an NEA Artist Fellowship and two Pennsylvania Council on the Arts grants. Phoebe Adams' work combines natural elements, both biological and anatomical, to elicit an emotional as well as psychological response. Her early work was predominantly organic in form. In the 1980's she began to juxtapose abstract elements with biomorphic forms and her most recent work has heralded a shift to a more figurative style.
(See page 300)

AGOSTINI, PETER (1913 - present)
b. New York City, New York

Peter Agostini grew up in Hell's Kitchen. He joined the WPA Arts Project in 1939 and met Gorky, Pollack, Kline, de Kooning and others who were to form the post-war New York school. With less than two years of formal training at the Leonardo da Vinci School, it was from climate and ambiance created by the daily meshing of life, work, and talk among Agostini and his friends from which he cultivated the daring aesthetic perspectives and the search for the new that was to mark his later work. Agostini is one of the first artists to create a large body of work in plaster and has been working with the material for over forty years, creating evocative and lyrical sculptures defined by light, line and movement. Agostini has long recognized the aesthetic and expressive possibilities inherent in plaster which, because of its fluidity, is a perfect vehicle for interpreting emotion and creating new forms.
(See page 301)

ALBUQUERQUE, LITA (1946 - present)
b. Santa Monica, California

Education: Univ of CA, LA, 68, BA, cum laude. **Selected Solo Exhibitions:** Diane Brown Gallery, Wash, DC, 80; Mairanne Deson Gallery, Chicago, IL, 80, 84; Lerner-Heller Gallery, NYC, 81; Robert Cronin Inc, Houston, TX, 82; Janus Gallery, LA, CA, 82; Loyola Marymount Univ, LA, CA, 84; Saxon-Lee Gallery, LA, CA, 86; The Works Gallery, Long Beach, CA, 86, 89-90; Richard Green Gallery, LA, CA, 88; Career Survey sponsored by the Fellows of Contemp Art, Santa Monica Museum of Art, CA, 90, travelled. **Permanent Outdoor Environmental Works:** Sailing, City of Oakland Estuary, CA, 82; Tangency Horizon, Natural Elements Park, Santa Monica, CA, 86; Legend, Orange Coast College, Costa Mesa, CA, 86; Green Valley Obelisk, Green Valley, NV, 88; Grand Hope Project, LA, CA, 88. **Selected Collections:** LA County Museum of Art, CA; Newport Harbor Art Museum, Newport Beach, CA; Palm Springs Desert Museum, CA; Frederick Weisman Corp, LA, CA; ARCO Corp, LA, CA; Sohio Corp, Cleveland, OH; Cedars-Sinai Medical Center, LA, CA; Prudential Insurance Co, Newark, NJ; Security Pacific Nat'l Bank, LA, CA; American Telephone & Telegraph Corp, NYC; Times-Mirror Corp; Vesti Trust Int'l. **Selected Awards:** NEA, Individual Fellowship Grant, 75; NEA, Art in Public Places, 83-84; Palm Springs Museum of Art, Woman of the Year in Visual Art, 85; Vesta Award, Achievement in the Visual Art, 89.
(See page 41)

ALEXANDER, KEITH (1946 - present)
b. Sinoia, Rhodesia (Zimbabwe)

Chronology: Keith Alexander graduated from Pietermaritzburg University, S Africa, Fine Arts Honors, lectured in sculpture, sculptured mural for Psych Dept, 69; Natal Artists group show, moved to Johannesburg, S Africa, 70; Lidchi Gallery group show, solo show at the Rembrandt Gallery, Cape Town, 71; group shows at Lidchi Gallery; Downstairs Gallery in Benoni; Gallery 21, Sandton, 72; Transvaal Sculptures, Gallery 101, Johannesburg; Gallery 21, Sandton; Assoc of Arts Gallery, Pretoria, 73; completed commission for Pietermaritzburg Municipality; Four steel sculptures outside Natalia NPA Building, began to paint, 74; Madden Galleries group show, 75; Madame Haenggi Gallery, Holland St, 76; Univ of Natal at Pietermaritzburg & Durban, 77; Crake Gallery group show, established studio in White River, Eastern Transvaal, 79; Crake Gallery solo show, 80; Stellenbosch Farmers' Winery Centre, Johannesburg, 82; SA Realism, Pretoria Art Museum, group show, 83; Rembrandt Art Centre, Univ of the Witwatersrand, Sperrgebiet series, solo show, 83; Eduard Bohlen series, Rembrandt Art Centre, Univ of the Witwatersrand, 85; Doubletake, Natalie Knight Gallery, UK, 87; Univ of the Orange Free State, Stegmann Gallery, 88; Alexander's Namibia, Knight Gallery, Windhoek, 89; No Title, No Comment & Yet, group show, Ergane Gallery, NYC, 90; Ergane Gallery, group show, NYC, 91.
(See page 42)

AMEDEE, WAYNE (1946 - present)
b. White Castle, Louisiana

Education: Univ of Southwestern Louisiana, Lafayette, 69, BA. **Selected Solo Exhibitions:** Huntington Fine Arts Gallery, Huntington College, Montgomery, AL, 82; Invitational, Perez Associates, architects, New Orleans, 82; Galerie Simonne Stern, New Orleans, LA, 74-75, 79, 81, 85; Academy Gallery, New Orleans, 89. **Selected Group Exhibitions:** The Fertile Crescent, Contemp Arts Center, New Orleans, 85, travelled; Art Collection Twelve, First Place, winner of televised studio visit, educational television, New Orleans, 88; Southern Abstraction, Peter Frank, juror, LA, 88, travelled; River Oaks Square, competition, Alexandria, LA, 88; Selections Nine Int'l, Univ of New Orleans, Fine Arts Gallery, 89. **Selected Collections:** Arts Council of Greater New Orleans; New Orleans Museum of Art; Univ of New Orleans.
(See page 302)

ANTRIM, CRAIG KEITH (1942 - present)
b. Pasadena, California

Education: Univ of CA, Santa Barbara, Honors Program, 63-65, BA with Honors; Ford Foundation, EPIC, Univ of CA, funds & grant for European Study; California State Fellowship, Claremont Graduate School, 69-70, MFA. **Selected Exhibitions:** Monterey Peninsula Museum of Art, CA; California Artists, Art Space Newz, Tokyo, Japan, 84; Five Artists from Los Angeles, Dongsanbang Gallery, Seoul, Korea, 84; Pan Pacific Art Exhibition, Fine Art Center, Seoul, 85; Haags Gemeentemuseum, The Hague, The Netherlands, 87; Museum of Contemp Art, Chicago, IL, 87; Spiritual in Art/Abstract Painting 1890-1985, LA County Museum of Art, CA, 87;The Works Gallery, Long Beach,CA, 90-91; The Works Gallery, Costa Mesa, CA, 92. **Selected Collections:** NEA, Library, Wash, DC; San Francisco Museum of Modern Art, CA; Museum of Modern Art, NYC; Corcoran Gallery of Art, Wash, DC; LA County Museum of Art, CA. **Selected Bibliog:** Eating the Angels Portion/Craig Antrim at Works, Artweek, Nancy Ann Jones, vol 21; Works Gallery, LA Times, Suvan Geer, Jan 19, 90. **Selected Publications:** Art of the Eighties, Edward Lucie-Smith, Oxford, Great Britain, Phaidon, 90; American Art Now, Edward Lucie-Smith, NY, Morrow, 85.
(See page 43)

ARMAN (1928 - present)
b. Nice, France (Armand Pierre Fernandez)

Selected Solo Exhibitions: Stedelijk Museum, Amsterdam, The Netherlands, 64; Walker Art Center, Minneapolis, MN, 64; Palais des Beaux-Arts, Bruxelles, Belgium, 66; Galerie Ileana Sonnabend, Paris, France, 66; Modern Art Museum, Stockholm, Sweden, 70; Galerie Bischofberger, Zurich, Switz, 71; Artcurial, Paris, France, 76; Hacker Gallery, Stuttgart, Germany, 80; Retrospective Exhibition, Hannover, Germany, travelled to Israel, France and Switz, 82; Goldman's Gallery, Haifa, Israel, 83; Museo Civico di Belle Arti, Lugano, Switz, 84; Seibu Museum of Art, Tokyo, Japan, 85; Museum of Toulon, France, 85; Gallery of Guy Pieters, Knokke-Zoute, Belgium 87; La Galerie de Poche, Paris, France, 88; Gana Gallery, Seoul, Korea, 89; Marisa Del Re Gallery, NYC, 90; Fiorella-Urbinati, LA, CA, 90.
(See page 303)

ARNING, EDDIE (1898 - present)
b. Kenney, Texas

Eddie Arning is the son of German immigrants. During his twenties, while working on his father's farm, he suffered bouts of severe depression and anger. Eventually, this forced him to be institutionalized for the next thirty years. At about age 60 he was transferred from the hospital to various nursing homes. He began making crayon drawings in 1964 at age 66. His early images were drawn from memory: plants, animals, implements and automobiles. During the ten years of his artistic career he developed a distinctive style, the use of vibrant crayon and craypas color combinations to create a complex arrangement of figures, patterns and designs. His later drawings were usually taken from reference materials such as magazines, newspapers and advertisements. He expressed his relationship to his world through these drawings and when, at the age of 75, he was forced to leave a group home and move in with a widowed sister, he ceased drawing. Unfortunately this move disturbed a long established creative and physical equilibrium and Arning has never been able to recover it.
(See page 251)

ARRANZ-BRAVO, EDUARDO (1941 - present)
b. Barcelona, Spain

Eduardo Arranz-Bravo has received a lot of attention in the past two years both abroad and in America. He has completed three commemorative stamps for the 1992 Olympics in Barcelona, his birth place, is representing Spain at the World Expo in 1992 in Seville, and is in the inaugural exhibition at the new Spanish Embassy in Washington, DC, in late 1991, early 1992. He will have an exhibition at the Birmingham Festival of Arts in their yearly festivalwhich in 1992 will be about Spain and has just started working on the illustrations for a new book, Christo versus Arizona, whose author is the Nobel prize winner, Camillo Jose Cela. The new Olympic museum that is presently under construction in Lausanne, Switzerland has purchased twenty-seven of Arranz-Bravo's works as well.
(See page 44)

ASADA, HIROSHI (1931 - present)
b. Kyoto, Japan

Both Hiroshi Asada's father and his elder brother were celebrated artists in traditional Japanese painting. Hiroshi, however, pursued oil painting in the Western style and from 1954 on has been a regular participant in major competitions throughout Japan. In 1971 he left for a ten-year sojourn in Paris, travelling and exhibiting extensively throughout Europe. Among his many awards and honors are memberships in the Salon d'Automne and the Salon de Societe des Beaux-Arts; the Prix Nat'l at the 6th Int'l Festival of Painting, Cagnes-sur-Mer in 1974; the Prix Henri Farman, 1983; the Prix Alfred Sisley, 1985. His work can be found in the following public collections: Nat'l Museum of Modern Art, Koyoto; Nat'l Museum of Int'l Art, Osaka; French Ministry of Culture, Bibliotheque Nationale, Paris; Belgian Ministry of Culture; Nat'l Museum, Warsaw; Nat'l Museum, Lodz; Museum of Central Finland.
(See page 45)

ARTIST BIOGRAPHIES

VANCOUVER

GALLERIES

Atelier Gallery *3084 Granville St* C8

Bau-Xi *3045 Granville St* C8

Buschlen Mowatt Fine Arts E2
1445 W Georgia St, Main Fl

Patrick Doheny Fine Art **B5**
1811 W First Ave

Equinox Gallery *2321 Granville St* C6

Diane Farris Gallery **C6**
1565 W Seventh Ave

Gallery Of Tribal Art C7
1521 W Eighth Ave

Heffel Gallery Limited **C6**
2247 Granville St

Catriona Jeffries Fine Art F2
550 Burrard St, 3rd Fl

Prior Editions **F4**
303-1028 Hamilton St

Marion Scott Gallery F3
671 Howe St

Woltjen/Udell Gallery C6
1558 W Sixth Ave

MUSEUMS

Contemporary Art Gallery G3
555 Hamilton St

Vancover Art Gallery E3
750 Hornby St

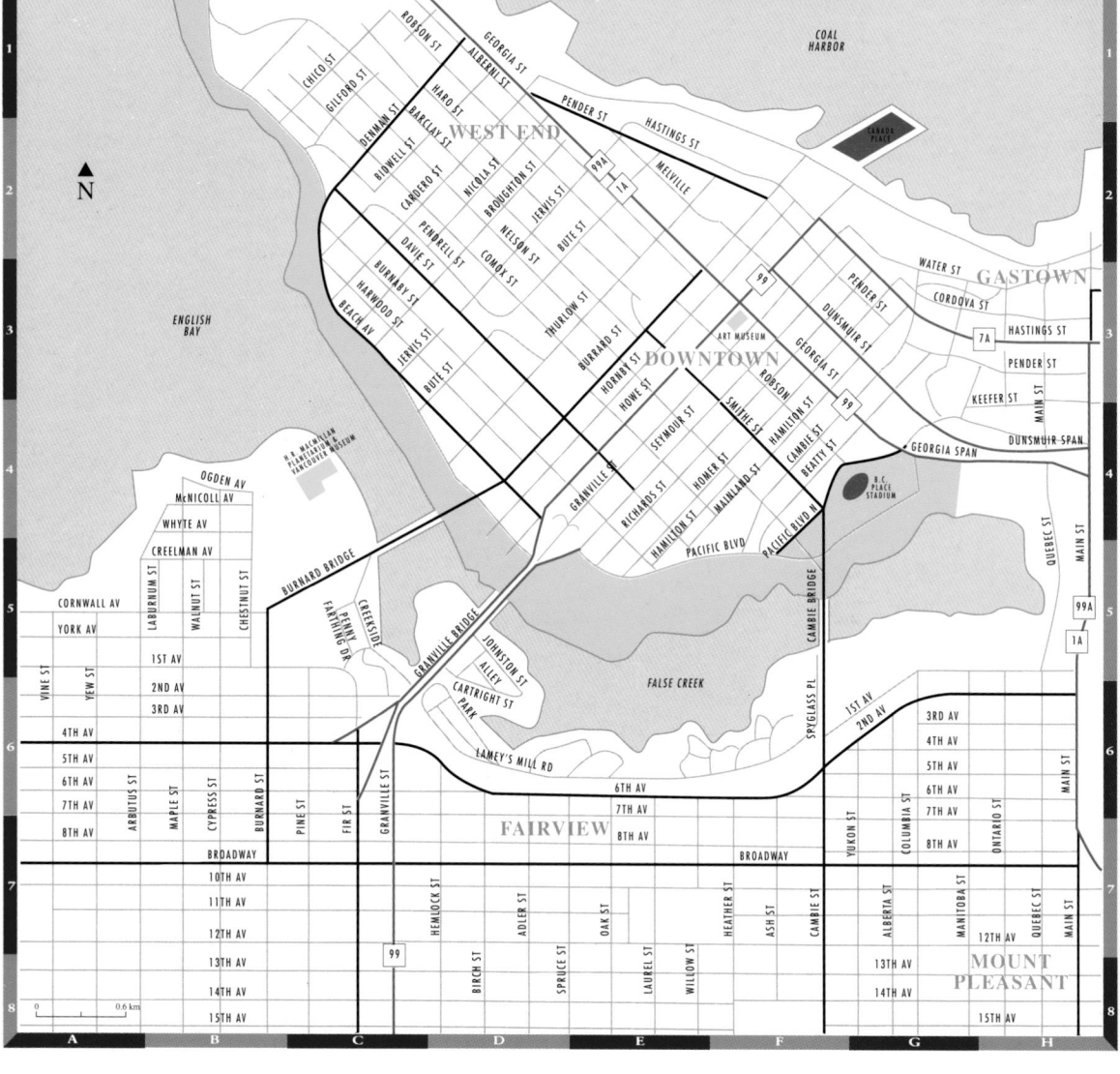

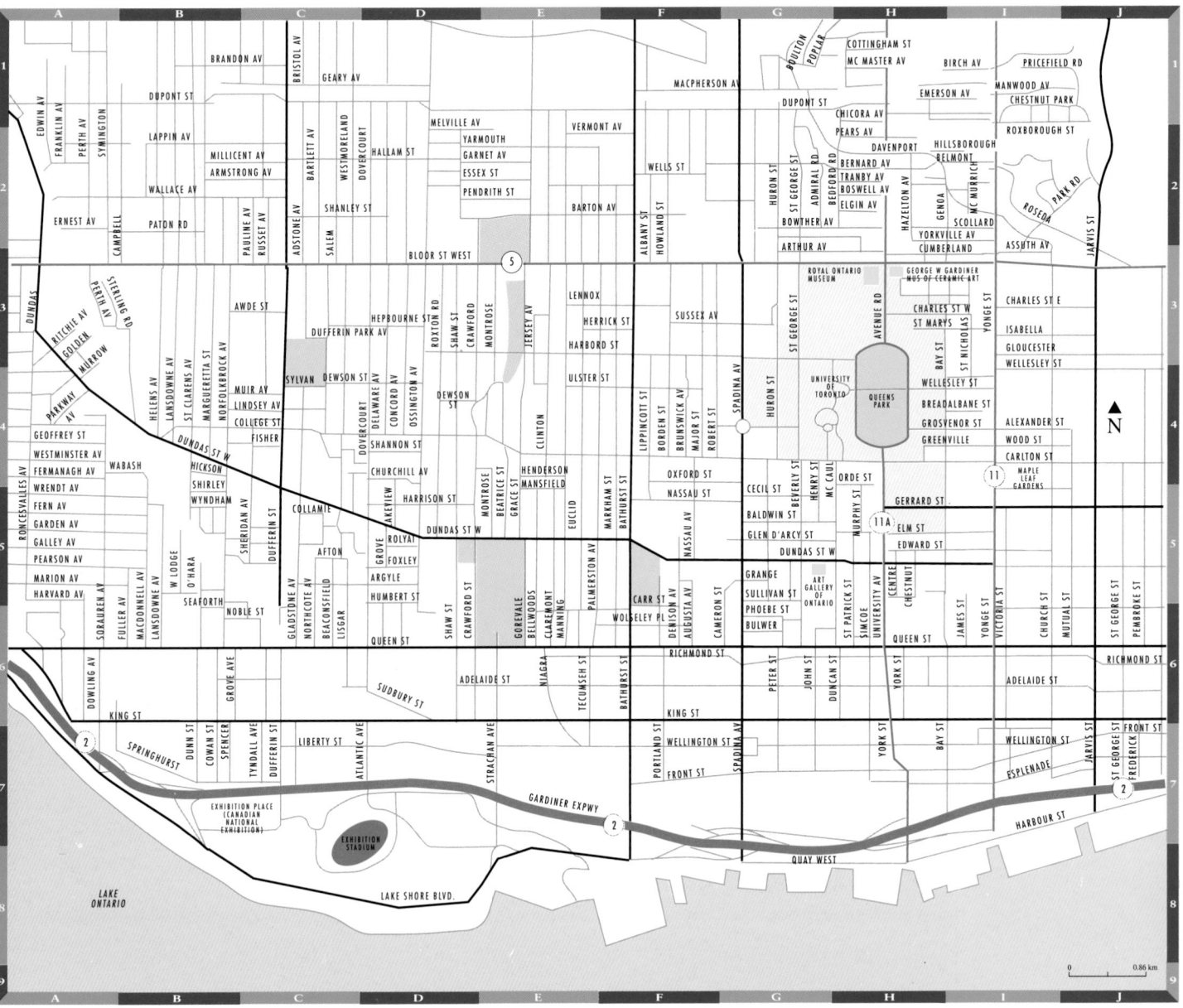

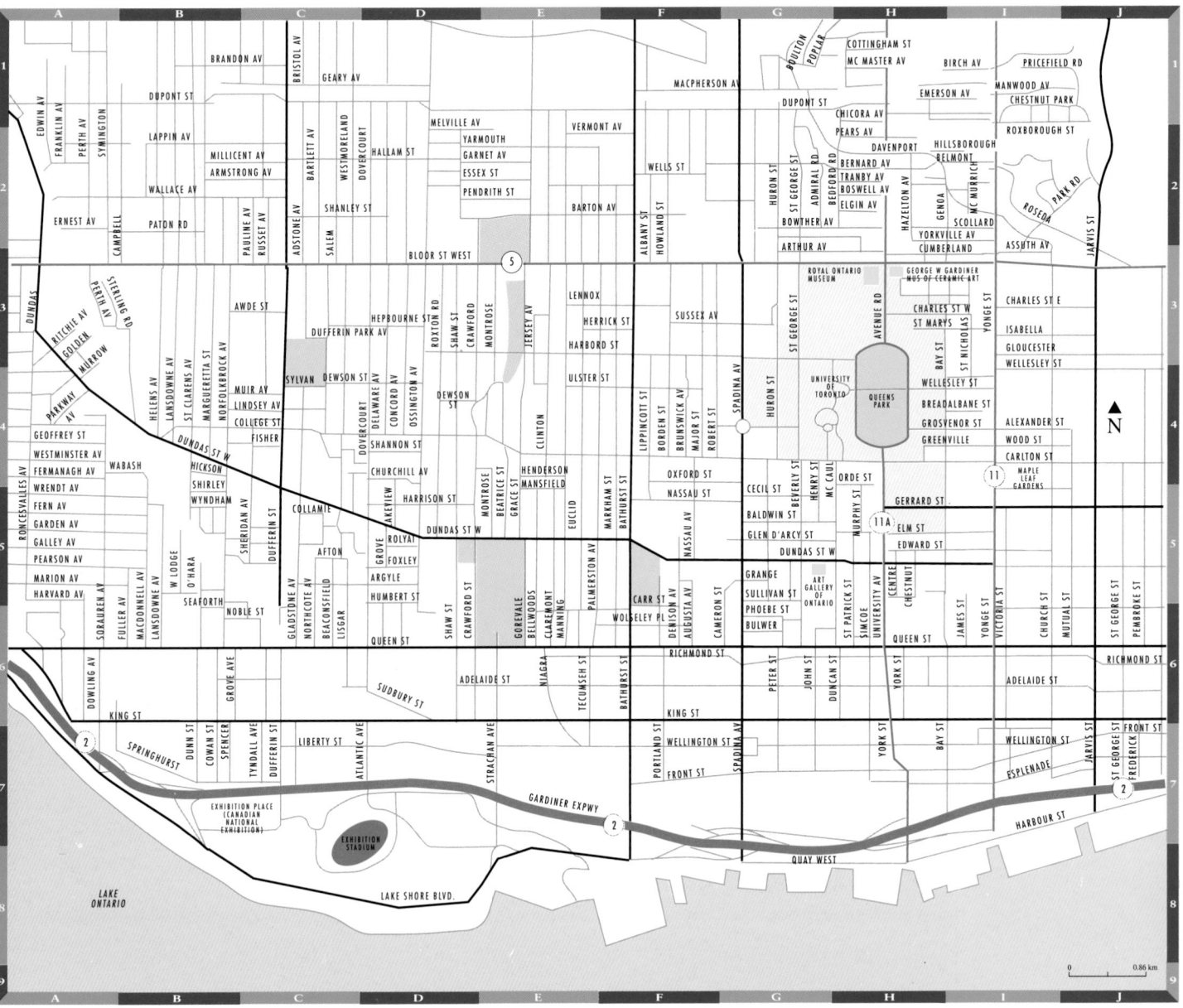

GALLERIES

Evelyn Aimis Gallery	H2
14 Hazelton Ave	
Sandra Ainsley Gallery	
2 First Canadian Pl, Box 262	
Jane Corkin Gallery	**G7**
179 John St, Ste 302	
The Drabinsky Gallery	**H2**
86 Scollard St	
Galerie Dresdnere *12 Hazelton Ave*	H2
Feheley Fine Arts *45 Avenue Rd*	H2
Gallery 44 *183 Bathurst St*	F7
Gallery Moos Ltd	H2
136 Yorkville Ave, 2nd Fl	

Gallery One Arts Inc	**H2**
121 Scollard St	
Garnet Press Gallery	G7
580 Richmond St W	
The Glass Art Gallery, Inc	H2
21 Hazelton Ave	
Mira Godard Gallery *22 Hazelton Ave*	H2
Jerrard Gallery *954 King St W*	E7
Klonaridis, Inc *80 Spadina Ave*	G7
Olga Korper Gallery *17 Morrow St*	**A4**
Carmen Lamanna Gallery	F7
788 King St W	
Mercer Union	G6
333 Adelaidest W, 5th Fl	

Nancy Poole's Studio	**H2**
16 Hazelton Ave	
Roberts Gallery Limited	I2
641 Yonge St	
Sable-Castelli *33 Hazelton Ave*	H2
Miriam Shiell Fine Art Ltd	H2
16A Hazelton Ave	
SL Simpson Gallery	H6
515 Queen St W	
Odon Wagner Gallery	H2
194 Davenport Rd	
Wynick/Tuck Gallery	**G7**
80 Spadina Ave, 4th Fl	

Yarlow-Salzman	
50 MacPherson Ave	
Yyz *1087 Queen St W*	E7

MUSEUMS

Art Gallery of Ontario	G5
317 Dundas St W	
The Justina M Barnicke Gallery,	G4
Hart House	
University Of Toronto	

VANCOUVER

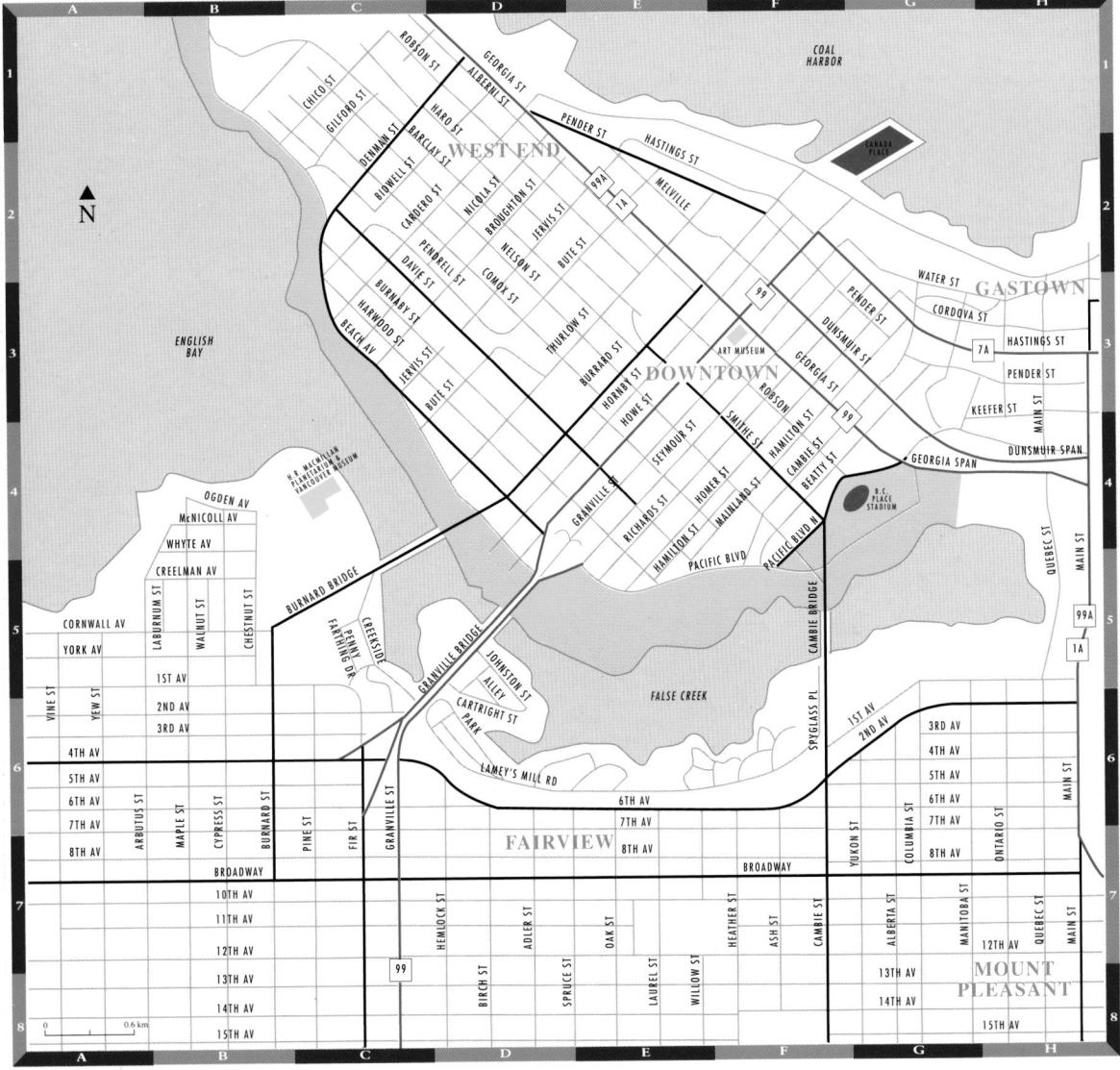

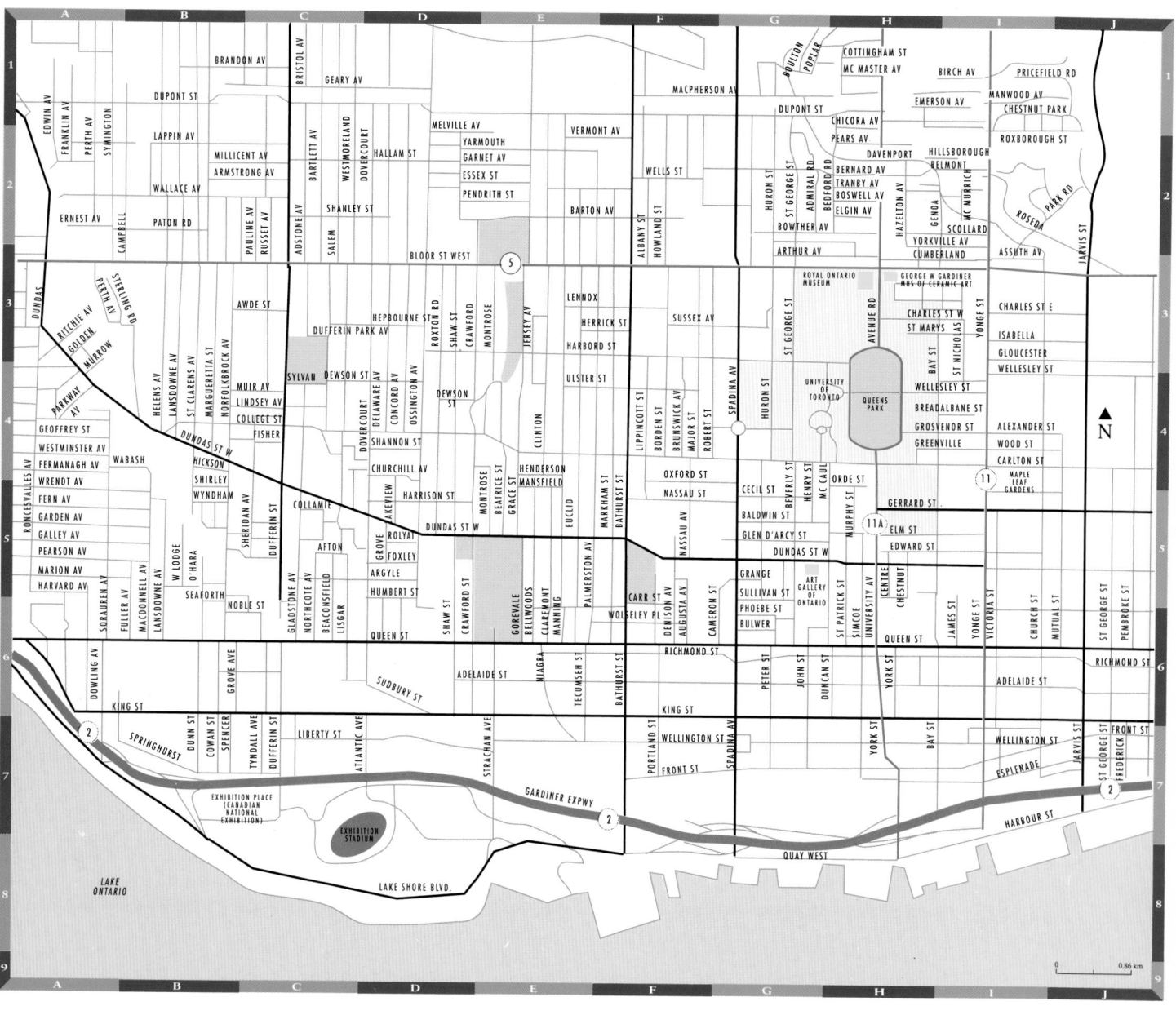

GALLERIES

Evelyn Aimis Gallery H2
14 Hazelton Ave

Sandra Ainsley Gallery
2 First Canadian Pl, Box 262

Jane Corkin Gallery **G7**
179 John St, Ste 302

The Drabinsky Gallery **H2**
86 Scollard St

Galerie Dresdnere *12 Hazelton Ave* H2

Feheley Fine Arts *45 Avenue Rd* H2

Gallery 44 *183 Bathurst St* F7

Gallery Moos Ltd H2
136 Yorkville Ave, 2nd Fl

Gallery One Arts Inc **H2**
121 Scollard St

Garnet Press Gallery G7
580 Richmond St W

The Glass Art Gallery, Inc H2
21 Hazelton Ave

Mira Godard Gallery *22 Hazelton Ave* H2

Jerrard Gallery *954 King St W* E7

Klonaridis, Inc *80 Spadina Ave* G7

Olga Korper Gallery *17 Morrow Ave* **A4**

Carmen Lamanna Gallery F7
788 King St W

Mercer Union G6
333 Adelaidest W, 5th Fl

Nancy Poole's Studio **H2**
16 Hazelton Ave

Roberts Gallery Limited I2
641 Yonge St

Sable-Castelli *33 Hazelton Ave* H2

Miriam Shiell Fine Art Ltd H2
16A Hazelton Ave

SL Simpson Gallery H6
515 Queen St W

Odon Wagner Gallery H2
194 Davenport Rd

Wynick/Tuck Gallery **G7**
80 Spadina Ave, 4th Fl

Yarlow-Salzman
50 MacPherson Ave

Yyz *1087 Queen St W* E7

MUSEUMS

Art Gallery of Ontario G5
317 Dundas St W

The Justina M Barnicke Gallery, G4
Hart House
University Of Toronto

GALLERIES

Galerie René Blouin G4
372 Ste-Catherine ouest, Ste 501

Galerie Boulanger Chantal G4
372 Rue Ste-Catherine ouest

Galerie Christiane Chassay E1
20 rue Marie-Anne ouest

Galerie Bernard Desroches Inc D4
1444 Sherbrooke St W

Dominion Gallery D4
1438 Sherbrooke St W

Edition John A. Schweitzer E2
42 ouest, avenue des Pins

Esperanza *2144 Mackay* D4

Galerie Graff *963 E Rachel* F1

Walter Klinkhoff Gallery G4
1200 Sherbrooke St W

Galerie Claude Lafitte D4
1480 Sherbrooke St W

Galerie Samuel Lallouz G4
372, Ste-Catherine ouest, Ste 528

Landau Fine Art D4
1456 Sherbrooke St W

Galerie Elca London C4
1616 Sherbrooke St W

Oboro F2
3981 boul St-Laurent, #499

Galerie Frederic Palardy F4
307 Rue Ste-Catherine ouest

Poirier Schweitzer E2
42 ouest, avenue des Pins

Galerie John A. Schweitzer E2
42 ouest, avenue des Pins

Galerie Barbara Silverberg D4
2148 Mackay St

Michel Tétreault Art Contemporain H3
1192 rue Beaudry

Galerie Trois Points F4
307 Ste-Catherine ouest, Ste 555

Waddington & Gorce Inc D4
2155 rue Mackay St

Galerie Brenda Wallace G4
372 rue Ste-Catherine ouest, # 508

MUSEUMS

Concordia Art Gallery D4
1455 ouest, boul de Maisonneuve

McCord Museum of F3
Canadian History
690 Sherbrooke St West

The Montreal Museum Of Fine Arts E4
1379 Sherbrooke St West

Musée d'Art Contemporain
de Montreal
Cité Du Hâvre

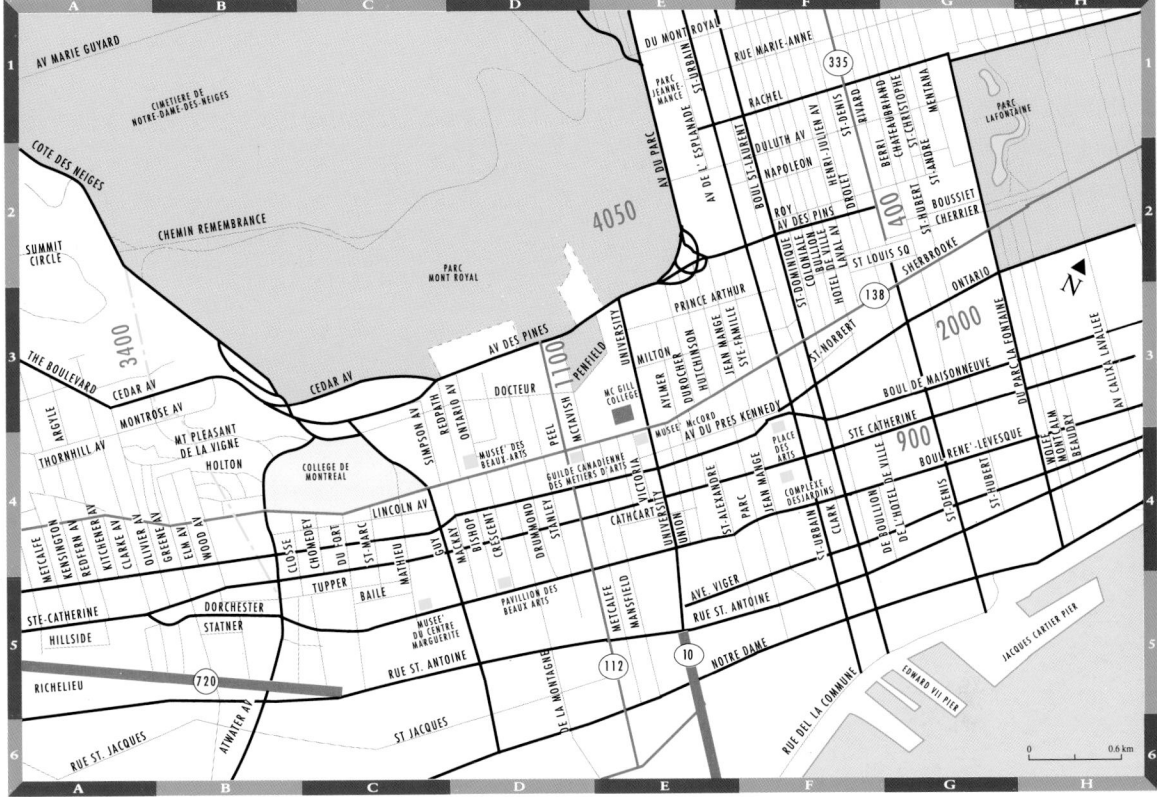

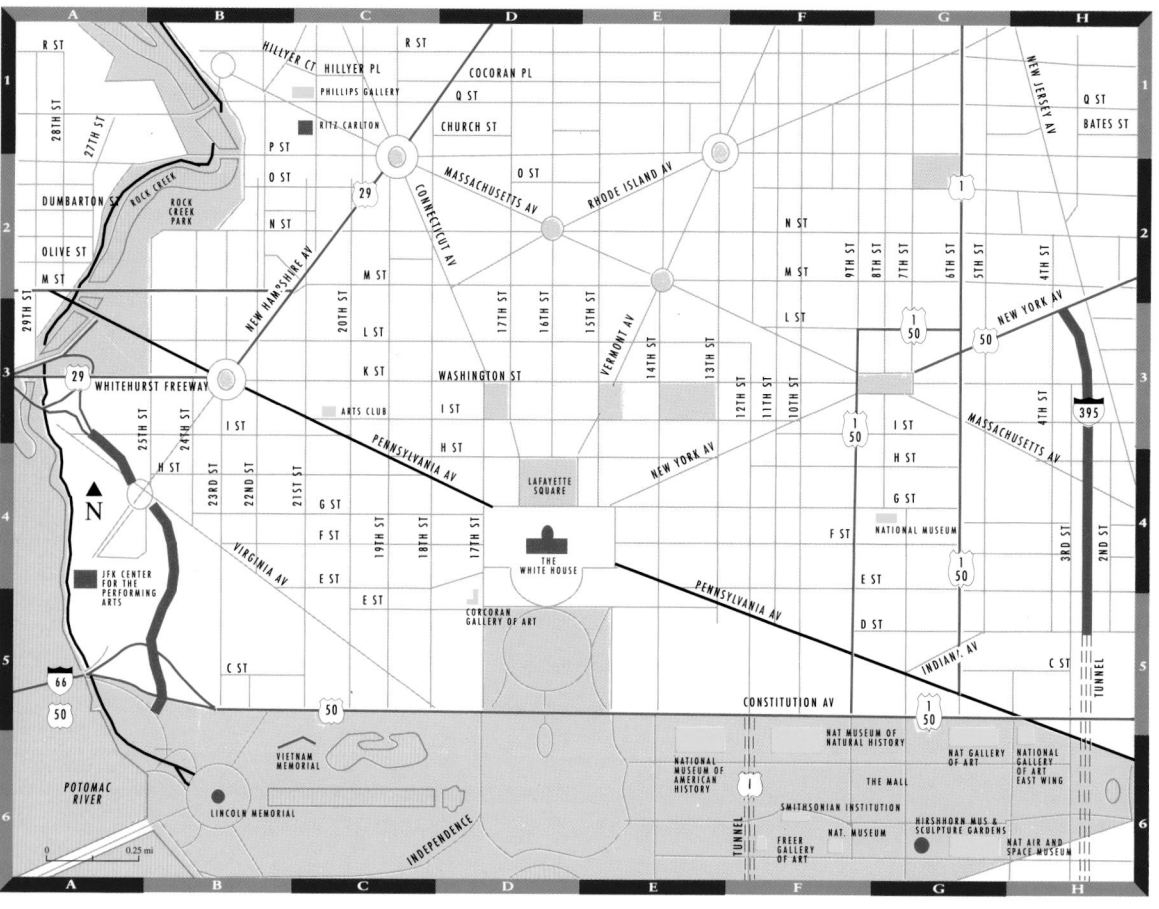

GALLERIES

David Adamson Gallery G4
406 Seventh St NW

Addison/Ripley Gallery C1
Nine Hillyer Ct

Alex Gallery *2106 R St NW* C1

Anton Gallery *2108 R St NW* C1

Franz Bader Gallery E3
1500 K St NW

Baumgartner Galleries Inc C1
2016 R St NW

Brody's Gallery *1706 21st St NW* D1

Robert Brown Gallery C1
2030 R St NW

Carega Foxley Leach Gallery C1
1732 Connecticut Ave NW

de Andino Fine Arts C1
1609 Connecticut Ave NW

Kathleen Ewing Gallery C1
1609 Connecticut Ave, Ste 200

Fendrick Gallery *3059 M St NW*

Foundry Nine *Hillyer Ct* C1

Gallery K *2010 R St NW* C1

Govinda Gallery *1227 34th St NW*

Jane Haslem Gallery C1
2025 Hillyer Place NW

Henri Gallery *1500 21st St W* C2

Internationl Sculpture Center
1050 Potomac St NW

Jones Troyer Fitzpatrick C1
1614 20th St NW

Kimberly Gallery C1
1621 21st St NW

BR Kornblatt Gallery G4
406 Seventh St NW

Le Marie Tranier Gallery
3304 M St NW

Maurine Littleton Gallery
1667 Wisconsin Ave NW

Marsha Mateyka Gallery C1
2012 R St NW

Middendorf Gallery
2009 Columbia R NW

Osuna Gallery *1919 Q St NW* C1

Pensler Galleries *2029 Q St NW* C1

Andrea Ruggiei Gallery
2610 Normanstone Ln

Studio Gallery *2108 R St NW* C1

Taggart & Jorgensen Gallery
3241 P St NW

Tartt Gallery *2017 Q St* C1

Washington Project For The Arts G4
400 Seventh St NW

Zenith Gallery *413 Seventh St NW* G4

MUSEUMS

The Corcoran Gallery Of Art D4
17th St & New York Ave NW

Hirshhorn Museum And G6
Sculpture Garden
Independence Ave At Seventh St, SW

National Gallery Of Art H5
4th & Constitution Ave, NW

National Museum Of American Art E5
14th St & Constitution Ave

The Phillips Collection C1
1600 21st St, NW

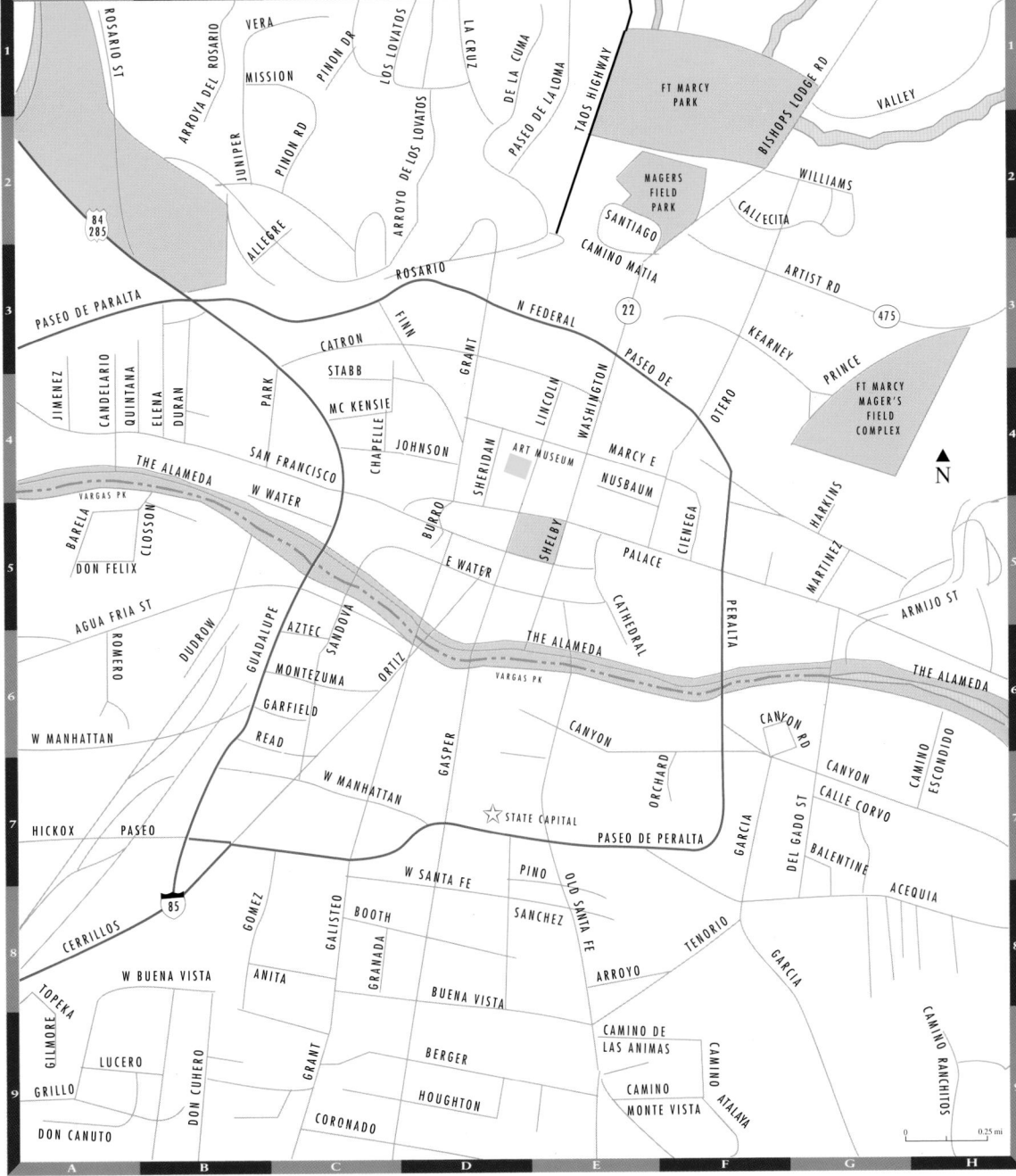

SAN FRANCISCO

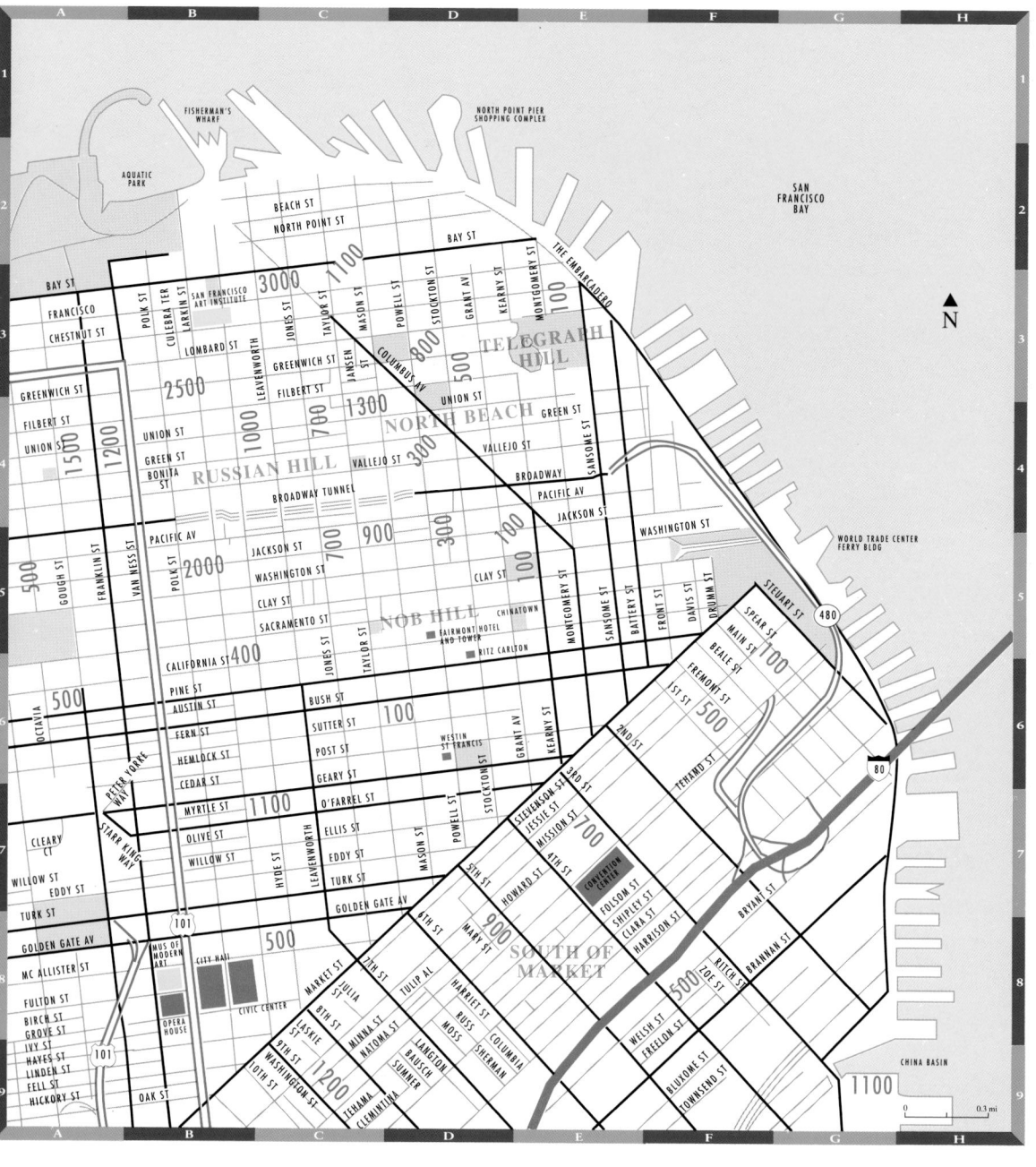

GALLERIES

871 Fine Arts Gallery D6
250 Sutter St, #450

The Allrich Gallery *251 Post St* D6

Art Com & Contemporary Arts Press
70 12th St, 3rd Fl

Eleonore Austerer Gallery **D6**
540 Sutter St

John Berggruen Gallery E6
228 Grant Ave

Bomani Gallery D6
251 Post St, Ste 600

Rena Bransten Gallery *77 Geary St* E6

Braunstein/Quay Gallery *250 Sutter* D6

Edith Caldwell Gallery D6
251 Post St, 2nd Fl

Campbell-Thiebaud Gallery D3
645 Chestnut St

Joanne Chappell Gallery F7
625 Second St, #400

Joseph Chowning Gallery *1717 17th St*

Contemporary Realist Gallery E6
23 Grant Ave, 6th Fl

Crown Point Press *657 Howard* **E7**

Olga Dollar Gallery D6
210 Post St, 2nd Fl

Michael Dunev Gallery *77 Geary* **E6**

Ebert Gallery *250 Sutter St* D6

Roberta English Gallery *250 Sutter* D6

Victor Fischer Galleries G6
350 Steuart St, Hill Plaza

Fraenkel Gallery *49 Geary St* E6

The Friends Of Photography E7
Ansel Adams Ctr, 250 Fourth St

Gallery Paule Anglim *14 Geary St* E7

Graystone *250 Sutter St, #330* **D6**

Brian Gross Fine Art D6
250 Sutter St, Ste 370

Haines Gallery *49 Geary St., 5th Fl* E6

Harcourts Modern & D6
Contemporary Art *460 Bush*

Hine Editions/Limestone Press F6
357 Tehama

Jan Holloway Gallery E6
59 Grant Ave, 2nd Fl

K Kimpton Gallery E6
228 Grant Ave, 5th Fl

Robert Koch Gallery *49 Geary St* **E6**

Peter Lembcke Gallery E6
23 Grant Ave

Erika Meyerovich Gallery E6
231 Grant Ave

Mincher/Wilcox Gallery E6
228 Grant Ave

Modernism Inc **E6**
685 Market St, Ste 290

John Pence Gallery *750 Post St* C6

San Francisco Arts Commission Gallery
155 Grove St

William Sawyer Gallery *3045 Clay St*

Michael Shapiro Gallery D6
250 Sutter St, 3rd Fl

Don Soker Contemporary Art D6
251 Post St, Ste 620

Southern Exposure *401 Alabama St*

Takada Fine Arts **D6**
251 Post St, 6th Fl

Trans Avant-Garde Gallery E6
41 Grant Ave

Udinotti Gallery *77 Geary St* E6

Vision Gallery *1155 Mission St* C8

Dorothy Weiss *Gallery 256 Sutter* **D6**

Stephen Wirtz Gallery **E6**
49 Geary St, 3rd Fl

MUSEUMS

The California Palace Of
The Legion Of Honor
34th & Clement St.

M.H. de Young Memorial Museum
Golden Gate Park

San Francisco Museum Of Modern Art
401 Van Ness Ave.

SEATTLE

GALLERIES

Davidson Galleries E8
313 Occidental Ave S

Linda Farris Gallery E7
322 Second Ave S

Fuller/Elwood Gallery E8
316 Occidental Ave S

Lisa Harris Gallery H5
1922 Pike Pl

Kimzey Miller Gallery E7
1225 Second Ave

Greg Kucera Gallery E7
626 Second Ave

Lynn McAllister Gallery E6
416 University Pl

Mia Gallery E8
314 Occidental Ave S

Cliff Michel Gallery E7
520 Second Ave

Francine Seders Gallery Ltd
6701 Greenwood Ave N

Silver Image Gallery E8
318 Occidental Ave S

William Traver Gallery D5
2219 Fourth St

Warwick Gallery *2512 Fifth Ave* D5

Gordon Woodside/John Braseth E5
1533 Ninth St

MUSEUMS

Henry Art Gallery E7
University Of Washington
Seattle Art Museum
First Ave & University St

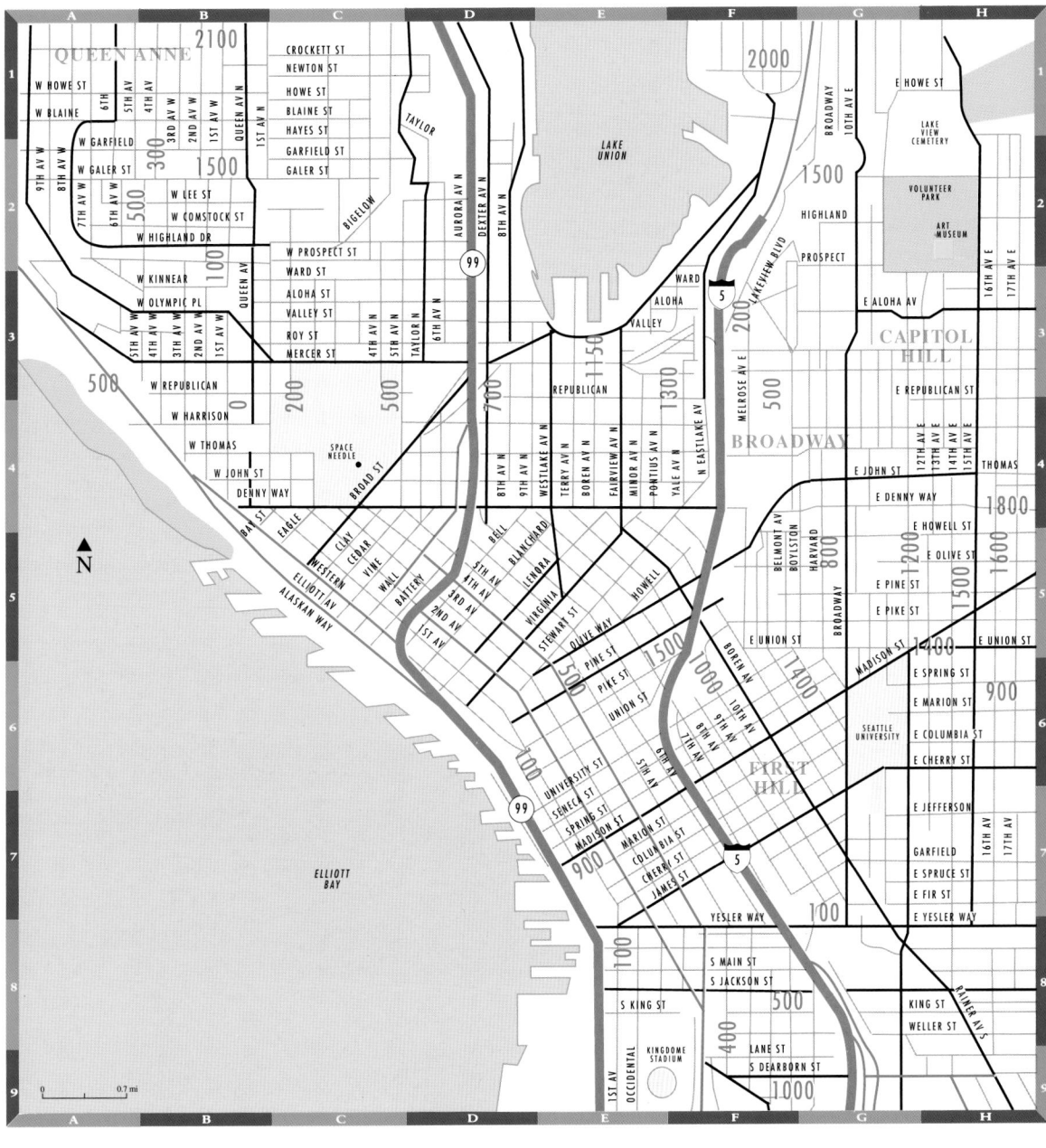

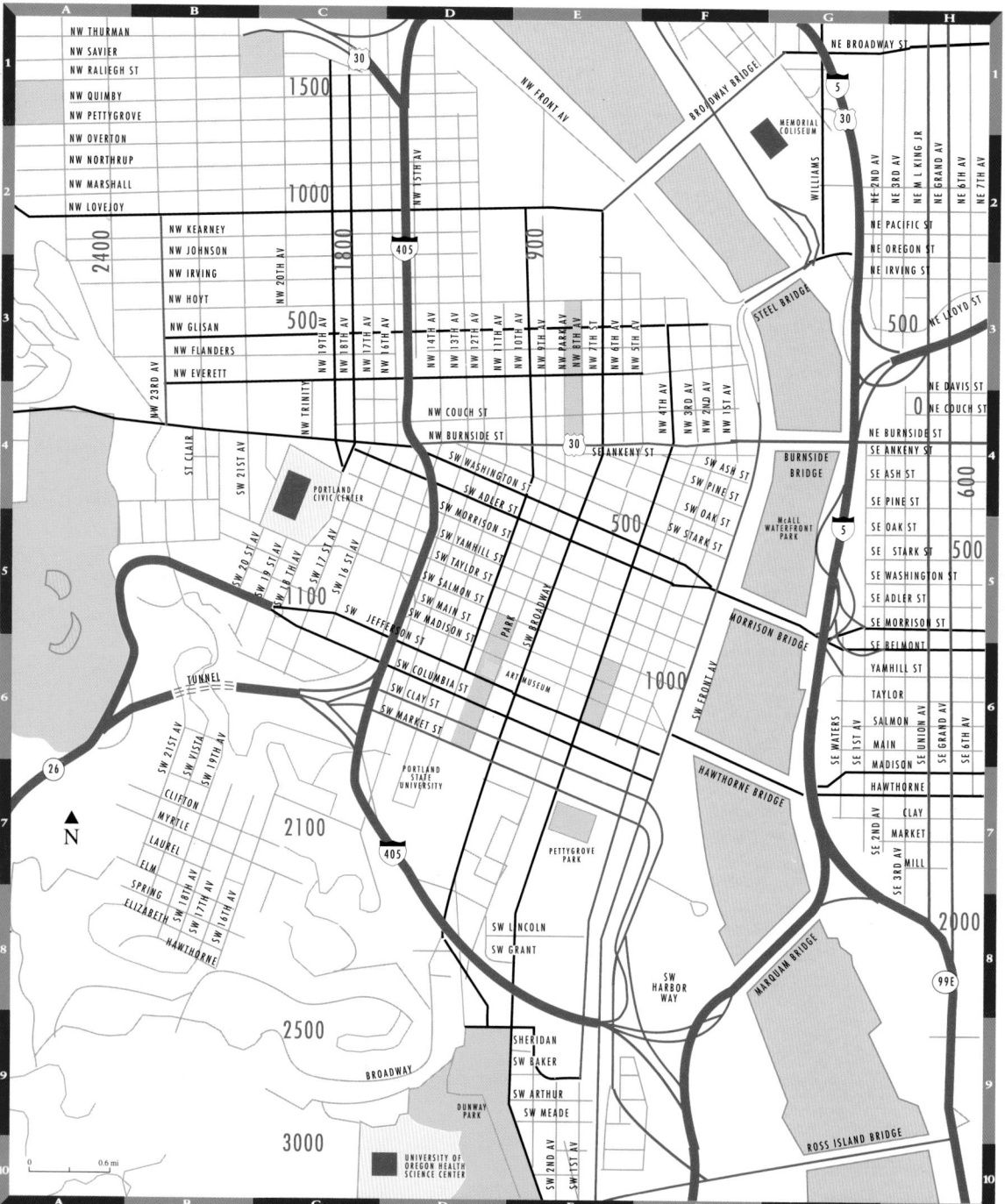

GALLERIES

Artist's Showroom *612 Dumaine St* D4

Casell Gallery *818 Royal St* E4

Merrill B. Domas Indian Art E4
824 Chartres St

Galerie Royale, Ltd *312 Royal St* D5

Galerie Simonne Stern *518 Julia St* D6

A Gallery For Fine Photography D5
313 Royal St

Gasperi Gallery *320 Julia St* D6

Hall-Barnett Gallery D5
320 Exchange Alley

Lemieux Galleries *332 Julia St* D6

Carmen Llewellyn Gallery E4
621 Decatur St

Christopher Maier Furniture D6
329 Julia St

Wyndy Morehead Fine Arts D6
603 Julia St

Marguerite Oestreicher Fine Art D5
636 Baronne St

Rodrigue Gallery of New Orleans D4
721 Royal St

Arthur Roger Gallery *432 Julia St* D6

Sylvia Schmidt Gallery *400 A Julia St* D6

Still-Zinsel Contemporary D6
328 Julia St

Tilden-Foley Gallery
4119 Magazine St

MUSEUMS

New Orleans Museum Of Art
1 Lelong Ave

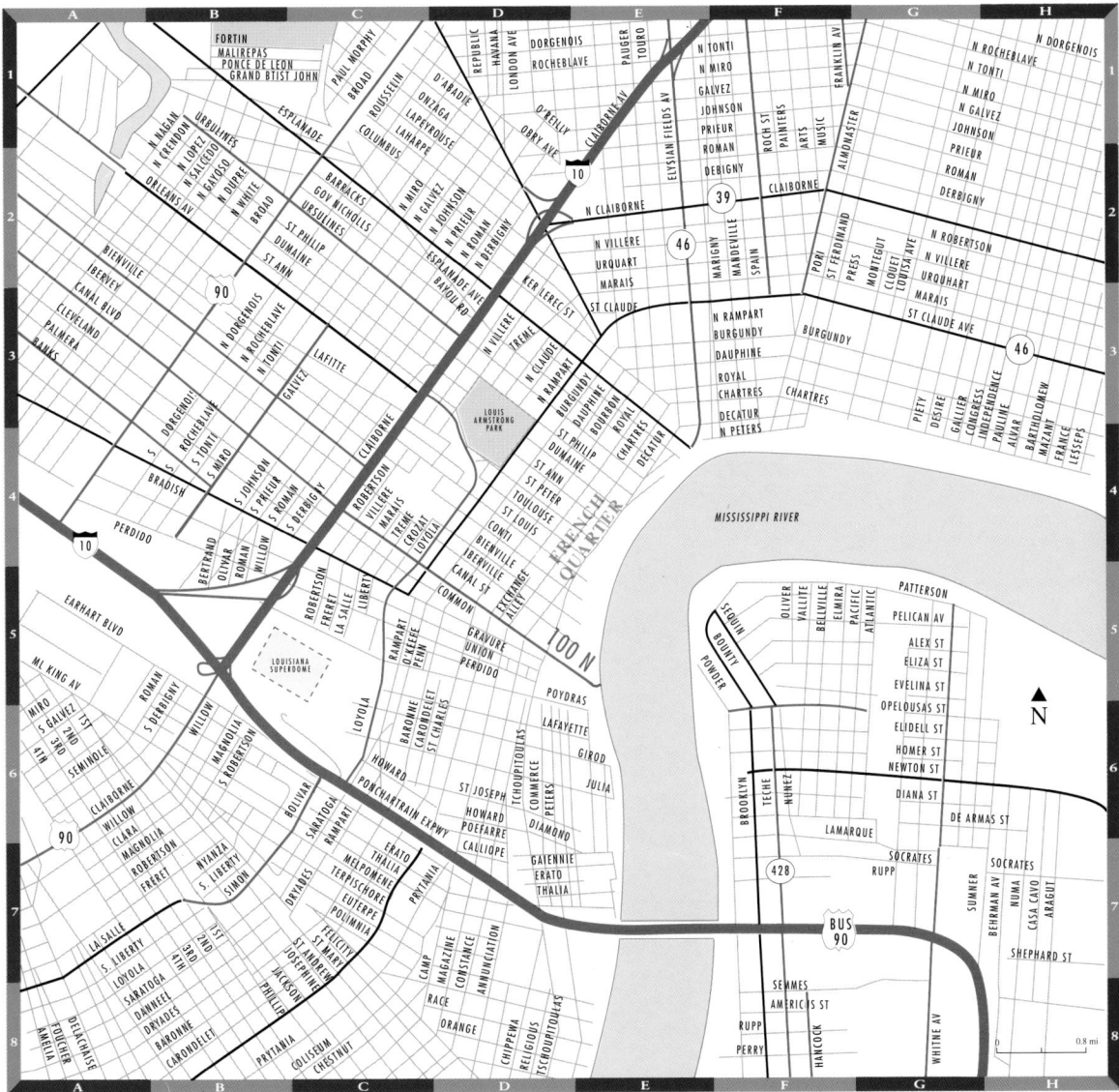

GALLERIES

101 Wooster Gallery *101 Wooster* D4

14 Sculptors Gallery *164 Mercer St* E3

14th Street Painters
114 W 14th St, 2W

303 Gallery *89 Greene St, 2nd Fl*

49th Parallel Gallery For Canadian Art
420 W Broadway, 4th Fl

A.I.R. Gallery *63 Crosby St* E4

Actual Art Foundation *7 Worth St*

Aesthetic Realism Foundation/Terrain
Gallery *141 Greene St*

Salvatore Ala *560 Broadway, 3rd Fl* E3

Fernando Alcolea Gallery D3
130 Prince St

Alex-Edmund Galleries D3
478 W Broadway

Brooke Alexander *59 Wooster St* D4

Brooke Alexander Editions
476 Broome Street

American Fine Arts Co D4
40 Wooster St

Ameringer & Avard Fine Art D4
131 Mercer St

Amos Eno Gallery D2
594 Broadway, #404

Arch Gallery *644 Broadway, #2E* E3

Art 54 *54 Greene St* D4

Atlantic Gallery *164 Mercer St* E3

Pamela Auchincloss Gallery E3
558 Broadway

Bill Bace Gallery *584 Broadway* E3

Josh Baer Gallery D4
476 Broome, 3rd Fl

Vrej Baghoomian Gallery E3
555 Broadway

Jayne H Baum Gallery E3
588 Broadway, Ste 202

David Beitzel Gallery *102 Prince St* D3

Bellas Artes *584 Broadway, #406* E3

Benedetti Gallery *52 Prince St* E4

Berland Hall Gallery *579 Broadway* E3

Berman-E.N. Gallery *138 Greene St* D3

Bettal Gallery *137 Duane St, 2nd Fl*

Michele Birnbaum Fine Art
530 W 23rd St

S Bitter-Larkin *597 Broadway* E3

Blom & Dom Gallery *164 Mercer St* E3

Bonino Gallery *48 Great Jones St*

Mary Boone Gallery D3
417 W Broadway

Damon Brandt *55 Vandam Ave* C3

Bridgewater/Lustberg Gallery E4
529 Broadway

Diane Brown Gallery *23 Watts St* C4

Christine Burgin Gallery D3
130 Prince St

Frank Bustamante Gallery E3
560 Broadway, Ste 605

C & A Gallery *96 Spring St, 8th Fl* D4

Leo Castelli Gallery D3
2420 W Broadway

Cavin-Morris Inc E4
1560 Broadway, 2nd Fl

Center For Tapestry Arts *167 Spring St*

Ceres Gallery *91 Franklin*

CFM Gallery *138 W 17th St*

Chinoh Art Gallery *69 Fifth Ave*

Cityarts, Inc *625 Broadway, 2nd Fl*

A Clean, Well-Lighted Place E3
363 Bleecker St

Clock Tower Gallery *108 Leonard St*

Condeso/Lawler Gallery *76 Greene* D4

Paula Cooper Gallery D3
149/155 Wooster St

Coup De Grace Gallery D4
579 Broadway

Charles Cowles Gallery, Inc D3
420 W Broadway

Crown Point Press *568 Broadway* E3

Tom Cugliani Gallery B5
508 Greenwich Ave

Bess Cutler Gallery *164 Mercer St* E3

Dannenberg Gallery *484 Broome St* D4

James Danziger Gallery D3
415 W Broadway, 3rd Fl

Maxwell Davidson Gallery
415 W Broadway

Mary Delahoyd Gallery *426 Broome St* E4

Dome Gallery *578 Broadway, 5th Fl* E3

EM Donahue Gallery E3
560 Broadway, #304

Fred Dorfman Gallery *123 Watts St* C4

Editions Schellmann *50 Greene St* D4

G W Einstein Co, Inc E3
591 Broadway

Vera Engelhorn Gallery E3
591 Broadway, 3rd Fl

Amos Eno Gallery D3
495 Broadway, #404

Thomas Erben Gallery, Inc D4
118 Spring St

Ergane Gallery *469 W Broadway* D3

Rosa Esman Gallery *575 Broadway* E3

Eleanor Ettinger Inc
155 Ave Of The Americas

Exit Art *578 Broadway, 8th Fl*

Fawbush Gallery *76 Grand St* D5

Feature *484 Broome St* D4

Ronald Feldman Fine Arts D5
31 Mercer St

fiction/nonfiction *21 Mercer St* D4

Fifty-Five Mercer Gallery D4
55 Mercer St

First Street Gallery E3
560 Broadway, 4th Fl

Flynn *113 Crosby St* E4

Gagosian Gallery *134-136 Wooster St*

Galerie Select Ltd *56 University Pl* E1

Gallery David *594 Broadway* E3

Gallery Henoch *80 Wooster St* D4

Gallery Revel *96 Spring St* D4

The Gallery Three-Zero *30 Bond St* E3

Gemini G.E.L. At Joni Weyl D4
375 W Broadway, 2nd Fl

Sandra Gering Gallery *476 Broome St* D4

Germans Van Eck *420 W Broadway* D3

John Gibson Gallery *568 Broadway* E3

Gimpel/Weitzenhoffer Gallery D3
415 West Broadway

Barbara Gladstone Gallery E4
99 Greene St

Caren Golden Fine Arts E3
270 Lafayette St, Ste 903

Foster Goldstrom E3
2560 Broadway, Ste 303

John Good Gallery *532 Broadway* E4

Jay Gorney Modern Art E3
100 Greene St

Greenwich House Pottery/Jane
16 Jones St

Howard Greenberg Gallery D3
120 Wooster St

William Haber *164 Duane St* C6

Haenah-Kent *25 Howard*

Stephen Haller Fine Art D3
415 W Broadway

Susan Harder At Twining Gallery E3
568 Broadway

O.K. Harris Works Of Art D4
383 W Broadway

Emily Harvey Gallery E4
537 Broadway, 2nd Fl

Sally Hawkins Fine Arts D3
448 West Broadway, 2nd Fl

Pat Hearn Gallery *39 Wooster St* D4

Helander Gallery *415 W Broadway* D3

Helio Galleries *588 Broadway, 4th Fl* E3

Heller Gallery *71 Greene St* D4

Henry Street Settlement Arts Center
466 Grand St

Carolyn Hill Gallery *109 Spring St* D4

Nancy Hoffman Gallery D3
429 W Broadway

Humphrey Fine Art E3
594 Broadway, 4th Fl

Illustration House Inc *96 Spring, 7th Fl* D4

Michael Ingbar Gallery *578 Broadway* E3

Jamison/Thomas Gallery E3
588 Broadway, Ste 303

Paul Kasmin Gallery E3
580 Broadway, 2nd Fl

Hal Katzen Gallery *475 Broome St* D4

June Kelly Gallery *591 Broadway, 3rd Fl* E3

Phyllis Kind Gallery *136 Greene St* D3

Nicole Klagsbrun *51 Greene St* D4

Michael Klein Inc E3
594 Broadway, Rm 302

La Mama La Galleria *6 E 1st St*

Ledel Gallery *168 Mercer St* E3

Ledisflam Gallery *584 Broadway, #309* E3

Lennon, Weinberg, Inc E3
3580 Broadway, 2nd Fl

Christopher Leonard Gallery E3
594 Broadway, 3rd Fl

Emil Leonard Gallery Ltd D3
138 Wooster St

Michael Leonard & Associates E4
419 Broome St

Chuck Levitan Gallery *42 Grand St* D4

Steuart Levy Gallery D3
415 W Broadway, 3rd Fl

Lieberman & Saul Gallery D4
155 Spring St

Limner Gallery *598 Broadway*

Amy Lipton *67 Prince At Crosby* E3

Lorence Monk *568 Broadway* E3

Louver Gallery *130 Prince St* D3

Simon Lowinsky Gallery E3
575 Broadway

Lucia Gallery *150 Spring St* D4

Luhring Augustine Gallery D3
130 Prince St

Virginia Lust Gallery *61 Sullivan St* C4

M-13 Gallery *72 Greene St* D4

Mallet Fine Art *141 Prince St* D3

Curt Marcus Gallery *578 Broadway* E3

Louis K. Meisel Gallery *141 Prince St* D3

Metro Pictures *150 Greene St* D3

Laurence Miller Gallery *138 Spring St* D4

Molica Giudarte Gallery D4
379 W Broadway

Montserrat Gallery E3
588 Broadway, 5th Fl

Morningstar Gallery Ltd E3
164 Mercer St

Victoria Munroe Gallery D3
130 Prince St

Nahan Galleries *381 W Broadway* D4

Neo Persona Gallery *178 Duane St* C6

New Glass *345 W Broadway* D4

Daniel Newburg Gallery E3
580 Broadway

NoHo Gallery *168 Mercer St* E3

David Nolan Gallery E3
560 Broadway, 6th Fl

Annina Nosei Gallery *100 Prince St* D3

Opsis Foundation E3
561 Broadway, #10C

The Pace Gallery *142 Greene St* D3

Marilyn Pearl Gallery D3
420 W Broadway

Katharina Rich Perlow Gallery E3
560 Broadway, 3rd Fl

Petersburg *130 Prince St* D3

Marcuse Pfeifer Gallery
311 1/2 W 20th St

Phoenix Gallery E3
568 Broadway, Ste 607

Pindar Gallery *127 Greene St* D3

Pleiades Gallery *164 Mercer St* E3

Anne Plumb Gallery *81 Greene St* D4

Portico New York, Inc D4
139 Spring St, 2nd Fl

Postmasters Gallery D4
80 Greene St, 2nd Fl

P•P•O•W *532 Broadway, 3rd Fl* E4

Julian Pretto *103 Sullivan St* D3

Prince Street Gallery *121 Wooster St* D3

Max Protetch Gallery *560 Broadway* E3

Puchong Gallery *36a Third Ave* F1

Ricco/Maresca Gallery C5
105 Hudson St

Margarete Roeder Gallery E4
545 Broadway

Stephen Rosenberg Gallery D3
115 Wooster St

The Andrea Rosen Gallery D3
130 Prince St

Ross-Constantine *65 Prince St* E3

Perry Rubenstein *130 Prince St* D3

Rubin Spangle Gallery D4
395 W Broadway

Ruggiero *72 Thompson St* D4

Sander Gallery C5
105 Hudson St, Ste 208

CS Schulte Galleries E3
565 Broadway

Scott Alan Gallery E4
270 Lafayette St, Ste 204

Betsy Senior Contemp Prints D4
375 W Broadway

Kathryn Sermas Gallery D5
19 Green St, 4th Fl

Tony Shafrazi Gallery D3
130 Prince St

Jack Shainman Gallery, Inc E3
560 Broadway, 2nd Fl

Anita Shapolsky Gallery D4
99 Spring St

Brent Sikkema Fine Art D4
155 Spring St

Snyder Fine Art *588 Broadway* E3

SoHo 20 *469 Broome St* D4

SoHo Center For Visual Artists
114 Prince St

SoHo Graphic Arts Workshop D3
433 W Broadway

SoHo Photo Gallery *15 White St*

SOLO Gallery/SOLO Press E3
578 Broadway, 6th Fl

Sonnabend Gallery D3
420 W Broadway

Sorkin Gallery E3
596 Broadway, 2nd Fl

Sperone Westwater D3
121 Greene St

Sragow Gallery *73 Spring St* E4

Staempfli *415 W Broadway* D3

Philippe Staib Gallery D5
8 Greene St

Staley-Wise *560 Broadway* E3

Stark Gallery E3
594 Broadway, Ste 301

Bernice Steinbaum Gallery D3
132 Greene St

Steinglodstone *99 Wooster St* D4

Stricoff Galleries *484 Broome St* D4

Stux Gallery *155 Spring St, 3rd Fl* D4

Styria Studio *426 Broome St* E4

John Szoke Gallery *164 Mercer St* E3

Susan Teller Gallery E3
568 Broadway, Rm 405A

Tomoko Liguon Gallery *93 Grand St*

The Garner Tullis Workshop D6
Ten White St

Twining Gallery Inc E3
568 Broadway, Ste 107

Visual Arts Gallery D3
137 Wooster St

Walker, Ursitti & McGinniss B5
500 Greenwich Ave

Ward-Nasse Gallery D3
178 Prince St

Simon Watson *241 Lafayette St* E4

John Weber Gallery D3
142 Greene St

Jan Weiss Gallery *68 Laight St* C5

Wessel O'Connor Gallery E3
580 Broadway, 8th Fl

White Columns
154 Christopher St, 2nd Fl

Ealan Wingate Gallery E3
578 Broadway

The Witkin Gallery, Inc D3
415 W Broadway

Souyun Yi Gallery *249 Centre St* E4

Andre Zarre Gallery D4
379 W Broadway, 2nd Fl

MUSEUMS

The New Museum Of E3
Contemporary Art
583 Broadway

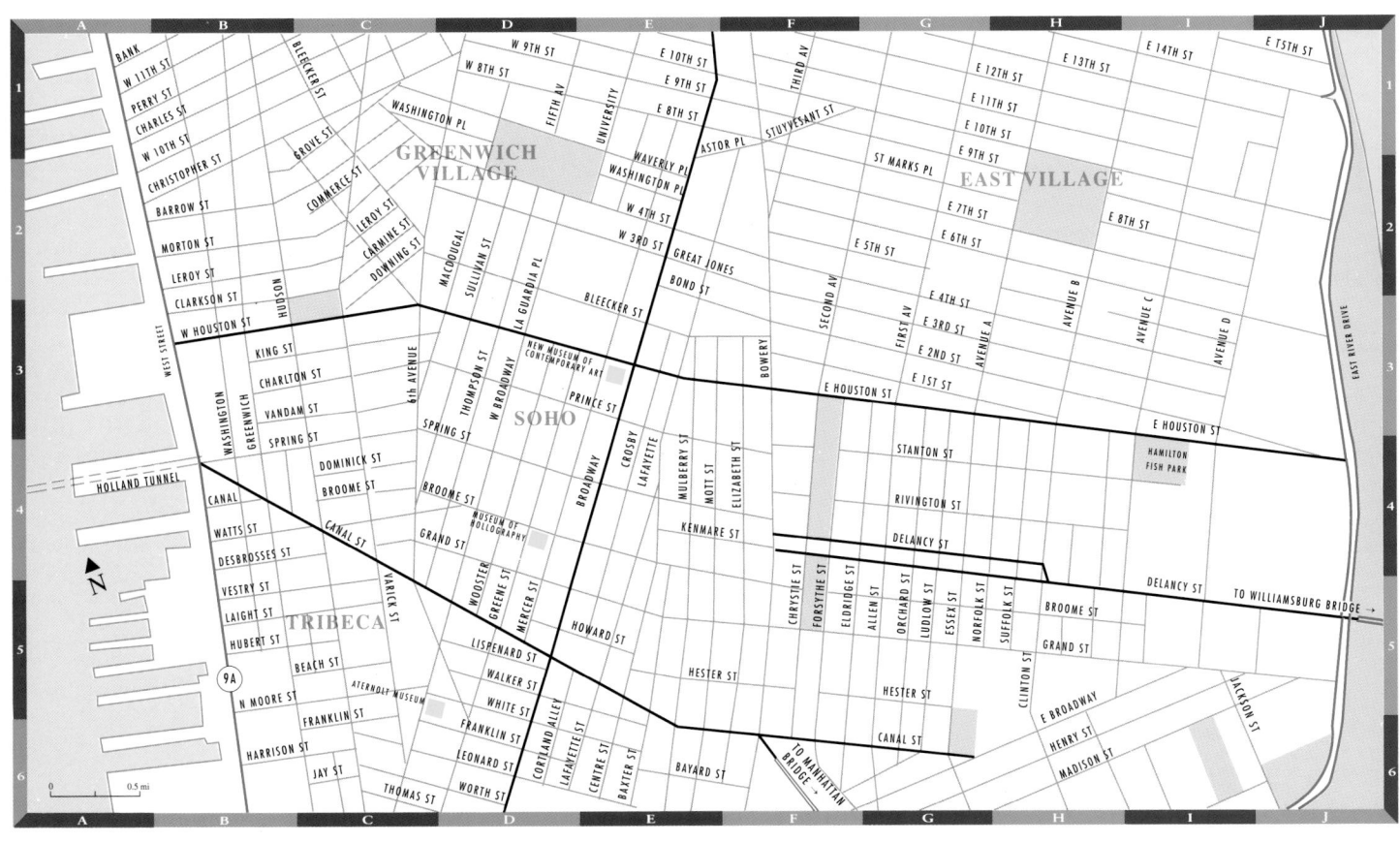

GALLERIES

ACA Galleries 41 E 57th St, 7th Fl G8

Adelson Galleries, Inc G3
25 E 77th St, 3rd Fl

Rachel Adler Gallery 41 E 57th St G8

Alexander Gallery G4
980 Madison Ave

Anderson-Gould Fine Art
31 Sutton Pl

Arsenal Gallery 5th Ave At 64th St G7

Artists Representing Environmenal Art
500 E 83rd St

ASF Gallery American-Scandinavian
725 Park Ave

Associated American Artists **F8**
20 W 57th St

Avanti Galleries Inc G4
956 Madison Ave

Babcock Galleries **G9**
724 Fifth Ave

Bag One Arts, Inc 110 W 79th St D3

Baron/Boisante Gallery F8
50 W 57th St

JN Bartfield Galleries F8
30 W 57th St

Claude Bernard Gallery, Ltd G4
33 E 74th St

Berry-Hill Galleries, Inc 11 E 70th St G5

BlumHelman Gallery, Inc F8
20 W 57th St

Grace Borgenicht Gallery G9
724 Fifth Ave

Brewster Gallery 41 W 57th St F8

Bruton Gallery, Inc 40 E 61st St G7

Steve Bush (A Leger De Main)
2710 Broadway, 3rd Fl

Denise Cade-Art Prospect Inc G3
1045 Madison Ave

Simon Capstick-Dale Fine Art G5
128 E 72nd St, Ste 3B

The Carus Gallery G5
872 Madison Ave

CDS 13 E 75th St G4

Childs Gallery 41 E 57th St, #702 G8

Garth Clark Gallery F8
24 W 57th St

Coe Kerr Gallery 49 E 82nd St G2

Sylvan Cole 101 W 57th St F8

Cudahy's Gallery Inc **H4**
170 E 75th St, 2nd Fl

Philippe Daverio Gallery G8
41 E 57th St

Davis & Langdale Co, Inc G8
231 E 60th St

Marisa del Re Gallery 41 E 57th St G8

Sid Deutsch Gallery F8
29 W 57th St

Terry Dintenfass Gallery F8
50 W 57th St

Douglas Drake Gallery F8
50 W 57th St

The Elkon Gallery, Inc 18 E 81st St G2

Andre Emmerich Gallery **G8**
41 E 57th St, 5th & 6th Fls

Richard L Feigen & Co G6
49 E 68th St

Figura Inc 53 E 75th St G4

David Findlay Galleries
984 Madison Ave

Peter Findlay Gallery G4
1001 Madison Ave

Fischbach Gallery 24 W 57th St F8

Fitch-Febvrel Gallery G8
Five E 57th St, 12th Fl

Forum Gallery 745 Fifth Ave **G8**

fotomann inc 42 E 76th St **G4**

Sherry French Gallery 24 W 57th St F8

Barry Friedman Ltd G2
1117 Madison Ave

Frumkin/Adams Gallery 50 W 57th St F8

Gagosian Gallery **G4**
980 Madison Ave, 6th Fl

Galeria Joan Prats F8
24 W 57th St, Ste 404

Galerie des Arts Limited 18 E 76th St G4

Galerie Felix Vercel 17 E 64th St

Galerie Lelong 20 W 57th St F8

Galerie Rienzo 922 Madison Ave G4

Galerie St Etienne 24 W 57th St F8

Galerie Tamnaga **G4**
982 Madison Ave

Gallery 84 50 W 57th St F8

Gallery International 157 E9
888 Seventh Ave

Gallery Korea 460 Park Ave, 6th Fl

Gallery Schlesinger Limited G4
24 E 73rd St

Hilde Gerst Gallery 685 Madison Ave G8

Stephen Gill Gallery 122 E 57th St G8

Glass Art Gallery
315 Central Park W, Ste 8W

Goethe House 1014 Fifth Ave

Alan M Goffman 264 E 78th St G3

Judy Goffman Fine Art 18 E 77th St G4

James Goodman Gallery G8
41 E 57th St, 8th Fl

Marian Goodman Gallery F8
24 W 57th St

Graham Modern 1014 Madison Ave G3

Grand Central Art Galleries F8
24 W 57th St

Nohra Haime Gallery G8
41 E 57th St, 6th Fl

Hammer Galleries 33 W 57th St **F8**

Lillian Heidenberg Gallery F8
50 W 57th St

Arnold Herstand & Company F8
24 W 57th St

Hirschl & Adler Modern **G6**
851 Madison Ave

Irena Hochman 22 E 72nd St G4

Vivian Horan Fine Art 35 E 67th St G6

Leonard Hutton Galleries G4
33 E 74th St

Intar Gallery 420 W 42nd St E12

Isselbacher Gallery 41 E 78th St G3

Jadite Galleries 415 W 50th St D10

Sidney Janis Gallery 110 W 57th St F8

Jordan-Volpe Gallery, Inc G4
958 Madison Ave

Peter Joseph Gallery G8
745 Fifth Ave, 4th Fl

Paul Judelson Arts 314 E 51st St G10

Alexander Kahan Fine Arts G3
40 E 76th St

Jane Kahan Gallery 922 Madison Ave G4

Joseph Keiffer Inc 28 E 72nd St G5

Kennedy Galleries, Inc **F8**
40 W 57th St

Kent Gallery, Inc 47 E 63rd St G7

Pat Kery Fine Arts, Inc 52 E 66th St G6

Knoedler & Company G5
19 E 70th Street

Kouros Gallery 23 East 73rd St G4

Paul Kovesdy 16 E 73rd St G4

Kraushaar Galleries, Inc 724 Fifth Ave F8

Jan Krugier Gallery 41 E 57th St G8

Lafayette Parke Gallery 58 E 79th St G3

Lewis Lehr Inc. 444 E 86th St I7

Bruce R. Lewin Fine Art G5
150 E 69th St

Daniël E. Lewitt Fine Art G3
16 E 79th St

Littlejohn-Smith Gallery G5
245 E 72nd St

Lladro Art Gallery 43 W 57th St F8

Lunn Ltd 42 E 76th St G4

Magidson Fine Art G3
1070 Madison Ave

Walter Maibaum F8
50 W 57th St, 7th Fl

Marcelle Fine Art, Inc **G4**
996 Madison Ave

Matthew Marks 1018 Madison Av G3

Marlborough Gallery, Inc F8
40 W 57th St

Mary-Anne Martin/Fine Art **G4**
23 E 73rd St

Barbara Mathes 851 Madison Ave G6

Pierre Matisse Gallery 41 E 57th St G8

Paul McCarron 1014 Madison Ave G3

Jason McCoy Inc 41 E 57th St G8

Mckee Gallery 745 Fifth Ave, 4th Fl G8

Midtown Payson Galleries **G8**
745 Fifth Ave

Robert Miller Gallery 41 E 57th St G8

Achim Moeller Fine Art 52 E 76th St G3

National Academy Of Design
1083 Fifth Ave

Enrico Navarra 41 E 57th St G8

Heidi Neuhoff Gallery Inc G4
999 Madison Ave

Jill Newhouse 12 E 86th St

Newmark Gallery 1194 Third Ave I5

New York Public Library
Fifth Ave & 42nd St

Nikon House 620 Fifth Ave F10

O'Hara Gallery 41 E 57th St G8

Outer Space (A Leger De Main)
2710 Broadway, 3rd Fl

Pace/MacGill Gallery G8
32 E 57th St, 9th Fl

The Pace Gallery 32 E 57th St **G8**

Perls Galleries 1016 Madison Ave G3

Praxis International Art G9
306 E 55th St 2nd Fl

Previti Gallery 110 Riverside Dr, #12B

Public Art Fund Inc
1285 Ave Of The Americas

Anthony Ralph Gallery 43 E 78th St G3

Reece Galleries 24 W 57th St F8

Reinhold-Brown Gallery 26 E 78th S. G3

Michael Rosenfeld Gallery F8
50 W 57th St

Peter Rose Gallery 200 E 58th St G8

Rosenfeld Fine Arts 44 E 82nd St G2

Luise Ross Gallery 50 W 57th St F8

Mary Ryan Gallery Inc
452 Columbus Ave

Sacks Fine Art 50 W 57th St F8

Saidenberg Gallery G3
1018 Madison Ave

Salander-O'Reilly Galleries G3
20 E 79th St

Martha Schaeffer Fine Art J1
500 E 77th St, Ste 512

Lisa Schiller Fine Art 19 E 74th St G4

Schillay & Rehs 305 E 63rd St H7

Schmidt Bingham F8
41 W 57th St, 3rd Fl

Schutz & Company 205 W 57th St E8

Sculpture Center Gallery
167 E 69th S

Susan Sheehan Gallery 41 E 57th St G8

Ruth Siegel Gallery 24 W 57th St F8

Linda R. Silverman Fine Art G6
160 E 65th St

Simon/Neuman Gallery G4
42 E 76th St

Sindin Galleries 1035 Madison Ave G4

Holly Solomon G8
Gallery 724 Fifth Ave

Soufer Gallery 1015 Madison Ave G4

Stiebel Modern **G8**
32 E 57th St, 6th Fl

Allan Stone Gallery 48 E 86th St G1

Martin Sumers Graphics F8
50 W 57th St

Leila Taghinia-Milani G3
1080 Madison Ave

Tambaran Gallery 20 E 76th St G4

Tatistcheff & Co, Inc F8
50 W 57th St, 8th Fl

Tibor de Nagy Gallery F8
41 W 57th St

Jack Tilton Gallery 24 W 57th St F8

David Tunick, Inc. 12 E 81st St G2

Edward Tyler Nahem Fine Art G6
56 E 66th St

Ulysses Gallery 41 E 57th St G8

Uptown Gallery, Inc G7
1194 Madison Ave

Bertha Urdang Gallery 23 E 74th St G4

Vanderwoude/Tananbaum G2
24 E 81st St

Viridian Gallery F8
24 W 57th St, 8th Fl

Washburn Gallery G8
41 E 57th St, 8th Fl

Phyllis Weil & Company H7
1065 Park Ave

Weintraub Gallery G4
988 Madison Ave

L J Wender Fine Chinese Painting G3
Three E 80th St

Michael Werner Gallery G6
21 E 67th St

D Wigmore Fine Art, Inc G4
22 E 76th St

Gerold Wunderlich & Co. F8
50 W 57th St, 12th Fl

Richard York Gallery 21 E 65th St G6

Yoshii Gallery 20 W 57th St F8

Zabriskie Gallery 724 Fifth Ave F8

MUSEUMS

Cooper-Hewitt Museum Of Design,
Smithsonian Institue
2 E 91st Street

The Frick Collection 1 E 70th St G5

Solomon R. Guggenheim Museum
1071 5th Ave

The IBM Museum Of Science & Art G11
500 Madison Ave

International Center Of Photography
1130 Fifth Ave At 94th St

Metropolitan Museum Of Art F2
1000 Fifth Ave

The Museum Of Modern Art F9
11 W 53rd Ave

The Studio Museum In Harlem
144 W 125th St

Whitney Museum Of American Art G4
945 Madison Ave At 75th St

NEW YORK

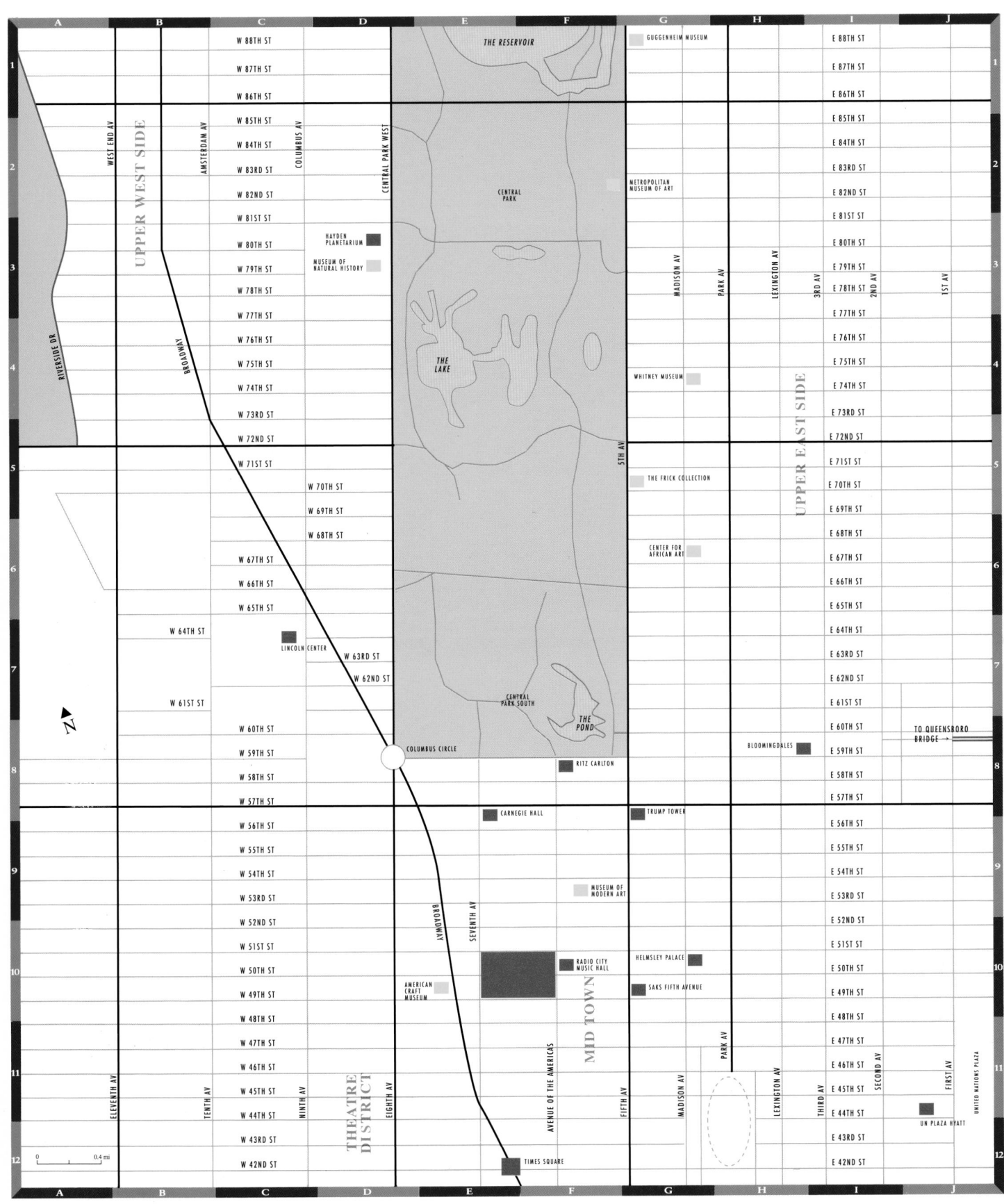

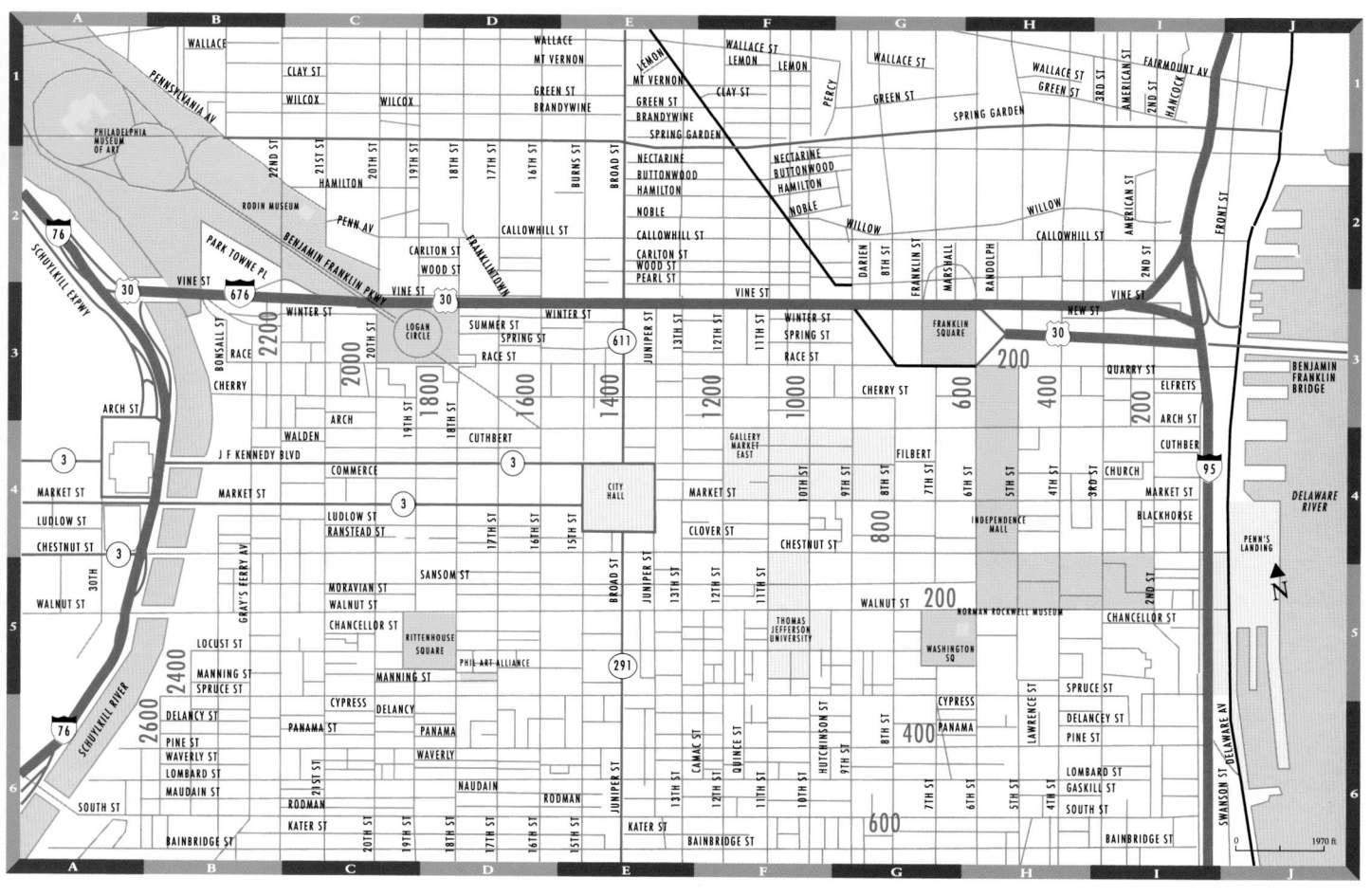

GALLERIES

479 Gallery 55 N Second I2

Art Space Gallery 2100 Spring St **C1**

Larry Becker 43 N Second St I2

Joy Berman Galleries C1
2201 Pennsylvania Ave

Jessica Berwind Gallery **H2**
301 Cherry St, 2nd Fl

Paul Cava Gallery 22 N Third St **H3**

The Clay Studio 139 N Second I2

David David Gallery **D4**
260 S 18th St

Dolan/Maxwell D3
2046 Rittenhouse Square

Helen Drutt Gallery **D3**
1721 Walnut St

The Fabric Workshop F1
1100 Vine St, 13th Fl

F.A.N. Gallery 311 Cherry St

Janet Fleisher Gallery **D4**
211 S 17th St

Jeffrey Fuller Fine Art, Ltd. D4
132 S 17th St

Galerie Nadeau 118 N Third St H2

Gallery Axiom 1206 Walnut St F3

Goforth Rittenhouse Gallery E3
1524 Walnut St

Gross Mccleaf Gallery 127 S 16th St D3

Rodger La Pelle Galleries H2
122 N Third St

Locks Gallery 600 Washington Sq S G4

Marian Locks Gallery E3
1524 Walnut St

Gilbert Luber Gallery F3
1220 Walnut St

Mangel Gallery D4
1714 Rittenhouse Square

The More Gallery, Inc D3
1630 Walnut St, 2nd Fl

Muse 1915 Walnut C3

Nexus Gallery 137-139 N Second I2

Lawrence Oliver Gallery **D3**
1617 Walnut St

Owen Patrick Gallery
4345 Main St, Manayunk

The Painted Bride Art Center I1
230 Vine St

Rosenfeld Gallery 113 Arch St I2

Schmidt/Dean Gallery D3
1636 Walnut St

Snyderman Gallery 317 South St

Studio Diabloiques 1114 Pine St F4

Temple Gallery 1619 Walnut St D3

Sande Webster Gallery C3
2018 Locust St

The Works Gallery 319 South St H5

MUSEUMS

Institute Of Contemporary Art
University Of Pennsylvania,
36th & Sansom St

Pennsylvania Academy E2
Of The Fine Arts
Broad & Cherry St

The Philadelphia Art Alliance D4
251 S 18th St

Philadelphia Museum Of Art A1
26th & Benjamin Franklin Pkwy

The Woodmere Art Museum
9201 Germantown

DENVER

GALLERIES

Alpha Gallery 959 Broadway — D7

Artyard 1251 S Pearl St — E6

Kyle Belding Gallery 1110 17th St — C4

The Camera Obscura Gallery
1309 Bannock St — D6

Sandy Carson Gallery
1734 Wazee St — C4

Hassel Haeseler Gallery — C4
1743 Wazee St

Inkfish Gallery 949 Broadway — D7

McConnell Gallery — C4
1444 Wazee St, Ste 120

Payton Rule Gallery — C4
1736 Wazee St

Joan Robey Gallery 939 Broadway — C4

Robischon Gallery 1740 Wazee St — C4

Brigitte Schluger Gallery — D7
929 Broadway

The Carol Siple Gallery, Ltd — C4
1401 17th St

Spark 3300 Osage

Ginny Williams Gallery — G8
299 Fillmore St

MUSEUMS

Denver Art Museum — C6
100 W 14th Ave

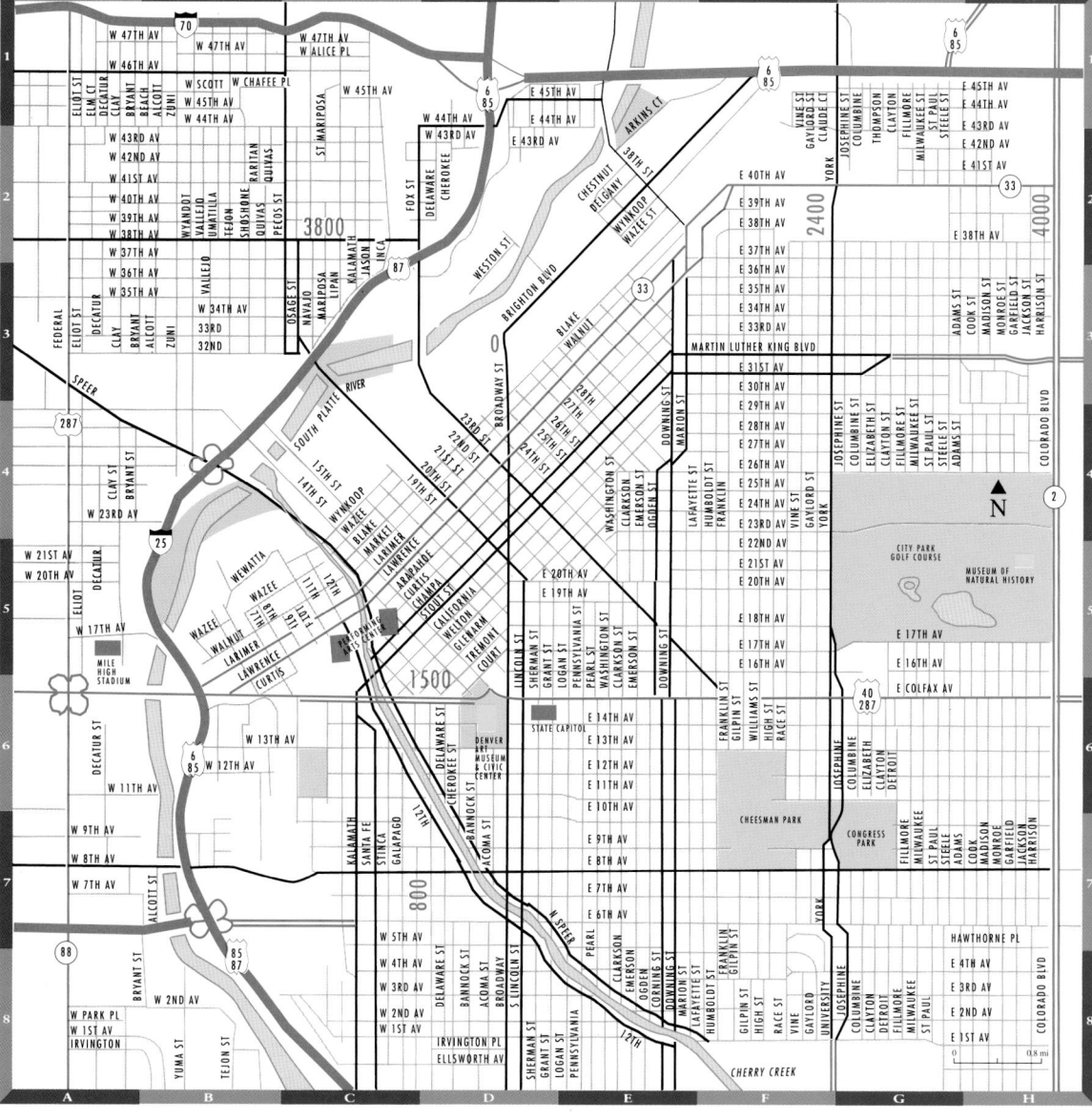

534 – The Fine Art Index

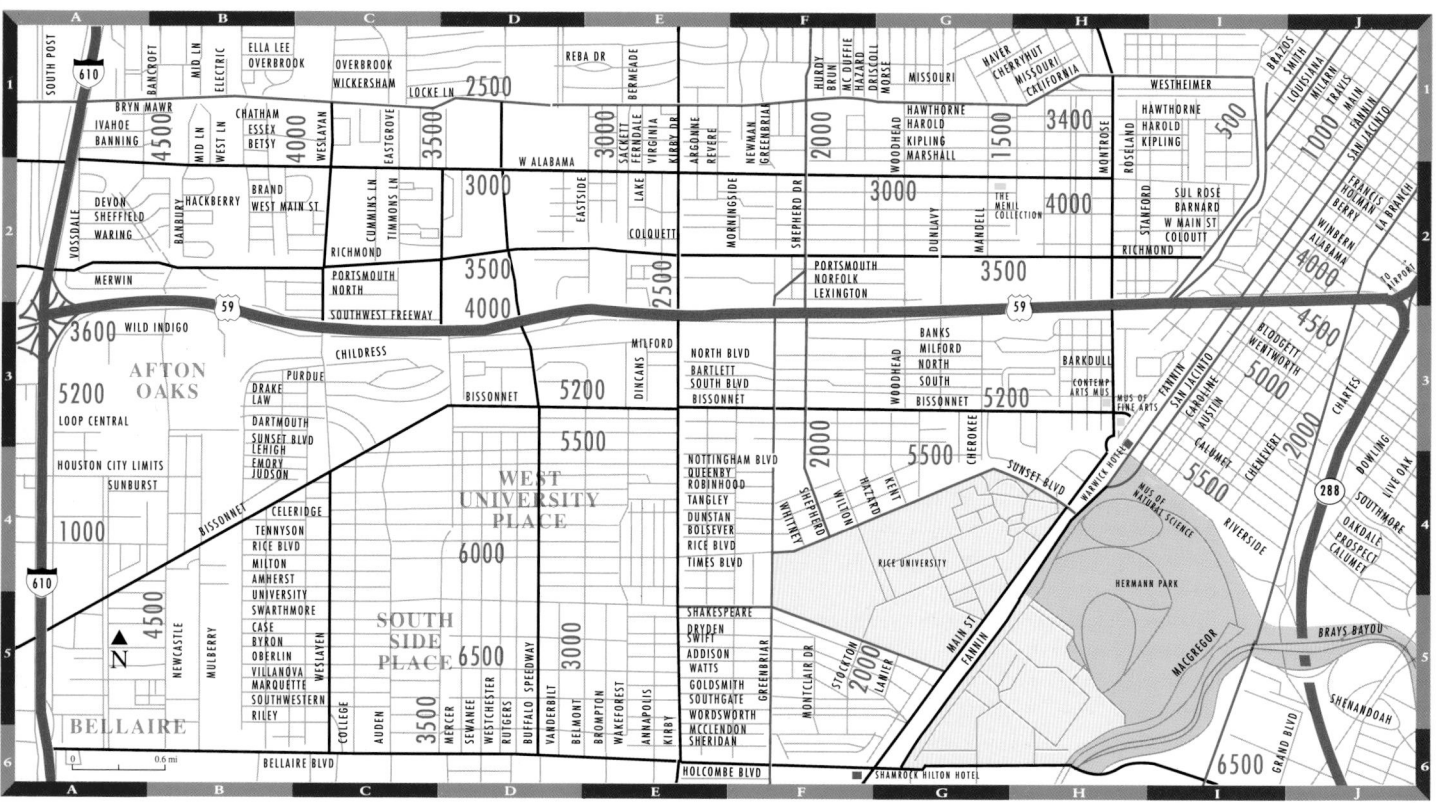

GALLERIES

Altermann & Morris Galleries D2
3461 W Alabama

Archway Gallery H1
2600 Montrose Blvd

Benteler-Morgan Galleries H2
4100 Montrose Blvd, Ste D

Hiram Butler Gallery
4520 Blossom St

Davis/McClain Gallery E2
2627 Colquitt

Diverse Works *1117 E Freeway*

Lynn Goode Gallery E2
2719 Colquitt.

Graham Gallery H2
1431 W Alabama

Gremillion & Co. Fine Art E3
2501 Sunset Blvd

Harris Gallery *1100 Bissonnet* H3

Inman Gallery *1114 Barkdull* H3

James Gallery *5616 Royalton*

Toni Jones Aries Gallery
1107 S Shepherd

Lanning Gallery U1
223 Westheimer, Ste 100

Meredith Long & Company E2
2323 San Felipe Rd

McMurtrey Gallery *3508 Lake St* E2

Jack Meier Gallery *2310 Bissonnet* E3

Millioud Gallery B2
4041 Richmond Ave, Ste 101

Moody Gallery *2815 Colquitt* E2

New Gallery *2639 Colquitt* E2

Parkerson Gallery *3510 Lake St* E2

Robinson Galleries C1
3733 Westheimer, #7

Marvin Seline Gallery E4
2501 Robin Hood, Ste 150

Texas Gallery *2012 Peden*

Gerhard Wurzer Gallery
5701 Memorial Dr

Judy Youens Gallery E1
2631 Colquitt St

MUSEUMS

Contemporary Arts Museum H3
5216 Montrose

Museum Of Fine Arts, Houston H3
1001 Bissonnet

GALLERIES

Adams-Middleton Gallery C2
3000 Maple Ave

The Afterimage Gallery C2
2828 Routh, Quad #115

Altermann & Morris Galleries **C2**
2727 Routh

Edith Baker Gallery C3
2404 Cedar Springs At Maple

Eugene Binder Gallery E4
840 Exposition Ave

Conduit Gallery E4
3200 Main St, Ste 25

Beverly Gordon Gallery C3
2404 Cedar Springs Rd, Ste 100

Peregrine Gallery C3
2200 Cedar Springs, Ste 138

Gerald Peters Gallery C2
2913 Fairmount

Southland Center Gallery D4
400 N Olive, Ste 1600

Valley House Gallery, Inc
6616 Spring Valley Rd

Barry Whistler Gallery F4
2909-A Canton St

MUSEUMS

Dallas Museum Of Art H5
1717 N Harwood

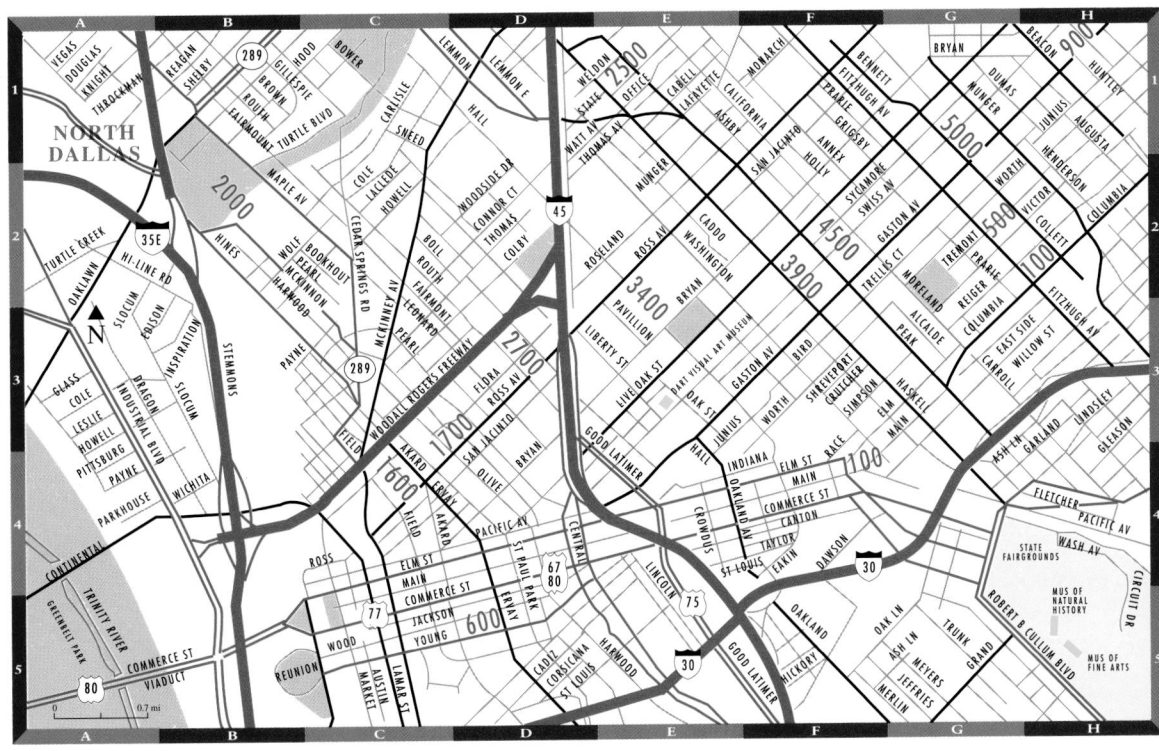

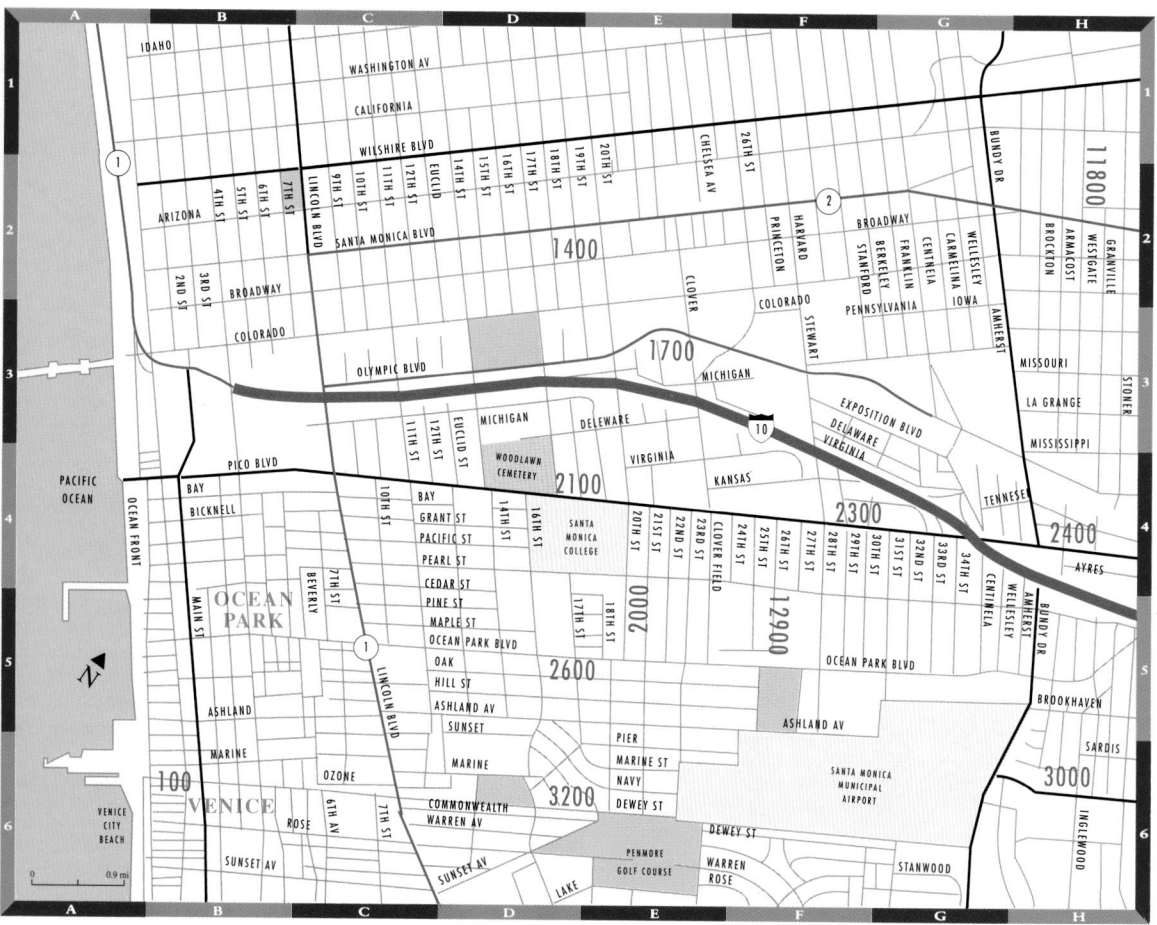

Angles Gallery 2230 Main St B4

Art Options 2507 Main St B5

B-1 Gallery 2730 Main St B5

Ruth Bachofner Gallery C3
926 Colorado Ave

Robert Berman Gallery E2
2044 Broadway

Blum Helman Gallery Inc C3
916 Colorado Ave

Boritzer/Gray Gallery C3
903 Colorado Ave

Roy Boyd Gallery 1547 Tenth St C3

Linda Cathcart Gallery C3
924 Colorado Ave

James Corcoran Gallery **B2**
1327 Fifth St

Ersgard Gallery 1434 Fourth St B3

Sherry Frumkin Gallery **B2**
1440 Ninth St

Gallery 5 1411 Fifth St B2

Gallery Of Functional Art B5
2429 Main St

Dorothy Goldeen Gallery C3
1547 Ninth St

Richard Green Gallery E2
2036 Broadway

Christopher Grimes Gallery **D3**
1644 17th St

G. Ray Hawkins Gallery **C3**
910 Colorado Ave

Fred Hoffman Gallery C3
912 Colorado Ave

Michael Kohn Gallery C3
920 Colorado Ave

Koplin Gallery 1438 Ninth St C2

Richard Kuhlenschmidt Gallery D3
1630 17th St

Luhring Augustine Hetzler B2
1330 Fourth St

Meyers/Bloom 2112 Broadway E2

Pence Gallery 908 Colorado Ave C3

The Remba Gallery/Mixografia C3
918 Colorado Ave

Marc Richards Gallery E2
2114 Broadway

Schwartz Cierlak Gallery B6
3015 Main St

Shea/Bornstein Gallery E2
2114 Broadway

Shoshana Wayne Gallery B2
1454 5th St

Tatistcheff Gallery, Inc. B3
1547 Tenth St

John Thomas Gallery B3
602 Colorado Ave

Tortue Gallery F2
2917 Santa Monica Blvd

Brendan Walter Gallery C3
1001 Colorado Ave

Daniel Weinberg Gallery E2
2032 Broadway

Venice

LA Louver 55 Venice Blvd

Sharon Truax Fine Art 1
625 Electric Ave

Long Beach

Williams/Lambs Gallery
102 W Third St

The Works Gallery
106 W Third St

Huntington Beach

Charles Whitchurch Gallery
5973 Engineer Dr

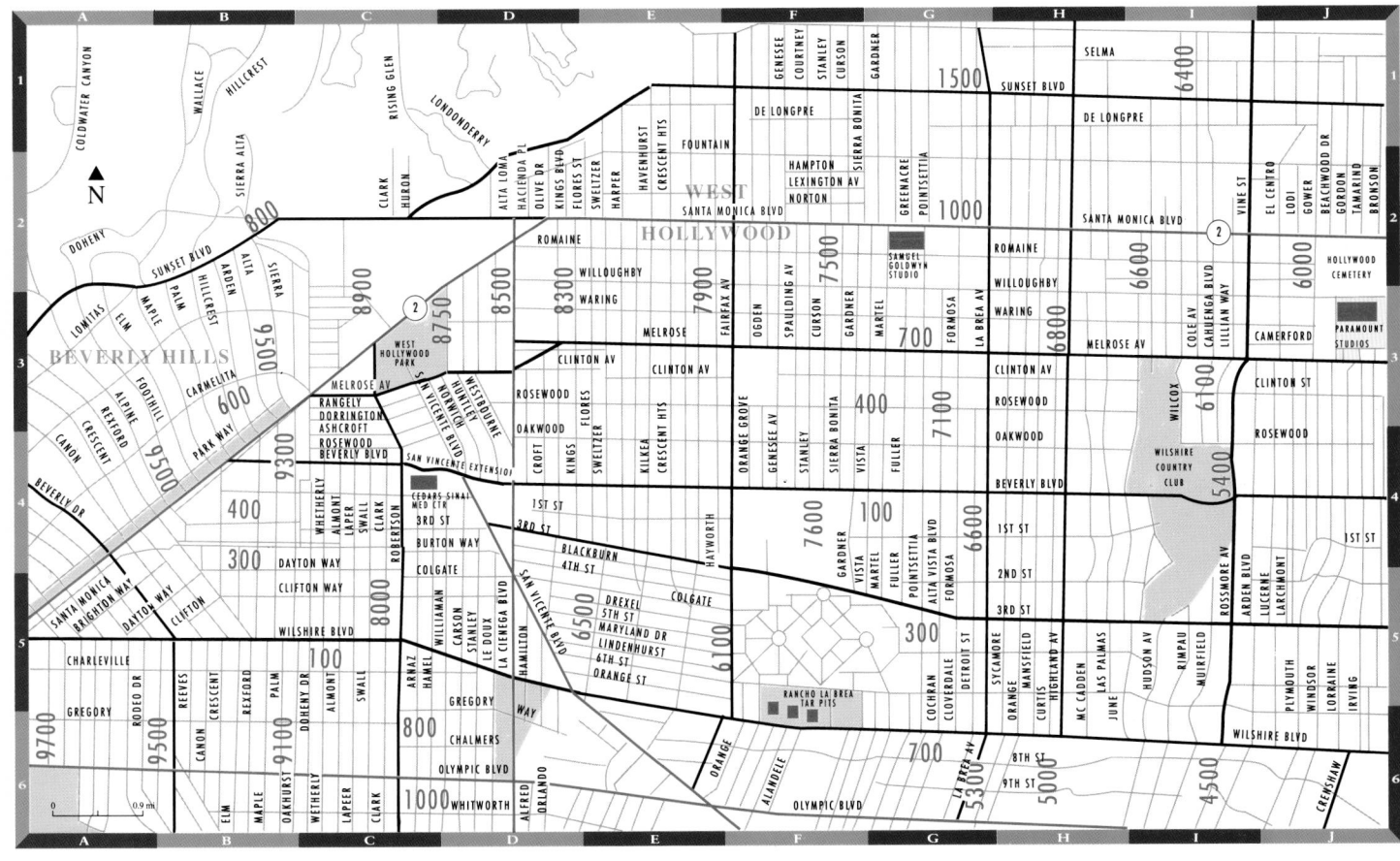

GALLERIES

Ace Contemporary Exhibitions I4
5514 Wilshire Blvd

Adamson-Duvannes Galleries E6
484 S San Vicente Blvd

Adler Gallery 667 N La Cienega Blvd D3

Art Resource Technology C3
508 N San Vicente Blvd

Art Space 10550 Santa Monica Blvd

The Art Store Gallery G4
7301 W Beverly Blvd

Asher/Faure 612 N Almont Dr D3

Ayzenberg Gallery D3
665 N La Cienega Blvd

Jan Baum Gallery 170 S La Brea Ave G5

Biota Gallery D3
8500 Melrose Ave, West Hollywood

Bowles-Sorokko Galleries A4
314 N Rodeo Dr, Beverly Hills

Cirrus Gallery 542 S Alameda St

Garth Clark Gallery 70 S La Brea Ave G5

Couturier Gallery 166 N La Cienega Ave G4

Del Mano Gallery
11981 San Vicente Blvd

De Ville Galleries 8751 Melrose Ave C3

Devorzon Gallery D3
18687 Melrose Ave, Ste B188

Andrew Dierken Fine Art E5
8274 W Fourth St

George J Doizaki Gallery/
Japan-American CC
244 S San Pedro St

Irene Dron Inc. 138 N Orange Dr H4

Dubins Gallery 11948 San Vicente Blvd

Francine Ellman Gallery D3
671 N La Cienega Blvd

Fahey/Klein Gallery 148 N La Brea Ave G4

Feingarten Galleries PO Box 691098 D3

Rosamund Felsen Gallery D2
8525 Santa Monica Blvd

Gallery West 107 S Robertson Blvd C4

The Gallery At 817 817 N La Brea Ave G3

Gemini G.E.L. 8365 Melrose Ave D3

Jack Glenn Gallery 962 N La Brea Ave G2

Goldfield Galleries 8400 Melrose Ave D3

Kiyo Higashi Gallery 8332 Melrose Ave D3

Hunsaker-Schlesinger D3
812 N. La Cienega Blvd

Iturralde Gallery 154 N La Brea Ave G4

Jan Kesner Gallery 164 N La Brea Ave G4

Kimberly Gallery 8000 Melrose Ave E3

Michael Kizhner Fine Art D3
746 N. La Cienega Blvd

Koslow Gallery 2507 W Seventh St

Kurland/Summers Gallery D3
8742 A Melrose Ave

L.A. Art Association D2
825 N. La Cienega Blvd

L.A. Artcore Center 652 Mateo St

L.A. Contemporary Exhibition (LACE)
1804 Industrial St.

Margo Leavin Gallery D3
812 N Robertson Blvd

Margo Leavin Gallery 817 N Hilldale Ave

Los Angeles Municipal Art Gallery
4804 Hollywood Blvd

Madison Galleries D3
808 N La Cienega Blvd

George Mayers Gallery D3
657 N La Cienega Blvd

Burnett Miller Gallery G2
964 N La Brea Ave

Mixografia Gallery-Workshop
1419 E Adams Blvd

Tobey C. Moss Gallery G4
7321 Beverly Blvd

Louis Newman Galleries B5
322 N Beverly Dr, Beverly Hills

Newspace 5241 Melrose Ave

Outside-In 6909 Melrose A6

Ovsey Gallery 126 N La Brea Ave G4

Paideia Gallery 765 N La Cienega Blvd D3

Herbert Palmer Gallery D3
802 N La Cienega Blvd

Parker Zanic Gallery G4
112 S La Brea Ave

Stuart Regen Gallery C3
619 N Almont Dr

Richard/Bennett Gallery
10337 Wilshire Blvd

Jack Rutberg Fine Arts G4
357 N La Brea Ave

Salander-O'Reilly Galleries
456 N Camden Dr

Daniel Saxon Gallery F4
7525 Beverly Blvd

Matthew Scott Fine Art C4
426 S Robertson Blvd

Manny Silverman Gallery D3
800 N La Cienega Blvd

Gene Sinser Gallery J4
331 N Larchmont Blvd

Thomas Solomon's Garage F2
928 N Fairfax Ave

Space Gallery J2
6015 Santa Monica Blvd

Louis Stern Galleries B5
9528 Brighton Way

David Stuart Galleries D3
748 N. La Cienega Blvd, Penthouse

Studio Sixteen-Seventeen
1617 Silverlake Blvd

James Turcotte Gallery 8128 Tianna Rd

Jan Turner Gallery C3
9006 Melrose Ave

Turner/Krull Gallery C3
9006 Melrose Ave

Wade Gallery D3
750 N La Cienega Blvd

Joanne Warfield Gallery C3
508 N San Vicente Blvd

Wenger Gallery G3
828 N La Brea Ave

Stephen White Gallery G4
Of Photography
7319 Beverly Blvd, #5

MUSEUMS

LA County Museum Of Art F6
5905 Wilshire Blvd

The Museum Of Contemporary Art
250 S Grand Ave

The Museum Of Contemporary Art,
Temporary Contemporary
152 N Central Ave

GALLERIES

1800 Gallery 1800 N Clyburn Ave A2
Aaron Galleries F7
220 N Michigan Ave, Ste 300
Jean Albano Gallery C7
311 W Superior St, Ste 207
ARC Gallery 1040 W Huron A7
Artemisia Gallery
700 N Carpenter, 3rd Fl
Jacques Baruch Gallery F6
40 E Delaware Pl, PH B
Mary Bell Galleries D7
215 W Superior St
Joy Boyd Gallery 739 N Wells St D7
Campanile Galleries F11
200 S Michigan Ave
BCA 325 W Huron St, Ste 208 C7
Centurion Galleries, Ltd F8
540 N Michigan Ave
Chicago Center For The Print
1509 W Fullerton
Chicago Public Library E12
Cultural Center
100 S State
Jan Cicero Gallery 221 W Erie St D7
Eva Cohon Gallery Ltd C7
301 W Superior St
CompassRose Gallery C7
325 W Huron St
Contemporary Art Workshop
542 W Grant Place
Dart Gallery 712 N Carpenter D7
Douglas Dawson Gallery C6
814 N Franklin St
De Graaf Fine Art, Inc 9 E Superior E7
Deson-Saunders Gallery C6
328 W Chicago Ave
East West Contemporary C6
Art Gallery
311 W Superior St, 3rd Fl

Catherine Edelman Gallery C7
300 W Superior St
Ehlers Caudill Gallery C7
750 N Orleans St
Feigen Incorporated C7
325 W Huron St, Ste 204
Franklin Square Gallery C6
900 N Franklin
Oskar Friedl Gallery C7
750 N Orleans St, #302
Galerie Thomas R. Monahan C7
301 W Superior St
Gallery 1616 1616 N Damen Ave
Gallery Astra 308 W Erie St C7
Kay Garvey Gallery 230 W Superior D7
Gilman-Gruen Gallery D7
226 W Superior St
Goldman Kraft Gallery C7
300 W Superior St
Grayson Gallery 833 N Orleans St C6
Richard Gray Gallery F7
620 N Michigan Ave
Carl Hammer Gallery D7
200 W Superior St
Rhona Hoffman Gallery D7
215 W Superior St
Joy Horwich Gallery 226 E Ontario St F7
Houk Gallery D7
200 W Superior St, Ste 306
Janice S Hunt Galleries Ltd D7
207 W Superior St
Hyde Park Art Center
1701 E 53rd St
Gwenda Jay Gallery C7
301 W Superior St, 2nd Fl
R.S. Johnson Fine Art 645 N Michigan F7
Kass/Meridian 215 W Superior St D7
Hokin Kaufman Gallery D7
210 W Superior
Phyllis Kind Gallery C7
313 W Superior St

Klein Art Works 400 N Morgan
Lannon Cole Gallery 365 W Chicago C7
Sybil Larney Gallery 733 Lincoln
Robbin Lockett Gallery D7
703 N Wells St
Nancy Lurie Gallery 1632 N LaSalle D2
Lydon Fine Art 203 W Superior St C7
Malbert Fine Arts 521 Dickens Ave
Mars Gallery 1139 W Fulton Market
Marx Gallery 208 W Kinzie St D8
Peter Miller Gallery 401 W Superior St C7
Richard Milliman Fine Art 3309 Central
Mongerson-Wunderlich 704 N Wells D7
Nab Gallery 1433 Wolfram
N.A.M.E. 700 N Carpenter St
Isobel Neal 200 W Superior St D7
Phyllis Needlman Gallery E3
1515 N Astor St
Neville-Sargent Gallery D7
708 N Wells St
Objects Gallery 230 W Huron St D7
Paper Press Gallery And Studio
1017 W Jackson
Perimeter Gallery Inc C7
750 N Orleans St
Maya Polsky Gallery C7
311 W Superior, Ste 210
Portals Ltd 230 W Huron D7
Prince Gallenes 357 W Erie St
Roger Ramsay Gallery D7
212 W Superior St, Ste 503
Randolph Street Gallery
756 N Milwaukee Ave
Ratner Gallery C7
750 N Orleans, Ste 403
Rezac Gallery C7
301 W Superior St, 2nd Fl
Betsy Rosenfield Gallery D7
212 W Superior St

J. Rosenthal Fine Arts, Ltd. D7
230 W Superior St
Esther Saks Gallery C7
311 W Superior St
Sazama Gallery 300 W Superior St C7
Martha Schneider Gallery D7
230 W Superior St
Schneider-Bluhm-Loeb D7
230 W Superior
Lloyd Shin Gallery C7
301 W Superior St
Stephen Solovy Fine Art F7
620 N Michigan, Ste 520
Space 900 900 N Franklin C6
State Of Illinois Art Gallery E10
100 W Randolph, Ste 2-100
Samuel Stein Fine Arts, Ltd F7
620 N Michigan Ave Ste 340
Struve Gallery 309 W Superior St C7
The New van Straaten Gallery D7
742 N Wells St
Mario Villa/Chicago 500 N Wells St D7
Ruth Volid Gallery 225 W Illinois Ave D8
Worthington Gallery F7
620 N Michigan Ave
Zaks Gallery F7
620 N Michigan Ave, Ste 305
Zolla/Lieberman Gallery D7
325 W Huron St

MUSEUMS

The Art Institute Of Chicago F11
Michigan Ave At Adams St
Museum Of Contemporary Art F8
237 E Ontario St
The Renaissance Society At
The University Of Illinois
5811 S Ellis Ave
Terra Museum Of American Art E/F7
666 N Michigan Ave

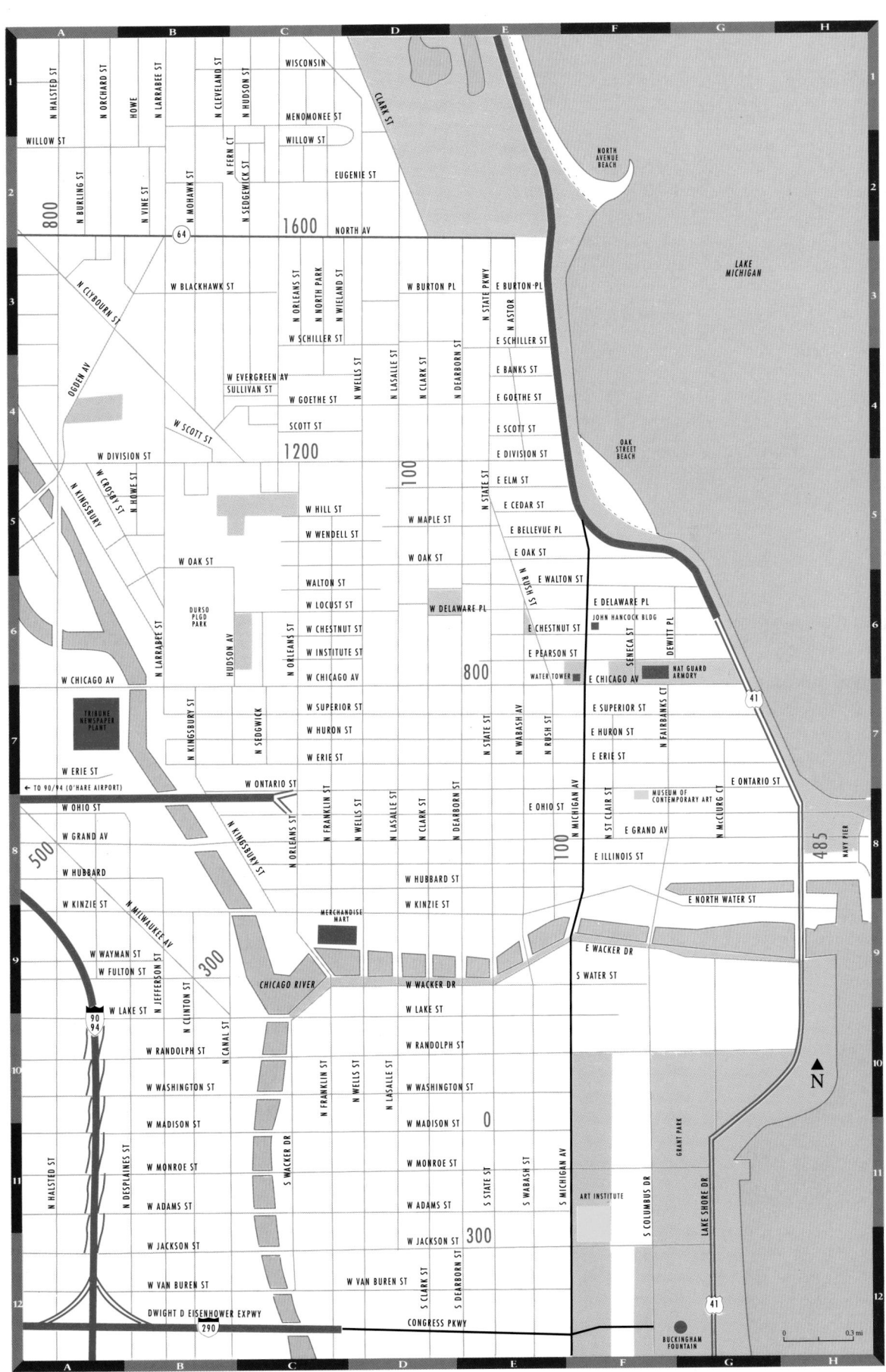

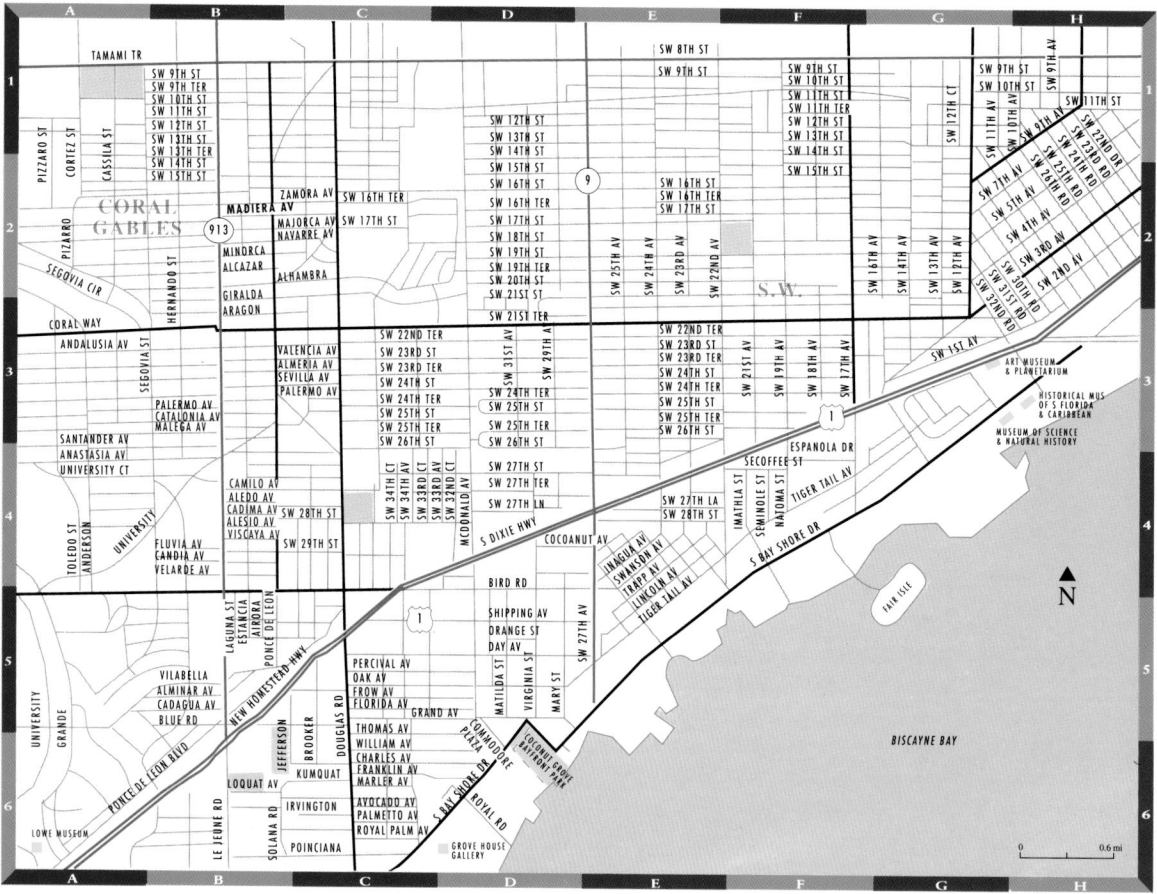

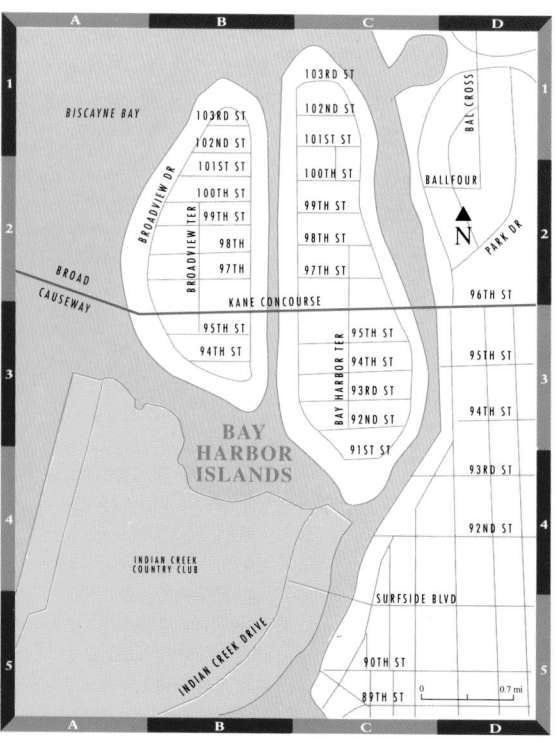

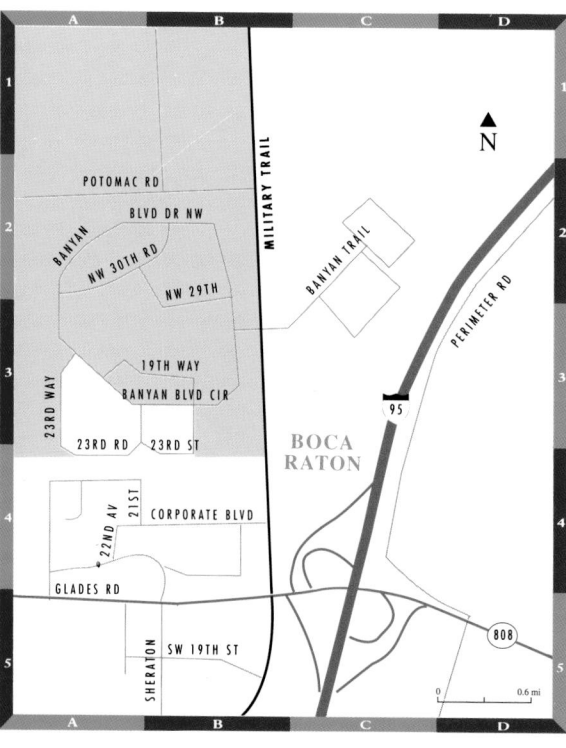

GALLERIES

Bay Harbor Island

Greene Gallery *1090 Kane Concourse*	B3
Hokin Gallery *1086 Kane Concourse*	B3
Ann Jaffe Gallery *1088 Kane Concourse*	B3
Gloria Luria Gallery *1033 Kane Concourse*	B3
Margulies Taplin Gallery *1060 Kane Concourse*	B3

Boca Raton

Gallery Camino Real *608 Banyan Tr*	C2
Habatat Galleries Inc *608 Banyan Tr*	C2
The Harrison Gallery, Inc *608 Banyan Tr*	C2
Jaffe Baker Gallery *608 Banyan Tr*	C2
Margaret Lipworth Gallery *608 Banyan Tr, Ste 113*	C2
Kenneth Raymond Gallery *799 E Palmetto Park Rd*	

Coconut Grove

Romero Britto Gallery *2911 Grand Ave, Promenade*	D5
Gary Nader Fine Arts *3121 Commodore Plaza, PH 1*	D6

Coral Gables

Arregui Hsia Fine Art *4105 Laguna St*	B5
Elite Fine Art *3140 Ponce De Leon Blvd*	B3
Virginia Miller Galleries *169 Madeira Ave*	C2
Opus Gallery *1810 Ponce de Leon Blvd*	B4

Key Biscayne

M Gutierrez Fine Arts, Inc
328 Crandon Blvd, Ste 227

Miami

Bacardi Art Gallery
2100 Biscayne Blvd

Bakehouse Art Complex
561 NW 32nd St

Beaux Art Collections	H2

Van Cleef Fine Arts
3930 NE Second Ave

MUSEUMS

Coral Gables

Lowe Art Museum
1301 Stanford Dr

Miami

Center For The Fine Arts
101 W Flagler St

Miami Beach

Bass Museum Of Art *2121 Park Ave*

GALLERIES

Akin Gallery *207 South St* G3

Alpha Gallery *121 Newbury St* E4

Arden Gallery *129 Newbury St* E4

Randall Beck Gallery D4
225 Newbury St

Boston Center For The Arts, C7
Mills Gallery
549 Tremont St

Bromfield Gallery *107 South St* G4

Cambridge Multicultural Arts D1
Center Gallery
41 Second St

Copley Society Of Boston E4
158 Newbury St

Mario Diacono Gallery G3
207 South St

Gallery Naga *67 Newbury St* E4

Genovese Gallery Annex G3
195 South St

The Golden Gallery D4
207 Newbury St

Grohe Glass Gallery H1
24 North St, Dock S

Guild Of Boston Artists E4
162 Newbury St

The Harcus Gallery *210 South St* G3

Robert Klein Gallery *207 South St* G3

Barbara Krakow Gallery E3
Ten Newbury St, 5th Fl

Levinson Kane Gallery E3
14 Newbury St

Andrea Marquit Fine Arts D4
207 Newbury St

Nielsen Gallery *179 Newbury St* E4

Thomas Segal Gallery *207 South St* G3

Beth Urdang Fine Art D4
207 Newbury St

Wendell Street Gallery H2
17 Wendell St

Howard Yezerski Gallery G3
186 South St

MUSEUMS

Harvard University Art Museums
32 Quincy St

The Institute Of Contemporary Art B6
955 Boylston St

Museum Of Fine Arts C6
465 Huntington Ave

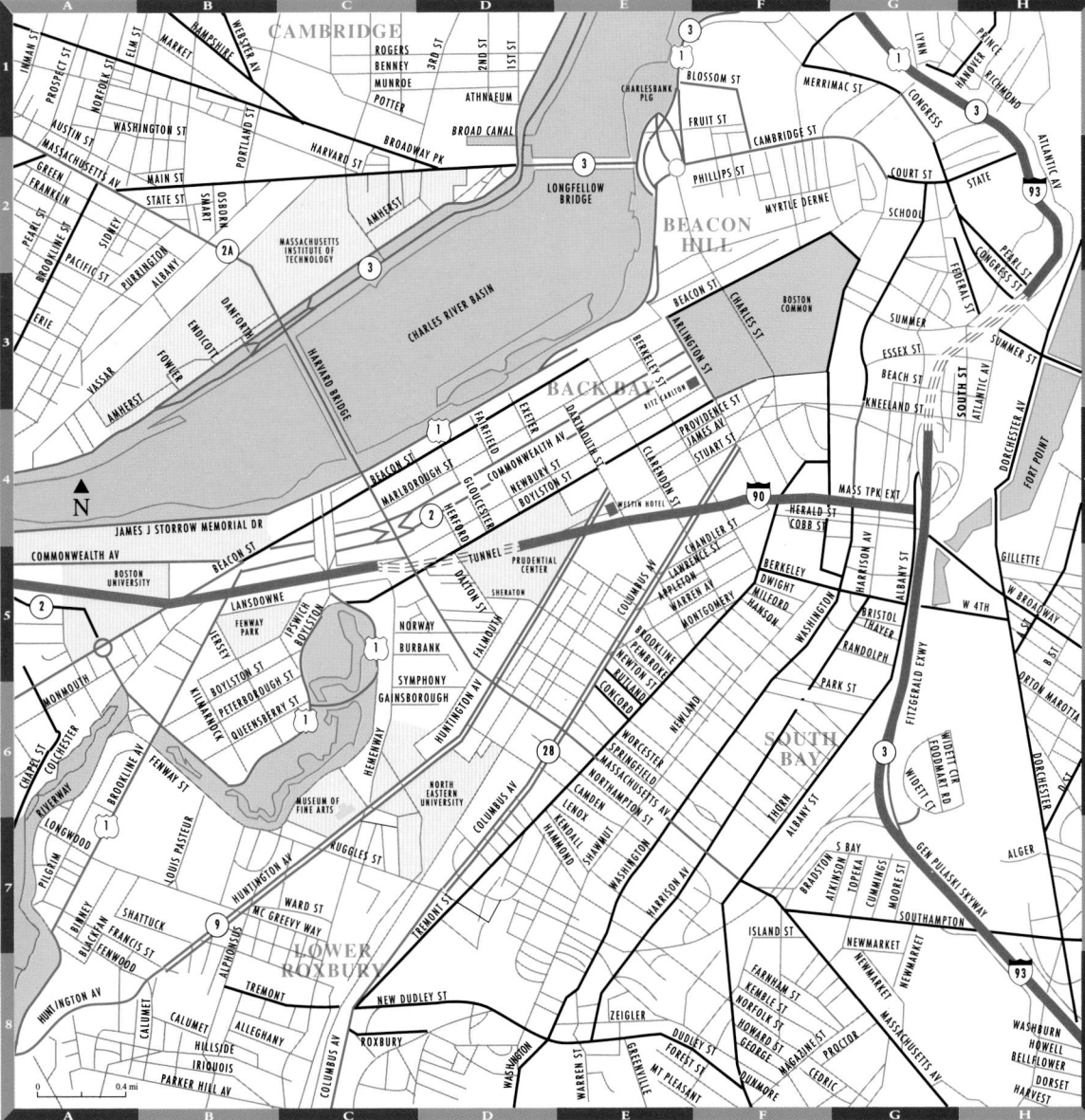

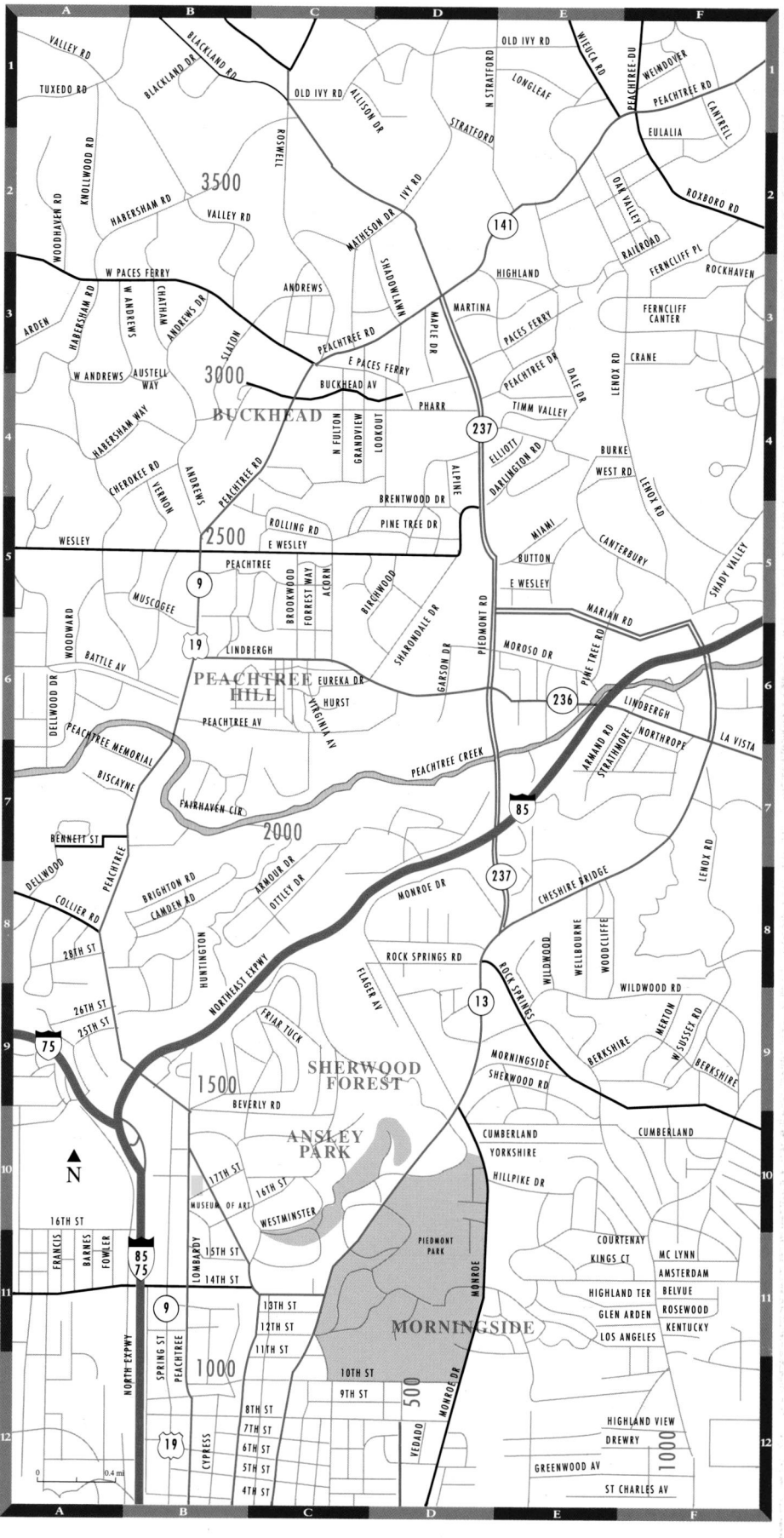

MAPS

CORPORATE COLLECTIONS

SOUTH CAROLINA

THE FIRST SAVINGS BANK 803.458.2000
301 College St., Greenville 29601
Contact: H. Ray Davis, Chrmn.

TENNESEE

AUTO ZONE 901.325.4200
3030 Poplar Ave., Box 1719, Memphis 38111
Contact: Donna Letter, Fine Arts Adv.

NORTHERN TELECOM INC. 615.734.4000
200 Athens Way, Nashville 37228
Contact: Yvonne Boyer, Arts Cur.

Collection Description: A collection of contemporary American art with an emphasis on works by Southeastern artists.

TEXAS

AMERICAN NATIONAL INSURANCE CO. 409.766.6513
One Moody Plaza, Galveston 77550 FAX: 409.766.6502
Contact: John Ferguson, Asst. V.P.
Art Consultant: Henderson Massengill Co.

Collection Description: Approx. 1500 pieces of American art.

BROWNING-FERRIS INDUSTRIES, INC. 713.870.8100
757 N. Eldridge, Houston 77079 FAX: 713.870.7844
Contact: Dennis Reynta, Div. V.P.

BUTLER & BINION 713.237.3111
First Interstate Bank Plaza, Houston 77002
Contact: Louis Paine, Mgng. Ptnr.

DEPOSIT GUARANTY BANK 214.353.8243
3300 Oaklawn, Dallas 75219
Contact: Jim Greer, Facilities Mgr.

FIRST CITY BANKCORP. OF TEXAS 713.658.4697
1001 Main St., 5th Fl., Houston 77252 FAX: 713.658.6966
Contact: Jeri Nordbrock, Art Program Dir.

Collection Description: 69 objects, predominantly painting with some sculpture; focus on American artists (Color Field), specifically Texas artists.

HUGHES & LUCE 214.939.5500
1717 Main St., Ste. 2800, Dallas 75201 FAX: 214.939.6100
Art Consultant: Hollanman Raney

MAXUS ENERGY CORP. 214.953.2000
717 N. Harwood St., Dallas 75201
Contact: Carol Carter, Dir. Gov't. Rel.

MCDONALD, SANDERS, GINSBURG, MADDOX, NEWKIRK, GIBS 817.336.8651
1300 Continental Plaza, Seven at Main, Ft. Worth 76102
Contact: Ellen Oppenheim, Corp. Art Adv.

RAYMOND D. NASHER COMPANY 214.369.6550
8950 N. Central Expwy., Ste. 400, Dallas 75231 FAX: 214.369.5267
Contact: Ellen Gordesky

UTAH

DESERET NEWS 801.237.2135
30 E. First S., Salt Lake City 84110 FAX: 801.237.2121
Contact: Keith West, Promotions Mgr.

Collection Description: 52 paintings on a variety of subjects in mixed media by early and contemporary Utah artists.

VIRGINIA

CENTRAL FIDELITY BANK 804.782.724?
1021 E. Cary St., Richmond 23219
Contact: Debbie Kerver, Design Specialist

CRESTAR 804.782.733?
919 E. Main St., 14th Fl., Richmond 23219 FAX: 804.782.530?
Contact: Rae Spilman, Dir. Corp. Art

FEDERAL RESERVE BANK OF RICHMOND 804.697.800?
701 W. Byrd St., 24th Fl, Richmond 23219
Contact: Jackson Blanton, Cur.

Collection Description: Approx. 650 pieces focusing on contemporary, 5th district artists; mixed media.

WASHINGTON

MICROSOFT CORP. 206.882.808?
One Microsoft Way, Redmond 98052
Contact: William Neukom, Chrmn. Art Comm.

PEOPLES STATE BANK 206.354.404?
418 Grover St., Box 233, Lynden 98264
Contact: Charles Le Cocq, Pres.

Collection Description: Works primarily by 28 Northwestern artists; includes William Ivey's untitled oil.

SHERATON SEATTLE HOTEL & TOWERS 206.621.900?
1400 6th Ave., Seattle 98101 FAX: 206.621.844?
Art Consultant: Magery Aronson

Collection Description: Approx. 2,000 pieces of contemporary Northwestern art with works from all media.

WASHINGTON TRUST BANK 509.455.387?
P.O. Box 2127, Spokane 99210
Contact: R. Scammell, Jr., Chrmn. Art Comm.

WISCONSIN

BANK ONE WISCONSIN CORP. 414.765.256?
111 E. Wisconsin Ave., Milwaukee 53201
Contact: Kelly Skindzelewski, Asst. V.P.

Collection Description: Features works of Wisconsin artists.

MARSHALL ERDMAN & ASSOCIATES, INC. 608.238.021?
5117 University Ave., Madison
Contact: Ellen Johnson, Cur.

QUAD GRAPHICS 414.691.920?
W. 224 N. 3322 Duplainville, Pewaukee 53072
Contact: Quad Galleries

Collection Description: Over 800 pieces of 20th-century contemporary prints.

WAUSAU INSURANCE CO. 715.842.609?
2000 Westwood Dr., Wausau 54401
Contact: Robert Pils, Cur.

Collection Description: 500 pieces in all media; primarily landscapes by midwest artists.

PRICE WATERHOUSE 212.489.8900
 1251 Ave. of the Americas, New York 10020
 Art Consultant: Art Option

SHEARSON LEHMAN BROTHERS INC. 212.298.2000
 200 Vessey St., 45th Fl., New York 10285 FAX: 212.619.8927
 Art Consultant: Diane Bliss

Collection Description: Approx. 5,000 contemporary paintings, prints, and works on paper.

TECHNIMETRICS INC. 212.509.5100
 80 South St., 6th Fl., New York 10038
 Contact: James Uffelman, Pres.

J. WALTER THOMPSON 212.210.7087
 466 Lexington Ave., New York 10017
 Contact: John Niemiec

Collection Description: Approx. 200 pieces in collection of Abstract contemporary art.

U.S. TRUST CO. OF NEW YORK 212.852.1000
 114 W. 47th St., New York 10036
 Contact: Daniel P. Davison, Chrmn. & CEO

Collection Description: Over 550 works of contemporary American and international art; artists include Joan Metchell, Tony Cragg and Elizabeth Murray.

WESTPAC BANKING CORP. 212.850.7962
 335 Madison Ave., New York 10017 FAX: 212.818.1499
 Contact: Marilyn E. Hill, Cur.
 Art Consultant: Merryl Wilson, Merryl Wilson Art Consultant

Collection Description: 186 pieces of Australian and Aboriginal art with works from mixed media.

NORTH CAROLINA

BRANCH BANKING & TRUST CO. 704.342.7000
 200 S. Tryon St., Charlotte 28202
 Contact: Cheryl Kiser, P.R.

Collection Description: 30 major pieces of state and regional art featuring works in all media.

BURROUGHS WELLCOME CO. 919.248.3000
 3030 Cornwallis Rd., Research, Triangle Parks 27709
 Contact: Thack Brown, Dir.

DISSTON CO. 919.852.9220
 7345-G W. Friendly St., Greensboro 27410
 Contact: Hank Libby, Pres.

GLAXO 919.248.2100
 Five Moore Dr., Research Trian 27709 FAX: 919.248.2381
 Art Consultant: Diane Dunning

Collection Description: Approx. 75 pieces focusing primarily on North Carolina artists with works in all media.

PETREE, STOCKTON & ROBINSON 919.725.2351
 1001 W. Fourth St., Winston-Salem 27101
 Contact: J. Robert Elster, Ptnr.

Collection Description: Focus on North Carolina artists in order to support local interests and the art community.

RAUCH INDUSTRIES INC. 704.867.5333
 6048 S. York Rd., P.O. Box 609, Gastonia 28053
 Contact: M.A. Rauch, CEO

OHIO

AMERITRUST CO. 216.737.5044
 900 Euclid Ave., Cleveland 44101
 Contact: Julie Seaborn

AUTOMATIC DATA PROCESSING 513.852.5200
 500 W. Seventh St., Cincinnati 45203
 Contact: Steve Major, Div. Pres.

DRUG EMPORIUM 614.888.6876
 7760 Olentangy River Rd., Ste. 207, Worthington 43085
 Art Consultant: Barkin-Leeds Ltd.

Collection Description: A collection of about 25 paintings and works on paper designed around the theme of harmony.

MEAD CORP. 513.222.6323
 Courthouse Plaza N.E., Dayton 45463
 Contact: Sally Sparell

METRO MEDIA STEAKHOUSES INCORPORATED 513.454.2400
 P.O. Box 578, Dayton 45401
 Contact: Nancy Miller

OHIO CITIZENS BANK 419.259.7700
 405 Madison Ave., Toledo 43603 FAX: 419.259.7744
 Contact: Penny McMorris, Cur.

OWENS-ILLINOIS 419.247.5000
 One Sea Gate, Toledo 43666 FAX: 419.247.1436
 Contact: Jerry Chamberlin, Cur.

Collection Description: Approx. 500 pieces of contemporary art with works from all media.

THE PROGRESSIVE CORP. 216.461.5000
 6000 Parkland Blvd., Mayfield Hts. 44124 FAX: 216.446.7699
 Contact: Toby D. Lewis, Cur.

Collection Description: Approx. 2,000 pieces focusing on works from all media by emerging artist.

TRW, INC. 216.291.7030
 1900 Richmond Rd., Lyndhurst 44124 FAX: 216.291.4542
 Contact: Peter N. Steigerwald, Art Program Admin.

OKLAHOMA

BANK OF OKLAHOMA, N.A. 918.588.6000
 P.O. Box 2300, Tulsa 74192
 Contact: Robert Hancock, Asst. V.P./Fac. Mgr.

THE WILLIAMS CO., INC 918.588.2106
 P.O. Box 2400, Tulsa 74102
 Contact: Hannah Davis Robson, Cur. Fine Arts

OREGON

HEATHMAN HOTEL 503.241.4100
 Southwest Broadway at Salmon, Portland 97205 FAX: 503.790.7111
 Contact: Tim Nuget, Dir. Sales Mktg.
 Art Consultant: Elizabeth Leach

Collection Description: Over 300 pieces; contemporary, Pacific Northwest paintings, sculpture, works on paper as well as works by international artists.

OREGON CUTTING SYSTEMS 503.653.4478
 4909 SE International Way, Portland 97222 FAX: 503.653.4201
 Contact: Gail Parrick, Advertising Admin.

Collection Description: Approx. 250 Pieces by Northwestern artists; works from all media.

PENNSYLVANIA

ALUMINUM CO. OF AMERICA 412.553.4545
 1501 Alcoa Bldg., Pittsburgh 15219

AMERICAN LOCKER GROUP, INC. 412.687.1400
 300 Craig St., Pittsburgh 15213 FAX: 412.687.1410
 Contact: Harold Ruttenberg, CEO

Collection Description: 70 pieces focusing on visual arts, primarily watercolor artists identified with Israel.

ARA SERVICES 215.238.3233
 1101 Market St., Philadelphia 19107 FAX: 215.238.3337
 Contact: Barbara Glickman, Chrmn.

Collection Description: 200 unique objects of all media with a broad focus on the human figure.

HOYLE, MORRIS & KERR 215.981.5700
 1650 Market St., Ste. 4900, Philadelphia 19103
 Contact: Diane Scott, Adm.

THE PHILADELPHIA CONTRIBUTIONSHIP 215.627.1752
 212 S. Fourth St., Philadelphia 19106 FAX: 215.627.8303
 Contact: Carol Wojtowicz Smit, Cur.

PNC FINANCIAL CORP. 412.762.2000
 Fifth Ave. and Wood St., Pittsburgh 15222
 Contact: Nancy Sherman, Real Estate Admin.

PROVIDENT NATIONAL BANK 215.985.1792
 Broad and Chestnut St., Philadelphia 19101
 Contact: Patty Fox, Cur.

ROHM AND HAAS 215.592.3000
 Sixth and Market St., Philadelphia 19105

TRACO CORP. 412.776.7000
 Cranberry Industrial Pk., Box 805-T, Warrendale 15095
 Contact: E. Robert Randall, Pres.

WESTINGHOUSE 412.642.5904
 6 Gateway Ctr., Pittsburgh 15222
 Contact: Barbara Conner, Art Adv.

MISSOURI *(cont.)*

MARK TWAIN BANCSHARES, INC. 314.727.1000
8820 Ladue Rd., St. Louis 63124
Contact: Alvin Siteman, Chrmn.

UNITED MISSOURI BANCSHARES 816.556.5600
1010 Grand, Kansas City 64106 FAX: 816.556.4858
Contact: Marshall Hendrickson, Art Adv.

NEBRASKA

AMERITAS FINANCIAL SERVICES 402.467.1122
5900 O St., Lincoln 68510
Contact: D. Doc Chaves, P.R.

NEVADA

LAS VEGAS HILTON HOTEL 702.732.5111
3000 Paradise Rd., Las Vegas 89109
Art Consultant: Marlene Streit

NEW HAMPSHIRE

CHUBB LIFEAMERICA 603.224.7741
One Granite Pl., P.O. Box 515, Concord 03301
Contact: Garry Ruwpert, Sr. V.P.

Collection Description: Focus on New Hampshire artists with art from all media.

NEW JERSEY

COMMODITIES CORP. 609.497.5560
CN 850, Princeton 08542 FAX: 609.497.5563
Contact: Ann Malko, Asst. Cur.

Collection Description: Collection focuses on works by emerging artists, and now includes works by such artists as Alice Aycock, John Baldessari and Robert Longo.

EDUCATIONAL TESTING SERVICE 609.243.8630
Rosedale Rd., Princeton 08541 FAX: 609.243.8620
Art Consultant: Jeri Mancuso

Collection Description: Approx. 500 works of art on paper purchased from local artists.

JOHNSON & JOHNSON 908.524.3698
One Johnson & Johnson Plaza, New Brunswick 08933
Contact: Michael Bzdak, Corp. Art Coord.

K.P.M.G. PEAT MARWICK 212.909.5000
3 Chestnut Ridge Rd., Montvale 07645

PRUDENTIAL INSURANCE CO. OF AMERICA 201.877.6000
751 Broad St., Newark 07102
Contact: Helene Zucker Seeman, Dir. Art Prog.

VALCOR ENGINEERING CORP. 201.467.8400
2 Lawrence Rd., Springfield 07081

NEW YORK

ALLEN ALLEN & HEMSLEY 212.867.1555
280 Pk. Ave., New York 10017
Contact: H. Jamieson, Sr. Ptnr.

AMERICAN EXPRESS TRAVEL RELATED SERVICES CO., INC. 212.640.4750
200 Vesey St., Ste. 45, New York 10285
Art Consultant: Diane Bliss

Collection Description: Contemporary paintings, prints and some sculpture.

AMERICAN SAVINGS BANK 914.287.2600
99 Church St., White Plains 10601
Contact: Howard Moskowitz, V.P.

AMERICAN TELEPHONE & TELEGRAPH 212.605.6003
550 Madison Ave., New York 10022 FAX: 201.560.6885
Contact: Natalie Jones, Fine Arts Admin.

Collection Description: 5,000 pieces by contemporary, emerging artists; features American and international artists.

AMERICAN ULTRAMAR LTD. 914.333.2000
120 White Plains Rd., 4th Fl., Tarrytown 10591
Contact: Salvador Ciazirella, Ofc. Mgr.

Collection Description: 100 contemporary paintings.

AMEV HOLDINGS, INC.
One World Trade Ctr., New York 10048
Contact: Mary Lanier, Art Adv.

Collection Description: A collection of American vintage photography focusing on phases of American history and faces of Americans.

BANKER'S TRUST 212.250.2500
280 Park Ave., New York 10017
Art Consultant: Betty Levin

Collection Description: Approx. 300 pieces featuring works of all media and imagery by emerging talent.

THE BANK OF NEW YORK 212.495.1784
48 Wall St., New York 10286
Art Consultant: Betty Levin

Collection Description: Approx. 75 pieces with a focus on American Realism; primarily contemporary with some 19th-century Hudson River paintings.

THE CHASE MANHATTAN BANK, N.A. 212.552.4794
One Chase Manhattan Plaza, 9th Fl., New York 10081
Contact: Margaret Della Cioppa, Mgr.
Art Consultant: Manuel Gonzalez

Collection Description: Over 13,000 pieces in approx. 400 locations worldwide with a focus on contemporary art.

CIBA-GEIGY CORP. 914.479.5000
Ardsley, New York 10502
Contact: Markus Low, Dir.

Collection Description: Over 600 pieces focusing on The New York School, particularly Expressionist and Figurative art.

DAVIS POLK & WARDWELL 212.255.1674
One Chase Manhattan Plaza, New York 10005
Art Consultant: Mary Lanier

Collection Description: 294 pieces in an eclectic collection of contemporary art, folk art, and photography.

DOW JONES & CO., INC. 212.255.1674
200 Liberty St., New York 10281
Art Consultant: Mary Lanier

Collection Description: 260 pieces of contemporary art featuring living artists in the New York area and a selection of African and Oceanic primative art.

THE FORBES MAGAZINE COLLECTION, NEW YORK 212.620.2389
60 Fifth Ave., New York 10011 FAX: 212.620.2426
Contact: Margaret Kelly, Cur.

Collection Description: Eclectic painting gallery; changing exhibitions of paintings, photography and other works of art from the collection.

FRIED, FRANK, HARRIS, SHRIVER & JACOBSON 212.820.800
One New York Plaza, New York 10004
Contact: Laura Perrotti, Marketing Coord.
Art Consultant: Paula Cooper, Brooke Alexander

Collection Description: Over 400 pieces in collection; focus on works on paper by contemporary, postwar artists.

HEARST 212.335.5370
959 Eighth Ave., Rm. 312, New York 10019 FAX: 212.977.414
Contact: James Lusnar, Serv. Mgr.
Art Consultant: Betty Levin

Collection Description: Approx. 50 pieces; predominant interest in Social Realism from 1920's-1940's with contemporary master graphics.

MANUFACTURERS HANOVER 212.270.061
140 E. 45th St., 23rd Fl., Manhattan 10017
Contact: Karla Rohland, Cur.

NYNEX, INC. 914.644.760
1113 Westchester Ave., White Plains 10604
Contact: J.M. Kayal, Dir.Of Corp.Identity
Art Consultant: Barkin-Leeds Ltd.

PEPSICO, INC. 914.253.290
700 Anderson Hill Rd., Purchase 10577

Collection Description: 43 pieces in 20th-century sculpture garden named after Donald M. Kendall at Pepsico, Inc.

PHILIP MORRIS CO., INC. 212.880.410
120 Pk. Ave., New York 10017 FAX: 212.878.216
Contact: Stephanie French, V.P.

Collection Description: 459 pieces in collection of contemporary American art with works from mixed medias.

PORT AUTHORITY OF NEW YORK AND NEW JERSEY 212.435.339
One World Trade Ctr., 82 W, New York 10048
Contact: Saul Wenegrat, Art Advisor
Art Consultant: Dorothy Miller

Collection Description: Contemporary art, primarily sculpture with a focus on internationally-recognized artists; approx. 1,500 works.

MICHIGAN

ALLIED-SIGNAL AUTOMOTIVE 313.827.5000
20650 Civic Ctr. Dr., Southfield 48086
Contact: Lynn Goodwyn

Collection Description: The Bendix Triology is composed of three contemporary sculptures commissioned by Louise Nevelson.

BATTLE CREEK GAS CO. 616.968.8111
155 Hamblin Ave., Battle Creek 49107
Contact: G.G. Phalen, Pres.

COMERICA INC. 313.370.5210
Fort and Washington Blvd., Detroit 48275 FAX: 313.370.5159
Contact: Jeff Wagner

COOPERS AND LYBRAND 313.446.7100
400 Renaissance Ctr., Detroit 48243
Contact: Bernadine Cousins, Offc. Mgr.

DOMINO'S PIZZA 313.995.4500
P.O. Box 44, Ann Arbor 48106 FAX: 313.663.6804
Contact: Darwin Matthews, Dir.
Art Consultant: David Hanks & Associates

Collection Description: Over 80 pieces focusing on the decorative art of Frank Lloyd Wright.

EDWARD W. DUFFY & CO. 313.841.8600
5840 W. Jefferson Ave., Detroit 48209
Contact: James Duffy, Pres.

FIRST FEDERAL OF MICHIGAN 313.965.1400
1001 Woodward Ave., Detroit 48226 FAX: 313.965.3453
Contact: Margaret Kassel, Pub. Sup.

Collection Description: A collection of 500 paintings focusing primarily on Michigan artists.

FORD MOTOR CO. 313.322.3000
The American Rd., Dearborn 48121
Contact: Jerry Anderson, Design Mgr.

Collection Description: 4,000 watercolors done by American artists.

SECURITY BANK OF COMMERCE 313.366.3200
11300 Joseph Campau, Hamtramck 48212
Contact: Stephen Kohut, V.P.
Art Consultant: Mary Dennison

Collection Description: 50 pieces in collection; paintings and photographs of leading Michigan artists acquired through a number of juried competitions.

STANDARD FEDERAL BANK 313.643.9600
2600 W. Big Beaver Rd., Troy 48084 FAX: 313.637.2787
Contact: William Zeidler, V.P.
Art Consultant: Phyllis Fenton

Collection Description: Over 400 works of postwar American Abstract art.

STEELCASE INC. 616.247.2710
901 44th St. S.E., Grand Rapids 49508
Contact: Duane E. Bucklin, Sr. V.P.

Collection Description: 500 pieces; unusual combination of Asian and Western works; contemporary and historical periods.

WARNER, NORCROSS & JUDD 616.459.6121
900 Old Kent Bldg., Grand Rapids 49503 FAX: 616.459.2611
Contact: Conrad Bradshaw, Ptnr.

Collection Description: 60 pieces by regional artists; features local art from all media.

MINNESOTA

3M COMPANY 612.733.1110
Bldg. 225-1S-01, St. Paul 55144
Contact: Charles Helsell, Cur. Art Collection

Collection Description: 3,000 original works by contemporary American artists with works from media.

AMERICAN BANK 612.298.6050
101 E. Fifth St., Ste. 550, St. Paul 55101 FAX: 612.298.6176
Contact: Joseph Kingman, Pres.

Collection Description: 200 pieces of regional art.

DAYTON-HUDSON CORP. 612.540.7269
777 Nicollet Mall, Minneapolis 55402
Art Consultant: Donald McNeil

Collection Description: 200 pieces of primarily contemporary art.

DORSEY AND WHITNEY 612.340.2600
2200 First Bank Pl. E., Minneapolis 55402 FAX: 612.340.2868
Contact: Vie Determan, Admin. Serv. Mgr.

FEDERAL RESERVE BANK OF MINNEAPOLIS 612.340.6928
250 Marquette Ave., Minneapolis 55401 FAX: 612.340.7757
Contact: Christine Power, Art Dir.

Collection Description: Regional collection representing artists who live and work in the 9th Federal Reserve District; 300 pieces in all media.

FIRST BANK SYSTEM, INC. 612.343.1519
120 S. 6th St., Minneapolis 55480
Contact: Jane Swingle, Cur.

Collection Description: 2,000 pieces including works created since 1980 by European and American artists working in all media.

GENERAL MILLS, INC. 612.540.7269
One General Mills Blvd., Minneapolis 55426
Contact: Donald McNeil, Cur.

NORTHWESTERN NATIONAL LIFE INSURANCE CO. 612.342.3605
20 Washington Ave. S., Minneapolis 55401
Contact: Judith Kurtz, Art Coord.

Collection Description: Approx. 600 pieces by regional artists with works in mixed media.

PIPER JAFFRAY & HOPWOOD, INC. 612.342.6000
222 S. Ninth St., Minneapolis 55402
Contact: Karen Bohn, Admin. Offcr.
Art Consultant: Shelly Ross

ROBINS, KAPLAN, MILLER & CIRESI 612.349.8500
1800 International Ctr., Minneapolis 55402
Contact: John Eisberg, Offc. Admin.

MISSOURI

ANHEUSER-BUSCH CO., INC. 314.577.2179
One Busch Pl., St. Louis 63118
Contact: William Vollmar, Mgr. Corp. Archives

Collection Description: Approx. 40 pieces in an eclectic collection of paintings.

BARNES HOSPITAL 314.362.5000
One Barnes Hospital Plaza, St. Louis 63110
Contact: Max Poll, Pres.
Art Consultant: Locus

Collection Description: Approx. 475 pieces of contemporary representational art which features watercolors and textiles.

BELGER CARTAGE SERVICES, INC. 816.474.3250
2100 Walnut St., Kansas City 64108
Contact: C. Richard Belger, Pres.

THE BOATMAN'S NATIONAL BANK 314.425.7500
100 N. Broadway, St. Louis 63166
Contact: Lisa Wangerin, Art Cur.

BOONE COUNTY NATIONAL BANK 314.874.8560
Eighth And Broadway, Columbia 65205 FAX: 314.874.8432
Contact: Peggy Glenn, Cur.

THE BRYANT GROUP 314.231.8066
701 Market St., Ste. 1200, St. Louis 63101
Art Consultant: Donald Bryant

GAGE AND TUCKER 816.474.6460
2345 Grand Rapids, Kansas City 64108
Contact: Myrt Williams

H & R BLOCK 816.753.6900
4410 Main St., Kansas City 64111
Contact: Robert Block, V.P.

Collection Description: 30 pieces of contemporary art by the professors at The Kansas City Art Institute and other contemporary artists.

HALLMARK CARDS INC. 816.274.5111
2501 McGee St., Kansas City 64108
Contact: Keith Davis, Mgr.

PLASTIC SALES AND MANUFACTURING CO., INC. 816.561.7050
3124 Gillham Plaza, Kansas City 64109
Contact: J.R. Popplewell, Pres.

SOUTHWESTERN BELL CORP. 314.235.7115
One Bell Ctr., Rm. 38-F-2, St. Louis 63101
Contact: Melinda Heart, Corp. Mgr.
Art Consultant: Carey Ellis Company

Collection Description: American contemporary and modernist collection includes 800 works of all media.

ILLINOIS *(cont.)*

MCDONALD'S CORP. 708.575.3585
1 McDonald's Plaza, Oakbrook 60521
Contact: Susan Pertl, Art Cur.

NOUVEAU PRODUCT GROUP, INC. 312.248.8074
2049 N. Fremont, Ste. A, Chicago 60614
Contact: Scott B. Johnson, Cur.

Collection Description: Over 150 major and internationally reknown artists featuring oils, pastels and drawings.

OLD KENT BANK 312.876.4273
Sears Tower, Chicago 60606
Contact: Robert Harsted, Mgr. Bank Serv.

REFCO, INC. 312.930.6500
111 W. Jackson Blvd., 17th Fl., Chicago 60604
Contact: Adam Brooks, Assoc. Cur.

ROBERTSON CECO CORP. 312.242.2000
One Tower Ln., Oakbrook Terra 60181
Contact: Joe Jezek, P.R.

SARA LEE CORP. 312.726.2600
3 First National Plaza, Chicago 60602 FAX: 312.558.4913
Contact: John Bryan, Chrmn. & CEO

SEARLE 708.470.6617
5200 Old Orchard Rd., Skokie 60077
Contact: Irma Gilgore, Cur.

INDIANA

1ST SOURCE CORP./1ST SOURCE BANK 219.235.2000
100 N. Michigan, South Bend 46601 FAX: 219.236.2912
Contact: E.W. Reznik, V.P.

AMERICAN ART CLAY CO., INC. 317.244.6871
4717 W. 16th St., Indianapolis 46222 FAX: 317.240.4208
Contact: Bond Sandoe, Pres.

Collection Description: Hundreds of pieces in collection, primarily ceramic and sculpture.

BAKER & DANIELS 317.237.0300
300 N. Meridian, Ste. 2700, Indianapolis 46204 FAX: 317.237.1000
Contact: David Frick, Mgng. Ptnr.

CUMMINS ENGINE COMPANY, INC. 812.377.5000
500 Jackson St., P.O. Box 3005, Columbus 47202

CURTIS PUBLISHING CO. 317.636.1000
1000 Waterway Blvd., Indianapolis 46202 FAX: 317.634.1791
Contact: Beurt Servaas, Chrmn.

INDIANA LUMBERMENS MUTUAL INSURANCE CO. 317.875.3600
3600 Woodview Trace, P.O. Box 68600, Indianapolis 46268 FAX: 317.875.8501
Contact: Pat Walter, V.P.

Collection Description: Approx. 25 pieces in collection featuring local, contemporary artists.

ELI LILLY AND CO. 317.276.2173
Lilly Corporate Ctr., Indianapolis 46285
Contact: Anita Martin, Archivist

Collection Description: Approx. 25 pieces in collection featuring oil portraits of Lilly executives.

IOWA

AMERICAN REPUBLIC INSURANCE CO. 515.245.2000
601 Sixth Ave., Des Moines 50334 FAX: 515.245.2382
Contact: David Busick, V.P.

Collection Description: 500-piece contemporary collection; 60's to present; works in all media by such artists as Calder, Warhol and Lichtenstein.

BRENTON BANKS, INC. 515.237.5100
400 Locust, Ste. 300, Des Moines 50309
Contact: William H. Brenton, Chrmn.

Collection Description: Approx. 400 pieces of contemporary art with focus on national and international artists; works from all media.

EQUITY DYNAMICS INC. 515.244.5746
666 Walnut St., Des Moines 50309 FAX: 515.244.2346
Contact: John Pappajohn, Pres.

Collection Description: Hundreds of pieces focusing on all medium of contemporary art.

IMT INSURANCE CO. (MUTUAL) 515.274.3531
6000 Grand Ave./P.O. Box 1336, Des Moines 50305 FAX: 515.271.4392
Contact: James Vickery, Pres.

MEREDITH CORP. 515.284.2289
1716 Locust St., Des Moines 50336 FAX: 515.284.3970
Contact: Larry Petersen, Corp. Facilities

Collection Description: Approx. 250 pieces by primarily Midwestern artists; collection features works from mixed media.

KANSAS

BANK IV, WICHITA 316.261.4679
100 N. Broadway, Wichita 67201 FAX: 316.292.5611
Contact: Vernon Wassinger, Chrmn.

CAPITAL CITY BANK 913.266.4575
37th and Topeka Blvd., Topeka 66609 FAX: 913.266.7680
Contact: Frank Sabatini, Chrmn.

ERC CORP. 913.676.5200
5200 Metcalf, Box 2991, Overland Pk. 66201
Contact: Pat Walker

FIRST STATE BANK 913.877.3341
105 West Main, P.O. Box 560, Norton 67654
Contact: Ann Hazlett, V.P.

Collection Description: 53 pieces featuring pictures of men who ran for president but were defeated.

HAYS MEDICAL CENTER 913.628.8251
201 E. Seventh St., Hays 67601 FAX: 913.628.7490
Contact: John Thorns, Jr., Chrmn.
Art Consultant: Ann Jeter

Collection Description: 260 pieces by prestigious Kansas artists in all media; largest collection in state owned by a private corporation.

INLAND ASSOCIATES, INC. 913.764.7977
P.O. Box 940, Olathe 66061 FAX: 913.764.8721
Contact: Don Omer, Pres.

Collection Description: Approx. 100 pieces focusing on contemporary prints.

KENTUCKY

ASHLAND OIL, INC. 606.329.4547
100 Ashland Dr., Russell 41169
Contact: Larry Colley

LOUISIANA

FREEPORT MCMORAN, INC. 504.582.4000
1615 Poydras St., New Orleans 70112 FAX: 504.582.4822
Contact: Adele Ward, Dir.

K & B, INC. 504.586.1234
1055 St. Charles Ave., New Orleans 70130
Contact: Patricia Chandler, Cur.

MARYLAND

THE ARTERY ORGANIZATION, INC. 301.961.8000
7200 Wisconsin Ave., Ste. 1100, Bethesda 20814
Contact: Alan Geller, Pres.
Art Consultant: Andrea Pollan

Collection Description: 200 pieces by Washington-based regional artists.

MASSACHUSETTS

AFFILIATED PUBLICATIONS, INC. 617.929.2000
135 Morrissey Blvd., Boston 02107

THE CHARLES HOTEL 617.864.1200
One Bennett at Eliot St., Cambridge 02138 FAX: 617.864.5715
Contact: Bob Holland, Gen. Mgr.
Art Consultant: Karen Lewis

Collection Description: 20 pieces of specially commissioned works by local artists all related to Cambridge and Harvard Square.

POLAROID 617.577.2000
119 Windsor St., Polaroid, Cambridge 02139
Art Consultant: Linda Benedict Jones

Collection Description: Collection is a repository for the best contemporary photography generated on/with Polaroid materials; 10,000 photos.

SONESTA INT'L. HOTELS 617.421.5400
200 Clarendon, Boston 02116
Art Consultant: Joan Sonnabend

Collection Description: Approx. 5,000 pieces of contemporary art with works from all media.

DIGITAL COMMUNICATIONS ASSOCIATES 404.442.4000
1000 Alderman Dr., Alpharetta 30202
Contact: Martha Osborne

Collection Description: 65 works in all media by Georgia artists including Carolyn Montague, Cynthia Knapp, Iannazzi, Jon Eric Riis, and Susan Starr.

EGON ZEHNDER INTERNATIONAL 404.875.3000
1201 W. Peachtree St., Ste. 3000, Atlanta 30309
Art Consultant: Barkin-Leeds Ltd.

Collection Description: Contemporary collection with an international and early modern reference.

ENGRAPH INC. 404.329.0332
2635 Century Pkwy., Ste. 900, Atlanta 30345
Art Consultant: Barkin-Leeds Ltd.

FEDERAL RESERVE BANK OF ATLANTA
104 Marietta St. N.W., Atlanta 30303
Art Consultant: Barkin-Leeds Ltd.

Collection Description: Works by approx. 30 artists from the 6th Federal Reserve District including FL, GA, AL, FL, TN and MS.

FIRST AMERICAN BANK 404.230.8630
34 Peachtree St., 28th Fl., Atlanta 30303 FAX: 404.230.8677
Contact: Robert Dussler, Pres.

FORTSON AND WHITE 404.239.1900
3333 Peachtree Rd. N.E., Ste. 300S, Atlanta 30326
Art Consultant: Barkin-Leeds Ltd.

HALPERN ENTERPRISES, INC. 404.451.0318
5269 Buford Hwy., Atlanta 30340
Contact: Owen Halpern, V.P.

KILPATRICK AND CODY 404.572.6500
3100 Equitable Bldg., Atlanta 30303
Contact: Louis Regenstein, Chrmn. Art Comm.

Collection Description: Approx. 100 pieces by Georgia artists; primarily painting and sculpture.

KUTAK ROCK & CAMPBELL 404.222.4600
133 Peachtree St., 44th Fl., Atlanta 30303
Art Consultant: Barkin-Leeds Ltd.

Collection Description: A collection of regional art designed to complement the contemporary, gallery-like setting of the law firm.

LIBERTY HOUSE RESTAURANT CORP. 404.262.3130
3423 Pedmont Rd. N.E., Ste. 318, Atlanta 30305
Contact: Susan De Rose, Owner

MCKINSEY & COMPANY, INC. 404.525.9900
133 Peachtree St., 23rd Fl., Atlanta 30303
Art Consultant: Barkin-Leeds Ltd.

Collection Description: "100 Years Of Photography In The Southeast" includes archival as well as contemporary and innovative photography.

PAUL, HASTINGS, JANOFSKY & WALKER 404.588.9900
133 Peachtree St. N.E., Atlanta 30303
Contact: John Steed, Chrmn. Art Comm.
Art Consultant: Barkin-Leeds Ltd.

Collection Description: A group of nationally-known and regionally prominent artists reflecting the theme of a "controlled dynamic".

PORTMAN BARRY INVESTMENTS INC. 404.686.5000
233 Peachtree St., Ste. 600, Atlanta 30303
Art Consultant: Barkin-Leeds Ltd.

Collection Description: Commissioned glass sculpture and works on paper.

ROGERS & HARDIN 404.522.4700
233 Peachtree, Atlanta 30303
Art Consultant: Barkin-Leeds Ltd.

Collection Description: A collection based on the "timeless" and enduring quality of service including classically referenced works.

THE STOUFFER WAVERLY HOTEL 404.953.4500
Galleria Pkwy., Atlanta 30339
Contact: Joe Guilbault, Gen. Mgr.
Art Consultant: Margret Evans

Collection Description: Over 90 pieces including American contemporary art, mixed with some traditional and oriental.

THYSSEN RHEINSTAHL TECHNIK CO. 404.955.5747
2000 Powers Ferry Rd., Ste. 400, Marietta 30067
Art Consultant: Barkin-Leeds Ltd.

Collection Description: 12 paintings.

HAWAII

ALEXANDER AND BALDWIN, INC. 808.525.6642
822 Bishop St., Honolulu 96813 FAX: 808.525.6652
Contact: Lucy Jokiel, Mgr., Corp. Comm.

IDAHO

BOISE CASCADE 208.384.6161
One Jefferson Sq., P.O. Box 50, Boise 83728 FAX: 208.384.7189
Contact: Mike Everett, Dir. Admin. Serv.

FIRST SECURITY BANK 208.338.4000
119 N. Ninth St., Boise 83702
Art Consultant: Sally Adams

WEST ONE BANCORP 208.383.7309
101 South Capitol Blvd., Box 8247, Boise 83733 FAX: 208.383.3858
Art Consultant: Pat Nelson

ILLINOIS

ABBOTT LABORATORIES 708.937.6100
1401 Sheridan Rd., Bldg -1, Dept. 796, North Chicago 60064 FAX: 708.938.5824

AKZO CHEMIE 312.906.7500
300 S. Riverside Plaza, 22nd Fl., Chicago 60606 FAX: 312.906.7680
Contact: Debbie Zandrew, Dir. Offc. Serv.

AMERICAN MEDICAL ASSOC. 312.464.5359
515 N. State, 15233, Chicago 60610 FAX: 312.464.4184
Contact: Steve Currier, Reg.
Art Consultant: John Neff, Art Advisory Services

Collection Description: 400 pieces focusing on American Modern art including paintings, sculpture and prints.

AMOCO CORP. 312.856.7165
200 E. Randolph Dr./MC-5206, Chicago 60601 FAX: 312.856.2460
Contact: Frank Carioti, Cur.

BELL & HOWELL CO. 708.470.7100
5215 Old Orchard Rd., Skokie 60077
Contact: Floydd Phillips, Mgr. Admin. Serv.

COLE TAYLOR FINANCIAL GROUP, INC./COLE TAYLOR BANKS 708.459.1111
350 E. Dundee Rd., Wheeling 60090 FAX: 708.459.4724
Contact: Sidney Taylor, Chrmn.

Collection Description: 147 pieces of Southwestern art; collection features significant representation from The Chicago Images School.

COMDISCO, INC. 708.698.3000
6111 N. River Rd., Rosemont 60018 FAX: 708.518.5440
Contact: Robert Bardagy, Exec. V.P.

Collection Description: Over 400 pieces by hundreds of artists; key watercolors by Joseph Raphael and oils by John Stephens.

DEERE & CO. 309.765.8000
John Deere Rd., Moline 61265 FAX: 309.765.4735
Contact: Robert Hanson, Chrmn. & CEO
Art Consultant: Larence Jonson

Collection Description: 1,600 works in all media; includes works by artists from Grant Wood to Henry Moore.

HELLER FINANCIAL, INC. 312.621.6700
200 N. La Salle St., Chicago 60601
Contact: Mike Blum, Pres.

IMCERA GROUP INC. 708.564.8600
2315 Sanders Rd., Northbrook 60062
Art Consultant: Paul Faberson

Collection Description: 800 pieces of contemporary art including paintings, prints, and sculpture.

KEMPER NATIONAL INSURANCE CO. 708.540.2502
Route 22, Long Grove 60049 FAX: 708.540.4279
Contact: Joan Robertson, Art Cur.

Collection Description: 688 pieces featuring emerging Chicago and Midwestern artists; works from all media.

LA SALLE NATIONAL BANK 312.781.8076
120 S. La Salle, Chicago 60603 FAX: 312.750.6467
Contact: Herbert Kahn, Cur.

Collection Description: A historic collection of photography composed of 1,700 pieces, including works from all nationalities.

LAKESHORE NATIONAL BANK 312.915.5708
605 N. Michigan Ave., Chicago 60611 FAX: 312.664.8517
Contact: Carol Calozzo, Corp. Admin. Asst.
Art Consultant: Allona Mitchell

CALIFORNIA *(cont.)*

TRANSAMERICA INSURANCE GROUP 818.596.5000
6300 Canoga Ave., Woodland Hills 91367
Contact: Bobbi Meeks

WALT DISNEY IMAGINERING 818.560.1000
500 S. Buena Vista St., Burbank 91521
Contact: Van Romans, Dir. Exhibits

WELLS FARGO BANK 415.396.4157
420 Montgomery St., 2nd Fl., San Francisco 94163
Contact: Harold Anderson, Corp. Archivist

Collection Description: Thousands of pieces, historic and contemporary, reflecting on the American West.

COLORADO

JOHN MADDEN CO. 303.773.0400
6312 S. Fiddler's Green Cir., #150E, Englewood 80111
Contact: Cynthia Madden Leitner, Dir.

US WEST 303.793.6500
7800 E. Orchard Rd., Ste. 380, Englewood 80111 FAX: 303.793.6654
Contact: Barbara Wright, Admin. Serv.

WESTERN CAPITOL INVESTMENT CORP. 303.623.5577
1675 Broadway, Ste. 1700, Denver 80202 FAX: 303.620.1886
Contact: Marvin Buckels, Exec. V.P.

Collection Description: Approx. 825 pieces in collection; primarily Abstract paintings but also focusing on Southwestern art by New Mexico and Colorado artists.

CONNECTICUT

CHESEBROUGH-POND'S INC. 203.661.2000
33 Benedict Pl., Greenwich 06830 FAX: 203.625.1968
Contact: Eileen Sharkey, Dir. Comm.

HARTFORD STEAM BOILER INSPECTION AND INSURANCE CO. 203.722.5400
One State St., Hartford 06102
Contact: Wilson Wilde, Pres. & CEO
Art Consultant: Judith LeFebvre

Collection Description: 150 pieces focusing on Connecticut Impressionist art.

PITNEY BOWES CORP. 203.356.5000
World Headquarters, 1 Elmcroft, Stamford 06926
Contact: Carol St. Mark

DISTRICT OF COLUMBIA

ARNOLD & PORTER, ATTORNEYS AT LAW 202.872.6700
1200 New Hampshire Ave. N.W., Washington 20036 FAX: 202.872.6720
Contact: James Dobkin, Chrmn. Of Art
Art Consultant: Andre Emmerich, Chris Middendorf

Collection Description: First major corporate art collection In Washington D.C.; 200 pieces of primarily post-World War II, contemporary art.

THE OLIVER CARR CO. 202.639.3896
1700 Pennsylvania Ave. N.W., Washington 20006
Contact: Ellen O'Toole, Cur. & Pubs. Mgr.

KUTAK ROCK & CAMPBELL 202.828.2400
1101 Connecticut Ave. N.W., Ste. 1000, Washington 20036
Contact: Jan Kietrich, Offc. Mgr.

LATHAM AND WATKINS 202.223.1626
1001 Pennsylvania Ave. N.W., Washington 10005
Art Consultant: Jean Efron

PATTON, BOGGS & BLOW 202.457.6000
2550 M St. N.W., Washington 20037
Contact: James R. Patton, Jr., Chrmn. Art Comm.

THOMPSON PUBLISHING GROUP 202.872.4000
1725 K St. N.W., Ste. 200, Washington 20006

THE WASHINGTON POST CO. 202.334.6647
1150 15th St. N.W., Washington 20071
Contact: Rima Calderon, Corp. Affairs

Collection Description: 900 works in all media by Washington-area artists including Thomas Downing and Jacob Kinen.

THE WORLD BANK 202.477.1234
1717 H St. N.W., Washington 20433
Contact: Sam Niedzviecki, Sr. Project Mgr.

FLORIDA

ARCHITECTS DESIGN GROUP, INC. 407.647.1706
P.O. Box 1210, Winter Pk. 327902 FAX: 407.645.5525
Contact: I.S.K. Reeves, V. P.

Collection Description: Collection is split between Florida contemporary in all media and antique Native American art.

AT&T AMERICAN TRANSTECH 904.636.2522
8000 Baymeadows Way, Jacksonville 32256
Contact: Laura Clavier, P.R. Assoc.
Art Consultant: Jacqui Holmes, Art Sources

Collection Description: 79 pieces in a variety of media by such Florida artists as F. Faulkner, L. Kirkland, J.G. Naylor, and A. Tomczak.

BARNETT BANK OF JACKSONVILLE, N.A. 904.791.7427
P.O. Box 990, Jacksonville 32231
Contact: Judy Russell, V.P.
Art Consultant: Sally Ann Freeman

FIRST UNION BANK OF FLORIDA 904.361.6940
214 Hogan St., Jacksonville 32202 FAX: 904.361.1314
Contact: Diane Bossworth, Interior Designer
Art Consultant: Art South

Collection Description: Over 100 pieces representing the ideals of freedom, imagination, talent, and innovation; works in all media.

HASKELL CO. 904.358.1600
111 Riverside Ave., Jacksonville 32202 FAX: 904.791.4699

HOLLAND AND KNIGHT 813.227.8500
400 N. Ashley, Tampa 33602 FAX: 813.229.0134
Contact: Gregg Thomas, Art Comm. Chrmn.

Collection Description: 91 works by artists who reside and work in Florida including L. Arnold, E. Fray, J. Rosenquist and B. Thelosen.

SOUTHEAST ATLANTIC CORP. 904.739.1000
6001 Bowendale Ave., Jacksonville 32216
Contact: Robert H. Paul, III, Pres.

SOUTHEAST BANKING CORP. 305.375.7305
200 S. Biscayne Blvd., 13th Fl., Miami 33131 FAX: 305.375.7701
Art Consultant: Lisa Austin

Collection Description: Approx. 4,000 works in all media by international, contemporary artists.

TUPPERWARE INT'L. HEADQUARTERS 407.826.5050
3175 N. Orange Blossom Trail, Kissimmee 34744 FAX: 407.826.8872
Contact: Netta Evans, Art Cur.

GEORGIA

AFCO REALTY ASSOCIATES, INC. 404.233.1700
4200 Northside Pkwy., Bldg. 12, Atlanta 30327 FAX: 404.233.6823
Contact: Sam Friedman, CEO

ALEMBIK, FINE & CALLNER 404.420.7147
245 Peachtree St. Ctr., 4th Fl., Atlanta 30303
Contact: Jan Knotty, Offc. Admin.

ALTMAN, KRITZER & LEVICK 404.955.3555
6400 Powers Ferry Rd., Ste. 224, Atlanta 30339

ARNALL, GOLDEN & GREGORY 404.577.5100
55 Park Pl., Atlanta 30335 FAX: 404.527.4790
Contact: Bertram Levy, Chrmn. Arts Cncl.
Art Consultant: Bertram Levy

Collection Description: Approx. 150 pieces with an emphasis on photography but also featuring contemporary master prints and African art.

BRADLEY MARKETING SERVICES 404.571.6053
P.O. Box 1300, Columbus 31993
Contact: Janet Miller, Arts Coord.

Collection Description: 114 paintings displaying past and present Southern lifestyles; commissioned by W. Hurley, W. Kahn, and H. Casselli.

COOPERS AND LYBRAND 404.870.1100
1155 Peachtree N.E., Atlanta 30309
Art Consultant: Reinike Gallery

Collection Description: An extensive collection of original paintings and wall sculpture by Georgia artists.

ALABAMA

BE&K 205.969.3600
2000 International Pk. Dr., Birmingham 35243
Contact: Scott Robertson, Dir. Commun.

BLOUNT, INC. 205.244.4354
4520 Executive Pk. Dr., Montgomery 36101 FAX: 205.271.8188
Contact: Shirley Milligan, Chrmn.

Collection Description: Over 300 pieces of American art; primarily oil paintings and works on paper with some contemporary sculpture.

THE DOWNTOWN CLUB 205.322.5656
2116 Sixth Ave. N., Birmingham 35203
Contact: Dean Stewart, Gen. Mgr.

Collection Description: Small collection which features early-1900, American artists.

ARIZONA

BROWN & BAIN 602.351.8000
2901 N. Central Ave., Ste. 2000, Phoenix 85004
Contact: Marley Hedges

FIRST INTERSTATE BANK OF ARIZONA 602.229.4624
100 W. Washington, Phoenix 85003
Contact: Patsy Koldoff, Cur.

Collection Description: Approx. 35 pieces in collection including works by Wyeth, Russell and Remington.

FRANCHISE FINANCE CORP. OF AMERICA 602.264.9639
3443 N. Central, Ste. 500, Phoenix 85102
Contact: Morton Fleischer, Pres.

HYATT REGENCY SCOTTSDALE 602.991.3388
7500 E. Doubletree Ranch Rd., Scottsdale 85258 FAX: 602.483-5550
Contact: Rick Riess, Gen. Mgr.
Art Consultant: National Art Resources

Collection Description: Collection spans many artistic movements and includes contemporary paintings, sculpture, works on paper, and textiles.

LEWIS AND ROCA 602.262.0844
40 N. Central, Phoenix 85004 FAX: 602.262.5747
Contact: Susan Martinez, Spec. Proj.

SECURITY PACIFIC BANK ARIZONA 602.431.3100
101 N. First Ave., Dept. 255, Phoenix 85003
Contact: Annie Hinojos, Art Adv.

CALIFORNIA

ASHTON-TATE 213.329.8000
20101 Hamilton Ave., Torrance 90509 FAX: 213.538.7996
Contact: Edward Esber, CEO
Art Consultant: Lorraine Kanholc

Collection Description: Approx. 250 paintings with a focus on contemporary art.

ATLANTIC RICHFIELD CO. 213.486.8666
515 S. Flower St., Apt. 4695, Los Angeles 90071
Contact: S. Bradley Gillaugh, Reg.
Art Consultant: Stephanie Jackson

Collection Description: Approx. 10,000 works in collection; primarily works on paper, but includes all media.

AVCO FINANCIAL SERVICES 714.553.5779
3349 Michelson Dr., Irvine 92715
Contact: Charles Castle, Afs Prog.

Collection Description: 700 pieces by Southern California artists featuring painting, sculpture, watercolors, and drawings.

BANKAMERICA CORP. 415.622.1265
P.O. Box 37000, San Francisco 94137
Contact: Bonnie Earls-Solari, Dir.

THE BROAD, INC./KAUFMAN AND BROAD HOME CORP. 213.399.4004
11601 Wilshire Blvd., 12th Fl., Los Angeles 90025
Contact: Michele De Angelus, Cur.

Collection Description: Approx. 200 works by Southern California, contemporary artists such as Robert Therrien and Charles Garabedian.

THE CAPITAL GROUP, INC. 213.486.9907
333 S. Hope St., Los Angeles 90071 FAX: 213.486.9217
Contact: Robert Egelston, Chrmn.

Collection Description: Collection focuses on works by contemporary California artists and includes a museum set by Ansel Adams; over 800 works.

CEDARS-SINAI CANCER CENTER 213.276.0732
8700 Beverly Blvd., Los Angeles 90048
Contact: Bernard Salick, CEO & Pres.

THE FIELDSTONE CO. 714.851.8313
14 Corporate Plaza, Newport Beach 92660
Contact: Mary Hendrickson, Art Collector Admin.

FIRST INTERSTATE BANK 213.614.4111
633 W. Fifth St., Los Angeles 90071
Contact: Stuart Laff, Sr. V.P.

GENDEL, RASKOFF 213.277.5400
1801 Century Pk. E., Los Angeles 90067 FAX: 213.556.3631
Contact: Diana Terry, Admin. Sec.

GFELLER DEVELOPMENT CO., INC. 714.557.7330
1580 Corporate Dr., Ste. 124, Costa Mesa 92626
Contact: Douglas Gfeller, Pres.

GIBSON, DUNN & CRUTCHER 213.229.7000
333 S. Grand Ave., Los Angeles 90071 FAX: 213.229.7520
Contact: Ron Beard, Mgng. Ptnr.

Collection Description: Over 150 pieces of photography, works on paper and paintings; "A Century Of California Landscapes"; works by Elmer and Wachtel.

GOLDEN STATE MUTUAL LIFE 213.731.1131
1999 W. Adams Blvd., Los Angeles 90018 FAX: 213.733.0320
Contact: William Paujaud, Art Cur.

GREAT WESTERN FINANCIAL CORP. 213.852.3411
8484 Wilshire Blvd., Beverly Hills 90211
Contact: Ralph Rivet, Chrmn.
Art Consultant: George Takyama, Property Admin

L'ERMITAGE HOTELS 213.854.6171
1020 N. San Vicente Blvd., West Hollywood 90069 Fax: 213.650.2126
Contact: Arnold Ashkenazy, V.P.

Collection Description: 15,000 works of contemporary art; works in all media including original oils and canvases by Van Gogh.

LEVI STRAUSS AND CO. 415.544.6000
1155 Battery St., San Francisco 94120

LOEWS SANTA MONICA BEACH HOTEL 213.458.2165
1700 Ocean Ave., Santa Monica 90401
Contact: Anne Flower, Dir. P.R.

Collection Description: A gallery of local and Southern California artists including works by C. Almaraz, J. Kinney, R. Stich, and B.A. Bengston.

MUNGER, GOLLES & OLSON 213.683.9100
355 S. Grand, Los Angeles 90071
Contact: Cary Lerman

PACIFIC BELL 415.542.9000
140 New Montgomery St., San Francisco 94105 FAX: 415.275.1256
Contact: Alan Curtis, Support Serv. Mgr.

QUINN, KULLY & MORROW 213.622.0300
520 S. Grand Ave., 8th Fl., Los Angeles 90071 FAX: 213.622.3799
Contact: Rusell I. Kully, Ptnr.

Collection Description: 150 works of mixed media by contemporary Southern California artists.

RANCON 714.676.6664
27720 Jefferson Ave., Temecula 92390 FAX: 714.699.4394
Contact: Rod McDonald, Dir. Construction
Art Consultant: Lonnie Ganns

Collection Description: 8 major pieces by such artists as Guy Dill and Rod Baer.

SYNTEX CORP. 415.855.5050
3401 Hillview Ave., Palo Alto 94304
Contact: Bill Cleere, Public Affairs Dept.

TACO BELL CORP. 714.863.4500
17901 Von Karman Ave., 503, Irvine 92714
Art Consultant: Sebastian-Moore

THE TIMES MIRROR CO. 213.237.3819
Times Mirror Square, Los Angeles 90053
Contact: Elke Corley, Supv. Admin. Serv.

Collection Description: 150 pieces featuring modern artists' paintings, sculpture, and lithographs.

CORPORATE COLLECTIONS

1991 **1992**

SEPT	OCT	NOV	DEC	JAN	FEB	MAR	APR	MAY	JUN	JUL	AUG

WASHINGTON

HENRY ART GALLERY
206.543.2281

- Imagenes Liricas: New Spanish Visions
- Ann Hamilton
- Architecture: Stephen Holl and Martha Schwartz
- In Our Times: The World as Seen by Magnum Photographers

SEATTLE ART MUSEUM
206.625.8900

- New World: Three Hispanic Photographers
- Tobey-Graves-I. Cunningham
- Dale Chihuly

WISCONSIN

MADISON ART CENTER
608.257.0158

- Brad Washburn
- The Elegant Image: Hollywood Portrait Photography II

MILWAUKEE ART MUSEUM
414.271.9508

- Painters of a New Century: The Eight
- Jackie Winsor
- Currents 19: Eric Fischl Drawings
- The Duane Michals Show
- Currents 20: Recent Narrative Sculpture
- Jasper Johns Prints: Prints and Multiples

CANADA

BRITISH COLUMBIA

CONTEMPORARY ART GALLERY
604.681.2700

- Joanne Tod
- Ulrich Horndash
- Annette Messager

VANCOUVER ART GALLERY
604.682.4668

- William G. R. Hind: The Pictou Sketchbook
- Lost Illusions: Recent Landscape Art
- Play Things
- David Milne Retrospective Exhibition
- Ronald Bladen: Early and Late
- Terence Johnson
- Jack Shadbolt
- Vancouver Collects

ONTARIO

ART GALLERY OF WINDSOR
519.258.7111

- Stations Along the Way
- Robert Coyle: Sideshow
- Kim Moodie: Recent Drawings
- From the Heart of the Heart of the Regions
- David Meritt: Habitus: Unswept Rooms
- "The Effect of the Imagination on the World": Brenda Pelkey
- Contemporary Hungarian Art
- Canadian Artists in Mexico
- Beyond Control: Critical Transitions in the Baltic Republic
- Selected Drawings of Tim Zuck
- Contemporary Windsor

ART GALLERY ST. THOMAS ELGIN
519.631.4040

- Cheryl Sourkes: Of Differences Lost and Retrieved
- Images of Conflict: War Art in the Twentieth Century
- Recent Gifts and Acquisitions I
- Recent Gifts and Acquisitions II
- Rick Nixon: New Sculptural Works
- Lila Carolin Taylor McGillivary Knowles

LAURENTIAN UNIVERSITY MUSEUM & ART CENTRE
705.675.1151

- Janice Gurney
- Jocko Chartrand: Landscapes
- Artists from Collection
- Changers: A Spiritual Renaissance
- Dennis Castellan
- Memory and Subjectivity
- Doug Donley: Adam and Eve
- Jean Eng: Grey Scales
- Liz Magor
- Dennis Geden: New Works from Canada
- A Living Tradition: Selections from American Abstract Artists
- Frederick Hagan Ray Laporte

MCMASTER UNIVERSITY ART GALLERY
416.525.9140

- Watercolours by Stan Parrot and Tapestries by Gitta Whillier
- Art/Facts
- Landscapes by Buttercup Garrad
- Re: Turning; Works by Stephen Hogbin
- John Massey Photographs
- Permanent Collection Exhibition

NATIONAL GALLERY OF CANADA
613.990.1985

- Tatsuo Miyajima
- Japanese Sculptors
- Roger Mertin: Tannenbaum Serie
- Sara Diamond (Video)
- Spring Hurlbut: The Sacrificial Moulding Series

PROVINCE OF QUEBEC

CONCORDIA ART GALLERY
514.848.4750

- The Landscape: Eight Canadian Photographers
- Susanna Heller: Recent Paintings
- Selections from the Permanent Collection

THE MONTREAL MUSEUM OF FINE ARTS
514.285.1600

- Jean-Paul Riopelle
- Morrice: A Gift to the Nation: The G. Blair Laing Collection
- A Fresh Look at Quebec Art

MUSÉE D'ART CONTEMPORAIN DE MONTREAL
514.873.2878

- John Baldessari

	1990			1991								
	SEPT	OCT	NOV	DEC	JAN	FEB	MAR	APR	MAY	JUN	JUL	AUG

WASHINGTON

HENRY ART GALLERY
Univ. of Washington, Seattle 98195

- New Works: Salise Hughes
- New Works: Amanda Finn
- Waves and Plagues: The Art of Masami Teraoka
- Immaterial Objects: Works from the Permanent Collection of the Whitney Museum
- New Works: Weldon Butler
- Through their Own Eyes: The Personal Portfolios of Edward Weston and Ansel Adams
- Projects in

SEATTLE ART MUSEUM
First Ave. & University St., Seattle 98112

- Documents NW: Paul Berger
- Documents NW: Jeffry Mitchell
- Mark Tansey: Art and Source
- Documents NW: Buster Simpson
- Old World/

WISCONSIN

MADISON ART CENTER
211 State St., Madison 53703

- A Different War: Vietnam in Art
- Projections: Photographs by Lorie Novak, 1983-1990
- The Landscape in Twentieth-Century Art: Selections from the Metropolitan Museum

MILWAUKEE ART MUSEUM
750 N. Lincoln Memorial Dr.
Milwaukee 53202

- The Pleasure Machine: Recent American Video

CANADA

BRITISH COLUMBIA

CONTEMPORARY ART GALLERY
555 Hamilton St., Vancouver V6B 2R1

VANCOUVER ART GALLERY
750 Hornby St., Vancouver V6Z 2H7

- From the Collection: Gathie Falk
- Jack Shadbolt: Works on Paper
- Landclaims
- Charles John Collings
- David MacWilliam: Recent Paintings
- Concept and Configuration: Landscape Since 1965
- What Does She Want
- Marion Penner Bancroft
- The Flat Side of the Landscape: Emma Lake Artists' Workshops
- Pastfuturetense
- 3 D
- Sara Diamond: Patternity
- Carole Itter: Where the Streets are Paved with Gold
- Marianna Schmidt
- Roger Fry in Provence
- 60 Years 60 Artists
- Rosebud: Myths of Childhood and the Family
- John Vanderpant
- Lisette Model

ONTARIO

ART GALLERY OF WINDSOR
445 Riverside Dr. W., Windsor N9A 6T8

- Celine Barile: Barcelone
- David Hlynsky: Windows through the Curtain
- Oshawa - A History of Local 222, United Auto Workers of America, CLC 1982-1983
- Rod Strickland: Around the Sweet Sea
- The Loaded Image
- Aurora Australis, Film and Photographic Works
- Barrie Jones: Young Women & Young Men of Canada
- Douglas Clark: Articles of Faith
- Selected Videos from the AGW Archives
- Southwest Biennial
- Contemporary Works from the AGW's Permanent Collection
- Robert Tombs: The History of Photography
- Honor Kever:

ART GALLERY ST. THOMAS ELGIN
301 Talbot St., St. Thomas N5P 3T9

- Carolyn Curtis: A Retrospective
- Figures of Speech - Drawings by Alan Dayton
- Fireworks 90 Forty Years of British Sculpture
- Robert Creighton - Recent Drawings
- The Thielsen Gift I: Herb Ariss and Rudolph Bikkers
- Seeing is Believing
- The Thielsen Gift II: Jacques Hurtubise, Brian Jones, John Ward and Alan Weinstein

LAURENTIAN UNIVERSITY MUSEUM & ART CENTRE
Laurentian Univ., 251 John St.
Sudbury P3E 2C6

- Confrontations of Form
- Bruno Cavallo
- Leda Watson
- Impressionism and its Context
- London Life: Young Contemporaries
- Contemporary the Permanent

MCMASTER UNIVERSITY ART GALLERY
Togo Salmon Hall, 114, 1280 Main St. W. Hamilton L8S 4M2

- Inquiries: Language in Art
- James Morrison: Recent Works
- Art/Facts
- SMS: A Collection of Original Multiples
- Joyce Wieland
- Inuit Sculpture
- Permanent Collection Prints
- Beneath a Canopy of Blue?
- Hamilton Artists in the McMaster Collection

NATIONAL GALLERY OF CANADA
380 Sussex Dr. #515, Ottawa KIN 9N4

- Contemporary American Prints from the Carol & Morton Rapp Collection
- Lisette Model
- Lucius O'Brien, Visions of Victorian Canada
- Video Untamed: Passages and Stolen Memories
- Colin Campbell: Media Works, 1972-1990
- Jana Sterbak: States of Being
- Guercino: Master Draftsman: Works from North American Collections
- A Primal Spirit: Ten Contemporary

PROVINCE OF QUEBEC

CONCORDIA ART GALLERY
1455 ouest, boul. de Maisonneuve
Montreal H3G 1M8

- Leopold Plotek - 5 Years of Painting
- Urban Images: Canadian Painting
- Drawing Beyond Categories
- Redefined: The Quilt as Art
- How to Read: Stan Denniston
- Regan O'Connor: Allegories
- Vehicule Art
- Marion Wagschal: Essential Lives
- The Land and the Village: View of Rural Quebec

THE MONTREAL MUSEUM OF FINE ARTS
1379 Sherbrooke St. W.
Montreal H3G 1K3

- From Geometry to Computer Technology
- Jasper Johns: Printed Symbols
- The 1920's: Age of the Metropolis

MUSÉE D'ART CONTEMPORAIN DE MONTREAL
Cité du Hâvre, Montreal H3C 3R4

- The Lovers: The Great Wall Walk
- Ron Martin (1971 - 1981)
- Le Corps Vacant

1991 **1992**

SEPT OCT NOV DEC JAN FEB MAR APR MAY JUN JUL AUG

OHIO (cont.)

COLUMBUS MUSEUM OF ART — 614.221.6801
- Tip of the Iceberg: Hidden Treasures from the Columbus Museum of Art
- 150 Years of American Art from Ohio Collections
- Elijah Pierce: Sermons in Wood
- Land Ho : The Mythic World of Rodney Alan Greenblat

THE CONTEMPORARY ARTS CENTER — 513.721.0390
- Cincinnati Collects: The Corporate View
- William Wiley: Musical Instruments
- South Bronx Hall of Fame: Sculpture by John Ahearn
- Next Generation: Southern Black Aesthetic
- Donald Lipski
- Mel Chin
- Jana Sterbak: States of Being
- Ritzy Business
- William Turnbull: A Regional Perspective
- American Dream House: Changing the Model

DAYTON ART INSTITUTE — 513.223.5277
- Quilts in Community: Ohio's Traditions
- Visions of the American West
- Art that Works
- DAI Contemporary Collection
- Fit to Print (Experiencenter)
- Moon
- Contrasts: Forty Years of Change and Continuity in Puerto Rico
- Spirits: Selections from the Collection of Geoffrey Holder

THE TOLEDO MUSEUM OF ART — 419.255.8000
- Design 1935-1965: What Modern Was; The Liliane and David M. Stewart Collection
- Tenth Annual Awards in the Visual Arts
- In our Time: The World as Seen by Magnum Photographers

WEXNER CENTER FOR THE ARTS — 614.292.0330
- Paper Tiger Television: Artist Residency
- Todd Slaughter: Rampwaves
- Re: Framing Cartoons

OKLAHOMA

THE PHILBROOK MUSEUM OF ART — 918.749.7941
- Reinstallation of the Museum's Permanent Collection
- On the Road: Selections from the San Diego Museum of Contemporary Art

PENNSYLVANIA

ALLENTOWN ART MUSEUM — 215.432.4333
- Biennial Juried Show
- Jack Savitsky
- Michael Kessler

INSTITUTE OF CONTEMPORARY ART — 215.898.7108
- Art of the Eighties
- Bill Viola: Slowly Turning Narrative
- Leon Golub
- Devil on the Stairs: Reflections on the Eighties
- Oleg Kudryashov
- Three Sculptors: Investigations in Clay
- The Bleeding Heart: Contemporary Mexican Art

PHILADELPHIA MUSEUM OF ART — 215.763.8100
- Joseph Beuys: Thinking is Form
- Picasso and Things: The Still Lifes of Picasso

TEXAS

THE ART CENTER, WACO — 817.752.4371
- Dianne Green
- Zeke and Marty/Cruz/Honeysweet
- Texas Printmakers: 1940-1965
- The China Trade
- Evidence of Texas: Ten Texas Photographers
- Pardners-Bill Verherst/Susan Lecky

CONTEMPORARY ARTS MUSEUM — 713.526.0773
- The South Bronx Hall of Fame: Sculpture by John Ahearn in Collaboration with Rigoberto Torres
- Bert L. Long Jr.: Looking and Seeing in Rome
- Christian Boltanski: Shadows
- Awards in the Visual Arts
- Meg Webster with Outside Projects
- Nancy Burson: The Age Machine
- William Wegman: Paintings, Drawings, Photographs and Videotapes
- Tony Cragg: Sculpture, 1975-1990

DALLAS MUSEUM OF ART — 214.922.1200
- The State I'm In: Texas Art at the Dallas Museum of Art
- Africa Explores: 20th-Century African Art

MUSEUM OF FINE ARTS, HOUSTON — 713.639.7300
- Three Modern Master Jewelers: Verdura, Schlumberger and Webb
- Paul Strand
- Contemporary Mexican Photography
- George Krause: Universal Issues
- Rescuers of the Holocaust
- Years of Cartoon Art
- Max Weber: The Cubist Decade, 1910-1920
- Arman 1955-1990: A Retrospective
- Object Transformed

VIRGINIA

VIRGINIA MUSEUM OF FINE ARTS — 804.367.0844
- Alfredo Jaar: Geography = War
- Emmet Gowin: Photographs
- Power: Its Myths and Mores in American Culture, 1961-1991

MUSEUM SCHEDULES

	1990 SEPT	OCT	NOV	DEC	1991 JAN	FEB	MAR	APR	MAY	JUN	JUL	AUG
OHIO *(cont.)*												
COLUMBUS MUSEUM OF ART 480 E. Broad St., Columbus 43215										I Dream a World: Portraits of Black Women Who Changed America	→	→
THE CONTEMPORARY ARTS CENTER 115 E. Fifth St., Cincinnati 45202	Mike and Doug Starn				Contemporary Soviet Photographers	Secrets, Dialogues, Revelations: The Art of Betye and Alison Saar	→				Biennial III	
					Tom Wesselmann: Works, 1965-1990		The Continuous Present of Organic Architecture	Mechanika				
DAYTON ART INSTITUTE Forest & Riverview Ave., Dayton 45405	Woven in Splendor and Majesty: Oriental Rugs from the Collection of Richard Markarian	Jerry Uelsmann Photographs		Irving Penn Master Photographs	100 Languages of Children				Corporate Culture: Selections from Southwestern Ohio Corporate Collections	Poems for Screens: Mt. Fuji and the Autumnal		
THE TOLEDO MUSEUM OF ART 2445 Monroe St., Toledo 43620												
WEXNER CENTER FOR THE ARTS N. High St. at 15th Ave., Columbus 43210	New Works for New Spaces: Into the Nineties	→	→	→	Leslie Payne: Visions of Flight	Expansions I: Susan Dallas-Swann and Richard Harned	Domestic Arrangements: A Lab Report by Tod Williams and Tsien			Passages de L'image		
OKLAHOMA												
THE PHILBROOK MUSEUM OF ART 2727 S. Rockford Rd., Tulsa 74114									The Landscape in Twentieth-Century Art: Selections from the Metropolitan Museum		Art that Works: The Decorative Arts of the 80's, Crafted in America	
PENNSYLVANIA												
ALLENTOWN ART MUSEUM Fifth and Court Sts., Allentown 18105										Four Artists: Kevin O'Toole, Herbert Simon, Allen Topolski, and Howard Greenberg		
INSTITUTE OF CONTEMPORARY ART Univ. of Pennsylvania, 36th and Sansom Sts. Philadelphia 19104					Philadelphia Art Now: Artists Choose Artists	David Hammons	Helen Chadwick		Interactions: Collaborations in the Visual and Performing Arts		Dorothy Cross	Chuck Fahlen: Terra Incognito
PHILADELPHIA MUSEUM OF ART 26th & Benjamin Franklin Parkway Philadelphia 19101			Contemporary American Crafts					Master Drawings from Leipzig	Jacob Lawrence: The Frederick Douglass and Harriet Tubman Series of Narrative Paintings	Picasso: The Vollard Suite	William Christenberry: Photographs	Art Beyond Sight
									Form in Art: Work by Blind and Partially Sighted Adults			
									Recent Acquisitions: Prints, Drawings and Photographs			
TEXAS												
THE ART CENTER, WACO 1300 College Dr., Waco 76708		Contemporary Hispanic Women Artists of Texas	On the Balcony of the Nation, Five Irish Artists from Belfast			Luanne Stovall/Margaret Hicks: Visual Storytellers		Danny Williams/ Margaret Hicks: New Visions by Two Artists	Sharon Kopriva			Decorative Arts
CONTEMPORARY ARTS MUSEUM 5216 Montrose, Houston 77006	The Perfect Thought: An Exhibition of Works by James Lee Byars	Everyday Miracles: Retablos, Ex-Votos and Contemporary Art In Texas	→		Contemporary Latin American Photographers	Manual: Forest/Products	Word as Image: American Art, 1960-1990	Word as Image: Installations: Vito Acconci, Robert Barry, Bretchen Bender				
DALLAS MUSEUM OF ART 1717 N. Harwood, Dallas 75201									New Photography from Mexico City			
MUSEUM OF FINE ARTS, HOUSTON 1001 Bissonnet, Houston 77005		Picasso, Braque, Gris, Leger: Douglas Cooper Collecting Cubism					Martin Luther King and the Civil Rights Movement		The New Vision: Photography Between the World Wars, Ford Motor Company from the Metropolitan Museum of Art	From Harlem to Hollywood: American Race Movies, 1912-1948	Great American Comics: 100	Pop Art: The
VIRGINIA												
VIRGINIA MUSEUM OF FINE ARTS 2800 Grove Ave., Richmond 23221		Un/Common Ground: Virginia Artists, 1990								Perspectives on the Permanent Collection: Contemporary Sculpture		

1991				1992								
SEPT	**OCT**	**NOV**	**DEC**	**JAN**	**FEB**	**MAR**	**APR**	**MAY**	**JUN**	**JUL**	**AUG**	

NEW YORK (cont.)

THE BROOKLYN MUSEUM 718.638.5000
- Alain Kirili (SEPT)
- Objects of Myth and Memory: American Indian Art at the Brooklyn Museum (OCT–NOV)
- Jin Soo Kim (MAR)
- Sigmar Polke (OCT)
- Houston Conwill, Joseph de Pace, and Estella Conwill Majoz (DEC–JAN)
- A Dialogue with Tradition: Six Contemporary Native American Artists (NOV–DEC)

EVERSON MUSEUM OF ART 315.474.6064
- Eternal Metaphor: New Art from Italy (SEPT)
- Dennis Adams (SEPT)

SOLOMON R. GUGGENHEIM MUSEUM 212.360.3500
- A Major Representation of Russian and Soviet Avant-Garde Art (JUN)

INTERNATIONAL CENTER OF PHOTOGRAPHY 212.860.1777
- Duane Michals (SEPT)

HERBERT F. JOHNSON MUSEUM OF ART 607.255.6464
- The Art of Paul Manship (SEPT)
- Agnes Denes: An Artist's Dialogue with the Universe (JAN)
- Nature's Changing Legacy: The Photos of Robert Glenn Ketchum (FEB–MAR)

METROPOLITAN MUSEUM OF ART 212.879.5500
- American Watercolors (OCT)
- Stuart Davis, American Painter (NOV)
- Photographs by Helen Levitt: A Retrospective (MAR)

THE MUSEUM OF MODERN ART 212.708.9400
- Pleasures and Terrors of Domestic Comfort (SEPT)
- Dislocations (OCT)
- Drawing Now: New Spaces (FEB)

THE NEW MUSEUM OF CONTEMPORARY ART 212.219.1222
- The Interrupted Life (SEPT)
- Alfredo Jaar (JAN)
- The Spatial Drive (MAY)

P.S.1 MUSEUM 718.784.2084
- Dennis Oppenheim: And the Mind Grew Fingers - Retrospective (JAN)

STORM KING ART CENTER 914.534.3115
- Ursula von Rydingsvard: Sculpture and Drawings (MAY)

THE STUDIO MUSEUM IN HARLEM 212.864.4500
- The Frederick Douglass and Harriet Tubman Series Paintings (SEPT)
- the Permanent Collections of SMH and ACPSOB (SEPT)
- The Art of Archibald J. Motley (APR)
- From the Studio: Artist-in-Residence (AUG)

WHITNEY MUSEUM OF AMERICAN ART 212.570.3676
- Scott Burton (OCT)
- Alexis Smith (OCT–NOV)
- Alexander Calder (NOV)
- William Wegman (JAN)
- Terry Winters (FEB)
- Paul Strand (MAR)
- Joan Mitchell Pastels (MAR)
- Richard Prince (APR)
- George Bellows (JUN)

OHIO

AKRON ART MUSEUM 216.376.9185
- Sculpture in America, 1930-70 (SEPT)
- Focus on the Collection: A Seventieth Anniversary Celebration (OCT)
- Power: Its Myths and Mores in American Culture, 1961-1991 (JAN)
- Elaine Reichek: Past Work (MAR)
- Adam Fuss: Photograms (JUN)

THE BUTLER INSTITUTE OF AMERICAN ART 216.743.1107
- The Quartet's and Other Prints (SEPT)
- Colleen Browning: A Retrospective (OCT)
- Artists at Ringside (MAR)
- Philip Pearlstein: Early Abstract Landscapes (MAR)

CINCINNATI ART MUSEUM 513.721.5204
- Temporary Exhibition Program Suspended due to Renovation (SEPT)

CLEVELAND CENTER FOR CONTEMPORARY ART 216.421.8671
- Allen Ginsberg: American Dharma (SEPT)
- Cruciformed (SEPT)
- Mineko Grimmer (SEPT)
- Richard Bosman (SEPT)
- Adrian Piper (OCT)
- Claudia Esslinger: Votive Garden (OCT)
- Ohio Selections X (OCT)
- Joe Andoe/April Gornik (JAN)
- Abstract Painting Today (JAN)
- Richard Artschwager Multiples (FEB)
- Petah Coyne (FEB)
- Off the Wall (APR)
- Progressive Corporation Exhibition (MAY)
- Jonathan Borofsky (MAY)
- Heide Fasnacht (MAY)
- Michael Book/Lois Connor (JUN)

THE CLEVELAND MUSEUM OF ART 216.421.7340
- Picasso as Printmaker (JAN)
- Picasso and Things: The Still Lifes of Picasso (FEB)

	1990				1991							
	SEPT	OCT	NOV	DEC	JAN	FEB	MAR	APR	MAY	JUN	JUL	AUG
NEW YORK (cont.)												
THE BROOKLYN MUSEUM 200 Eastern Pkwy., Brooklyn 11238	Joseph Kosuth						Chris Burden		Leon Golub: Worldwide	The Eight: Works on Paper		
	Milton Avery in Black and White: Drawings, 1929-59									Painters of a New Century: The Eight		
			In Pursuit of the Spiritual Oceanic Art, Given by Mr. and Mrs. John A. Friede and Mrs. Melville W. Hall	Reeva Potoff								
EVERSON MUSEUM OF ART 401 Harrison St., Syracuse 13202	Public Mind: Les Levine's Media Sculpture and Mass Ad Campaigns, 1969-1990								Umbria Rediscovered: Richard Upton at Cortona			
	The Empire State Biennial						Gretchen Bender: Work, 1981-1991					
SOLOMON R. GUGGENHEIM MUSEUM 1071 Fifth Ave., New York 10128												
INTERNATIONAL CENTER OF PHOTOGRAPHY 1130 Fifth Ave. at 94th St. New York 10021					Language of Light: Masterworks from the Collection					George Melies		
										Women Photographers in Camera Work		
HERBERT F. JOHNSON MUSEUM OF ART Cornell Univ., Ithaca 14853			Border Crossing: The Photographs of Johan van der Keuken		N.Y. State Artists IX: Message to the Future			Arthur S. Penn Photo Symposium:				
			Cornell University Art Department Faculty Exhibition					Lee Friedlander	American Clothing: Identity in Mass Culture, 1840-1990			
						New York State Artists IX: Art and the Environment						
METROPOLITAN MUSEUM OF ART 1000 Fifth Ave., New York 10028	Drawings by John Singleton Copley									Bronze Casting		
		Mexico: Splendors of Thirty Centuries								The Art of Paul Manship		
THE MUSEUM OF MODERN ART 11 W. 53rd St., New York 10019										Ad Reinhardt		
										Seven Master Printmakers: Innovations in the 80's		
										Roberto Burle Marx: The Unnatural Art of the Garden		
										Projects: Thierry Kuntzel		
											Lee Freidlander: Nudes	
THE NEW MUSEUM OF CONTEMPORARY ART 583 Broadway, New York 10012	From Receiver to Remote Control: The TV Set						Cadences: Icon and Abstraction in Context		Africa Explores New and Renewed Forms in 20th-Century African Art			
				Rhetorical Image								
P.S.1 MUSEUM 46-01 21st St., L.I.C., New York 11101				David Hammons: Rousing the Rubble		The P.S.1 Studio Artists Exhibition		Paul Panhuysen				
								New York Diary				
				Lewis Baltz: Rule Without Exception								
				Out of Site				Berlin Divided				
				Robert Price								
				Three Artists from Bohemia				Out Of Site: Part II				
STORM KING ART CENTER Old Pleasant Hill Rd., Mountainville 10953									Enclosures and Encounters: Architectural Aspects of Recent Sculpture			
THE STUDIO MUSEUM IN HARLEM 144 W. 125th St., New York 10027									Memory and Metaphor: The Art of Romare Bearden, 1940-1987			Jacob Lawrence: of Narrative
												Selections from
WHITNEY MUSEUM OF AMERICAN ART 945 Madison Ave. at 75th St. New York 10021	Burgoyne Diller	Adrian Piper	Non%*@&#?!Sense					1991 Biennial Exhibition			American Life in American Art	
		Mind Over Matter: Concept and Object										
	Contingent Realms: Four Contemporary Sculptors			Robert Rauschenberg: The Silkscreen Paintings, 1962-1964						Hunt Diederich		
		The Charade of Mastery: Deciphering Modernism in Contemporary Art									John Baldessari	
OHIO												
AKRON ART MUSEUM 70 E. Market St., Akron 44308												Abstract
THE BUTLER INSTITUTE OF AMERICAN ART 524 Wick Ave., Youngstown 44502												Mel Bochner
CINCINNATI ART MUSEUM Eden Park, Cincinnati 45202	Temporary Exhibition Program Suspended due to Renovation											
CLEVELAND CENTER FOR CONTEMPORARY ART 8501 Carnegie Ave., Cleveland 44106										Gertrude Stein: The American Collection		
THE CLEVELAND MUSEUM OF ART 11150 East Blvd., Cleveland 44106												

MUSEUM SCHEDULES

1991				1992							
SEPT	OCT	NOV	DEC	JAN	FEB	MAR	APR	MAY	JUN	JUL	AUG

MASSACHUSETTS (cont.)

WORCESTER ART MUSEUM
508.799.4406
- Renee Greene
- Lawrence Gipe
- Carol Hepper

MICHIGAN

THE DETROIT INSTITUTE OF ARTS
313.833.7900
- Arman Retrospective

MINNESOTA

WALKER ART CENTER
612.375.7600
- Jenny Holzer: The Venice Installation
- Viewpoints: Jac Leirner
- Interrogating Identity
- Ann Hamilton/David Ireland

MISSOURI

LAUMEIER SCULPTURE PARK & MUSEUM
314.821.1209
- Day of the Dead
- Fire and Ice, 1991
- Los Dias de los Muertes
- Environmental Sculptures by Susan Crowder and Patrick Dougherty (Park)
- The Living Series
- Team Spirit

NELSON-ATKINS MUSEUM OF ART
816.561.4000
- David Salle
- Artists from

THE SAINT LOUIS ART MUSEUM
314.721.0072
- New Design in the Age of Industry
- Currents 49: Joe Deal
- Highlights from the Permanent Collection of Prints, Drawings and Photographs

NEBRASKA

JOSLYN ART MUSEUM
402.342.3300
- Arnulf Rainer: Drawing on Death
- Elizabeth Layton: Drawing on Life
- The Landscape in Twentieth-Century Art: Selections from the Metropolitan Museum
- From Expressionism to Resistance, Art in Germany, 1909-1936
- Jerry Uelsman: Images, 1984-1989
- Departures: Photography, 1923 - 1990
- I Dream a World: Portraits of Black Women Who Changed America

NEW HAMPSHIRE

CHAPEL ART CENTER
603.641.7470
- Vanishing Spain

NEW JERSEY

THE NEWARK MUSEUM
201.596.6550

THE NOYES MUSEUM
609.652.8848
- New Jersey Masters

JANE VOORHEES ZIMMERLI ART MUSEUM
908.932.7237
- L'Estampe Originale
- New Directions: 25th Anniversary Selections from the Zimmerli Art Museum

NEW MEXICO

THE ALBUQUERQUE MUSEUM OF ART, HISTORY, & SCIENCE
505.243.7255
- Arnold Ronnebeck Prints
- Photographs by Karsh
- Sculpture Garden
- Awards in the Visual Arts
- E.I. Couse Retrospective
- Santiago: Saint of Two Worlds
- Western Federation of Water Color
- Focus on Youth
- Frieda Kahlo: Photographs by Lola Alvarez Bravo
- Richard Ross: Museology

NEW YORK

ALBRIGHT-KNOX ART GALLERY
716.882.8700
- Postwar Britain and the Aesthetics of Plenty
- A Celebration of American Ideals: Paintings from the Brooklyn Museum
- Moshe Kupferman
- Santos: The Household Saints of Puerto Rico
- 44th Western N.Y. Exhibition

MUSEUM SCHEDULES

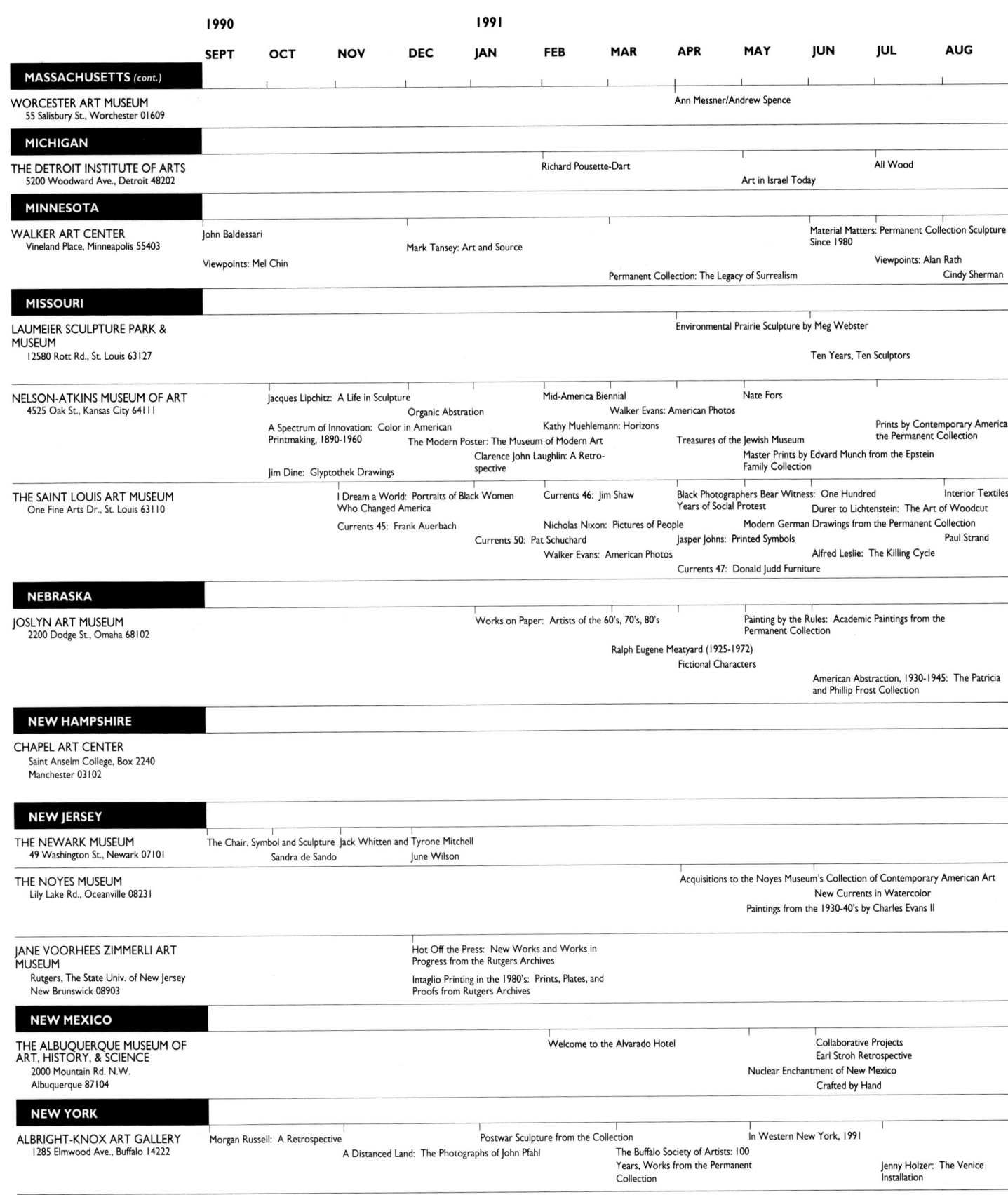

	1990				1991							
	SEPT	**OCT**	**NOV**	**DEC**	**JAN**	**FEB**	**MAR**	**APR**	**MAY**	**JUN**	**JUL**	**AUG**

MASSACHUSETTS (cont.)

WORCESTER ART MUSEUM
55 Salisbury St., Worchester 01609
- Ann Messner/Andrew Spence (May)

MICHIGAN

THE DETROIT INSTITUTE OF ARTS
5200 Woodward Ave., Detroit 48202
- Richard Pousette-Dart (Feb)
- Art in Israel Today (May)
- All Wood (Jul)

MINNESOTA

WALKER ART CENTER
Vineland Place, Minneapolis 55403
- John Baldessari (Sept)
- Viewpoints: Mel Chin (Sept)
- Mark Tansey: Art and Source (Dec)
- Permanent Collection: The Legacy of Surrealism (Mar)
- Material Matters: Permanent Collection Sculpture Since 1980 (Jun)
- Viewpoints: Alan Rath (Jul)
- Cindy Sherman (Aug)

MISSOURI

LAUMEIER SCULPTURE PARK & MUSEUM
12580 Rott Rd., St. Louis 63127
- Environmental Prairie Sculpture by Meg Webster (May)
- Ten Years, Ten Sculptors (May)

NELSON-ATKINS MUSEUM OF ART
4525 Oak St., Kansas City 64111
- Jacques Lipchitz: A Life in Sculpture (Oct)
- A Spectrum of Innovation: Color in American Printmaking, 1890-1960 (Oct)
- Jim Dine: Glyptothek Drawings (Oct)
- Organic Abstraction (Nov)
- The Modern Poster: The Museum of Modern Art (Dec)
- Clarence John Laughlin: A Retrospective (Jan)
- Mid-America Biennial (Feb)
- Kathy Muehlemann: Horizons (Feb)
- Walker Evans: American Photos (Mar)
- Treasures of the Jewish Museum (Apr)
- Nate Fors (May)
- Master Prints by Edvard Munch from the Epstein Family Collection (May)
- Prints by Contemporary American the Permanent Collection (Jul)

THE SAINT LOUIS ART MUSEUM
One Fine Arts Dr., St. Louis 63110
- I Dream a World: Portraits of Black Women Who Changed America (Nov)
- Currents 45: Frank Auerbach (Nov)
- Currents 50: Pat Schuchard (Jan)
- Currents 46: Jim Shaw (Feb)
- Nicholas Nixon: Pictures of People (Feb)
- Walker Evans: American Photos (Feb)
- Currents 47: Donald Judd Furniture (Apr)
- Black Photographers Bear Witness: One Hundred Years of Social Protest (Apr)
- Jasper Johns: Printed Symbols (Apr)
- Modern German Drawings from the Permanent Collection (May)
- Alfred Leslie: The Killing Cycle (May)
- Durer to Lichtenstein: The Art of Woodcut (Jun)
- Interior Textiles: (Aug)
- Paul Strand (Aug)

NEBRASKA

JOSLYN ART MUSEUM
2200 Dodge St., Omaha 68102
- Works on Paper: Artists of the 60's, 70's, 80's (Jan)
- Ralph Eugene Meatyard (1925-1972) (Mar)
- Fictional Characters (Mar)
- Painting by the Rules: Academic Paintings from the Permanent Collection (May)
- American Abstraction, 1930-1945: The Patricia and Phillip Frost Collection (Jun)

NEW HAMPSHIRE

CHAPEL ART CENTER
Saint Anselm College, Box 2240
Manchester 03102

NEW JERSEY

THE NEWARK MUSEUM
49 Washington St., Newark 07101
- The Chair, Symbol and Sculpture (Sept)
- Sandra de Sando (Oct)
- Jack Whitten and Tyrone Mitchell (Nov)
- June Wilson (Dec)

THE NOYES MUSEUM
Lily Lake Rd., Oceanville 08231
- Acquisitions to the Noyes Museum's Collection of Contemporary American Art (May)
- New Currents in Watercolor (Jun)
- Paintings from the 1930-40's by Charles Evans II (May)

JANE VOORHEES ZIMMERLI ART MUSEUM
Rutgers, The State Univ. of New Jersey
New Brunswick 08903
- Hot Off the Press: New Works and Works in Progress from the Rutgers Archives (Dec)
- Intaglio Printing in the 1980's: Prints, Plates, and Proofs from Rutgers Archives (Dec)

NEW MEXICO

THE ALBUQUERQUE MUSEUM OF ART, HISTORY, & SCIENCE
2000 Mountain Rd. N.W.
Albuquerque 87104
- Welcome to the Alvarado Hotel (Feb)
- Nuclear Enchantment of New Mexico (May)
- Crafted by Hand (May)
- Collaborative Projects (Jun)
- Earl Stroh Retrospective (Jun)

NEW YORK

ALBRIGHT-KNOX ART GALLERY
1285 Elmwood Ave., Buffalo 14222
- Morgan Russell: A Retrospective (Sept)
- A Distanced Land: The Photographs of John Pfahl (Nov)
- Postwar Sculpture from the Collection (Jan)
- The Buffalo Society of Artists: 100 Years, Works from the Permanent Collection (Mar)
- In Western New York, 1991 (Jun)
- Jenny Holzer: The Venice Installation (Jul)

1991 **1992**

SEPT	OCT	NOV	DEC	JAN	FEB	MAR	APR	MAY	JUN	JUL	AUG

ILLINOIS (cont.)

MUSEUM OF CONTEMPORARY ART
312.280.2660

- Romare Bearden: A Retrospective
- Rosemarie Trockel

TERRA MUSEUM OF AMERICAN ART
312.664.3939

- American Originals: Selections from Reynolda House, Museum of American Art
- Of Time and the City: American Modernish from the Sheldon Memorial Art Museum
- Abstract Sculpture in America: 1930-1970
- Santos: The Household Saints of Puerto Rico

INDIANA

INDIANAPOLIS MUSEUM OF ART
317.923.1331

- Power: Its Myths and Mores in American Culture, 1961-1991
- There's No There, There
- Jackie Ferrara Sculpture: A Retrospective
- The Collection of Herbert and Dorothy Vogel

IOWA

CEDAR RAPIDS MUSEUM OF ART
319.366.7503

- Frank Kinney
- John Snyder
- Ed Bruns
- Joe Messner
- Childe Hassam
- Marjorie Hayek
- Priscilla Steele
- James Landenberger
- Paul Manship
- Jim Dine
- Art of the 30's and 40's by the American Abstract Artists from the Guggenheim Museum

DES MOINES ART CENTER
515.277.4405

- Sympathy: Artists on Injustice
- The Abstract Tradition in American Art
- Oriental Prints
- Vivian Torrence: Chemistry Imagined
- Richard Fleischner: Recent Work
- Iowa Artists, 1991
- Print Exhibition

KANSAS

SPENCER MUSEUM OF ART
913.864.4710

- Pacific Parallels: Artist & the Landscape in New Zealand, 1840-1990
- Modern Japanese Prints

LOUISIANA

NEW ORLEANS MUSEUM OF ART
504.484.6662

- Master Prints by Gerald L. Brockhurst
- Ansel Adams: The American Wilderness

MAINE

BOWDOIN COLLEGE MUSEUM OF ART
207.725.3275

- Judy Glickman: Photographs of Holocaust Sites

PORTLAND MUSEUM OF ART
207.775.6148

- Berenice Abbott, Photographer: A Modern Vision

MARYLAND

THE BALTIMORE MUSEUM OF ART
301.396.7100

- Maryland Invitational, 1992
- Prints 1960-1990: Three Decades of Museum Selections from the Campbell Collection
- Accessions
- Baltimore Contemporary Print Fair, 1992
- Anne Truitt
- Design ,1935-1965: What Modern Was, The Liliane and David M. Stewart Collection
- American Drawings and Watercolors

MASSACHUSETTS

HARVARD UNIV. ART MUSEUMS
617.495.9400

- Mixing the Medium: Beyond Silver Photographs
- Contemporary German Art

THE INSTITUTE OF CONTEMPORARY ART
617.266.5152

- Bleeding Heart
- The Social and Political Meaning of Montage

WILLIAMS COLLEGE MUSEUM OF ART
413.597.2429

- and Other Issues in Conservation
- Art Since 1945
- The Wall
- Artworks: Marcy Hermansader, Abilities and Disabilities

	1990				1991							
	SEPT	OCT	NOV	DEC	JAN	FEB	MAR	APR	MAY	JUN	JUL	AUG

ILLINOIS (cont.)

MUSEUM OF CONTEMPORARY ART, 237 E. Ontario St., Chicago 60611
- A Primal Spirit: Ten Contemporary Japanese Sculptors (OCT–)
- Cuba-USA: The First Generation (JAN–)
- Options 41: Julia Wachtel (MAR–)
- Options 40: Cheri Samba (JAN)
- Jean-Pierre Raynaud (APR)
- Option 42: Daniel Senise (MAY)
- Sigmar Polke (JUN)

TERRA MUSEUM OF AMERICAN ART, 666 N. Michigan Ave., Chicago 60611
- Winslow Homer in Gloucester (OCT–)
- Gertrude Stein: The American Connection (JAN–)
- African-American Artists, 1880-1987: Selections from the Evans-Tibbs Collection (APR–)
- John La Farge: Watercolors and Drawings (JUN–)
- An American Collection: Painting and Sculpture from the American Academy of Design (MAY–)

INDIANA

INDIANAPOLIS MUSEUM OF ART, 1200 W. 38th St., Bloomington 46208
- Richard Pousette-Dart: A Retrospective (OCT–)
- The Dark Ages (MAR)

IOWA

CEDAR RAPIDS MUSEUM OF ART, 410 Third Ave. S.E., Cedar Rapids 52401
- Byron Burford: The Prints (JAN–)
- David Klamen (JAN–)
- Richard Pinney (MAR)
- Webster Gelman - Re: Genesis (FEB)
- Charles Barth (APR)
- Gods, Prophets and Heroes: Donald Delue (APR)
- Fiber Artists (MAY)
- Karen Hoyt (JUN)
- Jack Hines (JUN)
- William Shepard: Events About a Rectangle (JUL–)
- Dr. William Kettlekamp (AUG)

DES MOINES ART CENTER, 4700 Grand Ave., Des Moines 50312
- Emilio Ambasz: Architecture, Exhibition, Industrial and Graphic Design (APR–)
- Selected Print Acquisitions from the Past Ten Years (APR–)
- I Dream a World: Portraits of Black Women Who Changed America (JUN–)
- Lewis Baltz (JUL)
- Outrage and (AUG)

KANSAS

SPENCER MUSEUM OF ART, Univ. of Kansas, Lawrence 66045
- Aaron Siskind: New Expressions, 1947-1984 (APR–)
- Modern Chinese Paintings (MAY–)

LOUISIANA

NEW ORLEANS MUSEUM OF ART, P.O. Box 19123, One Lelong Ave. New Orleans 70179
- Julio Sequeira: Images of Eden (SEPT–)
- Louisiana Artists Put Their Stamp on NOMA (NOV)
- Two from Baton Rouge: Randell Henry and Emerson Bell (JAN)
- Master Silver by Paul Storr and his Contemporaries and Followers (DEC–)
- Figure/Ground: Louisiana Photography Today (MAR–)
- Altered Truths: Contemporary Photographs from the Michael Myers/Russell Albright Collection (FEB)
- Evelyn Witherspoon: Ceramics and Watercolors (APR)

MAINE

BOWDOIN COLLEGE MUSEUM OF ART, Walker Art Building, Brunswick 04011
- Paul Caponigro: Photographs (SEPT)
- Puzzling Prints (NOV–)
- From Durer to Picasso: Five Centuries of Master Prints from a Private Collection (OCT–)
- Katherine Porter: Paintings/Drawings (MAY)
- Selections from the Vinalhaven Press Collections (SEPT)
- Leonard Baskin: Prints, Drawings, and Sculpture (JUN)
- Modern Art: Selections (NOV)
- The Hand-Held Camera (JAN)
- The View Camera (JUN)
- Twentieth-Century Art from the Collections (SEPT)
- Recent Acquisitions in Photography 1987-1991 (JAN)

PORTLAND MUSEUM OF ART, Seven Congress Sq., Portland 04101
- Charles Martin: New Yorker Artist (OCT)
- N.C. Wyeth's Wild West (DEC)
- Perspectives: Celebrating Contemporary Art (NOV)
- Reflections of the Built Environment: Architectural Imagery (MAR–)
- Perspectives: Paul Heroux (APR)
- Perspectives: Elena Jahn (JUL)
- Works by Modern American and European Masters (MAR)
- Vincent Canade (MAR)
- Richard Estes: Urban Landscapes (JUN)
- Of Time and Place: Walker Evans and William Christenberry (MAR)

MARYLAND

THE BALTIMORE MUSEUM OF ART, Art Museum Dr., Baltimore 21218
- Drawings by Sculptors (SEPT)
- Joel Shapiro (SEPT)
- Warm Remembrances: The Fabric of Childhood (FEB–)
- Mirror, Mirror: What is a Portrait? (APR)
- Martin Luther King and the Civil Rights Movement (AUG)
- Peter Goin: The Land as Witness (FEB)

MASSACHUSETTS

HARVARD UNIV. ART MUSEUMS, 32 Quincy St., Cambridge 02138

THE INSTITUTE OF CONTEMPORARY ART, 955 Boylston St., Boston 02115
- Robert Mapplethorpe: The Perfect Moment (OCT)
- Gerhard Richter: 18 Oktober 1977 (JAN)
- Rosemarie Trockel (APR–)
- William Wegman (AUG)
- Between Spring and Summer: Soviet Conceptual Art in the Era of Late Communism (NOV)
- Boston Now 10 (JUN)

WILLIAMS COLLEGE MUSEUM OF ART, Main St., Williamstown 01267
- Artworks: Michael Singer (SEPT)
- Eye For I: Video Self-Portraits (OCT)
- Artworks: Christy Rupp (FEB)
- Fugitive Colors (AUG)
- Experimental Photography: The Painter-Photographer (SEPT)
- James Turrell (FEB)
- Durer to Matisse: Prints from the Collection of Elizabeth and David Tunick (MAY–)
- Surrealism and its Affinities (NOV)
- Selections from the Collection of Bennington College (JUL)
- Highlights of American Art: Selections from the Permanent Collection (MAR–)
- Companions in Art: William and Marguerite Zorach (JUL)

MUSEUM SCHEDULES

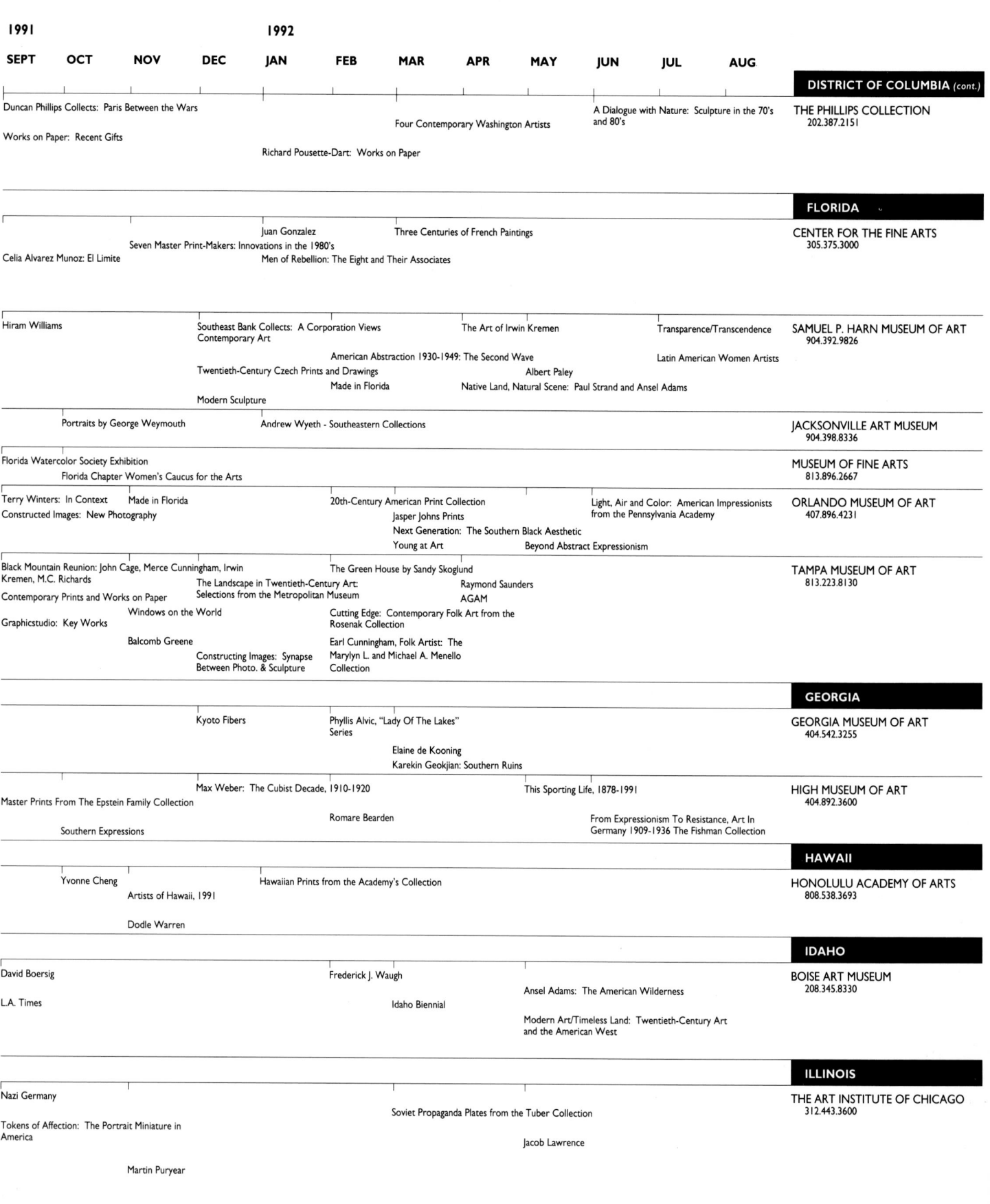

1991 **1992**

SEPT OCT NOV DEC JAN FEB MAR APR MAY JUN JUL AUG

DISTRICT OF COLUMBIA (cont.)

THE PHILLIPS COLLECTION
202.387.2151

Duncan Phillips Collects: Paris Between the Wars
Four Contemporary Washington Artists
A Dialogue with Nature: Sculpture in the 70's and 80's
Works on Paper: Recent Gifts
Richard Pousette-Dart: Works on Paper

FLORIDA

CENTER FOR THE FINE ARTS
305.375.3000

Juan Gonzalez
Three Centuries of French Paintings
Seven Master Print-Makers: Innovations in the 1980's
Celia Alvarez Munoz: El Limite
Men of Rebellion: The Eight and Their Associates

SAMUEL P. HARN MUSEUM OF ART
904.392.9826

Hiram Williams
Southeast Bank Collects: A Corporation Views Contemporary Art
The Art of Irwin Kremen
Transparence/Transcendence
American Abstraction 1930-1949: The Second Wave
Latin American Women Artists
Twentieth-Century Czech Prints and Drawings
Albert Paley
Made in Florida
Native Land, Natural Scene: Paul Strand and Ansel Adams
Modern Sculpture

JACKSONVILLE ART MUSEUM
904.398.8336

Portraits by George Weymouth
Andrew Wyeth - Southeastern Collections

MUSEUM OF FINE ARTS
813.896.2667

Florida Watercolor Society Exhibition
Florida Chapter Women's Caucus for the Arts

ORLANDO MUSEUM OF ART
407.896.4231

Terry Winters: In Context Made in Florida
20th-Century American Print Collection
Light, Air and Color: American Impressionists from the Pennsylvania Academy
Constructed Images: New Photography
Jasper Johns Prints
Next Generation: The Southern Black Aesthetic
Young at Art
Beyond Abstract Expressionism

TAMPA MUSEUM OF ART
813.223.8130

Black Mountain Reunion: John Cage, Merce Cunningham, Irwin Kremen, M.C. Richards
The Green House by Sandy Skoglund
The Landscape in Twentieth-Century Art: Selections from the Metropolitan Museum
Raymond Saunders
Contemporary Prints and Works on Paper
AGAM
Windows on the World
Cutting Edge: Contemporary Folk Art from the Rosenak Collection
Graphicstudio: Key Works
Balcomb Greene
Earl Cunningham, Folk Artist: The Marylyn L. and Michael A. Menello Collection
Constructing Images: Synapse Between Photo. & Sculpture

GEORGIA

GEORGIA MUSEUM OF ART
404.542.3255

Kyoto Fibers
Phyllis Alvic, "Lady Of The Lakes" Series
Elaine de Kooning
Karekin Geokjian: Southern Ruins

HIGH MUSEUM OF ART
404.892.3600

Max Weber: The Cubist Decade, 1910-1920
This Sporting Life, 1878-1991
Master Prints From The Epstein Family Collection
Romare Bearden
From Expressionism To Resistance, Art In Germany 1909-1936 The Fishman Collection
Southern Expressions

HAWAII

HONOLULU ACADEMY OF ARTS
808.538.3693

Yvonne Cheng
Hawaiian Prints from the Academy's Collection
Artists of Hawaii, 1991
Dodle Warren

IDAHO

BOISE ART MUSEUM
208.345.8330

David Boersig
Frederick J. Waugh
Ansel Adams: The American Wilderness
L.A. Times
Idaho Biennial
Modern Art/Timeless Land: Twentieth-Century Art and the American West

ILLINOIS

THE ART INSTITUTE OF CHICAGO
312.443.3600

Nazi Germany
Soviet Propaganda Plates from the Tuber Collection
Tokens of Affection: The Portrait Miniature in America
Jacob Lawrence
Martin Puryear

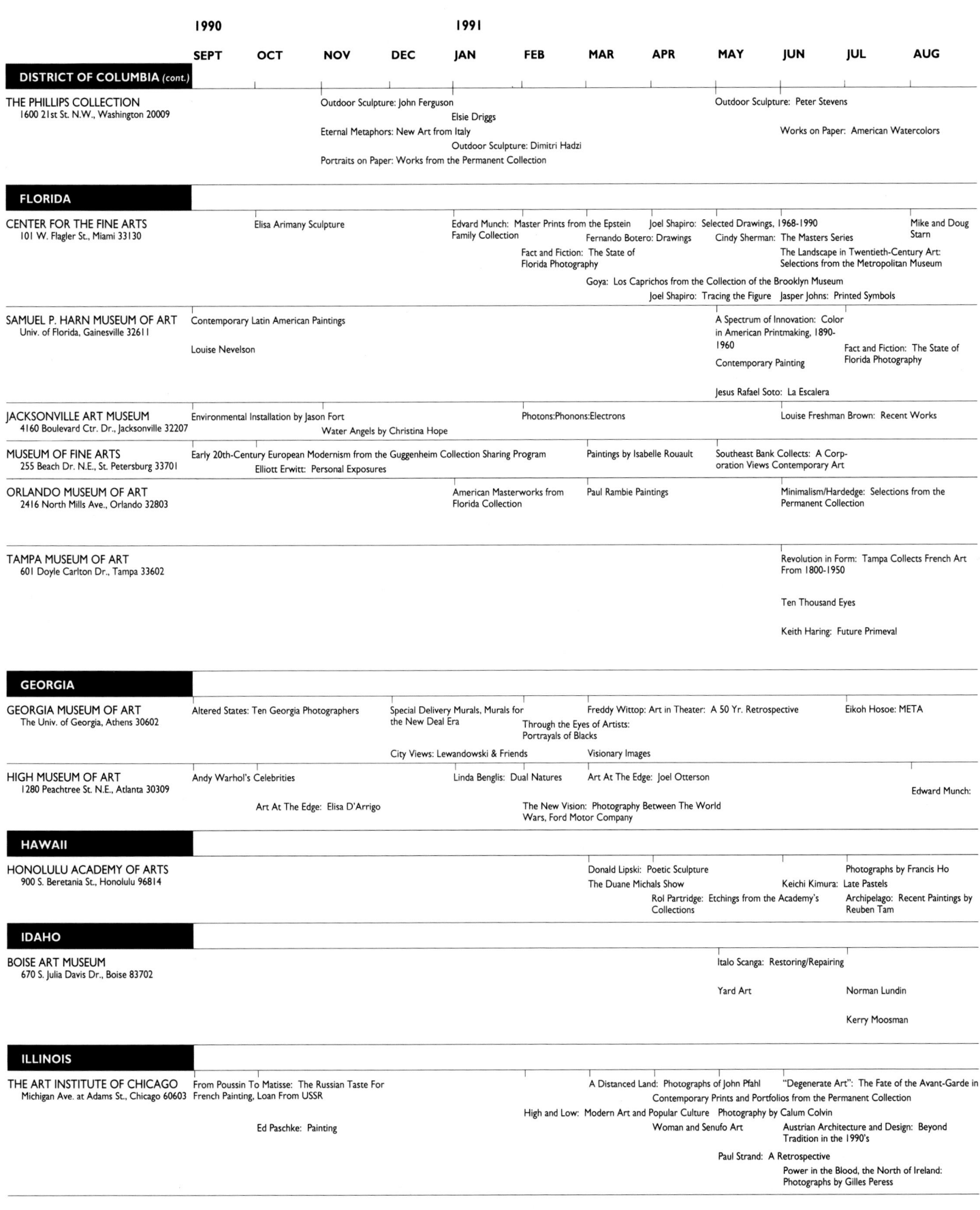

	1990				1991							
	SEPT	OCT	NOV	DEC	JAN	FEB	MAR	APR	MAY	JUN	JUL	AUG

DISTRICT OF COLUMBIA (cont.)

THE PHILLIPS COLLECTION
1600 21st St. N.W., Washington 20009
- Outdoor Sculpture: John Ferguson
- Elsie Driggs
- Eternal Metaphors: New Art from Italy
- Outdoor Sculpture: Dimitri Hadzi
- Portraits on Paper: Works from the Permanent Collection
- Outdoor Sculpture: Peter Stevens
- Works on Paper: American Watercolors

FLORIDA

CENTER FOR THE FINE ARTS
101 W. Flagler St., Miami 33130
- Elisa Arimany Sculpture
- Edvard Munch: Master Prints from the Epstein Family Collection
- Fact and Fiction: The State of Florida Photography
- Joel Shapiro: Selected Drawings, 1968-1990
- Fernando Botero: Drawings
- Cindy Sherman: The Masters Series
- The Landscape in Twentieth-Century Art: Selections from the Metropolitan Museum
- Goya: Los Caprichos from the Collection of the Brooklyn Museum
- Joel Shapiro: Tracing the Figure
- Jasper Johns: Printed Symbols
- Mike and Doug Starn

SAMUEL P. HARN MUSEUM OF ART
Univ. of Florida, Gainesville 32611
- Contemporary Latin American Paintings
- Louise Nevelson
- A Spectrum of Innovation: Color in American Printmaking, 1890-1960
- Contemporary Painting
- Jesus Rafael Soto: La Escalera
- Fact and Fiction: The State of Florida Photography

JACKSONVILLE ART MUSEUM
4160 Boulevard Ctr. Dr., Jacksonville 32207
- Environmental Installation by Jason Fort
- Water Angels by Christina Hope
- Photons:Phonons:Electrons
- Louise Freshman Brown: Recent Works

MUSEUM OF FINE ARTS
255 Beach Dr. N.E., St. Petersburg 33701
- Early 20th-Century European Modernism from the Guggenheim Collection Sharing Program
- Elliott Erwitt: Personal Exposures
- Paintings by Isabelle Rouault
- Southeast Bank Collects: A Corporation Views Contemporary Art

ORLANDO MUSEUM OF ART
2416 North Mills Ave., Orlando 32803
- American Masterworks from Florida Collection
- Paul Rambie Paintings
- Minimalism/Hardedge: Selections from the Permanent Collection

TAMPA MUSEUM OF ART
601 Doyle Carlton Dr., Tampa 33602
- Revolution in Form: Tampa Collects French Art From 1800-1950
- Ten Thousand Eyes
- Keith Haring: Future Primeval

GEORGIA

GEORGIA MUSEUM OF ART
The Univ. of Georgia, Athens 30602
- Altered States: Ten Georgia Photographers
- Special Delivery Murals, Murals for the New Deal Era
- Through the Eyes of Artists: Portrayals of Blacks
- Freddy Wittop: Art in Theater: A 50 Yr. Retrospective
- City Views: Lewandowski & Friends
- Visionary Images
- Eikoh Hosoe: META

HIGH MUSEUM OF ART
1280 Peachtree St. N.E., Atlanta 30309
- Andy Warhol's Celebrities
- Art At The Edge: Elisa D'Arrigo
- Linda Benglis: Dual Natures
- The New Vision: Photography Between The World Wars, Ford Motor Company
- Art At The Edge: Joel Otterson
- Edward Munch:

HAWAII

HONOLULU ACADEMY OF ARTS
900 S. Beretania St., Honolulu 96814
- Donald Lipski: Poetic Sculpture
- The Duane Michals Show
- Rol Partridge: Etchings from the Academy's Collections
- Keichi Kimura: Late Pastels
- Photographs by Francis Ho
- Archipelago: Recent Paintings by Reuben Tam

IDAHO

BOISE ART MUSEUM
670 S. Julia Davis Dr., Boise 83702
- Italo Scanga: Restoring/Repairing
- Yard Art
- Norman Lundin
- Kerry Moosman

ILLINOIS

THE ART INSTITUTE OF CHICAGO
Michigan Ave. at Adams St., Chicago 60603
- From Poussin To Matisse: The Russian Taste For French Painting, Loan From USSR
- Ed Paschke: Painting
- A Distanced Land: Photographs of John Pfahl
- High and Low: Modern Art and Popular Culture
- Woman and Senufo Art
- Paul Strand: A Retrospective
- "Degenerate Art": The Fate of the Avant-Garde in
- Contemporary Prints and Portfolios from the Permanent Collection
- Photography by Calum Colvin
- Austrian Architecture and Design: Beyond Tradition in the 1990's
- Power in the Blood, the North of Ireland: Photographs by Gilles Peress

1991				1992							
SEPT	OCT	NOV	DEC	JAN	FEB	MAR	APR	MAY	JUN	JUL	AUG

ALABAMA

BIRMINGHAM MUSEUM OF ART
205.254.2566

Photography Portfolios

Mass: A Collaborative Video Installation by Mary Lucier and Elizabeth Streb

Leave the Balcony Open: Contemporary Photographs from Spain

ARIZONA

PHOENIX ART MUSEUM
602.257.1880

ARKANSAS

THE ARKANSAS ARTS CENTER
501.372.4000

Popular and Preferred Imagery in American Photo.

Will Barnet Drawings, 1930-1990

The Drawings of Alex Katz, 1946-1989

Nancy Grossman Drawings

Louis Freund: Paintings

I Dream a World: Portraits of Black Women Who Changed America

Art by Arkansas Women

Oliphant's Presidents: 25 Years of Caricature by Pat Oliphant

CALIFORNIA

CROCKER ART MUSEUM
916.449.5423

The Trans Parent Thread: Asian Philosophy in Recent American Art

Photostroika: New Soviet Photography

67th Annual Crocker-Kingsley Exhibition

A Tribute Exhibition

THE MUSEUM OF CONTEMPORARY ART
213.626.6222

Ad Reinhardt

American Photography the Permanent Collection: 1975-90

Alexis Smith

Terry Winters

NEWPORT HARBOR ART MUSEUM
714.759.1122

Third Newport Biennial: Mapping Histories

Jackie Winsor

Devil on the Stairs: Looking Back on the Eighties

New California Artists XX

SAN DIEGO MUSEUM OF CONTEMPORARY ART
619.454.3541

Noboru Tsubaki

Border Art

Anish Kapoor

SAN FRANCISCO MUSEUM OF MODERN ART
415.252.4000

New Work: Robert Bechtle

Tom Arndt and Jeff Jacobsen

Passage of the Image

Typologies: Nine Contemporary Photographers

Lee Friedlander: Nudes

Robert Wilson's Vision

Calum Colvin

Robert Rauschenberg: Abstract Art and Imagist Prefigurations from the Early 50's

Ralph Eugene Meatyard: An American Visionary

Stuart Davis

The Psychoanalytic Drawings of Jackson Pollock

Helen Levitt: A Retrospective Exhibition

New California Art

In the Spirit of Modernism

UNIVERSITY ART MUSEUM
Univ. of California, Berkeley
415.642.1207

Howard Hodgkins

Africa Explores: New and Renewed Forms in 20th-Century African Art

Andrea Fraser

Edgar Heap-of-Birds

Bay Area Conceptual Art

Debra Bloomfield

The Here and the Hereafter: Images of Paradise in Islamic Art

UNIVERSITY ART MUSEUM
California State Univ.
213.985.5761

and Drawing of the Seventies and Eighties

Centric 45: Eugenia Vargas Daniels

DISTRICT OF COLUMBIA

THE CORCORAN GALLERY OF ART
202.638.3211

Songs of My People

The Director's Choice: Sport in Art from America's Great Art Museums

The 42nd Biennial Exhibition of Contemporary American Painting

HIRSHHORN MUSEUM AND SCULPTURE GARDEN
202.357.3091

Recent Acquisitions: 1989-1991

Martin Puryear

Four Latin American Pioneers of Modernism: Diego Rivera, Joaquin Torres-Garcia, Wifredo Lam, Matta

Alfredo Jaar Works

Tim Rollins + K.O.S.: Animal Farm

Saint Clair Cemin

	1990 SEPT	OCT	NOV	DEC	1991 JAN	FEB	MAR	APR	MAY	JUN	JUL	AUG
ALABAMA												
BIRMINGHAM MUSEUM OF ART 2000 8th Ave. N., Birmingham 35203								Camera Portraits, 1839-1989: Photographs from the National Portrait Gallery	In Our Time: The World as Seen by Magnum Photographers		Boxed Assortment: Prints and	
ARIZONA												
PHOENIX ART MUSEUM 1625 N. Central Ave., Phoenix 85004	The 1990 Phoenix Triennial					Annie Leibovitz: 1970-1990	Keith Haring, Andy Warhol and Walt Disney		Nuclear Landscapes: Peter Goin Photography			
ARKANSAS												
THE ARKANSAS ARTS CENTER P.O. Box 2137, MacArthur Park, Little Rock 72203							The Quest for Self-Expression: Painting in Moscow and Leningrad, 1965-1990	Pattern	Morris Graves: Vessels of Transformation			
CALIFORNIA												
CROCKER ART MUSEUM 216 O St., Sacramento 95814		Diego Rivera Drawings: Mexico and California; Folk Treasures from Mexico: Highlights of the Nelson A. Rockefeller Collection; Ofrendas; Rural Traditions: El Dia de los Muertos	Of Time and the City: American Modernism from the Sheldon Memorial Art Gallery				The Road to Heaven Is Paved By Good Works: The Art of Reverend Howard Finster	66th Annual Crocker-Kingsley Exhibition	Artful Deception: The Craft of the Forger			
THE MUSEUM OF CONTEMPORARY ART MOCA at Cal. Plaza, 250 S. Grand Ave. Los Angeles 90012 / MOCA at the Temporary Contemporary N. Central Ave., Los Angeles 90013										High and Low: Modern Art and Popular Culture; A Dialogue About European and; Selections from		
NEWPORT HARBOR ART MUSEUM 850 San Clemente, Newport Beach 92660		Tony Cragg: Sculpture, 1975-1990				Edward Hopper: Selections from the Permanent Collection of the Whitney Museum; Robert Millar: New California Artist XVIII		Kim Yasuda: New California Artists XIX	Typologies: Nine Contemporary Photographers		Different Stories: Five Views of the Collection	
SAN DIEGO MUSEUM OF CONTEMPORARY ART 700 Prospect St., La Jolla 92037						Billboard Project; Celia Alvarez Munoz: El Limite; Allan Wexler: Table/Building/Landscape; Ruby Wilkinson; Timken Exchange: Portraits				On the Road: Selections from the Permanent Collection of the San Diego Museum of Contemporary Art; The Artist's Hand; Desert Work: Walter Cotten & Stephen Depinto; Timken Exchange: Landscape	David Hammons	Mowry Baden
SAN FRANCISCO MUSEUM OF MODERN ART 401 Van Ness Ave., San Francisco 94102	Paul Klee: The Bauhaus Years, 1921-1931; New Work: Dawn Fryling; 1990 SECA Art Award	An Uncertain Grace: The Photographs of Sebastiao Salgado	Sigmar Polke	Florence Henri: Avant-Garde	Artist-Photographer of the; New Work: Sherrie Levine	Sid Grossman/Leon Levinstein: New York Street Photographers; Linda Connor; Josef Koudelka; Toward a New Museum: Recent Acquisitions in Painting and Sculpture, 1985-1991	The Projected Image	Lisette Model	Paul Klee: Signs and Symbols; Francesco Clemente: Three Worlds; New Work: Susana Solano; Ronald Bladen: Early and Late	New Work: Martin Kippenberger; Geological Architecture: The Work of Stanley Saitowitz; The Duane Michals Show; Chicano Art: Resistance and Affirmation, 1965-1985		
UNIVERSITY ART MUSEUM Univ. of California, Berkeley 2625 Durant Ave., Berkeley 94720						Kiki Smith; The Independent Group: Postwar Britain and the Aesthetics of Plenty		Zoe Leonard; Lewis deSoto		Philip Galgiani; Rosemarie Trockel	Ernst Caramelle/Tim Maul	
UNIVERSITY ART MUSEUM California State Univ. 1250 Bellflower, Long Beach 90840											Pluralism: Prints	
DISTRICT OF COLUMBIA												
THE CORCORAN GALLERY OF ART 17th St. and New York Ave. N.W. Washington 20006	James Drake: Place and Passage				Inability to Endure Or Deny the World: Representation and Text in the Work of Robert Morris; Transgressions: Donald Lipski and Buzz Spector; The Democratic Forest: Photography by William Eggleston	Tony Cragg: Sculpture, 1975-1990; Thomas Kovachevich: Seeing Invisible Things			Changing Reality: Recent Soviet Photography; Bernice Abbott, Photographer; William T. Wiley: Struck! Sure? Sound/Unsound	Robert Rauschenberg: Abstract Art and Imagist Prefigurations of the Early 1950's		
HIRSHHORN MUSEUM AND SCULPTURE GARDEN Independence Ave. at Seventh St. S.W. Washington 20560									Picasso Linocuts from the Museum's Collection; Awards in the Visual Arts 10	Adrian Piper: What It's Like, What It Is #2		

MUSEUM SCHEDULES

MUSEUM LISTINGS

CANADA

BRITISH COLUMBIA

CONTEMPORARY ART GALLERY 604.681.2700
555 Hamilton St., Vancouver V6B 2R1 FAX: 604.683.2710
Hours: Tues-Sat 11-5

Collection Highlights: Works by artists from Vancouver, Canada and other countries, in various media. **Publications:** Exhibition programs are accompanied by a publications program. **Administration:** Barbara Cole, Pres.; Linda Milrod, Dir. **Curatorial Staff:** Keith Wallace.

VANCOUVER ART GALLERY 604.682.4668
750 Hornby St., Vancouver V6Z 2H7 FAX: 604.682.1086
Hours: Mon, Wed, Fri, Sat 10-5; Thurs 10-9; Sun 12-5

Collection Highlights: International paintings and graphics with an emphasis on artists from British Columbia; Emily Carr video, sculpture, photography. **Administration:** Colin Dobell, Pres.; Willard Holmes, Dir.; Helle Viirlaid, Registrar. **Curatorial Staff:** Gary Dufour, Sr. Cur., Contemp. Art; Denise Oleksijczuk, Asst. Cur., Contemp. Art; Ian Thom, Sr. Cur., Historical; Joan Richardson, Asst. Cur., Historical. **Conservatorial Staff:** Diane Falvey, Beth Wolchok.

MANITOBA

WINNIPEG ART GALLERY 204.786.6641
300 Memorial Blvd., Winnipeg R3C 1V1 FAX: 204.788.4998
Hours: Tues, Fri, Sat, Sun 11-5; Wed & Thurs 11-9

Collection Highlights: Focus on works by major and developing Canadian artists. **Administration:** Carol Phillips, Dir.; Karen Kisiow, Registrar. **Curatorial Staff:** Jon Tupper, Cur. Mgr.; Shirley Madill, Contemp. Art & Photography; Darlene Wight, Assoc. Cur., Inuit; Kathleen Campbell, Assoc. Cur., Decorative; Gary Essar, Assoc. Cur., Historical; Robert McKaskill, Academic. **Conservatorial Staff:** Katherine Collins, Cynthia Ball.

ONTARIO

ART GALLERY OF WINDSOR 519.258.7111
445 Riverside Dr. West, Windsor N9A 6T8 FAX: 519.256.8071

Collection Highlights: Centered on the collection and discussion of Canadian art. **Administration:** Dennis J. Staudt, Pres.; Alf Bogusky, Dir.; Betty Wilkinson, Registrar. **Curatorial Staff:** Vincent J. Varga, Sr. Cur.; Catharine Mastin, Canadian Historical Art.

ART GALLERY ST. THOMAS ELGIN 519.631.4040
301 Talbot St., P.O. Box 224, St. Thomas N5P 3T9 FAX: 519.633.1371
Hours: Tues-Sat 10-5; Sun 12-5; Closed Mon

Collection Highlights: Works of all media by Canadian artists with a special focus on Southern Ontario, Elgin County and St. Thomas. Highlights include works by Clark McDougall, Ed Zelenak, Walter Redinger, Ron Kingswood, and Gerald Pedros. **Publications:** Catalogues published with exhibitions. **Administration:** Eleanor Ryder, Pres.; Ian D. Ross, Dir. **Curatorial Staff:** Patricia A. Moore, Public Program Officer.

THE JUSTINA M. BARNICKE GALLERY, HART HOUSE 416.978.8398
University of Toronto, Toronto M5S 1A1 FAX: 416.978.8387
Hours: Mon & Fri 11-6; Tues-Thurs 11-8; Sat-Sun 1-4

Collection Highlights: Canadian art from 1921 to present. **Administration:** Judith R. Schwartz, Dir.; Rae Moriyama, Registrar. **Curatorial Staff:** Judith Schwartz; Anna Hudson. **Conservatorial Staff:** June Bramall.

LAURENTIAN UNIVERSITY MUSEUM & ART CENTRE 705.675.1151
Laurentian University, 251 John St., Sudbury P3E 2C6 FAX: 705.674.3065
Hours: Gallery Hours: Tues-Sun 12-5; Office Hours: Mon-Fri 8:30-4:30

Collection Highlights: Canadian art with a concentration on Inuit & Native art; works by Carl Beam, Frederick Hagan, and Bert Weir. **Archival Description:** Institutional archives only. **Publications:** Exhibition publications. **Administration:** Ward Skinner, Chrmn. of the Board; Pamela Krueger, Dir.

MCMASTER UNIVERSITY ART GALLERY 416.525.9140
Togo Salmon Hall, 114 FAX: 416.577.6930
1280 Main St. W., Hamilton L8S 4M2
Hours: Mon-Fri 10-5; Tues 7-9; Sun 1-5; Summer Mon-Fri 12-5

Collection Highlights: 20th-century German prints (Expressionist), Canadian Inuit sculpture and prints, contemporary Canadian prints and paintings. **Archival Description:** Library of exhibition catalogues. **Publications:** "The Art Collection of McMaster University"; "Supplement To The Art Collection of McMaster University". **Administration:** Dr. W. Whiller, Chrmn. of the Board; Kim G. Ness, Dir.; Gerrie Loveys, Registrar. **Curatorial Staff:** Kim G. Ness. **Conservatorial Staff:** Jennifer Petteplace.

NATIONAL GALLERY OF CANADA 613.990.1985
380 Sussex Dr., Room 515, Ottawa K1N 9N4 FAX: 613.993.4385
Hours: Summer: Sat-Tues 10-6; Wed-Fri 10-8; Winter: Tues-Sun 10-5; Thurs 10-8

Collection Highlights: Collection emphasizes Canadian Art. In addition to painting and sculpture, the contemporary collection includes films, sound recordings, videos, multi-media installations, and a wide variety of works on paper. **Administration:** Jean Monty, Chrmn. of the Board; Shirley L. Thomson, Dir.; Delphine Bishop, Registrar. **Curatorial Staff:** Brydon Smith, Asst. Dir., Collections & Research; Charles Hill, Canadian Art; Diana Nemiroff, Canadian Contemp. Art; Catherine Johnston, European & American Art; J.W. Borcoman, Photographs; Mimi Cazort, Prints & Drawings.

PROVINCE OF QUEBEC

CONCORDIA ART GALLERY 514.848.4750
1455 ouest, boul. de Maisonneuve, Montreal H3G 1M8 FAX: 514.848.3494
Hours: Mon-Fri 10-8; Sat 10-5

Collection Highlights: Historical and contemporary Canadian paintings, drawings, sculpture, prints and photography. **Publications:** Exhibition catalogues. **Curatorial Staff:** Sandra Paikowsky, Canadian Art; Lois Valliant, Cur. Asst., Canadian Art.

MCCORD MUSEUM OF CANADIAN HISTORY 514.398.7100
690 Sherbrooke St. West, Montreal H4C 1B1
Hours: Reopening In May, 1992. Tues-Fri 10-6; Thurs until 9; Sat & Sun 10-5

Collection Highlights: Paintings, prints and drawings; costume and textiles; decorative arts. **Archival Description:** Papers of leaders of New France and Canada; 200 years of McCord family papers serve as a record of the collection as well as the life and times of Montreal. **Administration:** David M. Lank, Chrmn. of the Board; Luke Rombout, Dir.; Conrad Graham, Registrar. **Curatorial Staff:** France Gascon, Chief Cur.; Jacqueline Beaudoin Ross, Costume and Textiles. **Conservatorial Staff:** Eva Burnham, Bruno Pouliot.

THE MONTREAL MUSEUM OF FINE ARTS 514.285.1600
1379 Sherbrooke St. West, Montreal H3G 1K3 FAX: 514.844.6042
Hours: Tues-Sun 10-5

Collection Highlights: Canadian, American and European works by such artists as Rebecca Horn, Gerhard Richter, Barry Flan Aman, Mark Tansey, Apul-Emile Borduas, and Jean-Paul Riopelle. **Administration:** Bernard Lamarre, Pres.; Pierre Théberge, Dir. **Curatorial Staff:** John R. Porter, Chief Cur.; Yolande Racine, Contemp. Art.

MUSÉE D'ART CONTEMPORAIN DE MONTREAL 514.873.2878
Cité du Hâvre, Montreal H3C 3R4 FAX: 514.873.2047
Hours: Tues 10-6

Collection Highlights: 3,200 works by Quebec, Canadian and international artists; the principal movements in contemporary art represented by works dating from 1939 to present. **Archival Description:** 25,000 monographs and exhibition catalogues, over 300 periodical titles, 38,000 slides, and 9,000 documentary files. **Administration:** Mariettre Clermont, Pres.; Marcel Brisebois, Dir.; Gilles Bonin, Registrar. **Curatorial Staff:** Manon Blanchette, Chief Cur.; Paulette Gagnon, Acting Chief Cur.; Josee Belisle; Gilles Godmer; Pierre Landry; Real Lussier; Sandra Grant Marchand. **Conservatorial Staff:** Danielle Allard.

MEXICO

MEXICO D.F.

CENTRO CULTURAL/ARTE CONTEMPORANEO 52.5.203.5820
Campos Eliseos & Jorge Eliot, Col. Polanco 11560 FAX: 52.5.203.5947
Hours: Daily 10-6

Collection Highlights: Works by Anselm Kiefer, Jasper Johns, James Rosenquist, Rebecca Horn, Roy Lichtenstein, James Turrell, Sergio Hernandez, German Venegas, Rocio Maldonado. **Archival Description:** The photographic collection of the museum. **Administration:** Paula Cussi de Azcarraga, Pres.; Robert R. Littman, Dir.; Maria Eugenia Kocherga, Registrar. **Curatorial Staff:** Ana Zagury, Chief Cur.; Magda Carranza; Lilia Weber, Asst. Cur. **Conservatorial Staff:** Manuel Gutierrez; Java Feria; Elizabeth Alkon.

MUSEO DE ARTE MODERNO 52.5.553.6313
Paseo de la Reforma y Gandhi FAX: 52.5.553.621
Col. San Miguel Chapultepec 11850
Hours: Daily 10-6

Administration: Dra. Teresa del Conde, Dir.

MUSEO RUFINO TAMAYO 52.5.286.6529
Paseo de la Reforma y Gandhi FAX: 52.5.286.6539
Col. Bosque de Chapultepec 11850
Hours: Tues-Sun 10-6

Administration: Cristina Calbez Cuzzy, Dir.

CARNEGIE MUSEUM OF ART 412.622.1975
 4400 Forbes Ave., Pittsburgh 15213
 Hours: Tues-Sat 10-5; Fri until 9; Sun 1-5

Administration: Phillip M. Johnston, Dir.

INSTITUTE OF CONTEMPORARY ART 215.898.7108
 University of Pennsylvania FAX: 215.898.5050
 36th & Sansom St., Philadelphia 19104
 Hours: Tues-Sun 10-5; Wed until 7; Closed Mon

Collection Highlights: Ongoing exhibition program of contemporary art in all media including painting, photography, sculpture, installation, and video. No permanent collection. **Publications:** Catalogues are published for all ICA-originated shows. Recent titles include "Robert Mapplethorpe"; "The Perfect Moment"; "Signs of Life"; and "David Salle". **Administration:** Edna Tuttleman, Chrmn. of the Board; Patrick T. Murphy, Dir.; Jane Carroll, Registrar. **Curatorial Staff:** Judith Tannenbaum, Assoc. Dir. & Sr. Cur.; Melissa Feldman, Assoc. Cur.; Bill Adair, Coordinator of Education.

PHILADELPHIA MUSEUM OF ART 215.763.8100
 26th & Benjamin Franklin Pkwy. FAX: 215.236.4465
 P.O. Box 7646, Philadelphia 19101
 Hours: Tues-Sun 10-5; Closed Mon

Collection Highlights: Picasso, "Three Musicians"; Van Gogh, "Sunflowers"; Lipchitz, "Sailor With Guitar"; Duchamp, "The Bride Stripped Bare by Her Bachelors"; Rauschenberg, "Estate"; Oldenburg, "Giant Three-Way Plug, Scale B"; Lichtenstein, "Still Life With Goldfish Bowl". **Administration:** Philip I. Berman, Chrmn. of the Board; Anne d'Harnoncourt, Dir.; Irene Taurins, Registrar. **Curatorial Staff:** Ann Temkin, Berman Cur. of 20th-Century Art; Darrel L. Sewell, McNeil Cur. of American Art; Dean Walker, European Decorative Arts & Sculpture; Innis H. Shoemaker, Sr. Cur., Prints, Drawings & Photographs; Suzanne Wells, Coordinator Of Special Exhibitions; Danielle Rice, Education. **Conservatorial Staff:** Marigene Butler.

RHODE ISLAND

MUSEUM OF ART, RHODE ISLAND SCHOOL OF DESIGN 401.331.3511
 224 Benefit St., Providence 02903 FAX: 401.831.7106
 Hours: Tues, Wed, Fri 10:30-5; Thurs 12-8

Collection Highlights: Major collection of Cubist and School of Paris paintings; Latin American art; major works by such artists as Pollock, Twombly, Rothko, Kelly and Rivers. **Publications:** "A Handbook of the Museum of Art, Rhode Island School of Design". **Administration:** Peter Freeman, Chrmn. of the Board; Frank Robinson, Dir.; Louann Skorupa, Registrar. **Curatorial Staff:** Daniel Rosenfeld, Painting & Sculpture; Ann Slimmon, Asst. Cur., Painting & Sculpture; Susan Hay, Costume & Textiles; Maureen O'Brien, Prints, Drawings & Photographs; Lora Urbanelli, Asst. Cur., Prints, Drawings & Photographs; Thomas Michie, Decorative Arts. **Conservatorial Staff:** Linda Catano.

TEXAS

THE ART CENTER, WACO 817.752.4371
 1300 College Dr., Waco 76708
 Hours: Tues-Sat 10-5; Sun 1-5

Collection Highlights: Contemporary American and Texan artists. **Publications:** Exhibition catalogues (7-8 per year). **Administration:** Sharron Cuttbirth, Chrmn. of the Board; Joseph L. Eagle, Jr., Dir.; Sarah Logan, Registrar. **Curatorial Staff:** Mary Burke, Education.

CONTEMPORARY ARTS MUSEUM 713.526.0773
 5216 Montrose, Houston 77006 FAX: 713.526.6749
 Hours: Tues-Fri 10-5; Sat-Sun 12-5; Closed Mon

Collection Highlights: Emphasis on the visual arts of the present and recent past. **Publications:** Exhibition catalogues, Bayou books by artists, gallery notes, young people's guides, quarterly calendars. **Administration:** Nancy C. Allen, Chrmn. of the Board; William Howard, Jr., Pres.; Suzanne Delehanty, Dir.; Jill Newmark, Registrar. **Curatorial Staff:** Lynn Herbert, Asst. Cur.; Ellen Efsic, Cur. Asst.

DALLAS MUSEUM OF ART 214.922.1200
 1717 N. Harwood, Dallas 75201 FAX: 214.954.0174
 Hours: Tues-Sat 10-5; Thurs until 9; Sun 12-5

Collection Highlights: Works by Mondrian, Leger, Moore, Brancusi, Murphy, Pollock, Gorky, Rothko, Kline, Still, Francis, Motherwell, Tobey, Louis, Johns, Rosenquist, Wesselmann, Diebenkorn, Bartlett, Rauschenberg, Murray, Graves; Contemporary sculpture collection. **Publications:** "The Icebergs"; "Kazimir Malevich: Journey Into Non-Objectivity"; "Selected Works"; "The Wendy and Emery Reves Collection"; "Now/Then/Again". **Administration:** Irvin Levy, Chrmn. of the Board; C. Vincent Prothro, Pres.; Richard R. Brettell, Dir.; Kimberly Bush, Registrar. **Curatorial Staff:** Emily Sano, Asian, Japanese; Susan Barnes, European Painting & Sculpture; Annegreth Nill, Contemp. Art; Charles Venable, Decorative Arts; Carolyn Tate, Pre-Columbian; Carol Robbins, Textiles & New World Cultures. **Conservatorial Staff:** John Dennis.

MODERN ART MUSEUM OF FORT WORTH 817.738.9215
 1309 Montgomery St., Ft. Worth 76107
 Hours: Tues-Fri 10-5; Sat 11-5; Sun 12-5

Administration: Marla Price, Interim Dir.

MUSEUM OF FINE ARTS, HOUSTON 713.639.7300
 1001 Bissonnet, P.O. Box 6826, Houston 77005 FAX: 713.639.7399
 Hours: Tues-Sat 10-5; Thurs Evenings 5-9, Sun 12:15-6

Collection Highlights: Highlights include paintings, sculptures, and works on paper by such artists as Picasso, Matisse, Modigliani, D. Smith, Gottlieb, Philip Guston, Stella, Beuys, A. Kiefer, T. Eakins, N. Graves & Arman. Cullen Sculpture Garden exhibits major 20th-century sculpture. **Publications:** The research archives include materials on the history of the museum since its founding in 1990. Also contains a select collection of 20th-century artists' papers. **Administration:** Isaac Arnold, Jr., Chrmn. of the Board; Peter C. Marzio, Dir.; Charles Carroll, Registrar. **Curatorial Staff:** Alison Greene, 20th-Century Art; Katherine Howe, Decorative Arts; George Shackelford, 18th-19th Century; Anne Tucker, Photography; Barry Walker, Prints and Drawings; David Warren, Assoc. Dir. & Sr. Cur.

VIRGINIA

VIRGINIA MUSEUM OF FINE ARTS 804.367.0844
 2800 Grove Ave., Richmond 23221 FAX: 804.367.9393
 Hours: Tues-Sat 11-5; Sun 1-5

Collection Highlights: Lewis Collection of post-war to present painting & sculpture; design & decorative arts collection with emphasis on 1900-1935; Payne Collection of Early 20th-Century European Moderns; Mellon Collection of Post-Impressionists and early European Moderns. **Publications:** Exhibition catalogues. **Administration:** John R. Curtis, Jr., Pres.; Katharine Lee, Dir.; Lisa Hancock, Registrar. **Curatorial Staff:** David Park Curry, Deputy Dir. & Cur., American Art to 1900; Malcolm Cormack, Paul Mellon Collection; George A. Cruger, Photographs; Frederick Brandt, 20th-Century Art; Julia W. Boyd, Assoc. Cur., 20th-Century Art; Margo A. Crutchfield, Asst. Cur., 20th-Century Art. **Conservatorial Staff:** Carol W. Sawyer, Lawrence Becker.

WASHINGTON

HENRY ART GALLERY 206.543.2281
 University of Washington, Seattle 98195 FAX: 206.685.3123
 Hours: Tues-Wed, Fri-Sun 10-5; Thurs 10-9

Collection Highlights: The permanent collection includes 19th and 20th-century paintings, photography, works on paper, ceramics and extensive ethnographic textiles and western dress. **Publications:** On-going publication program includes catalogues of changing exhibitions. **Administration:** Walter Parsons, Pres.; Richard Andrews, Dir.; Anne Gendreau, Registrar. **Curatorial Staff:** Chris Bruce, Sr. Cur.; Judy Sourakli, Collections; Tamara Moats, Education.

SEATTLE ART MUSEUM 206.625.8900
 First Ave. & University St., Seattle 98112 FAX: 206.625.8913
 Hours: Tues-Sat 10-5; Thurs 10-9; Sun 12-5; Closed Mon

Collection Highlights: Greatest strengths in Abstract Expressionism, Pop, Color Field and Minimalism. Paintings by Gorky, Pollock, Frankenthaler, Kline, & Rothko. The contemporary Pacific Northwest Collection includes works by "The Northwest School". **Administration:** C. Calvert Knudsen, Chrmn. of the Board; Virginia Wright, Pres.; Jay Gates, Dir.; Gail Joice, Registrar. **Curatorial Staff:** Patterson Sims, Assoc. Dir. & Cur., Modern Art; William J. Rathbun, Asian Art; Julie Emerson, Assoc. Cur., Decorative Arts; Rod Slemmons, Assoc. Cur., Prints & Photography; Vicki Halper, Asst. Cur., Modern Art; Chiyo Ishikawa, Asst. Cur., European Painting. **Conservatorial Staff:** Phil Stoiber, Paula Wolf.

WISCONSIN

MADISON ART CENTER 608.257.0158
 211 State St., Madison 53703 FAX: 608.257.5722
 Hours: Tues-Thurs 11-5; Fri 11-9; Sat 10-5; Sun 1-5; Closed Mon

Collection Highlights: Collection emphasizes 20th-century American art, but also includes Mexican, South American and Japanese works. **Archival Description:** Archives related to collection. **Publications:** Exhibition catalogues, checklists and informational handouts. **Administration:** Orville Arnold, Pres.; Stephen Fleischman, Dir.; Marilyn Sohi, Registrar. **Curatorial Staff:** Réne Paul Barilleaux, Exhibitions; Karen Levitor, Cur. Asst.; Kathryn Howarth Ryan, Education; Sheri Castelnuovo, Education Asst.

MILWAUKEE ART MUSEUM 414.271.9508
 750 N. Lincoln Memorial Dr., Milwaukee 53202 FAX: 414.271.7588
 Hours: Tues-Wed, Fri-Sat 10-5; Thurs 12-9; Sun 12-5; Closed Mon

Collection Highlights: Bradley Collection of Contemporary and Modern works; special emphasis in German Expressionism, The American School of the Eight, and contemporary art since 1960. **Archival Description:** Milwaukee Art Museum records from 1887. **Publications:** Archives brochure; Milwaukee Art Museum published illustrated chronology. **Administration:** Susan M. Jennings, Pres.; Russell Bowman, Dir.; Leigh Albritton, Registrar. **Curatorial Staff:** Dean Sobel, Assoc. Cur., Contemp. Art; Jayne E. Stokes, Asst. Cur., Decorative Arts; Tom Bamberger, Adjunct Cur., Photography. **Conservatorial Staff:** Jim DeYoung.

NEW YORK (cont.)

P.S.1 MUSEUM 718.784.2084
46-01 21st St., L.I.C., New York 11101 FAX: 718.482.9454
Hours: Wed-Sun 12-6

Collection Highlights: P.S.1 does not house a permanent collection. There are three contemporary art exhibitions yearly. **Archival Description:** A small archive of exhibition documentation. **Publications:** Books and exhibition catalogs including "David Hammons: Rousing The Rubble"; "Dennis Oppenheim: And The Mind Grew Fingers". **Administration:** Alanna Heiss, Dir; Hank Stahler, Registrar.

STORM KING ART CENTER 914.534.3115
Old Pleasant Hill Rd., Mountainville 10953 FAX: 914.534.4457
Hours: Daily 11-5:30, April 1 through November 30

Collection Highlights: On the 400-acre sculpture park and museum, highlights include post-1945 sculpture, especially large-scale outdoor sculpture. Works by such artists as Aycock, Calder, Mark Di Suvero, Isamu Noguchi, Moore, David Smith, and Alexander Liberman. **Publications:** Handbook of the collection is titled, "A Landscape for Modern Sculpture, Storm King Art Center". **Administration:** H. Peter Stern, Pres.; David R. Collens, Dir. **Curatorial Staff:** Maureen Megerian, Contemp. Art; Kevin Eckstrom, Education. **Conservatorial Staff:** Steven Tatti.

THE STUDIO MUSEUM IN HARLEM 212.864.4500
144 W. 125th St., New York 10027 FAX: 212.666.5753
Hours: Wed-Fri 10-5; Sat & Sun 1-6

Collection Highlights: Changing exhibitions and permanent collection of contemporary African-American and African art, as well as Carribean and Latino works and exhibitions. **Archival Description:** James Van Der Zee archives of photographs documenting Harlem in the 1920's, 30's, and 40's. **Administration:** Kinshasha Holman Conwill, Dir.; Jon Hutton, Registrar. **Curatorial Staff:** Sharon F. Patton, Chief Cur.; Grace C. Stanislaus; Dorothy Desir-Davis, Asst. Cur.

WHITNEY MUSEUM OF AMERICAN ART 212.570.3676
945 Madison Ave. At 75th St., New York 10021 FAX: 212.570.1807
Hours: Tues 1-8; Wed-Sat 11-5; Sun 11-6; Closed Mon

Collection Highlights: Includes Alexander Calder, "Circus"; Edward Hopper, "Early Sunday Morning"; Jasper Johns, "Three Flags"; Elie Nadelman, "Tango"; important works by Arshile Gorky, Jackson Pollock and Georgia O'Keeffe. **Administration:** Flora Miller Biddle, Chrmn. of the Board; Leonard Lauder, Pres.; David A. Ross, Dir.; Nancy McGary, Registrar. **Curatorial Staff:** Richard Armstrong; John Hanhardt, Film and Video; Barbara Haskell; Richard Marshall; Lisa Phillips; Elisabeth Sussman.

OHIO

AKRON ART MUSEUM 216.376.9185
70 E. Market St., Akron 44308
Hours: Tues-Fri 11-5; Sat 10-5; Sun 12-5; Closed Mon

Collection Highlights: Includes contemporary painting and sculpture ranging from William Merritt Chase and Thomas Dewing to Philip Guston, Chuck Close, Frank Stella, Claes Oldenburg and Nam June Paik. Photography includes works from Lewis Hine to Lee Friedlander. **Publications:** "Ralph Eugene Meatyard: An American Visionary"; "Edwin C. Shaw Collection of American Impressionist and Tonalist Painting"; "William Merritt Chase: Portraits". **Administration:** Judith B. Isroff, Chrmn. of the Board; Mitchell Kahan, Dir. **Curatorial Staff:** Barbara Tannenbaum; Wendy Kendall-Hess, Asst. Cur.

THE BUTLER INSTITUTE OF AMERICAN ART 216.743.1107
524 Wick Ave., Youngstown 44502 FAX: 216.743.9567
Hours: Tues-Sat 11-4; Wed 11-8; Sun 12-4; Closed Mon

Collection Highlights: Works by such artists as G. O'Keeffe, C. Sheeler, E. Hopper, C. Burchfield, B. Shahn, M. Avery, A. Dove, M. Hartley, F. Kline, A. Gottlieb, A. Warhol, R. Lichtenstein, H. Frankenthaler, R. Ferrer, S. Gilliam, C. Close, and A. Lastie. **Publications:** Permanent collection catalogues, institutional brochure, temporary exhibition catalogues, newsletters. **Administration:** Thomas Cavalier, Pres.; Louis A. Zona, Dir.; Ken Platt, Registrar. **Curatorial Staff:** Clyde Singer, Permanent Collection; James Pernotto, Prints. **Conservatorial Staff:** Ray Johnson.

CINCINNATI ART MUSEUM 513.721.5204
Eden Park, Cincinnati 45202 FAX: 513.721.0129
Hours: Tues, Thurs, Fri & Sat 10-5; Wed 10-9; Sun 12-5; Closed Mon

Collection Highlights: Siah Armajani, "Notations for Reading Garden #1"; Steven Campbell, "After The Hunt"; Francesco Clemente, "Two Skulls"; Sandro Chia, "Lights and Can"; several sculptures by Italo Scanga; Jennifer Bartlett, "In The Garden". **Publications:** "New Visions In Contemporary Art: The RSM Company Collection" by Judith Kirschner; "The Alice & Harris Weston Collection of Post-War Art" by Sue Taylor. **Administration:** John W. Warrington, Chrmn. of the Board; John J. Schiff, Pres.; Millard F. Rogers, Jr., Dir.; Ellie Vuilleumier, Registrar. **Curatorial Staff:** Elisabeth Batchelor, Asst. Dir. for Collections; John Wilson, Painting & Sculpture; Jean Feinberg, Contemp. Art; Kristin Spangenberg, Prints & Drawings; Dennis Kiel, Assoc. Cur., Photographs & Design; Lynn Bilotta, Assoc. Cur., Arts of Africa & The Americas. **Conservatorial Staff:** Elisabeth Batchelor, Stephen Bonadies.

CLEVELAND CENTER FOR CONTEMPORARY ART 216.421.8671
8501 Carnegie Ave., Cleveland 44106 FAX: 216.421.0737
Hours: Tues-Wed 11-6; Thur-Fri 11-8:30; Sat 12-5; Sun 1-4

Collection Highlights: No permanent collection. Center features a year-long series of contemporary art exhibitions that change every 8-10 weeks. Center shows regional, national and international artists. **Archival Description:** Small library. **Publications:** Quarterly newsletter & museum-quality exhibition catalogues. **Administration:** Bill Ginn, Pres.; Marjorie Talalay, Dir. **Curatorial Staff:** David Rubin, Assoc. Dir. & Chief Cur.; Pamela R. Esch, Dir. of Education. **Conservatorial Staff:** Dan Witczak, Ray Juaire.

THE CLEVELAND MUSEUM OF ART 216.421.7340
11150 East Blvd., Cleveland 44106 FAX: 216.421.0411
Hours: Tues, Thurs, Fri 10-5:45; Wed 10-9:45; Sat 9-4:45; Sun 1-5:45; Closed Mon

Collection Highlights: A general survey of 20th-century American and European painting with examples of all leading trends. The collection of 20th-century photography is especially strong in works by Alfred Stieglitz and Paul Strand. **Archival Description:** A library of 167,000 volumes, 351,000 slides and 321,000 photographs. **Publications:** "Bulletin", a monthly journal; "News & Calendar", a monthly magazine for members; catalogues of the permanent collection and special exhibitions. **Administration:** Alton W. Whitehouse, Pres.; Evan Hopkins Turner, Dir. **Curatorial Staff:** Tom E. Hinson, Contemporary Art; William H. Robinson, Cur. Asst. Contemporary Art; Jane Glaubinger, Prints & Drawings. **Conservatorial Staff:** Bruce Christman; Marcia C. Steele.

COLUMBUS MUSEUM OF ART 614.221.6801
480 E. Broad St., Columbus 43215 FAX: 614.221.0226
Hours: Tues-Fri 11-4; Sat 10-5; Sun 11-5; Closed Mon

Collection Highlights: 20th-century American paintings, sculpture and photography, such as Edward Hopper's "Morning Sun", and works by Marsden Hartley, Charles Demuth, Alexander Calder, Imogene Cunningham, and Harold Edgerton. **Publications:** "The American Collections: Columbus Museum of Art", Harry N. Abrams, Inc., 1988. **Administration:** Douglas Olesen, Pres.; Merribell Parsons, Dir.; Rod Bouc, Registrar. **Curatorial Staff:** Roger Clisby, Dir. of Curatorial Affairs; E. Jane Connell; Nannette Maciejunes, American Collections.

THE CONTEMPORARY ARTS CENTER 513.721.0390
115 E. Fifth St., Cincinnati 45202 FAX: 513.721.7418
Hours: Mon-Sat 10-6; Sun 1-5

Collection Highlights: Changing exhibitions featuring contemporary art. **Publications:** Catalogues available on center-organized exhibitions. **Administration:** Roger Ach, Chrmn. of the Board; Sandra Walters; Dennis Barrie, Dir. **Curatorial Staff:** Jack Sawyer, Chief Cur.; Jan Riley; Elizabeth Scheurer.

DAYTON ART INSTITUTE 513.223.5277
Forest & Riverview Avenues, Dayton 45405 FAX: 513.223.3140
Hours: Tues-Sun 12-5

Collection Highlights: "Art of Our Time" Collection purchased from Ponderosa; Andy Warhol's "Russell Means". **Administration:** Brad Tilson, Chrmn. of the Board; Bruce Evans, Dir.; Dominique Vasseur, Registrar. **Curatorial Staff:** Dominique Vasseur, European Art; Clarence Kelley, Asian Art; Marianne Richter, American Art.

THE TOLEDO MUSEUM OF ART 419.255.8000
2445 Monroe St. at Scottwood, Toledo 43620 FAX: 419.255.5638
Hours: Tues-Sat 10-4; Sun 1-5; Closed Mon

Administration: Duane Stranahan, Jr., Pres.; David W. Steadman, Dir.; Patricia Whitesides, Registrar. **Curatorial Staff:** Robert F. Phillips, Chrmn. Cur. Dept.; Roger M. Berkowitz, Decorative Arts; William Hutton, Sr. Cur.; Kurt T. Luckner, Ancient Art; Davira S. Taragin, 19th & 20th-Century Glass.

WEXNER CENTER FOR THE ARTS 614.292.0330
North High St. At 15th Ave., Columbus 43210 FAX: 614.292.3369
Hours: Wed-Sat 10-8; Sun 12-5 (Summer Hours)

Collection Highlights: Works by American artists from the 1970's. **Administration:** Leslie H. Wexner, Chrmn. of the Board; Robert Stearns, Dir.; Maureen Alvim, Registrar. **Curatorial Staff:** William Cook, Assoc. Dir.; Sarah Rogers-Lafferty, Sr. Cur. of Exhibitions; Bill Horrigan, Media; Charles Helm, Dir. of Performing Arts.

OKLAHOMA

THE PHILBROOK MUSEUM OF ART 918.749.7941
2727 S. Rockford Rd., Tulsa 74114 FAX: 918.743.4230
Hours: Tues-Sat 10-5; Thurs Evening until 8; Sun 1-5

Collection Highlights: Contemporary American paintings, prints and contemporary American craft art. **Publications:** "The Eloquent Object"; "Realism-Photorealism"; "The Arts of The North American Indian"; "Nature's Forms/Nature's Forces-The Art of Alexandre Hogue". **Administration:** Robert J. LaFortune, Chrmn. of the Board; Marcia Y. Manhart, Dir.; Christine Kallenberger, Registrar. **Curatorial Staff:** Richard Townsend, European & American Art; Dr. Lydia Wyckoff, Native American Art.

OREGON

OREGON ART INSTITUTE 503.226.281
1219 S.W. Park, Portland 97205
Hours: Tues-Sat 11-5; Sun 1-5

Administration: Jerry Bolas, Dir.

PENNSYLVANIA

ALLENTOWN ART MUSEUM 215.432.4333
Fifth & Court Sts., P.O. Box 388, Allentown 18105 FAX: 215.434.7409
Hours: Tues-Sat 10-5; Sun 1-5; Closed Mon & Major Holidays

Publications: Quarterly newsletter; occasional exhibition catalogues. **Administration:** Leon C. Holt, Jr., Pres.; Peter F. Blume, Dir.; Patricia Delluva, Registrar. **Curatorial Staff:** Sarah McNear, Assoc. Cur.; Jan Reeder, Textile; Mimi Miley, Education; Peg Lewis, Assoc. Cur. of Education.

NE VOORHEES ZIMMERLI ART MUSEUM 908.932.7237
Rutgers, The State University of New Jersey FAX: 908.832.8201
George & Hamilton, New Brunswick 08903
Hours: Mon-Tues, Thur-Fri 10-4:30; Sat-Sun 12-5; Closed Wed

ollection Highlights: Prints and supplementary materials from 16 contemporary printmaking
udios; The Dodge Collection of Nonconformist Art from the Soviet Union containing 5,000
orks from 1956-1986; mid-20th century Surrealism, Abstraction & current artistic movements.
ublications: Comprehensive list of publications available through museum. Administration:
lan Maitlin, Chrmn. of the Board; Phillip D. Cate, Dir.; Barbara Trelstad, Registrar. Curatorial
taff: Jeffrey Wechsler, Asst. Dir. of Curatorial Affairs; Trudy Hansen, Prints and Drawings; Laura
attal, Education.

EW MEXICO

HE ALBUQUERQUE MUSEUM OF ART, HISTORY, & SCIENCE 505.243.7255
2000 Mountain Rd. N.W., Albuquerque 87104 FAX: 505.764.6546
Hours: Tues-Sun 9-5; Closed Mon

ollection Highlights: Works by Georgia O'Keeffe, John Sloan, Woody Gwyn, James Valerio,
Vilson Hurley, Larry Bell, Luis Jimenez, Jesus Bautista Moroles, Sebastian, Ernest Blumenschein,
ert Phillips. Publications: "Late 19th and Early 20th Century Paintings of Albuquerque and
nvirons". Administration: I.L. "Smokey" Sanchez-Davis, Chrmn. of the Board; James C. Moore,
ir.; Melissa Strickland, Registrar. Curatorial Staff: Ellen Landis; Robert Woltman, Exhibits; Chris
einer, Education; Tom Lark, Collections.

USEUM OF FINE ARTS 505.827.4468
107 W. Palace Ave., Santa Fe 87501
Hours: Daily 10-5; Jan & Feb Closed Mon

dministration: David Turner, Dir.

EW YORK

LBRIGHT-KNOX ART GALLERY 716.882.8700
1285 Elmwood Ave., Buffalo 14222 FAX: 716.882.1958
Hours: Tues-Sat 11-5; Sun 12-5

ollection Highlights: American and European painting and sculpture representative of the major
ovements and trends of the 60's, 70's & 80's; contemporary masters include works by Pollock,
ill, de Kooning, Stella, Moore, Rauschenberg, Lichtenstein, Clemente and Kiefer. Archival
escription: Documents the museum since its founding. Publications: Catalogues of the
ermanent collection and special exhibitions. Administration: Seymour H. Knox III, Pres.;
ouglas G. Schultz, Dir.; Laura Catalano, Registrar. Curatorial Staff: Michael Auping, Chief Cur.;
heryl A. Brutvan.

HE BROOKLYN MUSEUM 718.638.5000
200 Eastern Parkway, Brooklyn 11238 FAX: 718.638.3731
Hours: Wed-Sun 10-5

ollection Highlights: Highlights include O'Keeffe, "Brooklyn Bridge"; David Smith, "The Hero";
e Kooning, "Woman"; Ad Reinhart, "Untitled (Composition #4)"; Diebenkorn, "Ocean Park No.
7"; Mangold, "The Inversion"; and T. Otterness, "Head". Archival Description: Reference
rary with records dating back to 1823. Publications: Include "Albert Bierstadt: Art &
nterprise"; "Objects of Myth & Memory: American Indian Art At the Brooklyn Museum"; "The
achine Age". Administration: Robert S. Rubin, Chrmn. of the Board; Robert T. Buck, Dir.; Liz
eynolds, Registrar. Curatorial Staff: Linda S. Ferber, Chief Cur. & American Painting &
culpture; Sarah Faunce, Chrmn. Painting & Sculpture; Charlotta Kotik, Contemp. Painting &
culpture; Brooke Rappaport, Asst. Cur., Contemp. Painting & Sculpture; Linda Kramer, Prints &
rawings; Kevin Stayton, Decorative Arts. Conservatorial Staff: Ken Moser, Cathryn Anders.

OOPER-HEWITT MUSEUM OF DESIGN 212.860.6868
MITHSONIAN INSTITUTE FAX: 212.860.6909
2 E. 91st St., New York 10128
Hours: Tues 10-9; Wed-Sat 10-5; Sun 12-5, Closed Mon

ollection Highlights: More than 165,000 objects which represent 3,000 years of design history
orldwide; major holdings include drawings, prints, textiles, furniture, metalwork, ceramics, glass,
oodwork and wall coverings Archival Description: 50,000 books, including 5,000 rare
olumnes. Administration: Dianne H. Pilgrim, Dir.; Cordelia Rose, Registrar. Curatorial Staff:
avid McFadden, Decorative Arts; Deborah Shinn, Asst. Cur., Decorative Arts; Marilyn Symmes,
rawings & Prints; Gail Davidson, Asst. Cur., Drawings & Prints; Milton Sonday, Textiles; Gillian
oss, Asst. Cur., Textiles. Conservatorial Staff: Konstanze Bachmann, Lucy Commoner.

VERSON MUSEUM OF ART 315.474.6064
401 Harrison St., Syracuse 13202
Hours: Tues-Fri 12-5; Sat 10-5; Sun 12-5; Closed Mon

ollection Highlights: Works by A. Held, H. Frankenthaler, M. Louis, E. Trova, H. Moore, B.
epworth, F. Dzubas, Harmony Hammond, D. Oppenheim, M. Tracy, Les Levine, B. Kruger, Starn
wins, C. Sherman, N. Spero, M. Lucero, Mary Frank, R. Arneson, P. Voulkos, J. de Andrea.
rchival Description: Archives of the Ceramic National Exhibitions. Publications: Bi-monthly
embers' newsletter, bi-annual report, exhibition catalogs connected to major exhibitions.
dministration: Thomas R. Kennedy, Pres.; Ronald A. Kuchta, Dir.; John Rexine, Registrar.
uratorial Staff: Peter Doroshenko, Paintings and Sculpture; Barbara Perry, Ceramics; Terrie
hite, Education.

SOLOMON R. GUGGENHEIM MUSEUM 212.360.3500
1071 5th Ave., New York 10128
Hours: To be determined. Please call for updated information on hours and rates.

Collection Highlights: Focuses on 20th-century European painting and sculpture; a large
number of works by Vasily Kandinsky and Picasso; artists such as Leger, Ernst, Klee, Picabia, and
Mondrian; the Justin K. Thannhauser Collection of Impressionist and Post-Impressionist movements;
depth in the area of American Minimalism from the 60's and 70's. Archival Description:
Research library facilities available by appointment. Publications: Catalogues accompany
exhibitions. Administration: Thomas Krens, Dir.; Elizabeth Carpenter, Registrar. Curatorial
Staff: Diane Waldman, Deputy Dir. & Sr. Cur.; Carmen Gimenez, 20th-Century Art; Germano
Celeant, Contemporary Art; Lisa Dennison, Collections; Nancy Spector, Assoc. Cur. Research; Jane
Sharp, Project Assoc. Cur.; Holly Fullam, Project Asst. Cur. Conservatorial Staff: Paul
Schwartzbaum; Gillian McMillan.

INTERNATIONAL CENTER OF PHOTOGRAPHY 212.860.1777
1130 Fifth Ave. at 94th St., New York 10021 FAX: 212.360.6490
Hours: Tues 12-8; Wed-Fri 12-5; Sat & Sun 11-5; Closed Mon

Collection Highlights: Include works by such artists as Zeke Berman, Marilyn Bridges, Harry
Callahan, Paul Caponigro, Ellen Carey, Judy Dater, Bruce Davidson, Lynn Davis, Ralph Gibson, Len
Jenshel, Barbara Kasten, Josef Koudelka, Robert Mapplethorpe & Sebastiao Salgado. Archival
Description: Over 12,000 original photographic prints, several thousand hours of audio and video
tape, and film which document works in the permanent collection as well as various related
subjects. Administration: Mrs. Alex L. Hillman, Chrmn. of the Board; Jill Rose, Pres.; Cornell
Capa, Dir.; Madeleine Vogel, Registrar. Curatorial Staff: Willis Hartshorn, Deputy Dir. for
Programs; Miles Barth, Collections; Charles Stainback, Video and Media Programs.
Conservatorial Staff: Miles Barth.

INTERNATIONAL MUSEUM OF PHOTOGRAPHY 716.271.3361
900 East Ave., Rochester 14607 FAX: 716.271.3970
Hours: Tues-Sat 10-4:30; Sun 1-4:30

Collection Highlights: Examples of international photography including work by Dieter Appelt,
Hamish Fulton, Ralph Gibson, Jan Groover, Barbara Kasten, Susan Rankaitis, and Hiromi Tsuchida
Archival Description: 400,000 images available for study. Publications: "Image Magazine: A
Journal of Photography and Motion Pictures"; "Mary Ellen Mark: 25 Years". Administration:
James Enyeart, Dir.; Ann McCabe, Registrar. Curatorial Staff: Marianne Fulton, Sr. Cur.,
Photography; William Stapp, Sr. Cur., Photography. Conservatorial Staff: Grant Romer,
Catherine Ackerman.

HERBERT F. JOHNSON MUSEUM OF ART 607.255.6464
Cornell University, Ithaca 14853 FAX: 607.255.9940
Hours: Tues-Sun 10-5; Closed Mon

Collection Highlights: Works by William Zorach, John Flannagan, Giacometti, Jacques Lipchitz,
Marca-Relli, Loger, O'Keeffe, Arthur Dove, Edwin Dickinson, John Marin, Jasper Johns, Thomas
Eakins, Margaret Bourke-White, Andy Warhol, Robert Rauschenberg, Dubuffet, Mark Di Suvero.
Publications: "Collection of the Handbook" (1981); "Painting Up Front" (1981); "Earth Art"
(1969);"Lagoon Cycle" (1985); "Joa Mitchell" (1988); "Cornell Collects" (1990). Administration:
Richard J. Schwartz, Chrmn. of the Board; Thomas W. Leavitt, Dir.; Nancy Harm, Registrar.
Curatorial Staff: Nancy E. Green, Prints & Photographs; Nancy A. Jarzambel, Assoc. Cur. of
Painting & Sculpture; Leslie Schwartz, Assoc. Cur. of Exhibitions; Martie W. Young, Asian Art; Mary
Ann Hong, Asst. Cur. of Asian Art.

METROPOLITAN MUSEUM OF ART 212.879.5500
1000 Fifth Ave., New York 10028
Hours: Tues-Thurs 9:30-5:30; Fri-Sat 9:30-8:45

Collection Highlights: Lila Acheson Wallace Wing for 20th-Century Art; Iris and B. Gerald
Cantor Sculpture Garden. Administration: Philippe de Montebello, Dir.; John Buchanan,
Registrar. Curatorial Staff: William S. Lieberman, Gelman Chairman, Dept. of 20th-Century Art;
Kay Bearman, Administrator of 20th-Century Art; Sabina Rewald, Assoc. Cur., 20th-Century Art;
Lowery S. Sims, Assoc. Cur., 20th-Century Art; Lisa M. Messinger, Asst. Cur., 20th-Century Art.

THE MUSEUM OF MODERN ART 212.708.9400
11 W. 53rd St., New York 10019 FAX: 212.708.9889
Hours: Sun-Tues, Fri-Sat 11-6; Thurs 11-9; Closed Wed

Collection Highlights: More than 100,000 paintings, sculptures, drawings, prints, and
photographs, providing a comprehensive overview of the major artists and movements since the
1880's. Archival Description: 80,000 books & periodicals; 10,000 films. Administration:
William S. Paley, Chrmn. of the Board; Richard E. Oldenburg, Dir. Curatorial Staff: Kirk
Varnedoe, Dir., Painting & Sculpture; John Elderfield, Dir., Drawings; Riva Castleman, Prints &
Illustrated Books; Stuart Wrede, Dir., Architecture & Design; Mary Lea Bandy, Dir., Film.
Conservatorial Staff: Antoinette King, Director; Karl Buchberg.

THE NEW MUSEUM OF CONTEMPORARY ART 212.219.1222
583 Broadway, New York 10012 FAX: 212.431.5328
Hours: Wed-Thurs & Sun 12-6; Fri-Sat 12-8; Closed Mon-Tues

Collection Highlights: The New Museum has a semi-permanent collection. This collection
consists of works that are less than ten years old, and these, in turn, are retained for no less than
ten years and no more than twenty. Publications: "Documentary Sources In Contemporary Art",
a series of volumnes; "Art After Modernism"; "Blasted Allegories"; "Discourses: Conversations in
Postmodern Art and Culture"; "Out There: Marginalization and Contemporary Cultures".
Administration: Henry Luce III, Pres.; Marcia Tucker, Dir.; Debra Priestly, Registrar. Curatorial
Staff: France Morin, Sr. Cur.; Gary Sangster; Laura Trippi; Alice Yang, Asst. Cur.

MASSACHUSETTS (cont.)

SMITH COLLEGE MUSEUM OF ART 413.584.2770
Northampton 01063 FAX: 413.585.2075
Hours: Tues-Sat 12-5; Sun 2-5

Collection Highlights: 19th & 20th-century European and American art with representation of most periods and cultures. **Publications:** "Guide To The Collections, Smith College Museum of Art" (1986). **Administration:** Charles Parkhurst, Dir.; Louise Laplante, Registrar. **Curatorial Staff:** Linda Muehlig, Assoc. Cur., Painting & Sculpture; Ann H. Sievers, Assoc. Cur., Prints, Drawings & Photographs; Michael Goodison, Program Coordinator. **Conservatorial Staff:** David Dempsey.

WILLIAMS COLLEGE MUSEUM OF ART 413.597.2429
Main St., Williamstown 01267 FAX: 413.458.9017
Hours: Mon-Sat 10-5; Sun 1-5

Collection Highlights: Among the American artists represented are Ida Applebroog, Dottie Attie, Alice Aycock, Willem de Kooning, Jim Dine, Hans Hoffmann, Robert Morris, Louise Nevelson, Philip Pearlstein, Robert Rauschenberg, Ad Reinhardt, Faith Ringgold, Larry Rivers, David Smith, Andy Warhol, and Boyd Webb. Also includes important work by British artists Gilbert and George. **Publications:** "Maurice Brazil Prendergast, Charles Prendergast: A Catalogue Raisonne (1990)"; "Maurice Prendergast" (1990), "Mary Cassatt: The Color Prints" (1989). **Administration:** Linda Shearer, Dir.; Sally Shafto, Registrar. **Curatorial Staff:** Vivian Patterson, Assoc. Cur., Collections Mgmt.; Deborah Menaker, Assoc. Cur., Exhibitions; Nancy Mowll Mathews, Prendergast Curator.

WORCESTER ART MUSEUM 508.799.4406
55 Salisbury St., Worcester 01609 FAX: 508.798.5646
Hours: Tues-Wed, Fri 11-4; Thurs 11-8; Sat 10-5; Sun 1-5

Collection Highlights: The museum houses collections of 20th-century European and American paintings and sculpture with particular strength in 20th-century prints, drawings and photographs. **Archival Description:** 30,000-volume library and slide library. **Administration:** Harold N. Cotton, Pres.; James A. Welu, Dir.; Sally Freitag, Registrar. **Curatorial Staff:** Susan Strickler, Dir. of Curatorial Affairs; Donna Harkavy, Contemp. Art; Elizabeth Swinton, Asian Art; David Acton, Prints & Drawings; Stephen Jareckie, Photography. **Conservatorial Staff:** Jennifer Spohn.

MICHIGAN

THE DETROIT INSTITUTE OF ARTS 313.833.7900
5200 Woodward Ave., Detroit 48202 FAX: 313.833.2357
Hours: Wed-Sun 9:30-5:30

Collection Highlights: Comprehensive representation of 20th-century art beginning with Cubism, "Die Brücke" and "Blaue Reiter". Areas of strength include Abstract Expressionism, Color Field, Minimalism, Post-Minimalism and trends of the last decade, American and European. **Publications:** "The W. Hawkins Perry Collection", catalogue 1987. **Administration:** A. Alfred Taubman, Pres.; Samuels Sachs II, Dir.; Suzanne Quigley, Registrar. **Curatorial Staff:** Jan Van Der Marck, Chief Cur. & Cur., 20th-Century Painting & Sculpture; Maryann Wilkinson, Assoc. Cur., 20th-Century Painting & Sculpture; J. Patrice Marandel, European Painting; Iva Lisikewycz, Assoc. Cur., European Painting; Nancy Rivard Shaw, American Art; Alan P. Darr, European Sculpture & Decorative Arts. **Conservatorial Staff:** Barbara Heller, Alfred Ackerman.

MINNESOTA

MINNEAPOLIS INSTITUTE OF ARTS 612.870.3046
2400 Third Ave. S., Minneapolis 55404
Hours: Tues-Sat 10-5: Thurs 10-9: Sun 12-5; Closed Mon

Collection Highlights: Picasso, Dine, Close, Ernst, Warhol, Calder, O'Keeffe, Stella, Johns, Moore, Barlach, Magritte, Miro and Brancusi. **Administration:** Dr. Evan Maurer, Dir.; Cathy Davis, Registrar. **Curatorial Staff:** Michael Conforti, Chief Cur. and Decorative Arts; Louise Lincoln, AOA; Robert Jabobsen, Asian; George Keyes, Painting; Richard Campbell, Prints and Drawings; Ted Hartwell, Photography.

MINNESOTA MUSEUM OF ART 612.292.4355
75 W. Fifth St., St. Paul 55102
Hours: Tues-Fri 10:30-4:30; Thurs 10:30-7:30

Administration: M.J. Czarniecki, Dir.

WALKER ART CENTER 612.375.7600
Vineland Place, Minneapolis 55403 FAX: 612.375.7618
Hours: Tues-Sat 10-8; Sun 11-5

Collection Highlights: More than 5,000 pieces feature representative works from the major movements of 20th-century American & European art, with particular strengths in Abstract Expressionism, Pop Art, Minimalism, New Image Painting, and recent Neo-Expressionism. **Administration:** H.B. Atwater, Jr., Chrmn. of the Board; Gary Capen, Pres.; Kathy Halbreich, Dir.; Gwen Bitz, Registrar. **Curatorial Staff:** Gary Garrels, Sr. Cur.; Elizabeth Armstrong; Peter Boswell, Assoc. Cur.; Kellie Jones, Adjunct Cur.; Joan Rothfus, Assoc. Cur.

MISSOURI

LAUMEIER SCULPTURE PARK & MUSEUM 314.821.1209
12580 Rott Rd., St. Louis 63127 FAX: 314.821.1248
Hours: Tues-Sat 10-5; Sun 12-5

Collection Highlights: Twentieth-century sculpure collection including Acconci, Aycock, Caro, Di Suvero, Dusenbury, Ferrara, Fleischner, Frey, Graham, Heizer, Hera, Highstein, Hunt, Jaquard, Judd, Liberman, Long, Milles, Miss, Oppenheim, Pepper, Rickey, Rosenthal, Serra. **Publications:** "Jackie Ferrara and Mary Miss: Site Sculpture At Laumeier"; "Laumeier Sculpture Park: First Decade 1976-1986"; "Alice Aycock & Robert Stackhouse". **Administration:** Thomas M. Mayer, Pres.; Beej Nierengarten-Smith, Dir.; Mary-Edgar Patton, Registrar. **Curatorial Staff:** Blane de St. Croix, Collection.

NELSON-ATKINS MUSEUM OF ART 816.561.4000
4525 Oak St., Kansas City 64111 FAX: 816.561.7154
Hours: Tues-Sat 10-5; Sun 1-5

Collection Highlights: Major paintings by Willem de Kooning, Robert Rauschenberg, Ad Reinhardt, Franz Kline, Richard Diebenkorn, Mark Rothko and others. Extensive collection of Henry Moore sculptures (Maquettes & Working Models) and Henry Moore Sculpture Garden. **Archival Description:** Henry Moore photographic archive. **Publications:** "Horizons" catalogues accompanying the 12 Horizons exhibitions in 1989-1991; "Henry Moore: Maquettes and Working Models"; "The Nelson-Atkins Museum of Art Henry Moore Sculpture Garden". **Administration:** Marc F. Wilson, Dir.; Ann Erbacher, Registrar. **Curatorial Staff:** Deborah Emont Scott, Sanders Sosland Cur. of 20th-Century Art; Deni McIntosh McHenry, Asst. Cur. of 20th-Century Art. **Conservatorial Staff:** Forrest Bailey, Scott Heffley.

THE SAINT LOUIS ART MUSEUM 314.721.0072
1 Fine Arts Dr., St. Louis 63110 FAX: 314.721.6172
Hours: Tues 1:30-8:30; Wed-Sun 10-5; Closed Mon

Collection Highlights: Major holdings in modern German painting, particularly Max Beckmann and Die Brücke, contemporary German and American paintings and sculpture, particularly Anselm Kiefer, Gerhard Richter, and Philip Guston. **Publications:** "The Saint Louis Art Museum Handbook"; "Max Beckmann Catalogue"; "Modern German Masterpieces"; "20th-Century American Sculpture"; "American Drawings 1900-1945". **Administration:** Harvey Saligman, Pres.; James D. Burke, Dir.; Nick Ohlman, Registrar. **Curatorial Staff:** Michael E. Shapiro, Chief Cur.; Steven D. Owyoung, Asian Art; John W. Nunley, Africa, Oceania and the Americas; Barbara Butts, Prints, Drawings and Photographs; Laurie A. Stein, Assoc. Cur., Decorative Arts; Elizabeth Millard, Asst. Cur., Contemp. Art. **Conservatorial Staff:** Paul Haner, Diane Burke.

NEBRASKA

JOSLYN ART MUSEUM 402.342.3300
2200 Dodge St., Omaha 68102 FAX: 402.342.2376
Hours: Tues-Sat 10-5; Thurs until 9pm; Sun 1-5

Collection Highlights: Highlights include Kenneth Noland, "Cirium"; Jackson Pollock, "Galaxy"; Stuart Davis, "American Painting"; George Segal, "Times Square At Night"; Ross Bleckner, "1944-1945"; and Martin Puryear, "Self". **Administration:** Graham W.J. Beal, Dir.; Penelope Smith, Registrar. **Curatorial Staff:** Marsha V. Gallagher, Chief Cur.; Janet L. Farber, Assoc. Cur. of 20th-Century Art; David Hunt, Western American Art; Carol Wyrick, Education; Joseph Porter, Western American History. **Conservatorial Staff:** Michael Tegland, Theodore James.

NEW HAMPSHIRE

CHAPEL ART CENTER 603.641.7470
Saint Anselm College, Box 2240, Manchester 03102
Hours: Sept-April, Mon-Fri 10-4; Closed Holidays

Collection Highlights: Works by area craftsmen, sculpture, paintings & graphics. **Administration:** Donald A. Rosenthal, Dir. **Curatorial Staff:** Adrienne LaVallee, Exhibitions Coordinator.

NEW JERSEY

THE NEWARK MUSEUM 201.596.6550
49 Washington St., Newark 07101 FAX: 201.642.0459
Hours: Wed-Sun 12-5

Collection Highlights: 19th & early 20th-century American works including 19th-century Neoclassical sculpture, still life paintings and Impressionist works. Pre-World War II works include Hopper, Sheeler, Weber, Robert-Henri, J. Sloan, O'Keeffe, Stella and Gorky. **Archival Description:** 26,000 volumes. **Publications:** "Against the Odds"; "African American Artists and the Harman Foundation". **Administration:** Kevin Shanley, Chrmn. of the Board; Samuel C. Miller, Dir.; Audrey Koenig, Registrar. **Curatorial Staff:** Susan H. Auth, Classical; Ulysses A. Dietz, Decorative; Valrae Reynolds, Oriental. **Conservatorial Staff:** Richard Heaps.

NEW JERSEY STATE MUSEUM 609.292.5421
205 W. State St., CN-530, Trenton 08625 FAX: 609.599.4098
Hours: Tues-Sat 9-4:45; Sun 12-5

Collection Highlights: Works by the Stieglitz Circle; works by members of the American Abstract artists and by major independents; American paintings, sculpture and prints from the 1960's to present. **Administration:** Leah Sloshberg, Dir. **Curatorial Staff:** Zoltan Buki; Alison Weld, Asst. Cur., Contemp. NJ Arts; Karen Cummins, Education; John Mohr, Exhibitions.

THE NOYES MUSEUM 609.652.8848
Lily Lake Rd., Oceanville 08231 FAX: 609.652.6161
Hours: Wed-Sun 11-4

Collection Highlights: Contemporary paintings, sculpture, prints, crafts and folk art with emphasis on objects made by New Jersey artists. **Publications:** "American Folk Art from Collectionn of Herbert Waide Hemphill, Jr."; "Southern Visions II: Photo in Southern New Jersey"; "Sculpture by Charles Searles". **Administration:** Herbert Rothenberg, Pres.; Anne R. Fabbri, Dir.; Bonnie Pover, Registrar.

ILLINOIS

THE ART INSTITUTE OF CHICAGO 312.443.3600
Michigan Ave. at Adams St., Chicago 60603 FAX: 312.443.0849
Hours: Mon & Wed-Fri 10:30-4:30, Tues 10:30-8, Sat 10-5, Sun 12-5

Collection Highlights: As of June, 1991: Galleries of Modern Art 1900-1950, second floor of original building, including Albert Robin Families Galleries, Upper Morton Wing, and Selections of contemporary Art, second floor, Rice Building. **Publications:** Extensive scholarly and popular publications on the permanent collections; "Museum Studies", two issues per year; "New & Events" for members bi-monthly. **Administration:** Marshall Field, Pres.; James N. Wood, Dir.; Mary Solt, Registrar. **Curatorial Staff:** David Travis, Photography; Colin Westerbeck, Asst. Cur.; Christa Thurman, Textiles; Charles Stuckey, 20th-Century Painting & Sculpture; Neal Benezra; Courtney Donnell, Assoc Cur. **Conservatorial Staff:** William Leisher, Frank Zuccari.

MUSEUM OF CONTEMPORARY ART 312.280.2660
237 E. Ontario St., Chicago 60611 FAX: 312.280.2687
Hours: Tues-Sat 10-5; Sun 12-5; Closed Mon

Collection Highlights: Includes 3,300 works including painting, sculpture, drawing, prints, photography, film, video, audio works, installations & artists' books. Works by Bacon, Braque, Calder, Christo, Dubuffet, Duchamp, Magritte, Oldenburg, Paschke, & Warhol. **Publications:** Exhibition catalogues. **Administration:** Kevin E. Consey, Dir.; Lela Hersh, Registrar. **Curatorial Staff:** Bruce Guenther, Chief Cur.; Beryl Wright, Assoc. Cur.; Exhibitions; Lynne Warren, Assoc. Cur., Collections.

THE RENAISSANCE SOCIETY AT THE UNIVERSITY OF CHICAGO 312.702.8670
5811 S. Ellis Ave., Chicago 60637
Hours: Tues-Fri 10-4; Sat-Sun 12-4

Administration: Susanne Ghez.

TERRA MUSEUM OF AMERICAN ART 312.664.3939
666 N. Michigan Ave., Chicago 60611 FAX: 312.664.2052
Hours: Tues 12-8; Wed-Sat 10-5; Sun 12-5; Closed Mon

Collection Highlights: American Impressionism, Maurice Prendergast monotypes, early modernist paintings. **Administration:** Daniel J. Terra, Chrmn. of the Board; Harold P. O'Connell, Dir.; Jayne C.F. Johnson, Registrar. **Curatorial Staff:** D. Scott Atkinson; Jamie Smith, Cur. Asst.

INDIANA

INDIANAPOLIS MUSEUM OF ART 317.923.1331
1200 W. 38th St., Bloomington 46208 FAX: 317.926.8931
Hours: Tues-Wed, Fri-Sat 10-5; Thurs 10-8:30; Sun 12-5; Closed Mon

Collection Highlights: California light works; Cantor Collection of European art from 1950's; early 20th-century American & European art; installation work. **Publications:** Collections handbook; "Art of the Fantastic: Latin America, 1920-1987"; "Power: Its Myths and Mores In American Art, 1961-1991"; forefront exhibition catalogue. **Administration:** Bret Waller, Dir.; Vanessa Burkhart, Registrar. **Curatorial Staff:** Ellen W. Lee, Sr. Cur. of Painting and Sculpture; Holliday T. Day, Contemp. Art; Martin F. Krause, Prints and Drawings; James Robinson, The Jane Weldon Myers Cur. of Asian Art; Theodore Celenko, African, South Pacific and Pre-Columbian Art; Barry Shifman, Assoc. Cur. of Decorative Arts. **Conservatorial Staff:** Martin Radecki, David Miller.

IOWA

CEDAR RAPIDS MUSEUM OF ART 319.366.7503
410 Third Ave. S.E., Cedar Rapids 52401 FAX: 319.366.4111
Hours: Tues-Wed, Fri-Sat 10-4; Thurs 10-7; Sun 12-3; Closed Mon

Collection Highlights: Permanent collections of Grant Wood, Marvin Cone, Malvina Hoffman, James Swann, Mauricio Lasansky and Bertha Jaques. **Archival Description:** Extensive archival materials of permanent collection artists. **Administration:** Peter O. Stamats, Chrmn. of the Board; Joseph S. Czestochowski, Dir.; Reino J. Tuomala, Registrar. **Curatorial Staff:** Pam Curran, Exhibitions; Cindy Abel, Education.

DES MOINES ART CENTER 515.277.4405
4700 Grand Ave., Des Moines 50312 FAX: 515.279.3834
Hours: Tues-Wed, Fri-Sat 11-5; Thurs 11-9; Sun 12-5; Closed Mon

Collection Highlights: Paintings by Sargent, Bacon, Dubuffet, Rauschenberg, Johns, Stella and Kiefer. Sculptors whose works are represented include Moore, Arp, Brancusi, Smith, Oldenburg, Hesse and Judd. **Administration:** Charles C. Edwards, Jr., Pres.; M. Jessica Rowe, Dir.; Margaret Willard, Registrar. **Curatorial Staff:** Deborah Leveton, Assoc. Cur.; Lea Rosson DeLong, Adjunct Cur.

KANSAS

SPENCER MUSEUM OF ART 913.864.4710
University of Kansas, Lawrence 66045
Hours: Tues-Sat 8:30-5; Sun 12-5; Closed Mon

Collection Highlights: James Rosenquist, "One, Two, Three Outside"; Robert Cottingham, "Showboat"; Donald Judd, "Untitled Stack"; Louise Nevilson, "Seventh Decade Garden IX-X". **Publications:** "Calendar", a monthly newsletter; "The Register", an annual report with scholarly essays; Murphy Lectures in Art. **Administration:** Andrea S. Norris, Dir.; Janet Dreiling, Registrar. **Curatorial Staff:** Steve Goddard, Prints and Drawings; Pat Villeneuve, Education.

LOUISIANA

NEW ORLEANS MUSEUM OF ART 504.484.6662
P.O. Box 19123, 1 Lelong Ave., New Orleans 70179 FAX: 504.488.2631
Hours: Tues-Sun 10-5

Collection Highlights: American & European painting, sculpture, prints, drawings, photography, and the decorative arts. **Archival Description:** 25,000 volumes, slide library and archives. **Publications:** "Arts Quarterly"; "Handbook"; exhibition catalogues and brochures. **Administration:** Milton H. Ward, Pres.; E. John Bullard, Dir.; Paul Tarver, Registrar. **Curatorial Staff:** Daniel Piersol, Exhibitions; Nancy Barrett, Photography; William A. Fagaly, African, Oceanic & Native American Arts; John W. Keefe, Decorative Arts; Celia Liu, Traveling Exhibitions; Shirley Rabe Masinter, Education. **Conservatorial Staff:** Annette Breazeale.

MAINE

BOWDOIN COLLEGE MUSEUM OF ART 207.725.3275
Walker Art Building, Brunswick 04011 FAX: 207.725.3123
Hours: Tues-Sat 10-5; Sun 2-5; Closed Mon

Collection Highlights: Paintings by Marsden Hartley, Lyonel Feininger, Andrew Wyeth, Jack Tworkov, Alex Katz, Robert Bermelin, & Gregory Gillespie; collection of Vinalhaven Press Prints from 1985 to present; works by Man Ray & Eliot Porter, and contemporary photographers. **Publications:** "Handbook of The Collections" (1981); "Thomas Cornell Paintings: The Birth of Nature" (1990); "Katherine Porter: Paintings/Drawings" (1991). **Administration:** Katharine J. Watson, Dir.; Kathleen V. Kelley, Registrar.

PORTLAND MUSEUM OF ART 207.775.6148
7 Congress Square, Portland 04101 FAX: 207.773.7324
Hours: Tues-Sat 10-5; Thurs Open until 9; Sun 12-5

Collection Highlights: Contemporary works in all mediums by such artists as W. Allard, L. Allen, W. Barnet, D. Bell, P. Caponigro, M. Diamond, D. Durrance, P. Heroux, R. Indiana, Y. Jacquette, J. Kellar, M. Kuzio, F. Lynch, W. Manning, J. Nicoletti, E. Porter, and A. Shahn. **Administration:** Rachel F. Armstrong, Chrmn. of the Board; Leslie B. Otten, Pres.; Barbara Shissle Nosanow, Dir.; Barbara J. Redjinski, Registrar. **Curatorial Staff:** Martha Severens.

MARYLAND

THE BALTIMORE MUSEUM OF ART 301.396.7100
Art Museum Dr., Baltimore 21218 FAX: 301.396.6562
Hours: Tues-Wed, Fri 10-4; Thurs 10-7; Sat-Sun 11-6

Collection Highlights: Cone Collection of Matisse, Picasso & other Modern masters; Dalsheimer Collection of 20th-Century American & European Photographs; Levi & Wurtzburger Sculpture Gardens of Calder, Moore, and Ellsworth Kelly. **Publications:** "Dr. Claribel & Miss Ettg", Brenda Richardson (Cone Collection). **Administration:** Louis B. Thalheimer, Chrmn. of the Board; Arnold Lehman, Dir.; Melanie Harwood, Registrar. **Curatorial Staff:** Brenda Richardson, Painting & Sculpture Since 1900; Sona Johnston, Painting & Sculpture Before 1900; Jay Fisher, Prints, Drawings & Photographs; Wendy Coope, Decorative Arts; Frederick Lamp, Arts of Africa, the Americas & Oceania. **Conservatorial Staff:** Mary Sebera.

MASSACHUSETTS

HARVARD UNIVERSITY ART MUSEUMS 617.495.9400
Fogg Art, Busch-Reisinger, and Arthur M. Sackler Museums FAX: 617.495.9936
32 Quincy St., Cambridge 02138
Hours: Tues-Sun 10-5; Closed Mon

Collection Highlights: Important collections of post-war American art including works by Stella, Louis, Pollock, Rothko; 20th-century European works by such artists as Picasso, Matisse, Braque; Busch-Reisinger Museum includes collection of German Expressionist and East European Modernist works including Beckmann, Nolde, Klee, Kandinsky, El Lissitzky, Feininger, and Munch. **Archival Description:** Gropius, Feininger, and Bauhaus Archives at Busch-Reisinger. **Publications:** Regular program of publishing collections, special exhibition catalogues. **Administration:** James B. Cuno, Dir.; Jane Montgomery, Registrar. **Curatorial Staff:** Peter Nisbet, Daimler-Benz Cur. of Busch-Reisinger Museum; Marjorie Cohn, Carl A. Weyerhaeuser Cur. of Prints; William Robinson, Ian Woodner Cur. of Drawings. **Conservatorial Staff:** Henry Lie.

THE INSTITUTE OF CONTEMPORARY ART 617.266.5152
955 Boylston St., Boston 02115 FAX: 617.266.4021
Hours: Wed & Sun 11-5; Thurs, Fri, & Sat 11-8; Closed Mon & Tues

Collection Highlights: No permanent collection. The ICA curates and presents contemporary visual arts exhibitions. Film, video, performance and educational programs. **Administration:** Niki Friedberg, Pres.; Elisabeth Sussman, Dir.; Matthew Siegel, Registrar. **Curatorial Staff:** Elisabeth Sussman, Deputy Dir. of Programs, Chief Cur.; Matthew Teitelbaum; Ani Benglian, Asst. Cur. of Media; Gillian Levine, Music.

MUSEUM OF FINE ARTS 617.267.9300
465 Huntington Ave., Boston 02115 FAX: 617.267.0280
Hours: Tues-Sun 10-5; Wed 10-10; Thurs & Fri West Wing Only 5-10

Collection Highlights: Abstract painting including major works by Louis, Kline & Olitski. Sculpture highlights include works by Caro, Flavin & David Smith. Recent acquisitions include works by Baselitz, Kelly, Kiefer, Snyder, Warhol, and by Bleckner, Clemente & Starn. **Archival Description:** 250,000-volume art reference & research library. **Publications:** "Journal of The Museum of Fine Arts", an annual; annual report; monthly preview; exhibition & permanent collection catalogues. **Administration:** George Putnam, Chrmn. of the Board; Gale Guild, Pres.; Alan Shestack, Dir.; Linda Thomas, Registrar. **Curatorial Staff:** Trevor Fairbrother, Contemp. Art.

DISTRICT OF COLUMBIA (cont.)

NATIONAL GALLERY OF ART 202.737.4215
4th & Constitution Ave., N.W., Washington 20565 FAX: 202.789.2681
Hours: Mon-Sat 10-5; Sun 11-6

Collection Highlights: Modern and contemporary works in all mediums including J. Pollock, "Number 1 (Lavendar Mist)"; M. Rothko, "Red, Black, White On Yellow"; R. Lichtenstein, "Look Mickey"; W. Thiebaud, "Cakes"; D. Smith, "Cubi XXVI"; A. Kiefer, "Zim Zum". **Administration:** Franklin D. Murphy, Chrmn. of the Board; John R. Stevenson, Pres.; J. Carter Brown, Dir.; Mary Suzor, Registrar. **Curatorial Staff:** Charles S. Moffett, Sr. Cur. & Modern Paintings; Jack Cowart, Dept. Head, 20th-Century Art; Nan Rosenthal, 20th-Century Art; Ruth E. Fine, Modern Prints & Drawings; C. Douglas Lewis, Sculpture & Decorative Arts; Sarah Greenough, Photographs. **Conservatorial Staff:** Ross Merrill, David Bull.

NATIONAL MUSEUM OF AMERICAN ART 202.357.2700
8th & G St., Washington 20560
Hours: Daily 10-5:30

Administration: Elizabeth Brown, Dir.

THE PHILLIPS COLLECTION 202.387.2151
1600 21st St., N.W., Washington 20009
Hours: Tues-Sat 10-5; Sun 2-7; Closed Mon

Collection Highlights: Primarily 19th & 20th-century European and American paintings and sculpture, including Renoir's "Luncheon of the Boating Party" and works by Daumier, Cezanne, Klee, Bonnard, O'Keeffe and Rothko. **Archival Description:** 5,000 volumes; Duncan Phillips papers. **Publications:** Publications based on the collection, including exhibition catalogues and a quarterly bulletin. **Administration:** Laughlin Phillips, Dir. & Pres.; Joseph Holbach, Registrar. **Curatorial Staff:** Eliza Rathbone; Elizabeth Hutton Turner, Assoc. Cur.; Elizabeth Chew, Asst. Cur.; Willem de Looper, Consulting Cur.; Erika Passantino, Research Cur.; Grayson Harris, Asst. Research Cur. **Conservatorial Staff:** Elizabeth Steele.

FLORIDA

BASS MUSEUM OF ART 305.673.7530
2121 Park Ave., Miami Beach 33139 FAX: 305.673.7062
Hours: Tues-Sat 10-5; Sun 1-5; Closed Mon

Collection Highlights: 20th-century American graphics, architectural drawings and prints. **Publications:** Catalogues of special exhibitions, quarterly newsletter. **Administration:** Joyce Kaiser, Pres.; Diane W. Camber, Dir.; Edward Bann Williams, Registrar. **Curatorial Staff:** Wanda K. Texon, Education.

CENTER FOR THE FINE ARTS 305.375.3000
101 W. Flagler St., Miami 33130 FAX: 305.375.1725
Hours: Tues-Sat 10-5; Thurs 10-9; Sun 12-5; Closed Mon

Collection Highlights: The Center for the Fine Arts receives and initiates traveling exhibitions. It does not have a permanent collection. **Publications:** "CFA News". **Administration:** Gerald L. Greene, Pres.; Mark Ormond, Dir.; Arlene Dellis, Registrar. **Curatorial Staff:** Matt Zbornik, Cur. Asst.; Gloria Cabassa, Cur. Asst.

SALVADOR DALI MUSEUM 813.823.3767
1000 Third St. S., St. Petersburg 33701 FAX: 813.894.6068
Hours: Tues-Sat 10-5; Sun 12-5

Collection Highlights: A comprehensive collection of Salvador Dali's works. **Archival Description**: Approx. 5,000 volumes; extensive archival library on Dali and Surrealism. **Administration:** A. Reynolds Morse, Pres.; Marshall Rousseau, Dir. **Curatorial Staff:** Joan Kropf, Co-Director; Peter Tush, Asst. Cur.

SAMUEL P. HARN MUSEUM OF ART 904.392.9826
University of Florida, Gainesville 32611 FAX: 904.392.3892
Hours: Tues-Fri 11-5; Sat 10-5; Sun 1-5; Closed Mon

Collection Highlights: American paintings, prints, sculpture and photography. **Publications:** "Italian Old Master Drawings from the Collection of Jeffrey E. Horvitz", Linda Wolk-Simon. **Administration:** Budd Harris Bishop, Dir.; Peggy Bass Bridges, Registrar. **Curatorial Staff:** Larry Perkins, Collections; Anne Schroder, Exhibitions.

JACKSONVILLE ART MUSEUM 904.398.8336
4160 Boulevard Center Dr., Jacksonville 32207 FAX: 904.348.3167
Hours: Tues-Wed, Fri 10-4; Thurs 10-10; Sat & Sun 1-5

Collection Highlights: Works by artists such as Raffael, Pomodoro, Stella, Frankenthaler, Rosenquist, Katz, and Zakanitch. **Publications:** Exhibition Catalogues. **Administration:** Jeffrey Dunn, Pres.; Bruce Dempsey, Dir.; Barbara Salvage, Registrar. **Curatorial Staff:** Nofa Dixon, Education.

MUSEUM OF ART, INC. 305.525.5500
One East Las Olas Blvd., Fort Lauderdale 33301 FAX: 305.524.6011
Hours: Tues 11-9; Wed-Sat 10-5; Sun 12-5; Closed Mon

Collection Highlights: The Museum of Art holds a collection of over 5,250 works which includes The William Glackens Collection, CoBrA Art in the Americas and Primal, pre-Columbian, and American Indian art. **Archival Description:** 5,000 volumes, 8,000 exhibition catalogues, 12 periodicals, 100 videotapes, & 30,000 slides. **Publications:** Quarterly members' newletter and exhibition catalogues. **Administration:** Thomas P. O'Donnell, Pres.; Kenworth Moffett, Dir. **Curatorial Staff:** Jorge H. Santis, Collections.

MUSEUM OF FINE ARTS 813.896.2667
255 Beach Dr., N.E., St. Petersburg 33701 FAX: 813.894.4638
Hours: Tues-Sat 10-5; Sun 1-5; Closed Mon

Collection Highlights: Works by A. Jawlensky, B. Shann, G. O'Keeffe, L. Berkowitz, M. Canin, E. Donati, B. Greene, W. Pachner, J. Raffael, E. Trova, S. Brodsky. Prints by R. Mapplethorpe, F. Stella, R. Anuszkiewicz, R. Groom, A. Katz, R. Lichtenstein, R. Rauschenberg. **Publications:** "Mosaic", a bi-monthly newsletter to members; "Pharos", a bi-annual, scholarly publication of works in collection; museum exhibition catalogues. **Administration:** Charles W. Mackey, Pres.; Michael Milkovich, Dir.; Margarita G. Laughlin, Registrar. **Curatorial Staff:** Diane Lesko, Sr. Cur. of Collections & Exhibitions; Cynthia Duval, Decorative Arts & Asst. Dir.; Rebecca Russell, Education.

ORLANDO MUSEUM OF ART 407.896.4231
2416 North Mills Ave., Orlando 32803 FAX: 407.894.4314
Hours: Tues-Fri 9-5; Sat 10-5; Sun 12-5; Closed Mon

Collection Highlights: American art including 20th-century American print collection with more than 120 works on paper. **Administration:** William du Pont III, Pres.; Marena Grant Morrisey, Dir.; Andrea Farnick, Registrar. **Curatorial Staff:** Hansen Mulford, Exhibitions; Sue Scott, Contemp. American Art; Valerie Leeds, 19th-Century American Art; Susan Rosoff, Education.

TAMPA MUSEUM OF ART 813.223.8130
601 Doyle Carlton Dr., Tampa 33602 FAX: 813.223.8732
Hours: Tues-Sat 10-5; Wed 10-9; Sun 1-5; Closed Mon

Collection Highlights: Contemporary manipulated and fabricated photography (Baldessari, Skoglund, Sherman, Samaras, et al.) **Archival Description:** Specialized collections in Greek and South Italian antiquities, twentieth-century American art, important works on paper from all periods. **Administration:** A. Gerald Divers, Chrmn. of the Board; R. Andrew Maass, Dir.; Kay Morris, Registrar. **Curatorial Staff:** Genevieve Linnehan, Chief Cur.; J. Michael Padgett, Classical Art; Marilyn Mars, Education; R. Lynn Whitelaw, Asst. Cur., Education. **Conservatorial Staff:** Kay Morris.

GEORGIA

GEORGIA MUSEUM OF ART 404.542.3255
The University of Georgia, Athens 30602
Hours: Mon-Sat 9-5; Sun 1-5

Publications: "Elaine de Kooning" to be published in 1992. **Administration:** Jane K. Bledsoe, Dir.; Lynne Bowenkamp, Registrar. **Curatorial Staff:** Donald D. Keyes, American Painting; Patrici. Phagan, Prints & Drawings; Susan Longhenry, Education.

HIGH MUSEUM OF ART 404.892.3600
1280 Peachtree St., N.E., Atlanta 30309 FAX: 404.898.9578
Hours: Tues-Sat 10-5; Sun 12-5

Collection Highlights: The 20th-century collection contains both American and European work. Collecting activity focuses on the representation of works from 1970 to the present. Notable works include those by Ernst, Rothko, Gorky, Gottlieb and George L.K. Morris. **Publications:** Bi-monthly calendar, exhibition catalogues for HMA-organized exhibitions, bi-annual reports. **Administration:** Richard A. Denny, Jr., Pres.; Ned Rifkin, Dir.; Frances Francis, Registrar. **Curatorial Staff:** Ronni Baer, Assoc. Cur., European Art; Linda Dubler, Film & Video; Susan Krane, 20th-Century Art; Judy Larson, American Art; Donald Peirce, Decorative Arts; Carrie Przybilla, Asst. Cur., 20th-Century Art.

HAWAII

THE CONTEMPORARY MUSEUM 808.526.1322
2411 Makiki Heights Dr., Honolulu 96822 FAX: 808.536.5973
Hours: Tues-Sat 10-4; Sun 12-4; Closed Mon

Collection Highlights: Changing exhibitions of regional, national, and international contemporary art; sculpture garden; David Hockney environmental installation "L'Enfant et les Sortileges" based on Ravel's 1925 opera. **Administration:** Merrill C. Rueppel, Dir.; Deborah Dunn, Registrar. **Curatorial Staff:** James F. Jensen, Assoc. Dir. & Cur.; Catherine Wheeler, Exhibitions Coor..

HONOLULU ACADEMY OF ARTS 808.538.3693
900 S. Beretania St., Honolulu 96814 FAX: 808.521.6591
Hours: Tues-Sat 10-4:30; Sun 1-5; Closed Mon

Collection Highlights: Contemporary collection includes paintings, works on paper, and sculpture by such artists as Francis Bacon, Jim Dine, Robert Rauschenberg, Hans Hoffman, Helen Frankenthaler, Leon Golub and Richard Diebenkorn. **Administration:** Henry B. Clark, Jr., Chrmn of the Board; George R. Ellis, Dir.; Sanna Saks Deutsch, Registrar. **Curatorial Staff:** Jennifer Saville, Western Art; Stephen Little, Asian Art; James Furstenberg, Public Programs; Darrell Davis, Film & Video; Karen Thompson, Gallery Education.

IDAHO

BOISE ART MUSEUM 208.345.8330
670 S. Julia Davis Dr., Boise 83702 FAX: 208.345.8333
Hours: Tues-Fri 10-5; Sat-Sun 12-5

Collection Highlights: Janss Collection of American Realism; arranged image photography; regional contemporary artists. **Publications:** "100 Years of Idaho Art: 1850-1950"; "Yard Art"; "Milton Avery". **Administration:** Pat J. Nelson, Pres.; Dennis O'Leary, Dir.; Jen Ray, Registrar. **Curatorial Staff:** Sandy Harthorn, Exhibitions; Richard A. Young, Education.

ALABAMA

BIRMINGHAM MUSEUM OF ART 205.254.2566
2000 Eighth Ave. North, Birmingham 35203 FAX: 205.254.2714
Hours: Tues-Sat 10-5; Thurs Evening until 9; Sun 1-5; Closed Mon

Collection Highlights: Consists of work from the corners of the world from ancient to modern times. Areas of specialty include painting and sculpture, Oriental, pre-Columbian, African, Native American, and decorative art, photography & graphic works. **Archival Description:** 10,000+ volumes; non-circulating art research library is open to students, scholars and the general public by appointment. **Administration:** William M. Spencer III, Chrmn. of the Board; Douglas K.S. Hyland, Dir.; Melissa B. Falkner, Registrar. **Curatorial Staff:** Dr. John Wetenhall, Painting & Sculpture; Don Wood, Oriental Art; Bryding Henley, Decorative Arts; Ellen Elsas, Pre-Columbian, African & Native American; Trudy Wilner Stack, Assoc. Cur., Photography & Graphic Works.

ARIZONA

PHOENIX ART MUSEUM 602.257.1880
1625 N. Central Ave., Phoenix 85004 FAX: 602.253.8662
Hours: Tues, Thurs, Fri, Sat 10-5; Wed 10-9; Sun 12-5

Collection Highlights: "Flowers, Italy", Stella; "Pictogram", Manierre Dawson; "Woman by A Window", Richard Diebenkorn; "Noel On A Pony With Cloud", Joan Brown; "Dodge City", Billy Al Bengston; "Sirocco", Gregory Amenoff; "Untitled", Jill Giegerich; "No Place", Mike Kelley. **Archival Description:** 30,000 volumes, 100 periodical subscriptions. **Publications:** "Frank Lloyd Wright Drawings", co-published with The Frank Lloyd Wright Foundation & Harry N. Abrams; bi-monthly Phoenix Art Museum Members' Calendar. **Administration:** L. Gene Lemmon, Pres.; James K. Ballinger, Dir.; Heather D. Northway, Registrar. **Curatorial Staff:** Bruce D. Kurtz, 20th-Century Art; Claudia Brown, Asian Art; Susan P. Gordon, European Art; Jean Hildreth, Costume; Janet E. Krulick, Education; Karen C. Hodges, Asst. Cur.

ARKANSAS

THE ARKANSAS ARTS CENTER 501.372.4000
P.O. Box 2137, MacArthur Park, Little Rock 72203
Hours: Mon-Sat 10-5; Sun 12-5

Collection Highlights: Focuses on drawings in all media, and includes work by Picasso, Gris, Beckmann, Freud, Giacometti, Mondrian, Modigliani, Bellows, Sheeler, Marin, Dove, Gorky, Pollock, Diaziotes, Motherwell, de Kooning, Tworkov, Dine, Avery & Krasner. **Publications:** 12 exhibition catalogues (1983-1990) available. **Administration:** James H. Atkins, Chrmn. of the Board; Curt Bradbury, Pres.; Townsend Wolfe, Dir.; Thom Hall, Registrar. **Curatorial Staff:** William T. Henning; Alan DuBois, Decorative Arts; Karen Bryant, Asst. Cur.

CALIFORNIA

CROCKER ART MUSEUM 916.449.5423
216 O St., Sacramento, CA 95814
Hours: Tues-Sun 10-5; Thurs Evenings until 9; Closed Mon

Collection Highlights: Northern California art since 1945. **Administration:** Robert Bell, Pres.; Barbara Gibbs, Dir.; Paulette Hennum, Registrar. **Curatorial Staff:** Janice T. Driesbach; Steve Wilson; Patrick Minor.

LOS ANGELES COUNTY MUSEUM OF ART 213.857.6111
5905 Wilshire Blvd., Los Angeles 90036
Hours: Tues-Fri 10-5; Sat-Sun 10-6

Administration: Robert Powell

THE MUSEUM OF CONTEMPORARY ART 213.626.6222
MOCA at Cal. Plaza, 250 S. Grand Ave., Los Angeles 90012 FAX: 213.620.8674
MOCA at the Temporary Contemp., 152 N. Central Ave., Los Angeles 90013
Hours: Tues-Sun 11-6; Thurs Evenings until 8; Closed Mon

Collection Highlights: Works by Ellsworth Kelly, Anselm Kiefer, Franz Kline, Elizabeth Murray, Claes Oldenburg, Jackson Pollock, Robert Rauschenberg, Susan Rothenberg, Mark Rothko, Edward Ruscha, David Salle, Julian Schnabel, Joel Shapiro, and Cindy Sherman. **Publications:** "Individuals: A Selected History of Contemporary Art"; "John Baldessari"; "Arata Isozaki: Architecture 1960-1990". **Administration:** Frederick M. Nichols, Chrmn. of the Board; Douglas S. Cramer, Pres.; Richard Koshalek, Dir.; Mo Shannon, Registrar. **Curatorial Staff:** Kerry Brougher, Assoc. Cur.; Ann Goldstein, Assoc. Cur.; Julie Lazar; Alma Ruiz, Exhibitions Coordinator; Paul Schimmel, Chief Cur.; Elizabeth Smith.

NEWPORT HARBOR ART MUSEUM 714.759.1122
850 San Clemente, Newport Beach 92660 FAX: 714.759.5623
Hours: Tues-Sun 10-5

Collection Highlights: The permanent collection focuses on post-World War II California art. Its changing exhibitions feature local, national and international, modern and contemporary art. **Publications:** Bi-monthly members' calendar, exhibition catalogs, informational and educational brochures. **Administration:** Joan Beall, Pres.; Michael Botwinick, Dir.; Betsy Severance, Registrar. **Curatorial Staff:** Ellen Breitman, Acting Head, Cur. Dept.; Marilu Knode, Asst. Cur.

SAN DIEGO MUSEUM OF CONTEMPORARY ART 619.454.3541
700 Prospect St. La Jolla 92037 FAX: 619.454.6985
Hours: Tues-Sun 10-5; Wed 10-9; Closed Mon

Collection Highlights: Works from the 60's, 70's & 80's by Acconci, Baldessari, Andre, Burton, Flavin, Ruscha, Judd, Lewitt, Holzer, Lichtenstein, Oldenburg, Shapiro, Puryear, Gillespie & Stella. A distinguished collection of Pop, Conceptual and Minimal works. **Publications:** Include "Judith Shea", Lynda Forsha; "Douglas Huebler", Ronald J. Onorato; "Vernon Fisher", Dave Hickey; "Alfredo Jaar", Madeleine Grynsztejn. **Administration:** Lela G. Axline, Pres.; Hugh M. Davies, Dir.; Mary Johnson, Registrar. **Curatorial Staff:** Lynda Forsha, Head Cur., Contemp. Art; Madeleine Grynsztejn, Assoc. Cur., Contemp. Art.

SAN FRANCISCO MUSEUM OF MODERN ART 415.252.4000
401 Van Ness Ave., San Francisco 94102 FAX: 415.863.0603
Hours: Tues-Wed, Fri 10-5; Thurs 10-9; Sat-Sun 11-5; Closed Mon

Collection Highlights: International in scope, the permanent collection consists of more than 14,000 works in all mediums, including a growing collection of media and video works. Paintings by artists associated with the American Abstract Expressionist school. **Archival Description:** Louise Sloss Ackerman Fine Arts Library contains over 13,000 volumes. **Administration:** Brooks Walker, Jr., Chrmn. of the Board; Elaine McKeon, Pres.; John R. Lane, Dir.; Tina Garfinkel, Registrar. **Curatorial Staff:** John Caldwell, Painting and Sculpture; Sandra S. Phillips, Photography; Paolo Polledri, Architecture and Design; Robert Riley, Media Arts. **Conservatorial Staff:** J. William Shank.

UNIVERSITY ART MUSEUM 213.985.5761
Cal. State Univ., 1250 Bellflower, Long Beach 90840 FAX: 213.985.7602
Hours: Tues-Sat 11-5; Sun 1-5; Closed June-August

Collection Highlights: Contemporary works on paper, including photographs. Monumental outdoor sculpture collection available for viewing year-round. **Publications:** Publications include exhibition catalogues, major catalogues raisonnes, exhibition brochures for UAM series of exhibits known as "Centric". **Administration:** Constance W. Glenn, Dir. **Curatorial Staff:** Diana C. Du Pont, Exhibitions. **Conservatorial Staff:** Marie Laibinis-Craft.

UNIVERSITY ART MUSEUM 415.642.1207
Univ. of Cal., Berkeley, 2625 Durant Ave., Berkeley 94720 FAX: 415.642.4889
Hours: Wed-Sun 11-5; Closed Mon & Tues

Collection Highlights: International in scope, the permanent collection of the University Art Museum/Pacific Film Archive is comprised of a full range of art forms including film and video. Emphasis is painting and sculpture. **Publications:** "Rosemarie Trockel"; "The Independent Group: Post-War Britain and the Aesthetics of Plenty"; "Anxious Visions: Surrealist Art". **Administration:** Noel Nellis, Pres.; Jacquelynn Baas, Dir.; Lisa Calden, Registrar. **Curatorial Staff:** Lawrence Rinder, Contemp. Art.

COLORADO

COLORADO SPRINGS FINE ARTS CENTER 719.634.5581
30 West Dale St., Colorado Springs 80903 FAX: 719.634.0570
Hours: Tues-Fri 9-5; Sat 10-5; Sun 1-5

Collection Highlights: Include Arthur Dove, "Foghorns"; Georgia O'Keeffe, "Iris"; Humphrey's Collection of Contemporary Native American Prints. **Archival Description:** Museum archives of exhibition & administrative records dating from 1936. **Publications:** Approximately one museum book or catalogue published per year. **Administration:** David J. Wagner, Dir.; Kathy Reynolds, Registrar. **Curatorial Staff:** Cathy Wright, Dir. of Collections & Exhibitions; Gerry Riggs, Fine Art.

DENVER ART MUSEUM 303.640.2793
100 W. 14th Ave. Parkway, Denver 80204
Hours: Tues-Sat 10-5; Sun 12-5

Administration: Lewis Sharp, Dir.

DELAWARE

DELAWARE ART MUSEUM 302.571.9590
2301 Kentmere Parkway, Wilmington 19806 FAX: 302.571.0220
Hours: Tues 10-9; Wed-Sat 10-5; Sun 12-5

Collection Highlights: American prints & paintings on rotating view. **Publications:** Various permanent and temporary collections catalogues. **Administration:** Steven Rothschild, Pres.; Stephen T. Bruni, Dir.; Mary F. Holahan, Registrar. **Curatorial Staff:** Jenine Culligan, American Art; Rowland Elzea, Pre-Raphaelites & American Illustration; Mary F. Holahan, 19th Century.

DISTRICT OF COLUMBIA

THE CORCORAN GALLERY OF ART 202.638.3211
17th St. & New York Ave. N.W., Washington 20006 FAX: 202.737.2664
Hours: Tues-Sun 10-4:30; Thurs until 9

Collection Highlights: Include works of such 20th-century masters as Joseph Albers, Richard Diebenkorn, Helen Frankenthaler, Louise Nevelson, Mark Rothko and Andy Warhol. The Edward and Mary Walker Collection of Late 19th & 20th Century Paintings. **Publications:** Exhibition catalogs, monthly calendar, annual report. **Administration:** Mr. Robin B. Martin, Chrmn. of the Board; David C. Levy, Dir. & Pres.; Cindy Rom, Registrar. **Curatorial Staff:** William B. Bodine, Jr., Assoc. Dir., Curatorial Affairs; Terrie Sultan, Contemp. Art; Barbara Moore, Education; Frances Fralin, Asst. Cur., Photography. **Conservatorial Staff:** Dare Hartwell.

HIRSHHORN MUSEUM AND SCULPTURE GARDEN 202.357.3091
Independence Ave. At 7th St., S.W., Washington 20560 FAX: 202.786.2682
Hours: Daily 10-5:30; Closed December 25

Collection Highlights: Broad holdings in sculpture (Matisse, Giacometti, Picasso, D. Smith, Arneson, Jetelova, Puryear, Kapoor). Painting strengths include New York School, post-war Europeans, and spectrum of current works (Kiefer, Scully, Freud, Wiley, Fischl, Richter). **Archival Description:** 36,000-volume library and collection archive. **Publications:** Catalogs, brochures, quarterly events calendar. **Administration:** Jerome Greene, Chrmn. of the Board; James T. Demetrion, Dir.; Douglas Robinson, Registrar. **Curatorial Staff:** Amada Cruz, Asst. Cur., Contemp. Art; Valerie J. Fletcher, Sculpture; Frank Gettings, Prints & Drawings; Phyllis Rosenzweig, Contemp. Art; Judith Zilczer, Painting. **Conservatorial Staff:** Laurence Hoffman, A. Clarke Bedford.

MUSEUMS

	1991			1992								
SEPT	**OCT**	**NOV**	**DEC**	**JAN**	**FEB**	**MAR**	**APR**	**MAY**	**JUN**	**JUL**	**AUG**	
												ONTARIO
												T O R O N T O
Wolfgang Keuchl/Photographers	A. Kertész/H. Bristol/S. Coroni		L. Koch/C. von Tiedemann	Sandy Skoglund/Women on Women	Sheila Metzner/Modernism		Robert Bourdeau/Lisette Model	Rick Zolkower/Lubo Stacho		Edward S. Curtis		JANE CORKIN GALLERY 416.979.1980
Michael Smith	A. Colville/W. Bachinski	Marc Garneau	David Thauberger	Group Exhibition		Gordon Rayner	Victor Cicansky					THE DRABINSKY GALLERY 416.324.5766
Christopher Broadhurst	Douglas Stone	David Blackwood	Pat Service									GALLERY ONE ARTS INC. 416.929.3103
Yoshi Sankawa	Louis Comtois	Roland Poulin	Roland Brener	Susanna Heller	Henry Saxe	Tim Whiten						OLGA KORPER GALLERY 416.538.8220
Jordan Maclachlan	P. Amiot/Group Show	G. Fowler/B. McCarthy / Brian Jones		Vibrant New Faces	Diana Dean	Invitational 92	L. Climo/E. Higgins	V. Palmer/A. Valko	American Ceramics			NANCY POOLE'S STUDIO 416.964.9050
Arlene Stamp	D. Bierk/D. McCarthy	John Hall	Carroll Moppett	Janice Gurney	Gerald Ferguson	Guido Molinari	David Bierk	Gathie Falk	Ted Rettig	Gallery Artists #1	Gallery Artists #2	WYNICK/TUCK GALLERY 416.364.8716
												PROVINCE OF QUEBEC
												M O N T R E A L
Peggy Jarrell Kaplan	Post-War Amer. Abstraction			Scandia Design		Renate Pensold Motherwell	Art of Collage			Architecture on Paper		GALERIE JOHN A. SCHWEITZER 514.289.9262

GALLERY SCHEDULES

	1990				1991							
	SEPT	OCT	NOV	DEC	JAN	FEB	MAR	APR	MAY	JUN	JUL	AUG

ONTARIO

TORONTO

Gallery	SEPT	OCT	NOV	DEC	JAN	FEB	MAR	APR	MAY	JUN	JUL	AUG
JANE CORKIN GALLERY 179 John St., Ste. 302, Toronto M5T 1X4	André Kertész	Horst/Linda McCartney		Herb Ritts	B. Cole/D. Arbus		Carol Marino	M. Spano/J. Birchwood		G. Zimbel/M. Henrickson		Nigel Scott/Greg Staats
THE DRABINSKY GALLERY 86 Scollard St., Toronto M5R 1G2												
GALLERY ONE ARTS INC. 121 Scollard St., Toronto M5R 1G	Stanley Boxer	David Blackwood	Lynn Donoghue	Group Show	Harold Feist	Darryl Hughto	Joseph Drapell	Michael Matthews	Brian Burnett	Stanley Boxer	Larry Zox	Catherine McAvity
OLGA KORPER GALLERY 17 Morrow Ave. Toronto M6R 2H9	Roland Poulin	Lucio DeHeusch	Claude Mongrain	Leopold Plotek	John Noestheden	Helen Sebelius	Claude Luneau	Greg Murdock	Ian Averbuch	Bobbie Oliver	Modus Operandi	
NANCY POOLE'S STUDIO 16 Hazelton Ave., Toronto M5R 2E2	J. Maclachlan/C. French	E. Higgins/I. Kann	B. Jones/Impressionists	W. Blom/P. Amiot	Realism I/Landscape II	D. Ireland/D. Dean	L. Climo/N.A. Indian Art	V. Thierfelder/A. Dumas	C. Stewart/A. Valko	Ceramics/P. Craig		John B. Boyle
WYNICK/TUCK GALLERY 80 Spadina Ave., 4th Fl., Toronto M5V 2J3	The Salvage Paradigm	David Bierk	Gerald Ferguson	D. Foo Fat/J. Clark	Sorel Cohen	T. Urquhart/Gallery Artists	Richard Storms	Greg Curnoe	Landon Mackenzie	Gallery Artists #1	Gallery Artists #2	Gallery Artists #3

PROVINCE OF QUEBEC

MONTREAL

Gallery	SEPT	OCT	NOV	DEC	JAN	FEB	MAR	APR	MAY	JUN	JUL	AUG
GALERIE JOHN A. SCHWEITZER 42 ouest, avenue des Pins Montreal H2W 1R1	American Drawings		Venetian Glass		Private-Scale Sculpture		European Ceramics		Tribal Art of Oceania		Camera Lucida	

1991 | **1992**

Gallery	SEPT	OCT	NOV	DEC	JAN	FEB	MAR	APR	MAY	JUN	JUL	AUG

OREGON

PORTLAND

AUGEN GALLERY — 503.224.8182

JAMISON/THOMAS GALLERY — 503.222.0063

SEPT	OCT	NOV	DEC	JAN	FEB	MAR	APR	MAY	JUN	JUL	AUG
Cyrilla Mozenter		Mark Bulwinkle			David Jeffrey	Gregory Grenon		Heather Hutchison			
	D. Jeffrey/S. Buehler			Flechemuller/Calderon					Invitational Group Show		

LAURA RUSSO GALLERY — 503.226.2754

SEPT	OCT	NOV	DEC	JAN	FEB	MAR	APR	MAY	JUN	JUL	AUG
J. Portland/D.L. Louis		NW Invit. Glass Exhib.		Introduction Show		G. Ruffner/M.V. Thompson		Michihiro Kosuge		Cie Goulet	
	T. Fawkes/C. Gander		Frederick Heidel		Fay Jones				Stephen McClelland		

PENNSYLVANIA

PHILADELPHIA

ART SPACE GALLERY — 215.557.6555

SEPT	OCT	NOV	DEC	JAN	FEB	MAR	APR	MAY	JUN	JUL	AUG
D.R. Piqtoukun/J. Hill		91 Cape Dorset Prints		Kitikmeot				Haida Gwai			
			J. Cranmer/S. Point								

LARRY BECKER — 215.925.5389

SEPT	OCT	NOV	DEC	JAN	FEB	MAR	APR	MAY	JUN	JUL	AUG
Survey + R. Miller/M. Murphy			Works on Paper		Rebecca Johnson		Bill Walton				
	Iwan Nazarewycz										

JESSICA BERWIND GALLERY — 215.574.1645

SEPT	OCT	NOV	DEC	JAN	FEB	MAR	APR	MAY	JUN	JUL	AUG
Bonnie Levinthal		Betsey Batchelor			Mary Nomecos		Cheryl Goldsleger				
	B. Levinthal/E. Spirer			Objects In All Mediums		Ruth Thorne-Thomsen	Fritz Dietel				

PAUL CAVA GALLERY — 215.627.1172

SEPT	OCT	NOV	DEC	JAN	FEB	MAR	APR	MAY	JUN	JUL	AUG
4 Photographers on the Figure											

HELEN DRUTT GALLERY — 215.735.1625

SEPT	OCT	NOV	DEC	JAN	FEB	MAR	APR	MAY	JUN	JUL	AUG
Festival: Mythos/Czech Modern 91			Gold/Amer. Ceramics			Group Show					
	G. Bakker/Group Show			Australia Now							

JANET FLEISHER GALLERY — 215.545.7562

SEPT	OCT	NOV	DEC	JAN	FEB	MAR	APR	MAY	JUN	JUL	AUG
Visionary Architecture		Bill Traylor		Obsession		Susan Chrysler White	CIAE				
	Bruce Pollock		Group Show		Kamante Gatura		John Ferris		Group Show		

LAWRENCE OLIVER GALLERY — 215.751.9084

SEPT	OCT	NOV	DEC	JAN	FEB	MAR	APR	MAY	JUN	JUL	AUG
J. Krok/S. Beyer/C. Schorr		Anton Henning									
			Stephen Estock								

TEXAS

HOUSTON

ALTERMANN & MORRIS GALLERIES — 713.840.1922

SEPT	OCT	NOV	DEC	JAN	FEB	MAR	APR	MAY	JUN	JUL	AUG
Afsary/Balciar/Sander		TX Renaissance			Amer. Art Classic VII			Collectors Sale XII	Introduction 92		
			Small Works			Glenna Goodacre					

HIRAM BUTLER GALLERY — 713.863.7097

SEPT	OCT	NOV	DEC	JAN	FEB	MAR	APR	MAY	JUN	JUL	AUG
Levine/Dwyer/Horn		M. Hollis/J. Martin		Group Show/Brice Marden		H. Federle/S. Levine		The Garden	The Hand		

LANNING GALLERY — 713.524.5670

SEPT	OCT	NOV	DEC	JAN	FEB	MAR	APR	MAY	JUN	JUL	AUG
War		T. Barddal/C. Stuckey		D. Kemmerer/M. Wade			Invitational Group Show	Debut			
	Toby Topek				B. Jaffe/B. Poulos			Gary Parker			

WASHINGTON

SEATTLE

LISA HARRIS GALLERY — 206.443.3315

SEPT	OCT	NOV	DEC	JAN	FEB	MAR	APR	MAY	JUN	JUL	AUG
Manda Beckett		David McGranaghan		Charles Buell		Steve Engle		Lois Silver	Michael Greenspan		
	Richard Morhous	Gary Nisbet			Brian Chapman		Victoria Adams		Robert Buchanan	David Green	

GREG KUCERA GALLERY — 206.624.0770

SEPT	OCT	NOV	DEC	JAN	FEB	MAR	APR	MAY	JUN	JUL	AUG
Deborah Butterfield		Karin Helmich									
	8th Anniversary Exhib.	Frank Okada									

FRANCINE SEDERS GALLERY LTD. — 206.782.0355

SEPT	OCT	NOV	DEC	JAN	FEB	MAR	APR	MAY	JUN	JUL	AUG
	D. Carmichael/A. Lau	Ikune Sawada			F. Birchman/M. Wenet		Charles Nathan		Drawings		
		Elizabeth Sandvig		Karen Ganz		Dale Lindman		Bruce Park	Andreas Grunert		

CANADA

BRITISH COLUMBIA

VANCOUVER

PATRICK DOHENY FINE ART LTD. — 604.737.1733

SEPT	OCT	NOV	DEC	JAN	FEB	MAR	APR	MAY	JUN	JUL	AUG
S. Westlaken/M.A. Liu		Vicky Marshall			G. Pearson/B. Van Der Mey		R. Sutherland/C. Ducote				
	W. Eastcott/J.C. Watts	Alan Wood				M. Crenshaw/A. Shives					

DIANE FARRIS GALLERY — 604.737.2629

SEPT	OCT	NOV	DEC	JAN	FEB	MAR	APR	MAY	JUN	JUL	AUG
N. Wedman/R. Brener		L. Doucette/J. Koerner		Gallery Invitational				Attila Richard Lukacs			
	Xiong/Spalding/British Columbia	Gallery Artists									

HEFFEL GALLERY LIMITED — 604.732.6505

SEPT	OCT	NOV	DEC	JAN	FEB	MAR	APR	MAY	JUN	JUL	AUG
Jim McKenzie		Bonifacho				Richard Overfield			Britton Francis		
	David Blackwood		W.P. Weston								

PRIOR EDITIONS — 604.685.0535

SEPT	OCT	NOV	DEC	JAN	FEB	MAR	APR	MAY	JUN	JUL	AUG
Carel Moiseiwitsch											
	David Ostrem										

GALLERY SCHEDULES

	1990				1991							
	SEPT	OCT	NOV	DEC	JAN	FEB	MAR	APR	MAY	JUN	JUL	AUG

OREGON

PORTLAND

Gallery	SEPT	OCT	NOV	DEC	JAN	FEB	MAR	APR	MAY	JUN	JUL	AUG
AUGEN GALLERY, 817 S.W. Second Ave., Portland 97204	L.A. Latremoille	Peter Juvonen	Dan Allison	Bill Brewer	Shelly Jordan	Debra Norby	Julia O'Reilly	K.C. Joyce	Recent Prints from Tamarind Institute			
JAMISON/THOMAS GALLERY, 1313 N.W. Glisan, Portland 97209	Heather Hutchison	Flechemuller	Gregory Gremon		Eric Stotik	Stuart Buehler	Invitational Group Show		H. Hutchison/Flechemuller	Group Show		
LAURA RUSSO GALLERY, 805 N.W. 21st Ave., Portland 97209	Carl Morris	S. Duryea/M. Kosuge	J.P. Fawkes/I. Scanga	Ann Griffin Johnson	Isaka Shamsud-Din	G. Wilson/M. Brophy	L. Parker/R. Brown	Claudia Cave	R. Rickabaugh/M. Burks	M. Katz/M. Russo	Group Exhibition	K. Guzak/A. Surmon

PENNSYLVANIA

PHILADELPHIA

Gallery	SEPT	OCT	NOV	DEC	JAN	FEB	MAR	APR	MAY	JUN	JUL	AUG
ART SPACE GALLERY, 2100 Spring St., Philadelphia 19103	Men, Myth & Mountains	Woman's Vision		Alaskan Discoveries	Reality & Ritual		Judy Cranmer	Inuit Group Show	Inuit Miniures	NW Coast Prints	Art of Everyday Life	
LARRY BECKER, 43 N. Second St., Philadelphia 19106	Survey + R. Rose/D. Goerk	Darwin Nix		Publication Nix Aquatints	Marc Rosenquist		David Goerk		Robin Rose	Gallery Artists		
JESSICA BERWIND GALLERY, 301 Cherry St., 2nd Fl., Philadelphia 19106												
PAUL CAVA GALLERY, 22 N. Third St., Philadelphia 19106		Inaugural Group Exhibition	Jim Muehlemann		Jock Sturges		Thomas Nozkowski / John Newman/Mel Bochner	Brower Hatcher			Object/Subject: Sculpture/Installation	
HELEN DRUTT GALLERY, 1721 Walnut St., Philadelphia 19103	Chang/Shutov/Winokur	Bruno Martinazzi	M. Becker/A. Currier	R. Laskin/W. Higby	17 years: 1974 - 1991				B. O'Casey/R. Staffel			
JANET FLEISHER GALLERY, 211 S. 17th St., Philadelphia 19103	Image	Text	Gregory Van Maanen	Objects of Magic	Frank Jones	Simon Sparrow	Gladys Nilsson	Anda Dubinskis	CIAE	Group Show		
LAWRENCE OLIVER GALLERY, 1617 Walnut St., Philadelphia 19103	Olivier Richon	Stephen Westfall		Group Exhibition		Ala-Shehr	Group Exhibition		S.A. Bachman	Summer Group Exhibition		

TEXAS

HOUSTON

Gallery	SEPT	OCT	NOV	DEC	JAN	FEB	MAR	APR	MAY	JUN	JUL	AUG
ALTERMANN & MORRIS GALLERIES, 3461 W. Alabama, Houston 77027		TX Renaissance	Small Works			Amer. Art Classic VI	C. James Frazier	John Paul Strain	Collectors Sale XI		Introductions 91/Larry Ludtke	
HIRAM BUTLER GALLERY, 4520 Blossom St., Houston 77007	John Beerman	Dean Ruck	James Turrell		Doug MacWithey	C. Ernst/P. Kittelson	Terrell James			Creeley/Bluhm/Surls	The Circle & The Square	
LANNING GALLERY, 223 Westheimer, Ste. 100, Houston 77006	M. Newquist/S. Stout	Andreas Hadialexiou	John Calaway/Marci HarndenJ.		J. Daniel/G. Frields	Gary Parker		Jack Livingston	Lin Swanner	Debut War		

WASHINGTON

SEATTLE

Gallery	SEPT	OCT	NOV	DEC	JAN	FEB	MAR	APR	MAY	JUN	JUL	AUG
LISA HARRIS GALLERY, 1922 Pike Pl., Seattle 98101	Lois Silver	Victoria Adams	Robert Buchanan	Gallery Artists	Thomas Wood	Eugene Pizzuto	Deborah DeWit	Other Realms		John Cole	Joan Gold	Gallery Artists
GREG KUCERA GALLERY, 626 Second Ave., Seattle 98104	Alden Mason	7th Anniv. Exhibition	Cheryl Laemmle		J. Isaacson/J. Mitchell / R.P. Beecher/Pilchuck Monotypes	K. Kelly/Geometry & Minimalism	M. Calderon/A. Rowland	R. Shimomura/D. Sultan	F. Celentano/D. Rey	M. Lere/E. Murray	Oversized Prints & Portfolios	Bad Politics
FRANCINE SEDERS GALLERY LTD., 6701 Greenwood Ave. N., Seattle 98103	Barbara E. Thomas	Michael Dailey	Pat DeCaro		Robert C. Jones	M. Dingus/E. Musante	Michael Spafford		25th Anniv. Exhibition			

CANADA

BRITISH COLUMBIA

VANCOUVER

Gallery	SEPT	OCT	NOV	DEC	JAN	FEB	MAR	APR	MAY	JUN	JUL	AUG
PATRICK DOHENY FINE ART LTD., 1811 W. First Ave., Vancouver V6J 4M6												
DIANE FARRIS GALLERY, 1565 W. Seventh Ave., Vancouver V6J 1S1	Attila Richard Lukacs	V. Marshall/J. Koerner	Philippe Raphanel	Mary Frances Tuck	Gallery Invit./Big Picture	M. Fouquet/F. Mayrs	R. Hill/W. Hamlin	D. Root/D. Walker/A. Grossmann	L. Papov/P. Kuhn	Gillmore/Bierk/Masse	Gallery Artists	
HEFFEL GALLERY LIMITED, 2247 Granville St., Vancouver V6H 3G1	Yousuf Karsh	Peter Aspell	E.J. Hughes	Arnold Shives			David Alexander	Walter Bachinski	Lori-Ann Latremouille	Britton Francis		Selected Works
PRIOR EDITIONS, 303-1028 Hamilton St., Vancouver, V68 2R9												

Gallery	SEPT (1991)	OCT	NOV	DEC	JAN (1992)	FEB	MAR	APR	MAY	JUN	JUL	AUG
NEW YORK *(cont.)* / **NEW YORK CITY**												
FORUM GALLERY 212.355.4545	Alan Feltus											
GAGOSIAN GALLERY 212.744.2313	Francesco Clemente											
GALERIE TAMENAGA 212.734.6789		Hiroshi Asada	Giorgio Scalco		Masao Haijima							
FOSTER GOLDSTROM 212.941.9175	A.H. Meyers/S. Briscoe; David Maxim	David Maxim	David Maxim	Katherine Parker; Louise Nevelson	Dong Phan	Nathan Oliveira	Frank Stella	Charles Simonds	Raymond Waydelich	George Rickey		Gallery Artists
HAMMER GALLERIES 212.644.4400		R. Beal/P. Ellenshaw; Eastern European Painters	Eyvind Earle	19/20C European Paintings			Ettore DeConcillis; Harry Marinsky	Michel Henry				
O.K. HARRIS WORKS OF ART 212.431.3600	Del Rosario/Kazlov/Hall/Mackiewicz	Zago/Cone/Balboni	Goings/Nichols/Harrison	Patrick/Celender/Golden	Gardner/Richards/Sills	Jo/Vaadia/Del Grosso/Wolke	Dudley/Roje/Fish/Fujimi	Szeto/Rohm/Constantine/Dufresne	Maravell/Sato/Fox/Bromberg	Invitational Exhibition/A. Gerbault		
SALLY HAWKINS FINE ARTS 212.477.5699												
HELLER GALLERY 212.966.5948	Karel/Yokoyama/Zamecnikova; J. Musler/E. Nishi		W. Carlson/C. Cohen	J. Kuhn/P. Stankard	Glass America 92	Glass of Czechoslovakia	H.M. Adams/R. Carlson; Ibragimov/Savelyena/Rothenfeld		K. Fujita/M. Glancy; D. Clayman/S. Weinberg			
HIRSCHL & ADLER MODERN 212.744.6700	Lynn Davis	Rackstraw Downes	Cy Twombly		Bill Traylor	Christopher Wilmarth; Joseph Beuys						
HUMPHREY FINE ART 212.226.5360	Niki Ketchman	Jesús Rafael Soto	Jorg Madlener	G. Salomon/C.S.H Jhabvala	Therese Schwartz	Garance	Graham Ashton	Michael French	Catherine Lopes-Curval; Robert Cronbach			
KENNEDY GALLERIES, INC. 212.541.9600	Western Paintings/Mod. Amer. Prints	American Watercolors; Amer. Master Paintings			Selected American Paintings							
PHYLLIS KIND GALLERY 212.925.1200	Jim Nutt	Barbara Rossi	Recent Soviet Art	Singular Imagination	Mark Greenwold		Roger Brown	Rosemarie Koczy	E. Bulatov/O. Vassilyev			
SIMON LOWINSKY GALLERY 212.226.5440												
MARY-ANNE MARTIN/FINE ART 212.288.2213	Inventory Selections; Parallel Project-L.A	Parallel Project-L.A	Latin American Masters	Parallel Project-L.A	The Art Show				Latin American Masters; Elena Climent	Inventory Selections		
MIDTOWN PAYSON GALLERIES 212.758.1900	Leonard Baskin		Abby Shahn	Holiday Group Show; Self-Portraits	Flower Show	Paul Cadmus		Jared French				
MONTSERRAT GALLERY 212.941.8899	SoHo Eye	On The Cutting Edge	Works by Coll	Curator's Choice								
THE PACE GALLERY 212.421.3292	Donald Judd	Lucas Samaras		Joseph Cornell; Anges Martin	Robert Mangold; Richard Serra							
THE PACE GALLERY 212.431.9224	Jim Dine		Chuck Close	Robert Irwin								
PORTICO NEW YORK, INC. 212.941.1444			Art Cologne									
P·P·O·W 212.941.8642	Sandy Skoglund	D. Attie/R. Blanchard	David Wojnarowicz; Group Show		Erika Rothenberg	Lynne Cohen	Paul Marcus	Walter Martin	Carrie Mae Weems			
RICCO/MARESCA GALLERY 212.219.2756	William Greenspon	Bill Traylor	Hawkins Bolden	Eddie Arning	Karen Harris							
STEPHEN ROSENBERG GALLERY 212.431.4838	Dennis Pinette	Edvins Strautmanis; Group Show	Group Show		Gudrun Frady	Robert Kuszek	Richard Ballard	Martha Keller	Jim Waid; Group Show	Group Show		
RUBIN SPANGLE GALLERY 212.226.2161	Ilyse Soutine; Frank Stella	Frank Stella	Dan Flavin/Hans Coper									
ANITA SHAPOLSKY GALLERY 212.334.9755	Peter Agostini/Bob Blackburn		Elmar Rojas/Latin Artists; Boardman/Davies/50's Artists		Group Show/50's Artists			M. Gibian/B. Hasen/50's Artists; H. Cherry/D. Dehner/50's Artists	Group Show/50's Artists			
SOLO GALLERY/SOLO PRESS 212.925.3599	Lynda Benglis	Petah Coyne	Terry Winters	Willy Heeks	Guest Curator	Peggy Cyphers; Betty Woodman		Allen Ruppersberg; Alexis Rockman	Ursula Van Rydingsvard; David Kapp			Recent Publications
STIEBEL MODERN 212.759.5536												
EALAN WINGATE GALLERY 212.966.5777	Group Show	Braco Dimitrijevic	Dike Blair	Group Show								

GALLERY SCHEDULES

	1990				1991							
	SEPT	OCT	NOV	DEC	JAN	FEB	MAR	APR	MAY	JUN	JUL	AUG

NEW YORK *(cont.)*

NEW YORK CITY

Gallery	SEPT	OCT	NOV	DEC	JAN	FEB	MAR	APR	MAY	JUN	JUL	AUG
FORUM GALLERY 745 Fifth Ave., New York 10151		Recent Acquisitions / Honoré Sharrer		C. Wells/W. Mark / Gregory Gillespie			Max Weber	Marina Stern	Matt Phillips	Group Show		
GAGOSIAN GALLERY 980 Madison Ave., 6th Fl., New York 10021	Frank Stella		Brancusi		Brice Marden		David Salle		Sam Francis	Group Show		
GALERIE TAMENAGA 982 Madison Ave., New York 10021	Paul Guiramand	Paul Aizpiri	H. Asada/M. Haijima		David Romanelli			Frank Holmes / Jean Fusaro				
FOSTER GOLDSTROM 560 Broadway, Ste. 303, New York 10012									Richard Estes	Dalton Maroney	Peter West	Bertrand Freiseblen
HAMMER GALLERIES 33 W. 57th St., New York 10019												
O.K. HARRIS WORKS OF ART 383 W. Broadway, New York 10012	Lazarevic/German/Buechner / Koutroulis/Giese/Bacher/Teemer / Jacobson/Falsetta/Cho/Furman			Kwilecki/Wilkerson/Celender/Harris / Bond/Young/Salt/Wexler / Dalglish/Gozu/Fawcett/Del Valle/Gomez			Richbourg/Lynds/Baeder/Carlisle	Gieger/Brodsky/Ginder/Carlisle / Mendenhall/Levine/Chard		Invitational Exhibition		
SALLY HAWKINS FINE ARTS 448 West Broadway, 2nd Fl. New York 10012		Cynthia Eardley	Bill Schiffer		Gallery Artists			Toni Putnam		Last Picture Show		
HELLER GALLERY 71 Greene St., New York 10012	Anderson/Cash/Seide / D. Clayman/R. Grebe		C. Mason/G. Ruffner / Bertil Vallien		Glass America 91 / Glass 90 Japan		Clifford Rainey	E. Moulthrop/P. Trnka	Iburi/Moje/Watkins / Jensen/Klumpar/Yamano	New Czech Sculpture		
HIRSCHL & ADLER MODERN 851 Madison Ave., New York 10021	David Robilliard	Carlo Maria Mariani	Piero Manzoni / Pierre et Gilles		George McNeil	Philip Pearlstein	Jochen Gerz	David Storey	Joe Zucker	Elliott Greene		
HUMPHREY FINE ART 594 Broadway, 4th Fl., New York 10012	Jesus Rafael Soto	Meryl Joseph	James Jackson Burt / Nobuya Hitsuda		Art Miami/J.R. Soto			Yukimura S. Konishi / Carol Kreeger Davidson	5th Anniv. Group Exhib.	T. Mizushima/M. Mizushima / Selected Artists	Selected Artists	
KENNEDY GALLERIES, INC. 40 W. 57th St., New York 10019	American Paintings	Robert Vickrey	Charles Burchfield	American Master Paintings	Joseph O'Sickey	Early American Prints	Charles De Wolf Browne	Clarice Smith	J. Marin/C. Burchfield / American Paintings		Selected American Prints	
PHYLLIS KIND GALLERY 136 Greene St., New York 10012												
SIMON LOWINSKY GALLERY 575 Broadway, New York 10012			Ilse Bing		The European Eye		Madoka Takagi/Eugene Atget		Henry P. Bosse/André Kertész			
MARY-ANNE MARTIN/FINE ART 23 E. 73rd St., New York 10021	Mexican Art	Rufino Tamayo	Mexican Masters	Nahum B. Zenil		The Art Show			Orozco/Rivera/Siqueiros / Frida Kahlo			
MIDTOWN PAYSON GALLERIES 745 Fifth Ave., New York 10151		Jack Levine		Holiday Show	D. Bermingham/I. Bishop		Prints Group Show / Michael Bergt		W. Kuhn/H. Steers / Bernarda Bryson Shahn			
MONTSERRAT GALLERY 588 Broadway, 5th Fl., New York 10012	Zen	Robert Katona	New Tendencies of Spain / Lester Polakov		Rosa Valls	New Talent from Spain	Nancy Goldstein	SoHo Choices	SoHo On The Run	Critics Choice	Summer Splash	Summer Splash
THE PACE GALLERY 32 E. 57th St., New York 10022												
THE PACE GALLERY 142 Greene St., New York 10012												
PORTICO NEW YORK, INC. 139 Spring St., 2nd Fl., New York 10012	Group Installation	Art Cologne / D. Dominick Lombardi		Group Installation		Modern Art Works	Michael Tingley		James Sandler			Group Installation
P•P•O•W 532 Broadway, 3rd Fl., New York 10012	The Lazaretto	Carrie Mae Weems	David Wojnarowicz / Lynn Geesaman		Bo Bartlett	P. Graham/W. Martin	Michael Flanagan	D. Smith/G. Schneider	Thomas Woodruff / Teun Hocks	Gallery Artists		
RICCO/MARESCA GALLERY 105 Hudson St., New York 10013	Sam Doyle	William L. Hawkins	Thornton Dial, Sr.	David Butler	American Hangers	Victor Joseph Gatto		Gallery Artists	Purvis Young	Group Exhibition		
STEPHEN ROSENBERG GALLERY 115 Wooster St., New York 10012	Jeffrey Brosk	Claire Seidl		Patsy Krebs	Soren	Paper Trail	Arthur Cohen	Sharon Gold	Laura Thorne	The Painted Line		
RUBIN SPANGLE GALLERY 395 W. Broadway, New York 10012												
ANITA SHAPOLSKY GALLERY 99 Spring St., New York 10012												
SOLO GALLERY/SOLO PRESS 578 Broadway, 6th Fl., New York 10012	Conrad Atkinson	John Hejduk	Christian Marclay / Group Show				Michael David		Barbara Schwartz		Recent Publications	
STIEBEL MODERN 32 E. 57th St., 6th Fl., New York 10022	Group Show	Sara Rossberg	William Beckman						Michael Leonard			
EALAN WINGATE GALLERY 578 Broadway, New York 10012	Group Show	Georg Herold	Stephen Ellis	Guillaume Bijl	Brokish/Kardon/Kliaving	Stephen Laub	Meg Cranston	Bill Komoski	Alan Turner	F. West/M. Esterhazy		

1991 **1992**

Timeline columns: SEPT · OCT · NOV · DEC · JAN · FEB · MAR · APR · MAY · JUN · JUL · AUG

MASSACHUSETTS (cont.)

BOSTON

GENOVESE GALLERY ANNEX — 617.426.2062

SEPT	OCT	NOV	DEC	JAN	FEB	MAR	APR	MAY	JUN	JUL	AUG
Robert Hooper	Nancy Haynes	K. Grove/J. Kidd/J. Wachtel	F. Bosco/M. Wright · Tom Pappas	Large Scale Sculpture	Tom Duncan		Mary Boochever	Jake Grossberg · Phil Sims		Group Show I	Group Show II

LEVINSON KANE GALLERY — 617.247.0545

SEPT	OCT	NOV	DEC	JAN	FEB	MAR	APR	MAY	JUN	JUL	AUG
The Home Show	The City Show		Gerold Hirn	Charles Grigg	Alfred DeCredico		Michael H. Lewis	Stanley Boxer		1st Annual Levinson Kane Dog Show	

HOWARD YEZERSKI GALLERY — 617.426.8085

SEPT	OCT	NOV	DEC	JAN	FEB	MAR	APR	MAY	JUN	JUL	AUG
M. Moore/A. Laleian	Elaine Spatz-Rabinowitz	Morgan Bulkley	Paper Prayers (AIDS Benefit)	Group Show							

MICHIGAN

BIRMINGHAM

O.K. HARRIS WORKS OF ART — 313.433.3700

SEPT	OCT	NOV	DEC	JAN	FEB	MAR	APR	MAY	JUN	JUL	AUG
	Thomas Bacher	B. Helander/Z. Stefancic · Tetsuji Seta/Tom Terry	M. Del Rosario/T. Carlisle			S. Holcomb/S. MacGowan · N. Maravell/J. Stern	Eugene Brodsky	G. Jacobson/A. Stieglitz	Michigan Invitational		Gallery Artists

NEW MEXICO

SANTA FE

ELAINE HORWITCH GALLERIES — 505.988.8997

SEPT	OCT	NOV	DEC	JAN	FEB	MAR	APR	MAY	JUN	JUL	AUG
Susan Hertel	G. Wachs/P. Smilow										

JANUS GALLERY — 505.983.1590

SEPT	OCT	NOV	DEC	JAN	FEB	MAR	APR	MAY	JUN	JUL	AUG
Mary Ristow	Reg Loving	Diane Marsh									

LEWALLEN GALLERY — 505.988.5387

SEPT	OCT	NOV	DEC	JAN	FEB	MAR	APR	MAY	JUN	JUL	AUG
K. Cox/R. Brady	Bert Long Jr.	Brach/Davis/West	Roy Deforest	Berlant/Bates/Colescott · Scottie Parsons	Contemporary Folk Art Group Show		J. Lind/J. Geldersma	Director's Choice	L. Jimenez/T. Berlant	E. Whitehorse/J. Smith	

SANTA FÉ EAST — 505.988.3103

SEPT	OCT	NOV	DEC	JAN	FEB	MAR	APR	MAY	JUN	JUL	AUG
	M. Prince/R. Tipton/S. Chase										

SENA GALLERIES — 505.982.8808

SEPT	OCT	NOV	DEC	JAN	FEB	MAR	APR	MAY	JUN	JUL	AUG
R. Cooper/P. Shapiro	Inger Jirby	James Marshall									

NEW YORK

MOUNT KISCO

TYLER GRAPHICS LTD. — 914.241.2707

SEPT	OCT	NOV	DEC	JAN	FEB	MAR	APR	MAY	JUN	JUL	AUG
David Hockney	Terence La Noue	Steven Sorman	Hugh O'Donnell · John Mitchel		Frank Stella			James Rosenquist	Frank Stella		

NEW YORK CITY

303 GALLERY — 212.966.5605

SEPT	OCT	NOV	DEC	JAN	FEB	MAR	APR	MAY	JUN	JUL	AUG
Andreas Gursky	Liz Larner	David Cabrera	Group Show	Anne Doran	Group Show	Karen Sylvester	Pruitt-Early	Thomas Ruff	Group Show	Group Show	

ALEX-EDMUND GALLERIES — 212.260.5900

SEPT	OCT	NOV	DEC	JAN	FEB	MAR	APR	MAY	JUN	JUL	AUG
Palaces of St. Petersburg · Igor Tulipanov		Dmitri Plavinsky	Group Show			Mihail Chemiakin · Igor Tulipanov	Russian Avant-Garde				

ASSOCIATED AMERICAN ARTISTS — 212.399.5510

SEPT	OCT	NOV	DEC	JAN	FEB	MAR	APR	MAY	JUN	JUL	AUG
Wolf Kahn	J. Goldyne/M. Pogany · Modern Amer. Prints		Paris/New York 1860-1990								

BABCOCK GALLERIES — 212.767.1852

SEPT	OCT	NOV	DEC	JAN	FEB	MAR	APR	MAY	JUN	JUL	AUG
	S. Lipton/E. Dickinson	S. Lipton/W.M. Chase	Masterworks/W.M. Chase · C. Roussel/C. Hassam	C. Roussel/Siporin	Lucille Corcos		J. Dobbs/E. Levy & D. Smith · 140th Anniv. of Amer. Paintings		Group Show	Gone Fishin'	

MARY BOONE GALLERY — 212.431.1818

SEPT	OCT	NOV	DEC	JAN	FEB	MAR	APR	MAY	JUN	JUL	AUG

DIANE BROWN GALLERY — 212.219.1060

SEPT	OCT	NOV	DEC	JAN	FEB	MAR	APR	MAY	JUN	JUL	AUG
Petah Coyne	Tony Oursler	Lauren Ewing	Group Exhibition								

LEO CASTELLI GALLERY — 212.431.5160

SEPT	OCT	NOV	DEC	JAN	FEB	MAR	APR	MAY	JUN	JUL	AUG
Dianne Blell	Paul Waldman	Jean-Pierre Raynaud		Dan Flavin	Roy Lichtenstein	L. Grisi/C. Simonds	M. Vaisman/K. Sonnier · Bruce Nauman	Summer Group Show			

CFM GALLERY — 212.929.4001

SEPT	OCT	NOV	DEC	JAN	FEB	MAR	APR	MAY	JUN	JUL	AUG
	Leonor Fini	Marc Davet	Little Gems		Massimo Rao	Richard MacDonald · Dario Campanile	Michael Parkes		Leonor Fini		

CHARLES COWLES GALLERY, INC. — 212.925.3500

SEPT	OCT	NOV	DEC	JAN	FEB	MAR	APR	MAY	JUN	JUL	AUG
	Harry Kramer	Chema Cobo	Works on Paper	R.E. Gillet	Jock Sturges		Ken Price	David Bates	Skrebneski		

CROWN POINT PRESS — 212.226.5476

SEPT	OCT	NOV	DEC	JAN	FEB	MAR	APR	MAY	JUN	JUL	AUG
	Wayne Thiebaud/Christopher Brown	John Baldessari		John Cage/Janis Provisor		Group Exhibition		Judy Pfaff		Group Exhibition	

CUDAHY'S GALLERY INC. — 212.879.2405

SEPT	OCT	NOV	DEC	JAN	FEB	MAR	APR	MAY	JUN	JUL	AUG
Group Show	Peter Sculthorpe	Charles Basham	Holiday Group Show	James Torlakson					Group Show		

ANDRE EMMERICH GALLERY — 212.752.0124

SEPT	OCT	NOV	DEC	JAN	FEB	MAR	APR	MAY	JUN	JUL	AUG
Al Held	Anthony Caro	S. Boxer/B. Pepper	Sam Francis	Morris Louis	Dorothea Rockburne	T. La Noue/K. Porter · William Scott		Arthur Gibbons			

ERGANE GALLERY — 212.228.9600

SEPT	OCT	NOV	DEC	JAN	FEB	MAR	APR	MAY	JUN	JUL	AUG
Eduardo Arranz-Bravo · Vasily Kafanov	Keith Alexander			Group Show				Latin American Artists			

GALLERY SCHEDULES

	1990 SEPT	OCT	NOV	DEC	1991 JAN	FEB	MAR	APR	MAY	JUN	JUL	AUG

MASSACHUSETTS (cont.)

BOSTON

GENOVESE GALLERY ANNEX — 195 South St., Boston 02111

SEPT	OCT	NOV	DEC	JAN	FEB	MAR	APR	MAY	JUN	JUL	AUG
M. Boochever/C. Cohen/G. Fitzgerald	Hannah Wilke	Peter Campus	V.B. Wadada/L. Smith/M. Wright	Frank Bosco	Important Suites	D. Sullivan/Jay Swift	The Painted Landscape	N. Lorenz/J. Grossberg	K. Spalding/J. Wallace	Group Show I	Group Show II

LEVINSON KANE GALLERY — 14 Newbury St., Boston 02116

HOWARD YEZERSKI GALLERY — 186 South St., Boston 02111

MICHIGAN

BIRMINGHAM

O.K. HARRIS WORKS OF ART — 430 N. Woodward Ave., Birmingham 48009

NEW MEXICO

SANTA FE

ELAINE HORWITCH GALLERIES — 129 W. Palace Ave., Santa Fe 87501

SEPT	OCT	NOV	DEC	JAN	FEB	MAR	APR	MAY	JUN	JUL	AUG
								B. Schenck/M. McDowell / T. Noble/L. Lyon/J. Fincher	M. Yasami/K. Irvin		Merrill Mahaffey

JANUS GALLERY — 225 Canyon Rd., Santa Fe 87501

SEPT	OCT	NOV	DEC	JAN	FEB	MAR	APR	MAY	JUN	JUL	AUG
Aaron Karp		Amrit Rai			Russell Adams	Clinton Adams	New Sculpture	Madeline O'Connor		Tom Berg	Jane Shea

LEWALLEN GALLERY — 225 Galisteo, Santa Fe 87501

SEPT	OCT	NOV	DEC	JAN	FEB	MAR	APR	MAY	JUN	JUL	AUG
S. Parsons/J. Lind	H. Hersh/A. Nasisse	Brian O'Connor	Aboriginal Paintings	Contemporary Folk Art	Meridel Rubenstein	Charles Thysell	Aboriginal Paintings	NW Glass Masters	Luis Jimenez	Brian O'Connor	E. Whitehorse/J. Smith

SANTA FÉ EAST — 200 Old Santa Fe Trail, Santa Fe 87501

SEPT	OCT	NOV	DEC	JAN	FEB	MAR	APR	MAY	JUN	JUL	AUG
			10th Anniversary Exhibition / Joe Atteberry		Paul Dougherty			R.B. Sprague/K. Tatom/M. Johnson			Al Qoyawayma/L.M. Mann

SENA GALLERIES — 112 W. San Francisco St., Santa Fe 87501

SEPT	OCT	NOV	DEC	JAN	FEB	MAR	APR	MAY	JUN	JUL	AUG
Lynda Benglis	Inger Jirby	Ken Price	Sam Scott	Steven Swanson	Group Show		Drawings By Sculptors	Carlos Carulo	Michael Von Helms	O. Rigan/S. Horton-Trippe	L. Bell/D. Hall/C. Ross

NEW YORK

MOUNT KISCO

TYLER GRAPHICS LTD. — 250 Kisco Ave., Mt. Kisco 10549

SEPT	OCT	NOV	DEC	JAN	FEB	MAR	APR	MAY	JUN	JUL	AUG
Roy Lichtenstein				David Hockney	Robert Motherwell			Frank Stella			

NEW YORK CITY

303 GALLERY — 89 Greene St., 2nd Fl., New York 10012

SEPT	OCT	NOV	DEC	JAN	FEB	MAR	APR	MAY	JUN	JUL	AUG
Pruitt-Early	Thomas Ruff	Karen Sylvester		Gallery Artists	K. Kilimnik/R. Pettibon/A. Ruppersberg / Collier Schorr Karen Kilimnik			Larry Johnson	Michael Rees	Group Show	

ALEX-EDMUND GALLERIES — 478 W. Broadway, New York 10012

SEPT	OCT	NOV	DEC	JAN	FEB	MAR	APR	MAY	JUN	JUL	AUG
								Mihail Chemiakin	Group Show		

ASSOCIATED AMERICAN ARTISTS — 20 W. 57th St., New York 10019

BABCOCK GALLERIES — 724 Fifth Ave., New York 10019

SEPT	OCT	NOV	DEC	JAN	FEB	MAR	APR	MAY	JUN	JUL	AUG
S. Adam/S. Frost	Edwin Dickinson	American Masterworks	M. Siporin/J. Wilder	Joel Corcos Levy	Keith Jacobshagen	Harvey Breverman		American Masterworks	Particular Places		Gone Fishin'

MARY BOONE GALLERY — 417 W. Broadway, New York 10012

SEPT	OCT	NOV	DEC	JAN	FEB	MAR	APR	MAY	JUN	JUL	AUG
Ralph Humphrey	Clyfford Still	Eric Fischl		Barbara Kruger	Agnes Martin	Dan Flavin	Ross Bleckner	Sherrie Levine			

DIANE BROWN GALLERY — 23 Watts St., New York 10013

SEPT	OCT	NOV	DEC	JAN	FEB	MAR	APR	MAY	JUN	JUL	AUG
Wade Saunders	Steve Wolfe	Erik Levine	Construction of Knowledge		Inge Mahn	Robert Reitzfeld	Jan Groth	Leonel Moura			

LEO CASTELLI GALLERY — 420 W. Broadway, New York 10012

SEPT	OCT	NOV	DEC	JAN	FEB	MAR	APR	MAY	JUN	JUL	AUG
Robert Barry	James Rosenquist		Claes Oldenburg/Coosje van Bruggen	Lawrence Weiner/Chryssa	Jasper Johns	Richard Artschwager	Bertrand Lavier	Edward Ruscha	Summer Group Show		

CFM GALLERY — 138 W. 17th St., New York 10011

SEPT	OCT	NOV	DEC	JAN	FEB	MAR	APR	MAY	JUN	JUL	AUG
		Leonor Fini				Richard MacDonald		Massimo Rao			

CHARLES COWLES GALLERY, INC. — 420 W. Broadway, New York 10012

SEPT	OCT	NOV	DEC	JAN	FEB	MAR	APR	MAY	JUN	JUL	AUG
Patrick Ireland	Skrebneski	David Bates	Dale Chihuly	Duncan Hannah	Manuel Neri	G. Ohr/S. Williams	Gene Davis	Howard Ben Tré	8 Soviet Artists/W. Moser		

CROWN POINT PRESS — 568 Broadway, New York 10012

SEPT	OCT	NOV	DEC	JAN	FEB	MAR	APR	MAY	JUN	JUL	AUG
Post-Earthquake Prints		Al Held	Big Prints		Prints by Sculptures / Pat Steir		Francesco Clemente	Prints in Series	Changing Group Exhibitions		

CUDAHY'S GALLERY INC. — 170 E. 75th St., 2nd Fl., New York 10021

ANDRE EMMERICH GALLERY — 41 E. 57th St., 5th-6th Fl., New York 10022

SEPT	OCT	NOV	DEC	JAN	FEB	MAR	APR	MAY	JUN	JUL	AUG
Beverly Pepper	Friedel Dzubas	Al Held	David Hockney	Alexander Liberman	Jack Tworkov		Emil Schumacher	Helen Frankenthaler	Pierre Alechinsky	Anne Truitt	Table Sculpture

ERGANE GALLERY — 469 W. Broadway, New York 10012

SEPT	OCT	NOV	DEC	JAN	FEB	MAR	APR	MAY	JUN	JUL	AUG
Mark Kostabi	Group Show	Eduardo Arranz-Bravo		Ernst Neizvestny	Group Show				Dimitri Berea	Works on Paper	Daniel Riberzani

GALLERY SCHEDULES

1991 – 1992

Gallery	SEPT	OCT	NOV	DEC	JAN	FEB	MAR	APR	MAY	JUN	JUL	AUG
GEORGIA — ATLANTA												
CONNELL GALLERY/ GREAT AMERICAN GALLERY 404.261.1712	Eddie Owens Martin	Susan Plum	Tribute To Earl Pardon / Grady Kimsey		Paul Soldner	J. Farrell/P. Wadley		D. Jeck/D. Seigenthaler	David Hopper		African American Expressions	
GALERIE TIMOTHY TEW 404.352.0655	Jim Byrne	Adrian Ryan	Haidee Becker			Samuel Papazian	Kimo Minton		Lucy Currie	Stewart Helm	Drawings	
FAY GOLD GALLERY 404.233.3843	Stella/Salgado/Weber	F. Crull/J. Uelsmann	D. Chihuly/Y. Karsh	M. Weber/G. Ruffner/19th-Century French Photography								
THE LOWE GALLERY 404.352.8114	Peters/Schmidt/Weiss	McGarrell/Marx/Garnitz	Hernandez/Hersh/Lewis		Cox/de Bruycker/Whitehorse	P. Potter/A. Saftel			K. Morris/R. Painter / Gabriele Schnitzenbaumer			
ILLINOIS — CHICAGO												
CHICAGO CENTER FOR THE PRINT 312.477.1585	Jeanine Coupe-Ryding	Edward Herbeck	Gallery Artists	David Bumbeck		Yuji Hiratsuka			Vintage Posters	Monoprints & Monotypes		
DE GRAAF FINE ART, INC. 312.951.5180												
EAST WEST CONTEMPORARY ART 312.664.8003	Shan-Shan Sheng/R. Akers	Zhao/O. & J. Amrany	Bobby K. Owens		Cha Li		Joyce Novak/Charlotte Segal		Gallery Artists / Howard Hersh/Hu Xiang	Portrait Chicago		
RICHARD GRAY GALLERY 312.642.8877	Sam Francis			David Hockney			Richard Klamen					
RHONA HOFFMAN GALLERY 312.951.8828	Donald Lipski	Aldo Rossi/Tim Rollins+K.O.S.	Haim Steinbach									
GWENDA JAY GALLERY 312.664.3406	T. Lowly/J. Lichtenberg	Group Show	Ellen Frank/Sasha Sosno			Ruth Weisberg						
PHYLLIS KIND GALLERY 312.642.6302	William Copley	Margaret Wharton	Gladys Nilsson / Leonard Koscianski	Ed Paschke		Dennis Nechvatal		Robert Colescott / Eric Bulatov/Oleg Vassilyev				
ROBBIN LOCKETT GALLERY 312.649.1230	Wendy Jacob	Sean Landers	Group Show	Mitchell Kane								
NEVILLE-SARGENT GALLERY 312.664.2787	Tim Prentice	David Faber	Lamar Briggs	Group Show								
OBJECTS GALLERY 312.664.6622		Laurie Spencer	Lynn Duenow		Mary Jo Bole				Michael Gross			
PERIMETER GALLERY 312.266.9473	D. Look/W. Hamady	John Balsley	John Hoft/Mark Krastof	C. Kurre & P. Presnail		Keiko Hara	Graham Marks		M. Walker/J. Serr	Chinese Group Show		
J. ROSENTHAL FINE ARTS, LTD. 312.642.2966	Drew Gregory	Jules Maidoff	Sacha Sosno	Bob Fischer	Robert Paulson	Gallery Artists	K. Freed/L. Marinaro	Steve Pentak & Students / John Deom				
LOUISIANA — NEW ORLEANS												
WYNDY MOREHEAD FINE ARTS 504.568.9754	Lloyd Vogt	Myles McIntyre Maillie	G. Schmidt/G. White / Group Show		Frank Barham	W. Lewis/W. Merritt						
MARGUERITE OESTREICHER FINE ART 504.581.9253	Group Show	G. Amenoff/C. Pallazollo	J. Jennings/M. Haddon / Lynne Light		May Lesser	Roshan Houshmand		Rob Wynne	Goerge Snyder		Group Show	
RODRIGUE GALLERY OF NEW ORLEANS 800.899.4244												
STILL-ZINSEL CONTEMPORARY 504.588.9999		World Order	B. Iles/R. Erdle	G.B. Saunders/E. Wilson / H.R. Kelley/M.H. Lesser	William M. Fegan/Jan Thompson			R.S. Harris/J.A. Hamilton	Margi Wier/Linda Dautreuil	Preview/Review II		
MARYLAND — BALTIMORE												
C. GRIMALDIS GALLERY 301.539.1080	Amalie Rothschild	Trace Miller / Henry Coe	Leland Rice		Anthony Caro		Joseph Sheppard	Grace Hartigan	Anne Truitt			
MASSACHUSETTS — BOSTON												
ALPHA GALLERY 617.536.4465	Richard Sheehan	Bernard Chaet / Aaron Fink	Group Exhibition			Yanick Lapuh	Barbara Swan		Jim McShea	New Talent	Summer Group Show	

GEORGIA

ATLANTA

Gallery	SEPT (1990)	OCT	NOV	DEC	JAN (1991)	FEB	MAR	APR	MAY	JUN	JUL	AUG
CONNELL GALLERY/ GREAT AMERICAN GALLERY — 333 Buckhead Ave., Atlanta 30305	Roger Dorset	Studstill/Osolnik/Stocksdale; Earl Pardon		Susan Plum/Patrick Wadley; Doug Jeck			Diane Kempler			Contemporary Quilts		
GALERIE TIMOTHY TEW — Tula D-2, 75 Bennett St. N.W., Atlanta 30309	Breck Smith		Kimo Minton	L. Currie/J. Byrd/K. Wooten		Isabelle Melchior			Marie-Cecile Aptel		L. Currie/S. Helm/K. Minton	
FAY GOLD GALLERY — 247 Buckhead Ave., Atlanta 30305												
THE LOWE GALLERY — 75 Bennett St., Space A-2, at TULA, Atlanta 30309			C. de Musee/R. Zuckerman		Todd Murphy		Ke Francis		A. Saftel/P. Longobardi		Group Show	

ILLINOIS

CHICAGO

Gallery	SEPT (1990)	OCT	NOV	DEC	JAN (1991)	FEB	MAR	APR	MAY	JUN	JUL	AUG
CHICAGO CENTER FOR THE PRINT — 1509 W. Fullerton, Chicago 60614	Yuji Hiratsuka		Ed Herbeck	S. Hunt-Wulkowicz/S. Boudjenah	J. Bujnowski/C. Knipp				Monotypes & Monoprints			
DE GRAAF FINE ART, INC. — Nine E. Superior, Chicago 60611												
EAST WEST CONTEMPORARY ART — 311 W. Superior St., 3rd Fl., Chicago 60610	Shan-Shan Sheng	Weiliang Zhao	Cha Li		Group Show		C. Segal/J. Novak		Eastern Stars Group Show			
RICHARD GRAY GALLERY — 620 N. Michigan Ave., Chicago 60611	Magdalena Abakanowicz					Suzanne Caporael		Harold Gregor	J. Bartlett/B. Benson/T. Murakami			
RHONA HOFFMAN GALLERY — 215 W. Superior St., Chicago 60610	Fariba Hajamadi	Franz West	Wolfgang Laib		Tony Tasset	Dara Birnbaum	Richard Tuttle	Richard Artschwager	Peter Halley	Pedro Cabrita Reis		
GWENDA JAY GALLERY — 301 W. Superior St., 2nd Fl., Chicago 60610	Sam Richardson	Rosalyn Schwartz	5 Artists from the Decade		Paul Sierra	Heather Becker	Judith Raphael/Thomas N. Rajkovich		Richard Hunt	4 New Artists; Controversy on Color		
PHYLLIS KIND GALLERY — 313 W. Superior St., Chicago 60610												
ROBBIN LOCKETT GALLERY — 703 N. Wells St., Chicago 60610	Judy Ledgerwood	Stephen Prina	Heimo Zobernig	Gaylen Gerber	Joe Scanlan	Vincent Shine	Julia Fish		Jennifer Bolande	Videos and a Film		
NEVILLE-SARGENT GALLERY — 708 N. Wells St., Chicago 60610	Stephan Spicher	W. Dunlap/J. Fafard	W. Pfeiffer/K. Goldfarb; Weare/Boschulte/Houston	Group Show				Glenn Bradshaw	Takeshi Yamada	Bell/Hronek/Lake	David Hayes	Yuriko Takata
OBJECTS GALLERY — 230 W. Huron St., Chicago 60610	Kevin Hanna	Peter Gourfain	James Mesple	Reid/Gross/Kooyman		Mary Bero/Ann Agee			Stephen Whittlesey/Betye Saar		Brazilian Naives	
PERIMETER GALLERY — 750 N. Orleans St., Chicago 60610	Toshiko Takaezu	Kathleen Holder	David Shapiro		C. Davidson/F. Myers	Nathan Slate Joseph	Warrington Colescott	Paul Caster	Odd Nerdrum	Douglas Johnson	Group Show	
J. ROSENTHAL FINE ARTS, LTD. — 230 W. Superior St., Chicago 60610												

LOUISIANA

NEW ORLEANS

Gallery	SEPT (1990)	OCT	NOV	DEC	JAN (1991)	FEB	MAR	APR	MAY	JUN	JUL	AUG
WYNDY MOREHEAD FINE ARTS — 603 Julia St., New Orleans 70130												
MARGUERITE OESTREICHER FINE ART — 636 Baronne St., New Orleans 70113	William Goodman	Ralph Wickiser	Garance	Keith Milow		Zella Funck		William K. Greiner	G. Snyder/Joseph Kurhajec		Sylvain Fornaro	
RODRIGUE GALLERY OF NEW ORLEANS — 721 Royal St., New Orleans 70116		Continuing Exhibition of the Works of George Rodrigue										
STILL-ZINSEL CONTEMPORARY — 328 Julia St., New Orleans 70130	Linda Dautreuil	Ronna S. Harris/John A. Hamilton		E. Menge/J.H. Lawrence	Daniel Piersol	W. Amedeé/S. Still	M.S. Smith/J. Cooper	Hasmig Vartanian	Preview/Review			

MARYLAND

BALTIMORE

Gallery	SEPT (1990)	OCT	NOV	DEC	JAN (1991)	FEB	MAR	APR	MAY	JUN	JUL	AUG
C. GRIMALDIS GALLERY — 1006 Morton St., Baltimore 21201	Betsy Heuisler	Eugene Leake	Grace Hartigan	John Baldessari	C. Iglesias/J. Sanborn	Joel Fisher	Jonathan Silver	Barbara Kassel	J. Van Alstine/J. Ruppert	Ellen Burchena	Summer Group Show	

MASSACHUSETTS

BOSTON

Gallery	SEPT (1990)	OCT	NOV	DEC	JAN (1991)	FEB	MAR	APR	MAY	JUN	JUL	AUG
ALPHA GALLERY — 121 Newbury St., Boston 02116	Jim McShea	Elizabeth Mayor	Contemporary Monotypes; Small Paintings		Yanick Lapuh	David Kapp	Melissa Johnson	Scott Prior		Gyorgy Kepes	New Talent; Summer Group Show	

1991 — **1992**

Gallery	SEPT	OCT	NOV	DEC	JAN	FEB	MAR	APR	MAY	JUN	JUL	AUG
CALIFORNIA (cont.)												
SAN FRANCISCO												
ROBERT KOCH GALLERY 415.421.0122	Duane Michals	Gilles Peress	Balog/Botto/Whaley		Mary Ellen Mark		Lois Conner	Lynn Hershman				
MODERNISM INC. 415.541.0461		John Register	John Baeder		T. DeLap/R. Lemcke		John M. Miller/Mark Stock		Woody Gwyn		Guy Diehl	
MICHAEL SHAPIRO GALLERY 415.398.6655	20th-Century Photographic Selections From The Gallery Collection											
TAKADA FINE ARTS 415.956.5288					Gallery Artists	Jeff Ruocco	Judith Foosaner / Prints From 60's		N. Anello/M. Newman / Theodra Jones	Manuela Friedmann		Group Show
DOROTHY WEISS GALLERY 415.397.3611	Diane Olivier	Robert Turner	James Morris	Teapot Invitational	Gallery Artists	John Gill	Beverly Mayeri	Hank Murta Adams	Ruth Duckworth / Jay Musler		Introductions	Annette Corcoran
STEPHEN WIRTZ GALLERY 415.433.6879	S. Shannonhouse/P. Klein / C. Smith/L. Puls		S. Silas/M. Kenna				L. Baltz/J. Huntington					
COLORADO												
DENVER												
ARTYARD 303.777.3219	Gabriel Verderi	Robert Mangold	Group Exhibition				Jeff Richards		Betty Gold	Sebastian		Carolyn Braaksma
HASSEL HAESELER GALLERY 303.295.6442	J. Sawka/J. Polanco	John T. Haeseler	M. O'Neill/S. Felix/T. Felix		Overnight Juried Show	M. Daniels/E. Helland	Mardi Gras Group Show	L. Fodor/R. Pietruszewski	R.P. Wiemer/C. Romeo	Tom of Finland	Modern Women II	Mondo Haeseler
PAYTON RULE GALLERY 303.293.9080	Betsy Margolius/Homare Ikeda / Dale Chisman		Victoria Fuller		Introductions		Gallery Artist Exhibition		Louis Recchia			
BRIGITTE SCHLUGER GALLERY 303.825.8555	Anne Embree	Matti Berglund	17th Annual Holiday Exhibit		Gallery Selections		D. Aguirre/M. Pruneda/J. Wagner	Carol Hoy	Lynne Loshbaugh		Gallery Artists	
THE CAROL SIPLE GALLERY, LTD. 303.292.1401	Gallery Artists	D. Mitchell/G. Brown	Katy Tartakoff	Holiday Show	Introductions (DADA)			6th Anniversary Show / Patti Cramer				
GINNY WILLIAMS GALLERY 303.321.4077	Jane Gottlieb	European Photography			Introduction: Denver Artists		Noi Watanakul	Ruth Bernhard		Louise Bourgeois		
CONNECTICUT												
OLD LYME												
THE COOLEY GALLERY 203.434.8807			Tom Higgins	All Paintings Great and Small		Images and Objects						
DISTRICT OF COLUMBIA												
DAVID ADAMSON GALLERY 202.628.0257	Kevin MacDonald / Stephen T. Moore	Jody Mussoff		Jennifer Berringer	Nadezda Prvulovic	Patricia Keck						
ADDISON/RIPLEY GALLERY 202.328.2332	Michael Smallwood / M.M. Pipkin/L. Weiss	John Morrell		J. Mannarino/B. Donovan	Alan Campbell	Howard Carr	B. Lipman/L. Pepper	Rosaline Moore	Woong Kim			
FRANZ BADER GALLERY 202.393.6111	Heidi Lippman/Michael Platt / Rothschild/Hamilton/Montgomery/Milton / Meadows/Bickley/Watkins/O'Donnell		Wall/Goldberg/Laget/Keefe	Ruppert/Smith/Bergenfeld	B. Schmutzhart/M. Parker	Richard/Kahn/Winslow	Carol Bolsey/Dora Lee	Felrath Hines/Nizette Brennan				
DE ANDINO FINE ARTS 202.462.4772	William Dutterer	Lynn Schmidt / D. Samuels/J.M. Dow			Thomas Osgood		John Kirchner	Jan Sawka	Stacey Jones	Black Currated By J.W. Mahoney		
KIMBERLY GALLERY 202.234.1988	Raymundo Sesma / Graca Morais		Jose Luis Cuevas		Art Miami 92		Mexico: 4 Decades After The Muralists		Chicano & Latino: Parallels & Divergence			
FLORIDA												
MIAMI												
BEAUX ART COLLECTIONS 305.858.6776												
PALM BEACH												
HOKIN GALLERY 407.655.5177			Daniel Lang / Master Drawings		Sorel Etrog							

CALIFORNIA (cont.)

SAN FRANCISCO

Gallery	1990 SEPT	OCT	NOV	DEC	1991 JAN	FEB	MAR	APR	MAY	JUN	JUL	AUG
ROBERT KOCH GALLERY, 49 Geary St., San Francisco 94108	Czech Photography		Dick Arentz		Viktor Kolar	Josef Koudelka		Holly Roberts	Herb Ritts	Kevin Bubriski		Allen Ginsberg
MODERNISM INC., 685 Market St., San Francisco 94105	John Register		Mark Stock/E. Baumann-Hudson		Erik Saxon/Gus Heinze		Abstract Paintings/John Nava		Sam Tchakalian	C. Hess/Palm Tree Show		Aloys Lolo/Peter Shire
MICHAEL SHAPIRO GALLERY, 250 Sutter St., 3rd Fl., San Francisco 94108	20th-Century Photographic Selections From The Gallery Collection											
TAKADA FINE ARTS, 251 Post St., 6th Fl., San Francisco 94108												
DOROTHY WEISS GALLERY, 256 Sutter St., San Francisco 94108	Jamie Walker	Jun Kaneko	Tony Hepburn	Annette Corcoran	Sculpture 91	Stan Welsh	Yoshio Taylor	Barbara Bell Smith	Michael Lucero	New Sculpture	J. Popelka/S. Krusoe	New Glass
STEPHEN WIRTZ GALLERY, 49 Geary St., 3rd Fl., San Francisco 94108	Wax & Lead	B. Traylor/A. Shepp	C. Lee/R. Soss	S. Derrickson/B. Brandt	J. Huntington/R. Twaddle	L. Tripe/D. Potter	R. Arnitz/J. Highstein	Framed	Raymond Saunders	M. Katano/S. Martin	Introductions 91	Group Show

COLORADO

DENVER

Gallery	1990 SEPT	OCT	NOV	DEC	1991 JAN	FEB	MAR	APR	MAY	JUN	JUL	AUG
ARTYARD, 1251 S. Pearl St., Denver 80210												
HASSEL HAESELER GALLERY, 1743 Wazee St., Denver 80202					Group Show		R. Bernier/C.L. Lord	L. Howell/M. Friday	Larue/Carleno/Ballas	Dehner/Mueller/Chenoweth	Rex Ray/Beulah	Melton/Modren/Scottz
PAYTON RULE GALLERY, 1736 Wazee St., Denver 80202												
BRIGITTE SCHLUGER GALLERY, 929 Broadway, Denver 80203												
THE CAROL SIPLE GALLERY, LTD., 1401 17th St., Denver 80202	Gallery Artists	Katy Tartakoff	Patti Cramer	Joellyn Duesberry	Kim English/Rick Stoner			5th Anniversary Show	M. Daily/D. Sprick			
GINNY WILLIAMS GALLERY, 299 Fillmore St., Denver 80206		Louise Bourgeois			Marion Post Wolcott		John F. Collins		New Works By Gallery Artists	Photography 1980-1990		

CONNECTICUT

OLD LYME

Gallery	1990 SEPT	OCT	NOV	DEC	1991 JAN	FEB	MAR	APR	MAY	JUN	JUL	AUG
THE COOLEY GALLERY, 25 Lyme St., P.O. Box 447, Old Lyme 06371												

DISTRICT OF COLUMBIA

Gallery	1990 SEPT	OCT	NOV	DEC	1991 JAN	FEB	MAR	APR	MAY	JUN	JUL	AUG
DAVID ADAMSON GALLERY, 406 Seventh St. N.W., Washington 20004												
ADDISON/RIPLEY GALLERY, Nine Hillyer Ct., Washington 20008	Elzbieta Sikorska	Dickson Carroll	Wall Sculpture & Frieze		Valerie Brown	Unknown Secrets	Rebecca Cross		Greg Hannan	Henry Chalfant		
FRANZ BADER GALLERY, 1500 K St. N.W., Washington 20005	Gallery Artists	J. Iritani/S. Antholt	Wall/Nadler/Hurwitz	Suttman/Costigan/Findikoglu	Ragusea/Harrop/Crist/Hines/Stamm	J. Van Alstine/J. Pienkowski	S. Bickley/P. Friend	Rankine/Karpowicz/Holder	Ruppert/Behme/Mort/Evans/Pokrasso	Monteith/Root/Kahn	O'Leary/Soulders/Jogo	Group Show/Rosemary Luckett
DE ANDINO FINE ARTS, 1609 Connecticut Ave. N.W. Washington 20009												
KIMBERLY GALLERY, 1621 21st St. N.W., Washington 20009	Urueta/Szyszlo/Cuevas	Rufino Tamayo			Art Miami 91	Chab/Coen/Meza/Pena		Group Show	Tamayo/Sesma/Nishizawa	Szyszlo/Navarette	Mexican Photography	

FLORIDA

MIAMI

Gallery	1990 SEPT	OCT	NOV	DEC	1991 JAN	FEB	MAR	APR	MAY	JUN	JUL	AUG
BEAUX ART COLLECTIONS, 2451 Brickell Ave., Main Fl., Miami 33129	Permanent Exhibit: Manuel Carbonell, Maquettes To Monumental											

PALM BEACH

Gallery	1990 SEPT	OCT	NOV	DEC	1991 JAN	FEB	MAR	APR	MAY	JUN	JUL	AUG
HOKIN GALLERY, 245 Worth Ave., Palm Beach 33480	Richard Anuszkiewicz	Gene Davis	Terence La Noue	Tom Wesselmann	M. Castanis/S. Quasius	Niki de Saint Phalle	Grisha Bruskin	Before Color TV				

1991 **1992**

SEPT OCT NOV DEC JAN FEB MAR APR MAY JUN JUL AUG

ARIZONA

SCOTTSDALE

ELAINE HORWITCH GALLERIES
602.945.0791

- Larry Rivers
- J. Poitras/K. Walkingstick — Suzanne Klotz
- J.A. Potter/J. Lavadour — V. Thierfelder/Group Show
- David Kraisler — Masoud Yasami
- Lamar Briggs

CALIFORNIA

**COSTA MESA
HUNTINGTON BEACH**

CHARLES WHITCHURCH GALLERY
714.373.4459

- Quiang Chen
- Mexican Masters — Robert Motherwell
- Michael Rubin — K.L. Kim/N.J. Paik
- Basham/Scott/Welliver — Friesz/Welman/Owen
- J. Frisch/H. Kos

THE WORKS GALLERY SOUTH
714.979.6757

- Ann Thornycroft
- Eric Orr — Laddie John Dill
- Presence Of Absence — Real Space
- Michael Davis — Kris Cox
- Frank Dixon — Inscapes
- Craig Antrim

LONG BEACH

THE WORKS GALLERY
213.495.2787

- Spiritual Objects
- UCI: First 25 Yrs. — Tony DeLap
- Craig Cree Stone — Jim Morphesis
- Breaking The Code — Hoon Kwak
- Group Show — Spirit Of Matter
- Sternberger/Feinberg — Vernon Fisher

LOS ANGELES

BIOTA GALLERY
213.289.0979

- J. Watson/J. Sicre
- Brad Faegre — Brennan/Gantman/Morris/Webster

CIRRUS GALLERY
213.680.3473

- New Publications
- Charles Christopher Hill — The Day The Earth Stood Still

KIMBERLY GALLERY
213.653.0408

- Mexico: 4 Decades After The Muralists
- Chicano & Latino: Parallels & Divergence

MICHAEL KIZHNER FINE ART
213.659.5222

- Juliette Steele
- Richard Campbell — David Blower
- Pyotr Belenok

KURLAND/SUMMERS GALLERY
213.659.7098

- Elly Sherman
- H. Halem/D. Mermell
- C. Reid/C. Saindon — Ke Ke Cribbs
- Donna Billick — Joel Philip Myers
- Steve Linn — J. Nitzke Marquis/B. Changstrom
- Paul Seide

MARGO LEAVIN GALLERY
213.273.0603

- Lynda Benglis
- Dan Graham — Ellsworth Kelly

DANIEL SAXON GALLERY
213.933.5282

- Merion Estes
- Chicano & Latino: Parallels & Divergence, Parts I & II

MANNY SILVERMAN GALLERY
213.659.8256

- Rufus Zogbaum
- Sculpture of The 1950's — George McNeil
- Robert Motherwell

SPACE GALLERY
213.461.8166

- S. Bleifer/J. Grant — Seiji Kunishima
- P. Percy/S. Glass — Norman Lundin
- Norman Schwab — Robert Dale Anderson

WENGER GALLERY
213.464.4431

- Carlos Aguirre
- Gunther Gerzso — Antonio Rodriguez Luna
- Twentieth-Century Masters

SANTA MONICA

JAMES CORCORAN GALLERY
213.451.4666

- Don Bachardy

SHERRY FRUMKIN GALLERY
213.393.1853

- Gustavo Rivera
- David Gilhooly — R. Shelton/D. Van Earl
- Ted Kerzie — Kay Miller — Jean Edelstein
- Simon Toparovsky — Ron Pippin
- James Strombotne — Group Exhibition

CHRISTOPHER GRIMES GALLERY
213.450.5962

- Lewis deSoto
- Group Installation — Dawn Fryling
- Mary Brogger — Painting
- Nancy Barton

G. RAY HAWKINS GALLERY
213.394.5558

- E. Steichen/Stieglitz
- A. Kertesz/G. Holz — Art/LA 91—Booth 250
- George Hurrell

SAN FRANCISCO

ELEONORE AUSTERER GALLERY
415.986.2244

- Jean-Jacques Blot
- Roberto Lauro — S. Sprotte/J. Solmon
- Sergio Ferro — J. Neuse/C. Barnett
- J. Hornyak

CROWN POINT PRESS
415.974.6273

- Wayne Thiebaud/Christopher Brown
- John Baldessari — John Cage/Janis Provisor
- Group Exhibition — Judy Pfaff
- Group Exhibition

MICHAEL DUNEV GALLERY
415.398.7300

- Hans Sierverding
- Gustavo Ramos Rivera — Steven Sorman
- Sam Richardson

GRAYSTONE
415.956.7693

- Continuous Exhibition of Contemporary Prints and Works on Paper

GALLERY SCHEDULES

	1990 SEPT	OCT	NOV	DEC	1991 JAN	FEB	MAR	APR	MAY	JUN	JUL	AUG
ARIZONA												
SCOTTSDALE												
ELAINE HORWITCH GALLERIES 4211 N. Marshall Way, Scottsdale 85251												
CALIFORNIA												
COSTA MESA / HUNTINGTON BEACH												
CHARLES WHITCHURCH GALLERY 5973 Engineer Dr., Huntington Beach 92649									Jerome Gastaldi		Dan Allison	Modern to Contemporary
THE WORKS GALLERY SOUTH 3333 Bear St., Third Fl., Costa Mesa 92626				Billy Al Bengston	Peter Alexander		Craig Kauffman		Woods Davy	Bruce Richards	Jay McCafferty	
LONG BEACH												
THE WORKS GALLERY 106 W. Third St., Long Beach 90802					De Wain Valentine	Martin Facey			S. Weber/H. Pashgian/B. Sternberger	Michael Todd	G. Renfrow/J.J. L'Heureu/S. Lehrman	
LOS ANGELES												
BIOTA GALLERY 8500 Melrose Ave., West Hollywood 90069	Ancient Stillness/Ancient Silence		C. Brennan/C.S. Morris/L.S. Webster			S. Loper/L. O'Kane D. Jacobs/R. Small			M. Horse/K. Kristoffersen C. Goldmark/J. Stewart		The Spiritual Landscape	
CIRRUS GALLERY 542 S. Alameda St., Los Angeles 90013	John Baldessari	Jay McCafferty		Minimal 1960-90		David Austen	Richard Baker	Linda Stark	Jay Willis			Prints & Works on Paper
KIMBERLY GALLERY 8000 Melrose Ave., Los Angeles 90046												
MICHAEL KIZHNER FINE ART 746 N. La Cienega Blvd., Los Angeles 90027							Russian Contemporary Art		Juliette Steele			Group Show
KURLAND/SUMMERS GALLERY 8742-A Melrose Ave., Los Angeles 90069	Dan Dailey	Group Show	Diana Hobson		Cast Glass		R. Marquis/R. Ebendorf	David Hopper		Seth Randal	Christopher Lee	Damian Priour
MARGO LEAVIN GALLERY 812 N. Robertson Blvd. & 817 N. Hilldale, Los Angeles 90069	Joseph Kosuth	Mark Lere	Roni Horn/Rita McBride		20th-Century Collage	David Lloyd	Bill Jensen	Robert Morris	Sculpture Group Show Liubov Popova		Mbuti Pygmies	
DANIEL SAXON GALLERY 7525 Beverly Blvd., Los Angeles 90036	Gronk	Metzler/Parisi/Guerrero	Group Show		Group Show	S. Scott/S. Dadd/Gronk		R. Fisher/D. Arrowsmith/L. Serrano	Peter Shire		Group Show	
MANNY SILVERMAN GALLERY 800 N. La Cienega Blvd., Los Angeles 90069	Norman Bluhm		Emerson Woelffer	Group Exhibition				G. Cavallon/G. Santomaso	Edward Dugmore		Group Exhibition	
SPACE GALLERY 6015 Santa Monica Blvd. Los Angeles 90038	J. Foosaner/R. Castellon	N. Schwab/B. Foster		T. Stanton/C. Saindon	M. Ohira/M. Teraoka	On Paper		B. Feldman/G. Lee	Bob Alderette		W. Christensen/O. Seem	
WENGER GALLERY 828 N. La Brea Ave., Los Angeles 90038	Modern Masters' Multiples			Concept/Object		Max DeMoss	V. Mehner/R. Koenig		George Baker	Jan Vanriet		
SANTA MONICA												
JAMES CORCORAN GALLERY 1327 Fifth St., Santa Monica 90401	Andrew Spence	Tom Otterness		Joe Goode	Los Angeles: 50's & 60's	Peter Alexander	Donald Baechler	Sam Francis		Ken Price	Tom Holland	Gallery Artists
SHERRY FRUMKIN GALLERY 1440 Ninth St., Santa Monica 90401	John Wilson	Randye Sandel	James Strombotne	Ron Robertson/Ron Pippin		T. Palmore/R. Fernandez	S. Manoukian/M. Terzian	R. Roehl/D. Henderson D. Johnson/D. Sutherland		J. Reilly/J. Laudenslager	J. Edelstein/M.C. Johnson/P. Bender-Shore	
CHRISTOPHER GRIMES GALLERY 1644 17th St., Santa Monica 90404												
G. RAY HAWKINS GALLERY 910 Colorado Ave., Santa Monica 90401												
SAN FRANCISCO												
ELEONORE AUSTERER GALLERY 540 Sutter St., San Francisco 94102												
CROWN POINT PRESS 657 Howard St., San Francisco 94105	Post-Earthquake Prints	Al Held		Big Prints		Prints By Sculptures	Pat Steir	Francesco Clemente	Prints In Series	Changing Group Exhibitions		
MICHAEL DUNEV GALLERY 77 Geary St., San Francisco 94108	Margaret Rinkovsky	Painted Monotype I	Painted Monotype II	Douglas McClellan			Mark Perlman	Audrey T. Welch	Tactile Abstractions		Mark Eanes	Works on Paper
GRAYSTONE 250 Sutter St., #330, San Francisco 94108	Continuous Exhibition of Contemporary Prints and Works on Paper											

GALLERY SCHEDULES

GALLERY SCHEDULES

THE PAINTED BRIDE ART CENTER 215.925.9914
230 Vine St., Philadelphia 19106
Hours: Wed-Sat 12-6; Closed Summers
Contact: Gerry Givnish, Exec Director
Specialty: The Painted Bride Art Center features an everchanging panorama
of contemporary art, exhibitions and installations

PITTSBURGH

MATTRESS FACTORY, LTD. 412.231.3169
500 Sampsonia Way, Pittsburgh 15212 FAX: 412.322.2231
Hours: Wed-Sun 12-4
Contact: Michael Olijnyk, Curator
Specialty: Site-specific installations and performances in residence

PITTSBURGH CENTER FOR THE ARTS 412.361.0873
6300 Fifth Ave, Pittsburgh 15232
Hours: Tue, Thu, Sat 10-5; Wed 10-8; Sun 1-5
Contact: Stephen Berwind, Director
Specialty: Regional, national and local art; modern works in all media; gift shop

RHODE ISLAND

WAKEFIELD

HERA GALLERY, HERA EDUCATIONAL FOUNDATION 401.789.1488
327 Main St., PO Box 336, Wakefield 02880
Hours: Tues-Fri 12-3; Sat 10-4
Contact: Judith Bizikirski
Specialty: Contemporary art in all media

SOUTH CAROLINA

SPARTANBURG

THE ARTS COUNCIL OF SPARTANBURG COUNTY, INC. 803.583.2776
385 S. Spring St, Spartanburg 29301 FAX: 803.583.2777
Hours: Mon-Fri 9-5; Sat 10-2; Sun 2-5
Contact: Cassandra E. Baker, Exec. Director
Specialty: Educational gallery presenting all media of visual arts

THE GALLERY 803.582.7616
385 S. Spring St., Spartanburg 29301
Hours: Sun-Mon 2-4; Tues-Fri 10-12 & 2-4
Contact: Pamela Nienhuis, Curator
Specialty: Original artwork and fine crafts

TEXAS

AUSTIN

WOMEN & THEIR WORK 512.477.1064
1137 W. 6th St., Austin 78703
Hours: Mon-Fri 10-5; Sat 1-5
Contact: Chris Cowden, Director
Specialty: Works by women that reflect the ethnic and cultural diversity of Texas

CORPUS CHRISTI

ART COMMUNITY CENTER 512.884.6406
902 Park Ave., Corpus Christi 78401
Hours: Tues-Sat 10-4
Contact: Ricci Morgan
Specialty: Local and area artists; diverse group of monthly exhibitions
in all media; annual competitions held

EL PASO

BRIDGE CENTER FOR CONTEMPORARY ARTS 915.532.6707
600-A N Stanton, El Paso 79901
Hours: Tues-Sat 11-5:30
Contact: M.E. Sorrell, Director
Specialty: Visual art space focusing on contemporary living space; regional
and national artists; exhibitions selected via selection committee

HOUSTON

DIVERSE WORKS 713.223.8346
1117 E. Freeway, Houston 77002
Hours: Tues-Fri 10-5; Sat & Sun 12-4
Contact: Caroline Huber, Co-Director; Michael Parenteau, Co-Director
Specialty: Visual art space; performance art series; bookstore

ODESSA

BIG RED'S ART GROUPIES (BRAG) 915.368.0739
122 E. 52nd, Odessa 79762
Hours: Per Exhibition Schedule; By Appt
Contact: Barry Phillips, Director
Specialty: Contemporary art in all media

UTAH

PARK CITY

KIMBALL ART CENTER 801.649.8882
638 Park Ave., Park City 84060
Hours: Mon-Sat 10-6; Sun 12-6
Contact: Diane Balabar, Director
Specialty: Local and regional artists; paintings, pottery and jewelry are emphasized

VIRGINIA

CHARLOTTESVLLE

SECOND STREET GALLERY 804.977.7284
201 Second St. N.W., Charlottesvlle 22901
Hours: Tues-Sat 10-5; Sun 1-5
Contact: Paige Turner, Dvlpmnt. Assoc.
Specialty: Non-profit, contemporary art gallery displaying work
of new, emerging artists

RICHMOND

1708 E. MAIN ST. GALLERY 804.643.7825
1708 E. Main St., Richmond 23223
Hours: Tues-Sun 1-5
Contact: Lora Beldon, Asst. Director
Specialty: A non-profit, artist-run space created to present
and encourage contemporary art and artists

WISCONSIN

MARSHFIELD

NEW VISIONS GALLERY, INC. 715.387.5562
1000 N. Oak, Marshfield 54449
Hours: Mon-Fri 9-5:30; Sat 10-4
Contact: Ann Waisbrot, Director
Specialty: Changing exhibitions of contemporary and/or historically-significant art

SHEBOYGAN

JOHN MICHAEL KOHLER ARTS CENTER 414.458-6144
P.O. Box 489, Sheboygan 53082 FAX: 414.458.4473
Hours: Daily 12-5
Contact: Patti Colaser-Martin, Administrator
Specialty: Changing exhibitions of contemporary art

WYOMING

CLEARMONT

UCROSS FOUNDATION BIG RED BARN GALLERY 307.737.229
2836 US Hwy 14-16, 82835
Hours: Mon-Fri 8-5; Sun 12-5
Contact: Elizabeth Guheen, Exec Director
Specialty: Residency program; regional work; invite past residences

CANADA

ONTARIO

GALLERY 44 CENTRE FOR CONTEMP. PHOTOGRAPHY 416.363.518
183 Bathurst St., Ste. 202, Toronto M5T 2R7
Hours: Tues-Sat 11-6; Thurs 11-8
Contact: Terry Costantino, Director
Specialty: An artist-run centre committed to contemporary photographic art

MERCER UNION, A CENTRE FOR CONTEMPORARY VISUAL ART 416.977.141
333 Adelaide St. W., 5th Fl., Toronto M5V 1R5 FAX: 416.977.862
Hours: Tues-Sat 11-6
Contact: Annette Hurtig, Director
Specialty: A varied program of local, national and international
contemporary visual art

PROVINCE OF QUEBEC

CENTRE INTERNATIONAL D'ART CONTMP DE MONTREAL 514.845.503
C.P. 760 Succ., Pl Du Parc, Montreal H21 2P3

ORBORO 514.844.325
3981, Boul. St-Laurent, #499, Montreal H2W 1Y5 FAX: 514.289.968
Hours: Wed-Sun 12-5
Contact: Daniel Dion, Co-Director; Bernard Bilodeau, Co-Director
Specialty: Creative, critical, multidiscliplinary, experimental,
pancultural art and discourse

ETAUKET

ALLERY NORTH 516.751.2676
90 N. Country Rd., Setauket 11733
Hours: Tues-Sat 10-5; Sun 1-5
Contact: Elizabeth Goldberg, Director
Specialty: Contemporary Long Island artists and crafts people

T. JAMES

MITHTOWN TOWNSHIP ARTS COUN 516.862.6575
660 Rte. 25a Mills Pond Hse, St. James 11780
Hours: Mon-Fri 11-4; Sat & Sun 12-4
Contact: Norma Cohen, Exec Director
Specialty: Located in a 1838 Greek revival mansion in historic St James;
presents contemporary artists

TATEN ISLAND

EWHOUSE CENTER FOR CONTEMPORARY ART 718.448.2500
1000 Richmond Terrace, Staten Island 10301 FAX: 718.442.8534
Hours: Wed-Sun 12-5
Contact: Olivia Georgia, Director
Specialty: Contemporary art with an emphasis on emerging and
mid-career American artists

TICA

CULPTURE SPACE, INC. 315.724.8381
12 Gates St., Utica 13502
Contact: Sylvia De Swaan, Exec. Director
Specialty: Work space facility for professional artists

ORTH CAROLINA

HARLOTTE

NIGHT GALLERY/SPIRIT SQUARE 704.372.9664
110 E. Seventh St., Charlotte 28202
Hours: Mon-Sat 10-6
Contact: Donna Devereaux, Visual Director
Specialty: Visual, performing arts classes

URHAM

HE DURHAM ART GUILD, INC. 919.560.2713
120 Morris St., Durham 27701
Hours: Mon-Sat 9-9; Sun 1-9
Contact: Susan Lopez, Director
Specialty: Changing monthly exhibits of regional artists; large annual juried show

AYETTEVILLE

HE ARTS CENTER 919.323.1776
P.O. Box 318, Fayetteville 28302 FAX: 919.323.1727
Hours: Tues-Fri 10-5:30; Sat-Sun 1-5
Contact: Libby McNeill Seymour, Exec. Director
Specialty: Changing exhibits by local, national and international
artists in various mediums

ALEIGH

ITY GALLERY OF CONTEMPORARY ART 919.839.2077
220 S. Blount St., Raleigh 27601 FAX: 919.828.4973
Hours: Tues-Sat 10-5; Sun 1-5
Contact: Denise N. Dickens, Director
Specialty: Contemporary art, design, performance and public art projects

ORTH DAKOTA

INOT

INOT ART GALLERY 701.838.4445
Box 325, Minot 58701
Hours: Wed-Sun 1-5
Contact: Judith Allen, Exec. Director
Specialty: Contemporary art

HIO

CINCINNATI

ILLEL JEWISH STUDENT CENTER GALLERY 513.221.6728
2615 Clifton Ave., Cincinnati 45220 FAX: 513.221.7134
Hours: Mon-Thurs 9-5; Fri 9-3
Contact: Claire Lee, Curator
Specialty: Art in all media by Jewish artists

CLEVELAND

SPACES 216.621.2314
2220 Superior Viaduct, Cleveland 44113
Hours: Tues-Fri 11-5:30; Sat 11-5
Specialty: Non-profit alternative space art gallery

LIMA

ARTSPACE/LIMA 419.222.1721
65-67 Town Square, Box 1948, Lima 45802
Hours: Mon-Fri 9-4; Sat 10-1; Sun 2-4
Contact: Douglas Drury, Director
Specialty: Exhibiting regional visual artists through various medias;
10 exhibitions annually

NEWARK

LICKING COUNTY ART ASSOCIATE 614.349.8031
391 Hudson Ave., Newark 43055
Hours: Tues-Sun 1-4
Contact: Claire Wright, Director
Specialty: Member, student and main galleries; free admission; works of all
media; gift shop and kids summer art camp

VAN WERT

WASSENBERG ART CENTER 419.238.6837
643 S. Washington St., Van Wert 45891
Hours: Tues-Sun 1-5
Contact: Patricia Keister, Director
Specialty: Fine art exhibits including painting, photography, and most fine arts

OKLAHOMA

PONCE CITY

PONCE CITY ART ASSOCIATION 405.765.9746
819 E. Central, Ponce City 74601
Hours: Wed-Sun 1-5
Contact: Donna Secrest, Manger
Specialty: Located in historical home; invite artists to exhibit in the home

OREGAN

EUGENE

MAUDE I. KERNS ART CENTER 503.345.1571
1910 E. 15th Ave., Eugene 97403
Hours: Tues-Fri 10-5; Sat & Sun 1-5
Contact: Clare Feighan, Director
Specialty: Community visual art center; adult and child education program; artist
co-op program; artist co-op studio space

MEDFORD

ROGUE GALLERY 503.772.8118
40 S. Bartlett, Medford 97501
Hours: Tues-Fri 10-5, Sat 10-4
Contact: Elizabeth

PENNSYLVANIA

ELKINS PARK

TYLER SCHOOL OF ART GALLERIES 215.782.2776
Beech and Penrose Aves., Elkins Park 19126-1099 FAX: 215.782.2799
Hours: Tues-Sat 10-5
Contact: Don Desmett, Director; Cheryl Gelover, Cur/Asst. Dir.
Specialty: Thematic group and solo exhibitions by contemporary artists

KUTZTOWN

EXHIBITION SPACE, NAP 215.683.6440
173 W. Main St., Box 82, Kutztown 19530
Hours: Thurs-Fri 1-5; Sat 10-2
Contact: James F.L. Carroll, Director
Specialty: An organization devoted to providing the public with the opportunity
to meet, consult, and exchange ideas with working artists

PHILADELPHIA

THE FABRIC WORKSHOP 215.922.7303
1100 Vine St., 13th Fl., Philadelphia 19107 FAX: 215.922.3791
Hours: Mon-Fri 9-5; Sat 12-4
Contact: Elizabeth McIlvaine, Registrar
Specialty: Silk-screen fabrics by artists and limited editions produced in house

NON-PROFIT SPACES

NEW YORK (cont.)

ARTISTS REPRESENTING ENVIRONMENAL ART 212.288.7650
500 E. 83rd St., New York 10028
Hours: By Appt
Contact: Dorthea M. Silverman, Director
Specialty: An artist's service organization; locates public sites for artists;
documents, video and catalogues published for artists

ASF GALLERY AMERICAN-SCANDIN 212.879.9779
725 Park Ave, New York 10021
Hours: Please Call For Times
Contact: Leana Biorck Kaplan, President
Specialty: Sponsors various Scandinavian exhibitions at many locations

ATLANTIC GALLERY 212.219.3183
164 Mercer St., New York 10012
Hours: Tues-Sat 11-5
Contact: Carol Hamann, President
Specialty: Co-op gallery of 20 members with a varied focus of style

CENTER FOR TAPESTRY ARTS 212.431.7500
167 Spring St., New York 10012 FAX: 212.334.1979
Hours: Wed-Sat 12-5
Contact: Jean West, Director
Specialty: Focus on tapestry and related fiber arts; gallery, studio
and classroom facilities in SOHO district

CITYARTS, INC. 212.673.8670
625 Broadway, 2nd Fl., New York 10012 FAX: 212.673.8697
Hours: By Appt
Contact: Tsipi Ben-Haim, Exec. Director
Specialty: Public art, predominately sculpture and mosaic murals

CLOCK TOWER GALLERY 212.233.1096
108 Leonard St., New York 10013
Hours: Thurs-Sun 12-6
Contact: Miranda Banks, PR Director
Specialty: Education program; works in all media; exhibitions 2-3 times per year

CREATIVE TIME 212.619.1955
66 W. Broadway, New York 10007
Hours: Mon-Fri 10-5
Contact: Cee Brown, Exec Director
Specialty: Organization presenting artist works in public places

EXIT ART 212.966.7745
578 Broadway, 8th Fl., New York 10012
Hours: Tues-Fri 10-6; Sat 11-6
Contact: Jeanette Ingberman, Founder/Dir.
Specialty: A multi-disciplinary, transcultural art center

GALLERY KOREA 212.593.7144
460 Park Ave., 6th Fl., New York 10022 FAX: 212.688.8640
Hours: Mon-Fri 10-5
Contact: Soo-Dong 0, Consultant
Specialty: Contemporary fine art

GOETHE HOUSE 212.439.8700
1014 Fifth Ave, New York 10028
Hours: Tues & Thurs 9-7; Wed, Fri, Sat 9-5
Contact: Claudia Hahn Raabe, Director
Specialty: Changing exhibitions

GREENWICH HOUSE POTTERY/JANE 212.242.4106
16 Jones St., New York 10014
Hours: Tues-Sat 1-5
Contact: Gail Saari, Director
Specialty: Exhibitions held in the Jane Hartsook Gallery; emphasizes education of
historical and contemporary ceramics; works of established and emerging artists

HENRY STREET SETTLEMENT ARTS CENTER 212.598.0400
466 Grand St., New York 10002
Hours: Tues-Sat 12-6
Contact: Andrea Borsuk, Coordinator

INTAR GALLERY 212.695.6135
420 W. 42nd St., New York 10036 FAX: 212.268.0102
Hours: Mon-Fri 12-6
Contact: Inverna Lockpez, Director
Specialty: Multicultural visual arts

LA MAMA LA GALLERIA 212.489.9422
6 E. 1st St., New York 10003
Hours: Wed-Sun 1-6
Contact: Lawry Smith, Curator/Dir.
Specialty: Exhibitions of emerging artists and established international artists

NATIONAL ACADEMY OF DESIGN 212.369.4880
1083 Fifth Ave, New York 10128
Hours: Wed-Sat 12-5; Tues 12-8 (5-8 Free)
Contact: Edward P. Gallagher, Director
Specialty: Diverse fine art exhibitions which are constantly changing

NEW YORK PUBLIC LIBRARY 212.790.6161
Fifth Ave. & 42nd St., New York 10017

OUTER SPACE (A LEGER DE MAIN) 212.874.7142
2710 Broadway, 3rd Fl., New York 10025
Hours: Tues-Fri 2-5; Sat & Sun 12-6
Contact: Lauren Stevens, Co-Director
Specialty: Large space 29 x 30; featuring 'Art On The Edge', sculpture,
paintings, assemblage, video and large graphics

PRATT MANHATTAN CENTER 212.685.3169
160 Lexington At 30, New York 10016

PUBLIC ART FUND INC. 212.541.8423
1285 Ave Of The Americas, New York 10019-6071
Hours: Mon-Fri 10-6
Contact: James Clark, Exec Director
Specialty: Dedicated to exploring and expanding the boundaries of public art

SCULPTURE CENTER GALLERY 212.879.3500
167 E. 69th St., New York 10021
Hours: Tues-Sat 11-5
Contact: Marian Griffiths, Director
Specialty: Alternative exhibition space showing unaffiliated, emerging
and mid-career sculptors

SOHO 20 212.226.4167
469 Broome St., New York 10013
Hours: Tues-Sat 12-6
Contact: Eugenia Foxworth, Director
Specialty: Women's contemporary art in all mediums; lectures and exhibits;
Annual Int'l Women and Senior Women Series

SOHO CENTER FOR VISUAL ARTISTS 212.226.1995
114 Prince St., New York 10012
Hours: Tues-Sat 12-6
Contact: Bruce Wall, Director
Specialty: Non-profit, alternative space showing emerging artists in all media

SOHO PHOTO GALLERY 212.226.8571
15 White St., New York 10003 FAX: 212.997.2875
Hours: Tues 6-8pm; Fri-Sun 1-6
Contact: David Chalk, Director
Specialty: All styles of photography welcome; artist-run co-op with 140 members

STEVE BUSH (A LEGER DE MAIN) 212.874.7142
2710 Broadway, 3rd Fl., New York 10025
Hours: Tues & Fri 2-5; Sat & Sun 12-6
Contact: Ernst Acker, Director
Specialty: Small 10 x 20 gallery; displaying photography, graphics and small works

THE IBM MUSUEM OF SCIENCE & ART 212.745.6100
500 Madison Ave., New York 10022
Hours: Tues-Sat 11-6
Specialty: IBM Corp affiliation; development of the sciences; various
exhibitions throughout the year

VISUAL ARTS GALLERY 212.598.0221
137 Wooster St., New York 10012-3106
Hours: Tues-Sat 11-6
Contact: Francis Di Tommaso, Coordinator
Specialty: Works by students of the School of Visual Arts, New York City

WHITE COLUMNS 212.924.4212
154 Christopher St., 2nd Fl., New York 10014 FAX: 212.645.4764
Hours: Wed-Sun 12-6
Contact: Cathy Howe, Asst. Director
Specialty: Emerging artists; experimental works

R O C H E S T E R

VISUAL STUDIES WORKSHOP 716.442.8676
31 Prince St., Rochester 14607
Hours: Mon-Fri 9-5; Sat 12-5
Contact: James Wyman, Coordinator
Specialty: Primary focus on photography; local and international
artists represented

MASSACHUSETTS *(cont.)*

BOSTON

COPLEY SOCIETY OF BOSTON 617.536.5049
158 Newbury St, Boston 02116
Hours: Tues-Sat 10:30-5:30

GUILD OF BOSTON ARTISTS 617.536.7660
162 Newbury St, Boston 02116

CAMBRIDGE

CAMBRIDGE MULTICULTURAL ARTS CENTER GALLERY 617.577.1400
41 Second St., Cambridge 02141
Hours: Mon-Fri 9-5; Thurs 9-8
Contact: Janis Redlich, President
Specialty: Includes a theatre and two galleries; broad spectrum of arts and humanities programs that celebrate cultural diversity; exhibits, dance, workshops and lectures

NANTUCKET

ARTIST'S ASSOCIATION OF NANTUCKET 508.228.0722
Straight Wharf, Box 1104, Nantucket 02554
Hours: Mon-Sat 10-5, 7-10; Sun 1-5, 7-10
Contact: Barbara Capizzo, Director
Specialty: 200+ members within organization; demos, courses and events open to the public

MICHIGAN

ANN ARBOR

ANN ARBOR ART ASSOCIATION 313.994.8004
117 W. Liberty, Ann Arbor 48104
Hours: Mon 12-5; Tues-Sat 10-5
Contact: Alexa Lee, Director
Specialty: Exhibit and consignment gallery emphasizing exposure to local and regional artists

DETROIT

DETROIT REPERTORY THEATRE GALLERY 313.868.1347
13103 Woodwrow Wilson, Detroit 48238
Hours: Mon-Fri 9-5; Sat 9-1
Contact: Gilda Snowden, Director
Specialty: Exhibitions for emerging Detroit-area artists

MINNESOTA

ST. PAUL

W.A.R.M. GALLERY: WOMEN'S ART REGISTRY OF MINNESOTA 612.649.0059
2402 University Ave. W., St. Paul 55114
Hours: Mon-Fri 9-5
Contact: Jill Waterhouse, Director
Specialty: Promote and produce exhibits of female artists

NEVADA

KALISPELL

HOCKADAY CENTER FOR THE ARTS 406.755.5268
2nd Ave. E. and 3rd St., Kalispell 59901
Hours: Tues-Sat 10-5
Contact: Marianne Fielder

RENO

ARTISTS CO-OPERATIVE GALLERY 702.322.8896
627 Mill St., Reno 89502
Hours: Daily 11-4
Contact: Mahree Roberts, Adv. Director
Specialty: Co-op; depictions of regional North Nevada/Sierra; pottery, paintings; all mediums

NEW JERSEY

NEWARK

ALJIRA, A CENTER FOR CONTEMPORARY ART 201.643.6877
Two Washington Pl., 4th Fl., Newark 07102
Hours: Wed-Sun 12-6
Contact: Victor Davson, Exec. Director
Specialty: Promote the work of established and emerging artists

RUTHERFORD

THE GALLERY OF THE WILLIAMS 201.939.6969
One Williams Plaza, Rutherford 07070
Hours: Mon-Sat 10-10; Sun 12-10
Contact: Nancy Zikkal, Curator
Specialty: Performance art, disciplinary art, gallery; monthly shows

WOODBRIDGE

BARRON ARTS CENTER 908.634.0413
826 Terrace Ave., Woodbridge 07095
Hours: Mon-Sat 11-4; Sun 2-4
Contact: Stephen J. Kager, Director
Specialty: Cultural arts and concerts

NEW YORK

ALBANY

PRINT CLUB OF ALBANY AND MUSEUM 518.439.9514
P.O. Box 6578, Ft. Orange, Albany 12206
Hours: By Appt
Contact: Charles Semowich, President
Specialty: Printmaking

BUFFALO

BIG ORBIT GALLERY 716.881.3158
30 D Essex St., Buffalo 14213
Hours: Mon 2-8; Thurs By Appt; Sun 12-5
Contact: Alan Van Every, Co-Dir./Curator; Katrin Jurati, Co-Dir./Curator
Specialty: Contemporary American and International artists

HALLWALLS CONTEMPORARY ARTS CENTER 716.854.5828
 FAX: 716.855.3959
700 Main St., 4th Fl., Buffalo 14202
Hours: Tues-Fri 12-6; Sat 1-5
Contact: Edmund Cardoni, Exec. Director
Specialty: Conceptual, installation, video, film and performance art

ITHACA

UPSTAIRS GALLERY 607.272.8614
215 N. Coyuga St., Ithaca 14850
Hours: Tues-Sat 11-3
Contact: Doris Brown, President
Specialty: Local Ithaca artists

NEW YORK CITY

14TH STREET PAINTERS 212.627.9893
114 W. 14th St., Ste. 2W, New York 10011
Hours: By Appt
Contact: Craig Killy, Director
Specialty: Exhibition space and atelier; annual exhibitions

49TH PARALLEL GALLERY FOR CANADIAN ART 212.925.8349
 FAX: 212.925.8503
420 W. Broadway, 4th Fl., New York 10012
Hours: Tues-Sat 10-6
Contact: Philip Bull, Director's Asst.
Specialty: Contemporary Canadian art

ACTUAL ART FOUNDATION 212.226.3109
7 Worth St., New York 10013
Hours: By Appt
Contact: Valerie Shakespeare, President
Specialty: Actual art which evolves naturally over time

AESTHETIC REALISM FOUNDATION/TERRAIN GALLERY 212.777.4490
 FAX: 212.777.4426
141 Greene St., New York 10012
Hours: Sat 1-3:15
Contact: Marcia Rackow, Gly Coordinator
Specialty: Exhibitions and weekly art talks based on the historic principle of Aesthetic Realism

AMOS ENO GALLERY 212.226.5342
594 Broadway, #404, New York 10012
Hours: Tues-Sat 11-6
Contact: Daniel Ferris, Director
Specialty: Co-op which shows a diverse range of works including paintings and works on paper

ARSENAL GALLERY 212.360.8163
 FAX: 212.360.1329
5th Ave. At 64th St., Central Pk, New York 10021
Hours: Mon-Fri 9-4:30
Contact: Jonathan Peyser, Director
Specialty: Flat works with nature and urban themes by young and old, emerging and professional artists

HILO

WAILOA CENTER OF HAWAII PARK SYSTEM 808.961.7360
P.O. Box 936, Hilo 96720
Hours: Mon-Fri 8:30-4, Wed 12-8:30
Contact: Pudding Lassiter, Director
Specialty: All forms of media; mostly Hawaiian artists are represented

IDAHO

SUN VALLEY

SUN VALLEY CENTER GALLERY 208.726.9491
620 Sun Valley Rd., Box 656, Sun Valley 83353
Hours: Mon-Sat 9-5
Contact: Deirdre G. Riley, Director
Specialty: Contemporary artists venue for educational and museum exhibits

ILLINOIS

CHICAGO

1800 GALLERY 312.951.8390
1800 N. Clybourn Ave., Chicago 60614 FAX: 312.951.7294
Hours: Mon-Fri 10-7; Sat 10-6; Sun 12-5
Contact: Haley Cohen, Asst. Manager
Specialty: Exhibitions of paintings and sculptures, changing bi-monthly

CHICAGO PUBLIC LIBRARY CULTURAL CENTER 312.269.2900
400 S. State, Chicago 60605
Hours: Mon-Thurs 9-7; Fri 9-6; Sat 9-5
Contact: John Duff, Commissioner

CONTEMPORARY ART WORKSHOP 312.472.4004
542 W. Grant Pl., Chicago 60614

N.A.M.E. 312.226.0671
700 N. Carpenter St., Chicago 60622
Hours: Tues-Sat 12-6

NAB GALLERY 312.525.5418
1433 Wolfram, Chicago 60657
Hours: By Appt
Contact: Robert Horn, Director
Specialty: Contemporary paintings

PAPER PRESS GALLERY AND STUDIO 312.226.6300
1017 W. Jackson, Chicago 60607
Hours: Gallery by appt
Contact: Linda Sorkin Eisenberg, Co-Director; Marilyn Sward, Co-Director
Specialty: Workshops, classes, monthly shows

RANDOLPH STREET GALLERY 312.666.7737
756 N. Milwaukee Ave., Chicago 60622
Hours: Tues-Sat 12-6
Contact: Peter Taub, Director
Specialty: Multi-faceted gallery; exhibitions, time-based performance art, publications and public art projects; submissions accepted

SPACE 900 312.944.6844
900 N. Franklin, Chicago 60610
Hours: By Appt

STATE OF ILLINOIS ART GALLERY 312.814.5322
100 W. Randolph, Ste. 2-100, Chicago 60601
Hours: Mon-Fri 9-6
Contact: Debora Duez Donato, Administrator
Specialty: Contemporary and historical art produced in Illinois

EVANSTON

EVANSTON ART CENTER 708.475.5300
2603 Sheridan Rd., Evanston 60201 FAX: 708.475.5330
Hours: Mon-Sat 10-4; Thur 7-10; Sun 2-5
Contact: Michele Rowe-Shields, Director
Specialty: Exhibitions featuring emerging and under-recognized artists from the Midwest

GALESBURG

GALESBURG CIVIC ART CENTER 309.342.7415
114 E. Main St., Galesburg 61401
Hours: Tues-Fri 10:30-4:30; Sat 10:30-3
Contact: Paulette Thenhaus, Director
Specialty: Regional artists with 19th & 20th century emphasis; Illinois fine crafts, monthly exhibitions, permanent collection

INDIANA

FORT WAYNE

ARTLINK 219.424.7195
437 E. Barry St., Fort Wayne 46802
Hours: Tues-Sat 12-5; Sun 1-5
Contact: Betty Fishman, Artistic Dir.
Specialty: National and regional contemporary works; all media; 8 exhibitions annually

NASHVILLE

BROWN COUNTY ART GUILD, INC. 812.988.6185
P.O. Box 324, Nashville 47448
Hours: Mon-Sat 10-5; Sun 12-5
Contact: Margaret Colglazier, Director
Specialty: Visual art by professional artists

NEW HARMONY

NEW HARMONY GALLERY OF CONTEMPORARY ART 812.682.3156
506 Main St., New Harmony 47631 FAX: 812.682.4313
Hours: Tues-Sat 9-5; Sun 1-5
Contact: Connie Weinzapfel, Director
Specialty: Contemporary artwork in all media by artists in midwestern states

IOWA

BURLINGTON

ART GUILD OF BURLINGTON, INC. 319.754.8069
P.O. Box 5, Burlington 52601
Hours: Tues-Fri 12-5; Sat-Sun 2-5
Contact: Lois Rigdon, Director
Specialty: Monthly gallery exhibitions of art by regional artists

KENTUCKY

PADUCAH

YEISER ART CENTER 502.442.2453
200 Broadway, Paducah 42001
Hours: Tues-Sat 10-4; Sun 1-5
Contact: Dan Carver, Exec. Director
Specialty: Changing exhibitions of regional and national art

MAINE

PORTLAND

DANFORTH GALLERY 207.775.6245
34 Danforth St., Portland 04101 FAX: 207.774.8807
Hours: Tues-Sat 11-5
Contact: Helen Rivas, Director
Specialty: Installations, video, experimental film and video, performance art and works on contemporary themes

ROCKPORT

MAINE COAST ARTISTS 207.236.2875
P.O. Box 147, Russell Ave., Rockport 04843
Hours: Daily 10-5
Contact: Bruce Brown, Curator
Specialty: Contemporary Maine paintings, prints, and sculpture

MASSACHUSETTS

BOSTON

ARTISTS FOUNDATION GALLERY & ATRIUM 617.227.2782
8 Park Plaza, Boston 02116
Hours: Tues-Fri 10-6; Thurs 10-8
Contact: Catherine Mayes, Director

BOSTON CENTER FOR THE ARTS MILLS GALLERY 617.426.7700
549 Tremont St., Boston 02116
Hours: Tues-Sat 12-4; Thurs 12-7
Contact: Sara Grimm, Director

BROMFIELD GALLERY 617.451.360
107 South St., Boston 02111
Hours: Tues-Sat 10-5:30
Contact: Bob Baart, President
Specialty: Co-op; oldest artist gallery in Boston; run by members; exhibits by members and non-members

SOUTHERN EXPOSURE 415.863.2141
401 Alabama St., San Francisco 94110
Hours: Wed-Sat 12-5
Contact: Jon Winet, Director
Specialty: Innovative and risk taking works by non-commercial artists; present performance arts, artist talks and forums

SAN FRANCISCO

THE FRIENDS OF PHOTOGRAPHY, ANSEL ADAMS CENTER 415.495.7000
250 Fourth St., San Francisco 94103 FAX: 415.495.8517
Hours: Tues-Sun 11-6
Contact: Ronald S. Egherman, Exec. Director

THE LAB 415.346.4063
1807 Divisadero St., San Francisco 94115 FAX: 415.346.4567
Hours: Wed-Sat 12-5
Contact: Alan Millar, Exec. Director
Specialty: Multi-disciplinary experimental art

SAN JOSE

SAN JOSE ART LEAGUE DOWNTOWN 408.287.8435
14 S. First St., San Jose 95113
Hours: Tues-Sat 12-4
Contact: Anthony Torres, Director
Specialty: Serving as contemporary forum displaying established and developing artists

SANTA BARBARA

SANTA BARBARA CONTEMPORARY ARTS 805.966.5373
653 Paseo Nuevo, 2nd Fl., Santa Barbara 93101
Hours: Tues-Sat 11-6
Specialty: Non-profit contemporary exhibition space

COLORADO

BOULDER

THE BOULDER ART CENTER 303.443.2122
1750 13th St., Boulder 80302
Hours: Tues-Sat 11-5; Sun 12-4
Contact: Betsy Gruenberg, Exec. Director
Specialty: Community art center showing a broad range of regional and national art; exhibits change approximately every 6 weeks

DENVER

SPARK 303.477.6782
3300 Osage, Denver 80302
Hours: Fri 7-10; Sat-Sun 1-5
Contact: David Sharpe, Director
Specialty: Artists co-op showing painting, sculpture, photography and installation

CONNECTICUT

AVON

FISHER GALLERY 203.678.1867
25 Arts Center Ln., Avon 06001
Hours: Tues-Sat 10-4
Contact: Betty Friedman, Exec. Director
Specialty: Fine art contemporary crafts

HARTFORD

ARTWORKS GALLERY 203.231.9323
30 Arbor St. S., Hartford 06106
Hours: Tues-Fri 11-5; Sat 12-3
Contact: Robbin Zella, Exec. Director
Specialty: Emerging, contemporary artists

REAL ART WAYS 203.232.1006
56 Arbor St., Hartford 06106 FAX: 203.233.6691
Hours: Mon-Fri 10-5; Sat 12-5
Contact: Anne R. Pasternak, Curator
Specialty: Non-profit, multi-disciplinary, alternative exhibition space

NEW HAVEN

JOHN SLADE ELY HOUSE 203.624.8055
51 Trumbull St., New Haven 06510
Hours: Tues-Fri 12:30-4
Contact: Raymond Smith, Curator
Specialty: Monthly changing shows of contemporary art from the Connecticut region; many annual exhibitions

DELAWARE

WILMINGTON

DELAWARE CENTER FOR THE CONTEMPORARY ARTS 302.656.6466
103 E. 16th St., Wilmington 19801
Hours: Tues-Fri 11-5; Sat-Sun 1-5
Contact: Steve Lanier, Exec Director
Specialty: Alternative gallery featuring 20 exhibitions per year; regional and national contemporary artists

DISTRICT OF COLUMBIA

WASHINGTON

INTERNATIONAL SCULPTURE CENTER 202.965.6066
1050 Potomac St. N.W., Washington 20007
Hours: Mon-Fri 9-5
Contact: Carol Bonbo, Coordinator
Specialty: Organization promoting contemporary sculpture; publish 'Sculpture' Magazine

STUDIO GALLERY 202.232.8734
2108 R St. N.W., Washington 20008
Hours: Wed-Sat 11-5; Sun 1-5
Contact: June Linowitz, Manager
Specialty: Contemporary art of a wide variety; 30 local artists represented

WASHINGTON PROJECT FOR THE ARTS 202.347.4813
400 Seventh St. N.W., Washington 20004 FAX: 202.347.8393
Hours: Tues-Fri 10-5; Sat-Sun 11-5
Contact: Marilyn A. Zeitlin, Exec. Director
Specialty: Contemporary art, especially emerging artists; experimental works and social issues

FLORIDA

BELLEAIR

FLORIDA GULF COAST ART CENTER 813.584.8634
222 Ponce de Leon Blvd., Belleair 34616 FAX: 813.586.0782
Hours: Mon-Fri 10-4; Sat-Sun 12-4
Contact: Judith M. Cassidy, Exec. Director
Specialty: Contemporary art by national and regional artists

GAINESVILLE

ART COLLECTOR GALLERY 904.377.4211
802 W. University Ave., Gainesville 32601
Hours: Wed-Fri 10-5:30; Sat 12-4
Contact: Eleanor Schmidt, Owner
Specialty: Exhibiting fine contemporary art including handblown glass, painting, sculpture, graphics, jewelry, handcrafted wood, and ceramics

MIAMI

BACARDI ART GALLERY 305.573.8511
2100 Biscayne Blvd., Miami 33137
Hours: Mon-Fri 9-5
Specialty: Annual exhibition programs complemented by lectures; art education program with day county public schools

BAKEHOUSE ART COMPLEX 305.576.2828
561 N.W. 32nd St., Miami 33127
Hours: Please call for hours
Contact: Donna Wilt Sperow, Admin. Asst.
Specialty: Contemporary southern Florida artists in every medium

GEORGIA

ATLANTA

SWAN COACH HOUSE GALLERY 404.266.2636
3130 Slaton Dr. N.W., Atlanta 30305
Hours: Mon-Sat 10-5
Contact: Rebecca Warner, Director
Specialty: Diverse exhibits from traditional to contemporary; highest quality artwork

HAWAII

ISLAND OF HAWAII

VOLCANO ART CENTER 808.967.7511
Hawaii Volcanoes National Park, Hawaii Island 96718-0104
Hours: Daily 9-5
Contact: Audrey Forsier, Director
Specialty: Represents 200 artists; regional art; co-op with national park

ARIZONA

MESA

GALERIA MESA 602.644.2242
P.O. Box 1466, Mesa 85211
Hours: Tues-Thurs 12-8; Fri-Sat 12-5
Contact: Sue Hakala, Supervisor
Specialty: Contemporary art in all media of artists nationwide

PHOENIX

MARS ARTSPACE 602.253.3541
130 N. Central Ave., Phoenix 85004 FAX: 602.253.3550
Hours: Mon-Fri 10:30-4:30
Contact: Liz Lerma, Exec. Director
Specialty: Visual, performance and literary art by Arizona
and Mexican American artists

TEMPE

TEMPE ARTS CENTER 602.968.0888
54 W. First St., P.O. Box 549, Tempe 85281
Hours: Tues-Sun 12-5
Contact: Dawne Walczak, Exec. Director
Specialty: Contemporary crafts and sculpture

TUCSON

DINNERWARE 602.792.4503
135 E. Congress, Tucson 85701
Hours: Tues-Sat 12-5
Contact: Nora Kuehl, Gallery Manager
Specialty: Contemporary art in all media and experimental
work by emerging and established artists

CALIFORNIA

BERKELEY

KALA INSTITUTE 415.549.2977
1060 Heinz St., Berkeley 94710
Hours: Tues-Fri 10-5; Sat 12-4
Contact: Kate Snow Forest, Director
Specialty: A non-profit arts organization where art is both created
and presented; gallery and full facilities for all types of printmaking

HAYWARD

SUN GALLERY 510.581.4050
1015 E. St., Hayward 94541
Hours: Wed-Fri 11-6; Sat 11-5
Contact: Sylvia Medeiros, Exec. Director
Specialty: Contemporary art by northern California artists

IRVINE

IRVINE FINE ARTS CENTER 714.552.1018
14321 Yale Ave., Irvine 92714
Hours: Mon-Thurs 9-9; Fri 9-6; Sat 9-3; Sun 1-5
Contact: Amy Aspell, Supervisor
Specialty: Emerging artists from Orange County; multi-cultural and theme exhibits

LOS ANGELES

GEORGE J. DOIZAKI GALLERY/JAPAN-AMERICAN C.C. 213.628.2725
244 S. San Pedro St., Los Angeles 90012-3895
Hours: Tues-Fri 12-5; Sat-Sun 11-4
Contact: Robert Hori, Director
Specialty: Traditional and contemporary Japanese and Japanese-American art

L.A. ARTCORE CENTER 213.617.3274
652 Mateo St., Los Angeles 90021
Hours: Tues-Sun 11-4
Contact: Lydia Takeshita, Exec Director
Specialty: Exhibit artists nationally and internationally with special interest in
promoting emerging artists of the West Coast; Publish 'Visions' Magazine

L.A. ART ASSOCIATION 213.652.8272
825 N. La Cienega Blvd., Los Angeles 90069
Hours: Tues-Sat 12-5
Specialty: Alternative gallery space for emerging artists; works
of members only; free to the public

L.A. CONTEMPORARY EXHIBITION (LACE) 213.624.5650
1804 Industrial St., Los Angeles 90021
Hours: Wed-Fri 11-5; Sat-Sun 12-5
Contact: Gwen Darien, Exec Director
Specialty: Interdisciplinary organization specializing in exhibitions,
performance and video

LOS ANGELES MUNICIPAL ART GALLERY 213.485.4581
4804 Hollywood Blvd., Los Angeles 90027
Hours: Tues-Sun 12:30-5
Contact: Edward Leffingwell, Director
Specialty: Contemporary southern Californian artists with
works in all media; art and architecture

NAPA

THE HESS COLLECTION WINERY 707.255.1144
4411 Redwood Rd., Box 4140, Napa 94558 FAX: 707.253.1682
Hours: Daily 10-4
Contact: Donald Hess, Owner
Specialty: Over 120 paintings and sculptures by contemporary
European and American artists

OAKLAND

CREATIVE GROWTH ART CENTER 415.836.2340
355 24th St., Oakland 94612
Hours: Mon-Fri 10-4
Contact: Irene Ward Brydon, Director
Specialty: Studio and gallery for disabled adults; all media shown

LILLIAN PALEY CENTER FOR THE VISUAL ARTS 415.451.6300
1333 Broadway, Ste. 100, Oakland 94612
Hours: Tues-Fri 12-6
Contact: Tomye' Neal-Madison, President; Elizabeth Reis, Coordinator
Specialty: Slide registry and data bank of contemporary artists in all media

SAN DIEGO

INSTALLATION 619.232.9915
719 E Street, San Diego 92101
Hours: Tues-Sat 12-5
Contact: John Craig Freeman, Director
Specialty: Alternative art space

SAN DIEGO ART INSTITUTE 619.234.5946
1449 El Prado, Balboa Park, San Diego 92101
Hours: Tues-Sat 10-5; Sun 12:30-5
Contact: Shirley Viennese, Director
Specialty: Showcase for the work of local artists; annual print show;
annual international competition

SAN FRANCISCO

ART COM & CONTEMPORARY ARTS PRESS 415.431.7524
70 12th St, 3rd Fl., San Francisco 94119
Hours: Mon-Fri 10-6
Specialty: Computer network for artists; distribute art books,
videos; broadcasting program

CAPP STREET PROJECT/AVT 415.626.7747
270 14th St., San Francisco 94103 FAX: 415.626.7991
Hours: Call For Hours
Contact: Ann Hatch, Director
Specialty: Site-specific installation; experimental exhibitions; educational
workshops, lectures, and performances

NEW LANGTON ARTS 415.626.5416
1246 Folsom, San Francisco 94103
Hours: Tues-Sat 11-5

SAN FRANCISCO ARTS COMMISSION GALLERY 415.554.9682
155 Grove St., San Francisco 94102
Hours: Tues-Fri 11-5; Thurs 11-8; Sat 12-5
Specialty: Primarily Bay Area artists represented; diverse
collection; public welcome

SAN FRANCISCO ARTSPACE 415.626.9100
1286 Folsom St., San Francisco 94103
Hours: Tues-Sat 11-5
Contact: Anne Marie MacDonald, Director
Specialty: Contemporary exhibitions; video production facility; grants
offered to video artists and critical art writers

SAN FRANCISCO MUSEUM OF MODERN ART RENTAL GALLERY 415.441.4777
Building A, Fort Mason, San Francisco 94123
Hours: Tues-Sat 11:30-5:30
Contact: Marian Parmenter, Director
Specialty: Rental and sales of contemporary works of art; exhibition program

NON-PROFIT SPACES

NEW YORK (cont.)

BETSY SENIOR CONTEMPORARY PRINTS 212.941.0960
375 W. Broadway, New York 10012-4303 FAX: 212.334.3109
Hours: By Appt
Contact: Betsy Senior, Owner
Specialty: Contemporary prints

Artists Represented: Gregory Amenoff, Jake Berthot, Richard Bosman, Christopher Brown, Susan Caporel, April Gornik, Nancy Graves, Ron Janowich, Roberto Juarez, Alex Katz, Oskar Kokoschka, Susan Laufer, Mark Luyten, Robert Mangold, Sylvia Plimack Mangold, Deborah Oropallo, Ellen Phelan, Katherine Porter, Janis Provisor, Joel Shapiro, Judith Shea, Steven Sorman, David Storey, Mary Jo Vath, William Wegman, Robin Winters **Works Available By:** Richard Diebenkorn, Al Held, Donald Judd, Brice Marden, Robert Moskowitz, Elizabeth Murray, Sean Scully, Donald Sultan

SORRENTINO/MAYER FINE ART 212.532.4978
20 E. 35th St., New York 10016 FAX: 212.532.0699
Hours: By Appt
Contact: Vincent Sorrentino, Director; Sonya Mayer, Director
Specialty: Contemporary art in all mediums

Works Available By: Berenice Abbott, Peter Alexander, Milton Avery, Richard Estes, Eric Fischl, Red Grooms, Keith Haring, David Hockney, Roy Lichtenstein, Alfred Maurer, Malcolm Morley, Claes Oldenburg, Philip Pearlstein, David Salle, Donald Sultan, Vaclav Vtylachl, Tom Wesselmann

ANDREW L. TERNER, INC. 212.505.8521
680 Broadway, New York 10012 FAX: 212.979.9140
Hours: By Appt
Contact: Andrew L. Terner, President
Specialty: German, Italian, Latin American and American contemporary art; abstract expressionism, pop, and minimal art

Works Available By: Georg Baselitz, Jean-Michel Basquiat, Fernando Botero, John Chamberlain, Sandro Chia, Francesco Clemente, Peter Halley, Keith Haring, Jasper Johns, Jeff Koons, Louis Morris, Robert Motherwell, Bruce Nauman, A.R. Penck, Pablo Picasso, Sigmar Polke, Ed Ruscha, Frank Stella, Andy Warhol

THEA WESTREICH 212.941.9449
114 Greene St., New York 10012 FAX: 212.966.0174
Hours: Mon-Sat 10-6
Contact: Carolina Nitsch-Jones, Director
Specialty: Art consulting and limited editions

Works Available By: Sophie Calle, Larry Clark, Georg Herold, Mike Kelley, Martin Kippenberger, Peter Nadin, Albert Oehlen, Richard Prince, Oliver Wasow, Christopher Wool.

OHIO

CINCINNATI

MICHAEL LOWE GALLERY, INC. 513.651.4445
338 W. 4th St., Cincinnati 45202 FAX: 513.651.9123
Hours: Thurs-Sat 12-5
Contact: Kimberly Klosterman
Specialty: 20th-century fine art including books, multiples, graphics and paintings

Works Available By: Disler, Gunther Forg, Les Levine, Roy Lichtenstein, Claes Oldenburg

COLUMBUS

NICOLAE GALERIE 614.461.9111
641 N. High St., Columbus 43215
Hours: Tues-Sat 11-5; Sun 1-4
Contact: Nicolae Halmaghi, Owner/Curator
Specialty: 19th-& 20th-century and contemporary prints

Works Available By: Jean Arp, David Black, Marc Chagall, Charles Csuri, David Davis, Bryan Gough, Kajitani, Henri Matisse, Joan Miro, Elena Osterwalder, Pablo Picasso, Rohlman, Ralph Williams, Roger Williams

PENNSYLVANIA

NORRISTOWN

THE ART BANK 215-539-2265
3028 N. Whitehall Rd, Norristown 19403 FAX: 215.539.2265
Hours: Mon-Sat 9-5
Contact: Phyllis Sunberg, Dir/Owner
Specialty: Art planning for corporations, executives and homeowners

Artists Represented: Robert Badis, Mary Lou Cummings, Lisa Fedon, Marcy Hartman, Jon Barlow Hudson, June Jasen, Robert Koffler, Judith Krieger, Morris Yudelson

TEXAS

DALLAS

CONTEMPORARY GALLERY 214.247.5246
4152 Shady Bend Dr., Dallas 75244
Hours: By Appt
Contact: Patsy C. Kahn, Owner/Director
Specialty: Late 19th-& 20th-century prints

Works Available By: Marc Chagall, Richard Diebenkorn, Jim Dine, David Hockney, Henri de Tolouse-Lautrec, Henri Matisse, Joan Miro, Robert Motherwell, Claes Oldenburg, Pablo Picasso, Frank Stella

FORT WORTH

FENTON FINE ARTS 817.429.0161
1420 Shady Oaks Ln., Fort Worth 76107 FAX: 817.731.3003
Hours: Daily 10-6
Contact: Phyllis Fenton, Director
Specialty: Contemporary prints, paintings, drawings and sculpture

Works Available By: Richmond Burton, Jim Dine, Julian Lethbridge, Roy Lichtenstein, Allan McCollum, Marilyn Minter, Frank Stella, Gary Stephan, Donald Sultan, Andy Warhol

HOUSTON

M. ROBERT RICE 713.528.0741
2627 Kipling, #102, , Houston 77098
Hours: By Appt
Contact: M. Robert Rice, Owner/President
Specialty: 19th-& 20th-century American and French art

Artists Represented: J. Carrol Beckwith, Emil Carlsen, Dines Carlsen, Edmund Graesen, Eugene Galien Lalou, Robert Logan, F. Luis Maura, Georges Rochegrosse, Robert Vonnah

WISCONSIN

MILWAUKEE

VERMILLION 414.272.8984
420 E. Wisconsin, Milwaukee 53202 FAX: 414.272.1450
Hours: Mon-Fri 9-5
Contact: Michael Lord, President
Specialty: Limited edition, fine art prints and multiples

Artists Represented: Nicholas Africano, Bruce Andersen, Duncan Hannah, Marcia Scanlon **Works Available By:** Sam Gilliam, Red Grooms, Robert Mapplethorpe, T.L. Solien, William Wegman, Adja Yunkers

NEW YORK *(cont.)*

NEW YORK CITY

AMERICAN EUROPEAN ART ASSOC. 212.517.4010
22 E. 72nd St., Ste. 5B, New York 10021 FAX: 212.439.9114
Hours: By Appt
Contact: Arnold Katzen, President
Specialty: 19th & 20th century master and contemporary paintings, drawings and sculpture

Works Available By: Pierre Alechinsky, Carl Andre, Karel Appel, Marc Chagall, John Chamberlain, Edgar Degas, Jean Dubuffet, Dan Flavin, Donald Judd, Rene Magritte, Robert Mangold, Brice Marden, Henri Matisse, Mario Merz, Claude Monet, Bruce Nauman, Georgia O'Keeffe, Pablo Picasso, Robert Rauschenberg, Gerhard Reichter, Auguste Renior, Robert Ryman, Frank Stella, George Tooker, Andy Warhol

KAREN AMIEL MODERN & CONTEMPORARY ART 212.439.1924
225 E. 73rd St., New York 10021 FAX: 212.861.1397
Hours: By Appt
Contact: Karen Amiel
Specialty: Modern and contemporary; European and American art

Works Available By: Rebecca Horn, Yves Klein, Brice Marden, Man Ray, Ed Ruscha, Starn Twins

JACK ARNOLD FINE ARTS 212.249.7218
5 E. 67th St., New York 10021 FAX: 212.249.7232
Hours: Mon-Fri 10-5, By Appt Only
Contact: Jack Arnold, Owner; Tazuko Arnold, Owner
Specialty: Contemporary graphics, paintings and sculpture

Artists Represented: George Blouin, William Crovello, Victor Manuel Garcia, Daniel Gelis, Claude Hemeret, France Hilon, Mel Hunter, Luis Mazorra, Dorothy Yung, Li Zhong-Liang
Works Available By: Salvador Dali, Don Eddy, Rene Gruau, Ron Kleemann, Malcolm Morley, Victor Vasarely

KATHY BIANCO FINE ARTS INTNATIONAL 212.534.2319
360 E. 88th St., New York 10128 FAX: 212.534.2327
Hours: By Appt
Contact: Kathy Bianco, President
Specialty: Contemporary masters; prints, multiples, drawings, paintings and sculpture

Works Available By: Alexander Calder, Lynn Chadwick, Chash, Christo, Mark Di Suvero, Keith Haring, Robert Indiana, Jasper Johns, Donald Judd, Mark Kostabi, Roy Lichtenstein, Robert Motherwell, Claes Oldenburg, Jules Olitski, James Rosenquist, Ed Ruscha, Donald Sultan, Wayne Thiebaud, Andy Warhol, Tom Wesselmann, Larry Zox

BONNIER GALLERY 212.431.8909
419 W. Broadway, New York 10012
Hours: By Appt
Contact: Frits de Kinegt
Specialty: Contemporary paintings, sculpture and prints

Works Available By: Karel Appel, Richard Artschwager, James Brown, Sandro Chia, Jim Dine, Keith Haring, Donald Judd, Roy Lichtenstein, Claes Oldenburg, Robert Rauschenberg, James Rosenquist, Julian Schnabel, Andy Warhol

BARBARA DIVVER FINE ART 212.734.2210
196 E. 75th St., New York 10021 FAX: 212.628.1140
Hours: By Appt
Contact: Barbara Divver, Director
Specialty: 19th- & 20th-century drawings, watercolors and paintings

Works Available By: Paul Cezanne, Edgar Degas, Michel Delacroix, Gustave Dore, Fernand Leger, Henri Matisse, Pablo Picasso, Pierre Puvis de Chavannes

E. M. DONAHUE, LTD. 212.477.3442
28 E. 10th St., New York 10003 FAX: 212.982.5579
Hours: By Appt
Contact: Ellen Donahue, President
Specialty: European and American Immpressionists and Modern Masters

Works Available By: Watson Cross, Willem de Kooning, Edgar Degas, Paul Gaugin, Alberto Giacometti, Anselm Kiefer, Henri Matisse, Claude Monet, Pablo Picasso, Camille Pissarro, Jackson Pollock, Gerhard Reichter, Ad Reinhardt, Auguste Renoir, Mark Rothko, Anne Marie Rousseau, Julian Schnabel, Ilyse Soutine, Vincent Van Gogh

DRANOFF FINE ART 212.966.0153
588 Broadway, Ste. 305, New York 10012 FAX: 212.941.1646
Hours: Mon-Fri 10-6
Contact: Glenn Dranoff, Owner
Specialty: Private dealer in post-war and contemporary paintings, drawings and prints

Works Available By: Willem de Kooning, Richard Diebenkorn, Jasper Johns, Roy Lichtenstein, Brice Marden, Sigmar Polke, Robert Rauschenberg, Gerhard Richter, Sean Scully, Cy Twombly

PHYLLIS ELLIOTT 212.260.4576
524 E. 20th St., New York 10009
Hours: Daily 10-6,
Contact: Phyllis Elloitt
Specialty: Posters and prints, 1890's-1940's

Artists Represented: A.M. Cassandre, Louis Icart, Alphonse Mucha, Henri de Toulouse-Lautrec

ELEANOR ETTINGER, INC 212.807.7607
155 Avenue of the Americas, New York 10013 FAX: 212.691.3508
Hours: Daily 9-5:30
Contact: Eleanor Ettinger, President
Specialty: Contemporary American realism

Artists Represented: Audean Johnson, Emily Kaufmann, Malcolm T. Liepke, Alice Neel, Mel Odom, Norman, Rockwell, John Rush, George Staurinos, Pat Trivigno

LESLIE FEELY FINE ART 212.737.4989
1000 Park Ave., New York 10028 FAX: 212.628.7294
Hours: By Appt
Contact: Leslie Feely, Dir/Proprietor
Specialty: Contemporary art since 1945; 20th-century masterpieces

Works Available By: Richard Diebenkorn, Friedel Dzubas, Sam Francis, Helen Frankenthaler, Adolph Gottlieb, David Hockney, Hans Hofmann, Ellsworth Kelly, Fernand Leger, Roy Lichtenstein, Morris Louis, Henri Matisse, Joan Miro, Robert Motherwell, Kenneth Noland, Jules Olitski, Pablo Picasso, Larry Poons, Robert Rauschenberg, Pierre-Auguste Renoir, James Rosenquist, Mark Rothko, Ed Ruscha, Frank Stella, Wayne Thiebaud

ARMANDO J. FLOREZ 212.889.4767
16 Park Ave., New York 10016
Hours: By Appt
Contact: Armondo J. Florez, Owner/Director
Specialty: Latin American modern and contemporary artists

Works Available By: Cundo Bermudez, Mario Carreno, Victor Manuel Garcia, Julio Girona, Guido Lilinas, Armando Morales, Fernando Moreno, Maria Luisa Paeheco, Rene Rortocarrero, Emilio Sanchez

SIGRID FREUNDORFER FINE ART 212.517.9700
790 Madison Ave., Ste. 402, New York 10021 FAX: 212.744.5982
Hours: By Appt
Contact: Sigrid Freundorfer
Specialty: 20th-century American and European painting and sculpture

Works Available By: Julius Bissier, Alexander Calder, Barbara Hepworth, Alexis Jawlensky, Henry Moore, Louise Nevelson, Ben Nicholson, Pablo Picasso, Arnaldo Pomodoro, Pierre Soulages

HELEN GETLER 212.683.1938
303 E. 37th St., New York 10016
Hours: By Appt
Contact: Helen Getler
Specialty: Contemporary prints

Works Available By: Jim Dine, Eric Fischl, David Hockney, Jasper Johns, Robert Rauschenberg, Marc Rosenquist, Susan Rothenberg, Frank Stella

MARTHA HENRY, INC. 212.308.2759
400 E. 57th St., New York 10022 FAX: 212.355.2134
Hours: Mon-Sat 10-6 By Appt
Contact: Martha Henry, President
Specialty: 20th-century art sales, appraisals, exhibitions

Artists Represented: Roger Dixon, Jay Milder, Robert Murray, Peter Solow, Barbara E. Thomas
Works Available By: Donald Baechler, Norman Bluhm, Marcel Duchamp, Donald Lipski, Jan Muller, Bob Thompson

IRENA HOCHMAN FINE ART, LTD. 212.772.2227
22 E. 72nd St., New York 10021 FAX: 212.772.2222
Hours: By Appt
Contact: Irena Hockman
Specialty: Modern and contemporary American and European art

Works Available By: Joseph Beuys, Donald Judd, Sol LeWitt, Robert Mangold, Tadeusz Myslowski, Bruce Nauman, Robert Rauschenberg, Robert Ryman, Cy Twombly, Andy Warhol

RITA KRAUSS 212.362.3087
60 West 66th St., #23E, New York 10023 FAX: 212.721.4354
Hours: Mon-Sat 9-5
Contact: Rita Krauss
Specialty: Contemporary and modern art

Works Available By: Jean Arp, Jean-Michel Basquiat, Fernando Botero, Bernard Buffet, Anthony Caro, Marc Chagall, Sam Francis, Keith Haring, Hans Hofmann, Robert Longo, Robert Motherwell, Robert Rauschenberg, Frank Stella

RENEE PRICE 212.879.5396
900 Park Ave., New York 10021 FAX: 212.879.5396
Hours: By Appt
Contact: Renee Price, Owner
Specialty: Early 20th-century; German and Austrian Expressionism

Artists Represented: Max Beckmann, Lyonel Feininger, George Grosz, Erich Heckel, Alexej Jawlensky, Ernst Ludwig Kirchner, Gustav Klimt, Oskar Kokoschka, Emil Nolde, Christian Rohlfs, Egon Schiele, Karl Schmidt-Rottluff

MASSACHUSETTS

BOSTON

THE GOLDEN GALLERY 617.247.8889
207 Newbury St., Boston 02116 FAX: 617.247.0990
Hours: Mon-Fri 10-5; Sat 10-6; Sun 12-5
Contact: Jim Golden, Director
Specialty: Contemporary master prints

Works Available By: Richard Diebenkorn, Jim Dine, Helen Frankenthaler, David Hockney, Jasper Johns, Alex Katz, Roy Lichtenstein, Robert Motherwell, James Rosenquist, Sean Scully, Frank Stella, Wayne Thiebaud

CAMBRIDGE

GLASS ARTS COLLABORATIVE, INC. 617.864.2276
84 Sherman St., Cambridge 02140 FAX: 617.547.3187
Hours: Mon-Fri 9:30-4:30
Contact: David Bernstein, President
Specialty: Lighting design, neon artwork, stained and etched glass

Artists Represented: Dan Dailey, Alejandro Sina, Moira Sina

PROVINCETOWN

UNIVERSAL FINE OBJECTS 508.487.4424
424 Commercial St., Provincetown 02657 FAX: 508.487.4743
Hours: Daily 11-4
Contact: James Balla, Owner; Albert Merola, Owner
Specialty: Contemporary artists from New York and New England; fine prints, Picasso ceramics

Artists Represented: Robert Bailey, James Balla, James Hanson, Jacqueline Humphries, Rick Klauber, Irene Lipton, Susan Lyman, Bill Mead, Gary Mitchell, Dyan Rey **Works Available By:** Milton Avery, Ann Chernow, Lester Johnson, Ellsworth Kelly, Pablo Picasso

WELLESLEY

JAMES FRANCIS TREZZA FINE ART 617.431.2576
200 Linden, Wellesley 02181
Hours: By Appt
Contact: James Francis Trezza, Director
Specialty: Post-modern and contemporary prints, paintings, and sculpture; African and Pre-Columbian art and artifacts

WEST NEWTON

MARTHA TEPPER CONTEMPORARY FINE ARTS 617.277.6612
120 Forest Ave., West Newton 02165
Hours: By Appt
Contact: Martha Tepper, Director
Specialty: Work with contemporary and emerging artists

Artists Represented: Olga Antonova, Harry Bartrick, Marisa Bernandez, Mitchell Gordon, Andrew Haines, David Headley, Ming Fen Hsu, Ernesto Leon, Isbesia Llavanderas, Seong Moy, Ansei Uching **Works Available By:** Leonard Baskin, Jack Beal, Robert Ferrandini, Stanley William Hayter, Alex Katz, Jack Levine, Michael Mazur, John Mcnamara, Peter Milton, Armando Morales, Don Nice, Annette Oko, Masaaki Sato

MISSOURI

KANSAS CITY

JAN WEINER GALLERY 816.931.8755
4800 Liberty St., Kansas City 64112
Hours: Sat & By Appt
Contact: Jan Weiner, Owner
Specialty: Contemporary prints, paintings, drawings, sculpture and clay

Artists Represented: Patrick Clancy, Philip Hershberger, Heather Marcus, Patrick Nagatani, Warren Rosser, Robert Russell **Works Available By:** Jim Dine, Helen Frankenthaler, David Hockney, Howard Hodgkin, Donald Judd, Ellsworth Kelly, Robert Motherwell, Steven Sorman, Frank Stella, Donald Sultan, Andy Warhol

ST LOUIS

GOTTHEINER FINE ARTS, LTD. 314.961.6175
219 Plant Ave., St Louis 63119 FAX: 314.961.3944
Hours: Mon-Sat By Appt
Contact: Gary S. Godwin, Director
Specialty: Modern and contemporary art

Artists Represented: Philip Galgiani, Michael McClard, Erica Uhlenbeck **Works Available By:** Joseph Beuys, Jonathan Borofsky, Richard Bosman, Louisa Chase, Jim Dine, Jean Dubuffet, Ian Hamilton Finlay, Eric Fischl, Helen Frankenthaler, David Hockney, Howard Hodgkin, Jasper Johns, Donald Judd, Ellsworth Kelly, Roy Lichtenstein, Robert Motherwell, Bruce Nauman, Claes Oldenburg, Robert Rauschenberg, James Rosenquist, Ed Ruscha, Frank Stella, Mark Tobey, James Turrell, Cy Twombly, Andy Warhol, William Wegman, Tom Wesselmann, H. C. Westermann, William T. Wiley, Terry Winters

RICK JONES MODERN & CONTEMPORARY 314.776.4556
3915 Fairview Ave., St Louis 63116 FAX: 314.776.0698
Hours: By Appt
Contact: Rick Jones, Director
Specialty: Contemporary European and American paintings, prints and works on paper

Artists Represented: John Hennessy, Kit Keith, Rick Ulman **Works Available By:** Miguel Barcelo, James Brown, Victor Mira, Claes Oldenburg, Mimmo Paladino, Jose Maria Sicilia, Vicenz Viaplana, Not Vital

NANCY SINGER GALLERY 314.727.1830
31 Crestwood Dr., St Louis 63105
Hours: By Appt
Contact: Nancy Singer
Specialty: Master and contemporary prints

Works Available By: Carolyne Brady, Anthony Caro, Eduardo Chillida, Robert Delaunay, Walter Duesenberry, Eric Fischl, April Gornik, Nancy Graves, Peter Haines, David Hockney, Howard Hodgkin, Jasper Johns, Sol LeWitt, Robert Motherwell, Judy Pfaff, Robert Rauschenberg, Marc Rosenquist, Steven Sorman, Frank Stella, Donald Sultan

NEBRASKA

OMAHA

GALLERY 72 402.345.3347
2709 Leavenworth, Omaha 68105
Hours: Daily 10-5, Closed Tues
Contact: Robert D. Rogers, President
Specialty: Contemporary art: paintings, drawings, prints and sculpture; appraisals and consultation

Artists Represented: Gary Bowling, Byron Burford, Debra Goldman, John Himmelfarb, Doug Martin, Richard Mock, Joseph Raffael, Warren Rosser, Steven Sorman, Carol Summers, Cheryl Wall

NEW YORK

ALBANY

SEMOWICH FINE ARTS 518.459.2674
168 N. Allen St., Albany 12206
Hours: By Appt
Contact: Charles Semowich, Director
Specialty: Art from all periods

BROOKLYN

CAROL EVANS FINE ARTS 718.852.6691
107 Wyckoff St., Brooklyn 11201 FAX: 718.852.9536
Hours: By Appt
Contact: Carol C. Evans, Director
Specialty: Contemporary prints and works on paper

Works Available By: John Baldessari, Joseph Beuys, Christo, Richard Diebenkorn, Donald Judd, Sol LeWitt, Brice Marden, Robert Motherwell, Sigmar Polke, Ed Ruscha, William Wegman

WIESNER GALLERY 718.492.1190
730 57th St., Brooklyn 11220
Hours: By Appt
Contact: Nikola Vizner, Private Dealer
Specialty: International and American contemporary art

Artists Represented: Bebe Barkar, David Channon, Bob Dombrosky, Deborah Greek, Craig Killy, Peter G. Lynch, Victor Macarol, Alexander Rutsch, Frank Shifreen **Works Available By:** Tom Bogdanovich, Boris Mardesic, Lester Rappaport, Fred T. Tannery

GLENS FALLS

FRANK LYONS COLLECTION 518.798.4747
P.O. Box 2601, Glens Falls 12801
Hours: By Appt
Contact: Frank Lyons, Director
Specialty: 19th-& 20th-century Japanese, European and American prints; photography

Artists Represented: Yoshitoshi Funasaka, Sho Kidokoro **Works Available By:** Julia M. Cameron, Jules Cheret, A.L. Coburn, Walter Crump, Honore Daumier, Rita Dibert, Frank Eckmair, Frank Eugene, Gavarni, David Lance Goines, Hiroshige, William Hogarth, Kunisada, Frederick McDuff, Kikuo Saito, Jan Sekino, Shunsho, Edward Steichen, Alfred Steiglitz, Eva Watson-Schutze, Ralph Wolfe

GREAT NECK

SORRENTINO/MAYER FINE ART 516.466.2430
6 Wooley Lane, Great Neck 11023 FAX: 516.466.1317
Hours: By Appt
Contact: Vincent Sorrentino, Director; Sonya Mayer, Director
Specialty: Early 20th-century American art in all mediums

Works Available By: Berenice Abbott, Peter Alexander, Milton Avery, Richard Estes, Eric Fischl, Red Grooms, Keith Haring, David Hockney, Roy Lichtenstein, Alfred Maurer, Malcolm Morley, Claes Oldenburg, Philip Pearlstein, David Salle, Donald Sultan, Vaclav Vtylachl, Tom Wesselmann

FLORIDA (cont.)

CORAL GABLES

ARREGUI HSIA FINE ART 305.446.1741
4105 Laguna St., Coral Gables 33146 FAX: 305.443.9776
Hours: Tues-Sat 10-6
Contact: Richard Arregui, Co-Director; Phyllis Hsia, Co-Director
Specialty: Emerging American and European artists

Artists Represented: Franco Adami, Carlos Alves, Garrick Dolberg, Norman Liebman, Carlos Macia, Joe Nicastri, Erin Parish

GLENN A. LONG FINE ARTS 305.662.2292
P.O. Box 144878, Coral Gables 33114 FAX: 305.667.0410
Hours: By Appt
Contact: Glenn A. Long, President
Specialty: 18th-,19th- & 20th-century American and European art

HOLLYWOOD

JAMES FRANCIS TREZZA FNE ART 305.962.4486
3389 Sheridan St., Ste. 201, Hollywood 33021 FAX: 305.963.3792
Hours: By Appt
Contact: James Francis Trezza, Director
Specialty: Post-modern and contemporary prints, paintings,
and sculpture; African and Pre-Columbian art and artifacts

Works Available By: Vito Acconci, Carl Andre, Karel Appel, Milton Avery, Fernando Botero, Marc Chagall, Willem de Kooning, Richard Diebenkorn, Jim Dine, Jean Dubuffet, Sam Francis, Helen Frankenthaler, Keith Haring, Jasper Johns, Ellsworth Kelly, Sol LeWitt, Brice Marden, Henry Moore, Robert Motherwell, Janet Siegel Rogers, James Rosenquist, Ed Ruscha, Andy Warhol, Tom Wesselmann

MIAMI

MARVIN ROSS FRIEDMAN & CO. 305.233.4281
15451 SW 67th Ct., Miami 33157 FAX: 305.448.7636
Hours: By Appt
Contact: Marvin Ross Friedman, President
Specialty: Major modern and contemporary works of art

Works Available By: Arakawa, Arman, Alexander Calder, Christo, John De Andrea, Willem Kooning, Don Eddy, Biff Irod, Helen Frankenthaler, Red Grooms, Keith Haring, David Hockney, Ellsworth Kelly, Franz Kline, Sol Lewitt, Roy Lichtenstein, Morris Louis, Joan Mitchell, Henry Moore, Malcolm Morley, Bruce Nauman, Claes Oldenburg, Dennis Oppenheim, Robert Rauschenberg, Larry Rivers, James Rosenquist, Mark Rothko, Ed Ruscha, Saul Steinberg, Donald Sultan, Antoni Tapies, Cy Twombly, Andy Warhol

GREENE GALLERY 305.865.6408
1090 Kane Concourse, Miami 33154
Hours: Tues-Sat 10:30-5:30
Contact: Barbara Greene, Director/Owner

Artists Represented: Carlos Alfonzo, Pablo Cano, Lynne Golob Gelfman, Mary Heilmann, Kim Macconnel, Robert Petersen, Arturo Rodriguez, Robert Yarber, Purvis Young **Works Available By:** Enrico Baj, Mel Bochner, Dan Christensen, Eric Fischl, Will Mentor, Joel Perlman, Bruce Piermarini, Robert Rauschenberg, James Rosenquist, Donald Sultan

MIAMI BEACH

HARRIS SAMUEL & CO., INC. 305.534.7709
P.O. Box 2513, Miami Beach 33140 FAX 305.531.5766
Hours: By Appt
Contact: Frank Kolbert
Specialty: Modern and contemporary works of art

Artists Represented: Frank Farmer **Works Available By:** Charles Clough, Michael Goldberg, Ellsworth Kelly, Tom Levine, Brice Marden, Robert Rauschenberg, Ad Reinhardt, Andres Serrano, Cindy Sherman, Laurie Simmons, Gary Stephan

NINA ZUBKOVA FINE ARTS 305.861.5898
528 W. 49th St., Miami Beach 33140 FAX: 305.864.8201
Hours: By Appt
Contact: Nina Zubkova
Specialty: Corporate and private consultant

Artists Represented: Enrique Castro Cid, Erika King, Paul Kus, Diego Ortega

NAPLES

MARTIN GORDON, INC. 813.434.6842
1840 8th St., Naples 33940 FAX: 813.434.6969
Hours: Mon-Fri 6-Noon
Contact: Marty Gordon, President
Specialty: 19th- & 20th-century original prints and Picasso ceramics

Works Available By: Georges Braque, Marc Chagall, Childe Hassam, Winslow Homer, Edward Hopper, Henri Matisse, Joan Miro, Pablo Picasso, Henri de Toulouse-Lautrec

GEORGIA

ATLANTA

ANTHONY ARDAVIN GALLERY 404.352.8738
75 Bennett St. Nw, #C2, Atlanta 30309
Hours: Tues-Sat 10-5
Contact: Anthony Ardavin, President
Specialty: Contemporary art

Artists Represented: Lee Bohoff, Jorge de Cubas, Jorge Escoto, Wendy Keith, Cornel Rubino, Lamar Scott Smith, Michael Tilson, Jean Williams **Works Available By:** John Brown, Connie Burnett, James Hebenstreit, Jane Jaskevich, John Michel, Carol Napoli

ILLINOIS

CHICAGO

JAN CICERO GALLERY 312.440.1904
221 W. Erie, Chicago 60610
Hours: Tues-Sat 11-5
Contact: Jan Cicero, Owner/Director
Specialty: Contemp paintings and drawings, with an emphasis on
regional art, realist and abstract

Artists Represented: Diane Canfield Bywaters, James Cook, Matthew Daub, Joe Feddersen, Theodore Halkin, Bryan Harrington, Peter Holbrook, Kenneth Holder, Joel Jaecks, James Juszczyk, Kathleen King, William Kohn, Karen Kunc, Arne Kvaalen, Arthur Lerner, Merrill Mahaffey, Peter Marcus, Deann Melton, Philip Melton, Diane Meyer Melton, John Miller, Anne Miotke, Andrew Paczos, Bernard Palchick, Tom Paquette, Peter Plagens, Corey Postiglione, Julie Richman, Charlotte Rollman, Juare (QTS) Smith, Jane Sangerman, John Sayers, Jon-Eric Schaffer, Carl Schwartz, Phyllis Seltzer, Robert Skaggs, Evelyn Statsinger, Annette Turow, Fern Valfer, Leslie Vansen, Bernadette Vigil, Ernest Viveiros, Theodore Waddell, Emmi Whitehorse, Debra Yoo

PHYLLIS NEEDLMAN GALLERY 312.642.7929
1515 N. Astor, Chicago 60610
Hours: Mon-Fri 9-4
Contact: Phyllis Needlman, President
Specialty: Latin American contemporary art

Artists Represented: Meuida, Victor Salmones, Rufino Tamayo, Francisco Zuniga **Works Available By:** Pedro Friedeberg

MAINE

BRUNSWICK

O'FARRELL GALLERY 207.729.8228
46 Maine St., Brunswick 04011 FAX: 207.729.8228
Hours: Tues-Sat 10-5
Contact: Ray Farrell, Director
Specialty: Contemporary fine art; painting, sculpture, limited edtion and prints

Artists Represented: Sigmund Abeles, Jaqueline Barrett, Eileen Gillespie, Ruthann Harrison, Robert Indiana, Nina Jerome, Dustan Knight, Margret Libby, Nonie O'Neill, Tom Painment, Marguerite Robichaux, Constance Rush, Hunt Slonem, Robert Stebelton, Neil Welliver **Works Available By:** Sandro Chia, Red Grooms, Alex Katz, Louise Nevelson, Andy Warhol

MARYLAND

BALTIMORE

COGNOSCENTI 800.735.0311
P.O. Box 4759, Baltimore 21211
Hours: By Appt
Contact: Richard Edson, Director
Specialty: Contemporary folk and Outsider Art

BROOKLANDVILLE

BRENDA EDELSON, INC 301.823.0030
P.O. Box 268, Brooklandville 21022 FAX: 301.823.0031
Hours: By Appt
Contact: Brenda Edelson
Specialty: Contemporary illustrated books with original graphics

Works Available By: Richard Bosman, Patrick Caulfield, Vija Celmins, Francesco Clemente, Willem de Kooning, Jim Dine, Eric Fischl, Lucio Fontana, Sam Francis, Jan Groover, David Hockney, Robert Indiana, Jasper Johns, Barbara Kruger, Jonathan Lasker, Sol LeWitt, Markus Lupertz, Ed Ruscha, Donald Sultan, Antoni Tapies, Not Vital

CHEVY CHASE

MARIE MARTIN: FINE ART PHOTOGRAPHS 301.907.0371
7301 Delfield St., Chevy Chase 20815 FAX: 301.913.0242
Hours: By Appt
Contact: Marie Martin, Director
Specialty: 19th- & 20th-century photography

Artists Represented: Debbie Fleming Caffery, M.P. Curtis, William Eggleston, David Plowden **Works Available By:** Berenice Abbott, Ansel Adams, Francis Johnston, Paul Kwilecki, Marion Post Wolcott

CALIFORNIA (cont.)

SAN FRANCISCO

FRANK BORN ARTS 415.647.6118
866 Capp St., San Francisco 94110
Hours: By Appt
Contact: Frank Born
Specialty: 20th-century paintings, drawings, sculpture and prints

Works Available By: Jean Arp, Jean-Michel Basquiat, Raymond Jonson, Yves Klein, Sol LeWitt, Agnes Martin, David Park, Rufino Tamayo, Wilfred Zogbaum

SHIRLEY CERF, INC 415.386.4709
132 Jordan Ave., San Francisco 94118 FAX: 415.221.1361
Hours: By Appt
Contact: Shirley Cerf, Pres/Dir
Specialty: Contemporary art

Works Available By: Richard Diebenkorn, Eric Fischl, Sam Francis, Al Held, Robert Mangold, Robert Motherwell

JANET LEVITT FINE ARTS 415.421.1407
850 Powell St., #901, San Francisco 94108 FAX: 415.296.0493
Hours: By Appt
Contact: Janet Levitt
Specialty: Contemporary prints

Artists Represented: Aaron Fink **Works Available By:** Christo, Francesco Clemente, Chuck Close, Richard Diebenkorn, Jasper Johns, Ellsworth Kelly, Roy Lichtenstein, Robert Motherwell, Claes Oldenburg, Robert Rauschenberg, James Rosenquist, Donald Sultan, Wayne Thiebaud, Andy Warhol, Tom Wesselmann

ANTHONY MEIER FINE ARTS 415.923.9962
145 Laurel St., #3, San Francisco 94118 FAX: 415.923.9317
Hours: By Appt
Contact: Anthony Meier, Owner
Specialty: Contemporary and modern art works

Works Available By: Carl Andre, Georg Baselitz, John Chamberlain, Richard Diebenkorn, Philip Guston, Richard Long, Brice Marden, Bruce Nauman, Julian Schnabel, Cy Twombly, Andy Warhol

THOMAS V. MEYER FINE ART 415.386.1225
169 25th Ave., San Francisco 94121 FAX 415.386.1634
Hours: Mon-Fri 9-6
Contact: Thomas V. Meyer, Proprietor
Specialty: 20th-century photography and contemporary prints

Artists Represented: Richard Barnes, Howard Frank, Stu Levy, Joseph Mcdonald, Roger Minick, Denny Moers, Philipp Scholz Ritterman, Jock Sturges, Elisabeth Sunday **Works Available By:** Berenice Abbott, Lewis Baltz, Harry Callahan, Francesco Clemente, Tony Cragg, Richard Diebenkorn, Laddie John Dill, Robert Doisneau, Ralph Gibson, E.O. Goldbeck, Al Held, Alex Katz, Andre Kertesz, Robert Kushner, Helen Levitt, Joel Meyerowitz, Richard Misrach, Tim Rollins + K.O.S., Ed Ruscha, Sebastiao Sallgado, Sean Scully, Jose Maria Sicilia, Pat Steir, Wayne Thiebaud, Jerry Uelsmann, Takako Yamaguchi

SANTA MONICA

DEBORAH SHARPE FINE ART 213.393.7957
1020 Pacific Coast Highway, Santa Monica 90403 FAX: 213.393.9587
Hours: By Appt
Contact: Deborah Sharpe

Artists Represented: Jaume Plensa **Works Available By:** Erwin Bohartsch, Mark Dean, Jane Irish, The Tinklers, Steve Wood

XILIARY TWIL FINE ARTS ADVISOR 213.450.2276
3435 Ocean Park Blvd., Ste 206-57, Santa Monica 90405 FAX: 213.392.5226
Hours: By Appt
Contact: Xiliary Twill, Owner
Specialty: Modern and contemporary American and European paintings, sculpture and prints

Artists Represented: K.C. Caruso, Fillipo Quaretti **Works Available By:** Carl Andre, John Baldessari, Alexander Calder, Sam Francis, Howard Hodgkin, Jasper Johns, Tadeusz Myslowski, Robert Rauschenberg, Ed Ruscha, Frank Stella, Robert Therrien, Andy Warhol, Allee Willis

STINSON BEACH

CLAUDIA CHAPLINE GALLERY 415.868.2308
3445 Shorline Hwy., Box 946, Stinson Beach 94970
Hours: Wed-Sun 11:30-5:30
Contact: Claudia Chapline
Specialty: Contemporary art of Northern California and West Marin

Artists Represented: Claudia Chapline, Whitson Cox, Linda Geary, Catherine Gibson, Gillian Hodge, Harold Schwarm **Works Available By:** Bonita Barlow, Jerry Barrish, J.B. Blunk, Peter Boiger, John Brandi, Marsha Connell, Maryann DeVine, Amy Evan, Barbara Hunt, Brigitte McReynolds, Jaquetta Nisbet, Billy Rose, Arnold Schifrin, Leah Schwartz, Gary Stephens, Gwen Stone, James Thornton, Ann White

COLORADO

BOULDER

WHITE HORSE GALLERY 303.443.6116
1218 Pearl St., Boulder 80302
Hours: Daily & Most Evenings
Contact: Shari Ross, Manager
Specialty: Authentic Native American artifacts, jewelry, fine art, pottery and weavings

Artists Represented: Robert Arnold, Doreman Burns, Albert Dreher, Kim Fox Means, Denny Haskew, Daryl Howard, Ben Nighthorse, Connie Seabourn, Sally Thielen **Works Available By:** Patty Fawn, Rance Hood, Nakwesee, Paladine Roye, Juan Sandoval, Marie Suazo, Donald Vann

CONNECTICUT

MADISON

P. HASTINGS FALK, INC. 203.245.2246
170 Boston Post Rd., Madison 06443
Contact: Peter H. Falk, President
Specialty: Private curator for corporations and individuals

OLD GREENWICH

ARTWORKS-FINE ART ADVISORS 203.637.5562
15 Potter Dr., Old Greenwich 06870
Hours: By Appt
Contact: Wendy T. Kelley, Director
Specialty: Painting, prints, photography and sculpture

Artists Represented: Claude Chevalley, Larry D'Amico, David Dunlop, James Flora, James Grabowski, Peter Hayward, Larry Horowitz, David Itchkawich, Elizabeth MacDonald, Ken Muenzenmayer, Tim Pogue, Guenther Reiss, Lubomir Tomaszewski **Works Available By:** James Carter, Robert Cottingham, Charlie Dye

SOUTH NORFOLK

JOHN CUSANO 203.866.5527
P.O. Box 1257, South Norfolk 06856
Hours: By Appt
Contact: John Cusano, Owner
Specialty: Contemporart art by artists throughout the United States

Artists Represented: Lois Bryant, Dale Dapkins, Nancy Iddings, Abigail Jurist Levy, Ben Mahmoud, Frank Ricco, Peggy Steinway

STAMFORD

SMITH-GIRARD 203.325.2979
One Strawberry Hill Ave., #1E, Stamford 06902
Hours: By Appt
Contact: Girard Jackson, Director
Specialty: Works by Theressa Bernstein and William Meyerowitz

Works Available By: Theresa Bernstein, William Meyerowitz, Frederick Terna

DISTRICT OF COLUMBIA

WASHINGTON

MONUMENTAL SCULPTURES 202.332.7460
2601 30th St. NW, Washington 20008 FAX: 202.328.9722
Hours: By Appt
Contact: Raquel Halegua, Director
Specialty: Modern and contemporary North and Latin American Art; European Old Masters

Artists Represented: Pedro Figari, Alfredo Halegua, Antonio Pena, J.L. Zorilla de San Martin **Works Available By:** Arbit Blatas, Fernando Botero, Emile Antoine Bourdelle, Lyle Carr, Jose Cuneo, Jean Louis Forian, James Hamilton, Geroge Hinz, Bela Kadar, Max Kuhene, Elisee Maclet, Aristide Maillol, Roberto Matta, Jules Pascin, John F. Perto, John Riley, August Rodin, Franz Leo Ruben, Joaquin Torres-Garcia

FLORIDA

COCONUT GROVE

GARY NADER FINE ARTS 305.442.0256
3121 Commodore Plaza, Ste. 1, Coconut Grove 33133 FAX: 305.443.9285
Hours: By Appt
Contact: Gary Nader
Specialty: Contemporary Latin American and Caribbean Master

CALIFORNIA

BEVERLY HILLS

DAVID LAWRENCE EDITIONS 213.278.0882
9507 Santa Monica Blvd., #310, Beverly Hills 90210 FAX: 213.278.0883
Hours: By Appt
Contact: David Lawrence, Director
Specialty: Contemporary prints: monoprints, serigraphy, lithography
and fabricated structures

Artists Represented: Carlos Almaraz, Daniel Brice, Ronald Davis, Robert Gil De Montes, F. Scott Hess, Lee Jaffe, Gilbert Lujan, Jim Morphesis, Andrew Radcliffe, Italo Scanga, Peter Shire, Bernar Venet **Works Available By:** Sam Francis, April Gornik, Red Grooms, David Hockney, Roy Lichtenstein, Robert Longo, Claes Oldenburg, Robert Rauschenberg, Man Ray, James Rosenquist, Alexis Smith, Andy Warhol, William Wegman

COSTA MESA

JAMES LODGE & ASSOCIATES 714.214.0806
2915 Redhill, #A106, Costa Mesa 92626 FAX: 714.241.0806
Hours: Mon-Fri 9-5
Contact: James Lodge, Owner
Specialty: 19th- & 20th-century American contemporary art

HUNTINGTON BEACH

BOLEN FINE ARTS 714.968.0806
P.O. Box 5654, Huntington Bch 92615
Hours: By Appt
Contact: John Bolen, Owner
Specialty: American works of art from the 20's, 30's & 40's

Works Available By: Thomas Hart Benton, Arnold Blanch, John Steuart Curry, Adolf Dehn, Jerry Farnsworth, Merrell Gage, Jackson Lee Nesbitt, Paul Sample, Rolph Scarlett, Charles Sheeler

LA JOLLA

QUINT KRICHMAN PROJECTS 619.454.3409
7447 Girard Ave., La Jolla 92037
Hours: By Appt
Contact: Mark Quint, Partner
Specialty: Contemporary artist residency program

Artists Represented: Lee Boronson, Manny Farber, George Trakas, Gary Lang, Mikolaj Smoczynski, Eric Snell, Al Souza, Jan Van Munster **Works Available By:** Vito Acconci, Peter Dreher, Julian Opie, Richard Wentworth

TASENDE GALLERY 619.454.3691
820 Prospect St., La Jolla 92037
Hours: Tues-Sat 10-6
Contact: Mary Beth Hynes, Director
Specialty: Modern and contemporary sculpture, painting,
drawings and works on paper

Artists Represented: Eduardo Chillida, Jose Luis Cuevas, Giacomo Manzu, Roberto Matta, Andres Nagel **Works Available By:** Lynn Chadwick, Mark di Suvero, Henry Moore, August Rodin, Tom Wesselmann,

LAGUNA BEACH

COLLECTOR'S CHOICE GALLERY 714.494.8214
20352 Laguna Canyon Rd., Laguna Beach 92651
Hours: By Appt
Contact: Beverly Inskeep, Director
Specialty: Folk art, art furnishings and video art

Artists Represented: Larry Gill, Lenord Glasser, Pat Klotz, Tom Kress, Beverly Richardson, Pat Sparkhule, Joan Swanson **Works Available By:** Willem de Kooning

LOS ANGELES

STEPHEN COHEN 213-654-1890
8277 Fountain Ave., #5, Los Angeles 90046 FAX: 213.654.1625
Hours: By Appt
Contact: Stephen Cohen
Specialty: 20th-century photography

Artists Represented: Dick Arentz, Daniel Kazimierski **Works Available By:** Berenice Abbott, Ansel Adams, Brassai Walker Evans, Robert Frank, Lewis Hine, Paul Strand, Weegee, Max Yavno

CYNTHIA DRENNON FINE ARTS 213.934.7712
1034 S. Orlando Ave., Los Angeles 90035 FAX: 213.939.4013
Hours: By Appt
Contact: Cynthia Drennon, Owner
Specialty: Contemporary art

Works Available By: Jonathan Borofsky, Richard Diebenkorn, Robert Graham, David Hockney, Jasper Johns, Roy Lichtenstein, Bruce Nauman, Frank Stella, Wayne Thiebaud

ULRIKE KANTOR GALLERY 213.273.5650
9143 St. Ives Dr., Los Angeles 90069 FAX: 213.275.3893
Hours: By Appt
Contact: Ulrike Kantor, Owner
Specialty: American and European 20th-century fine art; period
designer costume jewelry

MARILYN PINK/MASTER PRINTS 213.395.1465
P.O. Box 491446, Los Angeles 90049 FAX: 213.395.1465
Hours: Mon-Fri 10-5 By Appt
Contact: Marilyn Pink, Director
Specialty: 16th to 20th-century prints and drawings

Works Available By: James Audubon, Assadour, Ernst Barlach, Max Beckmann, Fletcher Benton, Pierre Bonnard, Georges Braque, Mary Cassatt, Paul Cezanne, Honore Daumier, Robert Delaunay, Lorser Feitelson, Sam Francis, May Gearhart, Alberto Giacometti, Burne Hogarth, Jacob Kainen, John Kelpe, Ernst Ludwig Kirchner, Kathe Kollwitz, Louis Lozowick, James MacBey, John Marin, Henri Matisse, Jean-Francois Millet, Edvard Munch, Rembrandt Auguste Renior, Ed Ruscha, Martin Schongauer, Georg Schrimpf, Henri de Toulouse-Lautrec, Felix Edouard Vallonton, Edouard Vuillard, Abraham Walkowitz, James Abbott McNeill Whistler, Ray Yoshida, Heinrich Zille, Anders Leonard Zorn

RICHARD & LIA POLSKY 213.274.0941
10341 1/2 Wilshire Blvd., Los Angeles 90024
Hours: By Appt
Contact: Richard Polsky, Co-Owner
Specialty: Contemporary painting and sculpture from 1960 to the present

Works Available By: John Chamberlain, Sam Francis, Ed Ruscha, Sean Scully, Bill Traylor, Andy Warhol

JOANNE WARFIELD GALLERY 213.855.0586
508 N. San Vincente Blvd., Los Angeles 90048
Hours: By Appt
Contact: Joanne Warfield, Owner/Director
Specialty: Contemporary fine art; paintings, sculpture, prints and mixed media

Artists Represented: Luis Bermudez, Peter Erskine, Martin L. Gunsaullus, Joanne Hammer, Maxine Martell, William Maxwell, Al Ring, William Turner **Works Available By:** Donald Farnsworth

JONI MOISANT WEYL 213.936.0853
200 S. Plymouth Blvd., Los Angeles 90004 FAX: 213.936.0114
Hours: By Appt
Contact: Joni Moisant Weyl, Owner/Director
Specialty: Contemporary paintings; sculpture, prints; expert in works on paper

Works Available By: Jonathan Borofsky, Mark di Suvero, Richard Diebenkorn, Sam Francis, David Hockney, Jasper Johns, Ellsworth Kelly, Roy Lichtenstein, Isamu Noguchi, Claes Oldenburg, Robert Rauschenberg

MENLO PARK

THE MERRYMAN COLLECTION 415.854.1727
2427 Sharon Oaks Drive, Menlo Park 94025
Hours: By Appt
Contact: Nancy Merryman, President
Specialty: Contemporary American prints and drawings

Works Available By: Donald Baechler, Richard Diebenkorn, Sam Francis, Al Held, David Hockney, Franz Kline, Roy Lichtenstein, Robert Motherwell, James Rosenquist, Frank Stella, Carol Summers, Wayne Thiebaud

MILL VALLEY

MICHAEL REIF/FINE ART HUNTERS 415.381.2400
P.O. Box 2037, Mill Valley 94942 FAX: 415.381.2490
Hours: By Appt
Contact: Michael Reif, Director
Specialty: 20th-century avant-garde and modernist painting, drawing and
sculpture; School of Paris

Works Available By: Milton Avery, Franz Bergmann, Bolesias Biegas, Emil Bisttram, Hans Burkhardt, Federico Castillon, Jean Marembert, Jacqueline Marval, Jais Nielsen, John O'Neil, Gen Paul, Zdenek Rykr, Clement Serveau

PACIFIC PALISADES

DEANNA MILLER FINE ARTS 213.454.6241
951 Kagawa St., Pacific Palisades 90272 FAX: 213.459.7752
Hours: Mon-Fri 9-5
Contact: Deanna Miller, Proprietor
Specialty: Corporate and private collections, aquisitions and exhibitions

Works Available By: Peter Alexander, Billy Al Bengston, Laddie John Dill, David Hockney, Malcolm Morley, Ed Moses, Robert Rauschenberg, Ed Ruscha, Richard Serra

PRIVATE DEALERS

GALERIE BRENDA WALLACE 514.393.4066
372 rue Ste Catherine ouest, # 508, Montreal H3B 1A2 FAX: 514.393.4571
Hours: Daily 11-6
Contact: Brenda Wallace, Director
Specialty: Photo-based work; installations

Artists Represented: Vikky Alexander, Marian Penner Bancroft, Ron Benner, Claude-Philippe Benoit, Liliana Berezowsky, Yves Bouliane, Wyn Geleynse, John Heward, Tadashi Kawamata, Holly King, Micah Lexier, Tim Maul, Regan Morris, Roberto Pellegrinuzzi, Mary Scott, Edward Zelenin

WALTER KLINKHOFF GALLERY 514.288.7306
1200 Sherbrooke St. W., Montreal H3A 1H6
Hours: Mon-Fri 9:30-5:30; Sat 9:30-5
Contact: Alan J. Klinkhoff, Director; Eric J. Klinkhoff, Director
Specialty: Important 19th- & 20th-Century Canadian art

Artists Represented: Franklin Arbuckle, Leon Bellefleur, Bruno Bobak, Molly Lamb Bobak, Horace Champagne, Bruce Ledain, John Little Robert, F.M. McInnis, Richard Mont Petit, Joe Plaskett, Antoine Prevost, Fred Ross, Claude A. Simard, William Winter

OBORO 514.844.3250
3981 boul. St. Laurent, #499, Montreal H2W 1Y5 FAX: 514.289.9680
Hours: Wed-Sun 12-5
Contact: Daniel Dion, Director; Bernard Bilodeau, Director

POIRIER SCHWEITZER (see Galerie John A, Schweitzer)

MICHEL TETREAULT ART CONTEMPORAIN 514.521.2141
1192 rue Beaudry, Montreal H2L 3E4 FAX: 514.521.6678
Hours: Tues-Sat 11-6
Contact: Michel Tetreault, Director
Specialty: Canadian and international artists

Artists Represented: Pierre Blanchette, Louis-Pierre Bougie, Kittie Bruneau, Christiane Gauthier, Jacques Hurtubise, Kevin Kelly, Christian Kiopini, Isabelle Leduc, Jennifer Macklem, Paul Mathieu, Jean-Pierre Morin, Jean Noel, Jacques Payette, Fabrizio Perozzi, Michel Saulnier, Susan Scott, Pierre-Leon Tetreault, Francois Vincent **Works Available By:** Le Corbusier

LANDAU FINE ART 514.849.3311
1456 Sherbrooke St. W., Montreal H3G 1K4 FAX: 514.289.9448
Contact: Renata Hochelber, Director

WADDINGTON & GORCE INC. 514.847.1112
2155 rue Mackay St., Montreal H3G 2J2 FAX: 514.847.1113
Hours: Tues-Fri 9:30-5:30; Sat 10-5
Contact: Gerard M. Gorce, Director
Specialty: Canadian and international contemporary art

Artists Represented: David Alexander, Wayne Alfred, Ulysse Comtois, Giuseppe Di Leo, Russell Gordon, Dorothy Knowles, Stephen Lack, Norman Laliberte, Rita Letendre, Louise Masson, Jean McEwen, Guido Molinari, Michel Morin, William Perehudoff, Jim Reed, John Stewart **Works Available By:** Arman, Milton Avery, Lynn Chadwick, Christo, Alex Colville, Jean-Philippe Dallaire, Jim Dine, Rainer Fetting, Clarence Gagnon, Betty Goodwin, David Hockney, Jean-Paul Lemieux, Henry Moore, David Nash, Mimmo Paladino, Alfred Pellan, Jean-Paul Riopelle, Tony Scherman, Philip H. Surrey, Antoni Tapies

WESTMOUNT

LA GALERIE KASTEL INC. 514.933.8735
1366 Greene Ave., Westmount H3Z 2B1
Hours: Tues-Sat 10-5:30
Contact: Paul Kastel, Director
Specialty: Traditional and contemporary Canadian artists

CANADA (cont.)

ONTARIO

TORONTO

ROBERTS GALLERY LIMITED 416.924.8731
641 Yonge St., Toronto M4Y 1Z9
Hours: Tues-Sat 9-5
Contact: L.J. Wildridge, President; Paul T. Wildridge, Director
Specialty: Historical and contemporary Canadian artists

Artists Represented: Franklin Arbuckle, Geoffrey Armstrong, A.J. Casson, Alan Collier, Pat Fairhead, Michael French, Mackay Houstoun, Paul Kelley, Arthur Shilling **Works Available By:** Paul-Emile Borduas, Jean-Paul Lemieux, Alfred Pellan, Jean-Paul Riopelle

SABLE-CASTELLI 416.961.0011
33 Hazelton Ave., Toronto M5R 2E3

MIRIAM SHIELL FINE ART LTD. 416.925.2461
16A Hazelton Ave., Toronto M5R 2E2 FAX: 416.925.2471
Hours: Tues-Sat 9:30-5:30
Contact: Miriam Shiell, Director
Specialty: Modern masters and contemporary international

Artists Represented: Luciano Castelli, Lynn Chadwick, Rainer Fetting, Dorothy Knowles, William Perehudoff **Works Available By:** Karel Appel, Arman, Milton Avery, Carolyn Morris, Bach, Sandro Chia, Jean Dufy, Helen Frankenthaler, Hodicke, John Latham, Bengt Lindstrom, Henri Matisse, Mimmo Paladino, Jules Pascin, David Salle

S.L. SIMPSON GALLERY 416.362.3738
515 Queen St. W., Toronto M5V 2B4 FAX: 416.362.0979
Hours: Tues-Sat 11-6
Contact: Sandra Simpson, Owner
Specialty: Commercial art gallery; contemporary Canadian and American art

Artists Represented: Shelagh Alexander, David Baker, Brian Boigon, David Clarkson, Christine Davis, Judith Doyle, Jack Goldstein, General Idea, Gordon Lebredt, Robert McNealy, Andy Patton, Judith Schwarz, Michael Snow, Nancy Spero, David Tomas, Renee Van Halm, Carol Wainio, David Walker, Carolyn White

ODON WAGNER GALLERY 416.962.0438
194 Davenport Rd., Toronto M5R 1J2 FAX: 416.962.1581

WYNICK/TUCK GALLERY 416.364.8716
80 Spadina Ave., 4th Fl., Toronto M5V 2J3
Hours: Tues-Sat 11-5:30
Contact: Lynne Wynick, Director; David Tuck, Director
Specialty: Contemporary Canadian art: painting, sculpture, works on paper and installations

Artists Represented: David Barnett, **David Bierk (See page 55),** John Clark, Sorel Cohen, Greg Curnoe, Joseph Devellano, Gathie Falk, Dulcie Foo Fat, Gerald Ferguson, Janice Gurney, **John Hall (See page 125),** George Hawken, Landon MacKenzie, Guido Molinari, Evan Penny, Richard Storms

YARLOW-SALZMAN 416.964.3466
50 Macpherson Ave., Toronto M5R 1W8

YYZ 416.531.7869
1087 Queen St. W., Toronto M6J 1H3

PROVINCE OF QUEBEC

MONTREAL

DOMINION GALLERY 514.845.7833
1438 Sherbrooke St. W., Montreal H3G 1K4 FAX: 514.845.2903
Hours: Tues-Fri 10-5:30; Sat 10-5
Contact: Michael Barnwell; Michel L. Moreault
Specialty: Sculpture and paintings; Canadian and international; contemporary and 19th- Century masters

EDITION JOHN A. SCHWEITZER (See Galerie John A. Schweitzer)

ESPERANZA 514.933.6455
2144 Mackay, Montreal H3G 2J1

GALERIE RENE BLOUIN 514.393.9969
372 Ste-Catherine ouest, Ste. 501, Montreal H3B 1A2 FAX: 514.393.4571
Hours: Tues-Sat 12-5:30, And By Appt
Contact: Rene Blouin, Director
Specialty: Advanced contemporary art

Artists Represented: Robert Adrian, Daniel Buren, Genevieve Cadieux, Melvin Charney, Tom Dean, Pierre Dorion, Catherine Everett, Charles Gagnon, Betty Goodwin, Geoffrey James, Marcel Lemyre, Rober Racine, Tom Sherman, Kiki Smith, Barbara Steinman, Jana Sterbak **Works Available By:** Jasper Johns, Robert Rauschenberg, Susan Rothenberg, Terry Winters

GALERIE BOULANGER CHANTAL 514.397.0044
372 rue St. Catherine W., Montreal H3B 1A2
Contact: Chantal Boulanger, Director

GALERIE CHRISTIANE CHASSAY 514.284.2631
20 W. Rue Marie-Anne ouest, Montreal H2W 1B5
Hours: Wed-Sat 12-5
Contact: Christiane Chassay, Director
Specialty: Contemporary art in sculpture and installation

Artists Represented: Kim Adams, Guy Bourassa, Eva Brandl, Michel Daigneault, Andrew Dutkewych, Trevor Gould, Michel Goulet, Pierre Granche, Jacek Jarnuszkiewicz, Jean Lantier, Claude Mongrain, Richard Purdy, Brigitte Radecki, Denis Rousseau, Stephen Schofield, Laurie Walker

GALERIE BERNARD DESROCHES INC. 514.842.8648
1444 Sherbrooke St. W., Montreal H3G 1K4 FAX: 514.842.7951
Hours: Mon-Sat 9-5:30
Contact: Bernard Desroches, Director
Specialty: Canadian, European and American masters from the 19th- & 20th centuries

Artists Represented: Paul-Emile Borduas, Stanley Cosgrove, Jean-Philippe, Dallaire Marc-Aurele de Foy Suzor-Cote, Marc-Aurele Fortin, Clarence Gagnon, The Group of Seven, Theophile Hamel, Kieff, Cornelius Krieghoff, Ozias Leduc, Jean-Paul Lemieux, Jean McEwen, James Wilson Morrice, Paul Peel, Alfred Pellan, Jean-Paul Riopelle **Works Available By:** Karel Appel, Emile Antoine Bourdelle, Bernard Buffet, Henri Harpignies, Henri Le Sidaner, Henri Lebasque, Fernand, Leger, Maximilien Luce, Henri Martin, Andre Masson

GALERIE GRAFF 514.526.2616
963 E. Rachel, Montreal H2J 2J4
Contact: Madeleine Forcier, Director

GALERIE CLAUDE LAFITTE 514.939.9898
1480 Sherbrooke St. W., Montreal H3G 1L3 FAX: 514.939.7116
Contact: Claude Lafitte, Director

GALERIE SAMUEL LALLOUZ 514.398.9806
372, Ste-Catherine ouest, Ste. 528, Montreal H3B 1A2 FAX: 514.398.9807
Hours: Tues-Fri 10-6; Sat 11-5
Contact: Samuel Lallouz, Director
Specialty: Canadian and international contemporary art

Artists Represented: John Francis, Joan Jonas, Naomi London, John McEwen, Anne & Patrick Poirier, Sylvie Readman, Claude A. Simard, Serge Tousignant, Franz Erhard Walther, Irene F. Whittome **Works Available By:** Carl Andre, Karel Appel, John Baldessari, Daniel Buren, Donald Judd, Jannis Kounellis, Sol LeWitt, Brice Marden, Allan McCollum, Roman Opalka, Robert Rauschenberg, Jean-Paul Riopelle, Cindy Sherman, Haim Steinbach, Meyer Vaisman

GALERIE ELCA LONDON 514.931.3646
1616 Sherbrooke St. W., Montreal H3H 1C9
Hours: Tues-Sat 10-5:30
Contact: Elca London, President; Mark London, Director
Specialty: Contemporary, Canadian and American paintings and sculpture

Artists Represented: Stanley Boxer, Alex Cameron, Michele Drouin, Harold Feist, Greg Hardy, Darryl Hughto, Jules Olitski, Alan Reynolds, Susan Roth **Works Available By:** Jack Bush

GALERIE FREDERIC PALARDY 514.844.4464
307 rue Ste-Catherine ouest, Montreal H2X 2A3
Contact: Caroline Bussieres, Asst. Director

GALERIE JOHN A. SCHWEITZER 514.289.9262
42 ouest, avenue des Pins, Montreal H2W 1R1 FAX: 514.289.9262
Hours: By Appt
Contact: Robert Poirier, Director; John A. Schweitzer, Director
Specialty: Modern and contemporary American and European painting, sculpture and photography

Works Available By: Diane Arbus, Richard Avedon, Jake Berthot, Sam Francis, Helen Frankenthaler, David Hockney, Hans Hofmann, Bryan Hunt, Robert Mapplethorpe, Brice Marden, Agnes Martin, Duane Michals, Robert Moskowitz, **Robert Motherwell (See page 177),** Jules Olitski, Irving Penn, Martin Puryear, Milton Resnick, Dorothea Rockburne, Robert Ryman, Sean Scully, Richard Serra, Joel Shapiro, Jose Maria Sicilia, Ettore Sottsass, Frank Stella, Myron Stout, Donald Sultan, Cy Twombly, Christopher Wilmarth

GALERIE BARBARA SILVERBERG 514.932.398?
2148 Mackay St., Montreal H3G 2J1
Contact: Barbara Silverberg, Owner
Specialty: Contemporary ceramics

GALERIE TROIS POINTS 514.845.555?
307 Ste Catherine ouest, Ste. 555, Montreal H2X 2A3 FAX: 514.481.088?
Hours: Tues-Fri 11-6; Sat 11-5
Contact: Jocelyne Aumont, Director
Specialty: Contemporary art

PRIOR EDITIONS 604.685.0535
303-1028 Hamilton St., Vancouver V68 2R9
Hours: Mon-Sat 10-6
Contact: Torrie Groening; Nigel Harrison
Specialty: Contemporary Canadian graphics

Works Available By: Lyne Bastien, Doug Biden, Robert Bigelow, Patrick Cox, Ron Eckert, William T. Wiley, Libby Hague, Don Holman, Brian Kelley, Harold Klunder, Mary Miles, Carel Moiseiwitsch, Greg Murdock, Steven Nelson, Toni Onley, **David Ostrem (See page 276)**, Ken Pattern, Art Perry, Jack Shadbolt, Arnold Shives, Alan Storey, Robert Sutherland, Otis Tamasauskas, Takao Tanabe, Joseph Therrien, Neil Wedman, Alan Wood, Robert Young

ONTARIO

TORONTO

EVELYN AIMIS GALLERY 416.961.0878
14 Hazelton Ave., Toronto M5R 2E2 FAX: 416.323.0627
Hours: Daily 10:30-5:30
Contact: Paul Petro, Director; Evelyn Aimis, Owner
Specialty: Contemporary Canadian and international paintings, drawings, sculpture, and prints

Artists Represented: Sheila Butler, Janet Cardiff, Jim Davies, Sorel Etrog, Gordon Ferguson, Ron Giii, Jiri Ladocha, Nino Longobardi, Michael Morris, Ken Nutt, Sylvia Safdie **Works Available By:** Karel Appel, Milton Avery, Lynn Chadwick, Jim Dine, Jean Dubuffet, David Hockney, Henri Matisse, Mimmo Paladino, Pablo Picasso, Arnulf Rainer, Robert Rauschenberg, Gerhard Richter, Jean-Paul Riopelle, Frank Stella, Andy Warhol

SANDRA AINSLEY GALLERY 416.362.4480
2 First Canadian Pl., Box 262, Toronto M5X 1C8
Contact: Sandra Ainsley, Owner

JANE CORKIN GALLERY 416.979.1980
179 John St., Ste. 302, Toronto M5T 1X4 FAX: 416.979.7018
Hours: Tues-Fri 10-5:30; Sat 10-5
Contact: Jane Corkin, President; Patti Cooke, Director
Specialty: Historical and contemporary fine art photography

Artists Represented: Robert Bourdeau (See page 379), Barbara Cole, Horst, **Carol Marino (See page 392)**, Sheila Metzner, Irving Penn, Deborah Samuel, **Nigel Scott (See page 397)**, Rick Zolkower **Works Available By:** Eugene Atget, Margaret Bourke-White, **Frantisek Drtikol (See page 384)**, Laszlo Moholy-Nagy, Man Ray, **Alexander Rodchenko (See page 396)**, Edward Weston **Estates Represented: André Kertész (See page 389)**

THE DRABINSKY GALLERY 416.324.5766
86 Scollard St., Toronto M5R 1G2 FAX: 416.324.5770
Hours: Tues-Sat 11-6
Contact: Marilyn Burnett, Director
Specialty: Contemporary Canadian painting and sculpture

Artists Represented: Peter Aspell, Walter Bachinski, Paul Beliveau, Oscar Cahén, Victor Cicansky, **Alex Colville (See page 79)**, Graham Coughtry, Marc Garneau, Tom, Hopkins, Wanda Koop, Fernand Leduc, Vicky Marshall, Gordon Rayner, Michael Smith, Jeffrey Spalding, David Thauberger, Claude Tousignant, Harold Town, Daniel Villeneuve **Works Available By:** Paul-Émile Borduas, Jack Bush, Jean-Paul Lemieux, Alfred Pellan, Jean-Paul Riopelle, William Ronald, Tony Scherman

GALERIE DRESDNERE 416.923.4662
12 Hazelton Ave., Toronto M5R 2E2
Contact: Judy Scolnik, Director

FEHELEY FINE ARTS 416.323.1373
45 Avenue Rd., Toronto M4K 1L9 FAX: 416.323.0121
Hours: Tues-Sat 10:30-5:30
Contact: Patricia Feheley, Director
Specialty: Inuit art.

Artists Represented: Kenojuak Ashevak, Kiawak Ashoona, Kaka Ashoona, Osuitok Ipeelee, Jessie Oonark, Kananginak Pootoogook, Pauta Saila, Ovillu Tunillie, Kabubuwa Tunillie **Works Available By:** J.F. Lansdowne

GALLERY 44 416.363.5187
183 Bathurst St., Toronto M5T 2R7
Contact: Terry Costantino, Director

GALLERY MOOS LTD. 416.922.0627
136 Yorkville Ave., 2nd Fl., Toronto M5R 1C2 FAX: 416.922.6612
Hours: Tues-Sat 11-6
Contact: Walter A. Moos, President; Gerard M. Jennings, Director
Specialty: Contemporary Canadian and international art

Artists Represented: Karel Appel, Ken Danby, Sorel Etrog, Rainer Gross, Gershon Iskowitz, Alex Janvier, Paul Jenkins, Lester Johnson, John McKee, Jim Reed, Jean-Paul Riopelle, Ramon Roig, Robert Scott, William Scott, Michael Stefura, Tatino

GALLERY ONE 416.929.3103
121 Scollard St., Toronto M5R 1G4 FAX: 416.929.0278
Hours: Tues-Sat 10:30-5:30
Contact: Goldie Konopny, Director; Sharon Fischtein, Director
Specialty: Contemporary Canadian, American and international painting, sculpture and graphics

Artists Represented: David Blackwood (See page 262), Stanley Boxer, Christopher Broadhurst, Brian Burnett, **Anthony Caro (See page 313)**, Reta Cowley, Lynn Donoghue, Joseph Drapell, Friedel Dzubas, Andre Fauteux, Harold Feist, **Helen Frankenthaler (See page 109)**, Douglas Haynes, Darryl Hughto, Kenneth Lochhead, Michael Matthews, Catherine McAvity, Wynona Mulcaster, Kenneth Noland, **Jules Olitski (See page 183)**, Mary Pavey, Rebecca Perehudoff, Larry Poons, Alan Reynolds, Charles Robb, Susan Roth, Pat Service, Douglas Stone, Bobby Tamo, Alice Teichert, Larry Zox **Works Available By:** Milton Avery, Alexander Calder, Terry Fenton, Sam Francis, Adolph Gottlieb, Maryann Harman, David Hockney, Charles Killam, Morris Louis, Robert Motherwell, Harold Town, Andy Warhol, Joyce Weinstein **Estates Represented: Jack Bush (See page 66)**

GARNET PRESS GALLERY 416.366.5012
580 Richmond St. W., Toronto M5V 1Y9
Hours: Tues-Sat 12-6
Contact: Carla Garnet, Director
Specialty: Contemporary Canadian fine art

Artists Represented: John Abrams, Stephen Andrews, Isaac Applebaum, Rebecca Baird, Jane Buyers, Carlo Cesta, Paul Collins, Alex Decosson, Andy Fabo, Robert Flack, Sybil Goldstein, Natalka Husar, Bill Jones, Michael Merrill, Warren Quigley, Chrysanne Staphacos, Ben Walmsley

THE GLASS ART GALLERY, INC. 416.968.1823
21 Hazelton Ave., Toronto M5R 2E1 FAX: 416.968.1823
Hours: Tues-Sat 11-5:30
Contact: Janak K. Khendry, Director/Owner
Specialty: Contemporary glass and metal sculpture

Artists Represented: Karl Berg, Warren Carther, Robert Cook, Mary Filer, Janak K. Khendry, Barbara Lekberg, Harvey K. Littleton, William Morris, Mark Peiser, Jack Schmidt, Livio Seguso

MIRA GODARD GALLERY 416.964.8197
22 Hazelton Ave., Toronto M5R 2E2 FAX: 416.964.5912
Contact: Nicholas Metivier, Director

JERRARD GALLERY 416.345.8442
954 King St. W., Toronto M6K 1E5
Contact: Michael James Allen, Director

KLONARIDIS, INC. 416.360.7800
80 Spadina Ave., Toronto M5V 2J3
Hours: Tues-Sat 11-5
Contact: Alkis Klonaridis, Owner
Specialty: Contemporary fine art

Artists Represented: David Bolduc, Robert Cronin, Paul Fournier, K.M. Graham, Dan Solomon

OLGA KORPER GALLERY 416.538.8220
17 Morrow Ave., Toronto M6R 2H9
Hours: Tues-Sat 10-6
Contact: Olga Korper, Director; Sasha Korper, Director
Specialty: Contemporary Canadian painting, sculpture and paperworks

Artists Represented: Kim Andrews, **Ilan Averbuch (See page 304)**, Roland Brener, Louis, Comtois, Lucio de Heusch, Yves Gaucher, Susanna Heller, Hugh LeRoy, Claude Luneau, Claude Mongrain, Greg Murdock, John Noestheden, Bobbie Oliver, Leopold Plotek, Roland Poulin, Yoshi Sankawa, Henry Saxe, Helen Sebelius, Ron Shuebrook, Eric Snell, Patrick Thibert, Tim Whiten

CARMEN LAMANNA GALLERY 416.363.8787
788 King St. W., Toronto M5V 1N6
Hours: Tues-Sat 10-6
Specialty: Contemporary Canadian art

Artists Represented: Iain Baxter, John Brown, Ian Carr-Harris, Magdalen Celestino, Robin Collyer, Marc de Guerre, Paterson Ewen, Murray Favro, Robert Fones, Mary Janitch, Ray Johnson, Joseph Kosuth, Ron Martin, Reinhard Reitzenstein, John Scott, Vincent Tangredi, Joanne Tod, Colette Whiten, Robert Wiens, Shirley Wiitasalo

MERCER UNION 416.977.1412
333 Adelaidest W., 5th Fl., Toronto M5V 1R5

NANCY POOLE'S STUDIO 416.964.9050
16 Hazelton Ave., Toronto M5R 2E2
Hours: Tues-Sat 10-5:30
Contact: Joan M. Martyn, Owner; Pat Marshall, Owner
Specialty: Canadian: twenty-one years searching and exhibiting the best

Artists Represented: Patrick Amiot, **John B. Boyle (See page 59)**, Lindee Climo, Diana Dean, Elizabeth Higgins, Brian Jones, Andrew Valko

WASHINGTON

SEATTLE

DAVIDSON GALLERIES 206.624.7684
313 Occidental Ave. S., Seattle 98104
Hours: Tues-Sat 11-5:30; Sun 1-5
Contact: Kate Joyce, Director

LINDA FARRIS GALLERY 206.623.1110
322 Second Ave. S., Seattle 98104
Hours: Tues-Sat 11:30-5; Sun 1-5
Contact: Linda Farris, Director

FULLER/ELWOOD GALLERY 206.625.0890
316 Occidental Ave. S., Seattle 98104
Hours: Wed-Sat 11-5
Contact: Sean Elwood, Director; Carole Fuller, Director

LISA HARRIS GALLERY 206.443.3315
1922 Pike Pl., Seattle 98101
Hours: Mon-Sat 11-5:30
Contact: Lisa Harris, Director
Specialty: Contemporary Northwest and West Coast
paintings, prints and sculpture

Artists Represented: Manda Beckett, Robert Buchanan, Charles Buell, Brian Chapman, **John Cole (See page 76),** Deborah DeWit, Steve Engel, **Terry Furchgott (See page 112),** Joan Gold, David Green, Michael Greenspan, Barbara Hart, Leah Kosh, David McGranaghan, Richard Morhous, Gary Nisbet, Nelleke Nix, Eugene Pizzuto, Lois Silver, John Sisko, Matt Timo, Thomas Wood

KIMZEY MILLER GALLERY 206.682.2339
1225 Second Ave., Seattle 98101
Hours: Mon-Sat 10-6; Sun 12-5
Contact: Terry Miller, Director

GREG KUCERA GALLERY 206.624.0770
626 Second Ave., Seattle 98104
Hours: Tues-Sat 10:30-5:30; Sun 12-5
Contact: Greg Kucera, Owner
Specialty: Contemporary works by nationally recognized
artists and emerging northwest artists

Artists Represented: Mark Calderon, Francis Celentano, Michael Ehle, Gene Gentry McMahon, Karin Helmich, Jody Isaacson, Ken Kelly, Cheryl Laemmle, Steve Larson, **Alden Mason (See page 168),** Jeffry Mitchell, Frank Okada, Ross Palmer Beecher, Richard Posner, Dyan Rey, Roger Shimomura, Ed Wicklander **Works Available By:** Jennifer Bartlett, Deborah Butterfield, Francesco, Clemente, Tony Cragg, Richard Diebenkorn, Carroll Dunham, Eric Fischl, Helen Frankenthaler, Jane Hammond, Keith Haring, Bill Jensen, Jasper Johns, Robert Motherwell, Elizabeth Murray, Manuel Neri, Mimmo Paladino, Robert Rauschenberg, Susan Rothenberg, Frank Stella, Donald Sultan, Wayne Thiebaud, Terry Winters

LYNN MCALLISTER GALLERY 206.624.6864
416 University Pl., Seattle 98104
Contact: Lynn McAllister, Director

MIA GALLERY 206.467.8283
314 Occidental Ave. S., Seattle 98104
Hours: Tues-Sat 11-5:30; Sun 1-5
Contact: Mia McEldowney, Director

CLIFF MICHEL GALLERY 206.623.4484
520 Second Ave., Seattle 98104

FRANCINE SEDERS GALLERY LTD. 206.782.0355
6701 Greenwood Ave. N., Seattle 98103 FAX: 206.783.6593
Hours: Tues-Sat 11-5; Sun 1-5
Contact: Francine Seders, President; Patricia Scott
Specialty: Contemporary American art

Artists Represented: Juan Alonso, Guy Anderson, Michael Barnes, Karl Benjamin, Fred Birchman, Dan W. Carmichael, Michael Dailey, Pat DeCaro, James Deitz, Marita Dingus, Nanci Erskine, Karen Ganz, Andreas Grunert, Juliana Heyne, Fay Jones, Robert C. Jones, E. Kaye Kaminski, Ed Kamuda, John Keppelman, Gwen Knight, Kevin Koch, Alan Lau, **Jacob Lawrence (See page 154),** Phillip Lewis, Dale Lindman, Norman Lundin, Ed Musante, Charles Nathan, Royal Nebeker, Linda Okazaki, Bruce Park, Elizabeth Sandvig, Ikune Sawada, Michael Spafford, Barbara E. Thomas, James Thompson, Willem Volkersz, Marc Wenet, Ted Wiprud **Works Available By:** Pehr, Mark Tobey **Estates Represented:** Wendell Brazeau, Boyer Gonzales, Walter Isaacs, Paul Jenkins

SILVER IMAGE GALLERY 206.623.8116
318 Occidental Ave. S., Seattle 98104
Hours: Tues-Sat 11:30-5:30; Mon By Appt
Contact: Steven Charles, Director

WILLIAM TRAVER GALLERY 206.448.4234
2219 Fourth.St., Seattle 98121 FAX: 206.448.9050
Hours: Tues-Fri 10-6; Sat-Sun 12-5
Contact: William Traver, Director
Specialty: Contemporary studio glass, painting, and sculpture

Artists Represented: Linda Beaumont, Sonja Biomdahl, Curtiss Brock, George Chacona, Fritz Dreisbach, Gregory Grenon, Lauren Grossman, Walter Lieberman, Paul Marioni, Dante Marioni, Stephen McClelland, Peter Shire, Lino Tagliapietra, Bertil Vallien, Merrill Wagner, Dick Weiss

WARWICK GALLERY 206.728.5656
2512 Fifth Ave., Seattle 98104

GORDON WOODSIDE/JOHN BRASETH 206.622.243
1533 Ninth St., Seattle 98104
Hours: Mon-Sat 11-6; Sun 1-6
Contact: Gordon Woodside, Director; John Braseth, Director

CANADA

BRITISH COLUMBIA

VANCOUVER

ATELIER GALLERY 604.732.3021
3084 Granville St., Vancouver V6H 3J8

BAU-XI 604.733.7011
3045 Granville St., Vancouver V6H 3J9 FAX: 604.733.3211

BUSCHLEN MOWATT FINE ARTS 604.682.1234
1445 W. Georgia St., Main Fl., Vancouver V6G 2T3 FAX: 604.682.6004
Hours: Mon-Wed, Fri-Sat 10-6; Thurs 10-9; Sun 12-5
Contact: Ingunn Kemble, Director
Specialty: Contemporary international and Canadian artworks

PATRICK DOHENY FINE ART LTD. 604.737.1733
1811 W. First Ave., Vancouver V6J 4M6 FAX: 604.731.4576
Contact: Patrick Doheny; Alison Davis
Specialty: Modern and contemporary painting, drawing, sculpture and holography

Artists Represented: Nancy Boyd, **Crenshaw & Dinsmore (See page 288),** Wayne Eastcott, Brenda Hemsing, Vicky Marshall, Gary Pearson, Arnold Shives, **Robert Sutherland (See page 296),** Bob Van Der Mey, **Antoniucci Volti (See page 371),** Peter John Voormeij, John Clair Watts, Shawn Westlaken, **Alan Wood (See page 246)**

EQUINOX GALLERY 604.736.2405
2321 Granville St., Vancouver V6H 3G3 FAX: 604.736.0464

DIANE FARRIS GALLERY 604.737.2629
1565 W. Seventh Ave., Vancouver V6J 1S1 FAX: 604.737.2675
Hours: Tues-Sat 10-5:30
Contact: Diane Farris, Owner
Specialty: Canadian contemporary paintings, drawings and sculpture

Artists Represented: David Bierk, Roland Brener, Lionel Doucette, Monique Fouquet, Graham Gillmore, Angela Grossmann, John Koerner, Paul Kuhn, **Attila Richard Lukacs (See page 162),** Laurie Papou, Philippe Raphanel, Elsbeth Rodger, Derek Root, Jeffrey Spalding, David Walker, Neil Wedman, Gu Xiong

GALLERY OF TRIBAL ART 604.732.455
1521 W. Eighth Ave., Vancouver V6J 1T5 FAX: 604.732.543
Hours: Tues-Sat 10-6
Contact: Isabelle Procter, Assoc. Director
Specialty: Northwest coast, Papua New Guinea, Aboriginal,
Australia, and George Littlechild

Artists Represented: Wayne Alfred, Joe David, Reg Davidson, Robert Davidson, George Littlechild, Erna Motna Nakamarra, Joe Peters, Jr., Larry Rosso, Isaac Tait, Clifford Possum, Tjapaltjarri

HEFFEL GALLERY LIMITED 604.732.650
2247 Granville St., Vancouver V6H 3G1 FAX: 604.732.424
Hours: Tues-Sat 10-6; Fri 10-8:30
Contact: Robert Heffel, Director
Specialty: Important historical and contemporary Canadian art

Artists Represented: David Alexander, Peter Aspell, Walter Bachinski, David Blackwood, **Bonifacho (See page 58),** Alex Colville, John Fox, Britton Francis, Ann Kipling, William McElcheran, Jean McEwen, Jim McKenzie, Guido Molinari, Toni Onley, **Richard Overfield (See page 185),** **Arnold Shives (See page 216),** W.P. Weston, **Works Available By:** Emily Carr, The Group of Seven, E.J. Hughes, David Milne, W.J. Phillips, Jean-Paul Riopelle, Tony Scherman, Jack Shadbolt, Gordon Smith **Estates Represented:** B.C. Binning, Lawren Harris, Charles H. Scott

CATRIONA JEFFRIES FINE ART 604.683.24
550 Burrard St., 3rd Fl., Vancouver V6C 2J6
Hours: Tues-Sat 10-6
Contact: Catriona Jeffries
Specialty: Contemporary Canadian and international art

Artists Represented: Bill Baker, Brent Boechler, Pamela Chapman, Brad Chernoff, Greg Edmonson, Lesley Finlayson, Lorne Greenberg, Theo Humblet, Keith Mitchell, Rich Nielsen, Jennifer Olszamowski

INMAN GALLERY 713.529.9676
1114 Barkdull, Houston 77006
Hours: Thurs & Fri 12-5; Sat 10-6
Contact: Kerry Inman, Director
Specialty: Contemporary paintings, sculpture, and
works on paper by emerging artists

Artists Represented: Jennie Couch, Linda Haagcarter, Jane Hinton, Paul, Miller, Kristin Musgnug **Works Available By:** Janice La Motta, Jeri Moore

JAMES GALLERY 713.661.8003
5616 Royalton, Houston 77081 FAX: 713.667.1854
Hours: Tues-Fri 10-5; Sat 10-3
Contact: Kathleen James, President
Specialty: Contemporary American art by emerging, regional artists

Artists Represented: Linda Blackburn, Jim Cogswell, Rick Dingus, Charles Field, Lance Letscher, Reg Loving, Dennis Olsen, Mark Perlman, Sam Scott **Works Available By:** Frank Gohlke, Jack Hanley, Gary Retherford

TONI JONES ARIES GALLERY 713.528.7998
1107 S. Shepherd, Houston 77019 FAX: 713.521.0124
Hours: Mon-Fri 9:30-5; Sat 11-4
Contact: Toni Jones, President
Specialty: Abstractions in all media; old and young master prints

Artists Represented: Lu Ellis, Gena Haber, Dennis Kemmerer, Byron Lacy, Lucie Miller, Bette Wentworth, Robert White, Del Zimmerman, David Bekker, Ellen Deisler, Priscilla Ferguson, Brigitta Frisch, Larry Graeber, Roland Ladvig, Mary Ann Mcfall, Mark Mynatt, Robert Ramos, Becky Soria, Dorothy Sumner, Doug Sweet, Gretchen Van Atta Loro

LANNING GALLERY 713.524.5670
223 Westheimer, Ste. 100, Houston 77006
Hours: Tues-Fri 12-7; Sat 12-5
Contact: Karen Lanning, Director; Allison Stewart, Asst. Director

Artists Represented: Thor Barrdal, John Daniel, Barry Jordan, Kelli Scott Kelley, Dennis Kemmerer, **Jack Livingston (See page 160),** Marc Newquist, Gary Parker, Alejandrino Ramirez, Lin Swanner **Works Available By:** Gary Frields, Rafael Gaytan, Andreas Hadialexiou, Marci Harden, Bob Ligon, Scotland Stout

MEREDITH LONG & COMPANY 713.523.6671
2323 San Felipe Rd., Houston 77019 FAX: 713.523.2355
Hours: Tues-Sat 10-6
Contact: Meredith Long, Director
Specialty: 19th- & 20th-Century American paintings,
drawings, prints, and sculptures

Artists Represented: Stanley Boxer, Joseph Glasco, Billy Hassell, Dorothy Hood, Kenneth Noland, Jules Olitski, Larry Poons, Charles, Schorre, Aaron Shikler, Peter Solow, Michael Steiner, Joyce Weinstein **Works Available By:** Anthony Caro, Dan Christensen, Michael David, Willem, de Kooning Herbert Ferber, Janet Fish, Helen Frankenthaler, Nancy Graves, Michael Heizer, Howard Hodgkin, Darryl Hughto, Roberto, Juarez, Lee Krasner, Robert Motherwell, Graham Nickson, Nathan Oliveira, Mimmo Paladino, David Park, Robert Rauschenberg, Paul Resika, Milton Resnick, Kikuo Saito, Julian Schnabel, David Smith, Frank Stella, Donald Sultan, William Turnbull **Estates Represented:** Wayman Adams, Jack Bush, Burgoyne Diller

MCMURTREY GALLERY 713.523.8238
3508 Lake St., Houston 77098
Hours: Tues-Sat 10-5:30
Contact: Eleanor McMurtrey, Owner/Director
Specialty: Contemporary American paintings, sculpture and photographs

Artists Represented: Karen Broker, Sandi Seltzer Bryant, Keith Carter, Ibsen Espada, Francis Pavy, Marc Rawls, Jean Wetta

JACK MEIER GALLERY 713.526.2983
2310 Bissonnet, Houston 77005 FAX: 713.526.2984
Hours: Tues-Fri 10-5:30; Sat 10-4
Contact: Martha Meier, Director
Specialty: Contemporary American paintings, sculpture and photography

Artists Represented: Richard Davis, Anne Embree, Trudi Frank, Francoise Gerard, Nivia Gonzalez, James Groody, Ronny Lhotka, Victoria Martinez-Rodgers, Dorothy Norris Moses, Shirley Romer, Martha Slaymaker, Wade Thompson, Kenneth Young

MOODY GALLERY 713.526.9911
2815 Colquitt, Houston 77098
Hours: Tues-Sat 10-5:30
Contact: Betty Moody, Director
Specialty: Contemporary American art with an emphasis on Texas artists

Artists Represented: Terry Allen, Luis Jimenez, Lucas Johnson, Manual Al Souza, Gael Stack, Randy Twaddle, Dick Wray **Works Available By:** Ed Blackburn, Robert Bourdon, Lamar Briggs, William Christenberry, John Hernandez, Lynn Hurst, Ida Kohlmeyer, Anstis Lundy, Paul Manes, Skeet McAuley, Jack Mims, Madeline O'Connor, Nancy O'Connor, Charles Pebworth, Philip Renteria, Richard Shaffer, Earl Staley, Bill, Steffy **Estates Represented:** James Reaben

NEW GALLERY 713.520.7053
2639 Colquitt, Houston 77098
Hours: Tues-Sat 10:30-5
Contact: Thom Andriola, Director
Specialty: Exhibiting nationally prominent contemporary artists

Artists Represented: Larry Bell, Alice Lok Cahana, Dan F. Howard, Tony Magar, Lee Mullican, Michal Rovner, Miriam Tinguely, Annette Wilzig **Works Available By:** Jaroslav Belik, Emil Bisttram, Pablo Bobbio, Joan, Brossa, Ary Stillman

PARKERSON GALLERY 713.524.4945
3510 Lake St., Houston 77098
Hours: Tues-Fri 10-5; Sat 12-5
Contact: John Parkerson
Specialty: Vintage American and European art

Artists Represented: Nina Beall, Henry Finkelstein, Sara Stites **Works Available By:** E. Martin Hennings, Edwin Landseer, James Kerr Lawson, Robert Preusser, Jamie Wyeth

ROBINSON GALLERIES 713.961.5229
3733 Westheimer, #7, Houston 77027 FAX: 713.961.0828
Hours: Tues-Fri 10-5:30; Sat 10-4
Contact: Thomas V. Robinson, Director
Specialty: International, contemporary art; American art
of the 19th- & 20th centuries

Artists Represented: Tom Allen, Dae Duck Cha, John Dawson, Ron English, Lahib Jaddo, James Johnson, Ann Judd, Glenna Park, Sam Smith, Lamar Scott Smith, Lady Stuart, John Walker **Works Available By:** Thomas Hart Benton, Childe Hassam, Eugene Jardin, Rufino Tamayo, Oswaldo Viteri

MARVIN SELINE GALLERY 713.520.5550
2501 Robin Hood, Ste. 150, , Houston 77005
Hours: By Appt
Contact: Marvin Seline, Owner
Specialty: Contemporary painting, sculpture, and monotypes

TEXAS GALLERY 713.524.1593
2012 Peden, Houston 77019 FAX: 713.521.0124
Hours: Tues-Fri 9:30-5:30; Sat 9:30-5
Contact: Fredericka Hunter, Director
Specialty: Contemporary art

Artists Represented: Gregory Amenoff, Charles Arnoldi, Lynda Benglis, Billy Al Bengston, Derek Boshier, Julie Bossi, James Drake, Nancy Dwyer, Manny Farber, Janet Fish, Dan Flavin, Jedd Garet, Joe Goode, Robert Graham, Rachel Hecker, Jene Highstein, Barry Le Va, Sol LeWitt, Robert Longo, Melissa Miller, Donald Moffett, Ed Moses, Matt Mullican, Bruce Nauman, Ken Price, Robert Rauschenberg, Allen Ruppersberg, Ed Ruscha, Peter Saul, Lee Smith, William Wegman, Susan Whyne, Joe Zucker **Works Available By:** Ellen Carey, Lee Friedlander, Sally Gall, Robert Mapplethorpe, Nic Nicosia, Cindy Sherman, Eve Sonneman, Casey Williams

GERHARD WURZER GALLERY 713.863.1933
5701 Memorial Dr., Houston 77007 FAX: 713.869.9466
Hours: Tues-Fri 10-7; Sat 10-5
Contact: Gerhard Wurzer, Owner
Specialty: 19th- & 20th-Century master prints

Artists Represented: Chris Britz, Ava Cooley, Thom Kapheim, Robert Kipniss, Edo Murtic, Bruno Zupan **Works Available By:** Marc Chagall, Henri Matisse, Joan Miro, Henry Moore, Pablo Picasso, Jean Francois Raffaelli, Rembrandt, Georges Rouault, James McNeill Whistler

JUDY YOUENS GALLERY 713.527.0303
2631 Colquitt St., Houston 77098 FAX: 713.524.5111
Hours: Tues-Fri 10-5:30; Sat 11-5
Contact: Judy Youens, Owner
Specialty: American studio art; glass, painting, sculpture and photography

Artists Represented: Susan Budge, Sydney Cash, Sue Castleman, Robert Longhurst, Frank Owen, Damian Priour, Michael Taylor, Steven Tobin **Works Available By:** Dale Chihuly, Daniel Clayman, Dan Dailey, Laddie John Dill, Richard Fluhr, Herb Jackson, Mimmo Paladino

SAN ANTONIO

JANSEN-PEREZ GALLERY 512.227.0900
175 E. Houston St., San Antonio 78205 FAX: 512.227.9132
Hours: Tues-Fri 12-6; Sat 10-3
Contact: Angelika Jansen, Co-Director; Sofia Gonzales Perez, Co-Director
Specialty: Contemporary art with emphasis on Hispanic and Latin American art

Artists Represented: Mel Casas, James Cobb, Jose Fors, Adan Hernandez, Cesar Martinez, Carlos Merida, Arturo Rivera, Ismael Vargas, Babis Vekris **Works Available By:** Fernando Alba, Luis Anguiano, Michael Bigger, Leonora Carrington, Jose Luis Cuevas, Manuel Felguerez, Erwin Guillermo, Lucia Maya, Aceves Navarro, Jose Luis Rivera, Elmar Rojas, Ito Romo, Kazuya Sakai Siqueiros, Juan Soriano, Rufino Tamayo, Francisco Toledo, Andy Villerreal

TEXAS (cont.)

DALLAS

MODERN REALISM
1903 McMillan Ave., Dallas 75206
Hours: By Appt
Contact: John Held Jr., Director
Specialty: Post-World War II avant-garde

214.553.1116

Artists Represented: Guy Bleus, G.A. Cavellini, H.R. Fricker, Ilmar Kruusamae, Ruggero Maggi, Clemente Padin, Shozo Shimamoto, Edgardo-Antonio Vigo

PEREGRINE GALLERY
2200 Cedar Springs, Ste. 138, Dallas 75201
Hours: Tues-Sat 10-6
Contact: Jo Ann Hart, Director
Specialty: Contemporary gallery exhibiting works on paper, painting, sculpture, and ceramics

214.871.3770

Artists Represented: Linda Blackburn, David Duncan, Rob Erdle, Mike Hart, Pam Nelson, Jack Robbins, Isaac Smith, Warren Taylor **Works Available By:** John Alexander, III, Richard Ash, Eric Avery, David Bates, Ed Blackburn, Kaleta Doolin, Otis Dozier, Joseph Glasco, Susan Harrington, Billy Hassell, Peter Julian, James McGarrell, Laurence Scholder, Ellen F. Tuchman, Elizabeth Yarosz, Judy Youngblood, Miguel Zapata, Karen Zelanka

GERALD PETERS GALLERY
2913 Fairmount, Dallas 75201
Hours: Mon-Fri 9-5; Sat 12-5
Contact: Lisa Webster, Manager
Specialty: 20th-Century American and European art

214.969.9410
FAX: 214.969.9023

Artists Represented: Milton Avery, Richard Fleischner, Susana Jaime-Mena, Walter Nelson, Linda Ridgway, James Watral, Robin Winters **Works Available By:** Christian Boltanski, Helen Frankenthaler, Anish Kapoor, Wolfgang Laib, Kenneth Noland, Frank Stella, Wayne Thiebaud

SOUTHLAND CENTER GALLERY
400 N. Olive, Ste. 1600, Dallas 75201
Hours: Mon-Fri 10-5
Contact: Carolyn Lowrey, Director
Specialty: Contemporary, regional art

214.922.0380
FAX: 214.922.0308

Artists Represented: Tracy Colby, Mark Goad, Lo Jordan, Pat Kochan, Carol Miller, Hershall Seals, Li Shan

SOUTHWEST GALLERY
737 Preston Forest Ctr., Dallas 75230
Hours: Tues-Wed, Fri-Sat 9-6; Thur 9-8; Sun 1-6
Contact: Bob Malenfant, Director
Specialty: Western, southwestern, antiques, and modern art

214.696.0182
FAX: 214.696.0195

Artists Represented: David Baca, Tony Bass, Isabelle Duret-Dujarric, R. C. Gorman, Daryl Howard, Ed Koch, Harold Kraus, Amado Pena, Jean Richardson, James Rizzi, John Stephens, Rufino Tamayo, Paul Waldon, Doug West, Mark Whitmarsh, Larry Young

VALLEY HOUSE GALLERY, INC.
6616 Spring Valley Rd., Dallas 75240
Hours: Mon-Sat 10-5
Contact: Kevin Vogel, Director
Specialty: 19th-, 20th-Century and contemporary paintings, sculpture drawings, and prints

214.239.2441
FAX: 214.239.1462

Artists Represented: Lloyd Brown, David Everett, Barnaby Fitzgerald, Anita Huffington, Robert Peterson, Donna Phipps Stout, Bob Stuth-Wade, **Valton Tyler (See page 238),** Donald Vogel, Anne Weary, Glenn Whitehead **Works Available By:** Tom Benrimo, Ernestine Betsberg, Hugh H., Breckenridge, Mike Cunningham, Loren Mozley, Nat Neujean, Arthur Osver, Zolita Sverdlove, Clara McDonald Williamson **Estates Represented:** Fred Nagler

BARRY WHISTLER GALLERY
2909-A Canton St., Dallas 75226
Hours: Tues-Sat 11-5 And By Appt
Contact: Barry Whistler, Director
Specialty: Contemporary painting, sculpture, prints, drawings and photography

214.939.0242

Artists Represented: The Aaart Guys, Ed Blackburn, Dennis Blagg, Clyde Connell, Vernon Fisher, Jack Hanley, Susan Harrington, Joseph Havel, Otis Jones, Douglas MacWithey, Skeet McAuley, Michael C. McMillen, Michael Miller, Nic Nicosia, Tom Nussbaum, Lee Smith, Al Souza **Works Available By:** Ann Stautberg, James Surls, Randy Twaddle, Danny, Williams

HOUSTON

ALTERMANN & MORRIS GALLERIES
3461 W. Alabama, Houston 77027
Hours: Mon-Fri 9-5; Sat 11-4
Contact: Jack A. Morris, Jr., Director
Specialty: 19th- & 20th-Century paintings and sculpture

713.840.1922
FAX: 713.840.0119

Artists Represented: Cyrus Afsary, Gerald Balciar, Harley Brown, Michael Coleman, Fred Fellows, **Glenna Goodacre (See page 328),** David Halbach, Wilson Hurley, Ramon Kelley, Frank McCarthy, Bill Nebeker, Gary Niblett, Sherry Sander, Lowell E. Smith, William Whitaker **Works Available By:** William Acheff, Joe Beeler, James Boren, G. Harvey, Clark Hulings, Tom Lovell, Kenneth Riley, Gordon Snidow, Grant Speed, Melvin Warren, Fritz White

ARCHWAY GALLERY
2600 Montrose Blvd., Houston 77006
Hours: Mon-Sat 10-5:30
Contact: Pat Moberley Moore, Director
Specialty: An artist cooperative

713.522.2409

Artists Represented: Margaret Scott Bock, Marian Ford, Marcie Masterson, Pat Moberley Moore, Gayle Reynolds, Mark Spiewak, Janean Thompson, Tim Vanya, Helgy White, Louise Williams

BENTELER-MORGAN GALLERIES
4100 Montrose Blvd., Ste. D, Houston 77006
Hours: Tues-Fri 11-6; Sat 11-5
Contact: Susan R. Morgan, Director
Specialty: Fine art photography

713.522.8228
FAX: 713.522.6098

Artists Represented: Debbie Fleming Caffery, Carl Chiarenza, Robert Doisneau, Elliott Erwitt, Jr., Earlie Hudnall, Floris M. Neusuess, Marc Riboud, Holly Roberts **Works Available By:** Anita Chernewski, Pierre Cordier, Harold Edgerton, Andre Gelpke, Hubert Grooteclaes, Wanda Hammerbeck, Thomas Harding, Taishi Hirokawa, Marta Hoepffner, Klaus Kammerichs, Andre Kertesz, Ferne Koch, Cay Lang, Philipp Scholz Ritterman, Willy Ronis, Karin Szekessy, Ruth Thorne-Thomsen, Jerry Uelsmann, John Wawrzonek

HIRAM BUTLER GALLERY
4520 Blossom St., Houston 77007
Hours: Mon-Fri 10-5; Sat 11-4
Contact: Hiram Butler, Director
Specialty: Contemporary American and European

713.863.7097
FAX: 713.863.7130

Artists Represented: Forrest Bess, Peter Blume, Clyde Connell, Jeff, Cowie, Ben Culwell, **Vernon Fisher (See page 105),** Dewitt Godfrey, Virgil Grotfeldt, Terrell James, Paul Kittelson, Brian Portman, Dean Ruck, **James Surls (See page 364)**

DAVIS/McCLAIN GALLERY
2627 Colquitt, Houston 77098
Hours: Mon-Fri 10-5:30; Sat 11-5
Contact: Barbara Davis, Director; Bob McClain, Director
Specialty: Contemporary, American and European, painting, sculpture, drawing and photographs

713.520.9200
FAX: 713.520.8409

Artists Represented: Joseph Beuys, Ross Bleckner, Frank Faulkner, Rebecca Horn, Perry House, Magdalena Jetelova, Donald Judd, Terence La Noue, Donald Lipski, Ken Luce, Joe Mancuso, Jesus Bautista Moroles, David Storey **Works Available By:** Jean-Michel Basquiat, Joseph Cornell, Tony Cragg, Allan McCollum, Andy Warhol

LYNN GOODE GALLERY
2719 Colquitt, Houston 77098
Hours: Mon-Wed, Fri 10-5:30; Thurs 10-8; Sat 11-5:30
Contact: Lynn Goode, Owner
Specialty: Contemporary, primarily Texas artists

713.526.5966
FAX: 713.526.5967

Artists Represented: Katherine Alexander, Bruno Andrade, Malinda Beeman, Jack Boynton, Steve Brudniak, Andy Feehan, Marilyn Lanfear, Annell Livingstone, Frank Martin, Cesar Martinez, Betty Mobley, Floyd Newsum, Max Pruneda, April Rapier, Barbra Riley, Gail Siptak, Dee Wolff

W.A. GRAHAM GALLERY
1431 W. Alabama, Houston 77006
Hours: Tues-Sat 10-5:30
Contact: Bill Graham, Director
Specialty: Contemporary art

713.528.495
FAX: 713.528.756

Artists Represented: Eric Avery, Alain Clement, Tracy Harris, Ron Hoover, Haydn Larsen, Lynn Randolph

GREMILLION & CO. FINE ART
2501 Sunset Blvd., Houston 77005
Hours: Tues-Sat 10-5
Contact: Christopher Skidmore, Director
Specialty: Contemporary American paintings, sculpture and works on paper

713.522.270
FAX: 713.522.371

Artists Represented: David Anderson, Wulf Barsch, Stephen Bartholomew, Bruce Brainard, David Fick, Mary Louise Gallaway, James Groff, Karen Gunderson, Dimitri Hadzi, Stephen Hazel, Batu Jagchid, Lionel Kalish, Wayne Kimball, Chris Knipp, Knox Martin, Reuben Nakian, Peter Nickel, Minoru Niizuma, John Pavlicek, Dimitri Petrov, Kathleen Rabel, Robert Rector, Susan Rodgers, Doug Semivan, Jonathan Silver, Marco Spalatin, Joan Steinman, Todd Stilson, Alphonse Van Woerkom, Clay Wagstaff

HARRIS GALLERY
1100 Bissonnet, Houston 77005
Hours: Tues-Fri 10-5; Sat 11-5
Contact: J. Harrison Itz, Director
Specialty: Contemporary and traditional American paintings, works on paper, photography and sculpture

713.522.91

Artists Represented: Chris Burkholder, George Krause, Charles Mary Kubricht, Robert McCo, Stephen Rolfe Powell, Harold Reddicliffe, Tim Saska, Richard Thompson, Glenn Whitehead, Mac Whitney **Works Available By:** Richard Diebenkorn, Eric Fischl, Robert Kushner, Robert Motherwell

OWEN PATRICK GALLERY 215.482.9395
4345 Main St., Manayunk, Philadelphia 19127
Hours: Tues-Thurs 11-6; Fri-Sat 11-10; Sun 12-6
Contact: James Gilroy, Co-Owner; Gary Pelkey, Co-Owner
Specialty: Fine contemporary art

Artists Represented: Edward Eberle, Michael Gustavson, Catherine Jansen, Geoffrey Lardiere, Leslie Leupp, Patrick Locicero, Rod McCormick, Greg, Parker, Tabitha Vevers, Olmsted Vincent Leon

ROSENFELD GALLERY 215.922.1376
113 Arch St., Philadelphia 19106
Hours: Wed-Sat 10-5; Sun 12-5
Contact: Richard Rosenfeld, Owner
Specialty: Emerging contemporary American artists in all media

Artists Represented: Jennifer Berringer, Vincent Falsetta, E. Sherman, Hayman, Judith Ingman, Earl B. Lewis, Mitch Lyons, Dan Miller, Chuck Olson, Doris Sams, Bruce Samuelson, Helene Sayshen, Mary Spinelli, Jill Terranova, James Toogood, Ken Vaurek, Doug Zucco

SCHMIDT/DEAN GALLERY 215.546.7212
1636 Walnut St., Philadelphia 19103
Hours: Tues-Sat 10:30-6
Contact: Christopher Schmidt, Director
Specialty: International, national and regional visually-Literate work

Artists Represented: Linda Adlestein, Robert Asman, Randy Bolton, Tom Buck, Emily Cheng, Alida Fish, Bradford Graves, Howard Greenberg, Susan Hagen, David Hannah, Sharon Horwath, Wei Jia, Michael Kessler, James Parlin Archie Rand, Masami Teraoka, Toni Vandegrift **Works Available By:** Christopher Brown, Gunther Brus, John Cage, Charles Clough, Ross Neher, Arnulf Rainer, David True, John Walker

SNYDERMAN GALLERY 215.238.9576
317 South St., Philadelphia 19147
Contact: Kristin Peterson, Asst. Director

STUDIO DIABOLIQUES 215.238.0860
1114 Pine St., Philadelphia 19107
Hours: Wed-Sun 12-6
Contact: Robert Carb, Partner; Stephen Carb, Partner
Specialty: Representational painting with symbolist, visionary content and decorative arts

Artists Represented: J.A. Cline, Jerry Difalco, Moi Dugan, Susan Fisher, Mitchell Gillette, Pinkwater Glass, Heather Hassinger, Jonathan Hertzel, Adriana, Kulczycky Alan Lerner, Thelma McCarthy, Nandini, Leslie Nichols, Richard Prigg, Houston Ripley, Bill Russell, Jonathan Schweitzer, Stephen Spera, Bryan Willette, Michael Zarcimba

TEMPLE GALLERY 215.787.5041
1619 Walnut St., Philadelphia 19103
Hours: Tues-Sat 10-5
Contact: Don Desmett, Director

SANDE WEBSTER GALLERY 215.732.8850
2018 Locust St., Philadelphia 19103 FAX: 215.732.7850
Hours: Mon-Fri 10-6; Sat 11-4
Contact: Sande Webster
Specialty: Innovative, abstract and representational contemporary art

Artists Represented: James Brantley, Moe Brooker, Charles Burwell, Syd Carpenter, Nannette Acker Clark, Tim Harbeson, Charles Searles, Gary Weisman **Works Available By:** Nanette Carter, Tom Ferris, Bob Reinhardt

THE WORKS GALLERY 215.922.7775
319 South St., Philadelphia 19147
Hours: Mon-Sat 11-7; Sun 12-6
Contact: Bruce Hoffman, Asst. Director
Specialty: Contemporary American crafts in ceramic, fiber, metal, jewelry, wood and glass

Artists Represented: John Babcock, Bennett Bean, Jon Brooks, Paul Chaleff, Michael James, Judith Larzelere, William Morris, Jacquelyn Rice, Jamie Walker **Works Available By:** Dan Anderson, Ruth Brockmann, Colette, Barbara Hienrich, Anne Hirondelle, Michael Lamar, Nancee Meeker, Jeff Oestreich, D.X. Ross, William Scholl, Sandy Shaw, Rob Sieminski, Chris Staley, Bob Trotman

TENNESSEE

MEMPHIS

BINGHAM KURTS GALLERY 901.683.6200
766 S. White Station Rd., Memphis 38117 FAX: 901.683.6265
Hours: Tues-Fri 10-5:30; Sat 11-4
Contact: Lisa Kurts, Director
Specialty: Southeastern regional artists

Artists Represented: John Alexander, Will Barnett, Wendell Castle, Carroll Cloak, Alice Neel, Manuel Neri, Helen Shirk, Lee Tribe **Works Available By:** Edward Giobbi, Sheora Hamblett, Clementine Hunter, Adele Lemon, Edward Taiers

TEXAS

DALLAS

ADAMS-MIDDLETON GALLERY 214.871.7080
3000 Maple Ave., Dallas 75201 FAX: 214.871.7084
Hours: Mon-Fri 10-5; Sat By Appt
Contact: Anita Middleton, Owner; Holly Johnson, Director
Specialty: 20th-Century contemporary and modern masters

Artists Represented: Eduardo Chillida, David Deming, Herbert Ferber, Joe Guy, Oscar Lakeman Robert Lowe, Norman Lundin, Marcia Myers, Andres Nagel, Paul Rotterdam, Miguel Zapata **Works Available By:** Jorge Castillo, Helen Frankenthaler, Terence La Noue, Robert Motherwell, James Rosenquist, Tom Wesselmann

THE AFTERIMAGE GALLERY 214.871.9140
2828 Routh, Quad #115, Dallas 75201
Hours: Mon-Sat 10-5:30
Contact: Ben Breard, Director
Specialty: Photography

Artists Represented: Dick Arentz, Bruce Barnbaum, Howard Bond, Christopher Burkett, Michael Johnson, Robert Glenn Ketchum, John Sexton, George Tice **Works Available By:** Berenice Abbott, Edouard Boubat, Robert Doisneau, Yousuf Karsh, Michael Kenna, Jerry Uelsmann

ALTERMANN & MORRIS GALLERIES 214.871.3035
2727 Routh, Dallas 75201 FAX: 214.880.0816
Hours: Mon-Fri 9-5; Sat 11-4
Contact: Tony Altermann, Director
Specialty: 19th- & 20th-Century paintings and sculpture

Artists Represented: Cyrus Afsary, Gerald Balciar, Harley Brown, Michael Coleman, Fred Fellows, **Glenna Goodacre (See page 328),** David Halbach, Wilson Hurley, Ramon Kelley, Frank McCarthy, Bill Nebecker, Gary Niblett, Sherry Sander, Lowell E. Smith, William Whitaker **Works Available By:** William Acheff, Joe Beeler, James Boren, G. Harvey, Clark Hulings, Tom Lovell, Kenneth Riley, Gordon Snidow, Grant Speed, Melvin Warren, Fritz White

EDITH BAKER GALLERY 214.855.5101
2404 Cedar Springs At Maple, Dallas 75201
Hours: Tues-Fri 10-6; Sat 11-5
Contact: Rebecca Brasher Bish, Director
Specialty: Contemporary works by regional and nationally recognized artists

Artists Represented: Frank Brown, Denise Brown, Chong Keun Chu, Jim Cogswell, Patrick Kelly, Julie Lazarus, Gail Siptak, Cecil Touchon **Works Available By:** Perez Celis, Gary Komarin, Mark Perlman, Peter Presnail, Florence Putterman

EUGENE BINDER GALLERY 214.821.5864
840 Exposition Ave., Dallas 75226 FAX: 214.824.8668
Hours: Wed-Sat 1-6
Contact: Eugene Binder, Owner
Specialty: Contemporary American and European art from 1950 to present

Artists Represented: David Baker, David Bates, Sam Gummelt, Ken Hale, Bill Haveron, Gregory Horndeski, Jimmy Jalapeeno, Ken Luce, Ann McCoy, John Pomara, Dan Rizzie, Richard Shaffer, Barbara Simco, Luanne Stovall, Frank X. Tolbert II, Roscoe West, Michael Whitehead **Works Available By:** Joseph Beuys, Sandro Chia, Francesco Clemente, Enzo Cucchi, Mimmo Paladino, A.R. Penck, Sigmar Polke, Gerhard Richter

CONDUIT GALLERY 214.939.0064
3200 Main St., Ste. 25, Dallas 75226
Hours: Tues-Sat 11-5
Contact: Nancy Whitenack, Director
Specialty: Contemporary paintings, works on paper and sculpture by regional artists

Artists Represented: Robert Barsamian, Betsy Belcher, Vincent Falsetta, Patrick Faulhaber, Tracy Hicks, Kenneth Holder, Geoff Holle, Marilyn Jolly, Mark Lavatelli, Roberto Munguia, Laura Noland, Tom Orr, Damian Priour, Jim Sullivan, Stephen Wilder

GALERIE INTERNATIONAL 214.661.8778
1170 Valley View Center, Dallas 75240
Hours: Mon-Sat 10-9; Sun 12-5
Contact: Ken Winkler, Director; Jay Forte, Owner

Artists Represented: Benny Anderson, John Asaro, Barret de Busk, G. Harvey, Kaiko Moti, Ann Smith, Vivian Swain

BEVERLY GORDON GALLERY 214.880.9600
2404 Cedar Springs Rd., Ste. 100, Dallas 75201
Hours: Tues-Fri 10-6; Sat 11-5
Contact: Beverly Gordon, Owner
Specialty: American and European contemporary art in various mediums

Artists Represented: Dan Allison, Anton Cetin, Michael Gustavson, Alexandre Hogue, Steven Kline, Norman Laliberte, Jack Roberts, Miguel Zapata

JACKSON GALLERY 214.363.1543
3540 Wentwood Dr., Dallas 75225
Hours: By Appt
Contact: John Jackson, Owner
Specialty: 20th-Century American and European art

Artists Represented: Johanne Berthelson, Antoine Blanchard, George Burrows, Edouard Cortes, Dennis Downey, Jean Dufy, Marcel Dyf, Peter, Hurd, Eric Sloane, W. R. Thrasher, Robert Wood

PENNSYLVANIA *(cont.)*

PHILADELPHIA

DAVID DAVID GALLERY
215.735.2922
260 S. 18th-St., Philadelphia 19103
FAX: 215.735.4244
Hours: Mon-Fri 9:30-5; Sat-Sun By Appt
Contact: Carl David, President
Specialty: American and European paintings, drawings,
watercolors; 16th-20th century

Artists Represented: Sidney Gross (See page 123), Alice Kent Stoddard, Fred Wagner, Martha Walter, Frank Reed Whiteside

DOLAN/MAXWELL
215.732.7787
2046 Rittenhouse Square, Philadelphia 19103
FAX: 215.790.1866
Hours: By Appt Only
Contact: Margo Dolan
Specialty: Distinguished contemporary and modern works on paper

Artists Represented: Norman Ackroyd, Milton Avery, Morris Blackburn, Dean Dass, Claes Eklundh, Bill Freeland, Anthony Petr Gorny, Stanley, William Hayter, Joseph Hecht, Jane Kent, Robert Keyser, Winifred Lutz, Michael Manzavrakos, Mick Moon, Shirley Moskowitz, Wally Reinhardt, Nigel Rolfe, David Shapiro, Steven Sorman, Robert Stackhouse, Stephen, Talasnik, Claire Van Vliet **Works Available By:** Carroll Dunham, Eric Fischl, Sam Gilliam, David Hockney, Robert Motherwell, Elizabeth Murray, John Newman, Ben Nicholson, Susan Rothenberg, Frank Stella, Terry Winters

HELEN DRUTT GALLERY
215.735.1625
1721 Walnut St., Philadelphia 19103
FAX: 215.557.9417
Hours: Mon & Tues By Appt; Wed-Sat 11-5
Contact: Helen W. Drutt English, Founder/Dir.; Patricia Farrand Harner
Specialty: Contemporary ceramics, textiles, jewelry, sculpture, drawings and architectural studies

Artists Represented: Adela Akers, Gijs Bakker, Michael Becker, Manfred, Bischoff, **Jill Bonovitz (See page 308)**, Mark Burns, Nancy Carman, Anton Cepka, Anne Currier, William Daley, Georg Dobler, Elizabeth Garrison, Thomas Gentille, Wayne Higby, Rena Koopman, Stanley Lechtzin, Bruno Martinazzi, Rise Nagin, Breon O'Casey, Michael Olszewski, Pavel Opocensky, Francesco Pavan, Scott Rothstein, Marjorie Schick, Deganit Schocken, Olaf Skoogfors, Robert Smit, Rudolf Staffel, Lizbeth Stewart, Robert Turner, Tone Vigeland, Robert Winokur, **Paula Winokur (See page 374)**

THE FABRIC WORKSHOP
215/922.7303
1100 Vine St., 13th Fl., Philadelphia 19107
FAX: 215.922.3791
Hours: Mon-Fri 9-5; Sat 12-4
Contact: Marion Boulton Stroud, Director
Specialty: Limited edition silk-screen fabrics by artists produced in-house

Artists Represented: Gregory Amenoff, David Ireland, Roy Lichtenstein, Donald Lipski, Louise Nevelson, Judy Pfaff, Faith Ringgold, Robert Venturi **Works Available By:** Dale Chihuly, Howard Finster, Red Grooms, Margo Humphrey, Jun Kaneko, Tom Marioni, Italo Scanga, Carrie Mae Weems

JANET FLEISHER GALLERY
215.545.7562
211 S. 17th St., Philadelphia 19103
FAX: 215.545.6140
Hours: Mon-Fri 10:30-5:30; Sat 11-5:30
Contact: John E. Ollman, Director
Specialty: Contemporary American art, self-taught and visionary artists

Artists Represented: Charles Burns, Don Colley, Anda Dubinskis, John Ferris, **Tony Fitzpatrick (See page 253)**, Marcy Hermansader, Susan Moore, **Bruce Pollock (See page 192)**, **Bill Traylor (See page 236)**, Susan Chrysler White **Works Available By:** William Edmondson, Howard Finster, William Hawkins, Frank Jones, Horace Pippin, Martin Ramirez, P.M. Wentworth, Philadelphia Wireman, Joseph Yoakum

JEFFREY FULLER FINE ART, LTD.
215.564.9977
132 S. 17th St., Philadelphia 19103
FAX: 215.564.9792
Hours: Mon-Fri 9:30-5:30
Contact: Jeffrey P. Fuller, President
Specialty: 19th- & 20th-Century American and European masters

Works Available By: Joseph Cornell, Edgar Degas, Richard Diebenkorn, Emlen Etting, Adolph Gottlieb, David Hockney, Eugene Jardin, Jasper Johns, Martha Madigan, Claude Monet, Jackson Pollock, Odilon Redon

GALERIE NADEAU
215.574.0202
118 N. Third St., Philadelphia 19106
FAX: 215.574.0411
Hours: Wed-Sun 12-5
Contact: Richard Nadeau, Owner
Specialty: Contemporary painting and sculpture

Artists Represented: Brett Bender, George Dunbar, Joe Mooney **Works Available By:** Philip Carroll, Philip Corey, Keith Haring, Stephen Lack, Ronnie Landfield, Michael Rubin, David Saunders

GALLERY AXIOM
215.546.0449
1206 Walnut St., Philadelphia 19107
FAX: 215.546.2009
Hours: Tues-Sat 10-6
Contact: John Sparacio, Director
Specialty: Extraordinary quality modern oil paintings by established artists

Artists Represented: Clarence H. Carter, Fred Floyd, Michael Guinn, Shinichi Kamatani, Alexander Kostetsky, John Sparacio

GOFORTH RITTENHOUSE GALLERY
215.735.192
1524 Walnut St., Philadelphia 19102
Hours: Tues-Fri 10-6; Sat 11-4
Contact: John D. Lock, Director

GROSS MCCLEAF GALLERY
215.665.813
127 S. 16th St., Philadelphia 19102
Hours: Mon-Sat 10-5
Contact: Estelle Gross, President
Specialty: American contemporary with emphasis on painterly realism

Artists Represented: Benny Andrews, Jacqueline Chesley, Paul Flexner, Dean Hartung, Elaine Kurtz, Bertha Leonard, Max Mason, Joe Sweeney

RODGER LA PELLE GALLERIES
215.592.023
122 N. Third St., Philadelphia 19106
Contact: Rodger Lapelle, Owner

LOCKS GALLERY
215.629.100
600 Washington Sq. S., Philadelphia 19106
FAX: 215.629.386
Hours: Tues-Fri 10-6; Sat 10-5
Contact: Sueyun Locks, Director
Specialty: Contemporary and modern masters

Artists Represented: Ronald Bateman, Lanny Bergner, Diane Burko, Thomas Chimes, Chuck Connelly, David Fartig, James Havard, Warren Kohrer, Wonsook-Kim Lolinton, Elizabeth Osborne, William T. Wiley, Isaac Witkin **Works Available By:** Anthony Caro, Willem de Kooning, Nanc Graves, Robert Motherwell, Louise Nevelson

MARIAN LOCKS GALLERY
215.546.032
1524 Walnut St., Philadelphia 19102
Hours: Tues-Fri 10-6; Sat 10-5
Contact: Sueyun Locks, Director
Specialty: Contemporary and modern masters

GILBERT LUBER GALLERY
215.732.299
1220 Walnut St., Philadelphia 19107
FAX: 215.546.22
Hours: Mon-Sat 11:30-5:30; Wed 11:30-6
Contact: Shirley Luber, Co-Owner
Specialty: Antique and contemporary Japanese graphics,
Chinese watercolors and Thai artifacts

Artists Represented: Hiroshige, Yoshiharu Kimura, Thavorn Ko-Udomvit, Shigeki Koeda, Shige Kuroda, Akira Kurosaki, Toyokuni III, Yoshitoshi

MANGEL GALLERY
215.545.43
1714 Rittenhouse Square, Philadelphia 19103
Hours: Mon-Sat 11-6
Contact: Benjamin Mangel, Secretary/Tres.
Specialty: Contemporary paintings, prints and sculpture

Artists Represented: Harry Bertoia, Rafael Ferrer, Yoko Haru, Alex Katz, Allen Koss, Francis McCarthy, Jane Piper **Works Available By:** Will Barnet, Adolph Gottlieb, Red Grooms, Charn Harris, Sue Horvitz, Jasper Johns, Jimmy Leuders, Robert Motherwell, Irving Petlin, Merhi Reid, Marco Spalatin, Merle Spandorfeh, Barbara Zucker

THE MORE GALLERY, INC.
215.735.182
1630 Walnut St., 2nd Fl., Philadelphia 19103
Hours: Mon-Sat 10-5:30
Contact: Charles N. More, Director
Specialty: Contemporary painting and works on paper
from Philadelphia and New York areas

Artists Represented: Eugene Baguskas, Cynthia Carlson, James Dewoody, Randall Exon, Cynth Gallagher, Frank Galuszka, Paul Georges, John Gintoff, Sidney Goodman, Frank Hyder, James McGarrell, Peter Milton, Leonard Nelson, Tina Newberry, Gerald Nichols, Scott Noel, John Opie, Susan Opie, Diane Pieri, Michael Rossman, Marc Salz, Douglas Wirls **Works Available By:** Michele Amato, Tina Barney, Martha Mayer Erlebacher, Ben Kamihira, Edith Neff, Jude Tallichet, Michael Willse

MUSE
215.963.095
1915 Walnut, Philadelphia 19103
Hours: Tues-Sat 11-5

NEXUS GALLERY
215.629.11
137-139 N. Second, Philadelphia 19106
Hours: Tues-Fri 12-6; Sat-Sun 12-5

LAWRENCE OLIVER GALLERY
215.751.900
1617 Walnut St., Philadelphia 19103
FAX: 215.751.07
Hours: Tues-Fri 10-6; Sat 11-5
Contact: Lawrence Mangel, President
Specialty: Museum-quality contemporary art in all mediums

Artists Represented: Phoebe Adams (See page 300), S.A. Bachman, Stephen Estock, Chuck Fahlen, Eileen Neff **Works Available By:** John Baldessari, Michael Byron, Ronald Jones, Donald Judd, Sol LeWitt, Gerhard Merz, Matt Mullican, Richard Serra, Nancy Spero, Stephen Westfall

LEVELAND

RENDA KROOS GALLERY 216.621.1164
1360 W. Ninth St., Cleveland 44113
Contact: Brenda Kroos, Director
Specialty: Contemporary fine art

AMUEL ROTH & COMPANY 216.464.0898
23533 Mercantile Rd., Cleveland 44122

REGON

ORTLAND

UGEN GALLERY 503.224.8182
817 S.W. Second Ave., Portland 97204
Hours: Mon-Sat 10:30-5:30
Contact: Robert Kochs, Director
Specialty: Emerging northwest artists and prints by important contemporary artists

rtists Represented: Dan Allison, Bill Brewer, Roy de Forest, David Fish, K.C. Joyce, Peter vonen, L.A. Latremouille, **Royal Nebeker (See page 180) Works Available By:** Francesco lemente, Robert Colescott, Jim Dine, Sam Francis, Peter Halley, Ed Henderson, David Hockney, obert Motherwell, John Newman, Robert Rauschenberg, Italo Scanga, Steven Sorman, Frank Stella, erry Winters

LACKFISH GALLERY 503.224.2634
420 N.W. 9th Ave., Portland 97209
Hours: Tues-Sat 12-5
Contact: Cheryl Snow, Director
Specialty: An artist's cooperative featuring contemporary art in all media

rtists Represented: Al Y. Bain, Robert Bibler, Barbara Black, Mario Caoile, Greg Conyne, rry Cwik, Robert Dozono, Angela Dworkin, Joan English, Helen Issifu, Suellen Johnson, Maryellen ndsay, Paul Missal, Joyce Morgareidge, Howard Neufeld, Barry Pelzner, Dennis Peterson, Sandra oumagoux, Manya Shapiro, Mary Ann Smith, Stephan Soihl, Julia Stoll, Gary Westford, Carolyn Vilhelm

UTTERS GALLERY, LTD. 503.248.9378
312 N.W. Tenth Ave., Portland 97209 FAX: 503.248.9390
Hours: Tues-Sat 11-6
Contact: Jeffrey Butters, Director
Specialty: Variety of nationally-shown artists working with challenging content and media

rtists Represented: Avi Adler, Edward Aglipay, Robert Calvo, Michael Cochran, Anne Connell, ing Fay, David Geiser, Bill Hoppe, Michael Hoskins, Frank Hyder, Ted Katz, Dennis Leon, Helen essick, Shari Mendelson, Jeanette Pasin Sloan, Melinda Stickney-Gibson, Jock Sturges, Gunter emech, Max Weber, Harry Widman **Works Available By:** Barbara Bartholomew, Debra Beers, ristos Gianakos, Cindy Kane, Michael Kenna, Moshe Kupferman, Robert Morgan, John Newman, ans Sieverding, Kari Walden

AMISON/THOMAS GALLERY 503.222.0063
1313 N.W. Glisan, Portland 97209 FAX: 503.224.4517
Hours: Tues-Sat 10-6; Sun 12-4
Contact: William Jamison, Director
Specialty: Contemporary paintings, sculpture, drawings and prints

rtists Represented: Jay Backstrand, R.E. Bartow, Nick Blosser, Christine Bourdette, Stuart uehler, Mark Bulwinkle, Mark Calderon, Kathleen Caprario, Dennis Cunningham, Flechemuller, **iregory Grenon (See page 120),** Robert Herdlein, Bryan Illsley, D.E. May, Jon Serl, Eric Stotik, mes David Thomas **Works Available By:** Richard Diebenkorn, George Dureau, Erceg, Amy strin, Robert Gilkerson, Alfred Harris, Robert Mangold, Robert Motherwell

LIZABETH LEACH GALLERY 503.224.0521
207 S.W. Pine St., Portland 97204
Hours: Mon-Fri 10:30-5:30; Sat 11-5
Contact: Elizabeth Leach, Director

MAVEETY GALLERY 503.224.9442
1314 N.W. Irving, Ste. 508, Portland 97209
Hours: By Appt
Contact: Billey Turner, Director
Specialty: Contemporary and traditional fine art

rtists Represented: Nancy Adams, Rudy Autio, Sonja Blomdahl, Ruth Brockmann, Mike Burns, llen Cox, George Johanson, Thomas Jones, Karen Koblitz, Geoffrey Pagan, Don Reitz, Carol Riley, everly Saito, Melinda Thorsnes, Sherrie Wolf

QUARTERSAW GALLERY 503.223.2264
528 N.W. 12th St., Portland 97209
Hours: Tues-Fri 10-6; Sat 12-5
Contact: Victoria Frey, Director

LAURA RUSSO GALLERY 503.226.2754
805 N.W. 21st Ave., Portland 97209
Hours: Mon-Sat 11-5
Contact: Laura Russo
Specialty: Exhibiting contemporary northwest paintings, sculpture, prints, works on paper, and glass

Artists Represented: Frank Boyden, Michael Brophy, Myrna Burks, Claudia Cave, Robert Colescott, Michael Dailey, Suzanne Duryea, Tom Fawkes, Judith Poxson Fawkes, Chris Gander, Cie Goulet, Karen Guzak, Sally Haley, Frederick Heidel, Manuel Izquierdo, Fay Jones, **Mel Katz (See page 336),** Michihiro Kosuge, Stephen McClelland, William Moore, Carl Morris, Frank Okada, **Lucinda Parker (See page 186),** Orleonok Pitkin, Jack Portland, Rene Rickabaugh, Michele Russo, Angelita Surmon, Margot Voorhees Thompson, Gina Wilson **Works Available By:** Francis Celentano, Dale Chihuly, Italo Scanga **Estates Represented:** Louis Bunce, Kenneth Callahan, Hilda Morris

PENNSYLVANIA

PHILADELPHIA

479 GALLERY 215.922.1444
55 N. Second, Philadelphia 19106
Hours: Wed-Fri 12-6; Sat-Sun 12-5

ART SPACE GALLERY 215.557.6555
2100 Spring St., Philadelphia 19103 FAX: 215.557.6586
Hours: Tues-Sat 12-5
Contact: Carol Heppenstall, President
Specialty: The art of Arctic Inuit and Northwest Coast Indian

Artists Represented: Abraham Anghik, Ed Archie, Greg Colfax, Judy Cranmer, Reg Davidson, Robert Davidson, Beau Dick, Simon Dick, **David Ruben Piqtoukun (See page 356),** Susan Point, Don Yeomans

LARRY BECKER 215.925.5389
43 N. Second St., Philadelphia 19106
Hours: Tues-Sat 11-5
Contact: Heidi Nivling, Co-Director; Larry Becker, Co-Director
Specialty: Contemporary art: primary representing gallery for approximately ten artists; limited representation/invitational of other

Artists Represented: Harry Anderson, David Goerk, Barry Goldberg, Rebecca Johnson, Mary Ann Krutsick, Sjak Marks, Iwan Nazarewycz, Darwin Nix, Robin Rose, Marc Rosenquist, Italo Scanga, Anne Seidman, Merrill Wagner, **Bill Walton (See page 372) Works Available By:** Neil Anderson, Waldo Bien, Willy Heeks, Jacobus Kloppenburg, Mary Murphy

JOY BERMAN GALLERIES 215.854.8166
2201 Pennsylvania Ave., Philadelphia 19130 FAX: 215.854.0132
Hours: Tues-Fri 10-6; Sat 10-4
Contact: Joy Berman, President
Specialty: Representing over 80 established and emerging painters, print-Makers, sculptors and jewelers

Artists Represented: Anne Boysen, Anthony Ferrara, Beatrice Goldfine, Al, Hopkins Clay Johnson, Bernard Petlock, Netty Simon, James Tormey, Jane Winter **Works Available By:** Robert Morris, James Rosenquist

JESSICA BERWIND GALLERY 215.574.1645
301 Cherry St., 2nd Fl., Philadelphia 19106 FAX: 215.574.1646
Hours: Tues-Fri 10-5; Sat 11-5
Contact: Jessica Berwind, Director
Specialty: Contemporary art in all mediums

Artists Represented: Betsey Batchelor, Helen Bershad, Betsy Brandt, Matthew Courtney, Fritz Dietel, Bilge Friedlaender, Michael Gitlin, Cheryl Goldsleger, Joseph Haske, Kate Javens, Marilyn Kirsch, Ron Klein, Dan Ladd, Bonnie Levinthal, Clyde Lynds, Nancy McCormick, Shoji Okutani, Susan Pasquarelli, Jeffrey Peezick, Doris Stafel, Linda Stoudt, **Andrew Topolski (See page 257),** Vivian Wolovitz **Works Available By:** Norinne Betjemann, Cristos Gianakos, Ruth Thorne-Thomsen

PAUL CAVA GALLERY 215.627.1172
22 N. Third St., Philadelphia 19106 FAX: 215.627.7667
Hours: Tues-Sat 11-5; And By Appt
Contact: Paul Cava, Owner
Specialty: Contemporary art, all media including photography

Artists Represented: Steven Baris, Barbara Diduk, **Susan Fenton (See page 385),** Philip Govedare, Susan Hambleton, Brower Hatcher, David Lebe, Jim Muehleman, **Jock Sturges (See page 398),** Fulvio Testa **Works Available By:** Mel Bochner, Philip Guston, Ron Janowich, John Newman, Tom Nozkowski, David Row

THE CLAY STUDIO 215.925.3453
139 N. Second, Philadelphia 19106

NEW YORK *(cont.)*

NEW YORK CITY

L.J. WENDER FINE CHINESE PAINTING 212.734.3460
Three E. 80th St., New York 10021 FAX: 212.427.4945
Hours: Mon-Sat 10-5
Contact: Karen Wender, Owner; Leon Wender, Owner
Specialty: 17th-20th century Chinese paintings

Artists Represented: Wang Fangyu, Zhu Qizhan, Zeng Xiaojun **Works Available By:** Qi Baishi, Fu Baoshi, Wu Changshuo, Zhang Daqian, Xu, Gu Bada Shanren, Shitao

MICHAEL WERNER GALLERY 212.988.1623
21 E. 67th St., New York 10021 FAX: 212.988.1774
Hours: Mon-Sat 10-6
Contact: Gordon Veneklasen, Director
Specialty: Modern and contemporary art

Artists Represented: Hans Arp, Georg Baselitz, Marcel Broodthaers, James Lee Byars, Jorg Immendorff, Per Kirkeby, Eugene Leroy, Markus Lupertz, A.R. Penck, Sigmar Polke, Kurt Schwitters, Don Van Vliet

WESSEL O'CONNOR GALLERY 212.219.9524
580 Broadway, 8th Fl., New York 10012 FAX: 212.274.1631
Hours: Tues-Sat 10-6
Contact: John Wessel
Specialty: Contemporary art and photography

Artists Represented: Alan Bonicatti, Christopher Ciccone, John Dugdale, Loring McAlpin, Adam Rolston, Dread Scott, Joe Ziolkowski **Works Available By:** Luis de Jesus, Scott Lifshutz, George Platt Lynes, Robert Mapplethorpe, Herb Ritts, Stanley Stellar **Estates Represented:** Jon Cockrell, Bruce of Los Angeles

WHITE COLUMNS 212.924.4212
154 Christopher St., 2nd Fl., New York 10014
Hours: Wed-Sun 12-6

D. WIGMORE FINE ART, INC. 212.794.2128
22 E. 76th St., New York 10021

EALAN WINGATE GALLERY 212.966.5777
578 Broadway, New York 10012 FAX: 212.941.1455
Hours: Tues-Sat 10-6
Contact: Ealan Wingate, President
Specialty: Contemporary American and European art

Artists Represented: Guillaume Bijl, Dike Blair, Tom Brokish, Meg, Cranston, Stephen Ellis, **Eric Fischl (See Page 386),** General Idea, Serge Kliaving, Bill Komoski, Stephen Laub, Meuser, Cary Smith, Wolfgang Staehle, Alan Turner, Franz West

THE WITKIN GALLERY, INC. 212.925.5510
415 W. Broadway, New York 10012 FAX: 212.925.5648
Hours: Tues-Sat 11-6
Contact: Evelyne Z. Daitz, Director
Specialty: Photography only

Artists Represented: William Abranowicz, Manuel Alvarez-Bravo, Bruce Barnbaum, Edouard Boubat, Stephen Brigidi, Denis Brihat, Susanna Briselli, Linda Butler, Keith Carter, Margaret Courtney-Clarke, Neelon Crawford, Roy DeCarava, Robert Doisneau, Michael Eastman, Diane Farris, Sandi Fellman, John Flattau, Robert Flynt, Joann Frank, Victor Friedman, Oliver Gagliani, Fay Godwin, Jon Goodman, Betty Hahn, Karen Halverson, Charles Harbutt, Beatrice Helg, Evelyn Hofer, Connie Imboden, Monique Jacot, Christopher James, Michael Johnson, Grace Knowlton, Wendell Macrae, Elli Marcus, Tony Mendoza, Wright Morris, David Noble, Ruth Orkin, Paul Owen, Beverly Pabst, David Plowden, Doug Prince, Cervin Robinson, Willy Ronis, Eiichi Sakurai, Peter Sekaer, Howell Nina Starr, Martha Strawn, Connie Sullivan, Leonard Sussman, Gary Tepfer, George Tice, Philip Trager, Jane Tuckerman, Jerry Uelsmann, Doris Ulman, Collette Urbajtel Alvarez, Michael Von Graffenried, Cole Weston, Leigh Wiener, Marion Post Wolcott, Don Worth, Stanley Wulc, Mariana Yampolsky, Becky Young

GEROLD WUNDERLICH & CO. 212.974.8444
50 W. 57th St., 12th Fl., New York 10019
Hours: Tues-Sat 10-5:30

SOUYUN YI GALLERY 212.334.5189
249 Centre St., New York 10013 FAX: 212.966.2963
Hours: Tues-Sat 10-6
Contact: Souyun Yi, Director
Specialty: Contemporary art

Artists Represented: Nicole Carstens, Terry Corgey, Garrick Dolberg, Laura Foreman, David Hatchett, Yeong-Gill Kim, Harold Lohner, Bonnie Lucas, Richard Mock, John Pai, Jon Singer, Peter Whitney

RICHARD YORK GALLERY 212.772.9155
21 E. 65th St., New York 10021 FAX: 212.288.0410
Hours: Tues-Sat 10-5:30
Contact: Eric Widing, Director
Specialty: American painting, drawing and sculpture from 1800-1950

Artists Represented: Albert Bierstadt, William Mason Brown, George Brush, Charles Burchfield, William Merritt Chase, Jo Davidson, Charles Demuth, Arthur Dove, Martin Johnson Heade, John William Hill, Hamet Hosmer, Eugene Jardin, Luigi Lucioni, Louis Mignof, Raphaelle Peale, Maurice Prendergast, Charles Sheeler, Joseph Stella, Will Henry Stevens, Grant Wood

YOSHII GALLERY 212.265.8876
20 W. 57th St., New York 10019 FAX: 212.265.8893
Hours: Mon-Fri 9:30-6:30, Sat 9:30-6
Contact: Kazuhito Yoshii; Ted Greenwald
Specialty: 20th-Century modern and contemporary masters; emerging artists

Artists Represented: Jaime Franco **Works Available By:** Georges Braque, Paul Cezanne, Willem de Kooning, Jean Dubuffet, Max Ernst, Sam Francis, Alberto Giacometti, Jasper Johns, Fernand Leger, Pablo Picasso, Ad Reinhardt, Bradley Walker Tomlin

ZABRISKIE GALLERY 212.307.7430
724 Fifth Ave., New York 10019 FAX: 212.974.8492
Hours: Mon-Fri 10-5:30
Contact: Leslie Tonkonow, Director

Artists Represented: Pat Adams, John Batho, Tom Bills, Joan Fontcuberta, Mary Frank, Lee Friedlander, Pascal Kern, William Klein, Nicholas Nixon, Kenneth Snelson, Jacques Villegle, Hannah Villiger, Timothy Woodman **Works Available By:** Alexander Archipenko, Eugene Atget, Saul Baizerman, Ella Bergman, Brassai, Claude Cahun, Enrico Donati, Arthur Dove, Marcel Duchamp, Arnold Friedman, Wood Gaylor, Marsden Hartley, Lester Johnson, Elie Nadelman, Man Ray, Theodore Roszak, David Smith, Eve Sonneman, Daniel Spoerri, Jean Tinguely, Robert Watts

ANDRE ZARRE GALLERY 212.431.3456
379 W. Broadway, 2nd Fl., New York 10012
Hours: Tues-Sat 10:30-5:30

NORTH CAROLINA

CHAPEL HILL

SOMERHILL GALLERY 919.968.8868
3 Eastgate, E. Franklin St., Chapel Hill 27514 FAX: 919.967.1879
Hours: Mon-Sat 10-5:30
Contact: Tom Dominick, Asst. Director
Specialty: Contemporary art

Artists Represented: Andrew Braitman, Raymond Chorneau, Fran Dropkin, Yale Epstein, Be Gardiner, Maud Gatewood, Mary Lou Higgins **Works Available By:** Paul Hrusovsky, Vic Huggins, Dean Leary, Edith London, Nancy Tuttle May, Danny Robinette

JERALD MELBERG GALLERY INC. 704.333.8601
119 E. Seventh St., Charlotte 28202 FAX: 704.333.8607
Hours: Tues-Fri 10-5:30; Sat 11-4
Contact: Jerald Melberg, President
Specialty: Works by contemporary, American artists

Artists Represented: Charles Basham, Andreas Bechtler, Carl R. Blair, Edgar Buonagurio, Toby Buonagurio, Clara Couch, Arless Day, Daniel Douke, Kenneth Freed, Rick Horton, Herb Jackson, Wolf Kahn, Marty Levenson, Denise Lisiecki, Juan Logan, Thomas McNickle, Dennis Olsen, Robert Peterson, Alan Roberts, Richard Stenhouse, Donna Phipps Stout, Vlada Vukadinovich, Joe Walters, Kes Woodward, James Yohe **Works Available By:** Romare Bearden, Robert Motherwell

OHIO

CINCINNATI

TONI BIRCKHEAD GALLERY 513.241.0212
342 W. Fourth St., Cincinnati 45202 FAX: 513.723.806
Hours: Mon-Fri 10-4
Contact: Suzann Kokoefer, Gallery Assoc.
Specialty: Contemporary art with a regional focus

Artists Represented: Stephanie Cooper, Ana England, Stuart Fink, Frank Herrmann, Kim Krause, Deborah Morrissey-McGoff, John Pearson, Al Pounders, Larry Shineman, Todd Slaughter **Works Available By:** Jim Dine, Joel Shapiro

MILLER GALLERY 513.871.442
2715 Erie Ave., Cincinnati 45208
Hours: Mon-Sat 10-5
Contact: Norman Miller, Director; Barbara Miller, Director
Specialty: Contemporary and traditional paintings, sculpture, glass, ceramics and fiber

Artists Represented: Joseph Abbrescia, Thomas Hart Benton, Peter Bramhall, Jean Juhlin, Dominick Labino, Charles Lotton, Marino Marini, Robert Natkin, James O'Neil, Christopher Ries, Ron Romano, John Terlak

CARL SOLWAY GALLERY 513.621.006
314 W. Fourth St., Cincinnati 45202 FAX: 513.621.631
Hours: Mon-Sat 10-5:30
Contact: Carl Solway, Director
Specialty: American and European contemporary art, editions and special projects

Artists Represented: Vito Acconci, John Cage, R.M. Fischer, Buckminster Fuller, Richard Hamilton, Joseph Kosuth, Donald Lipski, Matt Mullican, Claes Oldenburg, Joel Otterson, Scott Owen, Alan Rath, Daniel Spoerri, John Torreano, Julia Wachtel, Robert Watts

USAN TELLER GALLERY 212.941.7335
568 Broadway, Rm. 405A, New York 10012
Hours: Tues-Sat 11-6
Contact: Susan Teller, Owner
Specialty: American prints and drawings from the 1930's to 1950's

Artists Represented: Minna Citron, Dorothy Dehner, Michael J. Gallagher, Riva Helfond, Claire ahl Moore, Albert Potter, Harry Sternberg Works Available By: Alexander Archipenko, John aylor Arms, Isabel Bishop, Howard Cook, Victoria Hutson Huntley, Martin Lewis, James Penney, avid Smith

BOR DE NAGY GALLERY 212.421.3780
41 W. 57th St., New York 10019
Hours: Tues-Sat 10-5:30
Contact: Steven Bradley Beer, Director
Specialty: Contemporary abstract and representational art

Artists Represented: Deborah Brown, James Butler, Rosemarie Castoro, Larry Cohen, Chuck orsman, Jeremy Foss, Maurice Golubov, Robert Goodnough, Harold Gregor, Stephen Hannock, aul Hunter, Stephanie Kirschen-Cole, Cynthia Knott, Marc Lambrechts, Nachume Miller, Darragh ark, Bruce Porter, Ephraim Rubenstein, Ed Stitt, Robin Utterback Works Available By: Walter arby Bannard, Stanley Boxer, Richard Jardin, Fairfield Porter, William Schwedler, Horacio Torres

CK TILTON GALLERY 212.247.7480
24 W. 57th St., New York 10019 FAX: 212.586.1861
Hours: Tues-Sat 10-6; Mon By Appt
Contact: Janine Cirincione, Director

states Represented: Ruth Vollmer Artists Represented: Eric Andriesse, Leo Copers, Jan bre, Ron Gorchov, David Hammons, Alan Johnston, Minoru Kawabata, Alvin Lucier, Rebecca ardum, Hubert Scheibl

OMOKO LIGUORI GALLERY 212.334.0190
93 Grand St., New York 10013 FAX: 212.274.8641
Hours: Tues-Sat 10-6
Contact: Tomoko Liguori, Director
Specialty: Contemporary art; publisher of prints

rtists Represented: Susanna Heller, Tadaaki Kuwayama, David Lachapelle, Peter Waite Works Available By: Carl Andre, Richard Estes, Donald Judd, Sol LeWitt, Ed Ruscha, Robert yman, Robert Smithson, Donald Sultan, Wayne Thiebaud

HE GARNER TULLIS WORKSHOP 212.226.6665
Ten White St., New York 10013 FAX: 212.941.0678
Hours: Mon-Fri 9-6; By Appt Only
Contact: Garner Tullis, Master Printer
Specialty: Publishers of monotype and woodcut prints

rtists Represented: Charles Arnoldi, Jean Charles Blais, Richard Diebenkorn, Helen rankenthaler, Nancy Graves, Nancy Haynes, Ron Janowich, Ken Kiff, Per Kirkeby, Catherine Lee, avid Row, Sean Scully, Emilio Vedova

AVID TUNICK, INC. 212.570.0090
12 E. 81st St., New York 10028 FAX: 212.744.8931
Hours: Mon-Fri 10-5
Contact: Amy Kershaw, Gallery Asst.
Specialty: Works of art on paper from the 15th century to c. 1950

Works Available By: George Bellows, Antonio Canaletto, Mary Cassatt, Edgar Degas, Albrecht urer, Francisco Goya, Edward Hopper, Ernst Ludwig Kirchner, Henri Matisse, Edvard Munch, ablo Picasso, Giambattista Piranesi, Rembrandt, Giovanni Tiepolo, Henri de Toulouse-Lautrec, mes McNeill Whistler

WINING GALLERY INC. 212.431.1830
568 Broadway, Ste. 107, New York 10012

DWARD TYLER NAHEM FINE ART 212.517.2453
56 E. 66th St., New York 10021 FAX: 212.861.3566
Hours: Mon-Fri 10-6
Contact: Edward Tyler Nahem, Director
Specialty: European and American art of the late 19th- & 20th centuries

Works Available By: Norman Bluhm, Mariapia Borgnini, Chuck Connelly, Jean Dubuffet, Michael oldberg, Grace Hartigan, Anselm Kiefer, Franz Kline, Roy Lichtenstein, Joan Mitchell, Robert Motherwell, Pablo Picasso, Robert Rauschenberg, Ad Reinhardt, Larry Rivers, Mark Rothko, Sean cully, Frank Stella, Donald Sultan, Cy Twombly, Andy Warhol

LYSSES GALLERY 212.754.4666
41 E. 57th St., New York 10022

PTOWN GALLERY, INC. 212.722.3677
1194 Madison Ave., New York 10128 FAX: 212.410.2097
Hours: Mon-Sat 10-6
Contact: Steven Williams, V.P.
Specialty: Contemporary realism, figurative and landscape; modern masters

Artists Represented: June Adler, Bascove, Arthur Biehl, Ann Chernow, Jeffrey Craven, Barbara didin, Jon Friedman, Michael H. Lewis, Hely Lima, Kathleen Piunti, Elsie Dinsmore Popkin, uenther Riess, Janis Theodore, Chuck Wood Works Available By: Alexander Calder, Christo, eter Milton, Joan Miro, Pablo Picasso, Francisco Zuniga

BERTHA URDANG GALLERY 212.288.7004
23 E. 74th St., New York 10021
Hours: Tues-Sat 10-5:30
Contact: Bertha Urdang, Director
Specialty: American, European and Israeli abstract works; photography

Artists Represented: Avi Adler, Betty Collings, Marianne Engberg, Cheryl Goldsleger, Richard Killeen, Moshe Kupferman, Philip Lieberman, Margalit Mannor, Joshua Neustein, Alisa Olmert, Flavia Robinson, Zelig Segal, John Stockdale, Micha Ullman

VANDERWOUDE/TANANBAUM 212.879.8200
24 E. 81st St., New York 10028
Hours: Tues-Sat 10-5:30

VIRIDIAN GALLERY 212.245.2882
24 W. 57th St., 8th Fl., New York 10019
Hours: Tues-Sat 10:30-6
Contact: Paul Cohen, Director
Specialty: Contemporary, eclectic, emerging artists

Artists Represented: Paul Blake, Bernice Faegenburg, James Fortune, Susan Hockaday, Susan Manspeizer, Glenn Rothman, Barbara Schwartz Works Available By: Janet L. Bohman, Carol Crawford, Tazuko Fujii, Mark Planisek, Herb Rosenberg, Karen Salup, Oi Sawa, Susan Sills, Craig Snyder

VISUAL ARTS GALLERY 212.598.0221
137 Wooster St., New York 10012
Hours: Tues-Sat 11a-6p

WALKER, URSITTI & MCGINNISS 212.966.7543
500 Greenwich Ave., New York 10013

WARD-NASSE GALLERY 212.925.6951
178 Prince St., New York 10012
Hours: Tues-Sat 11-6; Sun 1-4

WASHBURN GALLERY 212.753.0546
41 E. 57th St., 8th Fl., New York 10022 FAX: 212.935.7697
Hours: Tues-Sat 10-6
Contact: Joan Washburn, Director

Artists Represented: James Abbe, Richard Baker, Richard Benson, Norman Bluhm, Patrick Henry Bruce, Arthur B. Carles, Alan Cote, Bill Jensen, Gerome Kamrowski, George Sugarman, Jack Youngerman Works Available By: Stuart Davis, Arthur Dove, O. Louis Guglielmi, Marsden Hartley, John William Hill, John Henry Hill, Eugene Jardin, Morgan Russell, Rolph Scarlett, Niles Spencer Estates Represented: Ronald Bladen, Ilya Bolotowsky, Elaine de Kooning, Harry Holtzman, Alice Trumbull Mason, Anne Ryan, Charles G. Shaw, David, Smith

SIMON WATSON 212.925.1955
241 Lafayette St., New York 10012

JOHN WEBER GALLERY 212.966.6115
142 Greene St., New York 10012 FAX: 212.941.8727
Hours: Tues-Sat 10-6
Specialty: Conceptual, minimal and political art

Artists Represented: Terry Allen, Massimo Antonaci, Papunya Tula Artists, Alice Aycock, James Biederman, Alighiero Boetti, Bruce Boice, Joe Breidel, Daniel Buren, Victor Burgin, Thomas Joshua Cooper, Hamish Fulton, Charles Gaines, Marco Gastini, Jack Goldstein, Hans Haacke, Nancy Holt, Magdalena Jetelova, Barbara Kasten, Mel Kendrick, Susan Leopold, Sol LeWitt, Allan McCollum, John Murphy, Roman Opalka, Adrian Piper, Franz Erhard Walther, Kes Zapkus Estates Represented: Robert Smithson

PHYLLIS WEIL & COMPANY 212.369.0255
1065 Park Ave., New York 10128
Hours: By Appt

WEINTRAUB GALLERY 212.879.1195
988 Madison Ave., New York 10021 FAX: 212.570.4192
Hours: Tues-Sat 10-5
Contact: Jacob Weintraub, Owner
Specialty: 20th-Century master sculptors

Artists Represented: Richard Erdman Works Available By: Jean Arp, Fernando Botero, Alexander Calder, Giacomo, Manzu Marino Marini, Henri Matisse, Henry Moore

JAN WEISS GALLERY 212.925.7313
68 Laight St., New York 10013
Hours: Thurs-Sat 12-6
Contact: Jan Weiss, Director
Specialty: American, European and Australian contemporary art

Artists Represented: Susan Ambrico, Bronwyn Bancroft, Lew Graham, Elisabeth Grajales, Joel Handorff, Ronn Johnson, Thomas McAnulty, Sally Morgan, Mary Neumuth, Karen Roth, Julius Tobias, Richard Vaux Works Available By: Sandra de Sando, Grace Graupe-Pillard, Claire Heimarck, Sarah Savidge

NEW YORK (cont.)

NEW YORK CITY

SOHO GRAPHIC ARTS WORKSHOP 212.966.7292
433 W. Broadway, New York 10012

HOLLY SOLOMON GALLERY 212.757.7777
724 Fifth Ave., New York 10019 FAX: 212.582.4283
Hours: Mon-Sat 10-6
Contact: Lance Fung, Director
Specialty: Contemporary paintings, sculpture and photography

Artists Represented: Nicholas Africano, Laurie Anderson, Robert Barry, Brad Davis, Alain Kirili, Robert Kushner, Thomas Lanigan-Schmidt, Kim MacConnel, Frank Majore, Gordon Matta-Clark, Melissa Meyer, Melissa Miller, Dennis Oppenheim, Nam Jun Paik, Izhar Patkin, Judy Pfaff, Elsa Rady, William Wegman

SOLO GALLERY/SOLO PRESS 212.925.3599
578 Broadway, 6th Fl., New York 10012 FAX: 212.226.3251
Hours: Mon-Fri 10-6; Sat By Appt
Contact: Ruth Resnicow, Director; Judith Solodkin, President
Specialty: Publishers, printers, and exhibitors of fine prints and livres d'artiste

Works Available By: Ida Applebroog, Conrad Atkinson, **Lynda Benglis (See page 261),** Louise Bourgeois, Petah Coyne, Peggy Cyphers, **Michael David (See page 265),** Francoise Gilot, Willy Heeks, John Hejduk, David Kapp, Steve Keister, Komar & Melamid, Christian Marclay, Michael Mazur, Alexis Rockman, Allen Ruppersberg, Barbara Schwartz, Altoon Sultan, John Torreano, Ursula Van Rydingsvard, William Wegman, Terry Winters, Betty Woodman

SONNABEND GALLERY 212.966.6160
420 W. Broadway, New York 10012

SORKIN GALLERY 212.925.4942
596 Broadway, 2nd Fl., New York 10012

SOUFER GALLERY 212.628.3225
1015 Madison Ave., New York 10021 FAX: 212.628.3752
Hours: Tues-Sat 10:30-5
Contact: M. Soufer, Director
Specialty: 20th-Century European Post-Impressionists and German Expressionists

Artists Represented: Samuel Bak Works Available By: Ernst Barlach, Camille Bombois, Yves Brayer, Raoul Dufy, George Grosz, Jean Lambert-Rucki, Marie Laurencin, Andre Lhote, Maximilien Luce, Maurice Utrillo

SPERONE WESTWATER 212.460.5497
121 Greene St., New York 10012

SRAGOW GALLERY 212.219.1793
73 Spring St., New York 10012
Hours: Call For Hours
Contact: Ellen Sragow, Director
Specialty: Contemporary and American prints, paintings and works on paper from the 1920's, 30's and 40's

Artists Represented: Elizabeth Catlett, Agnes Denes, Alice Neel Works Available By: Philip Guston, Robert Motherwell, Louise Nevelson, James Rosenquist, Saul Steinberg

STAEMPFLI 212.941.7100
415 W. Broadway, New York 10012

PHILIPPE STAIB GALLERY 212.941.5977
8 Greene St., New York 10013 FAX: 212.941.5979
Hours: Tues-Fri 11-6
Contact: Rene Grayre, Director; Sarita Dubin, Director
Specialty: Contemporary sculpture

Artists Represented: Martine Boileam, Emilie Brzezinski, Louis Derbre, Jurgen Goertz, Ruth Hardinger, Zero Higashida, Philip King, Owen Morrel, Paul Suttman, Yuriko Yamaguchi Works Available By: Henry Moore, Lee Tribe, William Zucker

STALEY-WISE 212.966.6223
560 Broadway, New York 10012 FAX: 212.966.6293
Hours: Tues-Sat 11-5
Contact: Etheleen Staley; Taki Wise

Artists Represented: Sid Avery, Jeannette Barron, Erwin Blumenfeld, Clarence Bull, Louise Dahl-Wolfe, Baron Adolph de Meyer, Leah Demchick, Disfarmer, Max Dupain, Philippe Halsman, Horst, Hoyningen-Huene, George Hurrell, Jacques-Henri Lartigue, Marcia Lippman, Kurt Markus, Wayne Maser, Steven Meisel, Sheila Metzner, Lee Miller, Sara Moon, Helmut Newton, Denis Piel, Herb Ritts, Matthew Rolston, Martin Schreiber, Edward Steichen, Phil Stern, Deborah Turbeville, Raymond Voinquel

STARK GALLERY 212.925.4484
594 Broadway, Ste. 301, New York 10012 FAX: 212.274.9525
Hours: Tues-Sat 10-6
Contact: Eric Stark, Co-Director; Margaret Thatcher, Co-Director
Specialty: Reductivist abstract painting and sculpture by contemporary American and European artists

Artists Represented: Frank Gerritz, Cristos Gianakos, Michael Gitlin, Ken Greenleaf, Russell Maltz, Marica Presic, Winston Roeth, Stephen Rosenthal, Andrew Topolski, Merrill Wagner

BERNICE STEINBAUM GALLERY 212.431.4224
132 Greene St., New York 10012 FAX: 212.431.3252
Hours: Tues-Sat 10-6
Contact: Bernice Steinbaum, Director
Specialty: Contemporary American art

Artists Represented: Paul Brach, Helene Brandt, Beverly Buchanan, Hung, Liu, Tom Nakashima, Greg O'Halloran, Faith Ringgold, Miriam Schapiro, Roger Shimomura, Jaune (QTS) Smith, Grace Wapner, David Weinrib Works Available By: Joanne Hammer, Ilisha Helfman, Dinh Le

STIEBEL MODERN 212.759.5536
32 E. 57th St., 6th Fl., New York 10022 FAX: 212.935.5736
Hours: Tues-Sat 10-5
Contact: Katherine Chapin, Director
Specialty: Painterly realism from 1945 to present

Artists Represented: **William Beckman (See page 52),** Michael Leonard **(See page 155), Sara Rossberg (See page 205)**
Works Available By: Paul Cadmus, Lucian Freud, Philip Pearlstein

STEINGLADSTONE 212.925.7474
99 Wooster St., New York 10012 FAX: 212.226.1139
Hours: Tues-Sat 10-6
Contact: Daniel Salvioni, Director

ALLAN STONE GALLERY 212.988.6870
48 E. 86th St., New York 10028

STRICOFF GALLERIES 212.219.3977
484 Broome St., New York 10013

STUX GALLERY 212.219.0010
155 Spring St., 3rd Fl., New York 10012 FAX: 212.219.2243
Hours: Tues-Sat 10-6
Contact: Kim M. Heirston, Director
Specialty: Contemporary painting, sculpture and photography

Artists Represented: Doug Anderson, Lawrence Carroll, Russell Floersch, Jeffrey Jenkins, Cary S. Leibowitz/Candyass, Fabian Marcaccio, Vik Muniz, Sean Scherer, Andres Serrano, Mike & Doug Starn

STYRIA STUDIO 212.226.1373
426 Broome St., New York 10013

MARTIN SUMERS GRAPHICS 212.541.8334
50 W. 57th St., New York 10019

JOHN SZOKE GALLERY 212.219.8300
164 Mercer St., New York 10012 FAX: 212.966.3064
Hours: Tues-Fri 11-5; Sat 12-5
Contact: John Szoke, President
Specialty: Contemporary works on paper, both unique and multiples

Artists Represented: Arthur Bauman, Peter Milton, Frederick Phillips, David Preston, Jean Richardson, James Rizzi, Leslie Smith Works Available By: Romare Bearden, Richard Diebenkorn, Jim Dine, Janet Fish, Sam Francis, Jane Frielicher, Red Grooms, Wayne Thiebaud

LEILA TAGHINIA-MILANI 212.570.6173
1080 Madison Ave., New York 10028 FAX: 212.744.6523
Hours: By Appt
Contact: Leila Taghinia-Milani, President
Specialty: Impressionists, modern and contemporary art

Works Available By: Pierre Bonnard, Paul Cezanne, Marc Chagall, Georges, d'Espagnat, Jean-Louis Forain, Albert Gleizes, Edouard Manet, Jules Pascin, Pablo Picasso, Pierre-Auguste Renoir, Paul Signac, Chaim Soutine

TAMBARAN GALLERY 212.570.0655
20 E. 76th St., New York 10021

TATISTCHEFF & CO., INC. 212.664.0907
50 W. 57th St., 8th Fl., New York 10019 FAX: 212.541.8814
Hours: Tues-Sat 10-6
Contact: Frank Bernarducci, Director
Specialty: Contemporary, American, figurative painting and drawing

Artists Represented: Michael Beck, Kent Bellows, Joan Brady, Theophilus Brown, Irene Busko, James Cook, Richard Crozier, Mary Ann Currier, David Dewey, Kim Do, Linda Etcoff, Kathryn Freeman, Philip Geiger, George Harkins, John Stuart Ingle, Simeon Lagodich, G. Daniel Massad, Dan McCleary, Daniel Morper, Harry Orlyk, Elizabeth Osborne, Lincoln Perry, Matthew Radford, Harold Reddicliffe, Peter Schlesinger, Sarh Supplee, Nigel Van Wieck, Mark Wethli, Nancy Wissemann-Widrig Estates Represented: Milet Andrejevic, James Aponovich

TATYANA GALLERY 212.683.2387
145 E. 27th St., 6th Fl., New York 10016 FAX: 212.683.9147
Hours: Tues-Sat 12-5
Contact: Tatyana B. Gribanova, Director
Specialty: Russian/Soviet art from the 18th-to 20th centuries

Works Available By: Ivan Aivazovsky, V. Aralov, Kuprin, Isaac Levitan, V. Polenov, Ilya Repin, Schischkin, Yusn

MARTHA SCHAEFFER FINE ART 212.794.9712
500 E. 77th St., Ste. 512, New York 10162 FAX: 212.861.3106
Hours: By Appt
Contact: Martha Schaeffer, Owner/Pres.
Specialty: Drawings, paintings and sculpture by 20th-Century European, Latin and American masters

Works Available By: Karel Appel, Arman, Fernando Botero, Alexander Calder, Mary Cassatt, Willem de Kooning, Helen Frankenthaler, Pablo Gargallo, Julio Gonzalez, Wifredo Lam, Rene Magritte, Henri Matisse, Roberto Matta, Joan Miro, Jules Pascin, Pablo Picasso, Joaquin Torres-Garcia, Victor Vasarely

SCHILLAY & REHS 212.355.5710
305 E. 63rd St., New York 10021
Hours: Mon-Fri 9-5
Contact: Joseph Rehs; Howard Rehs
Specialty: 19th- & 20th-Century paintings

Artists Represented: Warner Friedman, Barry Oretsky

LISA SCHILLER FINE ART 212.772.8627
19 E. 74th St, New York 10021 FAX: 212.535.5943
Hours: By Appt
Contact: Lisa Schiller; Susan Bodo
Specialty: Spanish 20th-Century

Works Available By: Martin Ball, Francisco Bores, Antoni Clave, Ismael de La Serna, Francisco Farreras, Luis Feito, Jose Guerrero, Manolo Millares, Lucio Munoz, Manuel Rivera, Antonio Saura

SCHMIDT BINGHAM 212.888.1122
41 W. 57th St., 3rd Fl., New York 10019 FAX: 212.754.1863
Hours: Mon-Sat 10-6
Contact: Liz K. Garvey, Manager
Specialty: Contemporary American with representational focus

Artists Represented: Adele Alsop, Brooks Anderson, Dozier Bell, Ben Berns, Alan Bray, Frederick Brosen, Daish Craddock, Morris Graves, Philip Hershberger, Holly Lane, Alan Magee, John Meyer, James Moore, Charles Moser, Ed Musante, Gregory Paquette, Peter Poskas, Doug Sapranek, Yolanda Shashaty, Carroll Todd, Joyce Treiman, John Wilde **Works Available By:** Wendell Castle, Mark Tobey

CS SCHULTE GALLERIES 212.925.8485
565 Broadway, New York 10012
Hours: By Appt
Contact: Stephen Schulte; Carol Schulte
Specialty: Contemporary American painting and sculpture

Artists Represented: Dan Christensen, Bill Drew, John Adams Griefen, Gary Komarin, Roy Lerner, David Logan, Sandi Slone, Michael Steiner, Francine Tint, Larry Zox **Works Available By:** Reuben Nakian

SCHUTZ & COMPANY 212-245-0287
205 W. 57th St., New York 10019 FAX: 203.629.3756
Hours: By Appt
Contact: Herbert Schutz, President
Specialty: 19th Century and American impressionist and modernist paintings

Works Available By: George Ault, Hyman Bloom, Jasper Francis Cropsey, William Glackens, Roy Lichtenstein, Reginald Marsh, Charles Sheeler

SCOTT ALAN GALLERY 212.226.5145
270 Lafayette St., Ste. 204, New York 10012 FAX: 212.274.9520
Hours: Tues-Sat 11-6
Contact: Scott Alan Krawitz, Director
Specialty: Contemporary art

Artists Represented: Alfred DeCredico, Ismael Frigerio, Billy Hassell, Ricardo Mazal, Freddy Rodriguez, Paul Sierra, Irene Valincius

BETSY SENIOR CONTEMP. PRINTS 212.941.0960
375 W. Broadway, New York 10012

KATHRYN SERMAS GALLERY 212.431.5743
19 Green St., 4th Fl., New York 10013

TONY SHAFRAZI GALLERY 212.274.9300
130 Prince St., New York 10012 FAX: 212.334.9499
Hours: Tues-Sat 10-6
Contact: Margaret Poser, Director
Specialty: Contemporary American and European paintings, sculpture, works on paper and prints

Artists Represented: Donald Baechler, Ford Beckman, David Carrino, Steve Dibenedetto, Dennis Hopper, Kenny Scharf, Michael Scott **Works Available By:** Carl Andre, Jean-Michel Basquiat, Larry Bell, James Brown, William Burroughs, George Condo, Fred Fehlau, Peter Halley, Donald Judd, Olivier Mosset, Robert Rauschenberg, James Rosenquist, Ed Ruscha, Andreas Schon, Richard Serra, Keith Sonnier, Tom Wesselmann **Estates Represented:** Keith Haring

JACK SHAINMAN GALLERY, INC. 212.966.3866
560 Broadway, 2nd Fl., New York 10012 FAX: 212.334.8453
Hours: Tues-Sat 10-6
Contact: Mary Dinaburg, Director
Specialty: Contemporary sculpture, painting, photography and video

Artists Represented: Guillaume Bijl, Paul Bowen, Luigi Campanelli, Luigi Carboni, Bruno Ceccobelli, Petah Coyne, Pierre Dorion, Evergon, Isa Genzken, Michel Goulet, Marie Jo Lafontaine, Marc Maet, Robert McCurdy, Marcel Odenbach, Maurizio Pellegrin, Vettor Pisani, Olivier Richon, Claude A. Simard, Jacques Vielle

ANITA SHAPOLSKY GALLERY 212.334.9755
99 Spring St., New York 10012 FAX: 212.334.6817
Hours: Tues-Sat 11-6
Contact: Anita Shapolsky, Director
Specialty: 20th-Century paintings and sculpture; first and second generation abstract expressionists

Artists Represented: Peter Agostini (See page 301), Ernest Briggs, Lawrence Calcagno, Perez Celis, Herman Cherry, Emilio Cruz, Mark Gibian, Burt Hasen, John Hultberg, Frank Hyder, William Manning, **Thomas Nonn (See page 182), Richards Ruben (See page 206)** **Works Available By:** Friedel Dzubas, Claire Falkenstein, Antoni Tapies

SUSAN SHEEHAN GALLERY 212.888.4220
41 East 57th St., New York 10022 FAX: 212.888.0497
Hours: Mon-Sat 10-6
Contact: William J. Harkins, Director
Specialty: American and European works on paper of the 20th century

Works Available By: Josef Albers, George Bellows, Mary Cassatt, Jim Dine, Dan Flavin, Edward Hopper, Robert Indiana, Jasper Johns, Donald Judd, Ellsworth Kelly, Roy Lichtenstein, Robert Mangold, Brice Marden, Claes Oldenburg, Pablo Picasso, Sigmar Polke, Robert Rauschenberg, Gerhard Richter, Tim Rollins + K.O.S., David Smith, Cy Twombly, Andy Warhol

RUTH SIEGEL GALLERY 212.586.0605
24 W. 57th St., New York 10019 FAX: 212.765.5409
Hours: Tues-Sat 10-6
Specialty: Contemporary art and modern masters

Artists Represented: Thomas Bang, John Bellany, Hans Breder, Jo Anne Carson, Bruce Cohen, Valentina Dubasky, Mineko Grimmer, Rainer Gross, Creighton Michael, Dan Rizzie, Katsuhisa Sakai **Works Available By:** Robert Indiana, Thomas Lange, Sam Messer, Eric Orr, James Rosenquist, Jose Maria Sicilia, Gert Wollheim

BRENT SIKKEMA FINE ART 212.941.6210
155 Spring St., New York 10012

LINDA R. SILVERMAN FINE ART 212.794.1352
160 E. 65th St., New York 10021

SIMON/NEUMAN GALLERY 212.744.8460
42 E. 76th St., New York 10021 FAX: 212.744.0576
Hours: By Appt
Contact: Amy Simon, President
Specialty: Works from the Bauhaus and modern masters

Artists Represented: James Bishop, Harald Lyth **Works Available By:** Max Ernst, Wassily Kandinsky, Paul Klee, Fernand Leger, Henri Matisse, Joan Miro, Pablo Picasso, Ad Reinhardt, Mark Rothko, Kurt Schwitters, David Smith **Estates Represented:** Barbro Backstrom

SINDIN GALLERIES 212.288.7902
1035 Madison Ave., New York 10021 FAX: 212.288.7895
Hours: Daily 10-5:30
Contact: Claudia Levy, Sales Rep.
Specialty: Graphic work, sculpture, and paintings

Works Available By: Benjamin Canas, Marc Chagall, Wifredo Lam, Joan Miro, Frederico Nordalm, Pablo Picasso, Rufino Tamayo, Francisco Zuniga

SNYDER FINE ART 212.941.6860
588 Broadway, New York 10012
Hours: Tues-Sat 11-6
Contact: Gary Snyder, Director
Specialty: Modern American art rooted in the 1920's through 1950's

Artists Represented: Howard Daum, Werner Drewes, Norris Embry, Thomas George, Josef Meierhans, Ralph Rosenborg **Works Available By:** Milton Avery, Charles Biederman, Albert E. Gallatin, Raymond Jonson, Charles G. Shaw, Joseph Stella

SOHO 20 212.226.4167
469 Broome St., New York 10013 FAX: 212.226.4167
Hours: Tues-Sat 12-6
Contact: Eugenia C. Foxworth, Director
Specialty: Contemporary sculptures, paintings, drawings, monotypes and photographs

Artists Represented: Catherine Allen, Vivian Browne, Judi Church, Regina Corritore, Linda Cunningham, Martha Edelheit, Katherine Hu Fan, Elaine Galen, Janet Goldner, Shirley Gorelick, Lucy Hodgson, Eve Ingalls, Carla Rae Johnson, Penny Kaplan, Constance Kiermaier, Jessica Lenard, Cynthia Mailman, Phyllis Mark, Molly Mason, Adrienne Mim, Harriet Mishkin, Judith Ostrowitz, Marion Ranyak, Barbara Roux, Halina Rusak, Lucy Sallick, Rosalind Schneider, Susan Sharp, Linda Stein, Judith Steinberg

NEW YORK *(cont.)*

NEW YORK CITY

STEPHEN ROSENBERG GALLERY 212.431.4838
115 Wooster St., New York 10012
Hours: Tues-Sat 11-6
Contact: Fran Kaufman, Director
Specialty: Contemporary American and European painting,
sculpture, works on paper and prints

Artists Represented: Lisa Allen, Richard Ballard, Linda Besemer, **Jeffrey Brosk**
(See page 309), Michael Chandler, Arthur Cohen, Virginia Cuppaidge, Gudrun Frady, Sharon
Gold, Martha Keller, Patsy Krebs, Robert Kuszek, Michael Mulhern, Dennis Pinette, Claire Seidl,
Soren, **Edvins Strautmanis (See page 227),** Laura Thorne, Jim Waid **Works Available By:**
Martin Ball, Ellen Banks, Yasmin Brandolini, David Bryson, Anthony Dubovsky, Bella T. Feldman, Del
Geist, Matthew Giuffrida, Glenn Grafelman, Hachiro Kanno, Ted Kurahara, Leslie Lerner, Peter
Wayne Lewis, Richard Overfield

PETER ROSE GALLERY 212.759.8173
200 E. 58th St., New York 10022
Hours: Mon-Fri 10-6
Contact: Peter Rose, Owner/Director
Specialty: Contemporary painting and sculpture

Artists Represented: John Manning, Clement Meadmore, Jack Roth, Richards Ruben, David
Simpson

MICHAEL ROSENFELD GALLERY 212.247.0082
50 W. 57th St., New York 10019 FAX: 212.247.0402
Hours: Tues-Sat 10-6
Contact: Michael Rosenfeld, Owner
Specialty: 20th-Century American art 1910-1950; realism and modernism

Artists Represented: Benjamin Benno, Byron Browne, Ed Garman, Dwinell Grant, James Guy,
Louis Schanker, Charles Seliger, Joseph Vogel **Works Available By:** Alexander Archipenko,
Milton Avery, Thomas Hart Benton, Eugene Berman, Paul Cadmus, Arthur B. Davies, Louis
Eilshemius, Philip Evergood, William Gropper, Hans Hofmann, Leon Kroll, Blanche, Lazzell, Reginald
Marsh, Walter Murch, Irene Pereira, Attilio Salemme, William Schwartz, Ben Shahn, Moses Soyer,
Raphael M. Soyer, Pavel Tchelitchew, George Tooker, W.P.A., Max Weber

THE ANDREA ROSEN GALLERY 212.941.0203
130 Prince St., New York 10003 FAX: 212.941.0327
Hours: Tues-Sat 10-6
Contact: Andrea Rosen, President
Specialty: Contemporary emerging artists

Artists Represented: Neil Campbell, John Currin, Felix Gonzalez-Torres, Sean Landers, Ken
Lum, Curtis Mitchell, Heimo Zobernig **Works Available By:** Cosima Bonin, Wendy Jacob, Zoe
Leonard

ROSENFELD FINE ARTS 212.734.3284
44 E. 82nd St., New York 10028 FAX: 212.734.3322
Hours: By Appt
Contact: Rosenfeld Samuel L., Owner/Director
Specialty: American realists and modernists between
the world wars especially WPA artists

Works Available By: Eugene Berman, Byron Browne, David Burliuk, Clarence K. Chatterton,
Arthur B. Davies, Louis Elshemius, Philip Evergood, Emil Ganso, William Gropper, Chaim Gross,
George Grosz, Blanche Lazzell, Lawrence Lebduska, Reginald Marsh, Jerome Myers, Irene Pereira,
Robert Philipp, Hugo Robus, Ben Shahn, John Sloan, Raphael M. Soyer, Moses Soyer, Eugene
Speicher, Pavel Tchelichew, Abraham Walkowitz

ROSS-CONSTANTINE 212.226.0391
65 Prince St., New York 10012
Hours: Tues-Sat 12-6
Contact: Stewart Ross, President
Specialty: Early modern; W.P.A; abstract art

LUISE ROSS GALLERY 212.307.0400
50 W. 57th St., New York 10019
Hours: Tues-Sat 10-5:30
Contact: Robert A. Manley, Assistant
Specialty: Outsider art; 20th-Century American art

Artists Represented: Walter Anderson, Herman Cherry, Minnie Evans, Paul H-O,
Alun Leach-Jones, Jim, Napierala, Wallace Putnam, Kimber Smith, John, R. Thompson **Works
Available By:** Emil Bisttram, Don Eddy, Ted Gordon, Justin McCarthy, Henry Speller, Bill
Traylor, Joseph Yoakum

PERRY RUBENSTEIN 212.431.4221
130 Prince St., New York 10012 FAX: 212.431.4369
Hours: Tues-Sat 10-6
Contact: Perry Rubenstein

RUBIN SPANGLE GALLERY 212.226.2161
395 W. Broadway, New York 10012 FAX: 212.226.5337
Hours: Tues-Sat 10-6
Contact: Morgan Spangle, President
Specialty: Contemporary paintings, drawings and sculpture

Artists Represented: John Boskovich, Christian Eckart, **Dan Flavin (See page 326),**
Joseph Kosuth, Will Mentor, Richard Phillips, Ilyse Soutine, Michael Venezia **Works Available By:**
Carl Andre, Richard Artschwager, Donald Judd, Robert Motherwell, Claes Oldenburg, Robert
Rauschenberg, Ed Ruscha, Frank Stella

RUGGIERO 212.966.3711
72 Thompson St., New York 10012 FAX: 212.966.3740
Hours: Wed-Sat 12-6

MARY RYAN GALLERY INC. 212.799.2304
452 Columbus Ave., New York 10024 FAX: 212.595.9010
Hours: Tues-Sat 11-6
Specialty: British and American prints and drawings, 1920 to present

Artists Represented: Ward Davenny, Nona Hershey, Tobi Kahn, Ida Kohlmeyer, Michael
Mazur, Craig McPherson, Anthony Rice **Works Available By:** Gregory Amenoff, Jiri Anderle,
Sybil Andrews, Eric Avery, Nanette Carter, Laurent de Brunhoff, James DeWoody, Martha,
Diamond, Richard Diebenkorn, Arthur Wesley Dow, Eric Fischl, Lucian Freud, Philip Guston,
Michael Hafftka, Stanley William Hayter, David Hockney, Howard Hodgkin, Edna Boies Hopkins,
Jacob Lawrence, Blanche Lazzell, Martin Lewis, Brice Marden, Robert Motherwell, Cynthia Nartonis,
Susan Rothenberg, Anne Ryan, Gretchen Dow Simpson, Donald Sultan, James Turrell

SACKS FINE ART 212.333.7755
50 W. 57th St., New York 10019 FAX: 212.541.6065
Hours: Tues-Sat 11-5
Contact: Beverly Sacks
Specialty: African-American artists and vintage American illustrators

Works Available By: George R. Barse Jr., Virginia Berresford, Albert Bloch, Robert Blum,
Helen Blumenshein, Byron Browne, Dane Chanase, Conrad Wise Chapman, Glenn Coleman,
Warren Davis, Julio de Diego, Lauren Ford, Oronzo Gasparo, Paul Gaulois, Kahlil Gibran, William
Glackens, Morris Graves, James Guy, Bertram Hartman, Cleo Hartwig, Raymond Jonson, Morris
Kantor, Franz Kline, Rico Lebrun, Gaston Longchamps, Manigault, Pickney Marcius-Simons, Boris
Margo, E. Middleton, Ambrose Patterson, Anton Refregier, Phillip Reisman, Rolph Scarlett, Louis
Schanker, Charles Schreyvogel, John Sennhauser, Charles G. Shaw, Everett Shinn, Edward Sorel,
Eugene Speicher, Annette St. Gaudens, Edward Steichen, Maurice Sterne, Lewis Stone, Walter
Stuempfig, Agnes Tait, Franz Taussig, Richard Taylor, Abraham Walkowitz, Max Weber, Walter E.
Webster

SAIDENBERG GALLERY 212.288.3387
1018 Madison Ave., New York 10021
Hours: Tues-Fri 10-5; Sat 1-5
Contact: Eleanore Saidenberg, Owner
Specialty: European 20th-Century masters

Artists Represented: Herbert Bayer, Gyorgy Kepes **Works Available By:** Lyonel Feininger,
Alberto Giacometti, Julio Gonzalez, Paul Klee, Fernand Leger, Andre Masson, Henri Matisse, Joan
Miro, Pablo Picasso, Liubov Popova, Puni, Alexander Rodchenko, Vavarva Stepanova

SALANDER-O'REILLY GALLERIES 212.879.6606
20 E. 79th St., New York 10021 FAX: 212.744.0655
Hours: Mon-Sat 9:30-5:30
Contact: Michele M. Bernatz
Specialty: Early American modernists; French/English 19th- Century;
contemporary paintings and sculpture

Artists Represented: Joby Baker, Leland Bell, Dan Christensen, Jacob Collins, Mark Davis Sr.,
Robert Deniro, John Adams Griefen, Darryl Hughto, Louisa Matthiasdottir, Graham Nickson,
Kenneth Noland, Jules Olitski, Nathan Oliveira, Larry Poons, Paul Resika, Clifford Ross, Susan Roth,
Kikuo Saito, Joseph Solman, Michael Steiner, Paul Weingarten **Works Available By:** Thomas
Hart Benton, Henry Billings, Ralph Albert Blakelock, Samuel Colman, Jean-Baptiste Corot, James
Daugherty, Willem, de Kooning, Eugene Delacroix, Charles Demuth, Arthur Dove, Theodore,
Gericault, Joseph Glasco, Marsden Hartley, George Inness, Gaston Lachaise, Henri Le Fauconnier,
Alfred Maurer, A.R. Penck, Morton Schamberg, David Smith, Nicolas A. Tarkhoff, Harold Weston
Estates Represented: Jack Bush, John Constable, Stuart Davis, Arnold Friedman, David Park,
Morgan Russell, Horacio Torres

SANDER GALLERY 212.219.2200
105 Hudson St., Ste. 208, New York 10013 FAX: 212.219.2203
Hours: By Appt
Contact: Gerhard Sander; Eleanor Barefoot
Specialty: 20th-Century photography

Artists Represented: Marcel Broodthaers, Edvereder Elsken, Louis Faurer, Peter Keetman,
Adolph Lazi, Walter Peterhaus, Heimrich Riebesehl, Jeroslav Roessler, Peter Rose-Pulham, Elfriede
Stegemeyer, Josef Sudek, Frantisek Vobecky, WeeGee **Estates Represented:** Lisette Model,
August Sander

THE PACE GALLERY 212.421.3292
32 E. 57th St., New York 10022 FAX: 212.421.0835
Hours: Tues-Sat 10-6
Contact: Marc Glimcher
Specialty: 20th-Century paintings, drawings and sculpture

THE PACE GALLERY 212.431.9224
142 Greene St., New York 10012 FAX: 212.431.9280

Artists Represented: Georg Baselitz (See page 48), Alexander Calder, John Chamberlain, **Chuck Close (See page 75)**, George Condo, Joseph Cornell, **Jim Dine (See page 91), Jean Dubuffet (See page 94)**, Barry Flanagan, Robert Irwin, Alfred Jensen, **Donald Judd (See page 334)**, **Robert Mangold (See page 164), Agnes Martin (See page 167)**, Malcolm Morley, Louise Nevelson, Isamu Noguchi, **Claes Oldenburg (See page 351)**, Pablo Picasso, Ad Reinhardt, Mark Rothko, Robert Ryman, **Lucas Samaras (See page 359), Julian Schnabel (See page 214)**, Richard Serra, Saul Steinberg

PACE/MACGILL GALLERY 212.759.7999
32 E. 57th St., 9th Fl., New York 10022 FAX: 212.759.8964
Hours: Tues-Fri 9:30-5:30; Sat 10-6
Contact: Chris Ruggieri
Specialty: 20th-Century photography

Artists Represented: Harry Callahan, William Christenberry, Chuck Close, Robert Frank, Nan Goldin, Emmet Gowin, Robert Heinecken, Nancy Hellebrand, Mark Klett, Irving Penn, Robert Rauschenberg, Lucas Samaras, Victor Schrager, Joel Sternfeld, William Wegman, Joel-Peter Witkin **Works Available By:** Richard Avedon, Walker Evans, Kathy Grove, Jean Kallina, Josef Koudelka, Stephen Shore, Frederick Sommer, Carl Toth, Garry Winogrand

MARILYN PEARL GALLERY 212.966.5506
420 W. Broadway, New York 10012
Contact: Marilyn Pearl

KATHARINA RICH PERLOW GALLERY 212.941.1220
560 Broadway, 3rd Fl., New York 10012
Hours: Tues-Sat 10-6
Contact: Katharina Rich Perlow

PERLS GALLERIES 212.472.3200
1016 Madison Ave., New York 10021
Specialty: Modern French masters to Calder
Works Available By: Pablo Picasso

PETERSBURG 212.966.4099
130 Prince St., New York 10012

MARCUSE PFEIFER GALLERY 212.924.1011
311 1/2 W. 20th St., New York 10011

PHOENIX GALLERY 212.226.8711
568 Broadway, Ste. 607, New York 10012

PINDAR GALLERY 212.353.2040
127 Greene St., New York 10012

PLEIADES GALLERY 212.226.9093
164 Mercer St., New York 10012

ANNE PLUMB GALLERY 212.219.2007
81 Greene St., New York 10012
Hours: Tues-Sat 10-6
Contact: Anne Plumb, Director
Specialty: Contemporary art

Artists Represented: Gregory Botts, Eric de La Cova, Richard Degaetano, Roy Fowler, Paul Georges, David Hacker, Christian Haub, Laurie Lambrecht, George Moore, Teresa Serrano **Works Available By:** Dennis Oppenheim

PORTICO NEW YORK, INC. 212.941.1444
139 Spring St., 2nd Fl., New York 10012 FAX: 212.941.8248
Hours: Tues-Thurs 10-6; Appt Recommended
Contact: Steven Lowy, President
Specialty: 20th-Century art; modernism and contemporary; art of tomorrow artists

Artists Represented: Ellen Carey, D. Dominick Lombardi, Victor Matthews, James Sandler, Daniel Simmons, Michael Tingley, Peter Vogel **Works Available By:** Peter Astrom, Alice Aycock, Elizabeth S. Cuevas, William Dutterer, Mark Ed, Scott Gillis, Richard Hambleton, Hans Hinterreiter, Hans Jaenisch, Tony Moore, Jorge Olarte, Hilla Rebay, Rolph Scarlett, Amanda Watt, Peter White **Estates Represented: Rudolf Bauer (See page 50)**

POSTMASTERS GALLERY 212.941.5711
80 Greene St., 2N, New York 10012 FAX: 212.431.4679
Hours: Tues-Sat 11-6
Contact: Magdalena Sawon, Director
Specialty: Contemporary art

Artists Represented: Ron Boorobein, David Diao, Geralyn Donohue, Perry Hoberman, Mary Kelly, Silvia Kolbowski, Sarah Morri, David Nyzio, Jack Risley, Vincent Shine, Joan Wallace, Matthew Weinstein

P•P•O•W 212.941.8642
532 Broadway, 3rd Fl., New York 10012 FAX: 212.274.8339
Hours: Tues-Sat 10-6; Wed 10-8
Contact: Wendy Olsoff, Owner; Penny Pilkington, Owner
Specialty: International contemporary art

Artists Represented: Dotty Attie (See page 46), Bo Bartlett, Paul Benney, Roxanne Blanchard, Lynne Cohen, Michael Flanagan, Martha Fleming, Lynn Geesaman, Paul Graham, Ilona Granet, Teun Hocks, Joe Houston, Jed Jackson, Lyne Lapaointe, Paul Marcus, Walter Martin, Erika Rothenberg, Christy Rupp, Gary Schneider, Sandy Skoglund, David Smith Todt, Todd Watts, Carrie Mae Weems, David Wojnarowicz, Thomas Woodruff

PRAXIS INTERNATIONAL ART 212.838.2748
306 E. 55th St., 2nd Fl., New York 10022

JULIAN PRETTO 212.431.3041
103 Sullivan St., New York 10012
Hours: Tues-Sat 10-6
Contact: Julian Pretto, Proprietor
Specialty: Contemporary painting and sculpture

PREVITI GALLERY 212.724.1826
110 Riverside Dr., #12B, New York 10024 FAX: 212.724.1826
Hours: By Appt
Contact: Marte Previti, Director
Specialty: 19th- & early 20th-Century American art

Works Available By: Charles Appel, Walter Borridge, Alfred Thompson Bricher, H.R. Butler, James Costigan, Henry G. Dearth, Sanford Gifford, Gerald Leake, Hayley Lever, E.D. Lewis, Barnard Lintott, G.H. McCord, J.F. Murphy, Leonard Ochtman, R.E. Owens, Samuel Rothbort, G. Smillie, Guy Wiggins

PRINCE STREET GALLERY 212.226.9402
121 Wooster St., New York 10012

MAX PROTETCH GALLERY 212.966.5454
560 Broadway, New York 10012

PUCHONG GALLERY 212.982.1811
36A Third Ave., New York 10003

ANTHONY RALPH GALLERY 212.288.5222
43 E. 78th St., New York 10021

REECE GALLERIES 212.333.5830
24 W. 57th St., New York 10019 FAX: 212.333.7366
Hours: Tues-Sat 10-5:30
Contact: Leon Reece, V.P.

Artists Represented: Ricardo Benaim, Douglas Eisman, Phyllis Gaughran, Tsugio Hattori, Martha Margulis, Joanne Miller Rafferty, Sica, Jian-Guo Xu

REINHOLD-BROWN GALLERY 212.734.7999
26 E. 78th St., New York 10021
Hours: Tues-Sat 10:30-5
Contact: Susan Reinhold; Robert Brown

RICCO/MARESCA GALLERY 212.219.2756
105 Hudson St., New York 10013 FAX: 212.219.2756
Hours: Tues-Sat 10-6
Contact: Roger R. Ricco; Frank Maresca
Specialty: Masters of American self-taught and outsider art; emerging contemporary artists

Artists Represented: Eddie Arning, Sr. (See page 251), Thornton Dial, **William Hawkins (See page 130)**, Purvis Young **Works Available By:** Sam Doyle, William Edmondson, Martin Ramirez, Bill Traylor

MARGARETE ROEDER GALLERY 212.925.6098
545 Broadway, New York 10012 FAX: 212.431.7050
Hours: Wed-Sat 11-5:30
Contact: Margarete Roeder, Director

Artists Represented: Georg Baselitz, John Cage, Gunther Forg, Bernhard Garbert, Gary Kuehn, A.R. Penck, Arnulf Rainer, Susan Smith **Works Available By:** Bernhard Blume, Anna Blume, Gunther Brus, Richard Deacon, Peter Emch, Stefan Gritsch, Georg Herold, Per Kirkeby, Markus Raetz, Andre Thomkins, Bill Woodrow

NEW YORK (cont.)

NEW YORK CITY

ROBERT MILLER GALLERY 212.980.5454
41 E. 57th St., New York 10022 FAX: 212.935.3350
Hours: Tues-Sat 10-5:30
Specialty: Photography and contemporary fine art

Artists Represented: Berenice Abbott, Louise Bourgeois Brassai, William Brice, Martha Diamond, Jiri Georg Dokoupil, Walker Evans, Janet Fish, Adam Fuss, Jedd Garet, Herbert George, Stephen Gilbert, Robert Graham, Robert Greene, Jan Groover, Al Held, Roberto Juarez, Alex Katz, Leon Kossoff, Heinrich Kuhn, Milan Kunc, Robert Mapplethorpe, McDermott, & McGough, Joan Mitchell, Rodrigo Moynihan, Joan Nelson, Man Ray, Milton Resnick, Ed Ruscha, Pat Steir, W. H. F. Talbot, Andy Warhol, Bruce Weber **Estates Represented:** Diane Arbus, Jean-Michel Basquiat, Ralston Crawford, Eva Hesse, Lee Krasner, Clarence John Laughlin, George Platt, Lynes Alice Neel, Paul Outerbridge

ACHIM MOELLER FINE ART 212.988.8483
52 E. 76th St., New York 10021 FAX: 212.439.6663
Hours: Mon-Sat By Appt
Contact: Achim Moeller; Colette Moeller
Specialty: 19th- & 20th-Century European and American masters

Artists Represented: Piero Dorazio, Dunel, Liuba, Pravoslav Sovak **Works Available By:** Paul Cezanne, Jean-Baptiste Corot, Edgar Degas, Marcel Duchamp, Max Ernst, Lyonel Feininger, Wassily Kandinsky, R.B. Kitaj, Paul Klee, Gustav Klimt, Oskar Kokoschka, Henri Matisse, Jean-Francois Millet, Claude Monet, Henry Moore, Robert Motherwell, Pablo Picasso, Camille Pissarro, Egon Schiele, Mark Tobey

MOLICA GIUDARTE GALLERY 212.219.2244
379 W. Broadway, New York 10012

MONTSERRAT GALLERY 212.941.8899
588 Broadway, 5th Fl., New York 10012 FAX: 212.941.8728
Hours: Tues-Sat 12-6
Contact: Marie Montserrat, Director
Specialty: Contemporary paintings, drawings, sculpture and watercolor

Artists Represented: Coll (See page 78), Nancy Goldstein, Robert Katona, Angeles Muntadas, Marcos Palazzi, Pete Silvia, Blanca Vernis **Works Available By:** Joan Miro, Antoni Tapies

MORNINGSTAR GALLERY LTD. 212.334.9330
164 Mercer St., New York 10012
Hours: Wed-Fri 3:30-5:30; Sat-Sun 12-5:30
Contact: Jack Krumholz, Director
Specialty: Original graphics; signed and numbered limited editions; realism

Artists Represented: Betsy Arvidson, Judith Shahn, Lynn Shaler **Works Available By:** Harold Altman, Will Barnet, William Behnken, Ralph Fasanella, Frederick Mershimer, Kaiko Moti, Ben Shahn, Guillermo Silva

VICTORIA MUNROE GALLERY 212.226.0400
130 Prince St., New York 10012
Hours: Tues-Sat 10-6
Contact: Margaret Winslow, Director
Specialty: Contemporary works on paper

Artists Represented: Mary Armstrong, Domingo Barrares, Christina Bertoni, Suzanne Bocanegra, Katherine Bradford, Nancy Brett, Elizabeth Dworkin, Robert Ferrandini, Sharon Hovbath, Jon Imber, Joel Janowitz, Bruce Kruland, John Lash, Laura Newman, Peter Schroth, Lee Tribe **Estates Represented:** Sam Glankoff

NAHAN GALLERIES 212.966.9313
381 W. Broadway, New York 10012 FAX: 212.966.9316
Hours: Daily 9:30-6
Contact: Kenneth Nahan, Owner
Specialty: Unique and original graphics by major international artists published exclusively

Artists Represented: Berthois-Rigal, Elena Borstein, James Coignard, Oscar de Mejo, Nissan Engel, Max Papart, Mayeu Passa, Theo Tobiasse **Works Available By:** Max Ernst, Marino Marini **Estates Represented:** Attilio Salemme

ENRICO NAVARRA 212.223.2828
41 E. 57th St., New York 10019

NEO PERSONA GALLERY 212.966.5105
178 Duane St., New York 10013
Hours: Tues-Fri 10-6; Sat 12-5
Contact: Betty Rose Richardson, Director
Specialty: Emerging and established contemporary paintings

Artists Represented: Everett Adelman, Burt Hasen, Willy Lenski, Robert Mango, John Paul

HEIDI NEUHOFF GALLERY INC. 212.879.8890
999 Madison Ave., New York 10021 FAX: 212.861.4921
Hours: Daily 10-6:30
Contact: Heidi Neuhoff, President
Specialty: European and American contemporary art; impressionist and figurative painting and sculpture

Artists Represented: Ellen Brenner, Harry Caesar, Lionel Garner, Michel Henry, Susan Kahn, Jean Kevorkian, Lepho, Charles Levier, Caryl Picker, H. Claude Pissarro, Luciano Rampaso, George Shawe, Laurent Vialet **Works Available By:** Jacques Bouyssou, Jean Pierre Dubord, Jean Dufy, Suzanne Eisendeick, Donald Purdy, Gabriel Spat

NEW GLASS 212.431.0050
345 W. Broadway, New York 10013
Hours: Tues-Sat 12-7; Sun 12-6
Contact: Barbara Nilsson, Director
Specialty: Hand blown colored crystals

Artists Represented: Wilke Adolfsson, Baldwin-Guggisberg, Kosta Boda, Strondershyttan, Transjo

DANIEL NEWBURG GALLERY 212.219.1885
580 Broadway, New York 10012 FAX: 212.941.7980
Hours: Tues-Sat 10-6
Contact: Robyn Geddes

Artists Represented: John Armleder, Mary Boochever, Herbert Hamak, Peter Klashorst Nicholas Krushenick, Matthew McClasin, Kirsten Mosher, Blinky Palermo, Stephen Parrino, Brigitta Rohrbach, Wolfgang Staehle, Rudolf Stingel, Peer Veneman, Mark Wallinger, Stephen Westfall

JILL NEWHOUSE 212.249.9216
12 E. 86th St., New York 10028
Hours: By Appt
Contact: Jill Newhouse, Director
Specialty: Late 18th-, 19th- & early 20th-Century drawings and watercolors

NEWMARK GALLERY 212.744.7779
1194 Third Ave., New York 10021
Hours: Mon-Sat 10-7; Sun 1-6
Specialty: Contemporary fine art graphics

Artists Represented: Harold Altman, Frederick Mershimer, Lynn Shaler

NIKON HOUSE 212.586.3907
620 Fifth Ave., New York 10020
Hours: Tues-Sat 9:30-5:30

NOHO GALLERY 212.219.2210
168 Mercer St., New York 10012
Hours: Tues-Sun 11-6
Contact: Libby Robinson, Director
Specialty: Co-op gallery which shows diversity of each artist

DAVID NOLAN GALLERY 212.925.6190
560 Broadway, 6th Fl., New York 10012
Hours: Tues-Sat 11-5
Contact: David Nolan

ANNINA NOSEI GALLERY 212.431.9253
100 Prince St., New York 10012
Hours: Tues-Sat 10-6
Contact: Annina Nosei
Specialty: Contemporary emerging artists

Artists Represented: Nancy Bowen, Beth Brenner, Julio Galan, Tsibi Geva, Guillermo Kuitca, Gary Lang, Helmut Middendorf, Gian Marco Montesano, Stephen Mueller, Mary Obering, Nunzio Pizzicannella, Cheri Samba, Jenny Watson **Works Available By:** Jean-Michel Basquiat, Gunther Forg, Vincent Gall, Barbara Kruger, Mimmo Paladino, Salvatore Scarpitta

O'HARA GALLERY 212.355.3330
41 E. 57th St., New York 10022 FAX: 212.355.3361
Hours: Tues-Sat 10-5:30; Mon By Appt
Contact: Steve O'Hara, Director

Works Available By: Marc Chagall, Jasper Johns, Franz Kline, Roy Lichtenstein, Joan Miro, Pablo Picasso, Robert Rauschenberg, Susan, Rothenberg, Donald Sultan, Andy Warhol

M-13 GALLERY 212.925.3007
72 Greene St.New York 10012 FAX: 212.925.9741
Hours: Tues-Sat 10-6
Contact: Howard M. Scott, Director
Specialty: Contemporary American art

Artists Represented: Robert Beauchamp, Adolf Benca, Peter Brown, Thom Cooney Crawford, Ford Crull, Charles Hewitt, Andrew Jansons, Woong Kim, Toon Kuijpers, Nicholas Maffei, Donald McLaughlin, Ken Sofer, Helen Soreff, Kay Walking Stick, James Wang

MAGIDSON FINE ART 212.288.0666
1070 Madison Ave., New York 10028 FAX: 212.288.6050
Hours: Tues-Sat 10-6
Contact: Melton Magidson
Specialty: Modern and contemporary art

Artists Represented: Fernando Alvim, Josep Cisquella Passada, Roger Nellens **Works Available By:** Karel Appel, Fernando Botero, Alexander Calder, Marc Chagall, Edgar Chahine, Edouard Cortes, Raoul Dufy, Dietz Edzard, Keith Haring, Paul Helleu, Paul Jenkins, Henri Matisse, Joan Miro, Pablo Picasso, Pierre-Auguste Renoir, Andy Warhol

WALTER MAIBAUM 212.541.5000
50 W. 57th St., 7th Fl., New York 10019

MALLET FINE ART 212.477.8291
141 Prince St., New York 10012

MARCELLE FINE ART, INC. 212.737.5786
996 Madison Ave., New York 10021 FAX: 212.737.4387
Hours: Mon-Fri 10-6
Contact: Caroline Ryan

Artists Represented: Andrew Wyeth (See pages 247 & 282)

CURT MARCUS GALLERY 212.226.3200
578 Broadway, New York 10012 FAX: 212.941.6365
Hours: Tues-Sat 10-6
Contact: Katie Gass, Asst. To Dir.

Artists Represented: Phoebe Adams, Tom Butter, Peter Drake, Barbara Ess, Gloria Friedmann, Mark Innerst, Kevin Larmon, Gina Pane, Richard Pettibone, Garnett Puett, Scott Richter, Nancy Shaver, Mark Tansey, Michael Zwack

MATTHEW MARKS 212.861.9455
1018 Madison Ave., New York 10021 FAX: 212.861.9382
Hours: Tues-Sat 10-5:30
Specialty: Contemporary art

Artists Represented: Richmond Burton, Gary Hume, Brice Marden **Works Available By:** Carl Andre, Georg Baselitz, Willem de Kooning, Ellsworth Kelly, Bruce Nauman, Barnett Newman, Gerhard Richter, Cy Twombly, Andy Warhol, Lawrence Weiner

MARLBOROUGH GALLERY, INC. 212.541.4900
40 W. 57th St., New York 10019 FAX: 212.541.4948
Hours: Mon-Sat 10-5:30
Contact: Pierre Levai, President
Specialty: International contemporary artists

Artists Represented: Magdalena Abakanowicz, John Alexander, Abigdor Arikha, Frank Auerbach, Francis Bacon, Fernando Botero, Claudio Bravo, Grisha Bruskin, Jorge Castillo, Lynn Chadwick, John Davies, Antonio Lopez Garcia, Juan Genoves, Louis Gordillo, Red Grooms, Bill Jacklin, Howard Kanovitz, Alex Katz, R.B. Kitaj, Francisco Leiro, Raymond Mason, Claude Monet, Henry Moore, Hugh O'Donnell, Victor Pasmore, Daniel Quintero, Larry Rivers, Altoon Sultan, Rufino Tamayo, Manolo Valdes, Neil Welliver **Estates Represented:** Barbara Hepworth, Oskar Kokoschka, Jacques Lipchitz, James Rosati, Kurt Schwitters, Graham Sutherland

JANET MARQUSEE FINE ARTS LTD 212.744.4070
Lenox Hill Station, P.O. Box 851, New York 10021 FAX: 212.879.8514
Hours: By Appt
Contact: Janet Marqusee, Director
Specialty: American art 1920's-1940's, realism and moderism; paintings and works on paper

Estates Represented: Fred Buchholz, Clarence H. Carter, Daniel Celentano, Lucille Corcos, James Daugherty, Werner Drewes, William Gropper, Michael Lenson, Reginald Marsh, Ben Shahn, Simka Simkhovitch, Isaac Soyer

MARY-ANNE MARTIN/FINE ART 212.288.2213
23 E. 73rd St., New York 10021 FAX: 212.861.7656
Hours: Tues-Sat 11-5
Contact: Mary-Anne Martin, President
Specialty: Modern Mexican and Latin American paintings and sculpture

Artists Represented: Alfredo Castaneda, Elena Climent, **Rufino Tamayo (See page 366)**, Nahum B. Zenil **Works Available By:** Fernando Botero, Leonora Carrington, Pedro Figari, Gunther Gerzso, Frida Kahlo, Wifredo Lam, Roberto Matta, Jose Clemente Orozco, Gustavo Ramos Rivera, David A. Siqueiros, Francisco Toledo, Remedios Varo

BARBARA MATHES 212.249.3600
851 Madison Ave., New York 10021
Hours: Tues-Sat 9:30-5:30
Contact: Barbara Mathes, Director
Specialty: American and European modern and contemporary art

Works Available By: Carl Andre, Oscar Bluemner, Alexander Calder, Stuart Davis, Edgar Degas, Arthur Dove, Jean Dubuffet, Marsden Hartley, Hans Hofmann, Neil Jenney, Sol LeWitt, Robert Mangold, Agnes Martin, Joan Mitchell, Georgia O'Keeffe, Pablo Picasso, Ad Reinhardt, Charles Shieler, Joseph Stella, Andy Warhol **Estates Represented:** Hannelore Baron

PAUL MCCARRON 212.772.1181
1014 Madison Ave., New York 10021
Hours: Mon-Sat 9:30-6
Contact: Paul McCarron, Director
Specialty: Old Masters to modern works

Works Available By: Albrecht Durer, Frank Gallo, Kathe Kollwitz, Martin Lewis, Rembrandt, James McNeill Whistler

JASON MCCOY INC. 212.319.1996
41 E. 57th St., New York 10022 FAX: 212.319.4799
Contact: Noella Fachinetti, Director

Artists Represented: Anna Bialobroda, Giorgio Cavallon, William Crozier, William Garbe, Jane Kaplowitz, Frederick Kiesler, Edvard Lieber, Gregoire Muller, George Negroponte, Charles Pollock, Steven Posen, Philip Smith, Leonard Stokes, Michael Tetherow, Helen Miranda Wilson **Works Available By:** William Baziotes, Thomas Hart Benton, Constantin Brankusi, Alexander Calder, Joseph Cornell, Willem de Kooning, Edgar Degas, Alberto Giacometti, Philip Guston, Hans Hofmann, Ellsworth Kelly, Franz Kline, Brice Marden, Henri Matisse, Edvard Munch, Jackson Pollock, Andy Warhol, Tom Wesselmann

MCKEE GALLERY 212.688.5951
745 Fifth Ave., 4th Fl., New York 10151 FAX: 212.752.5638
Hours: Tues-Sat 10-6
Contact: David McKee, Director; Renee McKee, Director
Specialty: Contemporary painting, sculpture and drawing

Artists Represented: Jake Berthot, Vija Celmins, Stuart Diamond, Philip Guston, David Humphrey, Loren Madsen, Martin Puryear, Harvey Quaytman, Sean Scully **Works Available By:** William Tucker

LOUIS K. MEISEL GALLERY 212.677.1340
141 Prince St., New York 10012 FAX: 212.533.7340
Hours: Tues-Sat 10-6
Contact: Louis K. Meisel, Director
Specialty: Specializing in highly-disciplined super-realist paintings and other movements

Artists Represented: Noa Attia, Charles Bell, Tom Blackwell, Hilo Chen, John Clem Clarke, Tony Deblasi, Audrey Flack, Paul Giovanopoulos, Robert Gniewek, George D. Green, Oded Halahmy, Don Jacot, Ben Johnson, Guy Johnson, Jerome Kirk, Ron Kleemann, Steve Linn, Dennis Martin, Susan Pear Meisel, Rey Milici, David Parrish, Ralle, Mel Ramos, Alan Wolfson **Works Available By:** Robert Bechtle, Chuck Close, Robert Cottingham, Richard Estes, Franz Gertsch, Ralph Goings, Jack Lembeck, Richard McLean, Jud Nelson, Theodoros Stamos

METRO PICTURES 212.925.8335
150 Greene St., New York 10012 FAX: 212.219.2027
Hours: Tues-Sat 10-6
Contact: Janelle Reiring; Helene Winer
Specialty: Contemporary art

Artists Represented: Jennifer Bolande, Ronald Jones, Mike Kelley, Martin Kippenberger, Louise Lawler, Robert Longo, Marlene McCarty, John M. Miller, Jim Shaw, Cindy Sherman, Laurie Simmons, Fred Wilson

MIDTOWN PAYSON GALLERIES 212.758.1900
745 Fifth Ave., New York 10151 FAX: 212.832.2226
Hours: Tues-Sat 10-5:30
Contact: Bridget L. Moore, Director
Specialty: 20th-Century and contemporary American art

Artists Represented: Leonard Baskin, Michael Bergt, Debra Bermingham, Bernarda Bryson, Paul Cadmus, David Driskell, Beverly Hallam, **Jack Levine (See page 157),** Ethel Magafan, Richard Mayhew, Hans Moller, Abby Shahn, Hugh Steers, William Thon **Works Available By:** Rockwell Kent, Yasou Kuniyoshi, Reginald Marsh, Ben Shahn **Estates Represented:** Isabel Bishop, Maurice Freedman, Jared French, **Walt Kuhn (See page 149),** Bernard Langlais, Gregorio Prestopino

LAURENCE MILLER GALLERY 212.226.2120
138 Spring St., New York 10012 FAX: 212.226.2343
Hours: Tues-Sat 10-6
Contact: Laurence Miller, Director
Specialty: Contemporary and fine vintage photographs

Artists Represented: Gary Brotmeyer, Larry Burrows, Lois Conner, William Eggleston, Lee Friedlander, David Graham, Koichiro Kurita, David Levinthal, Helen Levitt, John Maggiotto, Joe Maloney, Ray K. Metzker, William Parker, Michael Spano, Val Telberg, Ruth Thorne-Thomsen, Susan Unterberg, Ito Yoshihiko **Works Available By:** Diane Arbus, Eugene Atget, Brassai, Harry Callahan, Henri Cartier-Bresson, Harold Edgerton, Walker Evans, Louis Faurer, Robert Frank, Emmet Gowin, Andre Kertesz, Eadweard Muybridge, Aaron Siskind, Alfred Stieglitz, Paul Strand, Josef Sudek, Edmund Teske, WeeGee, Minor White, Garry Winogrand **Estates Represented:** Len Jenshel

NEW YORK (cont.)

NEW YORK CITY

LEWIS LEHR INC. 212.288.6765
444 E. 86th St., New York 10028
Hours: By Appt
Contact: Lewis Lehr, Director
Specialty: Photography from 1840-1991

Artists Represented: Ben Snead **Works Available By:** Cecil Beaton, Matthew Brady, A.L. Coburn, Dr. Edgerton, Alfred Eisenstaedt, Peter Henry Emerson, William Henry Jackson, Gary Justis, Timothy O'Sullivan, Arthur Rothston, Ben Shahn, Edward Steichen, Alfred Stieglitz, WeeGee, Marion Post Wolcott

LENNON, WEINBERG, INC. 212.941.0012
580 Broadway, 2nd Fl., New York 10012 FAX: 212.941.7980
Hours: Tues-Sat 10-6; Mon By Appt
Contact: Jill Weinberg Adams, Director
Specialty: Modern and contemporary painting, sculpture and drawings

Artists Represented: Chuck Connelly, Joe Felber, Michael Goldberg, Frederique Lucien, Catherine Murphy, Carl Palazzolo, Mia Westerlund, Roosen, H. C. Westermann **Works Available By:** Walter De Maria, Willem De Kooning, Louise Fishman, Arshile Gorky, Joan Mitchell, Malcolm Morley, Tony Smith

EMIL LEONARD GALLERY LTD. 212.677.1223
138 Wooster St., New York 10012

CHRISTOPHER LEONARD GALLERY 212.941.0430
594 Broadway, 3rd Fl., New York 10012

MICHAEL LEONARD & ASSOCIATES 212.226.6709
419 Broome St., New York 10013 FAX: 212.226.1070
Hours: By Appt
Contact: Michael Leonard, Director
Specialty: Wide variety of original works by emerging and established artists

Artists Represented: Tom Burkhardt, Anthony Chimento, Chor Foo Choi, John Fudge, Gordon Hart, Marvin Hayle, Anthony Huff, Douglas McCredy, Art Michael Staats, Jeff Starr, Larry Lee Webb

CHUCK LEVITAN GALLERY 212.966.2782
42 Grand St., New York 10013

STEUART LEVY GALLERY 212.941.0009
415 W. Broadway, 3rd Fl., New York 10012
Hours: Tues-Sat 10-6
Contact: Steuart Levy, Director
Specialty: Eastern European, Soviet and American contemporary art

Artists Represented: Laszlo Feher, Attila Kovacs, Leo Manso, Boris Margo, Ladislav Novak, Yuri Petrouk, Osmo Rauhala, Semyonov & Jute, Wolfgang Smy, Miroslav Svolik, Alexander Zakharov

DANIEL E. LEWITT FINE ART 212.628.0918
16 E. 79th St., New York 10021
Hours: Tues-Sat 12-5
Contact: Daniel E. LeWitt, Owner
Specialty: Works from the 1913 armory show period through the W.P.A.

Works Available By: Ben Benn, Nicoli Cikovsky, Louis Eilshemius, Henry Gasser, John Grabach, Bernard Gusso, Adolf Konrad, August Mosca, Raphael M. Soyer, Joseph Stella, Hans Weingaertner

BRUCE R. LEWIN FINE ART 212.517.7869
150 E. 69th St., New York 10021 FAX: 212.628.8957
Hours: Mon-Sat 10-6, By Appt Only
Contact: Bruce R. Lewin, President

Artists Represented: Eric Goulder **Works Available By:** Jean-Michel Basquiat, Robert Bechtle, Bernard Buffet, Christo, Robert Cottingham, Georges D'espagnat, Tamara De Lempicka, Keith Haring, Robert Indiana, Jasper Johns, Maxfield Parrish, Mel Ramos, Oleg Tselkov

LIEBERMAN & SAUL GALLERY 212.431.0747
155 Spring St., New York 10012 FAX: 212.925.3491
Hours: Tues-Fri 10-6; Sat 11-6
Contact: Julie Saul, Director
Specialty: Fine art photographs; contemporary painting

Artists Represented: Zeke Berman, Andrew Bush, Mitch Epstein, Sally Gall, Andrea Moclica, Richard Ross, John Schlesinger, Jan Staller, Mitchell Syrop, Colin Thomson

LIMNER GALLERY 212.431.1190
598 Broadway, New York 10012
Hours: Tues-Sat 11-6
Contact: Reni Celeste, Director
Specialty: Contemporary fine art

Artists Represented: Reni Celeste, Jeremy Eagle, Ophelia Marques Huitzil, George Pobedinsky, Tim Slowinski **Works Available By:** Stasys Eidrigevicius, Andrej Pagowski, Wiktor Sadowski

AMY LIPTON 212.925.7140
67 Prince At Crosby, New York 10012

LITTLEJOHN-SMITH GALLERY 212.420.6090
245 E. 72nd St., New York 10021
Hours: Tues-Sat 11-6
Contact: Jacquie Littlejohn, President
Specialty: Contemporary painting, sculpture and works on paper

Artists Represented: Julie Heffernan, Diane Kepford, John Kindness, Jim, Morphesis, Eduardo Oliveira Cezar, Melinda Stickney-Gibson, Vicki Teague-Cooper **Works Available By:** Constance DeJong, Judith Foosaner, Brenda Goodman, Scott Ponemone, Zarko Stefancic, Neil Watson, Stephanie Weber

LLADRO ART GALLERY 212.838.9341
43 W. 57th St., New York 10019 FAX: 212.758.1928
Hours: Tues-Sat 10-5:30
Contact: Gloria Ortiz, Director
Specialty: Contemporary paintings and limited edition graphics from Spain

Artists Represented: Vicente Alonso, Jose Beulas, Ramon Bilbao, Andres Cillero Cuixart, Francisco Lozano, Cirilo Martinez Novillo, Vicente Peris, Jose Vega Ossorio

LORENCE-MONK 212.431.3555
578 Broadway, New York 10012
Hours: Tues-Sat 10-6
Contact: Susan Lorence; Robert Monk

LORENCE-MONK GRAPHICS 212.431.3555
568 Broadway, New York 10012
Hours: Tues-Sat 10-6

LOUVER GALLERY 212.925.9205
130 Prince St., New York 10012 FAX: 212.219.8527
Hours: Tues-Sat 10-6
Contact: Sean F. Kelly, Director
Specialty: American and European contemporary art

Artists Represented: Tony Berlant, Wallace Berman, Tony Bevan, Alan Charlton, Ann Hamilton, Edward & Nancy Kienholz, Pieter Laurens Mol, Ed Moses, David Nash, Juliao Sarmento, Peter Shelton, John Virtue

SIMON LOWINSKY GALLERY 212.226.5440
575 Broadway, New York 10012 FAX: 212.226.5442
Hours: Tues-Sat 11-6
Contact: Michael Malcolm, Director
Specialty: 19th- & 20th-Century master photographs

Artists Represented: Mariette Pathy Allen, Ilse Bing, Ed Grazda, Robert Glenn Ketchum, Sally Larsen, Skeet McAuley, Graham Nash, Suzanne Opton, **Madoka Takagi (See page 399) Works Available By:** Berenice Abbott, Diane Arbus, Eugene Atget, Anna Atkins, Eduoard-Denis Baldus, Henry P. Bosse, Brassai, Imogen Cunningham, Louis de Clercq, Walker Evans, Robert Frank, Laura Gilpin, Emmet Gowin, Lewis Hine, Andre Kertesz, Dorothea Lange, Danny Lyon, Robert Mapplethorpe, Charles Negre, Paul Outerbridge, Arthur Siegel, Eugene Smith, Alfred Stieglitz, Paul Strand, Linnaeus Tripe, Edward Weston, Garry Winogrand

LUCIA GALLERY 212.941.9296
150 Spring St., New York 10012
Hours: Daily 11-6
Contact: Lucia Chen, Owner/Director
Specialty: Post-Modernism limited editions

Artists Represented: Tsing Fang Chen **Works Available By:** Marc Chagall, Sam Francis, Jasper Johns, Roy Lichtenstein, Pablo Picasso, Robert Rauschenberg, Victor Vasarely, Andy Warhol

LUHRING AUGUSTINE GALLERY 212.219.9600
130 Prince St., New York 10012 FAX: 212.966.1891
Hours: Tues-Sat 10-6
Contact: Roland Augustine
Specialty: Contemporary art

Artists Represented: Larry Clark, Gunther Forg, Kenji Fujita, Jon Kessler, Hubert Kiecol, Tatsuo Miyajima, Albert Oehlen, Stephen Prina, Christopher Williams, Christopher Wool **Works Available By:** Marcel Duchamp, Philip Guston, Neil Jenney, Sigmar Polke, Gerhard Richter, Susan Rothenberg, Joel Shapiro

JEAN LUMBARD FINE ARTS 212.996.4484
Gracie Station, PO Box W, New York 10028
Hours: By Appt
Contact: Jean Lumbard, Owner
Specialty: Traditional art by modern masters

Artists Represented: Siri Berg, Larry D'amico, John Grillo, Robert Kipress, Robert Longhurst, Jean Miotte, Sica

LUNN LTD. 212.535.7924
42 E. 76th St., New York 10021

VIRGINIA LUST GALLERY 212.941.9220
61 Sullivan St., New York 10012
Hours: Tues-Sat 11:30-6

Works Available By: Arman Arakawa, Enrico Baj, Mary Bauermeister, Hans Bellmer, Chryssa Corpron, Alberto Giacometti, Stanley William Hayter, Charles Hinman, Robert Indiana, Man Ray, Yves Tanguy

HAL KATZEN GALLERY 212.966.4469
475 Broome St., New York 10013 FAX: 212.266.1428
Hours: Tues-Sat 10-6
Contact: Hal Katzen, Director
Specialty: International contemporary paintings and drawings by established and emerging artists

Artists Represented: Sedar Arat, Michelle Charles, Max Coyer, Terry Elkins, Beverly Fishman, Marcia Gygli King, Stephanie Brody Lederman, Robert Mason, Jim Morphesis, Michael Porter, Anne Marie Rosseau, Jorge Salazar, Christina Schlesinger **Works Available By:** Norris Embry, Gustavo Ramos Rivera, John Walker

JOSEPH KEIFFER INC. 212.249.8249
28 E. 72nd St., New York 10021 FAX: 212.288.3851
Hours: By Appt Except During Announced Exhibitions
Contact: Joseph Keiffer, President
Specialty: Realist painting and works on paper from 1950 to present

Artists Represented: Mary Beth Mckenzie, George Stave, George Wingate, C.W. Yeiser **Works Available By:** Milet Andrejevic, Robert Brackman, Wolf Kahn, John Koch, Adolf Konrad, Walter Murch, Ogden Pleissner, Fairfield Porter, Burt Silverman

JUNE KELLY GALLERY 212.226.1660
591 Broadway, 3rd Fl., New York 10012
Contact: June Kelly, Principal

KENNEDY GALLERIES, INC. 212.541.9600
40 W. 57th St., New York 10019 FAX: 212.333.7451
Hours: Tues-Sat 9:30-5:30
Contact: Lawrence A. Fleischman; Martha Fleischman
Specialty: 18th-, 19th- & 20th-Century American paintings, prints and sculpture

Artists Represented: Ivan Albright, Leonard Baskin, George Bellows, Thomas Hart Benton, **Charles E. Burchfield (See page 65)**, Arthur B. Davies, Stuart Davis, Charles Demuth, Arthur Dove, Philip Evergood, Lyonel Feininger, John, Flannagan, Morris Graves, Marsden Hartley, Childe Hassam, Robert Henri, Joseph Hirsch, Edward Hopper, Eugene Jardin, Joe Jones, Walt Kuhn, Martin Lewis, George Luks, John Marin, Reginald Marsh, Richard E. Miller, Walter Murch, Jerome Myers, Joseph O'Sickey, Carolyn Plochmann, Maurice Prendergast, Abraham Rattner, Edward W. Redfield, Ben Shahn, Charles Sheeler, Millard Sheets, Everett Shinn, John Sloan, Clarice Smith, Robert Vickrey

KENT GALLERY, INC. 212.980.9696
47 E. 63rd St., New York 10021 FAX: 212.421.5368
Hours: Mon-Fri 10-6
Contact: Douglas Walla, President
Specialty: Modern and contemporary sculpture; masters of the historic avant-garde

Works Available By: Dennis Adams, Richard Artschwager, Troy Brauntugh, Chris Burden, Reg Butler, Genevieve Cadieux, Llyn Foulkes, John Heartfield, Jerry Kearns, Paul Laffoley, Marino Marini, Henry Moore, Muntadas, Dennis Oppenheim, Irving Petlin, Francis Picabia, August Rodin, Carriere Rosso

PAT KERY FINE ARTS, INC. 212.734.5187
52 E. 66th St., New York 10021 FAX: 212.734.4841
Hours: By Appt
Contact: Pat Kery, Director
Specialty: 20th-Century masters

Works Available By: Marc Chagall, Francesco Clemente, Jean Dubuffet, David Hockney, Anselm Kiefer, Franz Kline, Henri Matisse, Joan Miro, Pablo Picasso, Jackson Pollock, Jose Maria Sicilia, Frank Stella, Tom Wesselmann

PHYLLIS KIND GALLERY 212.925.1200
136 Greene St., New York 10012 FAX: 212.941.7841
Hours: Tues-Sat 10-5:30
Contact: Phyllis Kind, President
Specialty: Contemporary American, Soviet, naive and outsider art

Artists Represented: Stephen Anderson, **Roger Brown (See page 64)**, Eric Bulatov, **Robert Colescott (See page 77)**, William Copley, Yuri Dyshlenko, Simon Faibisovich, Howard Finster, Art Green, Mark Greenwold, Richard Hull, Sue Israel, Miyoko Ito, Luis Jimenez, Svetlana Kopystianskaya, Igor Kopystianski, Leonard Koscianski, Igor Makarevich, Langston Moffett, J.B. Murry, Irina Nakhova Dennis Nechvatal, Gladys Nilsson, Timur Novikov, Jim Nutt, **Ed Paschke (See page 187)**, Christina Ramberg, Martin Ramirez, Suellen Rocca, Patrick Rodriguez, Barbara Rossi, Oleg Vassilyev, Margaret Wharton, Karl Wirsum **Adolf Wölfli (See page 258)**, Robin Woodsome, Joseph Yoakum, Ray Yoshida, Zush

NICOLE KLAGSBRUN 212.925.5157
51 Greene St., New York 10013 FAX: 212.925.0759
Hours: Tues, Thur-Sat 10-6; Wed 10-8
Contact: Nicole Klagsbrun, Director
Specialty: Conceptually based American and European work by younger, emerging artists

Artists Represented: Sally Apfelbaum, Judith Barry, Mary Beyt, Jimmie Durham, Peter Greenaway, Candida Hofer, Claudia Matzko, Nicolas Rule, Ian Wallace **Works Available By:** Barbara Kruger, Hirsch Perlman, David Salle

MICHAEL KLEIN INC. 212.431.1980
594 Broadway, Rm. 302, New York 10012 FAX: 212.431.1985
Hours: Tues-Sat 10-6
Contact: David Frazer Gray
Specialty: Contemporary art

Artists Represented: James Casebere, Kate Ericson, Jackie Ferrara, Jene Highstein, Gary Lang, Gerry Morehead, Matt Mullican, Elaine Reichek, Robin Winters, Mel Ziegler

KNOEDLER & COMPANY 212.794.0550
19 E. 70th Street, New York 10021 FAX: 212.772.6932
Hours: Tues-Fri 9:30-5:30; Sat 10-5:30
Contact: Carol Corey, Asst. To Pres.
Specialty: Contemporary art

Artists Represented: Michael David, Richard Diebenkorn, Herbert Ferber, Glenn Goldberg, Adolph Gottlieb, Nancy Graves, Michael Heizer, Howard Hodgkin, Robert Motherwell, Robert Rauschenberg, David Smith, Frank Stella, Donald Sultan, Jamie Walker

KOUROS GALLERY 212.288.5888
23 East 73rd St., New York 10021 FAX: 212.794.9397
Hours: Tues-Sat 10-6
Contact: Charlotte Camillos, Owner
Specialty: Contemporary paintings and sculpture; 20th-Century masters

Artists Represented: Janice Biala, Juan Bordes, Daniel Brustlein, Lin Emery, Dimitri Hadzi, Paul Manes, Bruno Romeda, Paul Russotto, Theodoros Stamos, Nicolas Vlavianos **Works Available By:** Giacomo Balla, Rudolf Bauer, Eugene Boudin, Bruno Ceccobelli, Marc Chagall, Vieira Da Silva, Edgar Degas, Andre Derain, Marcel Duchamp, Wassily Kandinsky, Nina Kogan, Le Corbusier, Andre Masson, Henri Matisse, Joan Miro, Amedeu Modigliani, Claude Monet, Camille Pissarro, Serge Poliakoff, Odilon Redon, Pierre-Auguste Renoir, Alfred Reth, Georges Rouault, Joaquin Torres-Garcia, Maurice Utrillo, Anatoli Zverev

PAUL KOVESDY 212.737.4563
16 E. 73rd St., New York 10021

KRAUSHAAR GALLERIES, INC. 212.307.5730
724 Fifth Ave., New York 10019
Hours: Tues-Fri 9:30-5:30; Sat 10-5
Specialty: 20th-Century American art

Artists Represented: Karen Breunig, David Cantine, Sonia Gechtoff, Leon Goldin, John Hartell, John Heliker, Robert Lahotan, Joe Lasker, James Lechay, Elsie Manville, Carl Morris, Ben Frank Moss, Daniel O'Sullivan, Andree Ruellan, Karl Schrag, Isabelle H. Siegel, David Smalley, Linda Sokolowski, Jane Wasey **Works Available By:** Charles Demuth, Renee Dubois, Marsden Hartley, Alfred Maurer, Maurice Prendergast **Estates Represented:** Peggy Bacon, G. Beal, L. Bouche, Kenneth Callahan, William Glackens, W. Kienbusch, John Koch, Anne Ryan, John Sloan, Marguerite Zorach

JAN KRUGIER GALLERY 212.755.7288
41 E. 57th St., New York 10022 FAX: 212.980.6079
Hours: Tues-Sat 10-5:30
Specialty: Modern and contemporary European and American masters

Artists Represented: Pablo Picasso **Works Available By:** Balthus, Pierre Bonnard, Georges Braque, Alexander Calder, Marc Chagall, Edgar Degas, Richard Diebenkorn, Jean Dubuffet, Alberto Giacometti, Richard Haas, Paul Klee, Yuri Kuper, Fernand Leger, Henri Matisse, Joan Miro, Henry Moore, Anton Zoran Music, Antoni Tapies, Edouard Vuillard

LAFAYETTE PARKE GALLERY 212.517.5550
58 E. 79th St., New York 10021 FAX: 212.734.2791
Hours: Tues-Sat 10:30-5:30
Contact: Roy Karlen, Director
Specialty: German Expressionism, Vienna Secession, French Post-Impressionism and Symbolism

Artists Represented: Max Beckmann, Edgar Degas, Otto Dix, Lyonel Feininger, Conrad Felixmuller, Albert Gleizes, George Grosz, Erich Heckel, Auguste Herbin, Karl Hubbuch, Wassily Kandinsky, Fernand Khnopff, Ernst Ludwig Kirchner, Gustav Klimt, Oskar Kokoschka, Kathe Kollwitz, Gerhard Marcks, Henri Matisse, Paula Modersohn-Becker, Otto Mueller, Max Pechstein, Rudolf-Schlichter, Christian Schad, Egon Schiele, Karl Schmidt-Rottluff, Franz Von Stuck, Alej Von Jawlensky, Edouard Vuillard

LEDEL GALLERY 212.966.7659
168 Mercer St., New York 10012
Hours: Wed-Sat 12-6

LEDISFLAM GALLERY 212.925.2806
584 Broadway, #309, New York 10012 FAX: 212.925.2971
Hours: Tues-Sat 10-6
Contact: Robert E. Flam, Director
Specialty: Contemporary art in all media by international artists

Artists Represented: Terry Adkins, Peter Aeheson, Pieter Engels, Dina Ghen, Tyree Guyton, James Harrison, Jim Lutes, David Mann, Deborah Mastero, Joe McGill, Amy Sillman, Rebecca Smith **Works Available By:** Judy Mannarino, Heather Nicol, Alan Sonfist, Shela White, Frances Whitehead

NEW YORK *(cont.)*

NEW YORK CITY

ARNOLD HERSTAND & COMPANY
212.664.1379
24 W. 57th St., New York 10019
FAX: 212.757.3204
Hours: Mon-Sat 10-5:30
Contact: Scott Cook, Director
Specialty: Modern and contemporary paintings, drawings, and sculpture

Artists Represented: Pol Bury, Clyde Connell, Gonyalo Fonseca, Jenny Lee, Ann McCoy, Georgen Noel, Paul Rotterdam, William Turnbull **Works Available By:** Jean Arp, Balthus, Alexander Calder, Salvador Dali, Jean Dubuffet, Ernest Alberto Giacometti, Julio Gonzalez, Fernand Leger, Henri Matisse, Joan Miro, Isamu Noguchi, Pablo Picasso, Carriere Rosso, Richard Stankiewicz
Estates Represented: Oyvind Fahlstrom

CAROLYN HILL GALLERY
212.226.4611
109 Spring St., New York 10012
FAX: 212.226.5952
Hours: Wed-Sun 12-6
Contact: Carolyn Hill, Director
Specialty: Contemporary paintings, drawings and sculpture with new division of Old Masters

Artists Represented: Eda Shigeri Akino, Arias-Murueta, Peter Cox, Andelka Gajsak, Franklin Gilliam, Lorrie Goulet, Bogdan Kostrzynski, Olivier Leloup, Yang Ming-Yi, Tom Nicholas, Jan Sawka, Joseph Sheppard, Joel Zakow, Bruno Zupan

HIRSCHL & ADLER MODERN
212.744.6700
851 Madison Ave., New York 10021
FAX: 212.737.2614
Hours: Tues-Fri 9:30-5:30; Sat 9:30-5
Contact: Donald McKinney, Director
Specialty: Contemporary European and American art

Artists Represented: Roger Ackling, Gregory Amenoff, **Lynn Davis (See page 383)**, Rackstraw Downes **(See page 93)**, Pierre et Gilles, Jochen Gerz, Elliott Green, Paul Laster, John Lees, **Piero Manzoni (See page 165)**, Carlo Maria Mariani, George McNeil, John Moore, **Philip Pearlstein (See page 188)**, Norbert Prangenberg, Barbara Schwartz, **Joan Snyder (See page 220)**, David Storey, James Weeks, Alison Wilding, **Christopher Wilmarth (See page 373)**
Works Available By: Georg Baselitz, Forrest Bess, Gilbert & George, Brice Marden, David Robillard, Cy Twombly **Estates Represented:** Joseph Breitenbach, Fairfield Porter, Bill Traylor

IRENA HOCHMAN
212.772.2227
22 E. 72nd St., New York 10021

NANCY HOFFMAN GALLERY
212.966.6676
429 W. Broadway, New York 10012
FAX: 212.334.5078
Hours: Tues-Sat 10-6
Contact: Sique Spence, Director
Specialty: Contemporary oil and watercolor paintings, sculpture, drawings, and prints

Artists Represented: Ilan Averbuch, Carolyne Brady, Howard Buchwald, Rupert Deese, Don Eddy, Rafael Ferrer, Viola Frey, Juan Gonzalez, Michael Gregory, Rohan Harris, Claire Khalil, Susan Norrie, John Okulick, Frank Owen, Peter Plagens, Joseph Raffael, Bill Richards, Alan Siegel, Jim Sullivan

VIVIAN HORAN FINE ART
212.517.9410
35 E. 67th St., New York 10021
FAX: 212.772.6107
Hours: Mon-Sat 10-6
Specialty: 20th-Century paintings, drawings, and sculpture

Works Available By: Carl Andre, Dan Flavin, Robert Gober, Donald Judd, On Kawara, Sigmar Polke, Mark Rothko

HUMPHREY FINE ART
212.226.5360
594 Broadway, 4th Fl., New York 10012
FAX: 212.226.5363
Hours: Tues-Sat 11-6
Contact: Richard Humphrey, President; Cheryl Dolby, V.P.
Specialty: Contemporary painting, sculpture and photography

Artists Represented: James Jackson Burt, Robert Cronbach, Carol Kreeger Davidson, Michael French, Garance, Nobuya Hitsuda, Meryl Joseph, Niki Ketchman, Yukimura S. Konishi, Hans Kooi, Catherine Lopes-Curval, Jorg Madlener, Miguel Pena, Gabriel Salomon, Therese Schwartz, **Jesús Rafael Soto (See page 362)**, Christoph Speich

LEONARD HUTTON GALLERIES
212.249.9700
33 E. 74th St., New York 10021

ILLUSTRATION HOUSE INC.
212.966.9444
96 Spring St., 7th Fl., New York 10012
FAX: 212.966.9448
Hours: Tues-Sat 10:30-5:30
Contact: Fred Taraba, Asst. Director
Specialty: Original illustrative paintings and drawings over the past century

Works Available By: Dean Cornwell, Steve Dohanos, John Held, J.C. Leyendecker, Henry Raleigh, Saul Tepper, Harold Von Schmidt

MICHAEL INGBAR GALLERY
212.334.1100
578 Broadway, New York 10012
Hours: Mon-Fri 9-6; Sat 12-6
Contact: Laura Maxey, Director
Specialty: Paintings, works on paper, and sculpture

Artists Represented: Beatrice Findlay, Frederick Frazowatz, Susan Hamady, Michael Pattinson, Richard L. Strong

ISSELBACHER GALLERY
212.472.1766
41 E. 78th St., New York 10021
FAX: 212.472.3078
Hours: Tues-Sat 10:30-5:30
Specialty: Late 19th- & 20th-Century prints and drawings

Works Available By: Max Beckmann, Pierre Bonnard, Marc Chagall, Henri Matisse, Joan Miro, Emil Nolde, Pablo Picasso, Henri de Toulouse-Lautrec

JADITE GALLERIES
212.315.2740
415 W. 50th St., New York 10019
Hours: Mon-Sat 11-6
Contact: Roland Sainz, Director
Specialty: National and international emerging contemporary artists in all media

Artists Represented: Delene Bartholdi, Dionisio Blanco, Douglas Chess, Tony La Greca, Clara Meneres

JAMISON/THOMAS GALLERY
212.925.1055
588 Broadway, Ste. 303, New York 10012
FAX: 212.925.1090
Hours: Tues-Sat 10-6
Contact: Jeffrey Thomas, Director
Specialty: Contemporary paintings, sculpture, drawings and prints

Artists Represented: Rick Bartow, Stuart Buehler, Mark Bulwinkle, Mark Calderon, Flechemuller, **Gregory Grenon (See page 120)**, Robert Heardlein, Heather Hutchison, David Jeffrey, D. E. May, Cyrilla Mozenter, Eric Stotik

SIDNEY JANIS GALLERY
212.586.0110
110 W. 57th St., New York 10019
FAX: 212.262.0525
Hours: Mon-Sat 10-5:30
Contact: Carroll Janis, Director
Specialty: Nine decades of 20th-Century masters

Artists Represented: Eduardo Chillida, Crash, Herve & Richard Di Rosa, R.M. Fischer, Valerie Jaudon, Maya Lin Marisol, Duane Michals, Fiona, Rae, Bridget Riley, George Segal, Tom Wesselmann, Robert Zakanitch **Works Available By:** Josef Albers, Jean Arp, Constantin Brancusi, Georges, Braque Willem de Kooning, Jean Dubuffet, Louis Eilshemius, Oyvind Fahlstrom, Alberto Giacometti, Arshile Gorky, Auguste Herbin, Morris Hirshfield, Vilmos Huszar, Alexis Jawlensky, Paul Klee, Yves Klein, Franz Kline, Fernand Leger, Jean Metzinger, Piet Mondrian, Claes Oldenburg, Kurt Schwitters, Saul Steinberg, Joaquin Torres-Garcia

JORDAN-VOLPE GALLERY, INC.
212.570.9500
958 Madison Ave., New York 10021
FAX: 212.737.1611
Hours: Tues-Sat 10:30-5:30
Contact: B.J. Topol, Gallery Asst.
Specialty: Oils, watercolors and pastels by early 20th-Century American artists

Works Available By: Charles Burchfield, Arthur Dove, Marsden Hartley, John Marin, Alfred Maurer, Joseph Stella

PETER JOSEPH GALLERY
212.751.5500
745 Fifth Ave., 4th Fl., New York 10151
FAX: 212.751.0213
Hours: Tues-Sat 10-6
Contact: Lorry Dudley, Director; Nancy Gobes
Specialty: One-of-a-kind studio furniture

Artists Represented: Jonathan Bonner, James Carpenter, Wendell Castle, John Dunnigan, Michelle Holzapfel, Thomas Hucker, Michael Hurwitz, Thomas Loeser, Wendy Maruyama, Alphonse Mattia, Richard Newman, Albert Paley, Gaetano Pesce, Timothy Philbrick, James Schriber, Rosanne Somerson, Wendy Wahl, Edward Zucca **Works Available By:** Wharton Esherick, Elizabeth Jackson, John Makepeace

PAUL JUDELSON ARTS
212.888.9833
314 E. 51st St., New York 10022
FAX: 212.838.6724
Hours: By Appt
Contact: Paul Judelson, Director
Specialty: Contemporary work from the studios of leningrad artists

Artists Represented: Afrika, Gustav Gurianov, Andrei Khlobystin, Timur Novikov

JANE KAHAN GALLERY
212.744.1490
922 Madison Ave., New York 10021

ALEXANDER KAHAN FINE ARTS
212.737.4231
40 E. 76th St., New York 10021
FAX: 212.744.1564
Hours: Mon-Fri 10:30-5:30; Sat By Appt
Contact: Jason Kahan, Asst. Director

Works Available By: Yaacov Agam, Karel Appel, Jean-Michel Atlan, Rudolphe Baur, Camille Bombois, Alexander Calder, Marc Chagall, Guillaume Corneille, Georges D'espagnat, Giorgio De Chirico, Robert Delaunay, Jean Dubuffet, Jean Dufy, Sam Francis, Albert Gleizes, Auguste Herbin, Paul Jenkins, Henri Lebasque, Fernand Leger, Maximilien Luce, Mane-Katz, Giacomo Manzu, Marino Marini, Roberto Matta, Jean Metzinger, Joan Miro, Henry Moore, Pablo Picasso, H. Claude Pissarro, Jean-Paul Riopelle, August Rodin, Reuven Rubin, Paulo Salvador, Gino Severini, Frank Stella, Leopol Survage, Maurice Utrillo, Louis Valtat, Victor Vasarely, Maurice De Vlaminck

PAUL KASMIN GALLERY
212.219.321
580 Broadway, 2nd Fl., New York 10012
FAX: 212.941.7980
Hours: Tues-Sat 10-4

MARIAN GOODMAN GALLERY 212.977.7160
24 W. 57th St., New York 10019
Hours: Mon-Sat 10-6

JAY GORNEY MODERN ART 212.966.4480
100 Greene St., New York 10012 FAX: 212.925.1239
Hours: Tues-Sat 10-6
Contact: Jay Gorney, President
Specialty: Contemporary photography, painting and sculpture

Artists Represented: Barbara Bloom, Sarah Charlesworth, Clegg & Guttman, Michael Jenkins, Justen Ladda, Michael Landy, Peter Nadin, Peter Nagy, Joel Otterson, Lari Pittman, Alexis Rockman, Haim Steinbach, Meyer Vaisman, James Welling **Works Available By:** R.M. Fischer, Thomas Locher, Michelangelo Pistoletto, Tim Rollins + K.O.S., Andreas Schon

GRAHAM MODERN 212.535.5767
1014 Madison Ave., New York 10021 FAX: 212.794.2454
Hours: Tues-Sat 10-5
Contact: Lisa Travers, Director

Artists Represented: Judith Cotton, Susan Crile, Joellyn Duesberry, Nancy Fried, Bayat Keerl, Rick Patrick, Anne Poor, Jonathan Santlofer, Reéve Schley, Peter Stevens, Joan Thorne, Robert White **Works Available By:** Carmen Cicero, Seymour Fogel, Jasper Johns, Wayne Thiebaud

GRAND CENTRAL ART GALLERIES 212.867.3344
24 W. 57th St., New York 10019 FAX: 212.867.3346
Hours: Mon-Fri 10-6; Sat 10-4
Contact: John Stuart Evans, Director
Specialty: 19th- & 20th-Century American Realism

Artists Represented: Ernie Barries, Tony Bennett, Chris Blossom, Scott Fraser, George Gallo, Jin Gao, Mary Anna Goetz, Gregg Kreutz **Works Available By:** Dines Carlsen, James Chapin, William Merritt Chase, Robert Henri, Frederic Remington, Margery Ryerson, Henry O. Tanner

HOWARD GREENBERG GALLERY 212.334.0010
120 Wooster St., New York 10012 FAX: 212.941.7479
Hours: Tues-Sat 11-6
Contact: Howard Greenberg
Specialty: Fine vintage and contemporary photography

Artists Represented: Debbie Fleming Caffery, Imogen Cunningham, Eikoh Hosoe, Kenro Izu, William Klein, Yasou Kuniyoshi, Ralph Eugene Meatyard, Martin Munkacsi, Arnold Newman **Works Available By:** Frantisek Drtikol, Walker Evans, Robert Frank, Lewis Hine, Andre Kertesz

WILLIAM HABER 212.334.1212
164 Duane St., New York 10013

HAENAH-KENT 212.941.6180
25 Howard, New York 10013

NOHRA HAIME GALLERY 212.888.3550
41 E. 57th St., 6th Fl., New York 10022 FAX: 212.888.7869
Hours: Mon-Sat 10-6
Contact: Joanna Skoler, Registrar
Specialty: International contemporary art

Artists Represented: Luis Caballero, Pierre Dunoyer, Menashe Kadishman, Julio Larraz, Ramiro Llona, Silvio Merlino, Payton Miller, Keith Milow, Lika Mutal, Milo Reice, Adam Straus, Francisca Sutil, Jorge Tacla, John Van Alstine, Sophia Vari **Works Available By:** Fernando Botero, James Brown, Sandro Chia, Friedel Dzubas, Pedro Figari, Bryan Hunt, Wifredo Lam, Roberto Matta, Henry Moore, Malcolm Morley, Mimmo Paladino, Joel Perlman, Antonio Sequi, David A. Siqueiros, Francisco Toledo, Joaquin Torres-Garcia

STEPHEN HALLER FINE ART 212.219.2500
415 W. Broadway, New York 10012 FAX: 212.219.3246
Hours: Tues-Sat 10-6
Contact: Stephen Haller
Specialty: Contemporary American and European artists references to ritual and ceremony

Artists Represented: Elaine Anthony, Lothar Fischer, Johannes Girardoni, Laurie Kaplowitz, Ronnie Landfield, Norman Lundin, Marc Rawls, Judith Streeter **Works Available By:** James Brown, Richard Diebenkorn, Jean Dubuffet, Giorgio Morandi

HAMMER GALLERIES 212.644.4400
33 W. 57th St., New York 10019 FAX: 212.832.3763
Hours: Mon-Fri 9:30-5:30; Sat 10-5
Contact: Richard Lynch, Director
Specialty: 19th century, 20th-Century , and contemporary paintings and sculpture; European and American

Artists Represented: David Armstrong, Ettore de Conciliis, **Eyvind Earle (See page 97),** Harrison Ellenshaw, Peter Ellenshaw, Chen Yi Fei, Mort Kunstler, Harry Marinsky, Chen Yi Ming

JAMES M. HANSEN FINE ARTS 212.425.4090
44 Trinity Place, New York 10006 FAX: 212.809.5862
Hours: By Appt
Contact: James M. Hansen
Specialty: American paintings; California Impressionists

Artists Represented: Elen Sevy, David Starwood

SUSAN HARDER AT TWINING GALLERY 212.475.5992
568 Broadway, New York 10012

O.K. HARRIS WORKS OF ART 212.431.3600
383 W. Broadway, New York 10012
Hours: Tues-Sat 10-6
Contact: Ivan C. Karp, Director
Specialty: Contemporary American and European painting, sculpture, photography, antiques, collectibles and documentation

Artists Represented: Thomas Bacher, John Baeder, Robert Bechtle, Douglas Bond, Allen Brandenburg, **Muriel Castanis (See page 314),** Don Celender, Daniel Chard, Y.J. Cho, **Davis Cone (See page 80),** Greg Constantine, **Jamie Dalglish (See page 81),** Mariano Del Rosario, **James Del Grosso (See page 86),** Daniel Douke, **Randy Dudley (See page 95),** Leonard Dufresne, Vincent Falsetta, John Fawcett, Stephen Fox, Kevin Franke, Marilynn Gelfman, Vladimir German, David Giese, Robert Ginder, Ralph Goings, Masao Gozu, D.J. Hall, Allen Harrison, Yan Hsia, Gary Jacobson, Jonathan Janson, Sook-Jin Jo, John Kacere, Alan Kessler, Hai.Knafo, Stanislav Kolibal, **Aris Koutroulis (See page 147),** Oscar Lakeman, Milo Lazarevic, Josef Levi, Marilyn Levine, Robert Lowe, Clyde Lynds, John Mackiewicz, Nicholas Maravell, Richard McLean, Jack Mendenhall, Kenneth Morgan, William Nichols, Rikuro Okamoto, Pavel Opocensky, Sharron Quasius, Jack Radetsky, Joseph Richards, Lance Richbourg, Robert Rohm, Arsen Roje, Richard Rudich, John Salt, Masaaki Sato, Steve Silver, Keung Szeto, **Boaz Vaadia (See page 369), Robert Van Vranken (See page 240),** Tom Wesselmann, John T. Young, Tino Zago **Works Available By:** Stefan Beltzig, Thomas Buechner, Tamara Carlisle, David Furman, Peter Gabrielse, Vladimir Grigorovich, Tom Hebert, Brian Kazlov, Robert Kogge, Zdeno Majercak, Jerry Wilkerson

EMILY HARVEY GALLERY 212.925.7651
537 Broadway, 2nd Fl., New York 10012

SALLY HAWKINS GALLERY 212.477.5699
448 West Broadway, 2nd Fl., New York 10012 FAX: 212.260.1928
Hours: Tues-Sat 11-6
Contact: Sally Hawkins, Director
Specialty: Contemporary paintings, drawings and sculpture

Artists Represented: John O. Buck, Cynthia Eardley, Grace Graupe-Pillard, Toni Putnam, **Bill Schiffer (See page 213) Works Available By:** Alexander Calder, Sonia Delaunay, Robert Gordy, Ed Paschke, Francis Picabia, Jim Radakovich, Ramon

PAT HEARN GALLERY 212.941.7055
39 Wooster St., New York 10013 FAX: 212.941.7046
Hours: Tues-Sat 10-6
Contact: Pat Hearn, Director
Specialty: Contemporary art

Artists Represented: Jimmy De Sana, Gretchen Faust, Renez Green, Mary Heilmann, Lisa Hein, Susan Hiller, Tishan Hsu, Patty Martori, Thom Merrick, Mark Morrisroe, Julia Scher, St. Bernard

LILLIAN HEIDENBERG GALLERY 212.586.3808
50 W. 57th St., New York 10019 FAX: 212.977.4363
Hours: Tues-Sat 10-5:30
Contact: Philip Tifft, Director
Specialty: 20th-Century modern masters printing, sculpture, drawings and prints

Artists Represented: Lynn Chadwick, Yrjo Edelmann, Ellen Frank, Clement Meadmore, Henry Moore **Works Available By:** Jean Arp, Pierre Bonnard, Fernando Botero, Sandro Chia, Henri Manguin, Joan Miro, Mimmo Paladino, Larry Rivers, Frank Stella, Edouard Vuillard

HELANDER GALLERY 212.966.9797
415 W. Broadway, New York 10012 FAX: 212.966.9873
Hours: Tues-Fri 10-6; Sat 11-6
Contact: Bruce Helander, Director
Specialty: Contemporary American painting and sculpture

Artists Represented: John Albers, Bill Drew, Steve Heino, Todd McKie, Richard Merkin, Peter Saari, Harold Shapinsky, Hunt Slonem**Works Available By:** John De Andrea, Duane Hanson, Kenneth Noland, Larry Poons, Robert Rauschenberg, Italo Scanga, John Torreano

HELIO GALLERIES 212.966.5156
588 Broadway, 4th Fl., New York 10012

HELLER GALLERY 212.966.5948
71 Greene St., New York 10012 FAX: 212.966.5956
Hours: Tues-Sat 11-6; Sun 12-5
Contact: Douglas Heller, Director
Specialty: Exhibiting museum-quality contemporary glass sculpture

Artists Represented: Hank Murta Adams, Doug Anderson, Jaroslava Brychtova, William Carlson, Robert Carlson, Sydney Cash, Daniel Clayman, Carol Cohen, Bohumil Elias, Kyohei Fujita, Michael Glancy, Robin Grebe, Pavel Hlava, David Hopper, Ulrica Hydman-Vallien, Kisao Iburi, Judy Bally Jensen, Marian Karel, Vladimira Klumpar, Jon Kuhn, Etienne Leperlier, Antoine Leperlier, Stanislav Libensky, Harvey K. Littleton, William Morris, Jay Musler, Joel Philip Myers, Etsuko Nishi, John Nygren, Robert Palusky, **Michael Pavlik (See page 353),** Mark Peiser, Clifford Rainey, Richard Ritter, Daniel Rothenfeld, Ginny Ruffner, Paul Stankard, Pavel Trnka, Bertil Vallien, James Watkins, Steven Weinberg, Hiroshi Yamano, Naoto Yokoyama, Dana Zamecnikova **Works Available By:** Peter Aldridge, Dale Chihuly, David Dowler, Erwin Eisch, Eric Hilton, Dominick Labino, Tom Patti, Livio Seguso, Paul Seide, Carmen Spera

NEW YORK *(cont.)*

NEW YORK CITY

GALLERY INTERNATIONAL 57 212.582.2200
888 Seventh Ave., New York 10106

GALLERY REVEL 212.925.0600
96 Spring St., New York 10012 FAX: 212.431.6270
Hours: Mon-Fri 9-6; Sat 11-6; Sun 12-6
Contact: Marvin Carson, Director; Lynda Foshie

Artists Represented: Hing Biv, Charles Cobelle, **Guy Dessapt (See page 88)**, Manuel, Rodriguez Jr., Yoli

GALLERY SCHLESINGER LIMITED 212.734.3600
24 E. 73rd St., New York 10021 FAX: 212.472.6519
Hours: Mon-Sat 10-6
Contact: Stephen L. Schlesinger, President
Specialty: Fine works of art by inspired artists

Artists Represented: Fritz Bultman, Peter Heinemann, Roy Newell **Works Available By:** Hannelore Baron, Jean-Michel Basquiat, Thomas Hart Benton, Norman Bluhm, Byron Browne, Balcomb Greene, Fernand Leger, Rene Magritte, Henri Matisse, Parkett, George Segal, Ben Shahn

THE GALLERY THREE-ZERO 212.505.9668
30 Bond St., New York 10012 FAX: 212.505.9679
Hours: Tues-Sat 10-6
Contact: Thomas Zollner, Director; Barbara Petersen, Director
Specialty: Contemporary art

Artists Represented: Michael Abrams, Ed Batcheller, Sandy Gellis, Larry Gray, Taka Kawachi, Francesco Pistolesi

GEMINI G.E.L. AT JONI WEYL 212.219.1446
375 W. Broadway, 2nd Fl., New York 10012 FAX: 212.334.3109
Hours: Daily By Appt
Contact: Joni Moisant Weyl, Owner/Director
Specialty: New York representative for contemporary print and sculpture publisher Gemini G.E.L.

Artists Represented: Jonathan Borofsky, Vija Celmins, Mark Di Suvero, Richard Diebenkorn, Sam Francis, Philip Guston, David Hockney, Jasper Johns, Ellsworth Kelly, Roy Lichtenstein, Malcolm Morley, Bruce Nauman, Isamu Noguchi, Claes Oldenburg, Robert Rauschenberg, James Rosenquist, Ed Ruscha, Richard Serra, Saul Steinberg, Frank Stella

SANDRA GERING GALLERY 212.226.8195
476 Broome St., New York 10012 FAX: 212.226.7186
Hours: Tues-Sat 10-6; Wed Until 8
Contact: Nicole Nicola, Asst. Director
Specialty: 20th-Century contemporary art

Artists Represented: William Anastasi, Janine Antoni, Dove Bradshaw, Willie Cole, Jarg Geismar, Ben Kinmont, Vivienne Koorland, Eve Laramee, Choong Sup Lim, Simon Ungers, Vulto

GERMANS VAN ECK 212.219.0717
420 W. Broadway, New York 10012 FAX: 212.219.0728
Hours: Tues-Sat 10-6
Specialty: Contemporary art in all media; modern masters

Artists Represented: Bard Breivik, Heide Fasnacht, Jan Hafstrom, Michael Hardesty, Susan Laufer, Nino Longobardi, Lisette Model, Deborah Oropallo, Clifton Peacock, Hans Schuil

HILDE GERST GALLERY 212.751.5655
685 Madison Ave., New York 10021 FAX: 212.751.0886
Hours: Mon-Sat 11-5
Contact: Hilde W. Gerst, Owner
Specialty: Impressionist and post-impressionist paintings

Works Available By: Marc Chagall, Watson Cross, Childe Hassam, Henri Lebasque, Fernand Leger, Albert Marquet, Henri Martin, Pablo Picasso, Maurice Prendergast, Pierre-Auguste Renoir, Paul Signac, Maurice Utrillo, Suzanne Valadon, Maurice de Vlaminck

JOHN GIBSON GALLERY 212.925.1192
568 Broadway, New York 10012 FAX: 212.925.1274
Hours: Tues-Sat 10-6
Contact: Valerie Del-Sol, Director
Specialty: Contemporary art

Artists Represented: Mac Adams, John Armleder, Joseph Beuys, Eberhard Bosslet, Peter Hutchinson, Kazuo Katase, Bertrand Lavier, Olivier Mosset, Dennis Oppenheim, Wolfgang Robbe, Frank Schroder, Patrick Weidmann **Works Available By:** Marcel Broodthaers, Alberto Garutti

STEPHEN GILL GALLERY 212.832.0800
122 E. 57th St., New York 10022 FAX: 212.832.0800
Hours: Mon-Fri 10-6 By Appt
Contact: Stephen Gill, President
Specialty: Oils and acrylics by emerging artists

Artists Represented: Stephen Gill, Alexander Shnurov

GIMPEL/WEITZENHOFFER GALLERY 212.925.6090
415 West Broadway, New York 10012 FAX: 212.925.6103
Hours: Tues-Sat 10-6
Contact: Joseph Rickards, Director
Specialty: Contemporary American and European painting and sculpture

Artists Represented: Bennett Bean, Leslie Bohnenkamp, Clarence H. Carter, Robert Courtright, Alan Davie, Niki de St. Phalle, Enrico Donati, Robert Jessup, Lester Johnson, Ida Kohlmeyer, Louis Le Brocquy, Mark Mahosky, Judy Kensley McKie, Jonathan Talbot **Works Available By:** Robert Adams, Karel Appel, Robert Cottingham, Robert Cronin, Red Grooms, Hans Hartung, Barbara Hepworth, Alfred Jensen, Helmut Middendorf, Jean Miotte, Robert Natkin, Ben Nicholson, Thomas Schindler, Oskar Schlemmer, Lothar Schreyer, William Scott, Peter Sedgeley, Pierre Soulages, Mark Tobey, Tom Wesselmann, Zao Wou-Ki

BARBARA GLADSTONE GALLERY 212.431.3334
99 Greene St., New York 10012 FAX: 212.966.9310
Hours: Tues-Sat 10-6
Contact: Richard Flood, Director
Specialty: Contemporary painting, sculpture and photography

Artists Represented: Vito AcConci, Matthew Barney, Mike Glier, Michael Joaquin Grey, Jenny Holzer, Anish Kapoor, Richard Prince, Rosemarie Trockel, Meg Webster **Works Available By:** Walter Dahn, Patrick Faigenbaum, Helmut Federle, Craigie Horsfield, Imi Knoebel, Gerhard Merz, Bill Woodrow

GLASS ART GALLERY 212.787.4704
315 Central Park W., Ste. 8W, New York 10025
Hours: By Appt
Contact: Wendy D. Glass, Proprietor
Specialty: American and European works on paper; Japanese Ukiyo-e prints

Works Available By: Benny Andrews, Chaim Gross, Zoltan Hecht, Hirosada, Hiroshige, Hokusai, Shi Jihong, Raphael M. Soyer, Toyokuni, Max Weber, Yoshitoshi

JUDY GOFFMAN FINE ART 212.744.5190
18 E. 77th St., New York 10021
Hours: Tues-Sat 10-5

ALAN M. GOFFMAN 212.517.8192
264 E. 78th St., New York 10021
Hours: By Appt
Contact: Alan M. Goffman, Owner
Specialty: Paintings, watercolors and drawings by American illustrators

Works Available By: Howard Chandler Christy, John Clymer, Dean Cornwell, Harvey Dunn, John Falter, Harrison Fisher, Charles Dana Gibson, J.C., Leyendecker, Maxfield Parrish, Howard Pyle, Norman Rockwell, Walter G., Smith

FOSTER GOLDSTROM 212.941.9175
560 Broadway, Ste. 303, New York 10012 FAX: 212.274.8759
Hours: Tues-Sat 11-6
Contact: Foster Goldstrom
Specialty: Works by American and international artists

Artists Represented: Alan Greenberg, Bill Kane, **David Maxim (See page 169)**, Augusta Huggins Meyers, Katherine Parker, Dong Phan, Cam Schoepp, **Mark Todd (See page 256)**, Raymond Waydelich **Works Available By:** Milton Avery, Richard Estes, Friedensreich Hundertwasser, Neil Jenney, Louise Nevelson, M. Oppenheim, George Rickey, Charles Simonds, Frank Stella, Wayne Thiebaud

CAREN GOLDEN FINE ARTS 212.274.0080
270 Lafayette St., Ste. 903, New York 10012 FAX: 212.431.325
Hours: By Appt
Contact: Caren Golden, President
Specialty: Contemporary prints, photographs and unique works

Works Available By: John Baldessari, Bernd & Hilla Becher, Christo, Sam, Francis, Keith Haring, Robert Mapplethorpe, Sigmar Polke, Robert Rauschenberg, James Rosenquist, Cindy Sherman, Donald Sultan, Andy Warhol

JOHN GOOD GALLERY 212.941.806
532 Broadway, New York 10012 FAX: 212.274.012
Hours: Tues-Sat 10-6
Contact: Carol A. Greene, Director
Specialty: Contemporary abstraction

Artists Represented: Nancy Haynes, Felix Stephan Huber, Jacqueline Humphries, James Hyde, Christopher Lucas, Chris Martin, David Row, Juan Usle, Karsten Wittke

JAMES GOODMAN GALLERY 212.593.373
41 E. 57th St., 8th Fl., New York 10022 FAX: 212.980.019
Hours: Tues-Sat 10-6; Mon By Appt
Contact: Patricia H. Tompkins, Exec. Director
Specialty: 20th-Century, European and American, modern and contemporary art

Works Available By: Fernando Botero, Alexander Calder, Edgar Degas, Jean Dubuffet, Alberto Giacometti, Fernand Leger, Roy Lichtenstein, Henri Matisse, Joan Miro, Henry Moore, Pablo Picasso, Robert Rauschenberg

DAVID FINDLAY GALLERIES 212.249.2909
984 Madison Ave., New York 10021 FAX: 212.249.2912
Hours: Mon-Sat 10-5
Contact: Lindsay Findlay, President
Specialty: European and American paintings and sculpture

Artists Represented: Tadashi Asoma, Guy Bardone, Joachim Berthold, Igor Galanin, Rene Genis, Gabriel Godard, Pierre Lesieur, Roger Muhl, Gunther Ris, David Wynne

FIRST STREET GALLERY 212.226.9127
560 Broadway, 4th Fl., New York 10012

FISCHBACH GALLERY 212.759.2345
24 W. 57th St., New York 10019
Hours: Tues-Sat 10-5:30
Contact: Neil Winkel, Assoc. Director
Specialty: Contemporary, American representational paintings, sculpture, and works on paper

Artists Represented: Anne Arnold, Leigh Behnke, Brett Bigbee, Neil Blaine, Warren Brandt, Alice Dalton Brown, Willard Dixon, Lois Dodd, Barbara Dixon Drewa, Patricia T. Forrester, Jane Freilicher, Christopher Gerlach, P.S. Gordon, Harvey Gordon, Nancy Hagin, David Hendricks, Candace Jans, Polly Kraft, Peter Loftus, George Nick, Herman Rose, Amy Scott, Susan Shatter, Billy Sullivan, Jim Touchton, George Wexler, Jane Wilson, Roger Winter, Cole Young **Estates Represented:** John Button, Elaine de Kooning

FITCH-FEBVREL GALLERY 212.688.8522
Five E. 57th St., 12th Fl., New York 10022 FAX: 212.207.8065
Hours: Tues-Sat 11-5:30; Aug By Appt
Contact: Andrew Fitch, President
Specialty: 19th- & 20th-Century prints and drawings

Artists Represented: Erik Desmazieres, David Finkbeiner, David Itchkawich, Friedrich Meckseper, Gunnar Norrman, Janet Yake **Works Available By:** Mario Avati, Georges Braque, Rodolphe Bresdin, M.C., Escher, Yozo Hamaguchi, Paul Helleu, Max Klinger, Jean-Emile Laboureur, Louis Legrand, John Martin, Milton, Philippe Mohlitz, Jules Pascin, Odilon Redon, Manuel Robbe, Lynn Shaler, James Tissot, Francois Villon, Carol Wax

FLYNN 212.966.0426
113 Crosby St., New York 10012
Hours: Tues-Fri 10-5; Sat 11-6
Contact: Barbara Flynn, Director
Specialty: Contemporary art

Artists Represented: Alfred Leslie, David Rabinowitch, Myron Stout

FORUM GALLERY 212.355.4545
745 Fifth Ave., New York 10151
Hours: Tues-Sat 10-5:30
Contact: Robert Fishko, Director
Specialty: 20th-Century American realism; paintings, drawings and sculpture

Artists Represented: John Dubrow, **Alan Feltus (See page 100), Gregory Gillespie (See page 115),** Jules Kirschenbaum, **David Levine (See page 156),** Bruno Lucchesi, Jane Lund, Wendy Mark, William McElcheran, Elliot Offner, Carole Robb, Honore Sharrer, Sarai Sherman, Marina Stern, Jack Zajac, Laura Ziegler **Estates Represented:** Chaim Gross, Bernard Karfiol, Hugo Robus, **Raphael M. Soyer (See page 221), Max Weber (See page 242)**

FOTOMANN INC. 212.570.1223
42 E. 76th St., New York 10021 FAX: 212.570.1699
Hours: By Appt
Contact: Robert Mann, Director
Specialty: 19th- & 20th-Century vintage and contemporary photography

Artists Represented: Berenice Abbott, **Ansel Adams (See page 377),** James Balog, Henri Cartier-Bresson, Walker Evans, Robert Frank, Leslie Gill, David T. Hanson, Lewis Hine, Yousuf Karsh, Robert Glenn Ketchum, O. Winston Link, Richard Misrach, Lisette Model, Paul Outerbridge, Charles Pratt, **Man Ray (See page 395),** Walter Rosenblum, Aaron Siskind, Paul Strand, David Vestal, WeeGee **Works Available By:** Diane Arbus, Eugene Atget, William Henry Jackson, Alfred Stieglitz, Carleton Watins, Edward Weston

SHERRY FRENCH GALLERY 212.247.2457
24 W. 57th St., New York 10019
Hours: Mon-Sat 10-6
Contact: Sherry French, Director
Specialty: American contemporary realism

Artists Represented: Ronni Bogaev, Matthew Daub, William Dunlap, Jeanne Duval, William L. Haney, Janet Manafo, Hansen Mulford, Leigh Palmer, Michael Scott, Sharon Sprung, William M. Sullivan, Stephen Tanis, Amy Weiskopf, James Winn, Jerome Witkin

BARRY FRIEDMAN LTD. 212.794.8950
1117 Madison Ave., New York 10028

FRUMKIN/ADAMS GALLERY 212.757.6655
New York 10019 FAX: 212.489.5064
50 W. 57th St.
Hours: Tues-Fri 10-6; Sat 10-5:30
Contact: George Adams, Director
Specialty: Contemporary art

Artists Represented: Frederic Amat, Robert Arneson, Luis Cruz Azaceta, Jack Beal, Jose Bedia, Joan Brown, Roy De Forest, James McGarrell, Arnaldo Roche-Rabell, Peter Saul, James Valerio, Philip Wofford **Works Available By:** Max Beckmann, Mel Chin, Lovis Corinth, Ernst Ludwig Kirchner, Arthur Leipzig, Thomas Tulis, H. C. Westermann

GAGOSIAN GALLERY 212.744.2313
980 Madison Ave., 6th Fl., New York 10021 FAX: 212.772.7962
Hours: Tues-Sat 10-6
Contact: Melissa Lazarov, Director
Specialty: Contemporary paintings, drawings and sculpture

Artists Represented: Francesco Clemente (See page 74), Walter de Maria **(See page 323), Yves Klein (See page 145), David Salle (See page 211), Philip Taaffe (See page 230) Works Available By:** Willem de Kooning, Jasper Johns, Roy Lichtenstein, Frank Stella, Cy Twombly, Andy Warhol

GALERIA JOAN PRATS 212.315.3680
24 W. 57th St., Ste. 404, New York 10019 FAX: 212.247.2738
Hours: Tues-Sat 10:30-5:30
Contact: Dorothy Cater, Director
Specialty: Work from Barcelona and New York

Artists Represented: Sergi Aguilar, Jim Bird, James Bohary, Alfons Borrell, Albert Rafols Casamada, Josep Guinovart, Manel Lledos, Perejaume, Joan Hernandez Pijuan **Works Available By:** Francis Bacon, Eduardo Chillida, Christo, Helen Frankenthaler, Roberto Matta, Kenneth Noland, Larry Rivers, Ed Ruscha, Rufino Tamayo, Antoni Tapies, Francisco Toledo

GALERIE DES ARTS LIMITED 212.861.7925
18 E. 76th St., New York 10021

GALERIE FELIX VERCEL 212.744.3131
17 E. 64th St., New York 10021

GALERIE SELECT LTD. 212.529.5550
56 University Pl., New York 10003
Hours: Mon, Wed-Sat 12-8; Sun 12-7
Contact: Manfred E. Huffman, President
Specialty: 20th-Century fine prints, paintings and illustrated books

Artists Represented: Alexander Befelein, Rene Carcan, Brigitte Coudrain, Bertrand Dorny, Max Ernst, Johnny Friedlaender, Robert Kipniss, Andre, Masson, Andre Minaux **Works Available By:** Hans Bellmer, Marc Chagall, Henri Matisse, Pablo, Picasso, Jacques Villon

GALERIE LELONG 212.315.0470
20 W. 57th St., New York 10019 FAX: 212.262.0624

GALERIE ST. ETIENNE 212.245.6734
24 W. 57th St., New York 10019 FAX: 212.765.8493
Hours: Tues-Sat 11-5
Contact: Hildegard Bachert, Co-Director; Jane Kallir, Co-Director
Specialty: Austrian and German Expressionism; folk art

Artists Represented: Sue Coe, Lovis Corinth, John Kane, Gustav Klimt, Oskar Kokoschka, Kathe Kollwitz, Grandma Moses, Egon Schiele **Works Available By:** Richard Gerstl, Alfred Kubin, Paula Modersohn-Becker

GALERIE RIENZO 212.288.2226
922 Madison Ave., New York 10021
Hours: Tues-Sat 10:30-5:30

GALERIE TAMENAGA 212.734.6789
982 Madison Ave., New York 10021 FAX: 212.734.9413
Hours: Tues-Sat 10-5
Contact: Howard Rutkowski, Director
Specialty: Modern and contemporary American, European and Japanese art

Artists Represented: Paul Aizpiri, **Hiroshi Asada (See page 45),** Andre Cottavoz, Jean Fusaro, Paul Guiramand, Masao Haijima, **Frank Holmes (See page 135),** Hiroki Oda, David Romanelli, Giorgio Scalco, Claude Weisbuch

GALLERY 84 212.581.6000
50 W. 57th St., New York 10019

GALLERY DAVID 212.431.1015
594 Broadway, New York 10012

GALLERY HENOCH 212.966.6360
80 Wooster St., New York 10012
Hours: Tues-Sat 10:30-6
Contact: George Henoch Shechtman, Director
Specialty: Contemporary realism and furniture

Artists Represented: Olga Antonova, Max Ferguson, Carole Jeane Feuerman, Daniel Greene, Silas Kopf, Mel Leipzig, Bernardino Luino, Catherine Means, Steve Mills, Robert Neffson, Joseph Reboli, Wade Reynolds, Cesar Santander, David Schofield, Barbara Segal, Daniel Tennant

NEW YORK *(cont.)*

NEW YORK CITY

DOUGLAS DRAKE GALLERY 212.582.5930
50 W. 57th St., New York 10019 FAX: 212.541.5845
Hours: Tues-Sat 10-5:30
Specialty: Contemporary paintings, sculpture, photography,
works on paper and prints

Artists Represented: Richard Bogart, Dan Christensen, Charles Hinman, Sandra Jackman, Virginia Jaramillo, Gary Kuehn, Tony Naponic, Vivian Torrence **Works Available By:** Milton Avery, Jack Bush, Jo Ann Callis, Laddie John Dill, Helen Frankenthaler, Mike Mandel, Robert Motherwell, Robert Natkin, Kenneth Noland, Jules Olitski, Kimber Smith

EDITIONS SCHELLMANN 212.219.1821
50 Greene St., New York 10013 FAX: 212.941.9206
Hours: Mon-Fri 12-6
Contact: Meg Malloy, Director
Specialty: Publishers of contemporary prints and objects in editions

Artists Represented: Joseph Beuys, Jannis Kounellis, Sol LeWitt, Nam Jun, Paik Thomas Ruff, Cindy Sherman, Haim Steinbach **Works Available By:** Keith Haring, Richard Long, Gerhard Merz, Sigmar Polke, Gerhard Richter, Cy Twombly, Andy Warhol

G. W. EINSTEIN CO., INC. 212.226.1414
591 Broadway, New York 10012 FAX: 212.941.9561
Hours: Tues-Fri 10-5:30; Sat 11-6
Contact: Gil Einstein
Specialty: American paintings and works on paper, modern to contemporary

Artists Represented: Elizabeth Awalt, Pamela Berkeley, Phyllis Bramson, Bill Cass, Thomas Cornell, Tom Duncan, Lawrence Faden, Charles Parness, Mel Pekarsky, Linda Plotkin, Lucy Sallick, Mary Joan Wald **Works Available By:** Jim Dine, Red Grooms, Alex Katz, Lee Krasner, Claes Oldenburg, Philip Pearlstein

THE ELKON GALLERY, INC. 212.535.3940
18 E. 81st St., New York 10028 FAX: 212.737.3940
Hours: Tues-Sat 9:30-5:30
Contact: Dorothea McKenna Elkon, President
Specialty: Modern and contemporary masters

Works Available By: Balthus, Fernando Botero, Paul Delvaux, Jean, Dubuffet, Max Ernst, Sam Francis, Fernand Leger, Rene Magritte, Agnes, Martin, Henri Matisse, Joan Miro, Pablo Picasso, Antoni Tapies

ANDRE EMMERICH GALLERY 212.752.0124
41 E. 57th St., 5th-6th Fl, New York 10022 FAX: 212.371.7345
Hours: Tue-Sat 10-5:30
Contact: James Yohe, Director
Specialty: Contemporary painting and sculpture; antiquities

Artists Represented: Pierre Alechinsky, Willard Boepple, Bram Bogart, Stanley Boxer, Roberto Caracciolo, Anthony Caro, Friedel Dzubas, **Sam Francis (See page 107), Helen Frankenthaler (See page 108),** Arthur Gibbons, **Al Held (See page 131), David Hockney (See page 133),** Terence La Noue, Alexander Liberman, Beverly Pepper, Joel Perlman, Katherine Porter, Dorothea Rockburne, Emil Schumacher, Anne Truitt, James Wolfe **Estates Represented:** Burgoyne Diller, John Graham, **Hans Hoffman (See page 134),** Morris Louis, John McLaughlin, William Scott, Jack Tworkov

VERA ENGELHORN GALLERY 212.966.6882
591 Broadway, 3rd Fl., New York 10012

AMOS ENO GALLERY 212.226.5342
495 Broadway, #404, New York 10012
Hours: Tues-Sat 11-6
Contact: Daniel Ferris, Director
Specialty: Contemporary art in all media

Artists Represented: Ittai Altshuller, R. Winslow Bronson, Anthony Cuneo, Constance Dodge, Joseph Dunn, Raymond Dupuis, Suellen Glashausser, Erin Goodwin-Guerrero, Lou Hicks, Emily Hixon, Joe Kaminski, Madeline Kaufman, Charleen Kavleski, Miriam Kley, Lisa Houck Leary, Knut Loewe, Soile Yli Maeyry, Jane McClintock, Deeje Mitchell, Mimi Oritsky, Patricia Pardini, Margaret Plaganis, Jose Presman, Gary Rauchbach, Wayne Reida, Eva Sayles, Ann Schaumburger, Patricia Search, Joyce Sills, Mary Spencer, Walter Swales, Molly Ziedler

THOMAS ERBEN GALLERY, INC. 212.966.5283
118 Spring St., New York 10012 FAX: 212.941.0752
Hours: Mon-Fri 11-6
Contact: Thomas Erben
Specialty: International contemporary installations,
paintings, sculptures, and multiples

Artists Represented: Cor Dera, Valeriy/Rimma Gerlovin/a, **Lilo Kinne (See page 143)**
Works Available By: Josef Albers, Arman, Georg Baselitz, Joseph Beuys, Marc Chagall, Christo, Niki De St. Phalle, Willem de Kooning, Sam Francis, David Hockney, Robert Indiana, Jasper Johns, Donald Judd, Roy Lichtenstein, Rene Magritte, Edouard Manet, Joan Miro, Claude Monet, Robert Motherwell, A.R. Penck, Pablo Picasso, Sigmar Polke, Robert Rauschenberg, Pierre-Auguste Renoir, Gerhard Richter, James Rosenquist, Julian Schnabel, Miriam Tinguely, Cy Twombly, Andy Warhol, Tom Wesselmann

ERGANE GALLERY 212.228.9600
469 W. Broadway, New York 10012 FAX: 212.228.9736
Hours: Tues-Sun 10-7
Contact: Mary Hansen, Director
Specialty: Contemporary paintings, drawings and prints

Artists Represented: Keith Alexander (See page 42), Eduardo Arranz-Bravo (See page 44), Vasily Kafanov, Josefina Robirosa, Dimitri Strizhov **Works Available By:** Jean-Michel Basquiat, Fernando De Szyszlo, Sam Francis, Keith Haring, David Hockney, Manabu Mabe, Kazuo Wakabayashi, Andy Warhol

ROSA ESMAN GALLERY 212.219.3044
575 Broadway, New York 10012 FAX: 212.941.5921
Hours: Tues-Sat 10-6
Contact: Pamela Freund, Director
Specialty: Contemporary, pop, modernism and works of the Russian avant-garde

Artists Represented: Peter Ambrose, Betsy Berne, Peter Boynton, Ed Henderson, Carol Hepper, Robbin Murphy

ELEANOR ETTINGER INC. 212.807.7607
155 Ave. Of The Americas, New York 10013

FAWBUSH GALLERY 212.274.0500
76 Grand St., New York 10013
Hours: Tues-Sat 10-6
Contact: Joseph Fawbush, Owner; Tom Jones, Director
Specialty: Contemporary painting, sculpture, and works on paper by young artists

Artists Represented: Ed Albers, Ann Messner, Kiki Smith, Michelle Stuart

FEATURE 212.941.7077
484 BROOME ST., NEW YORK 10013 FAX: 212.431.7187
Hours: Tues-Sat 11-6
Specialty: Recent contemporary art

Artists Represented: John Balsley, Michael Banicki, Sue Benner, Sandi Seltzer Bryant, Janet Carkeek, Jeanne Dunning, Arnold Fern, Jason Fox, Tom Friedman, Peter Huttinger, Jim Isermann, Jennifer Kiernan, David Moreno, Hirsch Perlman, Raymond Pettibon, Heinz Dieter Pietsch, Charles Ray, Richard Rezac, David Robbins, Kay Rosen, Rene Santos, Christopher Sasser

RICHARD L. FEIGEN & CO. 212.628.0700
49 E. 68th St., New York 10021 FAX: 212.249.4574
Hours: Daily 10-6
Contact: Frances F.L. Beatty, V.P.
Specialty: Museum-quality paintings, drawings and sculpture

Works Available By: William Baziotes, Willem de Kooning, Jean Dubuffet, Arshile Gorky, Ray Johnson, Jackson Pollock, Robert Rauschenberg, James Rosenquist, Mark Rothko, Charles Simmonds, Richard Smith

RONALD FELDMAN FINE ARTS 212.226.3232
31 Mercer St., New York 10013 FAX: 212.941.1536
Hours: Tues-Sat 10-6
Contact: Marc Nochella, Dir. Of Sales
Specialty: Contemporary American, European and
Russian art, including installation art

Artists Represented: Eleanor Antin, Ida Applebroog, Arman Arakawa, Conrad Atkinson, Brodsky & Utkin, Nancy Chunn, Douglas Davis, Jud Fine, Terry Fox, Margaret Harrison, Newton Harrison, Ilya Kabakov, Peggy Jarrell Kaplan, Komar & Melamid, Mark Kostabi, Piotr Kowalski, Helen Mayer, Panamarenko, The Peppers, Fred Riskin, Tomas Ruller, Edwin Schlossberg, Todd Siler, Mierle Laderman Ukeles, Clemens Weiss, Allan Wexler, Hannah Wilke **Works Available By:** Vincenzo Agnetti, Joseph Beuys, Andy Warhol

FICTION/NONFICTION 212.941.861▌
21 Mercer St., New York 10013
Hours: Tues-Sat 10-6
Contact: Jose Freire, Director

Artists Represented: Bill Barrette, Linda Daniels, Jane Hammond, Jill Levine, Andrew Masullo, Rona Pondick, Susan Silas, Adam Simon, John Wesley

FIGURA INC. 212.772.662▌
53 E. 75th St., New York 10021 FAX: 212.517.468▌
Hours: Mon-Fri 10-6
Contact: Tom Korzelius, Director
Specialty: European and American, contemporary and
modern prints and unique works

Works Available By: Josef Albers, Victor Brauner, Marc Chagall, Christo, Giorgio de Chirico, Keith Haring, David Hockney, Robert Indiana, Paul Klee, Roy Lichtenstein, Robert Rauschenberg, James Rosenquist, Cy Twombly, Andy Warhol

PETER FINDLAY GALLERY 212.772.866▌
1001 Madison Ave., New York 10021

COUP DE GRACE GALLERY 212.431.5799
579 Broadway, New York 10012 FAX: 201.333.7707
Hours: Tues-Sat 11-5
Contact: Minna Zielonka, Director
Specialty: Contemporary and secondary market painting and photography

Artists Represented: John Brill, Thomas MicChelli, Karl Petrunak, John Salvest, Richard Torchia
Works Available By: Hans Hofmann, Franz Kline, George McNeil, Geanna Merola, August Rodin

CHARLES COWLES GALLERY 212.925.3500
420 W. Broadway, New York 10012 FAX: 212.925.3501
Hours: Tues-Sat 10-6
Contact: Bill Carroll, Director
Specialty: Contemporary art

Artists Represented: Charles Arnoldi, **David Bates (See page 49)**, Howard Ben Tré **(See page 307)**, Marsha Burns, **Dale Chihuly (See page 315)**, Chema Cobo, Garth Evans, R.E. Gillet, Duncan Hannah, Tom Holland, Gerold Immonen, Patrick Ireland, Harry Kramer, Sylvia Martins, Wilhelm Moser, Ron Nagle, Manuel Neri, Sabina Ott, Beverly Pepper, Jeff Perrone, Ken Price, Skrebneski, Jock Sturges, Peter Voulkos **Works Available By:** Gene Davis

CROWN POINT PRESS 212.226.5476
568 Broadway, New York 10012 FAX: 212.966.7042
Hours: Tues-Fri 9:30-5:30; Sat 10-6
Contact: Karen McCready, Director
Specialty: Publishers of etchings and color woodblock prints

Artists Represented: Vito AcConci, John Baldessari, Robert Bechtle, Christian Boltanski, William Brice, Christopher Brown, Chris Burden, **John Cage (See page 263)**, Francesco Clemente, Chuck Close, Tony Cragg, Richard Diebenkorn, Eric Fischl, Joel Fisher, Hamish Fulton, Katsura Funakoshi, April Gornik, Hans Haacke, Al Held, Tom Holland, Robert Hudson, Bryan Hunt, Shoichi Ida, Yvonne Jacquette, Joan Jonas, Anish Kapoor, Alex Katz, Jannis Kounellis, Joyce Kozloff, Robert Kushner, Bertrand Lavier, Li Lin Lee, Sherrie Levine, Sol LeWitt, Markus Lupertz, Robert Mangold, Brice Marden, Tom Marioni, Robert Moskowitz, Judy Pfaff, Janis Provisor, Markus Raetz, Rammellzee, Tim Rollins + K.O.S., Ed Ruscha, David Salle, Italo Scanga, Sean Scully, Jose Maria Sicilia, Susanna Solano, Pat Steir, Gary Stephan, Wayne Thiebaud, David True, William T. Wiley

CUDAHY'S GALLERY INC. 212.879.2405
170 E. 75th St., 2nd Fl., New York 10021 FAX: 212.535.6259
Hours: Tues-Fri 10-6; Sat 11-6
Contact: Fred J. Boyle, Director
Specialty: Contemporary American realism and photo-realism

Artists Represented: Charles Basham, Arless Day, Gary Godbee, Gus Heinze, Kirk Lybecker, Thomas McNickle, **Kim Mendenhall (See page 171)**, Peter Sculthorpe, Zarko Stefancic, **James Torlakson (See page 235)**, Cara Wood, Diane Zaugra

TOM CUGLIANI GALLERY 212.966.9006
508 Greenwich Ave., New York 10013

BESS CUTLER GALLERY 212.219.1577
164 Mercer St., New York 10012

DANNENBERG GALLERY 212.219.0140
484 Broome St., New York 10013

JAMES DANZIGER GALLERY 212.226.0056
415 W. Broadway, 3rd Fl., New York 10012

PHILIPPE DAVERIO GALLERY 212.826.4210
41 E. 57th St., New York 10022 FAX: 212.826.4292
Hours: Tues-Sat 10-5:30
Contact: Philip Ottenbrite, Director
Specialty: Modern and contemporary Italian and international art

Artists Represented: Gabriele Basilico, Frances Lansing, Medrie MacPhee, Ruggero Savinio, Ernesto Tatafiore **Works Available By:** Luciano Baldessari, Giacomo Balla, Umberto Boccioni, Carlo Carra, Giorgio de Chirico, Fortunato Depero, Lucio Fontana, Paola Gandolfi, Tom Hopkins, Amedeu Modigliani, Giorgio Morandi, Mario Sironi

DAVIS & LANGDALE CO., INC. 212.838.0333
231 E. 60th St., New York 10022 FAX: 212.752.7764
Hours: Tues-Sat 10-5
Specialty: American and british watercolors and drawings; contemporary art

Artists Represented: Nicol Allan, Lennart Anderson, Bessie Jamieson, Robert Kulicke, Harry Roseman, Aaron Shikler, Albert York

MAXWELL DAVIDSON GALLERY 212.925.5300
415 W. Broadway, New York 10012 FAX: 212.941.8529
Hours: Tues-Sat 10-6
Contact: Carol Craven, Director
Specialty: Impressionist, modern, and contemporary drawings, paintings and sculpture

Artists Represented: Carol Anthony, Deborah Deichler, Sondra Freckelton, David Hollowell, Barbara Kassel, Tim Prentice, Scott Prior, George Rickey, Mel Rosas **Works Available By:** Arman, Alexander Calder, Edgar Degas, Burgoyne, Diller, Jean Dubuffet, Raoul Dufy, Sam Francis, Alberto Giacometti, Fernand Leger, Henri Matisse, Roberto Matta, Pablo Picasso, Camille Pissarro, Tom Wesselmann

MARISA DEL RE GALLERY 212.688.1843
41 E. 57th St., New York 10022 FAX: 212.688.7019
Hours: Tues-Sat 10-6
Contact: Bill Maynes, Director
Specialty: Modern and contemporary European and American sculpture and painting

Artists Represented: Valerio Adami, Karel Appel, Arman, Enrico Baj, Robert Cottingham, Robert Indiana, F.X and Claude Lalanne, Catherine Lee, Conrad Marca-Relli, Momen, Robert Motherwell, Kenzo Okada, Arnaldo Pomodoro, Rodney Ripps, George Tooker, Bettina Werner
Works Available By: Christo, Willem de Kooning, Dan Flavin, Lucio Fontana, David Hockney, Donald Judd, Franz Kline, Jannis Kounellis, Gerhard Richter, Larry Rivers, Frank Stella

MARY DELAHOYD GALLERY 212.219.2111
426 Broome St., New York 10013
Hours: Sat 1-6; And By Appt
Contact: Mary Delahoyd, Owner
Specialty: Contemporary works in all media

Artists Represented: Bill Adams, John French, Betsy Friedman, David Richey Johnson, Timothy Ross, John Turturro, Adele Ursone

SID DEUTSCH GALLERY 212.754.6660
29 W. 57th St., New York 10019 FAX: 212.980.7649
Hours: Tues-Sat 9:30-5:30
Contact: Aaron G. Payne, Director

Artists Represented: Abe Ajay, Benny Andrews, Isabel Case Borgatta, Clarence H. Carter, Nassos Daphnis, Harvey Dinnerstein, Peter Grippe, Hoff Margo, Lionel Kalish, Ibram Lassaw, James Little, Vincent Pepi, Peter, Eileen Rita, Lincoln Seitzman, Sal Sirugo, Esphyr Slobodkina **Works Available By:** Milton Avery, Rudolf Bauer, Romare Bearden, Tom Benrimo, Thomas Hart Benton, Emil Bisttram, Oscar Bluemner, Ilya Bolotowsky, Hugh H. Breckenridge, Charles Burchfield, Alexander Calder, Konrad Cramer, Francis Criss, Andrew Dasburg, Stuart Davis, Beauford Delaney, Joseph Delaney, Charles Demuth, Preston Dickinson, Arthur Dove, Werner Drewes, Betsy Friedman, Albert E. Gallatin, William Glackens, Arshile Gorky, John Graham, Morris Graves, Gertrude Greene, Balcomb Greene, Marsden Hartley, Hans Hofmann, Carl Hotly, Alfred Jensen, Raymond Jonson, Paul Kelpe, Karl Knaths, Jiri Kolar, Walt Kuhn, Yasou Kuniyoshi, Jacob Lawrence, Jack Levine, Jan Maltulka, John Marin, Reginald Marsh, Alfred Maurer, Henry B. McCarter, Henry Lee McFee, George L.K. Morris, Walter Murch, Elie Nadelman, Louise Nevelson, B.J.O. Nordfeldt, Georgia O'Keeffe, Agnes Pelson, Guy Pene Du Bois, Maurice Prendergast, Ben Shahn, Charles G. Shaw, Charles Sheeler, John Sloan, David Smith, Raphael M. Soyer, Niles Spencer, Saul Steinberg, Joseph Stella, Alma Thomas, Bob Thompson, Mark Tobey, Abraham Walkowitz, Max Weber, Rudolph Weisenborn, William Zorach, Marguerite Zorach **Estates Represented:** Harry Bertoia, Albert Bloch, Lee Gatch, George, Josimovich, Louis Lozowick, Karl Zerbe

TERRY DINTENFASS GALLERY 212.581.2268
50 W. 57th St., New York 10019 FAX: 212.307.1443
Hours: Tues-Sat 10-5:30; Closed Aug
Contact: Terry Dintenfass, Owner; Marie Erskine, Associate
Specialty: 20th-Century American artists

Artists Represented: Will Barnet, Peter Blume, Philip Evergood, Antonio Frasconi, Elisabeth Frink, Sidney Goodman, Robert Gwathmey, John Himmelfarb, France Hynes, Herbert Katzman, William King, Ed Koren, Cheryl Laemmle, Jacob Lawrence, Robert Andrew Parker, Ben Shahn, Kim Whanki **Estates Represented:** Arthur Dove

DOME GALLERY 212.226.5068
578 Broadway, 5th Fl., New York 10012 FAX: 212.219.8776
Hours: Tues-Sat 10-5:30
Contact: Janet Townsend, Assoc. Director
Specialty: Contemporary painting, sculpture, prints and Latin American art

Artists Represented: Ken Botto, Santo Bruno, Leonard Cave, Yale Epstein, Gerard Haggerty, Jolyon Hofsted, Carol May, David Oliveras, Larry Schulte, Eva Stettner, Victoria Thorson

E.M. DONAHUE GALLERY 212.226.1111
560 Broadway, #304, New York 10012 FAX: 212.982.5579
Hours: Tues-Sat 10-6
Contact: Ronald Sosinski, Director
Specialty: Contemporary paintings

Artists Represented: Rande Barke, Peggy Cyphers, Robert Ensel, Li Lin Lee, Fredda Mekul, Nachume Miller, Gary Petri, Brenda Zlamany **Works Available By:** Arnold Mesches, Michael Mooney, Stephanie Rose, Randall Schmit, Marjorie Welish

FRED DORFMAN GALLERY 212.966.4611
123 Watts St., New York 10013 FAX: 212.941.7515
Hours: Mon-Fri 10-6; Sat By Appt
Contact: Steven Levy, Asst. Director
Specialty: Paintings, works on paper sculpture and graphics by European and American contemporary artists

Works Available By: Enrico Baj, Keith Haring, Alex Katz, Mark Kostabi, Roy Lichtenstein, James Rosenquist, Francesco Scavullo, Andy Warhol

NEW YORK *(cont.)*

NEW YORK CITY

DIANE BROWN GALLERY 212.219.1060
23 Watts St., New York 10013 FAX: 212.966.3687
Hours: Tues-Sat 10-6
Contact: Diane Brown
Specialty: Contemporary art with an emphasis on sculpture

Artists Represented: Edward Allington, Frederick Childs, Lauren Ewing, Joel Fisher, Jan Groth, **Erik Levine (See page 341)**, Inge Mahn, Leonel Moura, Tony Oursler, Robert Reitzfeld, Wade Saunders, Steve Wolfe **Works Available By:** Alfredo Jaar, Robert Smithson

BRUTON GALLERY, INC. 212.980.1640
40 E. 61st St., New York 10021 FAX: 212.223.2593
Hours: By Appt
Contact: Jay S. Cantor, N. Amer. Rep.
Specialty: 19th- & 20th-Century European sculpture

Works Available By: Joseph Bernard, Emile Antoine Bourdelle, Stephan Buxin, Jean Carton, Paul Cornet, Charles Despiau, Aristide Maillol, August Rodin, Robert Wlerick

CHRISTINE BURGIN GALLERY 212.219.8379
130 Prince St., New York 10012 FAX: 212.941.6435
Hours: Tues-Sat 10-6
Contact: Lisa Jacobs, Director

Artists Represented: Ernst Caramelle, Ian Hamilton Finlay, Rodney Graham, Tracy Grayson, Fariba Hajamadi, Paul Etienne Lincoln, Jurgen Meyer, John Murphy, Hermann Pitz, Allen Ruppersberg, Alan Saret, Jeanne Silverthorne, Jan Vercruysse **Works Available By:** Rene Daniels, Walter Swennen

FRANK BUSTAMANTE GALLERY 212.226.2108
560 Broadway, Ste. 605, New York 10012
Hours: Tues-Sat 10-6
Contact: Frank Bustamante, Director
Specialty: American and European artists; abstract expressionism paintings, sculpture and graphics

Artists Represented: Marc Dennis, Simon Gaon, Bogdan Korczowski, Henning Kurschner, Ruth Roosevelt, Pablo Tauler, Peter Van der Akker, Jean Weinbaum **Works Available By:** Joseph Bednar, Gudjon Bjarnason, Lawrence Calcagno, Via Lewandowsky, Toby & Zero Mostel, David Paris

C & A GALLERY 212.431.8664
96 Spring St., 8th Fl., New York 10012

DENISE CADE-ART PROSPECT INC. 212.734.3670
1045 Madison Ave., New York 10021 FAX: 212.737.7206
Hours: Tues-Sat 11-6
Specialty: Modern and contemporary art

Artists Represented: John Bennett, Yann Charbonnier, Fred Deux, Bertrand Dorny, Christian JacCard, Jean-Pierre Pincemin, Guillermo Roux, Tony Soulie, Wakako, Paul Wallach **Works Available By:** Vieira da Silva, Nicolas de Stael, Serge Poliakoff, Hans Reichel, Paul Rotterdam, Pierre Soulages, Gerard Titus-Carmel, Mark Tobe

SIMON CAPSTICK-DALE FINE ART 212.628.2067
128 E. 72nd St., Ste. 3b, New York 10022
Hours: Mon-Fri 10-6
Contact: Simon Capstick-Dale, Owner/Pres.
Specialty: 20th-Century Impressionists; modern and contemporary artists

Artists Represented: David Cregeen, Jane Greer **Works Available By:** Karel Appel, Ellen Auerbach, Francis Bacon, Alexander Calder, Lynn Chadwick. Jean Cocteau, Lucian Freud, David Hockney, R.B. Kitaj, Jiri Kolar, Leon Kossoff, Fernand Leger, Jean Lurcat, Malcolm Morley, Ben Nicholson, Jules Olitski, William Roberts

THE CARUS GALLERY 212.879.4660
872 Madison Ave., New York 10021 FAX: 212.879.4660
Hours: Tues-Sat 11-5
Contact: Dorothea Carus, President
Specialty: Avant-garde art of the early 20th-Century

Works Available By: Giacomo Balla, Vasilii Bobrov, Hannah Hoech, Wassily Kandinsky, Lajos Kassak, Paul Kelpe, Ernst Ludwig Kirchner, El Lissitsky, Kasimir Malevich, Laszlo Moholy-Nagy, Emil Nolde, Karl Schmidt-Rottluff, Kurt Schwitters

LEO CASTELLI GALLERY 212.431.5160
420 W. Broadway, New York 10012 FAX: 212.431.5361
Hours: Tues-Sat 10-6
Contact: Susan Brundage, Director

Artists Represented: Miguel Barcelo, Robert Barry, James Brown, Hanne Darboven, Jan Dibbets, Dan Flavin, Douglas Huebler, **Jasper Johns (See page 139)**, Ellsworth Kelly, Joseph Kosuth, **Roy Lichtenstein (See page 159)**, Robert Morris, **Bruce Nauman (See page 350)**, **James Rosenquist (See page 204)**, **Ed Ruscha (See page 209)**, David Salle, Salvatore Scarpitta, Richard Serra, Charles Simonds, **Keith Sonnier (See page 360)**, Mike & Doug Starn, Frank Stella, Robert Therrien, Meyer Vaisman, Andy Warhol, Lawrence Weiner

CAVIN-MORRIS INC. 212.226.3768
560 Broadway, 2nd Fl., New York 10012 FAX: 212.226.0155
Hours: Tues-Sat 11-6
Contact: Randall Morris, Director; Shari Cavin, Director
Specialty: Contemporary, self-taught, and tribal art

Artists Represented: Chelo Amezcua, Arturo Elizondo, Willie Leroy, Elliott, Dana Garrett, John Harvey, Bessie Harvey, Kofi Kayiga, Carrie Lederer, George Liautaud, Bernard Maisner, Brian Rutenberg, Anthony Joseph Salvatore, Jon Serl, Matthew Smith, Gregory Van Maanen, James Watkinson, Philadelphia Wireman **Works Available By:** Howard Finster, Martin Ramirez, Bill Traylor, Joseph Yoaku

CDS 212.772.9555
13 E. 75th St., New York 10021

CERES GALLERY 212.226.4725
91 Franklin, New York 10013

CFM GALLERY 212.929.4001
138 W. 17th St., New York 10011 FAX: 212.691.5453
Hours: By Appt
Contact: Neil P. Zukerman, President
Specialty: Contemporary European and American masters; surrealism and representational

Artists Represented: Anne Bachelier (See page 47), Dario Campanile (See page 67), Marc Davet (See page 83), Leonor Fini (See page 101), Richard MacDonald (See page 346), Bruno Monvoisin (See page 174), Michael Parkes (See page 277), Massimo Rao, (See page 197) **Works Available By:** Berthois-Rigal, Christina De Musee, Marcel Delmotte, Walter Girotto, Jurgen Gorg, Jean-Francois Ibos, Hans Kanters, Charles Klabunde, Stanislau Lepri, Felix Mas, Fabrizzio RicCardi

CHILDS GALLERY 212.838.1881
41 E. 57th St., #702, New York 10022
Hours: Tues-Sat 10-5:30

CHINOH ART GALLERY 212.255.0377
69 Fifth Ave., New York 10003 FAX: 212.255.0377
Hours: Daily 10-7
Contact: Momoko Chino, Director
Specialty: Contemporary Japanese and American art

Artists Represented: Tadashi Asoma, Franz Kline, Diane Marinaro, Masaaki Noda, Shunji Sakuyama, Toshiyuki Seki, Toshi Utagawa

GARTH CLARK GALLERY 212.246.2205
24 W 57th St., New York 10019
Hours: Tues-Sat 10-5
Contact: Mark Del VecChio, Director
Specialty: Vessels in ceramic and other media

A CLEAN, WELL-LIGHTED PLACE 212.255.3656
363 Bleecker St., New York 10014 FAX: 212.727.0950
Hours: Tues-Sat 12-6
Contact: Thomas Martinelli, President
Specialty: Contemporary prints

Artists Represented: David Hockney, Brice Marden, Robert Motherwell, Susan Rothenberg, Sean Scully, Andy Spence, Donald Sultan **Works Available By:** Jennifer Bartlett, Jane Dickson, Richard Estes, Eric Fischl, Jonathan Lasker, Robert Ryman, Terry Winters

COE KERR GALLERY 212.628.1340
49 E. 82nd St., New York 10028

SYLVAN COLE 212.333.7760
101 W. 57th St., New York 10019
Hours: By Appt
Contact: Sylvan Cole, Director
Specialty: American prints and drawings 1900-1960

Artists Represented: Will Barnet, Peter Milton, Karl Schrag **Works Available By:** Thomas Hart Benton, Isabel Bishop, John Steuart Curry, Marsden Hartley, Childe Hassam, Martin Lewis, George Tsellows, James McNeill Whistler, Grant Wood **Estates Represented:** John Taylor Arms, Milton Avery, Stuart Davis, Ernest Haskell, Armin Landeck, Charles Locke, Raphael M. Soyer

CONDESO/LAWLER GALLERY 212.219.1283
76 Greene St., New York 10012

PAULA COOPER GALLERY 212.674.0766
149/155 Wooster St., New York 10012 FAX: 212.674.1938
Hours: Tues-Sat 10-6
Contact: Paula Cooper
Specialty: Sculpture, paintings, drawings and prints by contemporary artists

Artists Represented: Carl Andre, Jennifer Bartlett, Lynda Benglis, Jonathan Borofsky, Peter Campus, Robert Gober, Robert Grosvenor, Michael Hurson, Zoe Leonard, Julian Lethbridge, Elizabeth Murray, Joel Shapiro, Alan Shields, Tony Smith, Robert Wilson, Jackie Winsor **Works Available By:** Roni Horn, Jasper Johns, Donald Judd, Sol LeWitt, Brice Marden

AVID BEITZEL GALLERY 212.219.2863
102 Prince St., New York 10012 FAX: 212.941.7158
Hours: Tues-Sat 10-6
Contact: David Beitzel, Owner; Eliza Beghe, Director
Specialty: Painting and sculpture by young contemporary artists

Artists Represented: George Dudding, Simon Edmondson, Aaron Fink, Dewitt, Godfrey Willy
eeks, Peter Hristoff, David Kapp, Eva Lootz, Chris MacDonald, Sam Messer, David Moriarty, Ross
her, Andrew Young

LLAS ARTES 212.274.1116
584 Broadway, #406, New York 10012
Hours: Tues-Sat 12-6
Contact: Barbara Juster, Director
Specialty: Contemporary fiber, ceramics and pre-Columbian art.

Artists Represented: Olga Amaral, Lia Cook, David Ellsworth, Christine, Federighi, Priscilla
enderson, Tony Hepburn, Kiyomi Iwata, Knodel Wee Lay Laq, Logsdon, Medel, Gertrud & Otto
atzler, Norelene, Ed Rossbach, June Schwarcz Works Available By: Edward Curtis

NEDETTI GALLERY 212.226.2238
52 Prince St., New York 10012 FAX: 212.431.8106
Hours: Daily 11-6
Contact: Charles Huller, Director
Specialty: Erte sculpture, among the largest collection on display

tists Represented: Luigi Falai, Sara Gilboa, Rino Li Causi, Anthony, Quinn, Benedetto Robazza
orks Available By: Arturo Dimodica, Erte, Erik Freyman, Claude Gaveau, Giancarlo Impiglia,
cky Montesinos, Moshe Monzon, Donald Swann, Alberto Vargas, Victor Vasarely

ERLAND HALL GALLERY 212.274.9580
579 Broadway, New York 10012

ERMAN-E.N. GALLERY 212.431.1010
138 Greene St., New York 10012

LAUDE BERNARD GALLERY, LTD. 212.988.2050
33 E. 74th St., New York 10021 FAX: 212.737.2290
Hours: Tues-Sat 9:30-5:30
Contact: Michel Soskine, Director
Specialty: Contemporary American and European and Latin American art

tists Represented: Gerard Barthelemy, Robert Birmelin, Varujan Boghosian, Juan Cardenas,
bor Csernus, Alan Glass, Horst Janssen, Maryan, Armando Morales, Eduard Schteinberg, Antonio
gui, Sam Szafran, Fulvio Testa Works Available By: Balthus, Julius Bissier, Peter Blake, Alberto
acometti, Frantisek Kupka, Mark Tobey, Francisco Toledo

ERRY-HILL GALLERIES, INC. 212.744.2300
11 E. 70th St., New York 10021 FAX: 212.744.2838
Hours: Mon-Sat 9:30-5:30
Contact: Jennifer Brown, Director
Specialty: 19th- & 20th-Century American art

rtists Represented: James Brooks, Enrico Donati, Bunny Harvey, Esteban Vicente, Michael
ansky Works Available By: Thomas Anshutz, George Bellows, Frank Benson, Albert Bierstadt
fred Thompson Bricher, Mary Cassatt, William Merritt Chase, Frederick Edwin Church, Thomas
ole, Charles Demuth, Thomas Wilmer Dewing, Arthur Dove, George Henry Durrie, John F.
rancis, Frederick Frieseke, Sanford Gifford, William Glackens, John Haberle, Ernest Haberle,
illiam Harnett, Marsden Hartley, Childe Hassam, Martin Johnson Heade, Robert Henri, Winslow
omer, Edward Hopper, George Inness, Eugene Jardin, John F. Kensett, George Luks, William
etcalf, Raphaelle Peale, John F. Peto, Maurice Prendergast, Theodore Robinson, Roesen, John
nger Sargent, Charles Sheeler, John Sloan, Arthur Tait, John Henry Twachtman, Robert William
onnoh, John Weir, Margi Weir, Thomas W. Whittredge

ETTAL GALLERY 212.233.7824
137 Duane St., 2nd Fl., New York 10013
Hours: Tues-Sat 12-6
Contact: Sergei O. Betekhtin, Director
Specialty: Contemporary and international art

artists Represented: D.J. Buck, Christopher Chambers, Timothy Higginbotham, K. Kotvics,
heldon Mukamal, Richard Taddei, G. Warren Works Available By: Betekhtin-Taleporovs,
imattia, Betsy Friedman, Solomon

MICHELE BIRNBAUM FINE ART 212.427.8250
530 W. 23rd St., New York 10011 FAX: 212.427.8250
Hours: By Appt
Contact: Michele Birnbaum
Specialty: Fine contemporary prints and multiples

artists Represented: Elyse, Charles Ford, Isaac Kahn, Sue McNary Works Available By:
andro Chia, Christo, Red Grooms, Michael Heizer, Roy Lichtenstein, Joan Miro, Susan Moore,
obert Motherwell, Mimmo Paladino, Robert Rauschenberg, Richard Serra, Steven Sorman, Frank
tella, Andy Warhol

S. BITTER-LARKIN 212.219.0150
597 Broadway, New York 10012 FAX: 212.219.0037
Hours: Tues-Sat 10-6
Contact: Lori Friedman, Director
Specialty: American and European contemporary art

Artists Represented: Patrick Corillon, Thomas C. Demand, Yigal Ozeri, Linda Roush, Dorry
Sack, Karin Sander, Antonio Tocornal, Bernard Villers, Richard Ziello Works Available By:
Marcel Broodthaers, Scott Burton, Donald Judd, On Kawara, Joseph Kosuth, Gerhard Richter,
Gunter Umberg, Lawrence Weiner

BLOM & DORN GALLERY 212.219.0761
164 Mercer St., New York 10012

BLUMHELMAN GALLERY, INC. 212.245.2888
20 W. 57th St., New York 10019 FAX: 212.265.4592
Hours: Tues-Sat 10-6
Contact: Christine Wachter, Director

Artists Represented: Joe Andoe, Jack Barth, William Baziotes, Katherine, Bowling, Xavier
Corbero, David Deutsch, John Duff, Bryan Hunt, Steve Keister, Ellsworth Kelly, Win Knowlton,
Robert Lobe, Robert Moskowitz, Edda Renouf, Jose Maria Sicilia, Ettore Sottsass, David True,
Michael Young

BONINO GALLERY 212.598.4262
48 Great Jones St., New York 10012 FAX: 212.982.2842
Hours: By Appt
Contact: Fernanda Bonino, Pres./Director
Specialty: Mexican, Latin American and European painters and sculptors

MARY BOONE GALLERY 212.431.1818
417 W. Broadway, New York 10012 FAX: 212.431.1548
Hours: Tues-Sat 10-6
Contact: Mary Boone
Specialty: Contemporary paintings, drawings and sculpture

Artists Represented: Richard Artschwager, **Ross Bleckner (See page 56)**, Moira Dryer,
Eric Fischl (See page 103), Roni Horn, **Barbara Kruger (See page 148)**, Sherrie Levine
(See page 158), **Brice Marden (See page 166)**, **Sigmar Polke (See page 191)**, Tim Rollins
+ K.O.S., Gary Stephan Works Available By: Georg Baselitz, Francesco Clemente, Anselm
Kiefer, Agnes Martin, David Salle, Julian Schnabel, Cy Twombly

GRACE BORGENICHT GALLERY 212.247.2111
724 Fifth Ave., New York 10019 FAX: 212.247.2119
Hours: Tues-Fri 10-5:30; Sat 11-5:30
Contact: Douglas Still, Registrar
Specialty: Modern and contemporary paintings and sculpture

Artists Represented: Milton Avery, Charles Biederman, David Lee Brown, Paul Burlin, Martin
Chirino, Edward Corbett, Steve Currie, Jose de, Rivera, Andre Derain, John Gill, Roy Gussow,
Royce Howes, John Hull, Angelo Ippolito, Reuben Kadish, Wolf Kahn, David Lund, Emily Mason,
John Opper, Gabor Peterdi, James Romberger, Jane Rosen, David Saunders, Houghton Smith,
Gwenn Thomas, Elbert Weinberg

DAMON BRANDT 212.620.3830
55 Vandam Ave., New York 10013
Hours: Tues-Sat 10-6; Mon By Appt
Contact: Jennifer Rotanz, Director
Specialty: Contemporary art

Artists Represented: Ellen Driscoll, David Ireland, Jones & Ginzel, Mark, Luyten Elena Sisto,
Serge Spitzer, Randy Twaddle, Peter Waite

BREWSTER GALLERY 212.980.1975
41 W. 57th St., New York 10019 FAX: 212.754.6551
Hours: Mon-Sat 10:30-5:30
Contact: Amy Beth Fischoff, Director
Specialty: Latin American and European masters

Artists Represented: Branko Bahunek, Leonora Carrington, Ira Moskowitz, Francisco Zuniga
Works Available By: Appel, Alexander Calder, Marc Chagall, Catharina Cosin, Jose Luis Cuevas,
Salvador Dali, Maximo Javier, Frida Kahlo, Wifredo Lam, Marie Laurencin, Doo-Shik Lee, Ricardo
Martinez, Andre Masson, Roberto Matta, Joan Miro, Pablo Picasso, Ivan Rabuzin, Man Ray, Diego
Rivera, David A. Siqueiros, Rufino Tamayo

BRIDGEWATER/LUSTBERG GALLERY 212.941.6355
529 Broadway, New York 10012

HAL BROMM GALLERY 212.732.6196
90 W. Broadway, New York 10007
Hours: Mon-Fri 10-6
Contact: Hal Bromm, Director
Specialty: Contemporary American, European and Russian art

Works Available By: Mike Bidlo, Macyn Bolt, Rosemarie Castoro, Mike Glier, Robert
Mapplethorpe, Natalya Nesterova, Jody Pinto, Livio Saganic, Russell Sharon, Andy Warhol,
Krzysztof Wodiczko, David Wojnarowicz

NEW YORK (cont.)

NEW YORK CITY

BROOKE ALEXANDER 212.925.4338
59 Wooster St., New York 10012 FAX: 212.941.9565
Hours: Tues-Sat 10-6
Contact: Ted Bonin, Director; Cade Tompkins, Asst. Director
Specialty: Paintings, sculpture and drawings by contemporary American and European artists

Artists Represented: John Ahearn, Robert Bordo, Richard Bosman, Louisa Chase, Jane Dickson, Pepe Espaliu, Federico Guzman, Yvonne Jacquette, Sylvia Plimack Mangold, Peter Nadin, Joseph Nechvatal, Tom Otterness, Judy Rifka, Paul Thek, Richard Tobias, Robin Winters **Works Available By:** Helmut Dorner, Allan McCollum, Matt Mullican, Claes Oldenburg, Markus Raetz, Richard Tuttle, Remy Zaugg

BROOKE ALEXANDER EDITIONS 212.925.2070
476 Broome Street, New York 10013 FAX: 212.941.9565
Hours: Tues-Sat 10-6
Contact: Elizabeth Sarnoff, Director
Specialty: Contemporary American and European prints and multiples

Artists Represented: Richard Artschwager, John Baldessari, Richard Bosman, Louisa Chase, Lucian Freud, Yvonne Jacquette, Jasper Johns, Donald Judd, Annette Lemieux, Sol LeWitt, Robert Longo, Andrew Lord, Robert Mangold, Bruce Nauman, Claes Oldenburg, Sean Scully, Andy Warhol **Works Available By:** Nancy Graves

AMERICAN FINE ARTS CO. 212.941.0401
40 Wooster St., New York 10013 FAX: 212.274.8706
Contact: Regina Moller, Director

Artists Represented: Nancy Barton, Ocean Earth Construct and Develop, Jessica Diamond, Mark Dion, Daniel Faust, Peter Fend, Andrea Fraser, Peter Hopkins, Thom Merrick, Cady Noland, Sam Samore, Peter Santino, Jessica Stockholder, Jon Tower **Works Available By:** Charles Clough, Aimee Morgana, David Robbins, Julia Wachtel

AMERINGER & AVARD FINE ART 212.219.3108
131 Mercer St., New York 10012 FAX: 212.941.9838
Hours: Tues-Sat 11-6
Specialty: Contemporary masters.

Works Available By: Milton Avery, Anthony Caro, Willem de Kooning, Richard Diebenkorn, Sam Francis, Helen Frankenthaler, Adolph Gottlieb, David Hockney, Howard Hodgkin, Hans Hofmann, Morris Louis, Joan Mitchell, Robert Motherwell, Kenneth Noland, David Salle, David Smith

ANDERSON-GOULD FINE ART 212.888.8072
31 Sutton Pl., New York 10022 FAX: 212.754.4585
Hours: By Appt
Contact: Lynda Gould-Anderson, President
Specialty: 20th-Century modern masters

Artists Represented: Ellen Brenner, Bernard Meadows, Eric Orr **Works Available By:** Alexander Archipenko, Jean Arp, Alexander Calder, Joseph Csaky, Gaston Lachaise, Henry Moore, Ghana Orioff, John Storrs

ARCH GALLERY 212.505.1292
644 Broadway, #2E, New York 10012 FAX: 212.260.5847
Hours: By Appt
Contact: Daniela Montana, Director
Specialty: Contemporary and Latin American art

Artists Represented: Marta Gamond, Elisabeth Grajales, Naum Knop, Marta, Minujin, Emma Pineiro, Liliana Porter, Hector Saunier

ART 54 212.226.1605
54 Greene St., New York 10013

ASSOCIATED AMERICAN ARTISTS 212.399.5510
20 W. 57th St., New York 10019 FAX: 212.582.9697
Hours: Tues-Sat 10-6
Contact: Stephen Long, Sr. Assoc. Dir.; Charles Young, Assoc. Dir.
Specialty: Modern and contemporary American prints

Artists Represented: Stanley Boxer, Sam Francis (See page 267), Helen Frankenthaler, Wolf Kahn, Emily Mason, Robert Motherwell, Adja Yunkers **Works Available By:** Milton Avery, George Bellows, Thomas Hart Benton, Richard Diebenkorn, Jim Dine, Frank Faulkner, Joseph Goldyne, Nancy Graves, Childe Hassam, Edward Hopper, Paul Jenkins, Rockwell Kent, Martin Lewis, Louis Lozowick, Neil Marshall, Jules Olitski, Miklos Pogany, Karl Schrag, Antoni Tapies, Wayne Thiebaud, Ruth Weisberg, Grant Wood

ATLANTIC GALLERY 212.219.3183
164 Mercer St., 2nd Fl., New York 10012

PAMELA AUCHINCLOSS GALLERY 212.966.7753
558 Broadway, New York 10012 FAX: 212.431.3763
Hours: Tues-Sat 10-6
Contact: Rick Ward, Director
Specialty: Contemporary American and European paintings, drawings and sculpture

Artists Represented: Farrell Brickhouse, Michael Dvortcsak, Michel Frere, Christian Garnett, Jon Groom, Mary Hambleton, Margrit Lewczuk, Kathy Muehlemann, David Ortins, Masami Teraoka **Works Available By:** Garner Tullis

AVANTI GALLERIES INC. 212.628.3377
956 Madison Ave., New York 10021 FAX: 212.628.3707
Hours: Mon-Sat 10:30-5:30
Contact: Donald Taglialatella, Director
Specialty: 20th-Century contemporary art specializing in the CoBra movement

Artists Represented: Eugene Brands, Rachel Friedberg, William Gear, Stephen Gilbert, Anton Martineau, Carl-Henning Pedersen, Reinhoud, Jan Sierhuis, Rik Van Iersel **Works Available By:** Pierre Alechinsky, Karel Appel, Alexander Calder, Lynn Chadwick, Sandro Chia, Guillaume Corneille, Jim Dine, Asger Jorn, Bengt Lindstrom, Lucebert, Marino Marini, Pablo Picasso, Larry Rivers, Anton Rooskens, Andy Warhol, Tom Wesselmann, Theo Wolvecam

BABCOCK GALLERIES 212.767.1852
724 Fifth Ave., New York 10019 FAX: 212.767.1857
Hours: Tues-Sat 10-5:30
Contact: Dr. John Driscoll, Director; Michael St. Clair, Director
Specialty: Fine American paintings, sculpture and works on paper; historical and contemporary

Artists Represented: Sigmund Abeles, Stephanie Adam, Harvey Breverman, Jim Butler, **Edwin Dickinson (See page 89)**, John Dobbs, Stuart Frost, Walter Hatke, Keith Jacobshagen, Joel Corcos Levy, **Seymour Lipton (See page 343)**, Joe Wilder **Works Available By:** Benn, Blakelock, Brush, Burchfield, Casilear, Cassatt, Champhey, Chase, Church, Corcos, Crawford, Davies, Decker, Dewing, Dove, Duncanson, Curand, Eakins, Evergood, Gifford, Gignoux, Groshans, Hartley, Hassam, Hawthorne, Homer, Inness, Hehsett, Kent, Kroll, Lawson, Levy, Luks, Marin, Maurer, Moran, Poor, Prendergast, Richards, Rimmer, Robinson, Schofield, Shaffer, Siporin, Smith, Sommer, Tarbell, Thayer, Vedder, Walker, Webster, Wyeth, Zorach.

BILL BACE GALLERY 212.925.3989
584 Broadway, New York 10012
Hours: Tues-Sat 11-6
Contact: Bill Bace, Director
Specialty: Contemporary works

Artists Represented: David Aldera, Tora Beck-Friedman, Tom Doyle, Lawrence Fane, Elen Feinberg, Ione Haney, Maura Maguire, Robert Reid, James Russell, Joan Stolz **Works Available By:** William Congdon, Petah Coyne, Elisa D'Arrigo, Keith, M. Martin, Creighton Michael, Michel Nedjar, John Van Alstine

JOSH BAER GALLERY 212.431.4774
476 Broome St., 3rd Fl., New York 10013 FAX: 212.431.3631
Hours: Tues-Sat 10-6; Wed 10-8
Contact: Josh Baer, Owner
Specialty: Contemporary art

Artists Represented: Alan Belcher, Dara Birnbaum, Chris Burden, Kevin Carter, Nancy Dwyer, Leon Golub, Annette Lemieux, Lorna Simpson, Alexis Smith, Nancy Spero, Oliver Wasow, Krzysztof Wodiczko **Works Available By:** Joseph Beuys

BAG ONE ARTS, INC. 212.595.5537
110 W. 79th St., New York 10024 FAX: 212.595.6470
Hours: Mon-Fri 9-5
Contact: Lynne Clifford, Director
Specialty: Limited edition graphics and sculpture

Artists Represented: John Lennon, Yoko Ono

VREJ BAGHOOMIAN GALLERY 212.941.1410
555 Broadway, New York 10012
Hours: Tues-Sat 10-6

BARON/BOISANTE GALLERY 212.581.9191
50 W. 57th St., New York 10019 FAX: 212.581.9291
Hours: Tues-Sat 10-6
Contact: Mark Baron, Partner
Specialty: Publishers of prints and multiples

Artists Represented: Curtis Anderson, Donald Baechler, Michael Byron, Chris MacDonald, Peter Nagy, Salvatore Scarpitta, Not Vital **Works Available By:** Joseph Beuys, Ingrid Dinter, Sigmar Polke, Gerhard Richter, Rosemarie Trockel, Rolf Walz

J.N. BARTFIELD GALLERIES 212.245.8890
30 W. 57th St., New York 10019 FAX: 212.541.4860
Hours: Mon-Fri 10-5; Sat 10-3
Contact: Michael Frost, President
Specialty: 19th- & 20th-Century American western paintings and sculpture

Artists Represented: William Acheff, Douglas Allen, Michael Coleman, Noel Daggett, Daro Flood, Gordon Phillips, Chet Reneson **Works Available By:** Albert Bierstadt, E.L. Blumenshein, Edward Borein, Eanger I. Couse, Henry Farny, A.B. Frost, E. Martin Hennings, W.R. Leigh, Alfred Jacob Miller, Ogden Pleissner, Frederic Remington, Carl Rungius, Charles Russell, Charles Schreyvogel, O.C. Seltzer, Walter Ufer

JAYNE H. BAUM GALLERY 212.219.9854
588 Broadway, Ste. 202, New York 10012 FAX: 212.219.9877
Hours: Tues-Sat 10-6
Contact: Jayne Baum; Molly Rudder
Specialty: Contemporary art in all media

Artists Represented: Nancy Burson, Bruce Charlesworth, Eileen Cowin, John Divola, Manual Nagatani & Tracey, Holly Roberts, Elliot Schwartz **Works Available By:** Michael Dubina, Sandi Fellman, Alain Fleischer, Ellen Garvens, Lori Novak, Sandy Skoglund

MOUNT KISCO

TYLER GRAPHICS LTD. 914.241.2707
250 Kisco Ave., Mount Kisco 10549 FAX: 914.241.7756
Hours: Mon-Sat 10-5:30
Contact: Barbara Delano, Assoc. Director of Sales
Specialty: Fine art publishers/printers of limited edition graphics and multiples

Artists Represented: Josef Albers, Anni Albers, Ed Baynard, Stanley Boxer, Anthony Caro, Mark di Suvero, Helen Frankenthaler, Nancy Graves, Richard Hamilton, Michael Heizer, David Hockney, Paul Jenkins, Ellsworth Kelly, **Terence La Noue (See page 272),** Roy Lichtenstein, Joan Mitchell, Malcolm Morley, Robert Motherwell, **John Newman (See page 275),** Hugh O'Donnell, Claes Oldenburg, James Rosenquist, Alan Shields, Richard Smith, Steven Sorman, Frank Stella, Altoon Sultan, Masami Teraoka, Robert Zakanitch

NEW YORK CITY

101 WOOSTER GALLERY 212.219.2790
101 Wooster, New York 10012
Hours: Sat & Sun 12-6

14 SCULPTORS GALLERY 212.966.5790
164 Mercer St., New York 10012

303 GALLERY 212.966.5605
89 Greene St., 2nd Fl., New York 10012 FAX: 212.941.9828
Hours: Tues-Sat 10-6
Contact: Lisa Spellman
Specialty: Emerging conceptual artists from the U.S. and Europe

Artists Represented: David Cabrera, Anne Doran, Andreas Gursky, Larry Johnson, Karen Kilimnik, Liz Larner, Pruitt-Early, **Thomas Ruff (See page 291),** Collier Schorr, Karen Sylvester

A.I.R. GALLERY 212.966.0799
63 Crosby St., New York 10012

ACA GALLERIES 212.644.8300
41 E. 57th St., 7th Fl., New York 10022 FAX: 212.644.8306
Hours: Tues-Sat 10-5:30
Contact: Martin H. Bush, President
Specialty: Contemporary art, 19th- & 20th-Century art

Artists Represented: Richard Anuszkiewicz, Kenneth Armitage, Daniel Barrett, Colleen Browning, John De Andrea, Enrico Donati, Grace Hartigan, Friedensreich Hundertwasser, Richard Pousette-Dart, Pierre Soulages, Theodoros Stamos, Ernest Trova **Works Available By:** Jean Arp, Thomas Hart Benton, Alfred Thompson Bricher, Stuart Davis, Frank Duveneck, William Glackens, Childe Hassam, Rockwell Kent, Yasou Kuniyoshi, Fantin La Tour, Reginald Marsh, Camille, Pissarro, Fairfield Porter, Maurice Prendergast, Norman Rockwell, Raphael M. Soyer **Estates Represented:** Romare Bearden, Joseph Cornell, John Steuart Curry, Ludwig Sander

ADELSON GALLERIES, INC. 212.439.6800
25 E. 77th St., 3rd Fl., New York 10021 FAX: 212.439.6870
Hours: Mon-Fri 9:30-5:30
Contact: Warren Adelson, President
Specialty: 19th- & 20th-Century American and European art

Artists Represented: Peter Nadin, Peter Reginato, Jim Ritchie, Andrew, Stevovich **Works Available By:** George Bellows, Mary Cassatt, Vilhelm Hammershi, William Harnett, Childe Hassam, Martin Johnson Heade, Winslow Homer, Peter Ilsted, Maurice Prendergast, John Singer Sargent

RACHEL ADLER GALLERY 212.308.0511
41 E. 57th St., New York 10022 FAX: 212.308.0516
Hours: Tues-Sat 10-5:30; Mon By Appt
Contact: Susan Dague, Asst. Director
Specialty: Russian avant-garde, Italian futurism, European abstraction of the 20's and 30's

Works Available By: Alexander Calder, Alexandra Exter, Otto Gutfreund, Jean Helion, Wassily Kandinsky, Frantisek Kupka, Le Corbusier, Fernand Leger, El Lissitsky, Robert Michel, Amedee Ozenfant, Liubov Popova, Joaquin Torres-Garcia, Kyril Zdanevich **Estates Represented:** Alexander Archipenko, Adolf Hoffmeister, Alejandro Xul Solar

SALVATORE ALA 212.941.1990
560 Broadway, 3rd Fl., New York 10012
Hours: Tues-Sat 10-6

FERNANDO ALCOLEA GALLERY 212.966.4020
130 Prince St., New York 10012

ALEX-EDMUND GALLERIES 212.260.5900
478 W. Broadway, New York 10012 FAX: 212.260.6715
Hours: Mon-Fri 10-6; Sat 11-7; Sun 11-6
Contact: Alex Oronov, Director
Specialty: Contemporary Russian paintings, sculpture, works on paper and limited editions

Artists Represented: Michail Aleksandrov, Mihail Chemiakin, Ernst Neizvestny, **Dmitri Plavinsky (See page 190),** Oleg Tselkov, Igor Tulipanov

ALEXANDER GALLERY 212.472.1636
980 Madison Ave., New York 10021

SANTA FÉ EAST 505.988.3103
200 Old Santa Fe Trail, Santa Fe 87501
Hours: Mon-Sat 9:30-5
Contact: Ron Cahill, Director
Specialty: American art; contemporary painting and sculpture

Artists Represented: Steven Chase, **Geoffrey Landis (See page 153),** L. M. Mann, **Mitzi Prince (See page 195), Sherri Silverman (See page 218), Roger B. Sprague (See page 223), Kirk Tatom (See page 367), Randall Tipton (See page 234), William F. Tull (See page 237) Works Available By:** Thomas Hart Benton, Charles Demuth, Paul Dougherty, Fremont Ellis, Leon Gaspard

SCHEINBAUM & RUSSEK LTD. 505.988.5116
328 Guadalupe, Ste. M, Santa Fe 87501 FAX: 505.988.5116
Hours: Tues-Sat 11-5
Contact: David Scheinbaum, Owner; Janet Russek, Owner
Specialty: Rare and contemporary photography

Artists Represented: Ansel Adams, Manuel Alvarez-Bravo, Ellen Auerbach, Henri Cartier-Bresson, Laura Gilpin, Beaumont Newhall, Nancy Newhall, Arnold Newman, Eliot Porter, Sebastiao Salgado, Ralph Steiner, Willard Van Dyke, Todd Webb, Edward Weston

SENA GALLERIES 505.982.8808
112 W. San Francisco St., Santa Fe 87501 FAX: 505.982.0878
Hours: Mon-Fri 9-6; Sat 10-6; Sun 11-3
Contact: Mary Thompson, Director

Artists Represented: Charles Arnoldi, Larry Bell, William Burroughs, Jerry Cajko, Carlos Carulo, Ron Cooper, Laddie John Dill, Martin Facey, Douglas Hall, Shelley Horton-Trippe, Basia Irland, Inger Jirby, Tom Lieber, James Marshall, Eric Orr, Ken Price, Otto Rigan, Sam Scott, Paul Shapiro, Patrick Simpson, Mark Spencer, Eva Stettner, Steven Swanson, **Michael Von Helms (See page 241),** Anne Wu **Works Available By:** Terry Allen, Lynda Benglis, John Cage, Keith Haring, William Metcalf, Douglas Metzler, Fritz Scholder, Rufino Tamayo

VENTANA FINE ART 505.983.8815
211 Old Santa Fe Tr., Santa Fe 87501 FAX: 505.988.4780
Hours: Mon-Sat 9:30-5:30; Sun 10-2
Contact: Connie Axton, Owner
Specialty: Contemporary Southwest gallery

Artists Represented: John Axton, Dane Clark, Doug Dawson, Albert Handell, Ramon Kelley, Heath Krieger, John Nieto

WAXLANDER GALLERY 505.984.2202
622 Canyon Rd., Santa Fe 87501
Hours: Daily 10-5

TAOS

FENIX GALLERY 505.758.9120
228B N. Pueblo Rd., Taos 87571 FAX: 505.758.1343
Hours: Daily 10-5
Contact: Judith Eyre, Owner
Specialty: Contemporary fine art and sculpture

Artists Represented: Cynthia Barber, Jane Ellen Burke, Leslie Crespin, Brenda Euwer, Gretchen Ewert, Alyce Frank, Ginger Mongiello, Lee Mullican, Pat Smith, Mimi Chen Ting, R. Doen Tobey, Ben Wade, Melissa Zink

MICHAEL MCCORMICK 505.758.1372
121C North Plaza, Taos 87571 FAX: 505.758.2051
Hours: Daily 10-5
Contact: Michael McCormick, Director
Specialty: Modern and contemporary art; regionally sophisticated

Artists Represented: Connie Downey, Miguel Martinez, Laurie Phelps, Bill Rane, Michio Takayama, Mary Witkop

NEW YORK

EAST HAMPTON

VERED GALLERY 516.324.3303
68 Park Place Passage, East Hampton 11937 FAX: 516.324.3303
Hours: Daily 11-6
Contact: Ruth Vered, Director

Works Available By: Warren Brandt, Dan Christensen, Audrey Flack, Paul Georges, Balcomb Greene, William King, Donald Lipski, Tina Nivola, Dennis Oppenheim, Larry Rivers

MISSOURI

ST. LOUIS

THE GREENBERG GALLERY 314.361.7600
44 Maryland Pl., St. Louis 63108 FAX: 314.361.7743
Hours: Tues-Sat 10-5
Contact: Ronald Greenberg, Owner/Director
Specialty: Post-World War II American and European
paintings, sculpture, and drawings

Works Available By: Donald Baechler, Jean-Michel Basquiat, James Brown, Alexander Calder, Christo, Willem de Kooning, Richard Diebenkorn, Jean Dubuffet, Eric Fischl, Dan Flavin, Sam Francis, Helen Frankenthaler, Alberto Giacometti, David Hockney, Hans Hofmann, Edward Hopper, Jasper Johns, Donald Judd, Ellsworth Kelly, Jannis Kounellis Lalnne, Roy Lichtenstein, Henry Moore, Robert Motherwell, Louise Nevelson, Robert Rauschenberg, Gerhard Richter, Larry Rivers, Susan Rothenberg, Joel Shapiro, Frank Stella, Donald Sultan, Richard Tuttle, Cy Twombly, Bernar Venet, Andy Warhol, Tom Wesselmann

LOCUS 314.231.2515
710 N. Tucker Blvd., #315, St. Louis 63101
Hours: Tues-Fri 12-5; Sat 1-5
Contact: Kate Anderson, Director
Specialty: Contemporary fine art

Artists Represented: Kenneth Anderson, Robert Bourdon, Meredith Dean, Phyllis Plattner, Dana Romeis, John Rozelle, Susan Sensemann, James Smith, Jeff Vaughn **Works Available By:** George Bartko, Glenn Brill, Patti Cohn, Carol Crouppen, Tim Curtis, Roger Desrosiers, Tim Hahn, Lynn Hurst, Peter Marcus, Genell Miller, Quinta Scott, Salvatore Ventura, David Woesthaus

PHILIP SAMUELS FINE ART 314.727.2444
8112 Maryland Ave., St. Louis 63105 FAX: 314.727.6084
Hours: Office Hours: 9-5; Gallery Hours: 10:30-4:30
Contact: Katherine Eckhardt, Director
Specialty: Contemporary painting, collage, drawing, and sculpture

Artists Represented: Michael Rubin, Ernest Trova **Works Available By:** Alexander Calder, Willem de Kooning, Sam Francis, Keith Haring, Franz Kline, Morris Louis, Tom Slaughter, George Tooker

SIGNET ARTS 314.534.0181
4100 Laclede Ave., #206, St. Louis 63130
Hours: By Appt
Contact: George Schelling, Owner/Director
Specialty: Contemporary prints (post 1960)

Works Available By: Richard Bosman, Robert Cottingham, Jim Dine, Claes Oldenburg, Philip Pearlstein, Susan Rothenberg

NEW MEXICO

SANTA FE

RUTGERS BARCLAY GALLERY 505.986.1400
325 W. San Francisco St., Santa Fe 87501 FAX: 505.984.3007
Hours: Tues-Sat 10-6
Contact: Laurie B. Innes, Assoc. Director
Specialty: Contemporary art

Artists Represented: Rick Bartow, Scott Duce, Klaus Fussmann, Dennis Hare, Holly Lane, Lisa Houck Leary, Todd Mckie **Works Available By:** Anthony Caro, Arthur Dove, Aaron Fink, Raymond Han, Paul Klee, Gwynn Murrill, Robert Rauschenberg, Wayne Thiebaud

LINDA DURHAM GALLERY 505.988.1313
400 Canyon Rd., Santa Fe 87501
Hours: Mon-Fri 9-5; Sat 10-5
Contact: Russell Isaacs
Specialty: Contemporary American art

Artists Represented: David Anderson, Timothy App, Rodney Carswell, **John Connell (See page 316), Constance DeJong (See page 321),** Rick Dillingham, Richard Hogan, **Phyllis Ideal (See page 137),** Avra Leodas, Susan Linnell, Lucy Maki, William Masterson, Joan Myers, Eugene Newmann, Gail Rieke, Zachariah Rieke, Holly Roberts, Erika Wanenmacher **Works Available By:** Raymond Jonson, Louis Ribak, Paul Sarkisian **Robert Kelly (See page 141),**

FENN GALLERIES LTD 505.982.4631
1075 Paseo De Peralta, Santa Fe 87501
Hours: Mon-Sat 8:30-5
Contact: Harry Mckee, Director

GARLAND GALLERY 505.984.1555
125 Lincoln Ave., Ste. 113, Santa Fe 87501 FAX: 505.988.2746
Hours: Mon-Sat 9:30-5:30
Contact: Karen Garland, Director
Specialty: Contemporary glass sculpture

Artists Represented: Mark Abildgaard, Ken Carder, John Farrell, David, Hopper, Flo Perkins, Shelley Robinson, Lino Tagliapietra, Jon Wolfe **Works Available By:** Rick Eckerd, Larry Fielder, Judy Bally Jensen, Dulany Lingo, Josh Simpson, Peter Vanderlaan

GLENN GREEN GALLERIES 505.988.4168
50 E. San Francisco St., Santa Fe 87501 FAX: 505.989.8260
Hours: Mon-Sat 9:30-5:30; Sun 12-5
Contact: Glenn Green, Owner/Director
Specialty: Exclusive representatives for Allan Houser

Artists Represented: Jim Alford, Rob Bird-Robinson, Tony Campodonico, John Hogan, John Hoover, Allen Houser, Daniel Nunez, Eduardo Oropeza, Susanne Page

ELAINE HORWITCH GALLERIES 505.988.8997
129 W. Palace Ave., Santa Fe 87501 FAX: 505.989.8702
Hours: Mon-Sat 10-5
Contact: Elaine Horwitch, President
Specialty: Contemporary American and southwest paintings and sculpture

Artists Represented: Frank Duchamp, John Fincher, James Havard, Susan Hertel, Dick Jemison, **David Kraisler (See page 337),** Merrill Mahaffey, Dick Mason, Robert Wade **Works Available By:** Fritz Scholder

CHARLOTTE JACKSON FINE ART 505.989.8688
123 E. Marcy St., Ste. 208, Santa Fe 87501 FAX: 505.989.9898
Contact: Charlotte Jackson, Director

JANUS GALLERY 505.983.1590
225 Canyon Rd., Santa Fe 87501
Hours: Mon-Sat 10-5
Contact: Joan Clark, Owner/Director
Specialty: Contemporary paintings, drawings, sculpture and photography

Artists Represented: Clinton Adams, Jesus Bautista Moroles, Tom Berg, William Conger, Aaron Karp, Reg Loving, Diane Marsh, Elliot Norquist, Paul Pollaro, **Mary Ristow (See page 255)**

EDITH LAMBERT GALLERY 505.984.2783
707 Canyon Rd., Santa Fe 87501
Hours: Daily 10-5
Contact: Edith Lambert, Owner
Specialty: Contemporary art and American crafts

Artists Represented: Gretchen Ewert, Carol Hoy, Wes Hunting, Margaret Nes, Bruce Pizzichillo

ALLENE LAPIDES GALLERY 505.984.0191
217 Johnson St., Santa Fe 87501 FAX: 505.982.5351
Hours: Mon-Sat 9-5; Sun 10-4
Contact: Allene Lapides, Owner; Mary Pat Butler, Director
Specialty: Contemporary art by modern masters and emerging artists

Artists Represented: John Buck, Dale Chisman, Tony Delap, Sam Gummelt, Woody Gwyn, Eugene Jardin, Ida Kohlmeyer, Cheryl Laemmle **Works Available By:** Mary Frank

LEWALLEN GALLERY 505.988.5387
225 Galisteo, Santa Fe 87501
Hours: Mon-Sat 10-5
Contact: Geoffrey Gorman, Asst. Director
Specialty: Exhibiting contemporary and American folk art

Artists Represented: David Bates, Martin Blank, Paul Brach, Robert Brady, Robert Colescott, Kris Cox, James G. Davis, Roy De Forest, John Geldersma, Howard Hersh, **Luis Jimenez (See page 333),** Jenny Lind, Bert Long Jr., Dante Marioni, N. Scott Momaday, Benjamin Moore, William Morris, Andy Nasisse, Brian O'Connor, Scottie Parsons, Richard Royal, Meridel Rubenstein, Miriam Schapiro, Paul Sierra, Jaune (QTS) Smith, Charles Thysell, Jerry R. West, Emmi Whitehorse **Works Available By:** Ron Adams, Tony Berlant

MAYANS GALLERIES LTD. 505.983.8068
601 Canyon Rd., Santa Fe 87501 FAX: 505.982.1999
Hours: Mon-Sat 10-5
Contact: Leonor Mayans, President; Ernesto Mayans, V.P.
Specialty: 20th-Century American and Latin American art

MUNSON GALLERY 505.983.1657
225 Canyon Rd., Santa Fe 87501 FAX: 505.988.9867
Hours: Daily 10-5
Contact: Jo Chapman, Director
Specialty: Contemporary American paintings, graphics and sculpture

Artists Represented: Douglas Atwill, Russell Chatham, Eddie Dominguez, George Harkins, William Lumpkins, Forrest Moses, Elias Rivera, Elmer Schooley, Doug West **Works Available By:** Ken Anderson, Al Lostetter, Alan Magee, Frank McCulloch, Agnes Sims

GERALD PETERS GALLERY 505.988.896
439 Camino Del Monte Sol, Santa Fe 87504 FAX: 505.983.248
Hours: Mon-Fri 9-5; Sat 10-5
Contact: Gayle Maxon, Director
Specialty: Contemporary painting and sculpture

Artists Represented: Dale Chihuly, Charles Ginnever, Lucero Isaac, Carol Mothner, Joe Nicastri, Albert Paley, Tim Prythero, William Shepherd, John Van Alstine **Works Available By:** Scott Fife, Janet Fish, Helen Frankenthaler, Beverly Pepper, George Rickey

FARMINGTON HILLS

HABATAT GALLERY 313.851.9090
32255 Northwest Highway, Ste. 45, Farmington Hills 48018
Contact: Ferdinand C. Hampson, Director
Specialty: Contemporary sculpture

ROYAL OAK

SWIDLER GALLERY 313.542.4880
308 W. Fourth St., Royal Oak 48067 FAX: 313.541.6376
Hours: Tues-Sat 11-5
Contact: Allan Swidler, Owner; Paul Kotula, Director
Specialty: Contemporary ceramics and metals

Artists Represented: Susan Fox Beznos, Lucy Breslin, Bill Brouillard, Andrea Gill, Paul Kotula, Jean-Pierre Larocque, Tony Marsh, David Shaner, John Stephenson, Susanne Stephenson, Gregory A. Zeorlin **Works Available By:** Nina Borgia-Aberle, Val Cushing, Frank Martin, John Neely, Kris Nelson, John Rohlfing, Judith Salomon

MINNESOTA

MINNEAPOLIS

ANDERSON & ANDERSON GALLERY 612.332.4889
414 First Ave. N., Minneapolis 55401
Hours: Tues-Sat 12-4; And By Appt
Contact: John H. Anderson Jr., Director; Sue M. Anderson, Director
Specialty: Contemporary sculpture, painting, drawing and 20th-Century furnishings

Artists Represented: John Battenberg, Joseph De Luca, Eugene Larkin, Herman Rowan, Julius Schmidt

THOMAS BARRY FINE ARTS 612.338.3656
400 First Ave. N., Ste. 304, Minneapolis 55401 FAX: 612.338.8415
Hours: Tues-Sat 11-4; And By Appt
Contact: Thomas Barry, Director
Specialty: Contemporary art in all media

Artists Represented: Matt Brown, Bruce Charlesworth, Don Gahr, Lynn Geesaman, David Goldes, James Kielkopf, Polly Kiesel, Barbara Kreft, David Madzo, Dan Mason, Jeff Millikan, Ken Moylan, Arne Nyen, Dan Powell, Scott Stack, Steven Woodward **Works Available By:** Scott Belville, Alison Saar, Dan Wilson

BOCKLEY GALLERY 612.339.3139
400 First Ave. N., Minneapolis 55401 FAX: 612.344.1643
Hours: Tues-Sat 11-4
Contact: Todd Bockley, Director
Specialty: Contemporary art, art brut, outsider art and folk art

Artists Represented: Bruce Anderson, Doug Argue, Frank Bigbear, Andrew Masullo, Michael Mercil, George Morrison, Ari Purhonen, John Snyder **Works Available By:** Prophet William Blackmon, Clementine Hunter, Walter Jost, Carrie Ann Peirce, Jonathan Rosen, Paul Shambroom, Mose Tolliver

PETER M. DAVID GALLERY 612.339.1825
400 First Ave. N., Ste. 236, Minneapolis 55401
Hours: Tues-Sat 12-4
Contact: Bonnie K. Sussman, Director

DOLLY FITERMAN FINE ARTS 612.623.3300
100 University Ave. S.E., Minneapolis 55414 FAX: 612.623.0203
Hours: Mon-Fri 10-5:30; Sat-Sun By Appt
Contact: Dolly J. Fiterman, Director
Specialty: Contemporary American and European masters

Artists Represented: Ivor Abrahams, Sigfried Anzinger, William Crutchfield, Dre Devens, Michael Heindorff, Rick Horton, Mary Ingebrand, Raymond Jacobson, Mary Francis Judge, Luciano Lattanzi, David McCullough, Jacob Mishori, Michelangelo Pistoletto, John Raimondi, David Rich, William Tillyer, Joe Tilson, Thom Wolfe **Works Available By:** Karel Appel, Milton Avery, Christo, Allan D'arcangelo, Jim Dine, Rainer Fetting, Dorothy Gillespie, Grace Hartigan, Roy Lichtenstein, Henry Moore, Louise Nevelson, Mimmo Paladino, A.R. Penck, James Rosenquist, Richard Smith, Andy Warhol, Tom Wesselmann, Adja Yunkers

FLANDERS CONTEMPORARY ART 612.344.1700
400 N. First Ave., Ste. 104, Minneapolis 55401 FAX: 612.344.1643
Hours: Tues-Sat 10-4
Contact: Douglas Flanders, Director
Specialty: Paintings, sculpture, drawings, graphics and photography from 1860 to present

Artists Represented: Jim Bird, Ellen Buljeta, Jon Marc Edwards, Ginnie Gardiner, Don Holzschuch, Bruce Stillman, Steven Swanson, Mike Willett **Works Available By:** Charles Arnoldi, Ross Bleckner, Francesco Clemente, Jim Dine, Sam Francis, Helen Frankenthaler, Nancy Graves, Jasper Johns, Roy Lichtenstein, Robert Mapplethorpe, Kenneth Noland, Sean Scully, Frank Stella, Gary Stephan, Donald Sultan, Antoni Tapies, Wayne Thiebaud, Cy Twombly, Terry Winters

FORUM GALLERY 612.333.1825
119 N. Fourth St., Minneapolis 55401
Hours: Tues-Sat 11-4
Contact: Kit Wilson, Director; Margo Sanida, Director
Specialty: Contemporary fine art

Artists Represented: J.R. Barnes, Carolyn Braaksma, Patricia Bratnober, Victoria Christen, Charles Cowles, Anne Davey, Steven Erickson, Stewart Luckman, Billy Mayer, Sheryl Mcroberts, Vietati Ngo, Philip Rickey, Stanton Sears, Kristen Sheronis, Mary Sullivan-Rickey, Russell Vogt

GROVELAND GALLERY 612.377.7800
25 Groveland Terr., Minneapolis 55403 FAX: 612.377.8822
Hours: Tues-Fri 12-5; Sat 12-4
Contact: Sally Johnson, Director
Specialty: Contemporary representational paintings and drawings by regional artists

Artists Represented: William Barnes, Gary Bowling, Joseph Byrne, Carol Lee Chase, Eric Austen Erickson, John Gordon, Larry Hofmann, Gendron Jensen, Greg Kelsey, Mike Lynch, Rod Massey, Robert McKibbin, Paula Nees, Carl Oltvedt, Dani Roach, Matthew Smith, Laura Stone, Lauren Stringer

HASTINGS RUFF GALLERY
400 First Ave. N., Ste. 134, Minneapolis
Contact: Holly Hastings, Principal; Carolyn Ruff, Principal

SUZANNE KOHN GALLERY 612.341.3441
100 Second Ave. N., Minneapolis 55401
Hours: Mon.Sat 9:30.6; Sun 12-5

M.C. GALLERY, INC. 612.339.1480
400 First Ave. N., Ste. 332, Minneapolis 55401 FAX: 612.339.1480
Hours: Tues-Sat 12-4
Contact: M.C. Anderson, Director
Specialty: Fine art and fine art crafts

Artists Represented: Ken Anderson, Paul Benson, Indira Johnson, Tom Kerrigan, Gisela Moyer, Paula Sethre, Steven Tobin

JON OULMAN GALLERY 612.333.2386
400 First Ave. N., Ste. 706, Minneapolis 55401 FAX: 612.339.9432
Hours: Tues-Sat 9-6
Contact: Jon Oulman, Director
Specialty: Contemporary paintings, drawings and photography

Artists Represented: Nicholas Africano, Phillip Barber, John Bowman, Bob Chaplin, Dennis Farber, Carl Goldhagen, Duncan Hannah, Richard Merkin, Volker Seding, Ruth Thorne-Thomsen, Ken Thurlbeck

RAVEN GALLERY 612.925.4474
3827 W. 50th St., Minneapolis 55410
Hours: Mon-Sat 10-5:30; Thur 10-8:30

JOHN C. STOLLER & CO. 612.339.7060
81 S. Ninth St., Minneapolis 55402 FAX: 612.349.2850
Hours: Mon-Fri 10-5:30; Appt Suggested
Contact: John C. Stoller, President
Specialty: Contemporary American and European paintings, drawings, sculpture and prints

Artists Represented: William Clutz, Sol LeWitt, Michael Mazur, John Newman, T.L. Solien, Robert Therrien **Works Available By:** Ford Beckman, Daniel Buren, Alexander Calder, John Chamberlain, Francesco Clemente, John Duff, Dan Flavin, Lucian Freud, Hans Hofmann, Jasper Johns, Ellsworth Kelly, Fernand Leger, Agnes Martin, Joan Mitchell, Robert Motherwell, Pablo Picasso, Robert Rauschenberg, Susan Rothenberg, Joel Shapiro, Pat Steir. Frank Stella, Donald Sultan, James Turrell, Terry Winters

THOMSON GALLERY 612.338.7734
321 Second Ave. N., Minneapolis 55401 FAX: 612.337.5293
Hours: Mon-Fri 10-5; Sat 11-4
Contact: Robert Thomson, Director; Leah Stoddard
Specialty: Contemporary American painting, drawing, graphics, photography and sculpture

Artists Represented: David Bierk, David Coggins, Jill Evans, Michael Gregory, Stephen Hartman, Curtis Hoard, Philip Larson, Barbara Madsen, Stuart Nielsen, Dan Rizzie, Thomas Rose, David Shapiro, Steven Sorman, Joann Verburg **Works Available By:** Joe Andoe, Richard Diebenkorn, Nancy Graves, Alex Katz, Markus Lupertz, Robert Mapplethorpe, Robert Motherwell, Larry Rivers, Ed Ruscha, T.L. Solien, Donald Sultan, Wayne Thiebaud, William T. Wiley

ST. PAUL

SUZANNE KOHN GALLERY 612.699.0477
1690 Grand Ave., St. Paul 55105
Hours: Mon-Sat 1-5; Jul & Aug By Appt

MASSACHUSETTS (cont.)

BOSTON

ANDREA MARQUIT FINE ARTS 617.859.0190
207 Newbury St., Boston 02116
Hours: Mon-Thurs By Appt; Fri-Sat 11-5
Contact: Andrea Marquit Clagett, Director
Specialty: Corporate and private consultation, emerging
and master contemporary art

Artists Represented: Arlyne Bayer, Nancy Berlin, Michael Bisbee, Wilfredo Chiesa, Luciano Franchi De Alfaro III, Ronaldo De Juan, Barbara Farrell Benno Friedman, Pat Hammerman, Jim Jacobs, Anne Krinsky, Saul Lambert, Gieselle Maya, Sigrid McCabe, Leslie Parke, Don Resnick, Victoria Ryan, Fanny Sanin, Susan Schwalb, Andy Tavarelli, Rafael Vadia, Adrianne Wortzel

NIELSEN GALLERY 617.266.4835
179 Newbury St., Boston 02116 FAX: 617.266.0480
Hours: Tues-Sat 10-5:30
Contact: Nina Neilson, Director
Specialty: Contemporary art paintings, sculpture, and prints

Artists Represented: Gregory Amenoff, Jake Berthot, Anne-Marie Cucchiara, Damian Dibona, Porfirio Didonna, Neill Fearnley, Gregory Gillespie, Stephen Greene, Chris Hearn, Willy Heeks, Ralph Humphrey, Jon Imber, Mario Kon, Jeff Kotun, Dexter Lazenby, Catherine McCarthy, John McNamara, Sam Messer, Naoto Nakagawa, Lee Newton, Katherine Porter, Fernando Ramos Prida, Harvey Quaytman, Robert Rohm, Paul Rotterdam, Jane Smaldone, Joan Snyder, Bill Thompson

THOMAS SEGAL GALLERY 617.292.0789
207 South St., Boston 02111 FAX: 617.292.0787
Hours: Tues-Fri 10-5:30; Sat 12-5:30
Contact: Jeremy Fowler, Asst. Director
Specialty: American and European contemporary art

Artists Represented: Robert Bauer, Gerry Bergstein, David Campbell, Nan Goldin, Ralph Hamilton, Wolf Kahn, Mela Lyman, Christopher Osgood, Clifton Peacock, George Rickey, Jo Sandman Works Available By: Miguel Barcelo, Georg Baselitz, Dan Flavin, Jasper Johns, Donald Judd, Anselm Kiefer, Sol LeWitt, Roy Lichtenstein, Yasumasa Morimura, Robert Ryman, Andres Serrano, Tony Smith, Cy Twombly

BETH URDANG FINE ART 617.424.8468
207 Newbury St., Boston 02116
Hours: Tues-Sat 10-5:30
Contact: Beth Urdang, Owner
Specialty: 20th-Century American painting and sculpture

Artists Represented: Ilya Bolotowsky, Marcia Dalby, Lawrence Kupferman, Margo Margolis, Ed Mayer, Elie Nadelman Works Available By: Alexander Archipenko, George Ault, John Chamberlain, Jasper Johns, Robert Lobe, Man Ray, Scott Richter, Ed Ruscha, Richard Stankiewicz, Robin Winters

HOWARD YEZERSKI GALLERY 617.426.8085
186 South St., Boston 02111
Hours: Tues-Sat 10-5:30
Contact: Jeri Slavin, Director

Artists Represented: Natalie Alper, Karl Baden, Domingo Barreres, Sam Cady, Robert Colescott, Mark Cooper, **John Coplans (See page 382)**, Gayle Fichtinger, Richard Jacobs, Aida Laleian, Marjorie Moore, John O'Reilly, David Raymond, Richard Rosenblum, Dana Salvo, Paul Shakespear, **Elaine Spatz-Rabinowitz (See page 222)**, Harold Tovish, John Tracey, Yu-wen Wu Works Available By: John Cummings, Jeffrey Mathias, Barbara Norfleet, Dennis Oppenheim

CAMBRIDGE

WENDELL STREET GALLERY 617.864.9294
17 Wendell St., Cambridge 02138
Hours: Call For Open Hours
Contact: Constance Brown, Partner; Jane Shapiro, Partner
Specialty: Black artists

Artists Represented: Benny Andrews, Romare Bearden, Robert Freeman, Richard Yarde Works Available By: Emma Amos, Camille Billops, Elizabeth Catlett, Edward McCluney, Bryan McFarlane

MICHIGAN

BIRMINGHAM

FEIGENSON/PRESTON GALLERY 313.644.3955
796 N. Woodward Ave., Birmingham 48009
Hours: Tues-Sat 11-5
Contact: Mary Preston, Director
Specialty: Contemporary American painting, sculpture and drawing

Artists Represented: Joseph Bernard, Tom Bills, John O. Buck, James Chatelain, Michelle Oka Doner, Ted Lee Hadfield, Jane Hammond, David Kapp, Ruth Leonard, Ursula Von Rydingsvard Works Available By: Valerie Parks, James Stephens, John Yau

THE HALSTED GALLERY, INC. 313.644.8284
560 N. Woodward Ave., Birmingham 48009 FAX: 313.644.3911
Hours: Tues-Sat 10-5:30
Contact: Thomas Halsted, Director
Specialty: 19th- & 20th-Century photography

Artists Represented: Ansel Adams, Bill Brandt, Henri Cartier-Bresson, Imogen Cunningham, Edward Curtis, Peter Henry Emerson, Walker Evans, Michael Kenna, Joel Meyerowitz, Herb Ritts, Edward Weston, Max Yavno

O.K. HARRIS WORKS OF ART 313.433.3700
430 N. Woodward Ave., Birmingham 48009 FAX: 313.433.3702
Hours: Tues-Sat 11-6
Contact: David Klein, Director
Specialty: Contemporary American art

Artists Represented: Thomas Bacher, **Eugene Brodsky (See page 62)**, Mariano Del Rosario, Rebecca Fagg, Gary Jacobson, Sook-Jin Jo, Aris Koutroulis, Nicholas Maravell, Joseph Richards Works Available By: James Del Grosso, John Fawcett, David Furman, Vladimir German, Bruce Helander, Leonard Koscianski

SUSANNE HILBERRY GALLERY 313.642.8250
555 S. Woodward, Birmingham 48009 FAX: 313.642.9039
Hours: Tues-Sat 11-6
Contact: Susanne Feld Hilberry, Owner/Director
Specialty: Contemporary American painting and sculpture

Artists Represented: Richard Artschwager, Lynda Benglis, John Egner, Roni Horn, Alex Katz, Nancy Mitchnick, Gordon Newton, Judy Pfaff, Ellen Phelan, Richard Rezac, Italo Scanga, Joel Shapiro, Keith Sonnier, John Torreano, Beatrice Wood

HILL GALLERY 313.540.9288
163 Townsend St., Birmingham 48009 FAX: 313.540.6965
Hours: Tues-Sat 11-5:30
Contact: Pamela Hill, Director; Timothy Hill, Director
Specialty: 20th-Century American sculpture and painting,
19th--century American folk art

Artists Represented: Larry Cressman, Richard De Vore, Mark Di Suvero, Heide Fasnacht, Glenn Goldberg, Michael Hall, Michael Heizer, Carol Hepper, Alfred Leslie, Richard Nonas, Sandra Osip, Joseph Wesner

ROBERT KIDD GALLERY 313.642.3909
107 Townsend St., Birmingham 48009
Hours: Tues-Sat 10:30-5:30

LEMBERG GALLERY 313.642.6623
538 N. Woodward Ave., Birmingham 48009 FAX: 313.642.6628
Hours: Tues-Sat 11-5:30
Contact: Corrine Lemberg, Director
Specialty: Contemporary paintings, sculpture and graphics

Artists Represented: Harold Allen, William Antonow, Douglas Bulka, Todd Erickson, Steven Murakishi, James Rutkowski, Robert Schefman, Doug Semivan, Electra Stamelos Works Available By: Christo, Jim Dine, Eric Fischl, Sam Francis, T.L., Solien, Steven Sorman, Robert Stackhouse

DONALD MORRIS GALLERY 313.642.8812
105 Townsend St., Birmingham 48009 FAX: 313.642.3968
Hours: Tues-Sat 10:30-5:30
Contact: Florence M. Morris, Director; Donald Morris, Director

G.R. N'NAMDI GALLERY 313.642.2700
161 Townsend, Birmingham 48009
Hours: Tues-Sat 11:00-5:30
Contact: George R. N'namdi, Owner

Artists Represented: Emanoel Araujo, Nanette Carter, Perez Celis, Ed Clark, Herbert Gentry, Richard Hunt, Alvin Loving, Allie McGhee, Jean Miotte, Tyronne Mitchell, Howardena Pindell, Faith Ringgold, Bill Sanders, Vincent Smith, Jack Whitten Works Available By: Romare Bearden, Jacob Lawrence

PIERCE STREET GALLERY 313.646.6950
217 Pierce St., Birmingham 48009
Hours: Wed-Sat 12-5
Contact: Elaine Yaker, Director
Specialty: 20th-Century photography

Artists Represented: Ruth Bernhard, Lynn Geesaman, Lois Greenfield, O. Winston Link, Denny Moers, Bill Rauhauser

XOCHIPILLI GALLERY 313.645.1905
568 N. Woodward Ave., Birmingham 48009 FAX: 313.646.3873
Hours: Tues-Sat 11-5
Contact: Mary C. Wright, Director; Lisa Konikow, Manager
Specialty: Contemporary American artists

Artists Represented: Susan Aaron-Taylor, Allen Berke, Dewey Blocksma, Maggie Citrin, Claudia De Monte, Rita Dibert, Jerome Ferretti, Stephen Goodfellow, Stephen Hansen, Robert Jacobson, Don Jacot, Michael Joseph, Edward Levine, Bruce McCombs, Sheila Ruen, John Tormey, Richard Tucker, Doug Warner, Ellen Wilt

STILL-ZINSEL CONTEMPORARY
504.588.9999
328 Julia St., New Orleans 70130 FAX: 504.588.9900
Hours: Mon-Sat 10-5
Contact: Sam Still, Co-Director; Suzanne Zinsel, Co-Director
Specialty: Contemporary paintings, sculpture, photography, and works on paper

Artists Represented: Wayne Amedee (See page 302), Laura Brenholtz-Gipson, Gerald Cannon, **Judith Cooper (See page 381),** Linda Dautreuil, Rob Erdle, William M. Fegan, Jason Guynes, John A. Hamilton, **Ronna S. Harris (See page 128), Bill Iles (See page 138), Heather Ryan Kelley (See page 140),** Robert R. Landry Jr., John H. Lawrence, May H. Lesser, Douglas James MacCash, Evelyn Menge, Daniel Piersol, Walter E. Rutkowski, Gregory B. Saunders, Mark S. Smith, John Stennett, Jan Thompson, Hasmig Vartanian, Margi Wier, Emily Wilson

TILDEN-FOLEY GALLERY
504.897.5300
4119 Magazine St., New Orleans 70115 FAX: 504.895.4751
Hours: Tues-Sat 10-6
Contact: Timothey A. Foley, Director
Specialty: 19th- & 20th-Century contemporary art (American and European).

Artists Represented: Adrienne Anderson, Lynda Benglis, Jacqueline Humphries, Molly Mason, Victor Matthews, Eric Orr, Randall Schmit, Hunt Slonem, Keith Sonnier **Works Available By** Walter Anderson, Fritz Bultman, Manierre Dawson, Sam Glankof

MARYLAND

BALTIMORE

C. GRIMALDIS GALLERY
301.539.1080
1006 Morton St., Baltimore 21201
Hours: Tues-Sat 10-5
Contact: Constantine Grimaldis, Director
Specialty: Contemporary American and European art

Artists Represented: Salvador Bru, Anthony Caro, Henry Coe, Joel Fisher, **Grace Hartigan (See page 129),** Eugene Leake, John McCarty, Leland Rice, John Ruppert, Wade Saunders, Joseph Sheppard, Jonathan Silver, John Van Alstine **Works Available By:** John Baldessari, Gunther Forg, Jene Highstein, Cristina Iglesias, Barbara Kassel, Mel Kendrick, Ulrich Ruckriem, Jim Sanborn, Jan Vercruysse

MASSACHUSETTS

BOSTON

AKIN GALLERY
617.426.2726
207 South St., Boston 02111
Hours: Tues-Sat 10:30-6
Contact: Alison Akin Righter, Owner/Director
Specialty: Contemporary art in all media by Boston-based artists

Artists Represented: Jocelyn Ajami, Ellen Banks, Thaddeus Beal, George Creamer, Stephen Dirado, Judy Haberl, Bob Lewis, Denise Marika, Lynda Ray, Wellington Reiter, Johnnie Ross, John B. Stockwell, Randal Thurston, Nan Tull

ALPHA GALLERY
617.536.4465
121 Newbury St., Boston 02116 FAX: 617.536.5695
Hours: Tues-Sat 10-5:30
Contact: Joanna E. Fink, Director; Alan Fink, Director
Specialty: Contemporary American and European art; modern master prints

Artists Represented: Milton Avery, T. Wiley Carr, **Bernard Chaet (See page 70), Aaron Fink (See page 102),** Melissa Johnson, David Kapp, Gyorgy Kepes, Yanick Lapuh, Elizabeth Mayor Jim McShea, Anne Neely, Scott Prior, Barnet Rubenstein, Richard Sheehan, Barbara Swan **Works Available By:** Max Beckmann, Therese Oulton, Pablo Picasso, Fairfield Porter, Michael Singer, Henri de Toulouse-Lautrec, John Walker, Robert Wilson

ARDEN GALLERY
617.247.0610
129 Newbury St., Boston 02116 FAX: 617.643.4848
Hours: Tues-Fri 10-5:30; Sat 11-5
Contact: Hope Turner, Director
Specialty: Abstractionists, pattern painters and contemporary realists

Artists Represented: Sally Bishop, Norma Bossouet, Paula Clendenin, Scott Duce, Frank Faulkner, Cheryl Goldsleger, Charles Jupiter Hamilton, Edward Lee Hendricks, Vytas Sakalas, George Snyder, James Yohe **Works Available By:** Josef Albers

RANDALL BECK GALLERY
617.266.2475
225 Newbury St., Boston 02116
Hours: Tues-Sat 10-6; Sun 12-5
Contact: Kelly Barrette, Owner
Specialty: Contemporary works on paper and paintings

Artists Represented: Susan Bush, Diana Gonzales Gandolfi, Jennifer Milton, Katja Oxman, Lonny Schiff, Carol Summers **Works Available By:** Robert Delaunay, Jim Dine, Helen Frankenthaler, Roy, Lichtenstein, Joan Miro, Henry Moore, Robert Motherwell, Claes Oldenburg, Philip Pearlstein, Neil Welliver

MARIO DIACONO GALLERY
617.695.2933
207 South St., Boston 02111 FAX: 617.695.2995
Hours: Tues-Sat 12-5
Contact: Mario Diacono, Director

GALLERY NAGA
617.267.9060
67 Newbury St., Boston 02116
Hours: Tues-Sat 10-5:30
Contact: Mary J. Olmsted, Asst. Director
Specialty: Contemporary painting, sculpture, prints and studio furniture

Artists Represented: Joseph Barbieri, David Brody, Sam Earle, Robert Ferrandini, James Gemmill, Rosemary Gilroy, Pier Gustafson, George Hagerty, Lorie Hamermesh, Alan Klein, David Palmer, Paul Rahilly, Peter Rappoli, Henry Schwartz, Peter Scott, Robert Siegelman, Brenda Star, Ed Stitt, Irene Valincius, Suzanne Vincent, Cheryl Warrick, Michael B. Wilson

GENOVESE GALLERY ANNEX
617.426.2062
195 South St., Boston 02111 FAX 617.423.3718
Hours: Tues-Sat 10-5:30
Contact: Camellia Sullivan, Owner/Director
Specialty: Contemporary art

GENOVESE GALLERY
617.426.9738
535 Albany St., Boston 02111
Hours: Tues-Sat 10-5:30
Contact: Camellia Sullivan, Owner/Director
Specialty: Contemporary art

Artists Represented: Frank Bosco, Virginia Brennan, **Calvin Brown (See page 63),** Jeffrey Michael Catalano, Max Gimblett, Jake Grossberg, Julia Kidd, Nancy Lorenz, Maura Robinson, Kelly Spalding, David Sullivan, Jay Swift, Jeffrey Wallace, Hannah Wilke

THE GOLDEN GALLERY
617.247.8889
207 Newbury St., Boston 02116 FAX: 617.247.0990
Hours: Mon-Fri 10-5; Sat 10-6; Sun 12-4
Contact: James Golden, Director
Specialty: Contemporary masters prints

Works Available By: Richard Diebenkorn, Jim Dine, Helen Frankenthaler, David Hockney, Jasper Johns, Alex Katz, Roy Lichtenstein, Robert Motherwell, Claes Oldenburg, Larry Rivers, James Rosenquist, Sean Scully, Frank Stella, Wayne Thiebaud

GROHE GLASS GALLERY
617.227.4885
24 North St., Dock Sq., Boston 02109 FAX: 508.539.0509
Hours: Mon-Thurs 10-8; Fri-Sat 10-9; Sun 12-5
Contact: Erin Huggard, Director
Specialty: Contemporary glass art

Artists Represented: Robert Bellucci, Irene Frolic, page Hazlegrove, David Hopper, Jon Kuhn, Tom Patti, Paul Stankard, Hiroshi Yamano **Works Available By:** Harvey K. Littleton, Mark Peiser

THE HARCUS GALLERY
617.262.4445
210 South St., Boston 02111 FAX: 617.451.3221
Hours: Tues-Sat 9-5:30
Contact: Portia Harcus, Director
Specialty: Post-World War II paintings, sculpture, prints, and photographs

Artists Represented: Carol Anthony, Fletcher Benton, Anthony Caro, James Ford, Tobi Kahn, Joel Meygrowitz, Keith Milow, George Nick, Carl Palazzolo, John Seery, Susan Shatter, Pat Steir, Neil Welliver, Robert Zakanitch **Works Available By:** Suzanne Caporael, Louisa Chase, Hans Hofmann, Alex Katz, Lee Krasner, Joan Mitchell, Robert Motherwell, Jules Olitski, Frank Stella, John Walker

ROBERT KLEIN GALLERY
617.482.8188
207 South St., Boston 02111 FAX: 617.482.5077
Hours: Tues-Fri 10-5:30; Sat 12-5
Contact: Robert Klein, Owner
Specialty: 19th- & 20th-Century photographic masterworks

Artists Represented: Lucien Aigner, Richard Avedon, Carl Chiarenza, Mario Giacomelli, Anton Grassl, Jock Levitt Helen, O. Winston Link, Sheila Metzner, Jeffrey Silverthorne, Ralph Steiner, George Tice, John Woolf **Works Available By:** Berenice Abbott, Ansel Adams, Diane Arbus, Eugene Atget, Eduoard-Denis, Baldus Brassai, Peter Henry Emerson, Robert Frank, J.B. Greene, Lewis Hine, Heinrich Kuhn, Gustave Le Gray, Charles Marville, Charles Negre, Paul Outerbridge, Irving Penn, Man Ray, George Seeley, W. H. F. Talbot, Edward Weston, Clarence White

BARBARA KRAKOW GALLERY
617.262.4490
Ten Newbury St., 5th Fl., Boston 02116 FAX: 617.262.8971
Hours: Tues-Sat 10-5:30
Contact: Barbara Krakow, Director

LEVINSON KANE GALLERY
617.247.0545
14 Newbury St.Boston 02116 FAX: 617.247.3096
Hours: Tues-Sat 10-5:30
Contact: June Levinson; Barbara Kane
Specialty: Contemporary art in all media by emerging and established American and European artists

Artists Represented: James Aponovich, Stanley Boxer, **Alfred DeCredico (See page 85),** Martha Diamond, Lawrence Gipe, Charles Grigg, Dimitri Hadzi, Duane Hanson, Gerold Hirn, Elizabeth Johansson, Oleg Kudryashov, Michael H. Lewis, James Linehan, Bruce Monteith, John Moore, Carol S. Pylant, Cora Roth, Harriet Shorr, Adam Strauss, Samuel Tager, Christian Walker, Jody Zellen **Works Available By:** Mel Bochner, Richard Estes, Sam Francis, David Hockney, Per Kirkeby, Malcolm Morley, Robert Motherwell, James Rosenquist, Donald Sultan

ILLINOIS (cont.)

EVANSTON

SYBIL LARNEY GALLERY 312.829.3915
733 Lincoln, Evanston 60607
Hours: By Appt Only

RICHARD MILLIMAN FINE ART 708.328.3232
3309 Central, Evanston 60201 FAX: 708.328.8802
Hours: By Appt
Contact: Richard Milliman, Director
Specialty: Contemporary prints and works on paper.

Artists Represented: Carlos Gonzalez, Ito Handoku, Tim High, Yuji Hiratsuka, Wayne Kimball, Masaaki Noda, Scott Sandell, Zdzislaw Sikora, Jean Pierre Tanguy

KANSAS

WICHITA

VALHALLA GALLERY 316.683.1131
6130 E. Central, #123, Wichita 67208
Hours: Mon-Fri 10-5:30; Sat 12-5
Contact: Tom Messman, Director

Artists Represented: Jasper D'Ambrosi, Doug Dawson, Gary Kahle, Ramon Kelley, Mario Kontny, P.A. Kontny, Lee Simpson, George Tate, Zhang Wen, Xin

LOUISIANA

NEW ORLEANS

ARTIST'S SHOWROOM 504.566.7418
612 Dumaine St., New Orleans 70116 FAX: 504.566.1088
Hours: Wed-Sun 11-5:30
Contact: Alice Barry, Director
Specialty: Southern impressionist oil paintings

Artists Represented: James D. Gilbert, Dan Girourd, Adolf Kroengold, Marylou Liberty, Charles Richards, Sam Rigling, Lacey Stinston, Jean Warner

CASELL GALLERY 504.524.0671
818 Royal St., New Orleans 70116
Hours: Daily 10-6
Contact: Janice Bezervkov, Art Director
Specialty: Pastels

Artists Represented: Joachim Casell

MERRILL B. DOMAS INDIAN ART 504.586.0479
824 Chartres St., New Orleans 70116
Hours: Tues-Sat 11-5
Contact: Merrill Domas, Director
Specialty: Antique and contemporary Native American art

Artists Represented: Effie Garcia, Kaniatobe, Dwayne Maktima, Dan, Townsend

GALERIE SIMONNE STERN 504.529.1118
518 Julia St., New Orleans 70130 FAX: 504.525.7030
Hours: Mon By Appt; Tues-Fri 10-5; Sat 11-4
Contact: Donna C. Perret, Director
Specialty: Fine contemporary paintings, sculpture, photography and master prints

Artists Represented: Peter Alexander, Randy Asprodites, Ron Bechet Jr, Fletcher Benton, Jim Bird, Gary Brotmeyer, Frances De La Rosa, George Dunbar, Frank Fleming, Doyle Gertjejansen, Sam Gilliam, Christopher, Guarisco, Simon Gunning, Richard Johnson, Fernando La Rosa, Ronnie Landfield, James McGarrell, Harold Reddicliffe, Stan Rice, Jeanne Rovegno, John Scott, Arthur Silverman, Pat Trivigno

GALERIE ROYALE, LTD. 800.582.9351
312 Royal St., New Orleans 70130 FAX: 504.523.1588
Hours: Sun-Thur 10-7; Fri-Sat 10-10
Contact: Bob Crutchfield, Administrator
Specialty: Contemporary originals and graphics

Artists Represented: Michel Delacroix, Erte, Melanie Taylor Kent, Thomas McKnight, G. H. Rothe, Wong Shue, William Tolliver **Works Available By:** Romare Bearden, Alexander Calder, Joan Miro, Claes Oldenburg, Larry Poons, Frank Stella

A GALLERY FOR FINE PHOTOGRAPHY 504.569.1313
313 Royal St., New Orleans 70130
Hours: Daily 10-6
Contact: Joshua Mann Pailet
Specialty: Rare 19th- & 20th-Century photographs

Artists Represented: Ansel Adams, Paul Caponigro, Henri Cartier-Bresson, Edward Curtis, Birney Imes, Helmut Newton, Wendi Schneider, Jerry Uelsmann **Works Available By:** Walker Evans, Edward Steichen, Alfred Stieglitz, Edward Weston

GASPERI GALLERY 504.524.937
320 Julia St., New Orleans 70130
Hours: Tues-Sat 10-5
Contact: Richard Gasperi, Director
Specialty: Contemporary fine art; folk/outsider art

Artists Represented: Andrew Bascle, Jacqueline Bishop, David Butler, Howard Finster, Ann Hornback, Clementine Hunter, Jade Jewett, Patricia Kaschalk, Dona Lief **Works Available By:** Gertrude Morgan, Jimmy Lee Sudduth, Mose Tolliver, Willie White

HALL-BARNETT GALLERY 504.525.565
320 Exchange Alley, New Orleans 70130 FAX: 504.525.443
Hours: Mon-Sat 10-5
Contact: Vesta Deyampert, Asst. Director
Specialty: Specializes in emerging and established regional artists

Artists Represented: Ronnie Boudreaux, Jeffrey Cook, Chuck Crosby, Rebecca Dugas, Martin Humphreys, Glenn Kennedy, Sharon Kopriva, Bryan Mavor, William Montgomery, Melissa Smith, Setchie Smith **Works Available By:** Jan Gilbert, Rosemary Goodell, Libby Johnson, Lynn Katsafouras, Beth Lambert

LEMIEUX GALLERIES 504.565.535
332 Julia St., New Orleans 70130
Hours: Tues-Fri 10-5:30; Sat 11-4 And By Appt
Contact: Denise Berthiaume, Director
Specialty: Louisiana and "third coast" contemporary artists

Artists Represented: Tom Cramer, David Duncan, Mary Lee Eggart, Jay Etkin, David Lambert, Kathleen Lemoine, Kathleen Sidwell, Howard Smith, Leslie Smith

CARMEN LLEWELLYN GALLERY 504.891.530
621 Decatur St., New Orleans
Hours: Wed-Sat 11-5 And By Appt
Contact: Carmen Llewellyn, Director

WYNDY MOREHEAD FINE ARTS 504.568.975
603 Julia St., New Orleans 70130
Hours: Mon-Fri 10-5:30; Sat 11-4
Contact: Wyndy Morehead, Owner
Specialty: Contemporary paintings, drawings, sculpture, ceramics, and photography by established and emerging artists

Artists Represented: Frank Barham, **Paul Dominey (See page 92)**, Jim Giampaoli, Stephen Maxwell Gibson, Tony Green, Marilee Hall, Louise Hopson, Karen Jacobs, William Lewis, Linda Lighton, Myles Maillie, Wallace Merritt, Phyllis, Parun, Banister Pope, George Schmidt, Julia Sims

MARGUERITE OESTREICHER FINE ARTS 504.581.925
636 Baronne St., New Orleans 70113 FAX: 504.524.743
Hours: Tues-Sat 10-5
Contact: Marguerite Oestreicher, Owner/Director
Specialty: Contemporary paintings, sculpture and photography

Artists Represented: Sylvain Fornaro, Zella Funck, **William K. Greiner (See page 387)**, Martin Laborde **Works Available By:** Gregory Amenoff, James Ford, Roshan Houshmand, May H. Lesser, Michael Manjarris, Carl Palazzolo, George Snyder, Ralph Wickiser, Rob Wynne

RODRIGUE GALLERY OF NEW ORLEANS 800.899.424
721 Royal St., New Orleans 70116
Hours: Daily 10-6
Contact: Richard Steiner, Director
Specialty: A one-artist gallery devoted to George Rodrigue

Artists Represented: George Rodrigue (See page 201)

ARTHUR ROGER GALLERY 504.522.199
432 Julia St., New Orleans 70130 FAX: 504.522.699
Hours: Tues-Sat 10-5
Contact: Arthur Roger, Director
Specialty: Contemporary paintings, sculpture, photographs, and works on paper

Artists Represented: David Bates, Dub Brock, Dale Chihuly, Roy De Forest, George Dureau, Lin Emery, Ersy, Tina Freeman, Ida Kohlmeyer, Elemore Morgan, Francis Pavy, Francie Rich, Dan Rizzie, Steve Sweet, Terry Weldon

SYLVIA SCHMIDT GALLERY 504.522.200
400 A Julia St., New Orleans 70124 FAX: 504.885.874
Hours: Mon-Fri 10-5; Sat 11-4
Contact: Sylvia Schmidt, Director
Specialty: Contemporary paintings, sculpture and works on paper

Artists Represented: Jere Barnard, Ronald Cohen, Dennis Farber, Mark Grote, John Opie, Martin Payton, Maria Scotti, Robert Warrens **Works Available By:** James Butler, Jo Anne Carson, Peter Charles, Merridth Day, Nancy Elkins, Sujata Gopalan, Joseph Haske, Christopher Johns, Edward Pramuk, Christine Sauer, Paul Tarver, Paulette Whiteman, Patricia Whitty

PRINCE GALLERIES 312.266.9663
357 W. Erie St., Chicago 60610
Hours: Mon-Sat 10:30-5:30
Contact: Arnold Besse, Manager
Specialty: Realism by Chicago artists

Artists Represented: Herbert Davidson, Winifred Godfrey, George Lundeen, William Nelson, Irving Shapiro, Kent Ullberg, Charles Vickery, Gary, Weisman

ROGER RAMSAY GALLERY 312.337.4678
212 W. Superior St., Ste. 503, Chicago 60610
Hours: Tues-Sat 10-6

RATNER GALLERY 312.944.8884
750 N. Orleans, Ste. 403, Chicago 60610
Hours: Tues-Fri 10-5; Sat 11-5
Contact: Alison Weirick Edelstein, Director

REZAC GALLERY 312.751.0481
301 W. Superior St., 2nd Fl., Chicago 60610
Hours: Tues-Sat 11-5:30

J. ROSENTHAL FINE ARTS, LTD. 312.642.2966
230 W. Superior St., Chicago 60610 FAX: 312.642.5169
Hours: Tues-Fri 10-6; Sat 11-5
Contact: Dennis Rosenthal, Owner
Specialty: 20th-Century modern and contemporary international uniques and multiples

Artists Represented: Arman (See page 303), Christo (See page 264), Manon Cleary (See page 73), John Deom (See page 87), Martha Mayer Erlebacher (See page 99), Drew Gregory (See page 119), Sacha Sosno (See page 294) **Works Available By:** Josef Albers, Norman Bluhm, Alexander Calder, Lynn, Chadwick, Chuck Close, Willem de Kooning, Richard Diebenkorn, Jim Dine, Eric Fischl, Janet Fish, Sam Francis, Red Grooms, Keith Haring, David, Hockney, Hans Hofmann, Robert Indiana, Jasper Johns, Barbara Kruger, Roy, Lichtenstein Richard Lindner, Noel Mahaffey, Robert Mapplethorpe, Henri Matisse, Joan Miro, Robert Motherwell, Claes Oldenburg, Jules Olitski, Philip Pearlstein, Pablo Picasso, Martin Puryear, Robert Rauschenberg, Larry Rivers, Marc Rosenquist, Ed Ruscha, Frank Stella, Wayne Thiebaud, Mark Tobey, Andy Warhol, Tom Wesselmann

BETSY ROSENFIELD GALLERY 312.787.8020
212 W. Superior St., Chicago 60610 FAX: 312.787.8069
Hours: Tues-Fri 10-5:30; Sat 11:00-4:30
Contact: Betsy Bergman Rosenfield, Owner
Specialty: Contemporary painting, sculpture, drawings, photography, and studio glass

Artists Represented: Gregory Amenoff, Don Baum, Nancy Bowen, William Carlson, Louisa Chase, Dale Chihuly, Peggy Cyphers, Alfred Decredico, Victoria Faust, Jack Gilbert, Robert Greene, Jan Groover, Lillian Heard, Roberto Juarez, David Kroll, Kevin Larmon, Li Lin Lee, Robert Mapplethorpe, William Morris, Robbin Murphy, Sabina Ott, Chris Pfister, Joseph Piccillo, Wade Saunders, Italo Scanga, Peggy Shaw, Karla Trinkley, Nelson Valentine, Bertil Vallien, Thomas Woodruff, Andrew Young

ESTHER SAKS GALLERY 312.751.0911
311 W. Superior St., Chicago 60610
Hours: Tues-Sat 10-5; Thurs 10-9
Contact: Esther Saks, Director
Specialty: Contemporary paintings, works on paper, sculpture, and ceramics

Artists Represented: Bennett Bean, Jim Bird, Christine Federighi, John Ford, Tony Hepburn, Katie Kahn, Michael B. Lewis, Daniel Rhodes, Pia Stern

SAZAMA GALLERY 312.951.0004
300 W. Superior St., Chicago 60610
Hours: Tues-Sat 10-5
Contact: Susan Sazama, Director

MARTHA SCHNEIDER GALLERY 708.433.4420
230 W. Superior St., Chicago 60610
Hours: Tues-Sat 10-4

SCHNEIDER-BLUHM-LOEB 312.988.4033
230 W. Superior, Chicago 60610
Hours: Tues-Sat 10:30-5
Contact: Martha Schneider, Director
Specialty: Ceramics, jewelry and fiber

Artists Represented: Dan Anderson, Carolyn Morris Bach, Katherine Blacklock, Everette Busbee, Rose Cabat, Tom Coleman, Patrick Crabb, David Crane, Val Cushing, John Glick, Robly Glover, Tim Harding, Anne Hirondelle, Curtis Hoard, Mary Lee Hu, Karen Karnes, Yih-Wen Kuo, Micki Lippi, Paul Mathieu, Richard Mawdsley, Tod Pardon, Don Reitz, Lucie Rie, David Shaner, Robert Sperry, Susanne Stephenson, Gretchen Wachs

LLOYD SHIN GALLERY 312.752.5200
301 W. Superior St., Chicago 60610 FAX: 312.943.3893
Hours: Tues-Sat 9-6
Contact: Lloyd Shin, President
Specialty: American and international contemporary art

Works Available By: Pierre Alechinsky, Zhou Brothers, Sandro Chia, Eduardo Chillida, Christo, Jim Dine, Wilhelm Holderied, Jesse Holmes, Eric Maakestad, Alvin Paige, Mimmo Paladino, A.R. Penck, Robert Rauschenberg, James Rosenquist, Antoni Tapies, Zao Wou-Ki

STEPHEN SOLOVY FINE ART 312.664.4860
620 N. Michigan, Ste. 520, Chicago 60611 FAX: 312.664.6726
Hours: Tues-Sat 10-5:30
Contact: Stephen Solovy
Specialty: Modern and contemporary masters; paintings, sculpture, drawings and prints

Artists Represented: David Olivant **Works Available By:** John Cage, Willem de Kooning, Arshile Gorky, Howard Hodgkin, Donald Judd, Robert Longo, Morris Louis, Brice Marden, Henry Moore, Jackson Pollock, Robert Rauschenberg, Sean Scully

SAMUEL STEIN FINE ARTS, LTD. 312.337.1782
620 N. Michigan Ave., Ste. 340, Chicago 60611
Hours: Tues-Fri 10-5:30; Sat 10:30-5

STRUVE GALLERY 312.787.0563
309 W. Superior St., Chicago 60610 FAX: 312.787.7268
Hours: Mon-Fri 10-5:30; Sat 11-5
Contact: William Struve, Director; Deborah Struve, Director
Specialty: 20th-Century American and Soviet art

Artists Represented: Keith Achepohl, Robert Arneson, George Atkinson, Robert Barnes, William Barron, Byrone Brown, Grisha Bruskin, James Butler, Roy De Forest, Burgoyne Diller, Jane E. Fisher, Neil Goodman, Wesley Kimler, Kathryn Myers, Didier Nolet, Boris Orlov, Dmitri Prigov, Rolph Scarlett, John Sennhauser, Michelle Stone, Tom Uttech, Bill Vuksanovich, William T. Wiley, James Winn **Works Available By:** Duane Hanson

THE NEW VAN STRAATEN GALLERY 312.642.2900
742 N. Wells St., Chicago 60610 FAX: 312.642.5693
Hours: Tues-Sat 9-5
Contact: William Van Straaten; Jan Van Straaten
Specialty: Contemporary master prints

Artists Represented: Jennifer Bartlett, Richard Haas, Jasper Johns, Sol LeWitt, Robert Rauschenberg, Robert Ryman, Sean Scully, Terry Winters

MARIO VILLA/CHICAGO 612.338.8052
500 N. Wells St., Chicago 60610
Contact: Margie Benjamin, Director

RUTH VOLID GALLERY 312.644.3180
225 W. Illinois Ave., Chicago 60610 FAX: 312.644.3210
Hours: Mon-Fri 9-5; Sat 12-5
Contact: Ruth Volid, President
Specialty: Artwork and commissions in all media

Artists Represented: Ulla Mae Berggren, Berit Engen, Robert Gadonski, Larry Horowitz, Edmond Kanwischer, Kathleen Mulcahy, Florence Putterman, Russell Thayer, Rein Vanderhill

WORTHINGTON GALLERY 312.266.2424
620 N. Michigan Ave., Chicago 60611 FAX: 312.266.2461
Hours: Tues-Sat 10-5
Contact: Eva-Maria Worthington, President
Specialty: German Expressionism, blauer reiter, contemporary art

Artists Represented: Uwe Bangert, Klaus Fussmann, Horst Janssen, Marc, Velten

ZAKS GALLERY 312.943.8440
620 N. Michigan Ave., Ste. 305, Chicago 60611
Hours: Tues-Fri 11-5:30; Sat 12-5
Contact: Mrs. Sonia Zaks, Director
Specialty: Contemporary American paintings and sculptures

Artists Represented: Andrew Arvanetes, Mike Baur, Alan Crockett, Donna Essig, Bella T. Feldman, Moira Marti Geoffrion, Thomas Jewell-Vitale, Paul Lamantia, Philip Livingston, Lucy, Ben Mahmoud, Robert Mckibbin, Bob Middaugh, Jack Olson, Wayne Paige, Bradley Petersen, Jerry Savage, David Sharpe, Doug Shelton, Sylvia Sleigh, Eleanor Speiss-Ferris, Joan Taxey-Weinger, Bruce Thayer, Richard Wetzel, Richard Willenbrink **Works Available By:** John Flynn, Linda Freel, Dennison Griffth, Tim Hahn, Richard Hanson, Elizabeth Lewis, Bill Willers

ZOLLA/LIEBERMAN GALLERY 312.944.1990
325 W. Huron St., Chicago 60610 FAX: 312.944.8967
Hours: Tues-Fri 10-5:30; Sat 11-5:30
Contact: Roberta Lieberman; Robert Zolla
Specialty: Contemporary paintings and sculpture

Artists Represented: Christopher Brown, John Buck, Deborah Butterfield, Jane Hammond, Michael Nakoneczny, Helen O'Leary

ILLINOIS *(cont.)*

CHICAGO

KLEIN ART WORKS 312.243.0400
400 N. Morgan, Chicago 60622 FAX: 312.243.6782
Hours: Tues-Sat 10-5:30; Sun 12-4
Contact: Paul Klein, President; Judith Simon, Director
Specialty: Contemporary abstraction: paintings, sculpture, works on paper

Artists Represented: Charles Arnoldi, Jesus Bautista Moroles, Raye Bemis, James Bruss, Chuichi Fujii, Josh Garber, Sam Gilliam, Misha Gordin, Jesse Hickman, Ken Horii, Glenn Jampol, Jun Kaneko, Jacqueline Kazarian, Michael Kessler, Dean Langworthy, Stephen Pevnick, Les Sandelman, Steven Sorman, Michael Todd

LANNON COLE GALLERY 312.951.0700
365 W. Chicago, Chicago 60610 FAX: 312.951.8797
Hours: Tues-Sat 10-6
Contact: Marilu Lannon, Owner/Director
Specialty: American and European contemporary artists

Artists Represented: Curtis Bartone, Arlene Becker, Michelle Grabner, Anita Javasova, Brad Killan, Kim Soren Larsen, Linda Lee, Joseph Letitia Lupus, Todd Parola, Laura Plansker, Bill Rock, Peter Rosenbaum, Tom Scarff, Ted Stanuga **Works Available By:** Amanda Faulkner, Nicola Hicks, Peter Howson, John Kirby, David Mack

ROBBIN LOCKETT GALLERY 312.649.1230
703 N. Wells St., Chicago 60610 FAX: 312.649.9159
Hours: Tues-Sat 10-6
Contact: Robbin Lockett, Owner/Director
Specialty: Contemporary American and European art

Artists Represented: Alan Belcher, Jennifer Bolande, David Cabrera, **Julia Fish (See page 104)**, Gaylen Gerber, Mary Heilmann, Georg Herold, Wendy Jacob, **Mitchell Kane (See page 290)**, Judy Ledgerwood, Stephen Prina, Michael Ryan, Joe Scanlan, Vincent Shine, Heimo Zobernig

NANCY LURIE GALLERY 312.337.2882
1632 N. LaSalle, Chicago 60614 FAX: 312.649.2280
Hours: Tues-Sat 12-5
Contact: Nancy Lurie, Owner/Director
Specialty: Contemporary American art

Artists Represented: Eric Bowman, Charlotte Cain, Renee Dubois, Linda Emmerman, Mark Forth, Chris Geoghegan, Lorri Gunn, George Horner, John Hull, Steve Keister, Sheila Klein, Mike Lash, Judith Linhares, Jim Mckenzie, Michael Norton, Patricia Patterson, Joan Rudolph, Elizabeth Schoonmaker, Frank Shaw, Joseph Sim, Mark Vanwagner

LYDON FINE ART 312.943.1133
203 W. Superior St., Chicago 60610 FAX: 312.943.8090
Hours: Tues-Sat 10-5:30
Contact: Douglas K. Lydon, Owner/Director
Specialty: Contemporary European and American artists

Artists Represented: Trevor Bell, Bertille De Baudiniere, Stephen Dinsmore, John Edgcomb, Pat Fairhead, Tim Hadfield, Joan Lyon, Genell Miller, Nancy Mitton, Fredrick J. Nelson, Gay Phillips, Charles Ringness, Debora Gilbert Ryan, Margaret Vega

MALBERT FINE ARTS 312.348.3543
521 Dickens Ave., Chicago 60614
Hours: By Appt
Contact: Maurice A. Alberti, Director
Specialty: European and American prints 1800-1960; Japanese woodblock prints 1750-1880

MARS GALLERY 312.226.7808
1139 W. Fulton Market, Chicago 60607
Hours: Thurs 5-9; Sat 1-5 Or By Appt
Contact: Barbara Gazdik, Owner
Specialty: Pop and outsider works in all media

Artists Represented: Chuck Crosby, Janet De Berge Lange, Len Harris, Peter Mars **Works Available By:** Clark Ellithorpe, Howard Finster, Billy Lemming

MARX GALLERY 312.464.0400
208 W. Kinzie St., Chicago 60610 FAX: 312.661.0657
Hours: Tues-Sat 10-5:30
Contact: Bonita Marx, Director
Specialty: Contemporary studio glass

Artists Represented: Gary Beecham, Kate Bernstein, William Bernstein, Vernon Brejcha, George Bucquet, Craig Campbell, Ken Carder, Michael David, Stephen Dale Edwards, Linda Ethier, Shane Fero, Mark Fowler, Lance Friedman, Dick Huss, Hugh Jenkins, Kit Karbler, Richard Lalonde, Robert Levin, John C. Littleton, Tim O'Neill, Michael A. Rogers, John, Seitz, Yaffa Sikorsky-Todd, Josh Simpson, Jeffrey M. Todd, Katherine E. Vogel, David Wilson, Karen Zoot Wolfe, Jon Wolfe **Works Available By:** Mark Abildgaard, Curtiss Brock, Robert Croy, Michael Jaross Ginger Kelly, Jon Kuhn, John Lewis, Paul Manners, Densaburo Oku, Stephen Skillitzi, Judi Weilbacher, Lewis Woodruff

PETER MILLER GALLERY 312.951.0252
401 W. Superior St., Chicago 60610
Hours: Tues-Fri 10-6; Sat 11-5
Contact: Peter Miller, Owner
Specialty: Contemporary American art

Artists Represented: Jodi Aeling, Scott Bell, Michael Brennan, Jackie Chang, Sharon Gilmore, Laurie Hogin, Carl Johnson, Kevin Landis, Walt Myers, Josh Simons, Chuck Walker

MONGERSON-WUNDERLICH 312.943.2354
704 N. Wells, Chicago 60610 FAX: 312.943.5805
Hours: Mon-Sat 9:30-5:30
Contact: Susan Wunderlich, Owner; Rudy Wunderlich, Owner
Specialty: 19th- & 20th-Century American western art

Artists Represented: Joe Beeler, Allen Blagden, Ken Bunn, John Steuart, Curry, Dan Gerhartz, Robert Henri, Doug Hyde, Ramon Kelley, Frederic Remington, Charles Russell, Thetaos School, Grant Speed

ISOBEL NEAL 312.944.1570
200 W. Superior St., Chicago 60610

PHYLLIS NEEDLMAN GALLERY 312.642.7929
1515 N. Astor St., Chicago 60610
Hours: Tues-Fri 9-4:30; Sat 12-5

NEVILLE-SARGENT GALLERY 312.664.2787
708 N. Wells St., Chicago 60610 FAX: 312.337.7472
Hours: Tues-Fri 11-5:30; Sat 10-5
Contact: Don Neville; Jane Neville
Specialty: Contemporary paintings, prints and sculpture

Artists Represented: Marge Allegretti, Jay Paul Bell, Rick Boschulte, **Glenn Bradshaw (See page 60)**, Lamar Briggs, Bruce Campbell, Brian Carroll, Reginald Coleman, William Dunlap, Susan Dunshee, Kathy Eaton, David Faber, Alan, Flattmann, Daniel Goldstein, Steve Gordon, David Hayes, William Houston, Joseph Hronek, Edwardo Iglesias, Carol Kardon, Donald Kerr, Peter, Kitchell, Aleah Koury, Donald Lake, Cristina Lazar, Katherine Liu, Stanley Marcus, Henry Maron, Louis Pearson, Werner Pfeiffer, Rudy Pozzatti, Tim Prentice, Stevie Kesner Ricks, Ken Ryden, Sally Schock, Eric Shaw, Arthur Silverman, Robert Striffolino, Margie Swift, Yuriko Takata, Von Der Goltz, John Weare, Lee Weiss, Derek Wernher, **Takeshi Yamada (See page 248)**

OBJECTS GALLERY 312.664.6622
230 W. Huron St., Chicago 60610 FAX: 312.664.9392
Hours: Tues-Fri 10-5:30
Contact: Ann Nathan, Director
Specialty: Contemporary sculpture; artist-made furniture; American and African textiles and antiques

Artists Represented: Ann Agee, Mary Bero, Mary Jo Bole, Gordon Chandler, Frank Fleming, Peter Gourfain, **Michael Gross (See page 329)**, Betye Saar, Stephen Whittlesey

NINA OWEN, LTD. 312.664.0474
212 W. Superior Street:, Chicago 60610
Contact: Audrey Owen, Director
Hours: By Appt Only
Specialty: Contemporary sculpture (large-scale, architectural sculpture)

Artists Represented: Roger Barr, Bill Barrett, Tom Doyle, Dan Dykes, John Henry, Jon Barlow Hudson, Bruce Johnson, Roslyn Mazzilli **Works Available By:** Bill Cooper, Dennis Jones, Robert Longhurst, Edward, McCullough, Fritz Olsen, Barry Tinsley

PERIMETER GALLERY, INC. 312.266.9473
750 N. Orleans St., Chicago 60610 FAX: 312.266.7984
Hours: Tues-Sat 10:30-5:30
Contact: Frank Paluch, Director
Specialty: Contemporary art

Artists Represented: Paul Caster, Warrington Colescott, John Colt, **Franz Gertsch (See page 269)**, Keiko Hara, Kathleen Holder, Shoichi Ida, Nathan Slate, Joseph John Wilde **Works Available By:** John Cage, Francesco Clemente, Enzo Cucci, Richard Diebenkorn, Eric Fischl, Alex Katz, Roy Lichtenstein, Markus Lupertz, Joan Mitchell, Odd Nerdrum, Steven Sorman, Robert Stackhouse, Gary Stephan, Wayne Thiebaud, James Turrell

MAYA POLSKY GALLERY 312.440.0055
311 W. Superior, Ste. 210, Chicago 60610 FAX: 312.440.0501
Hours: Tues-Sat 10-5
Contact: Maya Polsky, Owner; Eva Belavsky, Director
Specialty: Contemporary Soviet and American art

Artists Represented: Eteri Chradua-tuite, Yuris Dimiters, Vasily Kafanov, Vadim Kravets, Vladimir Muraviov, Natalya Nesterova, Leonid Pinchevsky, Leonid Purygin, Seymour Rosofsky, Sergei Sherstiuk, Vasily Shulzhenko, Alexander Zakharov

PORTALS LTD. 312.642.1066
230 W. Huron, Chicago 60610 FAX: 312.642.2991
Hours: Mon-Fri 9:30-4:30; Sat 11-4
Contact: Bill McIlvaine, Director; Nancy McIlvaine, Director
Specialty: Sophisticated naif and representational contemporary artists

Artists Represented: Fleur Cowles, Benjamin Dominguez, Ann Griffin-Bernstorff, Claude Harrison, Tracey Heyes, Maria Palatini, Tom Palmore, Lizzie Riches, Jaroslav Solc, Francoise Syx, Jennifer Taylor, James Tormey, Eduardo Ungar

GALERIE THOMAS R. MONAHAN 312.266.7530
301 W. Superior St., Chicago 60610 FAX: 312.266.8726
Hours: Tues-Fri 10:30-6; Sat 10:30-5
Contact: Thomas R. Monahan, Owner; Mary Kay Touhy, Director
Specialty: Modern and contemporary paintings, drawing and sculpture

Artists Represented: Valerio Adami, Carlos Aresti, J. Castagnozzi, Heriberto Cogollo, Saul Kaminer, Peter Klasen, Roberto Matta, Peter Saul, Rafael Soriano **Works Available By:** Roberto Barni, Sandro Chia, Claudio Olivieri

GALLERY ASTRA 312.664.6880
308 W. Erie St., Chicago 60610
Hours: Tues-Sat 10-5:30

GALLERY 1616 312.486.7942
1616 N. Damen Ave., Chicago 60647 FAX: 312.489.5266
Hours: By Appt; Sat-Sun 1-5
Contact: Vicky Tesmer, Director
Specialty: Emerging artists with distinct vision in their fields

Artists Represented: Jo Aerne, Elisabeth Condon, Joanna Janowski, Peter Janowski, Lisa Ross Miller, Anne Moreau, Douglass Phillips, Dom Southard, Vicky Tesmer **Works Available By:** Catherine Arnold, Euhnee Choe, Alberto Ferrari, William Malaris, Margot Mcmahon, Liz Strausse

KAY GARVEY GALLERY 312.440.0522
230 W. Superior, Chicago 60610
Hours: Tues-Sat 11-5; Thurs 11-7
Contact: Kay Garvey, Owner/Director
Specialty: Contemporary paintings, sculpture and construction

Artists Represented: Dirk De Bruycker, Dale Enochs, James Wille Faust, Jim Ferringer, Mike Helbing, David Jokinen, Robert Kingsley, William Masterson, Dominique Morel, Jacqueline Moses, Gail Roberts, Joel Sheesley, Susan Tennant, Alice White

GILMAN-GRUEN GALLERY 312.337.6262
226 W. Superior St., Chicago 60610
Hours: Mon-Sat 10-4:30
Contact: Bradley Lincoln, Director; Renee Sax, Director
Specialty: Contemporary painting and sculpture and African artifacts

Artists Represented: Erika Marija Bajuk, Tom Balbo, Morris Barazani, Lowell Boileau, Karen Butler, Lu Dickens, Tony Droege, Philip Dusenbury, Lee Grantham, Mary Hatch, Charles Herndon, Pat Hidson, Bob Novak, Tom Parish, Adair Peck, Catherine Perehudoff, Rex Sexton, Lamar Scott Smith, Audrey Ushenko, Michael Yankowski **Works Available By:** Frank Gallo, Rudolph Weisenborn

GOLDMAN KRAFT GALLERY 312.943.9088
300 W. Superior St., Chicago 60610
Hours: Tues-Fri 10-5; Sat 11-5
Specialty: Modern American and European art

Artists Represented: Rita Blitt, Gidon Graetz, Cathy Halsted, Lebevedov, Philip Soosloff

GRAYSON GALLERY 312.266.1336
833 N. Orleans St., Chicago 60610
Hours: Tues-Sat 10-5:30

RICHARD GRAY GALLERY 312.642.8877
620 N. Michigan Ave., Chicago 60611 FAX: 312.642.8488
Hours: Tues-Sat 10-5:30
Contact: Paul Gray, Director
Specialty: Modern and contemporary American and European art

Artists Represented: Magdalena Abakanowicz (See page 299), Jennifer Bartlett, The Boyle Family, **Suzanne Caporael (See page 68),** Anthony Caro, **Luciano Castelli, (See page 69)** Sam Francis, Nancy Graves, **Harold Gregor (See page 118),** Dimitri Hadzi, David Hockney, **David Klamen (See page 144),** Roy Lichtenstein, John Okulick, Mimmo Paladino, **Jerry Peart (See page 354),** George Segal, Antoni Tapies **Works Available By:** Alexander Calder, Joseph Cornell, Jose De Rivera, Willem de Kooning, JimDine, Jean Dubuffet, Alberto Giacometti, Anselm Keifer, Franz Kline, Fernand Leger, Joan Miro, Henry Moore, Louise Nevelson, Claes Oldenburg, Mark Rothko, Edouard Vuillard

CARL HAMMER GALLERY 312.266.8512
200 W. Superior St., Chicago 60610 FAX: 312.664.5472
Hours: Tues-Sat 10-6; Sun & Mon By Appt
Contact: Carl Hammer, Owner/Director
Specialty: Self-taught, Outsider art

Artists Represented: Lou Cabeen, Howard Finster, Tony Fitzpatrick, Lee Godie, Elliott Green, Mr. Imagination, S. L. Jones, Clifton Monteith, David Montgomery, Michel Nedjar, Michael Noland, David Sandlin, Rebecca, Shore, Jerry Smith, John Snyder, Simon Sparrow, Bill Traylor, Eugene Von Bruenchenhein, Joseph Yoakum

RHONA HOFFMAN GALLERY 312.951.8828
215 W. Superior St., Chicago 60610 FAX: 312.951.5274
Hours: Tues-Fri 10-5:30; Sat 11-5:30
Contact: Rhona Hoffman; Susan Reynolds
Specialty: American and European contemporary art

Artists Represented: Vito Acconci, Jo Baer, Dara Birnbaum, Louise, Bourgeois, **Pedro Cabrita Reis (See page 286 & 287),** Nancy Dwyer, Christian Eckart, Leon Golub, Richard Haas, Fariba Hajamadi, Peter Halley, Jene Highstein, Jenny Holzer, Donald Judd, Barbara Kruger, Wolfgang Laib, Annette Lemieux, Sol LeWitt, Donald Lipski, Robert Mangold, Gordon Matta-Clark, Allan McCollum, Tim Rollins + K.O.S., Robert Ryman, Cindy Sherman, Nancy Spero Haim Steinbach, Elaine Sturtevant, Tony Tasset, Richard Tuttle, Franz West, Claire Zeisler

JOY HORWICH GALLERY 312.787.0171
226 E. Ontario St., Chicago 60611
Hours: Tues-Sat 10-5:30
Contact: Joy Horwich, Owner/Director
Specialty: Contemporary paintings and sculpture by emerging artists

Artists Represented: T. Barny, Dan F. Howard, Marie-Laure Llie, Nancy, Kittredge, Rhonda Root, Gretchen Sigmund, James Smith, Nancy Steinmeyer

HOUK GALLERY 312.943.0698
200 W. Superior St., Ste. 306, Chicago 60610 FAX: 312.943.6494
Hours: Tues-Sat 10-5
Contact: Amelia Kennedy
Specialty: Vintage and contemporary photography

Artists Represented: Bill Brandt, Brassai, Henri Cartier-Bresson, Imogen Cunningham, Lee Friedlander, Andre Kertesz, Dorothea Lange, Sally Mann, Vernon Miller **Works Available By:** Berenice Abbott, Richard Avedon, Harry Callahan, Walker Evans, Robert Frank, Jan Groover, Lewis Hine, Robert Mapplethorpe, Irving Penn, Aaron Siskind

JANICE S. HUNT GALLERIES LTD 312.951.5213
207 W. Superior St., Chicago 60610
Hours: Mon-Sat 10-5

GWENDA JAY GALLERY 312.664.3406
301 W. Superior St., 2nd Fl., Chicago 60610
Hours: Tues-Sat 10:30-5
Contact: Gwenda Jay, President
Specialty: Contemprary painting, sculpture and architectural works

Artists Represented: Douglas Darden, Ellen Frank, **Richard Hunt (See page 330),** Thomas Rajkovich, Judith Raphael, Sam Richardson, Eric Shultis, **Paul Sierra (See page 217)** **Works Available By:** Helmet Jahn, Jim Morphesis, Stanley Tigerman

R.S. JOHNSON FINE ART 312.943.1661
645 N. Michigan Ave., Chicago 60611 FAX: 312.943.4450
Contact: James Van Linden, Director
Specialty: Important old masters; 19th- & 20th-Century prints, drawings, paintings and sculpture

Artists Represented: Michael Ayrton, Duilio Barnabe, Bela Czobel, Paul, Guiramand, Albert Zavaro **Works Available By:** Albrecht Durer, Francisco Goya, Fernand Leger, Pablo Picasso, Henri De Toulouse-Lautrec, Rembrandt Van Rijn, Jacques Villon

KASS/MERIDIAN 312.266.5999
215 W. Superior St., Chicago 60610 FAX: 312.266.5931
Hours: Tues-Sat 11-5
Contact: Grace Kass, Owner/Director; Alan Kass, Owner/Director
Specialty: Limited editions by modern and contemporary masters

Artists Represented: Charles Arnoldi, Tom Holland, Robert Motherwell, Larry Rivers, Joseph Stabilito, Donald Sultan, Andy Warhol, Tom Wesselmann **Works Available By:** Willem de Kooning, Jim Dine, Jean Dubuffet, Keith Haring, Roy Lichtenstein, Frank Stella

HOKIN KAUFMAN GALLERY 312.266.1211
210 W. Superior, Chicago 60610 FAX: 312.266.2119
Hours: Tues-Fri 10-5; Sat 11-4:30
Contact: Lori Kaufman, Director; Gary Metzner, Director
Specialty: Contemporary painting, sculpture and artist-designed furniture

Artists Represented: Greg Constantine, Boaz Vaadia, Stanley Boxer, Peter Shire, David Anderson, Ruth Bauer, Peter Bradtke, Jonathan Bonner, Sigrid Burton, Wendell Castle, Robert Donley, Paul Giovanopoulos, George D. Green, Mike Green, Rodney Alan Greenblat, Sandra Jorgensen, Ida Kohlmeyer, Ed McGowin, Kazuma Oshita, Albert Paley, Claire Prussian, Mary Ann Currier

PHYLLIS KIND GALLERY 312.642.6302
313 W. Superior St., Chicago 60610 FAX: 312.642.8502
Hours: Tues-Sat 10-5:30
Contact: Phyllis Kind, President
Specialty: Contemporary American, Soviet, naive and outsider art

Artists Represented: Stephen Anderson, **Roger Brown (See page 64),** Eric Bulatov, **Robert Colescott (See page 77),** William Copley, Yuri Dyshlenko, Simon Faibisovich, Howard Finster, Art Green, Mark Greenwold, Richard Hull, Sue Israel, Miyoko Ito, Luis Jimenez, Svetlana Kopystianskaya, Igor Kopystianski, Leonard Koscianski, Igor Makarevich, Langston Moffett, J.B. Murry, Irina Nakhova, Dennis Nechvatal, Gladys Nilsson, Timur Novikov, Jim Nutt, **Ed Paschke (See page 187),** Christina Ramberg, Martin Ramirez, Suellen Rocca, Patrick Rodriguez, Barbara Rossi, Oleg Vassilyev, Margaret Wharton, Karl Wirsum, **Adolf Wölfli (See page 258),** Robin Woodsome, Joseph Yoakum, Ray Yoshida, Zush

ILLINOIS *(cont.)*

CHICAGO

CAMPANILE GALLERIES 312.642.3869
200 S. Michigan Ave., Chicago 60604
Hours: Mon-Fri 9-5:30; Sat 9:30-4

CCA 312.944.0094
325 W. Huron St., Ste. 208, Chicago 60610 FAX: 312.944.6696
Hours: Tues-Fri 10-5:30; Sat 10-5
Contact: Kathy Cottong, Director

Artists Represented: Bard Breivik, Michael Peter Cain, Antonia Contro, Steve Currie, Dan Devening, L.J. Douglas, Lynn Geesaman, Royce Howes, Susan Laufer, Donald McLaughlin, David Moreno, David Saunders, Dan Socha, Fred Stonehouse, Donna Tadelman, Rodney White, Terri Zupanc **Works Available By:** Joe Andoe, Christopher Brown, Robert Mangold, Robert Ryman, Donald Sultan, Wayne Thiebaud

CENTURION GALLERIES, LTD. 312.661.0220
540 N. Michigan Ave., Chicago 60611
Hours: Mon-Sat 10-6
Contact: Vam Lember, Director
Specialty: 20th-Century American and European artists

Artists Represented: Lidia Kirov, George Malva, Rein Pikat **Works Available By:** Graciela Boulanger, Marc Chagall, Edouard Cortes, A. Gisson, Jules Herve, Al Jackson, Jean Kevorkian, Jacques Lalande, Joan Miro, Kaiko Moti, Manuel Robbe

CHICAGO CENTER FOR THE PRINT 312.477.1585
1509 W. Fullerton, Chicago 60614
Hours: Tues-Sat 11-7; Sun 12-5
Contact: Richard H. Kasvin, Owner; David Grossfeld, Owner
Specialty: American contemporary prints, works on paper, and archival framing

Artists Represented: David Bumbeck, Jeanine Coupe-Ryding, David Driesbach, Yale Epstein, **Yuji Hiratsuka (See page 270),** Scott, Sandell **Works Available By:** Said Boudjenah, Joel Bujnowski, Nick Capaci, Carlos Gonzalez Villar, Ed Herbeck, Susan Hunt-Wulkowicz, George Johanson, Chris Knipp, Dale Osterle

JAN CICERO GALLERY 312.440.1904
221 W. Erie St., Chicago 60610
Hours: Tues-Sat 11-5
Contact: Jan Cicero, Director
Specialty: Contemporary paintings and drawings with an emphasis on regional art; realist and abstract

Artists Represented: Diane Canfield Bywaters, James Cook, Matthew Daub, Joe Feddersen, Theodore Halkin, Bryan Harrington, Peter Holbrook, Kenneth Holder, Joel Jaecks, James Juszczyk, Kathleen King, William Kohn, Karen Kunc, Arne Kvaalen, Arthur Lerner, Merrill Mahaffey, Peter Marcus, Deann Melton, Philip Melton, Diane Meyer Melton, John Miller, Anne Miotke, Andrew Paczos, Tom Paquette, Peter Plagens, Corey Postiglione, Julie Richman, Charlotte Rollman, Jane Sangerman, John, Sayers, Jon-Eric Schaffer, Carl Schwartz, Phyllis Seltzer, Robert Skaggs, Jaune (QTS) Smith, Evelyn Statsinger, Annette Turow, Fern Valfer, Leslie Vansen, Bernadette Vigil, Ernest Viveiros, Theodore, Waddell, Emmi Whitehorse, Debra Yoo

EVA COHON GALLERY LTD. 312.644.3669
301 W. Superior St., Chicago 60610
Hours: Tues-Sat 10:30-5
Contact: Myrna Tyson, Registrar
Specialty: Contemporary American and European paintings and sculpture

Artists Represented: Cleve Gray, John Hoyland, Margie Hughto, Agnes Jacobs, Esther Levy, Steve McGowen, Phillip Mullen, Hugh O'Donnell, George Snyder **Works Available By:** Anthony Caro, Dan Christensen, Edward Giobbi, Kenneth Noland, Kikuo Saito, Michael Steiner

COMPASS ROSE GALLERY 312.266.0434
325 W. Huron St., Chicago 60610 FAX: 312.664.3152
Hours: Tues-Fri 10-5:30, Sat 10-5
Contact: Deven Golden, Director
Specialty: Modern and contemporary art

Artists Represented: Joan Binkley, Frederick Childs, Susanne Doremus, Michael Goldberg, Gary Justis, Elizabeth Newman, Dave Richards, Mia Westerlund Roosen, Paul Rosin, Risa Sekiguchi, Joan Snyder, Stephen, Williams **Works Available By:** Jake Berthot, Ronald Bladen, Garth Evans, Joe Goode, Franz Graf, Ron Janowich, John Lees, Eugene Leroy, Philip Pearlstein, Ken Price, Milton Resnick, Sean Scully, Frederic M. Thursz, Richard Tuttle, H. C. Westermann, Nicholas Wilder

DART GALLERY 312.733.7864
712 N. Carpenter, Chicago 60622 FAX: 312.733.7892
Hours: Tues-Fri 10-5:30; Sat 11-5:30
Contact: Andree Stone, Owner/Director
Specialty: Contemporary paintings, drawings, photography, prints and sculpture

Artists Represented: Phyllis Bramson, Daniel Christmas, Paul Coffey, John Coplans, Jack Goldstein, Gregory Green, David Helm, David Hodges, Irwin Paul Labus, Jim Lutes, Darrel Morris, Nic Nicosia, John Phillips, Tony Phillips, Charles Brent Riley, Hollis Sigler, Daniel Smajo-Ramirez, David Snyder, John Torreano, Ken Warneke, Frances Whitehead, Charles, Wilson **Works Available By:** Nicholas Africano, Joe Andoe, Robert Lostutter, William Wegman, Joel-Peter Witkin

DOUGLAS DAWSON GALLERY 312.751.1961
814 N. Franklin St., Chicago 60610 FAX: 312.649.0440
Hours: Tues-Sat 10-5:30; Sat 10-5
Contact: Douglas Dawson, Owner
Specialty: Ancient and historic textiles from Africa, Asia, Central Asia, Indonesia, Central and South America

DE GRAAF FINE ART, INC. 312.951.5180
9 E. Superior, Chicago 60611 FAX: 312.951.6146
Hours: Tues-Sat 11-5:30
Contact: Daniel L. De Graaf
Specialty: Contemporary American, European and Latin American paintings, sculpture and graphics

Artists Represented: Bill Barrett (See page 305), G. Elyane Bick (See page 54), Romero Britto (See page 61), Charlie Brouwer (See page 310), Chuang Che (See page 71), Stefan Davidek (See page 84), Eugene Jardin (See page 331), Jim Jenkins (See page 332), Elisabeth Lalouschek (See page 152), Kurt Metzler (See page 349), David Miretsky (See page 173), Clayton Pond (See page 193), Scott Runion (See page 358), Michael Teague (See page 232)

DESON-SAUNDERS GALLERY 312.787.0005
328 W. Chicago Ave., Chicago 60610
Hours: Tues-Fri 10-5:30; Sat 10-5
Contact: Ken Saunders, Director
Specialty: European and American contemporary art in all mediums

Artists Represented: John Bakker, Diane Buckler, Bruce Charlesworth, Laurence Conn, Nereyda Garcia-Ferraz, Valeriy & Rimma Gerlovin, Moshe Gershuni, Michiko Itatani, Dennis Kowalski, Don Pollack, David Russick, Tom Stancliffe **Works Available By:** Bruno Ceccobelli

EAST WEST CONTEMPORARY ART 312.664.8003
311 W. Superior St., 3rd Fl., Chicago 60610 FAX: 312.664.3322
Hours: Mon-Sat 10-5:30; Thurs Until 7
Contact: Carole Jones, Co-Owner
Specialty: Chinese and American contemporary art; commissioned portraiture: Portraits/Chicago

Artists Represented: Richard Akers, Omri & Julie Amrany, Miles Bair, Howard Hersh, Leng Hong, Cha Li, Joyce Novak, Bobby K. Owens, Charlotte Segal, **Shan-Shan Sheng (See page 215),** Anna Koh Varilla, Jeffrey Varilla, Hu Xiang-Cheng, Weiliang Zhao **Works Available By:** Zhou Brothers, David Phillips

CATHERINE EDELMAN GALLERY 312.266.2350
300 W. Superior St., Chicago 60610 FAX: 312.266.1967
Hours: Tues-Sat 10-5:30
Contact: Catherine Edelman, Director/Owner
Specialty: Promotion, exhibition and sales of contemporary photography

Artists Represented: Sid Avery, Barbara Crane, Michael Kenna, Herman Leonard, Maria Martinez-Canas, David Plowden, Richard Ross, Jeffrey Wolin, Joe Ziolkowski **Works Available By:** Marilyn Bridges, Nan Goldin, Marc Hauser, Annie Leibovitz, Richard Misrach, Olivia Parker, Herb Ritts

EHLERS CAUDILL GALLERY 312.642.8611
750 N. Orleans St., Chicago 60610 FAX: 312.642.9151
Hours: Tues-Sat 10-5:30
Contact: Shashi Caudill, Director; Carol Ehlers, Director
Specialty: Vintage and contemporary photography

Artists Represented: Ellen Brooks, Patty Carroll, James Casebere, Helen Chadwick, Flor Garduno, Barbara Kasten, Nathan Lerner, Sandra Newbury, Sandy Skoglund **Works Available By:** Eugene Atget, Ilse Bing, Walker Evans, Robert Frank, Man Ray

FEIGEN INCORPORATED 312.787.0500
325 W. Huron St., Ste. 204, Chicago 60610 FAX: 312.787.7261
Hours: Mon-Fri 10-5:30; Sat 10:30-5
Contact: Lance Kine, Director
Specialty: Contemporary American and European artists

Artists Represented: Michael Banicki, Jeanne Dunning Evergon, Mike Hill, Peter Hunttinger, David Ortins, Maurizio Pellegrin, Robert Rauschenberg, Richard Rezac, James Rosenquist, Richard Roth, Richard Smith, Robert Wilson

OSKAR FRIEDL GALLERY 312.337.7550
750 N. Orleans St., #302, Chicago 60610 FAX: 312.337.2466
Hours: Tues-Sat 11-5:30
Contact: Oskar Friedl, Owner/Director; Michael Anderson, Asst. Director
Specialty: Contemporary international art; painting and sculpture from Germany, America, France and Japan

Artists Represented: Susan Bloch, Florian Depenthal, Herbert George, Ingrid Hartlieb, Masahito Katayama, Montana Morrison, David Seifert, Mary Sherman, Jean Brice Wallon, Mathias Wolf **Works Available By:** Ruth Tesmar, Beatrice Von Eidlitz, Ken Zezulka

WINTERPARK

ALBERTSON-PETERSON GALLERY 407.628.1258
329 Park Ave. S., Winterpark 32789
Hours: Tues-Fri 10-5:30 ; Sat 11-5:30
Specialty: Contemporary arts and crafts

Artists Represented: Carol Becktell, David Kraisler, Jane Shubert, Gary Staley

GEORGIA

ATLANTA

CONNELL GALLERY/GREAT AMERICAN GALLERY 404.261.1712
333 Buckhead Ave., Atlanta 30305
Hours: Mon-Sat 10-5
Contact: Martha Connell, Owner; Pat Connell, Owner
Specialty: Contemporary American art; clay, glass, wood, fiber,
metal and works on paper and canvas

Artists Represented: Hank Murta Adams, Glenda Arentzen, **Roger Dorset (See page 324)**, Arline Fisch, Pat Flynn, Barbra Gendell, Laurie Hall, Mary Lou Higgins, Doug Jeck, Indira Johnson, Diane Kempler, Grady Kimsey, Stoney Lamar, Therese May, Benjamin Moore, Craig Nutt, Harold O'Connor, Rude Osolnik, Earl Pardon, Tod Pardon, Susan Plum, Yvonne Porcella, Don Reitz, David Schwarz, Delia Seigenthaler, Bob Stocksdale, Pamela Studstill, Tim Taunton, Linda Threadgill, Chad Voorhees, Brent Kee Young

GALERIE TIMOTHY TEW 404.352.0655
Tula, D-2 75 Bennett St. N.W., Atlanta 30309
Hours: Tues-Sat 11-5
Contact: Timothy Tew, Owner
Specialty: Artists working in the classic tradition of western European art

Artists Represented: Marie-Cecil Aptel, Haidee Becker, Jean-Pierre Bourquin, Jim Byrne, Stewart Helm, **Isabelle Melchior (See page 170)**, Kimo Minton, Denis Rival **Works Available By:** Soon Myung Hong, Samuel Papazian, Isao Utsumiya

FAY GOLD GALLERY 404.233.3843
247 Buckhead Ave., Atlanta 30305 FAX: 404.365.8633
Hours: Tues-Sat 10-6
Contact: Fay Gold; Sophia Lyman
Specialty: Modern and contemporary art and photography

Artists Represented: Joseph Amar, Steve Arnold, Tarle Blackwell, Elizabeth Cain, Dale Chihuly, Robert Clements, Corrine Colarusso, Joseph Cornell, Ford Crull, Harris Dimitropoulos, Scott Duce, Karekin, Goekjian, Paige Harvey, Steven Heyman, Horst, Herb Jackson, Robert, Jessup, Richard Jolley, Yousuf Karsh, Cynthia Knapp, **Cheryl Laemmle (See page 151)**, Marcus Leatherdale, Annie Leibovitz, O. Winston Link, **Michael Lucero (See page 344)**, Ed, Maxey **McDermott & McGough (See page 393)**, Joel Meyerowitz, Duane Michals, Dann, Nardi, Ruth Orkin, Doug Prince, Herb Ritts, Sebastiao Salgado, Tom Savage, Andres Serrano, David Shapiro, **Sandy Skoglund (See page 293)**, Jerry Uelsmann, Bruce Weber, **William Wegman (See page 400)**, Joel-Peter Witkin **Works Available By:** Milton Avery, Jean-Michel Basquiat, Sophie Calle, Helen Frankenthaler, Keith Haring, Robert Mapplethorpe, Yasumasa Morimura, Lorna Simpson, Frank Stella

HEATH GALLERY, INC. 404.262.6407
416 E. Paces Ferry Rd., Atlanta 30305 FAX: 404.233.1343
Hours: Wed-Fri 11-5; Tues & Sat By Appt
Contact: R. Scott Mcrae, V.P.
Specialty: American art from the 1960's on; painting, sculpture and graphics

Artists Represented: Genevieve Arnold, Lynda Benglis, Judith Brown, Emery Clark, Sergio Dolfi, Frank Fleming, Helen Frankenthaler, Cheryl Goldsleger, Nancy Grossman, Linda Howard, Margie Hughto, David Ivie, Jun Kaneko, John Koegel, Ida Kohlmeyer, Clement Meadmore, Howardena Pindell

THE LOWE GALLERY 404.352.8114
75 Bennett St., Space A-2, At Tula, Atlanta 30309 FAX: 404.352.0564
Hours: Tues-Fri 10:30-5:30; Sat 12-5
Contact: Bill Lowe, Owner
Specialty: Contemporary painting, sculpture and objects

Artists Represented: **Michael Beauchemin (See page 51)**, **Ke Francis (See page 106)**, **Pam Longobardi (See page 161)**, **Kathleen Morris (See page 176)**, **Todd Murphy (See page 178)**, **Pat Potter (See page 194)**, **Andrew Saftel (See page 210)** **Works Available By:** Kris Cox, Dirk de Bruycker, Jean-Jacques Gaudel, Howard Hersh, James McGarrell, Sammy Peters, Florence Putterman, Gabriele Schnitzenbaumer, Colleen Sterling, Ruth Zuckerman

EVE MANNES GALLERY 404.351.6651
116 Bennett St., Ste. A, Atlanta 30309
Hours: Mon-Fri 9:30-5:30; Sat 11-5
Contact: Kathleen Cody Guy, Director
Specialty: Contemporary painting and sculpture; art glass and furniture

Artists Represented: Bill Barrett, George Beasley, Trevor Bell, John Buck, Sigrid Burton, Robert Cogan, Carl Andree Davidt, Sam Gilliam, Jack Goldstein, Edward Lee Hendricks, Richard Johnson, Aaron Karp, Ed Kellogg, Robert Glenn Ketchum, Judy Kensley Mckie, Andy Nasisse, Manuel Neri, Steven Sorman, Isaac Witkin **Works Available By:** James Crable, George Kozmon, Terence La Noue, Tom Lieber, Jesus Bautista Moroles, Joel Perlman, Ben Schonzeit, James Yohe

THE MCINTOSH GALLERY 404.892.4023
587 Virginia Ave., Atlanta 30306
Hours: Tues-Sat 11-5
Contact: Louisa McIntosh, Director
Specialty: Contemporary cross-cultural artists
producing figurative and abstract work

Artists Represented: Benny Andrews, Arless Day, Virginia Derryberry, Michael Ellison, Tom Francis, Sidney Guberman, Paul Kwilecki, Juan Logan, Duston Spear **Works Available By:** Romare Bearden, Beverly Buchanan, Jacob Lawrence

SANDLER HUDSON GALLERY 404.350.8480
1831-A Peachtree Rd. N.E., Atlanta 30309
Contact: Robin Sandler
Specialty: Contemporary, regional painting and sculpture

Artists Represented: Larry Anderson, Scott Belville, Anita Butler, Dana Cibulski, Polly Cook, Don Cooper, Pat Courtney, Frances De La Rosa, Leslie Dill, Tom Ferguson, Mark Flowers, Gina Gilmour, Nene Humphrey, Benjamin Jones, Miriam Karp, Gary Komarin, Amy Landesberg, Susan Loftin, Joni Mabe, John Martini, Clarence Morgan, Mario Petrirena, Tom P. Pfannerstill, Rocio Rodriguez, Alice Schindel, Joe Schneider, Barbara Schreiber, Paula Eubank Smith, Virginia Warren Smith, Sally Speed, Richard Sudden, Bob Trotman, Elizabeth Turk

TRINITY GALLERY 404.525.7546
249 Trinity Ave., Atlanta 30303 FAX: 404.659.8392

Artists Represented: Tadashi Asoma, Franz Kline, Diane Marinaro, Masaaki Noda, Shunji Sakuyama, Toshiyuki Seki, Toshi Utagawa

ILLINOIS

CHICAGO

AARON GALLERIES 312.943.0660
620 N. Michigan Ave., Ste. 300, Chicago 60611 FAX: 312.943.9839
Hours: Tues-Sat 10-6
Contact: Patrick L. Albano, Director
Specialty: 19th- & 20th-Century American painting and master prints; modernists, regionalists, early American abstraction

Artists Represented: Olen L. Bryant, Werner Drewes, Jesse Beard Rickly **Works Available By:** Peggy Bacon, Gustave Baumann, Helen Louise Beccard, George Bellows, Thomas Hart Benton, Isabel Bishop, Aaron Bohrod, Sheila Burlingame, Fred Green Carpenter, William Merritt Chase, Kathryn Cherry, John Steuart Curry, John Demartely, Helen West Heller, Rudolph Ingerle, Armin Landeck, Reginald Marsh, Joseph Meert, Joan Miro, Robert Riggs, Flora Schofield, Georges Schreiber, William Schwartz, Benton Spruance, Gordan Stevenson, Oscar Thalinger, Grant Wood

JEAN ALBANO GALLERY 312.440.0770
311 W. Superior St., Ste. 207, Chicago 60610 FAX: 312.645.1929
Hours: Tues-Sat 10-5; Thurs 10-7
Contact: Jean Albano, Director
Specialty: Contemporary American art

Artists Represented: Elizabeth Austin, Jacqueline Dreager, Martin Facey, Adu Gindy, Steve Grossman, Steve Lapin, Donna Salem, Jim Waid, Robert, Walker **Works Available By:** Larry Cohen

ARTEMISIA GALLERY 312.226.7323
700 N. Carpenter, Chicago 60622
Hours: Tues-Sat 11-5
Contact: Fern Shaffer, President
Specialty: Woman's coop gallery; all media

Artists Represented: Mary Burke, Sonja Carlborg, Mary Ellen Croteau, Gloria De Los Santos, Sarah Barnhart Fields, Diane Grams, Susan Grasberkowitz, Nancy Hild, Linda James, Margeaux Klein, Jill Machina, Silvia Malagrino, Kathy Pilat, Birgitte Reichl, Liese Ricketts, Eileen Ryan, Linda Talbott

JACQUES BARUCH GALLERY 312.944.3377
40 E. Delaware Pl., Pnths. B, Chicago 60611
Contact: Dr. Anne Baruch, Director

MARY BELL GALLERIES 312.642.0202
215 W. Superior St., Chicago 60610 FAX: 312.642.6672
Hours: Mon-Fri 9-5; Sat 11-5
Contact: Mary C. Bell, Owner
Specialty: American contemporary artists

Artists Represented: Gary Bukovnik, Richard Carter, Mark Dickson, Gloria Fischer, Betty Fulmer, Jonas Gerard, David Gibson, Janusz Glowacki, Peter Karis, Arthur Kdav, George Kozmon, Greg Milne, Joyce Nagel, Alice Welton

ROY BOYD GALLERY 312.642.1606
739 N. Wells St., Chicago 60610 FAX: 312.642.2143
Hours: Mon-Sat 10-5:30; Thurs 10-7
Contact: Roy Boyd, Director; Ann Boyd, Director
Specialty: Contemporary abstract paintings and sculpture and Soviet photography

Artists Represented: Rodney Carswell, William Conger, Frank Faulkner, Vera Klement, Robert McCauley, Dann Nardi, Gordon Powell, Buzz Spector, Anne Wilson

FLORIDA (cont.)

BOCA RATON

MARGARET LIPWORTH GALLERY 407.241.7955
608 Banyan Tr., Ste. 113, Boca Raton 33431
Hours: Mon-Sat 10:30-5
Contact: Margaret Lipworth, Director; Toni Marie Finn, Director

KENNETH RAYMOND GALLERY 407.368.2940
799 E. Palmetto Park Rd., Boca Raton 33432 FAX: 407.391.1982
Hours: Tues-Sat 10-6; Tues & Fri Until 9
Contact: Kenneth Raymond, Owner
Specialty: Contemporary and abstract paintings and sculpture;
noted international artists—French school

Artists Represented: Irmgard Arvin, Lucette Bellini, Jill Benjamin, Jacques Bolore, Alex Caro, GuyCharon, Robin Daniels, Peter Deluca, Marcel Dudouet, Jay Dunitz, Gerald Ellis, Arline Erdrich, Miguel Esparbe, Yves Geeraerts, Victor Hasch, Jean-Pierre Henaut, David Hostetler, Jean-Claude Hug, Idka, Michel Jarry, Gerard Le Nalbaut, Jacky Lezin, Rob Milgram, W. Nahle, Florence Putterman, George Ruggiere, Jr., Jean-Paul Savigny, Claude Schurr, Renee Sebelancon, Shahabuddin, Victor Villareal

COCONUT GROVE

ROMERO BRITTO GALLERY 305.445.3326
2911 Grand Ave., Promenade, Coconut Grove 33133 FAX: 305.445.3326
Hours: Daily 10-6
Contact: Michelle Zak, Asst. Director
Specialty: Originals, serigraphs, sculptures and acrylic on canvas.

Artists Represented: Romero Britto

GARY NADER FINE ARTS 305.442.0256
3121 Commodore Plaza, Ph. 1, Coconut Grove 33133 FAX: 305.443.9285
Hours: Mon-Sat 11:30-6:30
Contact: Gary Nader, Director; Mariangela Capuzzo, Asst. Director
Specialty: Latin American art

Works Available By: Dr. Alt, Cundo Bermudez, Fernando Botero, Claudio Bravo, Luis Caballero, Agustin Cardenas, Mario Carreno, Leonora Carrington, Alfredo Castaneda, Jose Luis Cuevas, Fernando De Szyszlo, Pedro Figari, Oswaldo Guayasamin, Manuel Izquierdo, Frida Kahlo, Wifredo Lam, Roberto Matta, Armando Morales, Frederico Nordalm, Ramon Oviedo, Amelia Pelaez, Emilio Pettoruti, Diego Rivera, David A. Siqueiros, Rufino Tamayo, Joaquin Torres- Garcia, Guillermo Trujillo, Remedios Varo, Jose Antonio Velasquez, Leoncio Villanueva, Alejandro Xul, Solar Francisco Zuniga

CORAL GABLES

ARREGUI HSIA FINE ART 305.446.1741
4105 Laguna St., Coral Gables 33146

ELITE FINE ART 305.448.3800
3140 Ponce De Leon Blvd., Coral Gables 33134

VIRGINIA MILLER GALLERIES 305.444.4493
169 Madeira Ave., Coral Gables 33134

OPUS GALLERY 305.448.8976
1810 Ponce De Leon Blvd., Coral Gables 33134

FORT LAUDERDALE

CARONE GALLERY 305.463.8833
600 S.E. Second Ct., Fort Lauderdale 33301

KEY BISCAYNE

M. GUTIERREZ FINE ARTS, INC. 305.361.2745
328 Crandon Blvd., Ste. 227, Key Biscayne 33149 FAX: 305.361.5766
Hours: Mon-Fri 10-5; Sat 11-4
Contact: Marta Gutierrez, Director
Specialty: Modern and contemporary Latin American art

Artists Represented: Carmen Aldunate, Carlos Alfonzo, Elisa Arimany, Ernesto Barreda, Jose De Guimaraes, Fernando De Szyszlo, Demi, Meme Ferre, Jose Gamarra, Beatriz Gonzalez, Ignacio Iturria, Maripaz Jaramillo, Guido Llinas, Ofelia Rodriguez, Pedro Ruiz, Carlos Salazar, Emilio Sanchez, Antonio Segui, Tom Uttech **Works Available By:** Fernando Botero, Claudio Bravo, Agustin Cardenas, Leonora Carrington, Lucio Fontana, Wifredo Lam, Roberto Matta, Armando, Morales, Candido Portinari, Diego Rivera, Jesus Rafael Soto, Francisco Zuniga

MIAMI

BEAUX ART COLLECTIONS LTD. 305.858.6776
2451 Brickell Ave., Main Fl., Miami 33129
Hours: Mon-Sat 9-7 By Appt
Contact: Ricardo J. Gonzales, III, Director
Specialty: Abstract-figurative sculptures and reliefs;
commissioned traditional realistic public works

Artists Represented: Manuel Carbonell (See page 312)

BARBARA GILLMAN GALLERY 305.573.4898
270 N.E. 39th St., Miami 33137 FAX: 305.576.1839
Hours: Mon-Sat 10-5
Contact: Barbara Gillman, President
Specialty: Contemporary American and Latin American paintings, sculpture, photography, and prints

Artists Represented: Eleanor Blair, Robert Calvo, Rosemarie Chiarlone, James Couper, Joe Davoli, Linda Howard, Laurie Julia, Dina Knapp, Pete Kuentzel, Silvia Lizama, Connie Lloveras, Stacey Mancuso, Chris Mangiaracina, Roberta Marks, Rosario Marquardt, Maria Martinez-Canas, Gilberto Ruiz, Ward Shelley, Cesar Trasobares, Jeff Whipple **Works Available By:** Francis Bacon, Christo, Chuck Close, Jim Dine, Roy Lichtenstein, Robert Mapplethorpe, Philip Pearlstein, James Rosenquist, Andy Warhol

VAN CLEEF FINE ARTS 305.573.2727
3930 N.E. Second Ave., Miami 33137
Hours: By Appt Only
Contact: George Gandelman, Director

NAPLES

HARMON-MEEK GALLERY 813.261.2637
386 Broad Ave. S., Naples 33940 FAX: 813.261.3804
Hours: Mon-Sat 10-5; Thurs Evening Until 9
Contact: J. William Meek, III, Director
Specialty: 20th-Century American art

Artists Represented: Greg Biolcahini, Ronald Julius Christensen, Liz Jacobs, Rick Olsen **Works Available By:** Will Barnett, Adolf Dehn, Richard Florsheim, Robert Allen Gough, Milton Hebald, Ralph Hurst, Bob Kane, Eliott O'Hara, Samuel Edmund Oppenheim Elliott Orr, Carl Schmalz, Richard Segalma, Robert Vickrey

PALM BEACH

ARIJ GASIUNASEN FINE ART 407.820.8920
440 S. County Rd., Palm Beach 33480 FAX: 407.820.8918
Hours: Mon-Sat 10-6
Contact: Arij Gasiunasen, President
Specialty: Works by modern and contemporary masters

Works Available By: Karel Appel, Arman, Milton Avery, Fernando Botero, Lynn Chadwick, Sandro Chia, Jim Dine, Jean Dubuffet, Helen Frankenthaler, David Hockney, Yves Klein, Roy Lichtenstein, Henri Matisse, Henry Moore, Mimmo Paladino, Pablo Picasso, Gerhard Richter, Jean-Paul Riopelle, Frank Stella, Antoni Tapies, Andy Warhol

HELANDER GALLERY 407.659.1711
210 Worth Ave., Palm Beach 33480 FAX: 407.659.4023
Hours: Mon-Sat 10-6
Contact: Wendy Helander, Director
Specialty: Contemporary, American painting, sculpture, and fine glass

Artists Represented: John Albers, Jonathan Bonner, Alfonse Borysewicz, William Carlson, Dale Chihuly, Bernard D'Onofrio, Dan Dailey, Bill Drew, Bruce Evans, Duane Hanson, Steve Heino, Phyllis Herfield, Aaron Karp, John Lewis, Roberta Marks, John Martini, Concetta Mason, Todd Mckie, Richard Merkin, William Morris, Martin Mull, Paula Deluccia Poons, Andrew Radcliffe, Peter Saari, Italo Scanga, David Schwarz, Harold, Shapinsky, Hunt Slonem, Jay Stanger, John Torreano, Steven Weinberg, Phillippe Weisbecker **Works Available By:** John Chamberlain, John De Andrea, George Deem, Viola Frey, Oscar Lakeman, Kenneth Noland, Jules Olitski, Larry Poons, Robert Rauschenberg, James Rosenquist, Boaz Vaadia

HOKIN GALLERY 407.655.5177
245 Worth Ave., Palm Beach 33480 FAX: 407.655.6315
Hours: Mon-Sat 10-5
Contact: Grace Hokin, Owner; Thomas Cullen, Director
Specialty: Modern and contemporary masters

Artists Represented: David Anderson. Richard Anuszkiewicz, Stanley Boxer, Grisha Bruskin, Muriel Castanis, Lynn Chadwick, Otto Duecker, **Sorel Etrog (See page 325)**, Paul Giovanopoulos, Ida Kohlmeyer, Terence La Noue, Daniel Lang, Julio Larraz, Alexander Liberman, Howard Newman, Sharron Quasius, Ernest Trova **Works Available By:** Fernando Botero, William Conlon, Robert Courtright, Gene Davis, Niki de Saint Phalle, Jim Dine, Jean Dubuffet, Friedel Dzubas, Helen Frankenthaler, Keith Haring, James Havard, David Hockney, Hans Hofmann, Richard Jolley, Alex Katz, F.X. and Claude Lalanne, Roy, Lichtenstein, Conrad Marca-Relli, Joan Miro, Henry Moore, Louise Nevelson, Pablo Picasso, Arnaldo Pomodoro, Larry Rivers, Harriet Shorr, Theodoros Stamos, Pat Steir, Frank Stella, Andy Warhol, Tom Wesselmann

IRVING GALLERIES 407.659.6221
332 Worth Ave., Palm Beach 33480 FAX: 407.659.0567
Hours: Mon-Sat 10-5
Contact: Holden Luntz, Director
Specialty: Contemporary American and European modern master

Artists Represented: Will Barnet, Varujan Boghosian, Gary Bukovnik, Helen Frankenthaler, Edward Giobbi, Cleve Gray, Paul Jenkins, Arnaldo Pomodoro, Larry Rivers, Ben Schonzeit, Nigel Van Weir, Fumio Yoshimura **Works Available By:** Fernando Botero, Nancy Graves, Clement Meadmore, Igor Mitoraj, Kenneth Noland, Frank Stella, Tom Wesselmann

JOHN H. SUROVEK GALLERY 407.832.0422
349 Worth Ave., Palm Beach 33480
Hours: Mon-Fri 9:30-5:30

KIMBERLY GALLERY 202.234.1988
1621 21st St. N.W., Washington 20009 FAX: 202.462.0773
Hours: Tues-Sat 11-6
Contact: Elyse Klaidman, Director; Elena Kimberly
Specialty: Contemporary Latin American artists

Artists Represented: Manuel Alvarez-Bravo, Feliciano Bejar, Antonio Castellanos, Victor Chab, Arnaldo Coen, Jose Luis Cuevas, Fernando de Szyszlo, Joy Laville, Guillermo Meza, Luis Nishizawa, Marina Nunez del Prado, Miguel Pena, **Elmar Rojas (See page 202),** Raymundo Sesma, **Cordelia Urueta (See page 239),** Roger Von Gunten **Works Available By:** Jose Chavez-morado, Alejandro Colunga, Olga Costa, Manuel Felguerez, Gunther Gerzso, Wifredo Lam, Gustavo Montoya, Rodolfo Morales, Vicente Rojo, Emilio Sanchez, Juan Soriano, Rufino Tamayo, Francisco Toledo, Mario Toral

B R KORNBLATT GALLERY 202.638.7657
406 Seventh St. N.W., Washington 20004 FAX: 202.737.5043
Hours: Tues-Sat 10:30-5:30
Contact: Jane Gillern, Registrar
Specialty: Contemporary paintings, drawings, sculpture, prints and installations

Artists Represented: Mel Bochner, Loren Calaway, Mel Chin, Jerry Clapsaddle, Susan Crile, Susan Crowder, Willem De Looper, John Ferguson, Martha Jackson-Jarvis, Agnes Jacobs, Wolf Kahn, Bayat Keerl, Sol LeWitt, Allyn Massey, Keith McCormack, Robert Stackhouse, Renee Stout, Michelle Stuart, Michael Todd, Thomas West **Works Available By:** Daniel Buren, Helmut Federle, Donald Judd, Erik Levine, Roy Lichtenstein, Robert Motherwell, Manuel Neri, Mimmo Paladino, Gerhard Richter, Larry Rivers, Frank Stella, Wayne Thiebaud, David True

LE MARIE TRANIER GALLERY 202.342.9600
3304 M St. N.W., Washington 20007 FAX: 202.342.9601
Hours: Mon-Sat 10-7; Sun 1-5
Contact: Marie-Pierre Le Marie, Owner/Director
Specialty: Contemporary, European and American, painters and sculptors

Artists Represented: Maria Eugenia Bigott, Jimenez Deredia, Peter Klasen, Benoit Luyckx, Vladimir Velickovic **Works Available By:** Arman, Robert Rauschenberg

MAURINE LITTLETON GALLERY 202.333.9307
1667 Wisconsin Ave. N.W., Washington 20007
Hours: Tues-Sat 11-6
Contact: Maurine Littleton, Director
Specialty: Representing artists working with glass and ceramic; vitreographs

Artists Represented: Dale Chihuly, Jack Earl, Erwin Eisch, Kyohei Fujita, Harvey K. Littleton, Joel Philip Myers, Ginny Ruffner, Paul Soldner, James L. Tanner

MARSHA MATEYKA GALLERY 202.328.0088
2012 R St. N.W., Washington 20009 FAX: 202.332.0520
Contact: Marsha Perry Mateyka, Director
Specialty: Contemporary painting, sculpture, and works on paper

Artists Represented: Judy Bass, Robert Brady, Aline Feldman, Christopher French, Elizabeth Ginsberg, Maria Moser, Matt Phillips, William T. Wiley, Nancy Wolf **Works Available By:** Agnes Denes, Mary Frank, Howard Hodgkin, Anish Kapoor, Robert Motherwell, Wayne Thiebaud

MIDDENDORF GALLERY 202.462.2009
2009 Columbia Rd. N.W., Washington 20

OSUNA GALLERY 202.296.1963
1919 Q St. N.W., Washington 20009 FAX: 202.296.1965
Hours: Tues-Sat 10-5
Contact: Andrea Cullinan, Director
Specialty: Old Masters; Latin American contemporary

Artists Represented: Carlos Alfonzo, Manon Cleary, Howard Mehring, Anne Truitt

PENSLER GALLERIES 202.328.9190
2029 Q St. N.W., Washington 20009
Hours: Tues-Sat 10-5
Contact: Alan Pensler, President
Specialty: 19th- & 20th-Century American and European paintings and drawings

Works Available By: Charles Burchfield, William Merritt Chase, Edwin Dickinson, Sanford Gifford, William Harnett, Reginald Marsh, John F. Peto, Joseph Stella

ANDREA RUGGIERI GALLERY 202.265.6191
2610 Normanstone Ln., Washington 20009 FAX: 202.234.9577
Hours: By Appt
Contact: Andrea Ruggieri
Specialty: Work with a strong conceptual basis

Artists Represented: Suzanne Anker, Gordon Bailey, Michael Blodget, Roni Horn, Richard Prince, Tim Rollins + K.O.S., Andres Serrano, Cindy, Sherman **Works Available By:** Tina Barney, Sophie Calle, Clegg & Guttman, Evergon, Christian Marclay

TAGGART & JORGENSEN GALLERY 202.298.7676
3241 P St. N.W., Washington 20007 FAX: 202.333.3087
Hours: Mon-Fri 10:30-5; Sat 11-5
Contact: Hollis Taggart, Director
Specialty: 19th- & early 20th-Century American and European paintings; contemporary Realists

Artists Represented: Mark Dassoulas, Ken Marlow **Works Available By:** Doug Brega, Michael Keane, Mark Myers, Andrew Wyeth

FLORIDA

BAY HARBOR ISLANDS

GREENE GALLERY 305.865.6408
1090 Kane Concourse, Bay Harbor Islands 33154
Hours: Tues-Sat 10:30-5:30
Contact: Barbara Greene, Director

HOKIN GALLERY 305.861.5700
1086 Kane Concourse, Bay Harbor Islands 33154 FAX: 305.865.5621
Hours: Mon-Sat 10-5
Contact: Grace Hokin, Owner; Thomas Cullen, Director
Specialty: Modern and contemporary masters

Artists Represented: David Anderson, Richard Anuszkiewicz, Stanley Boxer, Grisha Bruskin, Muriel Castanis, Lynn Chadwick, Otto Duecker, **Sorel Etrog (See page 325),** Paul Giovanopoulos, Ida Kohlmeyer, Terence La Noue, Daniel Lang, Julio Larraz, Alexander Liberman, Howard Newman, Sharron Quasius, Ernest Trova **Works Available By:** Fernando Botero, William Conlon, Robert Courtright, Gene Davis, Niki de Saint Phalle, Jim Dine, Jean Dubuffet, Friedel Dzubas, Helen Frankenthaler, Keith Haring, James Havard, David Hockney, Hans Hofmann, Richard Jolley, Alex Katz, F.X. and Claude Lalanne, Roy, Lichtenstein, Conrad Marca-Relli, Joan Miro, Henry Moore, Louise Nevelson, Pablo Picasso, Arnaldo Pomodoro, Larry Rivers, Harriet Shorr, Theodoros Stamos, Pat Steir, Frank Stella, Andy Warhol, Tom Wesselmann

ANN JAFFE GALLERY 305.865.5823
1088 Kane Concourse, Bay Harbor Islands 33154 FAX: 305.865.0446
Hours: Tues-Sat 10-5
Contact: Ann Jaffe
Specialty: Contemporary paintings, sculpture, works on paper

Works Available By: Elaine Anthony, Walter Darby Bannard, Maria Brito, Larry Brown, Jill Cannady, Lynn Chadwick, Friedel Dzubas, Sheila Elias, Carole Jeane Feuerman, Cheryl Goldsleger, Menashe Kadishman, Alberto Magnani, Juanita May, Doug Ohlson, Deborah Oropallo, Judy Rifka, Joan Snyder, Adam Straus, Carolee Thea, Tom Wesselmann

GLORIA LURIA GALLERY 305.865.3060
1033 Kane Concourse, Bay Harbor Islands 33154 FAX: 305.865.0216
Hours: Tues-Sat 10-5
Contact: Gloria Luria, Director
Specialty: Contemporary painting, sculpture, works on paper, and master prints

Artists Represented: Trevor Bell, Carol K. Brown, Ford Crull, Michelle Oka Doner, Christine Federighi, Ron Fondaw, Patricia T. Forrester, Robert Huff, Tobi Kahn, Ida Kohlmeyer, Arnaldo Roche-Rabell, Lydia Rubio, Deborah Schneider, David Shapiro, Rafael Vadia, Sandy Winters

MARGULIES TAPLIN GALLERY 305.861.9600
1060 Kane Concourse, Bay Harbor Isl 33154 FAX: 305.864.5744
Hours: Tues-Sat 10-5
Contact: Dwight D. Santiago, Director
Specialty: Contemporary art including abstract, photorealism, minimal and conceptual artwork

Artists Represented: Dennis Ashbaugh, Seth Dembar, David Dornan, Johannes Girardoni, Wesley Kimler, Tom Lieber, Kirk Lybecker, Ed McGowin, Manuel Neri, Gustavo Ramos Rivera, Phyliss Rosenblatt, Bettina Werner, Rob Wynne **Works Available By:** Donald Baechler, Michael David, Richard Estes, Keith Haring, Robert Indiana, Jasper Johns, Sol LeWitt, Roy Lichtenstein, Malcolm Morley, Claes Oldenburg, Robert Rauschenberg, James Rosenquist, Frank Stella

BOCA RATON

GALLERY CAMINO REAL 407.241.1606
608 Banyan Trail, Boca Raton 33431
Hours: Mon-Sat 10:30-5
Contact: Marjorie Margolis, President
Specialty: Contemporary painting sculpture and ceramics

Artists Represented: Stephan Achimore, Harm De Grijs, Joseph Drapell, Nobu Fukui, Robert Goodnough, Philip Livingston, Robert Lowe, Phillip Maberry, Graham Niedkson, Jules Olitski, Bruce Piermarini, Bruno Romeda, Harvey Sadow, Kikuo Saito, Randall Schmit, Jerald Webster

HABATAT GALLERIES INC. 407.241.4544
608 Banyan Tr., Boca Raton 33431

THE HARRISON GALLERY, INC. 407.241.9911
608 Banyan Tr., Boca Raton 33431 FAX: 407.241.6684
Hours: Mon-Sat 10-5 Or By Appt
Contact: Shelley Stone
Specialty: Contemporary works of art combining diversified media and styles

Artists Represented: Power Boothe, Donald De Lue, Mary Fisher, Andre Harvey, Melissa Johnson, Todd Mckie, Michael Van Horn, Albert Wein, Bert Yarborough **Works Available By:** Joel Hanowitz, Lisa Houck Leary, Mimmo Paladino, Julian Schnabel, Joseph Zina

JAFFE BAKER GALLERY 407.241.3050
608 Banyan Tr., Boca Raton 33431 FAX: 407.241.5976
Hours: Mon-Sat 11-4
Contact: Elaine Baker, Owner
Specialty: Regional, national, and international artists representing contemporary paintings and sculpture

Artists Represented: Mary Lee Adler-Ataie, Ron Banks, Perez Celis, Lynn, Chadwick, Brian Curtis, Allan D'arcangelo, Friedel Dzubas, Dorothy Gillespie, John Henry, Rhoda Hepner, Darryl Hughto, David Kraisler, Ronnie Landfield, Alberto Magnani, Joe Nicastri, Janet Siegel Rogers, Sherri Tan, Jeff Whyman

CONNECTICUT

OLD LYME

THE COOLEY GALLERY 203.434.8807
25 Lyme St., P.O. Box 447, Old Lyme 06371 FAX: 203.434.7526
Hours: Mon-Sat 10-5
Contact: Jeffrey W. Cooley, President
Specialty: 19th- & early 20th-Century American paintings
and contemporary realism

Artists Represented: Linden Frederick (See page 110), Peggy N. Root (See page 203)
Works Available By: Alfred Thompson Bricher, Emil Carlsen, Samuel Coleman, Bruce Crane, Jasper Francis Cropsey, Sanford Gifford, Wilson Irvine, Ogden Pleissner, Henry Ward Ranger, Aaron Draper Shattuck, Henry Pember Smith, Guy Wiggins

DISTRICT OF COLUMBIA

WASHINGTON

DAVID ADAMSON GALLERY 202.628.0257
406 Seventh St. N.W., Washington 20004 FAX: 202.628.0257
Hours: Tues-Sat 10:30-4:30
Contact: Laurie Hughs, Director
Specialty: Contemporary prints, paintings and sculpture

Artists Represented: Jennifer Berringer, Allen T. Carter, Nancy Depew, Patricia Keck, **Kevin MacDonald (See page 163)**, Stephen T. Moore, **Jody Mussoff (See page 179)**, Todd, Neal, **William Newman (See page 181)**, Katja Oxman, Nedezda Prvulovic, **Sherry Zvares Sanabria (See page 212)**

ADDISON/RIPLEY GALLERY 202.328.2332
Nine Hillyer Ct., Washington 20008 FAX: 202.328.2332
Hours: Tues-Sat 11-5
Contact: Chris Addison, Partner
Specialty: Contemporary art in all media

Artists Represented: Rebecca Cross, Tom Downing, **Greg Hannan (See page 127)**, Woong Kim, Edith Kuhnle, Val Lewton, Michael Smallwood, **Peter Stevens (See page 363)**
Works Available By: Sam Gilliam, Robert Indiana, Wolf Kahn, Malcolm Morley, Robert Motherwell, Helmut Newton, Frank Stella, Lee Weiss

ALEX GALLERY 202.667.2599
2106 R St. N.W., Washington 20008
Hours: Tues-Sat 11-5
Contact: Victor Gaetan, Director
Specialty: Contemporary paintings, sculptures and drawings by national and international artists

Artists Represented: Phoebe Beasley, Irene Iribarren, Libby Macavoy, Fred Morrison, Thomas O'Callaghan, Janet Siegel Rogers, George Saru, Hans Versteeg, Kari Walden

ANTON GALLERY 202.328.0828
2108 R Street N.W., Washington 20008
Hours: Tues-Sat 12-5

FRANZ BADER GALLERY 202.393.6111
1500 K St. N.W., Washington 20005
Hours: Tues-Sat 10-5
Contact: Wretha Hanson, Proprietor
Specialty: Contemporary American sculpture, paintings and works on paper

Artists Represented: Steven Bickley, Stanley Bleifeld, Nizette Brennan, Patricia Friend, Gary Goldberg, Simon Gouverneur, Jo Harrop, Felrath Hines, Kathleen Holder, James Iritani, Peter Jogo, Terrence Karpowicz, Ann Lyne, Scott McIntyre, Jerome Meadows, **Peter Milton (See page 273)**, Jerry Monteith, Greg Mort, Harry Nadler, Elliot Offner, Joni Pienkowski, Michael Platt, Ron Pokrasso, Amalie Rothschild, John Ruppert, Al Smith, Paul Suttman, **John Van Alstine (See page 370)**, F.L. Wall, Gail Watkins, **John Winslow (See page 244)**

BAUMGARTNER GALLERIES INC. 202.232.6320
2016 R St. N.W., Washington 20009 FAX: 202.667.4147
Hours: Tues-Sat 11-6
Contact: Manfred Baumgartner, President

Artists Represented: Michael Bisbee, Kendall Buster, Saint Clair Cemin, Peter Charles, Abraham David Christian, Stephen Ellis, John McCarty, Tom Nozkowski, David Reed, W.C. Richardson, Robin Rose, Jeff Spaulding, Gary Stephan, Yuriko Yamaguchi **Estates Represented:** Leon Berkowitz

BRODY'S GALLERY 202.462.4747
1706 21st St. N.W., Washington 20009
Hours: Tues-Sat 11-5:30

ROBERT BROWN GALLERY 202.483.4383
2030 R St. N.W., Washington 20009
Hours: Tues-Sat 12-6
Contact: Robert Brown
Specialty: 20th-Century works on paper

Artists Represented: Shahla Arbabi, Valeriy & Rimma Gelovin, Kit-Keung Kan, Oleg Kudryashov, Sarah McCoubrey, Joseph Solman, Fifo Stricker **Works Available By:** Donald Baechler, William Bailey, Alberto Giacometti, Anton Henning, Brice Marden, Carlo Maria Mariani, Friedrich Meckseper, Henry Moore, Eduardo Oliveira Cezar, Donald Sultan

CAREGA FOXLEY LEACH GALLERY 202.462.8462
1732 Connecticut Ave. N.W., Washington 20009
Hours: Tues-Sat 11-5

DE ANDINO FINE ARTS 202.462.4772
1609 Connecticut Ave. N.W., Washington 20009 FAX: 202.462.4766
Hours: Tues-Sat 11-5
Contact: Jean-Pierre de Andino, Director
Specialty: Modern and contemporary works of art

Artists Represented: Natalie Alper, **Rebecca Davenport (See page 82)**, Jane Margaret Dow, William Dutterer, Edgar Franceschi, Edward Lee Hendricks, Stacey Jones, John Kirchner, Thomas Osgood, Jan Sawka, Lynn Schmidt, Jeffrey Smith **Works Available By:** Elvira Bach, Walter Darby Bannard, Fernando Botero, The Boyle Family, Luciano Castelli, Christo, Jose Luis Cuevas, Jim Dine, Rainer Fetting, Eric Fischl, Helen Frankenthaler, Joan Mitchell, David, Nash, Mimmo Paladino, Robert Rauschenberg, Man Ray, Ed Ruscha, Donald Sultan, Antoni Tapies, Andy Warhol

KATHLEEN EWING GALLERY 202.328.0955
1609 Connecticut Ave., Ste. 200, Washington 20009 FAX: 202.462.1019
Hours: Wed-Sat 12-6
Contact: Kathleen Ewing, Director
Specialty: 19th- century, early-mid 20th-Century, and contemporary photography

Artists Represented: A. Aubrey Bodine, Esther Bubley, Frank Diperna, Zdenko Feyfar, Frank Herrera, Lisette Model, Mark Power, August Sander, Steve Szabo **Works Available By:** Sid Avery, James Balog, Bruce Barnbaum, Macduff, Everton, Louis Faurer, Neil Folberg, Allan Janus, Michael Johnson, Frank Lavelle, Alex Maclean, Jophn McWilliams, Joan Myers, Richard Ross, Eileen Toumanoff

FENDRICK GALLERY 202.338.4544
3059 M St. N.W., Washington 20007
Hours: Tues-Sat 9:30-6; Mon By Appt

FOUNDRY 202.387.0203
Nine Hillyer Ct., Washington 20008
Hours: Tues-Sat 10-5; Sun 1-5
Contact: Frank Cappello, President
Specialty: Contemporary experimental

Artists Represented: Frank Cappello, Char Gardner, Kathryn Henneberry, Mary Virginia Langston, Shawn Mcpartland, Randy Michener, Betty Murchison, Patricia Natirbov, Jay Orbach, Loise Spindel, Barbara Sweet, Elizabeth Vail

GALLERY K 202.234.0339
2010 R St. N.W., Washington 20009 FAX: 202.234.0605
Hours: Tues-Sat 11-6
Contact: Komei Wachi, Director
Specialty: Contemporary fine art; emerging talents

Artists Represented: Susan Abbott, Ed Ahlstrom, Catherine Bartza, Lanny Bergner, Patrick Craig, Robert Ferguson, Michael Francis, Wayne Paige, Jo Rango, Kay Ruane, Obie Simones, Bruce Thayer, Kenneth Young **Works Available By:** Joseph Cornell, Gene Davis, Robert Motherwell, Ben Nicholson, Jackson Pollock, Pierre Soulages, Andy Warhol, Scott Williams

GOVINDA GALLERY 202.333.1180
1227 34th St. N.W., Washington 20007 FAX: 202.625.0440
Hours: Tues-Sat 11-6
Contact: Christopher Murray, Director
Specialty: Contemporary paintings, photographs and prints

Artists Represented: Jay Burch, Howard Finster, Greg Gorman, Gendron Jensen, Douglas Kirkland, Christopher Makon, Byron Peck **Works Available By:** Harold Edgerton, Keith Haring, Roy Lichtenstein, Andy Warhol

JANE HASLEM GALLERY 202.232.4644
2025 Hillyer Place N.W., Washington 20009
Hours: Wed-Sat 12-6
Contact: Jane N. Haslem, President
Specialty: 20th-Century American art; paintings, prints and works on paper

Artists Represented: Larry Day, Carlton Fletcher, Betsy Friedman, Hayes Friedman, Billy Morrow Jackson, Misch Kohn, Mauricio Lasansky, Gabor Peterdi, Karl Schrag, Richard Ziemann **Works Available By:** Mark Adams, Will Barnet, David Becker, Neil Blaine, Bernard Chaet, Tom Edwards, Jacques Hnizdovsky, David Itchkawich, Philip Koch, Karen Kunc, Wanda Miller Matthews, Michael Mazur, James McGarrell, Nancy McIntyre, Gordon Mortensen, Elizabeth Osborne, Joe Price, Julie Schneider, Julian Stanczak, Beth Van Hoesen, Lynd Ward

HENRI GALLERY 202.659.9313
1500 21st St. N.W., Washington 20036
Hours: Tues-Sat 11-6; Sun 2-6

JONES TROYER FITZPATRICK 202.328.7189
1614 20th St. N.W., Washington 20009
Hours: Wed-Sat 11-5
Contact: Sally Troyer, Co-Director
Specialty: Contemporary photography and Washington painters

Artists Represented: Dick Arentz, Marcel Bardon, John Gossage, Jason, Horowitz, Rebecca Kamen, Tom Mullany, Lawley Paisley-Jones, Mindy Weise **Works Available By:** Zeke Berman, Barbara Crane, Claudia De Monte, Willem De Looper, Suzanne Hellmuth, Ed McGowin, Jock Reynolds, Ruth Thorne-Thomsen

COLORADO

BOULDER

SHARK'S INC. — 303.443.4601
2020 Ninth St., Boulder 80302 — FAX: 303.443.1245
Hours: By Appt
Contact: Bud Shark, Director
Specialty: Publishers of contemporary original prints

Artists Represented: Phyllis Bramson, John Buck, Rodney Carswell, Dale Chihuly, Rafael Ferrer, Red Grooms, Susan Hall, Robert Kushner, Janis Provisor, Michael Rubin, David Saunders, Italo Scanga, Hollis Sigler, Betty Woodman

DENVER

ALPHA GALLERY — 303.623.3577
959 Broadway, Denver 80203
Hours: Mon-Fri 10-6; Sat 10-4
Contact: Hilary Depolo, Director
Specialty: Contemporary paintings and custom framing

Artists Represented: Lynn Allbright, Michael Brangoccio, Louise Cadillac, David Dirrim, R. Elzo Dunn, Pam Furumo, Candice Gawne, Doug Hunley, Walt Hyler, Henry Isaacs, Robert Lait, Virginia Maitland, Mary Morrison, Sandra Nichols, Doug Osa, Helen Ragheb, Sangeeta Reddy, Sebastian

ARTYARD — 303.777.3219
1251 S. Pearl St., Denver 80210 — FAX: 303.871.0446
Hours: Tues-Fri 1:30-3:30
Contact: Peggy Mangold, Director
Specialty: Outdoor and indoor sculpture; contemporary American, Spanish and Mexican art

Artists Represented: Ramon Guillen Balmes, Carolyn Braaksma, Bill Burgess, Betty Gold, Sebastian, **Robert Mangold (See page 347)**, Charles Parson, Carl Reed, Kevin Robb, Saralegui, Tony Stanzione, **Frank Swanson (See page 365)**, Gabriel Verder

KYLE BELDING GALLERY — 303.825.2555
1110 17th St., Denver 80202
Hours: Mon-Fri 10-6; Sat 12-4
Contact: Kyle Belding, Director
Specialty: Contemporary paintings, drawings and sculptures; emerging artists and artists of stature.

Artists Represented: Zoa Ace, Michael Duffy, William Hayes, John Patrick, Kelly Jeri Moore, Louis Recchia, Allen Roth, Sahand Tabatabai, Andrew Taylor, Carrie Ungerman **Works Available By:** Michael Gonzalez, Richard Lee, Laura Stein, Chris Wilder

THE CAMERA OBSCURA GALLERY — 303.623.4059
1309 Bannock St., Denver 80204
Hours: Tues-Sat 10-5:30; Wed 10-8; Sun 1-5
Contact: Hal D. Gould, Director; C. Raye Gieseke, Asst. Director
Specialty: Vintage and contemporary photography

Artists Represented: Berenice Abbott, James Balog, Howard Bond, Christopher Burkett, Imogen Cunningham, Edward Curtis, Jay Dunitz, Sebastiao Salgado, Jerry Uelsmann, J. Vee, Todd Webb

SANDY CARSON GALLERY — 303.297.8585
1734 Wazee St., Denver 80202 — FAX: 303.297.8933
Hours: Mon-Fri 9-6; Sat 11-4
Contact: Jodi Carson, Director; Sandy Carson, Director
Specialty: Regional and national contemporary artists of all media

Artists Represented: John Balistreri, Timothy Berry, Sonja Blemdahl, Peter De Lory, Valeriy/Rimma Gerlovin/a, John Giarrizzo, Leslie Hawk, Frank Sampson, Lorraine Shirkus **Works Available By:** Neda Al Hilali, Carl Burwell, Tom Farbinash, Alden, Mason, Myron Melnick, Sherri Smith

HASSEL HAESELER GALLERY — 303.295.6442
1743 Wazee St., Denver 80202
Hours: Tues-Thurs 11-6; Fri 11-9; Sat 11-5
Contact: Joshua Hassel, Director
Specialty: Neo-pop, New Painters of the American Scene and Colorado's avant-garde

Artists Represented: Martha Daniels, SuShe Felix, Tracy Felix, **John T. Haeseler (See page 124)**, Liz Howell, Dede Larue, Matt O'Neill, Jesus Polanco, Chandler Romeo, Reed Philip Weimer **Works Available By:** V.C. Ballas, Roland Bernier, Beulah, Nancy Bohm, Don Carleno, Mary Chenoweth, Patti Genack, Eric Helland, Joe Higgins, Cindy Lee Lord, Jennifer Melton, Art Modren, Henrietta Mueller, Michael Pedziwiatr, Robert Pietruszewski, Rex Ray, Ivan Suvanjieff

INKFISH GALLERY — 303.825.6727
949 Broadway, Denver 80203
Hours: Mon-Fri 10-6; Sat 10-4
Specialty: Contemporary work in all mediums by local and international artists

Artists Represented: David Barbero, Susan Cooper, Roland Detke, Kalani Engles, Mark Gunning, Amy Metier, George Rickey, Philip Tsiaras, Dave Yust **Works Available By:** Harry Bertoia, Christo, Vance Kirkland, Italo Scanga

MCCONNELL GALLERY — 303.573.1310
1444 Wazee St., Ste. 120, Denver 80202
Contact: Ross C. McConnell, Director

PAYTON RULE GALLERY — 303.293.9080
1736 Wazee St., Denver 80202 — FAX: 303.298.9523
Hours: Tues-Fri 10-6; Sat 11-5
Contact: Robin Rule, Owner
Specialty: Modern and contemporary painting, sculpture and photography by regional and national artists

Artists Represented: Scott Chamberlin, **Dale Chisman (See page 72)**, **Victoria Fuller (See page 327)**, Wes Kennedy, Betsy Margolius, Anne Noggle, Clark Richert, Beverly Rosen, Mark Sink, Sandy Skoglund **Works Available By:** John Fudge, Homare Ikeda, Allan Packer, Jeff Starr

JOAN ROBEY GALLERY — 303.892.9600
939 Broadway, Denver 80203 — FAX: 303.892.1849
Hours: Mon-Fri 10-6; Sat 10-4
Contact: Joan Robey, Director; Mildred Caplitz, Consultant
Specialty: Contemporary paintings, three-dimensional works of art and art furniture

Artists Represented: Jeffrey Brosk, Rico Eastman, Karen Koblitz, Bethany Kriegsman, Robert McCauley, Clifton Monteith, Don Reitz, Mario Rivoli, Michael Stano, Peter Vandenberge

ROBISCHON GALLERY — 303.298.7788
1740 Wazee St., Denver 80202
Hours: Tues-Fri 10-6; Sat 11-5
Contact: Jim Robischon, Director; Jennifer Doran, Director
Specialty: Contemporary painting, sculpture, photography and works on paper by established and emerging American artists

Artists Represented: Jane Abrams, Russel Adams, Garo Antreasian, Jack Balas, Drex Brooks, Deborah Brown, John Buck, Trine Bumiller, Jim Cogswell, Jim Colbert, Luis Eades, Robert Ecker, Gary Emrich, Jill, Englebardt, Frank Ettenberg, Kathleen Ferguson, Linda Fleming, Ed Haddaway, Jeremy Hillhouse, Lorre Hoffman, Aaron Karp, Jerry Kunkel, Sam Lemly, Reg Loving, Nancy Maginn, Hugh Margerum, Blue McRight, Lloyd Menard, Stan Meyer, Creighton Michael, Brad Miller, Daniel Morper, Kathleen Morris, Louis Mueller, Tom Nussbaum, Kevin Oehler, Mary Peck, Michael Peed, Mary Ristow, Jean Roller, Antonette Rosato, Sam Scott, Patrick Simpson, Ruth Thorne-Thomsen, Richard Tompson, Mark Villarreal, Flint Whitlock, Jim Wolford **Works Available By:** Constance DeJong, Luis Jimenez

BRIGITTE SCHLUGER GALLERY — 303.825.8555
929 Broadway, Denver 80203
Hours: Mon-Fri 10-6; Sat 10-4
Contact: Brigitte Schluger, Owner/Director
Specialty: Contemporary painting and sculpture; folk and Eskimo art

Artists Represented: David Aguirre, Joanne Battiste, Matti Berglund, Anne Embree, **Carol Hoy (See page 136)**, Edward Larson, Lynne Loshbaugh, Max Pruneda, Julie Wagner **Works Available By:** David Alvarez, Leroy Archuleta, Barnabas Arnashunaaq, Dewey Blocksma, David Butler, Ned Cartledge, Cynthia Cook, Mamie Deschillie, "Uncle Pete" Drgac, Kim Dufford, Howard Finster, Robert Gallegos, Valerie Kaiser, Kananginak, Kenojuak, Kiakshuk, Lucy R. A. Miller, Ike Morgan, Pauta, Pitseolak, Martin Prechtel, Pudlo, Constance Roberts, Mike Rodriguez, Mary T. Smith, Kristine Smock, Jimmy, Lee Sudduth, Mose Tolliver, Ted Villa

THE CAROL SIPLE GALLERY, LTD — 303.292.1401
1401 17th St., Denver 80202
Hours: Mon-Fri 11-5; Sat 12-4
Contact: Carol B. Siple, President
Specialty: A unique blend of traditional and contemporary art

Artists Represented: Michael Bergt, Gordon Brown, Ruth Bryant, George Carlson, Patti Cramer. Mark Daily, Joellyn Duesberry, Mark English, Kim English, Bryan Gough, Steve Kestrel, Tamara Lichtenstein, Philip Maior, Chuck Mardosz, Dean Mitchell, Jeri N. Quinn, **Daniel Sprick (See page 224)**, Rick Stoner, Gregory Tonozzi, Madeline Wiener, Zhang Wen Xin

GINNY WILLIAMS GALLERY — 303.321.4077
299 Fillmore St., Denver 80206 — FAX: 303.394.2060
Hours: Tues-Sat 11-6
Contact: Ginny Williams, Director
Specialty: Contemporary photography, paintings and sculpture, and fine vintage photography

Artists Represented: Laura Audrey, Alicia Bailey, **Ruth Bernhard (See page 378)**, Louise Bourgeois, Jane Gottlieb, Ted Kuykendall, Dan Ragland, Holly Roberts, Paul Schroeder, Sandy Skoglund, Ellen Sollod, Noi Watanakul, Joel-Peter Witkin **Works Available By:** Berenice Abbott, Margaret Bourke-White, Paul Caponigro, Henri Cartier-Bresson, William Christenberry, Steve Collector, John Coplans, Walker Evans, William Fuller, Linda Girvin, Ernst Haas, Gary Huibregste, William Henry Jackson, Gyorgy Kepes, Dorothea Lange, Olivia Parker, Peter Ruting, Ruth Thorne-Thomsen, Mark Travis, Marion Post Wolcott

CALIFORNIA *(cont.)*

SANTA MONICA

RICHARD KUHLENSCHMIDT GALLERY
213.450.2010
1630 17th St., Santa Monica 90404 FAX: 213.450.0872
Hours: Tues-Sat 12-5
Contact: Richard Kuhlenschmidt, Owner; Barbara Steffen, Director
Specialty: Contemporary art

Artists Represented: Michael Asher, Cindy Bernard, Douglas Huebler, John Knight, William Leavitt, Allan McCollum, Matt Mullican, James Welling **Works Available By:** Nayland Blake, Barbara Bloom, David Cabrera, Louise Lawler

LUHRING AUGUSTINE HETZLER
213.394.3964
1330 Fourth St., Santa Monica 90401 FAX: 213.394.2644
Hours: Tues-Fri 10-6; Sat 11-5
Contact: Mia Von Sadovszky
Specialty: Contemporary art

Artists Represented: Larry Clark, Gunther Forg, Georg Herold, Jon Kessler, Hubert Kiecol, Martin Kippenberger, Zoe Leonard, Cady Noland, Albert Oehlen, Jorge Pardo, Stephen Prina, Sam Samore, Thaddeus Strode, Christopher West Franz, Christopher Wool **Works Available By:** Jean-Michel Basquiat, Joseph Beuys, Marcel Duchamp, Philip Guston, Bruce Nauman, Sigmar Polke, Gerhard Richter

MEYERS/BLOOM
213.829.0062
2112 Broadway, Santa Monica 90404
Hours: Tues-Fri 10-5; Sat 11-5
Contact: Mary Artino, Director
Specialty: Conceptually based combined media

Artists Represented: Dominique Blain, Kim Dingle, Steven Dubbin, Alfredo Jaar, Jerry Kearns, Bertrand Lavier, Erik Levine, Karl Matson, Marilyn Minter, Leonel Moura, Vik Muniz, Robbin Murphy, Jack Ox, Perejaume, Susan Rankaitis, Leon Polk Smith, George Stone, Boyd Webb, Millie Wilson **Works Available By:** David Hockney, Ellsworth Kelly, Andy Warhol

PENCE GALLERY
213.393.0069
908 Colorado Ave., Santa Monica 90401 FAX: 213.393.8864
Hours: Tues-Fri 10-5:30; Sat 11-5
Contact: Putter Pence, Owner
Specialty: New and emerging artists

Artists Represented: Phoebe Adams, Dale Chihuly, Lynn Davis, Tom, Knechtel, Paul Laster, Sabina Ott, Ann Preston, Arne Svenson, Nelson Valentine

THE REMBA GALLERY/MIXOGRAFIA
213.576.1011
918 Colorado Ave., Santa Monica 90401 FAX: 213.458.9688
Hours: Tues-Sat 10-5:30
Contact: Lea Remba, Director
Specialty: Fine art publishers of limited editions on handmade paper and metal

Artists Represented: Arman, Jonathan Borofsky, Stanley Boxer, Alberto, Burri, Laddie John Dill, Helen Frankenthaler, Robert Graham, Kenneth Noland, Larry Rivers, Pierre Soulages, Rufino Tamayo, William Tillyer, Costas Tsoclis

MARC RICHARDS GALLERY
213.453.1114
2114 Broadway, Santa Monica 90404 FAX: 213.453.1247
Hours: Tues-Sat 10-5
Contact: Marc Richards, Director
Specialty: Contemporary American and European painting, sculpture, and works on paper

Artists Represented: Meg Cranston, Steve Hanson, Cynthia Hollis, Nancy, Riegelman, Kevin White **Works Available By:** Josef Albers, Dan Flavin, Donald Judd, Sol LeWitt, Robert Mangold, Ed Ruscha

SCHWARTZ CIERLAK GALLERY
213.396.3814
3015 Main St., Santa Monica 90405
Hours: Tues-Sat 11-5

SHEA/BORNSTEIN GALLERY
213.452.4210
2114 Broadway, Santa Monica 90404
Hours: Tues-Fri 10-5:30; Sat 11-5

SHOSHANA WAYNE GALLERY
213.451.3733
1454 5th St., Santa Monica 90401 FAX: 213.458.1290
Hours: Tues-Fri 10-5:30; Sat 10-5
Contact: Shoshana Blank, Director
Specialty: Contemporary art

Artists Represented: David Best, Patrice Caire, John Gaspar, Rachel, Lachowicz, Cary S. Liebowitz, Claudia Matzko, Ann Messner, Joseph Nechvatal, Bogdan Prezynski, Mia Westerlund Roosen, Tom Savage, Eva, Schlegal, Michael Schulze, Leonard Seagal, Kiki Smith, Mauro Staccioli, Pae White **Works Available By:** John Baldessari, Christo, Marcel Duchamp, Roy Lichtenstein, Robert Motherwell, Frank Stella

TATISTCHEFF GALLERY, INC.
213.395.8807
1547 Tenth St., Santa Monica 90401 FAX: 213.394.0757
Hours: Tues-Sat 10-5:30
Contact: Terrence Rogers, Director
Specialty: Contemporary American representational painting and drawing

Artists Represented: Hilary Brace, Michael Chapman, William Clutz, Philip Geiger, Susan Hauptman, Simeon Lagodich, Harry Orlyk, Hank Pitcher, Stephanie Sanchez, Adam Schnitzer, Kurt Solmssen II **Works Available By:** Tina Barney, Richard Crozier, Lincoln Perry, Jeanette Pasin Sloan, Andrew Stevovich, James David Thomas, Don Williams

JOHN THOMAS GALLERY
213.396.6096
602 Colorado Ave., Santa Monica 90401
Hours: Tues-Sat 10-6; Sun 1-5
Contact: Jack Buick, Director
Specialty: Contemporary and emerging American art

Artists Represented: John Abrahamson, Craig Antrim, Lorraine Bubar, Domenic Cretara, Darryl Edwards, Cindy Evans, Ovidio Federici, Alan Firestone, John C. Hesketh, Kathryn Jacobi, Margaret Lazzari, David Limrite, Jim Reed, Stephen Royster, Michael Schrauzer

TORTUE GALLERY
213.828.8878
2917 Santa Monica Blvd., Santa Monica 90404
Hours: Tues-Sat 11-5:30
Contact: Mallory Freeman, Director
Specialty: Contemporary art

Artists Represented: Daniel Douke, Bruce Everett, Tom Foolery, David Furman, Allen Harrison, Randall Lavender, Diane Marsh, Jim Morphesis, James Murray, Mark Perlman, Shirley Pettibone, John Rose, Jon Swihart, Joyce Treiman **Estates Represented:** Patrick Hogan

BRENDAN WALTER GALLERY
213.395.1155
1001 Colorado Ave., Santa Monica 90401
Hours: Tues-Sat 10:30-5:30

DANIEL WEINBERG GALLERY
213.453.0180
2032 Broadway, Santa Monica 90404
Hours: Tues-Sat 10:30-5
Contact: Daniel Weinberg, Director

STINSON BEACH

CLAUDIA CHAPLINE GALLERY
415.868.2308
3445 Shoreline Hwy., Stinson Beach 94970

VENICE

L.A. LOUVER
213.822.4955
55 N. Venice Blvd., Venice 90291
Hours: Tues-Sat 12-5

SHARON TRUAX FINE ART
213.396.3162
1625 Electric Ave., Venice 90291 FAX: 213.396.3162
Hours: Mon-Sat By Appt
Contact: Sharon Truax, Owner/Director
Specialty: Contemporary paintings, drawings, sculpture, and prints

Artists Represented: Hope Alexander, Eve Aschheim, Guy Dill, Laddie John Dill, Phyllis Green, Nancy Kay, Peter Lodato, Mineo Mizuno, Derrik Van Nimwegen, Elsa Rady, Ed Ruscha **Works Available By:** Sam Francis, Ed Moses, Dewain Valentine

WEST HOLLYWOOD

BIOTA GALLERY
213.289.0979
8500 Melrose Ave., West Hollywood 90069 FAX: 213.289.0547
Hours: Tues-Fri 10-5; Sat 11-5
Contact: Donna M. Kobrin, Director
Specialty: Contemporary art by emerging artists

Artists Represented: Joseph Ginsberg, **Diana Jacobs (See page 254)**, Sharon Loper, Lynette O'Kane, **David Shipley (See page 292)**, Lee Spear Webster **Works Available By:** Christine Brennan, Karen Hirshan, Carol Spencer Morris, Anne Mudge, John Stewart, Jackie Watson, William Wegman

L. A. IMPRESSION
213.659.3336
811 N. West Knoll Dr., West Hollywood 90069
Hours: By Appt
Contact: Carlos Baez-Silva, Director
Specialty: 20th-Century Mexican masters and contemporary art

Artists Represented: Leo Acosta, Luis Anguiano, Edwiges Baez-Silva, Rafael Cauduro, Guillermo Ceniceros, Pedro Coronel Rafael Coronel, F. Corzas, Jose Luis Cuevas, Mario Martin Del Campo, Roberto Delgado, Jorge Lopez Garcia, Jose Clemente Orozco, Luis Magin, Carlos Merida, Humberto Oramas, Diego Rivera, David A. Siqueiros, Rufino Tamayo

ROBERT BERMAN GALLERY 213.453.9195
2044 Broadway, Santa Monica 90404
FAX: 213.453.2383
Hours: Tues-Sat 11-5; Sun 1-5
Contact: Jeff Poe, Director
Specialty: Contemporary art

Artists Represented: Sol Aquino, Daniel Brice, Robbie Conal, Ibsen, Espada, Daniel J. Martinez, Louis Renzoni, Frank Romero, Tom Slaughter, May Sun **Works Available By:** Jean-Michel Basquiat, Keith Haring, Andy Warhol

BLUMHELMAN GALLERIES INC. 213.451.0955
916 Colorado Ave., Santa Monica 90401
Hours: Tues-Fri 10-6; Sat 11-6
Contact: Deborah McLeod, Director

BORITZER/GRAY GALLERY 213.394.6652
903 Colorado Ave., Santa Monica 90401
FAX: 213.394.2604
Hours: Tues-Sat 11-6; Sun 1-6
Contact: Etan Boritzer, Director
Specialty: Contemporary painting, sculpture, and photography

Artists Represented: Nick Agid, Russ Andrade, Claude Bentley, Jae Hahn, Bonita Helmer, Eric Johnson, Blaine Mitchell

ROY BOYD GALLERY 213.394.1210
1547 Tenth St., Santa Monica 90401
FAX: 213.394.0757
Hours: Tues-Sat 10-5:30
Contact: Richard Telles, Director
Specialty: Contemporary art

Artists Represented: Judie Bamber, David Bunn, Eileen Cowin, Dorit Cypis, Jeanne Dunning, Connie Hatch, Bill Komoski, John Miller, Gary Simmons, Buzz Spector, Megan Williams

LINDA CATHCART GALLERY 213.451.1121
924 Colorado Ave., Santa Monica 90401
FAX: 213.451.2781
Hours: Tues-Fri 10-5:30; Sat 11-6
Contact: Linda Cathcart, Owner
Specialty: Contemporary art

Artists Represented: Louise Bourgeois, Robert Colescott, Nancy Dwyer, Janet Fish, Nancy Graves, Biff Henrich, Alfred Jensen, Ronald Jones, Richard Lee, Robert Longo, Dean Mcneil, Nic Nicosia, Jim Shaw, Cindy Sherman, Cary Smith, Pat Steir, William Wegman, Chris Wilder **Works Available By:** Lynda Benglis, Roger Brown, Sally Gall, Robert Mapplethorpe, Melissa Miller, Nancy Mitchnick, Ed Ruscha

JAMES CORCORAN GALLERY 213.451.4666
1327 Fifth St., Santa Monica 90401
FAX: 213.451.0950
Hours: Tues-Fri 10-6; Sat 11-5
Contact: Sandra Starr, Director

Artists Represented: Vito Acconci, Peter Alexander, Don Bachardy, Donald Baechler, **Billy Al Bengston (See page 252)**, Laddie John Dill, Sam Francis, **Joe Goode (See page 116)**, Tom Holland, Allen Jones, David Lynch, Tom Otterness, Beverly Pepper, **Ken Price (See page 357)**, **Ed Ruscha (See page 208)**, Andy Spence, Frank Stella, William Wegman, H. C. Westermann **Works Available By:** John Chamberlain, Joseph Cornell, Willem de Kooning, Richard Diebenkorn, David Hockney, Hans Hofmann, Ellsworth Kelly, Yves Klein, Roy Lichtenstein, Pablo Picasso, Robert Rauschenberg, Cy Twombly, Andy Warhol

ERSGARD GALLERY 213.319.1681
1434 Fourth St., Santa Monica 90401
FAX: 213.319.1671

SHERRY FRUMKIN GALLERY 213.393.1853
1440 Ninth St., Santa Monica 90401
FAX: 213.623.9130
Hours: Tues-Sat 10:30-5:30
Contact: Sherry Frumkin, Director
Specialty: Contemporary painting, sculpture and assemblage

Artists Represented: Phyllis Davidson, **Jean Edelstein (See page 98)**, Rudy Fernandez, David Gilhooly, Dal Henderson, Douglas Johnson, Mary Cady Johnson, Ted Kerzie, Seta Manoukian, Kay Miller, Tom Palmore, **Ron Pippin (See page 355)**, Jack Reilly, Gustavo Ramos Rivera, Ron Robertson, Richard Ralph Roehl, Randye Sandel, Richard Shelton, **James Strombotne (See page 228)**, Doug Sutherland, Missak Terzian, Simon Toparovsky, Delos Van Earl, John Wilson **Works Available By:** D.J. Hall, Jeffery Laudenslager

GALLERY OF FUNCTIONAL ART 213.450.2827
2429 Main St., Santa Monica 90405
FAX: 213.450.4831
Hours: Tues-Fri 11-7; Sat 11-6; Sun 12-6
Contact: Lois Lambert, Owner/Director
Specialty: Functional, three-dimensional art pieces; featuring art furniture

Artists Represented: Jon Box, Eugenia Butler, Kenny Farrell, Barbara, Field, Gregg Fleishmann, David Gale, John Kennedy, John Mcnaughton, Guy, Miller, David Perry, F.L. Wall

GALLERY 5 213.576.3466
1411 Fifth St., Santa Monica 90401
FAX: 213.576.3468

DOROTHY GOLDEEN GALLERY 213.395.0222
1547 Ninth St., Santa Monica 90401
FAX: 213.458.3368
Hours: Tues-Sat 10:30-5:30; Sun 1-5
Contact: Dorothy Goldeen, Director
Specialty: Contemporary painting, sculpture, photography, and works on paper

Artists Represented: Robert Arneson, Howard Ben Tre, Fletcher Benton, Ellen Brooks, Jo Ann Callis, Squeak Carnwath, Roy De Forest, Heide Fasnacht, Charles Ginnever, Robert Hudson, Paul Kos, Terence La Noue, Dennis Leon, Donald Lipski, Nam Jun Paik, Ed Paschke, Janis Provisor, Alan Rath, Zizi Raymond, Adam Ross **Works Available By:** Magdalena Abakanowicz, Christo, Charles Gaines, Patsy Krebs, Muntadas, Jurgen Partenheimer, Linda Roush, Diana Thater, David Wojnarowicz, Andrew Young **Estates Represented:** John Altoon

GORDON GALLERY 213.394.6545
1311 Montana Ave., Santa Monica 90403
FAX: 213.576.2453
Hours: Tues-Sat 10-6
Contact: Barry Gordon, Director
Specialty: Contemporary art and the work of nationally and internationally known modern masters

Artists Represented: Gigi Aramescu, Augusto Barca, Naya Bay-Schmidt, Neal Crosbie, Jose Gonzalez, Anne Karsenty-Laval, Orlando Mingo, R. Renaad, Gustavo Rosa, Carmen Vicuna **Works Available By:** Karel Appel, Marc Chagall, James Coignard, Friedensreich Hundertwasser, Roberto Matta, Joan Miro, Robert Motherwell, Max Papart, Pablo Picasso, Saul Steinberg, Frank Stella, Paul Wunderlich

RICHARD GREEN GALLERY 213.828.6666
2036 Broadway, Santa Monica 90404
FAX: 213.829.9328
Hours: Tues-Sat 11-5
Contact: Richard Green, Owner/Director; Usa Green, Assoc. Director
Specialty: Contemporary paintings and prints

Artists Represented: James Brown, Suzanne Caporael, Wess Dahlberg, Anton Henning, Roberto Juarez, Marc Katano, Jesus Morales, Michael Pavoni, Raymond Saunders **Works Available By:** David Hockney, Robert Indiana, Robert Mapplethorpe, Robert Rauschenberg, James Rosenquist, Ed Ruscha, Frank Stella, Donald, Sultan, Wayne Thiebaud

CHRISTOPHER GRIMES GALLERY 213.450.5962
1644 17th St., Santa Monica 90404
FAX: 213.450.7882
Hours: Tues-Sat 10-5:30
Contact: Christopher Grimes, Owner
Specialty: Contemporary art

Artists Represented: David Anderson, John Baldessari, Nancy Barton, Lisa Bloomfield, Mary Brogger, Julia Couzens, **Lewis deSoto (See page 289)**, Mark Alice Durant, Dawn Fryling **Works Available By:** Frank Damiano, Stuart Fineman

G. RAY HAWKINS GALLERY 213.394.5558
910 Colorado Ave., Santa Monica 90401
FAX: 213.576.2468
Hours: Tues-Sat 10-5:30
Contact: G. Ray Hawkins, Director
Specialty: Rare, vintage and contemporary photographs

Artists Represented: Diane Arbus, Dmitri Baltermants, Bill Brandt, Horace Bristol, Robert Capa, Henri Cartier-Bresson, **Judy Coleman (See page 380)**, Bruce Davidson, Robert Doisneau, Robert Frank, Anthony Friedkin, Greg Gorman, Lewis Hine, George Hurrell, Annie Leibovitz, Robert Mapplethorpe, Graham Nash, Man Ray, Alexander Rodchenko, Edward Steichen, Alfred Stieglitz, WeeGee, Brett Weston, Max Yavno **Estates Represented:** Edward Curtis, Baron Adolph de Meyer, **Paul Outerbridge, Jr. (See page 394)**

FRED HOFFMAN GALLERY 213.394.4199
912 Colorado Ave., Santa Monica 90401
Hours: Tues-Fri 9:30-5:30; Sat 10-5
Contact: Fred Hoffman, Director

MICHAEL KOHN GALLERY 213.393.7713
920 Colorado Ave., Santa Monica 90401
FAX: 213.393.1554
Hours: Tues-Sat 10-5:30
Contact: Michael Kohn, Director

KOPLIN GALLERY 213.319.9956
1438 Ninth St., Santa Monica 90401
FAX: 213.319.9959
Hours: Tues-Fri 10-5:30; Sat 11-5:30
Contact: Marti Koplin, Director
Specialty: Contemporary painting, drawing and sculpture by international and emerging artists

Artists Represented: Theophilus Brown, Roger Campbell, Carolyn Cardenas, Jung Yong Chaing, Kris Cox, Peter Doolin James, Michael Dvortcsak, Martha Mayer Erlebacher, Louis Fox, Candice Gawne, Sam Gilliam, Arthur Gonzalez, Mineko Grimmer, Gaylen Hansen, David Hines, Karla Holland-Scholer, Larry Hurst, Prudencio Irazabal, David Izu, Steve Jones, John Kilduff, David Ligare, Kerry James Marshall, Tyronne Mitchell, Barrie Mottishaw, Patrick Nagatani, John Nava, Orleonok Pitkin, Margaret Rinkovsky, Sandra Sallin, Terry Schoonhoven, Robert Schultz, David Settino Scott, Lee Smith, Janet Tholen, Andree Tracey, Christopher Warner, John Wehrle, Mark Wethli, Yuriko Yamaguchi

CALIFORNIA *(cont.)*

SAN FRANCISCO

ERIKA MEYEROVICH GALLERY
415.421.9997
231 Grant Ave., San Francisco 94108
FAX: 415.421.2775
Hours: Mon-Fri 9-6; Sat 9:30-5:30
Contact: Erika Meyerovich, Director
Specialty: European and American contemporary and modern art

Artists Represented: Giancarlo Impiglia, Christiane Lazard, Marilyn MacGregor, Anne Tabachnick, Ron Tatro **Works Available By:** Lynn Chadwick, Marc Chagall, Jim Dine, Eric Fischl, Sam Francis, Keith Haring, David Hockney, Alex Katz, Roy Lichtenstein, Henri Matisse, Joan Miro, Pablo Picasso, James Rosenquist, Frank Stella, Andy Warhol

MINCHER/WILCOX GALLERY
415.433.4660
228 Grant Ave., San Francisco 94108
FAX: 415.433.6818
Hours: Tues-Fri 10-5:30; Sat 10:30-5
Contact: Michele Mincher, Partner; Tessa Wilcox, Partner
Specialty: Modern to contemporary painting, drawing, and sculpture

Artists Represented: Lutz Bacher, Gabrielle Bakker, Nayland Blake, Jamie Brunson, Margaret Crane/Jon Winet, Peter Edlund, Douglas Hall, Tony Labat, John Meyer, Brett Reichman, David Simpson

MODERNISM INC.
415.541.0461
685 Market St., Ste. 290, San Francisco 94105
FAX: 415.541.0425
Hours: Tues-Sat 10-5:30
Contact: Katya Slavenska, Director
Specialty: Contemporary art, 20th-Century historical art, and Russian avant-garde 1910-1930

Artists Represented: John Baeder, Edith Baumann-Hudson, Charles Bell, Douglas Bond, **Alexander K. Bogomazov (See page 57)** R. Crumb, Guy Diehl, Tony DeLap, James Gucwa, Peter Gutkin, Woody Gwyn, **Frederick Hammersley (See page 126)**, James Hayward, Gus Heinze, Charles Hess, Stephen Hopkins, Jerry Kearns, Jan Lassetter, John M. Miller, Martin Myers, John Nava, Hermann Nitsch, Robin Palanker, Mel, Ramos, **John Register (See page 198)**, Erik Saxon, Peter Shire, David Simpson, **Mark Stock (See page 226)**, **Sam Tchakalian (See page 231)**, David Trowbridge

JOHN PENCE GALLERY
415.441.1138
750 Post St., San Francisco 94109
FAX: 415.771.4069
Hours: Mon-Fri 10-6; Sat 10-5
Contact: John Pence, Owner/Director
Specialty: 19th- & early 20th-Century and contemporary American Realism

Artists Represented: Michael Bergt, Donald Davis, Peter Holbrook, Donald Jurney, Randall Lake, Mike Lynch, Dorothy Morgan, Will Wilson, Evan Wilson **Works Available By:** Robert Brackman, Emil Carlsen, Minerva Chapman, Peter Cox, Randall Davey, Seldon Gile, Percy Gray, John Koch, Robert, Maione, Ferdinand Reichardt, William Ritschel, Frederick Schaefer, Gardner Symons, Irving Wiles

WILLIAM SAWYER GALLERY
415.921.1600
3045 Clay St., San Francisco 94115
Hours: Tues-Sat 11-6
Contact: Dr. William Sawyer
Specialty: Contemporary paintings, sculpture, and works on paper by emerging and established artists

Artists Represented: Dewey Crumpler, Rick Demont, Brian Isobe, David Izu, Peter Loftus, Frances McCormack, James B. Moore, Art Nelson, Rik Ritchey, Richard Schloss, Barbara Spring, Jerrold Turner, Merti Walker **Estates Represented:** William Dole

MICHAEL SHAPIRO GALLERY
415.398.6655
250 Sutter St., 3rd Fl., San Francisco 94108
FAX: 415.398.0667
Hours: Wed-Sat 11-5:30
Contact: Michael Shapiro, Owner
Specialty: 20th-Century classic black/white photography

Artists Represented: Berenice Abbott, Ansel Adams, Eugene Atget, Ruth, Bernhard, George Berticevich, Margaret Bourke-White, Bill Brandt, Stephen Brigidi, Steven Brock, Paul Caponigro, Henri Cartier-Bresson, Imogen Cunningham, Edward Curtis, Judy Dater, Robert Doisneau, Peter Henry Emerson, Elliott Erwitt, Walker Evans, Laura Gilpin, Otto Hagel, Uyeno Hikoma, Lewis Hine, Christopher James, Yousuf Karsh, Andre Kertesz, Kusakabe Kimbei, Jacques-Herni Lartigue, **Alma Lavenson (See page 391)**, Edwin Hale Lincoln, George Platt Lynes, Rose Mandel, Robert Mapplethorpe, Hansel Mieth, Vernon Miller, Ken Miller, Margaretta Mitchell, Nicholas Nixon, Jeanne O'Connor, Mary Peck, Sebastiao Salgado, John Sexton, Aaron Siskind, Eugene Smith, Edward Steichen, Lou Stoumen, George Tice, Roman Vishniac, WeeGee, Jack Welpott, Brett Weston, Edward Weston, John Wimberley, Max Yavno

DON SOKER CONTEMPORARY ART
415.291.0966
251 Post St., Ste. 620, San Francisco 94108
FAX: 415.291.0962
Hours: Tues-Sat 11-5
Contact: Don Soker, Director
Specialty: Contemporary art by Japanese and West Coast artists

Artists Represented: Judith Foosaner, Theodra V. Jones, Takesada, Matsutani, Atsuhiko Musashi, Kenjilo Nanao, Tetsuya Noda, Minoru Ohira, Shoichi Seino, Yutaka Yoshinaga

TAKADA FINE ARTS
415.956.5288
251 Post St., 6th Fl., San Francisco 94108
FAX: 415.956.5409
Hours: Tues-Sat 11-5
Contact: Hidekatsu Takada, Owner

Artists Represented: Nancy Anello, **Joe Goode (See page 117)**, Theodra V. Jones, Seiji Kunishima, Michael Newman, Minoru Nishiki, Tetsuya Noda, Minoru Ohira, Jeff Ruocco, Ed Ruscha, Yutaka Yoshinaga

TRANS AVANT-GARDE GALLERY
415.291.8911
41 Grant Ave., San Francisco 94108
FAX: 415.291.8940
Hours: Tues-Sat 10-5:30
Contact: Jack Hanley, Director/Owner
Specialty: Contemporary art by emerging and established artists

Artists Represented: David Cabrera, Zoe Leonard, Thomas Locher, Christian Marclay, Stephen Prina, Christopher Wool, Erwin Wurm **Works Available By:** Georg Herold, Agnes Martin, Robert Rauschenberg, Robert Ryman, David Salle, Julian Schnabel

UDINOTTI GALLERY
415.391.4334
77 Geary St., San Francisco 94108
Hours: Tues-Sat 11-6

VISION GALLERY
415.621.2107
1155 Mission St., San Francisco 94114
FAX: 415.621.5074
Hours: Mon-Sat 9-6
Contact: Joe Folberg, Owner
Specialty: Fine art photography

Artists Represented: Ruth Bernhard, Paul Caponigro, Robert Doisneau, Neil Folberg, William Garngit, Ralph Gibson, Marc Piboud, Jock Sturges **Works Available By:** Berenice Abbott, Ansel Adams, A. Aubrey Bodine, Walker Evans, Eikoh Hosoe, Andre Kertesz, Aaron Siskind, Eugene Smith, Roman Vishniac, WeeGee, Marion Post Wolcott

DOROTHY WEISS GALLERY
415.397.3611
256 Sutter St., San Francisco 94108
FAX: 415.397.2141
Hours: Tues-Sat 11-5
Contact: Dorothy Weiss, Owner
Specialty: Contemporary ceramic and glass sculpture

Artists Represented: Hank Murta Adams, Rudy Autio, Scott Chamberlin, Jose Chardiet, Annette Corcoran, Phil Cornelius, Bernard D'Onofrio, Ruth Duckworth, Jack Earl, John Gill, Robin Grebe, Tony Hepburn, **Jun Kaneko (See page 335)**, Michael Lucero, Louis Marak, Beverly Mayeri, Katherin Mcbride, James Morris, Jay Musler, Gertrud & Otto Natzler, Todd Pearson, June Raymond, Robert Sperry, Yoshio Taylor, Robert Turner, James Wakins, Jamie Walker, Stan Welsh

STEPHEN WIRTZ GALLERY
415.433.6879
49 Geary St., 3rd Fl., San Francisco 94108
FAX: 415.433.1608
Hours: Tues-Fri 9:30-5:30; Sat 10:30-5:30
Contact: Stephen Wirtz, Owner; Connie Wirtz, Owner

Artists Represented: Gregory Amenoff, Rick Arnitz, Richard Avedon, Lewis Baltz, Victoria Faust, Suzanne Hellmuth, Jim Huntington, **Michael Kenna (See page 388)**, George Miyasaki, **Deborah Oropallo (See page 184)**, Arnaldo Pomodoro, Lucy Puls, Raymond Saunders, Sandra Shannonhouse, Alan Shepp, **Rick Soss (See page 361)**

SANTA MONICA

ANGLES GALLERY
213.396.5019
2230 Main St., Santa Monica 90405
Hours: Tues-Sat 11-5:30
Contact: David McCauliffe, Director

ART OPTIONS
213.392.9099
2507 Main St., Santa Monica 90405
FAX: 213.396.4156
Hours: Tues, Wed, Fri, Sat 10-6; Thurs 12-8;Sun 12-6
Contact: Marlene Riceberg, Owners; Fran Cey, Owners
Specialty: Unique craft gallery specializing in ceramics, glass, art furniture and jewelry

Artists Represented: Jeffrey Andrews, Ariella Belkin, Susan Silver Brown, Gail Bush, Julie Chaffee, Carol Couthro, Patrick Crabb, Amy Danger, Jon Grauman, Stan Hain, Richard Lalonde, Jeffrey McDowell, Roger Nachman, Eduardo Rubio, Carole Sharp, Mary Kay Simoni, Michelle, Svoboda

B-1 GALLERY
213.392.9625
2730 Main St., Santa Monica 90405
Hours: Tues-Wed, Sat-Sun 10-6; Thur-Fri 10-10
Contact: Julie Rico, Director
Specialty: Emerging, urban Los Angeles artists

Artists Represented: Greg Gibbs, Brad Howe, Zara Kreigskin, Leo Limon, Frank Romero

RUTH BACHOFNER GALLERY
213.458.8007
926 Colorado Ave., Santa Monica 90401
FAX: 213.458.9087
Hours: Tues-Sat 10-5:30; Sun 1-5
Contact: Ruth Bachofner, Director
Specialty: Contemporary painting and sculpture

Artists Represented: Michel Alexis, Karl Benjamin, Stanley Boxer, Michael Brangoccio, Cheryl Calleri, Mary Chomenko, Stephen Greene, Eva, Holmstrom, Stephen Kafer, Robert Kingston, Leland Means, Richard Oginz, Reuben Ramot, Carl Reed, Lauri Sing, Matthew Thomas, Selina Trieff, Margi Weir

CROWN POINT PRESS
415.974.6273
657 Howard St., San Francisco 94105
FAX: 415.495.4220
Hours: Tues-Sat 10-5
Contact: Valerie Wade, Representative
Specialty: Publishers of etchings and color woodblock prints

Artists Represented: Vito Acconci, John Baldessari, Robert Bechtle, Christian Boltanski, William Brice, Christopher Brown, Chris Burden, **John Cage (See page 263)**, Francesco Clemente, Chuck Close, Tony Cragg, Richard Diebenkorn, Eric Fischl, Joel Fisher, Hamish Fulton, Katsura Funakoshi, April Gornik, Hans Haacke, Al Held, Tom Holland, Robert Hudson, Bryan, Hunt, Shoichi Ida, Yvonne Jacquette, Joan Jonas, Anish Kapoor, Alex Katz, Jannis Kounellis, Joyce Kozloff, Robert Kushner, Bertrand Lavier, Li Lin Lee, Sherrie Levine, Sol LeWitt, Markus Lupertz, Robert Mangold, Brice Marden, Tom Marioni, Robert Moskowitz, Judy Pfaff, Janis Provisor, Markus Raetz, Rammellzee, Tim Rollins + K.O.S., Ed Ruscha, David Salle, Italo Scanga, Sean Scully, Jose Maria Sicilia, Susanna Solano, Pat Steir, Gary Stephan, Wayne Thiebaud, David True, William T. Wiley

OLGA DOLLAR GALLERY
415.398.2297
210 Post St., 2nd Fl., San Francisco 94108
FAX: 415.398.2788
Hours: Tues-Sat 10:30-5:30
Contact: Olga Dollar, Owner
Specialty: Represents contemporary painters, sculptors, and printmakers from the Bay Area and entire United States

Artists Represented: Paul Davis, David Dornan, Susan Fenton, Paul, Harcharik, Norman Lundin, James Murray, Julie Speidel, Francesca, Sundsten **Works Available By:** Marilyn Baum, Corda Eby, Dewitt Hardy, Gerard, Howland, Tom Stanton, Don Williams

MICHAEL DUNEV GALLERY
415.398.7300
77 Geary St., San Francisco 94108
FAX: 415.398.7680
Hours: Tues-Sat 11-5:30
Contact: Michael Dunev, Director
Specialty: American and European contemporary drawings, paintings and sculpture

Artists Represented: Charles Arnoldi, Aristides Demetrios, Mark Eanes, Bella T. Feldman, Donald Fels, Hardy Hanson, Frank Hyder, Douglas, McClellan, Richard Moquin, Mark Perlman, Alek Rapoport, Sam Richardson, Margaret Rinkovsky, **Gustavo Ramos Rivera (See page 196)**, Hans Sieverding, Steven Sorman, Audrey T. Welch **Works Available By:** Richard Diebenkorn, Sam Francis, Robert Motherwell, Nathan Oliveira, Antoni Tapies

EBERT GALLERY
415.296.8405
250 Sutter St., San Francisco 94108
Hours: Tues-Fri 10:30-5:30; Sat 11-5
Contact: Dick Ebert, Owner
Specialty: 1950 to present work by Bay Area artists

Artists Represented: Boyd Allen, Jerrold Ballaine, Joseph Baraz, Warren Dreher

ROBERTA ENGLISH GALLERY
415.957.1007
250 Sutter St., San Francisco 94108
Hours: Tues-Fri 12-5:30; Sat 12-4

VICTOR FISCHER GALLERIES
415.777.0717
350 Steuart St., Hill Plaza, San Francisco 94119
Hours: Tues-Fri 10-6; Sat 11-5
Contact: Linda Fischer, Director
Specialty: Contemporary paintings and sculpture

FRAENKEL GALLERY
415.981.2661
49 Geary St., San Francisco 94108
Hours: Tues-Fri 10:30-5:30; Sat 11-5
Contact: Frish Brandt, Director
Specialty: 19th- & 20th-Century photographs

Artists Represented: Robert Adams, Bernd & Hilla Becher, Harry Callahan, Robert Frank, John Gutmann, Mark Klett, Helen Levitt, O. Winston Link, Sally Mann, McDermott & McGough, Richard Misrach, Nicholas Nixon, Irving Penn, William Wegman, Garry Winogrand, Joel-Peter Witkin **Works Available By:** Diane Arbus, Eugene Atget, Anna Atkins, E.J. Bellocq, Louis-Emile Duranelle, William Henry Jackson, Jacques-Herni Lartigue, Robert Mapplethorpe, Eadweard Muybridge, Timothy O'Sullivan, August Sander, Alfred Stieglitz, Paul Strand, W. H. F. Talbot, Carleton Watins, Edward Weston

GALLERY PAULE ANGLIM
415.433.2710
14 Geary St., San Francisco 94108
FAX: 415.433.1501
Hours: Tues-Fri 11-5:30; Sat 11-5
Contact: Ed Gilbert, Director
Specialty: Contemporary painting, sculpture and works on paper

Artists Represented: William Allan, Terry Allen, Milton Avery, Robert, Bechtle, John Beech, David Bottini, Christopher Brown, Deborah, Butterfield, Jay Defeo, Bill Fontana, Llyn Foulkes, Terry Fox **Works Available By:** Howard Fried, Dawn Fryling, David Ireland, Komar & Melamid, Paul Kos, Alan Rath, Michael Tracy

GRAYSTONE
415.956.7693
250 Sutter St., #330, San Francisco 94108
FAX: 415.398.0667
Hours: Tues-Sat 11-5:30
Contact: Edmond Russell, Director
Specialty: Contemporary prints and works on paper

Artists Represented: Richard Diebenkorn (See page 266), Anne Dykmans, **Sam Francis (See page 268)**, **Jasper Johns (See page 271)**, Louis La Brie, Roy Lichtenstein, **Robert Motherwell (See page 274)**, Robert Rauschenberg, Frank Stella, **Wayne Thiebaud (See page 281)**

BRIAN GROSS FINE ART
415.788.1050
250 Sutter St., Ste. 370, San Francisco 94108
FAX: 415.788.1059
Hours: Tues-Fri 11-5; Sat 12-4
Contact: Brian Gross
Specialty: Contemporary and modern paintings, sculpture and works on paper

Artists Represented: Peter Alexander, Robert Arneson, Charles Arnoldi, Laddie John Dill **Works Available By:** Joan Brown, Imogen Cunningham, Roy De Forest, Willem, de Kooning Richard Diebenkorn, Jasper Johns, Manuel Neri, David Park, Robert Rauschenberg, Ed Ruscha, William T. Wiley

HAINES GALLERY
415.397.8114
49 Geary St., 5th Fl., San Francisco 94108
Hours: Tues-Sat 10:30-5:30
Contact: Cheryl Haines, Director
Specialty: Contemporary painting, sculpture, drawing and installation

Artists Represented: Anthony Aziz, Ray Beldner, Max Cole, Mike Henderson, Wade Hoefer, Kevin Kearney, David Kezur, George Lawson, Dennis Leon, Carlos Loarca, Deloss McGraw, Arnold Mesches, Stephen, Namara, Joe Sam, M. Louise Stanley, Baochi Zhang **Works Available By:** Lita Albuquerque, Stephen Bambury, Max Gimblett, Roy Lichtenstein Loren Madsen, Eric Orr, Wayne Thiebaud

HARCOURTS MODERN & CONTEMPORARY ART
415.421.3428
460 Bush St., San Francisco 94108
FAX: 415.421.7842
Hours: Tues-Sat 10-5:30
Contact: Jim Healy, V.P.
Specialty: Modern and contemporary art

Artists Represented: John Battenberg, Robert Cottingham, Sam Francis, Nancy Genn, Robert Indiana, Jeffery Laudenslager, Robert Motherwell, Roland Petersen, Robert Rauschenberg **Works Available By:** Marc Chagall, Henri Matisse, Carlos Merida, Joan, Miro, Jose Clemente Orozco, Pablo Picasso, Pierre-Auguste Renoir, Diego Rivera, David A. Siqueiros, Rufino Tamayo, Francisco Zuniga

HINE EDITIONS/LIMESTONE PRESS
415.777.2214
357 Tehama, San Francisco 94103
FAX: 415.495.2665
Hours: Tues-Fri 10-5
Contact: Hank Hine, Director
Specialty: Print editions, livres d' artiste and sculpture editions

Artists Represented: James Brown, Gunther Forg, Gunther Gerszo, Markus, Lupertz, Joan Mitchell, Nathan Oliveira, Jurgen Partenheimer, Norbert Prangenberg

JAN HOLLOWAY GALLERY
415.398.2055
59 Grant Ave., 2nd Fl., San Francisco 94108
Hours: Tues-Fri 11-5; Sat 12-5
Contact: Jan Holloway, Director

K KIMPTON GALLERY
415.956.6661
228 Grant Ave., 5th Fl., San Francisco 94108
FAX: 415.956.9010
Hours: Tues-Fri 10-5:30; Sat 10:30-5
Contact: Kay Kimpton, Owner
Specialty: Contemporary painting and sculpture by emerging and mid-career artists and contemporary prints

Artists Represented: Jonathan Barbieri, Donald Bradford, Michael Brennan, Susan Crile, Guy Dill,Susan Marie Dopp, Alan Firestone, Robilee Frederick, Suzanne Hanson, Mary Heebner, Craig Henry, Robert McCauley, Tom Mckinley, Laura Russell, Linda K. Smith, Jerome Witkin

ROBERT KOCH GALLERY
415.421.0122
49 Geary St., San Francisco 94108
FAX: 415.421.6306
Hours: Tues-Sat 11-5:30
Contact: Ada Takahashi
Specialty: 19th- & 20th-Century and contemporary photography; surrealist, avant-garde and Eastern European photography

Artists Represented: Lois Conner, Allen Ginsberg, Lynn Hershman, Yousuf Karsh, **Josef Koudelka (See page 390)**, Mary Ellen Mark, Duane Michals, Herb Ritts, **Holly Roberts (See page 200) Works Available By:** Ansel Adams, Manuel Alvarez-Bravo, Dick Arentz, Eugene Atget, Ruth Bernhard, Henri Cartier-Bresson, Imogen Cunningham, Frantisek Drtikol, Jaromir Funke, Andre Kertesz, Danny Lyon, Laszlo, Moholy-Nagy, Irving Penn, Man Ray, Alexander Rodchenko, Jan Saudek, Paul, Strand Josef Sudek, Edward Weston

PETER LEMBCKE GALLERY
415.397.5510
23 Grant Ave., San Francisco 94108
FAX: 415.388.2506
Hours: Tues-Fri 10:30-5:30; Sat 12-5
Contact: Michael Pinto, Partner/Dir.
Specialty: Specializing in local, emerging artists of all styles

Artists Represented: June Chung, Daniel Dixon, Kathryn Dunlevie, Lawrence Ferlinghetti, Duane Foster, Randall Goni, Holden Herbert, Jacek Kawieck **Works Available By:** Todd Gray, Shantelle Julian, Douglas Knight, Katherine Knoll, Jan Lassetter, Forrest McFarland

CALIFORNIA (cont.)

SAN DIEGO

INTERNATIONAL GALLERY
619.235.8255
643 G St., San Diego 92101
Hours: Mon-Sat 10-6; Sun 11:30-4:30
Contact: Stephen Ross, Director
Specialty: Contemporary crafts, textiles, folk and primitive art

Artists Represented: Heide Darr-Hope, Tom Edwards, Evelyn Grant, Michael Herres, Kate & Will Jacobson, Dee Miller, Michelle Symeonides, Robert Tolone, Jim Winecoff, Aggie Zed

LINDA MOORE GALLERY
619.260.1101
1611 W. Lewis St., San Diego 92103
FAX: 619.260.1124
Hours: Mon-Fri 9-5; Sat 10-3
Contact: Elizabeth Schulman, Director

Artists Represented: Lacy Duarte, Joe Max Emminger, Ana Mercedes Hoyos, Ignacio Iturria, Fernando Lopez Lage, Deloss Mcgraw, Virginia Patrone, Nelson Ramos, Liza Von Rosenstiel
Works Available By: Helen Frankenthaler, Antoni Tapies

SWAHN FINE ARTS GALLERY
619.595.1153
861 Fifth Ave., San Diego 92101
FAX: 619-595-1156
Hours: Daily 11-9
Contact: Rick Swahn, Owner
Specialty: Contemporary art

Artists Represented: Howard Behrens, Zhou Brothers, Byron, Eyvind Earle, Jiang, Isaac Maimon, Peter Max, Leroy Neiman, A.B. Orlando, Hiro Yamagata **Works Available By:** Lu Hong, Mao Jie, Shao Kuang Jing, Mark Kostabi, Yuroz

TARBOX GALLERY
619.234.5020
1202 Kettner Blvd., San Diego 92101
Hours: Tues-Fri 11-9; Sat 5-10
Contact: Ruth Tarbox, Owner/Director
Specialty: Featuring recognized and advancing artists in all media

Artists Represented: Robert Berry, Teresa Cherny, Edward Evans, Elaine Farley, Stanley William Hayter, Barney Kuntz, Steve Kuntz, John Tucker Mertz, Charles Parks, Louis Pearson, Pedro Pereira, Mcneil Sargent, Arthur Secunda, Edwin Wordell

SAN FRANCISCO

871 FINE ARTS GALLERY
415.543.5155
250 Sutter St., #450, San Francisco 94108
FAX: 415.398.9388
Hours: Tues-Sat 10:30-5:30
Contact: Adrienne Fish, Director
Specialty: Modern and contemporary art and artbooks

Artists Represented: Anthony Dubovsky, June Felter, Norman Foster, Sonia Gechtoff, James Kelly, Adelie Landis, Ethel Schwabacher, Albert Smith **Works Available By:** Martha Alf, William T. Brown, Frances Lerner, Erle Loran, Bruce McGaw

THE ALLRICH GALLERY
415.398.8896
251 Post St., San Francisco 94108
FAX: 415.398.0401
Hours: Tues-Sat 10-5
Contact: Michelle Bello, Director
Specialty: Contemporary painting, sculpture, tapestry, and works on paper

Artists Represented: Neda Alhilali, Jackie Battenfield, Sharon Boysel, Glenn Brill, Mardi Burnham, Jerry Concha, Lia Cook, Cathleen Daly, Olga de Amaral, Gary Denmark, Richard Deutsch, Kris Dey, Eddie Dominguez, Stephen Fleming, Chung-Ray Fong, Ann Gardner, Robert Gonzales, Arthur Gonzalez, Jeanne Jackson, Glen Kaufman, Larry Kirkland, Lynn Klein, Karen Kunc, Michaele Le Compte, Nancy Mee, Graham Moody, Nance O'Banion, Younhee Paik, Dennis Parlante, Linda Ross, Sylvia Seventy, Susan Shaw, Dan Snyder, Scott Stephens, Angelita Surmon, D.R. Wagner

ELEONORE AUSTERER GALLERY
415.986.2244
540 Sutter St., San Francisco 94102
FAX: 415.986.2281
Hours: Mon-Sat 10-6
Contact: Eleonore Austerer, Owner

Artists Represented: Jean-Jacques Blot, Vera de Rivales, **Francesc Genoves (See page 114),** Jennifer Hornyak, Maria Korusiewicz, **Roberto Lauro (See page 339),** Jonathan Neuse, Valentin Oman, Francisco Ruiz, **Siegward Sprotte (See page 225) Works Available By:** Cheryl Barnett, Georges Braque, David Hockney, Wassily Kandinsky, Robert Lerner, Henri Matisse, Jay Milder, Joan Miro, Pablo Picasso, Man Ray, Pierre-Auguste Renoir, Henri de Toulouse-Lautrec, Andrew Wyeth

JOHN BERGGRUEN GALLERY
415.781.4629
228 Grant Ave., San Francisco 94108
FAX: 415.781.0126
Hours: Mon-Fri 9:30-5:15; Sat 10:30-5
Contact: John Berggruen
Specialty: 20th-Century paintings, drawings, sculpture and prints

Artists Represented: Mark Adams, Carol Anthony, David Bates, Fletcher, Benton, Tony Berlant, Elmer Bischoff, Theophilus Brown, John Buck, Mark Bulwinkle, Don Campbell, Squeak Carnwath, Bruce Cohen, Larry Cohen, Roy, De Forest, Stephen De Staebler, Roseline Delisle, Mark Di Suvero, Richard Diebenkorn, Sam Francis, Joseph Goldyne, Michael Gregory, Tom, Holland, Robert Hudson, Gregory Kondos, Tom Lieber, Fran Martin, Gwynn, Murrill, Manuel Neri, Don Nice, John Okulick, Nathan Oliveira, Tom, Otterness, Beverly Pepper, George Rickey, Joel Shapiro, Judith Shea, Frank Stella, Wayne Thiebaud, James Torlakson, Beth Van Hoesen, James, Weeks, Donald Roller Wilson, Paul Wonner **Works Available By:** William Bailey, Jennifer Bartlett, Alexander Calder, Jim Dine, Barry Flanagan, Helen Frankenthaler, Robert Graham, Al Held, Hans Hofmann, Henri Matisse, Henry Moore, Robert Motherwell, Elizabeth, Murray, William Turnbull

BOMANI GALLERY
415.296.8677
251 Post St., Ste. 600, San Francisco 94108
FAX: 415.296.8643
Hours: Tues-Fri 11-5; Sat 12-5
Contact: Asake Bomani, Owner
Specialty: Dedicated to expressing the cultural and artistic complexities of the world

Works Available By: Charles Alston, Romare Bearden, Elizabeth Catlett, Jennie Roldan Hayen, Nicholas Mukonberanwa

RENA BRANSTEN GALLERY
415.982.3292
77 Geary St., San Francisco 94108
FAX: 415.982.1807
Hours: Tues-Fri 10:30-5:30; Sat 11-5
Contact: Roberta Cove
Specialty: Exhibitions of contemporary sculpture, painting, photography and media arts

Artists Represented: Robert Arneson, Jim Campbell, Viola Frey, Dennis, Gallagher, Rupert Garcia, Marilyn Levine, Hung Liu, Chip Lord, Philip Morsberger **Works Available By:** Andreas Gursky, Markus Lupertz, Thomas Ruff, Patrick Tosan

BRAUNSTEIN/QUAY GALLERY
415.392.5532
250 Sutter St., San Francisco 94108
FAX: 415.788.1403
Hours: Tues-Fri 10:30-5:30; Sat 11-5
Contact: Ruth Braunstein, Director
Specialty: Contemporary art

Artists Represented: David Anderson, Larry Bell, Robert Brady, Patricia, T. Forrester, David Jones, Richard Shaw, Nell Sinton, Peter Voulkos **Estates Represented:** John Altoon, Jeremy Anderson

EDITH CALDWELL GALLERY
415.989.5414
251 Post St., 2nd Fl., San Francisco 94108
Hours: Mon-Sat 11-5
Contact: Edith Caldwell, Director
Specialty: Contemporary representational paintings, drawings, prints and sculpture

Artists Represented: Linda Bacon, Tom Blackwell, Ken Durkin, Paul Harmon, Patty Look Lewis, Alan Magee, Philip Michelson, Peter Milton, Joe Nicastri, Woodward Payne, Maria Olivieri Quinn, Hans Schiebold **Works Available By:** Fritz Scholder, L.C. Shank

CAMPBELL-THIEBAUD GALLERY
415.441.8680
645 Chestnut St., San Francisco 94133
Hours: Tues-Fri 11-5; Sat 12-4
Contact: Diana Young, Director
Specialty: Contemporary, Pre-Columbian, and primitive art

Artists Represented: Peter Allegaert, Charles Eckart, Dennis Hare, Frank, Lobdell Ed Musante, Mary Robertson, Michael Tompkins, Stan Washburn, James Weeks **Works Available By:** Theophilus Brown, Willem de Kooning, Richard Diebenkorn, Manuel Neri, Nathan Oliveira, Wayne Thiebaud, Jose Vermeersch, Paul Wonner **Estates Represented:** Harry Bowden, Lundy Siegriest

JOANNE CHAPPELL GALLERY
415.777.5711
625 Second St., #400, San Francisco 94107
FAX: 415.777.1390
Hours: Mon-Fri 9-5; Sat By Appt
Contact: Andrew Kornicj, Curator
Specialty: Contemporary American work in all media; corporate and investment art

Artists Represented: Christy Carleton, Deborah Dewit, Gloria Fischer, Margaret Herscher, Peter Kitchell, Judith Klausenstock Hiroki Morinque, Marcia Myers, Ralph O'Neill, Jean Richardson, Carol Summers, Brook Temple, Bruce Weinberg **Works Available By:** Jim Dine, Sam Francis, Helen Frankenthaler, Red, Grooms, Roy Lichtenstein, Robert Motherwell, Victor Pasmore, Frank Stella

JOSEPH CHOWNING GALLERY
415.626.7496
1717 17th St., San Francisco 94103
Hours: Tues-Fri 10:30-5:30; Sat 12-4

CONTEMPORARY REALIST GALLERY
415.362.7152
23 Grant Ave., 6th Fl., San Francisco 94108
Hours: Tues-Fri 10:30-5:30; Sat 12-5
Contact: Tracy Freedman, Partner; Michael Hackett, Partner
Specialty: Contemporary American realist painting, drawing and sculpture

Artists Represented: Steven Bigler, Bruno Civitico, Willard Dixon, Jane, E. Fisher, Diana Horowitz, Gabriel Laderman, Peter Nye, Gillian Pederson-Krag, Richard Piccolo, Andrew Radcliffe, Richard Savini, Terry St. John, David Tomb **Works Available By:** Mel Adamson, Tor Archer, Paul Braucher, Cynthia Charters, Diane Crane, Elen Feinberg, Stanley Freidman, April Funcke, James Heron, Brian Jermusyk, Lionel Kalish, Lynn Kotula, James Lecky, Anthony Martino, Raoul Middleman, Marjorie Portnow, Langdon Quin, Alfred, Russell Isaac Sands, Edward Schmidt, William Steiger, David Vereano

GENE SINSER GALLERY 213.464.2383
331 N. Larchmont Blvd., Los Angeles 90004 FAX: 213.464.2921
Hours: Mon-Fri 10-6; Sat 10-3:30
Contact: Gene Sinser, Owner
Specialty: Emerging California artists and corporate art

Artists Represented: Sheila Fein, Valerie Johnson, Mickey Myers, Joel Nakamura, Joanne Ross
Works Available By: Aldo Luongo, John Powell

THOMAS SOLOMON'S GARAGE 213.654.4731
928 N. Fairfax Ave., Los Angeles 90046 FAX: 213.654.4759
Hours: Tues-Sat 11-5; Sun 12-5
Contact: Thomas Solomon, Owner
Specialty: Contemporary Los Angeles, New York and international artists

Artists Represented: Nicholas Africano, Brad Dunning, David Dupuis, Stephan Glassman, Julian Goldwhite, Michael Gonzalez, Mac James, David Kremers, Robert Levin, Robert Millar, Jorge Pardo, Theresa Pendlebury, Laura Stein, Ed Tomney, Jon Tower, Jonathan White, John Zinsser, Michael Zwack **Works Available By:** Gordon Matta-Clark, Joan Mitchell, Alexis Rockman, Shigeo Toya, William Wegman

SPACE GALLERY 213.461.8166
6015 Santa Monica Blvd., Los Angeles 90038
Hours: Tues-Sat 11-5
Contact: Edward Den Lau, Director
Specialty: Contemporary paintings, drawings, and sculpture

Artists Represented: Bob Alderette, Robert D. Anderson, Sandy Bleifer, Rolando Castellon, Wes Christensen, Roberta Eisenberg, Bella T. Feldman, Judith Foosaner, Barbara Foster, Sylvia Glass, Robert Glover, Kazuo Kadonaga, **Seiji Kunishima (See page 338)**, Sam Lemly, Norman Lundin, Minoru Ohira, Ann page, Patrick Percy, Pepo Pichler, Norman Schwab, Olga Seem, Tom Stanton, Masami Teraoka, Maureen O'Hara Ure, Doug Young

DAVID STUART GALLERIES 213.652.7422
748 N. La Cienega Blvd., Penthouse, Los Angeles 90069
Hours: Tues-Sat 1-5
Contact: Mrs. David Stuart, Owner/Director
Specialty: Contemporary and primitive works of art

Works Available By: John Altoon, Robert Dowd, Robert Harvey, William King, Mel Ramos, James Rosenquist, Richard Shaw, Hassel Smith, Wayne Thiebaud, Emerson Woelffer

STUDIO SIXTEEN-SEVENTEEN 213.660.7991
1617 Silverlake Blvd., Los Angeles 90026
Hours: Mon-Fri 9:30-4:30
Contact: Bill Wheeler, Owner
Specialty: Contemporary prints and mixed media.

Artists Represented: Marty Gattuso, Ilee Kaplan, Ruth Kaspin, Lyn Mayer, Bill Wheeler

JAMES TURCOTTE GALLERY 213.385.2260
8128 Tianna Rd., Los Angeles 90046

JAN TURNER GALLERY 213.271.4453
9006 Melrose Ave., Los Angeles 90069 FAX: 213.271.3469
Hours: Tues-Fri 10-5:30; Sat 11-5:30
Contact: Carol Donnell Kotrozo, Director
Specialty: Contemporary paintings, drawings, and sculpture

Artists Represented: John Alexander, Carlos Almaraz, Timothy App, Cecile Bauer, Jim Bird, Christophe Boutin, Tim Bradley, Laurie Brown, David Bungay, Robert Cavolina, Elaine Lustig Cohen, Larry Cohen, Tony De Lap, Laurence Dreiband, Ole Fischer, John Frame, Michel Frere, Gil Garfield, Lynn Geesaman, Mieke Gelley, Christopher Georgesco, Patrick Gourley, Gary Hall, Tina Hulett, John Hull, Callum Innes, Alfred Leslie, Peter Liashkov, Manel Lledos, Michael Maglich, Paul Manes, Ton Mars, Michael Mazur, Dan McCleary, Paul Mogensen, Mary Obering, Astrid Preston, Fulvio Testa, Donald Roller Wilson, Hollywright, Jack Zajac, Victor Hugo Zayas **Works Available By:** Larry Bell, Joseph Beuys, Jonathan Borofsky, Natalya Goncharova, Arshile Gorky, Dieter Hacker, Christopher Lucas, Ed Moses, Joan Nelson, Gerhard Richter

TURNER/KRULL GALLERY 213.271.1536
9006 Melrose Ave., Los Angeles 90069 FAX: 213.271.3469
Hours: Tues-Fri 10-5:30; Sat 11-5:30
Contact: Craig Krull, Director
Specialty: 19th- & 20th-Century photography and contemporary art

Artists Represented: Kim Abeles, Robbert Flick, Randall Ingalls, Julius Shulman **Works Available By:** Robert Adams, Herbert Bayer, William Eggleston, Leland Rice, Edmund Teske, Catherine Wagner, Henry Wessel

WADE GALLERY 213.652.1733
750 N. La Cienega Blvd., Los Angeles 90069
Contact: Julie S. Miyoshi, Director

JOANNE WARFIELD GALLERY 213.855.0586
508 N. San Vicente Blvd., Los Angeles 90048
Hours: By Appt
Contact: Joanne Warfield, Owner
Specialty: Contemporary fine art

Artists Represented: Harry Carmean, Donald Farnsworth, Don Giffin, Martin L. Gunsaullus, Maxine Martell, William Maxwell, Al Ring, Annie Shows, Miriam Slater, William Turner, Efram Wolff **Works Available By:** Carlos Almaraz

WENGER GALLERY 213.464.4431
828 N. La Brea Ave., Los Angeles 90038 FAX: 213.464.4466
Hours: Tues-Sat 11-5
Contact: Sigmund Wenger, Director
Specialty: Modern and contemporary American and European art

Artists Represented: Carlos Aguirre, Alpert, Tom Aprile, Arman, Max DeMoss, Helen & Newton Harrison, Alfred Jensen, Dani Karavan, Jack Ogden, **A.R. Penck (See page 189)**, Antonio Rodriguez Luna, Kenneth Snelson, Jan Vanriet, Bernar Venet, Kay Walkingstick, Joseph Wesner **Works Available By:** Jean-Michel Alberola, S. Arakawa, Robert Arneson, Ellen Brooks, Stephen De Staebler, Francisco Farreras, Klaus Fussmann, Moshe Kupferman, Volker Mehner, Jean-Pierre Raynaud, Rodney Ripps, Mark Tobey, Andy Warhol, Neil Welliver, William T. Wiley

STEPHEN WHITE GALLERY OF PHOTO 213.476.5751
7319 Beverly Blvd., #5, Los Angeles 90036
Hours: By Appt

MILL VALLEY

SUSAN CUMMINS GALLERY 415.383.1512
12 Miller Ave., Mill Valley 94941
Hours: Mon-Sat 11-6; Sun 12-5
Contact: Susan Cummins, Owner
Specialty: Contemporary painting, sculpture, and contemporary jewelery

NEWPORT BEACH

PENNY CAMPBELL 714.645.0868
177 Riverside Dr., Newport Beach 92663
Hours: By Appt

DUNLAP FREIDENRICH FINE ART 714.720.1740
177 Riverside Dr., Ste. F, Newport Beach 92663 FAX: 714.854.2319
Hours: By Appt
Contact: Doree Dunlap, Director
Specialty: Modern and contemporary paintings, sculpture, drawings, and prints

Artists Represented: Julia Nee Chu, Luigi Galligani, Steve Heino, Steve Zoller **Works Available By:** Christopher Brown, Christo, Richard Diebenkorn, David Hockney, Ellsworth Kelly, Roy Lichtenstein, George McNell, Robert Motherwell, Gifford Myers, Ed Rusha, Frank Stella, Donald Sultan, Andy Warhol

OAKLAND

BOND STREET GALLERY 415.428.1662
5269 Broadway, Oakland 94618
Hours: Daily 9:30-5
Contact: Robert McDonald, Director
Specialty: Latin American art

PALO ALTO

LUCY BERMAN GALLERY 415.322.2533
238 Hamilton Ave., Palo Alto 94301 FAX: 415.321.3638
Hours: Tues-Fri 10-5; Sat 12-5
Contact: Lucy Berman, Owner
Specialty: Contemporary abstract work by American and European artists

Artists Represented: Mark Alsterlind, John Balsley, Sue Benner, Jim Bird, Sandi Seltzer Bryant, David Green, Jennifer Kiernan, Jenny Okun, Heinz Dieter Pietsch, Peter Shire, James David Thomas, James Wolfe **Works Available By:** Victor Pasmore, Antoni Tapies

PASADENA

DEL MANO GALLERY 818.793.6648
33 E. Colorado Blvd., Pasadena 91105 FAX: Upon Request
Hours: Tues-Thurs 10-6; Fri-Sat 1-10; Sun 12-5
Contact: Jan Peters, Co-Owner/Dir.
Specialty: Contemporary American art in craft media

Artists Represented: Michael Banzhaf, Daniel Gaumer, Bruce Hubbard, Yves Kamioner, Bob Moore, Ken Nakashima, Stephen Nelson, Josh Simpson, Cheryl Williams

SAN DIEGO

THE ANNEX GALLERY 619.531.0888
453 Sixth Ave., San Diego 92101 FAX: 619.531.0653
Hours: Mon-Fri 8:30-5:30
Contact: Joan Warren, Director
Specialty: Contemporary and modern 20th-Century paintings sculpture and drawings

Artists Represented: Laddie John Dill, Guy Dill, Jud Fine, Faiya Fredman, Howard Hersh, Hoon Kwak, Toshi Ohi, Eric Orr, Woodward Payne, Jerry Peart, Otto Rigan **Works Available By:** Stephen Maxwell Gibson, John Charles Gordon, Michael Hayden, David Jansheski, Nancy Loiuse Jones, Nancy Kay, Seiji Kunishima, Christopher Lee, Deloss McGraw, Dan Sayles, Barbara Weldon, Andrew Wernick

CALIFORNIA *(cont.)*

LOS ANGELES

KURLAND/SUMMERS GALLERY 213.659.7098
8742-A Melrose Ave., Los Angeles 90069 FAX: 213.659.7263
Hours: Tues-Sat 10-6
Contact: Ruth T. Summers, Pres./Director
Specialty: Contemporary sculptural glass/decorative arts

Artist Represented: Ké Ké Cribbs (See page 317), Dan Dailey (See page 318),
Christopher Lee, **Steve Linn (See page 342), John Gilbert Luebtow (See page 345)**,
Richard Marquis (See page 348), Susan Stinsmuehlen-Amend, Ann Wolf **Works Available By:**
Ricky Bernstein, Henry Halem, Diana Hobson, David Hopper, Richard Jolley, Dulany Lingo, Klaus Moje,
Joel Philip Myers, Will Pappenheimer, Damian Priour, Seth Randal, William Wertz

MARGO LEAVIN GALLERY 213.273.0603
812 N. Robertson Blvd. & 817 N. Hilldale, Los Angeles 90069 FAX: 213.273.9131
Hours: Robertson: Tues-Sat 11-5:30; N. Hilldale: 12-5
Contact: Margo Leavin, Wendy Brandow, Steve Henry
Specialty: Contemporary art from Europe and America

Artists Represented: John Baldessari (See page 285), Lynda Benglis (See page 306),
Mel Kendrick, Joseph Kosuth, **Mark Lere (See page 340)**, David Lloyd, Robert Morris, Claes
Oldenburg, Martin Puryear, **Alexis Smith (See page 219)**, David Smith, John Torreano **Works**
Available By: Carl Andre, Barbara Bloom, John Chamberlain, Clegg & Guttman, Willem de
Kooning, Dan Flavin, Bill Jensen, Jasper Johns, Donald Judd, Ellsworth Kelly, Jannis Kounellis, Morris
Louis, Brice Marden, Agnes Martin, Haim Steinbach, Terry Winters

MADISON GALLERIES 213.652.1286
808 N. La Cienega Blvd., Los Angeles 90069 FAX: 213.652.8310
Hours: Tues-Fri 11-7; Sat 11-6
Contact: Tim Geary, Director
Specialty: Figurative and realistic contemporary art

Artists Represented: Charles Bragg, Joan Leal Carter, Beryl Cook, Tim Geary, David Richey
Johnson, Robin Morris, Thomas Pradzynsky, Christian Vincent, Richard Walker **Works Available**
By: Robert Wraith

BURNETT MILLER GALLERY 213.874.4757
964 N. La Brea Ave., Los Angeles 90038 FAX: 213.874.7478
Hours: Tues-Sat 10-5:30
Contact: Pascale Rawley
Specialty: Contemporary American and European paintings,
drawings and sculpture

Artists Represented: Miroslaw Balka, Cliff Benjamin, Pedro Cabrita Reis, Fred Femlau, Ian
Hamilton Finlay, Leon Golub, Antony Gormley, Imi Knoebel, Wolfgang Laib, Charles Ray, Ulrich
Ruckriem, Fred Sandback, Sarah Seagen, Ettore Spalletti, Nancy Spero, Serge Spitzer, Ulay Gunter
Umberg, Franz Erhard Walther

MIXOGRAFIA GALLERY-WORKSHOP 213.232.1158
1419 E. Adams Blvd., Los Angeles 90011 FAX: 213.232.1655
Contact: Marlena Telvick, Director

TOBEY C. MOSS GALLERY 213.933.5523
7321 Beverly Blvd., Los Angeles 90036 FAX: 213.933.7618
Hours: Tues-Sat 10-4
Contact: Tobey C. Moss, Owner/Director
Specialty: California Modernism 1920's-1960's

Artists Represented: Clinton Adams, Dorr Bothwell, Jean Charlot, Werner Drewes, Jules Engel,
Lorser Feitelson, Oskar Fischinger, James Hueter, Peter Krasnow, Rico Lebrun, David Levine, Helen
Lundeberg, Jan Stussy, Emerson Woelffer **Works Available By:** Peggy Bacon, Francis Deerdely,
Leonard Edmondson, Paul Landacre, Stanton Wright

NEWSPACE 213.469.9353
5241 Melrose Ave., Los Angeles 90038 FAX: 213.469.1120
Hours: Tues-Sat 11-4
Contact: Joni Gordon, Director

Artists Represented: Lisa Adams, Martha Alf, Eugenia Butler, Sidney Gordin, Hikaru Hayakawa,
Julian Hills, Ken Hurbert, Paul Knotter, Nicholette Kominos, Douglas Meyer, Tiffanie Morrow,
Patricia Patterson, Jeff Price, James Trivers, Alan Wayne, Daniel Wheeler, Frederick Wight, Peter
Zokosky **Works Available By:** Vija Celmins, Eric Fischl, Sam Francis, Robert Irwin, Morris Louis,
Henry Moore, Georgia O'Keeffe, Frank Stella, Andy Warhol

OVSEY GALLERY 213.935.1883
126 N. La Brea Ave., Los Angeles 90036 FAX: 213.935.9589
Hours: Tues-Sat 11-5
Contact: Neil Ovsey, Owner
Specialty: Contemporary art

Artists Represented: Susan Hall, F. Scott Hess, Mary Jones, Tom Lesson, Lilla Locurto, Gladys
Nilsson, Ed Nunnery, Nancy Pierson, Ron Rizk, Bobby Ross, Stephen Schultz, Judith Simonian,
Michael Stevens, Chris Unterseher, Nancy Youdelman

PAIDEIA GALLERY 213.652.8224
765 N. La Cienega Blvd., Los Angeles 90069
Hours: Tues-Sat 11-4:30

HERBERT PALMER GALLERY 213.854.0096
802 N. La Cienega Blvd., Los Angeles 90069 FAX: 213.659.8545
Hours: Tues-Fri 10-6; Sat 11-5
Contact: Herbert Palmer, Director; Meredith Palmer, Director
Specialty: Modern and contemporary masters from America, Europe and Japan

Artists Represented: David Banks, Lee Mullican **Works Available By:** Alexander Archipenko,
Christo, Jim Dine, Helen Frankenthaler, Alfred Jensen, Lee Krasner, El Lissitsky, Henri Matisse,
Henry Moore, Jackson Pollock, Wayne Thiebaud

PARKER ZANIC GALLERY 213.936.9022
112 S. La Brea Ave., Los Angeles 90036 FAX: 213.936.9274
Hours: Tues-Sat 11-6
Contact: Dominica Salvatore, Director
Specialty: Emerging L.A. artists

Artists Represented: Nayland Blake, Keith Boadwee, Robbie Conal, David Dashiell, Rory
Devine, Didi Dunphy, Jamey Garza, Paula Metello, Hanneline Rogeberg, Randall Scott, Peter Seidler,
Cameron Shaw, Francesca Sundsten, Dani Tull, Andy Warhol

STUART REGEN GALLERY 213.276.5424
619 N. Almont Dr., Los Angeles 90069 FAX: 213.276.7430
Hours: Tues-Sat 10-6
Contact: Shaun Caley, Director
Specialty: American and European contemporary art

Works Available By: Matthew Barney, Jiri Georg Dokoupil, Michael Joaquin Grey, Jenny Holzer,
Larry Johnson, On Kawara, Liz Larner, Richard Prince, Thomas Ruff, Rosemarie Trockel, Meg
Webster, Lawrence Weiner

RICHARD/BENNETT GALLERY 213.829.2171
10337 Wilshire Blvd., Los Angeles 90024 FAX: 213.858.8034
Hours: By Appt
Contact: Richard Heller; Bennett Roberts
Specialty: Contemporary art and modern masters

Artists Represented: Nick Banks, Joseph Beuys, Daniel Laskarin, Yolande Mckay, Raymond
Pettibon, Craig Roper, Kevin Tasnik **Works Available By:** Francesco Clemente, Robert Morris,
Andres Serrano, Cameron Shaw, Tom Wesselmann, Terry Winters

JACK RUTBERG FINE ARTS 213.938.5222
357 N. La Brea Ave., Los Angeles 90036 FAX: 213.938.0577
Hours: Tues-Fri 11-6; Sat 11-5
Contact: Jack Rutberg, Director
Specialty: Modern and contemporary paintings, drawings, sculpture and prints

Artists Represented: Hans Burkhardt, Claire Falkenstein, Ed Glauder, Patrick Graham, Ruth
Weisberg **Works Available By:** Karel Appel, Hannelore Baron, Jean-Michel Basquiat, Max
Beckmann, Pierre Bonnard, Alexander Calder, Marc Chagall, Willem de Kooning, Henri Fantin-
Latour, Sam Francis, Helen Frankenthaler, Arshile Gorky, David Hockney, David Hopper,
Friedensreich Hundertwasser, Kathe Kollwitz, Henri Matisse, Joan Miro, Pablo Picasso, Robert
Rauschenberg, Pierre-Auguste Renoir, Georges Rouault, Frank Stella, Mark Tobey, Tom
Wesselmann

SALANDER-O'REILLY GALLERIES 213.879.6600
456 N. Camden Dr., Los Angeles 90210 FAX: 213.247.1505
Hours: Tues-Sat 10-6
Specialty: 19th--Century European art and American Modernists

Artists Represented: Joby Baker, Leland Bell, Dan Christensen, Jacob Collins, Stuart Davis,
Arnold Friedman, John Adams Griefen, Louisa Matthiasdottir, Graham Nickson, Kenneth Noland,
Jules Olitski, Nathan Oliveira, David Park, Larry Poons, Paul Resika, Morgan Russell, Kikuo Saito,
Morton Schamberg, Michael Steiner, Horacio Torres, Paul Weingarten **Estates Represented:**
John Constable

DANIEL SAXON GALLERY 213.933.5281
7525 Beverly Blvd., Los Angeles 90036 FAX: 213.933.8101
Hours: Tues-Sat 10-5:30
Contact: Daniel Saxon, President
Specialty: Contemporary painting and sculpture with emphasis on
Chicano/Latino art

Artists Represented: Dawn Arrowsmith, Bo Bartlett, Susanna Dadd, Dean DeCocker, Merion
Estes, Christina Fernandez, Rose-Lynn Fisher, Rupert Garcia, James Griffith, **Gronk**
(See page 122), Red Grooms, Margaret Honda, Steven LaPonsie, Douglas Metzler, Margaret
Munz, Judy Rifka, Patricia Rodriguez, Susan Scott, Luis Serrano, Peter Shire, Kenneth Shorr, John
Valadez, Patssi Valdez

MATTHEW SCOTT FINE ART 213.276.2555
426 S. Robertson Blvd., Los Angeles 90048
Hours: Mon-Fri 10-5

MANNY SILVERMAN GALLERY 213.659.8251
800 N. La Cienega Blvd., Los Angeles 90069 FAX: 213.659.1001
Hours: Tues-Sat 10-5
Contact: Manny Silverman, Owner; Linda Hooper-Kawakami, Director
Specialty: Post-war American art

Artists Represented: Edward Dugmore (See page 96), Michael Goldberg,
Robert Motherwell, **Emerson Woelffer (See page 245)**, Rufus Zogbaum **Works Available**
By: Norman Bluhm, Giorgio Cavallon, Mark Di Suvero, Sam Francis, Al Held, Alfred Leslie, Joan
Mitchell **Estates Represented:** Adolph Gottlieb

ANDREW DIERKEN FINE ART 213.935.4881
8274 W. Fourth St., Los Angeles 90048 FAX: 213.933.1735
Hours: By Appt
Contact: Andrew Dierken, Owner
Specialty: Modern and contemporary American and European paintings, sculpture and works on paper

Works Available By: Francis Bacon, Christian Boltanski, Fernando Botero, Richmond Burton, Alexander Calder, Calum Colvin, Sam Francis, Rebecca Horn, Jasper Johns, Juan Munoz, Claes Oldenburg, Pablo Picasso, Thomas Ruff, George Tooker

IRENE DRORI INC. 213.931.1779
138 N. Orange Dr., Los Angeles 90036 FAX: 213.931.4642
Hours: By Appt
Contact: Irene Drori, President
Specialty: Contemporary art including graphics, works on paper and sculpture

Works Available By: Sam Francis, David Hockney, Shoichi Ida, Akira Kurosaki, Roy Lichtenstein, Keiko Minami, Tetsuya Noda, Frank Stella, Donald Sultan, Hiroyuki Tajima, Wayne Thiebaud, Ann Thornycroft

DUBINS GALLERY 213.820.1409
11948 San Vicente Blvd., Los Angeles 90049
Hours: Tues-Sat 10-5
Contact: Lisa Dubins, Director

FRANCINE ELLMAN GALLERY 213.652.7879
671 N. La Cienega Blvd., Los Angeles 90069 FAX: 213.652.0336
Hours: Mon-Fri 10-5; During Exhibitions Sat 11-5
Contact: Francine Ellman, Director
Specialty: Contemporary fine art by emerging and established artists, all media

Artists Represented: Kim Cheselka, Jane Gottlieb, Robert Joll, Cindy Kane, Chris Knipp, Jeff Long, Jeff Low, Kirk Pedersen, Jacqueline Warren **Works Available By:** Christo, Jim Dine, Sam Francis, Al Held, David Hockney, Alex Katz, Robert Moskowitz, Robert Motherwell, Donald Sultan, Tom Wesselmann

FAHEY/KLEIN GALLERY 213.934.2250
148 N. La Brea Ave., Los Angeles 90036 FAX: 213.934.4243
Hours: Tues-Sat 10-6
Contact: David Fahey, Co-Owner; Randee Klein, Co-Owner
Specialty: Vintage and contemporary photography and contemporary painting

Artists Represented: Manuel Alvarez-Bravo, David Bailey, Henri Cartier-Bresson, Robert Doisneau, Allen Ginsberg, Robert Heiecken, Horst, Marcus Leatherdale, Matt Mahurin, Sheila Metzner, Duane Michals, Irving Penn, Herb Ritts, Matthew Rolston, Bruce Weber, Joel-Peter Witkin **Works Available By:** Berenice Abbott, Brassai, George Hurrell, Yousuf Karsh, Andre Kertesz, O. Winston Link, Robert Mapplethorpe, Mario Neto, Paul Outerbridge, Man Ray, Joel Sternfeld, Edward Weston

FEINGARTEN GALLERIES 213.274.7042
P.O. Box 691098, Los Angeles 90069 FAX: 213.274.4255
Hours: By Appt
Contact: Gail Feingarten, Owner
Specialty: Modern masters sculpture, painting and contemporary sculpture

Artists Represented: Barton Benes, Charley Brown, Blake Edwards, Howard Newman, Jessica Rice, Jim Ritchie, Rhonda Shearer, Yoshikawa **Works Available By:** Alexander Archipenko, Jean Arp, Ron Blumberg, Hans Burkhardt, Lynn Chadwick, Joseph Csaky, Chui Faising, Francoise Gilot, Barbara Hepworth, Philippe Judlin, Gaston Lachaise, Jacques Lipchitz, Henry Moore, August Rodin, Max Weber

ROSAMUND FELSEN GALLERY 213.652.9172
8525 Santa Monica Blvd., Los Angeles 90069 FAX: 213.652.2618
Hours: Tues-Sat 11-5
Specialty: Contemporary art

Artists Represented: John Boskovich, Chris Burden, Karen Carson, Roy Dowell, Tim Ebner, Jeff Gambill, Richard Jackson, Mike Kelley, Paul McCarthy, Grant Mudford, Maria Nordman, Marc Pally, Renee Petropoulos, Lari Pittman, Steve Rogers, Erika Rothenberg, Jeffrey Vallance

GALLERY WEST 213.271.1145
107 S. Robertson Blvd., Los Angeles 90048
Hours: Tues-Sat 10:30-5

THE GALLERY AT 817 213.933.5614
817 N. La Brea Ave., Los Angeles 90038 FAX: 213.933.7259
Hours: Tues-Sat 11-5
Contact: Catherine Whyte Rhodes, Director
Specialty: Contemporary photo-based art by emerging and established artists

Artists Represented: Ross Amador, Don Anton, Jerry Burchfield, James Fee, Fonville Winans **Works Available By:** Susan Stella, Grace Zabriskie

GEMINI G.E.L. 213.651.0513
8365 Melrose Ave., Los Angeles 90069 FAX: 213.651.4418
Hours: Mon-Fri 9:30-5:30
Contact: Amy Honbo, Sales Rep.
Specialty: Print publishing

Artists Represented: Jonathan Borofsky, Daniel Buren, Vija Celmins, Ronald Davis, Mark Di Suvero, Richard Diebenkorn, Sam Francis, Robert Graham, Philip Guston, Michael Heizer, David Hockney, Ellsworth Kelly, Edward & Nancy Kienholz, Roy Lichtenstein, Malcolm Morley, Robert Motherwell, Isamu Noguchi, Claes Oldenburg, Ken Price, Robert Rauschenberg, James Rosenquist, Ed Ruscha, Richard Serra, Saul Steinberg, Frank Stella

JACK GLENN GALLERY 213.874.5161
962 N. La Brea Ave., Los Angeles 90038 FAX: 213.874.8968
Contact: Jack Glenn, Principal
Specialty: Contemporary, large format photography; major resale paintings and graphics

Artists Represented: Andrew Bush, Axel Hutte, David Levinthal, Jock Sturges, Oliver Wason **Works Available By:** Jenny Holzer, Barbara Kruger, Roy Lichtenstein, Mike & Doug Starn, Edward Steichen, Frank Stella, Alfred Stieglitz, Andy Warhol, Tom Wesselmann

GOLDFIELD GALLERIES 213.651.1122
8400 Melrose Ave., Los Angeles 90069

KIYO HIGASHI GALLERY 213.655.2482
8332 Melrose Ave., Los Angeles 90069 FAX: 213.655.2482
Hours: Daily 11-6
Contact: Kiyo Higashi, Owner
Specialty: Abstract-reductive work (paintings and sculpture)

Artists Represented: Perry Araeipour, Larry Bell, Max Cole, William Dwyer, Scot Heywood, Lies Kraal, Penelope Krebs, Madeline O'Connor, Roy Thurston, R. Doen Tobey, Guy Williams

HUNSAKER-SCHLESINGER 213.657.2557
812 N. La Cienega Blvd., Los Angeles 90069
Hours: Tues-Sat 11-5

ITURRALDE GALLERY 213.937.4267
154 N. La Brea Ave., Los Angeles 90036 FAX: 213.937.4269
Contact: Teresa Iturralde, Director
Specialty: Contemporary Latin American art

JAN KESNER GALLERY 213.938.6834
164 N. La Brea Ave., Los Angeles 90036
Hours: Tues-Sat 11-5
Contact: Jan Kesner, Owner/Director
Specialty: 20th-Century master photographs and contemporary photo-based art

Artists Represented: Ansel Adams, Ty Allison, Manuel Alvarez-Bravo, Diane Arbus, Richard Benson, Bruce of Los Angeles, Nancy Burson, Harry Callahan, Larry Clark, John Divola, Walker Evans, Robert Frank, John Humble, Alfred Cheney Johnston, Andre Kertesz, Danny Lyon, Richard Misrach, Denny Moers, Patrick Nagatani, Erik Otsea, Anne Rowland, August Sander, Jan Saudek, Josef Sudek, Ruth Thorne-Thomsen, Andree Tracey, Miki Warner, Weegee Randy West, Garry Winograd **Works Available By:** Max Yavno

KIMBERLY GALLERY 213.653.0408
8000 Melrose Ave., Los Angeles 90046
Hours: Tues-Sat 11-6
Contact: Elyse Klaidman, Director; Elena Kimberly
Specialty: Contemporary Latin American art

Artists Represented: Manuel Alvarez-bravo, Feliciano Bejar, Antonio Castellanos, Victor Chab, Arnaldo Coen, Jose Luis Cuevas, Fernando De, Szyszlo, Joy Laville, Guillermo Meza, Rodolfo Morales, Marina Nunez del Prado, Miguel Pena, **Elmar Rojas (See page 202)**, Raymundo Sesma, **Cordelia Urueta (See page 239)**, Roger, Von Gunten **Works Available By:** Jose Chavez-Morado, Alejandro Colunga, Olga Costa, Manuel Felguerez, Gunther Gerzso, Wifredo Lam, Gustavo Montoya, Luis Nishizawa, Vicente Rojo, Emilio Sanchez, Juan Soriano, Rufino Tamayo, Francisco Toledo, Mario Toral

MICHAEL KIZHNER FINE ART 213.659.5222
746 N. La Cienega Blvd., Los Angeles 90069 FAX: 213.659.0838
Hours: Mon-Sat 10-5
Contact: Michael Kizhner, Owner/Director
Specialty: California Impressionists and contemporary Soviet art

Works Available By: Afrika, **Pyotr Belenok (See page 53)**, Farid Bogdalov, Sergei Bordachev, Leonid Borisov, Nicolai Filatov, Ilona Severovna Gansovskaya, Valery Ivanovich Yershov, Ilya Kabakov, Dmitri Kantorov, Georgi Kisevalter, Natta Konisheva, Igor Meglizky, Evgeny Mikhnov-Voitenko, Nikolai Ovchinnikov, Vladimir Petrovich Naumez, Dmitri Plavinsky, Andrei Roiter, Alexander W. Sacharov, Sergei Shutov, Boris Sveshnikov, Vladimir Yakovlev, Edward Zelenin, Anatoli Zverev

KOSLOW GALLERY 213.487.7610
2507 W. Seventh St., Los Angeles 90057
Hours: Tues-Sat 12-5

CALIFORNIA (cont.)

LA JOLLA

TASENDE GALLERY
619.454.3691
820 Prospect St., La Jolla 92037
FAX: 619.454.0589
Hours: Tues-Sat 10-6
Contact: Mary Beth Hynes, Director
Specialty: Contemporary and modern drawings, paintings and sculpture

Artists Represented: Lynn Chadwick, Eduardo Chillida, Jose Luis Cuevas, Mark Di Suvero, Roberto Matta, Andres Nagel **Works Available By:** Marino Marini, Henry Moore, Isamu Noguchi, August Rodin, Tom Wesselmann **Estates Represented:** Giacomo Manzu

LAGUNA BEACH

DIANE NELSON GALLERY
714.494.2440
278 Forest Ave., Laguna Beach 92651
FAX: 714.494.4853
Hours: Mon-Sat 10-5; Sun 11-5
Specialty: Contemporary art of established and emerging artists

Artists Represented:: Antonio Arellanes, Jorg Dubin, Wayne Forte, Craig French, Armen Gasparian, John Kennedy, Colas Moore, Marco Sassone

LONG BEACH

WILLIAMS/LAMB GALLERY
213.432.2291
102 W. Third St., Long Beach 90802
Hours: Tues-Sat 11-7; Sun 12-5
Contact: Marylea Williams, Director; Marcia Lamb, Director
Specialty: Contemporary figurative art

Artists Represented: Juan Alonso, Sol Aquino, Mark Bryan, Ann Chamberlin, Lee Chesney, Cindy Evans, Diane Gamboa, Hal Hornigsberg, Daniel Kelly, Leo Limon, Karen Taylor

THE WORKS GALLERY
213.495.2787
106 W. Third St., Long Beach 90802
FAX: 213.495.0370
Hours: Tues-Sat 10-6; Sun-Mon 12-5
Contact: Mark Moore, Director; Michael Bevilaqua, Assoc. Director
Specialty: Established and emerging contemporary
artists of the western United States

Artists Represented: Lita Albuquerque (See page 41), Craig Antrim (See page 43), Annie Appel, Deanne Belinoff, Larry Bell, Billy Al Bengston, Kris Cox, Judith Davies, **Michael Davis (See page 319)**, **Woods Davy (See page 320)**, Constance De Jong, **Tony De Lap (See page 322)**, **Laddie John Dill (See page 90)**, Frank Dixon, Brad Durham, Peter Erskine, Martin Facey, Elen Feinberg, Vernon Fisher, George Geyer, John Paul Jones, Craig Kauffman, **Hoon Kwak (See page 150)**, Jeffery Laudenslager, Gary Martin, Jay McCafferty, **Jim Morphesis (See page 175)**, **Eric Orr (See page 352)**, Helen Pashgian, **Bruce Richards (See page 199)**, Judy Stabile, Barbara Sternberger, **Craig Cree Stone (See page 295)**, **Craig Syverson (See page 229)**, Gary Szymanski, Mathew Thomas, **Ann Thornycroft (See page 233)**, **Michael Todd (See page 368)**, De Wain Valentine, Clark Walding, **Stephanie Weber (See page 243)** **Works Available By:** Peter Alexander, Charles Arnoldi, Richard Beckman, Vignir Johannssen, Ed Ruscha, Robert Therrien, Tom Waldron

LOS ANGELES

ACE CONTEMPORARY EXHIBITIONS
213.935.4411
5514 Wilshire Blvd., Los Angeles 90036

ADAMSON-DUVANNES GALLERIES
213.653.1015
484 S. San Vicente Blvd., Los Angeles 90048
Hours: Mon-Sat 10-6
Contact: Jerome D. Adamson, Jr., Director
Specialty: 19th- & early 20th-Century American and European paintings

Artists Represented: Peter Adams, Jean-Baptiste Corot, Maynard Dixon, Jean Dufy, Emile Gruppe, George Inness, Guy Rose, Marion Wachtel, Charles Zlatkoff **Works Available By:** Ralph Albert Blakelock, Rosa Bonheur Maurice Braun, Marie Dieterle, Thomas Doughty, Jules Dupre, E. Charlton Fortune, William Glackens, Henri Lebasque, Norman Rockwell, William Wendt

ADLER GALLERY
213.659.3637
667 N. La Cienega Blvd., Los Angeles 90069
Hours: Tues-Sat 11-5

ART SPACE
213.474.9813
10550 Santa Monic Blvd., Los Angeles 90025
Hours: Tues-Sat 11-5

THE ART STORE GALLERY
213.933.9284
7301 W. Beverly Blvd., Los Angeles 90036

ART RESOURCE TECHNOLOGY
213.855.0586
508 N. San Vicente Blvd., Los Angeles 90048
Contact: Joanne Warfield, Director

ASHER/FAURE
213.271.3665
612 N. Almont Dr., Los Angeles 90069
FAX: 213.275.9354
Hours: Sun-Fri 10:30-5:30; Sat 11-5:30
Contact: Patricia Faure, President
Specialty: Contemporary painting, sculpture and photography

Artists Represented: Stuart Arends, Marie Bourget, Bruce Cohen, Judy Fiskin, Llyn Foulkes, Viola Frey, Jack Goldstein, Maxwell Hendler, Gwynn Murrill, Margaret Neilsen, Ellen Phelan, Rona Pondick, David Reed, Joel Shapiro, Alison Wilding, Robert Yarbe **Works Available By:** Deborah Butterfield, Steve Gianakos, Ron Janowich, Hubert Kiecol, Andrew Masullo

AYZENBERG GALLERY
213.652.0814
665 N. La Cienega Blvd., Los Angeles 90069
FAX: 213.652.6987
Contact: Michael Ayzenberg, Director

JAN BAUM GALLERY
213.932.0170
170 S. La Brea Ave., Los Angeles 90036
FAX: 213.965.0068
Hours: Tues-Sat 10-5:30
Contact: Rick Barnett, Director
Specialty: Contemporary American and European painting and sculpture;
African and Indonesian sculpture

Artists Represented: Tom Carr, Jim Defrance, Herb Elsky, Joe Fay, Robert Gil de Montes, Phyllis Green, Steve Heino, Peter Plagens, Mel Rubin, Alison Saar, Ernest Silva, Steve Tannen, Darren Waterston, Takako Yamaguchi **Works Available By:** Rosemarie Castoro, Dave de Buck, Milano Kazanjian, Jenny Lee, Clifton Peacock, Livio Saganic, Christina Schlesinger

CIRRUS GALLERY
213.680.3473
542 S. Alameda St., Los Angeles 90013
FAX: 213.680.0930
Hours: Tues-Sat 11-5
Contact: Jean Milant, Director
Specialty: Contemporary painting and sculpture - publishers of fine art graphics

Artists Represented: Lita Albuquerque, Peter Alexander, Terry Allen, Jerry Anderson, Kyoko Asano, David Austen, Richard Baker, John Baldessari, Michael Balog, Chris Burden, Greg Card, Karen Carson, Vija Celmins, Judy Chicago, Bruce Cohen, Ron Cooper, Robert Cumming, Guy De Cointet, Tony De Lap, Laddie John Dill, Fred Fehlau, Charles Garabedian, Jedd Garet, Marco Gastini, Jill Giegerich, Joe Goode, Raul Guerrero, Marvin Harden, **Charles Christopher Hill (See page 132)**, Tom Holland, Craig Kauffman, Gloria Kisch, Mark Lere, Jay McCafferty, Allan McCollum, Ed Moses, Bruce Nauman, Joan Nelson, Eric Orr, Sabina Ott, Lari Pittman, Ken Price, Ed Ruscha, Betye Saar, Alexis Smith, Linda Stark, Eugene Sturman, Gillian Theobald, David Trowbridge, Stephan Von Huene, Theodore Waddell, William T. Wiley, Jay Willis **Works Available By:** Richard Artschwager, Billy Al Bengston, Francesco Clemente, Tony Cragg, Gus Foster, Sam Francis, Helen Frankenthaler, Nancy Graves, John McCracken, James Rosenquist, David Salle, George Segal, Eve Sonneman, Gary Stephan, H. C. Westermann

GARTH CLARK GALLERY
213.932.0170
170 S. La Brea Ave., Los Angeles 90036
Hours: Tues-Sat 10-5:30

COUTURIER GALLERY
213.933.5557
166 N. La Brea Ave., Los Angeles 90036
FAX: 213.933.2357
Hours: Tues-Sat 11-5
Contact: Darrel Couturier, Director
Specialty: Contemporary painting, sculpture and ceramics

Artists Represented: Aharon Bezalel, Eugene Jardin, Jens Jensen, Linda Jones, Marsha Judd, Karen Kitchel, Ye Wu Lin, Michael Madzo, Gertrud & Otto Natzler, Brian Ransom, Oscar Senn, Neill Slaughter, Maritta Tapanainen, Kent Twitchell, Cynda Valle **Works Available By:** Nemesio Antunez, Roberto Berdecio, Jose Luis Cuevas, Greg Daly, Gonzalez Tornero Jeffery Mincham, E.K. Morris, Jenny Orchard

DEL MANO GALLERY
213.476.8508
11981 San Vicente Blvd., Los Angeles 90049
FAX: Upon Request
Hours: Tues-Sat 10-6
Contact: Jan Peters, Co-Owner/Dir.
Specialty: Contemporary American art in craft media

Artists Represented: Doug Anderson, James Barker, William Hunter, Ron Kent, Cissy McCaa, Bob Moore, Eileen Richardson, Larissa Rosenstock

DE VILLE GALLERIES
213.652.0525
8751 Melrose Ave., Los Angeles 90069
Contact: Lyn Lincoln, Director

DEVORZON GALLERY
213.659.0555
8687 Melrose Ave., Ste. B188, Los Angeles 90069
FAX: 213.659.2830
Hours: Mon-Fri 10-6
Contact: Jennifer Van Ryn, Director
Specialty: Originals by California contemporary artists and prints
by modern masters

Artists Represented: Douglas Eisman, Joe Fay, Roark Gourley, Beverly Hyman, Ellen Hyman, John Kennedy, Jessica Kolesar, Muramasa Kudo, Mark Longley, Patrick Murphy, Greg Ochoki, Ron Pastucha, Mickey Paulos, Jack Roberts, John Rose, Joseph Stabilito, Vasa **Works Available By:** Josef Albers, Bruno Bratier, Marc Chagall, James Coignard, Salvador Dali, Leonor Fini, Giancarlo Impiglia, Lieberman, Mendij Joan Miro, Pablo Picasso, Ed Roche, Sica, Frank Stella, Marshall-Davis Taylor, Victor Vasarely, Andy Warhol, Francisco Zuniga

ARIZONA

SCOTTSDALE

SUZANNE BROWN GALLERIES 602.945.8475
7156 Main St., Scottsdale 85251 FAX: 602.945.6640
Hours: Mon-Sat 9:30-5:30
Contact: Linda Corderman, Director
Specialty: Contemporary works in all media

Artists Represented: Alvin Amason, David Barba, Richard Bunkall, Patti Cramer, William Matthews, Ed Mell, Paul Pollaro, Howard Post, Veloy Vigil

ELAINE HORWITCH GALLERIES, INC. 602.945.0791
4211 N. Marshall Way, Scottsdale 85251 FAX: 602.994.5568
Hours: Mon-Sat 10-5
Contact: Elaine Horwitch, President
Specialty: Contemporary American and southwest paintings and sculpture

Artists Represented: Joe Baker, Lamar Briggs, Emily Brock, Robert Brubaker, Anne Coe, Frank Duchamp, Otto Duecker, John Fincher, Frank Fleming, James Havard, Susan Hertel, Kevin Irvin, Dick Jemison, Suzanne Klotz, **David Kraisler (See page 337)**, James Lavadour, Lucy Lyon, Merrill Mahaffey, Dick Mason, Mark McDowell, Tom Noble, Jane Ash Poitras, J. Alex Potter, Larry Rivers, Bill Schenck, Fritz Scholder, Gary Slater, Pamela Smilow, Victor Spinski, Lynn Taber-Borcherdt, Vivian Thierfelder, Gretchen Wachs, Robert Wade, Kay Walkingstick, Tom Wesselmann, Liz Wolf, Masoud Yasami

JOANNE RAPP GALLERY/THE HAND AND THE SPIRIT 602.949.1262
4222 N. Marshall Way, Scottsdale 85251
Hours: Mon-Sat 10-5:30
Contact: Joanne Rapp, Owner
Specialty: Contemporary American craft media
including clay, metal, fiber, and wood

Artists Represented: Eddie Dominguez, Edward Eberle, Karen Karnes, Ann Baddeley Keister, Ed Moulthrop, Peter Shire, Tommy Simpson, Robert Sperry, Clare Yares **Works Available By:** Sonja Blomdahl, Gina Bobrowski, Gayle Fichtinger, Andrea Gill, Wendy Maruyama, Steve Maslach, Jeanne Otis, Janet Prip, Wendy Ramshaw, David Shaner, Carol Shinn, Janet Taylor **Estates Represented:** Ruth Kao

LISA SETTE GALLERY 602.990.7342
4142 N. Marshall Way, Scottsdale 85251 FAX: 602.970.0825
Hours: Tues-Fri 10-5; Thurs Eve 7-9; Sat 12-5
Contact: Peter Wirmusky, Director
Specialty: Contemporary painting, sculpture and photography

Artists Represented: Luis Cruz Azaceta, Kevin Berry, Suzanne Caporael, Dan Collins, Peter Drake, Aaron Fink, Barbara Gilson, Patricia Gonzalez, Luis Jimenez, Roberto Juarez, Mark Klett, Frank Martin, William Morris, Janis Provisor, Arnaldo Roche-Rabell, Dana Salvo, Kevin Sloan, James Turrell, William Wegman, Frances Whitehead

JOY TASH GALLERY 602.945.0195
4142 N. Marshall Way, Scottsdale 85251
Hours: Mon-Sat 10-5; Thurs 10-9
Contact: Joy A. Tash, Director

UDINOTTI GALLERY 602.946.7056
4215 N. Marshall Way, Scottsdale 85251

RIVA YARES GALLERY 602.947.3251
3625 N. Bishop Lane, Scottsdale 85251
Hours: Tues-Sat 10-5
Contact: Douglas Webster, Director

CALIFORNIA

BEVERLY HILLS

BOWLES-SOROKKO GALLERIES 213.278.4400
314 N. Rodeo Dr., Beverly Hills 90210 FAX: 213.278.6771
Contact: Tim L. Yarger, Assoc. Director

LOUIS NEWMAN GALLERIES 213.278.6311
322 N. Beverly Dr., Beverly Hills 90210
Contact: Carla Luna, Director/Pub.
Hours: Tues-Sat 10-9:30; Sun-Mon 10-6:30

LOUIS STERN GALLERIES 213.276.0147
9528 Brighton Way, Beverly Hills 90210
Hours: Mon-Fri 10-6; Sat 11-5; Closed Sun
Contact: Joan Vogel, Director
Specialty: Important impressionist, post-impressionist and modern works

Works Available By: Marc Chagall, Maximilien Luce, Claude Monet, Berthe Morisot, Pablo Picasso, Camille Pissarro, Paul Signac, Alfred Sisley

CARMEL

GALERIE BLUE DOG, LTD. 408.626.4444
P.O. Box S-3214, Carmel 93923
Hours: Daily 10-6
Contact: Richard Steiner, Director
Specialty: A one-artist gallery and studio devoted to George Rodrigue

Artists Represented: George Rodrigue (See page 201)

WESTON GALLERY 408.624.4453
P.O. Box 655, Carmel 93921 FAX: 408.624.7190
Hours: Tues-Fri 11-5; Sat 10-5; Sun 12-5
Contact: Margaret Weston, Owner
Specialty: 19th- & 20th-Century photographic prints

COSTA MESA

DE GRAAF FINE ART, INC. 714.557.5240
3400 Avenue of the Arts, Ste. C120 Costa Mesa 92626
Hours: Tues-Sat 11-5:30
Contact: Daniel L. De Graaf
Specialty: Contemporary American, European and Latin American
paintings, sculpture and graphics

Artists Represented: Bill Barrett (See page 305), G. Elyane Bick (See page 54), Romero Britto (See page 61), Charlie Brouwer (See page 310), Chuang Che (See page 71), Stefan Davidek (See page 84), Eugene Jardin (See page 331), Jim Jenkins (See page 332), Elisabeth Lalouschek (See page 152), Kurt Metzler (See page 349), David Miretsky (See page 173), Clayton Pond (See page 193), Scott Runion (See page 358), Michael Teague (See page 232)

THE WORKS GALLERY SOUTH 714.979.6757
3333 Bear St., Third Fl., Costa Mesa 92626 FAX: 714.979.6818
Hours: Mon-Fri 10-9; Sat 10-6; Sun 11-6
Contact: Mark Moore, Director; Steve Gillette, Assoc. Director
Specialty: Established and emerging contemporary artists
of the western United States

Artists Represented: Lita Albuquerque (See page 41), Craig Antrim (See page 43), Annie Appel, Deanne Belinoff, Larry Bell, Billy Al Bengston, Kris Cox, Judith Davies, **Michael Davis (See page 319), Woods Davy (See page 320),** Constance De Jong, **Tony De Lap (See page 322), Laddie John Dill (See page 90),** Frank Dixon, Brad Durham, Peter Erskine, Martin Facey, Elen Feinberg, Vernon Fisher, George Geyer, John Paul Jones, Craig Kauffman, **Hoon Kwak (See page 150),** Jeffery Laudenslager, Gary Martin, Jay McCafferty, **Jim Morphesis (See page 175), Eric Orr (See page 352),** Helen Pashgian, **Bruce Richards (See page 199),** Judy Stabile, Barbara Sternberger, **Craig Cree Stone (See page 295), Craig Syverson (See page 229),** Gary Szymanski, Mathew Thomas, **Ann Thornycroft (See page 233), Michael Todd (See page 368),** De Wain Valentine, Clark Walding, **Stephanie Weber (See page 243) Works Available By:** Peter Alexander, Charles Arnoldi, Richard Beckman, Vignir Johannssen, Ed Ruscha, Robert Therrien, Tom Waldron

GUALALA

ALINDER GALLERY 707.884.4884
39165 S. Highway One, Box 1146, Gualala 95445 FAX: 707.884.9124
Hours: Thurs-Mon 11-5:30
Contact: James & Mary Alinder, Owners
Specialty: 20th-Century masterworks of fine photography

Artists Represented: Ansel Adams, Ruth Bernhard, Paul Caponigro, Henri Cartier-Bresson, Wright Morris **Works Available By:** David Carey, Linda Connor, Roy De Carava, John C. Hesketh, Patrick Nagatani, George Tice, Jerry Uelsmann

HUNTINGTON BEACH

CHARLES WHITCHURCH GALLERY 714.373.4459
5973 Engineer Dr., Huntington Beach 92649 FAX: 714.373.4615
Hours: Mon-Fri 10-5; Sat 11-4
Contact: Douglas Deaver, Ph.D., Director
Specialty: Paintings, sculpture and graphic works by modern
and contemporary artists

Artists Represented: Ray Friesz (See page 111), Jurgen Frisch, **Jerome Gastaldi (See page 113), James Groff (See page 121), Ku-Lim Kim (See page 142), Helga Kos (See page 146), Michael Rubin (See pages 207 & 279) Works Available By:** Peter Alexander, Carlos Almaraz, Neil Anderson, Charles Arnoldi, Francis Bacon, Charles Basham, Fernando Botero, Marc Chagall, Qiang Chen, Willem de Kooning, Richard Diebenkorn, Laddie John Dill, Sam Francis, Helen Frankenthaler, David Hockney, Friedensreich Hundertwasser, Jasper Johns, Donald Judd, Duck Jun Kwak, Roy Lichtenstein, Henri Matisse, Roberto Matta, Joan Miro, Dolly Moreno, Jim Morphesis, Robert Motherwell, Elizabeth Murray, Claes Oldenburg, Eric Orr, Scott Owen, Nam Jun Paik, Pablo Picasso, Robert Rauschenberg, Robert Rector, Rosalyn Richards, **James Rosenquist (See page 278),** Scott Sorman, Judy Stabile, Theodoros Stamos, Frank Stella, Michael Sumner, **Rufino Tamayo (See page 280),** De Wain Valentine, Andy Warhol, Bert Yarborough, Francisco Zuniga

GALLERY LISTINGS

Representation:

FAY GOLD GALLERY

247 Buckhead Avenue
Atlanta, GA 30305
404.233.3843
404.365.8633 FAX

Contact:
Fay Gold
Sophia Lyman
Exhibiting:
Modern and contemporary
art and photography

William Wegman

1. *Ball and Garland*
 1989, Polaroid polacolor
 II photograph,
 24" x 20"

2. *Clownerina*
 1990, Polaroid polacolor
 II photograph,
 24" x 20"

3. *Chudaroo*
 1990, Polaroid polacolor
 II photograph,
 24" x 20"

Selected Biography:
1991 Fay Gold Gallery,
 Atlanta, GA

Representation:

**SIMON LOWINSKY
GALLERY**

575 Broadway
New York, NY 10012
212.226.5440
212.226.5442 FAX
Contact:
Michael Malcolm

Exhibiting:
19th and 20th-century
master photographs

Madoka Takagi

1. *Central Park West & 73rd St,
Manhattan, February
1990*, Platinum print,
9 1/2" x 7 1/2"

Selected Collections:
Museum of Modern Art,
New York, NY

National Museum of
American Art,
Smithsonian Institute,
Washington, DC

Representation:

**PAUL CAVA
GALLERY**

22 N. Third Street
Philadelphia, PA 19106
215.627.1172
215.627.7667 FAX
Contact:
Paul Cava

Exhibiting:
Contemporary art, all media
including photography

Jock Sturges

1. *Marine, The Last
Day of Summer;
Montalivet France*
1989, Silver gelatin
photograph,
24" x 20"

2. *La Marmaille;
Montalivet France*
1989, Silver gelatin
photograph,
24" x 20"

3. *Two Alexandras, Gaelle,
Jeanne, and Marine;
Montalivet France*
1987, Silver gelatin
photograph,
20" x 24"

STANDING ON WATER
is a portfolio of 10 silver
gelatin prints published
in an edition of 40 with
6 artists' proofs

Selected Biography:
1991 Exhibitions: The Body
in Question, Burden
Gallery, New York, NY;
Standing on Water,
Paul Cava Gallery,
Philadelphia, PA;
Collections: The
Metropolitan Museum
of Art, NY; The Museum
of Modern Art, NY;
The Philadelphia
Museum of Art; The
Fogg Art Museum,
Cambridge, MA

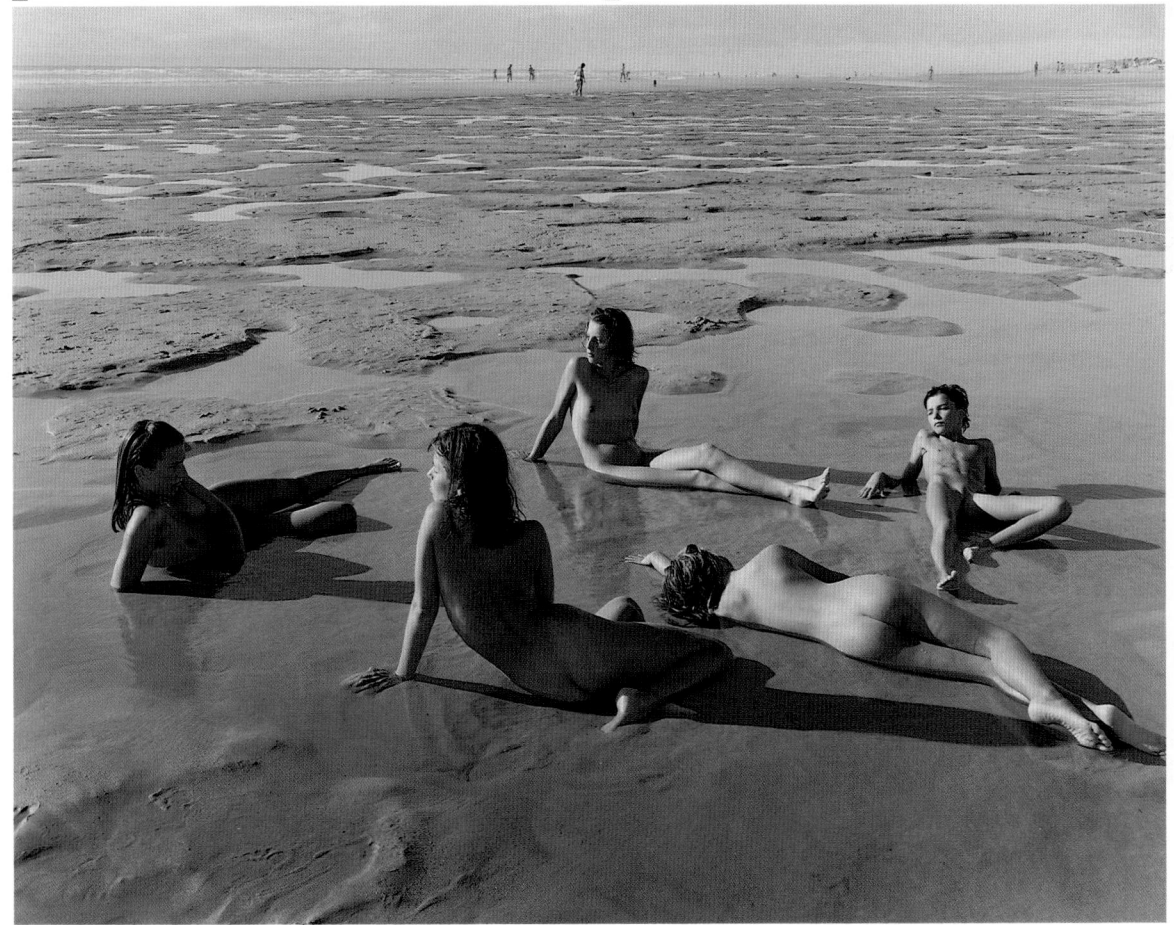

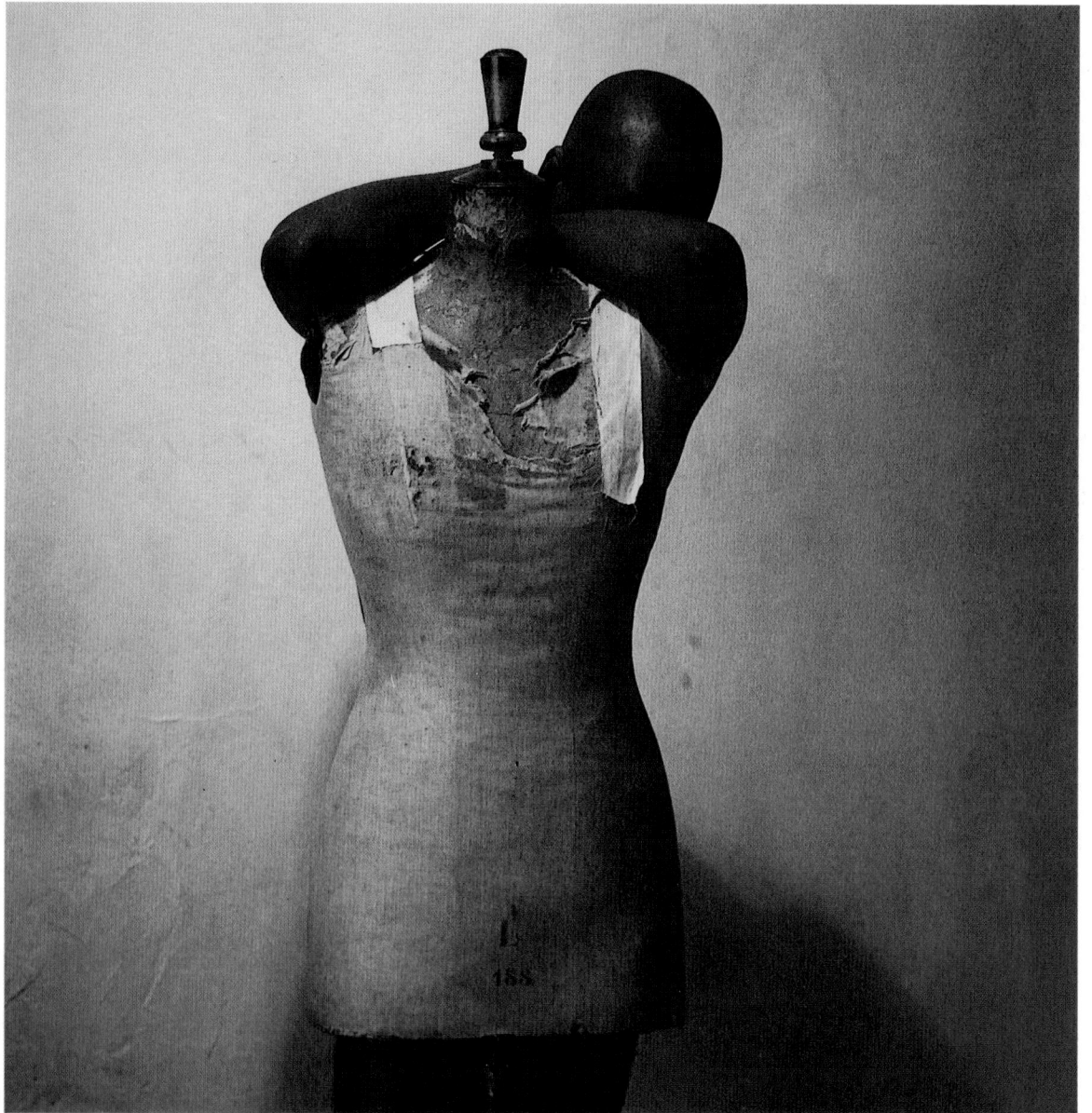

Representation:

JANE CORKIN GALLERY

179 John Street, Suite 302
Toronto, ON M5T 1X4
416.979.1980
416.979.7018 FAX
Contact:
Jane Corkin

Exhibiting:
Historical and contemporary
fine art photography

Nigel Scott

1. *Miguel Stockman I*
 1991, Paris, toned
 silver print,
 23" x 19"

Selected Biography:
1990 "Children in
 Photography: 150
 Years", sponsored by
 the Winnipeg Art
 Gallery and travelling to
 10 museums across
 Canada; Festival de la
 Photo de la Mode,
 Barcelona, Spain; Festival
 de la Photo de la Mode,
 Budapest, Hungary
1989 Festival de la Photo de
 la Mode, Trouville,
 France

Representation:

JANE CORKIN GALLERY

179 John Street, Suite 302
Toronto, ON M5T 1X4
416.979.1980
416.979.7018 FAX

Contact:
Jane Corkin

Exhibiting:
Historical and contemporary
fine art photography

Alexander Rodchenko

1. *Lila Brik*
 1924, Photomontage,
 6 5/8" x 4 3/8"

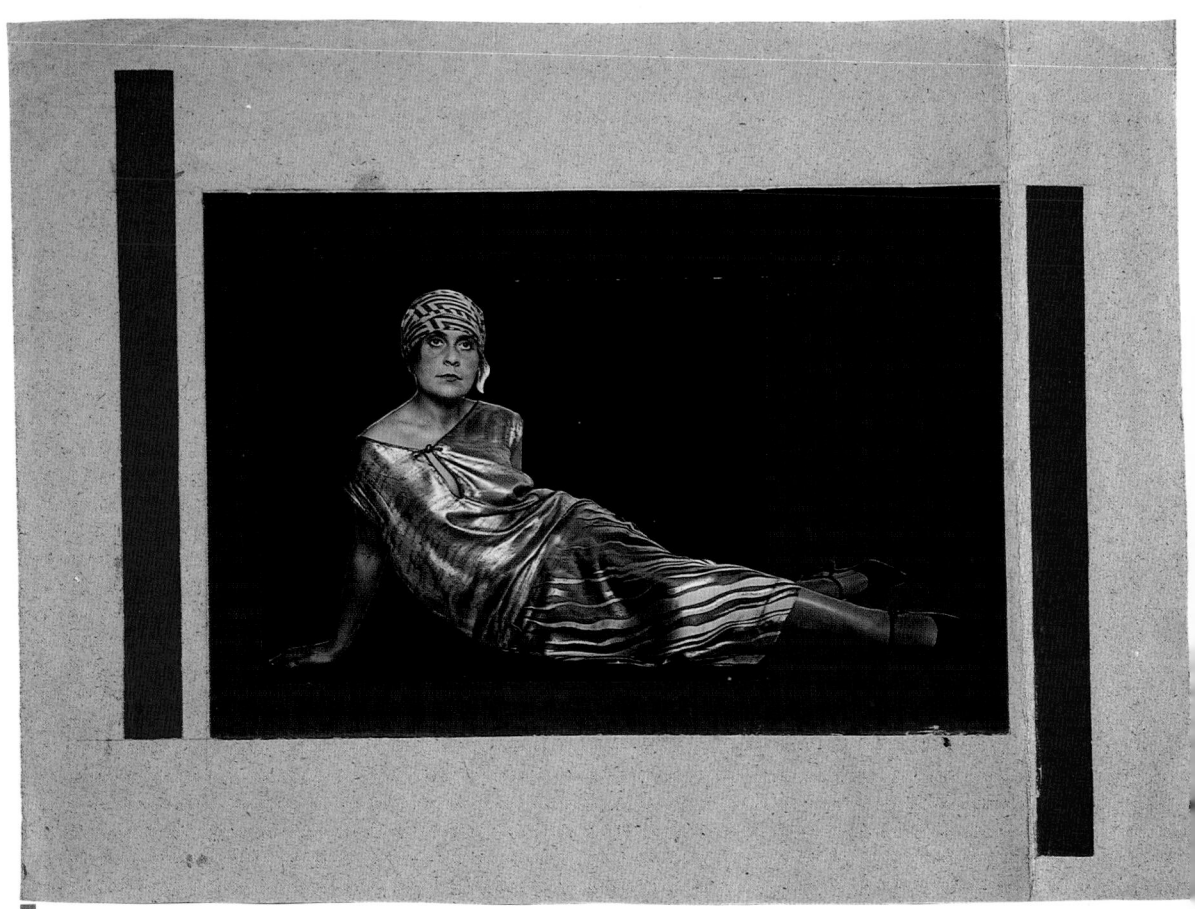

Selected Biography:

1992 "Children in
Photography: 150 Years",
sponsored by the
Winnipeg Art Gallery,
travelling to 10 museums
across Canada

1990 "On the Art of Fixing a
Shadow - One Hundred
and Fifty Years of
Photography", National
Gallery of Art,
Washington, DC; The
Art Institute of Chicago,
Chicago, IL; Los Angeles
County Museum, CA

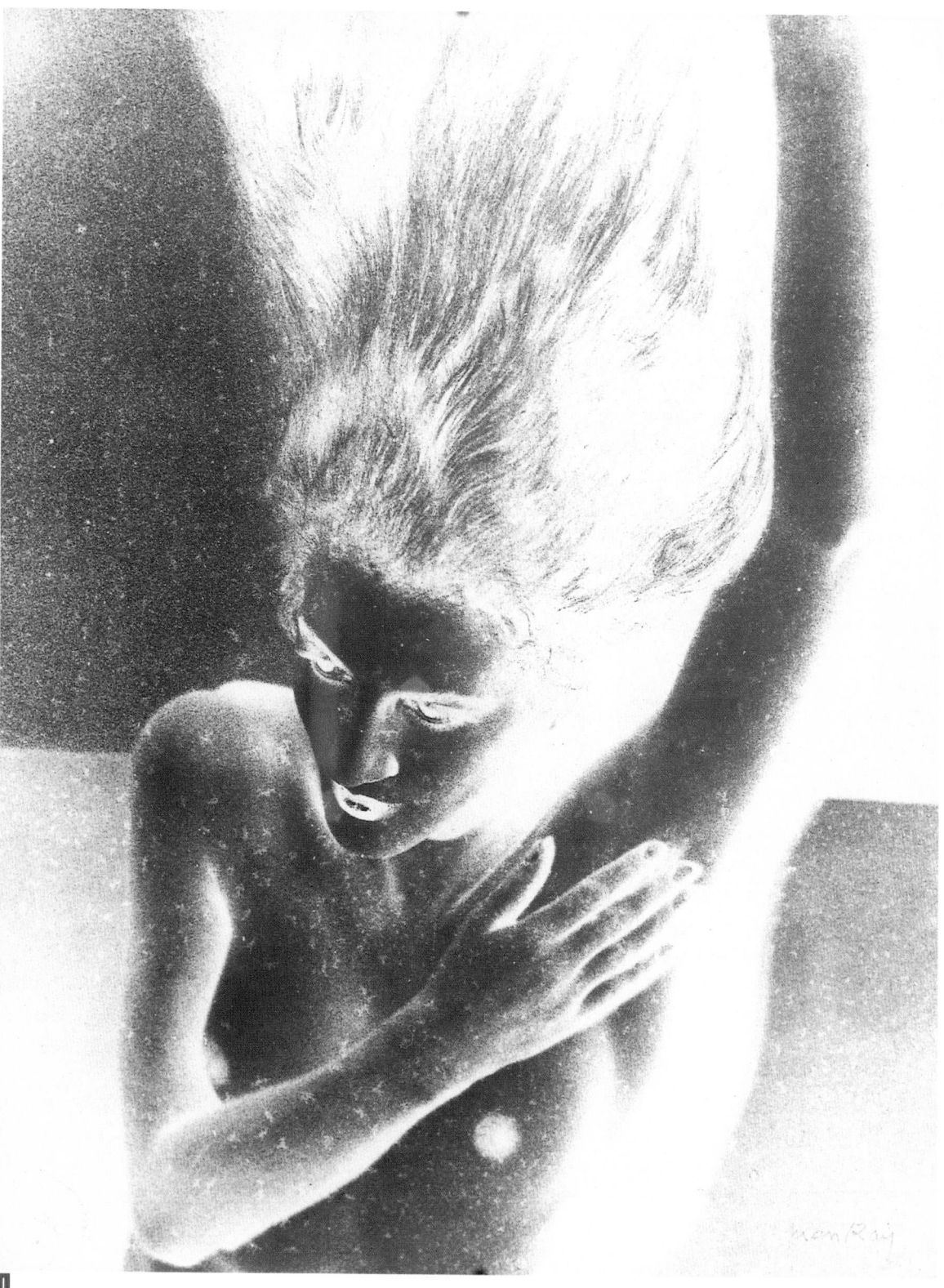

Representation:

FOTOMANN, INC.

42 E. 76th Street
New York, NY 10021
212.570.1223
212.570.1699 FAX
Contact:
Robert Mann

Exhibiting:
19th and 20th-century
vintage and contemporary
photography

Man Ray

1. *Nude (Jaqueline Goddard)*
 1929, Vintage solarized
 negative silver print,
 12 7/8" x 9 1/2"

Paul Outerbridge, Jr.

1. *Nude with Mask*
 1936, Photograph

Selected Exhibitions:
1990 Grand Rapids Art
 Museum, MI;
 Palm Springs Desert
 Museum, CA
1989 Columbus Museum
 of Art, OH
1983 Madison Art Center,
 WI; Baltimore Museum
 of Art, MD
1982 Minneapolis Institute
 of the Arts, MN;
 Kunsthalle, Cologne,
 Germany; Oklahoma
 Art Center, OK; San
 Francisco Museum of
 Modern Art, CA;
 Laguna Beach Museum
 of Art, CA

Representation:

FAY GOLD GALLERY

247 Buckhead Avenue
Atlanta, GA 30305
404.233.3843
404.365.8633 FAX

Contact:
Fay Gold
Sophia Lyman
Exhibiting:
Modern and contemporary
art and photography

David McDermott & Peter McGough

1. *To Protect the Head from the Weather or for Ornament*
 25th Instance of April 1911, 1991,
 3 Palladium prints,
 11" x 14" each, Edition of 3

2. *Our Famous Convincer is Much in Favor with Swell Dressers*
 6th Instance of December 1908, 1990,
 4 Palladium prints,
 11" x 14" each, Edition of 3

3. *Conductability of Sound by Solid Bodies*
 1884, 1990, Palladium print,
 11" x 14", Edition of 3

Selected Biography:
1991 Fay Gold Gallery, Atlanta, GA; Whitney Museum, Whitney Biennial, New York, NY

CAROL MARINO

CAROL MARINO

Representation:

JANE CORKIN GALLERY

179 John Street, Suite 302
Toronto, ON M5T 1X4
416.979.1980
416.979.7018 FAX

Contact:
Jane Corkin

Exhibiting:
Historical and contemporary
fine art photography

Carol Marino

1. *Balanced Diet*
 1989/90, Six-piece
 assemblage mounted on
 board, toned silver print,
 48 4/8" x 40 1/8"

Selected Biography:

1991 "Large Scale Recent
Work", Jane Corkin
Gallery, Toronto, ON

1990 "Children in
Photography: 150
Years", sponsored by
the Winnipeg Art
Gallery and travelling to
10 museums across
Canada

1987 "Life Forces", Agnes
Etherington Art Centre,
Queen's University,
Kingston, ON

Representation:

MICHAEL SHAPIRO GALLERY

250 Sutter Street, 3rd Fl.
San Francisco, CA 94108
415.398.6655
415.398.0667 FAX
Contact:
Michael Shapiro

Exhibiting:
20th-century classic
black/white photography

Alma Lavenson

1. *Self-Portrait*
 1932, Gelatin silver print,
 9" x 12"

2. *Hands of the Iris Breeder*
 1932, Vintage gelatin
 silver print,
 8" x 10"

3. *San Idlefonso Indians, Taos*
 1941, Gelatin silver print,
 11 5/8" x 10 1/8"

Representation:

ROBERT KOCH GALLERY

49 Geary Street
San Francisco, CA 94108
415.421.0122
415.421.6306 FAX

Contact:
Robert Koch
Ada Takahashi
Exhibiting:
19th, 20th-century and
contemporary photography,
Surrealist, avant-garde,
Eastern European
photography

Josef Koudelka

1. *France*
 1987, Gelatin silver print,
 20" x 24"

2. *Rumania*
 1968, Gelatin silver print,
 50 x 60 cm

Selected Biography:
1991 Awarded Henri
Cartier-Bresson Award
1988 Major retrospective
tours in Europe and
U.S.; Monograph
"Exiles" published by
Aperture
1986 Awarded Centre
National des Arts
Plastiques Grant

1

Representation:

JANE CORKIN
GALLERY

179 John Street, Suite 302
Toronto, ON M5T 1X4
416.979.1980
416.979.7018 FAX
Contact:
Jane Corkin

Exhibiting:
Historical and contemporary
fine art photography

André Kertész

1. *Street Pavers*
 1929, Paris, vintage
 silver print,
 9 11/16" x 11 3/8"

Selected Biography:
1991 A re-creation of
 Kertész's first exhibition
 in Paris in 1927 at Au
 Sacre du Printemps,
 Jane Corkin Gallery
1991 "Children in
 Photography: 150
 Years", sponsored by
 the Winnipeg Art
 Gallery, travelling to 10
 museums across Canada
1989 "The Art of Photography
 1839-1989", the
 Museum of Fine Arts,
 Houston, TX; Australian
 National Gallery,
 Canberra; Royal
 Academy of Arts,
 London

Representation:

STEPHEN WIRTZ GALLERY

49 Geary Street, 3rd Fl.
San Francisco, CA 94108
415.433.6879
415.433.1608 FAX

Contact:
Stephen Wirtz
Connie Wirtz

Michael Kenna

1. *Look Out, Chesil Beach, Dorset, England*
 1990, Sepia and selenium toned silver print,
 7 1/2" x 7 1/2"

Selected Biography:
1991 Solo exhibition:
 Catherine Edelman
 Gallery, Chicago, IL;
 Solo exhibition:
 Germans Van Eck
 Gallery, New York;
 Solo exhibition:
 Weston Gallery,
 Carmel, CA
1990 Solo exhibition:
 Halsted Gallery,
 Bimingham, MI

Representation:

MARGUERITE OESTREICHER FINE ARTS

636 Baronne Street
New Orleans, LA 70113
504.581.9253
504.524.7432 FAX

Contact:
Marguerite Oestreicher

Exhibiting:
Contemporary paintings,
sculpture and photography

William K. Greiner

1. *Blue Heart, Houma, LA*
 1989, Type C color
 photography,
 16" x 20"

2. *Red Cross, White Box,
 Raceland, LA*
 1980, Type C color
 photography,
 16" x 20"

3. *White Hall, Greenwood
 Cemetary*
 1989, Type C color
 photography,
 16" x 20"

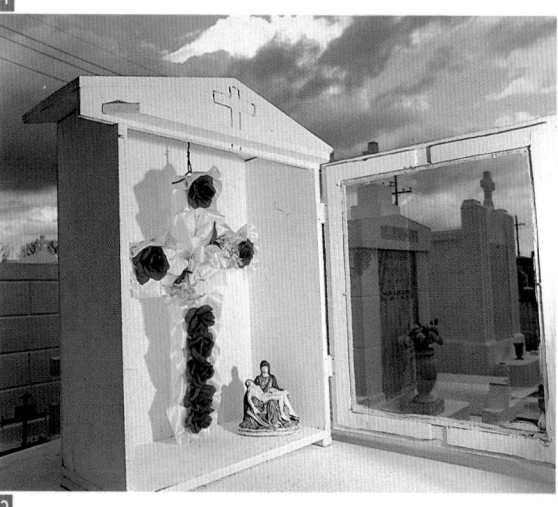

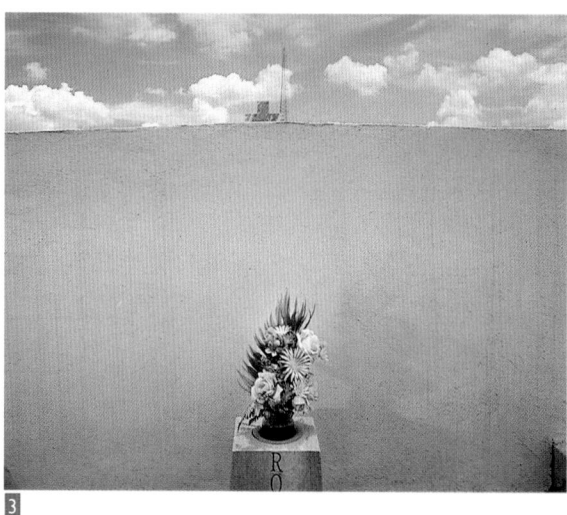

Selected Biography:

1992 "American Landscape
Photographers",
Addison Gallery
of American Art,
Andover, MA

1991 Solo show: "The
Reposed", Marguerite
Oestreicher Fine Arts,
New Orleans, LA

1988 "Tour de France
Series", X-Art Gallery,
New Orleans, LA

1984 Visual Arts Prize,
Suffolk University

Representation:

EALAN WINGATE GALLERY

578 Broadway
New York, NY 10012
212.966.5777
212.941.1455 FAX

Contact:
Ealan Wingate

Exhibiting:
Contemporary American
and European art

Eric Fischl

1. *Untitled from St. Tropez*
 1982-88, Dye transfer
 photograph,
 16" x 20"

2. *Untitled*
 1987/1990, Dye transfer
 photograph,
 20" x 15"
 A Portfolio of 16 Photographs,
 published in 1990

3. *Untitled*
 1984/1990, Dye transfer
 photograph,
 20" x 16"

Selected Biography:
1991 "Eric Fischl: A
 Cinematic View", Guild
 Hall, East Hampton, NY
1990 "Photographs and
 Prints", Cleveland
 Center for
 Contemporary Art;
 "St. Tropez",
 Photographs, Koury
 Wingate Gallery,
 New York, NY

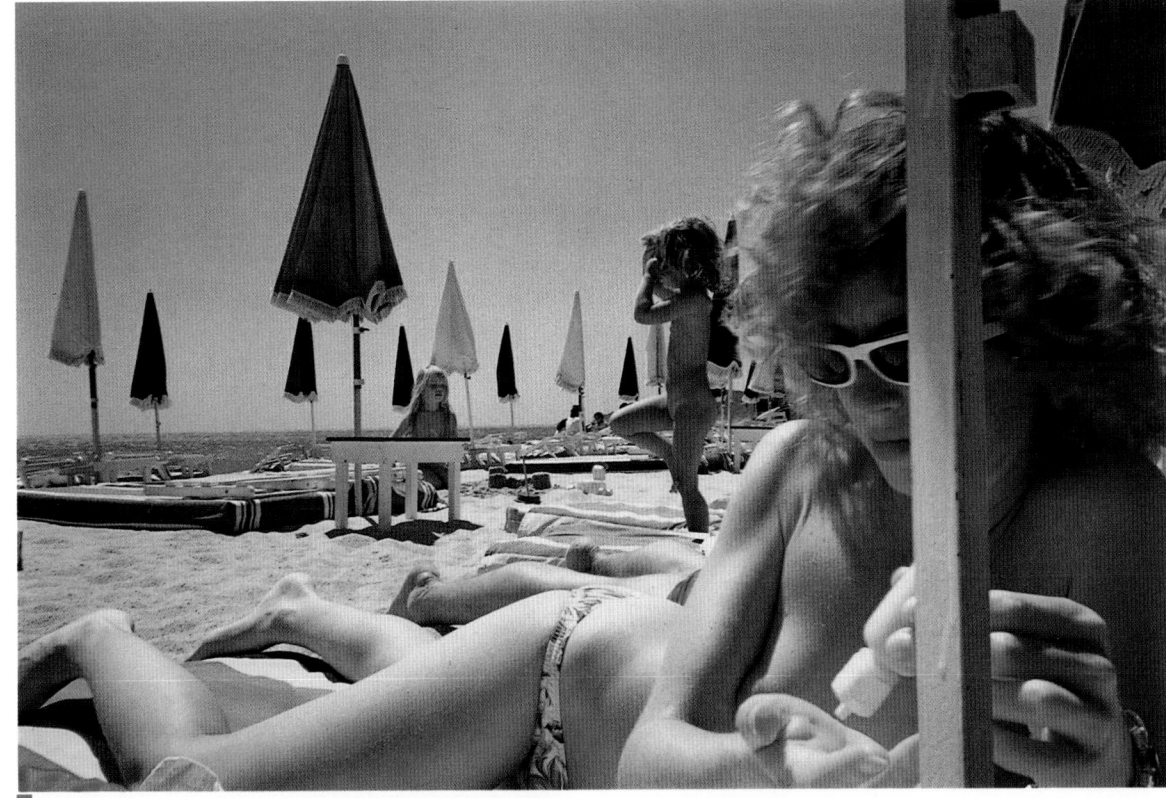

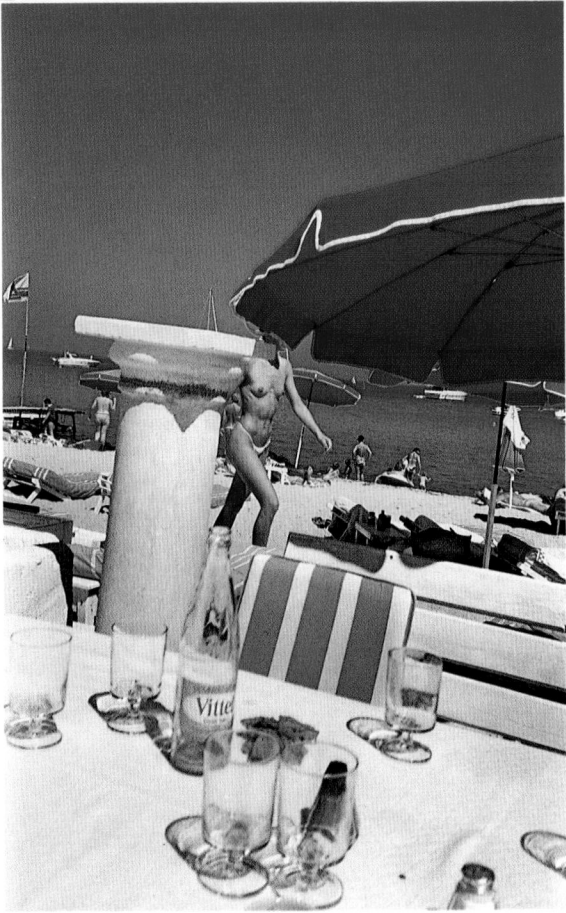

Representation:

**PAUL CAVA
GALLERY**

22 N. Third Street
Philadelphia, PA 19106
215.627.1172
215.627.7667 FAX
Contact:
Paul Cava

Exhibiting:
Contemporary art, all media
including photography

Susan Fenton

1. *Turned Head with Black
 Column*
 1988, Hand painted
 photograph,
 24" x 24", Edition 5

2. *White Satin Helmet*
 1990, Hand painted
 photograph,
 24" x 24", Edition 5

Selected Biography:
1991 "Pivot", Oriel Mostyn,
Wales and Philadelphia
1990 "Contemporary
Philadelphia Artists",
Philadelphia Museum
of Art; "Selections
from The Graham and
Susan Nash Collection",
Los Angeles County
Museum of Art; Morris
Gallery, Philadelphia
Academy of the Fine
Arts, Philadelphia, PA

Representation:

JANE CORKIN GALLERY

179 John Street, Suite 302
Toronto, ON M5T 1X4
416.979.1980
416.979.7018 FAX

Contact:
Jane Corkin

Exhibiting:
Historical and contemporary
fine art photography

Frantisek Drtikol

1. *Vertical Wave*
 1925, Vintage silver print,
 10 3/4" X 8 3/4"

Selected Biography:
1992 "Modernism II", Jane
Corkin Gallery
1989 "What is Photography -
150 Years of
Photography",
organized by the
Ministry of Culture,
Prague, Czechoslovakia;
"Modernism", Jane
Corkin Gallery

1

Representation:

**HIRSCHL & ADLER
MODERN**

851 Madison Avenue
New York, NY 10021
212.744.6700
212.737.2614 FAX
Contact:
Donald McKinney

Exhibiting:
Contemporary European
and American art

Lynn Davis

1. *Giza II, Dynasty IV*
 1989, Selenium-toned
 photograph,
 48" x 48"

Selected Biography:
1991 "Egypt: The Old
 Kingdom", Hirschl
 & Adler Modern,
 New York, NY
1990 "Lynn Davis
 Photographien",
 Frankfurter Kunstverein,
 Frankfurt, Germany
1988 "Body Work 1977-
 1987", Zoller Gallery,
 Pennsylvania State
 University, University
 Park, PA

Representation:

**HOWARD YEZERSKI
GALLERY**

186 South Street
Boston, MA 02111
617.426.8085

Contact:
Howard Yezerski
Jeri Slavin

John Coplans

1. *Self Portrait*
 1987, black & white
 photograph,
 34" x 30"

1

Selected Biography:

1992 Howard Yezerski
Gallery, Boston, MA
1991 "Biennial", Whitney
Museum of American
Art, New York, NY;
Galerie Lelong,
New York, NY
1990 "A Body of Work",
Frankfurt Kunstverein,
Germany; Howard
Yezerski Gallery,
Boston, MA
1989 "John Coplans:
Autoportrait 1984-
1989", Museé de la
Veille Charite,
Marseille, France;
Galerie Lelong,
New York, NY

Representation:

STILL-ZINSEL CONTEMPORARY

328 Julia Street
New Orleans, LA 70130
504.588.9999
504.588.9900 FAX

Contact:
Sam Still
Suzanne Zinsel
Exhibiting:
Contemporary paintings,
sculpture, photography,
works on paper

Judith Cooper

1. *Edna Mae Kline*
 1991, Hand-colored
 b/w photograph,
 34" x 34"

2. *Mrs. Robertson's Boys*
 1990, Hand-colored
 b/w photograph,
 30" x 40"

3. *Crossing Guards*
 1991, Hand-colored
 b/w mounted cutoff
 photograph,
 43" x 54" x 18"

Selected Biography:
1990 "Local Color",
 Still-Zinsel
 Contemporary Fine
 Art, New Orleans, LA;
 "Inspired Vision",
 Permanent Collection:
 New Orleans
 Museum of Art,
 New Orleans, LA
1989 "Bridging the Gap",
 Jurors: Heyman,
 Phillips & Stitch,
 San Francisco, CA
1988 "Common Ground"
 Juror: Lynn Gumpert,
 Dallas, TX

Representation:

G. RAY HAWKINS
GALLERY

910 Colorado Avenue
Santa Monica, CA 90401
213.394.5558
213.576.2468 FAX
Contact:
G. Ray Hawkins

Exhibiting:
Rare, vintage, and
contemporary photographs

Judy Coleman

1. *Awakening Nude*
 1988, Photograph

Selected Biography:
1991 Solo show: Print Room,
 Fogg Art Museum,
 Harvard University,
 Cambridge, MA
1990 Solo show: Parco
 Gallery, Tokyo, Japan
1989 Solo show: G. Ray
 Hawkins Gallery,
 Santa Monica, CA
1988 Robert Koch Gallery,
 San Francisco;
 Solo shows: Fay Gold
 Gallery, Atlanta, GA;
 G. Ray Hawkins Gallery,
 Santa Monica, CA

1

Representation:

**JANE CORKIN
GALLERY**

179 John Street, Suite 302
Toronto, ON M5T 1X4
416.979.1980
416.979.7018 FAX
Contact:
Jane Corkin

Exhibiting:
Historical and contemporary
fine art photography

Robert Bourdeau

1. *Tarn, France*
 1990, Gold toned
 silver print,
 13" x 10 1/4"

Selected Biography:
1990 "Children in
 Photography: 150 Years",
 sponsored by the
 Winnipeg Art Gallery
 and travelling to 10
 museums across Canada
1988 "The Meditated Image",
 travelled to the National
 Gallery of Canada and
 10 museums
1980 Solo exhibition:
 International Center
 of Photography,
 New York, NY

Representation:

GINNY WILLIAMS GALLERY

299 Fillmore Street
Denver, CO 80206
303.321.4077
303.394.2060 FAX
Contact:
Ginny Williams

Exhibiting:
Contemporary photography,
paintings and sculpture and
fine vintage photography

Ruth Bernhard

1. *Sand Dune*
 1967, Gelatin silver print,
 6 7/6" x 17 5/8"

2. *Classic Torso*
 1952, Gelatin silver print,
 9 1/2" x 7 3/16"

3. *Two Forms*
 1963, Gelatin silver print,
 13 11/16" x 10 1/2"

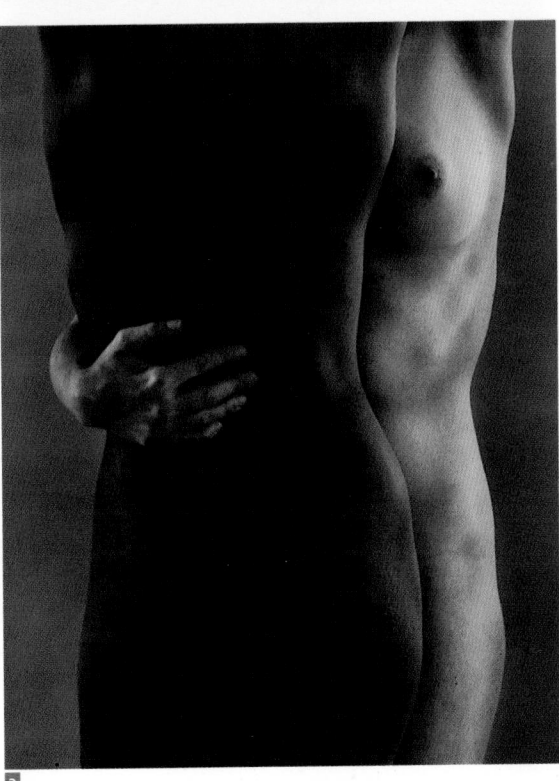

Selected Biography:
1989 Vision Gallery,
 San Francisco, CA
1987 International Center
 for Photography, New
 York, NY; Museum
 of Contemporary
 Photography, Columbia
 College, Chicago, IL;
 "The Eternal Body"
 (traveled to Europe)
1986 "The Eternal Body:
 Photographs by
 Ruth Bernhard",
 San Francisco Museum
 of Modern Art, CA

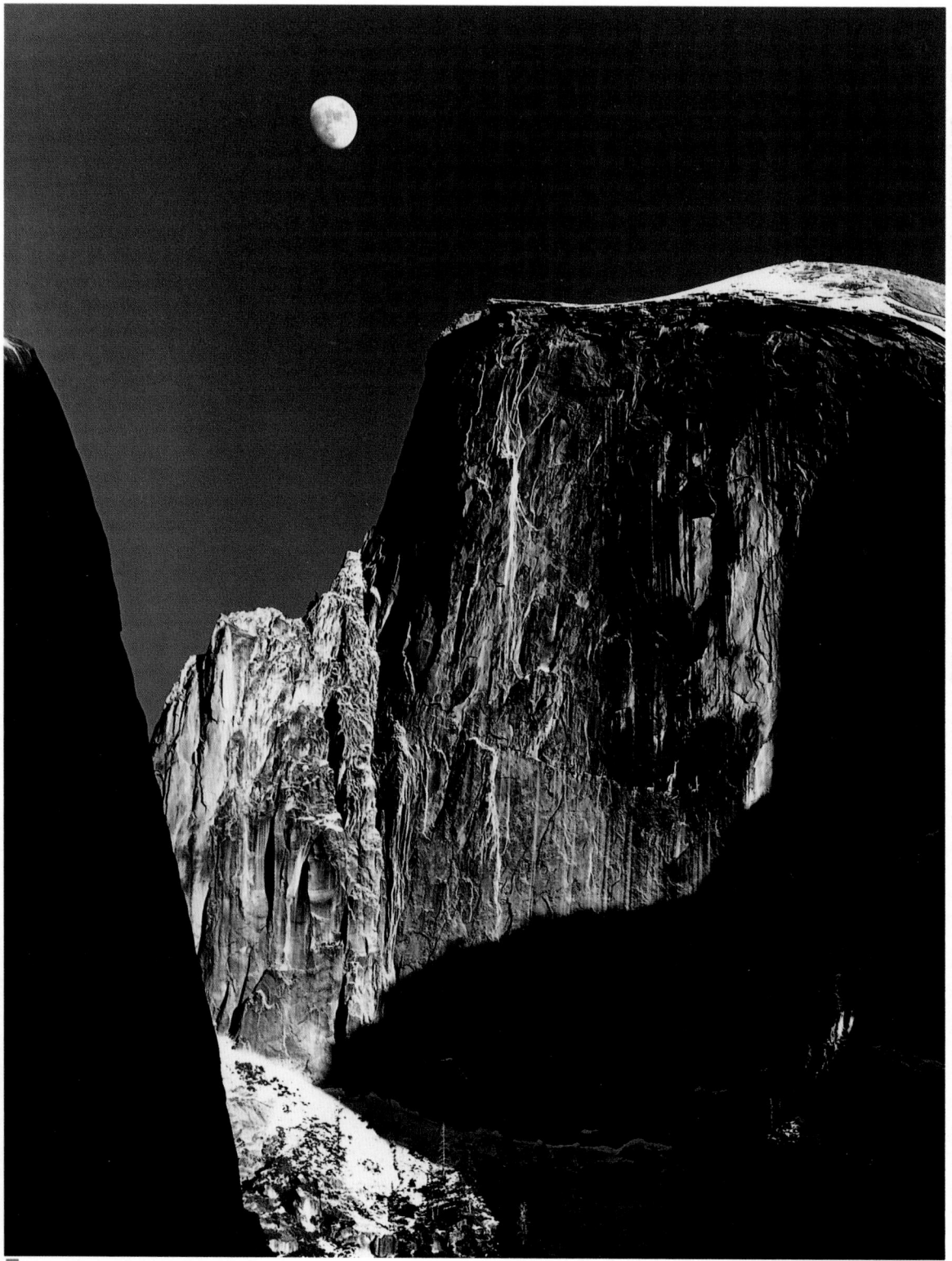

Representation:

FOTOMANN, INC.

42 E. 76th Street
New York, NY 10021
212.570.1223
212.570.1699 FAX
Contact:
Robert Mann

Exhibiting:
19th and 20th-century
vintage and contemporary
photography

Ansel Adams

1. *Moon and Half Dome,
 Yosemite National Park, CA*
 1960, Silver gelatin print,
 20" x 16"

PHOTOGRAPHY

Representation:

**HELEN DRUTT
GALLERY**

1721 Walnut Street
Philadelphia, PA 19103
215.735.1625
215.557.9417 FAX

Contact:
Helen W. Drutt English
Patricia Farrand Harner
Exhibiting:
Contemporary ceramic
sculpture and vessels,
jewelry, textiles, drawings

Paula Winokur

1. *Fireplace: Site VI*
 1988, Porcelain; slab
 constructed,
 53" x 50" x 14"
 Private Commission

2. *Canyon Wall: Site III*
 1990, Porcelain; slab
 constructed,
 16" x 74" x 9"

3. *Excavation: Site I*
 1990, Porcelain; slab
 constructed,
 16" x 32" x 14"

Selected Biography:
1992 "From The Ground
 Up", Moore College
 of Art, Philadelphia, PA
1990 "Contemporary
 Philadelphia Artists:
 Philadelphia Art Now",
 Philadelphia Museum
 of Art, PA

1

2

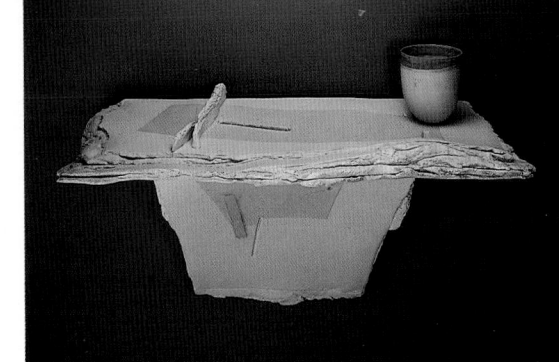

3

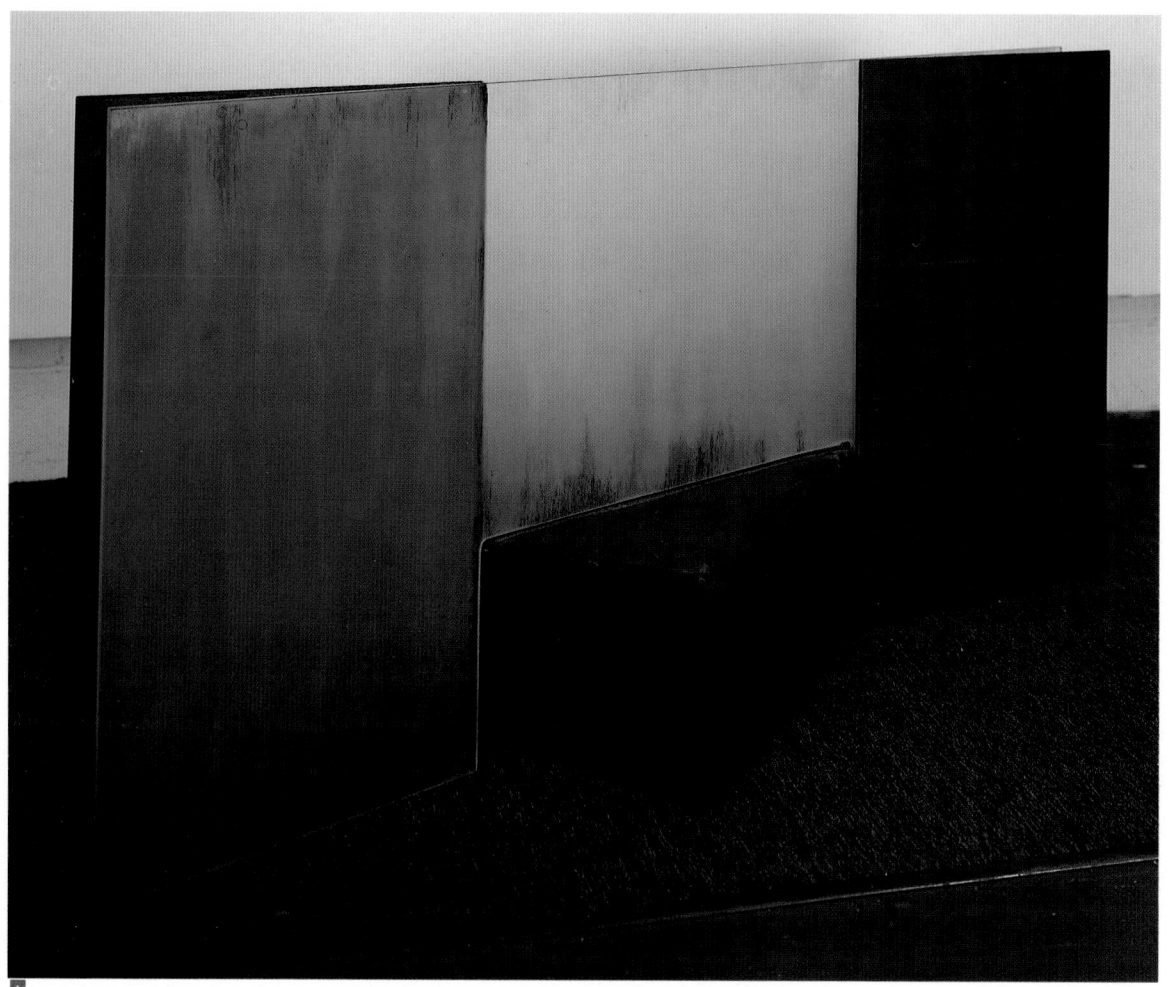

Representation:

HIRSCHL & ADLER MODERN

851 Madison Avenue
New York, NY 10021
212.744.6700
212.737.2614 FAX
Contact:
Donald McKinney

Exhibiting:
Contemporary European
and American art

Christopher Wilmarth

1. *Is/Was Softly*
 1975-76, Glass & steel,
 32" x 64" x 24"

Selected Biography:
1992 "Christopher Wilmarth",
Hirschl & Adler Modern,
New York, NY
1989 "Drawings: 1963-1987",
Hirschl & Adler Modern,
New York, NY;
"Christopher Wilmarth",
The Museum of Modern
Art, New York, NY

Representation:

LARRY BECKER

43 N. 2nd Street
Philadelphia, PA 19106
215.925.5389

Contact:
Heidi Nivling
Larry Becker
Exhibiting:
Contemporary Art: Primary
representing gallery for
approx. ten artists; limited
representation/invitational
exhibition of others

Bill Walton

1. *First Day Lake*
 Wood, copper,
 wax, linen, oil paint,
 68 5/8" x 57" x 19"

2. *Cinco Flat*
 Silver, aluminum, black
 iron, copper, lead,
 7/8" x 204" x 3/32"

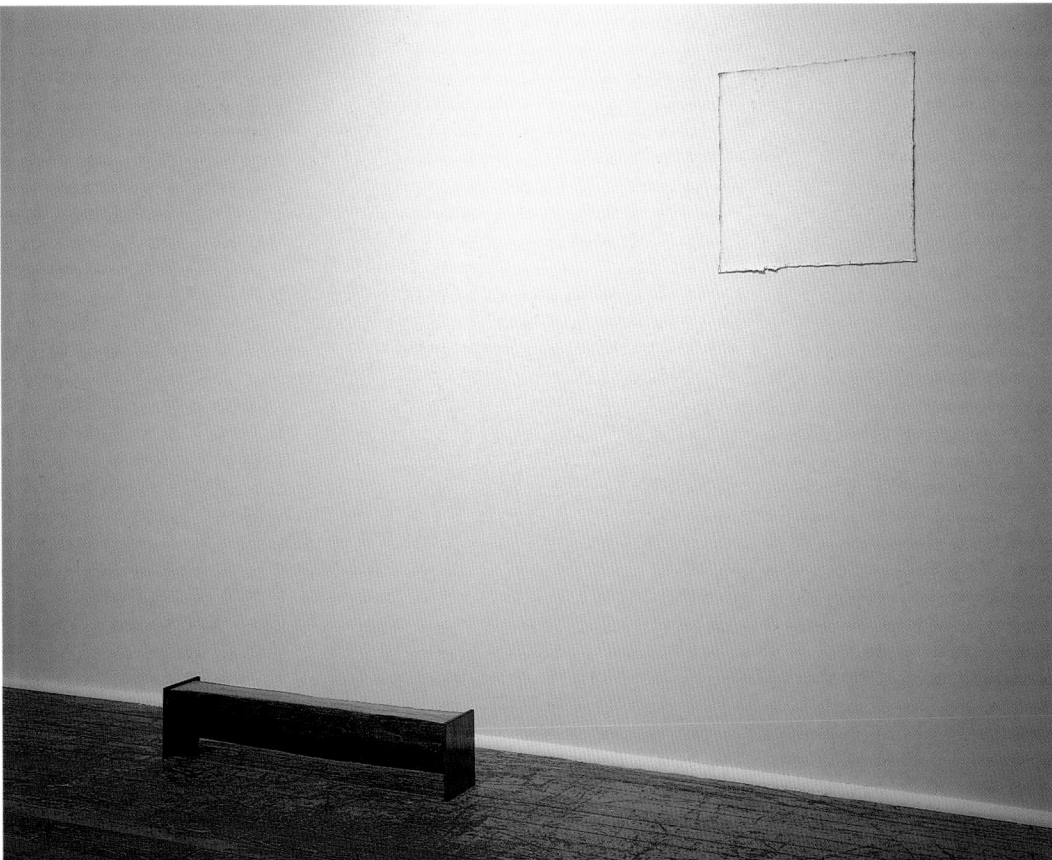

1

Selected Biography:
1992 Solo exhibition:
 Larry Becker,
 Philadelphia, PA
1991 Solo exhibition:
 North Dakota
 Museum of Art,
 Grand Forks, ND;
 Group Exhibition:
 The Institute of
 Contemporary
 Art, University
 of Pennsylvania,
 Philadelphia
1990 Solo exhibitions:
 Pennsylvania
 Academy of
 the Fine Arts,
 Philadelphia; Larry
 Becker, Philadelphia

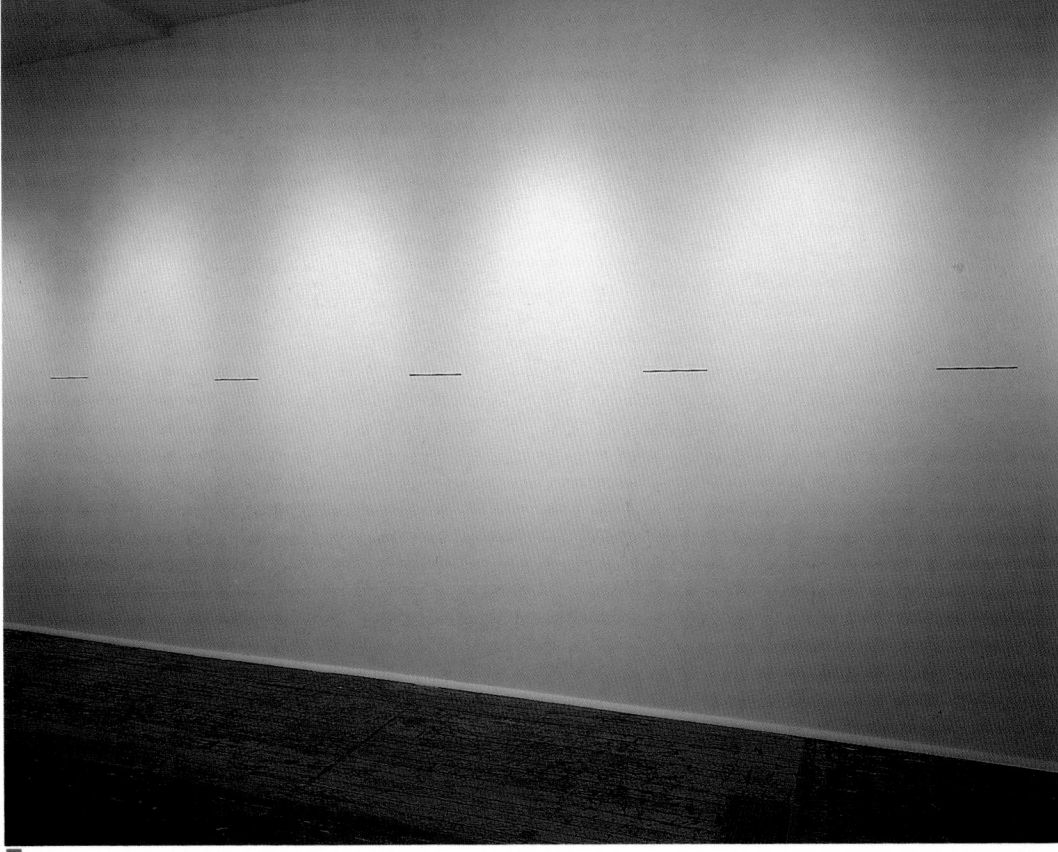

2

Representation:

**PATRICK DOHENY
& ASSOCIATES
FINE ART**
1811 W. 1st Avenue
Vancouver, BC V6J 4M6
604.737.1733
604.731.4576 FAX
Contact:
Patrick Doheny
Alison Davis
Exhibiting:
Modern and contemporary
painting, drawing, sculpture
and holography

Antoniucci Volti

1. *Agathe*
 Bronze, dark green patina,
 26 1/2" x 19 1/2" x 16 1/2"

Selected Exhibitions:
 Solo exhibitions:
 France, Canada,
 Tokyo, Osaka,
 Germany, Switzerland
 and New York

 Permanent exhibition:
 Muse Volti, Ville Frache
 Sur Mer, France

Representation:

FRANZ BADER GALLERY

1500 K Street NW
Washington, DC 20005
202.393.6111

Contact:
Wretha Hanson

Exhibiting:
Contemporary American
sculpture, paintings and
works on paper

John Van Alstine

1. *Carina (Keel)*
 1989, Granite and steel,
 82" x 32" x 16"

Representation:

O.K. HARRIS WORKS OF ART

383 W. Broadway
New York, NY 10012
212.431.3600

Contact:
Ivan C. Karp

Exhibiting:
Contemporary American
and European painting,
sculpture, photography,
antiques, collectibles,
documentation

Boaz Vaadia

1. *Naval*
 1990, Bluestone
 and boulder,
 68" x 108" x 75"

Selected Biography:
1992 Solo exhibition: O.K.
Harris Works of Art,
New York, NY
1990 Solo exhibition: O.K.
Harris Works of Art,
Birmingham, MI
1976 Brooklyn Museum of
Art School, Brooklyn,
NY
1967 Avni Institute of Fine
Arts, Tel Aviv, Israel,
B.F.A.

Representation:

THE WORKS GALLERY

106 W. Third Street
Long Beach, CA 90802
213.495.2787
213.495.0370 FAX

Crystal Court/S. Coast Plaza
3333 Bear Street, Third Fl.
Costa Mesa, CA 92626
714.979.6757
714.979.6818 FAX
Contact:
Mark Moore

Exhibiting:
Established and emerging
contemporary artists of
the western United States

Michael Todd

1. *Jazz I*
 1990, Bronze,
 71" x 42" x 28"

2. *Jazz III*
 1990, Bronze,
 72" x 76" x 38"

3. *Jazz IV*
 1990, Bronze,
 73" x 60" x 33"

Selected Biography:
1992 Group exhibition:
 "Real Space: A Survey
 In Sculpture", The
 Works Gallery South,
 Costa Mesa, CA
1991 Solo exhibitions: Klein
 Artworks, Chicago, IL;
 The Works Gallery,
 Long Beach, CA
1988 Solo exhibition: Laguna
 Beach Art Museum,
 Laguna Beach, CA

1

Representation:

SANTA FÉ EAST

200 Old Santa Fe Trail
Santa Fe, NM 87501
505.988.3103

Contact:
Ron Cahill

Exhibiting:
American art; contemporary
painting and sculpture

Kirk Tatom

1. *In The Spring*
 1987, Utah alabaster,
 21" x 9" x 13 1/2"

2. *Aurora*
 1988, Bronze,
 17" x 23" x 10"

3. *Waterfall*
 1991, Travertine,
 52" x 16" x 8"

2

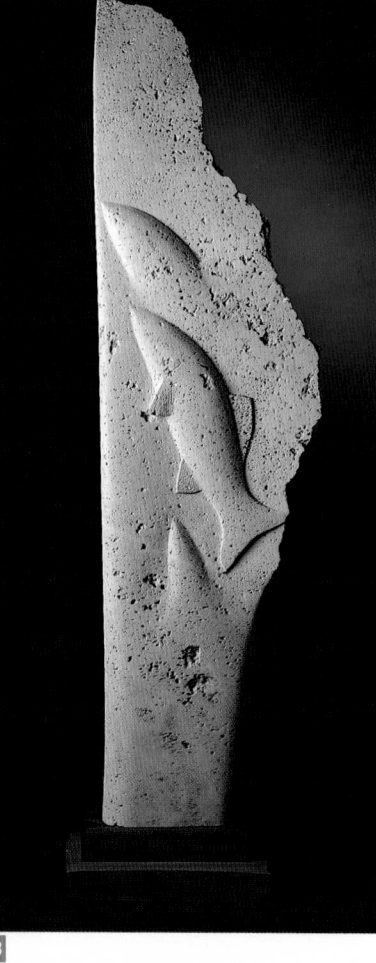

3

Selected Biography:
1991 "In The Moment",
Santa Fé East,
Santa Fe, NM
1988 "Eloquence In Stone",
Santa Fé East,
Santa Fe, NM
1986 "Quiet Realities II",
Santa Fé East,
Santa Fe, NM

Representation:

**MARY-ANNE
MARTIN/FINE ART**

23 E. 73rd Street
New York, NY 10021
212.288.2213
212.861.7656 FAX
Contact:
Mary-Anne Martin

Exhibiting:
Modern Mexican and Latin
American paintings and
sculpture

Rufino Tamayo

1. *Ancestro*
 1990, Steel with
 unique patina,
 Height 82 5/8"

 Mujer
 1990, Steel with
 unique patina,
 Height 85 1/2"

 Sideral
 1990, Steel with
 unique patina,
 Height 88 1/2"

 Atlante
 1990, Steel with
 unique patina,
 Height 83 1/2"

 Hombre Asombrado
 1990, Steel with
 unique patina,
 Height 98 1/8"

 Sculpture from left to right,
 editions of 3

Selected Biography:
1987 through 1990,
 Retrospectives:
 Mexico City, Madrid,
 Moscow, Oslo, Berlin
1981 Inauguration "Rufino
 Tamayo Museum of
 International
 Contemporary Art",
 Mexico City
1979 Retrospective: "Rufino
 Tamayo, Myth and
 Magic", Guggenheim
 Museum, New York
1977 Sao Paulo Biennial

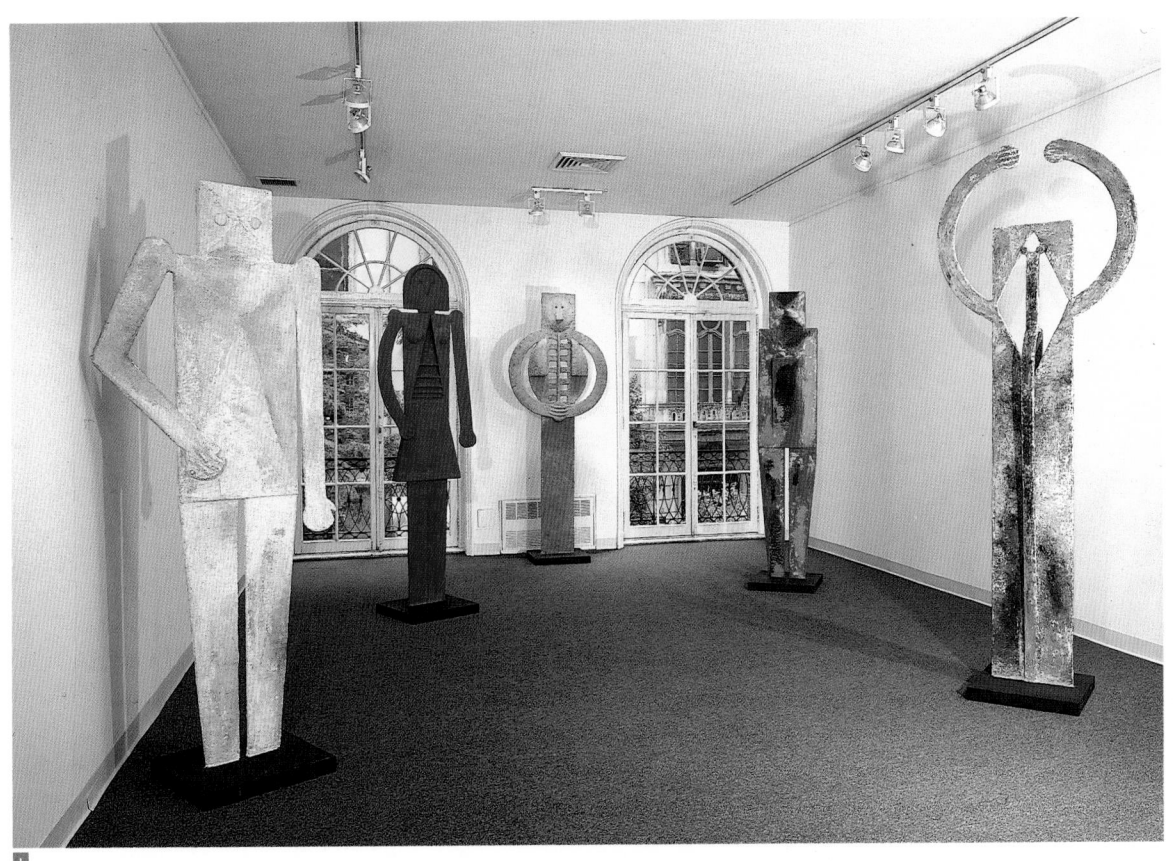

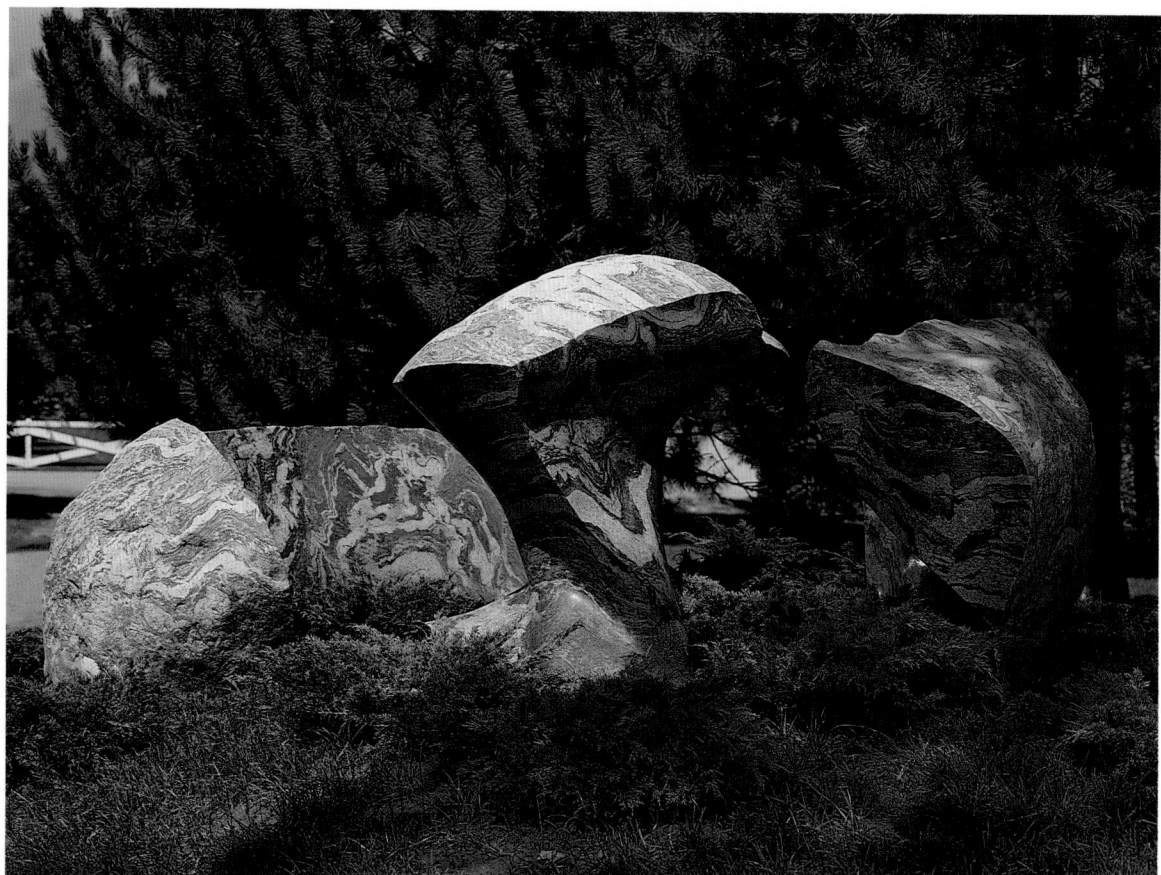

Representation:

ARTYARD

1251A S. Pearl Street
Denver, CO 80210
303.777.3219
303.871.0446 FAX

Contact:
Peggy Mangold

Exhibiting:
Outdoor and indoor
sculpture; Contemporary
American, Spanish, and
Mexican

Frank Swanson

1. *Glacial Moraine Boulder*
 1991, Colorado glacial
 boulder,
 4'6" x 16'x 7'
 Collection: Mark Shumate

2. *Spirit Stones*
 1988, Granite,
 7' x 12' x 12'
 Collection: Garden of the Gods,
 Colorado Springs, CO

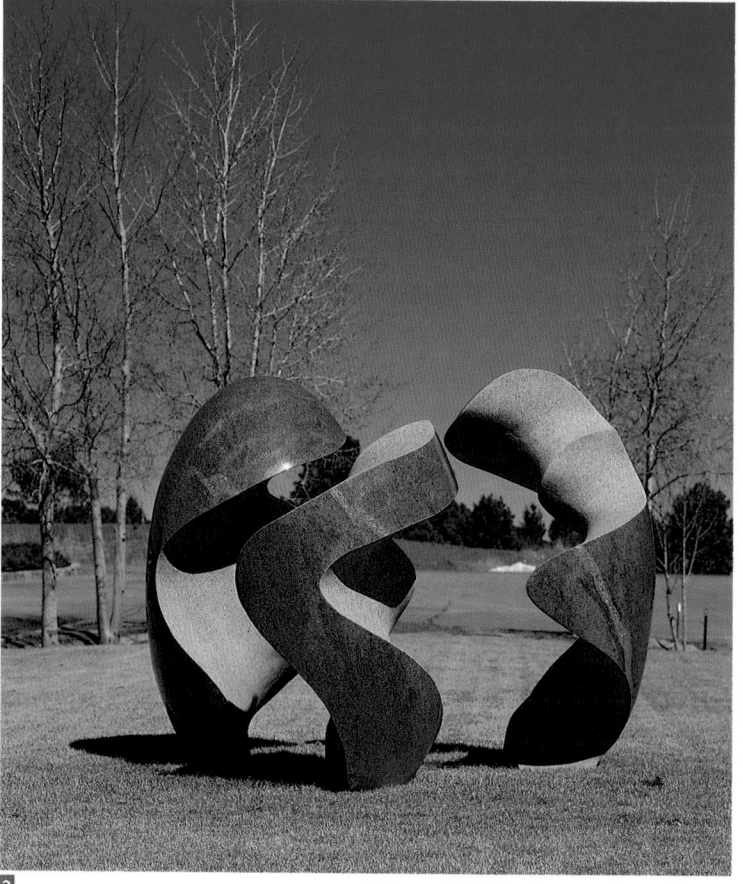

Selected Collections:
 Lawrence Aranson, IL

 Margaret Hunt Hill,
 Houston, TX

 Botanic Gardens,
 Denver, CO

Representation:

HIRAM BUTLER GALLERY

4520 Blossom Street
Houston, TX 77007
713.863.7097
713.863.7130 FAX
Contact:
Hiram Butler

Exhibiting:
Contemporary American
and European

James Surls

1. *Man Doing War*
 1984, White
 and red oak,
 176" x 96" x 72"
 Courtesy: Private Collection,
 Houston

2. *Walk and See*
 1988, Oak
 and steel,
 98" x 53" x 113"
 Courtesy: Centro Cultural/
 Arte Contemporaneo, A.C. &
 Fundacion Cultural Televisa,
 A.C. Mexico, D.F.

3. *Man Doing War*
 1984, Graphite
 on paper,
 64" x 96"

Selected Biography:
1991 "Looking Out";
 Sculpture, drawings,
 prints, The
 Contemporary
 Museum, Honolulu,
 HI; Group exhibition:
 "Sticks and Stones",
 Katonah Museum of
 Art, Katonah, NY
1990 Group exhibition:
 "Word as Image:
 American Art
 1960-1990"
1989 "Look and Listen",
 Hiram Butler Gallery,
 Houston, TX

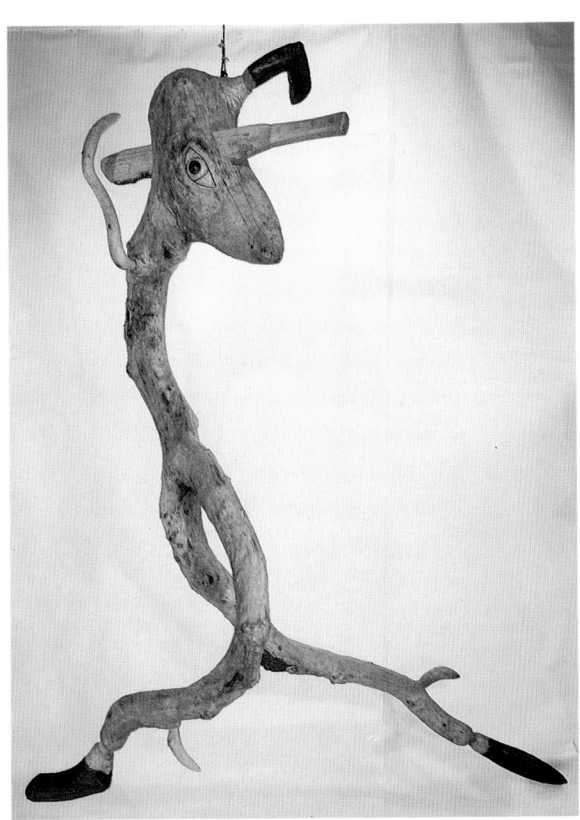

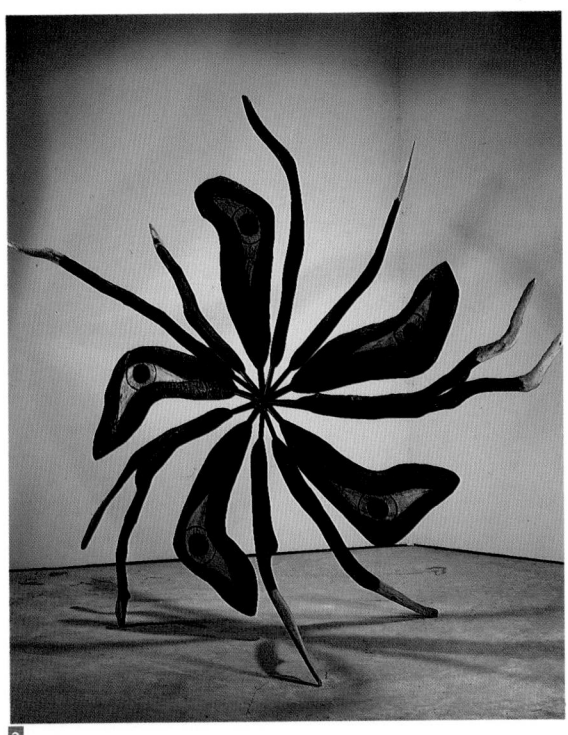

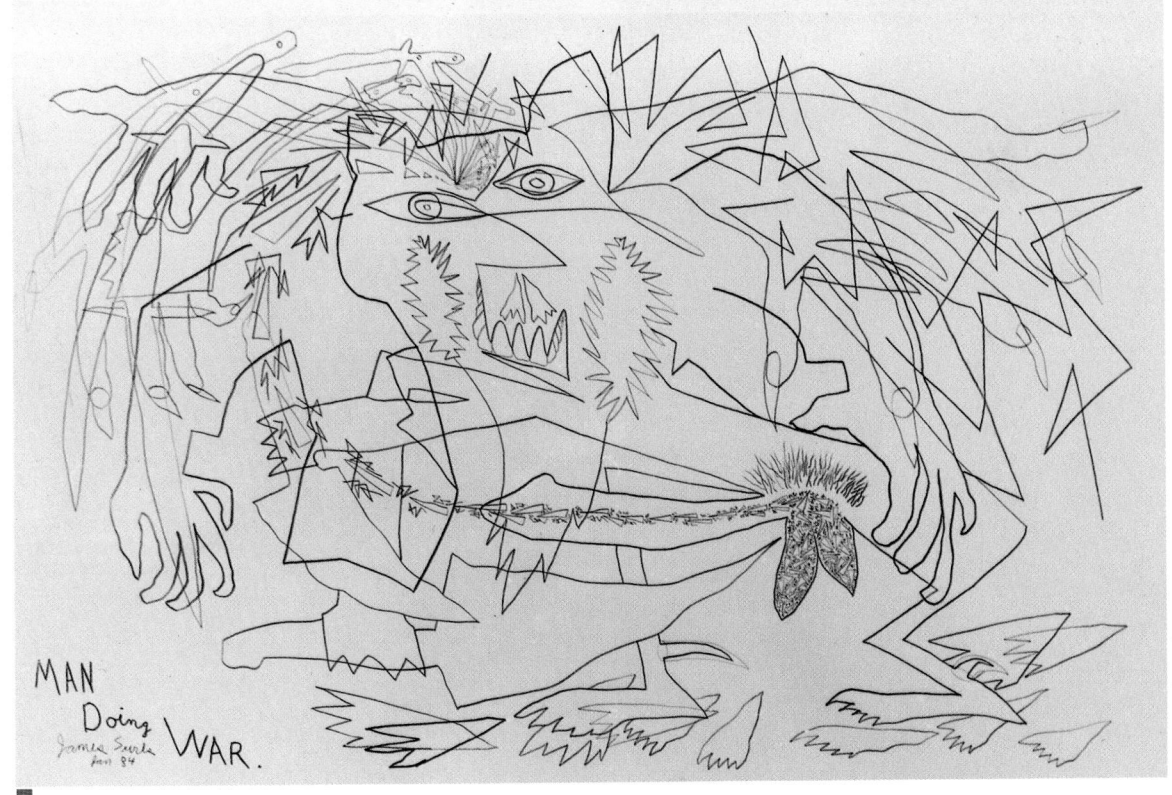

Representation:

ADDISON/RIPLEY GALLERY

9 Hillyer Court
Washington, DC 20008
202.328.2332
202.328.2332 FAX
Contact:
Chris Addison

Exhibiting:
Contemporary art in
all media

Peter Stevens

1. *Quadrafid*
 1987, Paint, rusted
 steel, stainless,
 12' x 8' x 6'

2. *Idol*
 1991, Concrete,
 aluminum,
 109" x 25.5" x 25.5"

Selected Biography:
1991 Exhibition: Phillips
 Collection,
 Washington, DC

Representation:

HUMPHREY
FINE ART

594 Broadway, 4th Fl.
New York, NY 10012
212.226.5360
212.226.5363 FAX

Contact:
Richard Humphrey
Cheryl Dolby
Exhibiting:
Contemporary painting,
sculpture and photography

Jesús Rafael Soto

1. *Escalera*
 1990, Wood, metal, and
 more than 2,500 strands
 of nylon filament with
 attached glazed metal
 tubing, painted yellow,
 white, orange,
 13' x 13' x 13'
 Installed in the Rotunda,
 Harn Museum of Art, FL

2. *Rojo Inferior*
 1991, Wood, metal,
 nylon, paint,
 41" x 81"

Selected Biography:
1991 New works, Humphrey
 Fine Art, NY;
 Sculptural installation,
 Harn Museum of
 Art, FL; Signature
 installation, Art
 Miami 91
1990 Year-long traveling
 museum retrospective,
 Japan

1

2

Representation:

STEPHEN WIRTZ GALLERY

49 Geary Street, 3rd Fl.
San Francisco, CA 94108
415.433.6879
415.433.1608 FAX
Contact:
Stephen Wirtz
Connie Wirtz

Rick Soss

1. *Key Man II*
 1990, Bronze, concrete, steel,
 68 1/2" x 14" x 14"

2. *Red Wall Horse*
 1990, Bronze, steel, concrete, & pigment,
 63 1/2" x 26 1/2" x 11 1/2"

Selected Biography:

1990 Stephen Wirtz Gallery, San Francisco, CA (also exhibited in 1986, 1984)

1987 "Four Bay Area Artists", Nancy Hoffman Gallery, New York, NY; "California Figurative Sculpture", Palm Springs Desert Museum, Palm Springs, CA

1985 "Rick Soss/S.E.C.A. Exhibition", San Francisco Museum of Modern Art, San Francisco, CA

Representation:

LEO CASTELLI GALLERY

420 W. Broadway
New York, NY 10012
212.431.5160
212.431.5361 FAX
Contact:
Susan Brundage

Keith Sonnier

1. *Wall Slash II*
 1988, Aluminum and neon,
 97" x 157" x 12"

2. *Propellor Spinner*
 1990, Aluminum and neon,
 76" x 83" x 29 1/2"

Selected Biography:
1990 Solo exhibitions:
"Centric 41: Keith
Sonnier", University
Art Museum, California
State University, Long
Beach, CA; Galeria II,
Rome, Italy; Blum
Helman Gallery,
Santa Monica, CA;
Group exhibitions:
"Newer Sculpture",
Charles Cowles
Gallery, New York,
NY; "Electricity in
Mayor Rowan Gallery,
London, England;
"Beyond The Frame",
Rubin Spangle Gallery,
New York, NY

Representation:

THE PACE GALLERY

32 E. 57th Street
New York, NY 10022
212.421.3292
212.421.0835 FAX

142 Greene Street
New York, NY 10012
212.431.9224
212.431.9280 FAX

Exhibiting:
20th-century paintings,
drawings and sculpture

Lucas Samaras

1. *Untitled*
 1991, Mixed media,
 12 1/2" x 16 1/2" x 15"

Representation:

DE GRAAF
FINE ART, INC.

9 E. Superior
Chicago, IL 60611
312.951.5180

3400 Avenue of the Arts
Suite C120
Costa Mesa, CA 92626
714.557.5240

Exhibiting:
Contemporary American,
European and Latin
American paintings,
sculpture and graphics

Scott Runion

1. *Crossing*
 Walnut,
 13" x 39" x 10"

2. *Repercussions*
 Privit and stone,
 75"

3. *Blue Totem*
 Douglas fir and tar,
 72"

Selected Biography:
1991 "New Artists",
 De Graaf Fine Art;
 Exhibitions:
 University of Illinois
 Art Institute of Chicago;
 Sacremento, CA
 San Francisco, CA
1962 Born: Stockton, CA

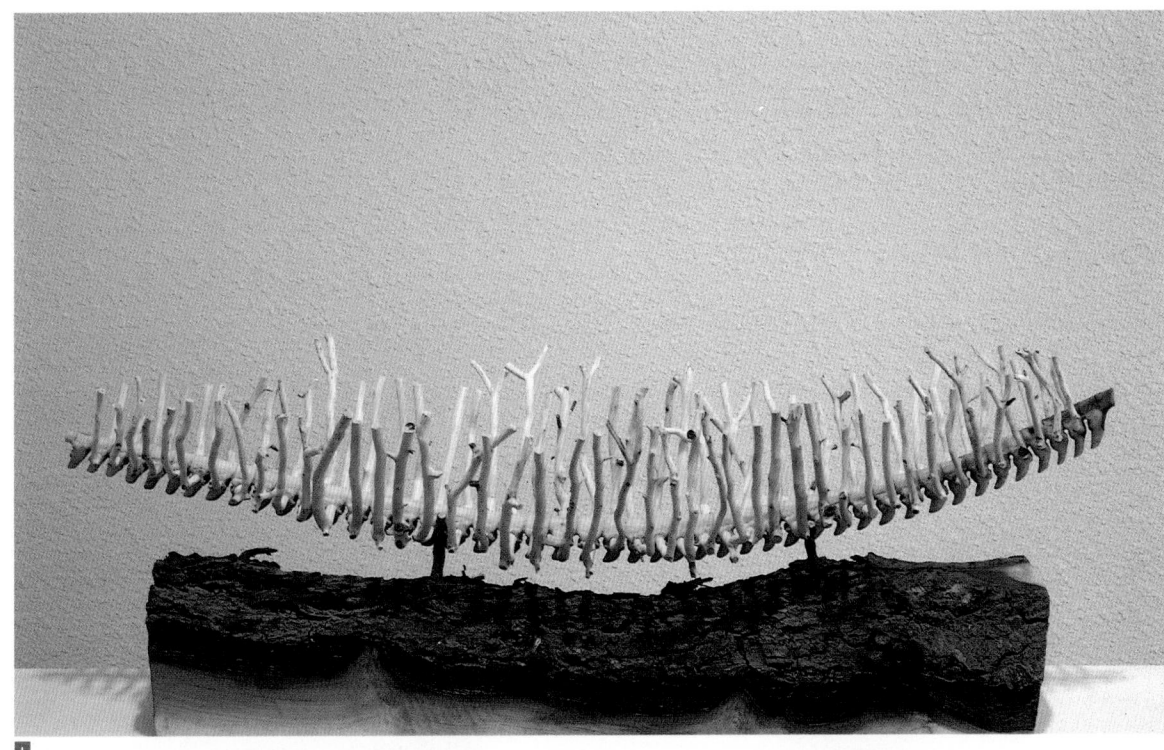

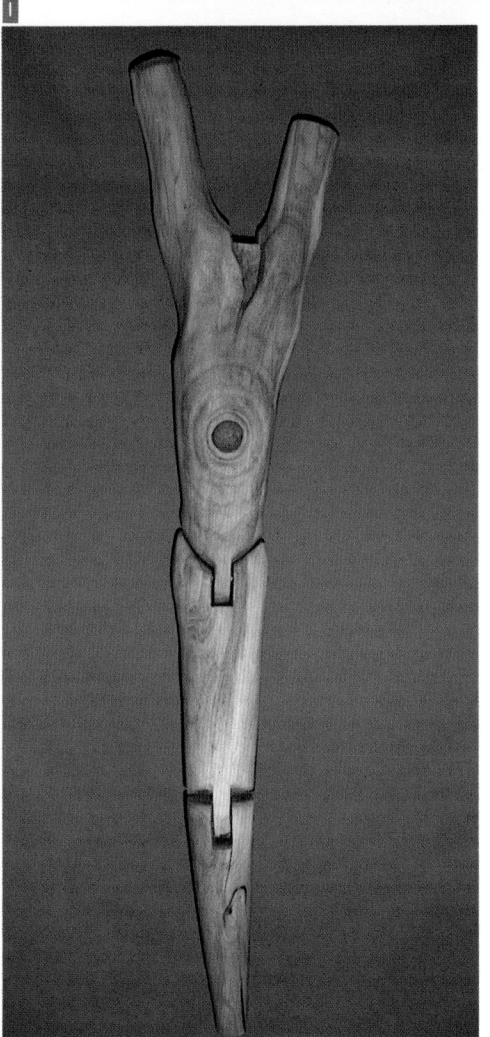

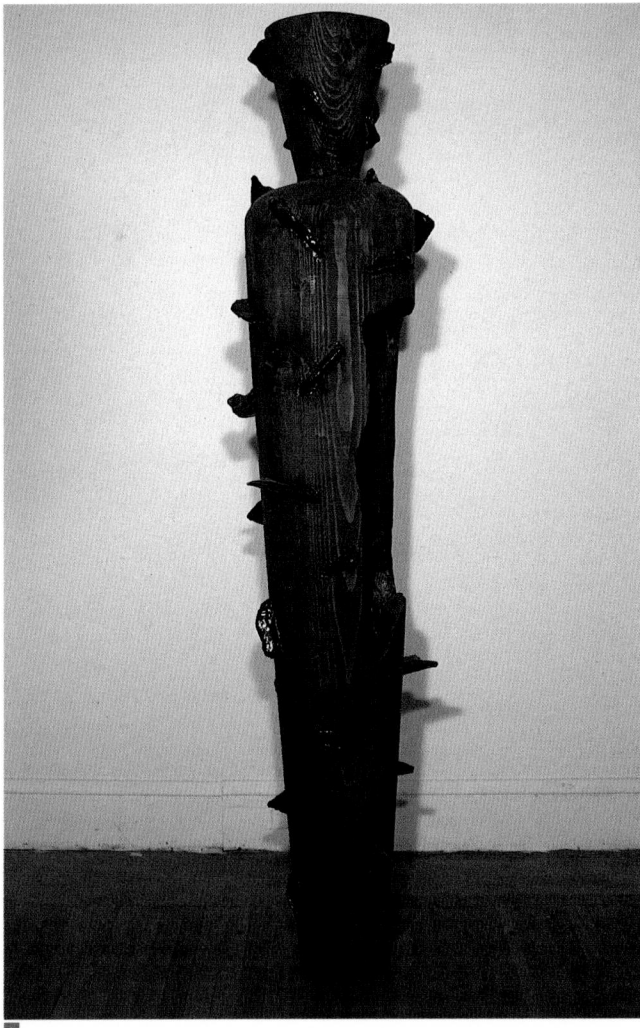

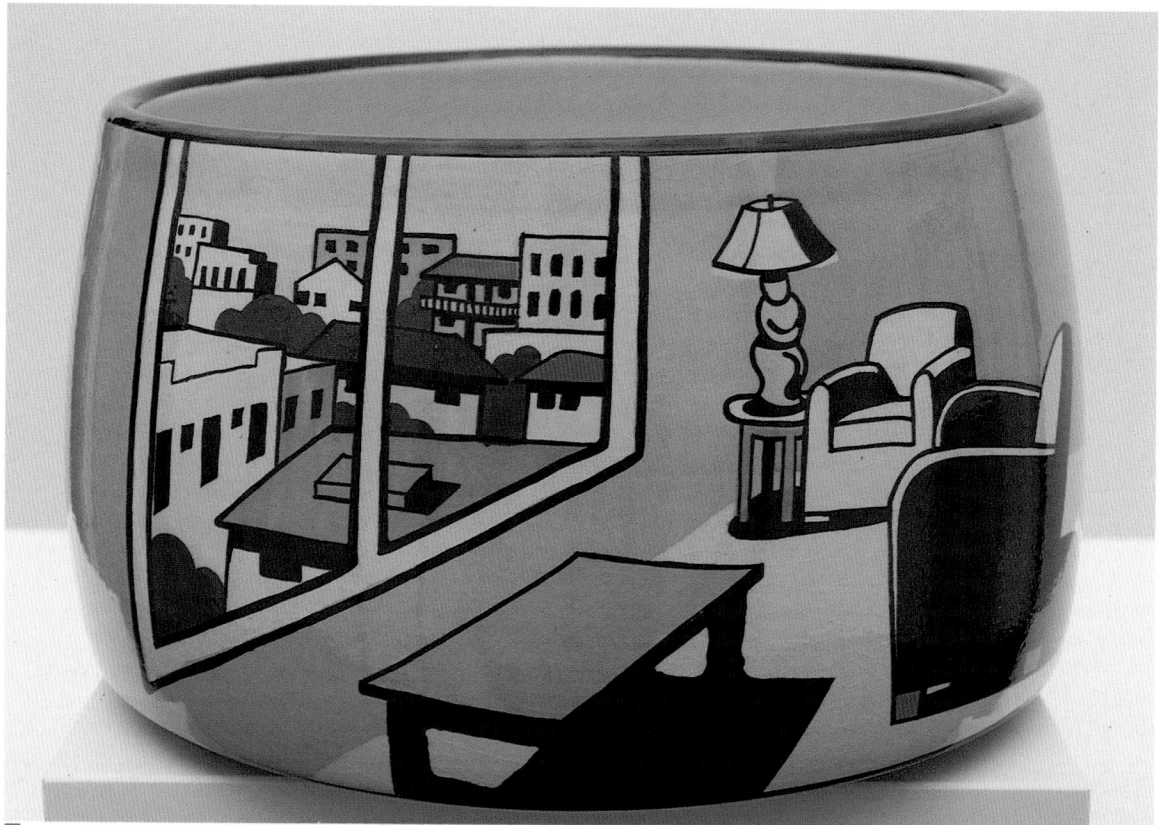

Representation:

**JAMES CORCORAN
GALLERY**

1327 Fifth Street
Santa Monica, CA 90401
213.451.4666
213.451.0950 FAX

Kenneth Price

1. *Untitled*
 1991, Glazed ceramic,
 4 1/8" x 7 1/2"

2. *Untitled*
 1991, Acrylic and colored
 pencil on paper,
 25 1/2" x 35 1/8"

Selected Biography:
1991 Solo show: James
 Corcoran Gallery,
 Santa Monica, CA

Representation:

ART SPACE GALLERY

2100 Spring Street
Philadelphia, PA 19103
215.557.6555
215.557.6586 FAX
Contact:
Carol Heppenstall

Exhibiting:
The Art of Arctic Inuit and
Northwest Coast Indian

David Ruben
Piqtoukun

1. *Seal with Spirit Helper*
 Brazilian soapstone, ivory,
 African wonderstone,
 18.6" x 38.5" x 16.8"
 Photo: Ernest Mayer
 Collection: Winnipeg Art Gallery

Selected Biography:
1991 "Masters of Myth",
 Art Space Gallery,
 Philadelphia; "Masters
 of the Arctic",
 Canadian Embassy,
 Tokyo, Japan
1990 "Inuit Art at the
 McMichael", McMichael
 Canadian Art
 Collection, Kleinburg,
 Canada
1989 "Out of Tradition",
 Winnipeg Art Gallery,
 Winnipeg, Canada

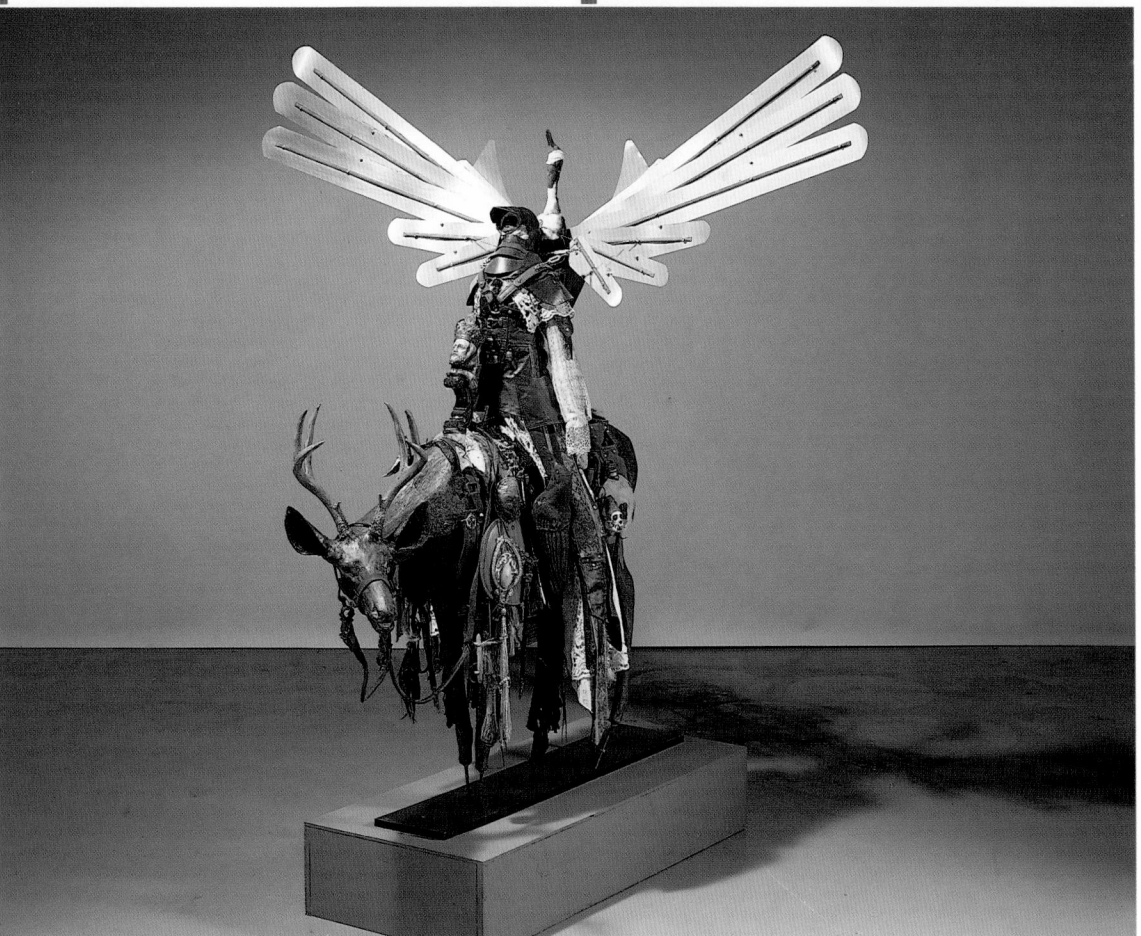

Representation:

SHERRY FRUMKIN GALLERY

1440 Ninth Street
Santa Monica, CA 90401
213.393.1853
213.623.9130 FAX
Contact:
Sherry Frumkin

Exhibiting:
Contemporary painting,
sculpture and assemblage

Ron Pippin

1. *Angel of the Dusk*
 1991, Mixed media
 assemblage,
 5' x 4' x 1.5'

2. *Annunciator II*
 1991, Mixed media
 assemblage,
 6.5' x 3' x 4'

3. *Angel of the*
 Morning Breeze
 1991, Mixed media
 assemblage,
 7' x 6.5' x 5'

Representation:

**RICHARD GRAY
GALLERY**

620 N. Michigan Avenue
Chicago, IL 60611
312.642.8877
312.642.8488 FAX

Contact:
Paul Gray

Exhibiting:
Modern and contemporary
American and European art

Jerry Peart

1. *Splash*
 1986, Painted aluminum,
 21' x 37' x 18'

2. *Japanese Gardener*
 1985, Painted aluminum,
 48" x 22" x 30"

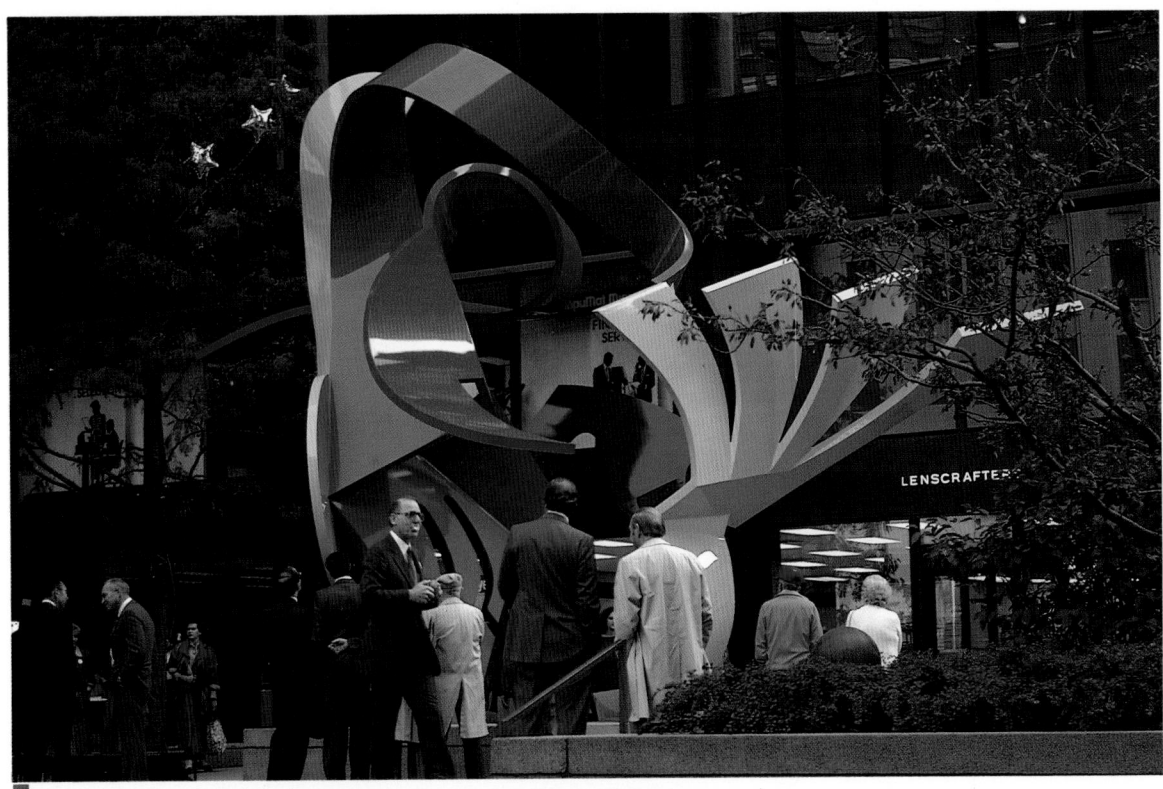

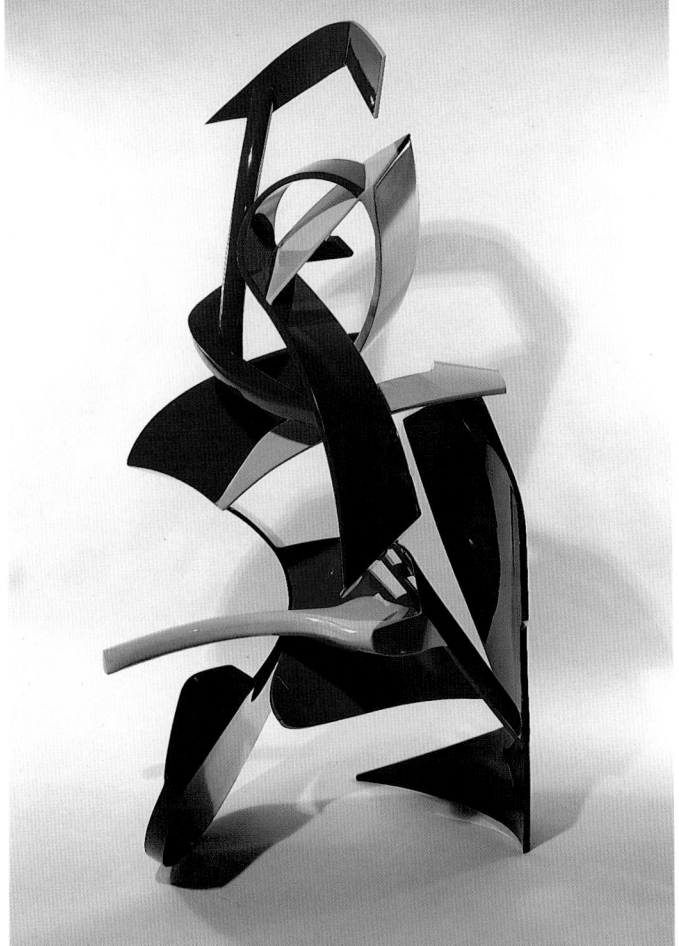

Selected Collections:
 Museum of
 Contemporary Art,
 Chicago

 Virginia Museum of
 Fine Arts, Richmond

 Palms Springs Desert
 Museum, California

 Museum of New
 Mexico, Santa Fe

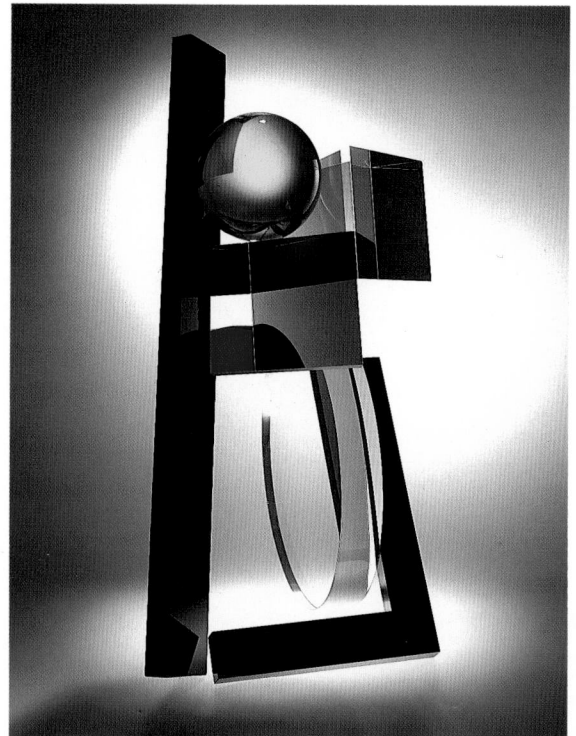

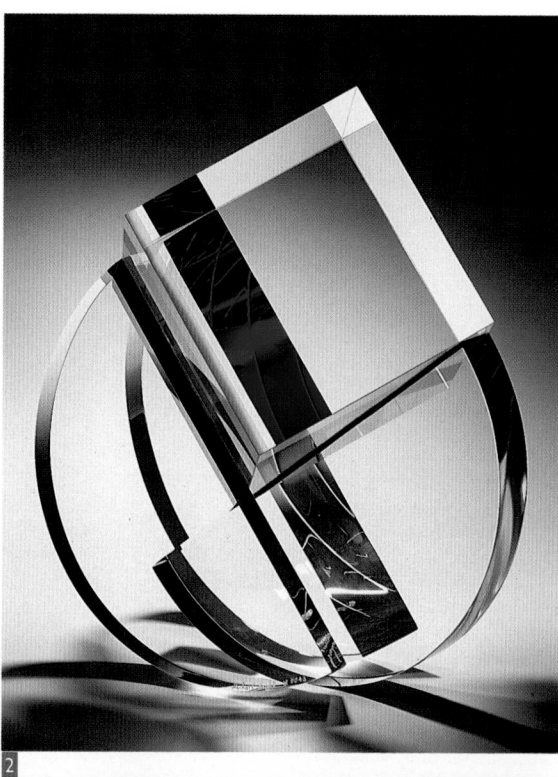

Representation:

HELLER GALLERY

71 Greene Street
New York, NY 10012
212.966.5948
212.966.5956 FAX

HELLER INTERNATIONAL
ART SERVICES
Zahrebska 39, 120 00 Praha 2
Prague, Czechoslovakia
422.25.2057

Exhibiting:
Museum quality
contemporary glass
sculpture

Michael Pavlik

1. *Kunsterstruction*
 1989, Cast and cut
 optical crystal,
 28" x 20" x 18"

2. *Circle and Cube
 Composition*
 1991, Cast and cut
 optical crystal,
 17" x 11" x 15"

3. *Kunsterstruction*
 1989, Cast and cut
 optical crystal,
 26" x 10" x 21"

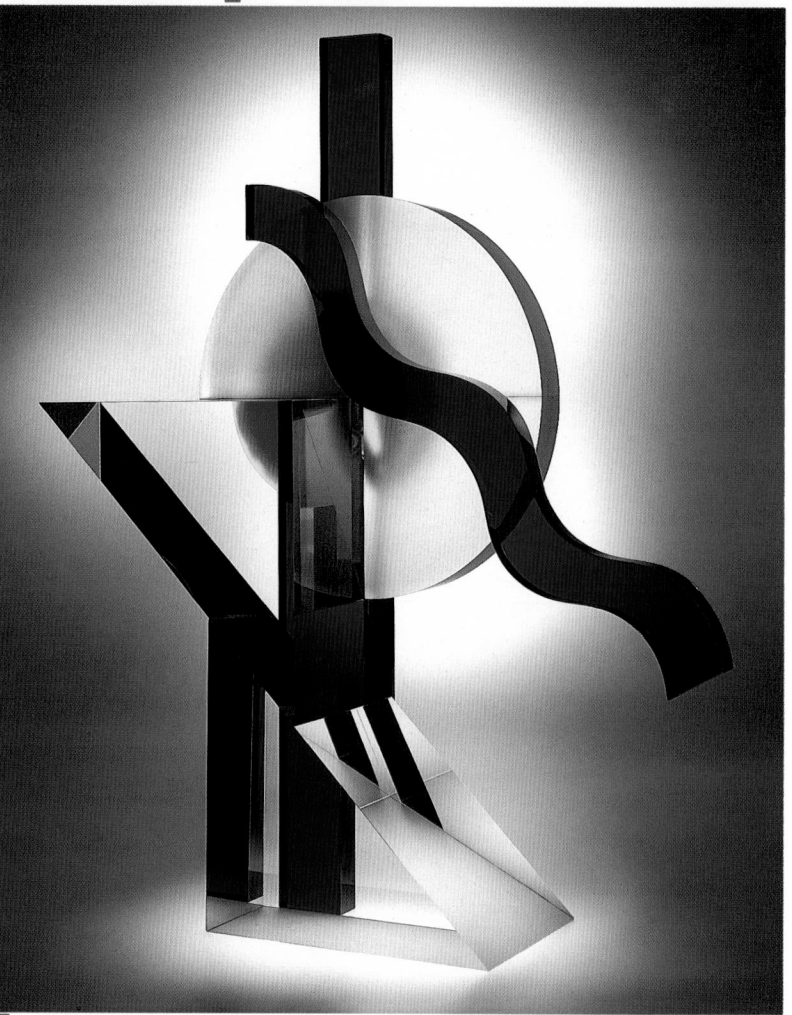

Selected Collections:
Philadelphia Museum of
Art, Pennsylvania;
Cooper-Hewitt
Museum, New York,
NY; The Corning
Museum of Glass,
Corning, NY;
Hessisches
Landesmuseum
Darmstadt, Darmstadt,
Germany; High
Museum of Art,
Atlanta, GA; Hokkaido
Museum of Art,
Sapporo, Japan; Musee
Des Arts Decoratifs,
Lausanne, Switzerland;
Whitney Museum of
Art, New York, NY

ERIC ORR

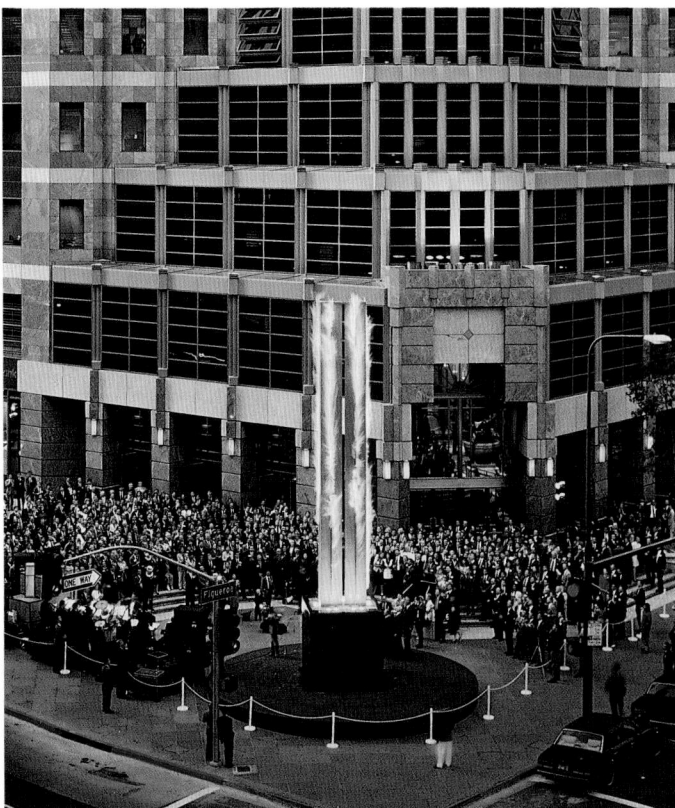

Representation:

THE WORKS GALLERY

Crystal Court/S. Coast Plaza
3333 Bear Street, Third Fl.
Costa Mesa, CA 92626
714.979.6757
714.979.6818 FAX

106 W. Third Street
Long Beach, CA 90802
213.495.2787
213.495.0370 FAX
Contact:
Mark Moore

Exhibiting:
Established and emerging
contemporary artists of
the western United States

Eric Orr

1. *Landmark Lumiere*
 1991, Light sculpture,
 8000'

2. *L.A. Prime Matter*
 1991, Bronze with fire,
 water and light,
 40'

3. *Lee Singularity*
 1989, Slate and water
 in rock garden,
 90" x 11"

Selected Biography:
1992 Group exhibition: "The
 Presence Of Absence",
 The Works Gallery
 South, Costa Mesa, CA
1991 Solo exhibition:
 "Recent Work", The
 Works Gallery South,
 Costa Mesa, CA
1989 Group exhibition:
 "L'Or et son Mythe",
 Grand Palais, Paris
1988 Group exhibition:
 Whitney Museum of
 American Art, New
 York

Representation:

THE PACE GALLERY

32 E. 57th Street
New York, NY 10022
212.421.3292
212.421.0835 FAX

142 Greene Street
New York, NY 10012
212.431.9224
212.431.9280 FAX

Exhibiting:
20th-century paintings,
drawings and sculpture

Claes Oldenberg

1. *Monument to the
 Last Horse*
 1989-90, Steel and
 concrete painted
 with latex,
 31" x 27" x 19 1/2"

Representation:

LEO CASTELLI GALLERY

420 W. Broadway
New York, NY 10012
212.431.5160
212.431.5361 FAX
Contact:
Susan Brundage

Bruce Nauman

1. *Animal Pyramid*
 1989, Foam,
 12' x 7' x 8'

2. *Andrew Head/Julie Head on Wax*
 1989, Castwax,
 14 3/4" x 18 1/4" x 11 3/4"

1

Selected Biography:
1991 Solo exhibitions:
 "Bruce Nauman:
 Prints and Multiples",
 Museum Van
 Hedendaagse Kunst,
 Ghent, Belgium; Daniel
 Weinberg Gallery,
 Santa Monica, CA;
 "The 1991 Biennial
 Exhibition", The
 Whitney Museum of
 Art, New York, NY
1990 Solo exhibition:
 Leo Castelli Gallery,
 New York, NY

2

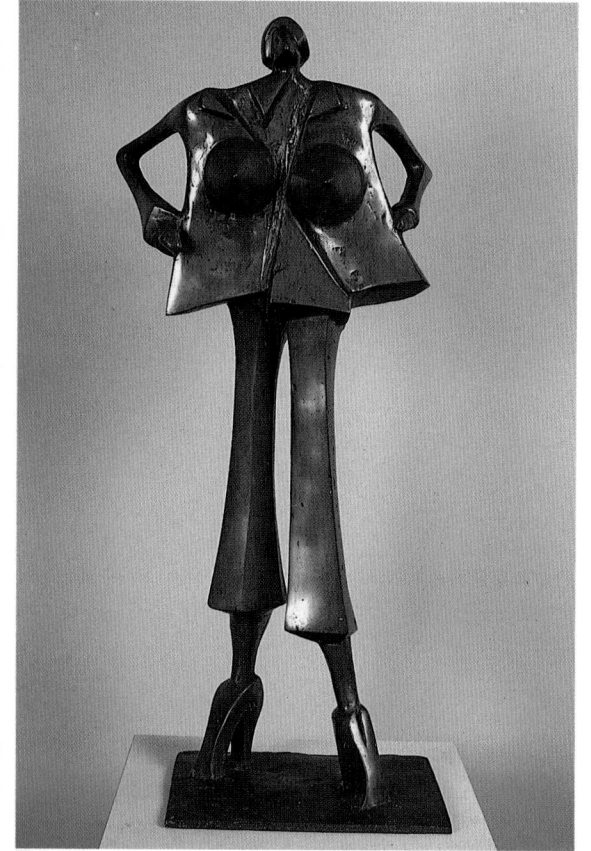

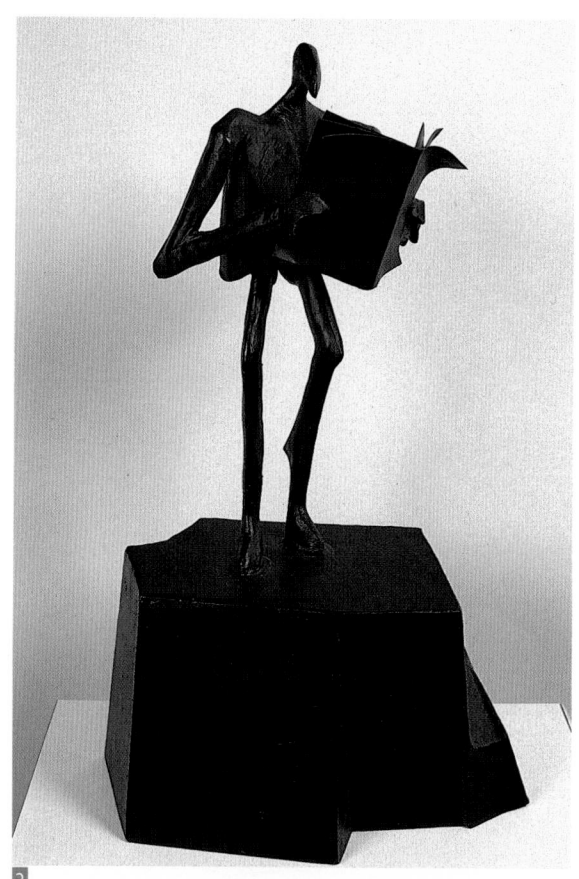

Representation:

DE GRAAF
FINE ART, INC.

9 E. Superior
Chicago, IL 60611
312.951.5180

3400 Avenue of the Arts
Suite C120
Costa Mesa, CA 92626
714.557.5240

Exhibiting:
Contemporary American,
European and Latin
American paintings,
sculpture and graphics

Kurt Laurenz Metzler

1. *Promenade*
 Cast bronze,
 37" x 18" x 10"

2. *Standing Reader*
 Worked steel,
 35" x 20" x 13"

3. *Standing Manhattan*
 Cast bronze,
 29" x 15" x 9 1/2"

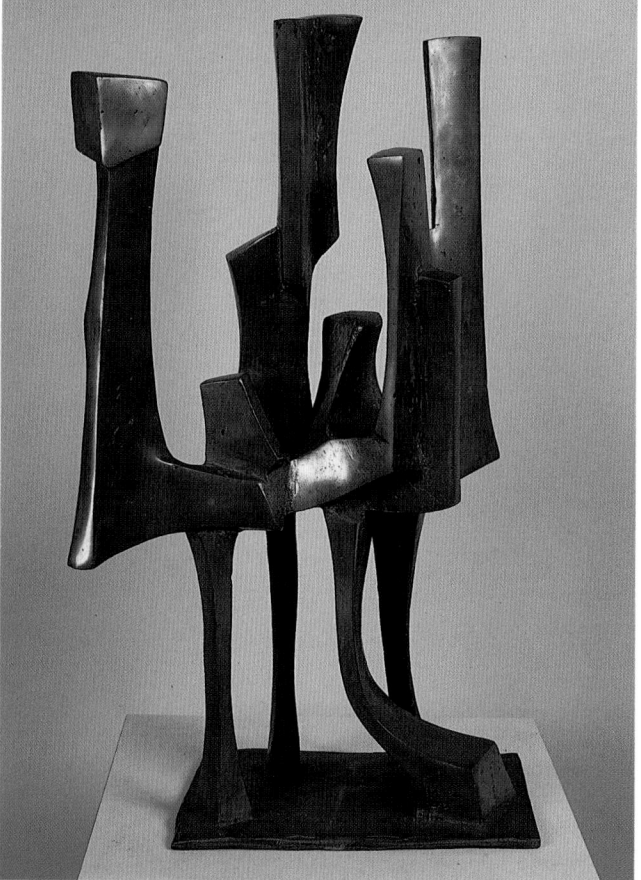

Selected Biography:
1991 Solo exhibitions:
 New York
 Zurich
 Amsterdam
 Stuttgart
 Basel
 Dusseldorf
 Permanent collection:
 Hope College
1941 Born: Switzerland

Representation:

KURLAND/SUMMERS GALLERY

8742-A Melrose Avenue
Los Angeles, CA 90069
213.659.7098
213.659.7263 FAX
Contact:
Ruth T. Summers

Exhibiting:
Contemporary sculptural
glass/decorative arts

Richard Marquis

1. *Installation, Private collection*
 1988, Glass, mixed media,
 6' x 4' x 20"

2. *Bell Jar #15*
 1990, Glass, mixed media,
 17" x 8" d.

3. *Marquiscarpa #14*
 1991, Glass,
 4 1/2" x 7 1/4" x 3 1/4"

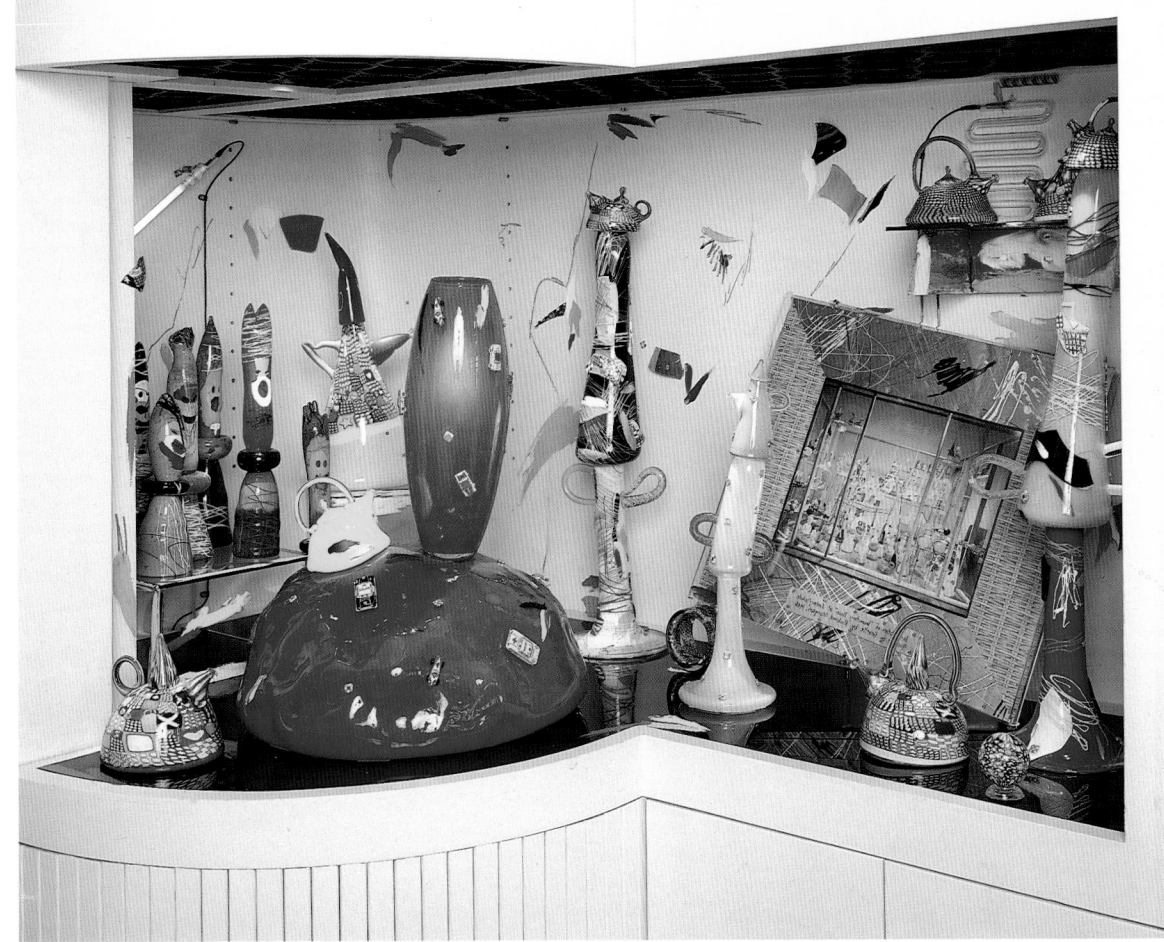

Selected Collections:
 Australian National
 Gallery, Canberra,
 Australia

 Johnson Wax,
 Racine, WI

 New Orleans
 Art Museum,
 New Orleans, LA

 The Detroit Institute
 of Arts, Detroit, MI

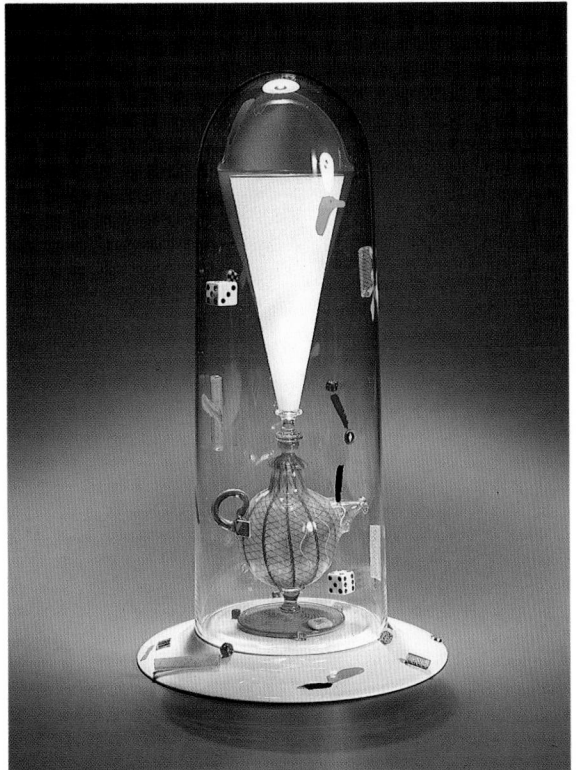

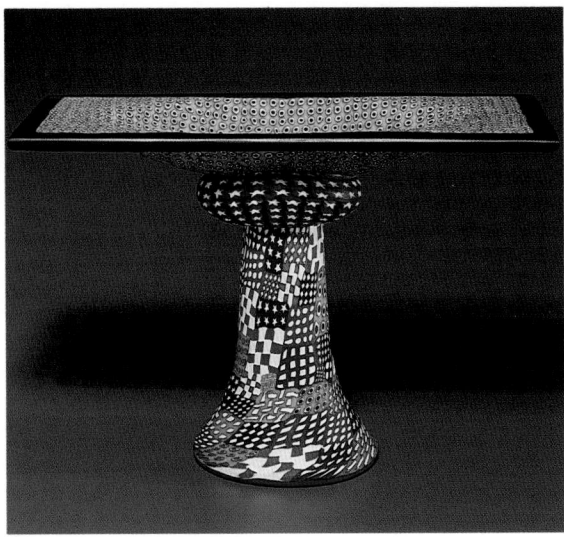

Representation:

ARTYARD

1251A S. Pearl Street
Denver, CO 80210
303.777.3219
303.871.0446 FAX
Contact:
Peggy Mangold

Exhibiting:
Outdoor and indoor
sculpture; Contemporary
American, Spanish, and
Mexican

Robert Mangold

1. *Anemotive Kinetic*
 1989, Painted
 stainless steel,
 19' x 6'6" x 6'6"
 Permanent collection of Hakone
 Open-air Museum, Tokyo, Japan

2. *El Viento Del Rio Mexico*
 1990, Painted steel,
 13'1" x 10'6" x 10'6"

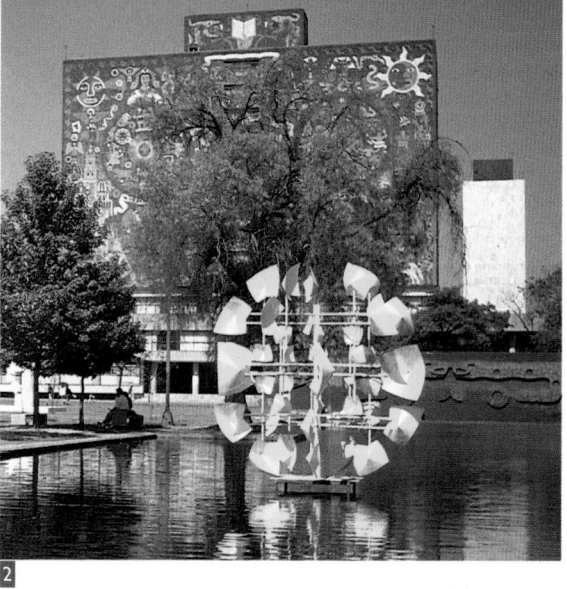

Selected Biography:
1991 Solo exhibition:
 Artyard, Denver, CO
1990 Solo exhibition:
 Expositvm Galleria
 de Arte, Mexico City
1989 6th Henry Moore
 Grand Prix, Hakone
 Open-air Museum,
 Tokyo, Japan

Representation:

CFM GALLERY

138 W. 17th Street
New York, NY 10011
212.929.4001
212.691.5453 FAX

Contact:
Neil P. Zukerman

Exhibiting:
Contemporary European
and American Masters;
Surrealism and
Representational

Richard MacDonald

1. *The Doves (A Ballet)*
 1991, Bronze,
 40" x 22" x 29"

2. *Orpheo*
 1990, Lucite,
 48" x 21" x 21"

3. *Jacque (In The Box)*
 1988, Bronze,
 11" x 13" x 8"

Selected Biography:
1991 Tribute to the Arts
 Monument, Citiarts
 Theatre, Concord,
 California
1989 National Sculpture
 Society Invitational,
 New York
1988 Cinema Architectonica,
 MGM Corporate
 Headquarters, Culver
 City, California
1985 Stephen F. Austin
 Monument, Texas
 Sesquicentennial,
 Austin, Texas

Representation:

KURLAND/SUMMERS GALLERY

8742-A Melrose Avenue
Los Angeles, CA 90069
213.659.7098
213.659.7263 FAX
Contact:
Ruth T. Summers

Exhibiting:
Contemporary sculptural
glass/decorative arts

John Gilbert Luebtow

1. *Sapentia II*
 1990, Stainless steel,
 glass,
 10' x 8' x 3'

2. *LFW4-91/5*
 1991, Glass, metal,
 ceramic,
 50" x 60" x 22"

3. *LWF9-88/7*
 1988, Glass, ceramic,
 72" x 44" x 12"

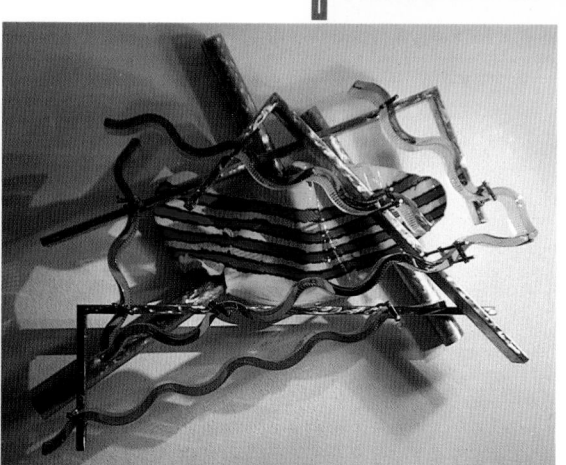

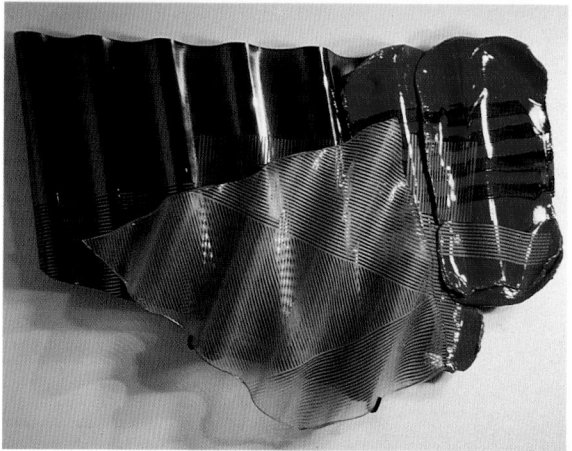

Selected Collections:
 ARCO, Atlantic
 Richfield Corporation,
 Los Angeles, CA

 Carnation Company,
 Glendale, CA

 Rose Hills Memorial
 Park, Whittier, CA

 Barker Patrinely Group,
 San Francisco, CA

Representation:

FAY GOLD GALLERY

247 Buckhead Avenue
Atlanta, GA 30305
404.233.3843
404.365.8633 FAX

Contact:
Fay Gold
Sophia Lyman
Exhibiting:
Modern and contemporary
art and photography

Michael Lucero

1. *Man with a Flat Top
 (Pre-Columbus)-Front View*
 1991, Ceramic with glazes,
 19" x 9" x 8 1/2"

1. *Man with a Flat Top
 (Pre-Columbus)-Back View*
 1991, Ceramic with glazes,
 19" x 9" x 8 1/2"

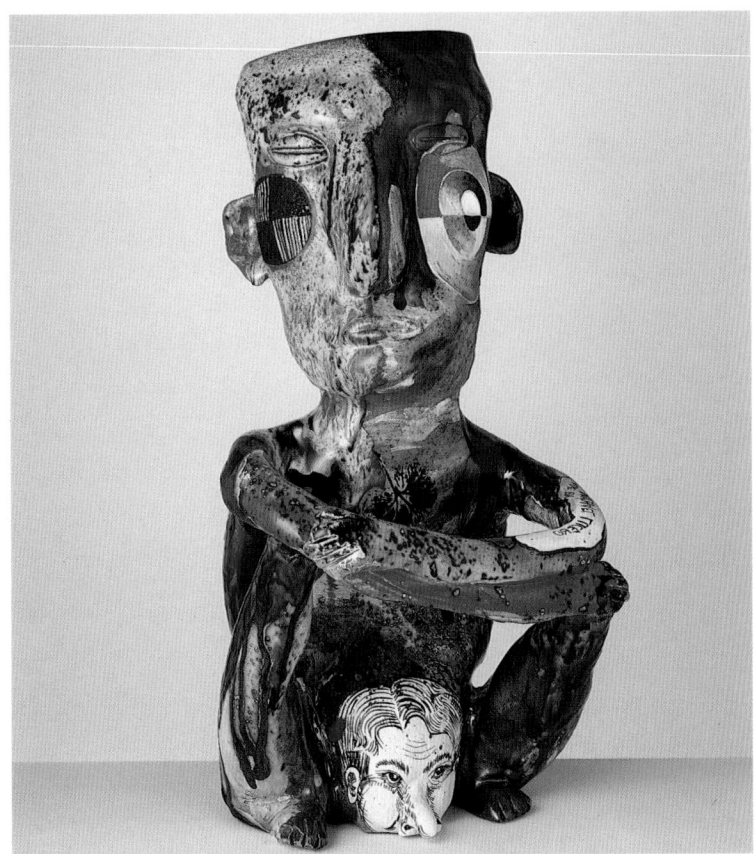

Selected Biography:
1991 Fay Gold Gallery,
 Atlanta, GA;
 Dorothy Weiss,
 San Francisco, CA

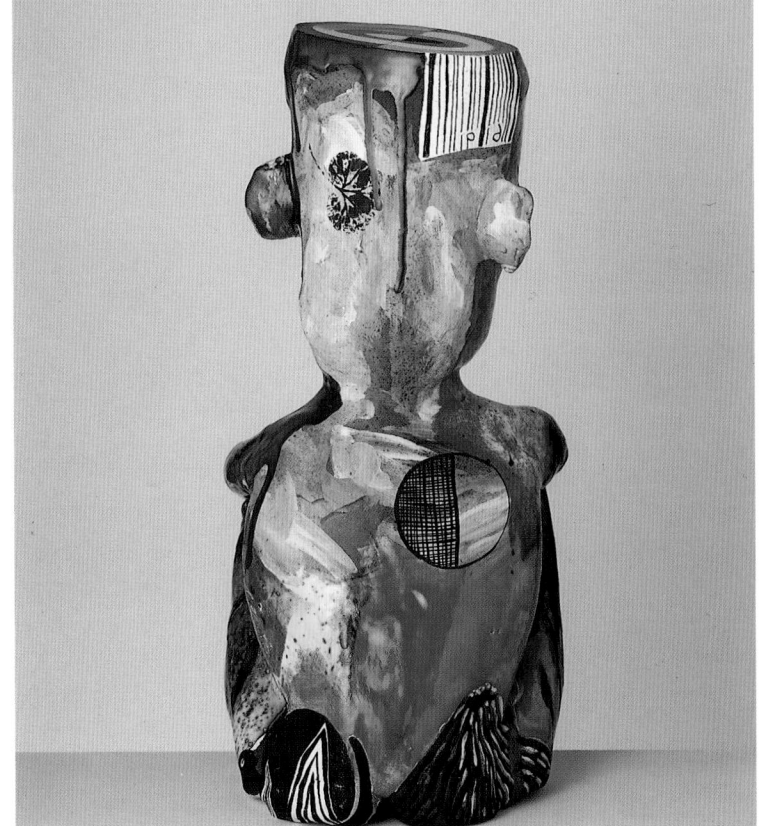

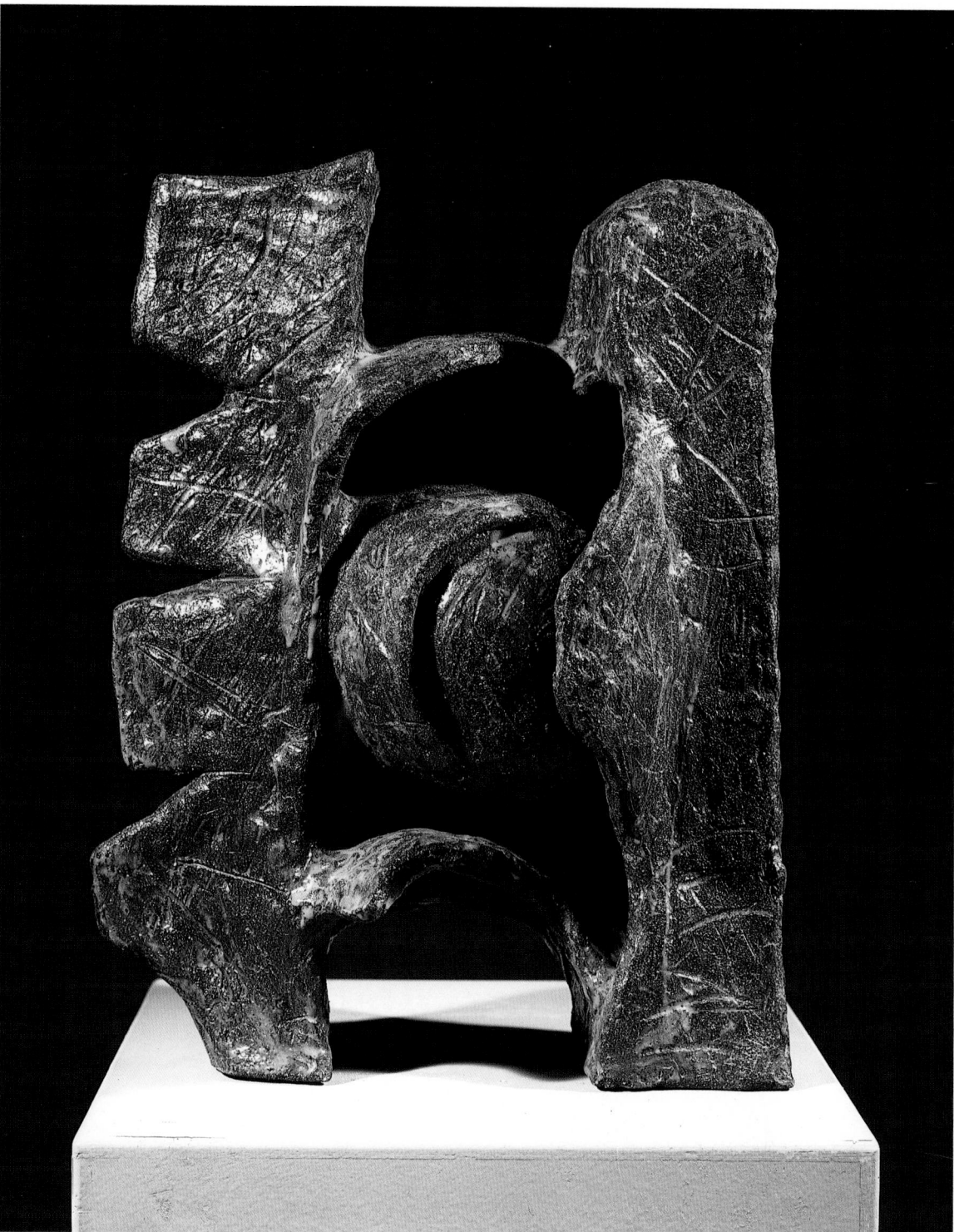

Representation:

BABCOCK GALLERIES

724 Fifth Avenue
New York, NY 10019
212.767.1852
212.767.1857 FAX

Contact:
Dr. John Driscoll
Michael St. Clair
Exhibiting:
Fine American paintings,
sculpture, works on paper;
Historical and contemporary

Seymour Lipton

1. *Gateway*
 1964, Glazed and fired clay,
 14"h.

Representation:

KURLAND/SUMMERS GALLERY

8742-A Melrose Avenue
Los Angeles, CA 90069
213.659.7098
213.659.7263 FAX

Contact:
Ruth T. Summers

Exhibiting:
Contemporary sculptural
glass/decorative arts

Steve Linn

1. *Passionaria*
 1991, Cast bronze,
 wood, glass,
 46" x 34 1/2" x 12 1/2 d.

2. *Passionaria (Open View)*
 1991, Cast bronze,
 wood, glass,
 46" x 34 1/2" x 12 1/2" d.

3. *Fools Crow*
 1990, Cast bronze, glass,
 mixed media,
 96" x 96" x 34" d.

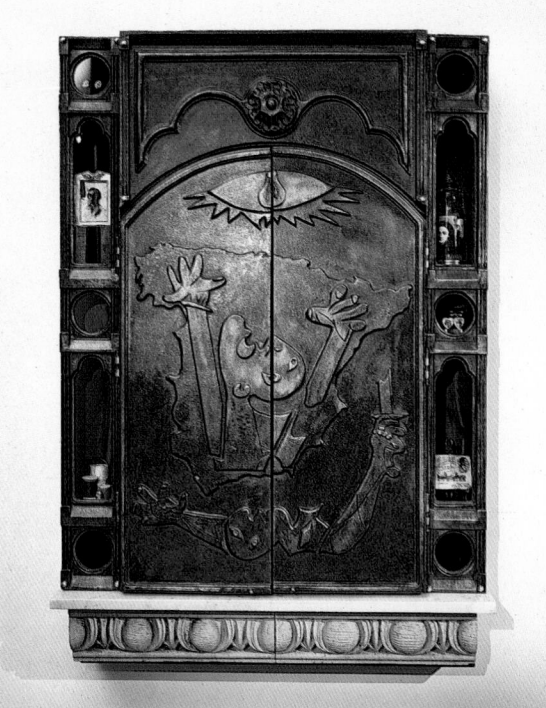
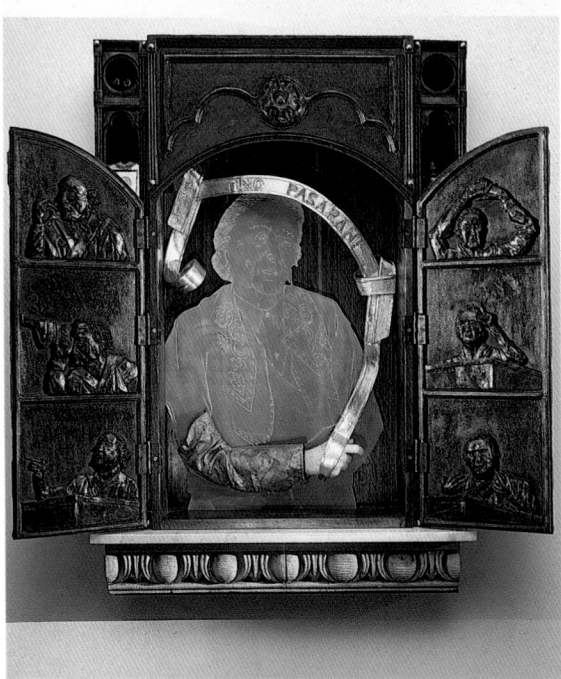

Selected Commissions:

1991 One Colorado Plaza,
The Stitzel Company,
Colorado and Fair
Oaks Avenue,
Pasadena, CA;
Nassau West
Corporate Center,
Reckson Associates,
Mitchell Field,
Long Island, NY

1989 Craft and Folk Art
Museum, Los Angeles,
CA

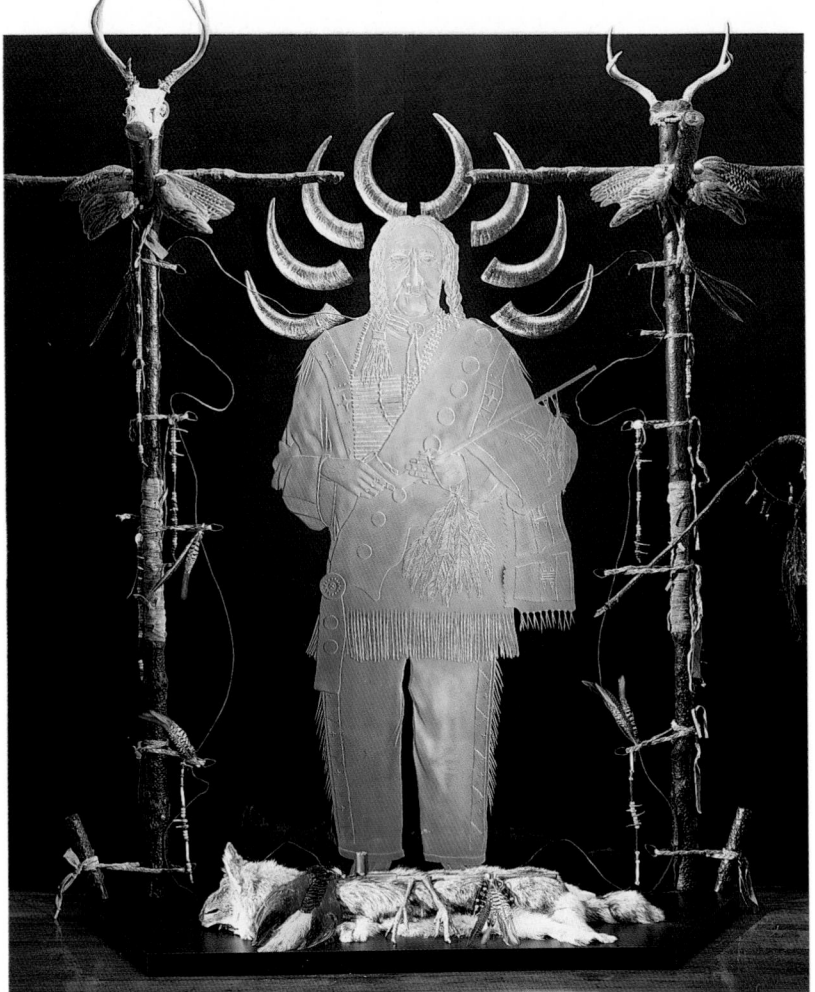

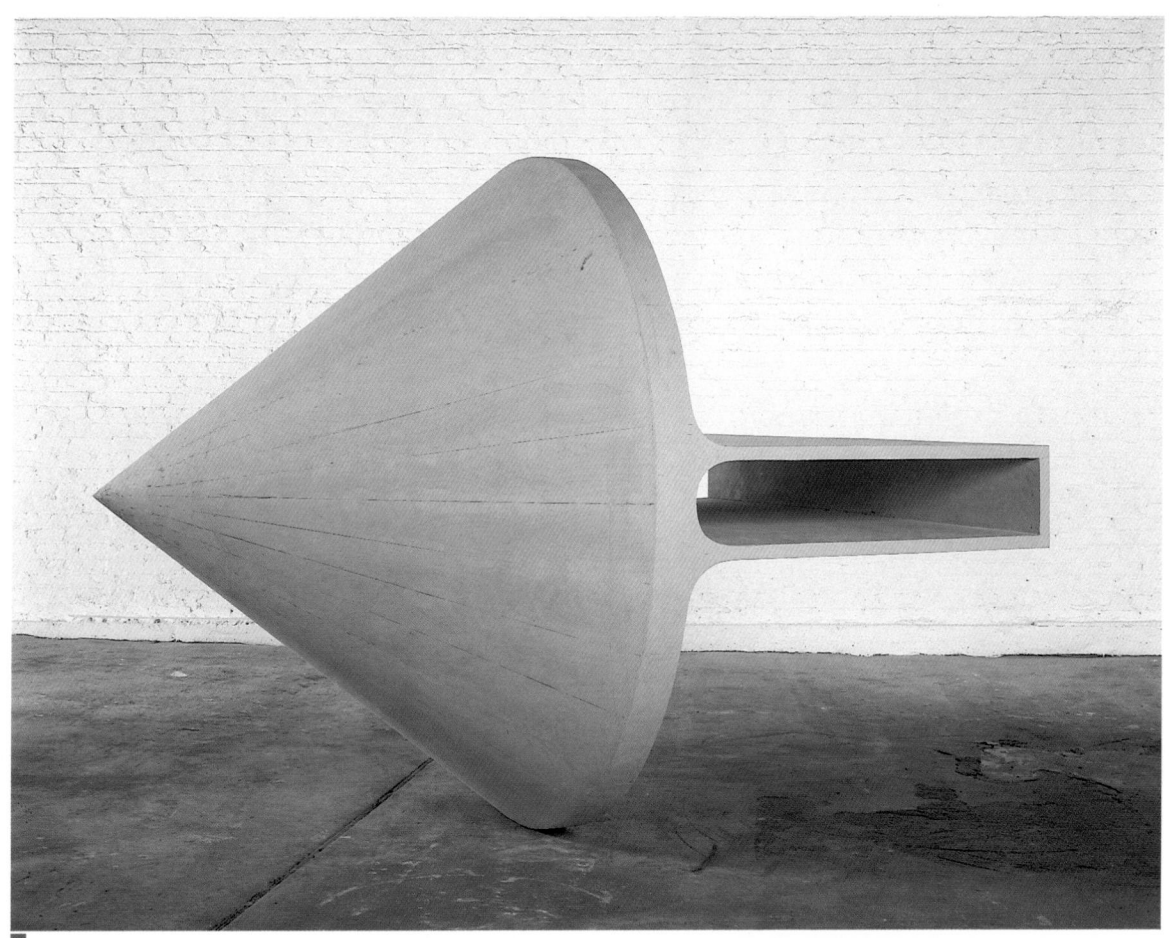

Representation:

**DIANE BROWN
GALLERY**

23 Watts Street
New York, NY 10013
212.219.1060
212.966.3687 FAX
Contact:
Diane Brown

Exhibiting:
Contemporary art with an
emphasis on sculpture

Erik Levine

1. *Untitled*
 1990, Plywood,
 72" x 72" x 94"
 Collection: Hirshhorn Museum,
 Sculpture Garden

Selected Biography:
1991 Solo exhibition:
 Georges-Phillipe
 Vallois, Paris
1990 Solo exhibitions:
 Diane Brown Gallery,
 New York; Meyers
 Bloom Gallery,
 Santa Monica, CA
1989 Solo exhibitions:
 The Louisiana Museum
 of Modern Art,
 Humlebaek, Denmark;
 Halle Sud, Geneva;
 Fundacio Joan Miro,
 Barcelona; Biennial
 Exhibition, Whitney
 Museum of American
 Art, New York

Representation:

MARGO LEAVIN GALLERY

812 N. Robertson Boulevard
Los Angeles, CA 90069
213.273.0603
213.273.9131 FAX

Contact:
Margo Leavin
Wendy Brandow
Exhibiting:
Contemporary art from
Europe and America

Mark Lere

1. *Earth as Single Organism*
 1990, Fiberglass,
 40" x 43" x 46 1/2"

2. *Revolver*
 1989, Rubber over wood,
 53" x 15 1/2" x 50

3. *Toll*
 1990, Cast aluminum,
 92" x 11 1/2" x 11 1/2"

Selected Biography:
1991 "Individual Realities",
 Sezon Museum, Tokyo;
 "Big Objects", Tacoma
 Art Museum, WA;
 "Contemporary
 Bronze", Atlanta
 College of Art, GA
1990 "Mark Lere: New
 Sculpture", Margo
 Leavin Gallery

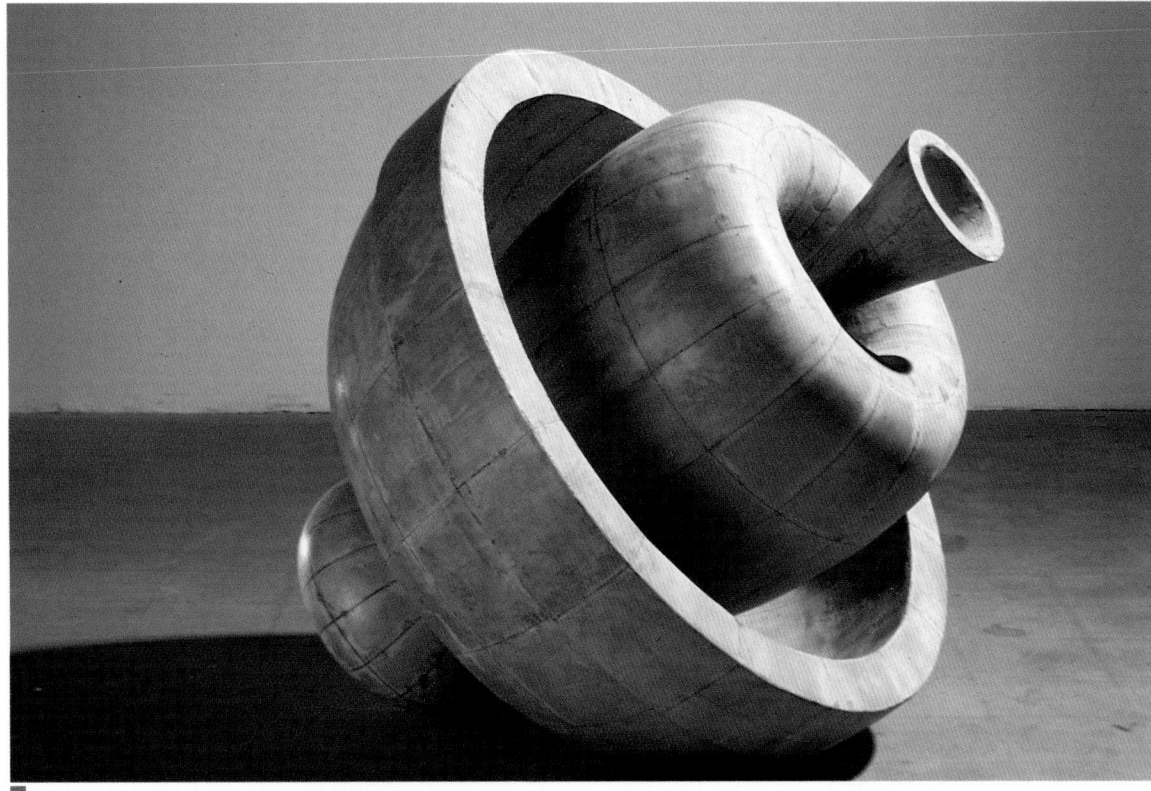

1

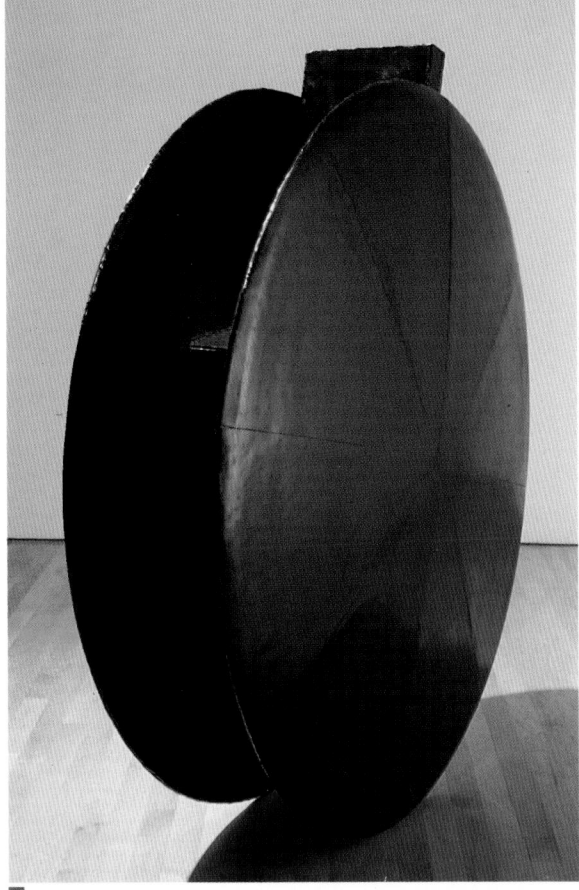

2

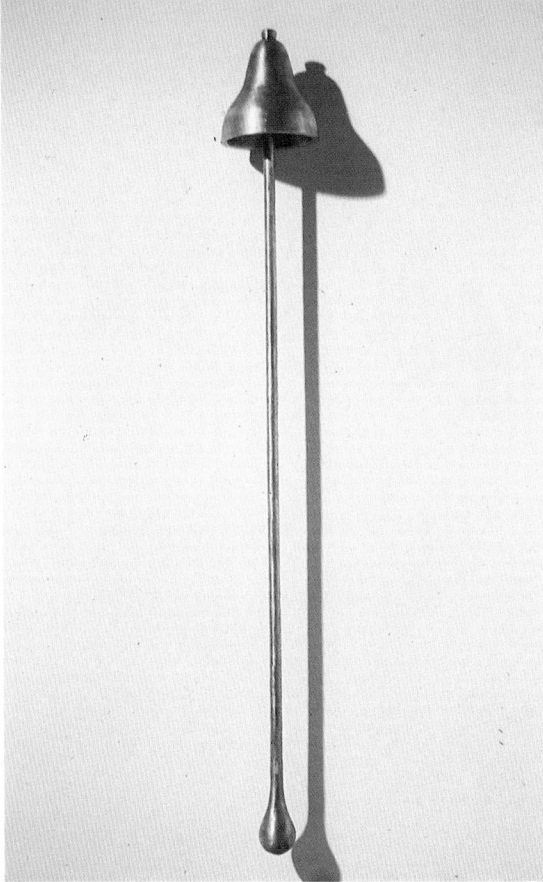

3

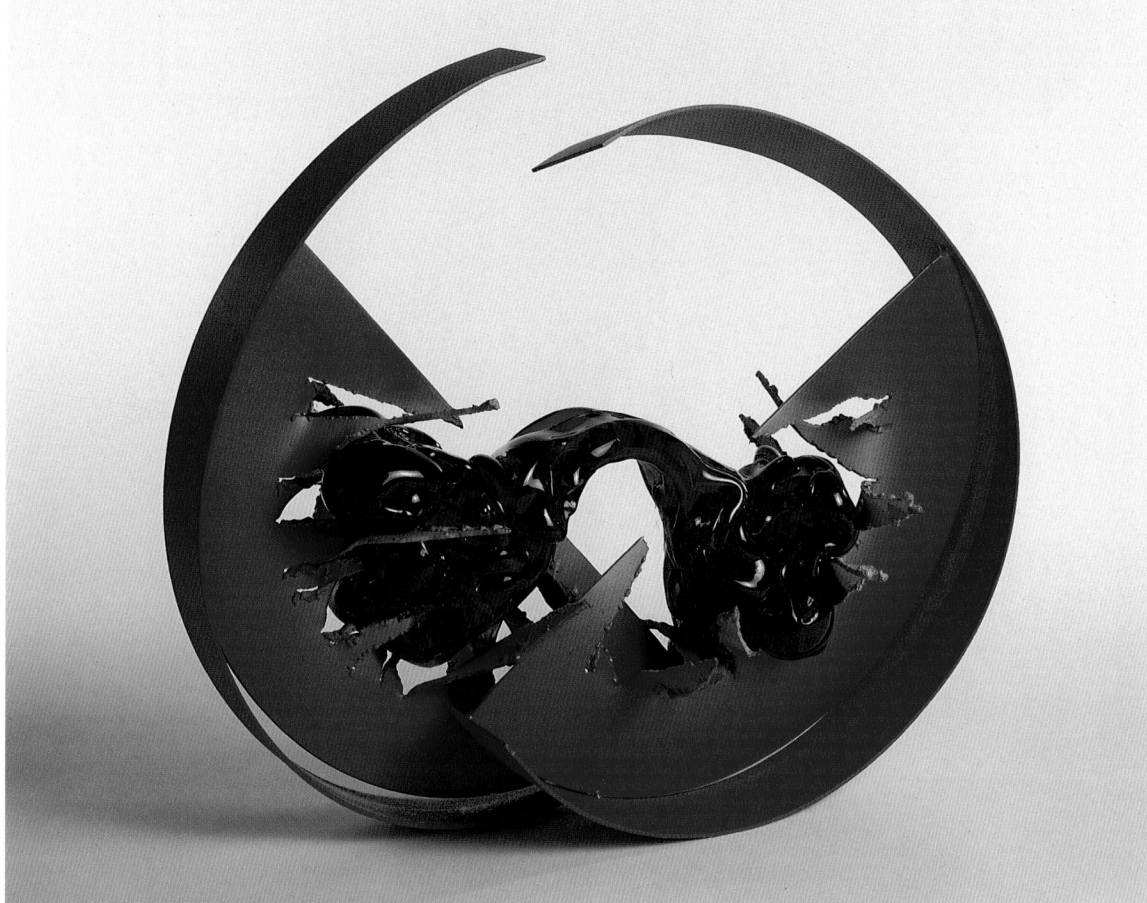

1

Representation:

ELEONORE AUSTERER GALLERY

540 Sutter Street
San Francisco, CA 94102
415.986.2244
415.986.2281 FAX
Contact:
Eleonore Austerer

Exhibiting:
Contemporary American
and European art

Roberto Lauro

1. *Parting of the Soul*
 1990, Painted
 iron and glass,
 20" x 21"

2. *Spirit of Light*
 1991, Painted
 iron and glass,
 23" x 27 1/2"

3. *Red Orchid*
 1991, Painted
 iron and glass,
 65 3/8" x 35 4/8" d.

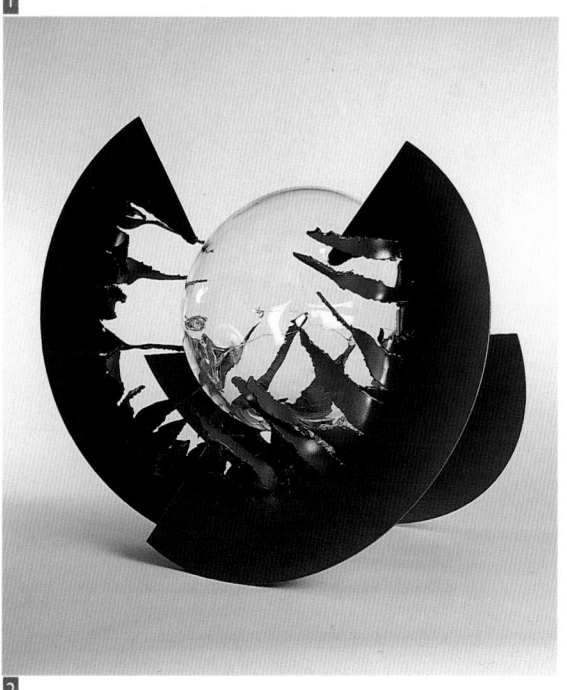

2

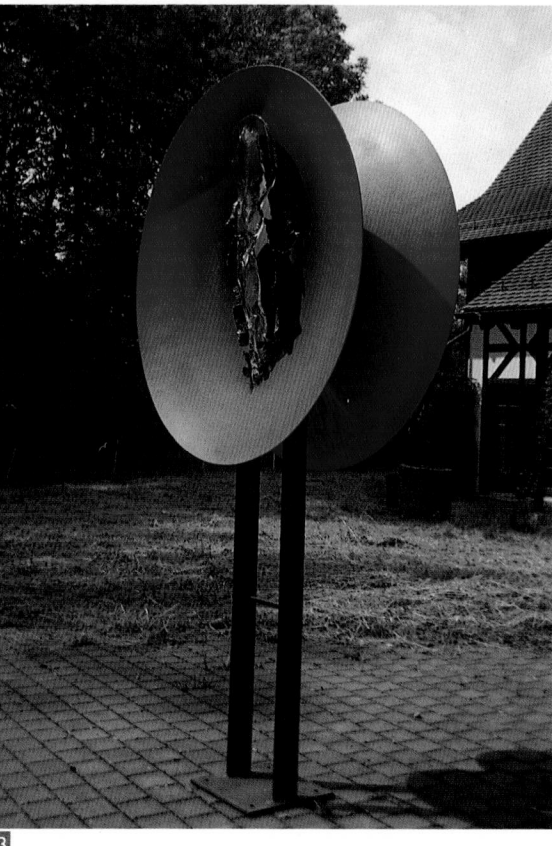

3

Selected Biography:
1991 Cemetery Weiningen,
Switzerland, large
outdoor metal & glass
sculpture commission
for church entrance
1990 Solo exhibition:
Eleonore Austerer
Gallery, San Francisco,
Co-sponsor Consulate
General of Switzerland;
Golfcourse Schladming,
Austria, monumental
outdoor sculpture
1989 Exhibition: Villa Sassa,
Lugano, Switzerland

Representation:

SPACE GALLERY

6015 Santa Monica Boulevard
Los Angeles, CA 90038
213.461.8166

Contact:
Edward Den Lau

Exhibiting:
Contemporary paintings,
drawings and sculpture

Seiji Kunishima

1. *Untitled 87-23*
 1987, Black granite/bronze,
 9.5" X 27.5" X 23.25"

2. *Untitled 86-35*
 1986, Black granite,
 26.5" X 24.75" X 17"

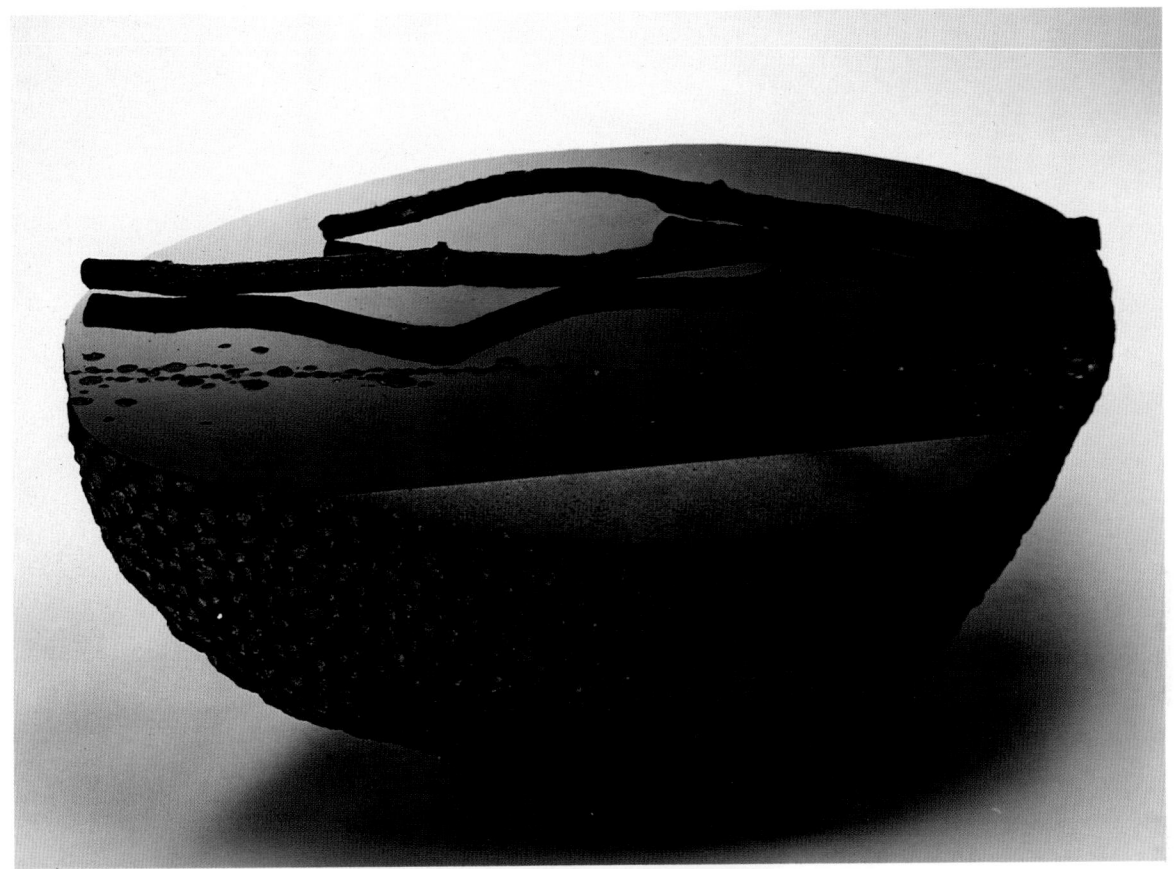

Selected Biography:
1991 Solo shows: Space
 Gallery, Los Angeles;
 Sakura Gallery,
 Nagoya, Japan
1990 Solo show: National
 Gallery, Bangkok,
 Thailand
1987 Solo show: Victorian
 College of Art,
 Melbourne, Australia
1986 Solo show: Grand
 Rapids Art Museum,
 Grand Rapids, MI

Representation:

ELAINE HORWITCH GALLERIES

4211 N. Marshall Way
Scottsdale, AZ 85251
602.945.0791
602.994.5568 FAX

129 W. Palace Avenue
Santa Fe, NM 87501
505.988.8997
505.989.8702 FAX

Contact:
Elaine Horwitch

Exhibiting:
Contemporary American
and Southwest paintings
and sculpture

David Kraisler

1. *Architype L*
 1991, Ferro cement with
 fresco on steel and
 concrete bases,
 12' h.

Selected Biography:
1991 "Architype L":
Commissioned by
Mr. and Mrs. David
Lieberman, Minneapolis,
MN, for private
collection

Mel Katz

1. *Four Poster*
 1990, Plastic laminate,
 vinyl/wood,
 89 1/2" x 44 1/4" x
 32 1/2"

2. *Shale*
 1991, Plastic laminate,
 vinyl/wood,
 96" x 46" x 31 1/2"

3. *Confetti, Stripes And
 Aluminum, Too*
 1991, Plastic laminate,
 vinyl/wood,
 96" x 46" x 31 1/2"

Selected Biography:
1991 Solo exhibition:
 Laura Russo Gallery,
 Portland, OR
1990 Invitational:
 Seattle Art Museum,
 Seattle, WA
1988 Retrospective:
 Portland Art Museum,
 Portland, OR
1987 Invitationals:
 Seattle Art Museum,
 Seattle, WA; Portland
 Center for the Visual
 Arts, Portland, OR

1

2

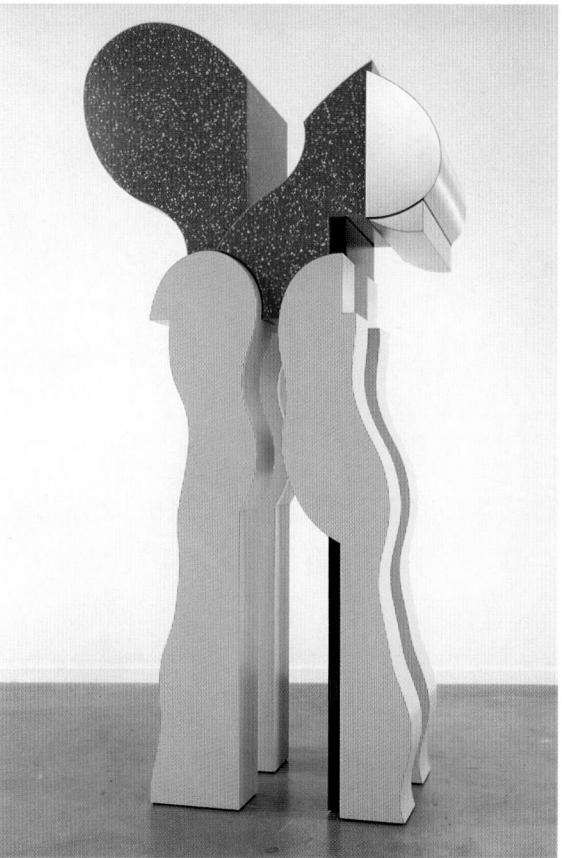

3

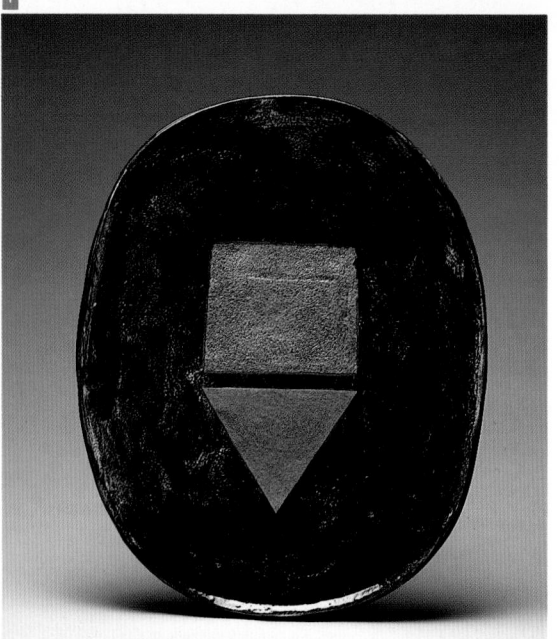

1

Representation:

DOROTHY WEISS GALLERY

256 Sutter Street
San Francisco, CA 94108
415.397.3611
415.397.2141 FAX
Contact:
Dorothy Weiss

Exhibiting:
Contemporary ceramic and
glass sculpture

Jun Kaneko

1. *Dango*
 1990, Ceramic,
 46" x 51" x 42"

2. *Plate*
 1990, Ceramic,
 28" x 22" x 3 3/4"

3. *Installation View*
 1990, Ceramic,
 17' x 34'

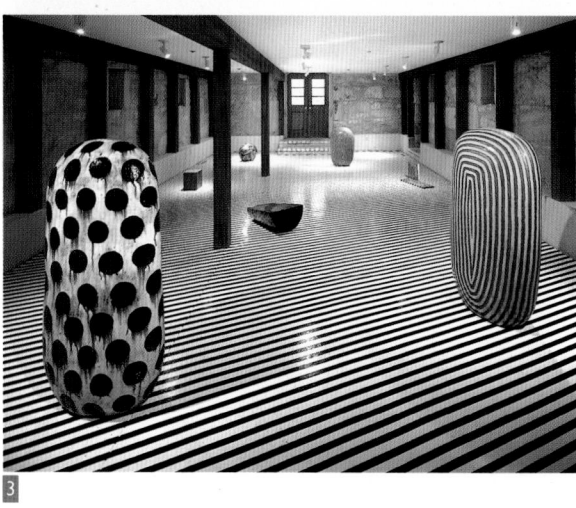

3

2

Selected Collections:
Philadelphia Museum of
Art, Philadelphia, PA;
Everson Museum of
Art, Syracuse, NY;
American Craft
Museum, New York,
NY;
Yamaguchi Prefectural
Museum of Art,
Yamaguchi, Japan;
Contemporary
Museum of Art,
Honolulu, HI;
Sheldon Memorial Art
Gallery, Lincoln, NE
Detroit Institute of Art,
Detroit, MI

Representation:

THE PACE GALLERY

32 E. 57th Street
New York, NY 10022
212.421.3292
212.421.0835 FAX

142 Greene Street
New York, NY 10012
212.431.9224
212.431.9280 FAX

Exhibiting:
20th-century paintings,
drawings and sculpture

Donald Judd

1. *Untitled*
 1990, Orange
 anodized aluminum
 with clear plexiglas,
 10 units, each
 6 1/8" x 27" x 24"

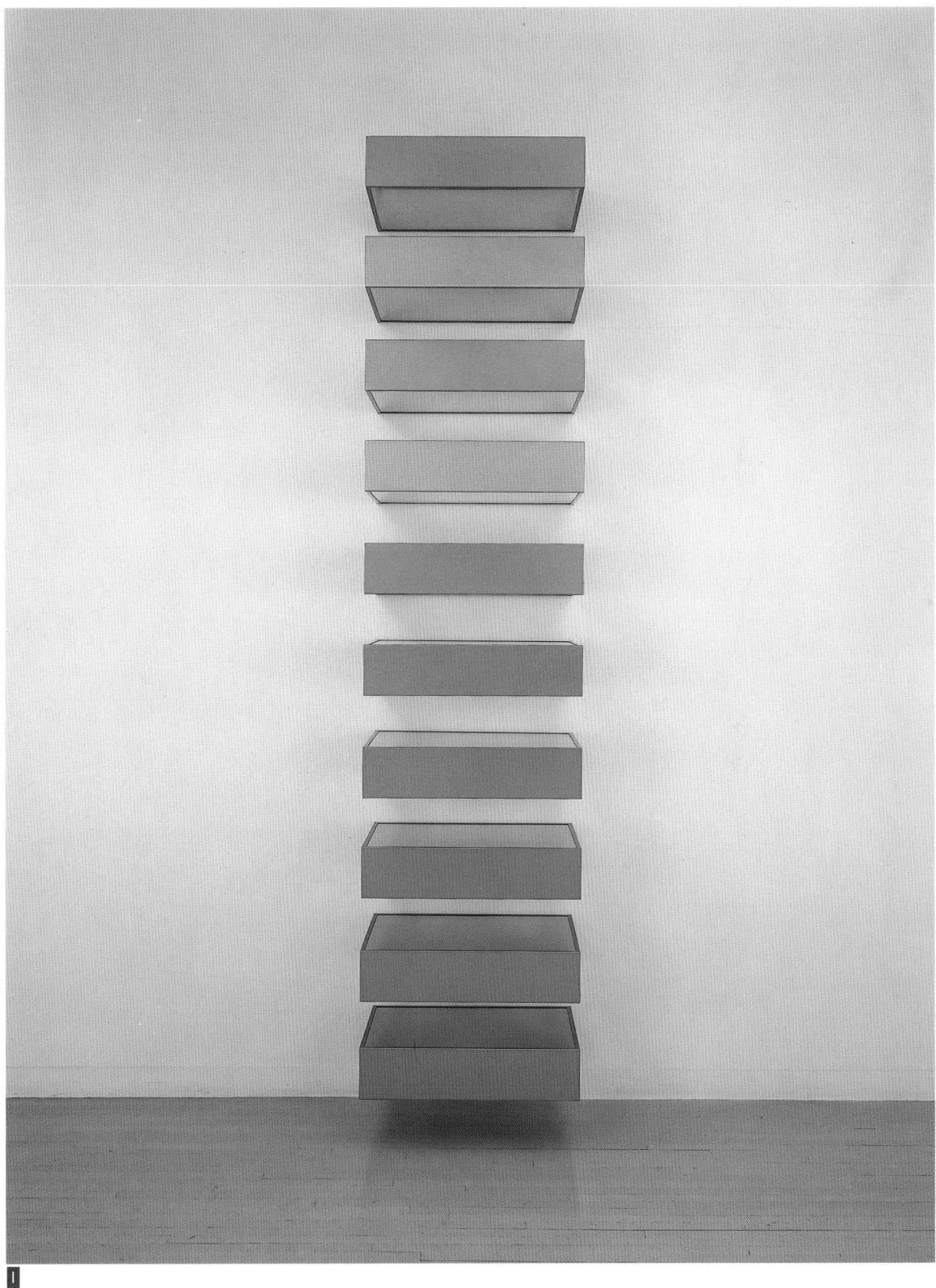

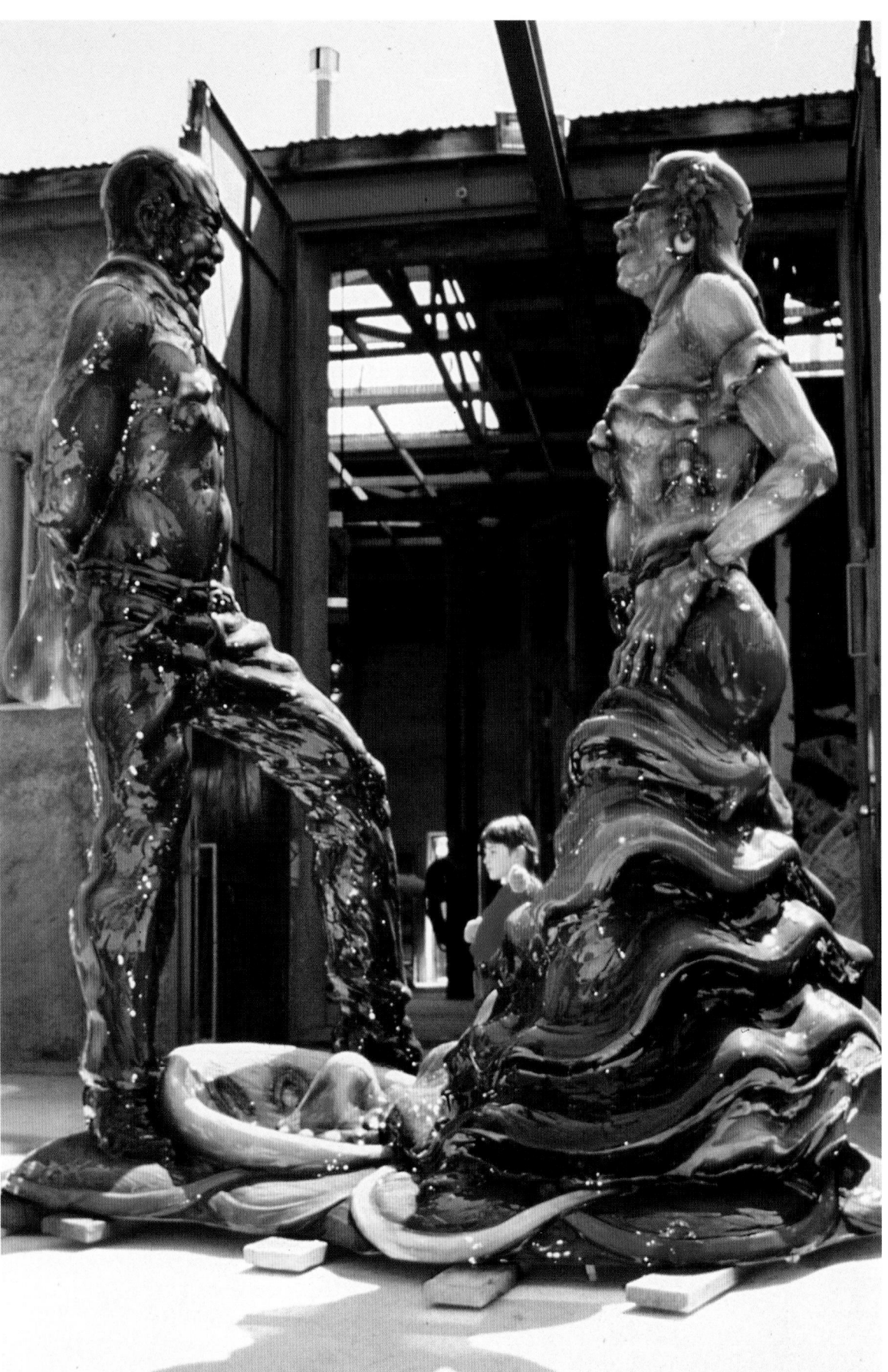

Representation:

LEWALLEN GALLERY

225 Galisteo
Santa Fe, NM 87501
505.988.5387

Contact:
Geoffrey Gorman

Exhibiting:
Exhibiting contemporary
American art

Luis Jimenez

1. *Fiesta Dancers*
 1991, Fiberglass,
 9'6" x 8' x 4'11"

Selected Biography:
1992 Solo exhibition:
 Albuquerque Museum
 Retrospect Show
1991 Group exhibition:
 Whitney Museum, NY,
 1991 Biennial Exhibiiton
1990 Group exhibitions;
 Museum of
 Contemporary Hispanic
 Art, The New Museum
 of Contemporary Art
 and The Studio Museum
 in Harlem, NY,
 "The Decade Show"
1988 Group exhibition:
 The Hirshhorn Museum
 and Sculpture Garden,
 Smithsonian Institution,
 Washington, DC

Representation:

DE GRAAF
FINE ART, INC.

9 E. Superior
Chicago, IL 60611
312.951.5180

3400 Avenue of the Arts
Suite C120
Costa Mesa, CA 92626
714.557.5240

Exhibiting:
Contemporary American,
European and Latin
American paintings,
sculpture and graphics

Jim Jenkins

1. *Seismophobic*
 Mixed media, motors,
 24" x 24" x 7"

2. *A Span of Consequence*
 Mixed media, motors,
 24" x 23" x 10"

3. *Time As An Ememy*
 Mixed media, motors,
 22" x 30" x 8"

Selected Biography:
1991 De Graaf Fine Art, Inc.,
 Chicago, IL
1990 Cerro Coso College,
 Ridgecrest, CA
1989 Koslow Gallery,
 Los Angeles, CA
1983 Lambert-Miller Gallery,
 Phoenix, AZ
1982 Museum of Neon Art,
 Los Angeles, CA

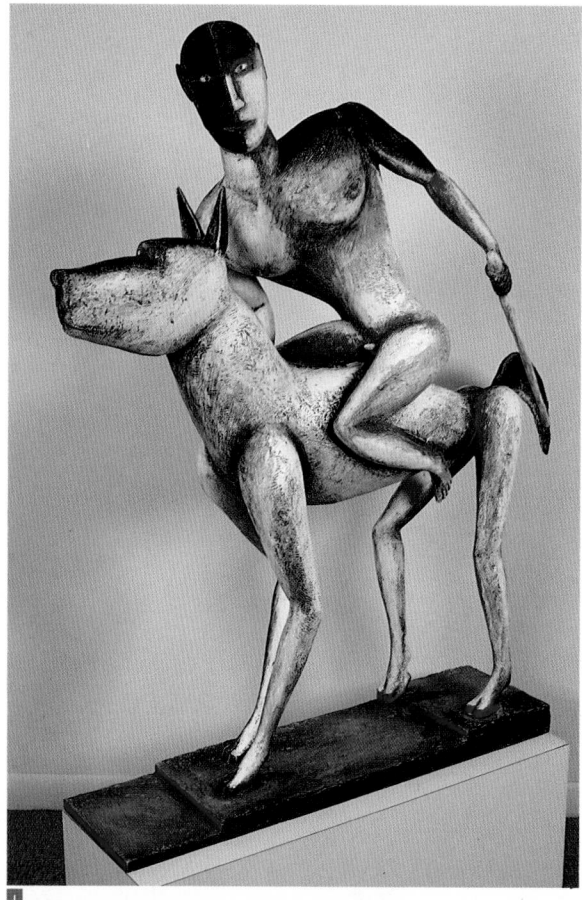

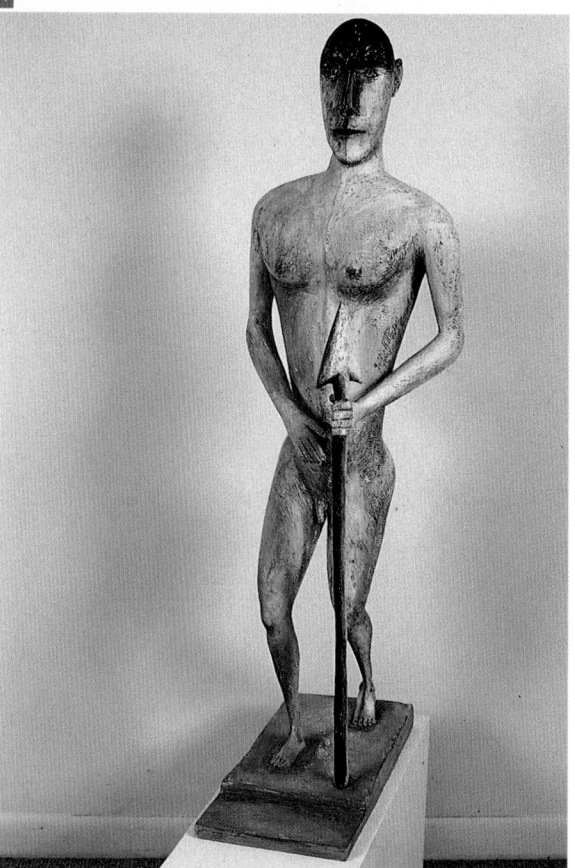

Representation:

**DE GRAAF
FINE ART, INC.**

9 E. Superior
Chicago, IL 60611
312.951.5180
312.951.6146 FAX

3400 Avenue of the Arts
Suite C120
Costa Mesa, CA 92626
714.557.5240
714.557.0778 FAX
Contact:
Daniel L. De Graaf
Steve Davies
Exhibiting:
Contemporary American,
European and Latin
American paintings,
sculpture and graphics

Eugene Jardin

1. *The Rider*
 Resin & fiberglass,
 50" x 45" x 15"

2. *Warrior*
 Resin & fiberglass,
 43" x 14 x 19 1/2"

Selected Biography:
1991 Solo exhibitions:
 Capetown, South
 Africa; Johannesburg,
 South Africa;
 Los Angeles, CA;
 Museum of Capetown
1947 Born: Hanover,
 Germany

Representation:

GWENDA JAY GALLERY

301 W. Superior, 2nd Fl.
Chicago, IL 60610
312.664.3406

Contact:
Gwenda Jay

Exhibiting:
Contemporary painting,
sculpture and architectural
works

Richard Hunt

1. *Spatial Improvisation I*
 1991, Welded bronze,
 98" x 60" x 40"

2. *Model for "Play"*
 1968 (Cast 1990),
 Cast bronze,
 10 1/2" x 8 1/2" x 7 1/2"

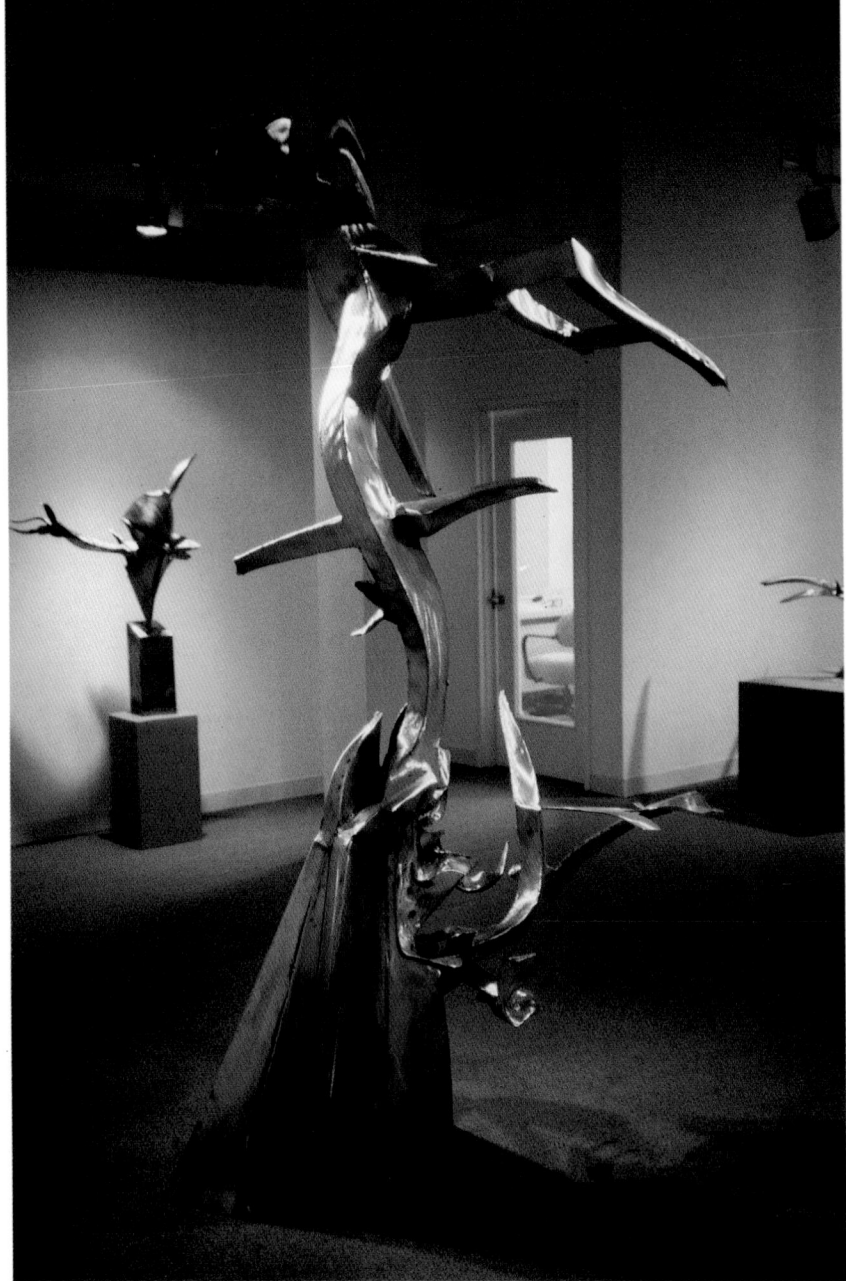

Selected Biography:
1991 Gwenda Jay Gallery,
Chicago, IL; Museum of
African American
History, Detroit, MI
1990 Kalamazoo Institute of
Art, Kalamazoo, MI
1987 U.S.I.S. touring exhibit:
Organized by Los
Angeles Museum of
African American Art,
Lagos, Monrovia,
Accra, Cotonou, Lome,
Dakar, Abidjan
1987-1988

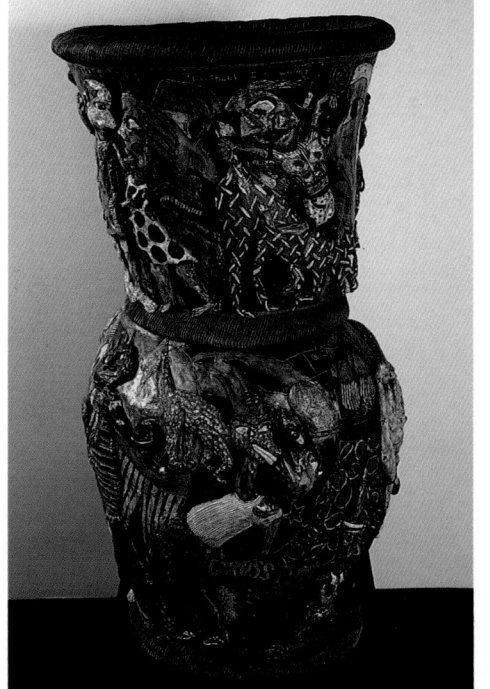

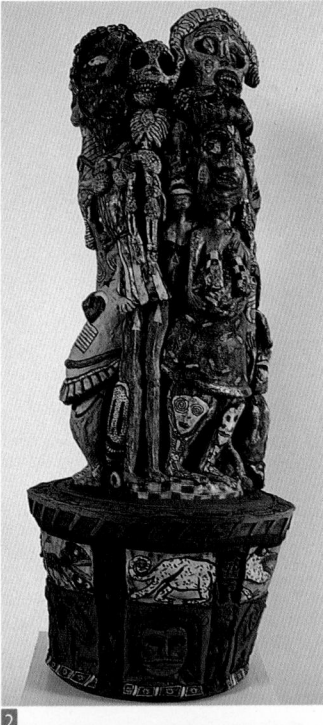

Representation:

OBJECTS GALLERY

230 W. Huron
Chicago, IL 60610
312.664.6622
312.664.9392 FAX
Contact:
Ann Nathan

Exhibiting:
Sculpture, three-dimensional
objects in clay, wood,
steel; artist-made furniture;
mixed-media painting

Michael Gross

1. *Vessel, Untitled*
 1989, Clay and
 relief carving,
 42" x 23"

2. *Sculpture, Untitled*
 1990, Clay and
 relief carving,
 38" x 14" x 16"

3. *Sculptural Table, Untitled*
 1991, Clay, wood base,
 22" h. x 21 1/2" x 21"

4. Detail: top-left of
 sculptural table #3

5. Detail: top-right of
 sculptural table #3

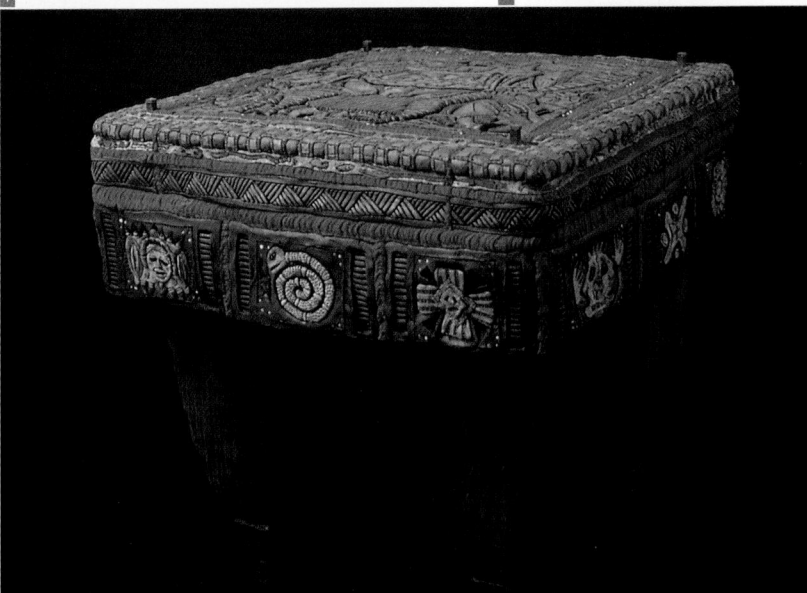

Selected Biography:
1990 Everson Museum,
 Syracuse, NY; Madison
 Art Center, Madison,
 WI; Scripps Annual,
 Claremont Colleges,
 Claremont, CA
1989 National Museum
 of Ceramic Art,
 Baltimore, MD;
 Arkansas Art Center,
 Little Rock, AR

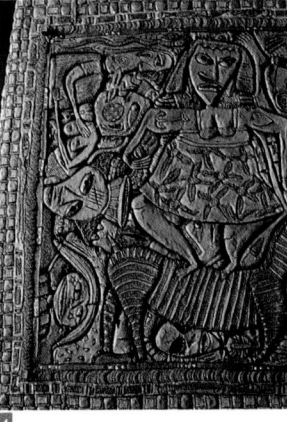

Representation:

**ALTERMANN &
MORRIS GALLERIES**

3461 W. Alabama
Houston, TX 77027
713.840.1922
713.840.0119 FAX

2727 Routh
Dallas, TX 75201
214.871.3035
214.880.0816 FAX

Contact:
Jack A. Morris
Tony Altermann
Exhibiting:
19th & 20th-Century
Paintings And Sculpture

Glenna Goodacre

1. *Niads*
 Bronze,
 Height 8'

2. *Ya Ta Hey*
 Bronze,
 Height 8'

Representation:

PAYTON RULE GALLERY

1736 Wazee Street
Denver, CO 80202
303.293.9080
303.298.9523 FAX

Contact:
Robin Rule

Exhibiting:
Modern and contemporary
painting, sculpture and
photography by regional
and national artists

Victoria Fuller

1. *Polor Bowler*
 1991, Wood and
 found objects,
 84" x 24" x 36"

Selected Biography:
1991 Solo show: Payton Rule
 Gallery, Denver, CO
1986 "Drawn and
 Quartered", White
 Columns Gallery,
 New York, NY
1983 Solo show: West
 Broadway Gallery,
 New York, NY

Representation:

RUBIN SPANGLE GALLERY

395 W. Broadway
New York, NY 10012
212.226.2161
212.226.5337 FAX
Contact:
Morgan Spangle

Exhibiting:
Contemporary paintings,
drawings and sculpture

Dan Flavin

1. *Untitled*
 ("monument" to V. Tatlin)
 1990, Cool white
 fluorescent light,
 8' high

2. *Untitled (to Donna)4*
 1971, Pink, yellow and
 blue fluorescent light,
 8' high

3. *Untitled (to Hans Coper,*
 Master Potter)15
 1990, Cool white
 fluorescent light
 8' high

Selected Exhibitions:
1992 The Solomon R.
 Guggenheim Museum,
 New York
1991 Galerie Karsten
 Greve, Paris
1990 Rubin Spangle Gallery,
 New York
1989 Leo Castelli Gallery,
 New York

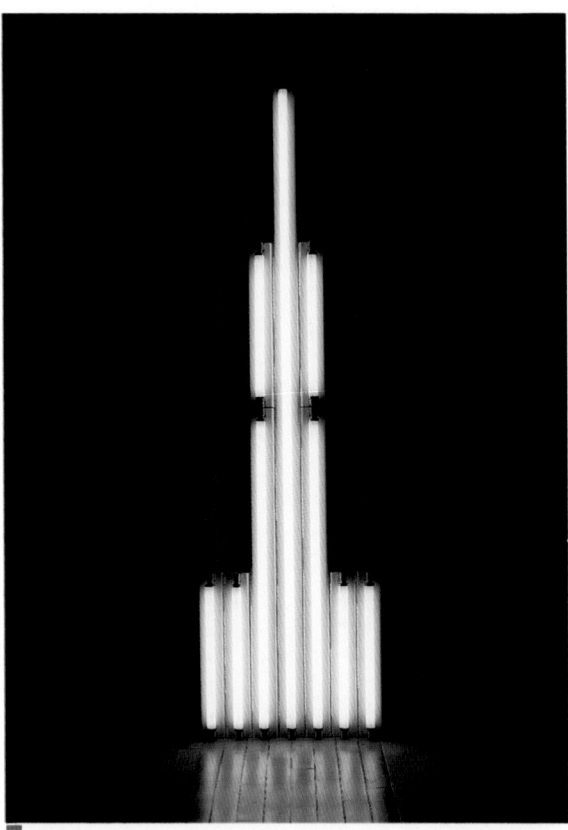

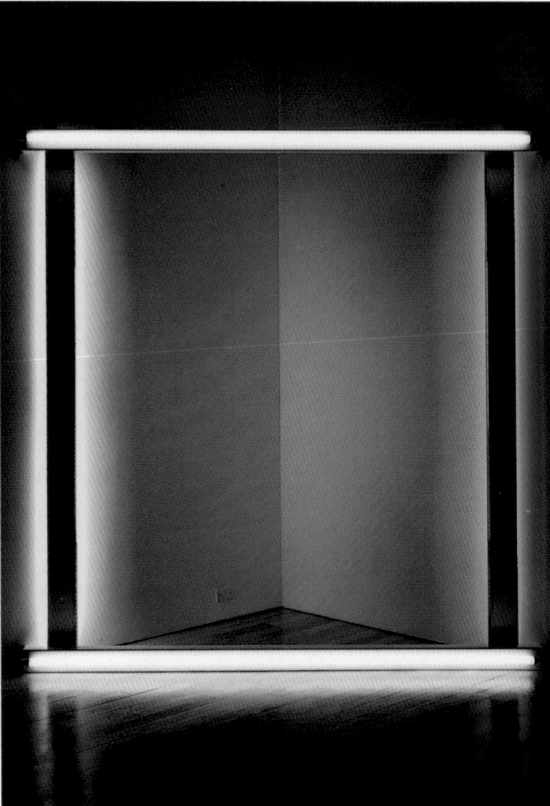

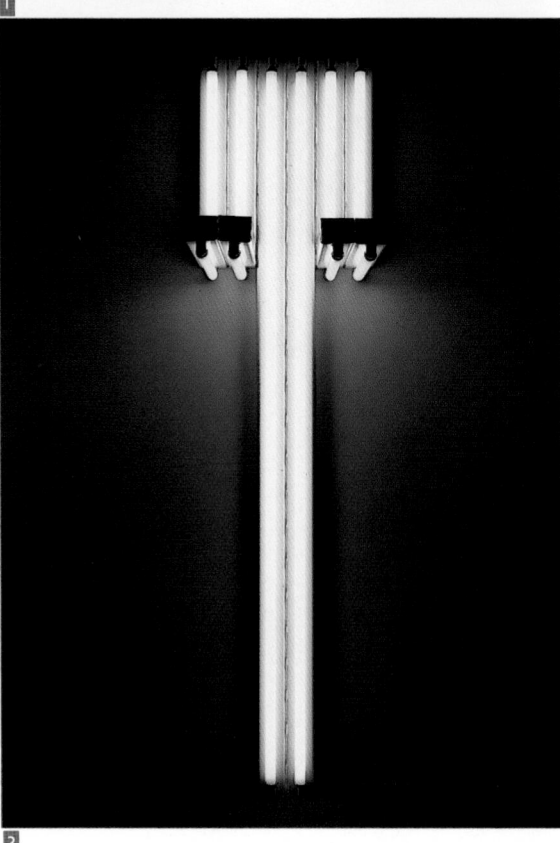

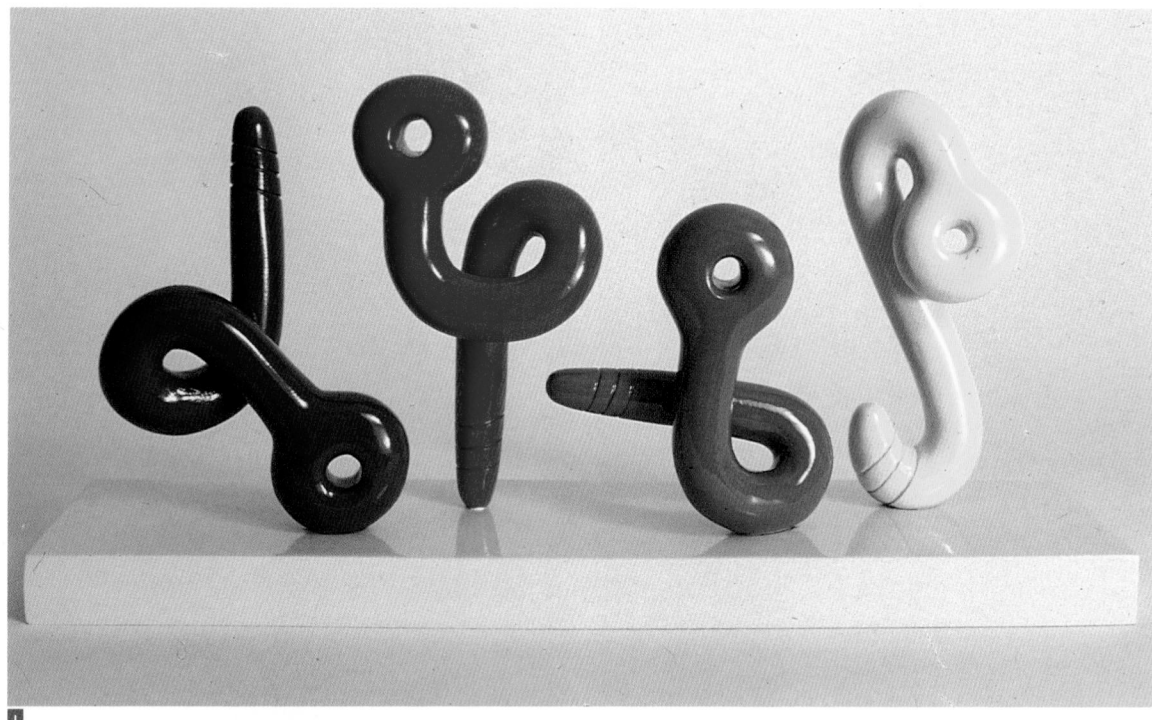

Representation:

HOKIN GALLERY

245 Worth Avenue
Palm Beach, FL 33480
407.655.5177
407.655.6315 FAX

1086 Kane Concourse
Bay Harbor Islands, FL 33154
305.861.5700
305.865.5621 FAX

Contact:
Grace Hokin

Exhibiting:
Modern and contemporary
masters

Sorel Etrog

1. *Quartet*
 1969, Painted bronze,
 54 3/4" h.

2. *Cybele*
 1971, Painted bronze,
 11" h., Edition of 9

3. *Clio*
 1971, Painted bronze,
 14" h., Edition of 9

Selected Biography:
1992 Solo exhibitions: Hokin
Gallery, Palm Beach and
Bay Harbor Islands, FL
1990 Solo exhibition: Gallery
Moos, Toronto, ON;

Collections: MOMA,
Guggenheim, Hirshhorn

Representation:

**CONNELL GALLERY/
GREAT AMERICAN
GALLERY**

333 Buckhead Avenue
Atlanta, GA 30305
404.261.1712

Contact:
Martha Connell
Pat Connell
Exhibiting:
Contemporary American
art; clay, glass, wood, fiber,
metal and works on paper
and canvas

Roger Dorset

1. *The River Styx*
 1990, Acrylic and mixed
 media on paper,
 30" x 22"
 Photo: Deloye Burrell

Representation:

GAGOSIAN
GALLERY

980 Madison Avenue, 6th Fl.
New York, NY 10021
212.744.2313
212.772.7962 FAX
Contact:
Melissa Lazarov

Exhibiting:
Contemporary paintings,
drawings and sculpture

Walter de Maria

1. *13, 14, 15 Sided
 Open Polygons*
 1984, Solid stainless steel
 with solid balls, 13-sided
 polygon 10 x 210 cm,
 14-sided polygon,
 10 x 226 cm, 15-sided
 polygon, 10 x 244 cm

Selected Biography:
1990 Group shows:
 "Power", It's Myths,
 Icons & Sculptures in
 American Culture,
 1961-1991, Indianapolis
 Museum of Art;
 "Pharmakon '90"
 Nippon Conventional
 Center, Tokyo;
 Bicentennial of the
 Nationale, Paris: A
 Sculpture by Walter
 de Maria

Tony Delap

1. *The Psychic*
 1991, Bronze,
 edition 12,
 24" x 5" x 4"

2. *Fantasma Gorique*
 1989, Wood, canvas,
 acrylic, paint,
 75" x 26" x 3"

3. *The Mysterious 3*
 1991, Wood, canvas,
 acrylic, paint,
 42 1/2" x 28" x 5 3/4"

Selected Biography:
1992 Solo exhibitions:
 Modernism, San
 Francisco, CA; The
 Works Gallery South,
 Costa Mesa, CA;
 Allene Lapides Gallery,
 Santa Fe, NM
1991 Solo exhibition: The
 Works Gallery, Long
 Beach, CA

1

2

3

1

Representation:

**LINDA DURHAM
GALLERY**

400 Canyon Road
Santa Fe, NM 87501
505.988.1313

Contact:
Russell Isaacs

Exhibiting:
Contemporary American Art

Constance DeJong

1. *Pharisee*
 1990, Copper and wood,
 80" x 78" x 12"

2. *Shroud*
 1989, Copper and wood,
 60" x 20" x 11"

2

Selected Biography:
1991 "The Plane Truth",
 Mulvane Art Museum,
 Washburn University,
 Topeka, KS
1989 Linda Durham Gallery,
 Santa Fe, NM
1989 "Five New Painters",
 curated by Sean Scully,
 John Davis Gallery,
 New York, NY

Representation:

THE WORKS GALLERY

106 W. Third Street
Long Beach, CA 90802
213.495.2787
213.495.0370 FAX

Crystal Court/S. Coast Plaza
3333 Bear Street, Third Fl.
Costa Mesa, CA 92626
714.979.6757
714.979.6818 FAX
Contact:
Mark Moore

Exhibiting:
Established and emerging
contemporary artists of
the western United States

Woods Davy

1. *Hemlock*
 1990, Oiled steel,
 granite,
 99"h x 21" x 14"

 Buckthorn
 1990, Oiled steel,
 144"h x 15" x 15"

 Wishbone II
 1990, Oiled steel,
 133"h x 11" x 7"

 Sculpture from left to right

Selected Biography:
1992 Solo exhibition: The
 Works Gallery South,
 Costa Mesa, CA
1987 Solo exhibition:
 Tortue Gallery,
 Santa Monica, CA
1986 Solo exhibition:
 McIntosh/Drysdale
 Gallery, Houston, TX
1980 Security Pacific Bank
 Plaza, Los Angeles, CA

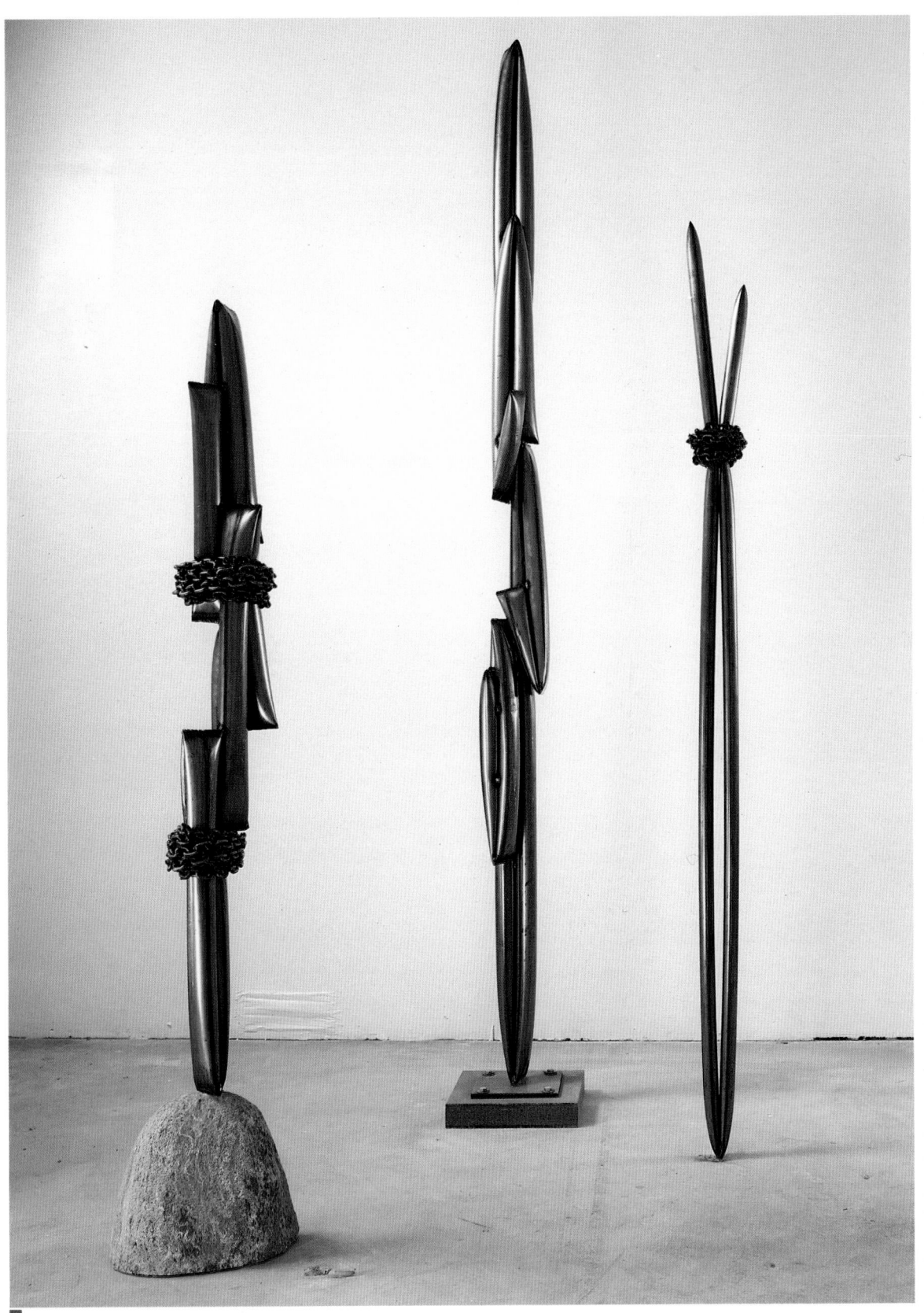

1

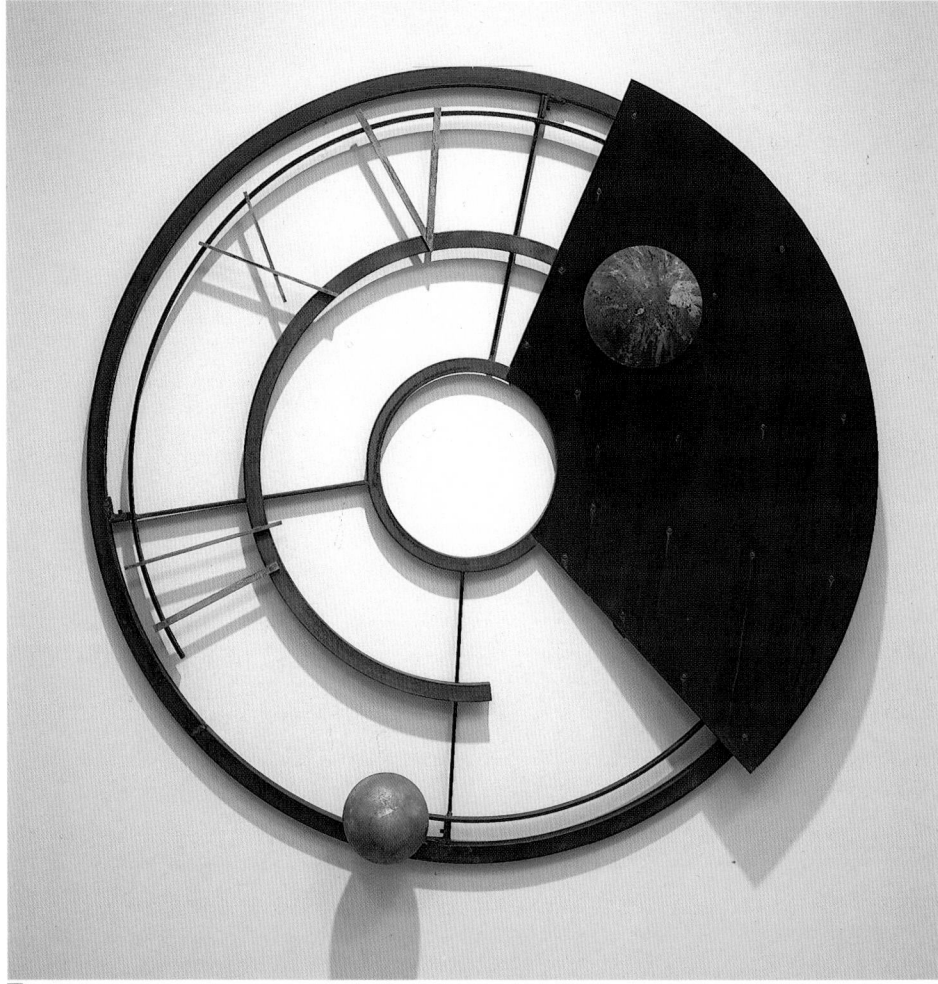

Representation:

THE WORKS
GALLERY

106 W. Third Street
Long Beach, CA 90802
213.495.2787
213.495.0370 FAX

Crystal Court/S. Coast Plaza
333 Bear street, Third Fl.
Costa Mesa, CA 92626
714.979.6757
714.979.6818 FAX
Contact:
Mark Moore

Exhibiting:
Established and emerging
contemporary artists of
the western United States

Michael Davis

1. *Event*
 1990, Steel, copper,
 brass, gold leaf,
 54" x 55" x 12"

2. *Illuminati*
 1989-90, Steel, found
 objects, video monitor
 and camera,
 9' x 8' x 8'

3. *Azimuthal Equidestant
 Projection*
 1990, Steel, glass,
 17" x 42" x 42"

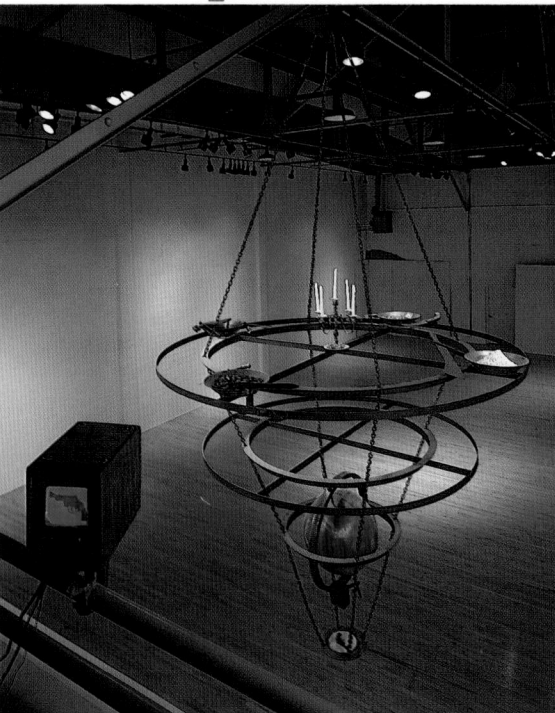

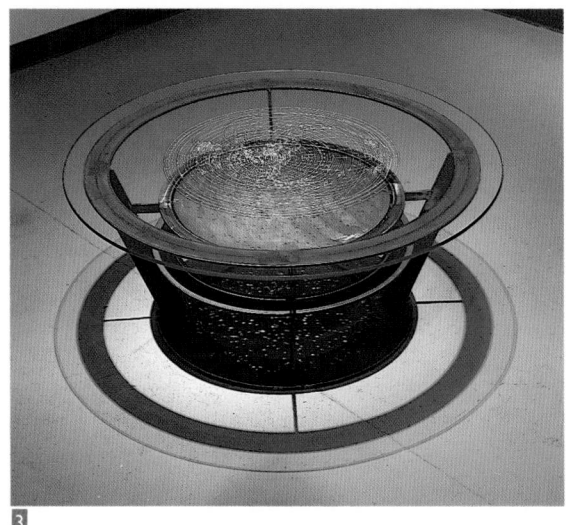

Selected Biography:
1992 Solo exhibition: The
 Works Gallery South,
 Costa Mesa, CA
1990 Group exhibition:
 "The Armory Show",
 Pasadena, CA
1988 Solo exhibition: Laguna
 Art Museum, site-
 specific installation,
 Laguna Beach, CA
1986 Group exhibitions:
 Fisher Gallery;
 University of Southern
 California, Los Angeles,
 CA

Representation:

KURLAND/SUMMERS GALLERY

8742-A Melrose Avenue
Los Angeles, CA 90069
213.659.7098
213.659.7263 FAX
Contact:
Ruth T. Summers

Exhibiting:
Contemporary sculptural
glass/decorative arts

Dan Dailey

1. *Scientist*
 1990, Glass, bronze,
 34" x 22 1/2" x 9" d.

2. *Smear*
 1990, Glass,
 21" x 12" x 12"

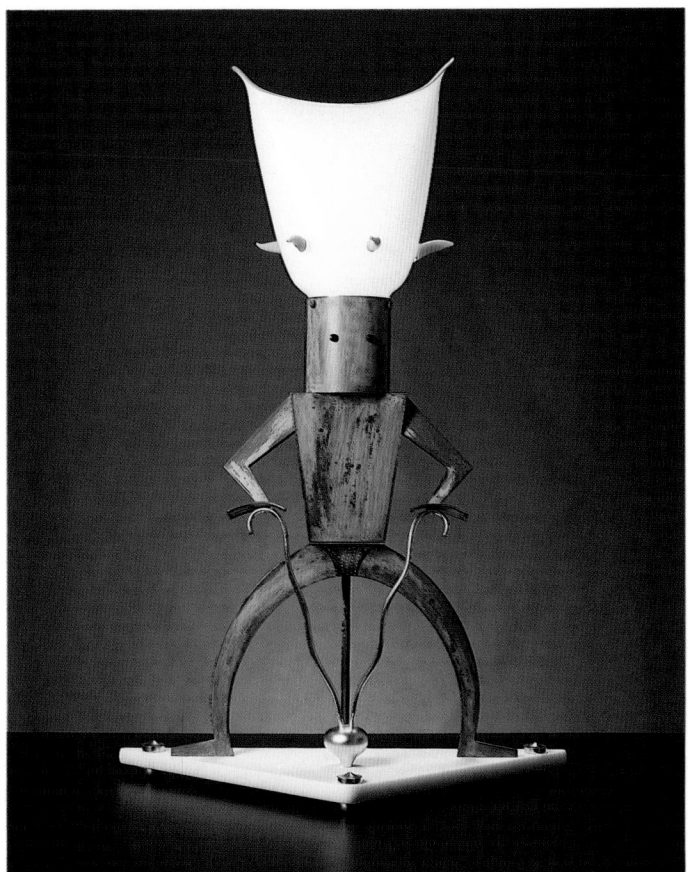

Selected Collections:
 Boston Museum of
 Fine Arts, Boston, MA

 The Metropolitan
 Museum of Art,
 New York, NY

 Los Angeles County
 Museum of Art,
 Los Angeles, CA

 Philadelphia Museum of
 Art, Philadelphia, PA

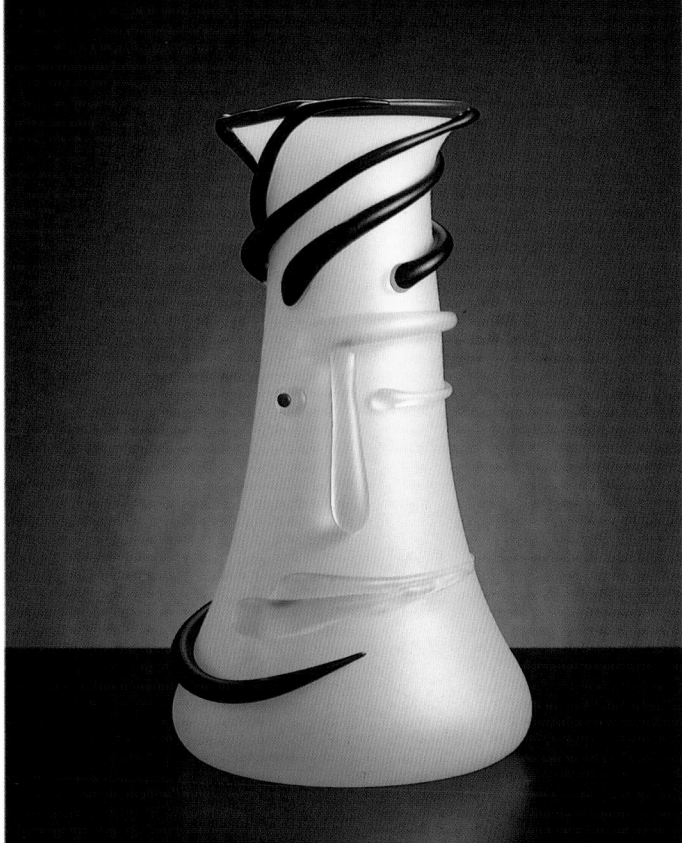

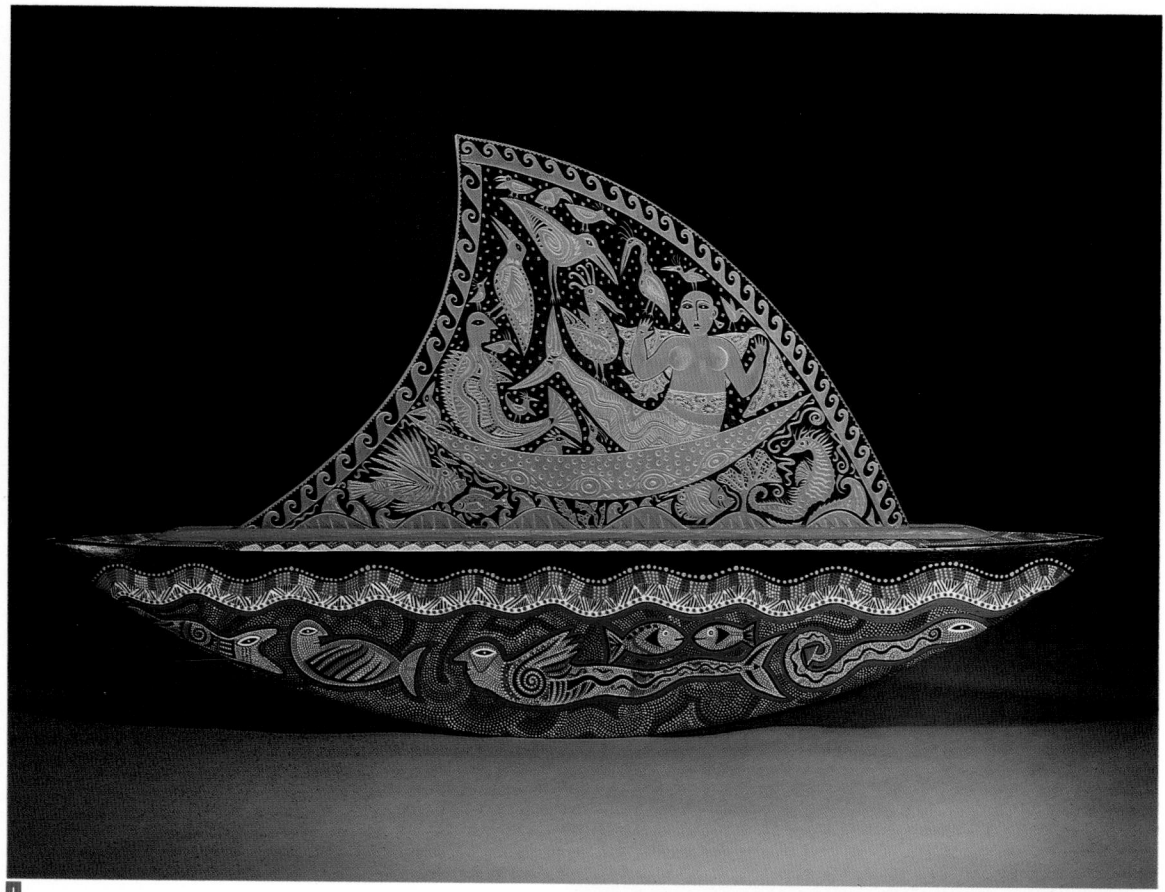

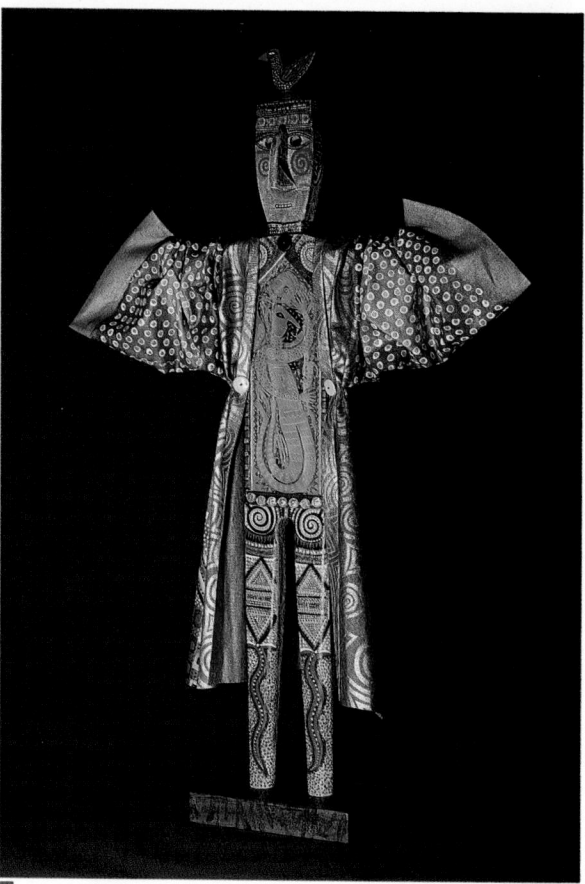

Representation:

KURLAND/SUMMERS GALLERY

8742-A Melrose Avenue
Los Angeles, CA 90069
213.659.7098
213.659.7263 FAX
Contact:
Ruth T. Summers

Exhibiting:
Contemporary sculptural
glass/decorative arts

Ké Ké Cribbs

1. *Grainne Uaile*
 1991, glass, mixed media,
 41 1/2" x 22 1/2" x 4" d.

2. *Lucio*
 1991, Glass, wood,
 mixed media,
 45" x 31" x 6 1/2" d.

Selected Collections:
Los Angeles County
Museum of Art,
Los Angeles, CA

The Corning Museum
of Glass, Corning, NY

Albuquerque Museum,
Albuquerque, NM

Representation:

**LINDA DURHAM
GALLERY**

400 Canyon Road
Santa Fe, NM 87501
505.988.1313

Contact:
Russell Isaacs

Exhibiting:
Contemporary American Art

John Connell

1. *Studio Shot*
 1989, Tar, wood,
 wire, paper,
 Lifesize

2. *Studio Shot*
 1990, Tar, wood,
 wire, paper

Selected Biography:

1990 "The Raft Project: A
Collaboration by John
Connell and Eugene
Newmann", Center
for Contemporary
Arts, Santa Fe, NM and
Blue Star Art Space,
San Antonio, TX

1986 "The Construction of
Kwan-Yin Lake", Inter-
Arts Program Grant,
National Endowment
for the Arts

Representation:

**CHARLES COWLES
GALLERY**

420 W. Broadway
New York, NY 10012
212.925.3500
212.925.3501 FAX

Exhibiting:
Contemporary art

Dale Chihuly

1. *Chartreuse Ventian with
 Coil and Two Violet Stems*
 1991, Glass,
 36" x 36" x 32"

Selected Collections:
 Australian National
 Gallery, Canberra

 Boston Museum of
 Fine Arts, MA

 Los Angeles County
 Museum of Art, CA

 Museum of Modern
 Art, CA

 National Museum of
 Modern Art, Kyoto,
 Japan

 Philadelphia Museum
 of Art, PA

Muriel Castanis

1. *Lot's Wife*
 1987, Cloth and epoxy,
 74" x 37" x 24"

Selected Biography:
1991 Solo exhibition:
"Muriel Castanis, Post-
Modernist Sculpture",
Hokin Gallery, Palm
Beach, FL
1990 Commission: IBM
Corporation Atrium,
Atlanta, GA
1989 Solo exhibition: O.K.
Harris Works of Art,
New York, NY
1988 Group exhibition:
"Architectural Art:
Affirming the Design
Relationship",
American Craft Museum,
New York, NY

Representation:

GALLERY ONE

121 Scollard Street
Toronto, Canada M5R 1G4
416.929.3103
416.929.0278 FAX
Contact:
Goldie Konopny
Sharon Fischtein
Exhibiting:
Contemporary Canadian,
American and International
painting, sculpture and
graphics

Anthony Caro

1. *Angel Bay*
 1984, Welded steel,
 80" x 80" x 60"

Selected Biography:
1991 Tate Gallery, London,
England; Annely Juda
F.A., London, England
1990 Museé Des Beaux Arts,
Calais, France; Gallery
Kasaharam Osaka,
Japan; Gallery One,
Toronto, Ont., Canada;
Galerie Lelong, Paris,
France

Representation:

BEAUX ART COLLECTIONS LTD.

2451 Brickell Avenue
Main Fl.
Miami, FL 33129
305.858.6776
Contact:
Ricardo J. Gonzalez III

Exhibiting:
Abstract-figurative
sculptures and reliefs;
Commissioned traditional
Realistic, corporate and
public works

Manuel Carbonell

1. *Outdoor Sculptures*
 1987-88, Bronzes,
 Monumental

2. *Statue of Jose Marti*
 1990, Marble,
 7'0"

3. *Gallery Exhibit*
 1961-91, Bronzes,
 Size varies

Selected Biography:
1992 Permanent exhibit:
Beaux Art Collections
Ltd., Miami, FL; Mielko
Gallery, June-October,
Nantucket, MA
1991 Permanent exhibit:
Beaux Art Collections
Ltd., Miami, FL

Representation:

**KEN BRYAN
CONTEMPORARY
ART**
P.O. Box 1977
Cambridge, MA 02238
617.868.2323
617.332.0914
Contact:
Ken Bryan

Exhibiting:
Contemporary sculpture,
mobiles, high-tech wall art
and kinetic wind sculptures

Ken Bryan

1. *Spectra-Wall
 Sculpture*
 1990, Ever-
 changing colors,
 58" x 70" x 5"

2. *Dream Baby*
 1991, Chrome
 steel and wood,
 79" x 72" x 4"

3. *Multi-Plyons
 Red and Blue*
 1990, Acrylic
 on oak,
 104" x 20" x 20

Representation:

DE GRAAF
FINE ART, INC.

9 E. Superior
Chicago, IL 60611
312.951.5180

3400 Avenue of the Arts
Suite C120
Costa Mesa, CA 92626
714.557.5240

Exhibiting:
Contemporary American,
European and Latin
American paintings,
sculpture and graphics

Charlie Brouwer

1. *Desire Greater Than Gravity*
 Painted wood,
 82" x 28" x 20

2. *Endless Column*
 Painted wood,
 84" x 40" x 30"

3. *Leaving*
 Stained, wolamnized wood,
 80" x 78" x 66"

Selected Biography:
1991 Exhibition:
 De Graaf Fine Art
1990 Exhibitions: Sculpture
 Center, Oronsko,
 Poland; International
 Sculpture Park,
 Nagyatad, Hungary;
 Kalamazoo Art Center
1989 De Graaf Fine Art
1946 Born: Holland, MI

1

Representation:

**STEPHEN
ROSENBERG
GALLERY**
115 Wooster Street
New York, NY 10012
212.431.4838

Contact:
Fran Kaufman

Exhibiting:
Contemporary American
and European painting,
sculpture, works on paper
and prints

Jeffrey Brosk

1. *Prairie Smoke I*
 1990, Wood and slate,
 44" x 130" x 3"
 Collection: AT & T,
 Silver Springs, MD

2. *Across The Day*
 1991, Wood and slate,
 16 1/4" x 41 1/2" x 4 1/2"

2

Selected Biography:
1992 Stephen Rosenberg
 Gallery, New York;
 Clark University,
 Worcester, MA
1991 Current Minimalists,
 Arts Festival of Atlanta;
 Joan Robey Gallery,
 Denver, CO
1990 Stephen Rosenberg
 Gallery, New York;
 Anne Reed Gallery,
 Ketchum, ID
1989 Installation, Fordham
 University at Lincoln
 Center; Stephen
 Rosenberg Gallery,
 New York

Representation:

**HELEN DRUTT
GALLERY**

1721 Walnut Street
Philadelphia, PA 19103
215.735.1625
215.557.9417 FAX

Contact:
Helen W. Drutt English
Patricia Farrand Harner
Exhibiting:
Contemporary ceramic
sculpture and vessels,
jewelry, textiles, drawings

Jill Bonovitz

1. *Softly Sighing*
 1989, Earthenware,
 terra sigillata,
 26" d. x 5" h.

2. *Gentle Hush*
 1989, Earthenware,
 terra sigillata,
 26" d. x 5" h.

3. *The Way Here*
 1989, Earthenware,
 terra sigillata,
 26" d. x 7" h.
 Collection of Duane,
 Morris and Heckscher

Selected Biography:
1992 "From The Ground
 Up", Moore College of
 Art, Philadelphia, PA
1990 "Contemporary
 Philadelphia Artists:
 Philadelphia Art Now",
 Philadelphia Museum
 of Art, PA

Representation:

CHARLES COWLES GALLERY

420 W. Broadway
New York, NY 10012
212.925.3500
212.925.3501 FAX

Exhibiting:
Contemporary art

Howard Ben Tré

1. *Primary Vessel #2*
 1991, Cast glass,
 iron powders,
 83" x 42" x 15 1/2"

Selected Collections:
 Brooklyn Museum,
 Brooklyn, NY

 Centro Cultural Arte
 Contemporano,
 Mexico City, Mexico

 High Museum of Art,
 Atlanta, GA

 Los Angeles County
 Museum of Art,
 Los Angeles, CA

 The Metropolitan
 Museum of Art, NY

Representation:

MARGO LEAVIN GALLERY

812 N. Robertson Boulevard
Los Angeles, CA 90069
213.273.0603
213.273.9131 FAX

Contact:
Margo Leavin
Wendy Brandow
Exhibiting:
Contemporary art from
Europe and America

Lynda Benglis

1. *Tama*
 1989, Aluminum,
 stainless steel,
 98" x 42" x 13 1/2"

2. *Stevens Durea*
 1988, Copper over
 wire mesh,
 76" x 59" x 17 1/2"

3. *XII*
 1991, Stainless steel,
 copper, babbitt,
 30" x 26" x 8"

Selected Biography:
1991 Margo Leavin Gallery,
 Los Angeles, CA
1990 Traveling exhibitions:
 "Lynda Benglis: Dual
 Natures", High Museum
 of Art, Atlanta; "The
 New Sculpture 1965-75:
 Between Geometry &
 Gesture", Whitney
 Museum of American
 Art

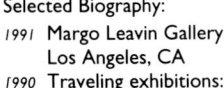

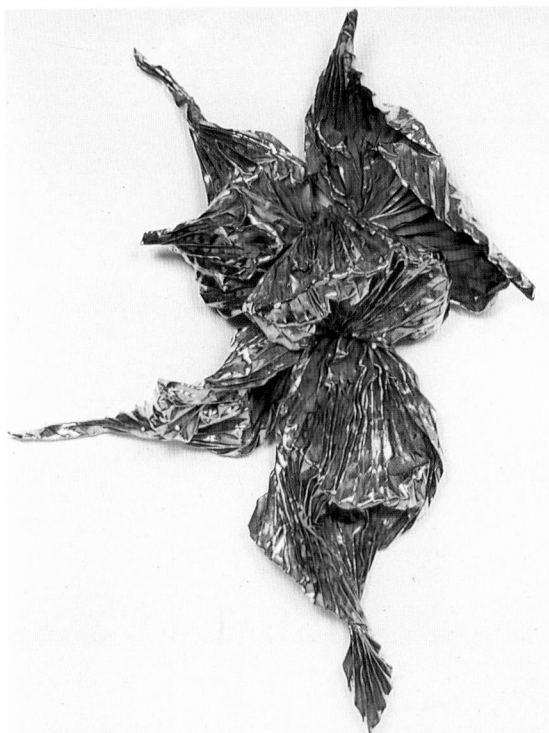

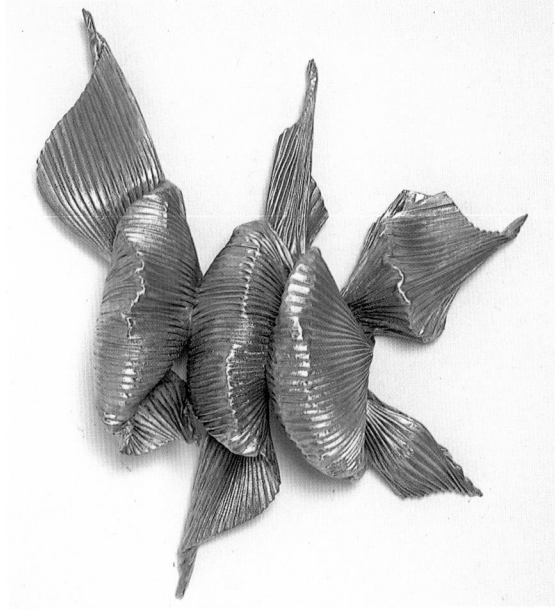

Representation:

DE GRAAF FINE ART, INC.

9 E. Superior
Chicago, IL 60611
312.951.5180

3400 Avenue of the Arts
Suite C120
Costa Mesa, CA 92626
714.557.5240

Exhibiting:
Contemporary American,
European and Latin
American paintings,
sculpture and graphics

Bill Barrett

1. *Nuk*
 Welded bronze,
 5' h.

2. *Kazotsky*
 Welded bronze,
 5'2" h.

3. *Sphinx II*
 Welded bronze,
 7'1" h.

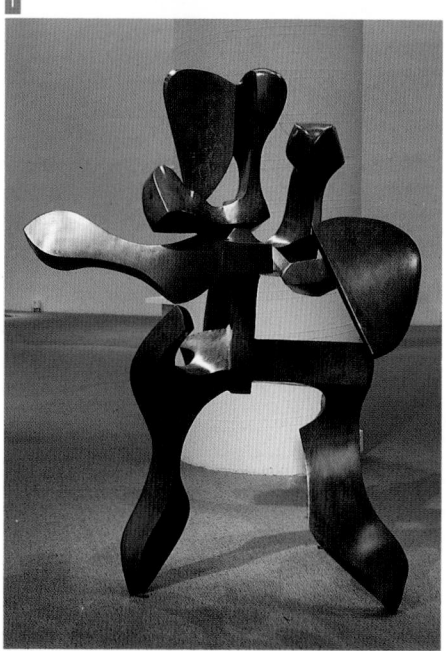

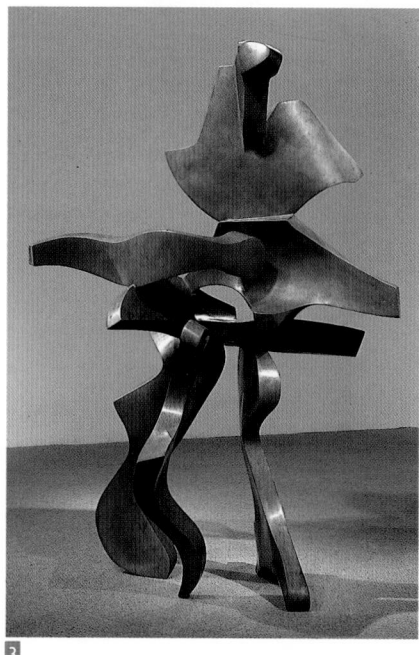

Selected Biography:
 Hakone Open Air
 Museum, Japan
 Cleveland Museum
 of Art
 Aldrich Museum of Art
 Scottsdale Center
 for the Arts
 New York City
 Richard Cooper
 Bob & Patsy Bohlen
 Pacific Enterprises
1934 Born: Los Angeles, CA

Representation:

OLGA KORPER GALLERY

17 Morrow Avenue
Toronto, ON M6R 2H9
416.538.8220

Contact:
Olga Korper
Sasha Korper
Exhibiting:
Contemporary painting,
sculpture and paperworks

Ilan Averbuch

1. *Deus ex Machina*
 1991, Wood and stone,
 117" x 308" x 185"

2. *Pomegranates*
 1991, Wood and lead,
 92" x 241" x 93"

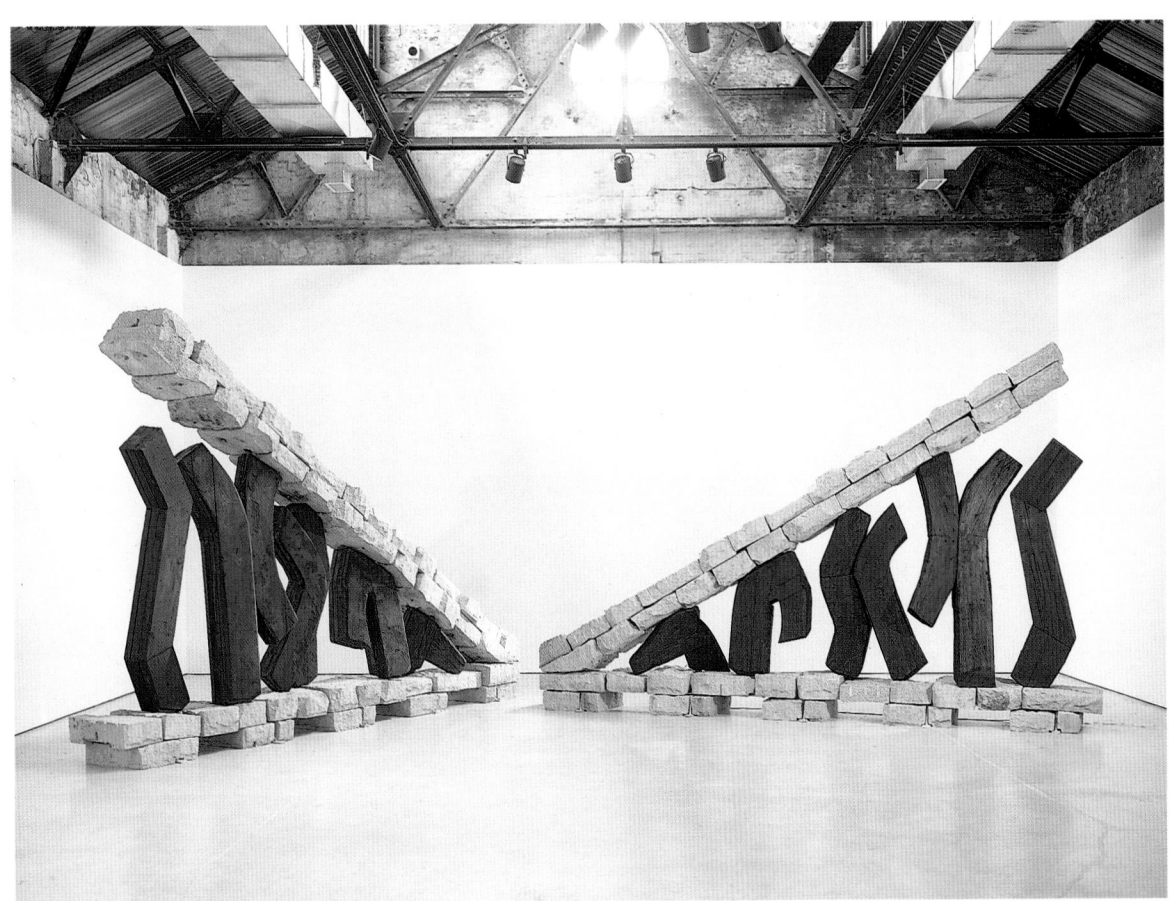

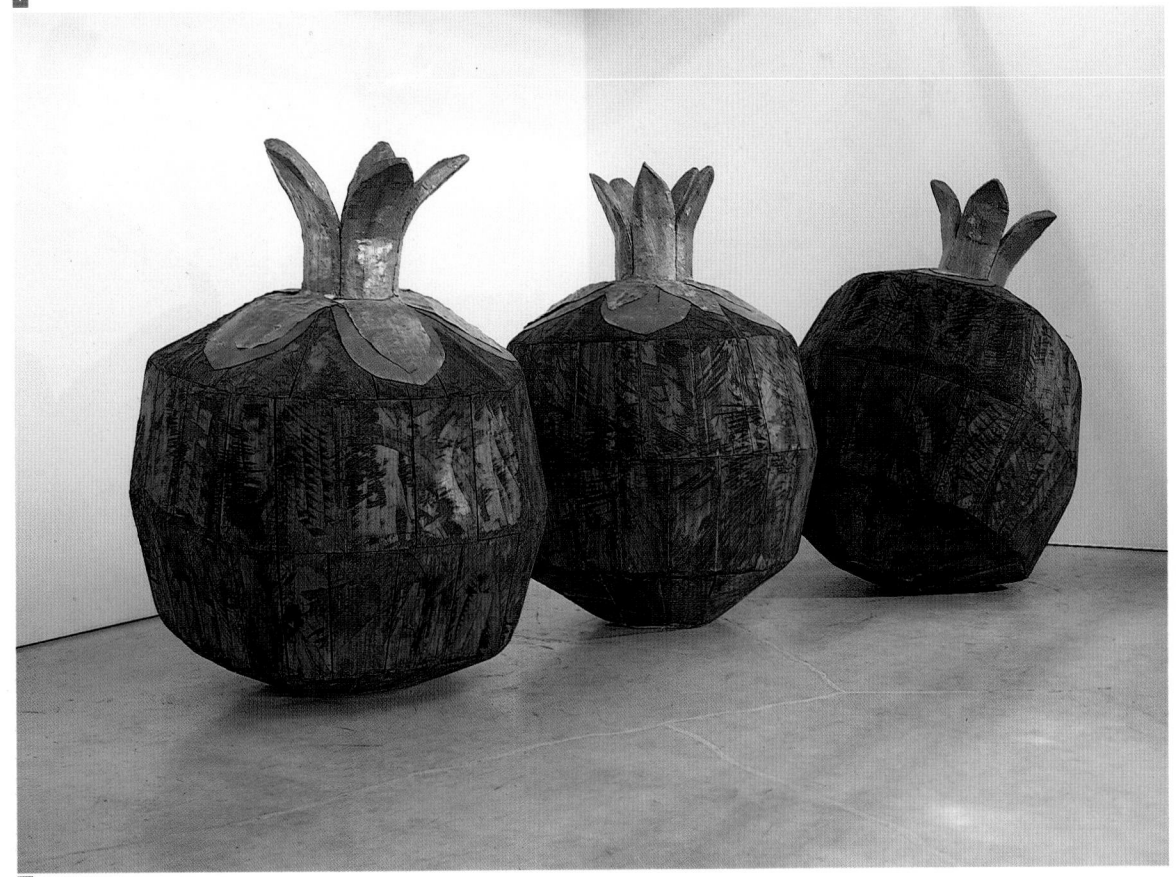

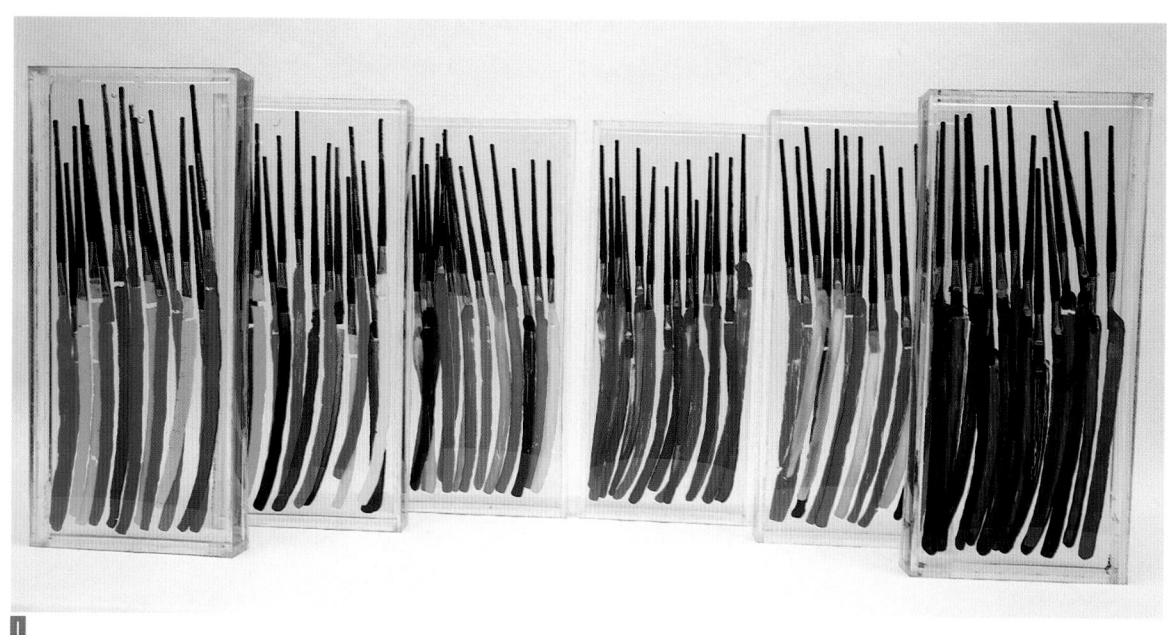

Representation:

J. ROSENTHAL FINE ARTS

230 W. Superior Street
Chicago, IL 60610
312.642.2966
312.642.5169 FAX
Contact:
Dennis Rosenthal

Exhibiting:
20th century modern and
contemporary international
uniques and multiples

Arman

1. *Untitled Paintbrushes*
 1991, Paintbrushes and
 brushstrokes of color
 embedded in polyester,
 edition 20,
 26" x 12" x 2 1/4"

Selected Biography:

1991 Published "Untitled
Paintbrushes" edition
with J. Rosenthal Fine
Arts/Miriam Shiell

1990 "Dirty Paintings",
Marisa del Re Gallery,
New York

Representation:

**STILL-ZINSEL
CONTEMPORARY**

328 Julia Street
New Orleans, LA 70130
504.588.9999
504.588.9900 FAX

Contact:
Sam Still
Suzanne Zinsel
Exhibiting:
Contemporary paintings,
sculpture, photography,
works on paper

Wayne Amedee

1. *Obstinate In Heart*
 1990, Acrylic/wood,
 54" x 3" x 36"

2. *Loosen The Bonds*
 1991, Acrylic/wood,
 26" x 26" x 17"

3. *Pride Of The Wicked*
 1991, Acrylic/wood,
 34" x 16" x 14"

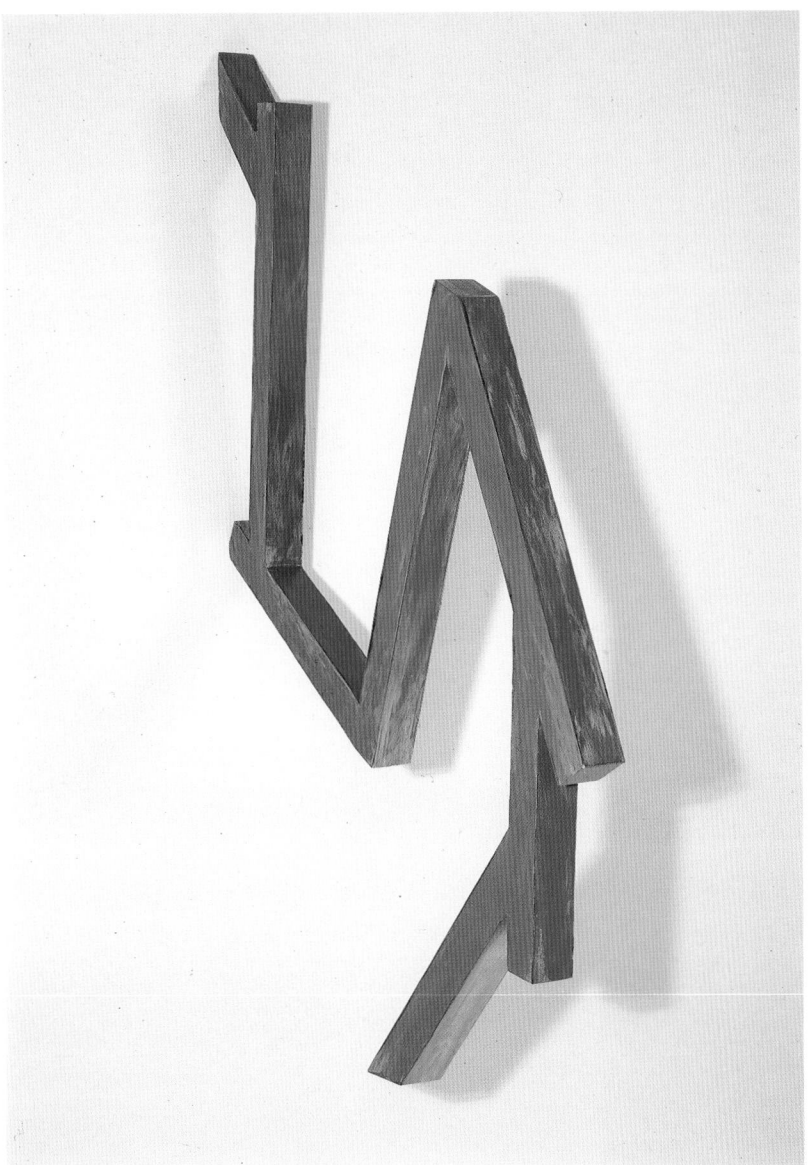

1

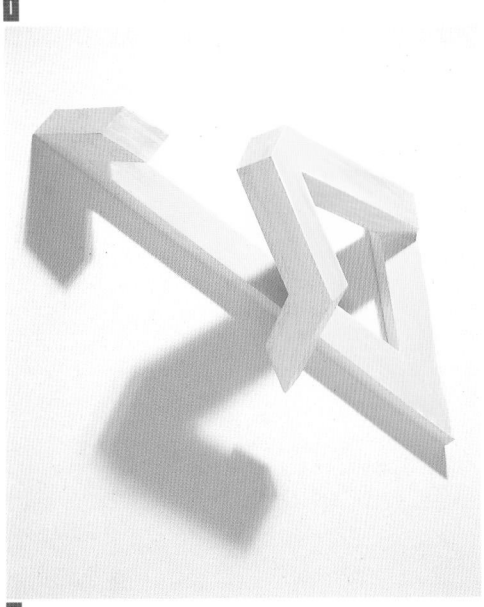

2

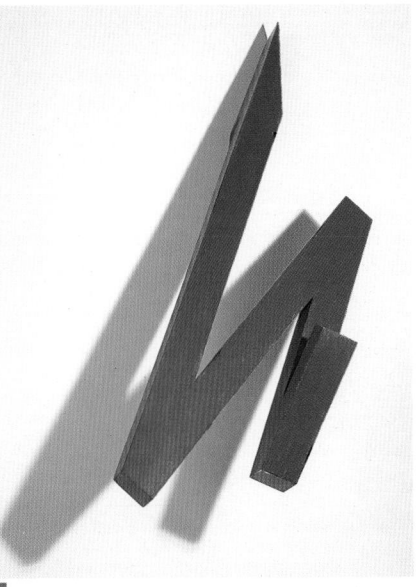

3

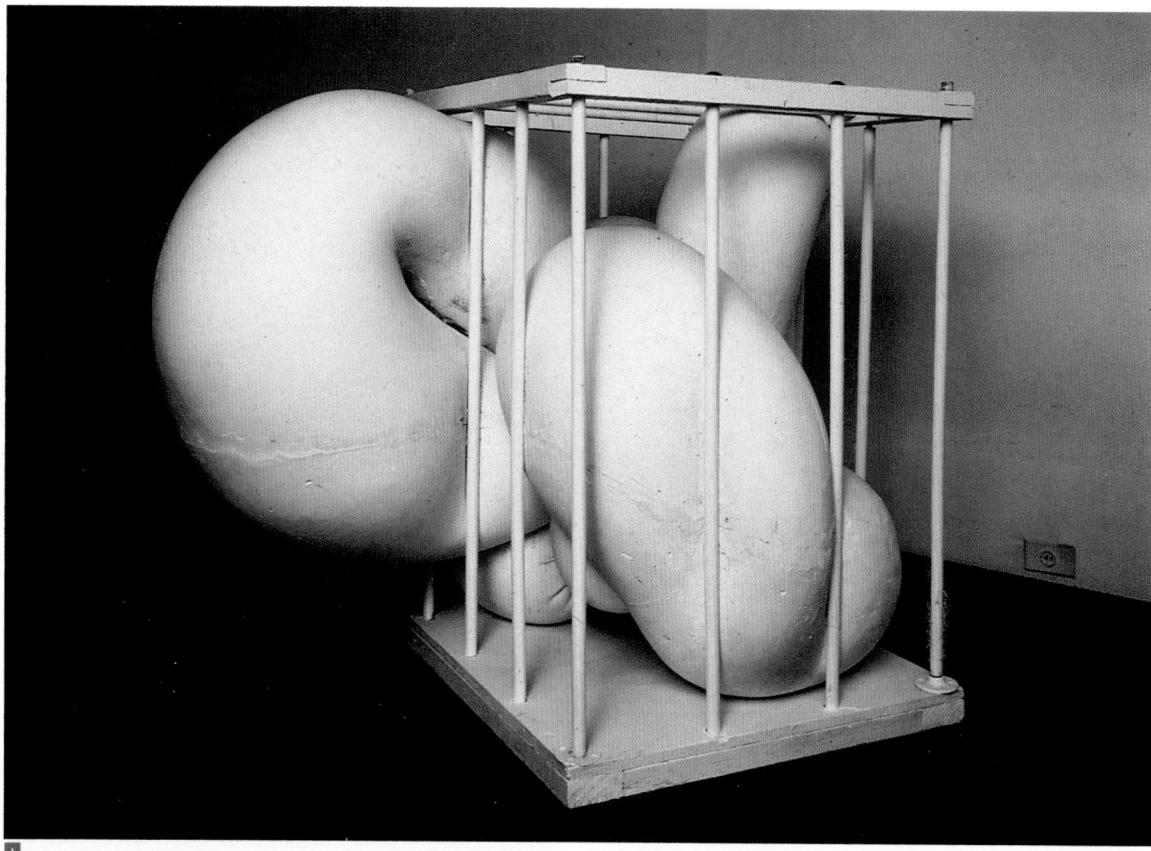

Representation:

**ANITA SHAPOLSKY
GALLERY**

99 Spring Street
New York, NY 10012
212.334.9755
212.334.6817 FAX
Contact:
Anita Shapolsky

Exhibiting:
20th-century paintings
and sculpture; First
and second generation
Abstract Expressionists

Peter Agostini

1. *Cage I*
 1965, Plaster,
 iron, wood,
 3' x 4'

2. *Portrait of a
 Burlesque Queen*
 1962, Plaster,
 iron, wood,
 2 1/2' x 2"

3. *Burlesque Queen #2*
 1950's, Plaster,
 14" x 4 3/4" x 2 3/4"

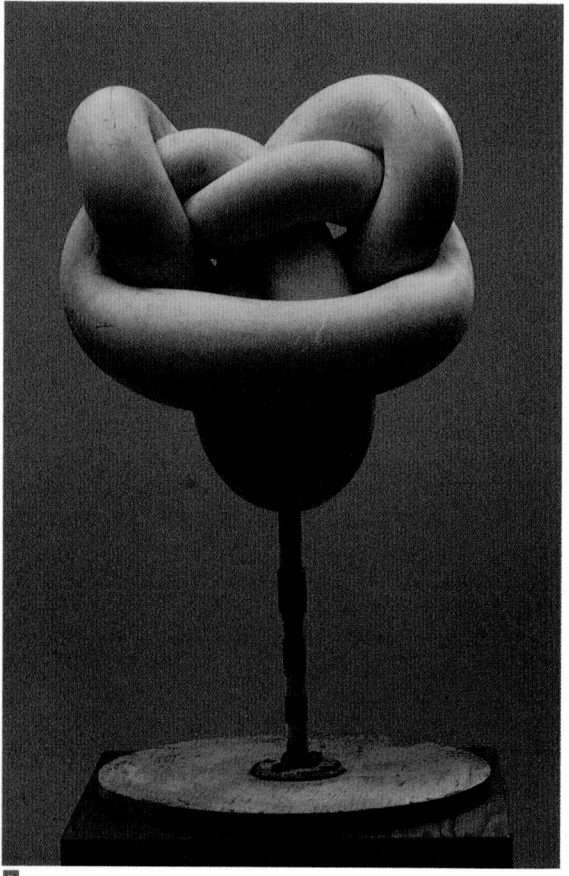

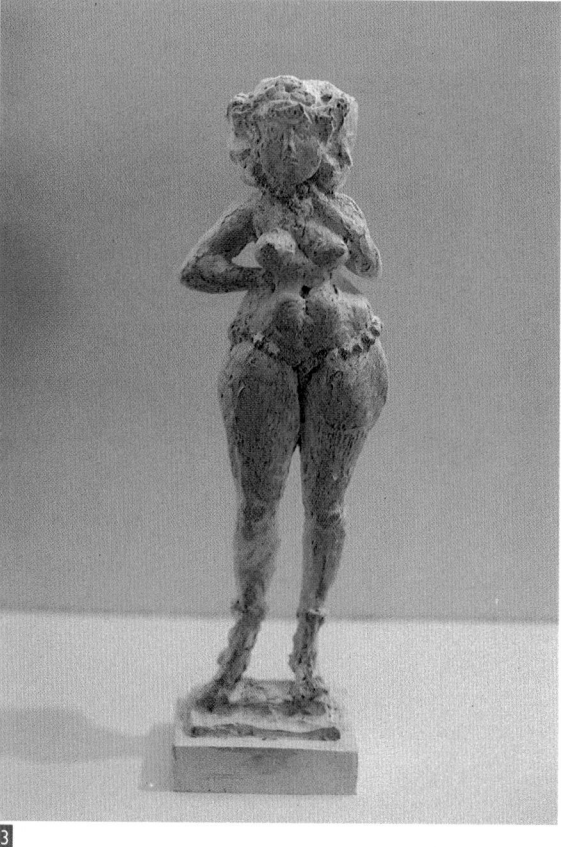

Selected Biography:
1991 Solo show: Anita
Shapolsky Gallery,
New York, NY
1986 Solo show: Bernice
Steinbaum Gallery,
New York, NY
1983 Solo show: New York
School, New York, NY
1966 Group show: Whitney
Museum of American
Art, New York, NY

Representation:

LAWRENCE OLIVER

1617 Walnut Street
Philadelphia, PA 19103
215.751.9084
215.751.0731 FAX
Contact:
Lawrence Mangel

Exhibiting:
Museum quality
contemporary art
in all mediums

Phoebe Adams

1. *It's Yours But It's Mine*
 1990, Bronze and wood,
 100" x 25" x 25"

2. *Collusion*
 1986, Cast bronze,
 95 1/2" x 23 1/2" x
 60 1/2"

3. *Which Way?*
 1986, Cast bronze,
 39" x 59" x 25"

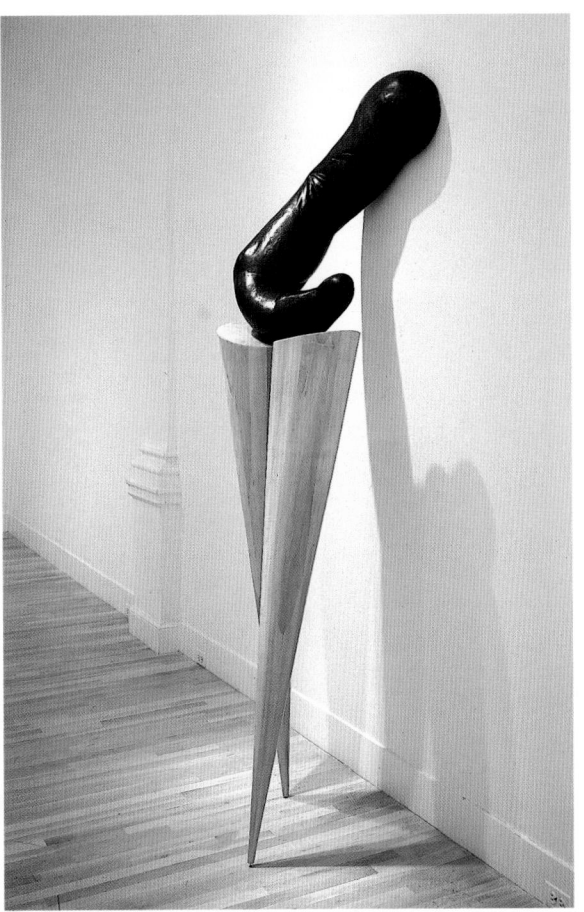

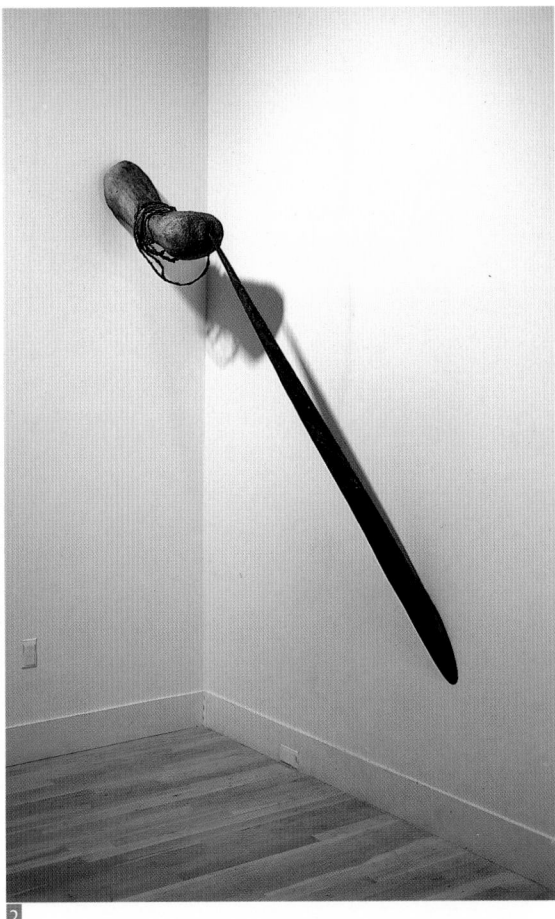

Selected Biography:

1990 Solo exhibitions: Curt
 Marcus; Lawrence
 Oliver; Beaver College
1989 Solo exhibitions: Curt
 Marcus; Lawrence
 Oliver; Beaver College;
 Group exhibition: De
 Cordova and Danna
 Museum and Park;
 Walker Art Center:
 Sculpture Inside Outside
1987 Group exhibition:
 Aldrich Museum of
 Contemporary Art

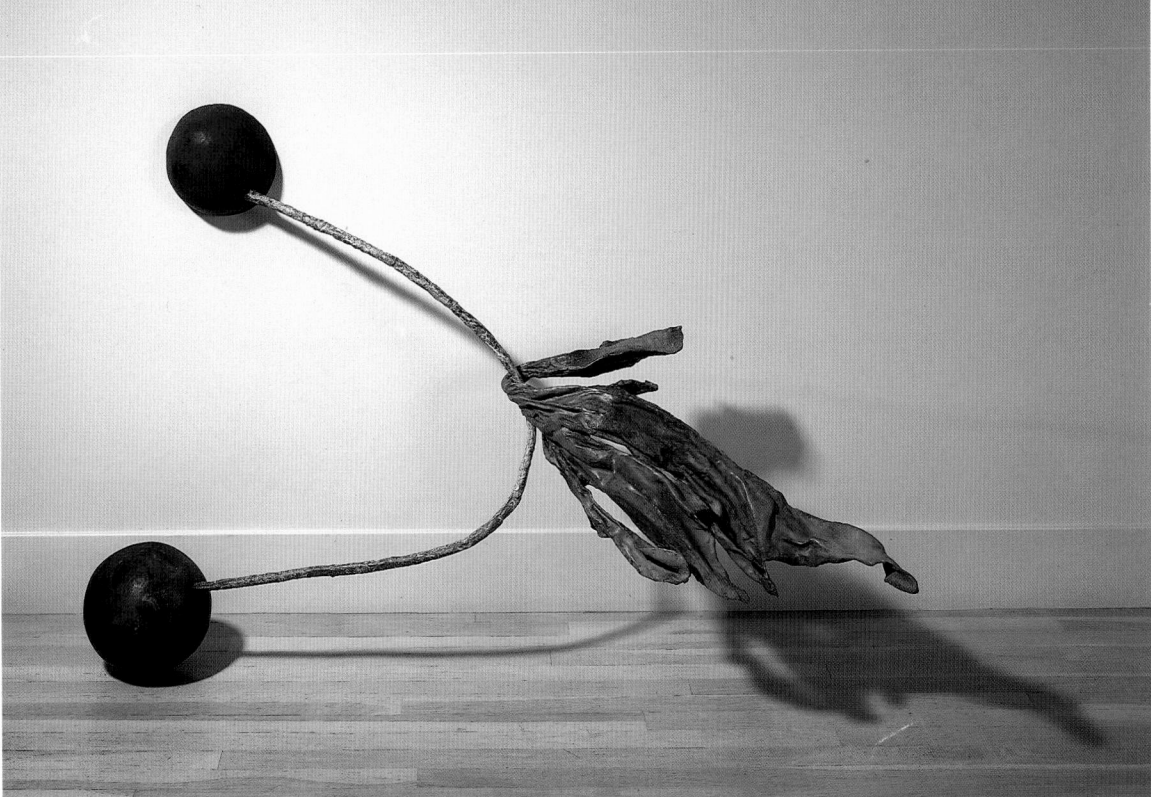

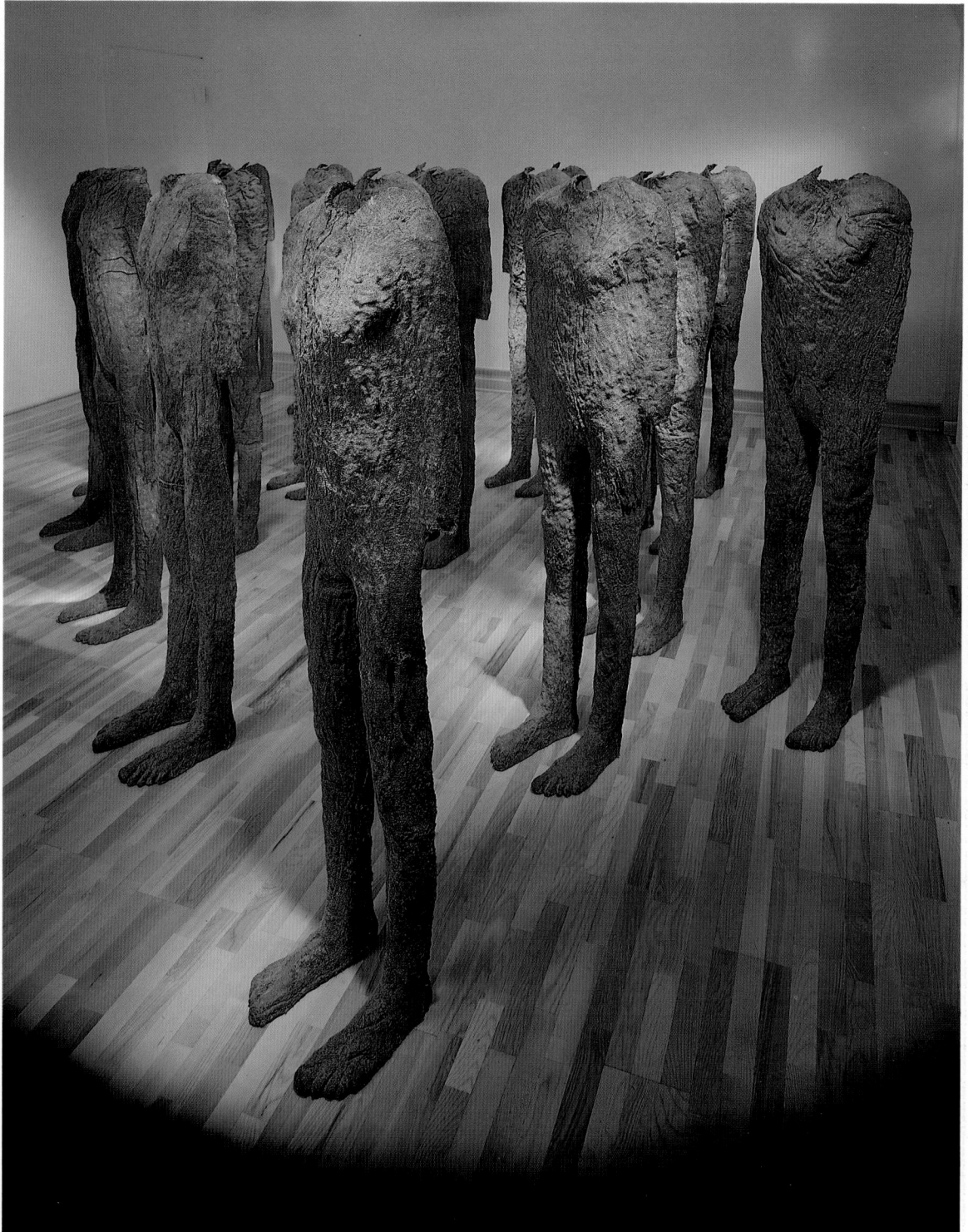

Representation:

RICHARD GRAY GALLERY

620 N. Michigan Avenue
Chicago, IL 60611
312.642.8877
312.642.8488 FAX
Contact:
Paul Gray

Exhibiting:
Modern and contemporary
American and European art

Magdalena Abakanowicz

1. *Crowd #2*
 1988, Burlap and resin,
 (20 Figures)
 67.7" x 20.8" x 15.7"
 each piece

Selected Collections:
 Centre Georges
 Pompidou, Paris

 Metropolitan Museum
 of Art, New York

 Museum of Modern Art,
 New York

 Stedelijk Museum,
 Amsterdam

SCULPTURE

Representation:

**PATRICK DOHENY
& ASSOCIATES
FINE ART**

1811 W. 1st Avenue
Vancouver, BC V6J 4M6
604.737.1733
604.731.4576 FAX

Contact:
Patrick Doheny
Alison Davis
Exhibiting:
Modern and contemporary
painting, drawing, sculpture
and holography

Robert Sutherland

1. *Suspended Light as
 Medium (Model)*
 1990, Rods 22 inches,
 12" x 18" x 36"

2. *Suspended Light as
 Medium (#1)*
 1990, Rods 34 inches,
 36" x 36" x 36"

3. *Mars Probe*
 1990, Base: 36 inches,
 6" x 6" x 1/4"

Selected Biography:
1990 Solo show: Patrick
 Doheny Fine Art Ltd.,
 Vancouver, BC; Group
 show: Glen Dranoff
 Fine Art, New York, NY

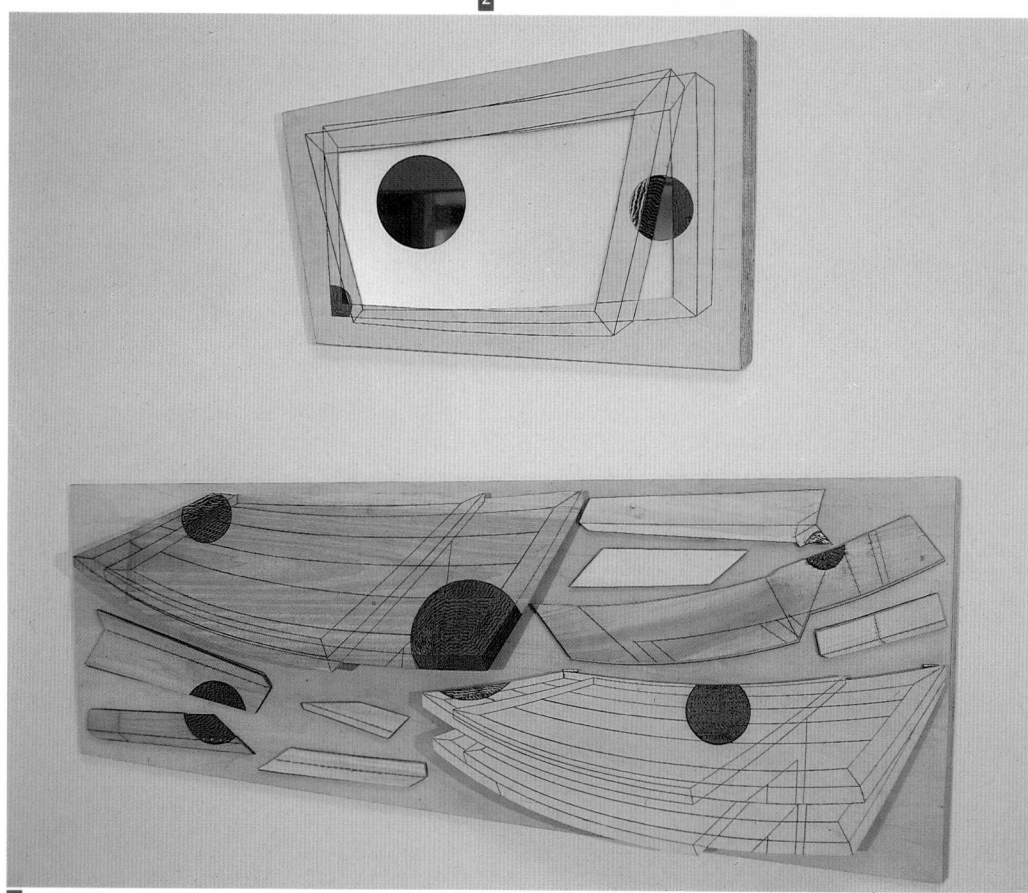

Representation:

THE WORKS GALLERY

106 W. Third Street
Long Beach, CA 90802
213.495.2787
213.495.0370 FAX

Crystal Court/S. Coast Plaza
3333 Bear Street, Third Fl.
Costa Mesa, CA 92626
714.979.6757
714.979.6818 FAX
Contact:
Mark Moore

Exhibiting:
Established and emerging
contemporary artists of
the western United States

Craig Cree Stone

1. *A Condensation of
 Coexistences: Drawing
 Table Series*
 1989, Lacquer on wood,
 acrylic and mirror,
 80" x 70" x 13"

2. *We Shatter Our Traditions
 Re/Deconstructing
 Fragments*
 1989, Lacquer on wood
 and mirror,
 45" x 40" x 10"

3. *Do-it-Yourself Appropriation
 Kit: Drawing Table Series*
 1990, Lacquer on wood,
 mirror and velcro,
 59" x 61" x 4"

Selected Biography:

1992 Solo exhibition: "Recent
Work", The Works
Gallery, Long Beach, CA

1990 Solo exhibition: "Instant
History: Retaining
ReSEMBLANCE",
The Works Gallery,
Long Beach, CA

1989 Solo exhibition: "Don't
Let Frenchmen Tell
You How to Think",
The Works Gallery,
Long Beach, CA

1982 "Craig Cree Stone at
Newport Harbor Art
Museum", Newport
Harbor Art Museum,
Newport Beach, CA

Representation:

J. ROSENTHAL FINE ARTS

230 W. Superior Street
Chicago, IL 60610
312.642.2966
312.642.5169 FAX
Contact:
Dennis Rosenthal

Exhibiting:
20th century modern and
contemporary international
uniques and multiples

Sacha Sosno

1. *That Which is Soft Gets
 Better of that Which is
 Hard*
 1983, Bronze,
 12 5/8" h.

2. *Head to the Four Winds*
 1980, Bronze,
 12 5/8" x 6 7/8" x 8 1/4"

3. *Monter Ici, Plus Haut*
 1989, Bronze,
 34 cm h.

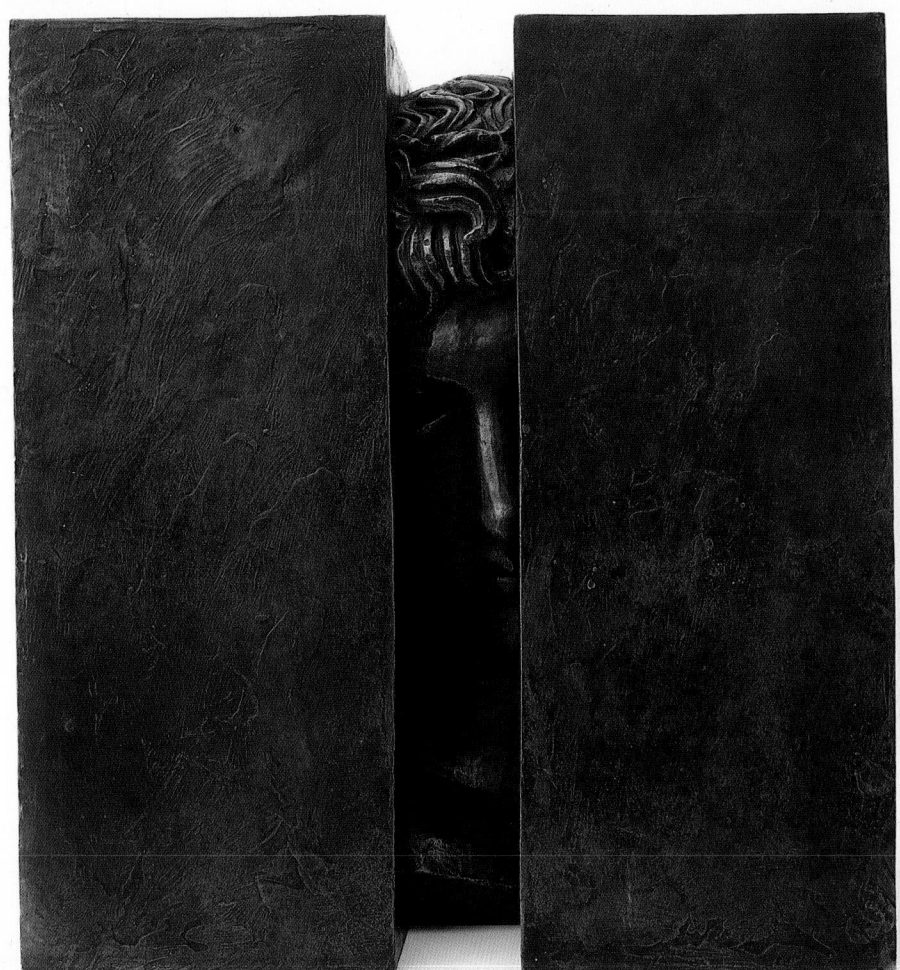

Selected Biography:
1991 J. Rosenthal Fine Arts,
 Chicago, IL; Galerie
 "Arts of this Century",
 Paris, France
1990 Bass Museum, Miami,
 FL; Taipei Fine Arts
 Museum, China
1989 Tampa Museum of Art,
 Tampa, FL

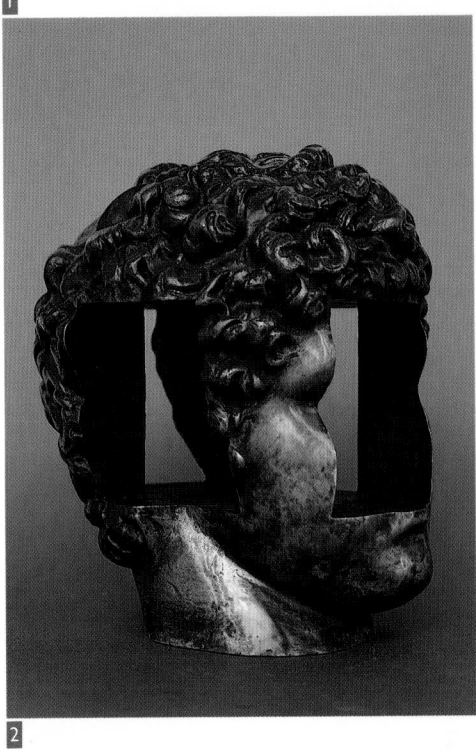

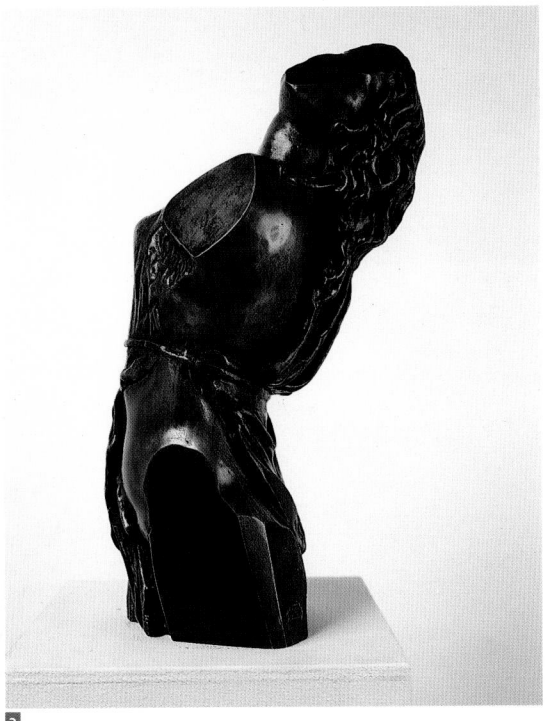

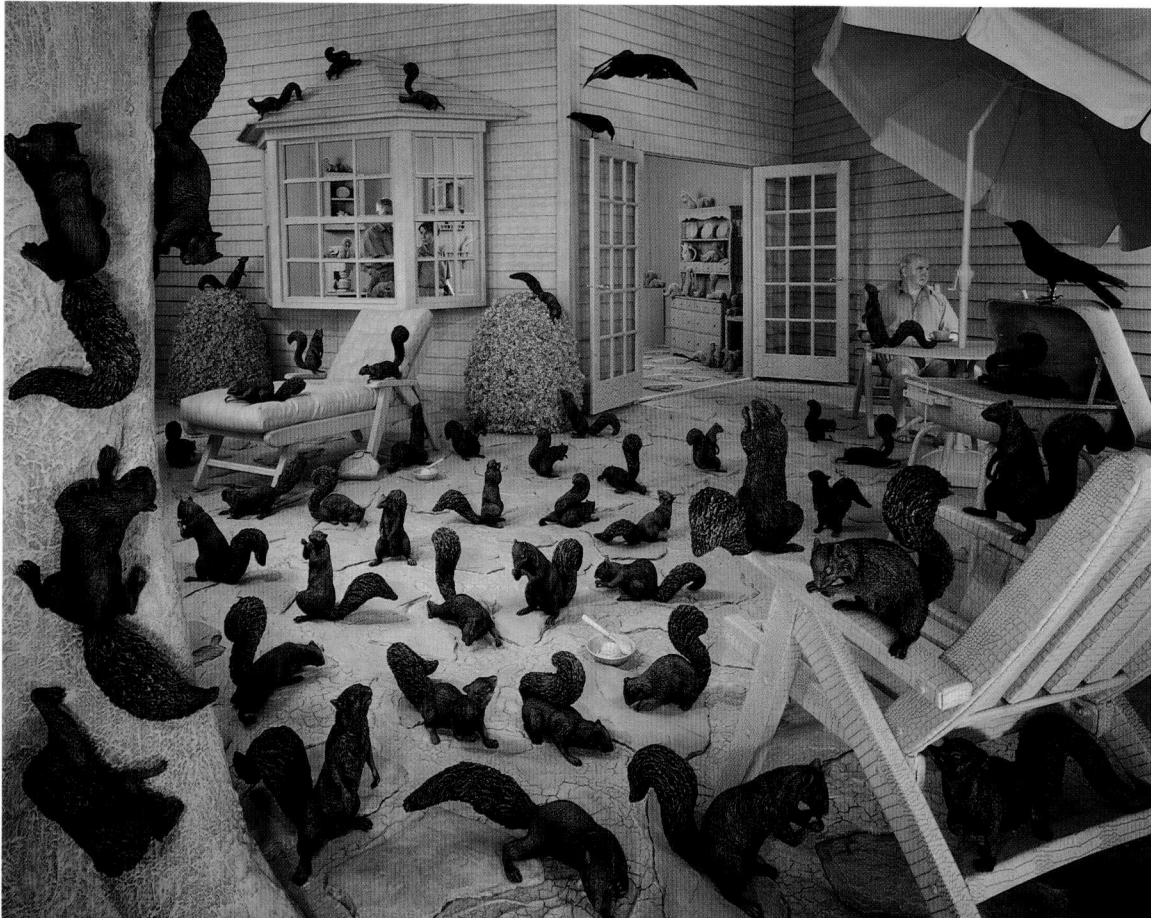

1

Representation:

FAY GOLD GALLERY

247 Buckhead Avenue
Atlanta, GA 30305
404.233.3843
404.365.8633 FAX

Contact:
Fay Gold
Sophia Lyman
Exhibiting:
Modern and contemporary
art and photography

Sandy Skoglund

1. *Gathering Paradise*,
 1991, Cibachrome
 photograph,
 50" x 70", Edition of 30

2. *A Breeze at Work*,
 1987, Cibachrome
 photograph,
 40" x 60", Edition of 30

3. *Fox Games*,
 1989, Cibachrome
 photograph,
 50" x 70", Edition of 30

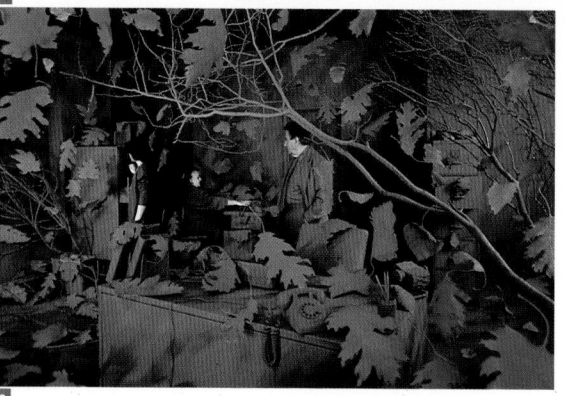

2

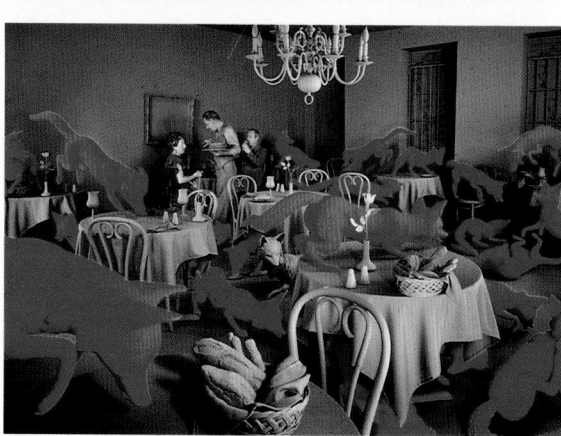

3

Selected Biography:
1991 "The Green House"
Installation, Fay Gold
Gallery, Atlanta, GA;
"Gathering Paradise"
Installation, Carl
Solway Gallery,
Cincinnati, OH

Representation:

BIOTA GALLERY

8500 Melrose Avenue
West Hollywood, CA 90069
213.289.0979
213.289.0547 FAX
Contact:
Donna M. Kobrin

Exhibiting:
Contemporary art by
emerging artists

David Shipley

1. *Sweet Dreams*
 1991, Mixed media,
 60" x 60" x 11"

2. *The Third Riddle*
 1991, Mixed media,
 60" x 23" x 9"

3. *The Whore of Babylon*
 1991, Mixed media,
 70" x 39" x 40"

Selected Biography:
1991 Solo show: "Spiritual
Torrents: A Study in
Contrasts", Biota
Gallery, West
Hollywood, CA
1990 Group show:
Devorzon Gallery,
West Hollywood, CA
1989 Group show:
Schwartz/Cierlak, Santa
Monica, CA
1983 Honorable Mention,
Artist Guild, Post, TX

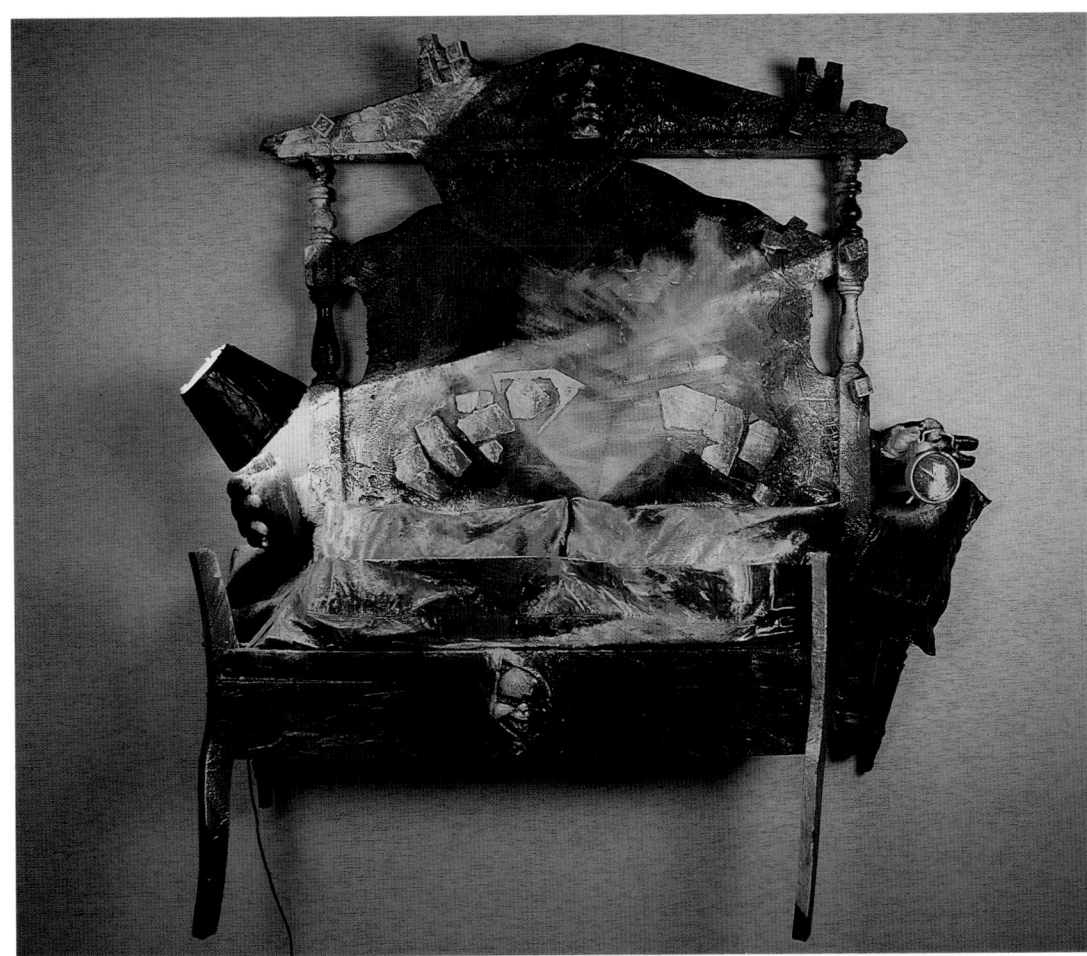

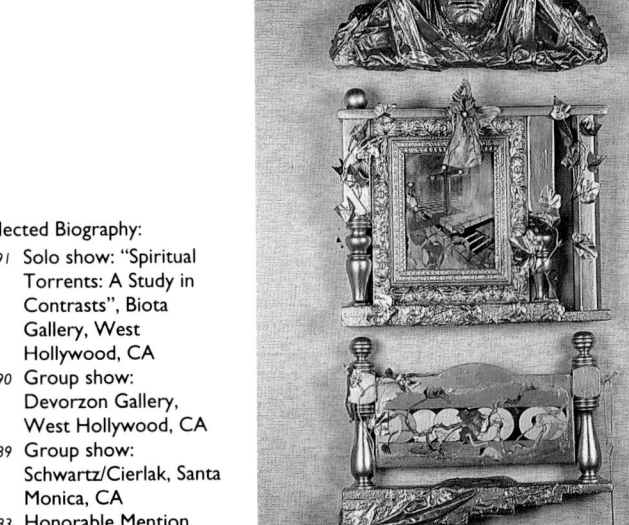

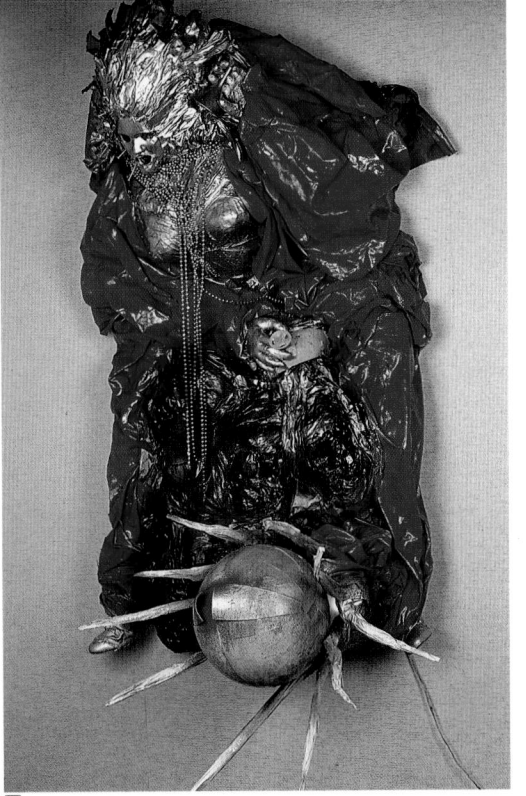

Representation:

303 GALLERY

89 Greene, 2nd Fl.
New York, NY 10012
212.966.5605
212.941.9828 FAX
Contact:
Lisa Spellman

Exhibiting:
Emerging conceptual artists
from the U.S. and Europe

Thomas Ruff

1. *Portrait*
 1989, Ektacolor print,
 83" x 65"
 Collection: Museum of
 Modern Art, NY

Selected Biography:
1991 Solo exhibition:
 Kunstverein, Bonn,
 Germany;
 Group exhibition:
 "Metropolis", Martin-
 Gropius Bau, Berlin,
 Germany
1990 Solo exhibition:
 "Stars", 303 Gallery,
 New York, NY
1989 Solo exhibition:
 "Portraits, Houses,
 Stars" Stedelijk
 Museum, Amsterdam,
 The Netherlands
1988 Group exhibition:
 "Aperto 88", Venice
 Beinnale, Venice, Italy

Representation:

ROBBIN LOCKETT GALLERY

703 N. Wells Street
Chicago, IL 60610
312.649.1230
312.649.9159 FAX
Contact:
Robbin Lockett

Exhibiting:
Contemporary American
and European art

Mitchell Kane

1. *Chuckles*
 1991, Enamel, imron,
 shellac, wood panel,
 wool sweater
 25" x 18" x 2"

Selected Biography:
1991 Solo exhibitions:
 Galerie Ralph
 Wernicke, Stuttgart;
 Herron Gallery, IUPUI,
 Indianapolis
1990 Solo exhibition:
 Andrea Rosen Gallery,
 New York, NY;
 Group exhibitions:
 Cleveland Center for
 Arts, Ohio; Carnegie
 Mellon Art Gallery,
 Pittsburgh
1989 Solo exhibition:
 Robbin Lockett Gallery,
 Chicago

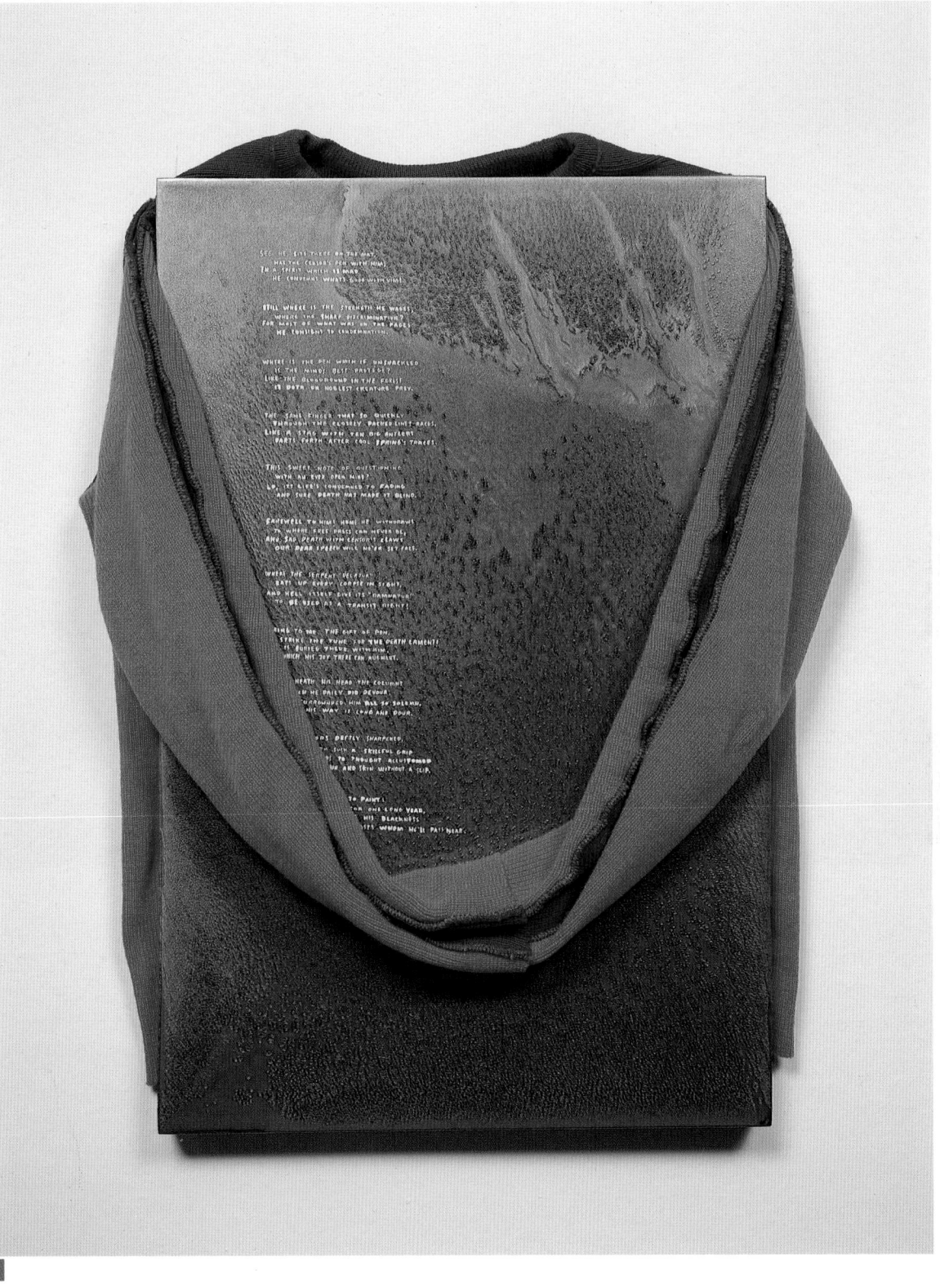

1

1

Representation:

CHRISTOPHER
GRIMES GALLERY

1644 17th Street
Santa Monica, CA 90404
213.450.5962
213.450.7882 FAX
Contact:
Christopher Grimes

Exhibiting:
Contemporary art

Lewis deSoto

1. *Edison Song (Tesla Sings for a Deaf Edison)*
 1990, Detail from audio installation, Headlands Center for the Arts, Fort Barry, Sausalito, CA

Selected Biography:
1992 "The Spacial Drive",
The New Museum of Contemporary Art,
New York, NY
1991 "Songs of Menil",
Christopher Grimes Gallery, Santa Monica, CA; "The Language of Paradise", Artist Space, New York, NY

Representation:

**PATRICK DOHENY
& ASSOCIATES
FINE ART**

1811 W. 1st Avenue
Vancouver, BC V6J 4M6
604.737.1733
604.731.4576 FAX

Contact:
Patrick Doheny
Alison Davis
Exhibiting:
Modern and contemporary
painting, drawing, sculpture
and holography

Melissa Crenshaw & Sydney Dinsmore

1. *Detail from Series,
"Is This What You Want?"*
1989-90, Hologram,
12" x 16"

2. *Detail from Series,
"Is This What You Want?"*
1989-90, Hologram,
12" x 16"

3. *Details from Series,
"Choice/What Choice"*
1989-90, Hologram,
Each 12" x 16"

Selected Biography:
1991 "Choice and
Circumstance",
The Atlanta Gallery of
Holography, Atlanta, GA
1990 Museum of Holography,
Koln, Germany
1989 International Exhibition
of Holography, Nagoya
Science Museum,
Nagoya, Japan; "Is This
What You Want?",
Israeli Museum of
Science and Technology,
Tel Aviv, Israel

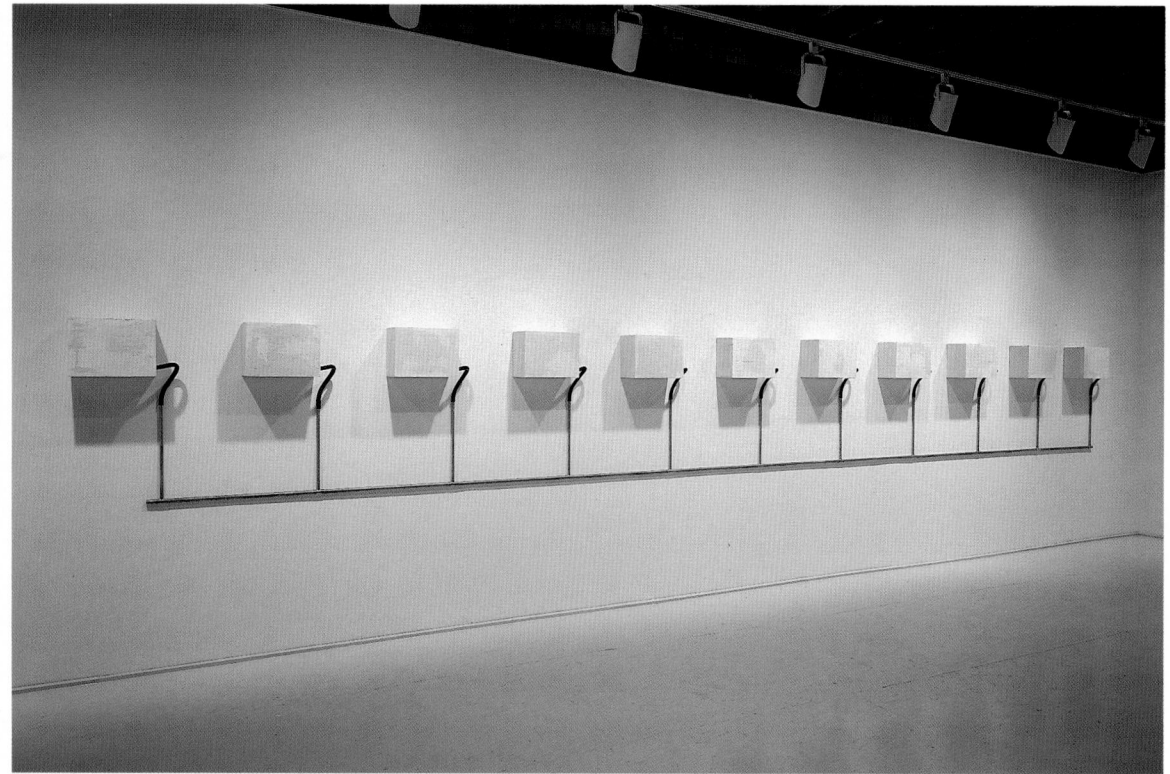

Representation:

RHONA HOFFMAN GALLERY

215 W. Superior Street
Chicago, IL 60610
312.951.8828
312.951.5274 FAX
Contact:
Rhona Hoffman
Susan Reynolds
Exhibiting:
American and European
contemporary art

Pedro Cabrita Reis

1. *Sistemas de Ansiedade (Systems of Anxiety)*
 1991, Plaster, wood, copper, rubber,
 37" x 330" x 8"

2. *O Mesmo e Outro (The Same and Other)*
 1991, Plaster, wood,
 60" x 50" x 23"

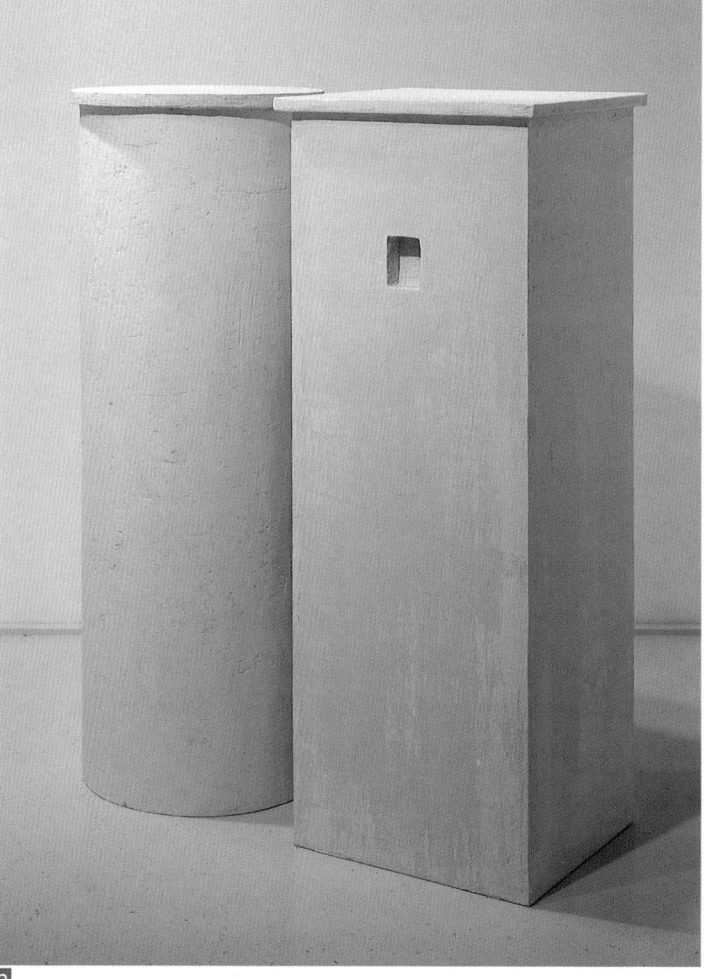

Selected Biography:
1992 "Documenta IX", Kassel, Germany; Power Plant, Toronto, Canada
1991 Rhona Hoffman Gallery, Chicago; Burnett Miller Gallery, Los Angeles; "Metropolis", Martin Gropius Bau, Berlin, Germany; "Os Lugares Cegos", Jennifer Flay Galerie, Paris, France

Representation:

RHONA HOFFMAN GALLERY

215 W. Superior Street
Chicago, IL 60610
312.951.8828
312.951.5274 FAX

Contact:
Rhona Hoffman
Susan Reynolds
Exhibiting:
American and European
contemporary art

Pedro Cabrita Reis

1. *Genitrix*
 1991, Plaster, wood,
 glass, felt, copper,
 rubber hose,
 48" x 40" x 48 1/2"

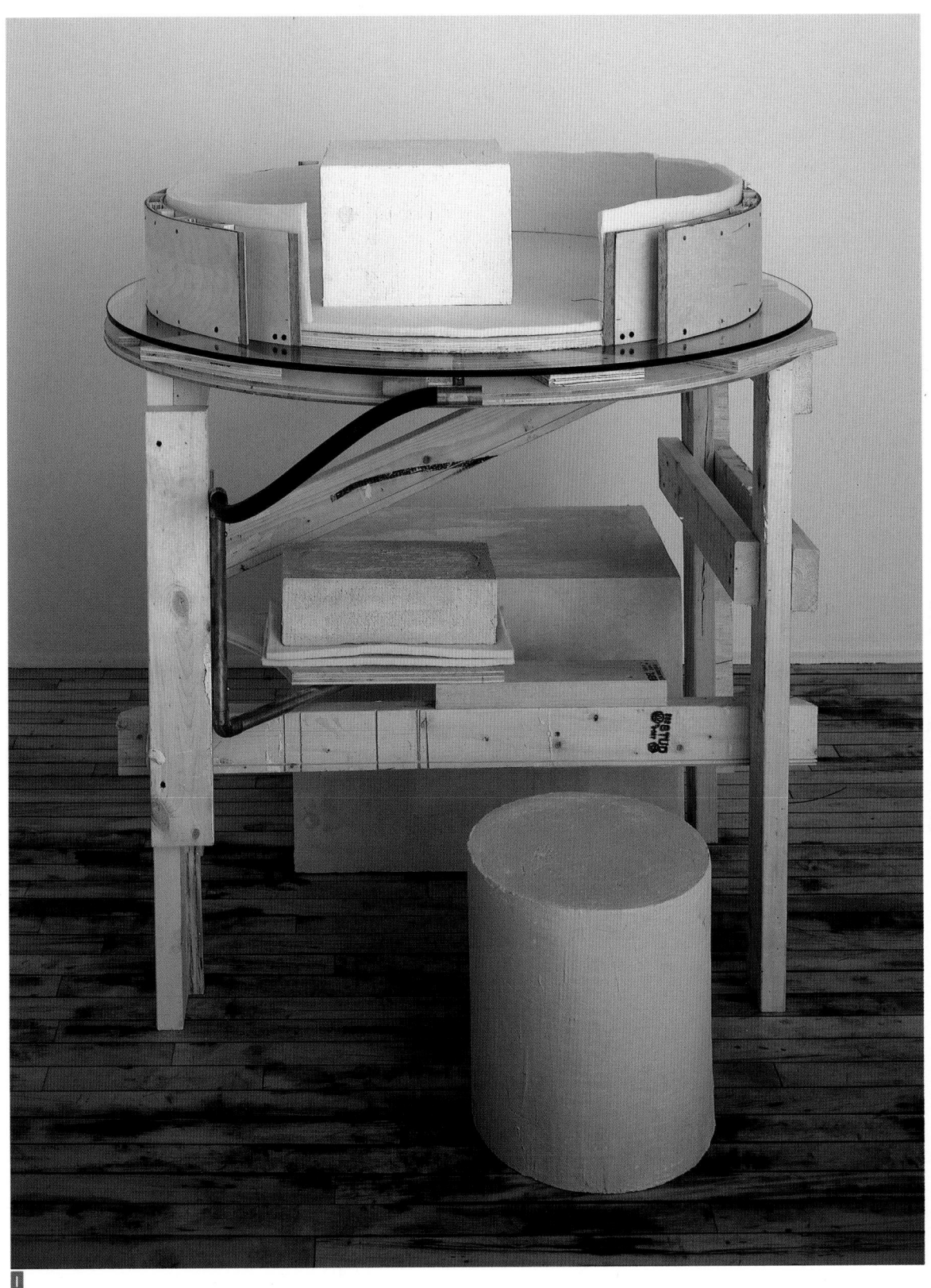

1

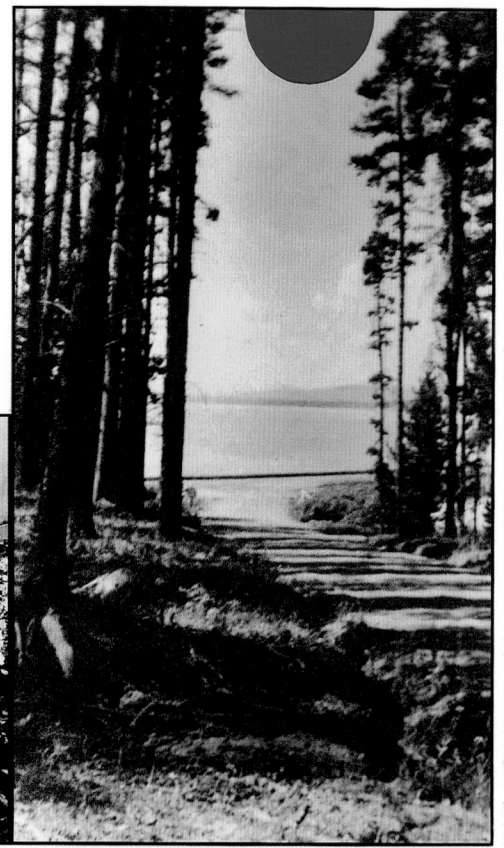

Representation:

**MARGO LEAVIN
GALLERY**

812 N. Robertson Boulevard
Los Angeles, CA 90069
213.273.0603
213.273.9131 FAX
Contact:
Margo Leavin
Wendy Brandow
Exhibiting:
Contemporary art from
Europe and America

John Baldessari

1. *Landscape and Person
 (With Bomb)*
 1990, B&W photos, oil
 tint, vinyl paint,
 80" x 116"

2. *Helicopter (Blue Sky And
 Cloud)/Covered Wagon
 (In Flames)*
 1991, Color photos,
 acrylic paint,
 48" x 24 1/2" ·

Selected Biography:
1991 "John Baldessari",
 Whitney Museum
 of American Art
 (Organized by
 The Museum of
 Contemporary Art, LA)
1990 Margo Leavin Gallery,
 Los Angeles, CA
1989 "Not Even in This
 Way: John Baldessari",
 Centro National de
 Exposiciones, Madrid

CONCEPTUAL & INSTALLATION

MARCELLE
FINE ARTS, INC.

996 Madison Avenue
New York, NY 10021
212.737.5786
212.737.4387 FAX

Andrew Wyeth

1. *Afternoon Flight*
Limited edition collotype,
22 7/8" x 28 1/2"
© Andrew Wyeth

Selected Biography:
1990 1st artist to receive Congressional Gold Medal, presented by President George Bush
1987 "The Helga Pictures", National Gallery of Art, Washington, DC
1976 The Metropolitan Museum of Art, New York, NY
1963 Presidential Freedom Medal, given by the President of the United States

Representation:

GRAYSTONE

250 Sutter Street #330
San Francisco, CA 94108
415.956.7693
415.398.0667 FAX

Contact:
Edmond Russell

Exhibiting:
Contemporary prints and
works on paper

Wayne Thiebaud

1. *Lipstick Row*
 1970, Silkscreen,
 22 1/2" x 30", Edition 50

2. *Cherry Stand*
 1964, Watercolor
 over etching,
 5" x 7"

Representation:

**CHARLES
WHITCHURCH
GALLERY**

5973 Engineer Drive
Huntington Beach, CA 92694
714.373.4459
714.373.4615 FAX

Contact:
Douglas Deaver, Ph.D.

Exhibiting:
Paintings, sculpture, and
graphic works by modern
and contemporary artists

Rufino Tamayo

1. *Hombre en la ventana*
 1980, Mixografía,
 36" x 28", Edition 99

2. *Hombre con bastón*
 1980, Mixografía,
 36" x 28", Edition 99

3. *Dos Personajes atacados
 por perros*
 1983, Mixografía,
 60" x 96", Edition 75

Selected Biography:
1991 "Mexican Masters",
Charles Whitchurch
Gallery, Huntington
Beach, CA; "Mexico:
Splendors of 30
Centuries", The
Metropolitan Museum,
NY and Los Angeles
County Museum of Art
1990 "Rufino Tamayo",
Charles Whitchurch
Gallery, Huntington
Beach, CA and The
Riverside Art Museum,
Riverside, CA

Representation:

**CHARLES
WHITCHURCH
GALLERY**
5973 Engineer Drive
Huntington Beach, CA 92694
714.373.4459
714.373.4615 FAX
Contact:
Douglas Deaver, Ph.D.

Exhibiting:
Paintings, sculpture, and
graphic works by modern
and contemporary artists

Michael Rubin

I. Red Weave
1990, Lithograph,
47 1/2" x 25", Edition 25
Published by Shark's Inc.

Selected Biography:
1991 "Michael Rubin: Inner
Galaxies", Charles
Whitchurch Gallery,
Huntington Beach, CA;
Group exhibition:
Shark's Incorporated,
New York Armory
1990 Group exhibition:
Shark's Incorporated,
Chicago International
Art Exposition

Representation:

**CHARLES
WHITCHURCH
GALLERY**

5973 Engineer Drive
Huntington Beach, CA 92694
714.373.4459
714.373.4615 FAX

Contact:
Douglas Deaver, Ph.D.

Exhibiting:
Paintings, sculpture, and
graphic works by modern
and contemporary artists

James Rosenquist

1. *The Bird of Paradise
 Approaches the Hot
 Water Planet*
 1989, Colored, pressed
 paper pulp, lithograph,
 collage,
 97" X 84 1/2" (2 sheets),
 Edition 28

Selected Biography:
1991 Group exhibition:
 Charles Whitchurch
 Gallery, Huntington
 Beach, CA
1990 "James Rosenquist:
 Welcome to the
 Water Planet", The
 Museum of Modern
 Art, New York;
 "James Rosenquist",
 Leo Castelli Gallery,
 New York

Representation:

CFM GALLERY

138 W. 17th Street
New York, NY 10011
212.929.4001
212.691.5453 FAX
Contact:
Neil P. Zukerman

Exhibiting:
Contemporary European
and American Masters;
Surrealism and
Representational

Michael Parkes

1. *Cleopatra*
 1990, Original
 stone lithograph,
 27" x 36"

2. *Returning the Sphere*
 1991, Original
 stone lithograph,
 25" x 35"

3. *Broken Promises*
 1985, Original
 stone lithograph,
 30" x 22"

Selected Biography:
1991 International Gallery
 Invitational, Chicago
1989 International Art Fair,
 Basel
1986 Galerie Steltman,
 Retrospective,
 Amsterdam
1985 International Senefelder
 Prize for Lithography

Representation:

PRIOR EDITIONS

303-1028 Hamilton Street
Vancouver, BC V6B 2R9
604.685.0535

Contact:
Torrie Groening
Nigel Harrison
Exhibiting:
Contemporary
Canadian graphics

David Ostrem

1. *Steadfast Contemplation*
 1991, Lithograph
 16" x 19"

2. *Male Figure*
 1991, Lithograph,
 20" x 26"

3. *Female Figure*
 1991, Lithograph,
 20" x 26"

Selected Biography:
1991 Solo show:
 Prior Editions,
 Vancouver, BC
1990 Solo show: Burnaby
 Public Art Gallery,
 Burnaby, BC

Representation:

**TYLER
GRAPHICS LTD.**

250 Kisco Avenue
Mount Kisco, NY 10549
914.241.2707
914.241.7756 FAX
Contact:
Barbara Delano

Exhibiting:
Fine art publishers/printers
of limited edition graphics
and multiples

John Newman

1. *Spin Cloud*
 1990, Etching,
 aquatint, drypoint,
 30" x 24", Edition 35

Selected Biography:
1991 John Berggruen Gallery,
San Francisco, CA;
Galerie Carola Mosch,
Berlin, Germany
1990 Galerie Jahn und
Fusban, Munich,
Germany; Heland
Wetterling Gallery,
Stockholm, Sweden;
David Nolan Gallery,
New York, NY;
Galerie Schmela,
Dusseldorf, Germany
1988 New York Academy of
Sciences, New York,
NY; Gagosian Gallery,
New York, NY; Daniel
Weinberg Gallery,
Los Angeles, CA

Representation:

GRAYSTONE

250 Sutter Street #330
San Francisco, CA 94108
415.956.7693
415.398.0667 FAX

Contact:
Edmond Russell

Exhibiting:
Contemporary prints and
works on paper

Robert Motherwell

1. *Black For Mozart*
 1991, Lithograph on
 handmade paper,
 64" x 41" Edition 40

Representation:

**FRANZ BADER
GALLERY**

1500 K Street NW
Washington, DC 20005
202.393.6111

Contact:
Wretha Hanson

Exhibiting:
Contemporary American
sculpture, paintings and
works on paper

Peter Milton

1. *Interiors VII: The
 Train from Munich*
 1991, Etching
 and engraving,
 20" x 36"

2. *Interiors IV: Hotel
 Paradise Cafe*
 1987, Etching
 and engraving,
 23 1/2" x 35 1/2"

Representation:

**TYLER
GRAPHICS LTD.**

250 Kisco Avenue
Mount Kisco, NY 10549
914.241.2707
914.241.7756 FAX
Contact:
Barbara Delano

Exhibiting:
Fine art publishers/printers
of limited edition graphics
and multiples

Terence La Noue

1. *Search for Atlantis*
 1991, Etching, aquatint,
 lithograph collage,
 43 1/4" x 52", Edition 35

Selected Biography:
1991 Zolla/Lieberman
Gallery, Chicago, IL;
Galerie Keeser-Bohbot,
Hamburg, Germany;
Galerie Charchut &
Werth, Dusseldorf,
Germany
1990 André Emmerich Gallery,
New York, NY; Dorothy
Goldeen Gallery, Santa
Monica, CA; Heland
Wetterling Gallery,
Stockholm, Sweden
1989 André Emmerich Gallery,
New York, NY; Heland
Wetterling Gallery,
Stockholm, Sweden;
Davis/McClain Gallery,
Houston, TX

Representation:

GRAYSTONE

250 Sutter Street, #330
San Francisco, CA 94108
415.956.7693
415.398.0667 FAX
Contact:
Edmond Russell

Exhibiting:
Contemporary prints
and works on paper

Jasper Johns

1. *Between the Clock
 and the Bed*
 1989, Fourteen-
 color lithograph,
 Edition of 50
 26 1/4" x 40 1/4"

Representation:

CHICAGO CENTER
FOR THE PRINT

1509 W. Fullerton
Chicago, IL 60614
312.477.1585

Contact:
Richard H. Kasvin
David Grossfeld
Exhibiting:
American contemporary
prints, 19th century vintage
posters, works on paper,
archival framing

Yuji Hiratsuka

1. *Rumba Queen Plays
 Her Song of Love*
 1990, Chine
 colle etching,
 35 3/4" x 24"

2. *Flower Crown*
 1991, Chine
 colle etching,
 24" x 17 3/4"

3. *Eternal Triangle*
 1991, Chine
 colle etching,
 35 1/2" x 47 1/2"

Selected Biography:
1991 Purchased by the
 British Museum
 of Art, London
1988 The 6th Seoul
 International Print
 Biennale - Korea,
 Superior Class Prize;
 5th International
 Biennial Exhibition,
 Tuzla, Yugoslavia,
 Grand Dipolma Award
1986 Pratt Silvermine,
 Pratt Graphic Center,
 New York City,
 Purchase Award

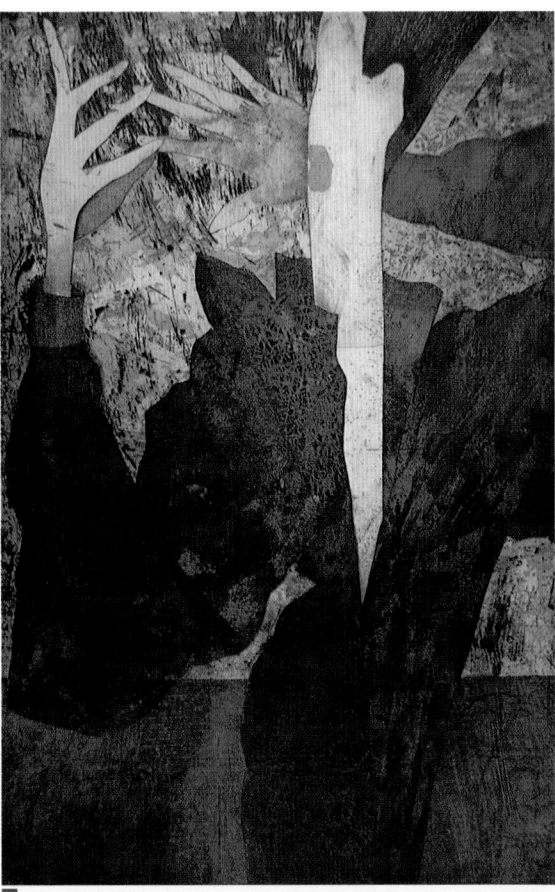

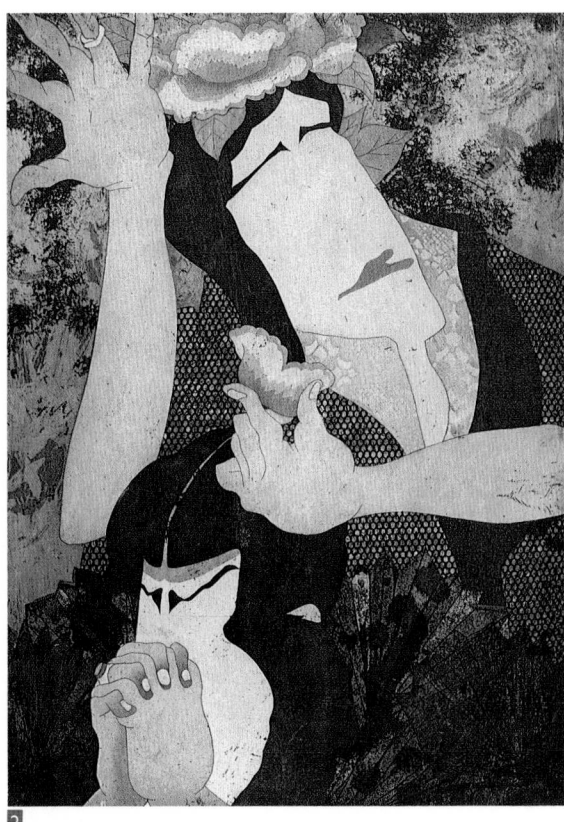

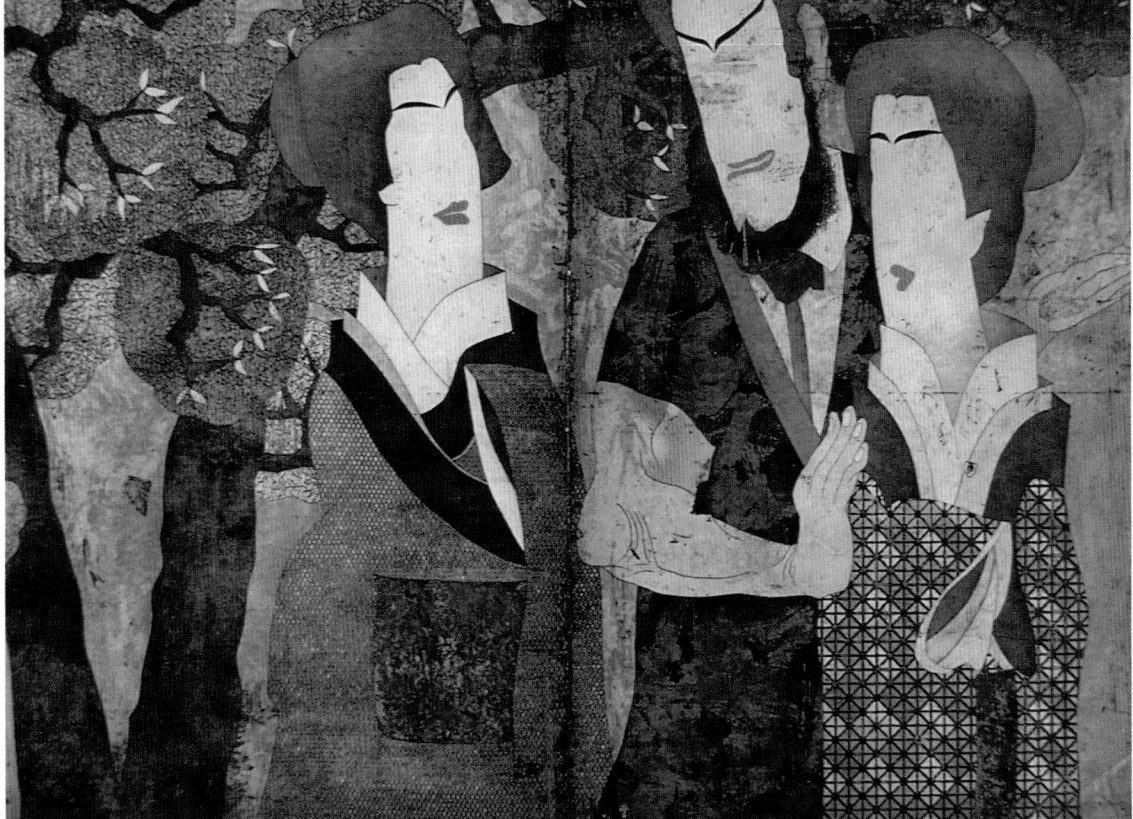

1

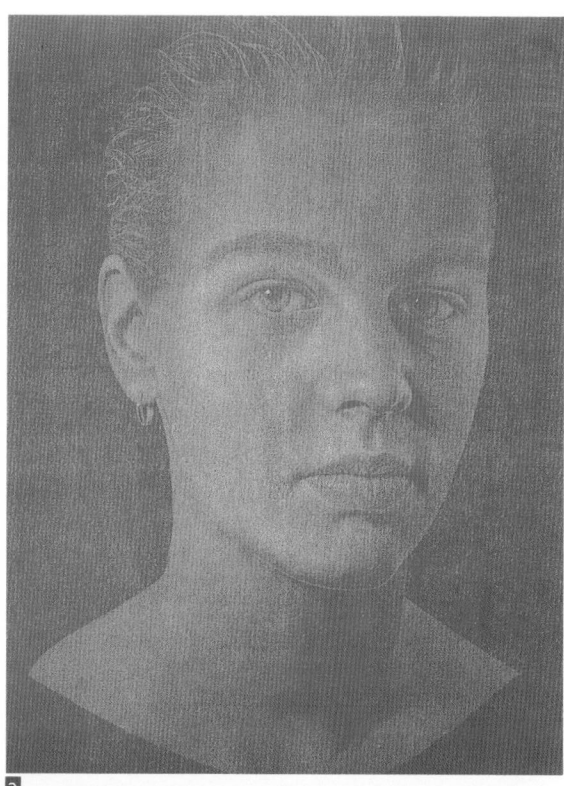

2

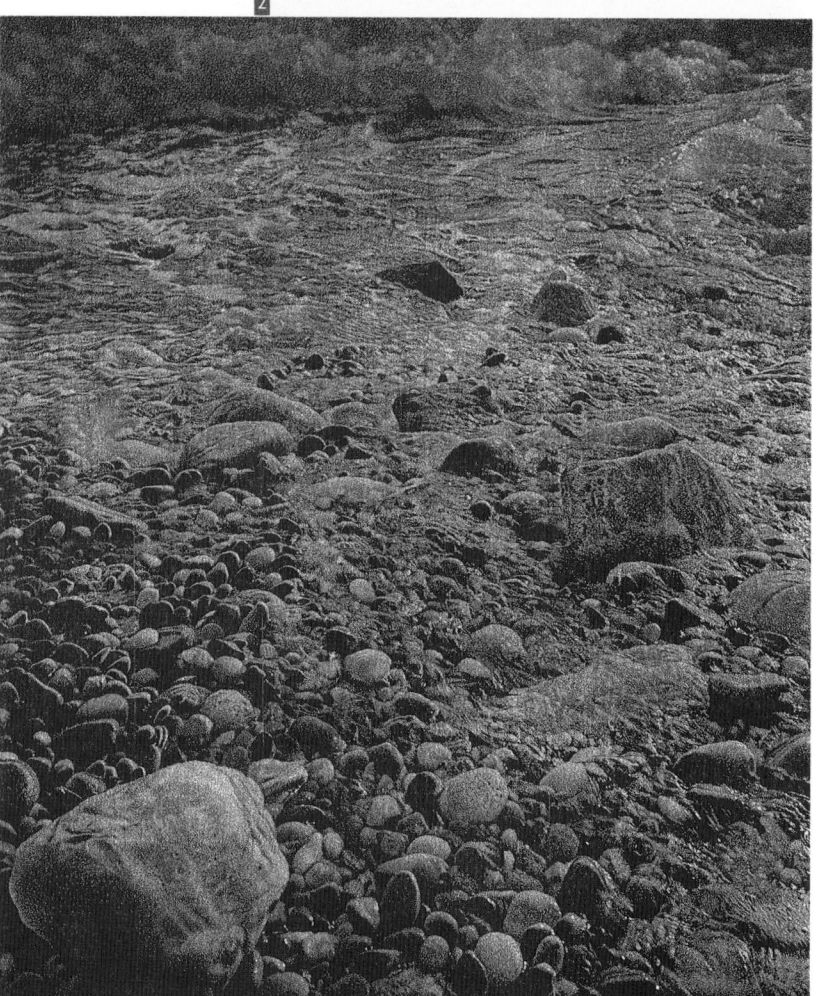

3

Representation:

PERIMETER GALLERY

750 N. Orleans Street
Chicago, IL 60610
312.266.9473
312.266.7984 FAX
Contact:
Frank Paluch

Exhibiting:
Contemporary art

Franz Gertsch

1. *Natasha II*
 1986, Woodcut,
 49" x 40"

2. *Natasha IV*
 1988, Woodcut,
 107" x 83"

3. *Cima Del Mar*
 1991, Woodcut,
 56" x 89 1/2"

Selected Biography:
1991 Solo shows: Hirshhorn
Mueum, Washington,
DC; San Jose Museum
of Art, San Jose, CA;
Centro Reina Sofia,
Madrid, Spain
1990 Solo show: Museum
of Modern Art,
New York, NY
1989 Solo show: Museé
Rath, Geneva,
Switzerland

Representation:

GRAYSTONE

250 Sutter Street #330
San Francisco, CA 94108
415.956.7693
415.398.0667 FAX

Contact:
Edmond Russell

Exhibiting:
Contemporary prints and
works on paper

Sam Francis

1. *Untitled*
 1980, Monotype,
 30" x 25"

2. *Untitled*
 1981, Monotype,
 29" x 24"

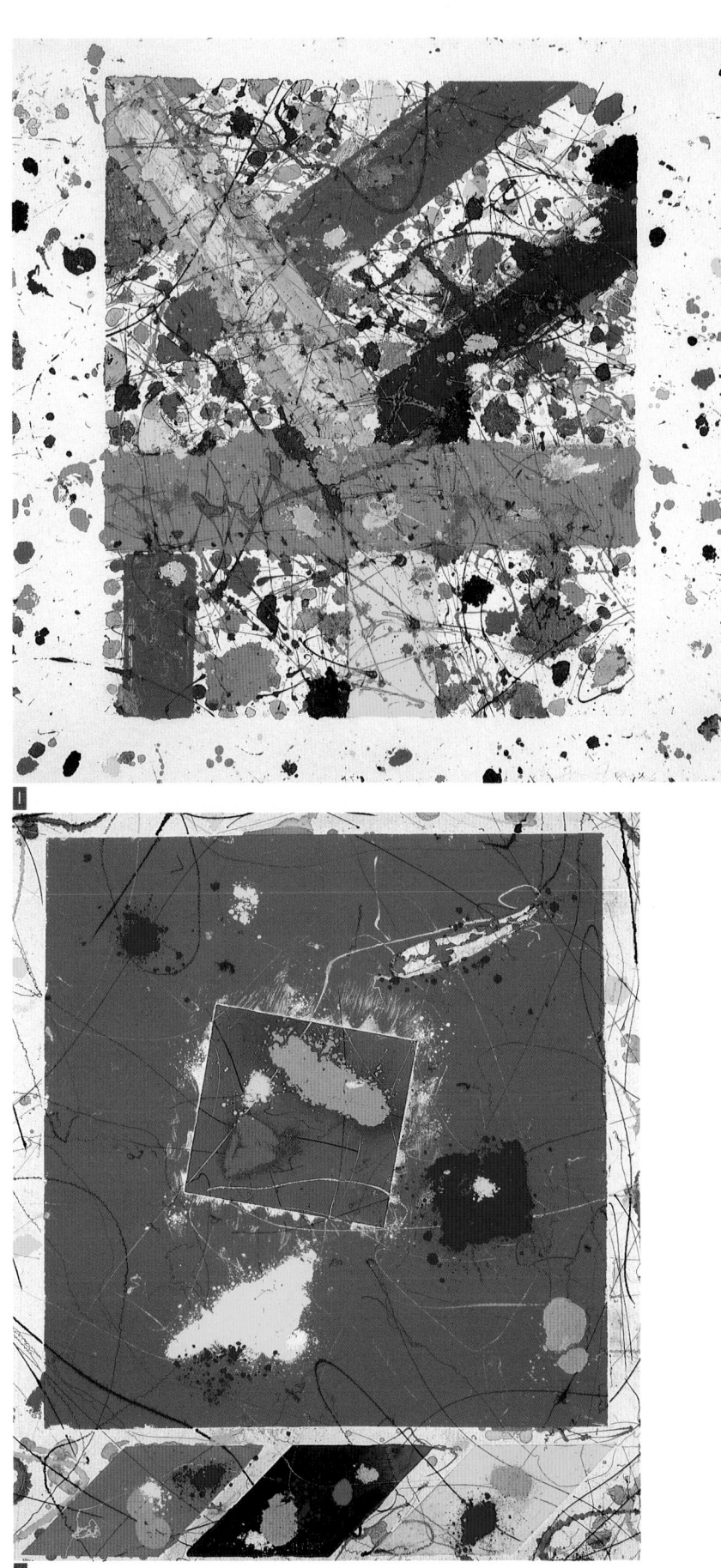

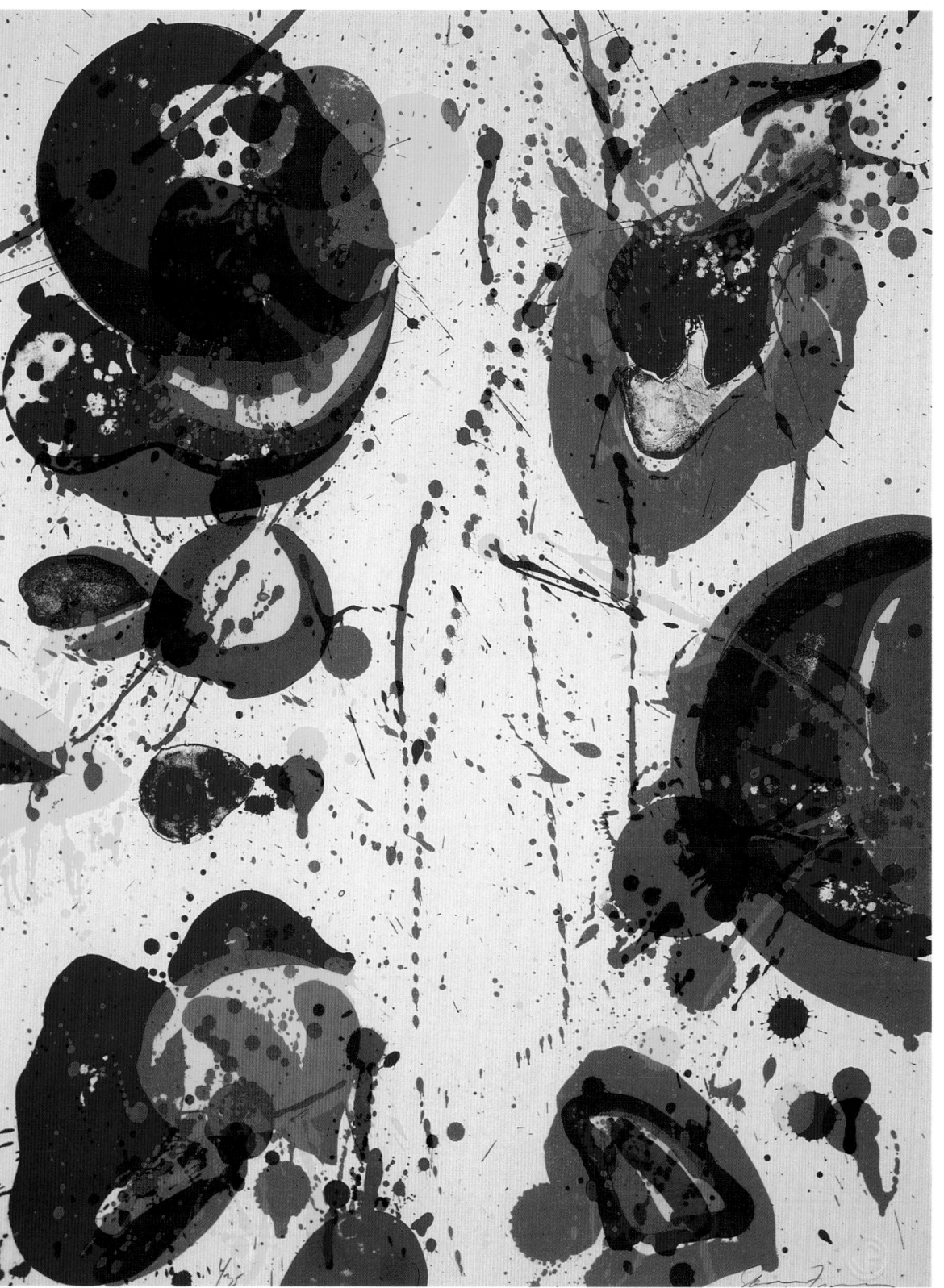

Representation:

**ASSOCIATED
AMERICAN ARTISTS**

20 W. 57th Street
New York, NY 10019
212.399.5510
212.582.9697 FAX

Exhibiting:
Modern and Contemporary
Prints

Sam Francis

1. *For Rudd (SF 45)*
 1963-64, Lithograph,
 13 1/2" x 10"

Selected Biography:

1991 "Sam Francis; Prints and
Drawings from the
1960s and 1970s",
Associated American
Artists

1990 "Sam Francis; Prints and
Drawings 1957-1989",
Associated American
Artists

1989 "Contemporary
Masters; Diebenkorn,
Dine, and Francis",
Associated American
Artists

Representation:

GRAYSTONE

250 Sutter Street #330
San Francisco, CA 94108
415.956.7693
415.398.0667 FAX

Contact:
Edmond Russell

Exhibiting:
Contemporary prints and
works on paper

Richard Diebenkorn

1. *Large Light Blue*
 1980, Spitbite and
 aquatint etching,
 40" x 26" Edition 35

SOLO GALLERY
SOLO PRESS

578 Broadway, 6th Fl.
New York, NY 10012
212.925.3599
212.226.3251 FAX

Contact:
Ruth Resnicow
Judith Solodkin

Publishers, printers and
exhibitors of fine prints
and livres d'artiste

Michael David

1. *The Georgia Series (Large)*
 1991, Lithograph,
 woodcut, chine collé
 and hand coloring,
 46" x 35", Edition of 50,
 from a series of 3

Selected Biography:
1991 Solo exhibitions: Solo
 Gallery, New York;
 M. Knoedler & Co.,
 New York
1990 Solo exhibitions:
 Meredith Long Co.,
 Houston, TX;
 M. Knoedler & Co.,
 New York
1989 Solo exhibiton:
 M. Knoedler & Co.,
 New York

Representation:

J. ROSENTHAL
FINE ARTS

230 W. Superior Street
Chicago, IL 60610
312.642.2966
312.642.5169 FAX
Contact:
Dennis Rosenthal

Exhibiting:
20th century modern and
contemporary international
uniques and multiples

Christo

1. *Lower Manhattan
 Wrapped Buildings,
 Project for 2 Broadway,
 20 Exchange Place*
 1964-90, Mixed media on
 lithograph with collaged
 fabric, twine and city map,
 40" x 26"

Selected Biography:

1985 Project in progress:
 "Umbrellas Project for
 Japan and Western
 U.S.A."

Representation:

**CROWN POINT
PRESS**

568 Broadway
New York, NY 10012
212.226.5476
212.966.7042 FAX

657 Howatd Street
San Francisco, CA 94105
415.974.6273
415.495.4220 FAX

Contact:
Karen McCready
Valerie Wade
Exhibiting:
Publishers of etchings and
color woodblock prints

John Cage

1. *Smoke Weather, Stone
 Weather #34*
 1991, Unique etching
 on smoked paper,
 15" x 25"

2. *The Missing Stone*
 1989, Spitbite aquatint
 etching on smoked paper,
 54" x 41", Edition 25

Representation:

GALLERY ONE

121 Scollard Street
Toronto, Canada M5R 1G4
416.929.3103
416.929.0278 FAX

Contact:
Goldie Konopny
Sharon Fischtein
Exhibiting:
Contemporary Canadian,
American & International
painting, sculpture & graphics

David Blackwood

1. *For Ishmael Tiller:*
 The Ledgy Rocks
 1990, Etching,
 36" x 24", Edition of 75

Selected Biography:
1991 Gallery One, Toronto,
Ont., Canada; Heffel
Gallery, Vancouver, BC
1990 Gallery One, Toronto,
Ont., Canada; Heffel
Gallery, Vancouver, BC
1987 Major 20 Year
Retrospective
Exhibition, (touring
Internationally)

1

SOLO GALLERY
SOLO PRESS

578 Broadway, 6th Floor
New York, NY 10012
212.925.3599
212.226.3251 FAX
Contact:
Ruth Resnicow
Judith Solodkin

Publishers, printers and
exhibitors of fine prints
and livres d'artiste

Lynda Benglis

1. *Dual Natures (Large)*
 1991, Two lithographs
 with gold leaf on hand
 tinted paper,
 Edition of 20
 47" x 31" each
 47" x 62" overall

2. *Dual Natures (Small)*
 1991, Four lithographs
 with gold leaf on hand
 tinted paper,
 Edition of 25
 31 1/2" x 24" each
 31 1/2" x 96" overall

Selected Biography:

1991 Retrospective
exhibition, High
Museum of Art,
Atlanta, GA; traveling
to New Orleans
Museum of Art, New
Orleans, LA and San
Jose Museum of Art,
San Jose, CA

1990 Solo exhibition:
Paula Cooper Gallery,
New York

PRINTS

Representation:

**PHYLLIS KIND
GALLERY**

136 Greene Street
New York, NY 10012
212.925.1200
212.941.7841 FAX

313 W. Superior Street
Chicago, IL 60610
312.642.6302
312.642.8502 FAX

Contact:
Phyllis Kind

Exhibiting:
Contemporary American,
Soviet, Naive and Outsider
art

Adolf Wölfli

1. *Bänggaalisches Feuerwärk,
 = Portree No. 2*
 1926, Colored pencil
 on paper,
 18 1/2" x 24 1/2"

2. *D's Schatz'l = Chrütz*
 1923, Colored pencil
 on paper,
 18 3/4" x 24 1/2"

Selected Biography:
1988 Traveling exhibition:
"The Other Side of
the Moon: The World
of Adolf Wölfli":
Organized by the
Paley Gallery/Moore
College of Art;
Phyllis Kind Gallery,
New York
1987 Stadelsches
Kunstinstitut Und
Stadtische Galerie,
Frankfurt

Representation:

JESSICA BERWIND GALLERY

301 Cherry Street, 2nd Fl.
Philadelphia, Pa 19106
215.574.1645
215.574.1646 FAX
Contact:
Jessica Berwind

Exhibiting:
Contemporary art in
all mediums

Andrew Topolski

1. *Sounding Break 7*
 1991, Graphite, pigment,
 transfer type on paper,
 53" x 36"

Selected Biography:
1991 Jessica Berwind
Gallery, "Land Mass",
sculpture & drawings;
Galerie von der Tann,
Berlin, West Germany;
A. B. Galeries, Paris,
France

Representation:

**FOSTER
GOLDSTROM**

560 Broadway, Suite 303
New York, NY 10012
212.941.9175
212.274.8759 FAX

Contact:
Foster Goldstrom

Exhibiting:
Works by American and
International artists

Mark Todd

1. *Wire & Gum*
 1990, Gouache, pastel
 conte crayon, pencil
 on paper,
 20" x 20"

2. *Talking To The Dead*
 1990, Gouache, pastel
 conte crayon, pencil
 on paper
 20" x 20"

3. *Chinese Checkers*
 1990, Gouache, pastel
 conte crayon, pencil
 on paper,
 20" x 20"

Selected Biography:
1990 Foster Goldstrom,
 New York, NY; Vera
 Van Laer Gallery,
 Knokke, Belguim;
 "Lineart", Ghent,
 Belgium; "Art
 Frankfurt",
 International Art Fair,
 Frankfurt, Germany
1989 Art P. Gallery, Munich,
 Germany, (catalog)
1988 "Conntemporary Icons
 & Explorations",
 Davenport Museum of
 Art, Davenport, IA

Representation:

JANUS GALLERY

225 Canyon Road
Santa Fe, NM 87501
505.983.1590

Contact:
Joan Clark

Exhibiting:
Contemporary paintings,
drawings, sculpture and
photography

Mary Ristow

1. *March Wind*
 1991, Pastel, collage,
 graphite on paper,
 41" x 29.5"

Selected Biography:
1991 Solo show: Janus
 Gallery, Santa Fe, NM
1990 Solo show: Robischon
 Gallery, Denver, CO
1989 Group show: Center
 for Contemporary
 Arts, Santa Fe, NM
1988 Group show: Roswell
 Museum, Roswell, NM

Representation:

BIOTA GALLERY

8500 Melrose Avenue
West Hollywood, CA 90069
213.289.0979
213.289.0547 FAX
Contact:
Donna M. Kobrin

Exhibiting:
Contemporary art by
emerging artists

Diana Jacobs

1. *Garden Gate*
 1991, Mixed media,
 6" x 8"

2. *The Adam and Eve Fork*
 1991, Mixed media,
 8" x 10"

3. *Garden in Mourning*
 1991, Mixed media,
 7" x 8"

Selected Biography:
1991 8th Annual Summer
 Exhibition, Carnegie
 Museum, Oxnard, CA;
 "Bodies Of Work:
 Parental Guidance
 Suggested", Biota
 Gallery, W. Hollywood
1990 "The Art Of Love",
 Riverside Museum,
 Riverside, CA; 1st
 National Portrait
 Competition,
 Broadway Arts
 Building, NC
1989 Solo exhibition: Biota
 Gallery, Los Angeles;
 "Western Images Of
 Erotica", Gallery Six
 Oh One, W. Hollywood

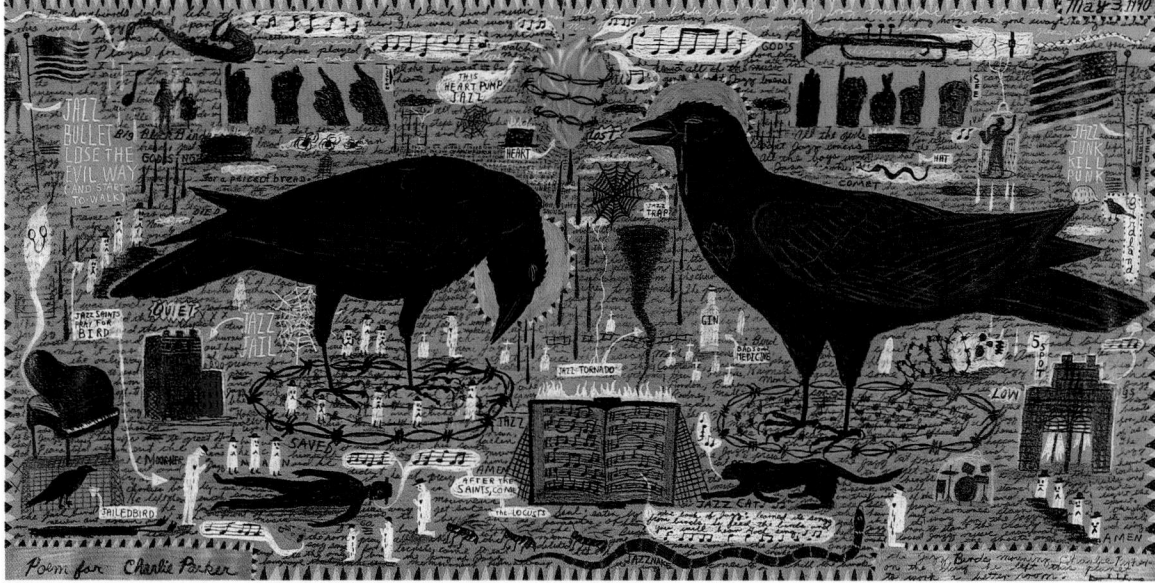

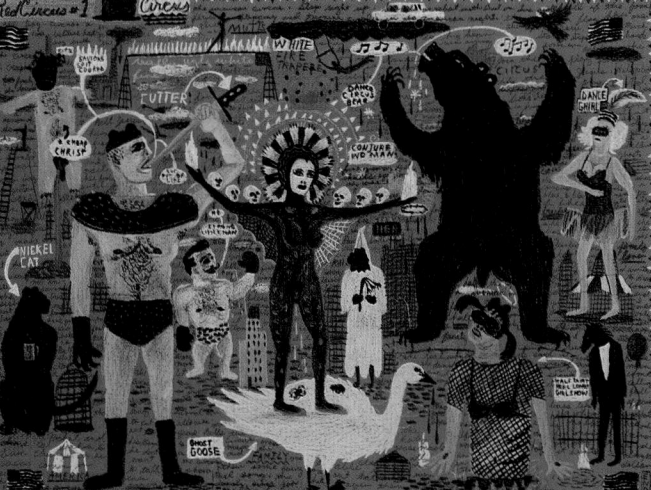

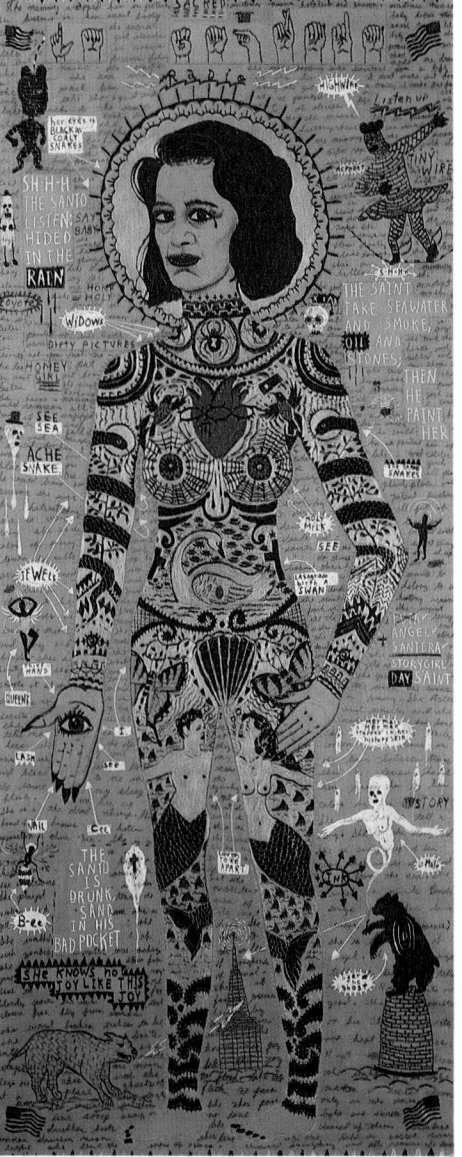

Representation:

JANET FLEISHER GALLERY

211 S. 17th Street
Philadelphia, PA 19103
215.545.7562
215.545.6140 FAX

Contact:
John E. Ollman

Exhibiting:
Contemporary American
art; self-taught and visionary
artists

Tony Fitzpatrick

1. *Jazz Birds, A Poem For Charlie Parker*
 1990, Colored pencil
 on paper,
 18" x 36.5"

2. *Red Circus #1*
 1990, Colored pencil
 on paper,
 17.25" x 22.25"

3. *Homegirl, The Sacred One*
 1991, Colored pencil
 on paper,
 42" x 18"

Selected Biography:
1992 Solo shows: Vrej
Baghoomian Gallery
and Cavin Morris
Gallery, New York, NY
1991 Solo show: Carl
Hammer Gallery,
Chicago, IL
1990 Solo show: Janet
Fleisher Gallery,
Philadelphia, PA

Representation:

JAMES CORCORAN GALLERY

1327 Fifth Street
Santa Monica, CA 90401
213.451.4666
213.451.0950 FAX

Billy Al Bengston

1. *January Watercolor*
 1991, Mixed media,
 24" x 20"

Selected Biography:

1991 Solo show: James
Corcoran Gallery,
Santa Monica, CA

1988 "Billy Al Bengston:
Paintings of Three
Decades",
Contemporary Arts
Museum, Houston, TX;
Oakland Museum, CA;
Los Angeles County
Museum of Art, CA;
The Contemporary
Museum, Honolulu, HI

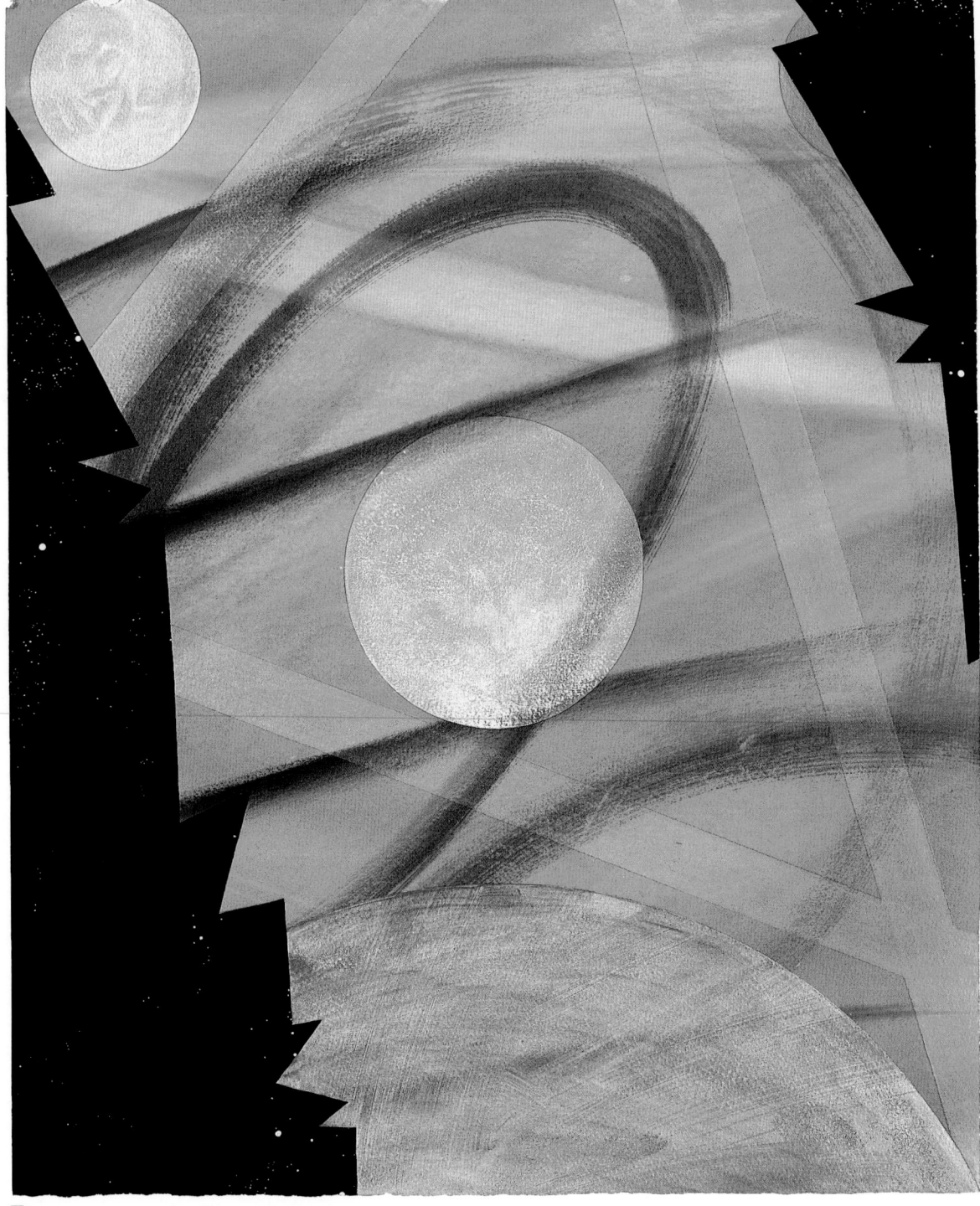

Representation:

RICCO/MARESCA GALLERY

105 Hudson Street
New York, NY 10013
212.219.2756
212.219.2756 FAX
Contact:
Roger R. Ricco
Frank Maresca
Exhibiting:
Masters of American
self-taught, Outsider Art,
emerging contemporary
artists

Eddie Arning

1. *Baseball Diamond/
 Red & Blue*
 1963-65, Crayon/
 craypas on paper,
 18" x 24"

2. *Man in Suit
 Sitting on Post*
 1966-69, Crayon/
 craypas on paper,
 22" x 28"

3. *Man Reclining
 Beside Colorful Pool*
 1966-69, Crayon/
 craypas on paper,
 22" x 28"

Selected Biography:
1991 Hill Gallery,
Birmingham, MI
1990 The Hemphill
Collection, National
Museum of American
Art, Washington, DC
1988 Solo exhibition:
Hirschl & Adler Folk,
New York
1985 Retrospective at
Abby Aldrich
Rockefeller Folk
Art Center, Colonial
Williamsburg, VA

DRAWINGS & PRINTS

Representation:

NEVILLE-SARGENT GALLERY

708 N. Wells Street
Chicago, IL 60610
312.664.2787
312.337.7472 FAX

Contact:
Don Neville
Jane Neville
Exhibiting:
Contemporary paintings,
prints and sculpture

Takeshi Yamada

1. *Hats*
 1985, Oil on canvas,
 36" x 40"

2. *Carson Pirie Scott*
 1991, Ceramic plate,
 12" diameter

3. *Rijks Museum #1*
 1990, Acrylic on canvas,
 30" x 40"

Selected Biography:

MARCELLE
FINE ARTS, INC.

996 Madison Avenue
New York, NY 10021
212.737.5786
212.737.4387 FAX

Andrew Wyeth

1. *Coon Dogs*
 1975, Drybrush,
 23" x 28 1/2"
 © Andrew Wyeth

Selected Biography:
1990 1st artist to receive
 Congressional Gold
 Medal, presented by
 President George Bush
1987 "The Helga Pictures",
 National Gallery of Art,
 Washington, DC
1976 The Metropolitan
 Museum of Art,
 New York, NY
1963 Presidential Freedom
 Medal, given by the
 President of the
 United States

Representation:

**PATRICK DOHENY
& ASSOCIATES
FINE ART**

1811 W. 1st Avenue
Vancouver, BC V6J 4M6
604.737.1733
604.731.4576 FAX

Contact:
Patrick Doheny
Alison Davis
Exhibiting:
Modern and contemporary
painting, drawing, sculpture
and holography

Alan Wood

1. *Coast Topple*
 1990, Acrylic/canvas,
 wood assemblage,
 6'3" x 6'1"

2. *Forest/Beach/Ocean #8*
 1990, Acrylic/canvas,
 wood assemblage,
 48" x 30"

3. *Forest/Beach/Ocean #6*
 1990, Acrylic/canvas,
 wood assemblage,
 48" x 30"

1

Selected Exhibitions:
1991 Solo exhibition:
 Patrick Doheny Fine Art,
 Vancouver, BC
1990 Solo exhibitions:
 Patrick Doheny Fine Art,
 Vancouver, BC;
 Franklin Silverstone
 Gallery, Toronto, ON;
 Gillian Jason Gallery,
 London, England

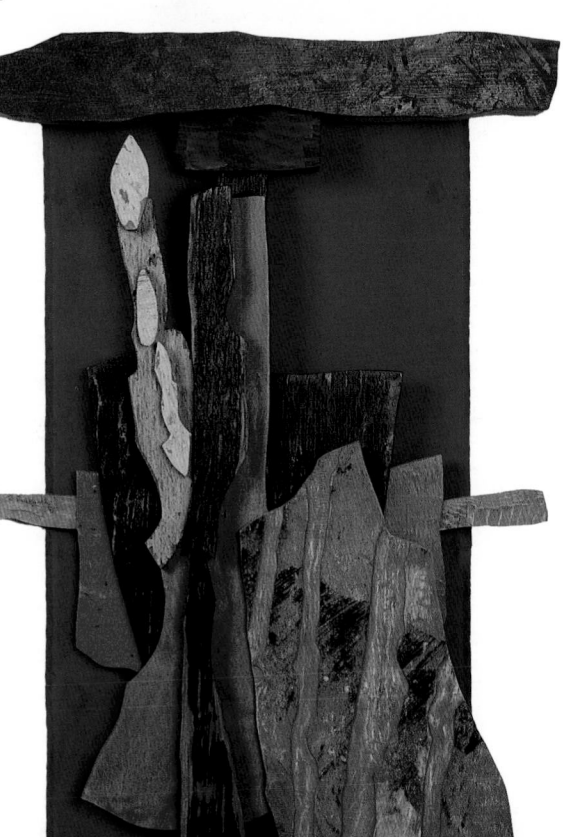

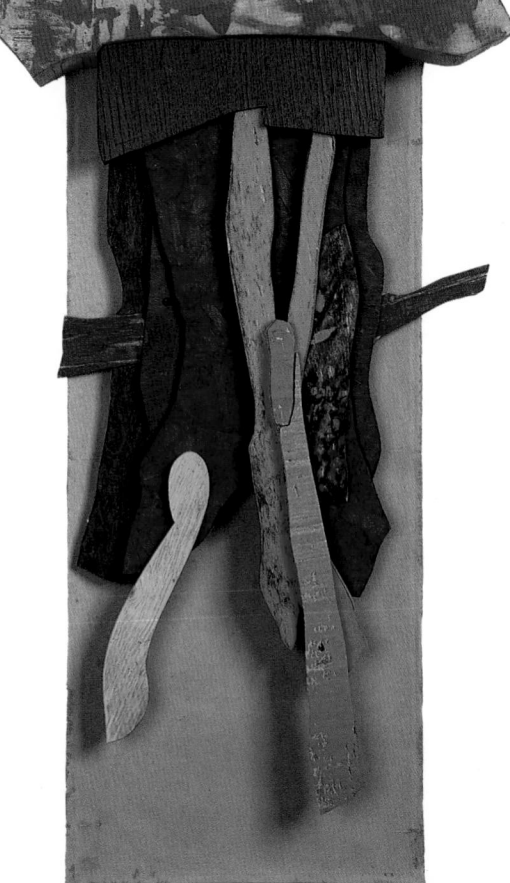

2

3

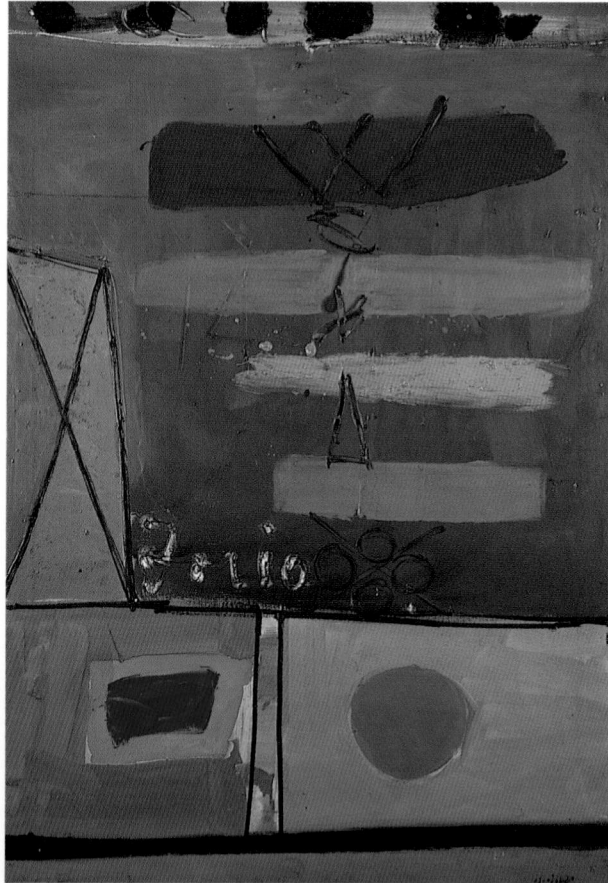

Representation:

MANNY SILVERMAN GALLERY

800 N. La Cienega Boulevard
Los Angeles, CA 90069
213.659.8256
213.659.1001 FAX
Contact:
Linda Hooper-Kawakami
Manny Silverman
Exhibiting:
Post-war American art

Emerson Woelffer

1. *Forio D'Ischia VIII*
 1957-58, Oil on canvas,
 55 1/4" x 39 1/4"

2. *Green Window*
 1982, Collage,
 24" x 18"

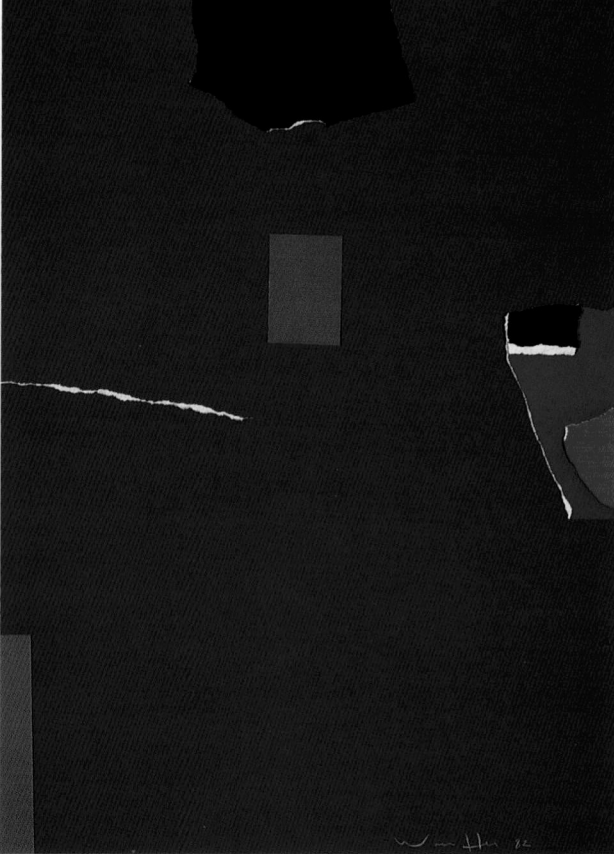

Selected Collections:
Art Institute of Chicago,
Chicago, IL;
Baltimore Art Museum,
Baltimore, MD;
La Jolla Museum of
Contemporary Art,
La Jolla, CA;
Los Angeles County
Museum of Art,
Los Angeles, CA;
The Museum of Modern
Art, New York, NY;
San Francisco Museum
of Art, San Francisco,
CA;
Seattle Museum of Art,
Seattle, WA;
Whitney Museum of
Art, New York, NY

Representation:

**FRANZ BADER
GALLERY**

1500 K Street NW
Washington, DC 20005
202.393.6111

Contact:
Wretha Hanson

Exhibiting:
Contemporary American
sculpture, paintings and
works on paper

John Winslow

1. *Ideas of Order*
 1991, Oil on canvas,
 48" x 60"

2. *Transport to Summer*
 1991, Oil on canvas,
 80" x 96"

Representation:

THE WORKS GALLERY

106 West Third Street
Long Beach, CA 90802
213.495.2787
213.495.0370 FAX

Crystal Court/S. Coast Plaza
3333 Bear Street, Third Fl.
Costa Mesa, CA 92626
714.979.6757
714.979.6818 FAX
Contact:
Mark Moore

Exhibiting:
Established and emerging
contemporary artists of
the western United States

Stephanie Weber

1. *Undertow Series I*
 1991, Mixed media
 27" x 62"

2. *Undertow Series II*
 1991, Mixed media
 28" x 62"

3. *Stratum Series F*
 1990, Mixed Media On
 Canvas
 48" x 24"

Selected Biography:
1992 Solo exhibitions:
 Harcourts
 Contemporary,
 San Francisco, CA;
 Klein Art Works,
 Chicago, IL
1991 Solo exhibition:
 Butters Gallery,
 Portland, OR;
 Group exhibition:
 The Works Gallery,
 Long Beach, CA

Representation:

FORUM GALLERY

745 Fifth Avenue
New York, NY 10151
212.355.4545

Contact:
Robert Fishko

Exhibiting:
20th-century American
Realism; paintings, drawings
and sculpture

Max Weber

1. *Still-Life with Three Jugs*
 1928, Oil on canvas,
 30" x 36"

2. *Sunday Tribune*
 1913, Pastel,
 22 3/4" x 16 3/4"

3. *The Young Model*
 1907, Oil on canvas,
 38 1/2" x 31 1/2"

Representation:

SENA GALLERIES

112 W. San Francisco Street
Santa Fe, NM 87501
505.982.8808
505.982.0878 FAX
Contact:
Mary Thompson

Michael Von Helms

1. *#36 Far Light Falling*
 1989-90, Oil on canvas,
 72" x 61"

Selected Biography:
1991 Sena Galleries, Santa
Fe, NM; International
de Art, Selection Best
American Painters,
Yerga Musee, Toronto,
ON; "New American
Talent", juried exhibit
at Laguna Gloria
Museum, Austin, TX
1990 "Southwest '90", juried
exhibit at Museum of
Fine Arts, Santa Fe,
NM
1989 Michael Von Helms -
11 East Ashland Place -
Phoenix, AZ

Representation:

O.K. HARRIS WORKS OF ART

383 W. Broadway
New York, NY 10012
212.431.3600

Contact:
Ivan C. Karp

Exhibiting:
Contemporary American and European painting, sculpture, photography, antiques, collectibles, documentation

Robert Van Vranken

1. *St. Jerome*
 1990, Oil, mixed media, plaster and wood,
 91.5" x 104"

Selected Biography:

1990 Group exhibition: "Expressionist Surface: Contemporary Art in Plaster", Queens Museum, Flushing, NY
1989 Solo exhibition: O.K. Harris Works of Art, New York, NY
1985 San Francisco Art Institute, San Francisco, CA; M.F.A.
1983 Bowdoin College, Brunswick, ME

Representation:

KIMBERLY GALLERY

1621 21st Street NW
Washington, DC 20009
202.234.1988
202.462.0773 FAX

8000 Melrose Avenue
Los Angeles, CA 90046
213.653.0408

Contact:
Elyse Klaidman
Elena Kimberly
Exhibiting:
Contemporary Latin
American artists

Cordelia Urueta

1. *Fulgor*
 1989, Oil on canvas,
 50" x 47"

Selected Biography:
1991 Exhibition:
 Kimberly Gallery,
 Los Angeles, CA
1990 Exhibition:
 Kimberly Gallery,
 Washington, D.C.
1986 Exhibition:
 Interamerican Biennial,
 Havana, Cuba
1985 Exhibition:
 Museum of Modern Art,
 Mexico City

Representation:

**VALLEY HOUSE
GALLERY, INC.**

6616 Spring Valley Road
Dallas, TX 75240
214.239.2441
214.239.1462 FAX
Contact:
Kevin Vogel

Exhibiting:
19th & 20th Century and
contemporary paintings,
sculpture, drawings
and prints

Valton Tyler

1. *Desert Shield*
 1990, Oil on canvas,
 38" x 48"

2. *Come Lie Down
 with Me in the Grass*
 1990, Oil on canvas,
 40" x 48"

3. *After the Rain*
 1990, Oil on canvas,
 38" x 48"

Selected Biography:

1989 Winner of Patrick
 Media Billboard
 Competition,
 Dallas, TX
1988 Exhibition at Valley
 House Gallery,
 Dallas, TX
1986 Retrospective
 Exhibition at DW
 Gallery, Dallas, TX
1985 Rosa Esman Gallery,
 New York, NY

Representation:

SANTA FÉ EAST

200 Old Santa Fe Trail
Santa Fe, NM 87501
505.988.3103

Contact:
Ron Cahill

Exhibiting:
American art; contemporary
painting and sculpture

William F. Tull

1. Simon's Studio
 1990, Acrylic on canvas,
 14" x 14"

Selected Biography:

1991 Santa Fe homecoming
for artist William Tull,
"Premier Southwest
Painter and Adobe
Architect has opened
Santa Fe Studio"

Representation:

JANET FLEISHER GALLERY

211 S. 17th Street
Philadelphia, PA 19103
215.545.7562
215.545.6140 FAX

Contact:
John E. Ollman

Exhibiting:
Contemporary American
art; self-taught and visionary
artists

Bill Traylor

1. *Man Talking To Bird*
 1939-42, Posterpaint
 on cardboard,
 16.5" x 13.25"

2. *Blue Man*
 1939-42, Posterpaint
 on cardboard,
 8" x 12"

3. *Untitled (Blue Wagon)*
 1939-42, Posterpaint
 on cardboard,
 14.5" x 22"

Selected Biography:
1991 Janet Fleisher Gallery,
 Philadelphia, PA
1990 Janet Fleisher Gallery,
 Philadelphia, PA
1988 Hirschl & Adler Modern,
 New York, NY

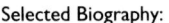

Representation:

**CUDAHY'S
GALLERY, INC.**

170 E. 75th Street, 2nd Fl.
New York, NY 10021
212.879.2405
212.535.6259 FAX
Contact:
Fred J. Boyle

Exhibiting:
Contemporary American
Realism and Photo-Realism

James Torlakson

1. *Deserted Drive-In*
 1991, Oil on canvas,
 18" x 24"

2. *July 6th*
 1988, Oil on canvas,
 33" x 48"

3. *Mammoth Orange*
 1991, Watercolor
 on paper,
 10" x 15"

Selected Biography:
1992 Solo show: Cudahy's
 Gallery, New York, NY
1991 "New Horizons in
 American Realism",
 Flint Institute of Arts,
 Flint, MI (Traveling)
1990 "Group Show/Small
 Works", Cudahy's
 Gallery, New York, NY

Representation:

SANTA FÉ EAST

200 Old Santa Fe Trail
Santa Fe, NM 87501
505.988.3103

Contact:
Ron Cahill

Exhibiting:
American art; contemporary
painting and sculpture

Randall Tipton

1. *Landscape From A
 Dream, Chasm*
 1991, Oil on canvas,
 30" x 40"

2. *Above Utah*
 1990, Watercolor/
 acrylic on paper,
 48" x 36"

3. *Quilcene*
 1990, Watercolor/
 acrylic on paper,
 48" x 36"

Selected Biography:
1991 "Between Dream and
Reality", Santa Fé East,
NM
1991 The Maveety Gallery,
Portland and Lincoln
City, OR
1989 White Bird Gallery,
Cannon Beach, OR

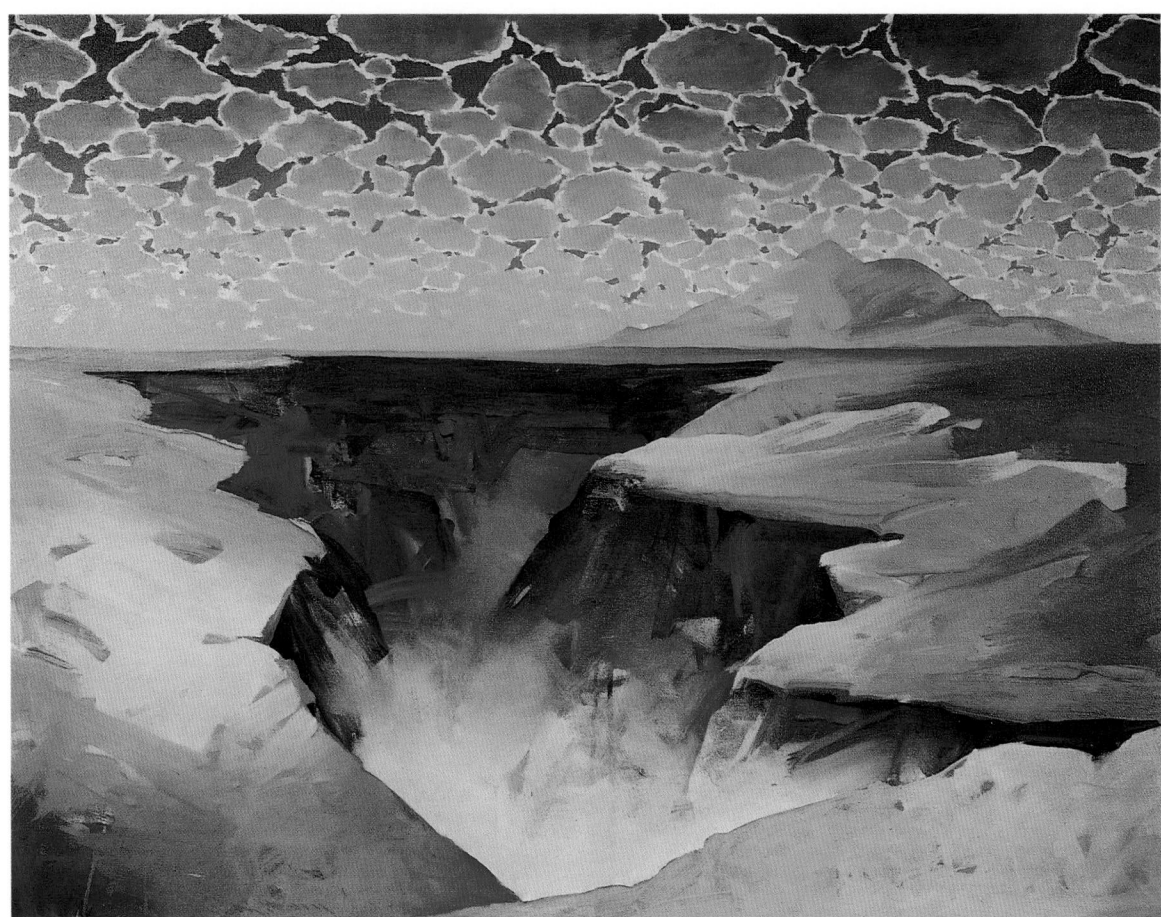

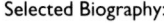

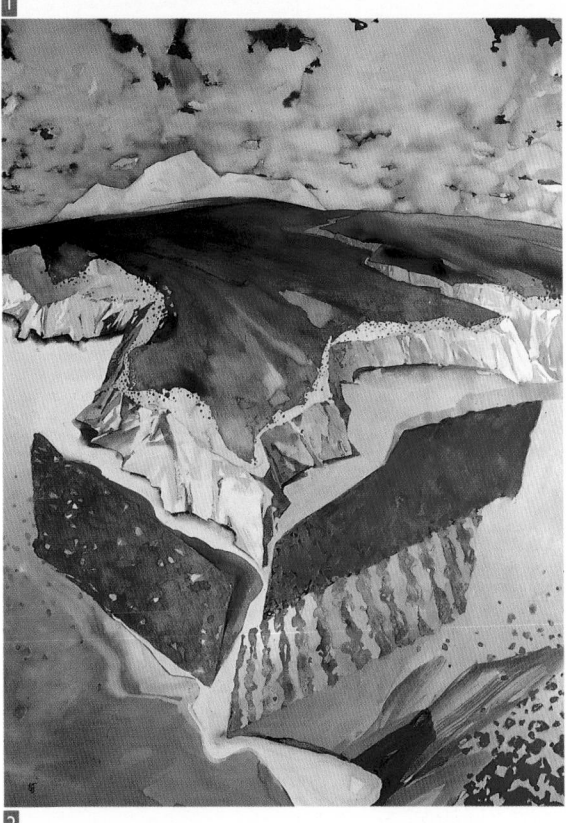

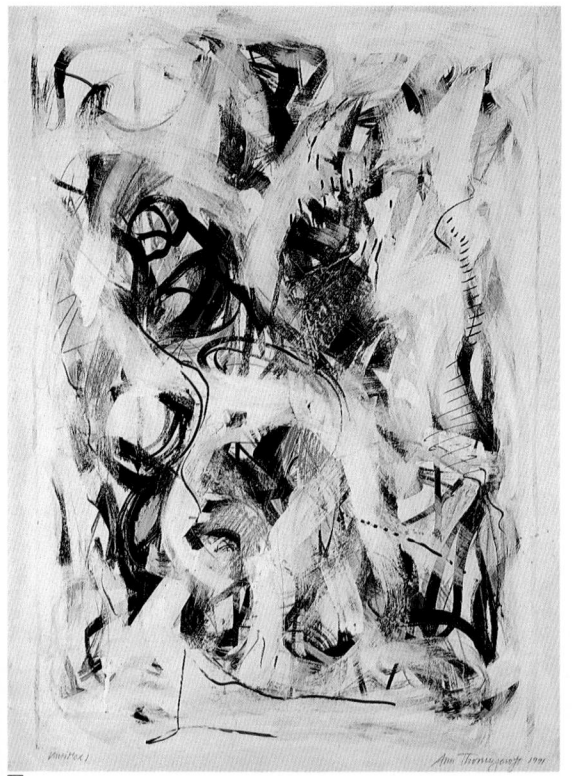

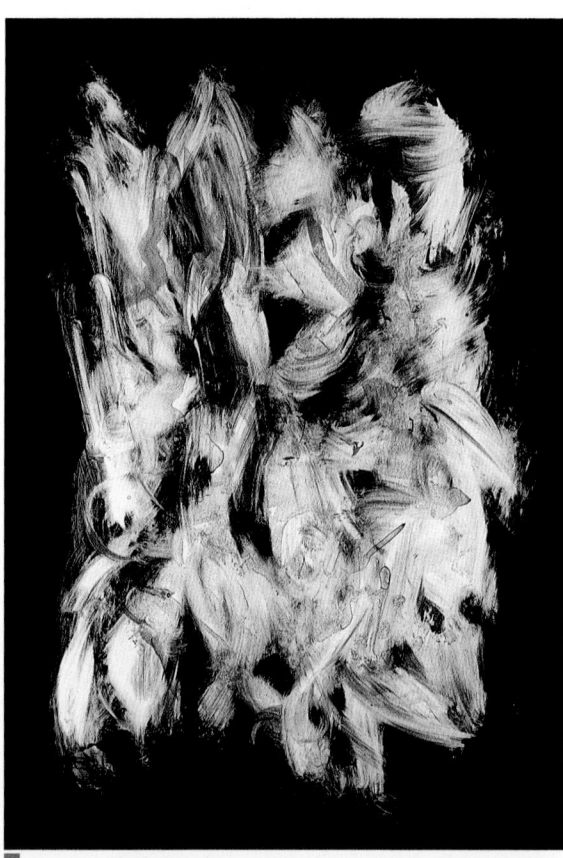

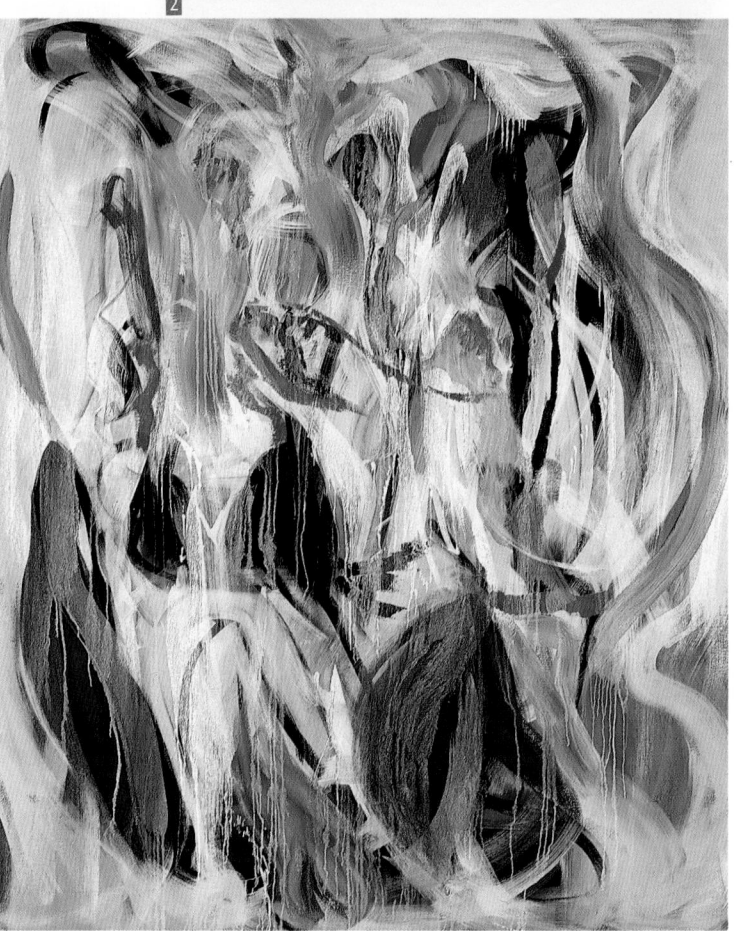

Representation:

THE WORKS GALLERY

106 W. Third Street
Long Beach, CA 90802
213.495.2787
213.495.0370 FAX

Crystal Court/S. Coast Plaza
3333 Bear Street, Third Fl.
Costa Mesa, CA 92626
714.979.6757
714.979.6818 FAX
Contact:
Mark Moore

Exhibiting:
Established and emerging
contemporary artists of
the western United States

Ann Thornycroft

1. *Untitled 1*
 1991, Gouache,
 crayon on paper,
 30" x 22"

2. *IX*
 1991, Monoprint,
 56" x 39 1/2"

3. *Shadows*
 1991, Oil on canvas,
 72 x 60"

Selected Biography:

1992 Solo exhibition: "H$_2$O:
Survey In Watercolor",
The Works Gallery
South, Costa Mesa, CA
1991 Solo exhibition: The
Works Gallery South,
Costa Mesa, CA
1987 Solo exhibition:
Thomas Babeor
Gallery, La Jolla, CA
1981 Rosamund Felsen
Gallery, Los Angeles,
CA

Representation:

**DE GRAAF
FINE ART, INC.**

9 E. Superior
Chicago, IL 60611
312.951.5180

3400 Avenue of the Arts
Suite C120
Costa Mesa, CA 92626
714.557.5240

Exhibiting:
Contemporary American,
European and Latin
American paintings,
sculpture and graphics

Michael Teague

1. *The Table*
 Oil on canvas,
 41" x 34"

2. *Que Sias-Je?*
 Oil on canvas,
 24" x 24"

3. *Nightmare In Rubber Clad*
 Oil on canvas,
 14" x 18"

Selected Biography:
1990 "The New Surrealist",
 De Graaf Fine Art
1988 "New Chicago",
 De Graaf Fine Art;
 M.F.A., Indiana
 Univeristy;
 Exhibitions: Memphis
 State University, Alice
 Bingham Gallery,
 Arbutus Gallery, IU
 Museum of Fine Art

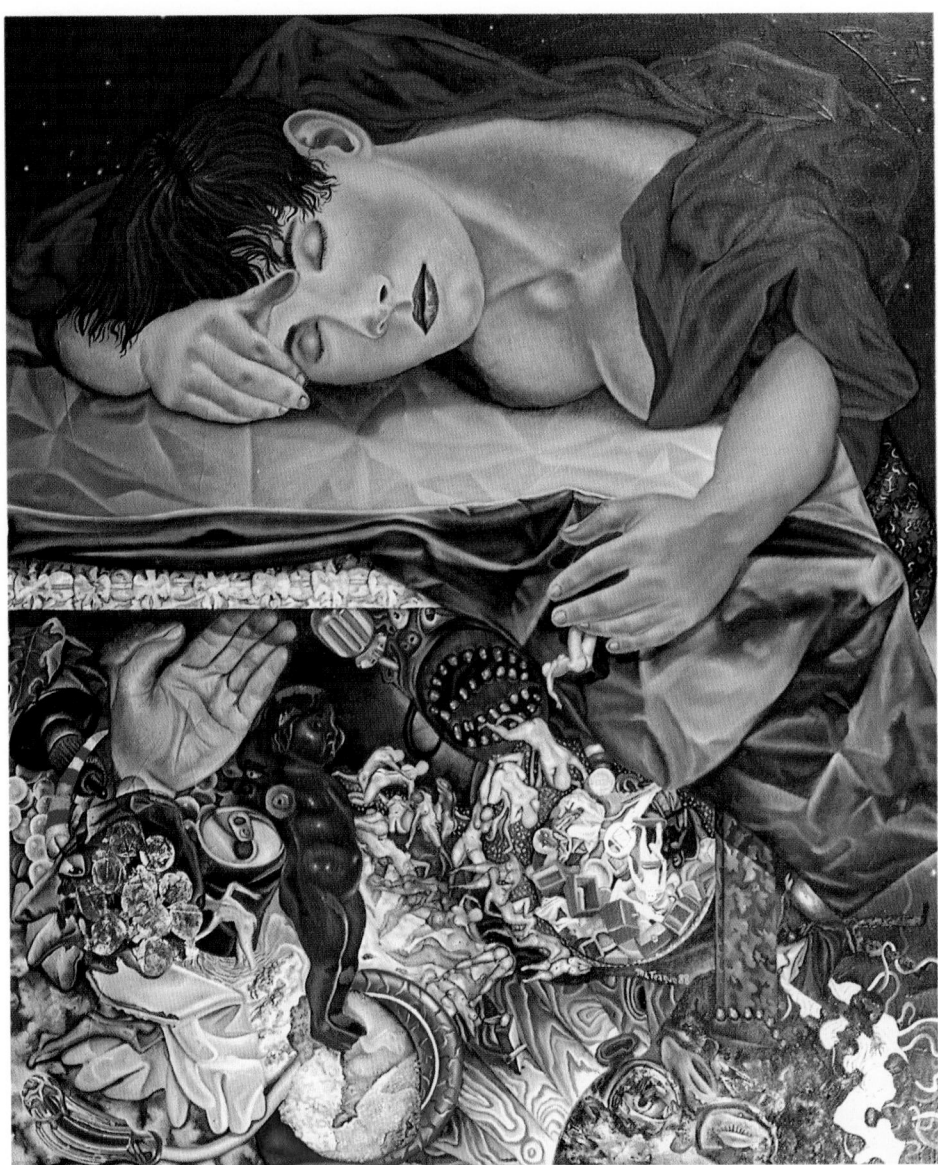

Representation:

MODERNISM INC.

685 Market Street, Suite 290
San Francisco, CA 94105
415.541.0461
415.541.0425 FAX
Contact:
Katya Slavenska

Exhibiting:
Contemporary art,
20th-century historical
art, Russian Avant-Garde
1900-1930

Sam Tchakalian

1. *Blue Belt*
 1989, Oil
 on canvas,
 72" x 72"

Selected Biography:
1989 The National Museum
 of Contemporary Art,
 Seoul, Korea
1979 Portland Museum
 for Visual Arts,
 Portland, OR
1978 Oakland Museum,
 Oakland, CA:
 Retrospective
1967 San Francisco Museum
 of Modern Art

Representation:

GAGOSIAN GALLERY

980 Madison Avenue, 6th Fl.
New York, NY 10021
212.744.2313
212.772.7962 FAX
Contact:
Melissa Lazarov

Exhibiting:
Contemporary paintings,
drawings and sculpture

Philip Taaffe

1. *Nefta*
 1990, Mixed media
 on linen,
 60" x 48"

Selected Biography:
1991 Solo show:
 Max Hetzler Gallery,
 Cologne; Group show:
 "Strange Abstraction",
 Touko Museum of
 Contemporary Art,
 Tokyo; Biennial
 Exhibition, Whitney
 Museum of Art,
 New York
1988 Solo show:
 Mary Boone Gallery,
 New York

Representation:

**THE WORKS
GALLERY**

106 W. Third Street
Long Beach, CA 90802
213.495.2787
213.495.0370 FAX

Crystal Court/S. Coast Plaza
3333 Bear Street, Third Fl.
Costa Mesa, CA 92626
714.979.6757
714.979.6818 FAX
Contact:
Michael Bevilacqua

Exhibiting:
Established and emerging
contemporary artists of
the western United States

Craig Syverson

1. *Mayavirupa*
 1991, Gold on silk,
 gold, lapis lapis lazuli
 on aluminum,
 26" x 16"

2. *Cor Manifestum*
 1991, Silver
 on aluminum,
 12" x 24"

Selected Biography:
1992 Solo exhibition: The
Works Gallery, Long
Beach, CA
1991 Group exhibitions:
The Works Gallery,
Long Beach, CA;
"Spiritual Objects",
The Works Gallery,
Long Beach, CA

Representation:

SHERRY FRUMKIN GALLERY

1440 Ninth Street
Santa Monica, CA 90401
213.393.1853
213.623.9130 FAX
Contact:
Sherry Frumkin

Exhibiting:
Contemporary painting,
sculpture and assemblage

James Strombotne

1. *Acrobat*
 1991, Acrylic/canvas,
 60" x 48"

Selected Biography:
1990 Solo exhibition:
 Sherry Frumkin Gallery,
 Santa Monica, CA
1989 Solo exhibition:
 Municipal Art Gallery,
 Los Angeles, CA
1987 Solo exhibition:
 Eilat Gordin Gallery,
 Los Angeles, CA
1981 Solo exhibition:
 Jacqueline Anhalt
 Gallery, Los Angeles, CA

Representation:

**STEPHEN
ROSENBERG
GALLERY**
115 Wooster Street
New York, NY 10012
212.431.4838

Contact:
Fran Kaufman

Exhibiting:
Contemporary American
and European painting,
sculpture, works on paper
and prints

Edvins Strautmanis

1. *One More*
 1990, Acrylic on canvas,
 94" x 71 1/2"

Selected Biography:
1991 Stephen Rosenberg
 Gallery, New York;
 Galerie Netta Linde,
 Lubeck, Germany;
 Haus Schönblick,
 Heimbach, Germany
1990 Stephen Rosenberg
 Gallery, New York
1988 Noordkunst,
 Groningen Museum,
 Denmark
1987 Galerie Sylvia Menzel,
 Berlin, Germany

Representation:

MODERNISM INC.

685 Market Street, Suite 290
San Francisco, CA 94105
415.541.0461
415.541.0425 FAX
Contact:
Katya Slavenska

Exhibiting:
Contemporary art,
20th-century historical
art, Russian Avant-Garde
1900-1930

Mark Stock

1. *The Butler's in Love #25*
 1986, Oil on canvas,
 56" x 48"

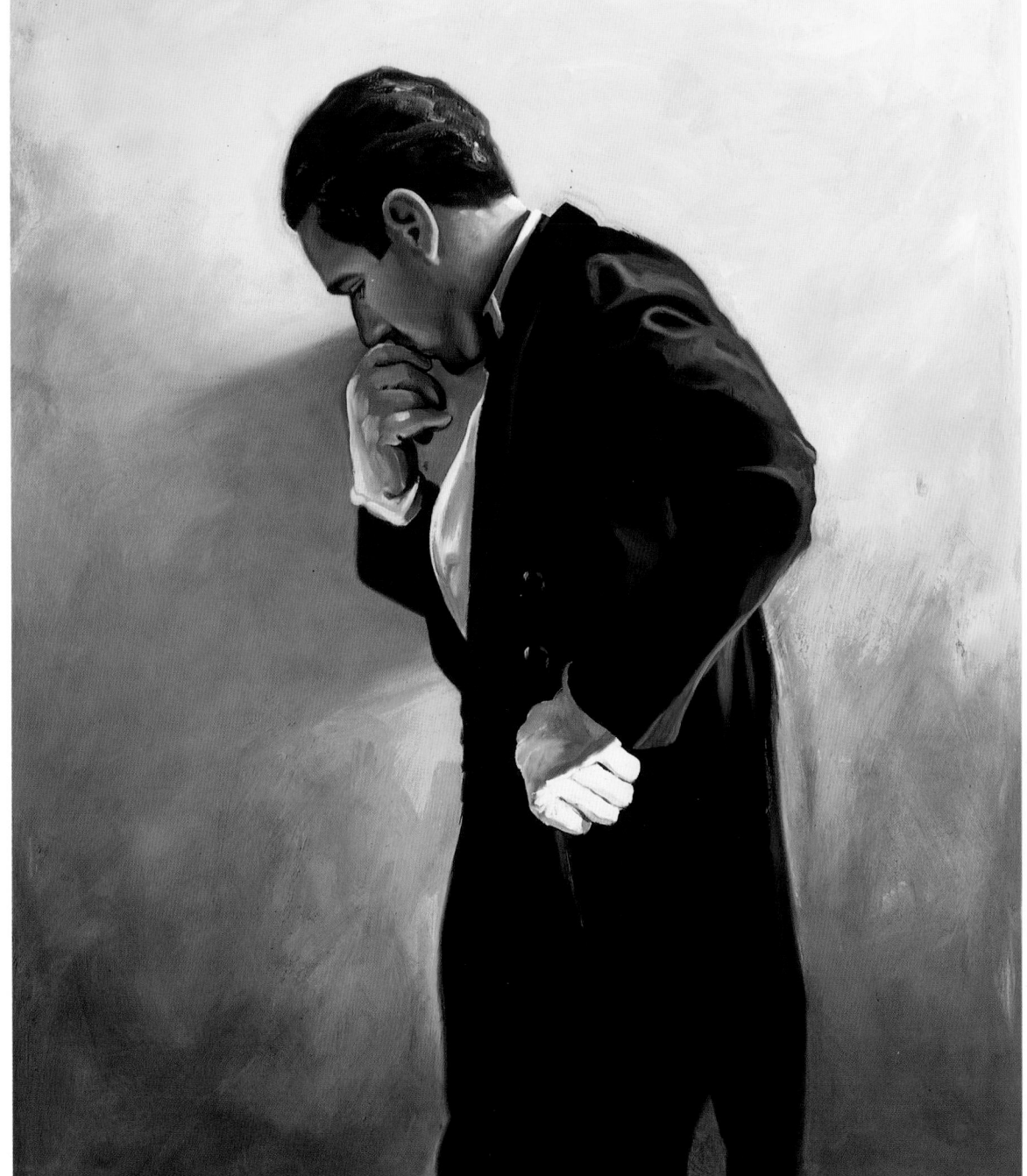

Selected Biography:
1987 California State
University, San
Bernardino
1986 Laguna Art Museum,
Laguna Beach, CA
1984 Brooklyn Museum,
Brooklyn, NY
1981 Hirschl & Adler
Modern, New York,
NY

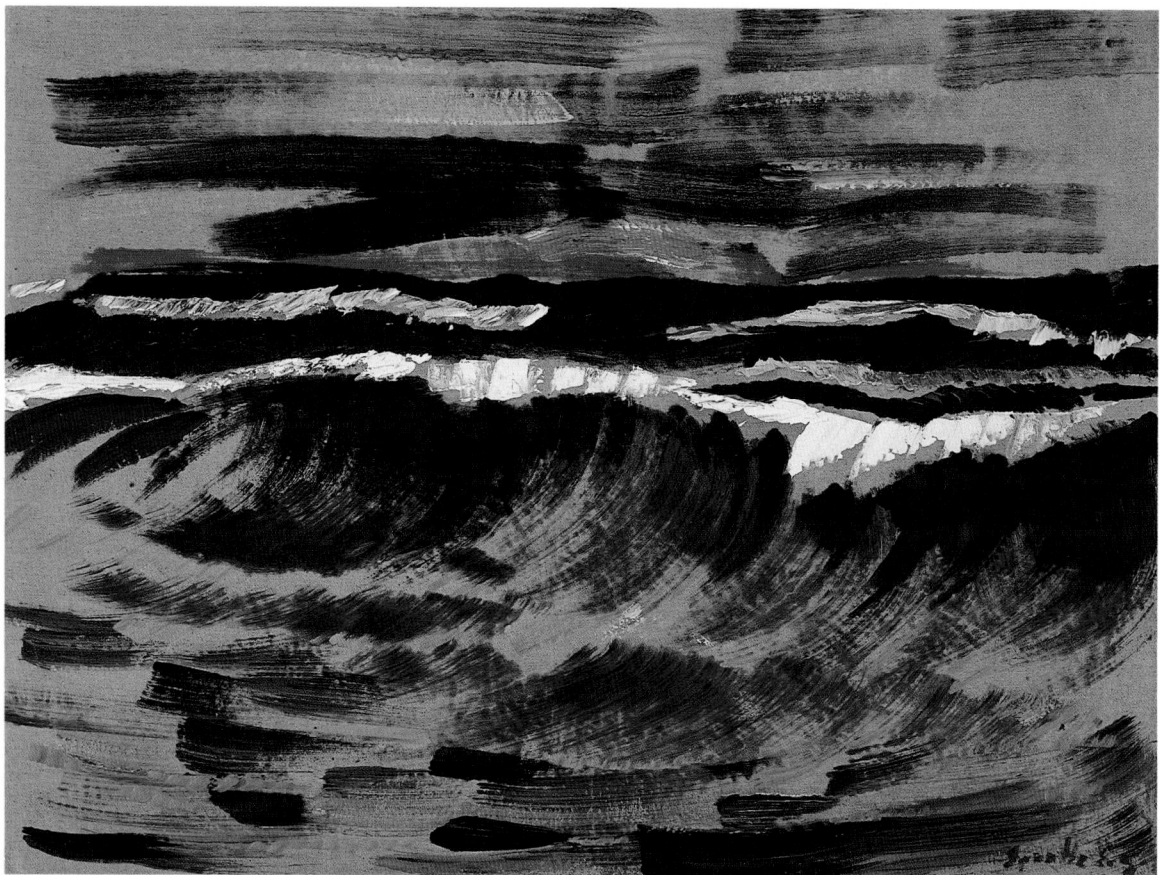

Representation:

**ELEONORE
AUSTERER GALLERY**

540 Sutter Street
San Francisco, CA 94102
415.986.2244
415.986.2281 FAX
Contact:
Eleonore Austerer

Exhibiting:
Contemporary American
and European art

Siegward Sprotte

1. *The Great Wave*
 1983, Oil on canvas,
 37 1/2" x 51 1/4"

2. *Sunflowers*
 1983, Oil on board,
 19" x 16"

3. *Blumen in Meinem Garten*
 1985, Gouache on
 Japon paper,
 24 1/2" x 18"

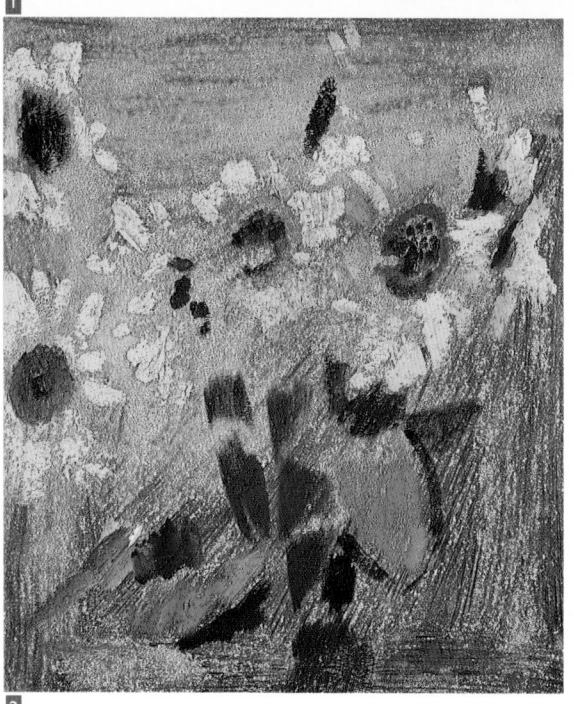

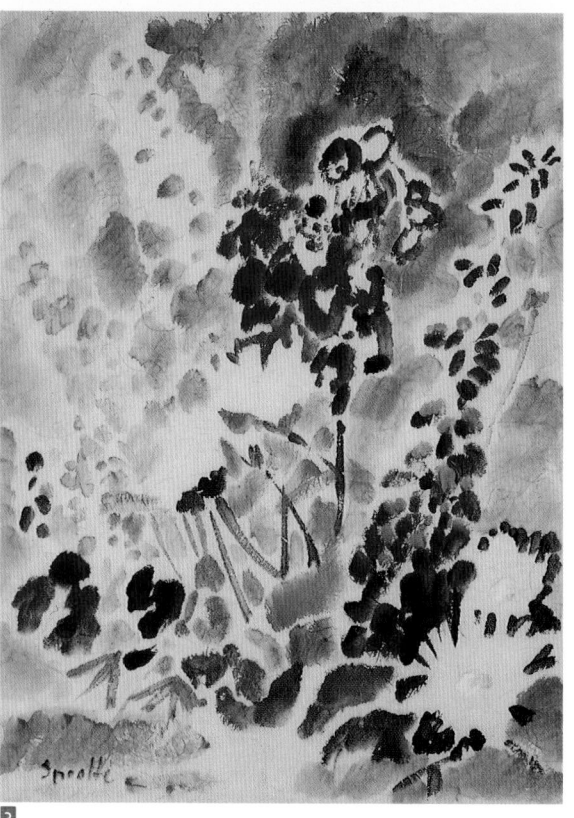

Selected Biography:
1990 Concurrent exhibitions:
 Eleonore Austerer
 Gallery, San Francisco
 and Auktionshaus-
 Galerie Kleinhenz,
 Germany
1989 Solo exhibitions:
 Falkenstern Fine Art,
 New York; Pushkin
 State Museum of Fine
 Arts, Moscow
1988 Solo exhibition:
 Museum Potsdam

Representation:

THE CAROL SIPLE GALLERY, LTD

1401 Seventeenth Street
Denver, CO 80202
303.292.1401

Contact:
Carol Siple

Exhibiting:
A unique blend of traditional
and contemporary art

Daniel Sprick

1. *The Modern Conciousness*
 1989, Oil,
 84" x 78"

Selected Biography:

ROGER B. SPRAGUE

Representation:

SANTA FÉ EAST

200 Old Santa Fe Trail
Santa Fe, NM 87501
505.988.3103

Contact:
Ron Cahill

Exhibiting:
American art; contemporary
painting and sculpture

Roger B. Sprague

1. *Joe's Geranium #1*
 1991, Oil on linen,
 36" x 38"

2. *Window and Draped Table*
 1991, Oil on linen,
 16" x 16"

3. *Church at Villanueva*
 1990, Oil on linen,
 36" x 38"

Selected Biography:
1991 Two person show:
 Leslie Levy Gallery,
 Scottsdale, AZ;
 "In the Moment",
 Santa Fé East,
 Santa Fe, NM
1990 Two man exhibition:
 J. Cacciola Gallery,
 New York, NY

Representation:

**HOWARD YEZERSKI
GALLERY**

186 South Street
Boston, MA 02111
617.426.8085

Contact:
Howard Yezerski
Jeri Slavin

Elaine Spatz-Rabinowitz

1. *Pierced Woods*
 1991, Oil on pigmented
 plasticized hydrocal,
 20" x 23" x 7 1/2"

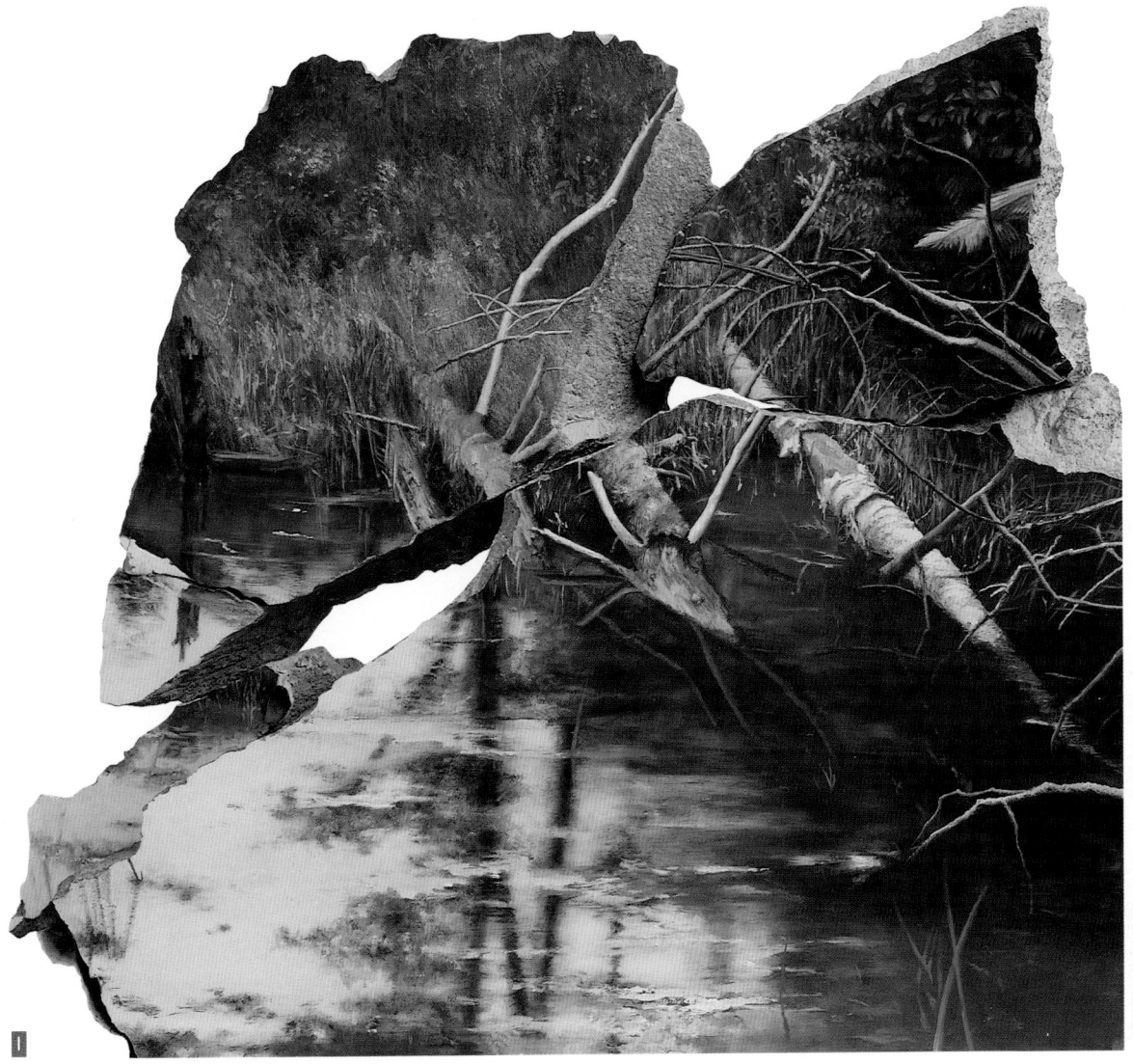

Selected Biography:
1991 Howard Yezerski
 Gallery, Boston, MA
1989 Howard Yezerski
 Gallery, Boston, MA
1987 "New Works New
 England", Decordova
 Museum, Lincoln, MA;
 ACA Galleries,
 New York, NY
1983 "Sudden Difficulties",
 Installation/
 collaboration with
 Peter Sellars, ICA,
 Boston, MA
1981 Allen Stone Gallery,
 New York, NY

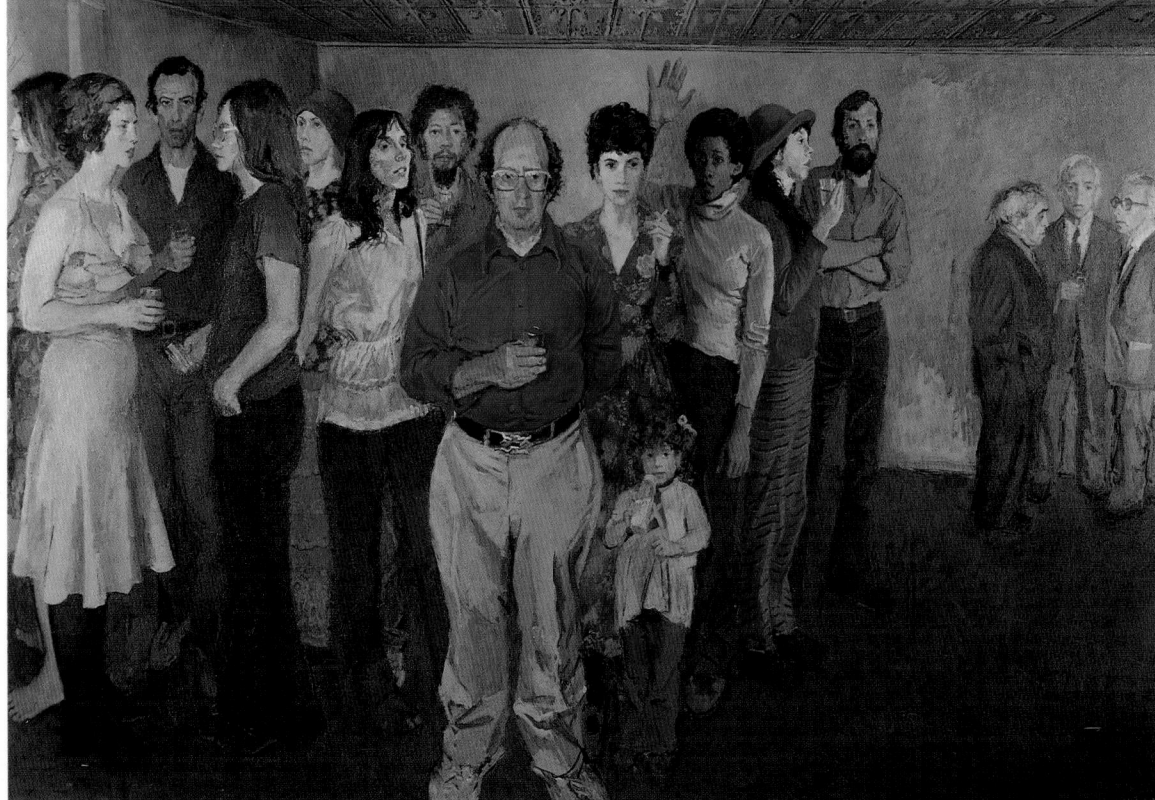

Representation:

FORUM GALLERY

745 Fifth Avenue
New York, NY 10151
212.355.4545

Contact:
Robert Fishko

Exhibiting:
20th-century American
Realism; paintings, drawings
and sculpture

Raphael Soyer

1. *Portraits at a Party*
 1974, Oil on canvas,
 54 1/2" x 80"
 Hirshhorn Museum and Sculpture
 Garden, Washington, D.C.

2. *Girl Putting Out a Cigarette*
 1950, Oil on canvas,
 33 1/4" x 20"

3. *Self-Portrait*
 1930s, Oil on canvas,
 14 3/4" x 11 1/2"

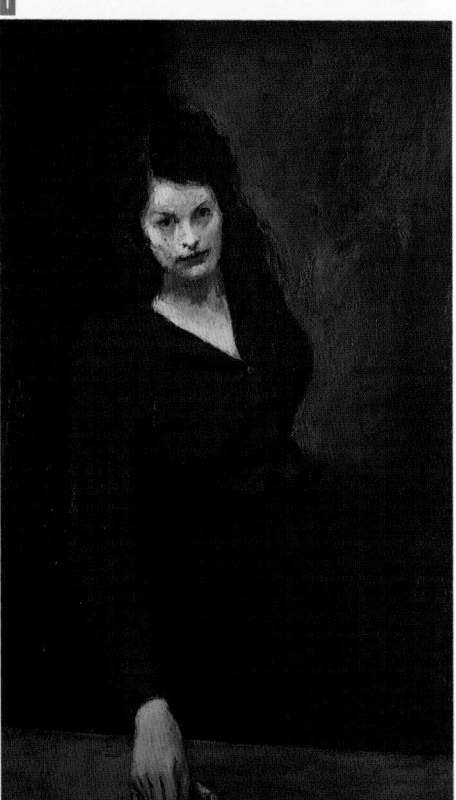

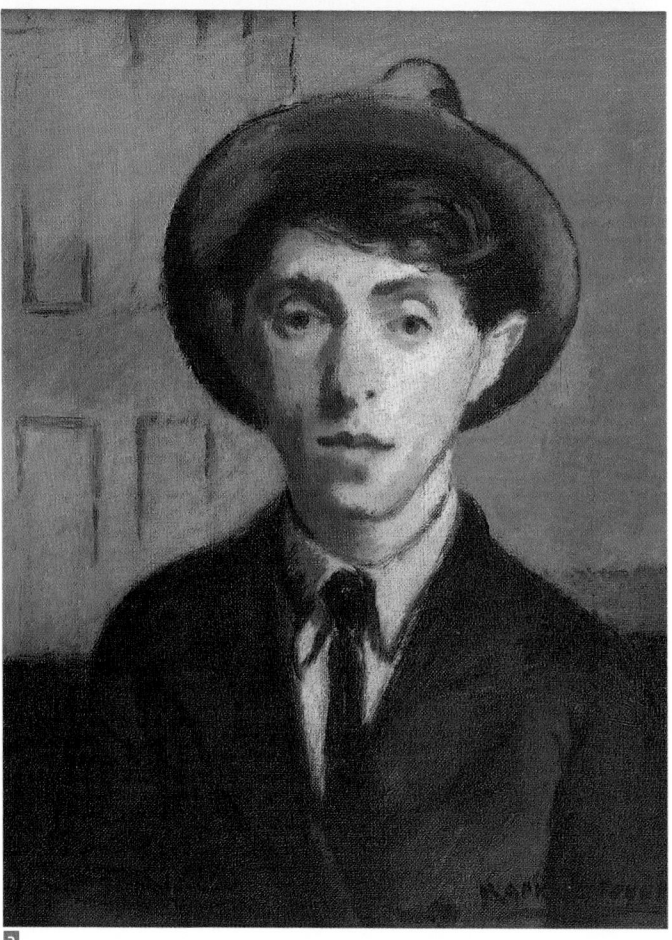

Representation:

HIRSCHL & ADLER MODERN

851 Madison Avenue
New York, NY 10021
212.744.6700
212.737.2614 FAX
Contact:
Donald McKinney

Exhibiting:
Contemporary European
and American art

Joan Snyder

1. *Beanfield/Brooklyn*
 1990, Oil & mixed
 media on canvas,
 60" x 72"

Selected Biography:
1990 "New Paintings by Joan
Snyder", Hirschl & Adler
Modern, New York, NY;
"Image of Abstraction in
the 80's", Rose Art
Museum, Brandeis
University, Waltham, MA
1988 "Joan Snyder Collects
Joan Snyder", Santa
Barbara Contemporary
Arts Forum, CA
(traveling)

1

2

Representation:

MARGO LEAVIN GALLERY

812 N. Robertson Boulevard
Los Angeles, CA 90069
213.273.0603
213.273.9131 FAX

Contact:
Margo Leavin
Wendy Brandow
Exhibiting:
Contemporary art from
Europe and America

Alexis Smith

1. *Rocky Road*
 1990, Mixed media,
 Overall: 64" x 57"

2. *Seven Wonders*
 1988, Mixed media,
 47 1/2" x 41"

3. *Boy's Life*
 1989, Lithograph/collage,
 30" x 44 1/4"

3

Selected Biography:
1991 Retrospective,
 Whitney Museum of
 American Art, NY;
 "Alexis Smith" Public
 Works", University
 of California, San Diego
1990 "Eldorado (On the
 Road, Part II), Margo
 Leavin Gallery
1989 "Past Lives", (with Amy
 Gerstler), Santa Monica
 Museum of Art, CA

Representation:

SANTA FÉ EAST

200 Old Santa Fe Trail
Santa Fe, NM 87501
505.988.3103

Contact:
Ron Cahill

Exhibiting:
American art; contemporary
painting and sculpture

Sherri Silverman

1. *Matthew #8*
 1990, Pastel on paper,
 29" x 41"

2. *Genesis*
 1988, Pastel on paper,
 21 1/2" x 14"

3. *Shiva*
 1988, Pastel on paper,
 11 1/2" x 11 3/4"

Selected Biography:

1991 Visions of Excellance,
AUA Annual Juried
Show, Albuquerque,
NM; Works On Paper
Show, Fay Gold
Gallery, Atlanta, GA;
Spring group show,
Taba, Inc., Bethesda, MD

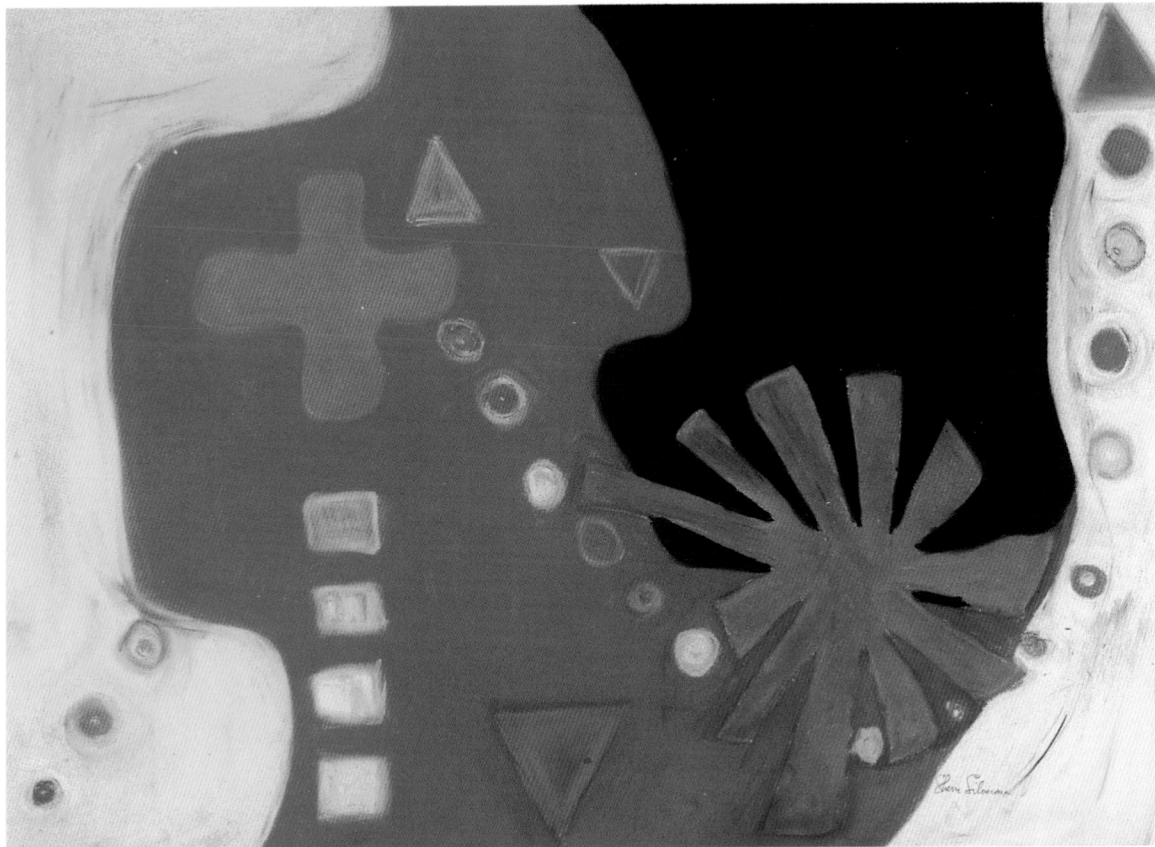

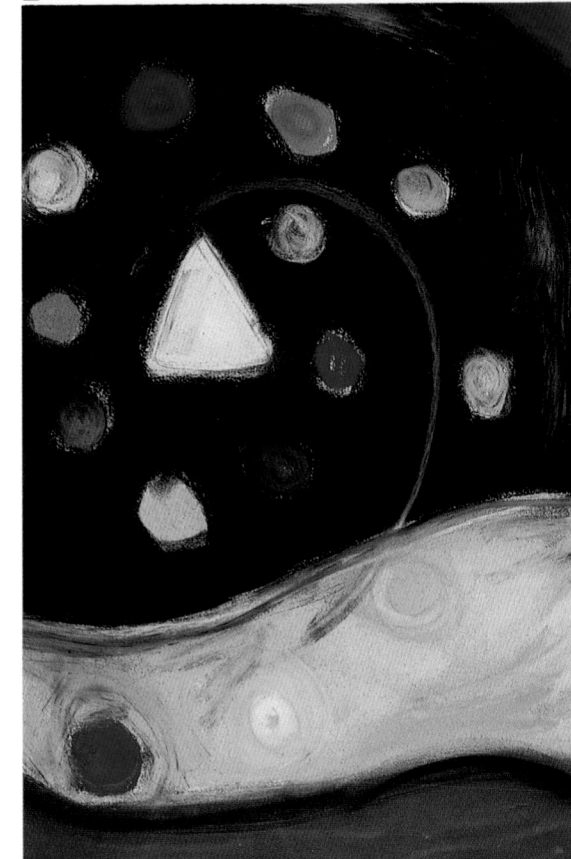

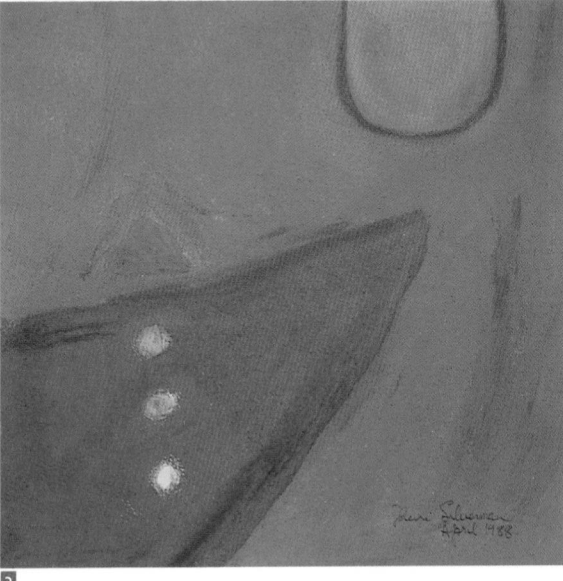

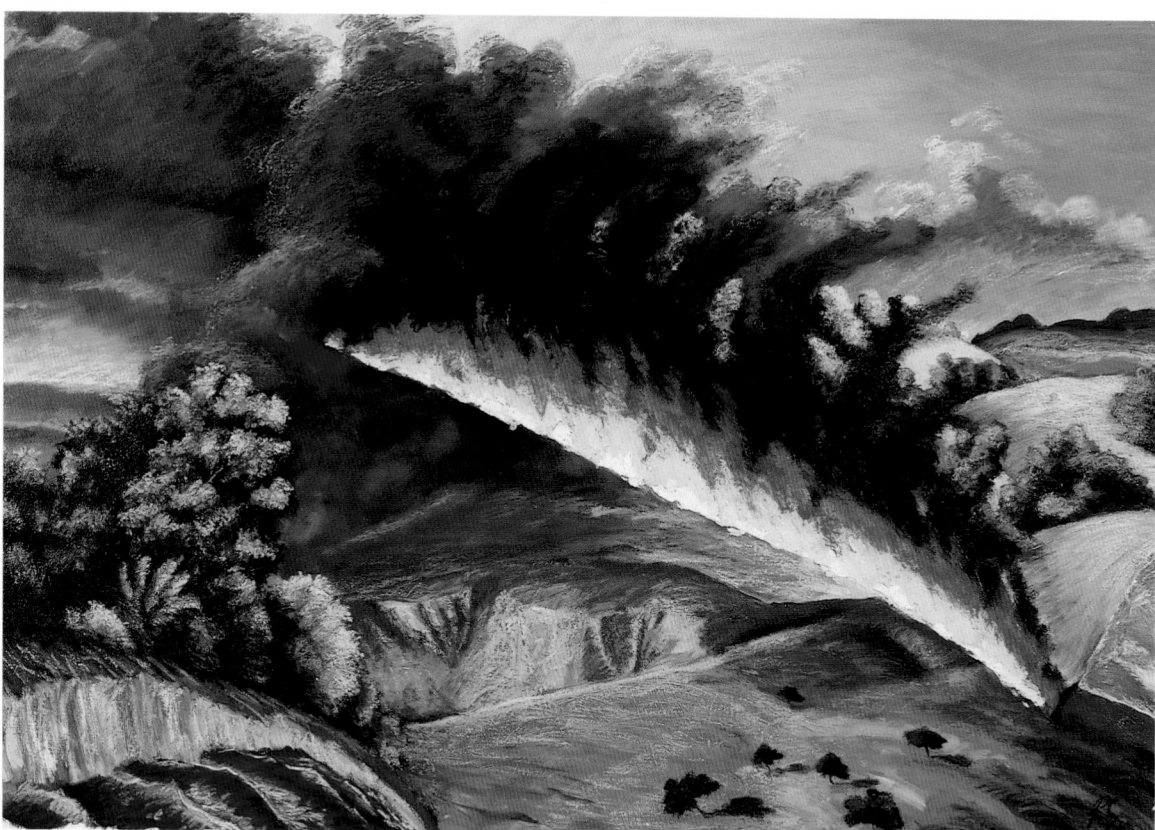

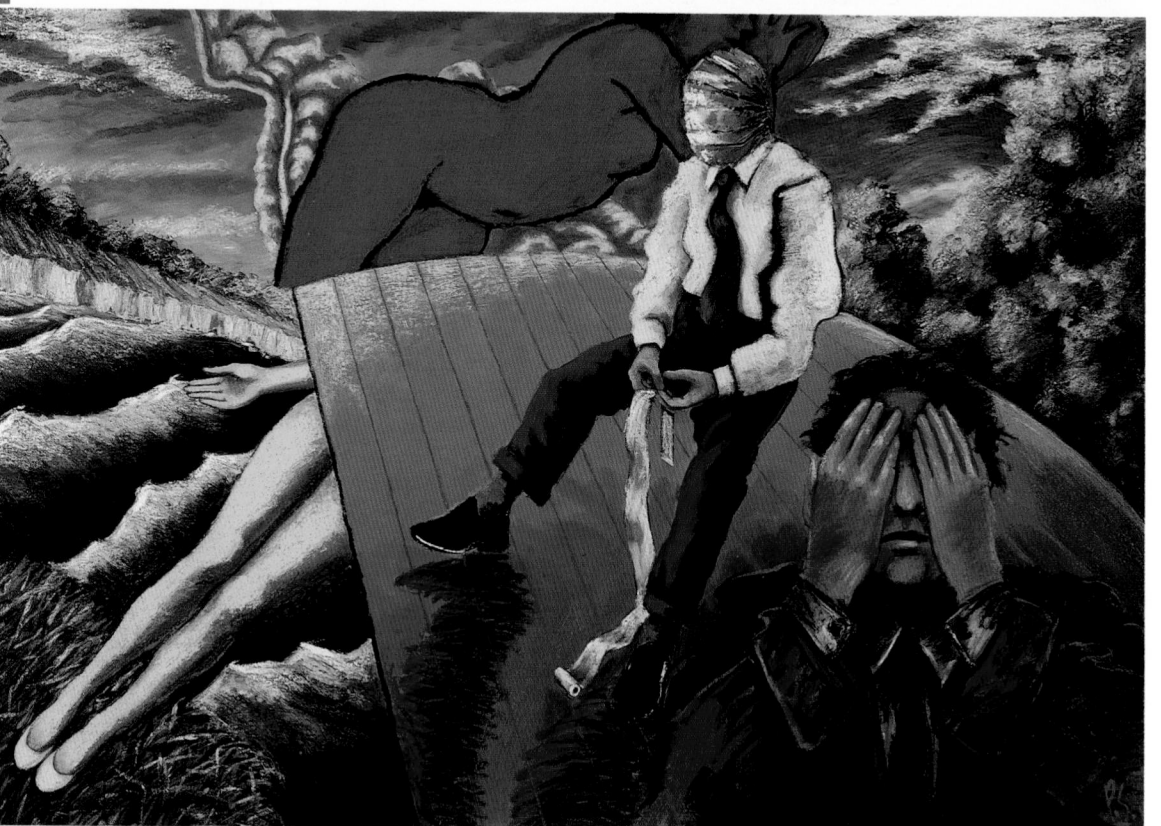

Representation:

GWENDA JAY GALLERY

301 W. Superior, 2nd Fl.
Chicago, IL 60610
312.664.3406

Contact:
Gwenda Jay

Exhibiting:
Contemporary painting,
sculpture and architectural
works

Paul Sierra

1. *Fire Lane*
 1991, Oil on canvas,
 60" x 90"

2. *After Eve*
 1991, Oil on canvas,
 56" x 83"

Selected Biography:
1991 Gwenda Jay Gallery,
Chicago; Group
exhibition: "Cuba/
U.S.A. - The First
Generation", Museum
of Contemporary Art,
Chicago
1990 Evanston Art Center,
Evanston, IL
1987 Traveling group
exhibition: "Hispanic
Art in the United
States", Corcoran
Gallery of Art,
Washington, D.C. and
Los Angeles County
Museum, Los Angeles,
CA

Representation:

HEFFEL GALLERY LIMITED

2247 Granville Street
Vancouver, B.C. V6H 3G1
604.732.6505
604.732.4245 FAX
Contact:
Robert Heffel

Exhibiting:
Important historical and
contemporary Canadian art

Arnold Shives

1. *Storm*
 1991, Acrylic and
 plastic on wood,
 48" x 32"

2. *Snow*
 1991, Acrylic and
 plastic on wood,
 48" x 32"

Selected Biography:
1989 Solo show: Heffel
 Gallery Ltd., Vancouver
1988 Solo show: Paul Kuhn
 Fine Arts, Calgary
1984 Traveling solo show:
 Art Gallery of Greater
 Victoria

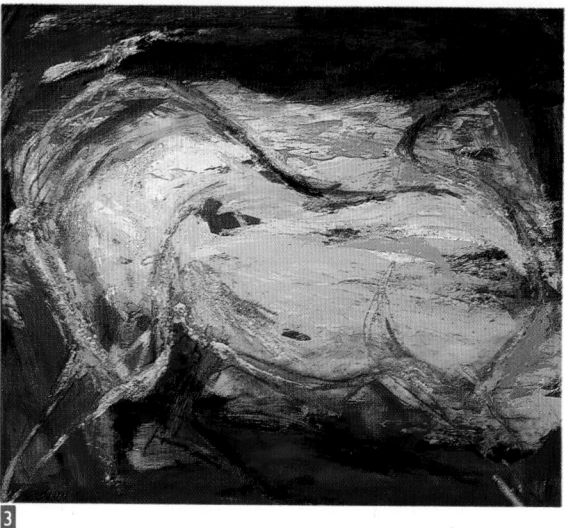

Representation:

EAST WEST CONTEMPORARY ART GALLERY

311 W. Superior, 3rd Fl.
Chicago, IL 60610
312.664.8003
312.664.3322 FAX
Contact:
Carole Jones

Exhibiting:
Chinese and American
contemporary art

Shan-Shan Sheng

1. *Shining Sun and Moon*
 1990, Oil and mixed
 media on canvas,
 76" x 86"

2. *Earth and Ocean*
 1990, Oil and mixed
 media on canvas,
 46" x 60"

3. *A Fragment of Ancient Wall*
 1991, Oil and mixed
 media on canvas,
 44" x 52"

Selected Biography:
1990 Solo show: Art
 Connection Gallery,
 Palm Springs, CA
1989 Solo show: East West
 Contemporary Art
 Gallery, Chicago, IL
1988 Solo shows: Art
 Wave Gallery, NYC;
 University of
 Wisconsin
1987 Artist in residence at
 Harvard University,
 Cambridge, MA

Representation:

THE PACE GALLERY

32 E. 57th Street
New York, NY 10022
212.421.3292
212.421.0835 FAX

142 Greene Street
New York, NY 10012
212.431.9224
212.431.9280 FAX

Exhibiting:
20th-century paintings,
drawings and sculpture

Julian Schnabel

1. *Untitled*
 1990, Oil and gesso
 on gray tarpaulin,
 16' x 16'

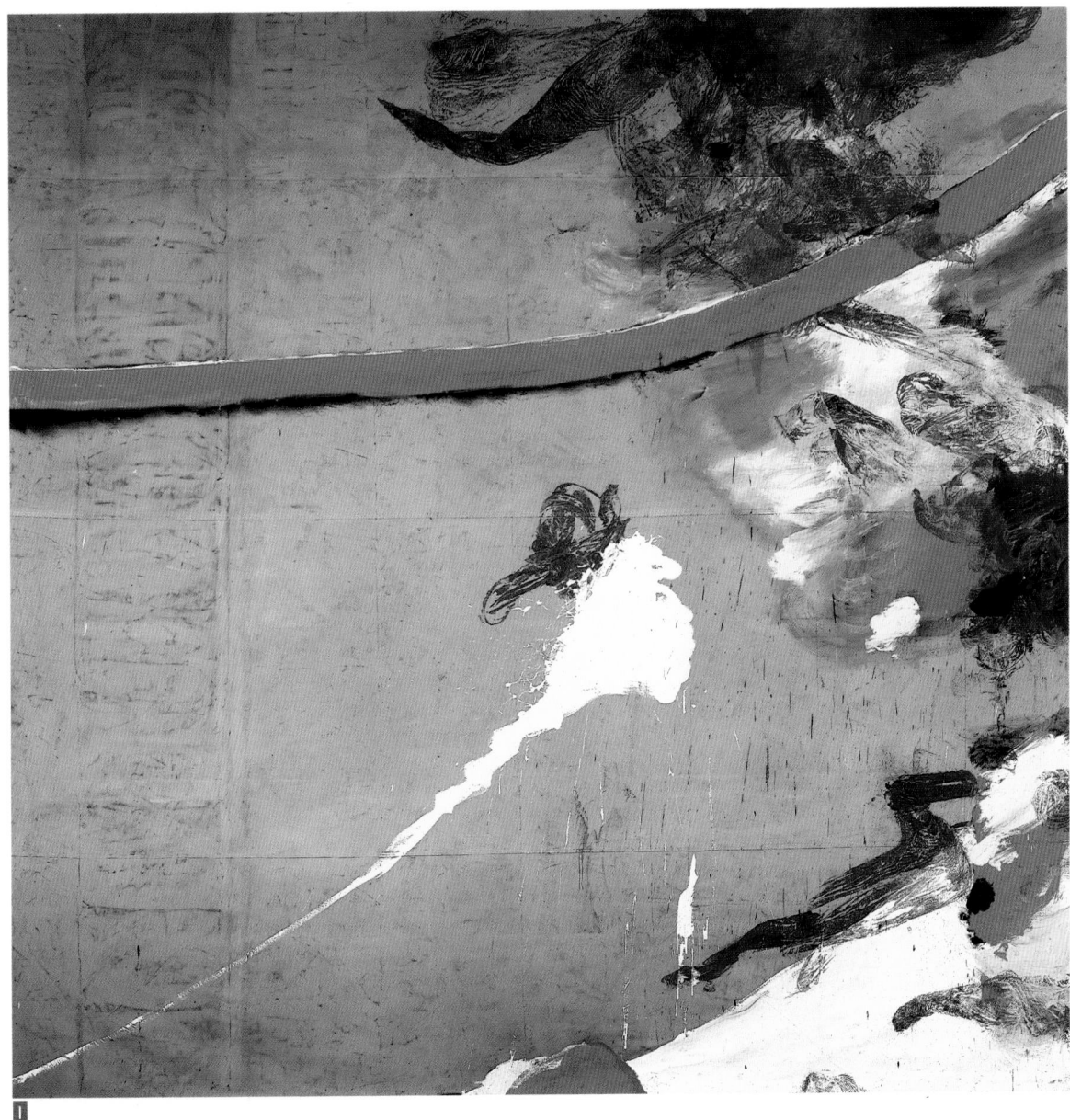

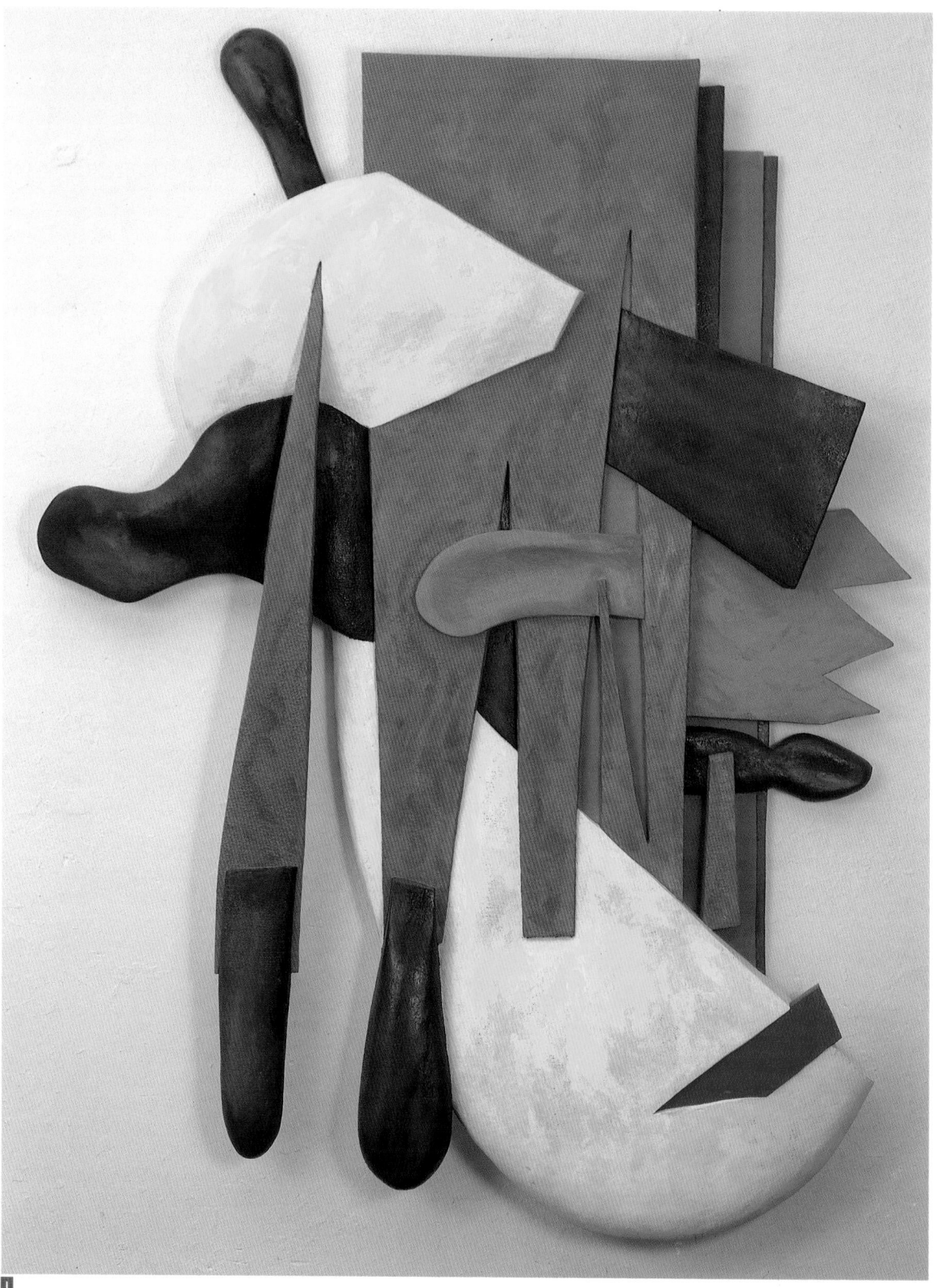

Representation:

SALLY HAWKINS GALLERY

448 West Broadway, 2nd Fl.
New York, NY 10012
212.477.5699
212.260.1928 FAX
Contact:
Sally Hawkins

Exhibiting:
Contemporary paintings,
drawings and sculpture

Bill Schiffer

1. *Landscape 49*
 1991, Acrylic, plaster
 and foam on wood,
 83" x 63 1/2" x 7"

Selected Biography:
1991 "Jewels of Fantasy":
 Museo Teatrale Alla
 Scala, Museum of
 Bellerive Zurick, Musee
 des Arts de Coratifs,
 Victoria and Albert
 Museum, Museum fur
 Angewandte Kunst
1990 Solo exhibition:
 Sally Hawkins Gallery,
 New York
1989 "Painters at the End
 of the Decade", Sally
 Hawkins Gallery,
 New York
1983 "West Broadway
 Boogie", public mural
 at West Broadway &
 Prince St., New York

Representation:

**DAVID ADAMSON
GALLERY**

406 7th Street NW
Washington, DC 20004
202.628.0257
202.628.0257 FAX

Contact:
Laurie Hughs

Exhibiting:
Contemporary prints,
paintings and sculpture

Sherry Zvares Sanabria

1. *Johnson Chapel*
 1988, Acrylic,
 48" x 83"

2. *Ellis Island
 Waiting Room*
 1989, Acrylic,
 40" x 60"

Selected Collections:
 The Phillips Collection

 The Washington Post

 Phillip Morris, USA

 Sallie Mae

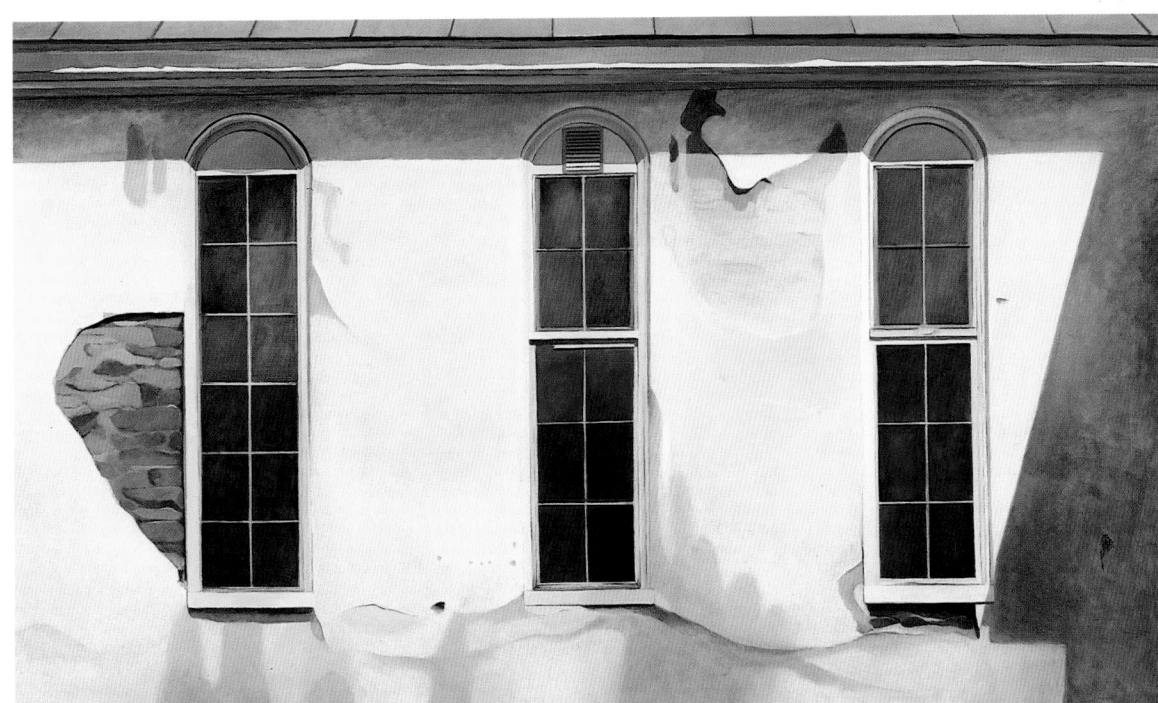

1

Representation:

**GAGOSIAN
GALLERY**

980 Madison Avenue, 6th Fl.
New York, NY 10021
212.744.2313
212.772.7962 FAX

Contact:
Melissa Lazarov

Exhibiting:
Contemporary paintings,
drawings and sculpture

David Salle

1. *Artists and Actors*
 1990-91, Oil and
 acrylic on canvas,
 115" x 90"

Selected Biography:
1991 Solo show: Gagosian
 Gallery, New York;
 Group show:
 Whitney Museum
 Biennial Exhibition
1990 Solo shows: Mario
 Diacono Gallery,
 Boston; Fred
 Hoffman Gallery,
 Los Angeles
1989 Solo show: Tel Aviv
 Museum of Art,
 Tel Aviv

Representation:

THE LOWE GALLERY

75 Bennett Street, Space A-2
Atlanta, GA 30309
404.352.8114
404.352.0564 FAX

Contact:
Bill Lowe

Exhibiting:
Contemporary painting,
sculpture and objects

Andrew Saftel

1. *Still Blue Water*
 1990, Acrylic, mixed
 media on wood,
 65" x 80"

2. *Brasil*
 1990, Acrylic, mixed
 media on wood,
 48" x 96"

3. *Voyager*
 1990, Acrylic, mixed
 media on wood,
 70" x 83"

Selected Biography:
1991 Solo shows: The Lowe
 Gallery, Atlanta, GA;
 Cumberland Gallery,
 Nashville, TN
1990 Solo show: Kyle
 Belding Gallery,
 Denver CO

1

2

3

Representation:

**LEO CASTELLI
GALLERY**

420 W. Broadway
New York, NY 10012
212.431.5160
212.431.5361 FAX
Contact:
Susan Brundage

Ed Ruscha

1. *Untitled*
 1989, Acrylic
 on canvas,
 60" x 112"

2. *The End*
 1991, Acrylic and
 pencil on canvas,
 72" x 112 1/8"

Selected Biography:
1991 Solo exhibitions:
 Museum of
 Contemporary Art,
 Los Angeles, CA;
 "Edward Ruscha
 Paintings", Leo Castelli
 Gallery, New York,
 NY; "Edward Ruscha:
 Recent Editions",
 Castelli Graphics,
 New York, NY;
 Galerie Carola Mosch
 Multiples & Editions,
 Berlin, Germany

Representation:

JAMES CORCORAN GALLERY

1327 Fifth Street
Santa Monica, CA 90401
213.451.4666
213.451.0950 FAX

Ed Ruscha

1. *The Land Beyond*
 1991, Acrylic on canvas,
 70" x 112"

Selected Biography:

1991 Metropolis
 Internationale
 Kunstausstellung, Berlin

1989 "Edward Ruscha:
 Paintings", Centre
 Georges Pompidou,
 Paris, France; Museum
 Boymans-Van
 Beuningen, Ritterdam,
 Holland; Centre
 Cultural de la Fundacio
 Caixa de Pensions;
 Barcelonia, Spain;
 Serpentine Gallery,
 London, Great Britain;
 The Museum of
 Contemporary Art,
 Los Angeles, CA

Representation:

CHARLES WHITCHURCH GALLERY

5973 Engineer Drive
Huntington Beach, CA 92694
714.373.4459
714.373.4615 FAX

Contact:
Douglas Deaver, Ph.D.

Exhibiting:
Paintings, sculpture, and
graphic works by modern
and contemporary artists

Michael Rubin

1. *Night's Fall (Detail)*
 1991, Acrylic on linen,
 42" X 54"

2. *Night's Fall
 (Apocalypse Series)*
 1991, Acrylic on linen,
 42" X 54"

Selected Biography:
1991 "Michael Rubin: Inner
Galaxies", Charles
Whitchurch Gallery,
Huntington Beach, CA;
Group exhibitions:
Philip Samuels, Chicago
International Art
Exposition and Fred
Dorfmann Fine Art,
New York

Representation:

ANITA SHAPOLSKY GALLERY

99 Spring Street
New York, NY 10012
212.334.9755
212.334.6817 FAX
Contact:
Anita Shapolsky

Exhibiting:
20th-century paintings
and sculpture; First
and second generation
Abstract Expressionists

Richards Ruben

1. *Atavistic Passage*
 1990, Oil
 on canvas,
 80" x 80"

2. *Glasslite*
 1991, Oil
 on canvas,
 84" x 84"

3. *Venetian
 Fragment #88*
 1989, Oil pastel
 on hand-made
 kochi paper,
 14" x 11"

1

2

3

Selected Biography:
1991 Solo show: Anita
 Shapolsky Gallery,
 New York, NY
1986 Group show: Lewis
 Meisel Gallery,
 New York, NY
1984 Solo show: Baruch
 College Gallery,
 New York, NY
1977 Solo show: Neuberger
 Museum of Art,
 Purchase, NY

Representation:

STIEBEL MODERN

32 E. 57th Street, 6th Fl.
New York, NY 10022
212.759.5536
212.935.5736 FAX
Contact:
Katherine Chapin

Exhibiting:
Painterly Realism from 1945
to present

Sara Rossberg

1. *Body Over Orange*
 1991, Acrylic/canvas,
 72" x 72"

2. *Layers*
 1990, Acrylic/canvas,
 76" x 96"

Selected Biography:
1991 Sara Rossberg
"Introspective Figure",
Stiebel Modern,
New York, NY
1990 British Petroleum
Portrait Award
Exhibition, National
Portrait Gallery,
London; Solo exhibition:
"Figuratively Speaking",
Rosenberg & Stiebel

Representation:

LEO CASTELLI
GALLERY

420 W. Broadway
New York, NY 10012
212.431.5160
212.431.5361 FAX

Contact:
Susan Brundage

James Rosenquist

1. *Pearls Before Swine,
 Flowers Before Flames*
 1990, Oil on canvas,
 90" x 120"

2. *Untitled*
 1990, Oil on canvas,
 78" x 81"

Selected Biography:
1991 Solo exhibitions:
"Rosenquist: Moscow-
USA", Tretyakov
Museum, Moscow,
USSR; Blum Helman
Gallery, Santa Monica,
CA; "Welcome to the
Water Planet and
House of Fire", Galerie
Nikolaus Sonne, Berlin;
I.V.A.M. Centro Julio
Gonzales, Valencia, Spain

Representation:

**THE COOLEY
GALLERY, INC.**

25 Lyme Street, P.O. Box 447
Old Lyme, CT 06371
203.434.8807
203.434.7526 FAX
Contact:
Jeffrey W. Cooley

Exhibiting:
19th & early 20th-century
American Paintings and
Contemporary Realism

Peggy N. Root

1. *Winter Sun*
 1990, Oil on canvas,
 36" x 36"

Representation:

KIMBERLY GALLERY

1621 21st Street NW
Washington, DC 20009
202.234.1988
202.462.0773 FAX

8000 Melrose Avenue
Los Angeles, CA 90046
213.653.0408
Contact:
Elyse Klaidman
Elena Kimberly
Exhibiting:
Contemporary Latin
American artists

Elmar Rojas

1. *Scarecrow Series:
The Banana Cutters*
1991, Oil on canvas,
47" x 38"

Selected Biography:
1992 Solo shows: Museum
of Modern Art,
Sao Paulo, Brazil;
Museum of Modern
Art, Guatemala
1991 Solo show: Elite Fine
Art, Coral Gables, FL;
Solo shows: Berheim
Gallery, Panama; Anita
Shapolsky Gallery,
New York
1990 Solo show: Galeria
Valanti, Costa Rica
1989 Solo show:
Kimberly Gallery,
Washington D.C.

Representation:

**RODRIGUE GALLERY
OF NEW ORLEANS**

721 Royal Street
New Orleans, LA 70116
800.899.4244

GALERIE BLUE DOG, LTD.
6th Avenue between
Lincoln & Dolores
Carmel, CA 93923
408.626.4444

Contact:
Richard Steiner

Exhibiting:
Two one artist galleries
devoted to George
Rodrigue

George Rodrigue

1. *Home on The Moon*
 1990, Oil on canvas,
 24" x 48"

2. *Right Time, Wrong Place*
 1990, Oil on canvas,
 48" x 36"

3. *Cosmos Dog*
 1989, Oil on canvas,
 36" x 24"

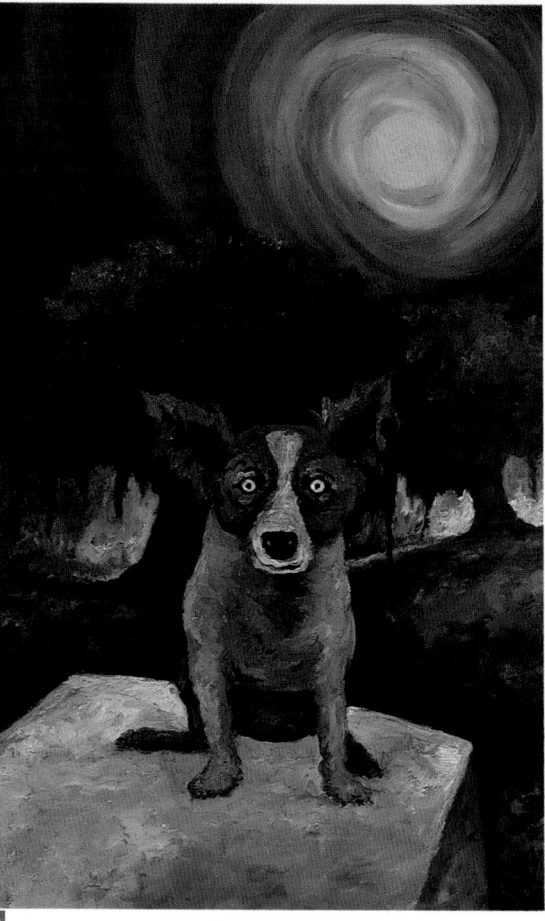

Selected Biography:
1991 Solo show:
 Thalheimer's Upstairs,
 Naples, FL
1988 Solo show: Moscow
 Summit, Moscow,
 USSR
1980 Solo show: Galerie
 Antinea, Paris, France
1974 Grand Palais Exhibition
 (Honorable Mention),
 Paris, France

Representation:

**ROBERT KOCH
GALLERY**

49 Geary Street
San Francisco, CA 94108
415.421.0122
415.421.6306 FAX

Contact:
Robert Koch
Ada Takahashi
Exhibiting:
19th, 20th-century and
contemporary photography,
Surrealist, avant-garde,
Eastern European
photography

Holly Roberts

1. *Man Giving Up*
 1991, Oil on gelatin
 silver print,
 30" x 25"

Selected Biography:
1992 Solo show: University
 of St. Louis
1991 Solo show: Friends of
 Photography
1990 Monograph published
 by Friends of
 Photography
1988 Awarded NEA Grant

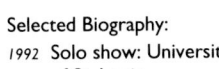

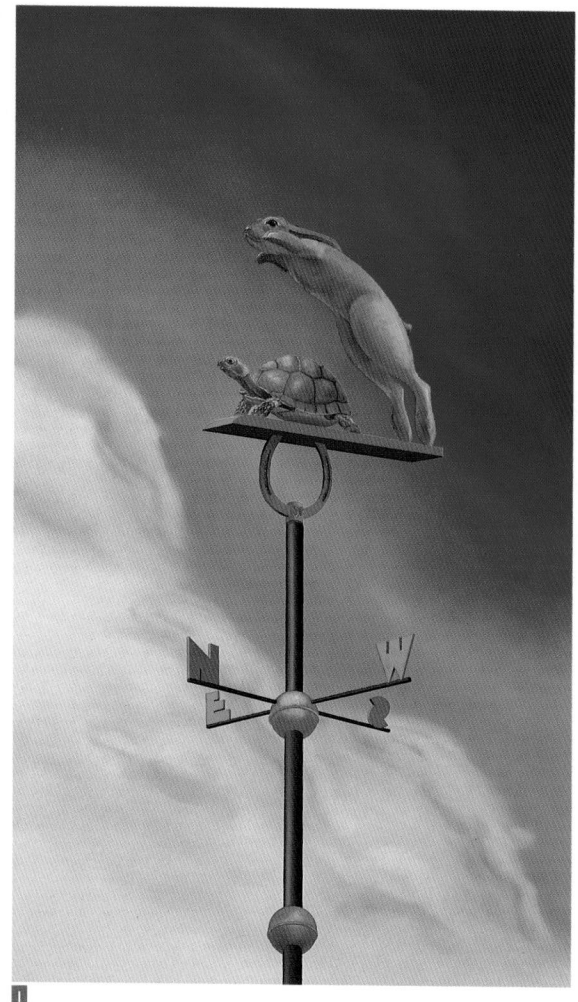

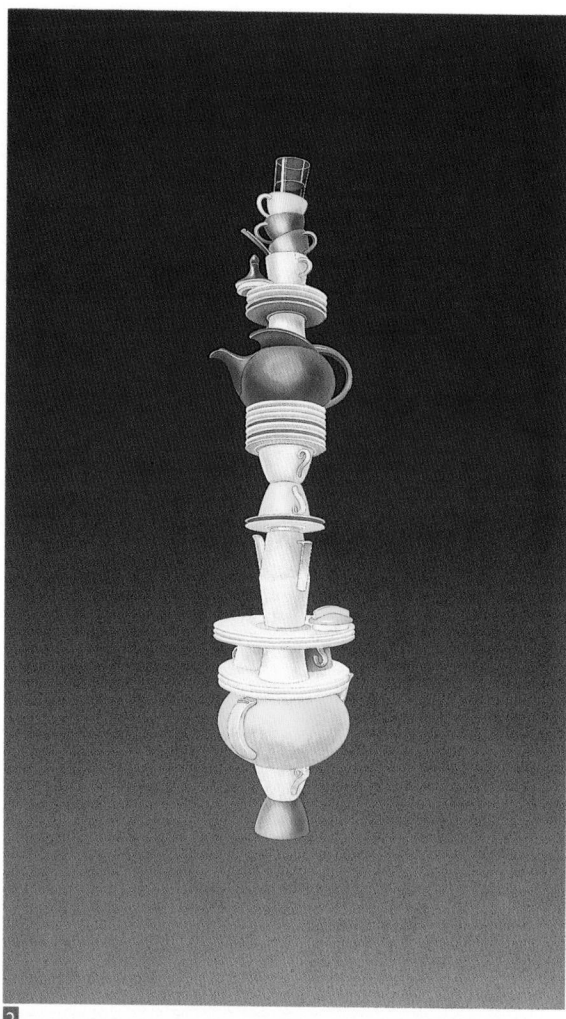

Representation:

THE WORKS GALLERY

106 W. Third Street
Long Beach, CA 90802
213.495.2787
213.495.0370 FAX

Crystal Court/S. Coast Plaza
3333 Bear Street, Third Fl.
Costa Mesa, CA 92626
714.979.6757
714.979.6818 FAX
Contact:
Mark Moore

Exhibiting:
Established and emerging
contemporary artists of
the western United States

Bruce Richards

1. *Post Time II*
 1989, Oil on canvas,
 60" x 36"

2. *Mad Hatter*
 1991, Acrylic,
 watercolor on paper,
 54 3/4" x 34 1/4"

3. *Tears*
 1990, Oil on canvas,
 17" x 14"

Selected Biography:
1992 Group exhibitions:
 "H$_2$O: A Survey in
 Watercolor", The
 Works Gallery South,
 Costa Mesa, CA;
 The Armoury Center
 for the Arts, Pasadena,
 CA
1991 Solo exhibition:
 "Works On Paper",
 The Works Gallery
 South, Costa Mesa,
 CA; Group exhibitions:
 "Individual Realities",
 Sezon Museum, Tokyo,
 Japan; Tsukashin Hall,
 Osaka, Japan

Representation:

MODERNISM INC.

685 Market Street, Suite 290
San Francisco, CA 94105
415.541.0461
415.541.0425 FAX
Contact:
Katya Slavenska

Exhibiting:
Contemporary art,
20th-century historical
art, Russian Avant-Garde
1900-1930

John Register

1. *The Window*
 1991, Oil
 on canvas,
 50" x 70"

Selected Biography:
1989 Santa Monica
 Heritage Museum,
 Santa Monica, CA
1986 Laguna Art Museum,
 Laguna Beach, CA;
 Francis J. Greenburger
 Foundation Award
 Exhibition, Ruth Siegel
 Gallery, New York, NY
1983 Parrish Museum,
 Southampton, NY

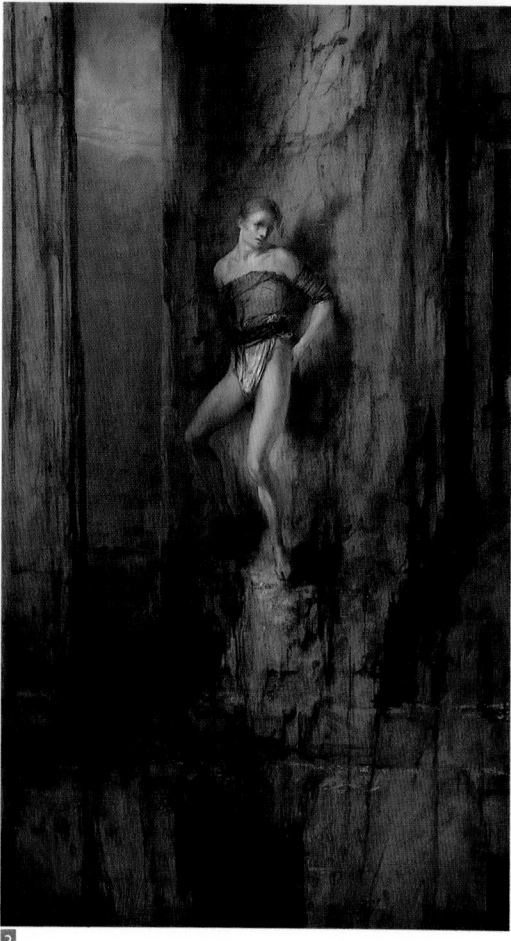

Representation:

CFM GALLERY

138 W. 17th Street
New York, NY 10011
212.929.4001
212.691.5453 FAX
Contact:
Neil P. Zukerman

Exhibiting:
Contemporary European
and American Masters;
Surrealism and
Representational

Massimo Rao

1. *Senzo Titolo*
 1989, Oil on board,
 15.5" x 20"

2. *In Fondo All'Arcipelago
 Dove Si Legge Nel Futuro*
 1989, Oil on canvas.
 48" diameter

3. *Prigioniero d'Amore*
 1989, Oil on canvas,
 54" x 31"

Selected Biography:
1991 Retrospective, Museum
Tour Frommage, Aosta,
Italy; International
Gallery Invitational,
Chicago
1989 International Art Fair,
Basel
1987 Biennale d'Arte,
Piacenca, Italy

Representation:

**MICHAEL DUNEV
GALLERY**

77 Geary Street
San Francisco, CA 94108
415.398.7300
415.398.7680 FAX

Contact:
Michael Dunev

Exhibiting:
American and European
contemporary drawings,
paintings and sculpture

Gustavo Ramos Rivera

1. *Untitled*
 1990, Oil on canvas,
 84" x 60"

2. *Untitled*
 1988-90, Oil and mixed
 media on canvas,
 57.25" x 58.5"

3. *Pasos A Tiempo*
 1982, Oil on canvas,
 72" x 96"

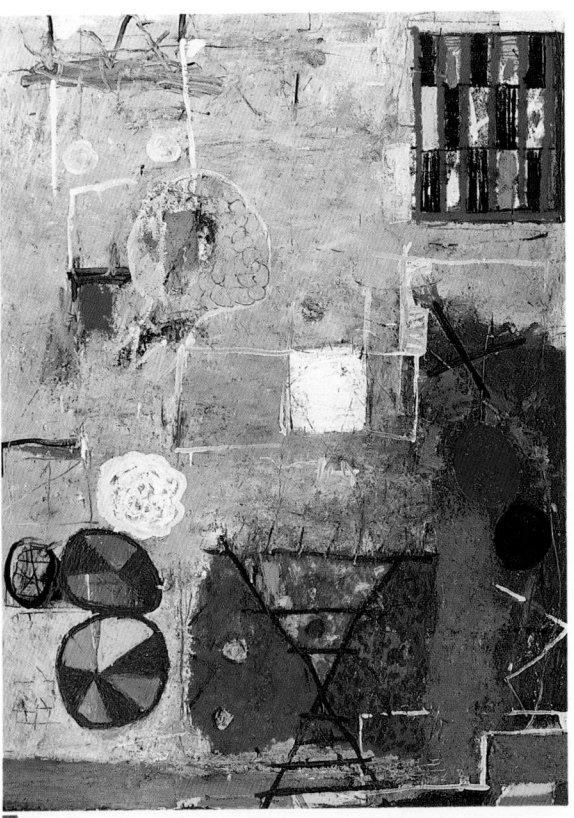

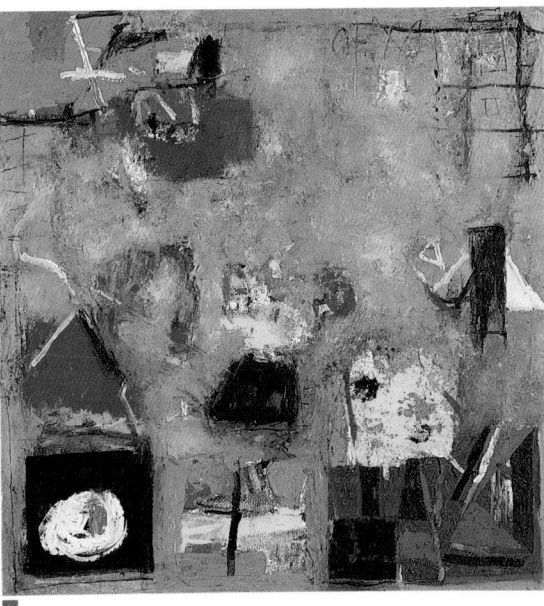

Selected Biography:
1991 Museum of Art,
 Santiago, Chile;
 Michael Dunev Gallery;
 Hal Katzen Gallery, NY;
 Iturralde Gallery,
 La Jolla, CA
1990 Michael Dunev Gallery,
 San Francisco; Smith-
 Andersen Gallery,
 Palo Alto
1989 San Jose Institute of
 Contemporary Art
1988 Alternative Museum,
 NY; Oakland Museum

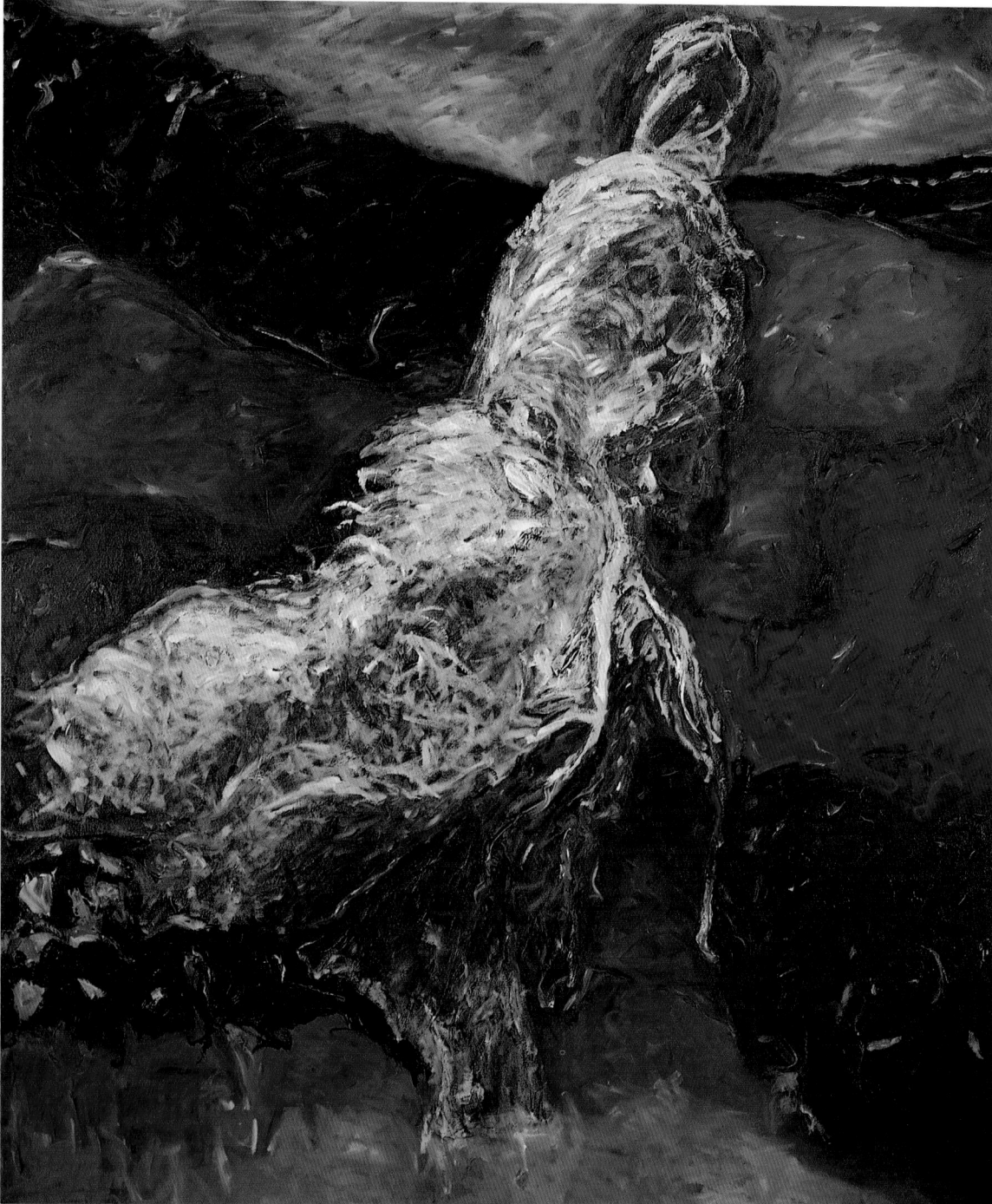

Representation:

SANTA FÉ EAST

200 Old Santa Fe Trail
Santa Fe, NM 87501
505.988.3103

Contact:
Ron Cahill

Exhibiting:
American art; contemporary
painting and sculpture

Mitzi Prince

1. *Gypsy Movement*
 1990, Oil on canvas,
 72" x 62"

Selected Biography:
1991 "Between Dream and
Reality", Santa Fe, NM;
"Five From Santa Fe",
Fagen-Peterson Gallery,
Scottsdale, AZ;
"On The Border",
New Mexico University,
Las Cruces, NM

Representation:

THE LOWE GALLERY

75 Bennett St., Space A-2
Atlanta, GA 30309
404.352.8114
404.352.0564 FAX

Contact:
Bill Lowe

Exhibiting:
Contemporary painting,
sculpture and objects

Patricia Boinest Potter

1. *Perpendicular
 Vanishing Points*
 1991, Oil/mixed
 media on board,
 72" x 110"

2. *Generative Point/s*
 1991, Oil/mixed
 media on board,
 90" x 137"

Selected Biography:
1991 "Inner Sections of Time
and Place", The Lowe
Gallery, Atlanta, GA

Representation:

**DE GRAAF
FINE ART, INC.**

9 E. Superior
Chicago, IL 60611
312.951.5180

3400 Avenue of the Arts
Suite C120
Costa Mesa, CA 92626
714.557.5240

Exhibiting:
Contemporary American,
European and Latin
American paintings,
sculpture and graphics

Clayton Pond

1. *Coming About No. 4*
 1987, Acrylic on canvas,
 88" x 90 1/2"

2. *Proposed Retrospective
 Exhibition In Space*
 1979, Serigraph
 30" x 40", Edition 300

3. *Toliet Seat*
 1974-79, Acrylic on canvas,
 66" x 49"

Selected Collections:
Museum of Modern
Art, Los Angeles
County Museum,
Boston Museum of
Fine Arts, Art Institue
of Chicago, Albright
Knox Museum,
Philadelphia Museum
of Fine Arts,
Minneapolis Institute
of Arts, Milwaukee
Art Center, Library of
Congress, Washington,
DC, Israel Museum,
Jerusalem

Representation:

JANET FLEISHER GALLERY

211 S. 17th Street
Philadelphia, PA 19103
215.545.7562
215.545.6140 FAX

Contact:
John E. Ollman
Patti Baird
Exhibiting:
Contemporary American art, self-taught and visionary artists

Bruce Pollock

1. *Fires Five*
 1988, Acrylic on canvas mounted on panel, 53" x 57"

2. *Lux Comb*
 1989, Acrylic on canvas mounted on panel, 60" x 52"

Selected Biography:
1991 Solo show:
 Janet Fleisher Gallery, Philadelphia, PA
1990 Solo shows:
 Morris Gallery, Philadelphia Academy of Arts, Philadelphia, PA; Janet Fleisher Gallery, Philadelphia, PA; Design Arts Gallery, Nesbitt College of Design Arts, Drexel University, Philadelphia, PA
1986 Solo show:
 Cavin Morris, Inc., New York, NY

1

2

3

Representation:

MARY BOONE GALLERY

417 W. Broadway
New York, NY 10012
212.431.1818
212.431.1548 FAX
Contact:
Mary Boone

Exhibiting:
Contemporary paintings,
drawings, and sculpture

Sigmar Polke

1. *Die Lebenden stinken und die Toten sind nicht anwesend*
 1983, Mixed media/
 cotton,
 115" x 140"
 Collection: Jerry/Emily Spiegel
 Family Collection, New York

2. *Lager*
 1982, Acrylic/cotton,
 158" x 99"
 Collection: Charlene Engelhard,
 Cambridge, MA, Promised Gift to
 The Museum of Fine Arts, Boston

3. *Lumpi hinter dem Ofen*
 1983, Mixed media/
 cotton,
 127" x 97.5"
 Collection: Thomas Ammann,
 Zurich, Switzerland

Selected Biography:

1991 Hirshhorn Museum and
Sculpture Garden,
Smithsonian Institution,
Washington, DC;
Museum of
Contemporary Art,
Chicago, IL; The
Brooklyn Museum,
Brooklyn, NY

1990 Mary Boone Gallery,
New York, NY; Galerie
Marie-Louise Wirth,
Zurich, Switzerland;
Michael Werner
Gallery, New York,
NY; San Francisco
Museum of Modern
Art, San Francisco, CA

Representation:

ALEX-EDMUND GALLERIES

478 W. Broadway
New York, NY 10012
212.260.5900
212.260.6715 FAX
Contact:
Alex Oronov

Exhibiting:
Contemporary Russian
paintings, sculpture, works
on paper, limited editions

Dmitri Plavinsky

1. *Golden Disk*
 1991, Mixed
 media on canvas,
 36" diameter

2. *Silver Disk*
 1991, Mixed
 media on canvas,
 36" diameter

3. *Order of Notes*
 1991, Mixed
 media on canvas,
 40" x 89"

Selected Biography:

1991 "The Other Art:
Moscow 1956-1976",
Tretyakov Gallery,
"Moscow Collection",
Moscow; "Modern Art
from Russia", Setagaya-
Ku Museum, Tokyo

1990 First Moscow Festival
of Art, Galleries
Central House of
Painters, Moscow

1988 Museé de l'Art Russe
Contemporaine
Opening, Paris

1977 "Russian and Soviet
Paintings", Metro-
politan Museum of
Art, New York

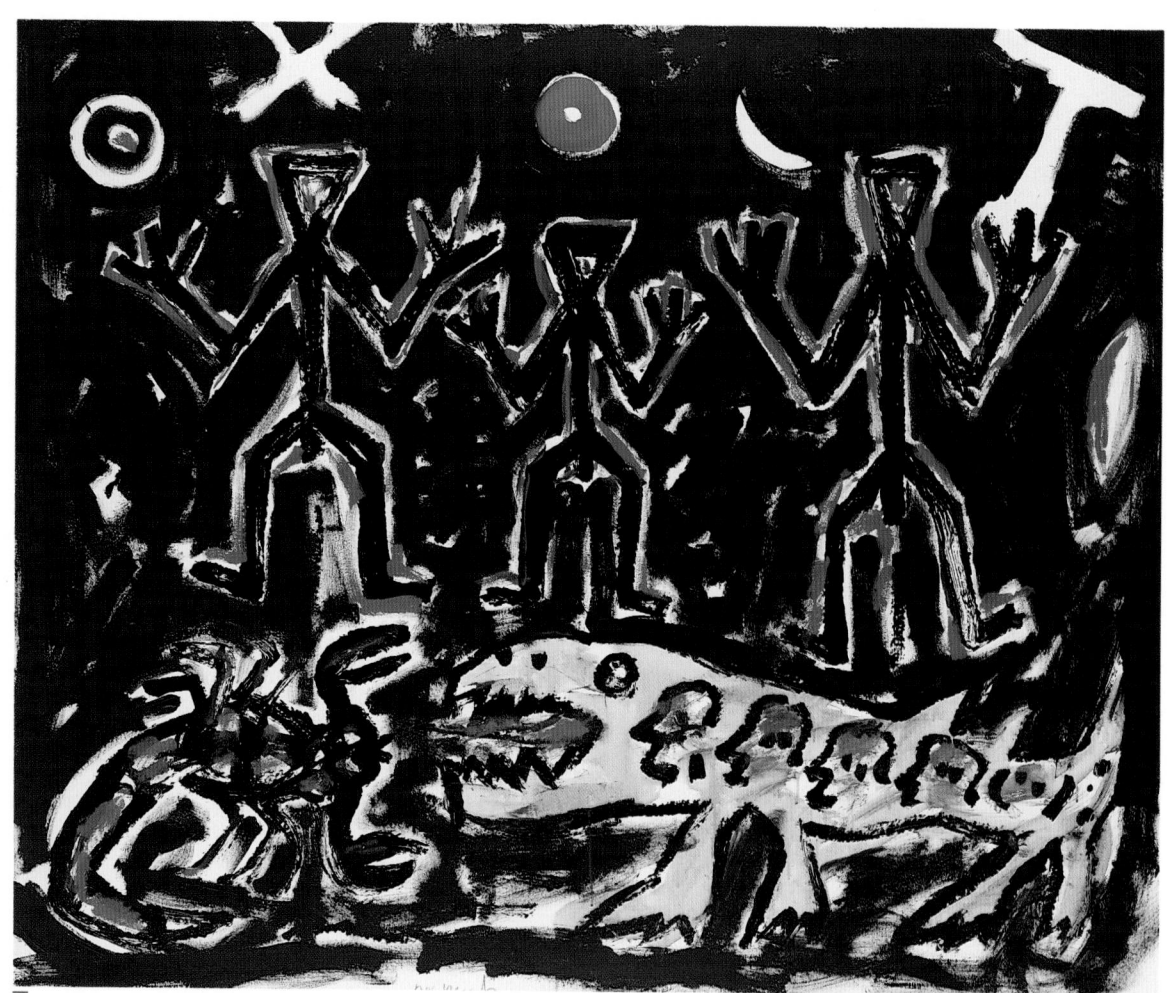

Representation:

WENGER GALLERY

828 N. La Brea Avenue
Los Angeles, CA 90038
213.464.4431
213.464.4466 FAX
Contact:
Sigmund Wenger

Exhibiting:
Mondern and contemporary
American and European art

A.R. Penck

1. *Three out of Many*
 1990, Acrylic on canvas,
 51" x 63"

Selected Biography:
1990 Commences
 collaboration with
 Wenger Gallery,
 Los Angeles
1988 Nationalgalerie, Berlin;
 Kunsthaus, Zurich;
 Kestner-Gesellschaft,
 Hanover; Lelong, Paris
1984 Venice Biennale; Tate
 Gallery, London; Mary
 Boone, New York;
 Maeght Lelong, Zurich
1982 Kunstmuseum Basel;
 Kunstmuseum, Bonn;
 Sonnabend, New York;
 Werner, Cologne;
 Amelio, Naples

Representation:

HIRSCHL & ADLER MODERN

851 Madison Avenue
New York, NY 10021
212.744.6700
212.737.2614 FAX
Contact:
Donald McKinney

Exhibiting:
Contemporary European
and American art

Philip Pearlstein

1. *Fox, Fish, Models and Wooden Lady*
 1991, Oil on canvas,
 96" x 72"

Selected Biography:

1991 "Philip Pearlstein",
Hirschl & Adler
Modern, New York,
NY; "1991 Biennial
Exhibition", Whitney
Museum of American
Art, New York, NY;
"Philip Pearlstein:
Recent Paintings and
Drawings", Compass
Rose, Chicago, IL

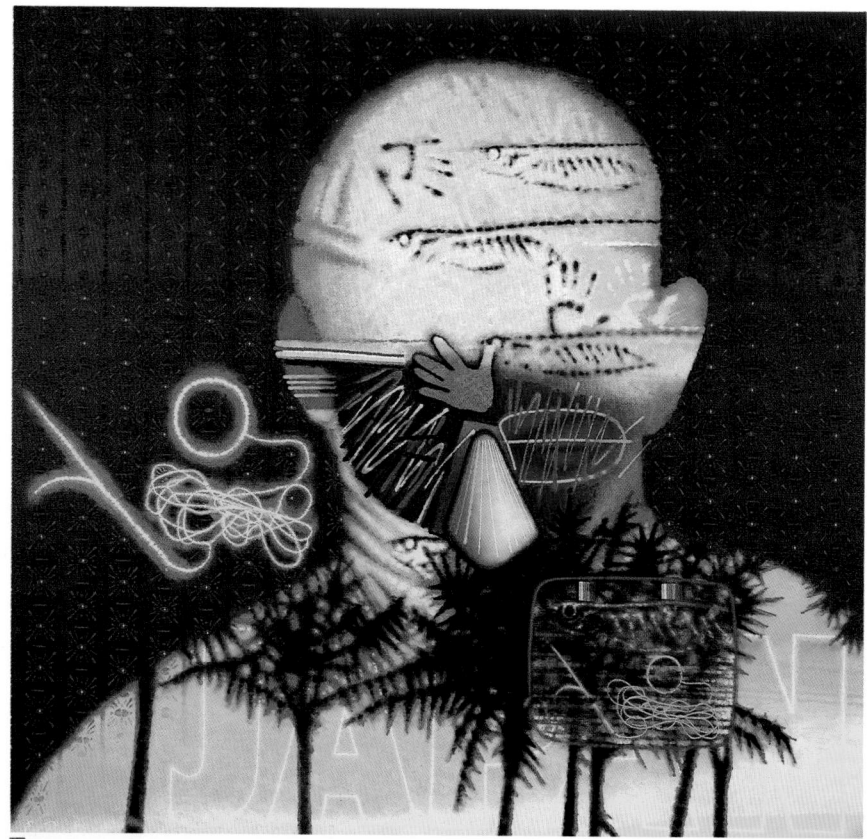

Representation:

PHYLLIS KIND
GALLERY

136 Greene Street
New York, NY 10012
212.925.1200
212.941.7841 FAX

313 W. Superior Street
Chicago, IL 60610
312.642.6302
312.642.8502 FAX

Contact:
Phyllis Kind

Exhibiting:
Contemporary American,
Soviet, Naive and Outsider
art

Ed Paschke

1. *Dr. Dr.*
 1990, Oil on linen,
 78" x 84"

2. *Nuvo-Retro*
 1990, Oil on linen,
 60" x 78"

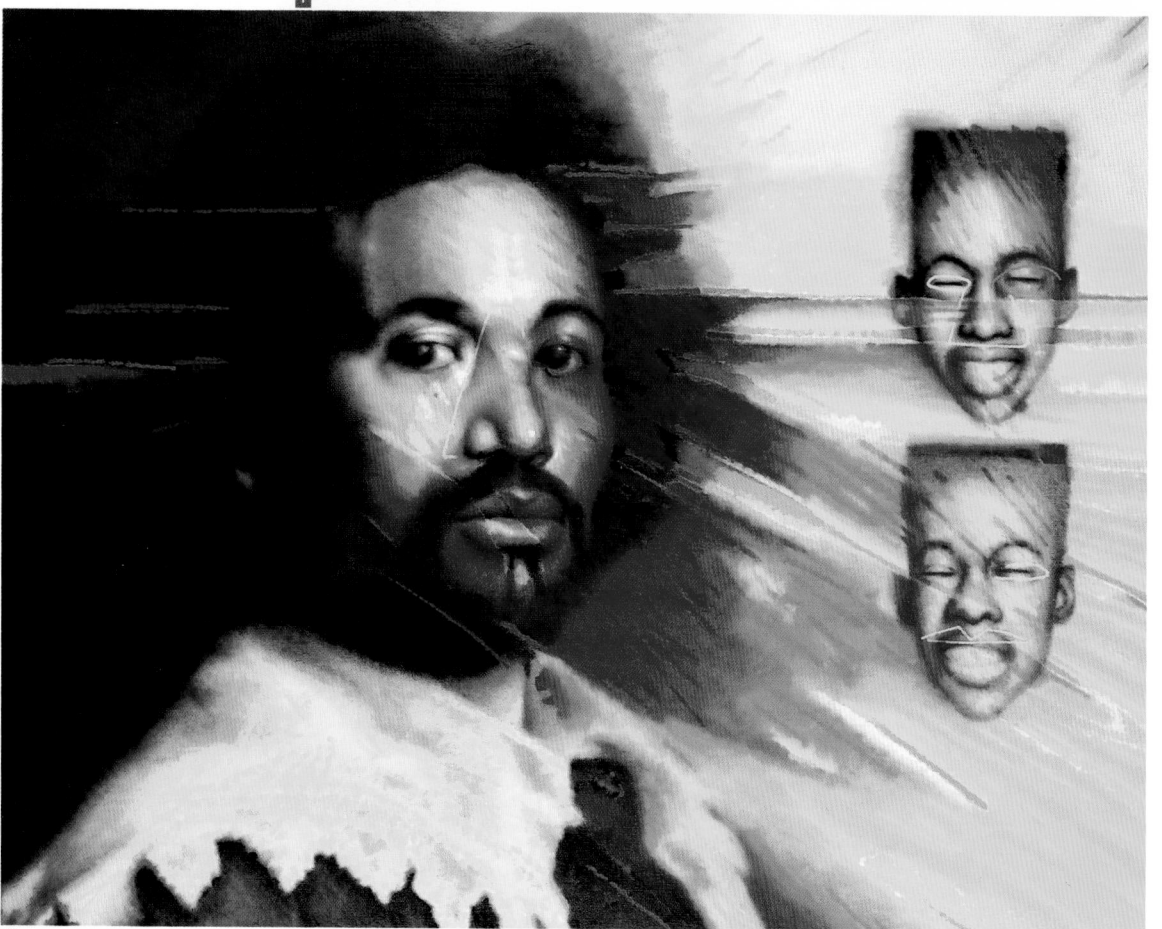

Selected Biography:
1992 Phyllis Kind Gallery,
Chicago
1991 Phyllis Kind Gallery,
New York
1989 Traveling exhibition:
"Ed Paschke
Retrospective":
Museé National d'Art
Moderne, Paris;
Dallas Art Museum,
Texas

Representation:

**LAURA RUSSO
GALLERY**

805 NW 21st Avenue
Portland, OR 97209
503.226.2754

Contact:
Laura Russo

Exhibiting:
Northwest paintings,
sculpture, prints, works
on paper, glass

Lucinda Parker

1. *Pythoness*
 1991, Acrylic on canvas,
 49" x 88"

2. *Eulachon*
 1991, Acrylic on canvas,
 69" x 56"

Selected Biography:
1991 Solo exhibition:
 Laura Russo Gallery,
 Portland, Oregon
1990 Invitational:
 Seattle Art Museum,
 Seattle; Portland Art
 Museum, Portland
1989 Solo exhibition:
 Davidson Gallery,
 Seattle, Washington
1986 Solo exhibition:
 Seattle Art Museum,
 Seattle, Washington

Representation:

HEFFEL GALLERY LIMITED

2247 Granville Street
Vancouver, BC V6H 3G1
604.732.6505
604.732.4245 FAX
Contact:
Robert Heffel

Exhibiting:
Important historical and
contemporary Canadian art

Richard Overfield

1. *The Assumption*
 1991, Oil on linen,
 48" x 48"

2. *Lasqueti (A Place to Live)*
 1991, Oil on linen,
 41" x 41"

Selected Biography:
1992 Solo show: Heffel
 Gallery Ltd., Vancouver
1991 Solo show: Galerie
 Dresdnere, Toronto
1990 Group show:
 Whatcom County
 Museum: "North of the
 Border", Washington
1986 Solo show: Fiona
 Whitney, Los Angeles

Representation:

STEPHEN WIRTZ GALLERY

49 Geary Street, 3rd Fl.
San Francisco, CA 94108
415.433.6879
415.433.1608 FAX
Contact:
Stephen Wirtz
Connie Wirtz

Deborah Oropallo

1. *Gray's Elegy*
 1990, Oil on canvas,
 86" x 90"

2. *The Human Target*
 1990, Oil on canvas,
 87" x 77"

Selected Biography:
1992 Exhibition: Raab
 Gallery, Berlin
 & London
1991 Exhibition: Germans
 Van Eck Gallery,
 New York
1990 Traveling exhibition:
 "Words as Image",
 Milwaukee Art
 Museum; Exhibition:
 Stephen Wirtz Gallery,
 San Francisco, CA

Representation:

GALLERY ONE

121 Scollard Street
Toronto, Canada M5R 1G4
416.929.3103
416.929.0278 FAX
Contact:
Goldie Konopny
Sharon Fischtein
Exhibiting:
Contemporary Canadian,
American & International
painting, sculpture & graphics

Jules Olitski

1. *Jam*
 1963, Magna
 acrylic on canvas,
 49" x 40"

Selected Biography:
1990 Galeria Afinsa/
 Galeria Almirante,
 Madrid, Spain;
 Francis Graham-
 Dixon Gallery,
 London; Gallery One,
 Toronto, Ont., Canada
 (Retrospective);
 Buschlen Mowatt
 Gallery, Vancouver, BC

Representation:

ANITA SHAPOLSKY GALLERY

99 Spring Street
New York, NY 10012
212.334.9755
212.334.6817 FAX
Contact:
Anita Shapolsky

Exhibiting:
20th-century paintings
and sculpture; First
and second generation
Abstract Expressionists

Thomas Nonn

1. *Elegy To Chico Mendes I*
 1990, Mixed media,
 63" x 87"

2. *Besigned*
 1986; 1990,
 Mixed media,
 84" x 48"

3. *Bovina Morning*
 1990, Mixed media,
 60" x 61"

Selected Biography:
1991 Solo show: Anita
Shapolsky Gallery,
New York, NY
1984 Solo show: Sara
Rentchler Gallery,
New York, NY
1980 Solo show: New
York University,
New York, NY
1972 Solo show: Mint
Museum of Art,
Charlotte, NC

Representation:

**DAVID ADAMSON
GALLERY**

406 7th Street NW
Washington, DC 20004
202.628.0257
202.628.0257 FAX
Contact:
Laurie Hughs

Exhibiting:
Contemporary prints,
paintings and sculpture

William Newman

1. *Bloody Mary and
 The Devil Dogs*
 Oil,
 54" x 40"

2. *Feathers*
 1991, Computer
 generated print,
 40" x 30"

3. *Cat and Mouse*
 Mixed media on plexi
 and canvas,
 58" x 72"

Selected Exhibitions:
 David Adamson Gallery,
 Washington, D.C.

 Corcoran Gallery of Art

 Bronx Museum of Art

 "Every Thing But",
 The Kitchen, New York

Representation:

AUGEN GALLERY

817 S.W. 2nd Avenue
Portland, OR 97204
503.224.8182

Contact:
Robert Kochs

Exhibiting:
Emerging Northwest artists
and prints by important
contemporary artists

Royal Nebeker

1. *There Will Come Moments*
 1991, Acrylic, oil and
 collage on paper,
 25.5" x 49.5"

2. *Untitled*
 1991, Mixed media
 on canvas,
 71" x 96"

3. *Lakerol*
 1991, Acrylic and
 collage on paper,
 22" x 30"

Selected Biography:
1989 Solo exhibitions: Augen
 Gallery, Portland;
 Francine Seders
 Gallery, Seattle
1988 Solo exhibitions: Augen
 Gallery, Portland;
 Galleri Gimele, Malmo,
 Sweden; Gallerie Levy,
 Paris
1987 Solo exhibitions: Augen
 Gallery, Portland;
 Bluxome Gallery,
 San Francisco
1985 Solo exhibitions:
 Gallery Levy, Hamburg;
 Frogner Galleriet,
 Aalesund, Norway

Representation:

DAVID ADAMSON GALLERY

406 7th Street NW
Washington, DC 20004
202.628.0257
202.628.0257 FAX
Contact:
Laurie Hughs

Exhibiting:
Contemporary prints,
paintings and sculpture

Judy Mussoff

1. *2 Flags*
 1989, Colored pencil,
 23" x 35"

2. *Green Dress*
 1990, Oil,
 48" x 36"

Selected Biography:
1992 Solo exhibitions:
David Adamson Gallery,
Washington, D.C.;
Monique Nolton,
New York; Gallery K,
Washington, D.C.;
Origraphica, Malmo,
Sweden

Representation:

THE LOWE GALLERY

75 Bennett Street, Space A-2
Atlanta, GA 30309
404.352.8114
404.352.0564 FAX

Contact:
Bill Lowe

Exhibiting:
Contemporary painting,
sculpture and objects

Todd Murphy

1. *Femmes of Red Clay Poetry*
 1990, Oil paint, tar on
 wood with plexi,
 144" x 180"

2. *Beckett*
 1990, Charcoal,
 mixed media,
 62" x 58"

3. *Mona Mona*
 1989, Layered plexi, oil
 paint, photo collage,
 113" x 156"

Selected Biography:
1991 Solo show: McKissick
 Museum of Art,
 Columbia, SC;
 Solo show: "Recent
 Works", The Lowe
 Gallery, Atlanta, GA

Representation:

EDITION JOHN A. SCHWEITZER

GALERIE JOHN A. SCHWEITZER

POIRIER SCHWEITZER

42 ouest, avenue des Pins
Montreal, Canada H2W 1R1
514.289.9262
514.289.9262 FAX

Contact:
John A. Schweitzer
Robert Poirier
Exhibiting:
Modern and contemporary
American and European
painting, sculpture,
photography, works on paper,
architectural & decorative art

Robert Motherwell

1. *Open #174 in Red
 with Blue Stripes*
 1970, Acrylic on canvas,
 96" x 47.5"
 In Memoriam: 1915-1991

Selected Exhibitions:
1979 The New York School,
The John A. Schweitzer
Foundation, Zurich
1976 through 1979,
"Extended Loan: The
Walker Court", Art
Gallery of Ontario,
Toronto
1972 "Abstract Painting in the
70's", Museum of Fine
Arts, Boston

Representation:

THE LOWE GALLERY

75 Bennett Street, Space A-2
Atlanta, GA 30309
404.352.8114
404.352.0564 FAX

Contact:
Bill Lowe

Exhibiting:
Contemporary painting,
sculpture and objects

Kathleen Morris

1. *Point Of Entry*
 1990, Oil on linen,
 66" x 60"

2. *Numbers*
 1991, Oil on linen,
 72" x 84"

Selected Biography:
1990 Solo show: The Lowe
 Gallery, Atlanta, GA
1980 Solo show: Sena West
 Gallery, Santa Fe, NM

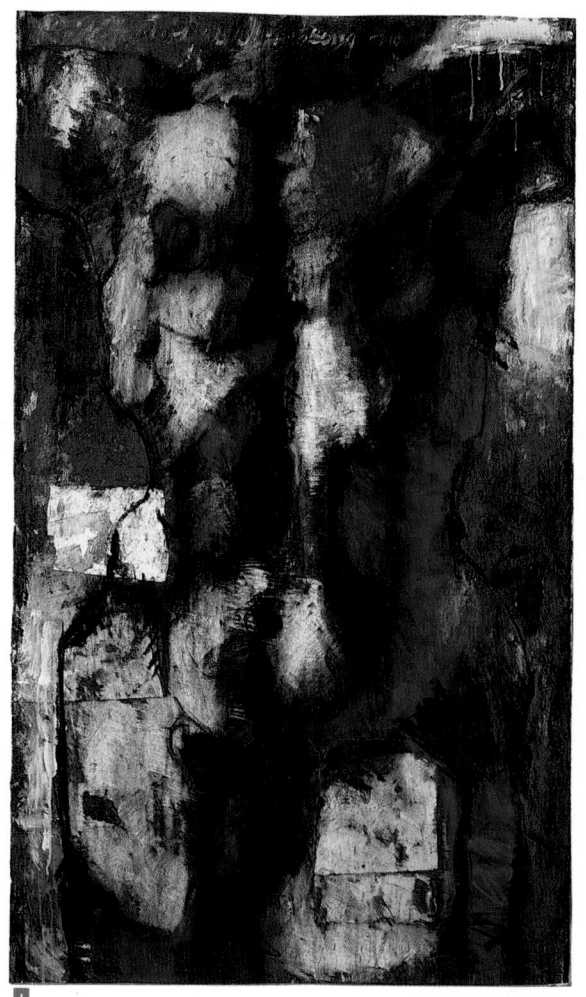

1

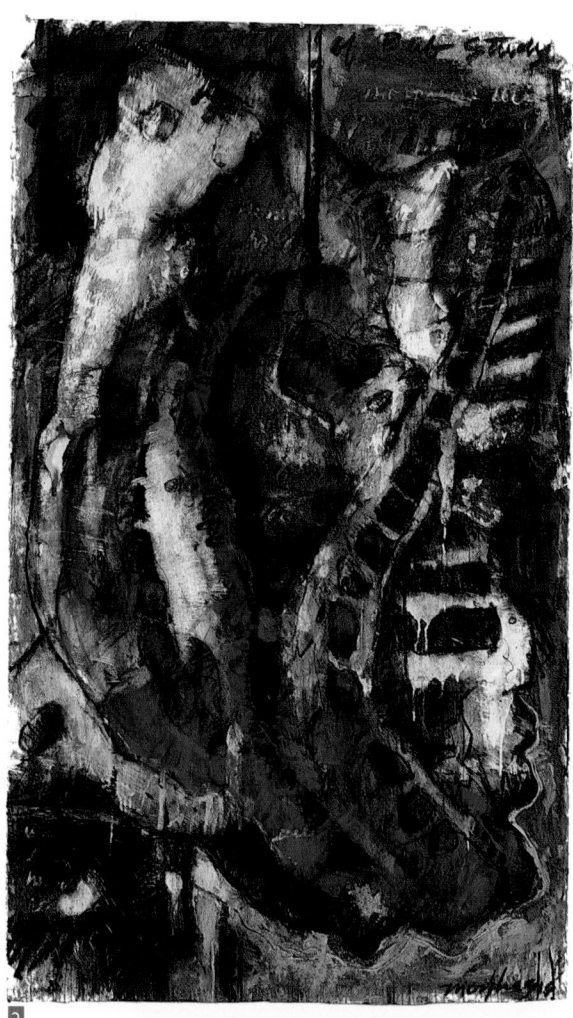

2

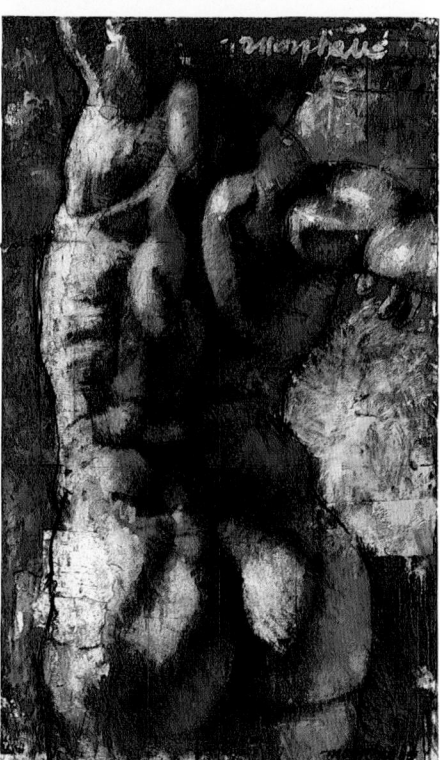

3

Representation:

**THE WORKS
GALLERY**

106 W. Third Street
Long Beach, CA 90802
213.495.2787
213.495.0370 FAX

3333 Bear St reet Third Fl.
Costa Mesa, CA 92626
714.979.6757
714.979.6818 FAX

Contact:
Mark Moore

Exhibiting:
Established and emerging
contemporary artists of
the western United States

Jim Morphesis

1. *Torso with Red and Green*
 1991, Oil, charcoal, pastel,
 collage on paper,
 60" x 36"

2. *Quarter of Beef with Green*
 1991, Oil, charcoal, pastel,
 collage on paper,
 76" x 45"

3. *Morpheus*
 1991, Oil, charcoal, pastel,
 collage on wood panel,
 60" x 36"

Selected Biography:
1992 Solo exhibitions:
 The Works Gallery,
 Long Beach, CA;
 Torue Gallery,
 Santa Monica, CA
1991 Group shows:
 Cleveland Center for
 Contemporary Art,
 Cleveland, OH;
 Hal Katzen Gallery,
 New York, NY;
 Helander Gallery,
 New York, NY

Representation:

CFM GALLERY

138 W. 17th Street
New York, NY 10011
212.929.4001
212.691.5453 FAX
Contact:
Neil P. Zukerman

Exhibiting:
Contemporary European
and American Masters;
Surrealism and
Representational

Bruno Monvoisin

1. *Le Tambour Ebouriffe*
 1988, Oil on canvas,
 22" x 27"

2. *La Lune*
 1989, Oil on canvas,
 10 3/4" x 14"

3. *Le Projectioniste*
 1989, Oil on canvas,
 68" x 32"

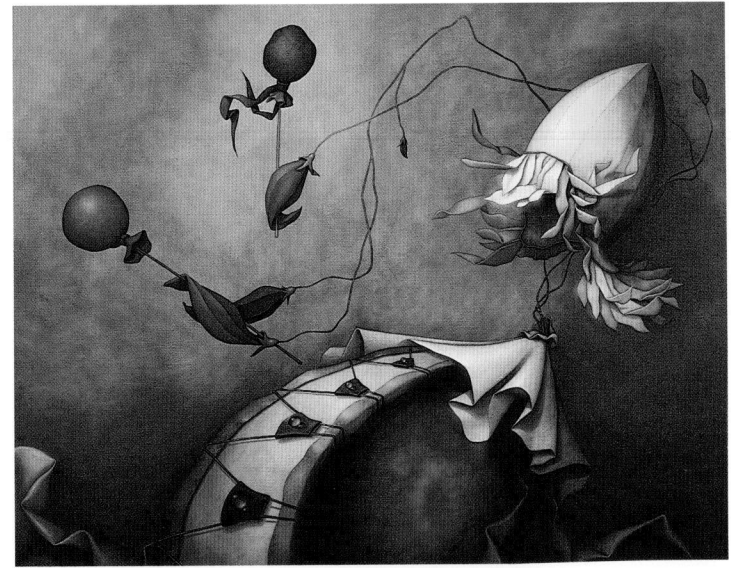

1

2

3

1

2

3

Representation:

DE GRAAF
FINE ART, INC.

9 E. Superior
Chicago, IL 60611
312.951.5180

3400 Avenue of the Arts
Suite C120
Costa Mesa, CA 92626
714.557.5240

Exhibiting:
Contemporary American,
European and Latin
American paintings,
sculpture and graphics

David Miretsky

1. *Cabaret II*
 Oil on canvas,
 63" x 60"

2. *Lady in the Hat
 at the Vanity Table*
 Oil on panel,
 17" diameter

3. *Conversation*
 Oil on panel,
 15" x 13 1/2"

Selected Biography:
1991 Solo exhibitions:
 New York, Cincinnati,
 Ann Arbor, Chicago
1965 Kiev Art Institute
1939 Born: Kiev, Russia

Representation:

EDDWIN MEYERS

2650 W. Belden Avenue
Suite 301
Chicago, IL 60647
312.772.6765
Contact:
Eddwin Meyers

Exhibiting:
Contemporary paintings
and drawings

Eddwin Meyers

1. *Wrestling with Powers and Potentialities (Humility)*
 Oil on canvas,
 48" x 60"

2. *Thunder*
 Oil on canvas,
 48" x 60"

3. *La Cage*
 Oil on canvas,
 48" x 60"

Selected Biography:

1989 "Atelier Neo Medici - France, 1974-1989", Gallery Revel, New York, NY

1987 Solo show: J. Rosenthal Fine Arts, Chicago, IL

1985 "Sporting Figures", Swope Gallery, Santa Monica, CA

1982 "Atelier Neo Medici", Galerie Jean-Pierre Lavignes, Paris, France

Representation:

**CUDAHY'S
GALLERY, INC.**

170 E. 75th Street, 2nd Fl.
New York, NY 10021
212.879.2405
212.535.6259 FAX

Contact:
Fred J. Boyle

Exhibiting:
Contemporary American
Realism and Photo-Realism

Kim Mendenhall

1. *40 TH*
 1990, Oil on linen,
 57" x 80"

2. *Birds of Paradise*
 1990, Oil on linen,
 71" x 60"

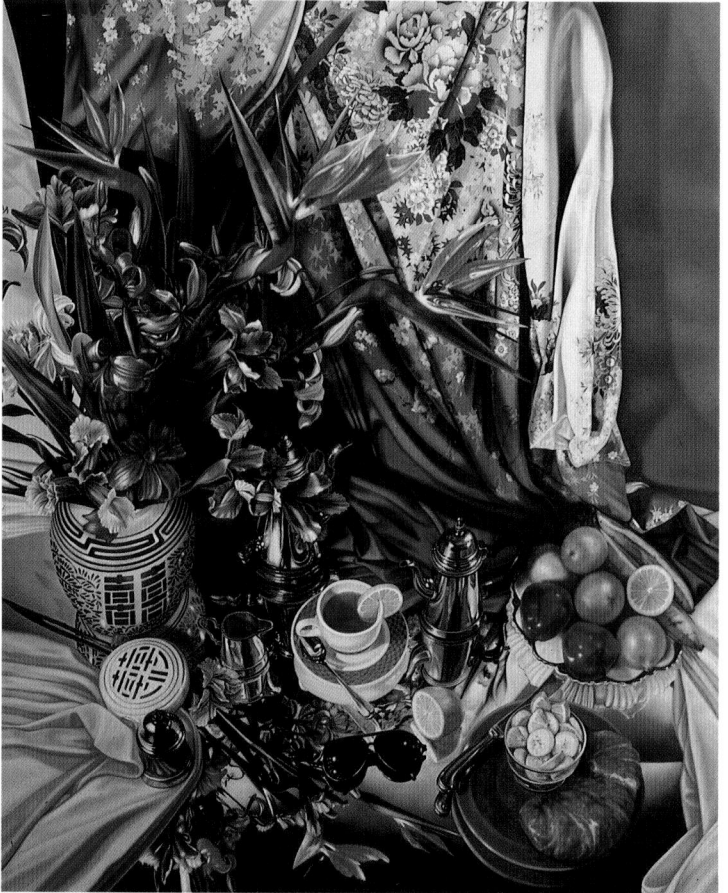

Selected Biography:
1991 Solo show: Cudahy's
 Gallery, New York, NY
1990 "Oakland Artists '90",
 Oakland Museum,
 Oakland, CA
1989 "Contemporary
 American Still-Life",
 J. Rosenthal Fine Arts,
 Chicago, IL

Representation:

**GALERIE
TIMOTHY TEW**

Tula, D-2
75 Bennett Street NW
Atlanta, GA 30309
404.352.0655
Contact:
Timothy Tew

Exhibiting:
Contemporary English,
French and American
painters

Isabelle Melchior

1. *Retrait et Couleurs*
1991, Oil on linen,
32" x 25 1/2"

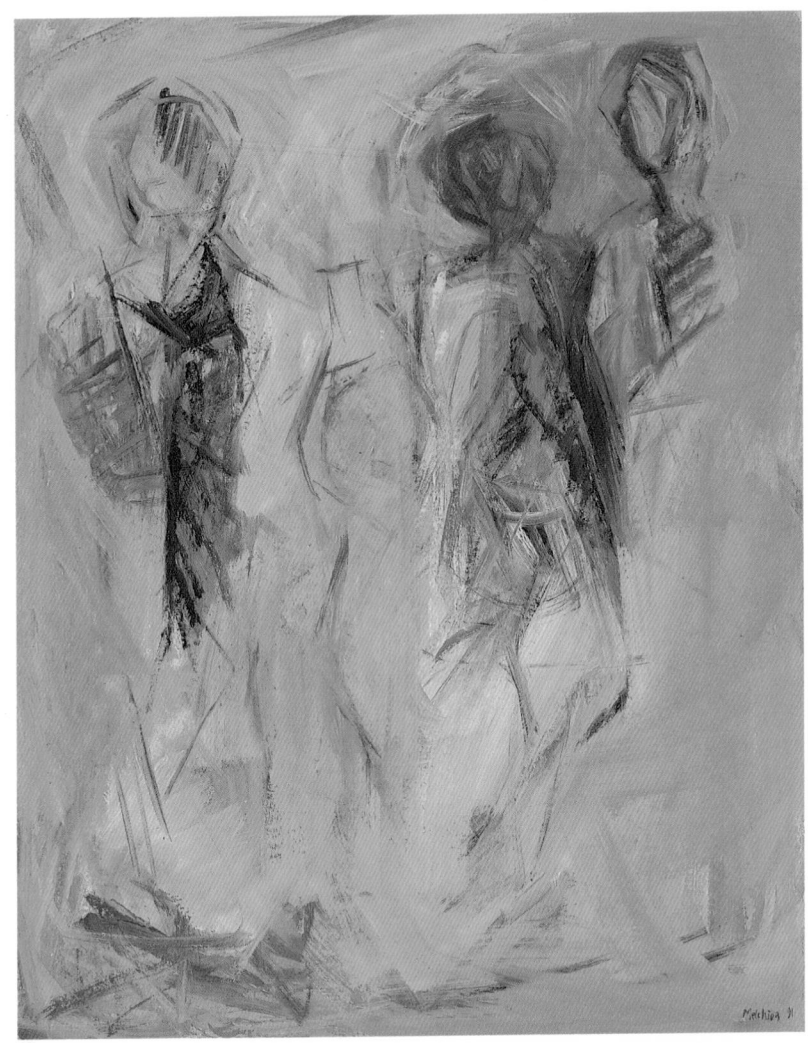

Selected Biography:
1991 Solo exhibitions:
Galerie Timothy Tew,
Atlanta; Galerie St.Paul,
Paris, France
1990 Solo exhibition:
Galerie Anne Blanc,
Paris, France
1989 Solo exhibition:
French Embassy, Prague,
Czechoslovakia
1981 Solo exhibition:
Villa Medicis, Rome, Italy

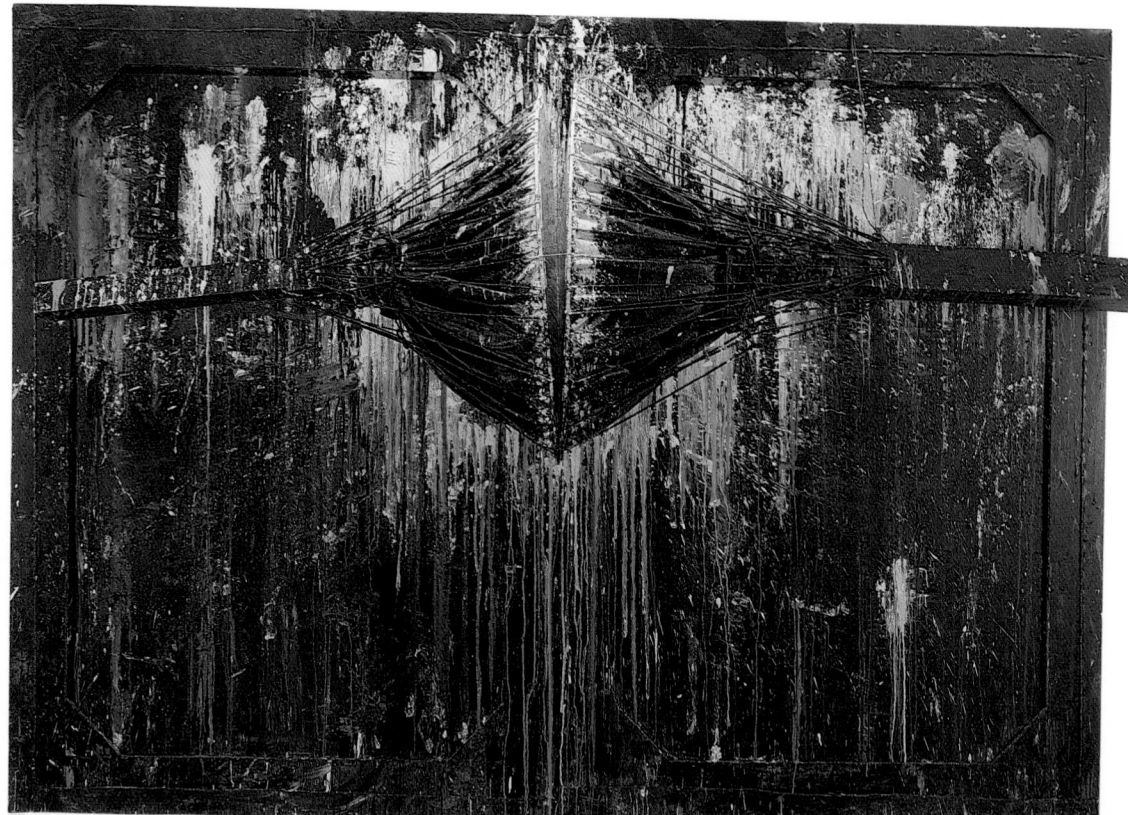

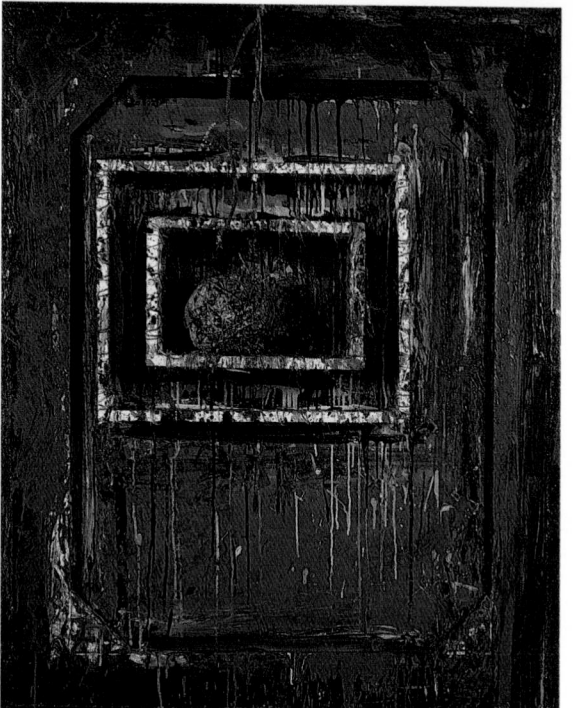

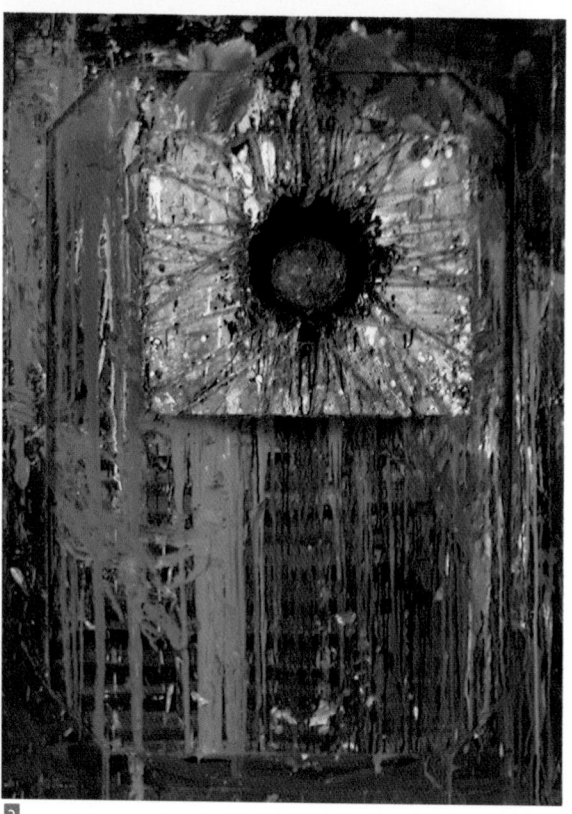

Representation:

**FOSTER
GOLDSTROM**

560 Broadway, Suite 303
New York, NY 10012
212.941.9175
212.274.8759 FAX
Contact:
Foster Goldstrom

Exhibiting:
Works by American and
International artists

David Maxim

1. *Shouts & Trumpets
 (from The Miracles)*
 1991, Acrylic on wood,
 canvas,
 100" x 142"

2. *High Walls*
 1991, Acrylic, wood,
 mixed media on canvas,
 53" x 43"

3. *For Seven Days*
 1991, Acrylic, mixed
 media on canvas,
 72" x 54"

Selected Collections:
 Museum für Moderne
 Kunst, Frankfurt,
 Germany

 Carnegie Institute of
 Art, Pittsburgh, PA

 San Francisco Museum
 of Modern Art,
 San Francisco, CA

Representation:

**GREG KUCERA
GALLERY**

608 Second Avenue
Seattle, WA 98104
206.624.0770

Contact:
Greg Kucera

Exhibiting:
Contemporary Works
by Nationally Recognized
Artists and Emerging
Northwest Artists

Alden Mason

1. *Aunt Violet Makes Dolls*
 1991, Acrylic on canvas,
 66" x 80"

2. *Bride Price Taboo*
 1990, Acrylic on canvas,
 66" x 80"

Selected Biography:
1990 Solo exhibition: Greg
 Kucera Gallery (Catalog)
 (Also 1984, '85, '87, '89)
1987 "Alden Mason-A
 Selective Survey", Henry
 Art Gallery, University
 of Washington, Seattle
 (Catalog)
1986 "Documents North-
 west: The PONCHO
 Series", Alden Mason,
 Seattle Art Museum
 (Catalog)

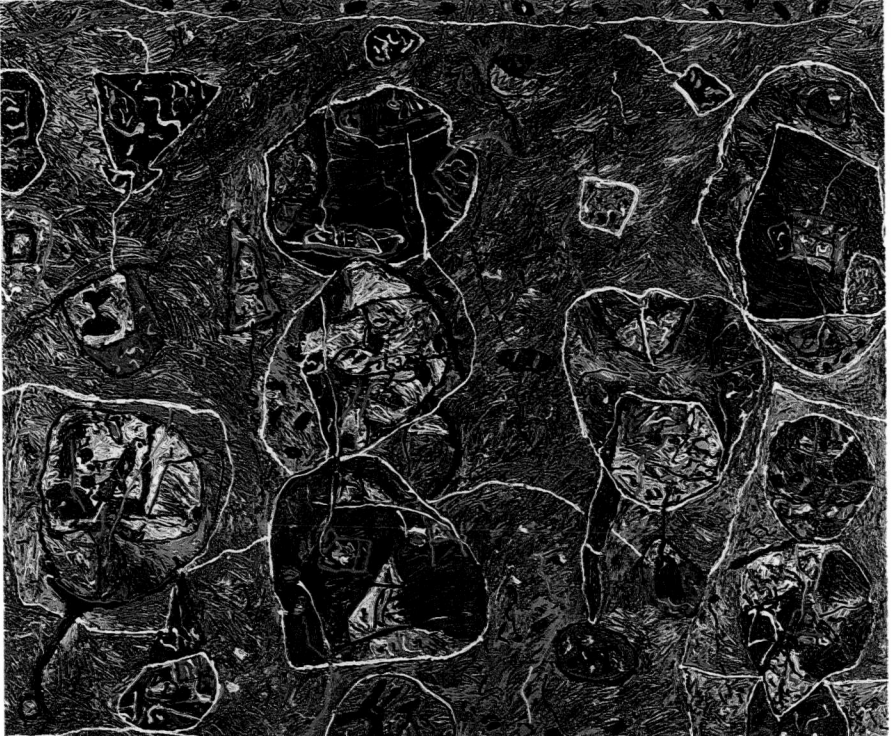

Representation:

THE PACE GALLERY

32 E. 57th Street
New York, NY 10022
212.421.3292
212.421.0835 FAX

142 Greene Street
New York, NY 10012
212.431.9224
212.431.9280 FAX

Exhibiting:
20th-century paintings,
drawings and sculpture

Agnes Martin

1. *Untitled # 4*
 1990, Acrylic on canvas,
 72" x 72"

MARY BOONE GALLERY

417 W. Broadway
New York, NY 10012
212.431.1818
212.431.1548 FAX

Contact:
Mary Boone

Exhibiting:
Contemporary paintings,
drawings and sculpture

Brice Marden

1. *Black Frieze*
 1987, Oil/linen,
 48" x 108"
 Collection: Keith Sachs, Rydal, PA

2. *Picasso's Skull*
 1989-90, Oil/linen,
 62" x 120" (2)
 Collection: Robert/Adrian Mnuchin,
 New York

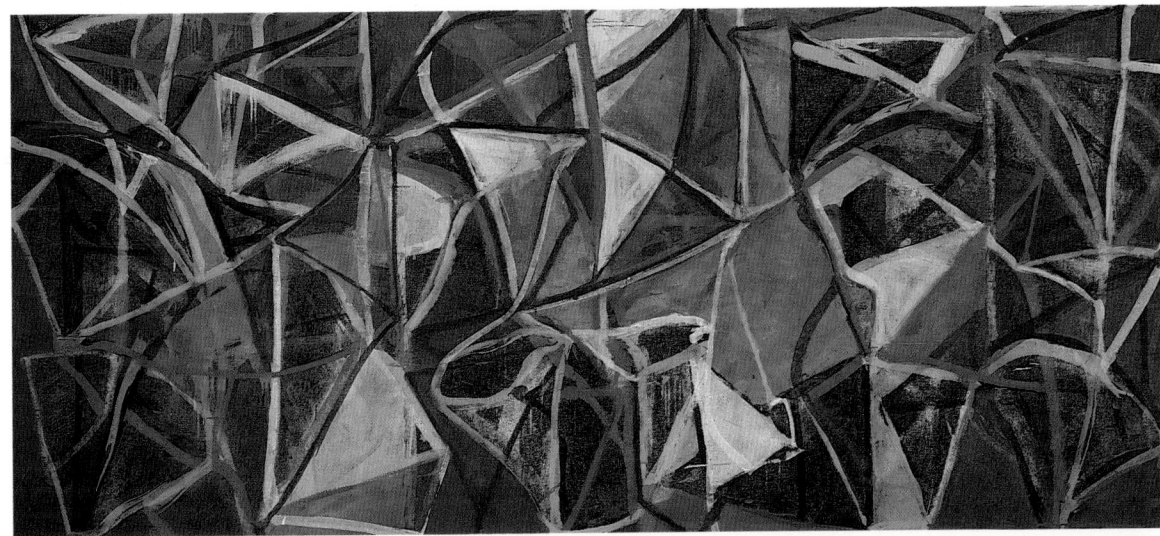

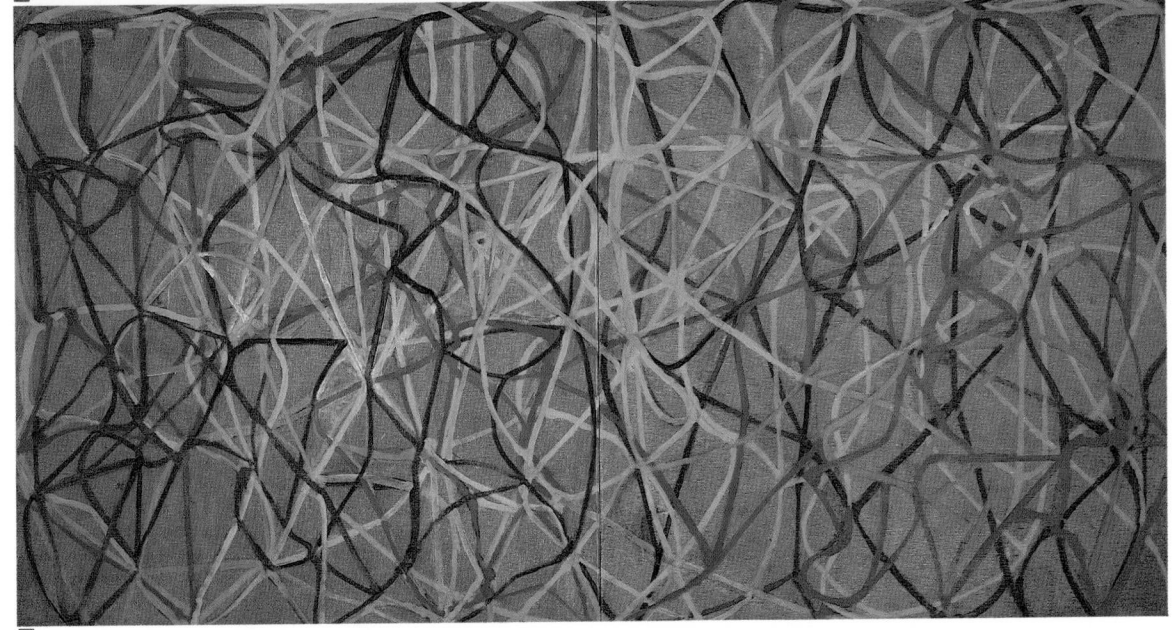

Selected Biography:
1992 Walker Art Center,
 Minneapolis, MN
1991 Larry Gagosian Gallery,
 New York, NY;
 Museum of Fine Arts,
 Boston, MA
1989 Galerie Michael
 Werner, Koln,
 West Germany
1988 Mary Boone Gallery,
 New York, NY;
 Anthony D'Offay
 Gallery, London,
 England

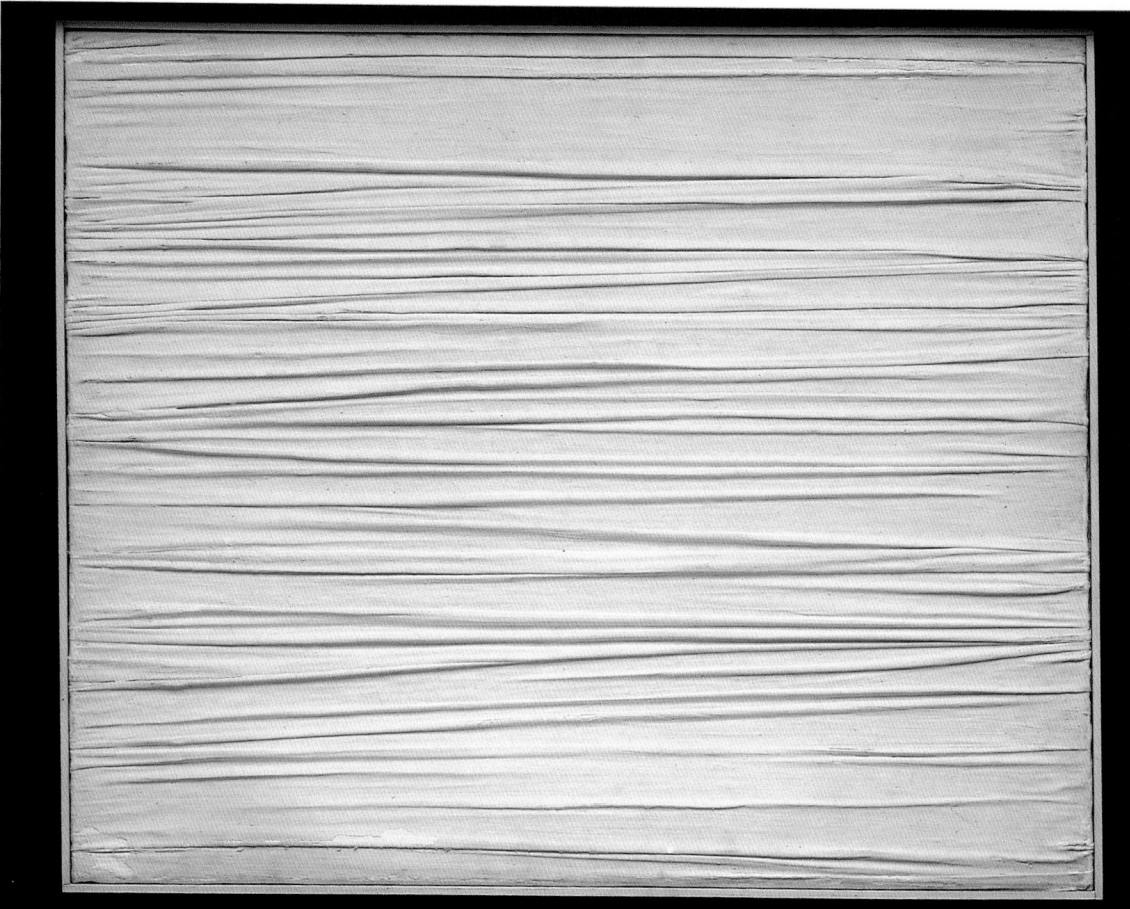

1

Representation:

HIRSCHL & ADLER MODERN

851 Madison Avenue
New York, NY 10021
212.744.6700
212.737.2614 FAX
Contact:
Donald McKinney

Exhibiting:
Contemporary European
and American art

Piero Manzoni

1. *Achrome*
 1957, Caolina on
 pleated canvas,
 29" x 40 3/4"

Selected Biography:
1991 "Piero Manzoni",
Museé d'Art Moderne
de la Ville de Paris,
Paris, France
1990 "Piero Manzoni",
Hirschl & Adler Modern,
New York, NY
1974 "Piero Manzoni:
Paintings, Reliefs and
Objects", Tate Gallery,
London, England
1973 "Piero Manzoni",
Museum of
Contemporary Art,
Chicago, IL

Representation:

THE PACE GALLERY

32 E. 57th Street
New York, NY 10022
212.421.3292
212.421.0835 FAX

142 Greene Street
New York, NY 10012
212.431.9224
212.431.9280 FAX

Exhibiting:
20th-century paintings,
drawings and sculpture

Robert Mangold

1. *Attic Series (Study) XI*
 1991, Acrylic on canvas,
 43" x 55 1/2"

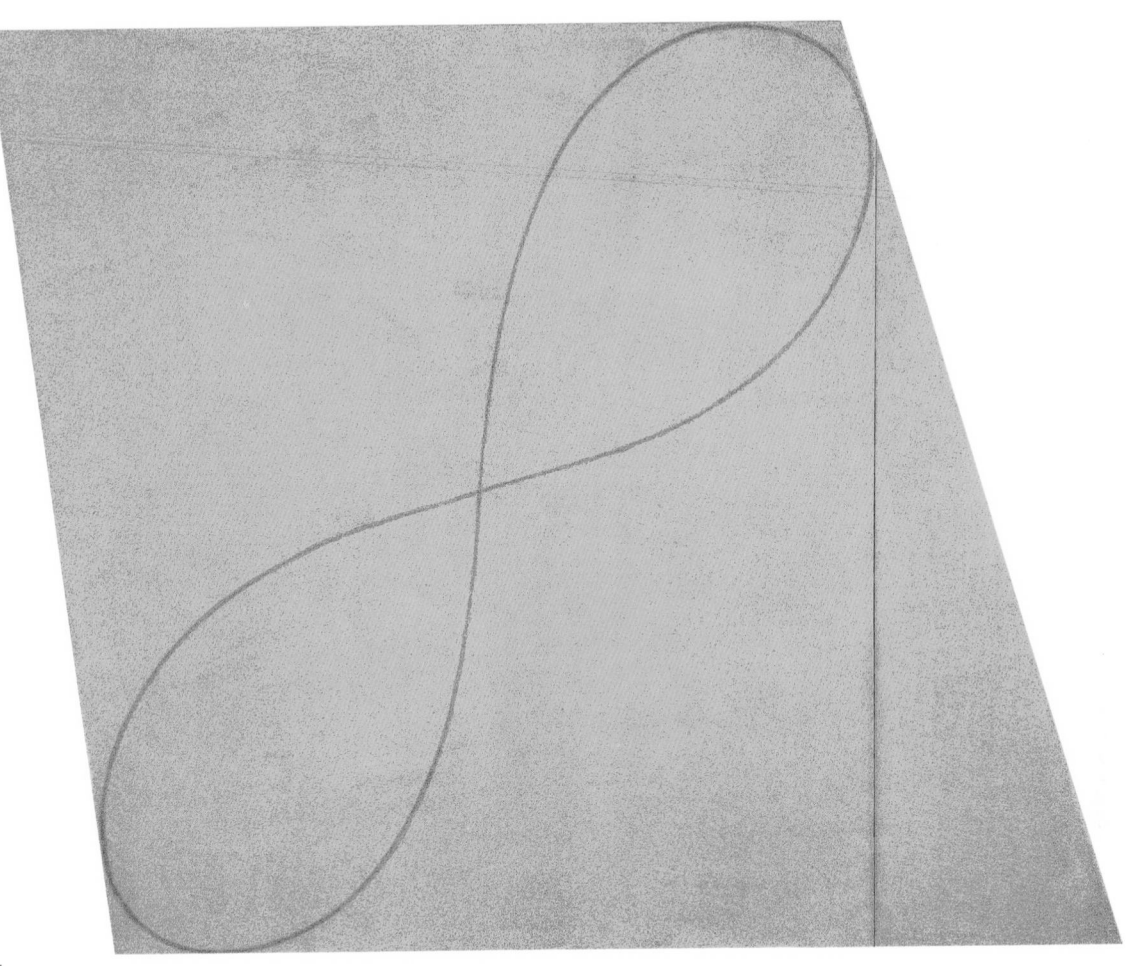

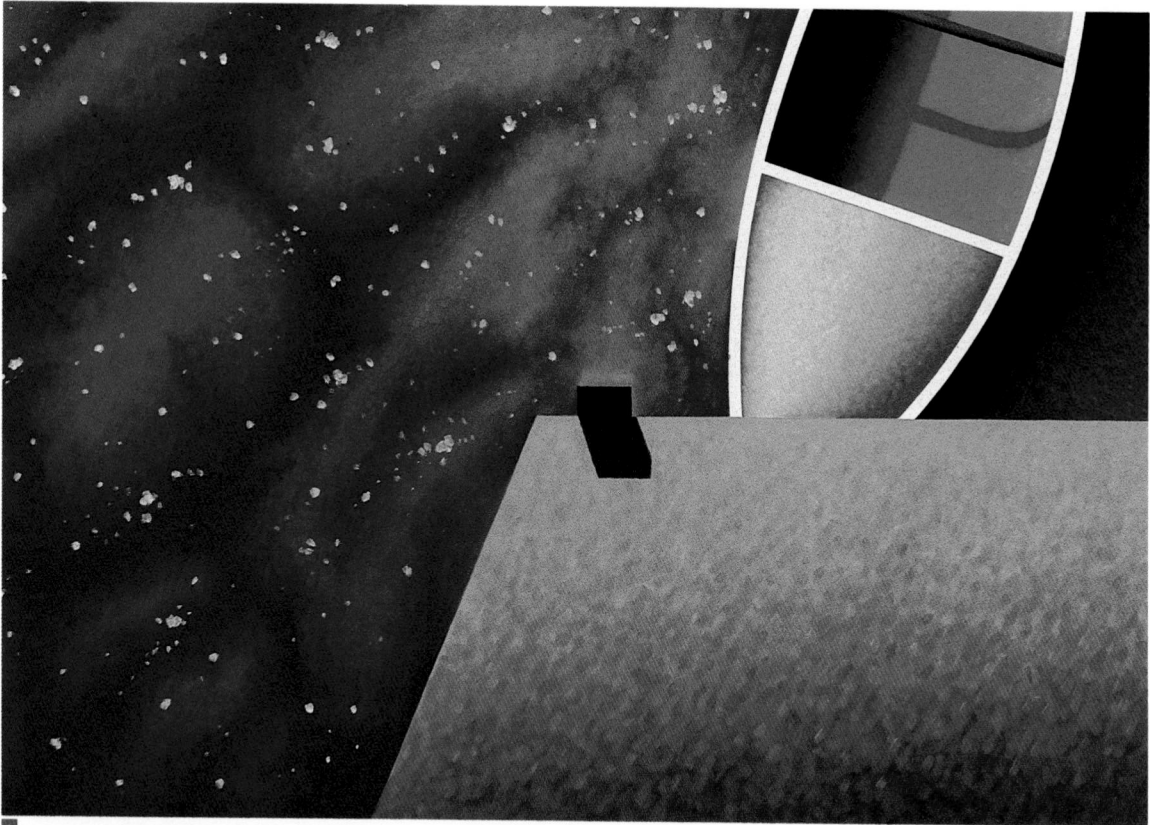

Representation:

**DAVID ADAMSON
GALLERY**

406 7th Street NW
Washington, DC 20004
202.628.0257
202.628.0257 FAX
Contact:
Laurie Hughs

Exhibiting:
Contemporary prints,
paintings and sculpture

Kevin MacDonald

1. *Journey to Avelon*
 1988, Oil,
 40" x 60"

2. *Snow Storm on
 Avenue A*
 Oil,
 45" x 65"

Selected Collections:
 The Metropolitan
 Museum of Art

 The Corcoran Gallery
 of Art

 The Baltimore Museum
 of Art

 The National Museum
 of American Art

Representation:

DIANE FARRIS GALLERY

1565 W. 7th Avenue
Vancouver, BC V6J 1S1
604.737.2629
604.737.2675 FAX

Contact:
Diane Farris

Exhibiting:
Canadian contemporary
paintings, drawings &
sculpture

Attila Richard Lukacs

1. *Four Small Words*
 1990, Oil on canvas,
 118" x 88", 4 panels

2. *No I'll Pay*
 1990, Oil, enamel
 on canvas,
 67.6" x 105.6"

Selected Biography:

1992 Diane Farris Gallery,
 New York; Documenta
 9, Kassel, Germany;
 Diane Farris Gallery,
 Vancouver
1991 Seoul International Art
 Festival, Seoul, Korea;
 "Myth and Magic in
 America: The Eighties",
 MARCO, Monterrey,
 Mexico
1990 Diane Farris Gallery;
 Moderne Kunst
 Dietmar Werle;
 Art LA '90

Representation:

THE LOWE GALLERY

75 Bennett St., Space A-2
Atlanta, GA 30309
404.352.8114
404.352.0564 FAX
Contact:
Bill Lowe

Exhibiting:
Contemporary painting,
sculpture and objects

Pam Longobardi

1. *Age of Reason*
 1991, Copper, patina,
 gold leaf on wood,
 32" x 84" x 12"

2. *Mapping The World:*
 Noblese Oblige
 1990, Oil on canvas,
 copper patina,
 54" x 108"

3. *Legacy (Alchemy/Unesco)*
 1991, Copper, patina,
 nails, wood,
 30" x 46" x 1 1/2"

Selected Biography:
1991 Awards in the Visual
 Arts; AVA Nomination;
 Solo show: The Lowe
 Gallery, GA
1990 Solo show: Artemesia
 Gallery, Chicago, IL

Representation:

LANNING GALLERY

223 Westheimer, Suite 100
Houston, TX 77006
713.524.5670

Contact:
Karen Lanning
Allison Stewart

Jack Livingston

1. *Untitled*
 1990, Oil on canvas,
 73" x 111"

2. *Untitled*
 1991, Gouache on paper,
 15" x 11"

3. *Untitled*
 1990, Oil on canvas,
 48" x 36"

Selected Biography:
1991 Solo exhibition:
 Lanning Gallery,
 Houston, TX
1988 Two person exhibition:
 Carson Sapiro Gallery,
 Denver, CO
1986 Group exhibition:
 "Amnesty
 International", Diverse
 Works, Houston, TX
1985 Solo exhibition:
 McMurtry Gallery,
 Houston, TX

Representation:

LEO CASTELLI
GALLERY

420 W. Broadway
New York, NY 10012
212.431.5160
212.431.5361 FAX
Contact:
Susan Brundage

Roy Lichtenstein

1. *Interior with African Mask*
 1991 Oil and magma
 on canvas,
 9'6" x 12'2"

2. *Reflections on Interior
 with Girl Drawing*
 1990, Oil and magma
 on canvas,
 75" x 108"

"Roy Lichtenstein:
Catalogue Raisonne
of the Paintings",
Leo Castelli and Larry
Gagosian are pleased
to announce the
preparation of the
Catalogue Raisonne
of the paintings
by Roy Lichenstein to
be published in several
volumes. Collectors
who own or who have
owned paintings from
1960-1970 are kindly
requested to contact
Robert Pincus-Witten
at the Gagosian Gallery.

Representation:

MARY BOONE GALLERY

417 W. Broadway
New York, NY 10012
212.431.1818
212.431.1548 FAX
Contact:
Mary Boone

Exhibiting:
Contemporary paintings,
drawings, and sculpture

Sherrie Levine

1. *Untitled (Broad Stripe : 3)*
 1985, Casein/wood,
 24" x 20"
 Collection: Vijak Mahdavi and
 Bernardo Nadal-Ginard, Boston

2. *Untitled (Golden Knots : 7)*
 1985, Oil/wood,
 20" x 16"
 Collection: Lewis/Susan Manilow,
 Chicago

3. *Untitled (Lead Checks/Lead
 Chevron : 11)*
 1988, Casein/lead,
 40" x 20"
 Collection: Refco Group, Ltd.,
 Chicago

4. *Untitled (Double Lead
 Checks : 8)*
 1988, Casein/lead,
 40" x 20"
 Collection: Private Collection

Selected Biography:
1991 San Francisco Museum
 of Modern Art,
 San Francisco, CA;
 Donald Young Gallery,
 Chicago, IL; Mary
 Boone Gallery,
 New York, NY;
 Kunsthalle Zurich,
 Zurich, Switzerland
1990 Daniel Weinberg
 Gallery, Santa Monica,
 CA
1989 Donald Young Gallery,
 Chicago, IL; Mary
 Boone Gallery, New
 York, NY

Representation:

MIDTOWN PAYSON GALLERIES

745 Fifth Avenue
New York, NY 10151
212.758.1900
212.832.2226 FAX
Contact:
Bridget L. Moore

Exhibiting:
20th-century and
contemporary American art

Jack Levine

1. *Auction*
 1987, Oil on canvas,
 30" x 35"

2. *Woman of Sint Olafstraat*
 1972, Oil on canvas,
 40" x 35"

Selected Biography
1990 Solo exhibition:
Midtown Payson
Galleries,
New York, NY
1979 "Jack Levine:
Retrospective
Exhibition", The
Jewish Museum,
New York, NY;
Noton Gallery and
School of Art, FL;
Brooks Memorial
Art Gallery, Memphis,
TN; Montgomery
Museum of Arts, AL;
Minnesota Museum
of Art, St. Paul, MN

Representation:

FORUM GALLERY

1018 Madison Avenue
New York, NY 10021
212.772.7666

Contact:
Robert Fishko

Exhibiting:
20th-Century American
Realism; paintings, drawings
and sculpture

David Levine

1. *Five Coney Queens*
 1989, Watercolor,
 14 1/2" x 24 1/4"

2. *Woman On The Rocks*
 1971, Watercolor,
 21 1/2" x 12 1/2"

3. *George Eliot*
 1985, Ink on paper,
 13 3/4" x 11"

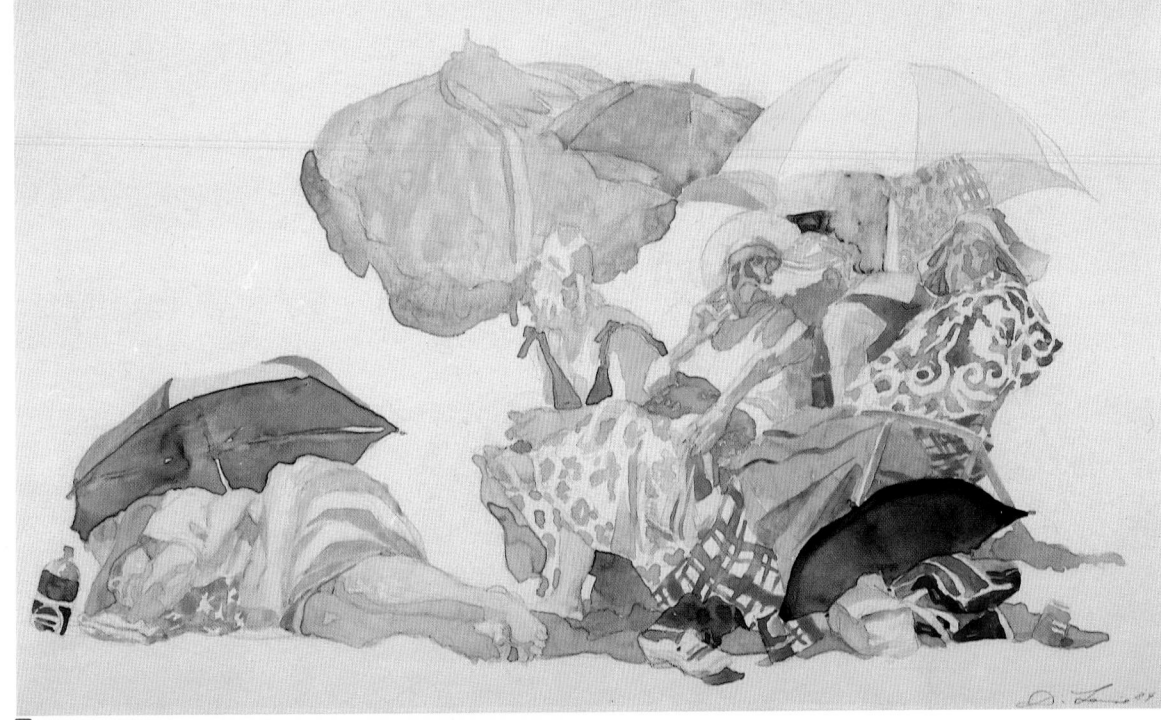

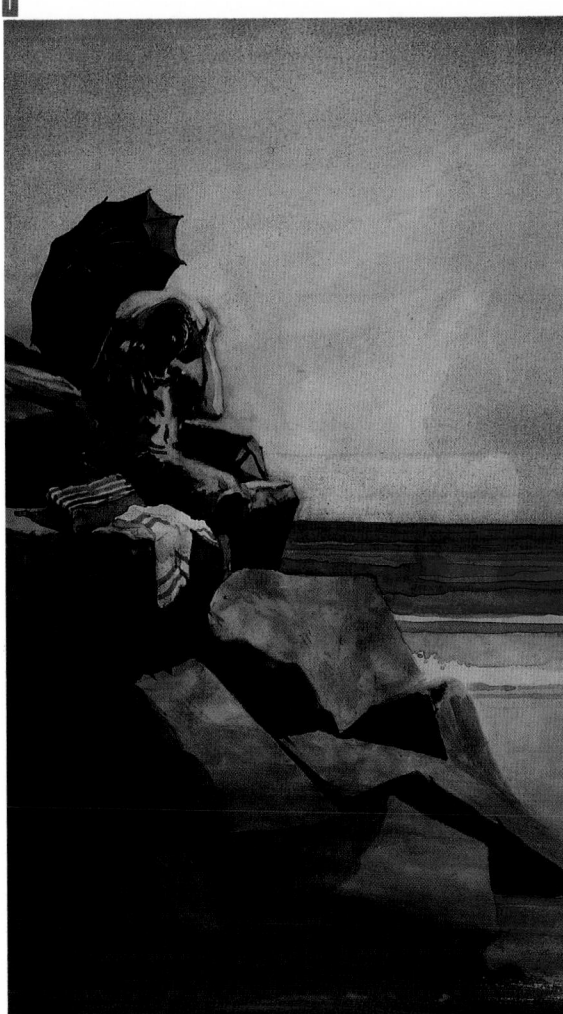

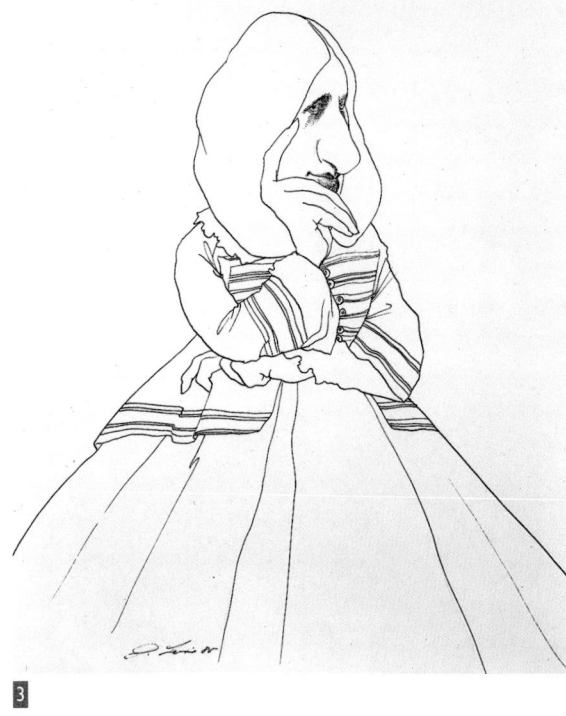

Selected Biography:
1991 Susan Conway
 Carroll Gallery,
 Washington, D.C.
1989 Louis Newman
 Galleries, Beverly Hills,
 California
1988 Wichita Art Museum,
 Wichita, Kansas
1987 Ashmolean Museum,
 Oxford, England

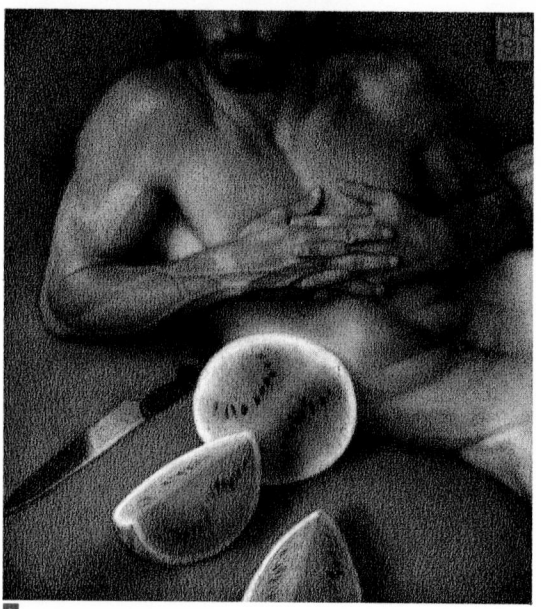

Representation:

STIEBEL MODERN

32 E. 57th Street, 6th Fl.
New York, NY 10022
212.759.5536
212.935.5736 FAX
Contact:
Katherine Chapin

Exhibiting:
Painterly Realism from 1945
to present

Michael Leonard

1. *Female Bather on Gold II*
 1989, Oil & alkyd on
 masonite,
 26" x 27 1/4"

2. *Watermelons*
 1991, Graphite on paper,
 7 5/8" x 7"

3. *Bather Drying His Legs*
 1991, Graphite on paper,
 7 1/4" x 7 1/2"

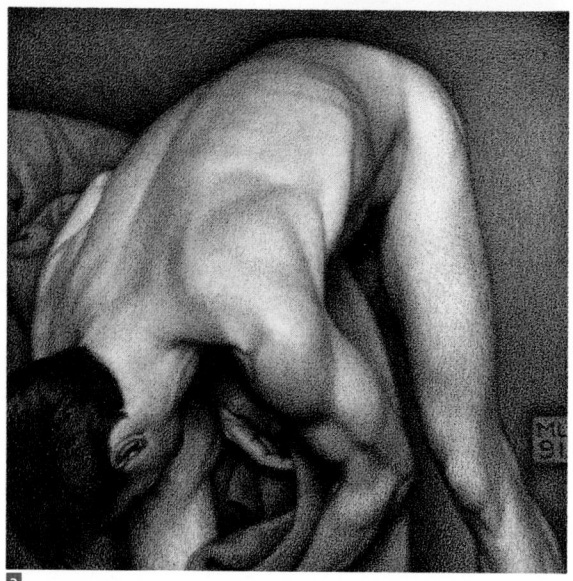

Selected Biography:
1992 Solo exhibition:
 Stiebel Modern,
 New York, NY
1989 Artiste Gallery,
 Bath, England
1988 Solo exhibitions:
 Fisher Fine Art,
 London (Also 1983,
 1980, 1977 & 1974)

Representation:

FRANCINE SEDERS
GALLERY LTD.

6701 Greenwood Ave. N
Seattle, WA 98103
206.782.0355
206.783.6593 FAX

Contact:
Francine Seders
Patricia Scott
Exhibiting:
Contemporary American Art

Jacob Lawrence

1. *Street Scene*
 1985, Gouache/paper,
 30" x 22"

Selected Biography:
1991 Frederick Douglass
 & Harriet Tubman
 Series, 1938-1940,
 touring exhibit
 organized by Hampton
 University Museum
1990 Recipient of the
 National Medal of Arts
1989 Touring exhibit of the
 Caribbean & Africa
 organized by the USIA

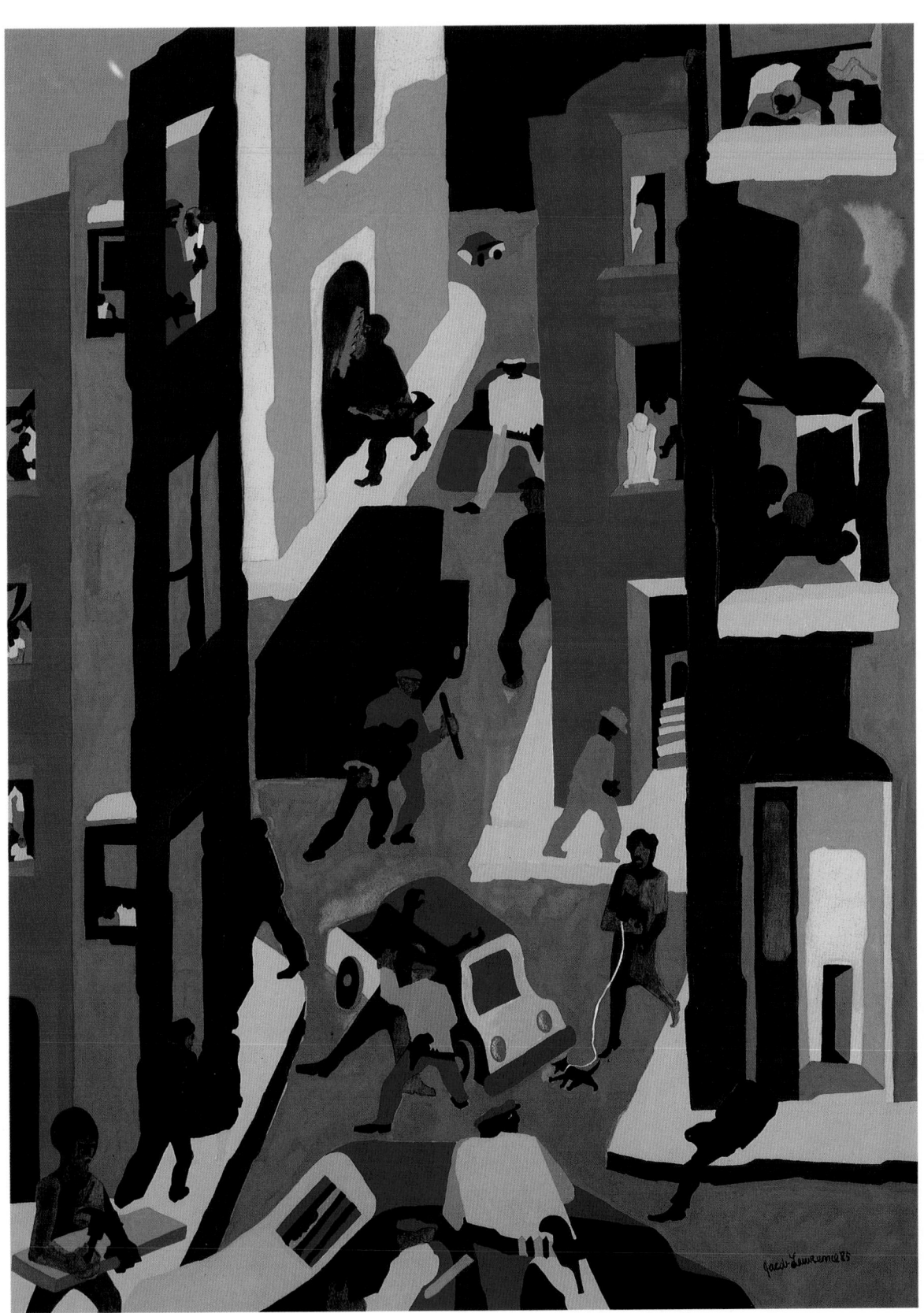

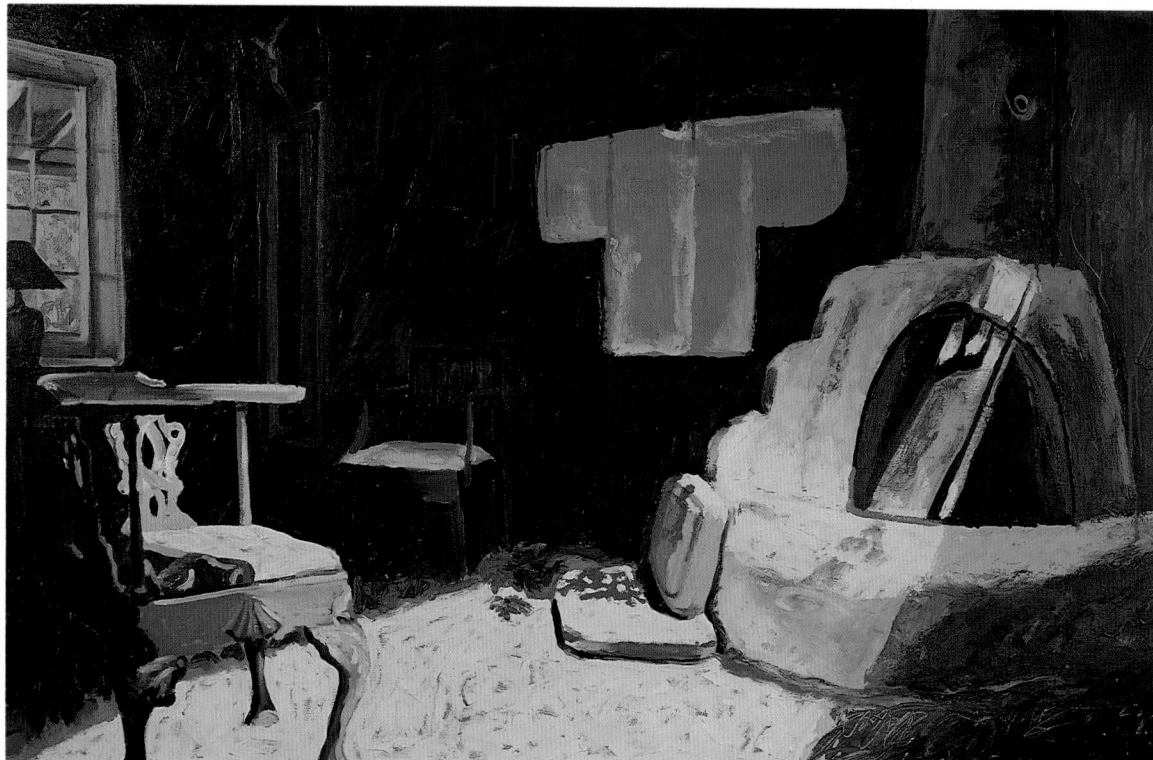

Representation:

SANTA FÉ EAST

200 Old Santa Fe Trail
Santa Fe, NM 87501
505.988.3103

Contact:
Ron Cahill

Exhibiting:
American art; contemporary
painting and sculpture

Geoffrey Landis

1. *Artist's Space*
 1991, Oil on canvas,
 30" x 48"

2. *Winter Dreams #4*
 1990, Oil on linen,
 30" x 54"

3. *Self-Portrait*
 1991, Oil on board,
 36" x 25 1/2"

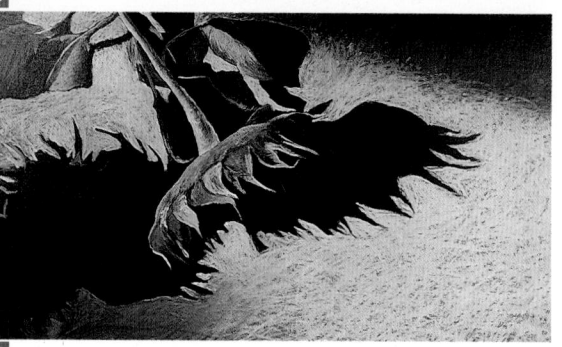

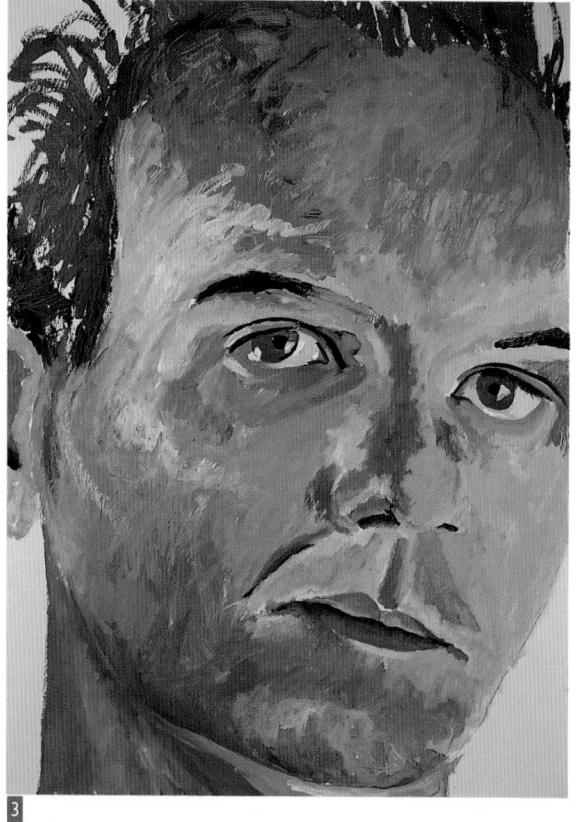

Selected Biography:
1991 Exhibition:
 Federal Reserve Bank,
 Philadelphia, PA
1990 Exhibition:
 Seibu Department Store,
 Toyko, Japan
1989 Exhibition:
 American College,
 Bryn Mawr, PA

Representation:

DE GRAAF
FINE ART, INC.

9 E. Superior
Chicago, IL 60611
312.951.5180

3400 Avenue of the Arts
Suite C120
Costa Mesa, CA 92626
714.557.5240

Exhibiting:
Contemporary American,
European and Latin
American paintings,
sculpture and graphics

Elisabeth Lalouschek

1. *149 Moons*
 Oil on canvas,
 86" x 76 1/2"

2. *Poet For An Afternoon*
 Oil on canvas,
 86" x 76 1/2"

3. *Nierica-Carressed By Fire*
 Oil on canvas,
 86" x 76 1/2"

Selected Biography:
 Solo shows: Royal
 College of Art,
 London, New Mexico,
 Mexico City, California,
 Chicago
1955 Born: Vienna

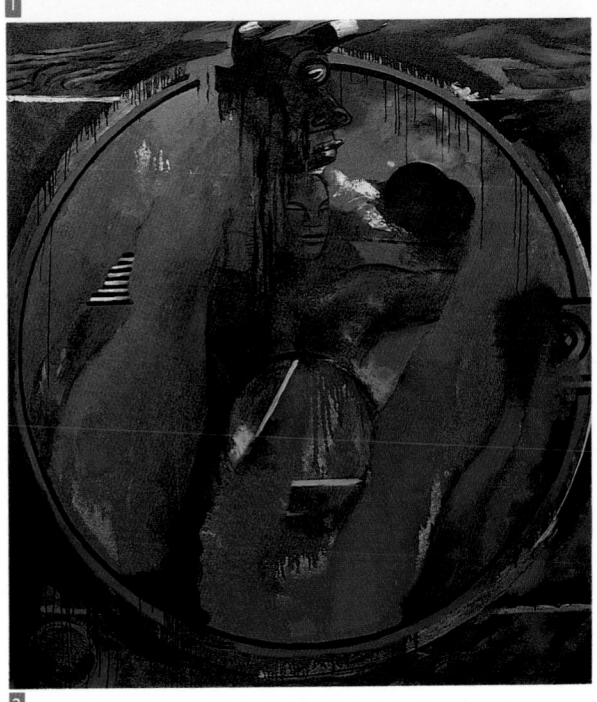

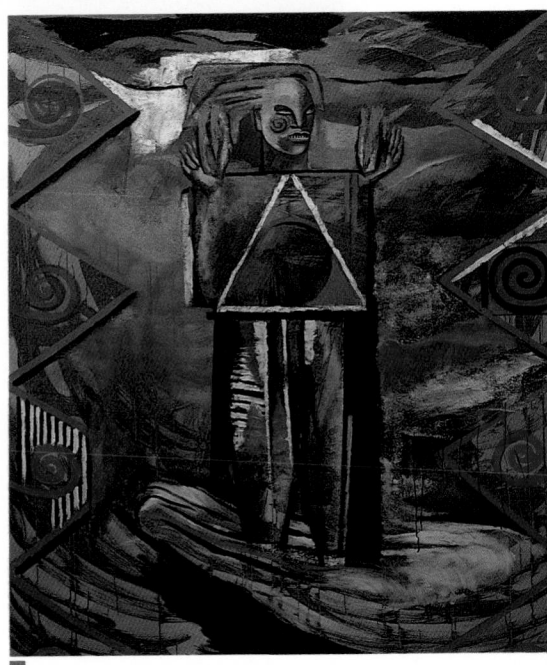

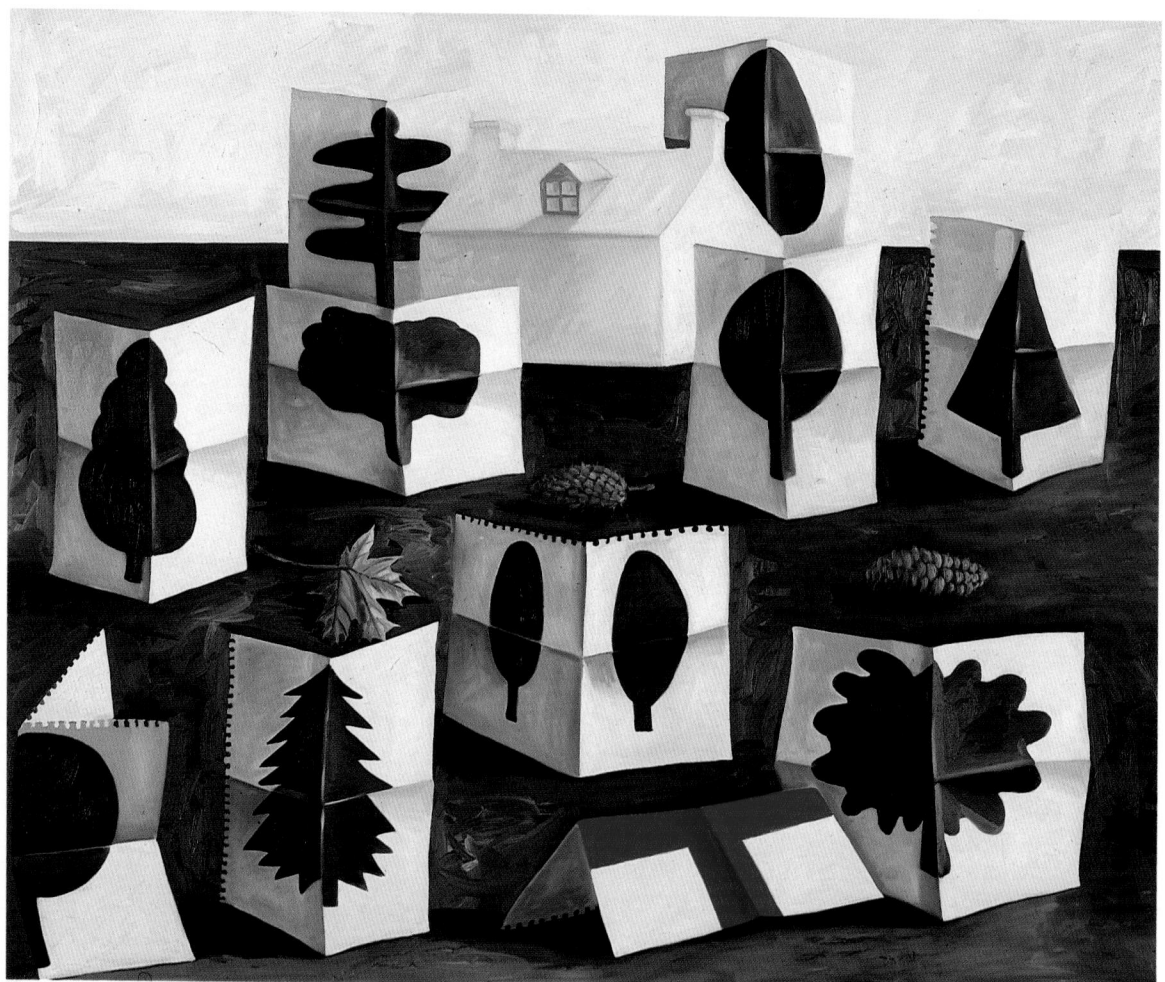

Representation:

FAY GOLD GALLERY

247 Buckhead Avenue
Atlanta, GA 30305
404.233.3843
404.365.8633 FAX

Contact:
Fay Gold
Sophia Lyman
Exhibiting:
Modern and contemporary
art and photography

Cheryl Laemmle

1. *Paper Trees*
 1991, Oil on canvas,
 48" x 60"

Representation:

**THE WORKS
GALLERY**

106 West Third Street
Long Beach, CA 90802
213.495.2787
213.495.0370 FAX

Crystal Court/S. Coast Plaza
3333 Bear Street, Third Fl.
Costa Mesa, CA 92626
714.979.6757
714.979.6818 FAX
Contact:
Mark Moore

Exhibiting:
Established and emerging
contemporary artists of
the western United States

Hoon Kwak

1. *Kapla*
 1991, Acrylic on canvas,
 6' x 5'

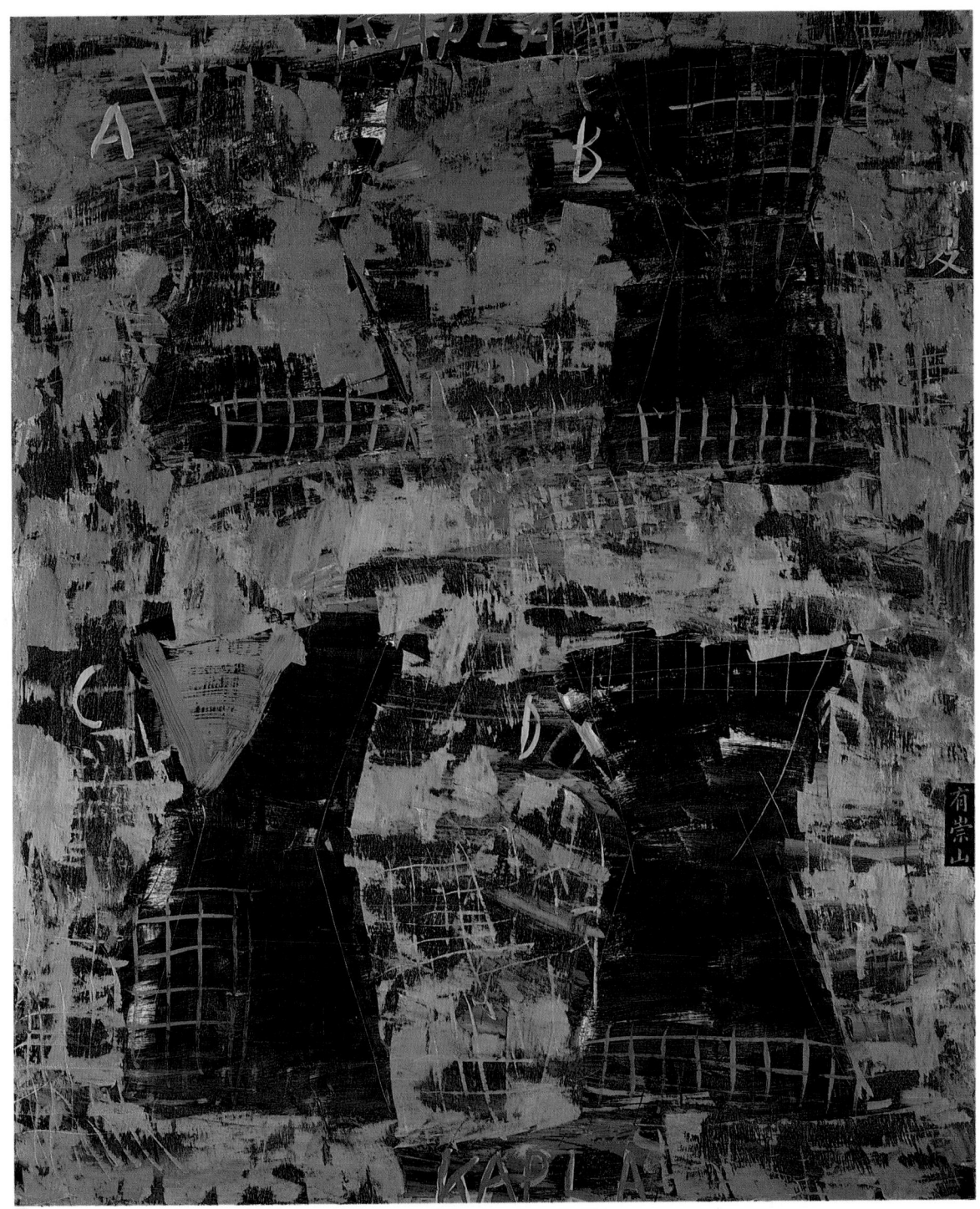

Selected Biography:
1992 Solo exhibition: The
 Works Gallery, Long
 Beach, CA
1991 Solo exhibition: Sun
 Art Gallery, Seoul,
 Korea
1990 Solo exhibitions:
 Naviglio Gallery,
 Milano, Italy;
 Macquarie Gallery,
 Sydney, Australia

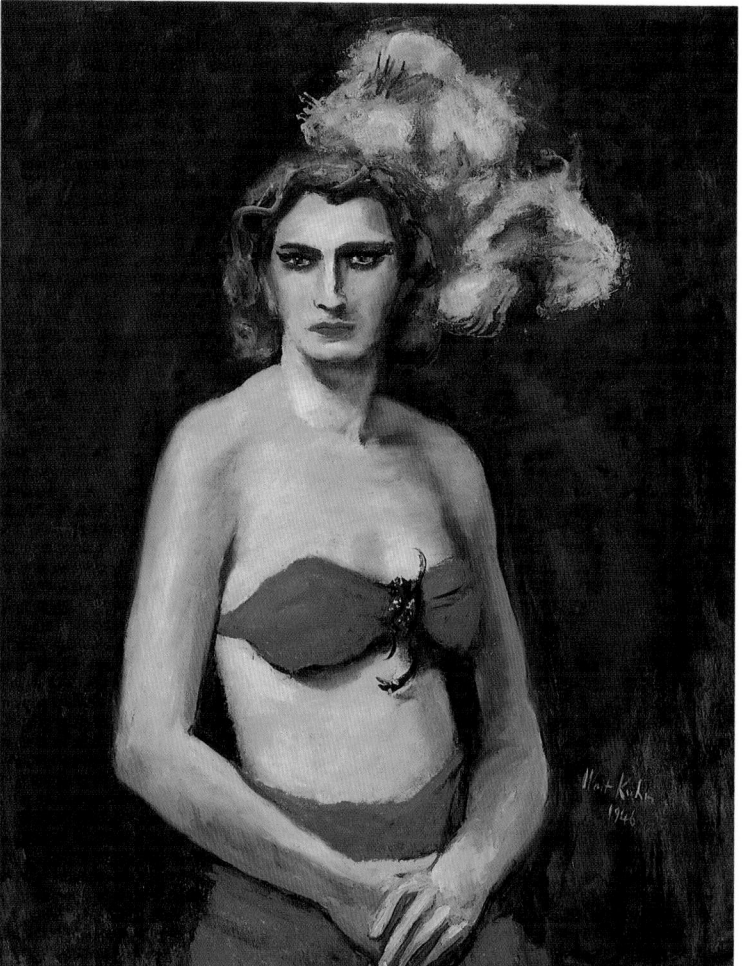

Representation:

MIDTOWN PAYSON GALLERIES

745 Fifth Avenue
New York, NY 10151
212.758.1900
212.832.2226 FAX

Contact:
Bridget L. Moore

Exhibiting:
20th-century and
contemporary American art

Walt Kuhn

1. *Melinda or Lady
 with Feathers*
 1946, Oil on canvas,
 36" x 29"

2. *Man with Hat and
 Mustache*
 1940, Oil on canvas,
 20" x 13"

3. *Summer Girl*
 1947, Oil on canvas,
 24" x 20"

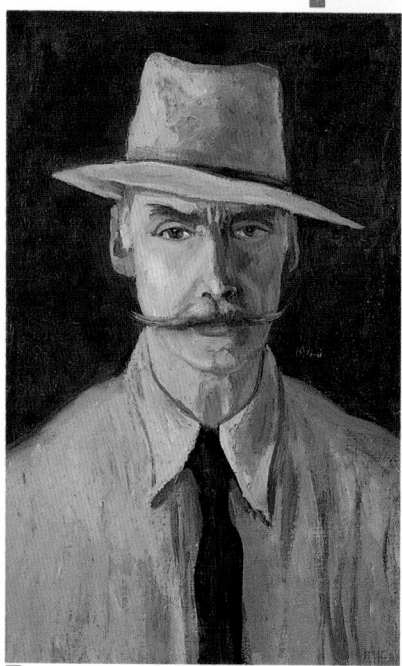

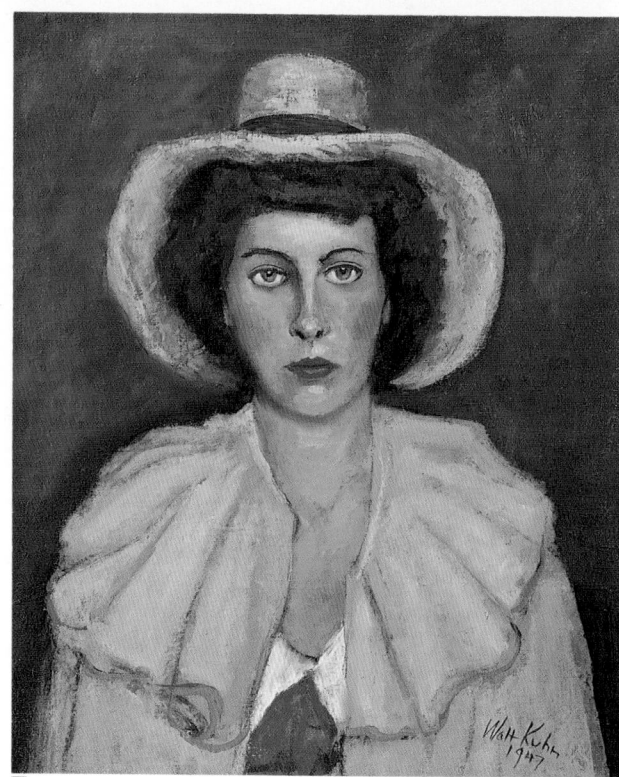

Selected Biography
1991 "Walt Kuhn
 Drawings", Midtown
 Payson Galleries,
 New York, NY
1990 "Men of Rebellion:
 The Eight & Their
 Associates", The
 Phillips Collection,
 Washington, DC
1989 Solo exhibition:
 Midtown Galleries,
 New York, NY
1987 "Walt Kuhn: The
 Entertainers", The
 Whitney Museum,
 New York, NY

Representation:

**MARY BOONE
GALLERY**

417 W. Broadway
New York, NY 10012
212.431.1818
212.431.1548 FAX

Contact:
Mary Boone

Exhibiting:
Contemporary paintings,
drawings and sculpture

Barbara Kruger

1. Installation:
 Mary Boone Gallery,
 New York, January 1991

Selected Biography:
1991 Mary Boone Gallery,
 New York, NY
1990 Duke University
 Museum of Art,
 Durham, NC; Monika
 Spruth Galerie, Koln,
 West Germany;
 Rhona Hoffman
 Gallery, Chicago, IL;
 Kolnischer
 Kunstverein, Koln,
 Germany
1989 Mary Boone Gallery,
 New York, NY; Galerie
 Bebert, Rotterdam,
 The Netherlands;
 Fred Hoffman Gallery,
 Santa Monica, CA

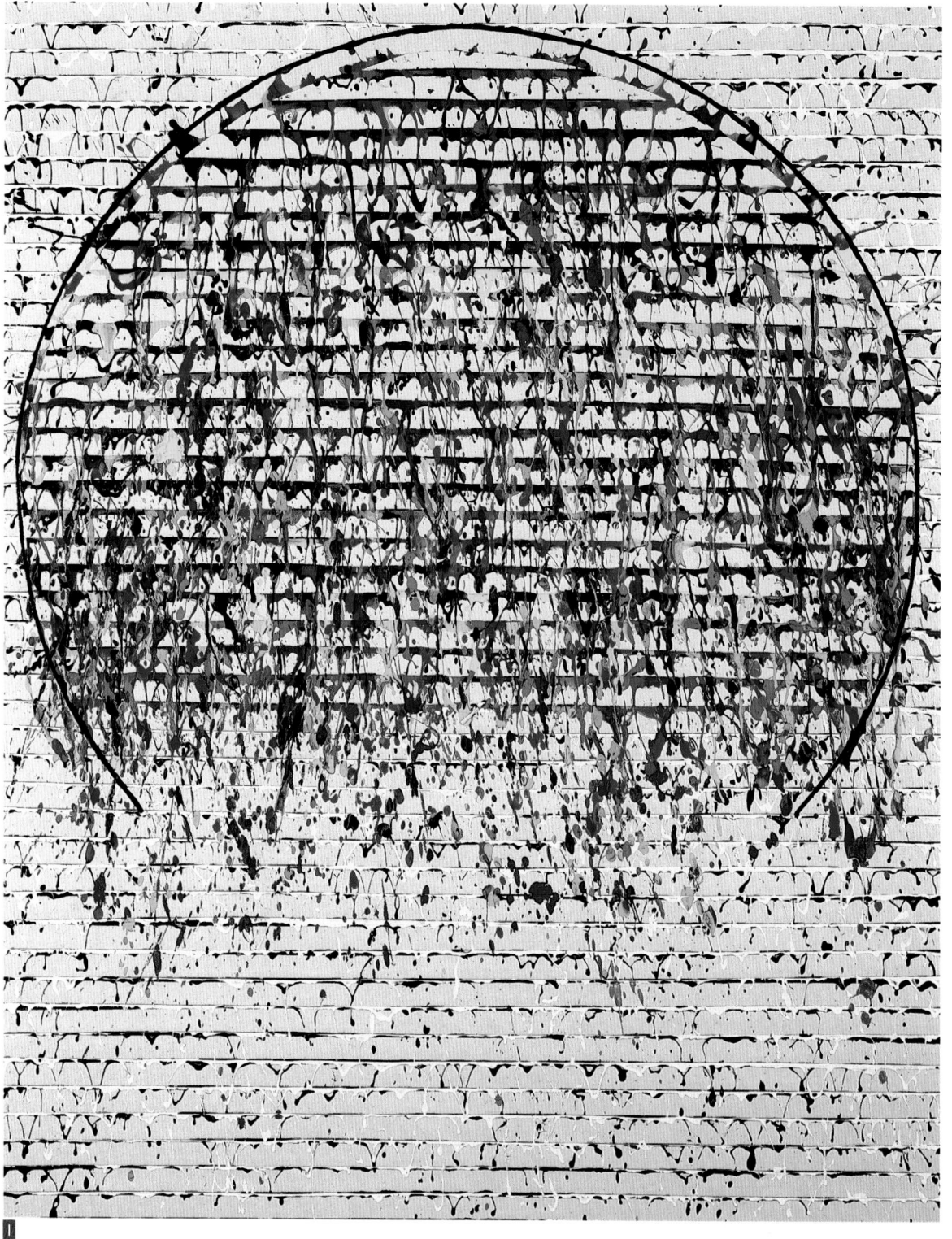

Representation:

O.K. HARRIS
WORKS OF ART

383 W. Broadway
New York, NY 10012
212.431.3600

Contact:
Ivan C. Karp

Exhibiting:
Contemporary American
and European painting,
sculpture, photography,
antiques, collectibles,
documentation

Aris Koutroulis

1. *Emergence #6*
 1990, Acrylic on canvas,
 85" x 65"

Selected Biography:
1991 Solo exhibition: O.K.
 Harris Works of Art,
 Birmingham, MI
1990 Solo exhibition: O.K.
 Harris Works of Art,
 New York, NY
1966 Cranbrook Academy
 of Art, Bloomfield
 Hills, MI; M.A.
1963 Tamarind Lithography
 Workshop, Los
 Angeles, CA; Master
 Printer

Representation:

**CHARLES
WHITCHURCH
GALLERY**

5973 Engineer Drive
Huntington Beach, CA 92694
714.373.4459
714.373.4615 FAX

Contact:
Douglas Deaver, Ph.D.

Exhibiting:
Paintings, sculpture, and
graphic works by modern
and contemporary artists

Helga Kos

1. *Don't Touch, Just Move*
 1991, Oil on canvas,
 48" x 48"

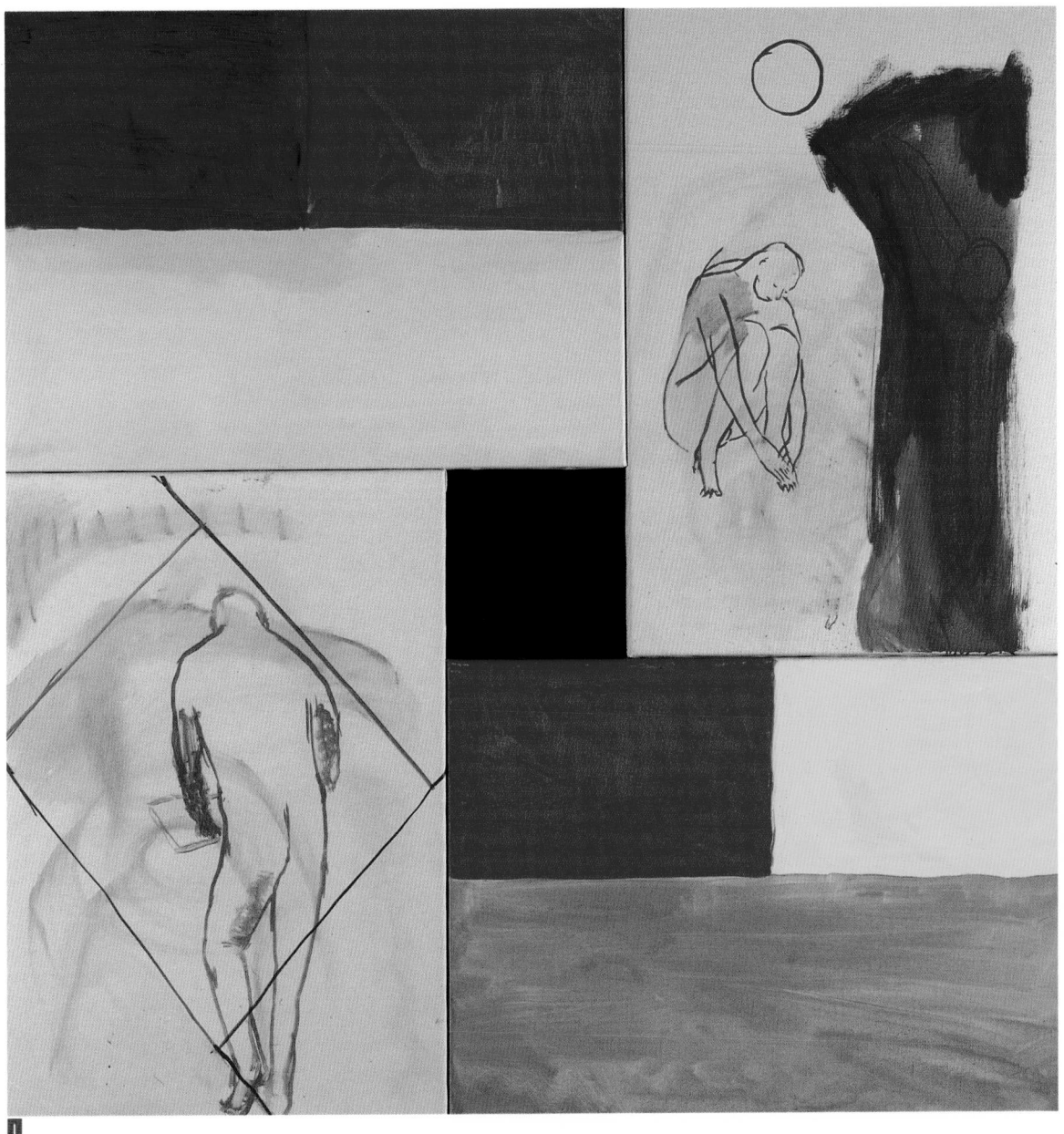

1

Selected Biography:

1992 "European Expressions",
Charles Whitchurch
Gallery, Huntington
Beach, CA

1991 "Helga Kos", Art Gallery
A'pert, Amsterdam

1990 "Helga Kos", Galerie
Traject, Utrecht

1988 Group exhibition:
Stedelijk Museum,
Amsterdam

1.

Representation:

**GAGOSIAN
GALLERY**

980 Madison Avenue, 6th Fl.
New York, NY 10021
212.744.2313
212.772.7962 FAX
Contact:
Melissa Lazarov

Exhibiting:
Contemporary paintings,
drawings and sculpture

Yves Klein

1. *IKB No. 232*
 1957, Pigment on
 canvas on wood,
 20 1/2" x 15 1/2"

Selected Biography:
1991 Group show: "Who
Framed Modern Art
or the Quantitative
Life of Roger Rabbit",
Sidney Janis Gallery,
New York
1989 Solo show: Gagosian
Gallery, New York;
Group Show: "Yves
Klein, Brice Marden,
Sigmar Polke", Hircshl
& Adler Modern,
New York; Biennale
Internationale de Sao
Paulo, Sao Paulo, Brazil

Representation:

RICHARD GRAY GALLERY

620 N. Michigan Avenue
Chicago, IL 60611
312.642.8877
312.642.8488 FAX

Contact:
Paul Gray

Exhibiting:
Modern and contemporary
American and European art

David Klamen

1. *Untitled*
 1991, Oil on linen,
 70" x 90"

2. *Untitled*
 1988, Oil on linen,
 60" x 84"

1

Selected Exhibitions:

1991 Galleria Paola Stelzer,
Trento, Italy
1988 Galerie L'Isola,
Rome, Italy
1987 Marianne Deson
Gallery, Chicago, IL
1986 Freeport Museum,
Freeport, IL

2

Representation:

**THOMAS ERBEN
GALLERY, INC.**

118 Spring Street
New York, NY 10012
212.966.5283
212.941.0752 FAX
Contact:
Thomas Erben

Exhibiting:
International contemporary
art: Installations, paintings,
sculptures, multiples

Lilo Kinne

1. *Selfportrait: Elements of
 Different Cultures*
 1990, Acrylic on linen,
 53" x 67"

2. *How Many Lives I
 Had to Live...*
 1991, Acrylic on linen,
 78" x 63"

3. *Once I was Black -
 Multidimensionality*
 1990, Acrylic on linen,
 78" x 63"

Selected Biography:
1991 Art LA '91, Los
 Angeles, CA; Art Miami
 '91, Miami, FL
1990 Solo show: "Mind Over
 Matter", Thomas Erben
 Gallery, New York,
 NY; Art LA '90, Los
 Angeles, CA
1989 Solo show: "The Louis
 XVI Series", Thomas
 Erben Gallery, New
 York, NY
1984 through 1989,
 Project: "The
 Transcendence of
 Matter", Paris, France

Representation:

**CHARLES
WHITCHURCH
GALLERY**

5973 Engineer Drive
Huntington Beach, CA 92694
714.373.4459
714.373.4615 FAX

Contact:
Douglas Deaver, Ph.D.

Exhibiting:
Paintings, sculpture, and
graphic works by modern
and contemporary artists

Ku-Lim Kim

1. *Yin and Yang 90-L12*
 1990, Mixed media,
 magazine, cotton and
 wire on canvas,
 48" x 84"

2. *Yin and Yang*
 1988, Acrylic on canvas,
 51" x 63"

1

2

Selected Biography:
1992 "Ku-Lim Kim and Naim
 Jun Paik" at Charles
 Whitchurch Gallery,
 Huntington Beach, CA
1990 "Ku-Lim Kim", Modern
 Cultural Center,
 Tokyo, Japan

Representation:

**LINDA DURHAM
GALLERY**

400 Canyon Road
Santa Fe, NM 87501
505.988.1313

Contact:
Russell Isaacs

Exhibiting:
Contemporary American art

Robert Kelly

1. *Jacob and Esau VI*
 1991, Oil on canvas,
 84" x 67"

Selected Biography:
1990 Linda Durham Gallery,
Santa Fe, NM;
"Collector's Choice",
Center for the Arts,
Vero Beach, FL
1989 Galleri Weinberger,
Copenhagen, Denmark

Representation:

STILL-ZINSEL CONTEMPORARY

328 Julia Street
New Orleans, LA 70130
504.588.9999
504.588.9900 FAX

Contact:
Sam Still
Suzanne Zinsel
Exhibiting:
Contemporary paintings,
sculpture, photography,
works on paper

Heather Ryan Kelley

1. *The Perils of Odysseus*
 1991, Oil, ink,
 acrylic, canvas,
 60" x 84"

2. *O'Connell Street*
 1991, Oil, ink,
 acrylic, canvas,
 90" x 66"

3. *Howth Hill*
 1991, Oil, canvas,
 72" x 60"

Selected Biography:
1990 "Image of The House",
Juror: Richard McLean,
Redding, CA;
"Signals", Still-Zinsel
Contemporary Fine
Art, New Orleans, LA;
"Small Works 1990",
Juror: Ivan Karp, New
York, NY; "Delmar
24th Annual", Juror:
James Surls, Corpus
Christi, TX

Representation:

LEO CASTELLI
GALLERY

420 W. Broadway
New York, NY 10012
212.431.5160
212.431.5361 FAX
Contact:
Susan Brundage

Jasper Johns

1. *Untitled*
 1991, Oil on canvas,
 48 1/4" x 60 1/4"

2. *Untitled*
 1991, Encaustic
 & sand on canvas,
 50 7/8" x 35 3/8"

3. *Green Angels*
 1990, Encaustic
 & sand on canvas,
 75 1/8" x 50 3/16"

Selected Biography:
1991 Solo exhibitions:
 Leo Castelli Gallery,
 New York, NY;
 "Symbol to Subject:
 Jasper Johns Prints:
 Alphabets, Flags,
 Numbers and Targets",
 Stux Modern, New
 York, NY; Group
 exhibitions: "20th-
 Century Collage",
 Margo Leavin Gallery,
 Los Angeles, CA;
 "Directions: Paintings,
 Sculpture, Prints",
 Locks Gallery,
 Philadelphia, PA

Representation:

STILL-ZINSEL CONTEMPORARY

328 Julia Street
New Orleans, LA 70130
504.588.9999
504.588.9900 FAX

Contact:
Sam Still
Suzanne Zinsel
Exhibiting:
Contemporary paintings,
sculpture, photography,
works on paper

Bill Iles

1. *Red Cow*
 1991, Oil on canvas,
 60" x 72"

2. *Salt Lick*
 1990, Mixed media/wood,
 35" x 36"

3. *Bull and Marker*
 1991, Enamel/oil/wood,
 80" x 70"

Selected Biography:
1990 "Dishman Competition",
 Juror: Betty Moody,
 Beaumont, TX;
 "24th University of
 Delaware Biennial",
 Juror: Jane Livingston,
 Newark, DE; "Small
 Work 1990",
 Juror: Ivan Karp, New
 York, NY; "Delmar
 24th Annual",
 Juror: James Surls,
 Corpus Christi, TX

1

2

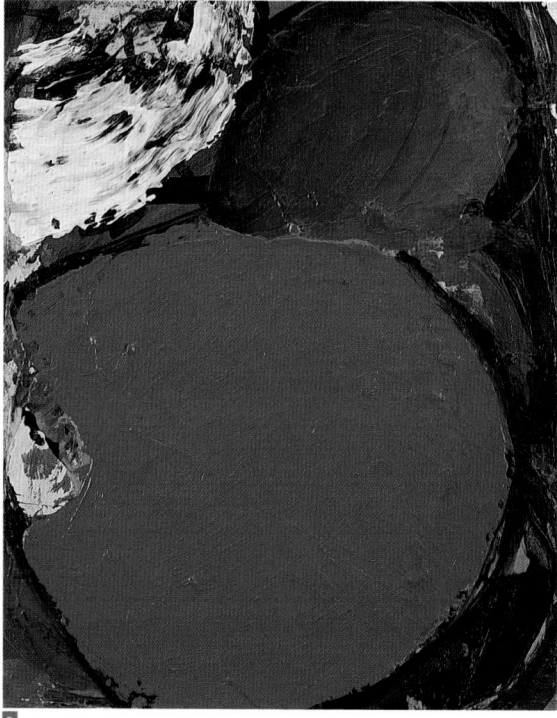

3

Representation:

LINDA DURHAM
GALLERY

400 Canyon Road
Santa Fe, NM 87501
505.988.1313

Contact:
Russell Isaacs

Exhibiting:
Contemporary American art

Phillis Ideal

1. *Untitled*
 1990, Mixed
 media on linen,
 12" x 10"

2. *Untitled*
 1990, Mixed
 media on linen,
 12" x 10"

3. *Untitled*
 1990, Mixed
 media on linen,
 12" x 10"

Selected Biography:
1991 Linda Durham Gallery,
 Santa Fe, NM
1990 Traveling exhibition:
 "Other Paintings",
 curated by Terry R.
 Meyers, David Pagel
 for Independent
 Curators
1988 "Inadmissible
 Evidence", SUNY
 Purchase, Visual Arts
 Gallery, Purchase, NY

Representation:

BRIGITTE SCHLUGER GALLERY

929 Broadway
Denver, CO 80203
303.825.8555

Contact:
Brigitte Schluger

Exhibiting:
Contemporary painting
and sculpture, folk and
Eskimo art

Carol Hoy

1. *The One in Chartreuse*
 1991, Casein on paper,
 30" x 22"

2. *Wire Cat with Tulips*
 1991, Casein on paper,
 30" x 22"

3. *Penitente Hill*
 1991, Oil on canvas,
 13" x 19"

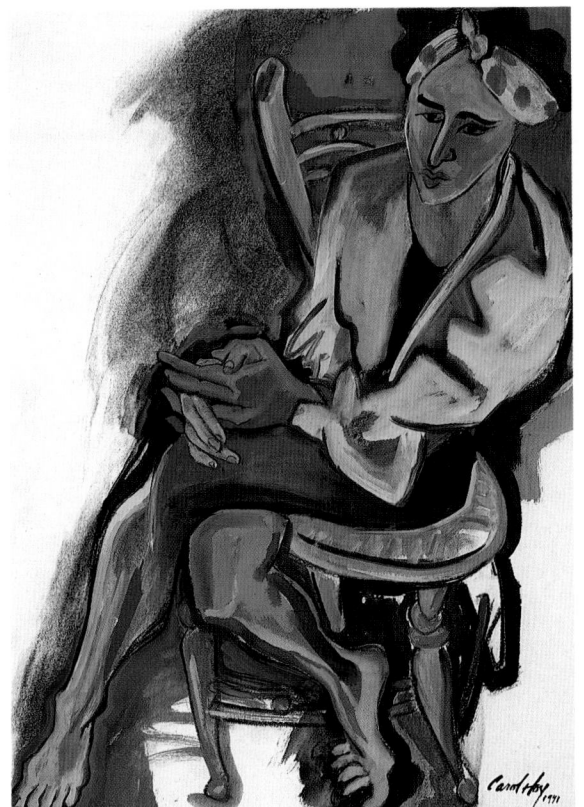
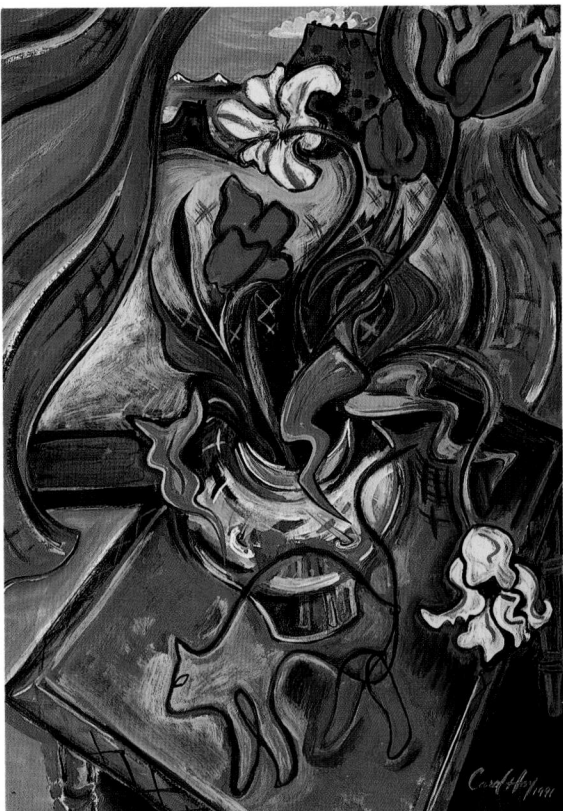

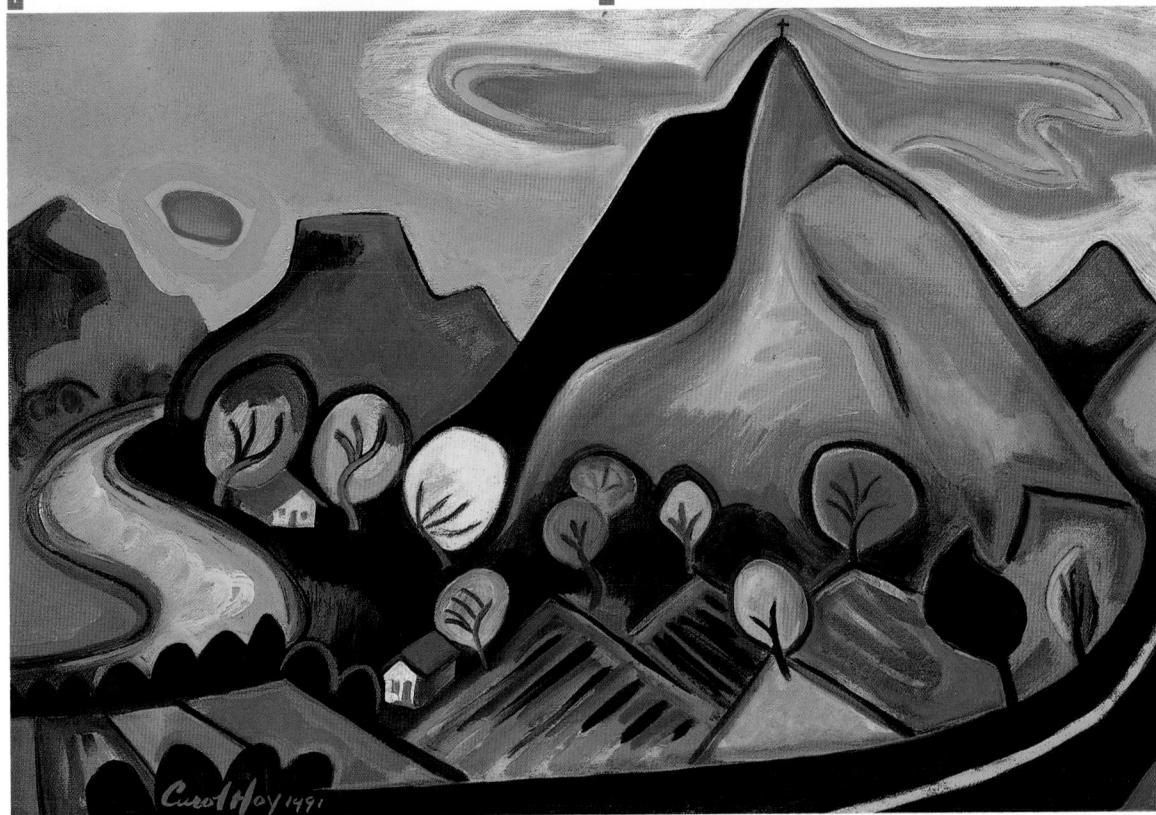

Selected Biography:

1991 Carol Hoy at Brigitte
Schluger Gallery,
Denver, CO

1990 Carol Hoy at "Art of
Albuquerque", juried
exhibit, The
Albuquerque Museum,
Albuquerque, NM;
Carol Hoy at "Vision of
Excellence",
Albuquerque United
Artists, juried exhibit,
New Mexico State Fair
Fine Arts Gallery,
Albuquerque, NM

Representation:

GALERIE TAMENAGA

982 Madison Avenue
New York, NY 10021
212.734.6789
212.734.9413 FAX
Contact:
Howard Rutkowski

Exhibiting:
Modern and contemporary
American, European and
Japanese art

Frank Holmes

1. *The Marble Room*
 1991, Oil on canvas,
 44" x 64"

2. *Still Life With French Doors*
 1991, Oil on canvas,
 50" x 72"

Selected Biography:
1991 Solo exhibition:
 Galerie Tamenaga,
 New York, NY
1989 Solo exhibition:
 Partners Gallery,
 Bethesda, MD;
 "Trains and Planes",
 National Academy
 of Engineering,
 Washington, DC
1987 Solo exhibition:
 Partners Gallery,
 Bethesda, MD

HANS HOFMANN

Representation:

ANDRE EMMERICH GALLERY

41 E. 57th St., 5th-6th Flrs.
New York, NY 10022
212.752.0124
212.371.7345 FAX
Contact:
James Yohe, Director

Exhibiting:
Contemporary painting and
sculpture; antiquities

Hans Hofmann

1. *Swamp Series II
 Autumnal Glory*
 1957, Oil on canvas,
 48" x 60"

2. *Joy Sparks of The Gods*
 1964, Oil on canvas,
 60" x 48"

3. *Mosaic for Apartment
 House-Sketch No. 14*
 1956, Gouache and
 collage on paper,
 39" x 22 5/8"

Selected Biography:
1991 "Hans Hofmann: The
Mosaic Studies", Andre
Emmerich Gallery,
New York; "Hans
Hofmann: A Selection
of Paintings &
Watercolors", Crane
Gallery, London
1990 "Hans Hofmann:
The Chimbote Mural
Project", Andre
Emmerich Gallery,
New York

Representation:

ANDRE EMMERICH GALLERY

41 E. 57th St., 5th-6th Flrs.
New York, NY 10022
212.752.0124
212.371.7345 FAX
Contact:
James Yohe, Director

Exhibiting:
Contemporary painting and
sculpture; antiquities

David Hockney

1. *A Bigger Wave*
 1989, Oil on 4 canvases,
 60 1/2 " X 72 1/2"

2. *A Realistic Still Life*
 1965, Acrylic on canvas,
 48" x 48"

3. *Nichols Canyon Road*
 1979-80, Oil on canvas,
 24" x 18 1/8"

Selected Biography:
1991 "David Hockney:
 Things Recent" Andre
 Emmerich Gallery,
 New York;
 "Seven Master
 Printmakers", The
 Museum Of Modern
 Art, New York
1988 "David Hockney: A
 Retrospective", Los
 Angeles County
 Museum, Metropolitan
 Museum Of Art, Tate
 Gallery

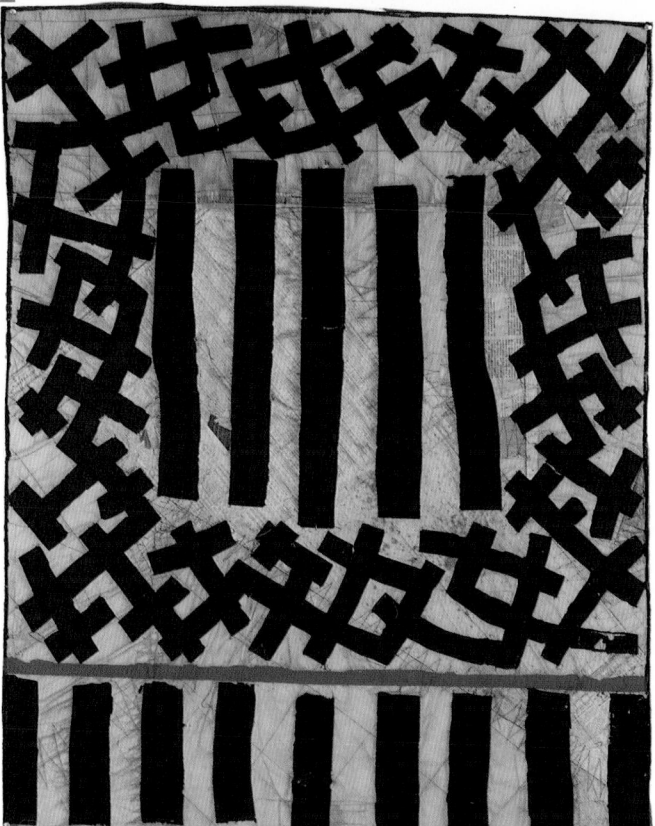

Representation:

CIRRUS GALLERY

542 S. Alameda Street
Los Angeles, CA 90013
213.680.3473
213.680.0930 FAX

Contact:
Jean Milant

Exhibiting:
Contemporary painting,
sculpture - publishers of fine
art graphics

Charles Hill

1. *Zola*
 1990, Stitched and
 layered paper,
 15" x 34"

2. *Oriflame*
 1990, Stitched and
 layered paper,
 16 1/2" x 41"

3. *Matisse*
 1990, Stitched and
 layered paper,
 60" x 48"

Selected Biography:
1991 Solo exhibition: Cirrus
Gallery, Los Angeles, CA
1988 Solo exhibition: Cirrus
Gallery, Los Angeles,
CA; "Le Bambou",
Galerie Nicole
Dortindeguey, Anduxe,
France
1987 Solo exhibition: Cirrus
Gallery, Los Angeles,
CA; Centre d' Action
Culturelle de Saint-
Brieuc, France
1985 Solo exhibition: Galleria
Del Cavallino, Venice,
Italy; Baudoin Lebon
Gallery, Paris, France

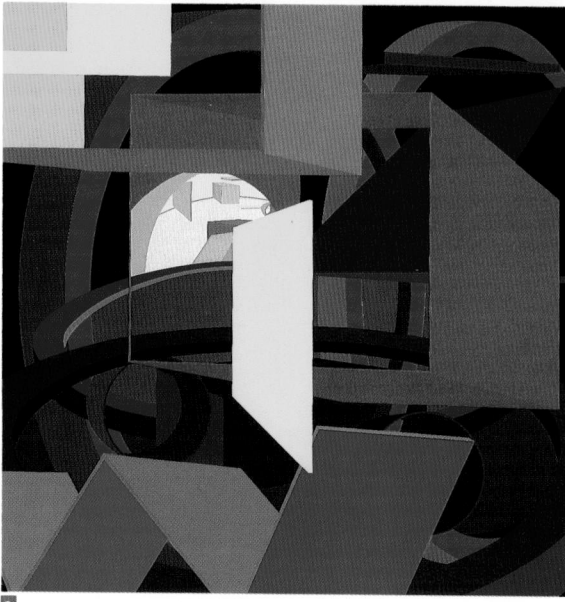

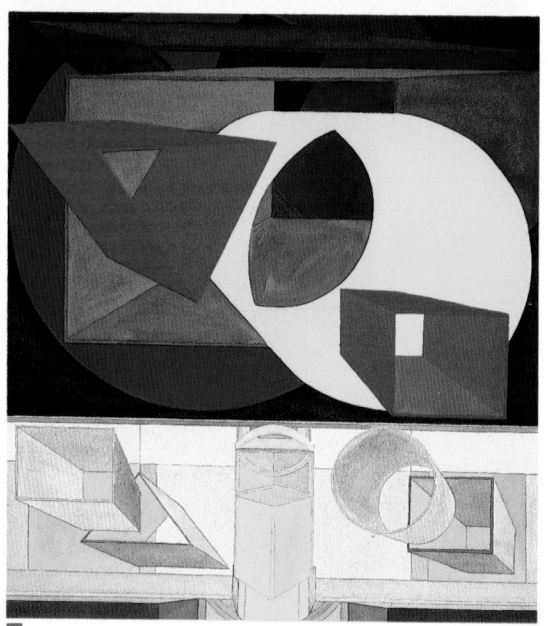

Representation:

ANDRE EMMERICH GALLERY

41 E. 57th St., 5th-6th Flrs.
New York, NY 10022
212.752.0124
212.371.7345 FAX

Contact:
James Yohe, Director

Exhibiting:
Contemporary painting and
sculpture; antiquities

Al Held

1. *H*
 1991, Acrylic on canvas,
 16' x 18'

2. *Quattro Centric XV*
 1990, Acrylic on canvas,
 7' x 7'

3. *Primo 11*
 1990, Watercolor on
 paper mounted on board,
 29 1/8" x 26"

Selected Biography:
1991 "The Italian
 Watercolors", Andre
 Emmerich Gallery,
 New York; "Al Held:
 Paintings 1990", Heland
 Wetterling Gallery,
 Stockholm, Sweden
1990 "Al Held: New
 Paintings", Andre
 Emmerich Gallery,
 New York

Representation:

**RICCO/MARESCA
GALLERY**

105 Hudson Street
New York, NY 10013
212.219.2756
212.219.2756 FAX

Contact:
Roger R. Ricco
Frank Maresca

Exhibiting:
Masters of American
self-taught, Outsider Art,
emerging contemporary
artists

William Hawkins

1. *Huntington Bank*
 1989, Enamel
 on masonite,
 62" x 48"

2. *The Blue Boar*
 1989, Enamel
 on masonite,
 55" x 48"

3. *Conquest of the Moon*
 1988, Enamel
 on masonite,
 46 3/4 x 53"

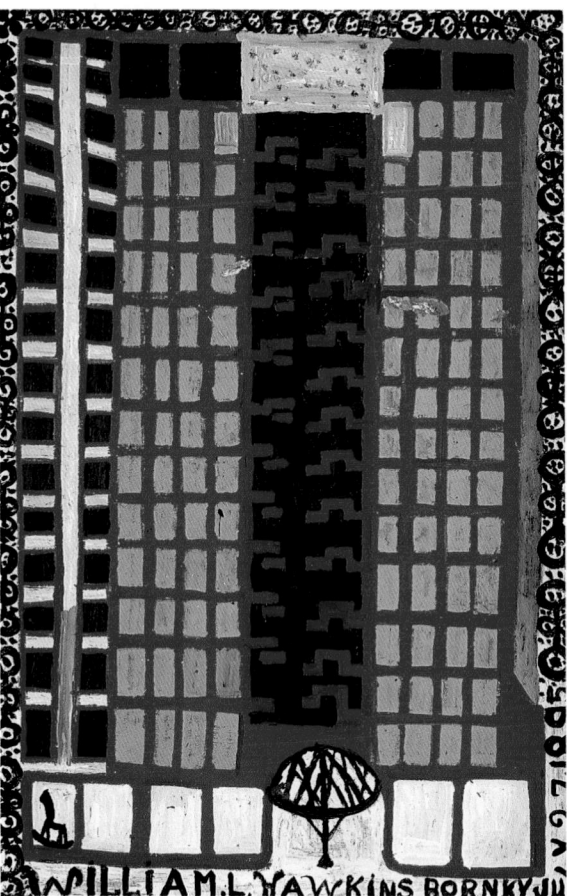

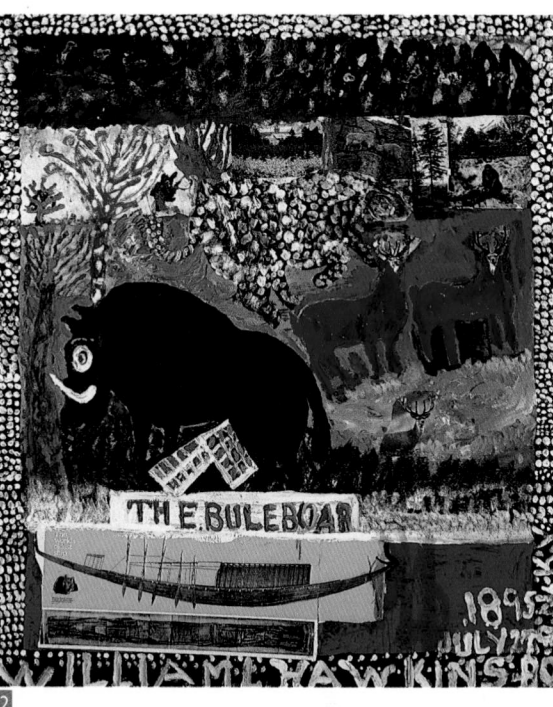

Selected Biography:

1990 Solo show: "The Art
 of William Hawkins",
 Columbus Museum of
 Art, Columbus, OH;
 Solo show: Ricco/
 Maresca Gallery,
 New York; In Hemphill
 Collection, National
 Museum of American
 Art, Washington, DC

1986 In "Muffled Voices",
 Museum of American
 Art, Paine Weber
 Galleries, New York

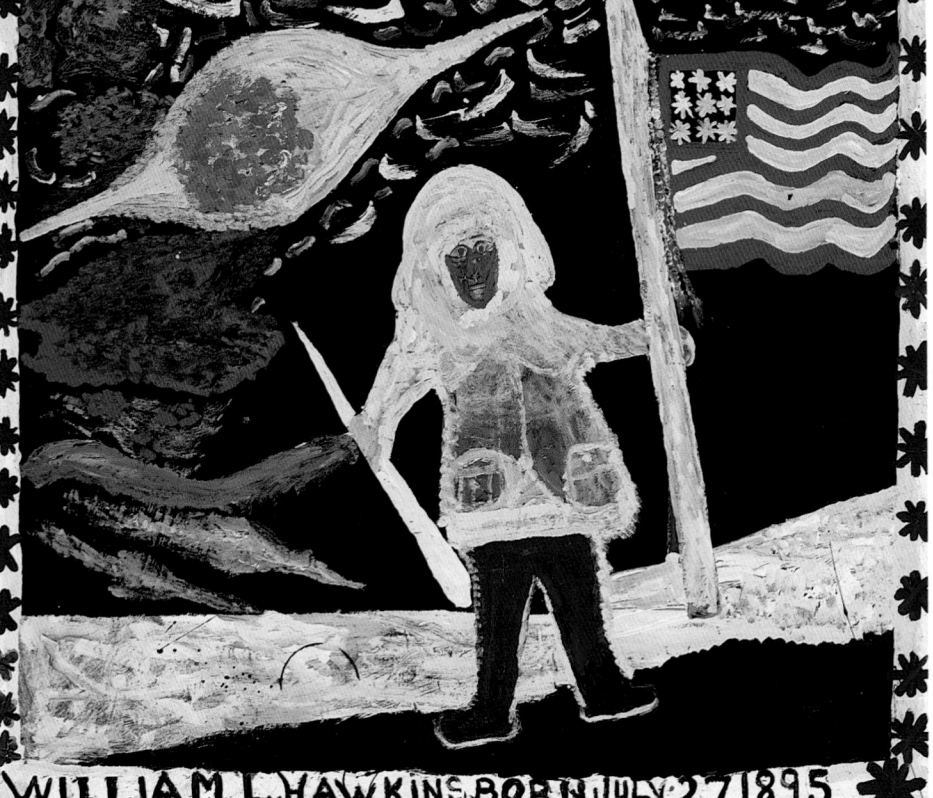

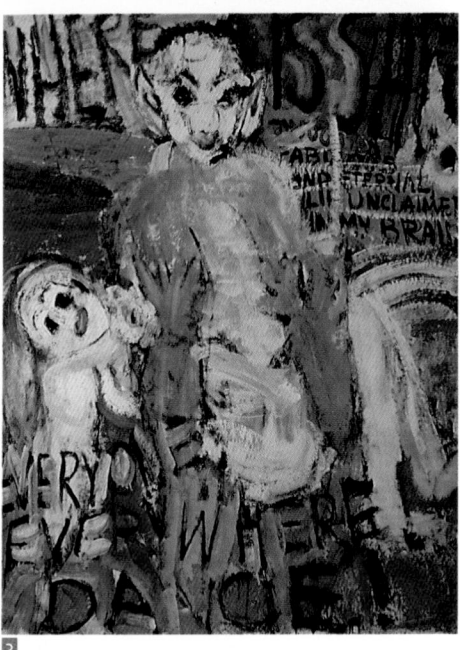

C. GRIMALDIS GALLERY

1006 Morton Street
Baltimore, MD 21201
301.539.1080

Contact:
Constantine Grimaldis

Exhibiting:
Contemporary American
and European art

Grace Hartigan

1. *Violent Femmes*
1991, Oil on canvas,
78" x 84"

2. *Where Is She?*
1952, Oil on paper,
37" x 46 1/2"

3. *Plastic Animals*
1991, Watercolor,
60" x 48"

Selected Biography:
1990 Grace Hartigan: "New
Works", C. Grimaldis
Gallery; Grace
Hartigan: "The
Complete Prints",
Baltimore Museum of
Art; Grace Hartigan:
"Forty Years of
Prints", ACA Galleries,
New York

Representation:

**STILL-ZINSEL
CONTEMPORARY**

328 Julia Street
New Orleans, LA 70130
504.588.9999
504.588.9900 FAX

Contact:
Sam Still
Suzanne Zinsel
Exhibiting:
Contemporary paintings,
sculpture, photography,
works on paper

Ronna S. Harris

1. *Dead Bride*
 1991, Oil/canvas,
 58" x 82"

2. *Surrender*
 1991, Oil/canvas,
 54" x 70"

Selected Biography:
1991 Group exhibition:
 Capricorn Gallery,
 Bethesda, MD
1990 "New Work", Still-
 Zinsel Contemporary
 Fine Art, New Orleans,
 LA; "New Work",
 Newcomb Gallery
 at Tulane University,
 New Orleans, LA;
 Group exhibition:
 Alexander F. Milliken,
 New York, NY

Representation:

ADDISON/RIPLEY GALLERY

9 Hillyer Court
Washington, DC 20008
202.328.2332
202.328.2332 FAX
Contact:
Chris Addison

Exhibiting:
Contemporary art in all
media

Greg Hannan

1. *Montello Gang*
 1991, Acrylic on wood,
 82" x 86"

Selected Biography:
1991 Addison/Ripley Gallery,
Washington, DC
1989 Arnold & Porter Gallery,
Washington, DC
1988 Addison/Ripley Gallery,
Washington, DC

*1992 North American Edition* – 127

Representation:

MODERNISM INC.

685 Market Street, Suite 290
San Francisco, CA 94105
415.541.0461
415.541.0425 FAX
Contact:
Katya Slavenska

Exhibiting:
Contemporary art,
20th-century historical
art, Russian Avant-Garde
1900-1930

Frederick Hammersley

1. *Betwain*
 1973, Oil on canvas,
 45" x 45"

Selected Biography:
1989 California State
 University, Northridge
1965 Santa Barbara
 Museum of Art
1961 Pasadena Museum
 of Art
1960 Traveling exhibition:
 "Four Abstact
 Classicists", San
 Francisco Museum
 of Modern Art

Representation:

**WYNICK/TUCK
GALLERY**

80 Spadina Avenue, 4th Fl.
Toronto, ON M5V 2J3
416.364.8716

Contact:
Lynne Wynick
David Tuck
Exhibiting:
Contemporary Canadian art:
painting, sculpture, works on
paper and installations

John Hall

1. *Love in the Animal Kingdom
 (Derek)*
 1991, Acrylic on canvas,
 60" x 90"

2. *Cut*
 1986, Acrylic on canvas,
 60" x 60"

3. *Chiapas*
 1988, Acrylic on canvas,
 24" x 24"

4. *Gerda and Marijke*
 1991, Acrylic on canvas,
 60" x 60"

Representation:

HASSEL HAESELER

1743 Wazee
Denver, CO 80202
303.295.6442

Contact:
Joshua Hassel

Exhibiting:
Neo-pop, New Painters
of the American Scene, and
Colorado's Avant Garde

John Thomas Haeseler

1. *9 Singing Dianes*
 (self-portrait)
 1990, Mixed media
 painting on board,
 48" x 48"

2. *Untitled*
 1991, Mixed media
 painting on board,
 48" x 48"

3. *You Can See Her If*
 The Light Is Right (The
 official unauthorized
 portrait of Dianne Perry
 Vanderlip)
 1991, Mixed media
 painting on board,
 24" x 24"

Selected Biography:
1992 "Portraits", Karen
 Briede Gallery,
 Chicago, IL
1991 "100 Portraits, People
 and Buildings", Hassel
 Haeseler, Denver, CO
1990 "John Thomas
 Haeseler", Hassel
 Haeseler, Denver, CO
1982 "Three Xeroxgraphers",
 University of Colorado,
 Colorado Springs, CO

1

2

3

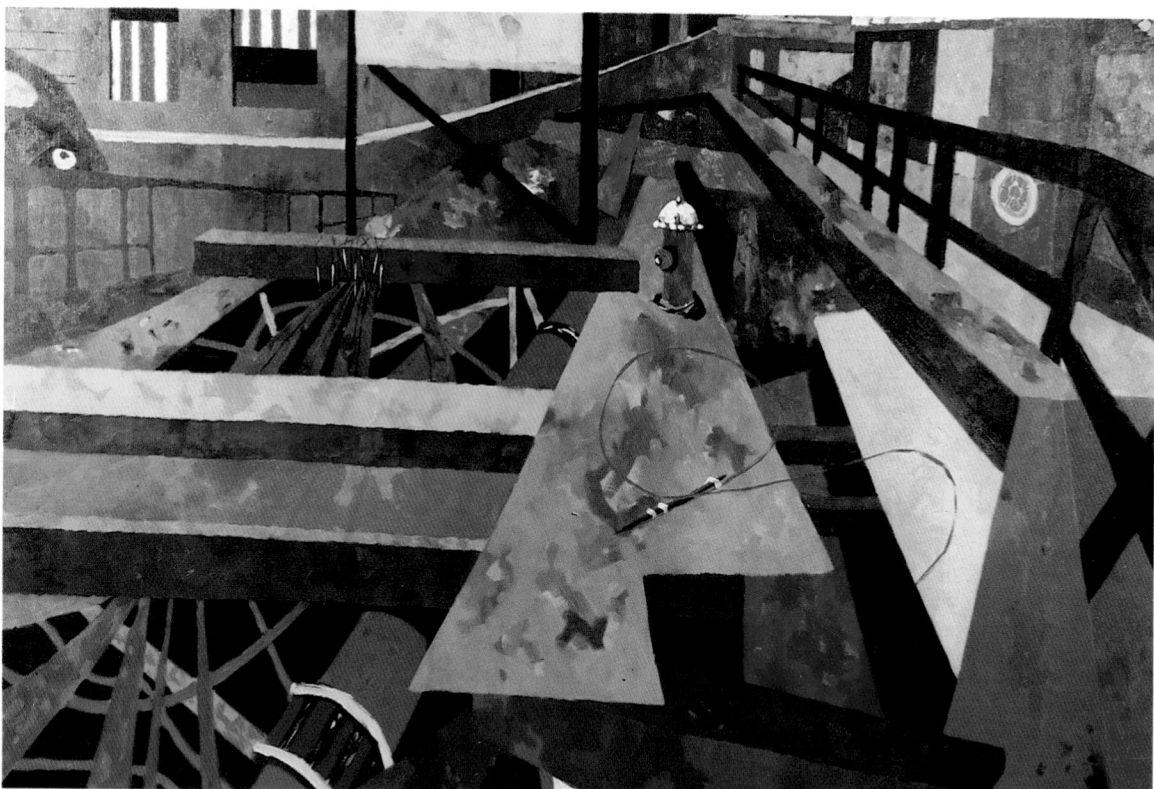

Representation:

DAVID DAVID GALLERY

260 S. 18th Street
Philadelphia, PA 19103
215.735.2922
215.735.4244 FAX
Contact:
Carl David

Exhibiting:
American and European
paintings, drawings,
watercolors 16th-20th
century

Sidney Gross

1. *Cityscape*
 Oil on canvas,
 36" x 48"

2. *UFO #18*
 Oil on canvas,
 75" x 66"

3. *Triptych*
 Oil on canvas,
 48" x 30"

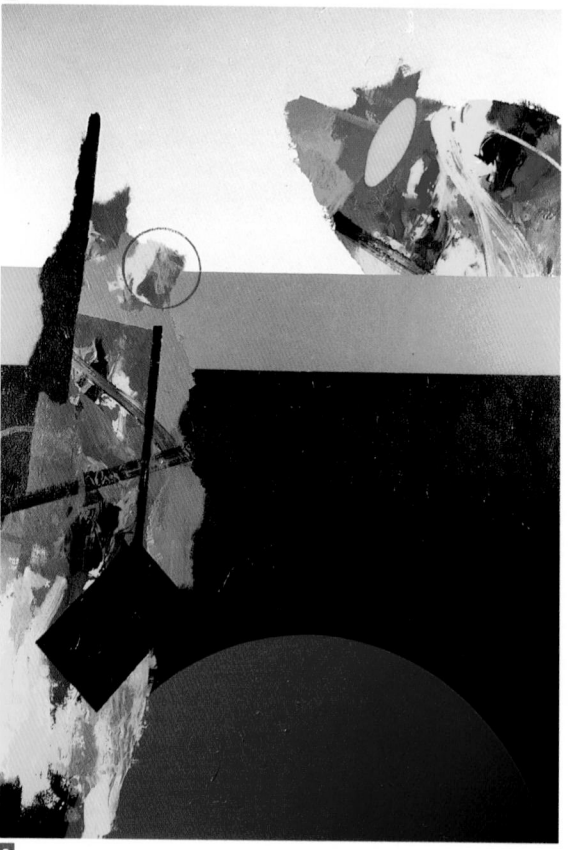

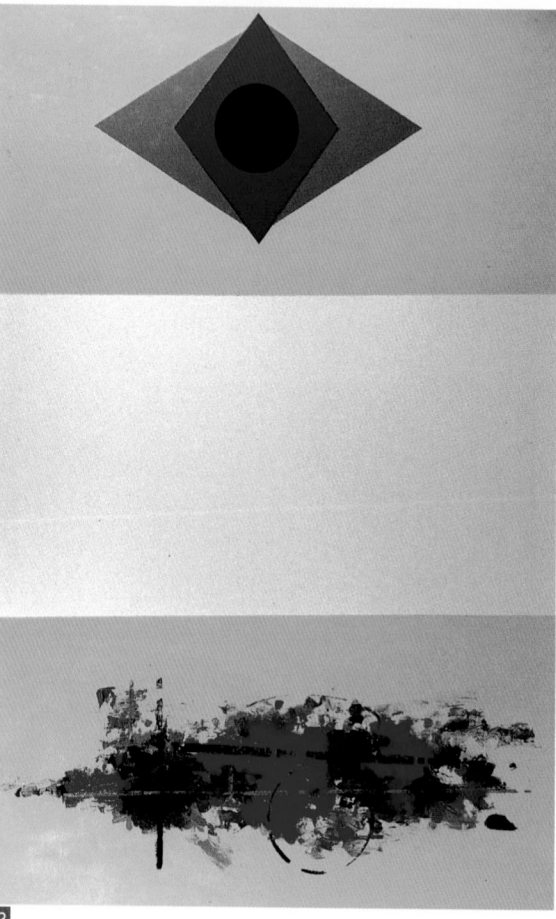

Selected Collections:
 Whitney Museum

 Butler Art Institute

 Syracuse University

 Washington University
 of Modern Art

Representation:

DANIEL SAXON GALLERY

7525 Beverly Boulevard
Los Angeles, CA 90036
213.933.5282
213.933.8105 FAX
Contact:
Daniel Saxon

Exhibiting:
Contemporary painting &
sculpture with emphasis
on Chicano/Latino art

GRONK

1. *Support*
 1990, Acrylic on paper,
 51" x 71"

2. *Mad Clowns*
 1990, Acrylic on wood,
 73 1/4" x 49 1/4"

3. *China Pattern*
 1990, Acrylic on canvas,
 61 1/4" x 73 1/4"

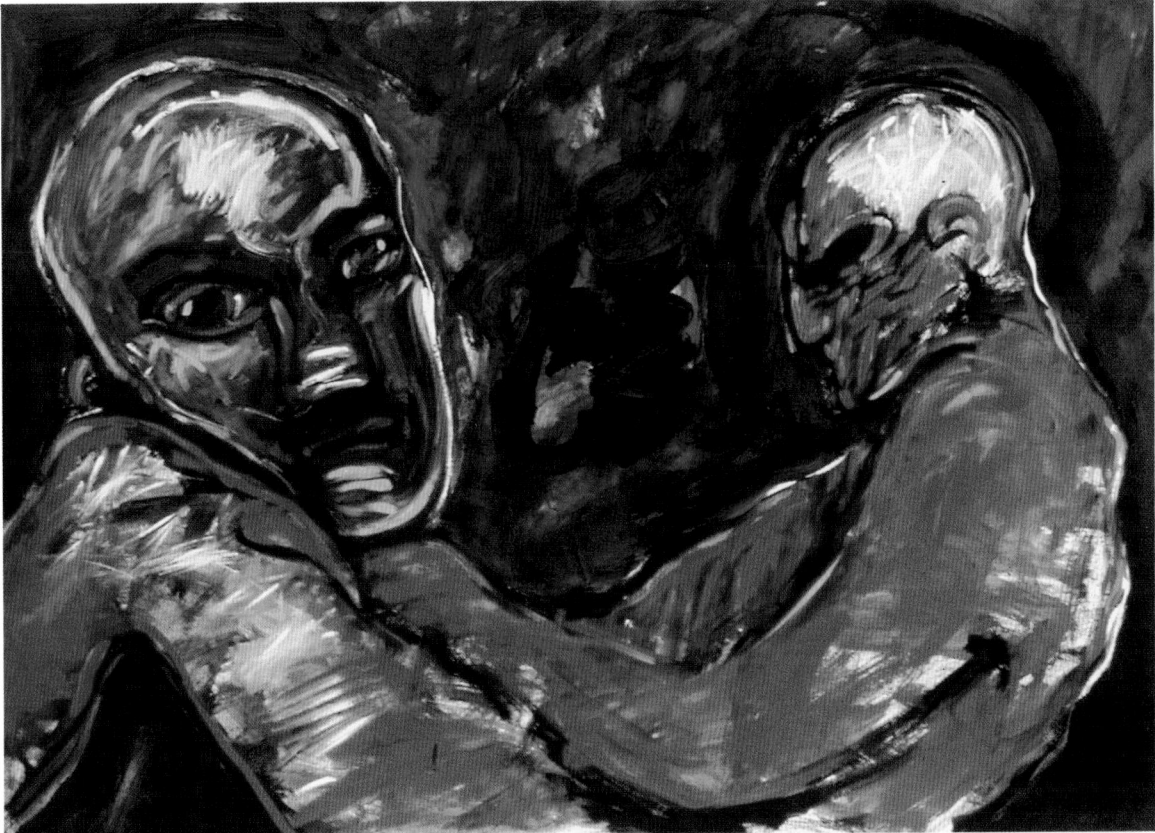

Selected Biography:
1992 Galerie Claude Samuel,
 Paris; Kimberly Gallery,
 Washington, DC;
 National Museum of
 American Art,
 Washington, DC
1991 Daniel Saxon Gallery,
 Los Angeles
1990 Denver Art Museum;
 San Francisco Museum;
 Tucson Museum
1989 Los Angeles County
 Museum of Art;
 Deson-Saunders
 Gallery, Chicago;
 Houston Fine Arts
 Museum

JAMES GROFF

Representation:

CHARLES WHITCHURCH GALLERY

5973 Engineer Drive
Huntington Beach, CA 92694
714.373.4459
714.373.4615 FAX

Contact:
Douglas Deaver, Ph.D.

Exhibiting:
Paintings, sculpture, and
graphic works by modern
and contemporary artists

James Groff

1. *Distant Passage #2*
 1990, Acrylic on canvas,
 88" x 60"

Selected Biography:
1992 "James Groff",
 Charles Whitchurch
 Gallery, Huntington
 Beach, CA
1991 Group exhibition:
 van Straaten, Chicago
 International Art
 Exposition

JAMISON/THOMAS GALLERY

588 Broadway, Suite 303
New York, NY 10012
212.925.1055
212.925.1090 FAX

1313 NW Glisan
Portland, OR 97209
503.222.0063
503.224.4517 FAX

Contact:
Jeffrey Thomas
William Jamison
Exhibiting:
Contemporary paintings,
sculpture, drawings & prints

Gregory Grenon

1. *It Would Mean So
 Much To Me*
 1990, Reverse oil
 painting on plexiglass,
 57 1/2" x 37 3/4"

Selected Biography
1990 "Against The Rules",
Jamison/Thomas
Gallery, New York, NY
1989 "Women on Women
in Women", William
Traver Gallery, Seattle,
WA; Oregon Biennial,
Oregon Art Institute,
Portland, OR
1988 "White Women",
Jamison/Thomas,
Portland, OR

Representation:

J. ROSENTHAL FINE ARTS

230 W. Superior Street
Chicago, IL 60610
312.642.2966
312.642.5169 FAX
Contact:
Dennis Rosenthal

Exhibiting:
20th century modern and
contemporary international
uniques and multiples

Drew Gregory

1. *Early Morning, Shearer's Quarters Yurdyilla Station N.S.W.*
 1991, Watercolor,
 13 1/2" x 26 3/4"

2. *Passing Emu*
 1991, Watercolor,
 20" x 20"

Selected Biography:
1991 J. Rosenthal Fine Arts,
 Chicago, IL;
 Mornington Gallery,
 Victoria, Australia
1990 Mornington Gallery,
 Victoria, Australia
1988 Eltham Gallery,
 Victoria, Australia

Representation:

**RICHARD GRAY
GALLERY**

620 N. Michigan Avenue
Chicago, IL 60611
312.642.8877
312.642.8488 FAX

Contact:
Paul Gray

Exhibiting:
Modern and contemporary
American and European art

Harold Gregor

1. *Illinois Autumn Evening*
 1990, Oil/acrylic on canvas,
 8'2" x 11'10"

2. *Illinois Spring Morning*
 1991, Oil/acrylic on canvas,
 8'2" x 11'10"

Selected Exhibitions:
1991 Richard Gray Gallery,
Chicago; Tibor De Nagy
Gallery, New York
1989 Tibor De Nagy Gallery,
New York; Iannetti-
Lanzone Gallery,
San Francisco
1988 Lakeview Museum
(Retrospective),
Peoria, IL

Representation:

TAKADA FINE ARTS

251 Post Street, 6th Fl.
San Francisco, CA 94108
415.956.5288
415.956.5409 FAX

Contact:
Hidekatsu Takada

Exhibiting:
Contemporary American
and Japanese art

Joe Goode

1. *Snyder*
 1991, Oil on canvas,
 17" x 15"

2. *Untitled, D18*
 1989, Oil pastel on paper,
 30" x 22"

3. *Untitled, Tree Series*
 1987, Oil pastel on paper,
 20" x 15"

Selected Biography:
1991 Solo show:
 Takada Fine Arts,
 San Francisco, CA
1990 Solo show: James
 Corcoran Gallery,
 Santa Monica, CA;
 Compass Gallery,
 Chicago, IL
1989 Solo show: James
 Corcoran Gallery,
 Santa Monica, CA

Representation:

JAMES CORCORAN
GALLERY

1327 Fifth Street
Santa Monica, CA 90401
213.451.4666
213.451.0950 FAX

Joe Goode

1. *Sluiskin (Waterfall
 Series #24)*
 1990, Oil on wood,
 81" x 18"

Selected Biography:
1991 Pop Art, Royal
Academy, London,
Great Britain
1990 Solo show: James
Corcoran Gallery,
Santa Monica, CA

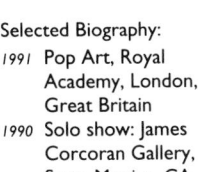

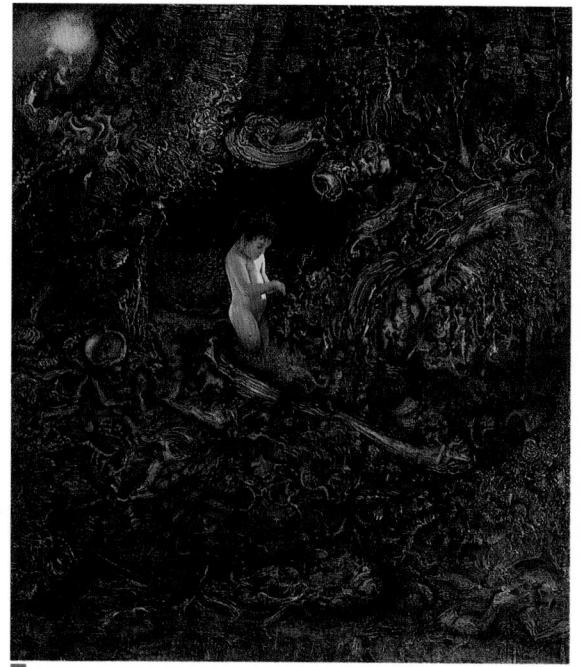

1

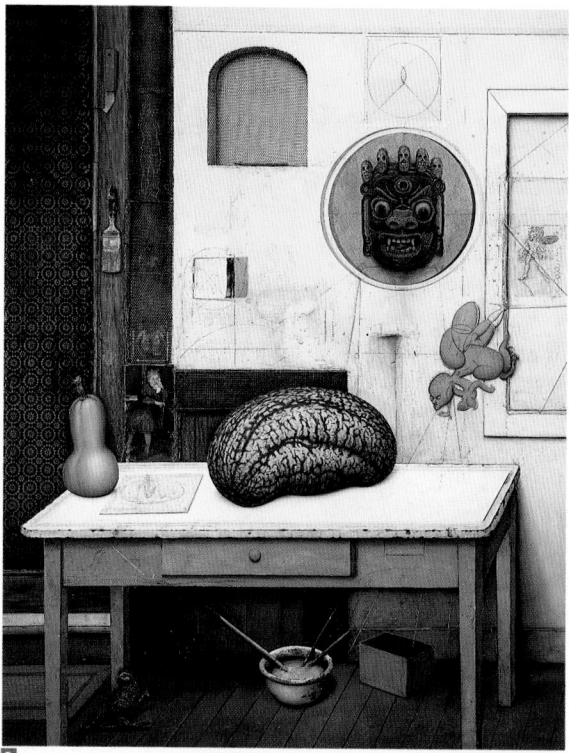

2

3

Representation:

FORUM GALLERY

745 Fifth Avenue
New York, NY 10151
212.355.4545

Contact:
Robert Fishko

Exhibiting:
20th-Century American
Realism; paintings, drawings
and sculpture

Gregory Gillespie

1. *Julianna*
 1991, Oil on wood,
 16 1/2" x 15"

2. *Still Life With Watermelon*
 1986-1987, Mixed
 media on wood,
 84" x 57"
 San Diego Museum of
 Contemporary Art, San Diego

3. *Self Portrait*
 1985, Mixed
 media on wood,
 60" x 43"
 Private collection

Representation:

ELEONORE AUSTERER GALLERY

540 Sutter Street
San Francisco, CA 94102
415.986.2244
415.986.2281 FAX
Contact:
Eleonore Austerer

Exhibiting:
Contemporary American
and European art

Francesc Genoves

1. *Negre i Roig*
 1990, Oil/collage
 on canvas,
 62 3/8" x 50 1/8"

2. *A Heart Marked by Time*
 1990, Mixed media/
 collage on paper,
 52" x 18"

3. *The King of My Dreams*
 1990, Oil/collage
 on canvas,
 62 1/4" x 50 1/4"

Selected Biography:
1991 Solo exhibition:
 Eleonore Austerer
 Gallery, San Francisco
1989 Solo exhibition:
 Olympia Palace,
 London and Locus
 Gallery, London
1987 "Four Artists from
 Spain", Nippon Club,
 New York
1983 through 1990,
 ARCO, Madrid, Spain,
 (Sala Gaspar Gallery,
 Barcelona)

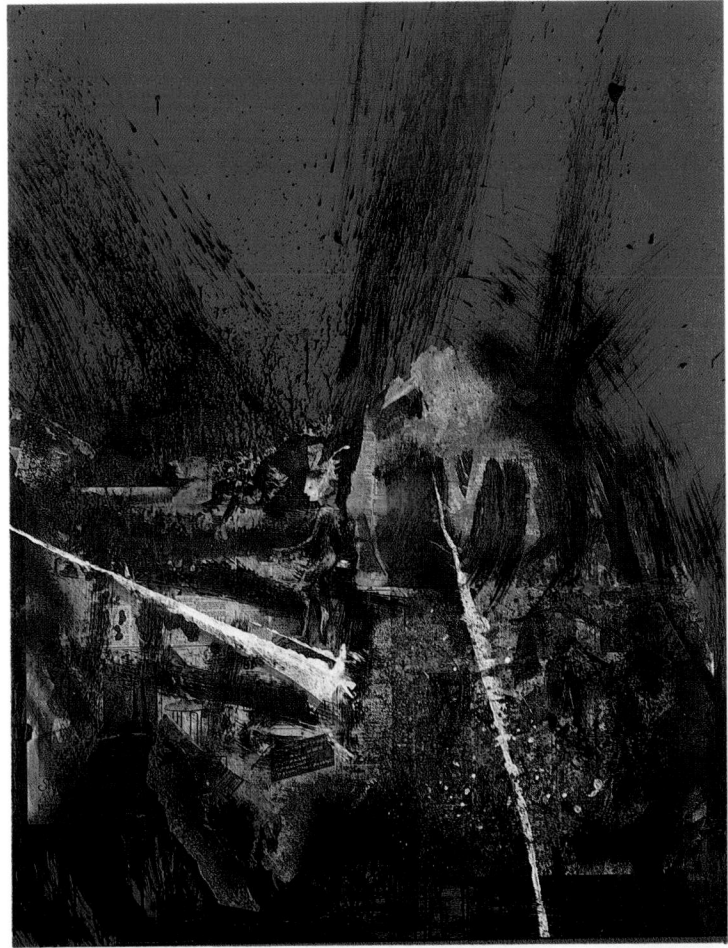

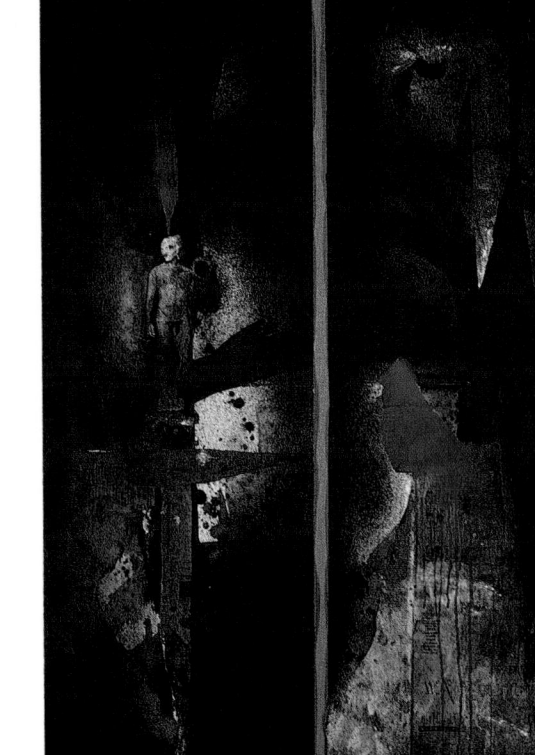

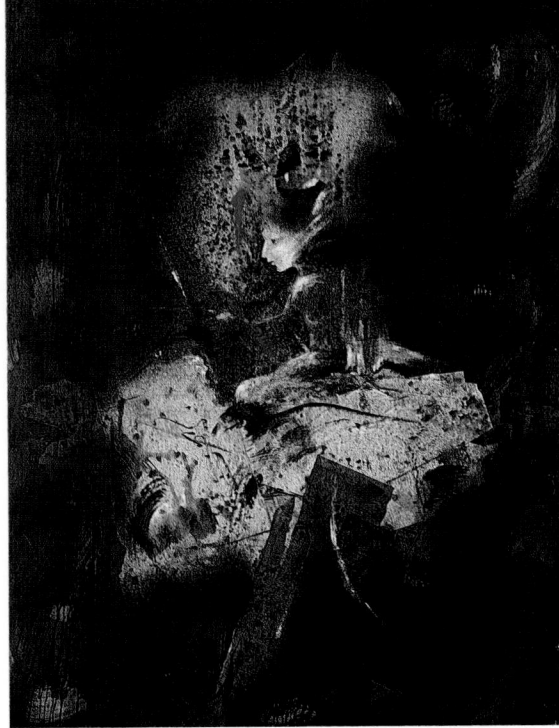

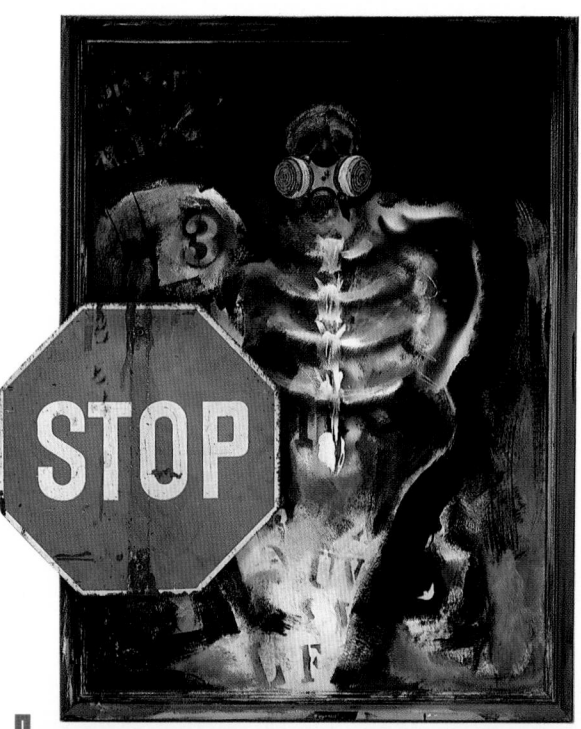

Representation:

CHARLES WHITCHURCH GALLERY

5973 Engineer Drive
Huntington Beach, CA 92694
714.373.4459
714.373.4615 FAX

Contact:
Douglas Deaver, Ph.D.

Exhibiting:
Paintings, sculpture, and
graphic works by modern
and contemporary artists

Jerome Gastaldi

1. *Swan Dive Highway*
 1990, Mixed media:
 oil on masonite, steel
 and respirator,
 53" x 39"

2. *Pseudo Critic*
 1989, Wood, straw,
 bronze, aluminum and
 silver print,
 7" x 11" x 10.5"

3. *The Truth*
 1990, Acrylic on canvas,
 72" x 132"

Selected Biography:
1991 "Jerome Gastaldi",
Charles Whitchurch
Gallery, Huntington
Beach, CA; Group
show: Art Walk,
Venice, CA

Representation:

LISA HARRIS
GALLERY

1922 Pike Place
Seattle, WA 98101
206.443.3315

Contact:
Lisa Harris

Exhibiting:
Contemporary Northwest
and West Coast paintings,
prints and sculpture

Terry Furchgott

1. *Sailors*
 1991, Pastel,
 18" x 60"

2. *Generations*
 1991, Pastel,
 60" x 34"

3. *Folding Laundry*
 1987, Pastel,
 37" x 25"

Selected Biography:
1990 "At Home with the
 Gods", solo exhibition
 at Lisa Harris Gallery
1972 Attended Camden
 Art Centre and
 Stanhope Institute,
 London, England
1970 Attended the Boston
 Museum School
1948 Born, New York, NY

Representation:

CHARLES WHITCHURCH GALLERY

5973 Engineer Drive
Huntington Beach, CA 92694
714.373.4459
714.373.4615 FAX

Contact:
Douglas Deaver, Ph.D.

Exhibiting:
Paintings, sculpture, and
graphic works by modern
and contemporary artists

Ray Friesz

1. *Disappearing Stream*
 1990, Acrylic on canvas,
 60" x 43"

Selected Biography:
1992 Charles Whitchurch
 Gallery, Huntington
 Beach, CA; Jerald
 Melberg Gallery,
 Charlotte, NC

Representation:

THE COOLEY GALLERY, INC.

25 Lyme Street, P.O. Box 447
Old Lyme, CT 06371
203.434.8807
203.434.7526 FAX

Contact:
Jeffrey W. Cooley

Exhibiting:
19th & early 20th-century
American paintings and
Contemporary Realism

Linden Frederick

1. *Siding*
 1990, Oil on canvas,
 39 1/2" x 39 1/2"

2. *Drift*
 1990, Oil on canvas,
 27 1/2" x 27 1/2"

I

Representation:

GALLERY ONE

121 Scollard Street
Toronto, Canada M5R 1G4
416.929.3103
416.929.0278 FAX

Contact:
Goldie Konopny
Sharon Fischtein
Exhibiting:
Contemporary Canadian,
American & International
painting, sculpture & graphics

Helen Frankenthaler

1. *Dialogue*
 1960, Gouache on paper,
 18 3/4" x 25 3/4"

Selected Biography:
1991 André Emmerich
 Gallery, New York, NY
1991 Gallery One, Toronto,
 Ont., Canada
1989 Major retrospective
 exhibition at the
 Metropolitan Museum
 of Fine Art, New York,
 organized by the
 Modern Art Museum
 of Fortworth, also
 shown at Los Angeles
 County Museum of Art;
 Detroit Institute of Arts

Representation:

ANDRE EMMERICH GALLERY

41 E. 57th St., 5th-6th Flrs.
New York, NY 10022
212.752.0124
212.371.7345 FAX

Contact:
James Yohe, Director

Exhibiting:
Contemporary painting and
sculpture; antiquities

Helen Frankenthaler

1. *Yellow Caterpillar*
 1961, Oil on canvas,
 93 1/2" x 120"

2. *Aqueduct*
 1987, Acrylic on canvas,
 63" x 39 1/2"

3. *Logging*
 1967, Acrylic on canvas,
 93 7/8" x 97 1/8"

Selected Biography:
1991 "Helen Frankenthaler:
 New Paintings", Andre
 Emmerich Gallery,
 New York;
1990 "Helen Frankenthaler:
 Paintings on Paper",
 Andre Emmerich
 Gallery, New York;
1989 "Helen Frankenthaler:
 Works on Paper,
 Gouaches & Prints",
 Bushlen Mowatt
 Gallery, Vancouver, BC

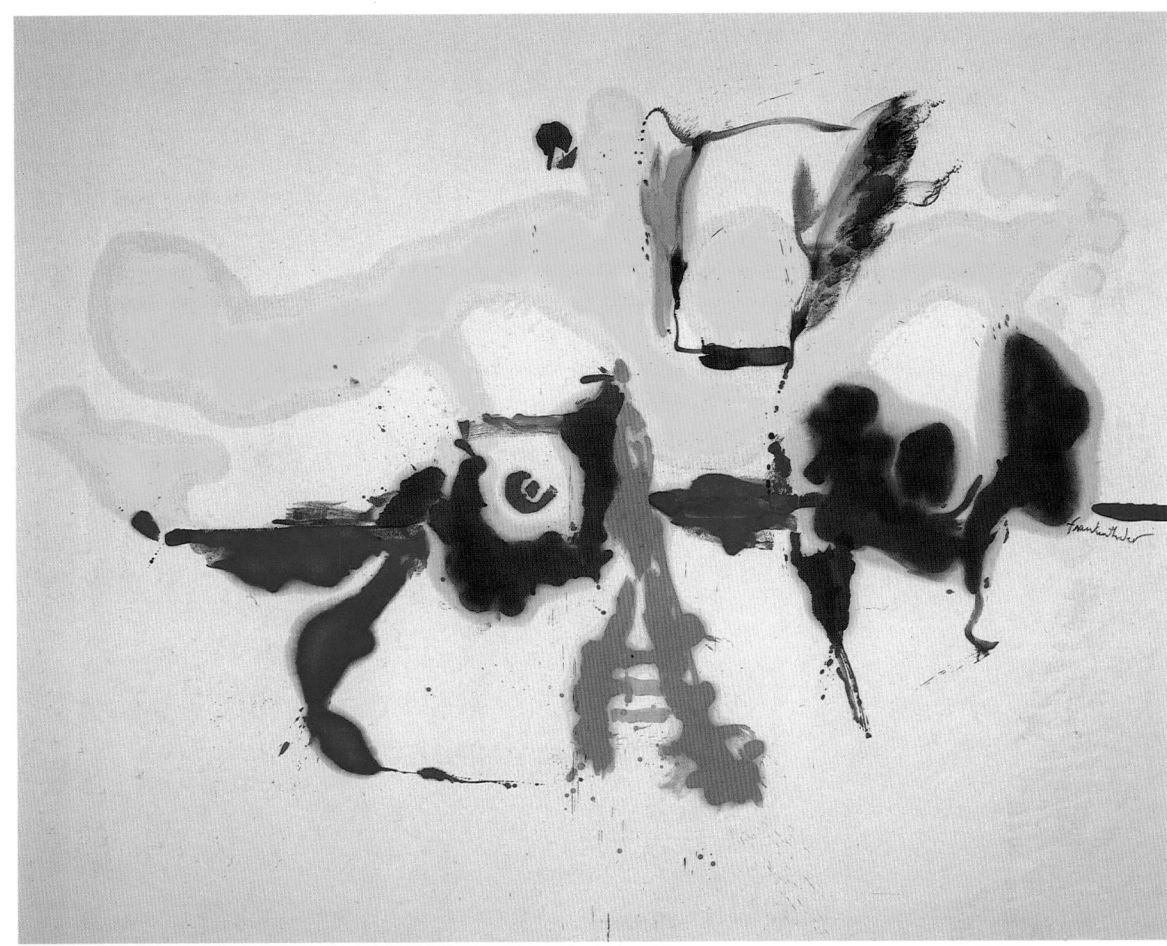

1

2

3

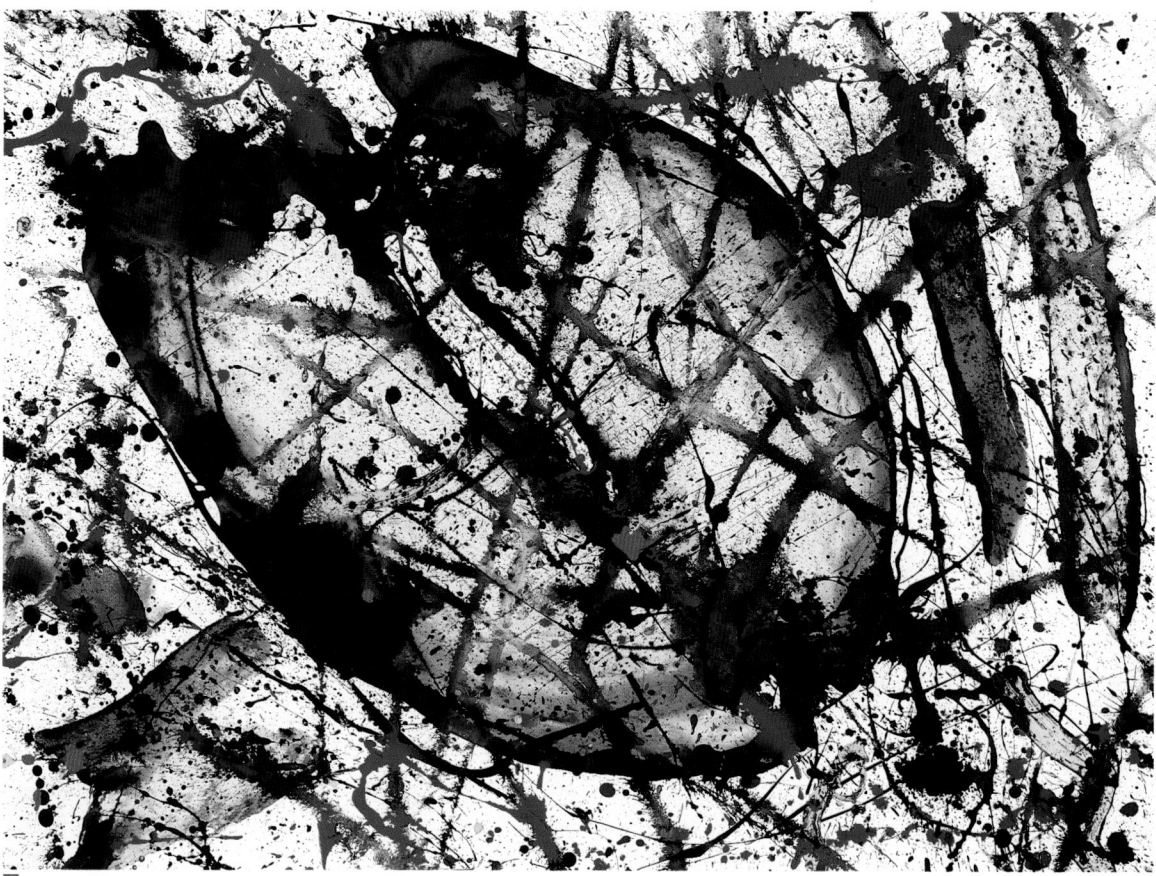

Representation:

ANDRE EMMERICH GALLERY

41 E. 57th St., 5th-6th Flrs.
New York, NY 10022
212.752.0124
212.371.7345 FAX
Contact:
James Yohe, Director

Exhibiting:
Contemporary painting and
sculpture; antiquities

Sam Francis

1. *Untitled*
 1980, Acrylic on canvas,
 89 1/8" x 80 1/4"

2. *Untitled*
 1990, Acrylic on canvas,
 29 1/2" x 42 1/2"

3. *Blue Balls*
 1960 Tokyo, Gouache
 on paper,
 37" x 23 1/2"

Selected Biography:
1991 "Sam Francis: Prints &
 Drawings from 1960's
 and 1970's",
 Associated American
 Artists, New York
1990 "Sam Francis: Early
 Works on Paper
 1956-1964", Andre
 Emmerich Gallery,
 New York
1989 "Sam Francis: New
 Paintings", Andre
 Emmerich Gallery,
 New York

Representation:

THE LOWE GALLERY

75 Bennett St., Space A-2
Atlanta, GA 30309
404.352.8114
404.352.0564 FAX
Contact:
Bill Lowe

Exhibiting:
Contemporary painting,
sculpture and objects

Ke Francis

1. *Tornado Series: Cyclops*
 1991, Painted wood,
 steel, acrylic,
 91" x 144"

2. *Manic Moon*
 1989, Mixed media,
 93" x 49" x 24"

Selected Biography:
1991 Solo exhibition: The
Lowe Gallery, Atlanta,
GA; Pyramid Atlantic
Workshop-Visiting
Artist
1990 Rockefeller Foundation
Grant, Bellagio Study
Center; Polaroid
Grant, Italy
1989 Contemporary Figura-
tive Work, Mississippi
Museum; The Blues
Aesthetic, W.P.A.,
Washington, DC
1987 Southern Arts
Federation Sculpture
Grant Award for Visual
Arts - M.I.A. & L.

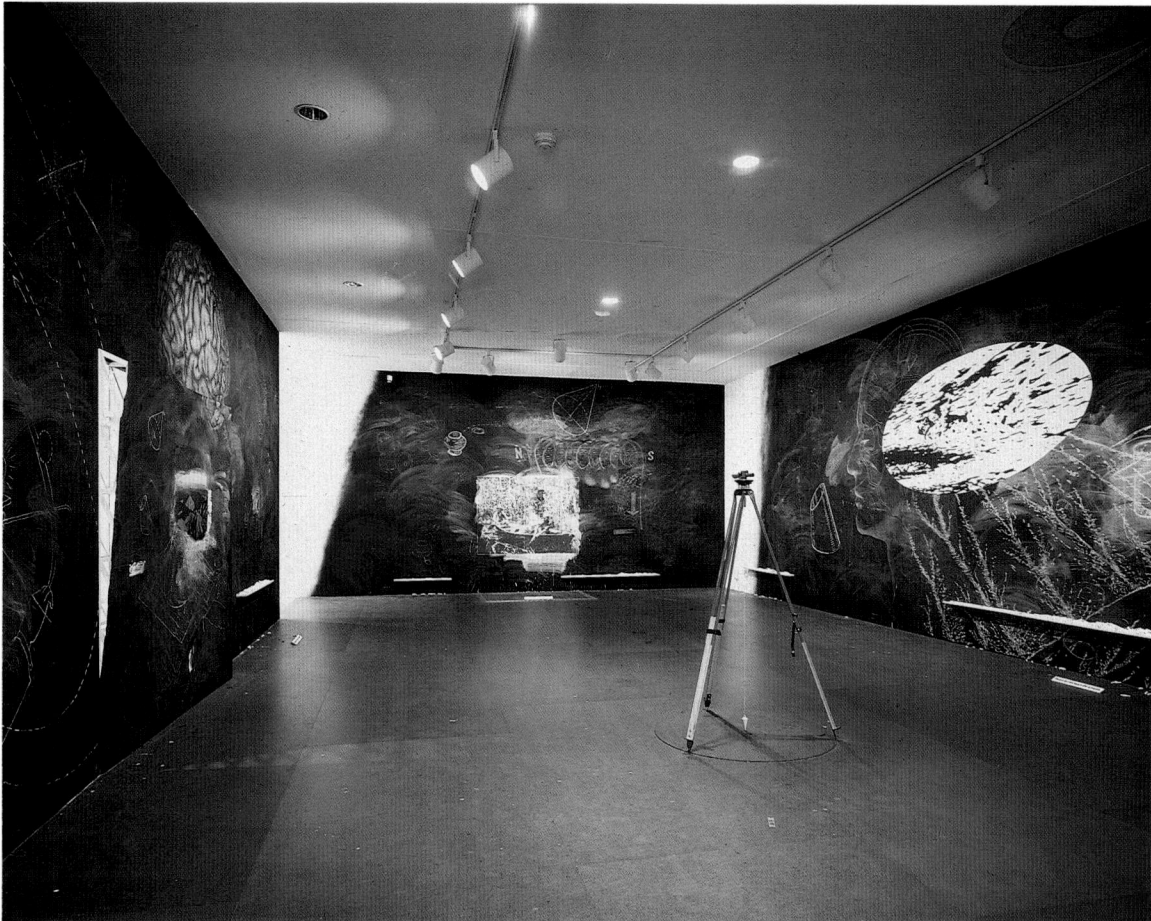

Representation:

HIRAM BUTLER GALLERY

4520 Blossom Street
Houston, TX 77007
713.863.7097
713.863.7130 FAX
Contact:
Hiram Butler

Exhibiting:
Contemporary American
and European

Vernon Fisher

1. *Movements
 Among the Dead*
 1990, Installation,
 135" x 507" x 270"

2. *Movements
 Among the Dead*
 1990, Installation,
 135" x 507" x 270"

3. *Movements Among
 the Dead (Detail)*
 1990, Installation,
 135" x 507" x 270"

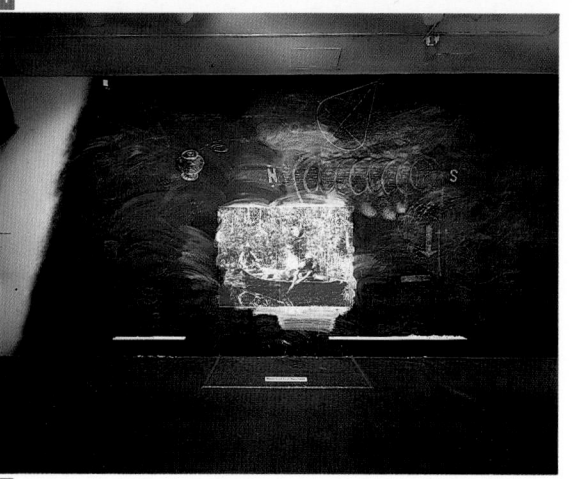

Selected Biography:
1990 "Movements Among
 the Dead"; Projects,
 Museum of Modern
 Art, NY
1989 Traveling exhibition:
 "Vernon Fischer";
 Organized by LaJolla
 Museum of Art, CA
1988 "Texas Art"; The
 Menil Collection,
 Houston, TX
1987 "Perdido en el Mar";
 Lannan Museum,
 Lake Worth, FL

Representation:

**ROBBIN LOCKETT
GALLERY**

703 N. Wells Street
Chicago, IL 60610
312.649.1230
312.649.9159 FAX
Contact:
Robbin Lockett

Exhibiting:
Contemporary American
and European art

Julia Fish

1. *Bloom*
 1989, Oil on canvas,
 30" x 27"

1

Selected Biography:
1991 Solo exhibition:
 Robbin Lockett
 Gallery, Chicago
1990 Group exhibitions:
 Museum of
 Contemporary Art,
 Chicago; Carnegie
 Mellon Art Gallery,
 Pittsburgh
1989 Solo exhibitions:
 Herron Gallery,
 IUPUI, Indianapolis;
 Loughelton Gallery,
 New York, NY;
 Group exhibition:
 Renaissance Society,
 Chicago

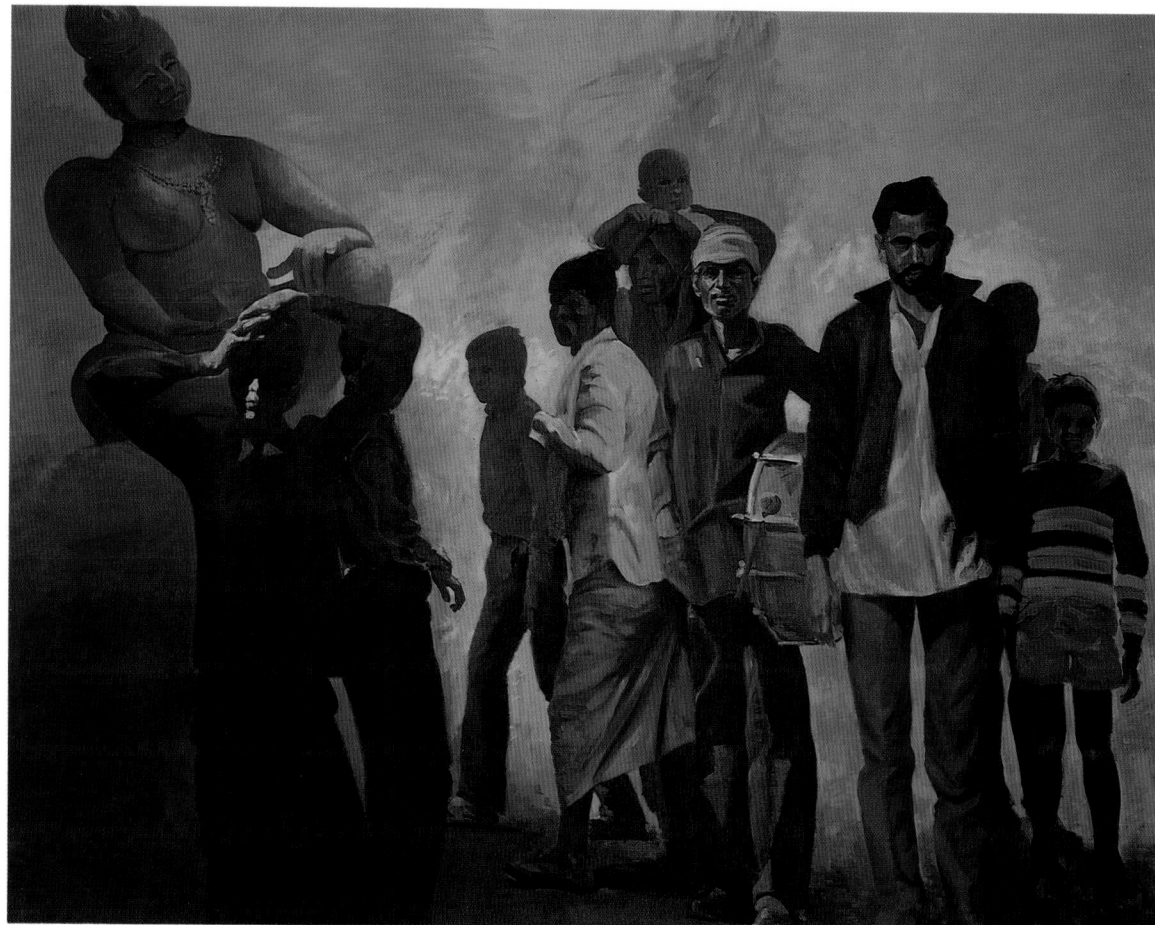

1

Representation:

**MARY BOONE
GALLERY**

417 W. Broadway
New York, NY 10012
212.431.1818
212.431.1548 FAX
Contact:
Mary Boone

Exhibiting:
Contemporary paintings,
drawings and sculpture

Eric Fischl

1. *Kowdoolie*
 1990, Oil/linen,
 98" x 130"
 Collection: Jerry/Emily Spiegel
 Family Collection, New York

2. *On the Stairs of the Temple*
 1989, Oil/linen,
 115" x 140"
 Collection: Boris/Sophie Leavitt,
 Promised Gift to The National
 Gallery of Art, Washington, DC

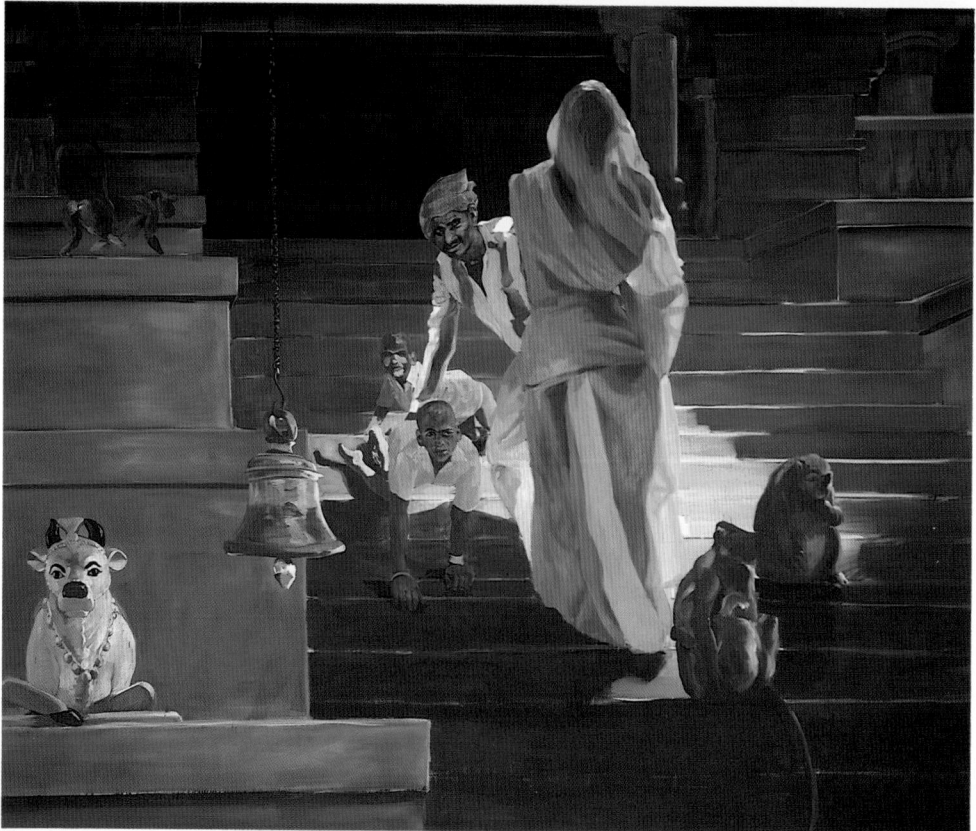

2

Selected Biography:
1991 The Hood Museum of
Art, Dartmouth
College, Hanover, NH;
Aarhus Kunstmuseum,
Aarhus, Denmark;
Louisiana Museum of
Modern Art,
Humlebaek, Denmark
1990 Akademie der
Bildenden Kunste,
Vienna, Austria; Museé
Cantonal des Beaux-
Arts de Lausanne,
Lausanne, Switzerland;
Mary Boone Gallery,
New York, NY
1989 Waddington Gallery,
London, England

Representation:

ALPHA GALLERY

121 Newbury Street
Boston, MA 02116
617.536.4465
617.536.5695 FAX

Contact:
Joanna E. Fink
Alan Fink
Exhibiting:
Contemporary American
and European art; Modern
master prints

Aaron Fink

1. *Steaming Cup*
 1991, Oil on linen,
 72" x 60"

2. *Red Pepper*
 1990, Oil on linen,
 84" x 60"

3. *Juniper Berries*
 1991, Oil on linen,
 90" x 36"

Selected Biography:
1991 Alpha Gallery, Boston,
MA; Galerie Barbara
Farber, Amsterdam
1990 "The Unique Print",
Museum of Fine Arts,
Boston, MA
1989 "Prints from the
Collection of Joshua
P. Smith", National
Gallery of Art,
Washington, DC

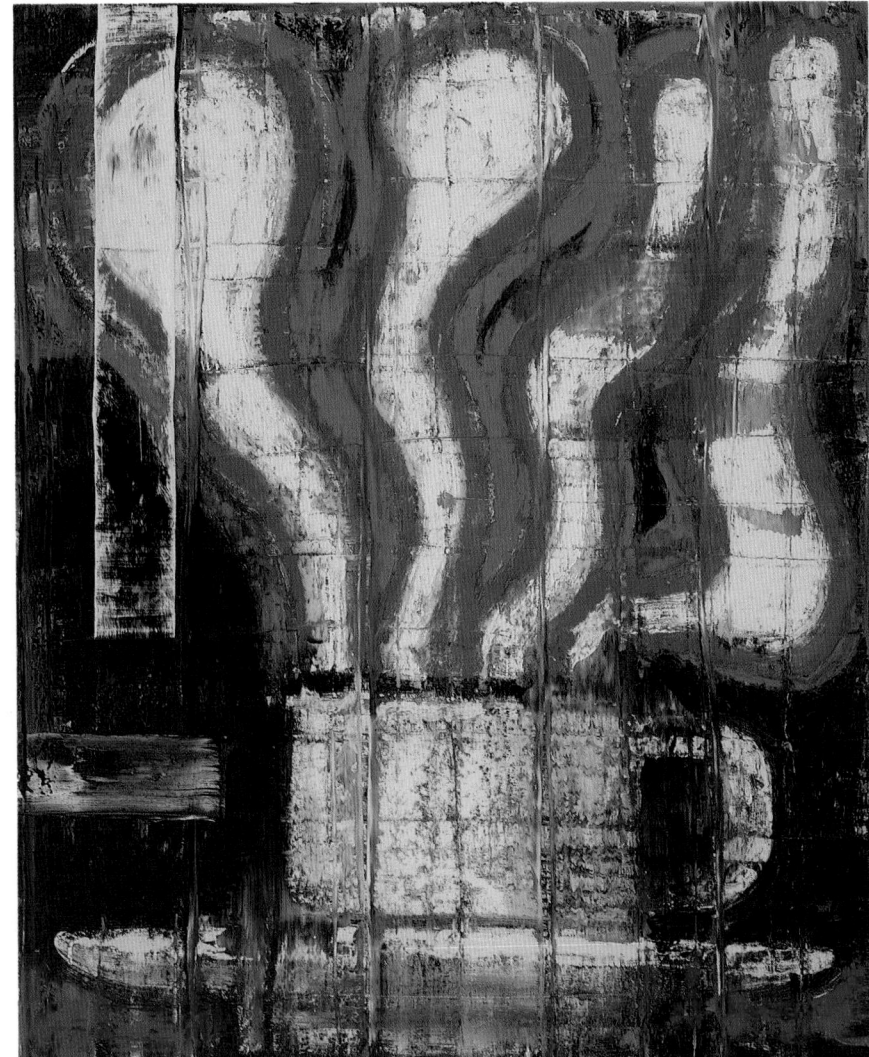

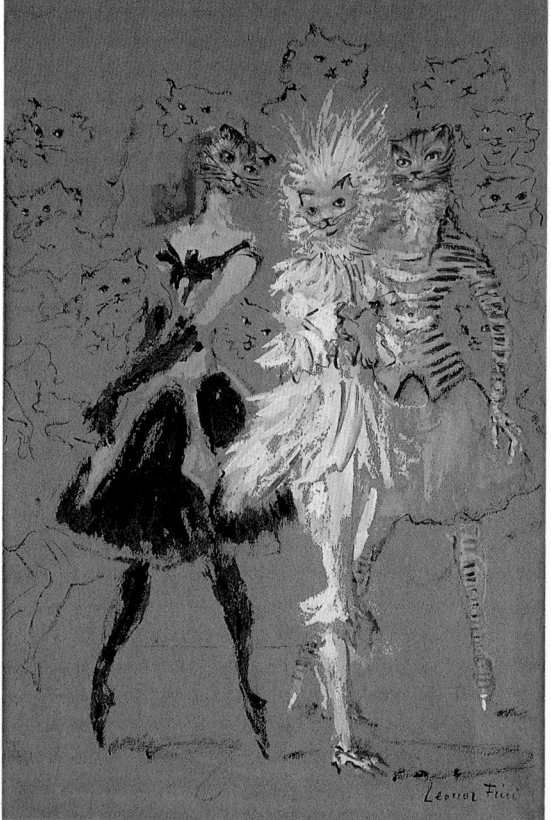

1

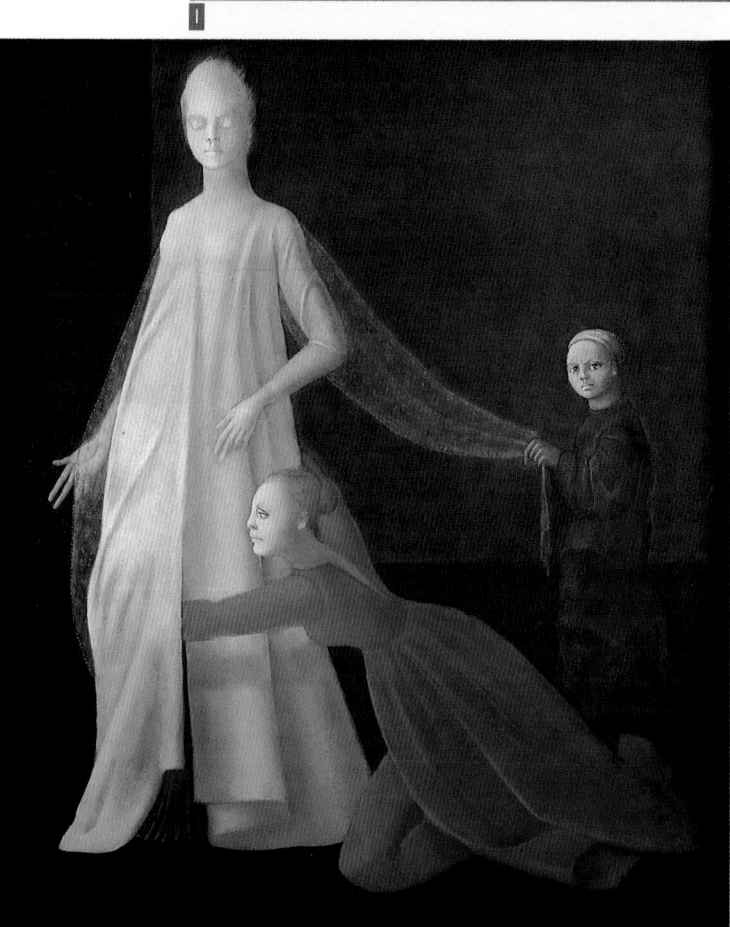

2

3

Representation:

CFM GALLERY

138 W. 17th Street
New York, NY 10011
212.929.4001
212.691.5453 FAX
Contact:
Neil P. Zukerman

Exhibiting:
Contemporary European
and American Masters;
Surrealism and
Representational

Leonor Fini

1. *Les Demoiselles de la Nuit*
 1948, Watercolor
 and gouache,
 13" x 9"

2. *La Vestition*
 1982, Oil on canvas,
 28.5" x 24"

3. *Le Mue*
 1956, Oil on canvas,
 60" x 10"

Selected Biography:
1986 Museé de Luxembourg,
 Retrospective, Paris
1983 Galleria Civica d'Arte
 Moderne, Retrospective,
 Ferrera, Italy
1965 Casino de Knokke-Le-
 Zoute, Retrospective,
 Belgium
1936 Fantastic Art Dada
 Surrealism, Museum of
 Modern Art, New York

ALAN FELTUS

Representation:

FORUM GALLERY

745 Fifth Avenue
New York, NY 10151
212.355.4545

Contact:
Robert Fishko

Exhibiting:
20th-Century American
Realism; paintings, drawings
and sculpture

Alan Feltus

1. *Piero Letters*
 1991, Oil on canvas,
 39 1/4" x 47 1/4"

2. *Duality*
 1991, Oil on canvas,
 47 1/4" x 39 1/2"

3. *Love Letters*
 1990-91, Oil on canvas,
 39 1/2" x 31 1/2"

1

2

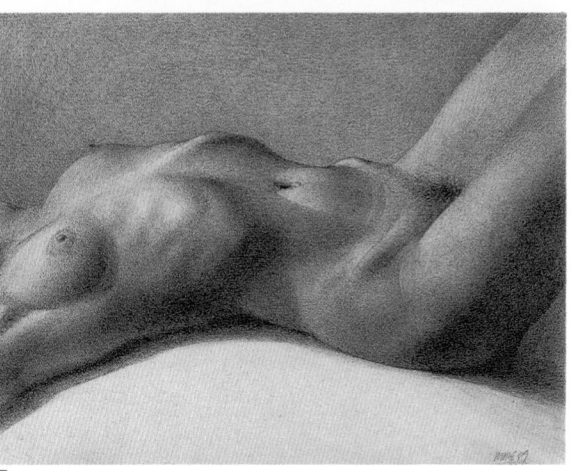

3

Representation:

J. ROSENTHAL FINE ARTS

230 W. Superior Street
Chicago, IL 60610
312.642.2966
312.642.5169 FAX

Contact:
Dennis Rosenthal

Exhibiting:
20th century modern and
contemporary international
uniques and multiples

Martha Mayer Erlebacher

1. *American Still Life II*
 1989, Oil on canvas,
 28" x 42"

2. *Departure*
 1988, Oil on canvas,
 64" x 80"

3. *Torso*
 1989, Graphite on paper,
 16" x 20 5/8"

Selected Biography:
1991 Orlando Museum of
Art; Koplin Gallery
1990 J. Rosenthal Fine Arts;
New Jersey State
Museum; Arkansas Art
Center
1989 Fendrick Gallery; J.
Rosenthal Fine Arts;
Kalamazoo Institute of
Arts

Representation:

**SHERRY FRUMKIN
GALLERY**

1440 Ninth Street
Santa Monica, CA 90401
213.393.1853
213.623.9130 FAX

Contact:
Sherry Frumkin

Exhibiting:
Contemporary painting,
sculpture and assemblage

Jean Edelstein

1. *The Artist and the Shaman*
 1991, Acrylic on canvas,
 60" x 40"

2. Jean Edelstein performs in
 her "Let's Dance" series
 Photo: Gary Moss

Selected Biography:
1992 Solo exhibition:
 Sherry Frumkin Gallery,
 Santa Monica, CA
1990 Solo exhibitions:
 Los Angeles Theater
 Center, Los Angeles,
 CA; Pacific Asia Museum
1989 Solo exhibitions:
 Karta Pustaka,
 Yogyakarta, Java,
 Indonesia; Ruth
 Bachofner Gallery,
 Santa Monica, CA
1987 Solo exhibition:
 Ruth Bachofner Gallery,
 Santa Monica, CA

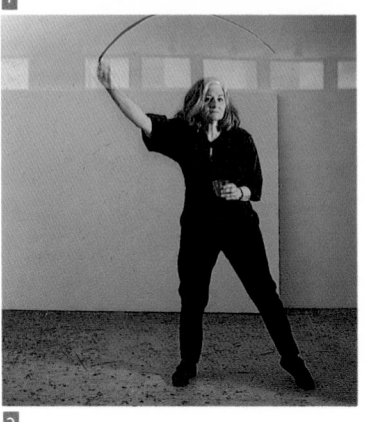
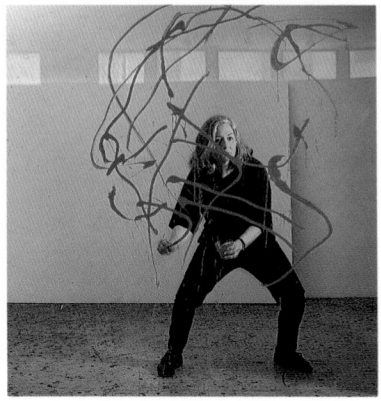
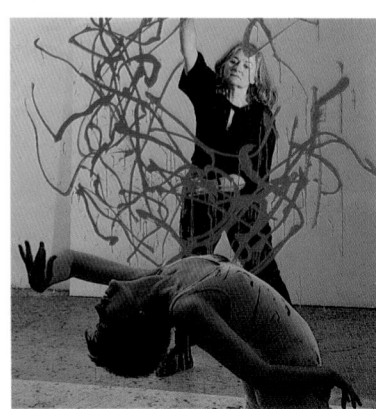

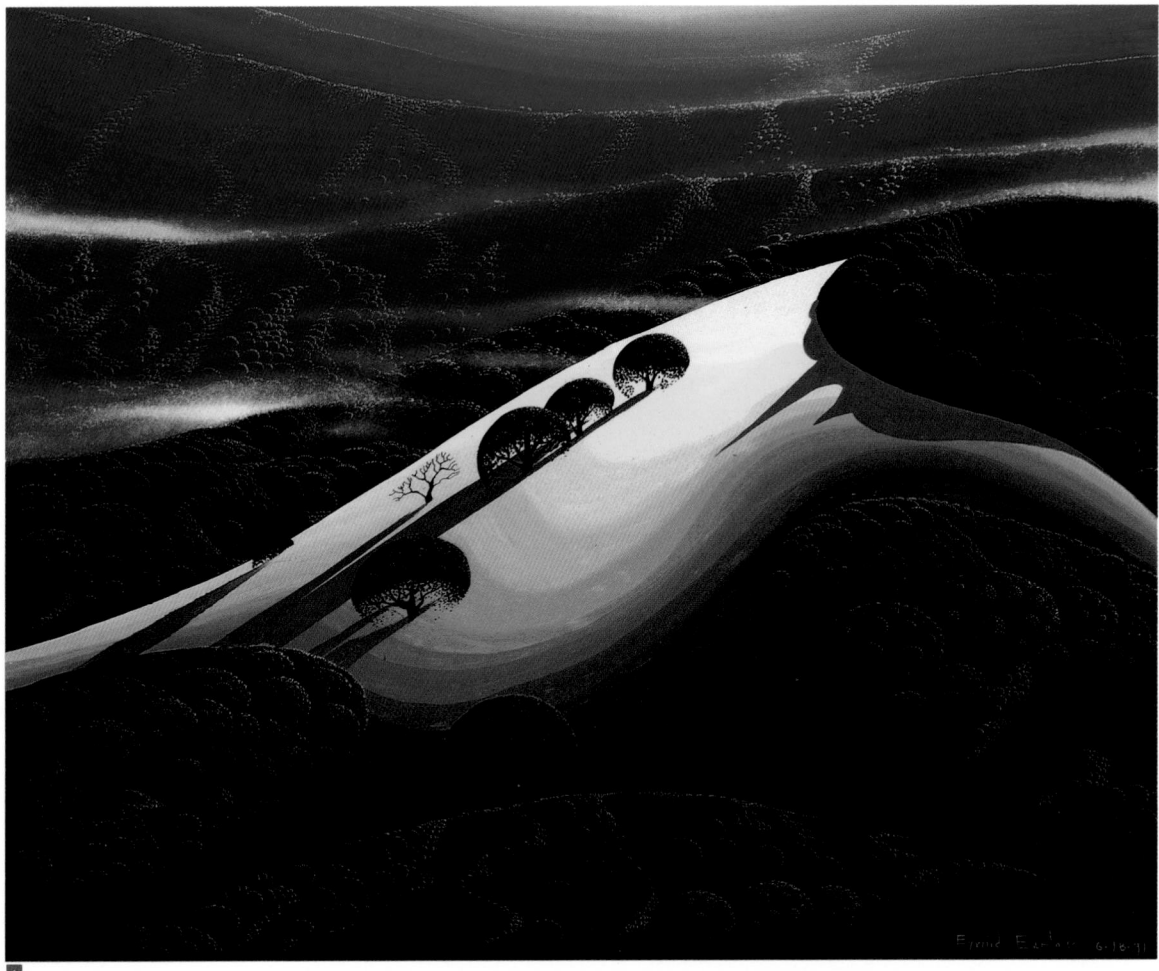

Representation:

HAMMER GALLERIES

33 W. 57th Street
New York, NY 10019
212.644.4400
212.832.3763 FAX
Contact:
Richard Lynch

Exhibiting:
19th & 20th century
European and American;
Contemporary paintings
and sculpture

Eyvind Earle

1. *Gaviota Pass*
 1991, Oil on panel,
 16" x 20"

Selected Biography:
1991 "Eyvind Earle: Recent
Paintings", Hammer
Galleries, New York

Representation:

**MANNY SILVERMAN
GALLERY**

800 N. La Cienega Boulevard
Los Angeles, CA 90069
213.659.8256
213.659.1001 FAX

Contact:
Linda Hooper-Kawakami
Manny Silverman
Exhibiting:
Post-war American art

Edward Dugmore

1. *Untitled*
 1954, Oil on canvas,
 77" x 52"

2. *Metart Series #17*
 1949, Oil on canvas,
 48" x 37"

3. *Untitled*
 1961, Oil on canvas,
 80" x 101 1/2"

Selected Collections:
 Albright-Knox Art
 Gallery, Buffalo, NY;
 Corcoran Gallery,
 Washington, DC;
 Des Moines Art Center,
 Des Moines, IA;
 Hirshhorn Museum &
 Sculpture Garden,
 Smithsonian Institution,
 Washington, DC;
 University of
 Guadalajara, Mexico;
 University of Southern
 Illinois, Carbondale, IL;
 Walker Art Center,
 Minneapolis, MN;
 Weatherspoon Art
 Gallery, Greensboro,
 NC

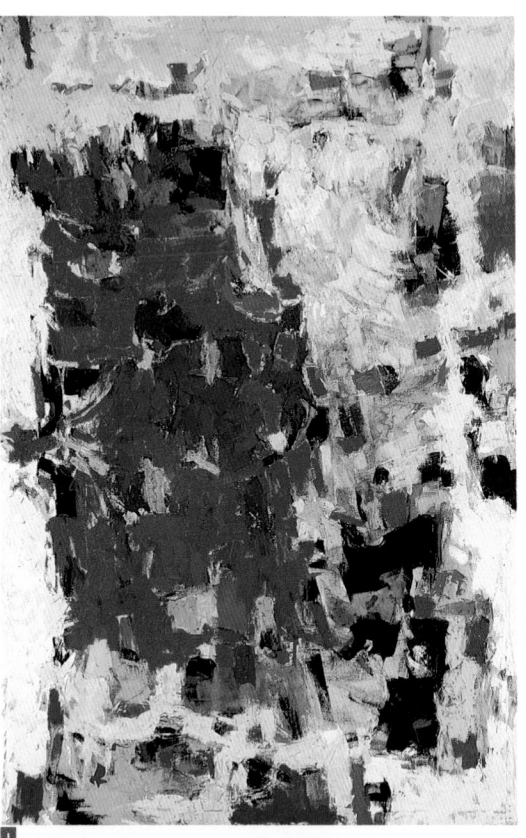
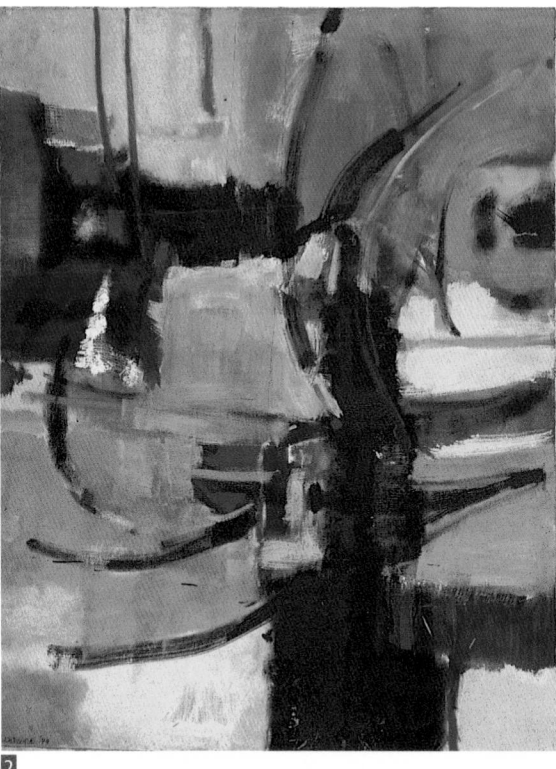
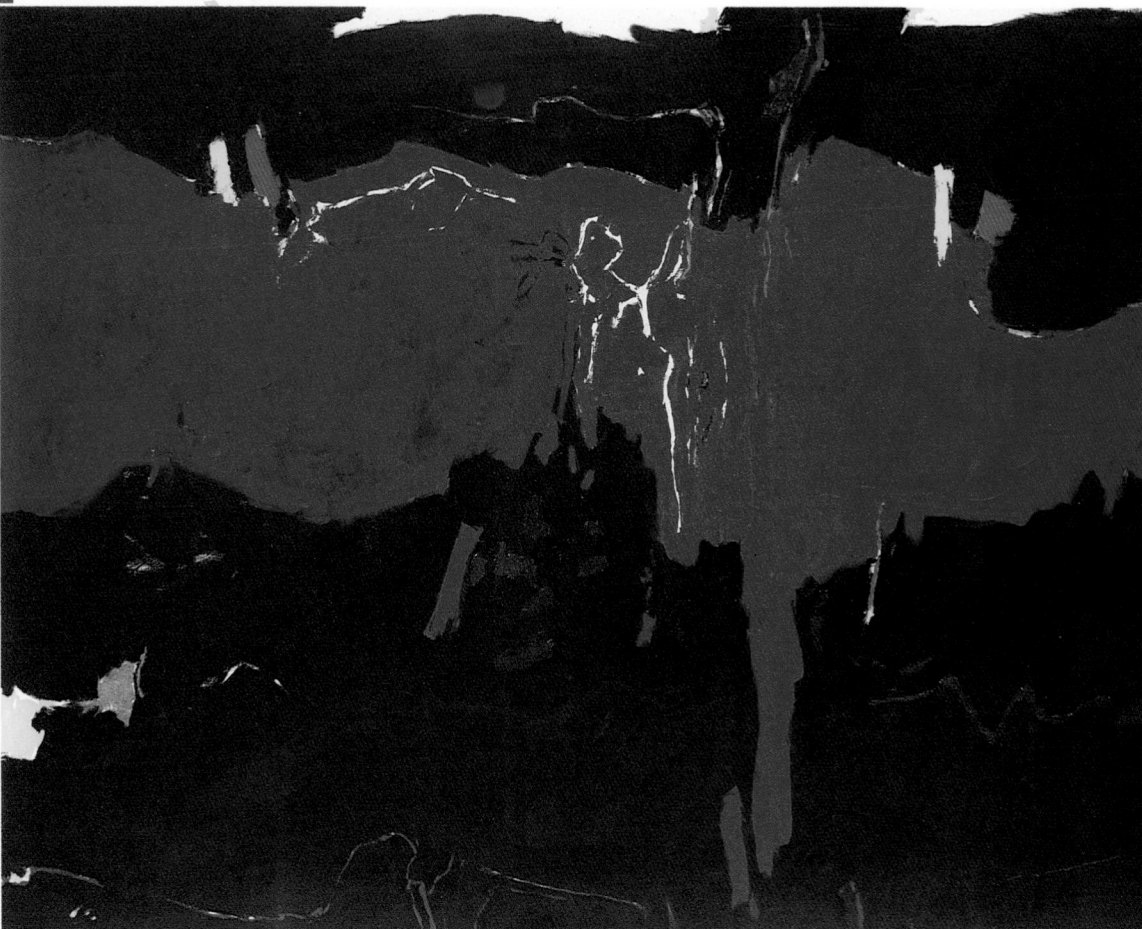

Representation:

O.K. HARRIS WORKS OF ART

383 W. Broadway
New York, NY 10012
212.431.3600

Contact:
Ivan C. Karp

Exhibiting:
Contemporary American
and European painting,
sculpture, photography,
antiques, collectibles,
documentation

Randy Dudley

1. *Dutch Kills Creek-Greenpoint*
 1990, Oil on canvas,
 28.5" X 54"

Selected Biography:
1989 Solo exhibition: O.K.
 Harris Works of Art,
 New York, NY
1988 Solo exhibition:
 Roger Ramsay Gallery,
 Chicago, IL
1976 Virginia Commonwealth
 University, Richmond,
 VA; M.F.A.
1973 Illinois State University,
 Normal, IL; B.S.

JEAN DUBUFFET

Representation:

THE PACE GALLERY

32 E. 57th Street
New York, NY 10022
212.421.3292
212.421.0835 FAX

142 Greene Street
New York, NY 10012
212.431.9224
212.431.9280 FAX

Exhibiting:
20th-century paintings,
drawings and sculpture

Jean Dubuffet

1. *Site avec 7 Personnages*
 Feb. 7, 1981, Acrylic
 on paper mounted
 on canvas,
 20" x 13 3/4"

1

Representation:

HIRSCHL & ADLER MODERN

851 Madison Avenue
New York, NY 10021
212.744.6700
212.737.2614 FAX
Contact:
Donald McKinney

Exhibiting:
Contemporary European
and American art

Rackstraw Downes

1. *Ventilation Tower with
 Estivating Snow Plows*
 1988, Oil on canvas,
 38 1/4" x 50 1/4"

Selected Biography:
1987 "Rackstraw Downes"
 Hirschl & Adler Modern,
 New York, NY
1984 "Rackstraw Downes"
 Hirschl & Adler Modern,
 New York, NY
 (catalogue with essay by
 John Yau)
1978 "Rackstraw Downes"
 Swain School of Design,
 New Bedford, MA

Representation:

**WYNDY
MOREHEAD
FINE ARTS**

603 Julia Street
New Orleans, LA 70130
504.568.9754

Contact:
Wyndy Morehead

Exhibiting:
Contemporary paintings,
drawings, sculpture,
ceramics, photography
by established and
emerging artists

Paul Dominey

1. *The Great Wurlitzer*
 1991, Mixed media
 on handmade paper,
 60" x 40"

Selected Biography:
1991 Wyndy Morehead Fine
 Arts, New Orleans
1989 Ann Jacob Gallery,
 West Palm Beach
1988 Gertrude Herbert
 Museum of Art
 Competitions, Augusta,
 GA, Award Winner
1986 Gertrude Herbert
 Museum of Art
 Competitions, Augusta,
 GA, Award Winner

Representation:

THE PACE GALLERY

32 E. 57th Street
New York, NY 10022
212.421.3292
212.421.0835 FAX

142 Greene Street
New York, NY 10012
212.431.9224
212.431.9280 FAX

Exhibiting:
20th-century paintings,
drawings and sculpture

Jim Dine

1. *The French Forest
 (Second Version)*
 1991, Oil, wood and
 steel on canvas,
 Two panels, overall size:
 46" x 72" x 4 1/2"

Representation:

**THE WORKS
GALLERY**

106 W. Third Street
Long Beach, CA 90802
213.495.2787
213.495.0370 FAX

Crystal Court/S. Coast Plaza
3333 Bear Street, Third Fl.
Costa Mesa, CA 92626
714.979.6757
714.9779.6818 FAX
Contact:
Mark Moore

Exhibiting:
Established and emerging
contemporary artists of
the western United States

Laddie John Dill

1. *Untitled*
 1990, Oil and cement
 wash on canvas,
 42" x 84"

2. *Death in Venice*
 1990, Cement and glass,
 30" x 36"

3. *Basalt Basin and Range*
 1990, Cement and glass,
 6' x 10'

Selected Biography:
1991 Solo exhibition: The
 Works Gallery South,
 Costa Mesa, CA
1990 Solo exhibition: Linda
 Farris Gallery, Seattle,
 WA
1989 Solo exhibitions: Sun
 Gallery, Seoul, Korea;
 Galeria Joan Prats,
 New York
1988 Solo exhibition:
 Persons/Lindell Gallery,
 Helsinki, Finland

Representation:

BABCOCK GALLERIES

724 Fifth Avenue
New York, NY 10019
212.767.1852
212.767.1857 FAX

Contact:
Dr. John Driscoll
Michael St. Clair
Exhibiting:
Fine American paintings,
sculpture, works on paper;
Historical and contemporary

Edwin Dickinson

1. *Evangeline*
 1942, Oil on canvas,
 20" x 23"

Representation:

GALLERY REVEL

96 Spring Street
New York, NY 10012
212.925.0600
212.431.6270 FAX
Contact:
Marvin Carson
Lynda Foshie

Guy Dessapt

1. *La Seine à Argenteuil*
 1991, Oil & acrylic
 on canvas,
 30" x 40"

2. *L'Après - Midi à Lorgue*
 1991, Oil & acrylic
 on canvas,
 30" x 40"

3. *La Rue du Port, St. Tropez*
 1991, Oil & acrylic
 on canvas,
 36" x 48"

Representation:

J. ROSENTHAL
FINE ARTS

230 W. Superior Street
Chicago, IL 60610
312.642.2966
312.642.5169 FAX
Contact:
Dennis Rosenthal

Exhibiting:
20th century modern and
contemporary international
uniques and multiples

John Deom

1. *Zap! Lightning turns
 Woman into Man*
 1988, Oil on canvas,
 54" x 46"

2. *Red Room Study II*
 1991, Technique mix
 on panel,
 27 3/4" x 23 3/4"

3. *Red Room Study III*
 1990, Graphite/paper,
 52 1/2" x 38"

Selected Biography:
1990 Solo exhibitions:
 J. Rosenthal Fine Arts,
 Chicago, IL;
 "Monochrome/
 Polychrome", Florida
 State University,
 Tallahassee, FL
1988 "Faces", Arkansas Art
 Center, Little Rock,
 AK

Representation:

O.K. HARRIS
WORKS OF ART

383 W. Broadway
New York, NY 10012
212.431.3600

Contact:
Ivan C. Karp

Exhibiting:
Contemporary American
and European painting,
sculpture, photography,
antiques, collectibles,
documentation

James Del Grosso

1. *Two White Onions*
 1988, Oil on canvas,
 32" x 50"

1

Selected Biography:

1990 Solo exhibitions: O.K.
Harris Works of Art,
New York, NY; O.K.
Harris Works of Art,
Birmingham, MI;
Group exhibitions:
"New Work -
New York", Galerie
Barbara Silverberg,
Montreal, Canada;
"Objects Observed:
Contemporary Still
Life", Gallery Henoch,
New York, NY

1

Representation:

LEVINSON KANE GALLERY

14 Newbury Street
Boston, MA 02116
617.247.0545
617.247.3096 FAX

Contact:
June Levinson
Barbara Kane
Exhibiting:
Contemporary art in all
media by emerging and
established American &
European artists

Alfred DeCredico

1. *As Rigoletto: Parts*
 1991, Mixed media on
 rubber, wood and fur
 mounted on wood,
 70" x 107"

2. *Arias*
 1991, Mixed media on
 paper, triptych,
 30" x 66"

2

Selected Exhibitions:
1991 Levinson Kane Gallery,
Boston, MA;
Scott Alan Gallery,
New York, NY;
Betsy Rosenfield
Gallery, Chicago, IL;
Reynolds Gallery,
Pittsburgh, PA;
Galerie Sigma,
Vienna, Austria;
Galerie Sechzig,
Feldkirch, Austria

STEFAN DAVIDEK

Representation:

DE GRAAF
FINE ART, INC.

9 E. Superior
Chicago, IL 60611
312.951.5180

3400 Avenue of the Arts
Suite C120
Costa Mesa, CA 92626
714.557.5240

Exhibiting:
Contemporary American,
European and Latin
American paintings,
sculpture and graphics

Stefan Davidek

1. *Pot Study 1985, No. 5*
 Oil on panel,
 24" x 24"

2. *He Likes It*
 Oil on linen,
 65" x 40"

3. *Brilliant Opposites*
 Oil on canvas,
 84" x 48"

Selected Biography:
 Founders Award:
 Detroit Institute of Art
 Flint Institute of Art
 Muskegon Museum
 of Art
 University of Omaha
 University of Maine

Representation:

CFM GALLERY

138 W. 17th Street
New York, NY 10011
212.929.4001
212.691.5453 FAX
Contact:
Neil P. Zukerman

Exhibiting:
Contemporary European
and American Masters;
Surrealism and
Representational

Marc Davet

1. *Les Temps*
 1989, Oil on canvas,
 29" x 36"

2. *La Loge*
 1990, Oil on canvas,
 36" x 28"

3. *Sequestration*
 1988, Oil on canvas,
 18" x 15"

Selected Biography:
1990 Galerie Vendome, Paris
1983 Bernard Jacobsen
 Gallery, Los Angeles
1980 Salon de Peinture
 Surrealiste et
 Fantastique, Avoriaz

Representation:

**DE ANDINO
FINE ARTS**

1609 Connecticut Ave. NW
Washington, DC 20009
202.462.4772
202.462.4766 FAX

Contact:
Jean-Pierre de Andino

Exhibiting:
Modern and contemporary
works of art

Rebecca Davenport

1. *1 G*
 1990, Oil on canvas,
 61 1/2" x 97 1/2"

2. *Signs*
 1990, Oil on
 canvas/collage,
 60" x 36"

3. *Bill's J.M.*
 1990, Oil on canvas,
 72" x 54"

Selected Biography:
1990 Art Against Aids
1983 "Beckman, Davenport,
 Gillespie", Virginia
 Museum
1980 Corcoran Gallery
 of Art
1978 Musee d'Art Modern
 de la Ville de Paris

1

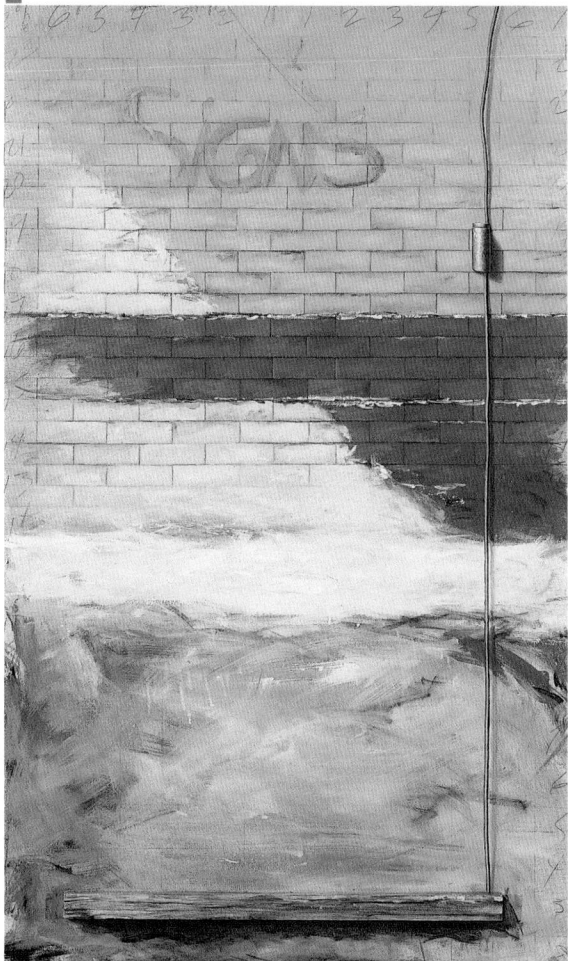

2

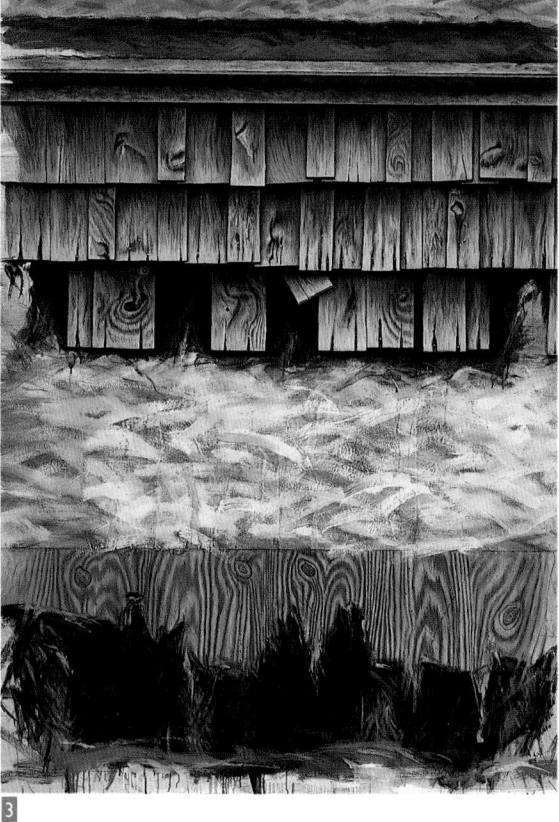

3

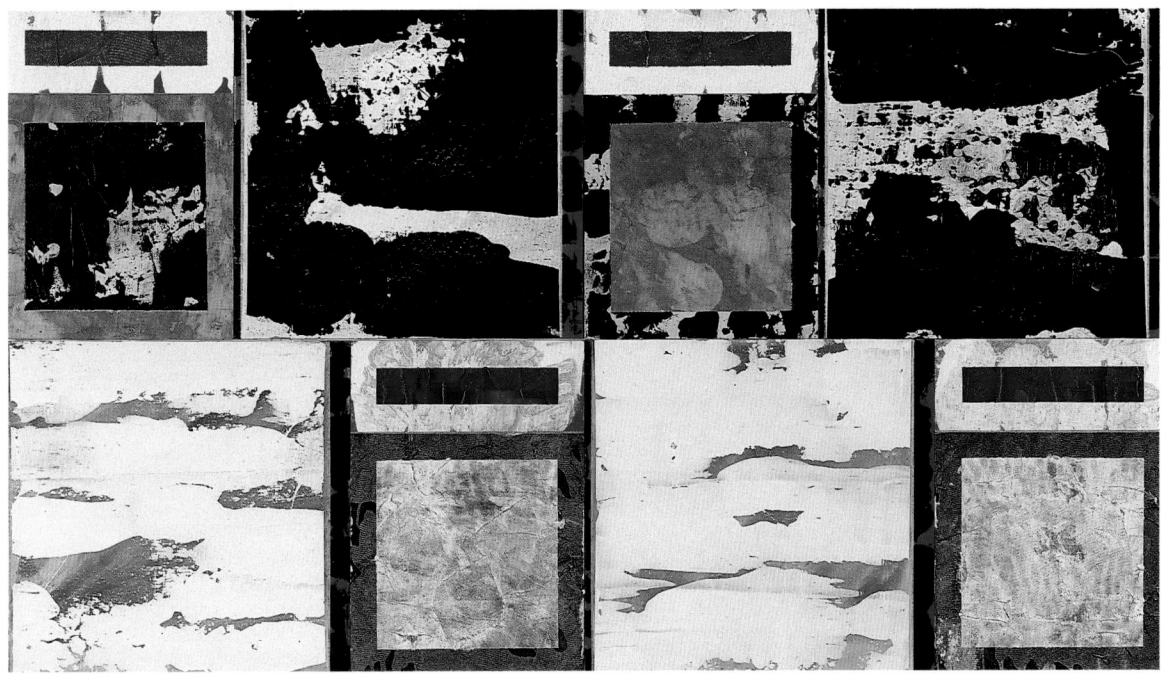

Representation:

O.K. HARRIS
WORKS OF ART

383 W. Broadway
New York, NY 10012
212.431.3600

Contact:
Ivan C. Karp

Exhibiting:
Contemporary American
and European painting,
sculpture, photography,
antiques, collectibles,
documentation

Jamie Dalglish

1. *Life/Under Antarctica*
 1989-90, Acrylic, gold
 powder on wood,
 48" x 87.25"

Selected Biography:
1991 Solo exhibition: O.K.
 Harris Works of Art,
 New York, NY
1989 Solo exhibition:
 "Palimpsests and
 Poltergeists", Barbara
 Braathen Gallery,
 New York, NY
1988 Solo exhibition:
 "Paintings/Cibachromes",
 Barbara Braathen
 Gallery, New York, NY

Representation:

O.K. HARRIS
WORKS OF ART

383 W. Broadway
New York, NY 10012
212.431.3600

Contact:
Ivan C. Karp

Exhibiting:
Contemporary American
and European painting,
sculpture, photography,
antiques, collectibles,
documentation

Davis Cone

1. *Everett In Late Afternoon*
 1990, Acrylic on canvas,
 38" x 55"

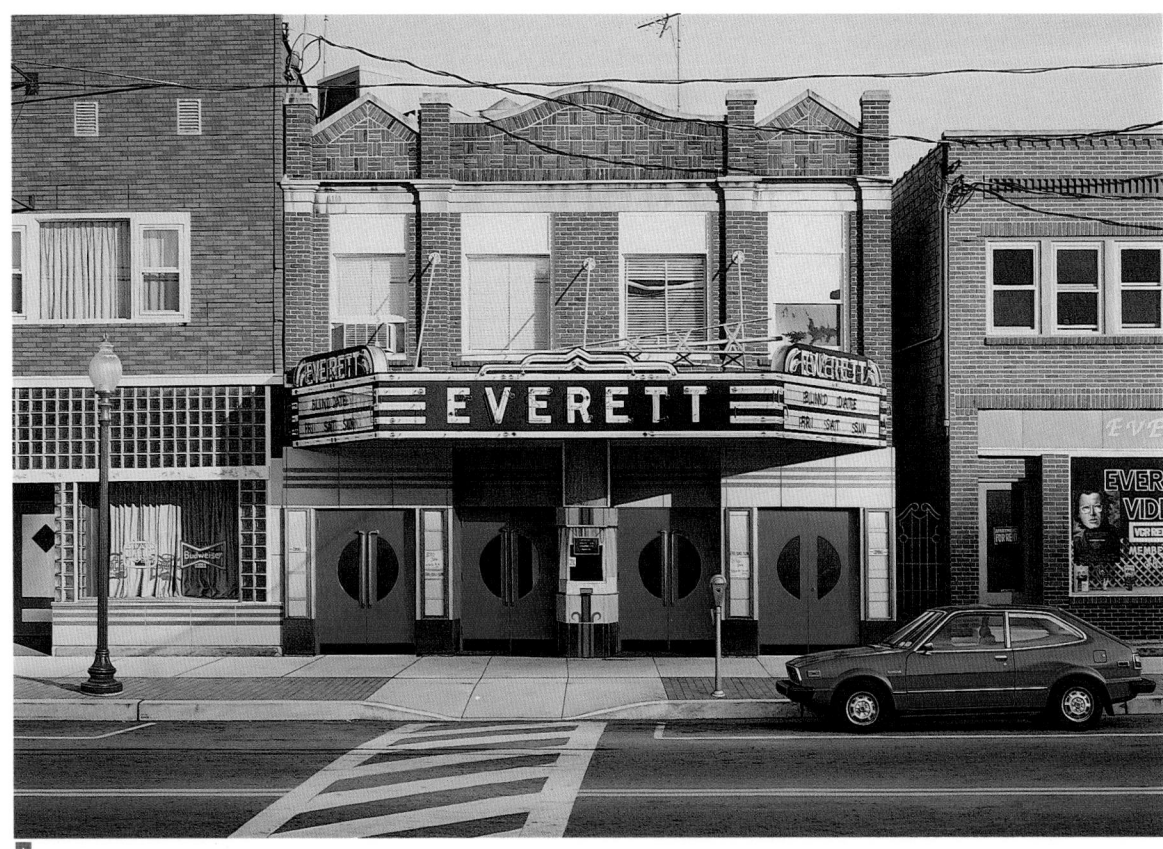

Selected Biography:

1991 Solo exhibition: O.K.
Harris Works of Art,
New York, NY;
Group exhibition: "In
Sharp Focus: Super-
Realism", Nassau
County Museum,
Roslyn Harbor, NY

1984 Solo exhibition:
"Davis Cone: Theatre
Paintings", Georgia
Museum of Art,
Athens, GA

Representation:

**THE DRABINSKY
GALLERY**

86 Scollard Street
Toronto, ON M5R 1G2
416.324.5766
416.324.5770 FAX

Exhibiting:
Contemporary Canadian
paintings and sculpture

Alex Colville

1. *Target Shooting*
 1990, Acrylic
 on board,
 31.5" x 31.5"

2. *Dog and Groom*
 1991, Acrylic
 on board,
 24.5" x 28.3"

Selected Biography:
1991 Exhibition of new and
 recent paintings, The
 Drabinsky Gallery,
 Toronto
1985 Exhibition to Beijing
 Exhibition Hall,
 University of Hong
 Kong, Teien Museum,
 Tokyo, Canada House,
 London

Representation:

MONTSERRAT GALLERY

588 Broadway, 5th Fl.
New York, NY 10012
212.941.8899
212.941.8728 FAX
Contact:
Marie Montserrat

Exhibiting:
Contemporary paintings,
drawings, sculpture and
watercolor

Coll

1. *Pink Roses*
 1990, Watercolor
 on board,
 30" x 40"
 C-Print, Edition of 75

2. *Roses*
 1983, Watercolor
 on board,
 30" x 40"
 C-Print, Edition of 75

3. *Mixed Bouquet*
 Watercolor on board,
 30" x 40"
 C-Print, Edition of 75

1

2

3

Selected Biography:
1991 Solo show: Montserrat
 Gallery, New York, NY
1990 Solo show: Montserrat
 West, New York, NY
1989 Solo show: Sport Soho
 Gallery, New York, NY

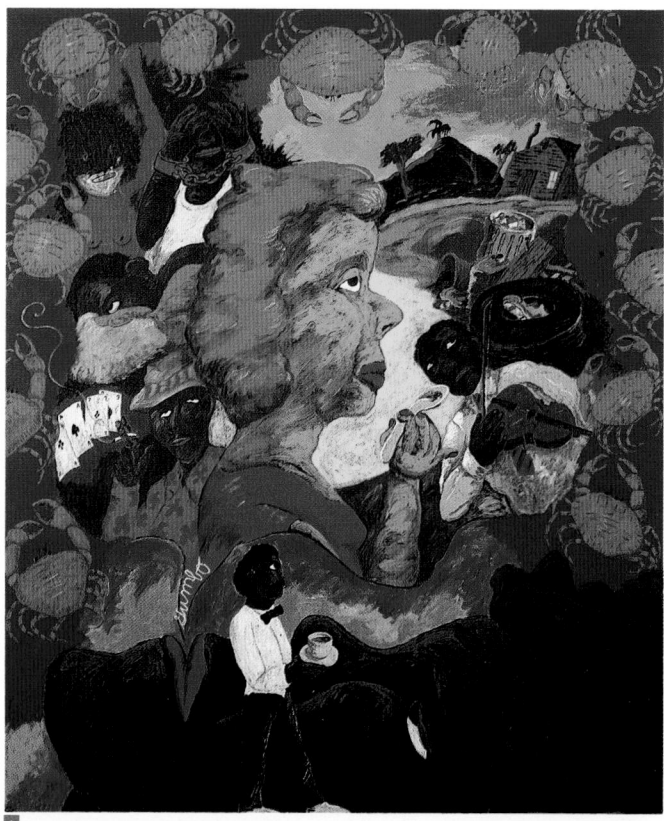

Representation:

**PHYLLIS KIND
GALLERY**

136 Greene Street
New York, NY 10012
212.925.1200
212.941.7841 FAX

313 W. Superior Street
Chicago, IL 60610
312.642.6302
312.642.8502 FAX

Contact:
Phyllis Kind

Exhibiting:
Contemporary American,
Soviet, Naive and Outsider
art

Robert Colescott

1. *A Taste Of Gumbo*
 1990, Acrylic on canvas,
 84" x 72"

2. *Emergency Room*
 1989, Acylic on canvas,
 90" x 114"

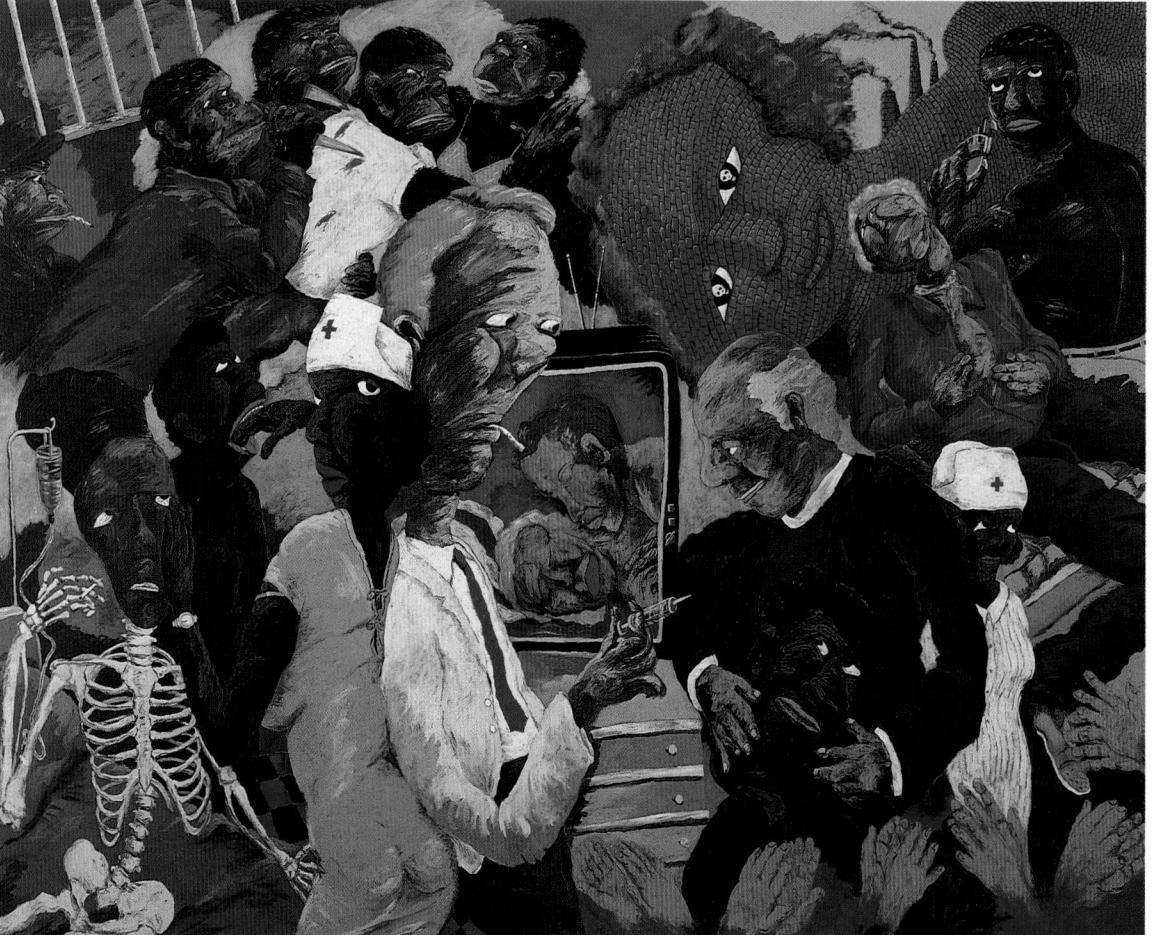

Selected Biography:
1991 Phyllis Kind Gallery,
 New York
1990 Phyllis Kind Gallery,
 Chicago
1987 Traveling exhibition:
 "Robert Colescott:
 A Retrospective":
 Organized be the San
 Jose Museum of Art

Representation:

LISA HARRIS GALLERY

1922 Pike Place
Seattle, WA 98101
206.443.3315

Contact:
Lisa Harris

Exhibiting:
Contemporary Northwest
and West Coast paintings,
prints and sculpture

John Cole

1. *Green Field*
 1991, Oil on linen,
 36" x 48"

2. *Chuckanut Overlook*
 1990, Oil on canvas,
 48" x 36"

3. *Northwest Evening*
 1991, Oil on linen,
 36" x 48"

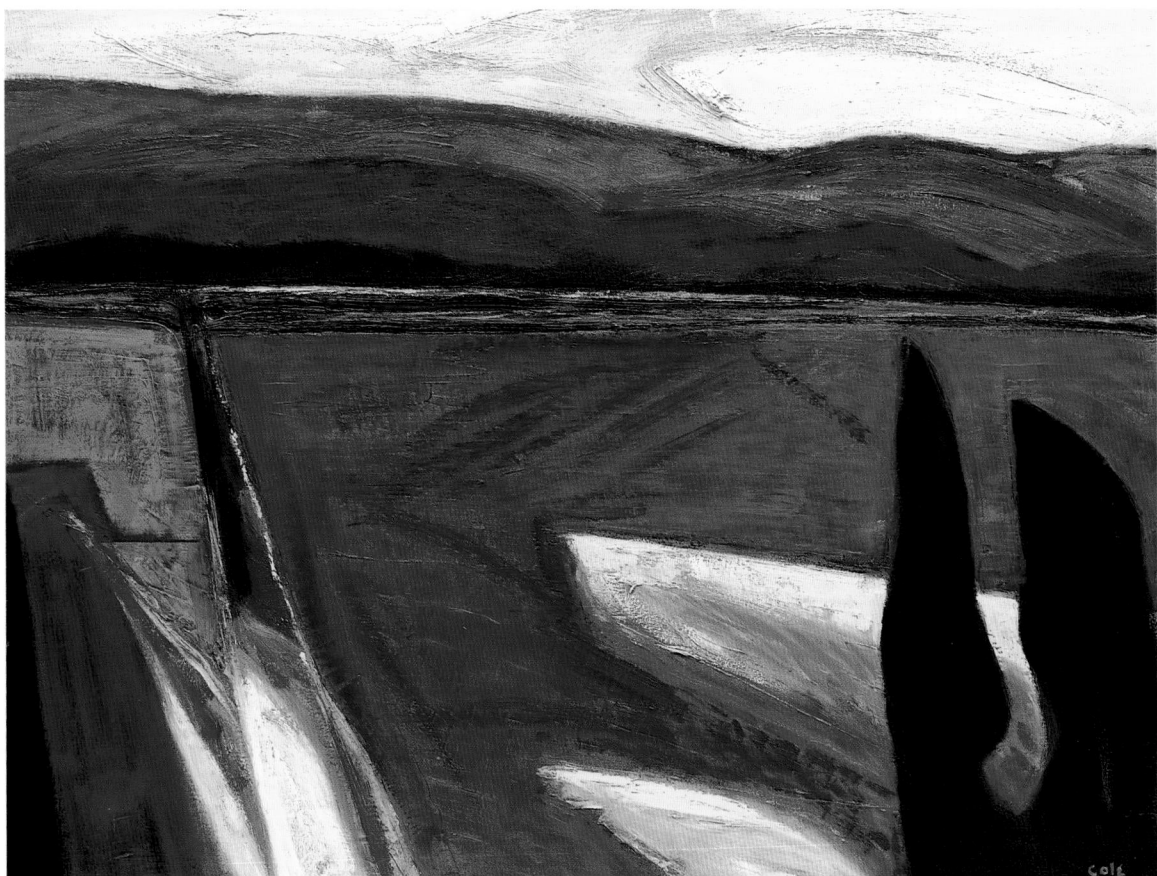

1

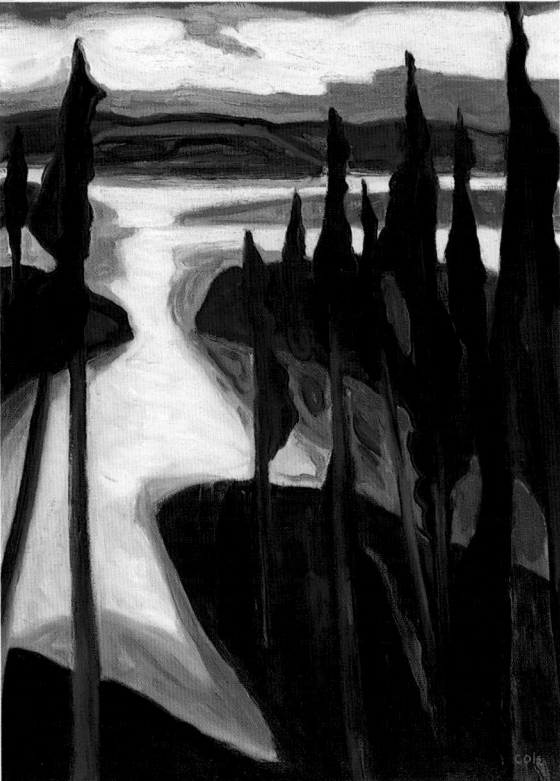

2

3

Selected Biography:

1991 Solo exhibition at
Lisa Harris Gallery
1975 Moved to Pacific
Northwest to paint
Canadian and
American landscapes
1962 Attended Pratt
Institute, New York,
NY (also 1955-58)
1936 Born, London, England

Representation:

THE PACE GALLERY

32 E. 57th Street
New York, NY 10022
212.421.3292
212.421.0835 FAX

142 Greene Street
New York, NY 10012
212.431.9224
212.431.9280 FAX

Exhibiting:
20th-century paintings,
drawings and sculpture

Chuck Close

1. *Bill*
 1990, Oil on canvas,
 72" x 60"

Representation:

**GAGOSIAN
GALLERY**

980 Madison Avenue, 6th Fl.
New York, NY 10021
212.744.2313
212.772.7962 FAX
Contact:
Melissa Lazarov

Exhibiting:
Contemporary paintings,
drawings and sculpture

Francesco Clemente

1. *Head*
1990-91, Pigment
on canvas,
17" x 17"

1

Representation:

J. ROSENTHAL
FINE ARTS

230 W. Superior Street
Chicago, IL 60610
312.642.2966
312.642.5169 FAX

Contact:
Dennis Rosenthal

Exhibiting:
20th century modern and
contemporary international
uniques and multiples

Manon Cleary

1. *Mystery Series #5*
 1989, Oil on canvas,
 60" x 48"

2. *Mystery Series #2*
 1988, Oil on canvas,
 60" x 48"

3. *White Rat*
 Oil on canvas,
 35" x 42"
 Collection: Lee Fleming

Selected Biography:
1991 Solo exhibition:
J. Rosenthal Fine Arts,
Chicago, IL
1989 Solo exhibition:
Osuna Gallery,
Washington, DC

Representation:

PAYTON RULE GALLERY

1736 Wazee Street
Denver, CO 80202
303.293.9080
303.298.9523 FAX

Contact:
Robin Rule

Exhibiting:
Modern and contemporary
painting, sculpture and
photography by regional
and national artists

Dale Chisman

1. *Blue Rider*
 1991, Acrylic/canvas,
 60" x 60"

2. *Procession*
 1987, Acrylic/canvas,
 68" x 68"

3. *Mandan*
 1989, Acrylic and oil
 canvas,
 60" x 60"

Selected Biography:
1991 Solo show: Payton
 Rule, Denver, CO
1990 "Colorado 1990",
 Denver Art Museum,
 Denver, CO
1989 Solo show: Sena
 Galleries West,
 Santa Fe, NM

Representation:

DE GRAAF FINE ART, INC.

9 E. Superior
Chicago, IL 60611
312.951.5180

3400 Avenue of the Arts
Suite C120
Costa Mesa, CA 92626
714.557.5240

Exhibiting:
Contemporary American,
European and Latin
American paintings,
sculpture and graphics

Chuang Che

1. *Landscape 1977- No. 7*
 Mixed media on canvas,
 34" x 34"

2. *Landscape 1987- No. 57*
 Mixed media on canvas,
 36 1/4" x 50"

3. *Landscape I*
 Serigraph
 31 1/2" x 37"

Selected Biography:
1958 Fifth Moon Group
 Bienal De Sao Paulo,
 Biennale De Paris;
 Collections:
 Detriot Institute of Art
 Cleveland Art Museum
 National Museum of
 Taiwan
1934 Born: Peking

Representation:

ALPHA GALLERY

121 Newbury Street
Boston, MA 02116
617.536.4465
617.536.5695 FAX

Contact:
Joanna E. Fink
Alan Fink
Exhibiting:
Contemporary American
and European art; Modern
master prints

Bernard Chaet

1. *Yellow October*
 1990, Oil on canvas,
 75" x 75"

2. *September Grays*
 1990-91, Oil on canvas,
 30" x 91"

Selected Biography:
1990 "The Drawings of
 Bernard Chaet",
 organized by The
 Boston Public Library,
 traveling (through
 1992) to Yale
 University, University
 of Louisville, Southern
 Methodist University,
 University of Montana,
 Holter Museum,
 Helena, Montana,
 Indiana University,
 University of Michigan,
 College of William &
 Mary, and Maryland
 Institute College of Art

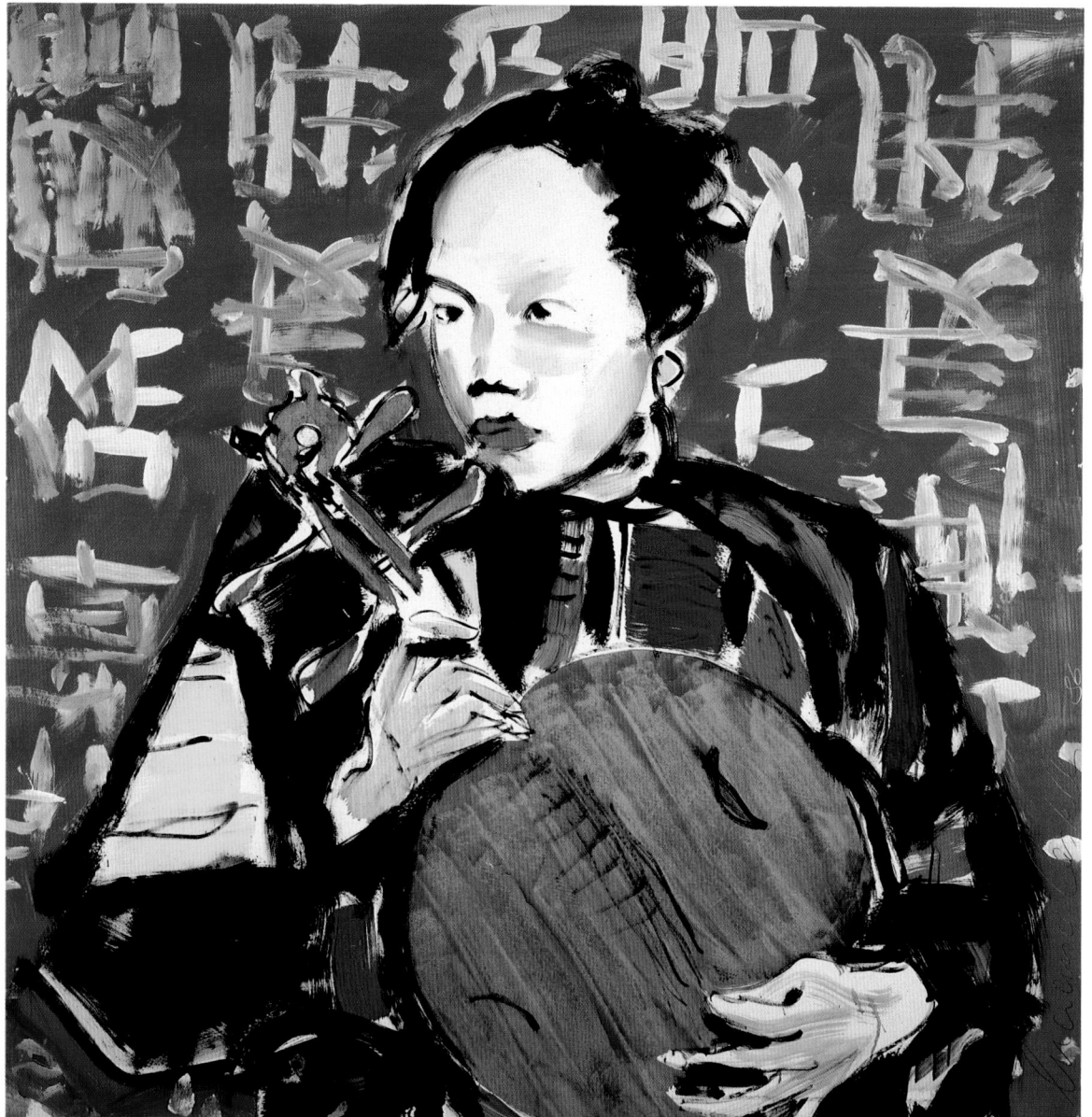

Representation:

RICHARD GRAY GALLERY

620 N. Michigan Avenue
Chicago, IL 60611
312.642.8877
312.642.8488 FAX

Contact:
Paul Gray

Exhibiting:
Modern and contemporary
American and European art

Luciano Castelli

1. *Chinesische Music*
 1986, Oil on paper,
 59.1" x 59.1"

Selected Exhibitions:
- *1990* Richard Gray Gallery, Chicago
- *1989* Museé Cantonal Des Beaux Arts, Lausanne, Switzerland
- *1986* "Representation Abroad", Hirshhorn Museum, Washington, DC

Representation:

**RICHARD GRAY
GALLERY**

620 N. Michigan Avenue
Chicago, IL 60611
312.642.8877
312.642.8488 FAX

Contact:
Paul Gray

Exhibiting:
Modern and contemporary
American and European art

Suzanne Caporael

1. *Ever Wise*
 1988, Oil on canvas,
 72" x 60"

2. *Trees Reflected*
 1990, Oil on canvas,
 72" x 60"

Selected Collections:
Art Institute of Chicago

Carnegie Museum of Art

Los Angeles County
Museum of Art

San Francisco Museum
of Modern Art

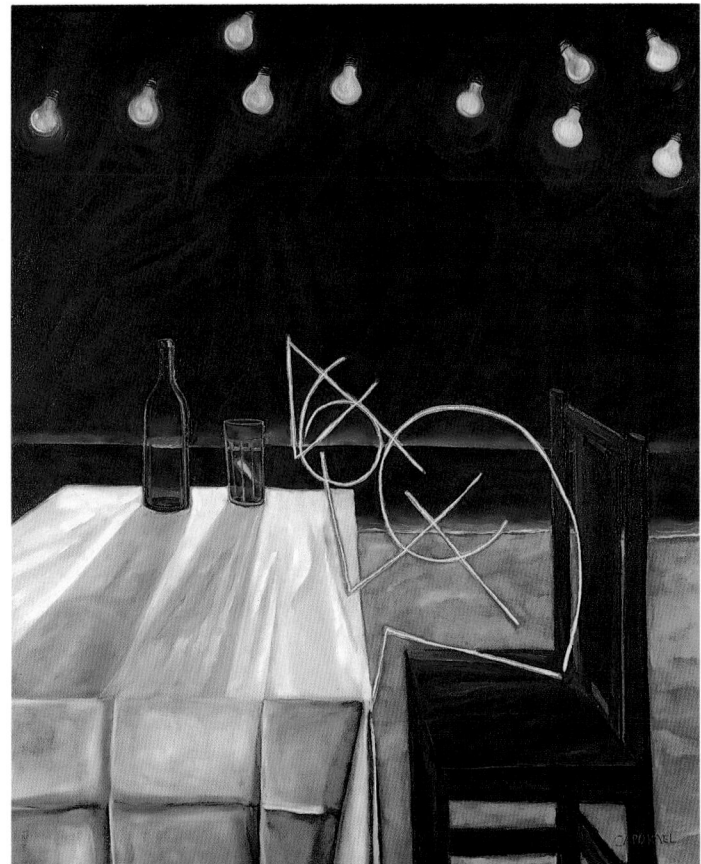

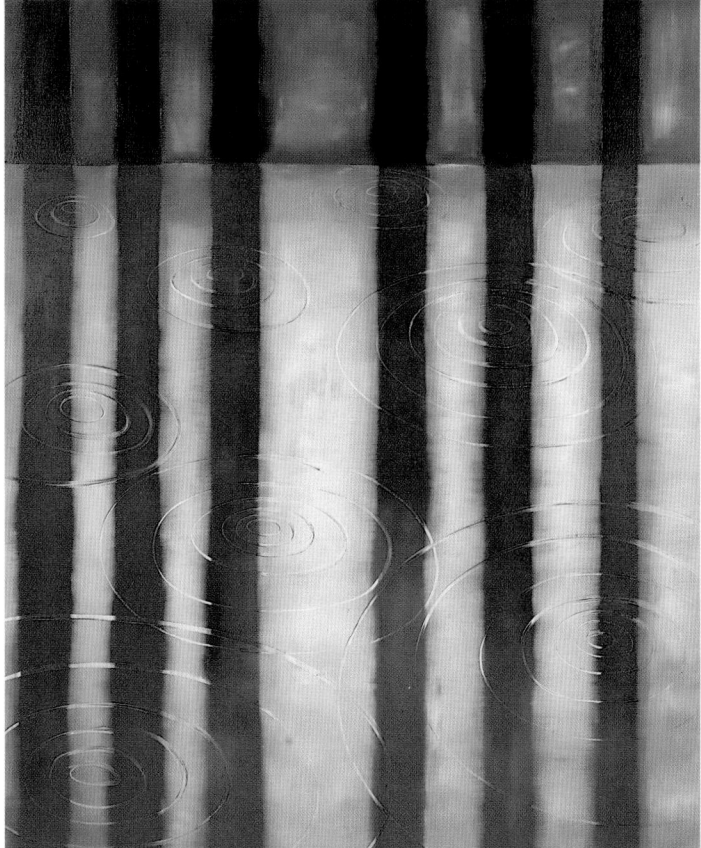

Representation:

CFM GALLERY

138 W. 17th Street
New York, NY 10011
212.929.4001
212.691.5453 FAX
Contact:
Neil P. Zukerman

Exhibiting:
Contemporary European
and American Masters;
Surrealism and
Representational

Dario Campanile

1. *Cose Meraviglios*
 1989, Oil on canvas,
 24" x 30"

2. *Rose*
 1991, Oil on canvas,
 9" x 12"

3. *Aranci*
 1988, Oil on board,
 24" x 30"

Selected Biography:
1991 One man shows:
 Hawaii, California
1983 Pratt Gallery, New York,
 other exhibits in Rome,
 Paris, London, Basel,
 New York, Los Angeles

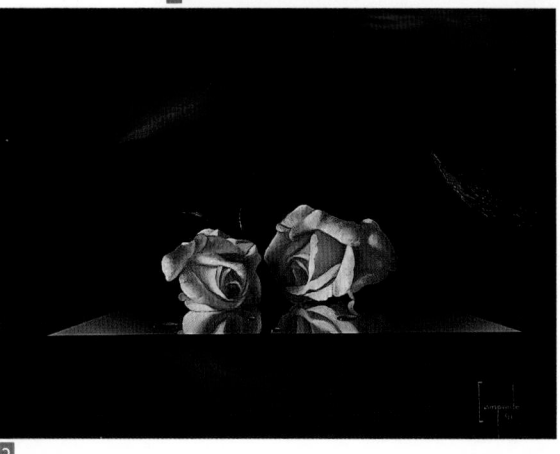

Representation:
GALLERY ONE

121 Scollard Street
Toronto, Canada M5R 1G4
416.929.3103
416.929.0278 FAX

Contact:
Goldie Konopny
Sharon Fischtein
Exhibiting:
Contemporary Canadian,
American & International
painting, sculpture & graphics

Jack Bush

1. *April Growth*
 1972, Acrylic on canvas,
 58 1/2" x 27"

Selected Biography:
1989 "Jack Bush; Fifty Years
of Painting", Gallery
One Toronto, Ont.,
Canada
1987 "Jack Bush: A Survey
1958-1976", Gallery
One Toronto, Ont.,
Canada
1980 "Jack Bush: Paintings
and Drawings 1955-
1976", Arts Council
of Great Britain;
"L'Amerique Aux
Independents",
Societe Des Artistes
Independents, Grand
Palais, Paris, France

1

Representation:

KENNEDY GALLERIES, INC.

40 W. 57th Street
New York, NY 10019
212.541.9600
212.333.7451 FAX

Contact:
Lawrence A. Fleischman
Martha Fleischman
Exhibiting:
18th, 19th & 20th-century
American paintings, prints
& sculpture

Charles E. Burchfield

1. *Country Road
 in December*
 1949, Watercolor
 on paper,
 26" x 40"

2. *The Golden Glow
 of Summer*
 1964, Watercolor
 on paper,
 40" x 29"

2

Selected Biography:
1991 Exhibitions: Trees as
seen through the eyes
of John Marin and
Charles Burchfield;
Charles Burchfield
watercolors 1915-1920

Representation:

**PHYLLIS KIND
GALLERY**

136 Greene Street
New York, NY 10012
212.925.1200
212.941.7841 FAX

313 W. Superior Street
Chicago, IL 60610
312.642.6302
312.642.8502 FAX

Contact:
Phyllis Kind

Exhibiting:
Contemporary American,
Soviet, Naive and Outsider
art

Roger Brown

1. *Stealth Building- Takes off,
 lands, and hides anywhere*
 1991, Oil on canvas,
 72" x 48"

2. *America with Intersections
 and Walmarts*
 1990, Oil on canvas,
 54" x 72"

Selected Biography:
1992 Phyllis Kind Gallery,
 New York
1991 Phyllis Kind Gallery,
 Chicago
1987 Hirshhorn Museum
 and Sculpture Garden,
 Washington, DC

1

2

3

Representation:

**GENOVESE GALLERY
ANNEX**

195 South Street
Boston, MA 02111
617.426.2062
617.423.3718 FAX
Contact:
Camellia Genovese

Exhibiting:
Contemporary art

Calvin Brown

1. *Serial Plate Protection 4/6*
 1990, Oil on steel & rust,
 36" x 36"
 Collection: The Addison Gallery
 of American Art, Andover, MA

2. *Serial Plate Protection 6/6*
 1989, Oil on steel & rust,
 36" x 36"
 Collection: The Addison Gallery
 of American Art, Andover, MA

3. *Plate Protection*
 1989, Oil on steel & rust,
 72" x 108"
 Courtesy of Genovese Gallery
 Annex

Selected Biography:
1991 "American
 Abstraction", Addison
 Gallery of American
 Art, Andover, MA
1990 Solo show: Genovese
 Gallery, Boston, MA
1989 "Strange Attractions:
 Spectacle of Chaos",
 Chicago, IL
1987 "Generations of
 Geometry", Whitney
 Museum of American
 Art, Equitable Branch,
 New York, NY

Representation:

**O.K. HARRIS
WORKS OF ART**

430 N. Woodward Avenue
Birmingham, MI 48009
313.433.3700
313.433.3702 FAX

Contact:
David Klein

Exhibiting:
Contemporary American art

Eugene Brodsky

1. *Boat with Tire*
 1991, Mixed media
 on canvas,
 78" x 97 1/2"

Selected Biography:
1991 Solo exhibition: O.K.
Harris Works of Art,
Birmingham, MI
1989 Solo exhibition: O.K.
Harris Works of Art,
New York, NY
1987 Solo exhibitions:
Grayson Gallery and
Struve Gallery,
Chicago, IL

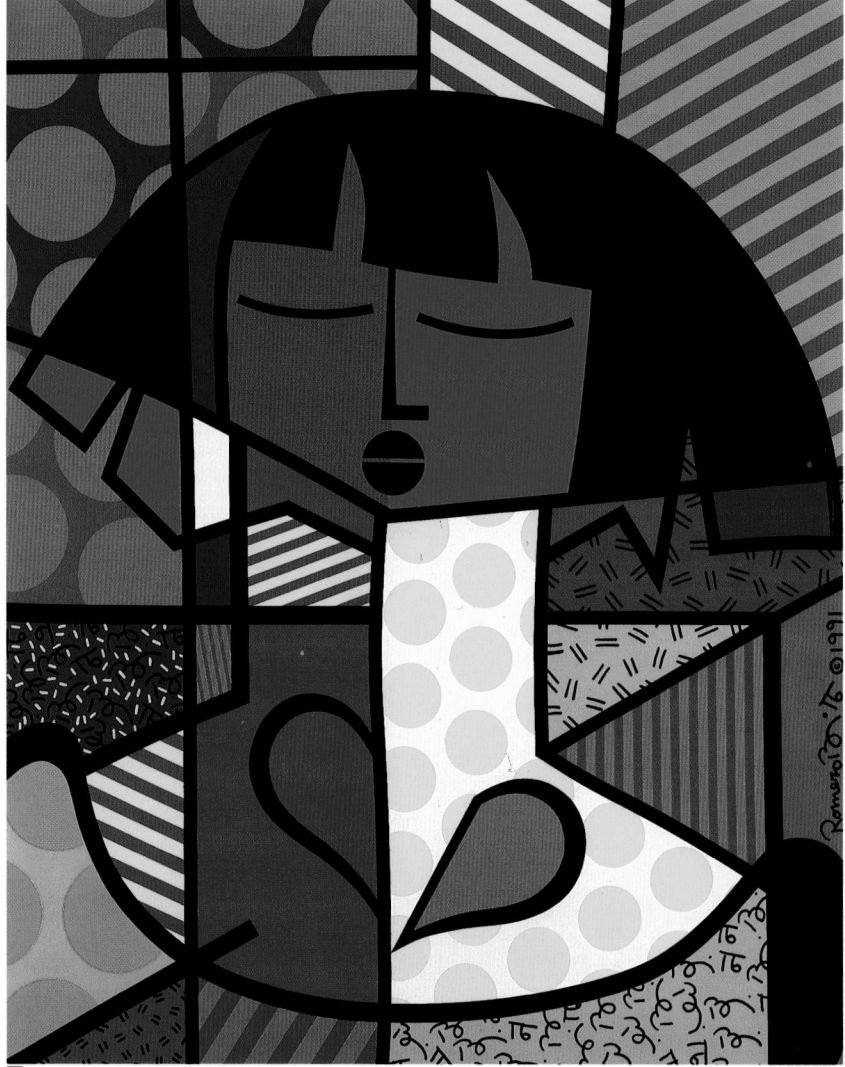

Representation:

DE GRAAF
FINE ART, INC.

9 E. Superior
Chicago, IL 60611
312.951.5180

3400 Avenue of the Arts
Suite C120
Costa Mesa, CA 92626
714.557.5240

Exhibiting:
Contemporary American,
European and Latin
American paintings,
sculpture and graphics

Romero Britto

1. *Indian Girl*
 Acrylic on canvas,
 58" x 48"

2. *Breath of Fresh Air*
 Acrylic on canvas,
 32" x 32"

3. *Florida Kid*
 Acrylic on canvas,
 58" x 48"

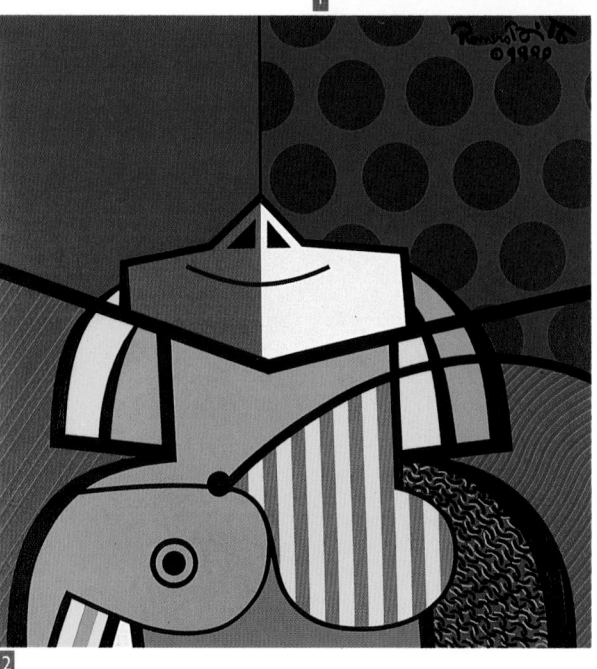

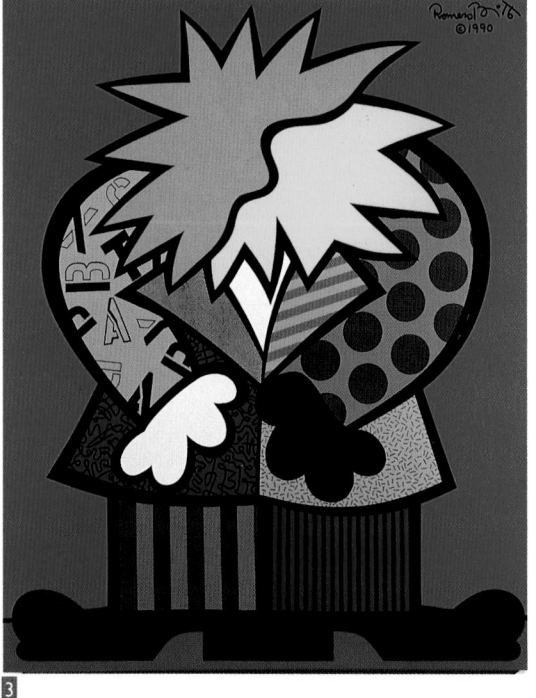

Selected Biography:
1991 Solo exhibition:
De Graaf Fine Art
1990 "Absolut Britto" Ads,
Collections:
Bob and Patsy Bohlen
President George Bush
French President,
Francois Mitterand
Queen of Sweden
1980 First public exhibition:
Brasilia
1964 Born: Brazil

Representation:

NEVILLE-SARGENT GALLERY

708 N. Wells Street
Chicago, IL 60610
312.664.2787
312.337.7472 FAX

Contact:
Don Neville
Jane Neville
Exhibiting:
Contemporary paintings,
prints and sculpture

Glenn Bradshaw

1. *Signet III*
 1991, Casein on
 rice paper,
 24" x 24"

2. *Signet IV*
 1991, Casein on
 rice paper,
 24" x 24"

3. *Token I*
 1991, Casein on
 rice paper,
 37" x 57"

Selected Biography:
1991 Neville-Sargent Gallery,
 Chicago, IL
1989 Neville-Sargent Gallery,
 Chicago, IL
1988 Elected Associate -
 National Academy of
 Design, New York, NY
1987 William A. Paten Prize -
 The National Academy
 of Design, New York,
 NY

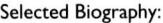

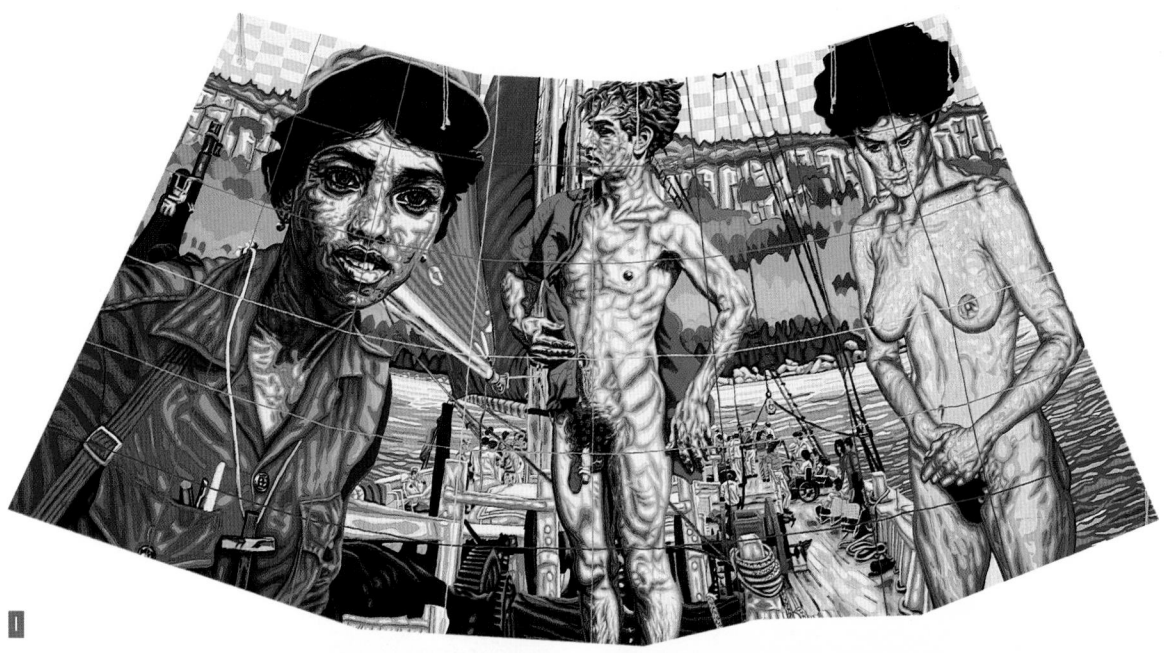

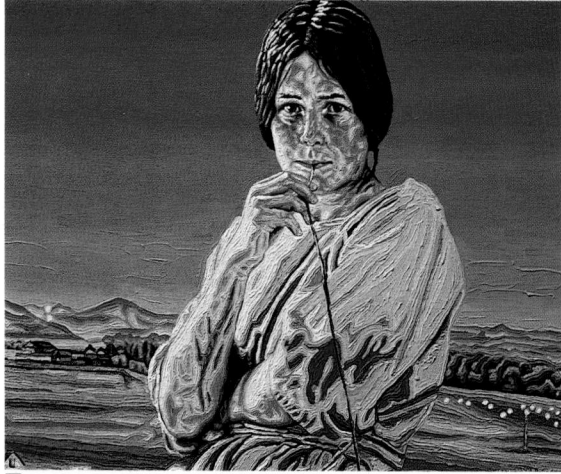

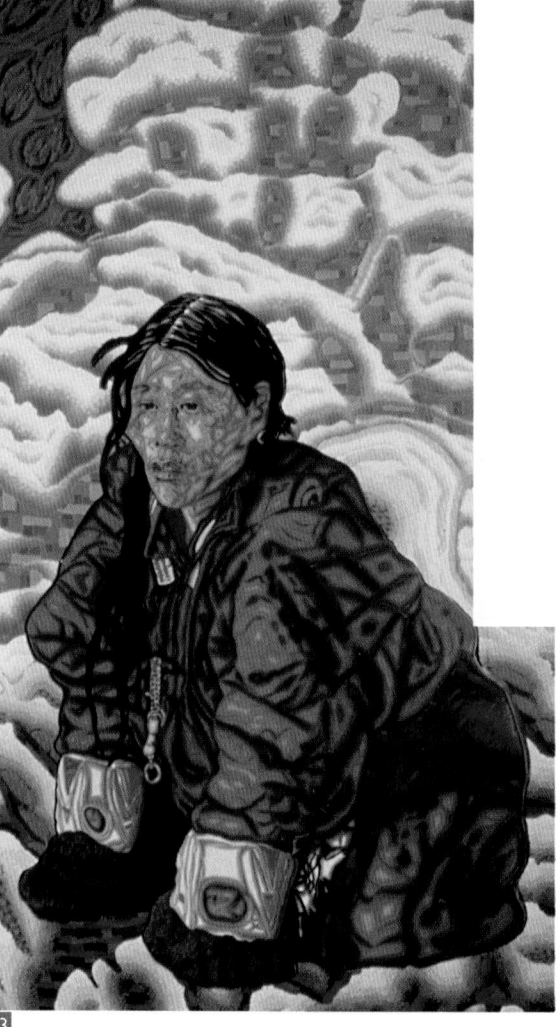

Representation:

NANCY POOLE'S STUDIO

16 Hazelton Avenue
Toronto, ON M5R 2E2
416.964.9050

Contact:
Joan Martyn
Pat Marshall
Exhibiting:
Canadian: Twenty-one years
searching and exhibiting the
BEST

John B. Boyle

1. *Reciprocity*
 Caroline Rose
 1987, Acrylic
 on canvas,
 7' x 13'

2. *Sara on a Slag Heap*
 Near Mons (Detail)
 1983, Oil on
 canvas on board,
 23" x 58"

3. *Inuit Woman in*
 Harrison Park
 1983, Pocelain
 enamel on steel
 set in oil on canvas,
 95" x 54"

Selected Biography:
1991 "The Unofficial
 Retrospective",
 Nancy Poole's Studio;
 J.B. Boyle Retro-
 spective, London
 Regional Art Gallery,
 London; Touring
 Canada, Belgium
1987 Canada Council
 "A" Grant
1985 "Human Touch";
 Seven Canadian and
 seven Belgium artists
 touring four Belgium
 public galleries

Representation:

**HEFFEL GALLERY
LIMITED**

2247 Granville Street
Vancouver, B.C. V6H 3G1
604.732.6505
604.732.4245 FAX
Contact:
Robert Heffel

Exhibiting:
Important historical and
contemporary Canadian art

Bonifacho

1. *Los Nada Que Ver*
 1991, Oil on canvas,
 69" x 57"

2. *The Obsolete What*
 1991, Oil on canvas,
 48" x 53"

Selected Biography:
1990 Solo show:
Heffel Gallery Ltd.,
Vancouver; Group
Show: Whatcom
County Museum:
"North of the Border",
Washington; National
Museum, Belgrade,
Yugoslavia

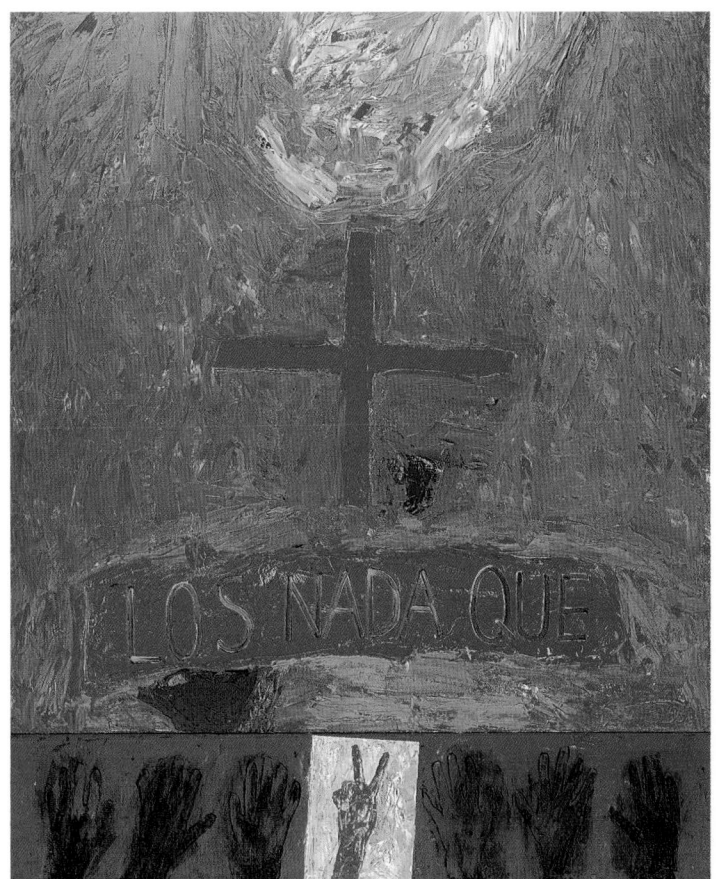

Representation:

MODERNISM INC.

685 Market Street, Suite 290
San Francisco, CA 94105
415.541.0461
415.541.0425 FAX
Contact:
Katya Slavenska

Exhibiting:
Contemporary art,
20th-century historical
art, Russian Avant-Garde
1900-1930

Alexander K. Bogomazov

1. *Cubo-Futurist Composition*
 1914-1915, Oil on canvas,
 12 7/8" x 12 7/8"

Selected Biography:
1914 Wrote the important
 theoretical treatise,
 Painting and Its
 Elements; Organized
 "The Circle"
 Exhibition, Kiev,
 with Alexandra Exter
1911 Graduated from The
 Kiev School of Art

Representation:

MARY BOONE
GALLERY

417 W. Broadway
New York, NY 10012
212.431.1818
212.431.1548 FAX

Contact:
Mary Boone

Exhibiting:
Contemporary paintings,
drawings and sculpture

Ross Bleckner

1. *The Tenth Examined Life*
 1991, Oil/canvas, linen,
 90" x 99" (35)
 Collection: Gilbert/Shelly
 Harrison, New York

2. *The Eleventh Examined Life*
 1991, Oil/linen,
 96" x 72"
 Collection: Ronald Pizzuti,
 Columbus, OH

3. *Architecture of the Sky*
 1990, Oil/canvas,
 106" x 92"
 Collection: Don/Mera Rubell,
 New York

Selected Biography:
1991 Kolnischer
 Kunstverein, Koln,
 Germany; Moderna
 Museet, Stockholm,
 Sweden; Mary Boone
 Gallery, New York, NY
1990 Art Gallery of Ontario,
 Toronto, Canada;
 Galeria Soledad
 Lorenzo, Madrid, Spain;
 Heland Wetterling
 Gallery, Stockholm,
 Sweden; Kunsthalle
 Zurich, Zurich,
 Switzerland

2

3

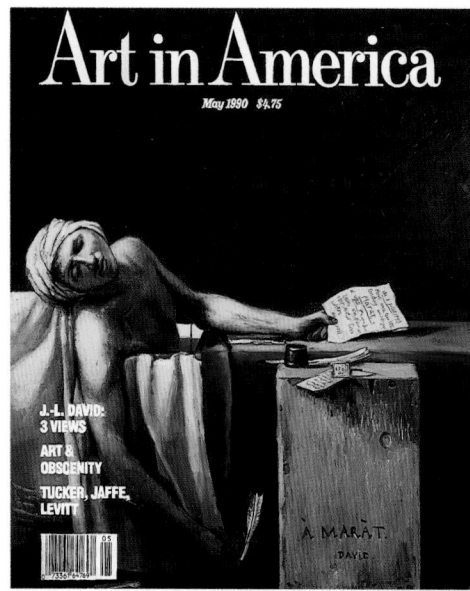

Representation:

WYNICK/TUCK GALLERY

80 Spadina Avenue, 4th Fl.
Toronto, ON M5V 2J3
416.364.8716

Contact:
Lynne Wynick
David Tuck
Exhibiting:
Contemporary Canadian art:
painting, sculpture, works on
paper and installations

David Bierk

1. *In the Absence of Virtue:
 Art in America, May 1990,
 to David and Manet*
 1990, Oil on canvas,
 44 1/2" x 74"

2. *Autumn Light, to Inness
 and Vermeer*
 1988, Oil on canvas,
 59" x 118"

3. *Silo/Vars, Ontario*
 1991, Painted photo-
 montage on canvas,
 20" x 47"

Representation:

DE GRAAF
FINE ART, INC.

9 E. Superior
Chicago, IL 60611
312.951.5180

3400 Avenue of the Arts
Suite C120
Costa Mesa, CA 92626
714.557.5240

Exhibiting:
Contemporary American,
European and Latin
American paintings,
sculpture and graphics

G. Elyane Bick

1. *Gold Rush Haze*
 Hand woven tapestry,
 66" x 59"

2. *Tintigane*
 Hand woven tapestry,
 76" x 42"

3. *Flight*
 Hand woven tapestry,
 69" x 100"

Selected Biography:
1990 De Graaf Fine Art
1987 De Graaf Fine Art;
 Permanent collections:
 Art Institute of Chicago,
 Toledo Museum of Art;
 Consultant:
 Metropolitan Museum
1922 Born: Tebessa, Algeria

Representation:

MICHAEL KIZHNER FINE ART

746 N. La Cienega Boulevard
Los Angeles, CA 90069
213.659.5222
213.659.0838 FAX
Contact:
Michael Kizhner

Exhibiting:
California Impressionists and
contemporary Soviet art

Pyotr Belenok

1. *Untitled*
 1988, Enamel paint,
 spray gun and collage
 on masonite,
 53 1/2" x 47"

2. *Untitled*
 1988, Enamel paint,
 spray gun and collage
 on masonite,
 53 3/4" x 46 3/4"

3. *Twilight*
 1979, Enamel paint,
 spray gun and collage
 on masonite,
 49" x 49"

Selected Biography:
1988 "International Images",
 Sewickley, PA
1980 Art Gallery, University
 of Maryland
1977 Institute of
 Contemporary Art,
 London; Arts Club,
 Washington, D.C.
1976 Russian Museum in
 Exile, Montgeron,
 France

Representation:

STIEBEL MODERN

32 E. 57th Street, 6th Fl.
New York, NY 10022
212.759.5536
212.935.5736 FAX
Contact:
Katherine Chapin

Exhibiting:
Painterly Realism from 1945
to present

William Beckman

1. *Classical Woman*
 1988-91, Oil on panel,
 80" x 80"

2. *C.W. #1*
 1989, Charcoal on paper,
 78" x 78"

3. *C.W. #3*
 1989, Charcoal on paper,
 42" x 30"

Selected Biography:
1991 "Dossier of a Classical
 Woman", Stiebel
 Modern, NY, traveling
 to Indiana University of
 Art Museum,
 Bloomington, IN;
 "American Realism and
 Figurative Art 1952-
 1991", Miyagi Museum
 of Art, Sendai, Japan;
 Tokashima
 Museum of Art;
 Sogumofa, Yokahama;
 Museum of Modern
 Art, Shiga; Kochi
 Prefectual Museum

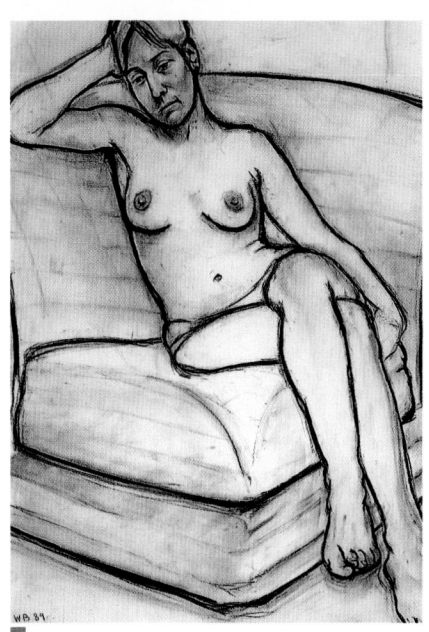

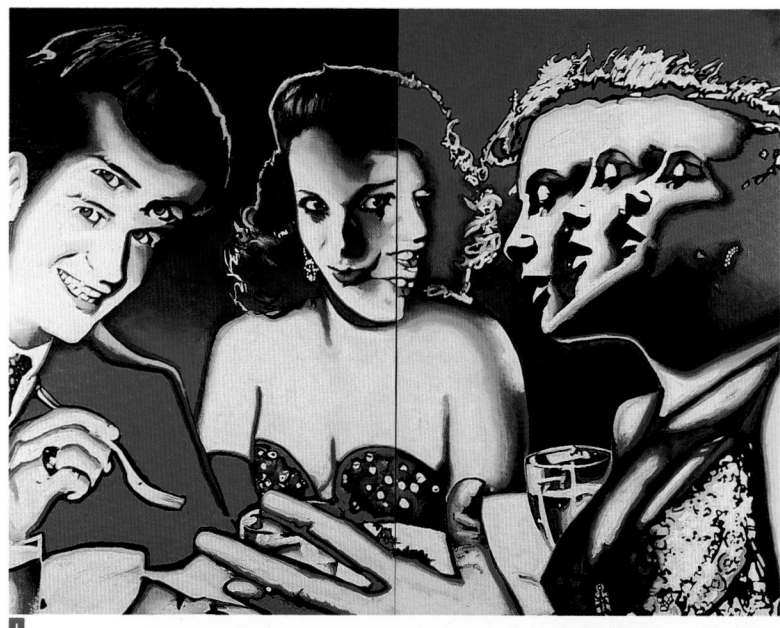

Representation:

THE LOWE GALLERY

75 Bennett Street, Space A-2
Atlanta, GA 30309
404.352.8114
404.352.0564 FAX

Contact:
Bill Lowe

Exhibiting:
Contemporary painting,
sculpture and objects

Michael Beauchemin

1. *Light Years at the Buffet*
 1991, Acrylic/oil,
 72" x 96"

2. *Resort to Plan B*
 1991, Acrylic/oil/canvas,
 48" x 60"

3. *Seven Seconds to Heaven*
 1991, Acrylic/oil,
 48" x 96"

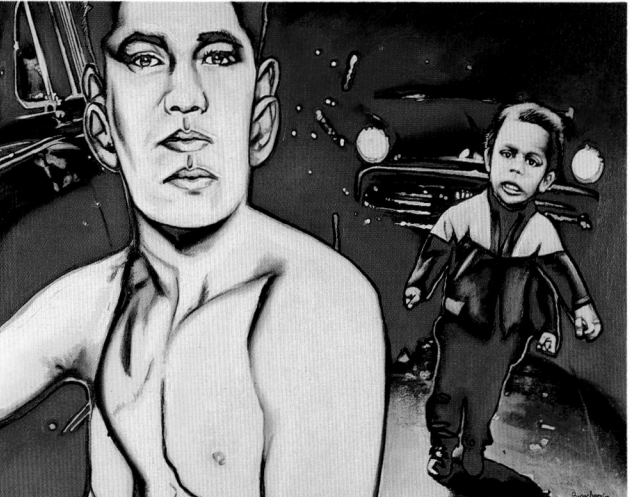

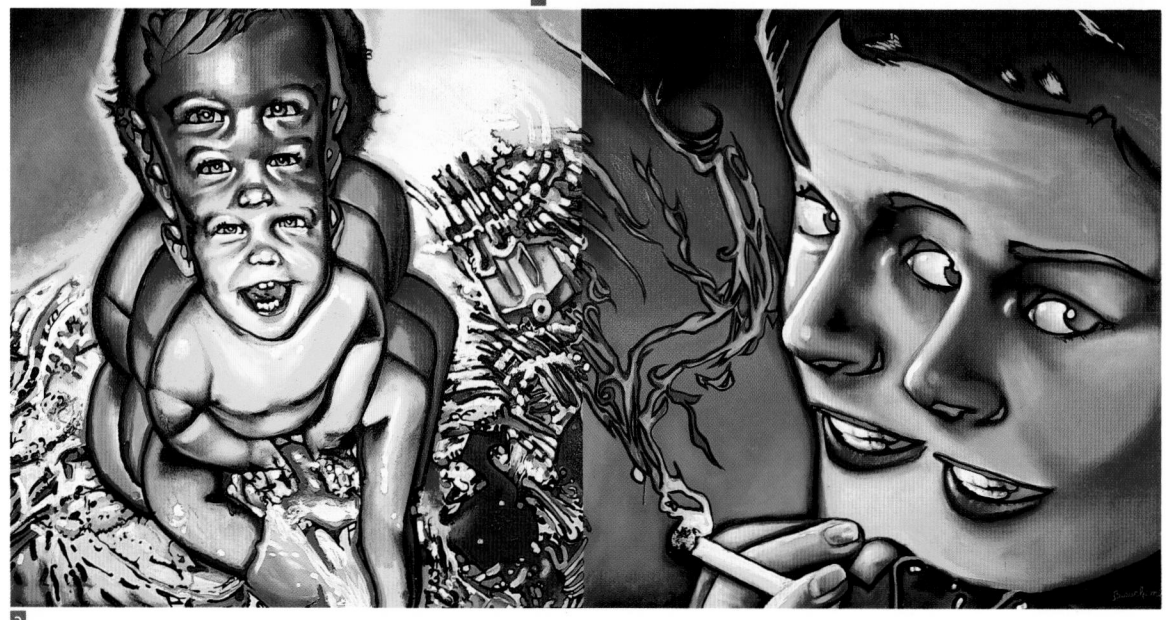

Selected Biography:
1991 Michael Beauchemin,
"Recent Paintings",
The Lowe Gallery,
Atlanta, GA

Representation:

**PORTICO
NEW YORK, INC.**

139 Spring Street
New York, NY 10012
212.941.1444
212.941.8248 FAX
Contact:
Steven Lowy

Exhibiting:
20th-century art; Modernism
and Contemporary

Rudolf Bauer

1. *Black Accents*
 1935-40, Oil on canvas,
 28" x 32.5"

2. *Allegro*
 1925, Mixed media
 on paper,
 18 7/8" x 14 3/4"

3. *Untitled*
 (cubist self-portrait)
 1910, Mixed media
 on paper,
 9 1/2" x 7 3/4"

Selected Biography:
1991 "Rudolf Bauer & Hilla
 Rebay: Paintings &
 Works on Paper",
 Art Cologne
1990 "Rudolf Bauer:
 Centennial Exhibition",
 Philadelphia Art
 Alliance; Group show:
 Peggy Guggenheim
 Museum, Venice, Italy
1989 "Masterworks from the
 Permanent Collection",
 Solomon Guggenhiem
 Museum

Representation:

CHARLES COWLES GALLERY

420 W. Broadway
New York, NY 10012
212.925.3500
212.925.3501 FAX

Exhibiting:
Contemporary art

David Bates

1. *Gulf of Mexico*
 1990, Oil on canvas,
 76" x 52"

Selected Collections:
 Hirshhorn Museum
 & Sculpture Garden,
 Washington, DC

 The Metropolitan
 Museum of Art, NY

 The Modern Art
 Museum of Fort
 Worth, TX

 The Museum of Fine
 Arts, Houston

 San Francisco Museum
 of Modern Art, CA

 Whitney Museum of
 American Art, NY

Representation:

THE PACE GALLERY

32 E. 57th Street
New York, NY 10022
212.421.3292
212.421.0835 FAX

142 Greene Street
New York, NY 10012
212.431.9224
212.431.9280 FAX

Exhibiting:
20th-century paintings,
drawings and sculpture

Georg Baselitz

1. *Geschwister Rosa*
1990-91, Oil on canvas,
118 1/8" x 98 3/8"

Representation:

CFM GALLERY

138 W. 17th Street
New York, NY 10011
212.929.4001
212.691.5453 FAX
Contact:
Neil P. Zukerman

Exhibiting:
Contemporary European
and American Masters;
Surrealism and
Representational

Anne Bachelier

1. *Les Guetteurs*
 1991, Oil on canvas,
 26" x 21"

2. *Soliel Noir*
 1991, Oil on canvas,
 36" x 29"

3. *La Grande Gorgonne*
 1991, Oil on canvas,
 51" x 38"

Selected Biography:
1991 Galerie Vendome, Paris;
Galerie Saint-Vincent,
Lyon
1990 Salon du Dauphine,
Fondation Hebert,
Grenoble

Representation:

P•P•O•W

532 Broadway, 3rd Fl.
New York, NY 10012
212.941.8642
212.274.8339 FAX

Contact:
Wendy Olsoff
Penny Pilkington
Exhibiting:
International
contemporary art

Dotty Attie

1. *A Surprise*
 1991, Oil on linen,
 4 Panels, Each 6" x 6"

2. *Father Always Swore*
 1991, Oil on linen,
 5 Panels, Each 6" x 6"

Selected Biography:

1991 Art In America,
"The Discreet Voyeur"
by Max Kozloff,
pp. 100-107, 137
(Cover Story); Solo
exhibition: "In the
Atelier", P•P•O•W,
New York

1989 Solo exhibition:
Pittsburgh Center
for the Arts

1988 Solo exhibition:
"Episodes in the Lives
of Masters", P•P•O•W,
New York

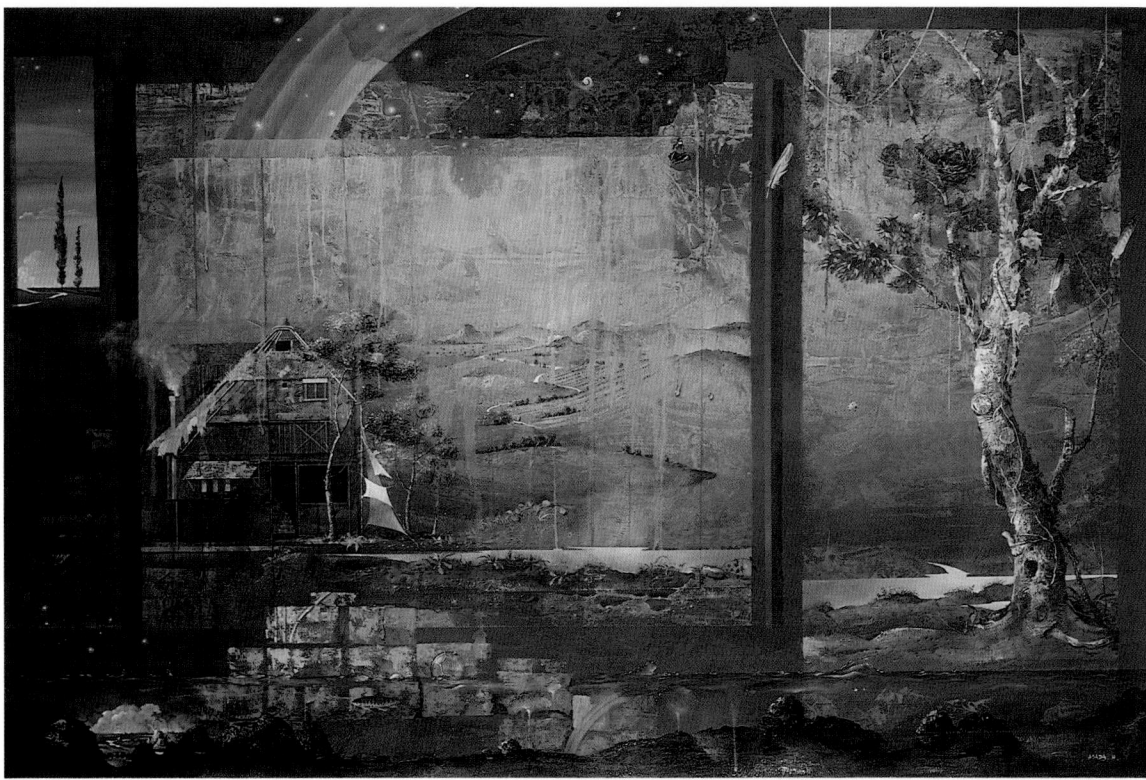

Representation:

GALERIE TAMENAGA

982 Madison Avenue
New York, NY 10021
212.734.6789
212.734.9413 FAX

Contact:
Howard Rutkowski

Exhibiting:
Modern and contemporary
American, European and
Japanese art

Hiroshi Asada

1. *A Place To Return*
 1989, Oil on canvas,
 57" x 89 1/2"

2. *Once Upon A Time*
 1989, Oil on canvas,
 31 1/2" x 21"

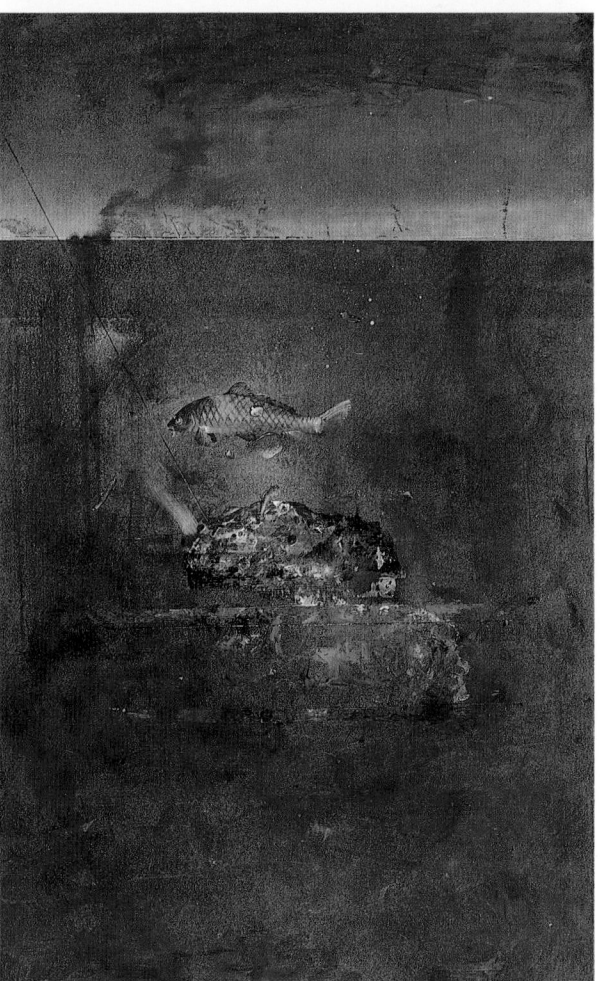

Selected Biography:
1991 Solo exhibition: Galerie
Tamenaga, New York,
New York
1985 Awarded Prix Alfred
Sisley, Salon De Société
Nationale Des Beaux-
Arts
1983 Awarded Prix Henri
Farman, Salon De
Société Nationale Des
Beaux-Arts

Representation:

ERGANE GALLERY

469 W. Broadway
New York, NY 10012
212.228.9600
212.228.9736 FAX

Contact:
Mary Hansen

Exhibiting:
Contemporary paintings,
drawings, and prints

Eduardo Arranz-Bravo

1. *Angel Multiple*
 1989, Oil on canvas,
 57" x 44"

2. *Pisces - Zodiac Series*
 1990, Oil on canvas,
 33" x 18"

3. *Susana Amor*
 1990, Oil on canvas,
 35" x 45"

Selected Biography:
1991 Chosen to represent
 Spain at the World
 Expo in Seville
1990 Designs three stamps
 for Olympic Games in
 Barcelonia
1989 "Panto-Crator", Series
 exhibition at Museum
 of Modern Art,
 Sao Paulo

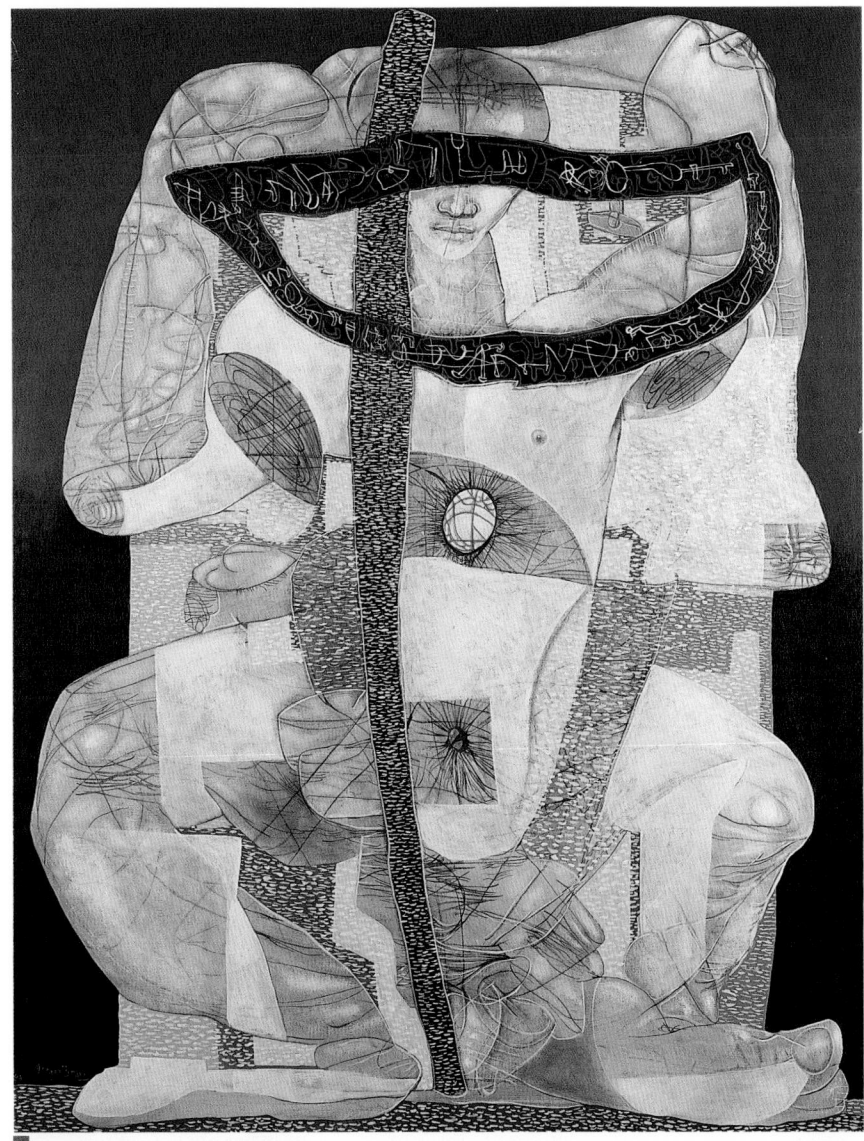

Representation:

**THE WORKS
GALLERY**

106 W. Third Street
Long Beach, CA 90802
213.495.2787
213.495.0370 FAX

Crystal Court/S. Court Plaza
3333 Bear Street, Third Fl.
Costa Mesa, CA 92626
714.979.6757
714.979.6818 FAX
Contact:
Mark Moore

Exhibiting:
Established and emerging
contemporary artists of
the western United States

Craig Antrim

1. *Dark Wing*
 1989, Wax, oil,
 acrylic on canvas,
 7' x 5'

2. *Place Beneath*
 1989, Wax, oil, magna,
 acrylic on canvas,
 36" x 32"

3. *Infinite*
 1989, Wax, oil, charcoal,
 acrylic on canvas,
 50" x 40"

Selected Biography:
1992 Solo exhibition:
 "Recent Work", The
 Works Gallery South,
 Costa Mesa, CA
1991 Group exhibition:
 "Spiritual Objects",
 The Works Gallery,
 Long Beach, CA
1987 "Spiritual in Art/
 Abstract Painting,
 1890-1985", Los
 Angeles County
 Museum, Los Angeles
1984 "Five Artists from Los
 Angeles", Dongsanbang
 Gallery, Seoul, Korea;
 "California Artists",
 Art Space Newz,
 Tokyo, Japan

Representation:

ERGANE GALLERY

469 W. Broadway
New York, NY 10012
212.228.9600
212.228.9736 FAX

Contact:
Mary Hansen

Exhibiting:
Contemporary paintings,
drawings, and prints

Keith Alexander

1. *The Fall of Pomona*
 1990, Acrylic on canvas,
 30" x 42"

2. *Refuge*
 1991, Acrylic on canvas,
 48" x 36"

3. *Black Eagle*
 1991, Acrylic on canvas,
 36" x 48"

1

Representation:

THE WORKS GALLERY

106 W. Third Street
Long Beach, CA 90802
213.495.2787
213.495.0370 FAX

Crystal Court/S. Court Plaza
3333 Bear Street, Third Fl.
Costa Mesa, CA 92626
714.979.6757
714.979.6818 FAX
Contact:
Mark Moore

Exhibiting:
Established and emerging
contemporary artists of
the western United States

Lita Albuquerque

1. *The Wave of the Breath...*
 1989, Oil, powdered
 pigment, gold leaf, stone,
 crustacean on panel,
 25 panels each 24" x 24",
 one title panel 6' x 95 1/2"

Selected Biography:
1992 Solo exhibition:
 The Works Gallery,
 Long Beach, CA
1990 Santa Monica Museum
 of Art, Santa Monica,
 CA; Career Survey
 sponsored by Fellows
 of Contemporary Art
1988 Solo exhibition:
 Richard Green Gallery,
 Los Angeles, CA
1980 Solo exhibition:
 Diane Brown Gallery,
 Washington, DC

PAINTINGS

November 1991

S	M	T	W	T	F	S
					1	2
3	4	5	6	7	8	9
10	11	12	13	14	15	16
17	18	19	20	21	22	23
24	25	26	27	28	29	30

December 1991

S	M	T	W	T	F	S
1	2	3	4	5	6	7
8	9	10	11	12	13	14
15	16	17	18	19	20	21
22	23	24	25	26	27	28
29	30	31				

January 1992

S	M	T	W	T	F	S
			1	2	3	4
5	6	7	8	9	10	11
12	13	14	15	16	17	18
19	20	21	22	23	24	25
26	27	28	29	30	31	

February 1992

S	M	T	W	T	F	S
						1
2	3	4	5	6	7	8
9	10	11	12	13	14	15
16	17	18	19	20	21	22
23	24	25	26	27	28	29

March 1992

S	M	T	W	T	F	S
1	2	3	4	5	6	7
8	9	10	11	12	13	14
15	16	17	18	19	20	21
22	23	24	25	26	27	28
29	30	31				

April 1992

S	M	T	W	T	F	S
			1	2	3	4
5	6	7	8	9	10	11
12	13	14	15	16	17	18
19	20	21	22	23	24	25
26	27	28	29	30		

May 1992

S	M	T	W	T	F	S
					1	2
3	4	5	6	7	8	9
10	11	12	13	14	15	16
17	18	19	20	21	22	23
$^{24}/_{31}$	25	26	27	28	29	30

June 1992

S	M	T	W	T	F	S
	1	2	3	4	5	6
7	8	9	10	11	12	13
14	15	16	17	18	19	20
21	22	23	24	25	26	27
28	29	30				

July 1992

S	M	T	W	T	F	S
			1	2	3	4
5	6	7	8	9	10	11
12	13	14	15	16	17	18
19	20	21	22	23	24	25
26	27	28	29	30	31	

August 1992

S	M	T	W	T	F	S
						1
2	3	4	5	6	7	8
9	10	11	12	13	14	15
16	17	18	19	20	21	22
$^{23}/_{30}$	$^{24}/_{31}$	25	26	27	28	29

September 1992

S	M	T	W	T	F	S
		1	2	3	4	5
6	7	8	9	10	11	12
13	14	15	16	17	18	19
20	21	22	23	24	25	26
27	28	29	30			

October 1992

S	M	T	W	T	F	S
				1	2	3
4	5	6	7	8	9	10
11	12	13	14	15	16	17
18	19	20	21	22	23	24
25	26	27	28	29	30	31

November 1992

S	M	T	W	T	F	S
1	2	3	4	5	6	7
8	9	10	11	12	13	14
15	16	17	18	19	20	21
22	23	24	25	26	27	28
29	30					

December 1992

S	M	T	W	T	F	S
		1	2	3	4	5
6	7	8	9	10	11	12
13	14	15	16	17	18	19
20	21	22	23	24	25	26
27	28	29	30	31		

December 1992

S	M	T	W	T	F	S
		1	2	3	4	5
6	7	8	9	10	11	12
13	14	15	16	17	18	19
20	21	22	23	24	25	26
27	28	29	30	31		

Tuesday 17

Wednesday 18

Thursday 19

Friday 20

Jackie Winsor: A Retrospective
Thru January 17, 1993
Akron Art Museum

Saturday 21

Sunday 22

Monday 23

CHRISTIE'S

Tuesday 24

Artists of Hawaii, 1992
Thru January 3, 1993
Honolulu Academy of Arts

Wednesday 25

Thanksgiving Day

Thursday 26

Friday 27

Gerhard Richter: Helga Matura
Thru January 17, 1993
Art Gallery of Windsor

Pamela Harris: Faces of Feminism
Thru January 23, 1993
Art Gallery of Windsor

Saturday 28

Sunday 29

Impressionist & Modern Paintings &
Sculpture/Impressionist & Modern
Paintings, Watercolour, Drawings And
Sculpture (Part III)
Christie's, London

Monday 30

Courtesy of Christies, London

November 1992

1 *Sunday*

2 *Monday*

3 *Tuesday* Election Day

4 *Wednesday*

Courtesy of the High Museum of Art

5 *Thursday*

6 *Friday*

7 *Saturday* Barbara Kassel
Thru January 3, 1993
Cedar Rapids Museum of Art

8 *Sunday* Animals/Animals
Thru January, 1993
Laumeier Sculpture Park & Museum,
St. Louis

9 *Monday* Martin Puryear
Thru January 3, 1993
Philadelphia Museum of Art

10 *Tuesday*

11 *Wednesday* Veterans Day
Remembrance Day (Canada)

12 *Thursday*

13 *Friday* Susan Rothenberg: Drawings & Paintings
Thru January 3, 1993
Albright-Knox Art Gallery, Buffalo

14 *Saturday* Recent Acquisitions: Selections From
The Permanent Collections
Thru January 31, 1993
Orlando Museum of Art

15 *Sunday* Max Weber: The Cubist Decade, Jeff Wall
1910-1920 Thru January 26, 1992
Thru January 10, 1993 San Diego Museum of Contemporary Art,
The Brooklyn Museum La Jolla

16 *Monday*

Courtesy of the San Diego Museum of
Contemporary Art

Saturday 17

Sunday 18

Monday 19

Tuesday 20

Contemporary Paintings Auction
Fine Photographs Auction, Prints Auction
3rd Week of October
Butterfield & Butterfield, Los Angeles

Wednesday 21

Thursday 22

Friday 23

Saturday 24

Courtesy of Butterfield & Butterfield

Sunday 25

Monday 26

Tuesday 27

Wednesday 28

Art New York
Thru November 1, 1992
Jacob K. Javits Convention
Center, New York

Thursday 29

Friday 30

Saturday 31

November 1992						
S	M	T	W	T	F	S
1	2	3	4	5	6	7
8	9	10	11	12	13	14
15	16	17	18	19	20	21
22	23	24	25	26	27	28
29	30					

1	*Thursday*		Rupert Garcia: Prints And Posters Thru November 29, 1992 Joslyn Art Museum, Omaha
2	*Friday*	FIAC October, 1992 Grand Palais des Champs - Elysees, Paris	Contemporary Inuit Drawings from Arctic Canada Thru January, 1993 The Saint Louis Art Museum
3	*Saturday*		Jack Shadbolt Thru November 14, 1992 Art Gallery of Windsor
4	*Sunday*	Elmer Bischoff & Joan Brown Thru December 31, 1992 University Art Museum, Berkeley	David Salle Thru November 22, 1992 Nelson-Atkins Museum of Art, Kansas City
5	*Monday*		Building In A New Spain: Contemporary Spanish Architecture October, 1992 - Winter, 1993 The Art Institute of Chicago
6	*Tuesday*		Stanley William Hayter Thru December 27, 1992 Cedar Rapids Museum of Art
7	*Wednesday*		Yom Kippur
8	*Thursday*		
9	*Friday*		
10	*Saturday*		
11	*Sunday*		The Paintings of George Bellows Thru January 3, 1993 Columbus Museum of Art
12	*Monday*		Columbus Day Thanksgiving Day (Canada)
13	*Tuesday*		
14	*Wednesday*		Eva Hesse Thru January 10, 1993 Hirshhorn Museum And Sculpture Garden, Washington, DC
15	*Thursday*		
16	*Friday*		Impressionist & Modern Paintings & Sculpture Christie's, London

Courtesy of FIAC

Courtesy of The Art Institute of Chicago

Thursday 17

Tim Rollins + K.O.S.
(Kids Of Survival): Animal Farm
Thru December 6, 1992
Hirshhorn Museum And Sculpture Garden,
Washington, DC

Friday 18

Kandinsky And The
American Avant-Garde
Thru November 29, 1992
The Phillips Collection, Washington, DC

The Visionary City
Thru January 17, 1993
The Baltimore Museum of Art

Saturday 19

Consuelo Kanaga: A Retrospective
Thru Winter 1993
The Brooklyn Museum

Sunday 20

Pat Steir:
Waves And Waterfalls, 1982-92
Fall, 1992 - Winter, 1993
The Brooklyn Museum

Monday 21

Wright Morris
Fall, 1992
San Francisco Museum of Modern Art

Tuesday 22

Wednesday 23

Courtesy of The Brooklyn Museum

Luciano Fabro
Thru December 6, 1992
San Francisco Museum of Modern Art

Thursday 24

An Other America
Thru November 22, 1992
National Gallery of Canada, Ottawa

James Turrell
Thru December 27, 1992
Henry Art Gallery, Seattle

Friday 25

Twentieth Century Sculpture
Fall, 1992
Museum of Fine Arts, Houston

Saturday 26

Marta Meszaros
Fall, 1992
The Museum of Modern Art, New York

Sunday 27

The Museum of Modern Art

Dennis Adams
Thru November 4, 1992
Everson Museum of Art, Syracuse

First Day of Rosh Hashanah

Monday 28

Tuesday 29

Art California
Thru October 4, 1992
Moscone Center, San Francisco

Transitional American Sculpture
Thru November 29, 1992
Tampa Museum of Art

Wednesday 30

October 1992						
S	M	T	W	T	F	S
				1	2	3
4	5	6	7	8	9	10
11	12	13	14	15	16	17
18	19	20	21	22	23	24
25	26	27	28	29	30	31

September 1992

1	Tuesday		Outdoor Sculpture By David Nash September, 1992 Laumeier Sculpture Park & Museum, St. Louis
2	Wednesday		
3	Thursday		Romare Bearden Printmaker Thru October 18, 1992 The Arkansas Arts Center, Little Rock
4	Friday		
5	Saturday		
6	Sunday		
7	Monday		Labor Day
8	Tuesday		Sigmund Abeles Thru November 1, 1992 Cedar Rapids Museum of Art
9	Wednesday		
10	Thursday		

Courtesy of The Museum of Modern Art

Courtesy of the High Museum of Art

11	Friday	Max Weber: The Cubist Decade, 1910-1920 Joshua Neustein: The Carbon Series Thru October 25, 1992 Albright-Knox Art Gallery, Buffalo	The Landscape In Twentieth-Century Art: Selections From The Metropolitan Museum Thru November 8, 1992 Grand Rapids Art Museum
12	Saturday	Oliphant's Presidents: Twenty-Five Years of Caricature By Pat Oliphant Thru October 25, 1992 Tampa Museum of Art	Revelaciones: The Art of Manuel Alvarez Bravo Thru November 8, 1992 Harvard University Art Museums, Cambridge
13	Sunday		Contemporary Works by Hispanic Artists Thru December 13, 1992 The Noyes Museum, Oceanville
14	Monday		
15	Tuesday		Henri Matisse: A Retrospective Mid-September, 1992 - Mid-January, 1993 The Museum of Modern Art, New York
16	Wednesday		

August 1992						
S	M	T	W	T	F	S
						1
2	3	4	5	6	7	8
9	10	11	12	13	14	15
16	17	18	19	20	21	22
23/30	24/31	25	26	27	28	29

Monday 17

Tuesday 18

Wednesday 19

Thursday 20

Friday 21

Joseph Albers and His Students:
Selections from The Permanent Collection
Thru November 8, 1992
Orlando Museum of Art

Saturday 22

Sunday 23

Monday 24

Courtesy of the Orlando Museum of Art

Tuesday 25

Wednesday 26

Thursday 27

Friday 28

Saturday 29

Sunday 30

Monday 31

September 1992						
S	M	T	W	T	F	S
		1	2	3	4	5
6	7	8	9	10	11	12
13	14	15	16	17	18	19
20	21	22	23	24	25	26
27	28	29	30			

August 1992

1	Saturday

2	Sunday

3	Monday

4	Tuesday

5	Wednesday

6	Thursday

7	Friday

Courtesy of the Museum of Fine Arts

8	Saturday

9	Sunday

Rescuers of the Holocaust
Thru November 11, 1992
Museum of Fine Arts, Houston

10	Monday

11	Tuesday

12	Wednesday

13	Thursday

14	Friday

15	Saturday

Santos: The Household Saints
of Puerto Rico
Thru October 11, 1992
Terra Museum of American Art, Chicago

16	Sunday

July 1992

S	M	T	W	T	F	S
			1	2	3	4
5	6	7	8	9	10	11
12	13	14	15	16	17	18
19	20	21	22	23	24	25
26	27	28	29	30	31	

44th Western New York Exhibition
Thru August 30, 1992
Albright-Knox Art Gallery, Buffalo

Friday 17

Saturday 18

On The Road: Selections from
The San Diego Museum
of Contemporary Art
Thru September 6, 1992
The Philbrook Museum of Art, Tulsa

Land Ho!: The Mythic World of Rodney
Alan Greenblat
Thru September 13, 1992
Columbus Museum of Art

Sunday 19

Monday 20

Tuesday 21

Wednesday 22

Courtesy of The San Diego Museum of Contemporary Art

Thursday 23

Friday 24

Saturday 25

Sunday 26

Monday 27

Tuesday 28

Wednesday 29

Thursday 30

Friday 31

August 1992						
S	M	T	W	T	F	S
						1
2	3	4	5	6	7	8
9	10	11	12	13	14	15
16	17	18	19	20	21	22
23/30	24/31	25	26	27	28	29

1	*Wednesday*		Canada Day

2	*Thursday*	The Psychoanalytic Drawings of Jackson Pollock Thru August 30, 1992 San Francisco Museum of Modern Art	Contemporary Art Auction Christie's, London

3 *Friday*

4	*Saturday*	Independence Day	Jack Shadbolt Thru August 30, 1992 Vancouver Art Gallery

5 *Sunday*

A Major Representation of Russian and Soviet Avant-Garde Art
Summer, 1992
Solomon R. Guggenheim Museum, New York

6 *Monday*

7 *Tuesday*

Courtesy of the Solomon R. Guggenheim Museum

8 *Wednesday*

9	*Thursday*		Oliphant's Presidents: Twenty-Five Years of Caricature by Pat Oliphant Thru August 23, 1992 The Arkansas Arts Center

10	*Friday*		Next Generation: Southern Black Aesthetic Thru October 31, 1992 The Contemporary Arts Center, Cincinnati

11 *Saturday*

12 *Sunday*

13 *Monday*

14 *Tuesday*

15 *Wednesday*

16 *Thursday*

June 1992						
S	M	T	W	T	F	S
	1	2	3	4	5	6
7	8	9	10	11	12	13
14	15	16	17	18	19	20
21	22	23	24	25	26	27
28	29	30				

Art 23 '92 & Edition 3/92 Basel
Thru June 22, 1992
Basel Fairgrounds

Wednesday 17

Dale Chihuly
Thru August 16, 1992
Seattle Art Museum

Thursday 18

Friday 19

Saturday 20

Father's Day

Sunday 21

Courtesy of the Seattle Art Museum

Contemporary Art Auction
Impressionist Drawings Auction
Impressionist Paintings Parts I & II
Last week in June, 1992
Sotheby's, London

Monday 22

American Drawings and Watercolors
Thru August 16, 1992
The Baltimore Museum of Art

Tuesday 23

Wednesday 24

Typologies: Nine Contemporary
Photographers
Thru August 23, 1992
San Francisco Museum of Modern Art

Thursday 25

Michael Book/Lois Connor
Thru August 16, 1992
Cleveland Center for Contemporary Art

Friday 26

Saturday 27

Sunday 28

Impressionist & Modern Paintings &
Sculpture (Part I)/Impressionist &
Modern Paintings, Watercolours,
Drawings, Sculpture (Part III)
Christie's, London

Monday 29

Impressionist & Modern
Watercolours & Drawings
Christie's, London

Tuesday 30

July 1992						
S	M	T	W	T	F	S
			1	2	3	4
5	6	7	8	9	10	11
12	13	14	15	16	17	18
19	20	21	22	23	24	25
26	27	28	29	30	31	

June 1992

1	Monday	

 image of sculpture at top

Courtesy of the Hirshhorn Museum and
Sculpture Garden

2 Tuesday

3 Wednesday

4 Thursday

5 Friday

Heide Fasnacht
Thru August 16, 1992
Cleveland Center for Contemporary Art

George Bellows
Thru August 30, 1992
Whitney Museum of American Art, New York

6 Saturday

The Landscape in Twentieth-Century
Art: Selections from
The Metropolitan Museum
Thru August 2, 1992
Madison Art Center

William Wegman: Paintings, Drawings,
Photographs & Videotapes
Thru August 16, 1992
Contemporary Arts Museum, Houston

A Dialogue With Nature: Sculpture
in The 70's and 80's
Thru August 23, 1992
The Phillips Collection, Washington, DC

7 Sunday

Design 1935-1965: What Modern
Was, The Liliane & David M. Stewart
Collection
Thru August 2, 1992
The Baltimore Museum of Art

8 Monday

9 Tuesday

Courtesy of Toledo Museum of Art

10 Wednesday

Four Latin American Pioneers of Modern-
ism: Rivera, Torres-Garcia, Lam & Matta
Thru September 7, 1992
Hirshhorn Museum and Sculpture Garden,
Washington, DC

11 Thursday

DOCUMENTA IX

12 Friday

13 Saturday

DOCUMENTA IX
Thru September 20, 1992
Kassel

14 Sunday

Picasso and Things:
The Still Lifes of Picasso
Thru August 23, 1992
Philadelphia Museum of Art

15 Monday

16 Tuesday

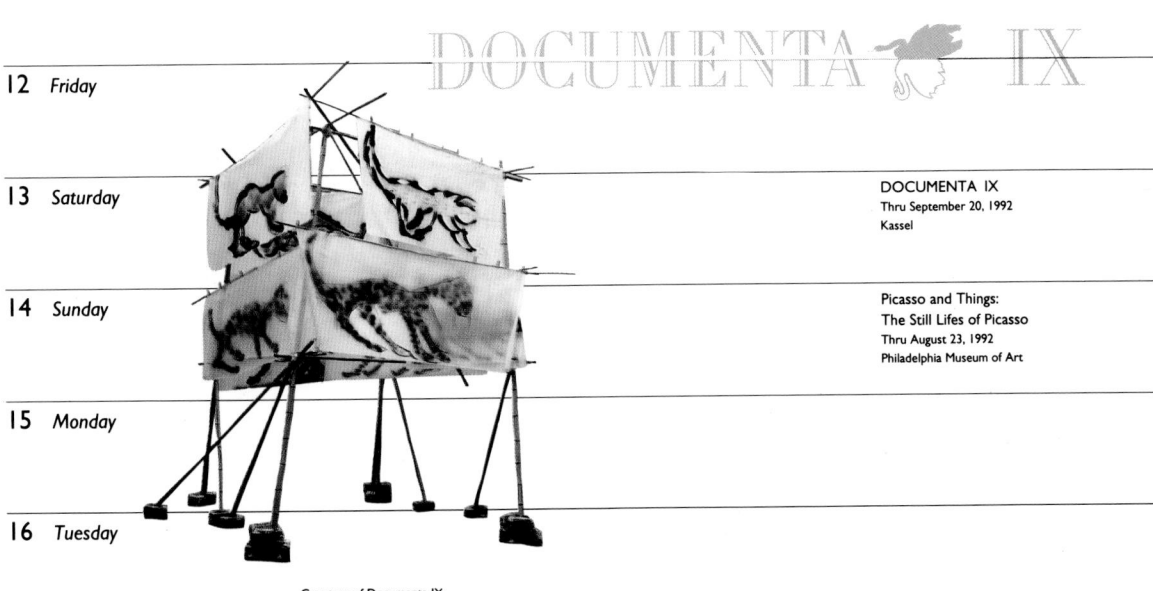

Courtesy of Documenta IX

May 1992

S	M	T	W	T	F	S
					1	2
3	4	5	6	7	8	9
10	11	12	13	14	15	16
17	18	19	20	21	22	23
24/31	25	26	27	28	29	30

The Bleeding Heart:
Contemporary Mexican Art
Mid-May thru Mid-July, 1992
Institute of Contemporary Art, Philadelphia

Sunday 17

Victoria Day (Canada)

Monday 18

Tuesday 19

In Our Times: The World As Seen
by Magnum Photographers
Thru August 2, 1992
Henry Art Gallery, Seattle

Wednesday 20

Thursday 21

Friday 22

Modern Art/Timeless Land:
Twentieth-Century Art and
The American West
Thru July 12, 1992
Boise Art Museum

Beyond Abstract Expressionism
Thru August 16, 1992
Orlando Museum of Art

Saturday 23

Sunday 24

Jerry Uelsman: Images, 1984-1989
May 25 - July 26, 1992
Joslyn Art Museum, Omaha

Memorial Day

Monday 25

Modern & Contemporary Art Auction
Third week in May, 1992
Sotheby's, Amsterdam
Sotheby's, Milan

Tuesday 26

Wednesday 27

Thursday 28

Friday 29

Courtesy of Sotheby's, London

Saturday 30

Sunday 31

June 1992						
S	M	T	W	T	F	S
	1	2	3	4	5	6
7	8	9	10	11	12	13
14	15	16	17	18	19	20
21	22	23	24	25	26	27
28	29	30				

May 1992

1 Friday		Progressive Corporation Exhibition Thru June 14, 1992 Cleveland Center for Contemporary Art	Jana Sterbak: States of Being Thru June 26, 1992 The Contemporary Arts Center, Cincinnati

2 Saturday

3 Sunday

Courtesy of Christie's

Contemporary Mexican Photography
Thru August 9, 1992
Museum of Fine Arts, Houston

4 Monday

Contemporary Art (Part I)
Contemporary Art (Part II)
First Week in May, 1992
Christie's, New York

5 Tuesday

Photographic Images & Related
Material Auction
First week in May, 1992
Sotheby's, London

6 Wednesday

DAI Contemporary Collection
Thru June, 1992
Dayton Art Institute

7 Thursday

8 Friday

Jonathan Borofsky
Thru August 16, 1992
Cleveland Center for Contemporary Art

9 Saturday

10 Sunday

Mother's Day

The Spatial Drive
Thru August 16, 1992
The New Museum of Contemporary Art,
New York

11 Monday

12 Tuesday

13 Wednesday

Power: Its Myths and Mores in
American Culture, 1961-1991
Thru July 12, 1992
Virginia Museum of Fine Arts

Art Chicago
Thru May 18, 1992
Expocenter - Wolf Point, Chicago

14 Thursday

Courtesy of the Chicago International Art Exposition

Chicago International Art Exposition
Thru May 19, 1992
Donnelly Int'l Hall at
McCormick Place, Chicago

15 Friday

Jasper Johns Prints:
Prints and Multiples
Thru August 23, 1992
Milwaukee Art Museum

16 Saturday

Meg Webster With Outside Projects
Thru July 19, 1992
Contemporary Arts Museum, Houston

This Sporting Life, 1878-1991
Thru September 13, 1992
High Museum of Art, Atlanta

Jacob Lawrence
Thru August 2, 1992
The Art Institute of Chicago

Courtesy of the Chicago International
Art Exposition

Devil on The Stairs: Looking Back on The Eighties Thru June 21, 1992 Newport Harbor Art Museum, Newport Beach	Good Friday	Friday	17
First Day of Passover		Saturday	18
Alexis Smith Thru July 5, 1992 The Museum of Contemporary Art, Los Angeles	Easter	Sunday	19
Fine Photographs Auction Butterfield & Butterfield, Los Angeles & San Francisco	Easter Monday (Canada)	Monday	20
		Tuesday	21
		Wednesday	22

Courtesy of Butterfield & Butterfield

	Thursday	23
	Friday	24
I Dream A World: Portraits of Black Women Who Changed America Thru June 28, 1992 Joslyn Art Museum, Omaha	Saturday	25
Prints Auction Butterfield & Butterfield, Los Angeles & San Francisco	Sunday	26
Contemporary Paintings Auction Butterfield & Butterfield, Los Angeles & San Francisco	Monday	27
Modern & Contemporary Paintings Auction April 28 or May 7, 1992 Edmund Peel & Asociados, Madrid	Tuesday	28
	Wednesday	29
Richard Prince Thru July 10, 1992 Whitney Museum of American Art, New York	Thursday	30

May 1992						
S	M	T	W	T	F	S
					1	2
3	4	5	6	7	8	9
10	11	12	13	14	15	16
17	18	19	20	21	22	23
24/31	25	26	27	28	29	30

April 1992

1	Wednesday		Frieda Kahlo: Photographs by Lola Alvarez Bravo Thru June 30, 1992 The Albuquerque Museum of Art
2	Thursday		Works on Paper '92 April 3-5, 1992; Preview April 2 Seventh Regiment Armory, New York
3	Friday	Off The Wall Thru May 3, 1992 Cleveland Center for Contemporary Art	American Dream House: Changing The Model Thru July 18, 1992 The Contemporary Arts Center, Cincinnati
4	Saturday		Modern & Contemporary Paintings Early April, 1992 Phillips Fine Art Auctioneers, London
5	Sunday		Raymond Saunders Thru June 14, 1992 Tampa Museum of Art
6	Monday		
7	Tuesday		
8	Wednesday		The Social and Political Meaning of Montage Thru June 22, 1992 The Institute of Contemporary Art, Boston
9	Thursday		
10	Friday		
11	Saturday		Abstract Sculpture in America: 1930-1970 Thru June 7, 1992 Terra Museum of American Art, Chicago
12	Sunday	Palm Sunday	Baltimore Contemporary Print Fair 1992 One Day Only The Baltimore Museum of Art
13	Monday		Print Auction Sotheby's, Tokyo
14	Tuesday		
15	Wednesday		
16	Thursday		

Courtesy of Sotheby's, Toyko

March 1992
S	M	T	W	T	F	S
1	2	3	4	5	6	7
8	9	10	11	12	13	14
15	16	17	18	19	20	21
22	23	24	25	26	27	28
29	30	31				

Oleg Kudryashov Leon Golub Mid-March thru May 3, 1992 Institute of Contemporary Art, Philadelphia	St. Patrick's Day		Tuesday	17
Tokyo Art Expo Thru March 22 The Tokyo International Trade Center			Wednesday	18
ART/London 92, The 7th International Contemporary Art Fair Thru March 22, 1992	Joan Mitchell Pastels Thru June 21, 1992 Whitney Museum of American Art, New York		Thursday	19
'92 Seoul International Arts & Craft Fair Thru March 24, 1992 KOEX Center, Pacific Main Hall, Seoul			Friday	20
Elaine de Kooning Thru May 3, 1992 Georgia Museum of Art			Saturday	21
Ann Hamilton/David Ireland Thru June 14, 1992 Walker Art Center, Minneapolis			Sunday	22
Contemporary Art Auction Impressionist Paintings & Drawings Auction Last week in March, 1992 Sotheby's, London			Monday	23
Arman Retrospective Spring, 1992 The Detroit Institute of Arts			Tuesday	24
			Wednesday	25
Contemporary Art Auction Christie's, London	Stuart Davis March 26 - June 7, 1992 San Francisco Museum of Modern Art		Thursday	26
Art Frankfurt Thru March 31, 1992 Frankfurt Fairgrounds, Frankfurt	Impressionist & Modern Paintings & Sculpture Auction Christie's, London	Jin Soo Kim Thru June 7, 1992 The Brooklyn Museum	Friday	27
Joseph Beuys: Thinking Is Form Thru June 14, 1992 Philadelphia Museum of Art			Saturday	28
			Sunday	29
Contemporary Prints Late March, 1992 Phillips Fine Art Auctioneers, London			Monday	30
Photographs by Helen Levitt: A Retrospective Thru June 28, 1992 Metropolitan Museum of Art, New York			Tuesday	31

Courtesy of the Tokyo Art Expo

Courtesy of the Institute of Contemporary Art

April 1992						
S	M	T	W	T	F	S
			1	2	3	4
5	6	7	8	9	10	11
12	13	14	15	16	17	18
19	20	21	22	23	24	25
26	27	28	29	30		

1 Sunday

2 Monday

3 Tuesday

4 Wednesday Ash Wednesday

5 Thursday

6 Friday

7 Saturday

8 Sunday

Courtesy of the Museum of Fine Arts

George Krause: Universal Issues
Thru May 17, 1992
Museum of Fine Arts, Houston

Max Weber:
The Cubist Decade 1910-1920
Thru May 3, 1992
Museum of Fine Arts, Houston

9 Monday

10 Tuesday

Soviet Propaganda Plates from
The Tuber Collection
Thru May 27, 1992
The Art Institute of Chicago

11 Wednesday

12 Thursday

13 Friday

Paul Strand
Thru May 24, 1992
Whitney Museum of American Art, New York

Richard Artschwager Multiples
Thru May 24, 1992
Cleveland Center for Contemporary Art

NICAF Yokohama '92-International
Contemporary Art Fair
Thru March 17
Exhibition Hall at Pacifico Yokohama, Tokyo

14 Saturday

Four Contemporary
Washington Artists
Thru May 17, 1992
The Phillips Collection, Washington, DC

Robert Rauschenberg: Abstract
Art and Imagist Prefigurations from
The Early 50's
Thru August 2, 1992
San Francisco Museum of Modern Art

Jasper Johns Prints
Thru May 17, 1992
Orlando Museum of Art

15 Sunday

Nancy Burson: The Age Machine
Thru May 3, 1992
Contemporary Arts Museum, Houston

Courtesy of Orlando Museum of Art

16 Monday

February 1992						
S	M	T	W	T	F	S
						1
2	3	4	5	6	7	8
9	10	11	12	13	14	15
16	17	18	19	20	21	22
23	24	25	26	27	28	29

Songs of My People
Thru May 3, 1992
The Corcoran Gallery of Art,
Washington, DC

Washington's Birthday (Observed)

Monday 17

Tuesday 18

Wednesday 19

Thursday 20

Friday 21

Art That Works
Thru April 19, 1992
Dayton Art Institute

Saturday 22

Made in Florida
Thru April 12, 1992
Samuel P. Harn Museum of Art, Gainesville

Sunday 23

Monday 24

Romare Bearden
Thru May 3, 1992
High Museum of Art, Atlanta

Tuesday 25

The Art Show
Preview February 26
Show-February 27 - March 2, 1992;
Seventh Regiment Armory, New York

Wednesday 26

Thursday 27

Courtesy of The Art Show

Petah Coyne
Abstract Painting Today
Thru April 21, 1992
Cleveland Center for Contemporary Art

Photostroika: New Soviet Photography
Thru April 5, 1992
Crocker Art Museum, Sacramento

Friday 28

Saturday 29

Courtesy of Cleveland Center for
Contemporary Art

March 1992						
S	M	T	W	T	F	S
1	2	3	4	5	6	7
8	9	10	11	12	13	14
15	16	17	18	19	20	21
22	23	24	25	26	27	28
29	30	31				

February 1992

1	*Saturday*			**Sara Diamond (Video)** February, 1992 National Gallery of Canada, Ottawa
2	*Sunday*			**Jackie Winsor** Thru March 29, 1992 Newport Harbor Art Museum, Newport Beach
3	*Monday*			

Courtesy of the Hirshhorn Museum and Sculpture Garden

4	*Tuesday*			**Anne Truitt** Thru April 5, 1992 The Baltimore Museum of Art
5	*Wednesday*			**Martin Puryear** Thru May 10, 1992 Hirshhorn Museum and Sculpture Garden, Washington, DC
6	*Thursday*			**Passage of The Image** Thru April 12, 1992 San Francisco Museum of Modern Art
7	*Friday*			**The Duane Michals Show** Thru April 5, 1992 Milwaukee Art Museum
8	*Saturday*			**Ronald Bladen: Early and Late** Thru April 13, 1992 Vancouver Art Gallery
9	*Sunday*			**Africa Explores:** **20th-Century African Art** Thru April 5, 1992 Dallas Museum of Art
10	*Monday*			**The Green House by Sandy Skoglund** Thru April 12, 1992 Tampa Museum of Art
11	*Tuesday*			

Courtesy of University of California,
University Art Museum, Berkley

12	*Wednesday*			**Lincoln's Birthday**
13	*Thursday*		**Drawing Now: New Spaces** Thru May 5, 1992 The Museum of Modern Art, New York	**ARCO '92 Madrid** Thru February 22, 1992 Madrid
14	*Friday*	**Joe Andoe/April Gornik** Thru March 29, 1992 Cleveland Center for Contemporary Art	**South Bronx Hall of Fame:** **Sculpture by John Ahearn** Thru April 18, 1992 The Contemporary Arts Center, Cincinnati	**Valentine's Day** **Terry Winters** Thru May 3, 1992 Whitney Museum of American Art, New York
15	*Saturday*			**Childe Hassam** Thru May 30, 1992 Cedar Rapids Museum of Art
16	*Sunday*			**In Our Time: The World As Seen** **by Magnum Photographers** Thru April 12, 1992 The Toledo Museum of Art

January 1992

S	M	T	W	T	F	S
			1	2	3	4
5	6	7	8	9	10	11
12	13	14	15	16	17	18
19	20	21	22	23	24	25
26	27	28	29	30	31	

Moshe Kupferman Thru March 1, 1992 Albright-Knox Art Gallery, Buffalo	William Turnbull: A Regional Perspective Thru March 28, 1992 The Contemporary Arts Center, Cincinnati	*Friday*	**17**
Bert L. Long Jr.: Looking and Seeing in Rome Thru March 1, 1992 Contemporary Arts Museum, Houston	Power: Its Myths and Mores in American Culture, 1961-1991 Thru March 22, 1992 Akron Art Museum	*Saturday*	**18**
		Sunday	**19**
		Monday	**20**
		Tuesday	**21**
Ann Hamilton Thru April 5, 1992 Henry Art Gallery, Seattle		*Wednesday*	**22**

The 2nd Annual Tokyo
International Art Show '92
Thru January 28
The Tokyo International Trade Center

William Wegman
Thru April 19, 1992
Whitney Museum of American Art
New York

Thursday **23**

Arte Fiera '92
International Fair of Contempoary Art
Thru January 27, 1992
Bologna

Friday **24**

Richard Pousette-Dart:
Works on Paper
Thru April 26, 1992
The Phillips Collection, Washington, DC

Saturday **25**

Sunday **26**

Courtesy of The Institute of Contemporary Art

Monday **27**

Tuesday **28**

Wednesday **29**

Thursday **30**

Courtesy of the San Diego Museum
of Contemporary Art

Anish Kapoor
Thru June 30, 1992
San Diego Museum of Contemporary Art

Friday **31**

February 1992						
S	M	T	W	T	F	S
						1
2	3	4	5	6	7	8
9	10	11	12	13	14	15
16	17	18	19	20	21	22
23	24	25	26	27	28	29

January 1992

1	Wednesday	New Year's Day Martin Luther King's Birthday (Observed)

2	Thursday	Noboru Tsubaki January, 1992 (Date Tentative) San Diego Museum of Contemporary Art

3 Friday

4 Saturday

5 Sunday

Courtesy of The First Los Angeles Photographic
Print Exposition

6 Monday

7 Tuesday

8 Wednesday

Art Miami
Thru January 12, 1992
Miami Beach Convention Center

9 Thursday

I Dream A World: Portraits of Black
Women Who Changed America
Thru February 16, 1992
The Arkansas Arts Center

10 Friday

Courtesy of Art Miami

Calum Colvin
Thru March 15, 1992
San Francisco Museum of Modern Art

The First Los Angeles Photographic
Print Exposition
Thru January 12
Butterfield & Butterfield, Los Angeles

11 Saturday

12 Sunday

Dennis Oppenheim: And The Mind
Grew Fingers—Retrospective
Thru March 8, 1992
P.S.1 Museum, New York

13 Monday

14 Tuesday

15 Wednesday

Alfredo Jaar
Thru April 12, 1992
The New Museum of Contemporary Art,
New York

16 Thursday

Courtesy of The New Museum of
Contemporary Art

Bill Viola: Slowly Turning Narrative
Three Sculptors: Investigations in Clay
Mid-January thru March 8, 1992
Institute of Contemporary Art, Philadelphia

December 1991

S	M	T	W	T	F	S
1	2	3	4	5	6	7
8	9	10	11	12	13	14
15	16	17	18	19	20	21
22	23	24	25	26	27	28
29	30	31				

Tom Arndt and Jeff Jacobsen Thru March 8, 1992 San Francisco Museum of Modern Art	Tuesday	17
	Wednesday	18
Helen Levitt: A Retrospective Exhibition Thru March 15, 1992 San Francisco Museum of Modern Art	Thursday	19
	Friday	20
Contemporary German Art Thru February 23, 1992 Harvard University Art Museums	Saturday	21
	Sunday	22
	Monday	23
	Tuesday	24
Christmas	Wednesday	25
Boxing Day (Canada)	Thursday	26
	Friday	27
	Saturday	28
	Sunday	29
	Monday	30
	Tuesday	31

January 1992						
S	M	T	W	T	F	S
			1	2	3	4
5	6	7	8	9	10	11
12	13	14	15	16	17	18
19	20	21	22	23	24	25
26	27	28	29	30	31	

December 1991

1	Sunday		Constructing Images: Synapse Between Photography and Sculpture Thru January 19, 1992 Tampa Museum of Art	
2	Monday	First Day of Hanukkah	Impressionist & Modern Paintings & Sculpture (Part I)/Impressionist & Modern Paintings, Watercolours, Drawings & Sculpture (Part III) Christie's, London	
3	Tuesday	Impressionist Paintings Part I Sotheby's, London	Impressionist & Modern Watercolours & Drawings/Impressionist & Modern Paintings & Sculpture (Part II) Christie's, London	
4	Wednesday	Modern & Contemporary Paintings and Contemporary Prints Auctions Early December, 1991 Phillips Fine Art Auctioneers, London	Impressionist Drawings Impressionist Paintings Part II & Watercolours Sotheby's, London	
5	Thursday	Southeast Bank Collects: A Corporation Views Contemporary Art Thru February 9, 1992 Samuel P. Harn Museum of Art, Gainesville	Prints Auction Contemporary Art Auction Sotheby's, London	Contemporary Art Auction Christie's, London
6	Friday		Roger Mertin: Tannenbaum Series Thru February 2, 1992 National Gallery of Canada, Ottawa	
7	Saturday	The Abstract Tradition in American Art Thru February 23, 1992 Des Moines Art Center	Mixing The Medium: Beyond Silver Photographs Thru February 2, 1992 Harvard University Art Museums	
8	Sunday			
9	Monday		Jim Dine Thru February 2, 1992 Cedar Rapids Museum of Art	
10	Tuesday		Max Weber: The Cubist Decade, 1910-1920 Thru February 9, 1992 High Museum of Art, Atlanta	
11	Wednesday		Impressionist, Modern & Contemporary Paintings & Sculpture Sotheby's, Amsterdam	
12	Thursday			
13	Friday			
14	Saturday			
15	Sunday		The Landscape in Twentieth-Century Art: Selections from The Metropolitan Museum Thru February 8, 1992 Tampa Museum of Art	
16	Monday			

Courtesy of the High Museum of Art

November 1991

S	M	T	W	T	F	S
					1	2
3	4	5	6	7	8	9
10	11	12	13	14	15	16
17	18	19	20	21	22	23
24	25	26	27	28	29	30

Arman 1955-1990: A Retrospective Thru February 2, 1992 Museum of Fine Arts, Houston		*Sunday* 17	
Art of The Eighties Thru December, 1991 Institute of Contemporary Art, Philadelphia		*Monday* 18	
		Tuesday 19	
ART/LA The 6th International Contemporary Art Fair November 20 - 24, 1991 Los Angeles Convention Center		*Wednesday* 20	
Modernism Thru November 24, 1991; Preview November 20 Seventh Regiment Armory, New York		*Thursday* 21	

Alexis Smith
Thru February 29, 1992
Whitney Museum of American Art,
New York

Adrian Piper
Thru February 7, 1992
Cleveland Center for Contemporary Art

Friday 22

Interrogating Identity
Thru February 23, 1992
Walker Art Center, Minneapolis

Stuart Davis, American Painter
Thru February 16, 1992
Metropolitan Museum of Art, New York

Tony Cragg: Sculpture 1975-1990
Thru February 9, 1992
Contemporary Arts Museum, Houston

Saturday 23

Balcomb Greene
Thru January 26, 1992
Tampa Museum of Art

Sunday 24

Monday 25

The Interrupted Life
Thru December 29, 1991
The New Museum of Contemporary Art,
New York

Tuesday 26

Wednesday 27

Modern & Contemporary Paintings Auction
Edmund Peel & Asociados, Madrid

Thanksgiving Day

Thursday 28

Courtesy of The New Museum of Contemporary Art

A Dialogue with Tradition:
Six Contemporary Native American Artists
Thru January 27, 1992
The Brooklyn Museum

Friday 29

Objects of Myth and Memory: American
Indian Art at The Brooklyn Museum
Thru December 29, 1991
The Brooklyn Museum

Saturday 30

November 1991

Courtesy of The Print Fair

1 *Friday*		The Print Fair Thru November 3, 1991 Seventh Regiment Armory, New York	Lee Friedlander: Nudes Thru January 5, 1992 San Francisco Museum of Modern Art
2 *Saturday*		Martin Puryear Thru January 5, 1992 The Art Institute of Chicago	Lineart Gent Thru November 10, 1991 Flanders Expo, Gent
3 *Sunday*			Viewpoints: Jac Leirner Thru February 9, 1992 Walker Art Center, Minneapolis
4 *Monday*			Old Master, Contemporary, American and Modern Prints, and Illustrated Books Auction November 4-5, 1991 Christie's, New York
5 *Tuesday*		Election Day	Impressionist & Modern Paintings & Sculpture (Part I) Admission is by ticket only. Christie's, New York
6 *Wednesday*			Impressionist & Modern Drawings and Watercolors Auction/Impressionist & Modern Paintings & Sculpture (Part II) Christie's, New York
7 *Thursday*	Courtesy of Christie's, New York		Alfredo Jaar Works Thru March 29, 1992 Hirshhorn Museum and Sculpture Garden, Washington, DC
8 *Friday*			Seven Master Print-Makers: Innovations in The 1980's Thru January 4, 1992 Center for The Fine Arts, Miami
9 *Saturday*			Ansel Adams: The American Wilderness Thru January 5, 1992 New Orleans Museum of Art
10 *Sunday*		Paul Strand Thru January 12, 1992 Museum of Fine Arts, Houston	John Baldessari Thru January 19, 1992 Musée D'art Contemporain De Montreal
11 *Monday*			
12 *Tuesday*		European & American Paintings Auction Butterfield & Butterfield, Los Angeles	Contemporary Art (Part I) Admission is by ticket only. Christie's, New York
13 *Wednesday*			Contemporary Art (Part II) Christie's, New York
14 *Thursday*		In The Spirit of Modernism Thru February 2, 1992 San Francisco Museum of Modern Art	Alexander Calder Thru February 2, 1992 Whitney Museum of American Art, New York
15 *Friday*			Donald Lipski Ritzy Business Thru February 1, 1992 The Contemporary Arts Center, Cincinnati
16 *Saturday*			A Celebration of American Ideals: Paintings from The Brooklyn Museum Thru January 5, 1992 Albright-Knox Art Gallery, Buffalo

Courtesy of Christie's, New York

Courtesy of the Whitney Museum of American Art

October 1991						
S	M	T	W	T	F	S
		1	2	3	4	5
6	7	8	9	10	11	12
13	14	15	16	17	18	19
20	21	22	23	24	25	26
27	28	29	30	31		

1992 SEASON - CALENDAR OF EVENTS

CALENDAR

CALENDAR

INTRODUCTION

Welcome to the inaugural edition of *The Fine Art Index*.

The Fine Art Index was created to help both the sophisticated collector and the new enthusiast to spend less time searching for great art and more time enjoying it.

In nearly 700 case bound pages, *The Fine Art Index* provides a comprehensive look into the aesthetic and business perspectives of the contemporary art world.

First, you will discover an unprecedented collection of art from the finest galleries across North America. In over 1,000 museum quality, full-color reproductions, *The Fine Art Index* showcases work from both established and emerging artists in a format that allows the art to speak for itself. To enhance your enjoyment, each piece of art is described and each artist is profiled in a special biography section of the book.

Second, *The Fine Art Index* serves as an invaluable source of information concerning the mechanics of enjoying and collecting contemporary art. The book features such useful tools as:

> An art world desk calendar with expo, auction and major museum exhibition dates identified.

> Museum and gallery exhibition schedules spanning the current and future art seasons.

> Gallery and artist listings with primary and secondary market representation clearly identified.

> 21 metropolitan area gallery maps identifying galleries, museums and other points of interest.

Finally, *The Fine Art Index* provides extensive cross-referencing to make search for information simple and effective.

We at International Art Reference are extremely proud of this inaugural edition and hope that you share our enthusiasm.

There is always room for improvement and so we encourage your comments on how to enhance *The Fine Art Index*. Our promise in return is to make the second edition even better than the first.

Sincerely,

N. David Shiba
Publisher

CONTENTS

CREDITS

Publisher:
N. David Shiba

Editor/ Director of Marketing:
Kathryn A. Lappin

Editorial Assisstant:
Julie E. Messick

Marketing Assistant:
Tracy L. Surufka

Director of Finance and Administration:
Kristina M. Linquist

Administrative Assistant:
Juliane Schwendau

Director of Production:
William Lai

National Account Representatives:
Sena Baron
Cynthia M. Callison
Tom Jones

Design:
Fish Eng Partners, Inc.

Cover Art:
Sam Francis

Typography:
Fish Eng Partners, Inc. / InfoComm

Color Separations:
Advance Laser Graphic Art, Hong Kong

Printing / Manufacturing:
Everbest Printing Company, Ltd., Hong Kong
Through Four Colour Imports, Ltd.

International Art Reference, Inc.
Officers:

Paul A. Casper
Chairman and Chief Executive Officer

N. David Shiba
President and Chief Operating Officer

Kristina M. Lindquist
Secretary and Treasurer

Editorial and Advertising Offices:
International Art Reference, Inc.
750 N. Rush Street, Suite 1304
Chicago, Illinois 60610
312.335.8219

The Fine Art Index

1992 NORTH AMERICAN EDITION

INTERNATIONAL
ART REFERENCE

ISBN 0-9629816-0-5

ISSN 1057-8269